P9-DDF-164

ARTS & HUMANITIES
Through the Eras

MONTGOMERY COLLEGE
ROCKVILLE CAMPUS LIBRARY
ROCKVILLE, MARYLAND

ARTS & HUMANITIES
Through the Eras

Renaissance Europe
1300–1600

Philip M. Soergel, Editor

THOMSON

GALE

Detroit • New York • San Francisco • San Diego • New Haven, Conn. • Waterville, Maine • London • Munich

292039

NOV 1 5 2004

THOMSON
GALE

Arts and Humanities Through The Eras: Renaissance Europe (1300–1600)

Philip M. Soergel

Project Editor
Rebecca Parks

Editorial
Danielle Behr, Pamela A. Dear, Jason Everett, Rachel J. Kain, Timothy Sisler, Ralph G. Zerbonia

Editorial Support Services
Mark Springer

Data Capture
Elizabeth Pilette

Indexing Services
Barbara Koch

Imaging and Multimedia
Randy Bassett, Mary K. Grimes, Lezlie Light, Michael Logusz, Kelly A. Quin

Rights and Acquisitions
Margaret Chamberlain, Shalice Shah-Caldwell

Product Design
Michelle DiMercurio

Composition and Electronic Prepress
Evi Seoud

Manufacturing
Wendy Blurton

© 2005 Thomson Gale, a part of the Thomson Corporation.

Thomson and Star Logo are trademarks and Gale is a registered trademark used herein under license.

For more information, contact
Thomson Gale
27500 Drake Rd.
Farmington Hills, MI 48331-3535
Or you can visit our Internet site at
http://www.gale.com

ALL RIGHTS RESERVED
No part of this work covered by the copyright hereon may be reproduced or used in any form or by any means—graphic, electronic, or mechanical, including photocopying, recording, taping, Web distribution, or information storage retrieval systems—without the written permission of the publisher.

This publication is a creative work fully protected by all applicable copyright laws, as well as by misappropriation, trade secret, unfair competition, and other applicable laws. The authors and editors of this work have added value to the underlying factual material herein through one or more of the following: unique and original selection, coordination, expression, arrangement, and classification of the information.

For permission to use material from this product, submit your request via the Web at http://www.gale-edit.com/permissions, or you may download our Permissions Request form and submit your request by fax or mail to:

Permissions Department
Thomson Gale
27500 Drake Rd.
Farmington Hills, MI 48331-3535
Permissions Hotline:
248-699-8006 or 800-877-4253, ext. 8006
Fax: 248-699-8074 or 800-762-4058

Cover photographs by permission of Corbis (seated statue of Pharaoh Djoser) and AP/Wide World Photos ("The Creation of Adam and Eve" detail by Orvieto).

Since this page cannot legibly accommodate all copyright notices, the acknowledgements constitute an extension of the copyright notice.

While every effort has been made to secure permission to reprint material and to ensure the reliability of the information presented in this publication, Thomson Gale neither guarantees the accuracy of the data contained herein nor assumes responsibility for errors, omissions, or discrepancies. Thomson Gale accepts no payment for listing; and inclusion in the publication of any organization, agency, institution, publication, service, or individual does not imply endorsement of the editors or publisher. Errors brought to the attention of the publisher and verified to the satisfaction of the publisher will be corrected in future editions.

LIBRARY OF CONGRESS CATALOGING-IN-PUBLICATION DATA

Arts and humanities through the eras.
 p. cm.
 Includes bibliographical references and index.
 ISBN 0-7876-5695-X (set hardcover : alk. paper) —
 ISBN 0-7876-5696-8 (Renaissance Europe : alk. paper) —
 ISBN 0-7876-5697-6 (Age of Baroque : alk. paper) —
 ISBN 0-7876-5698-4 (Ancient Egypt : alk. paper) —
 ISBN 0-7876-5699-2 (Ancient Greece : alk. paper) —
 ISBN 0-7876-5700-X (Medieval Europe : alk. paper)
 1. Arts—History. 2. Civilization—History.

NX440.A787 2004
700'.9—dc22 2004010243

This title is also available as an e-book.
ISBN 0-7876-9384-7 (set)
Contact your Thomson Gale sales representative for ordering information.

Printed in the United States of America
10 9 8 7 6 5 4 3 2 1

CONTENTS

Contents

ABOUT THE BOOK

SEEING HISTORY FROM A DIFFERENT ANGLE. An education in history involves more than facts concerning the rise and fall of kings, the conquest of lands, and the major battles fought between nations. While these events are pivotal to the study of any time period, the cultural aspects are of equal value in understanding the development of societies. Various forms of literature, the philosophical ideas developed, and even the type of clothes worn in a particular era provide important clues about the values of a society, and when these arts and humanities are studied in conjunction with political and historical events a more complete picture of that society is revealed. This inter-disciplinary approach to studying history is at the heart of the *Arts and Humanities Through the Eras* project. Patterned in its organization after the successful *American Decades, American Eras,* and *World Eras* products, this reference work aims to expose the reader to an in-depth perspective on a particular era in history through the study of nine different arts and humanities topics:

- Architecture and Design
- Dance
- Fashion
- Literature
- Music
- Philosophy
- Religion
- Theater
- Visual Arts

Although treated in separate chapters, the connections between these topics are highlighted both in the text and through the use of "See Also" references to give the reader a broad perspective on the culture of the time period. Readers can learn about the impact of religion on literature; explore the close relationships between dance, music, and theater; and see parallel movements in architecture and visual arts. The development of each of these fields is discussed within the context of important historical events so that the reader can see history from a different angle. This angle is unique to this reference work. Most history books about a particular time period only give a passing glance to the arts and humanities in an effort to give the broadest historical treatment possible. Those reference books that do cover the arts and humanities tend to cover only one of them, generally across multiple time periods, making it difficult to draw connections between disciplines and limiting the perspective of the discipline's impact on a specific era. In *Arts and Humanities Through the Eras* each of the nine disciplines is given substantial treatment in individual chapters, and the focus on one era ensures that the analysis will be thorough.

AUDIENCE AND ORGANIZATION. *Arts and Humanities Through the Eras* is designed to meet the needs of both the beginning and the advanced history student. The material is written by subject experts and covers a vast array of concepts and masterworks, yet these concepts are built "from the ground up" so that a reader with little or no background in history can follow them. Technical terms and other definitions appear both in the

text and in the glossary, and the background of historical events is also provided. The organization of the volume facilitates learning at all levels by presenting information in a variety of ways. Each chapter is organized according to the following structure:

- Chronology covering the important events in that discipline during that era

- Brief overview of the development of that discipline at the time

- Topics that highlight the movements, schools of thought, and masterworks that characterize the discipline during that era

- Biographies of significant people in that discipline

- Documentary sources contemporary to the time period

This structure facilitates comparative analysis, both between disciplines and also between volumes of *Arts and Humanities Through the Eras*, each of which covers a different era. In addition, readers can access additional research opportunities by looking at the "Further References" and "Media and Online Sources" that appear at the back of the volume. While every effort was made to include only those online sources that are connected to institutions such as museums and universities, the web-

sites are subject to change and may become obsolete in the future.

PRIMARY DOCUMENTS AND ILLUSTRATIONS. In an effort to provide the most in-depth perspective possible, *Arts and Humanities Through the Eras* also includes numerous primary documents from the time period, offering a first-hand account of the culture from the people who lived in it. Letters, poems, essays, epitaphs, and songs are just some of the multitude of document types included in this volume, all of which illuminate some aspect of the discipline being discussed. The text is further enhanced by 150 illustrations, maps, and line drawings that bring a visual dimension to the learning experience.

CONTACT INFORMATION. The editors welcome your comments and suggestions for enhancing and improving *Arts and Humanities Through the Eras*. Please mail comments or suggestions to:

The Editor
Arts and Humanities Through the Eras
Thomson Gale
27500 Drake Rd.
Farmington Hills, MI 48331-3535
Phone: (800) 347-4253

CONTRIBUTORS

Philip M. Soergel received the Ph.D. in history from the University of Michigan in 1988, and has been a member of the Department of History at Arizona State University since 1989. There he is responsible for teaching courses on the Renaissance, the Reformation, and early-modern Europe. From 1993–1995, he was a member of the Institute for Advanced Study in Princeton, and he has also held fellowships from the Friedrich Ebert and Woodrow Wilson foundations, the American Philosophical Society, and the National Endowment for the Humanities. He has twice served as a visiting professor at the University of Bielefeld in Germany. Professor Soergel's research interests lie in the history of the Protestant and Catholic Reformations, particularly in their use of miracles as propaganda. His books include *Wondrous in His Saints: Counter-Reformation Propaganda in Bavaria* (California, 1993); the forthcoming, *Miracles and the Protestant Imagination*; and the Baroque volume in Thomson Gale's *Arts and Humanities Through the Eras* series.

ERA OVERVIEW

DATING THE RENAISSANCE. The concept of the Renaissance as a broad cultural renewal in European history that occurred at the end of the Middle Ages has long been used to structure the larger narrative of Western history. This book focuses on developments in the arts, literature, religion, and philosophy between 1300 and 1600—three centuries that saw the rise of distinctive attitudes toward human creativity and its artistic and philosophical expression which shaped our modern notion of the humanities and the arts. The act of dating an historical period is significant in that it often reveals the underlying assumptions of those who establish the dates. Choosing a beginning or ending date for a period often highlights a particular development or event as decisive in producing key changes in the years that follow it. So, for instance, modern historians have often chosen the date 1789, the beginning of the French Revolution, as a decisive turning point leading to the rise of the modern period. In this way dating or naming a period also functions as a kind of intellectual shorthand that allows us to identify key changes that occurred from one period to the next. But in reality all schemes of historical periodization are artificial constructs. Scholars might speak of "nineteenth-century Victorian values," "Cold War mentalities," or "medieval economic realities," but human history itself is a web of events and movements in which what comes before continues to shape what follows. Societies are too varied and complex to be understood completely according to simplistic terminologies, and a time's values or beliefs do not change suddenly with the rise of a new king or political party. So, too, the Renaissance did not sweep away elements of medieval life. Instead it is best conceived as a broad, but sometimes diffuse, cultural renewal that affected the ideas, perceptions, and mentalities particularly of the upper classes and learned elite over a long stretch of European history. The choice of the dates 1300–1600 used in this volume has been largely one of convenience and tradition. Some historians have argued that the Renaissance's beginnings should be dated later, often around 1450; more recently, others have pushed back the rise of Renaissance values into the thirteenth century. The traditional periodization used here has been adopted for several reasons. The date 1300 corresponds roughly to the birth of Francesco Petrarch (1304–1374), a figure long noted as vital to the formation of Renaissance philosophy and literature. The fourteenth century also witnessed the first glimmer of a new naturalism in sculpture and painting, and it saw key changes in fashion and style as well. Although much of the tenor of fourteenth-century life seems traditional and medieval in nature, great economic and social changes were underway in Europe at this time that brought forth a new kind of society and intellectual life. These changes often appear in stark contrast to the relative peace and stability that had prevailed in Europe during the twelfth and thirteenth centuries. Increased famine, economic recession, the enormous catastrophe of the Black Death (1347–1351), as well as a series of great peasant and urban revolts were just a few of the trials that gripped the fourteenth century. From these trials a new set of economic and social realities was born that led to the even greater flowering of art and intellectual culture that occurred in Europe during the fifteenth and sixteenth centuries.

THE END OF THE RENAISSANCE. It is relatively easy to identify forces at work in the fourteenth century that helped to produce renewal in Europe, but the question of when the Renaissance ended is considerably more problematic. It has been argued that the relatively free and tolerant attitude of Renaissance intellectuals began to change with the rise of the Reformation in the first half of the sixteenth century—that the rise of Protestantism and the Counter-Reformation, in other words, led to a gradual eclipse of the Renaissance in the face of a renewed religious intolerance. On the other hand, other scholars have seen key elements of Renaissance intellectual life persisting even into the late seventeenth century, when the rise of science and the early Enlightenment began to alter Europe's high culture once again. There are elements of truth in both of these arguments, although the date of 1600 has again been used for several reasons. It corresponds roughly to the death of Michel de Montaigne (1533–1592), the last great philosopher to be universally recognized as a Renaissance thinker. In 1598, moreover, the promulgation of the Edict of Nantes in France granted a limited degree of religious toleration to French Protestants, a key event in bringing to an end the religious controversies that Montaigne himself decried in much of his writing. Only a few years later, in 1603, Queen Elizabeth I passed away in England, and the period to which she had given her name, the Elizabethan Age, gradually changed as a result of the accession of the Stuart kings and the religious controversies of their reigns. All these factors justify the choice of 1600 as a date that approximates the end of the Renaissance, a date that might, of course, be fixed elsewhere if one relied on different rationale.

CONCEPTUALIZING THE PERIOD. The concept of the Renaissance as a rebirth of culture and intellectual life in Europe has its origins in the period itself, as intellectuals and artists of the time spoke of their time as one of progress and achievement. They contrasted the innovative and inquiring spirit of their days against the "Middle Ages" that preceded them, and in this way they helped give birth to the tripartite division of Western history into the periods of antiquity, the Middle Ages, and the modern world, that has survived ever since their time. Scholarly conceptions of the Renaissance have been greatly influenced by the work of the great Swiss historian Jacob Burckhardt, who published *The Civilization of the Renaissance in Italy* in 1860. In that work, Burckhardt argued that the Renaissance witnessed a great awakening of modern individualism and human creativity, which he first saw emerging in Italy. There the absence of a strong monarch allowed the values of individual

achievement and merit to flourish, creating a society in which rank and status mattered less than a human being's intellect and creativity. While he generally celebrated the growth of individualism in the Renaissance as a positive development in Western history, Burckhardt's admiration for it was not unbounded. The darker side of Renaissance individualism led to the growth of a secular spirit and opened the door to intense egotism and even atheism, developments that Burckhardt saw as the root of problems in his own nineteenth-century Europe. Since Burckhardt's time, scholarship has often assessed the validity of his model, and while certain features of his picture have survived, many have been rejected as projections of his discontent with his own age onto the very different circumstances of the Renaissance. Few scholars would now characterize the beliefs of Renaissance intellectuals as secular, or as in any way connected to the growing atheism of the nineteenth century. Instead they recognize that the Renaissance represented a curious amalgam of medieval and innovative elements. While they agree with Burckhardt that the Renaissance was a period of outstanding artistic, literary, and intellectual creativity, they have also demonstrated that these forces were at work within the constraints of a society that was often conservative and highly traditional in nature.

THE REVIVAL OF ANTIQUITY. The love of precedent and custom expressed itself in the Renaissance world in a deep and abiding affection for the culture of ancient Rome and Greece. During the fourteenth century, figures like Petrarch and Boccaccio reached out to the ancient world in search of values and philosophies that might help them negotiate the problems of living in an urban world. Ancient philosophy and literature had never disappeared from the Latin world of medieval Europe, but the scholars of the Middle Ages had often considered the writings of the ancients like a database of factual information and insights that might be applied to problems of Christian theology and the law. Renaissance humanism, by contrast, embraced antiquity as an inspiration for resolving ethical and moral dilemmas and for creating a philosophy that might foster virtuous living. The word "humanism" itself was a nineteenth-century creation that described those Renaissance scholars who practiced the *studia humanitatis* or "humane studies," the origin of our modern notion of the humanities. While there was no creed or manifesto to which all these scholars subscribed, the humanists were united by a distaste for what they considered the logical and arid theorizing of scholasticism, the dominant intellectual movement of the medieval church. In place of the

scholastic curriculum, which emphasized logic, the humanists tried to create a philosophy that provided an ethical standard for living. The disciplines the humanists championed differed from place to place and across time, but most often humanists identified these studies as rhetoric (the art of graceful speaking and writing), moral philosophy, grammar, history, and poetry, perceiving the language arts as the primary keys to virtue. Beyond humanism's advocacy of a common curriculum, it remains difficult to generalize about the character of this movement. There were civic humanists, who concentrated their efforts on exploring the arts of government and civic involvement; humanists influenced by ancient Stoic philosophers, who argued that virtuous human beings should avoid social entanglements and develop an indifference to the world; and still other scholars who revived the ideas of Plato and used these to create a mystical philosophy that might join the human soul with God. Other forms of humanism also flourished in the Renaissance, and these are discussed in the pages that follow. While they attacked the methods of scholastic philosophy that prevailed in the European universities at the time, humanists could not avoid considering many of the same logical problems the scholastics had tackled in their works. Thus humanism and scholasticism shared many common concerns. At the same time the rivalry between the two movements was often intense, with the humanists attacking the scholastics' method of logical argumentation as "childish prattling" and "logic-chopping." By contrast, they argued that their goal of creating more virtuous human beings was far more important. Petrarch summarized these sentiments in the fourteenth century when he wrote, "It is better to will the good, than to understand truth." In choosing the word "truth," the fourteenth-century philosopher had in mind the scholastics' attempt to prove Christianity's teachings logically. For humanists like Petrarch, such attempts fell far short of the greater task of making Christianity's teachings relevant as a force of moral renewal.

CHRISTIANITY AND HUMANISM. In his *Civilization of the Renaissance in Italy* Burckhardt argued that secular values triumphed in the Renaissance world, a notion that has long been rejected by the scholars who followed him. Since Burckhardt's day, a long line of historians has called attention to the Christian roots of humanism and restored its character as an orthodox movement within Christianity. Indeed one prominent American scholar, Charles Trinkaus (1911–2000), demonstrated that humanism might best be conceived as a long Christian discourse on the concept of human creativity and its divine origins. Trinkaus agreed with Burckhardt that the Re-

naissance world saw an unparalleled growth in Western individualism. At the same time he called attention to the many humanists' discussions of mankind's creation in God's likeness, a Jewish and Christian teaching rooted in the scriptures. Humanist philosophers frequently considered the attributes human beings shared as a result of their creation in God's image, identifying language, poetry, music, and the arts as proof of the human race's divine origins. As the Renaissance progressed, the search for these signs of divinely inspired creativity grew more intense, and the exploration of ancient philosophy deepened, efforts that reached a high point in the movement known as Renaissance Platonism. This intellectual creed became attractive to many scholars and artists during the late fifteenth and sixteenth centuries. Renaissance Platonists like Marsilio Ficino (1433–1499) and Giovanni Pico della Mirandola (1463–1494) attempted to harmonize the ancient philosophy of Plato with the Christianity of their day. In works like his *Oration on the Dignity of Man* Pico celebrated human creativity and the arts in some of the most extravagant and optimistic terms ever used in the Western tradition. The larger goal of these explorations of human creativity was to identify ways in which the human soul might achieve mystical union with God. To achieve these ends, the Platonists embraced astrology, poetry, music, the visual arts, metaphysics, and many occult philosophies. The emphasis they placed on the arts, however, had a definite impact in fostering a distinctive Renaissance notion of human creativity as divinely inspired. Michelangelo Buonarroti and Sandro Botticelli were just a few of the many Renaissance artists who tried to give visual expression to many Platonic teachings, while more generally, the notion of artistic inspiration as divine is to be found in many Renaissance writings.

HUMANISM AS A PROFESSION. During the fifteenth century humanist investigations of ancient philosophy deepened, and humanists themselves emerged as a professional group in Renaissance Italy. At this time many humanists found employment in Italy's princely courts or in its cities. The most prized and rare positions of the day were as scholars-in-residence and tutors in princely courts and in the households of Italy's wealthiest merchants, situations that provided the humanist scholars with a large amount of free time to pursue their scholarship. The Medici family, the behind-the-scenes manipulators of Florence's fifteenth-century political scene, were just one of many Italian families who supported humanist scholars in this way. Among the many figures they brought under their patronage in the fifteenth century were Marsilio Ficino and the distinguished Latinist

Angelo Poliziano (1454–1494). Humanists also found employment as secretaries in the growing state bureaucracies of Italy. Towns and princes prized these intellectuals for their mastery of the skills of graceful speaking and writing, and many humanists rose to powerful positions of authority in Italy's governments. They often became ambassadors, entrusted with representing Italy's states in diplomatic negotiations. The church also nourished humanism, as many humanists were members of monastic orders, or some took priestly vows and found employment in ecclesiastical government. At Rome, there were many humanists employed in the papal court and in the households of cardinals and other church officials. The fashion for humanism at Rome grew throughout the fifteenth century, intensifying especially after the election of the humanist Pope Nicholas V (r. 1447–1455), who assured the city a lasting role in the movement by founding the Vatican Library in 1450. This institution played a key role in furthering scholarship in the humanities over the following centuries. Of all Italy's institutions, the universities proved most resistant to the new educational movement, a mark of the ongoing rivalry between humanists and scholastics. But even in academia, humanists began to make inroads by securing a number of appointments by the later fifteenth century.

INCREASING SCHOLARLY SOPHISTICATION. As humanism spread as an important intellectual movement, it acquired greater sophistication in dealing with language and history. During the fourteenth century new investigations of ancient Latin showed that the language had changed greatly over time, and in the work of Lorenzo Valla (1407–1457) a new discipline known as philology emerged. Philology, the historical study of literature and language, allowed scholars to date anonymous and disputed texts by examining the words, phrases, and syntax used in these documents. Although he had the support of the papacy as a scholar, Valla did not shy away from controversy. In several treatises he took on ancient claims of the church. In one of his works, for instance, he demonstrated that the *Donation of Constantine*, a document that had long been alleged to have been written by the fourth-century Roman emperor Constantine, was a forgery. Valla examined the language of the text and showed that it could not have been written earlier than the late eighth century. The papacy had long relied on this document to support its claims to secular power in Western Europe, and in this way, Valla challenged one of the church's sources of authority. His investigations into language also resulted in an important work, *The Elegancies of the Latin Language*, a grammar and stylistic manual that showed scholars how

to master the ancient Latin of the Golden Age. Valla's defense of pure Latin style had the enthusiastic support of many humanists in the fifteenth century, and the ability to write and to speak a grammatically correct ancient Latin became a mark of social distinction among Italy's elites. Other developments in fifteenth-century humanism allowed for scholars to judge the authenticity of various texts, as well as to date their origins. As scholars at the time studied ancient writings more thoroughly than before, they realized that there were frequently many variant editions of key texts. At Florence, Angelo Poliziano developed scholarly methods for establishing the authenticity of variant versions of a text, and for establishing which version was the earliest and hence likely the most authoritative. In the development of these techniques humanism played an important role in developing more critical forms of historical analysis.

THE MOVEMENT SPREADS. After 1450, the techniques and disciplines that the humanists had developed began to spread beyond Italy's borders, particularly to Germany, the Netherlands, England, Spain, and France. The character of humanism in northern Europe differed from place to place, but nevertheless shared certain similarities. Often humanists outside Italy pursued the mystical, magical, and artistic investigations of Renaissance Platonism. At the same time study of the Bible and the early church fathers was popular among Northern Renaissance scholars. As they studied the Bible, many humanists realized that the Latin translation that had long been used in medieval Europe, the Vulgate, had been seriously flawed with many mistranslations. By the early sixteenth century humanists like Desiderius Erasmus, John Guillaume Budé, and Jacques Lefèvre d'Étaples devoted themselves to biblical study and to correcting the Vulgate's errors. At the same time Northern Renaissance humanists championed the cause of reform in the church and the ethical renewal of society. Here Erasmus' brand of "Christian humanism" was particularly important, and the teachings of this greatest scholar of the Northern Renaissance influenced the demands of Protestant reformers like Martin Luther, Ulrich Zwingli, and John Calvin, although Erasmus and many of his fellow humanists remained loyal to the church. While scholars have sometimes seen an increasingly intolerant attitude developing toward humanism in the wake of the Protestant Reformation, more recent research has called attention to the ways in which the movement's educational concerns survived to be accommodated within new Protestant and Catholic schools and their curricula. It is true that the tenor of debate the Reformation and Counter Reformation produced sometimes resulted in

new repressive measures that outlawed the critical and inquiring spirit the humanists had championed in the previous centuries. At the same time, humanism as a scholarly method survived and was transformed in the later sixteenth century to become one of the most visible legacies of the Renaissance. Its techniques and discoveries were transmitted to the seventeenth-century Baroque world, where an even more disciplined and scientific examination of ancient literature, science, and history developed.

HUMANISM'S INFLUENCE ON THE ARTS. As a movement, Renaissance humanism was broad and diffuse, factors that still make it difficult for historians to summarize today. At the same time its close affiliation with and influence on the arts of the Renaissance has never been in doubt. Humanists like Petrarch and Boccaccio wrote great literary works that inspired later painters and sculptors, even as both these figures' studies of ancient literature and mythology continued to inspire later artists. Until the seventeenth century the humanist Boccaccio's *Genealogy of the Pagan Gods* (1350–1373) served as a kind of textbook for artists seeking to depict mythological themes. The alliance between the visual arts and humanism, however, ran deeper than just a preference for ancient themes. In Italian Renaissance cities artists mingled freely with humanists, acquiring a familiarity with the movement and its various philosophies. The great families of the era often appointed their own resident artists, even as they kept philosophers at work in their libraries and households. Michelangelo was for a time a student in the Medici household in Florence, where he acquired more than a passing familiarity with Renaissance Platonism, the dominant philosophy of the city's humanists in the late fifteenth century. In his subsequent works as a sculptor and a painter, Michelangelo labored to give visual expression to many of the Platonic ideals he had acquired in his youth. Michelangelo's education in the Medici household was one of the more extraordinary examples of the links that developed in the Renaissance between art and learning. Yet many similar, if perhaps less dramatic ties between the visual arts and humanism appear throughout the fifteenth and sixteenth centuries. In architecture, humanism's influence is readily visible in the revival of ancient styles that began in the early fifteenth century and continued through the sixteenth. Humanist scholars studied the proportions and building techniques of ancient architects like Vitruvius, often translating these works into Italian, and the designers of the time enthusiastically read and studied these new vernacular editions. During the fifteenth and sixteenth centuries Italian archi-

tects labored to clothe the medieval cityscapes of towns like Florence, Siena, Rome, and Venice with a new veneer of classicism that gave visual expression to the new humanist ethos. Many of these buildings became vehicles for conveying philosophical truths. In designing them, architects often relied on proportions, shapes, and numerical relationships that carried with them a philosophical message. The fashion for round structures and for churches constructed in a central style with equal radiating arms were two styles whose origins can be traced to the influence of humanism, and more particularly to Renaissance Platonism. In these and many other ways, works of Renaissance art expressed the philosophical viewpoints of learned elites and the wealthy merchants and princes who commissioned them.

STATUS OF THE ARTIST. Another byproduct of the ties between art and humanism was a rise in the social status of artists. In 1300, artists were considered craftspeople, and were usually members of urban craft guilds. Italy and northern Europe continued to produce many figures that enjoyed modest reputations as craftsmen, and artists' affiliations with the guilds largely survived intact throughout the period. At the same time the most accomplished painters, sculptors, architects, composers, and dancers enjoyed considerable reputations for their ability to create, and the modern notion of the artist as an individual charged with a powerful and unique vision began to emerge. This transformation can be seen in the voluminous notebooks that Leonardo da Vinci and Michelangelo kept, or in the *Autobiography* of the boastful sixteenth-century sculptor Benvenuto Cellini. As the status of the artist as a creator rose, many of the arts also began to acquire their own histories and a sense of lineage. Giorgio Vasari's *Lives of the Most Eminent Painters, Sculptors, and Artists* (1550) is now the most famous of the many histories of art that survive from the period, but many similar treatments of the history of music, literature, and dance were written at the time as well. A sense of achievement permeates many of these texts, a sense that is also to be found in the many theoretical manuals that treated the practice of the arts of painting, sculpture, architecture, dance, and music. Writers often traced recent innovations in their fields, crediting key figures with an enormous "divinely-inspired genius," even as they argued that these accomplishments proved the high status of a particular art form. In this way the defenders of various arts made use of the same arguments humanists had long exploited to defend their literary, philosophical, and poetic works. In some cases the claims artists made for themselves and for their art likely fell on deaf ears. Despite his own powerful sense of his art as a

divine gift, Michelangelo sometimes suffered treatment as a hired hand by the popes who employed him. They moved him from project to project at their whims, a fact that explains the many incomplete projects he left behind at his death. At the same time the enormous gifts of a Michelangelo, a Titian, a Palladio, or a Dürer gained wide recognition, and the greatest of Renaissance artists consequently rose to the status of gentlemen.

AN ARTFUL SOCIETY. Another feature of Renaissance life points to the vital role that all the arts played as indicators of social refinement. In his nineteenth-century classic Burckhardt called attention to the great number of "universal men" that existed in the Italy of the fifteenth and sixteenth centuries. One of these, Leon Battista Alberti (1404–1472), adopted the motto "Man can do all things, if he but will," and Alberti's life became a testimony to the pervasiveness of his philosophy. Trained in law, he was also a humanist and took minor orders in the church, eventually finding employment as a secretary to the humanist pope Nicholas V. While pursuing a life of active engagement in public affairs, Alberti became a practicing architect, sculptor, and painter, and his theoretical treatises on these subjects were widely read and disseminated among artists of the time. He was a gymnast, a horseman, a poet, a musician and composer, a theologian, a mathematician, and a philosopher. To his many other talents, Alberti also added skills as a comic, writing a number of popular spoofs on the lives of animals. This short snapshot of his many talents shows the role that the arts and humanities played in the Italian Renaissance. They were signs of refinement that displayed one's ability to live graciously. This trend intensified in the sixteenth-century world, and the ability to write at least a passable sonnet; to paint and sculpt; and to dance, sing, play an instrument, and compose music all became celebrated as skills necessary to participate in an increasingly rarefied court society. The conduct manuals of the time taught courtiers and wealthy patricians in Italy's cities how to refine their conversation, even as they often included an almost endless list of skills that were necessary for anyone hoping to be admitted into aristocratic society. Of these texts, Baldassare Castiglione's *Book of the Courtier* (1528) survives as the most famous and influential. In the course of the sixteenth century conduct manuals like this became popular in almost every corner of Renaissance Europe. They soon acquired a broader readership, being studied not only by courtiers and patricians but also by members of the urban bourgeoisie. As the conduct manual moved into these new frontiers, writers pared down the number of skills and arts that were necessary for their readers to master, while preserving some like dancing and singing as essential tools that demonstrated a person's refinement. This tendency can be seen already in Thomas Elyot's *Book of the Governor* (1531), one of the most widely read conduct manuals to survive from England. Elyot knew that the urban men for whom he wrote had neither the time nor the inclination to master all the disciplines and arts promoted in a rarefied courtly manual like Castiglione's, so he condensed the essence of that earlier work and showed his readers only the most essential skills for functioning in civil society. In this way achievement in the arts and at least a passable degree of classical learning functioned as necessary skills for those who desired to participate in the public world.

NEW MEDIA. The rise of technological innovations in fifteenth- and sixteenth-century Europe also influenced the arts and the humanities in new ways. The most visible and important of the many new media that emerged in the Renaissance was the printing press, which greatly increased the flow of information in Europe and played a vital role in informing artists and scholars of key developments elsewhere in the continent. Printing helped to fuel the dynamism of the religious controversies of the Reformation, while at the same time allowing for music, dances, plays, and other art forms to be performed far from the place at which they were written or composed. With the development of woodcut illustration and copper engraving techniques, the press also contributed greatly to the visual arts, giving birth to new forms of pictorial art that have persisted since the Renaissance. At the same time printing also constricted the rich variety of local art forms that had long flourished throughout Europe, particularly in the performing arts. As performance manuals in both dance and music sanctioned one set of practices as correct over other possibilities, longstanding local performance customs began to disappear in favor of the ones in printed books. In musical composition, too, the popularity of printed madrigals and motets throughout Europe tended to eclipse many native forms of music. Printing also sounded the death knell for the art of hand copying and illuminating manuscripts with beautiful miniatures. Scribes simply could no longer compete with the cheaper flood of books that now poured from Europe's printing houses. At the same time, printing was only the most visible of the many technological innovations that transformed the arts and scholarship in Renaissance Europe. In painting, new techniques in oils allowed for a broader range of color and provided artists with a medium that was more adaptable to an artist's expressive brushwork

than the true tempera techniques used in the Middle Ages and early Renaissance. In music, new instruments similarly increased the tonal range and volume of instruments, even as rich forms of polyphony introduced a new harmonic complexity and depth of sound in choral music. This list of technical innovations that occurred in the arts and humanistic scholarship of the period might be lengthened considerably, and it forms a significant focus in all the chapters that follow. But more fundamentally the rise of a climate of technological experimentation points to the development of a culture increasingly concerned with pioneering ways of mastering and extending the possibilities of the natural world, an observation that many scholars have long associated with the Renaissance. At the same time not every attempt to improve artistic production or scholarly techniques was successful. In creating his famous painting of the Last Supper at Milan, Leonardo da Vinci experimented with a new medium of fresco that mixed traditional pigments with oils. Soon after he completed his work, the painting began literally to slide off the wall, much to the chagrin of art lovers ever since. But many more technical innovations were successful than unsuccessful, and the legacy of Renaissance experimentation greatly extended the expressive power of the arts in Europe over the centuries that followed.

THE VERNACULAR LANGUAGES. A final fundamental transformation of which readers of this volume should be aware is the rise of vernacular languages as literary modes of expression, a development that did not proceed at the same rate in all of Europe's national cultures. Of all the medieval national languages spoken in Europe, only French had a rich tradition of use as a literary language during the Middle Ages. While native epics, religious poems, and other works survive from before 1300 in all Europe's languages, the explosion of vernacular literature in the fourteenth, fifteenth, and sixteenth centuries is undeniable. This rise of literary forms of Italian, German, Spanish, and English occurred at the same time as humanists avidly pursued the revival of a grammatically correct and uncorrupted style in Latin. In these efforts the works of the ancient Roman Golden Age, including the writings of Cicero, Livy, Horace, and Ovid, guided Renaissance authors. By 1500, their efforts in defense of an ancient pure form of Latin had triumphed over the many medieval usages that had long flourished in the language. The revival of classical Latin was widely successful; writers produced more literature in the language during the sixteenth century than at any other time in history. At the same time, the efforts of humanism in defense of pure Latin style produced a para-

doxical effect, since the language was no longer a living and expanding language as it had been throughout most of the Middle Ages when new vocabulary and usages had been constantly introduced over time. Scholars and authors soon became aware that Latin was no longer a growing, vital language, and many sensed that the future lay in the vernacular languages. The rise of native forms of Italian, French, Spanish, English, and German consequently began to inspire many disputes about the literary styles that were appropriate for these languages. In every country authors debated which dialect of the language and which syntax and vocabulary were best suited for writing in French, German, or English. These heated debates reveal to us the excitement surrounding the possibilities the native languages offered. In his *Book of the Courtier* Baldassare Castiglione neatly summarized this excitement when he judged Latin a "dead" language, and instead advocated his readers adopt the lively conversational form of Tuscan Italian since it was "a garden full of sundry fruits and flowers." The new nectar writers like Castiglione hoped to squeeze from national languages captivated authors even more as the sixteenth century progressed. Michel de Montaigne, who had been trained from his earliest youth to speak and write in Latin, nevertheless chose French to compose his *Essays*, and in so doing, he helped to extend its possibilities for literary expression. In England, the great achievements of the Elizabethan theater had a similar effect in raising the literary standard of English, and in Spain, the authors and playwrights of the emerging Golden Age fulfilled a similar function for modern Spanish. Latin was far from moribund by the end of the Renaissance; it remained an essential language for the educated for centuries to follow. But the quality of prose and poetry Renaissance authors composed in the various national languages helped to assure their further development as literary languages, even as the styles these languages used in subsequent centuries often continued to pay tribute to the Renaissance and its debates over syntax, structure, and vocabulary.

SCOPE OF THE BOOK. As the title suggests, this work focuses exclusively on the arts and humanistic scholarship. The definition of humanism, the source of the modern notion of the humanities, has been outlined in this introduction. At the same time the notion of the arts that is developed here demands some explanation. A broad and inclusive definition of the arts has defined the choice of chapters in this volume. During the seventeenth and eighteenth centuries aesthetic philosophers in Europe pioneered the concept of the "beaux arts" from which we derive our modern English term, "Fine Arts." That concept has been most often applied to the arts of

painting, sculpture, architecture, music, and poetry. In the eighteenth century an increasingly formal system of aesthetics also drew a firm distinction between the "Fine Arts" and the "crafts." Under crafts, aesthetic theorists once placed an entire variety of skills as diverse as needlepoint, weaving, tailoring, ceramics, and cabinet making. Value judgments lay hidden in these classification schemes, since these distinctions were intended to separate those practices that required art, understood as intellectual skill, and those that by contrast primarily demonstrated the powers of the hands. As anyone knows who has ever tried a hand at cabinet making, it is an enormously difficult craft that requires both great intellectual as well as physical skill. In considering the role of the arts in Renaissance culture, we can largely bypass these distinctions between what is an art and what is a craft. At this time, the system of the "Fine Arts" played no role in how people defined the term "art." When Renaissance people used that term, they had one of several meanings in mind. The arts referred, of course, to the seven liberal arts that were an identifiable curriculum in which educated people were schooled before entering university. At the same time "art" described the crafts that were practiced in the urban guilds. And by the sixteenth century the word "artist" had acquired much of its modern meaning; it implied someone who had developed a high degree of skill in one of the categories that we today associate with the arts: painting, sculpture, architecture, dance, music, poetry, and theater. In this sense tailors were not generally considered "artists" at the time, even though they practiced an "art" that was regulated by the craft guilds of the day. In trying to render the very different attitudes that Renaissance people had toward artistic production, then, we have come to emphasize many areas of cultural production. Numerous discussions of masterpieces abound in the chapters that follow, the traditional preserve of literary scholars and of art, theater, and music historians. At the same time we have treated a broad range of works and physical artifacts in order to suggest the inclusive nature of art in the Renaissance.

ACKNOWLEDGMENTS. I am grateful to the editors and staff at Gale for bringing this project to a successful completion. In particular, I would like to thank Tom Carson, who originally suggested the idea of this book to me; Julia Furtaw, who helped initially define the work and its contents; Rebecca Parks, who edited the book and eliminated numerous stylistic errors; and Shelly Dickey, who oversaw the entire venture. I also acknowledge the advice of the following scholars, who read and advised on portions of the manuscript: Andrew Barnes, Neithard Bulst, Ann Moyer, Sachiko Kusukawa, Thomas Tentler, and Retha Warnicke. Finally, I would like to thank the several thousand students I have taught during the past quarter century. They have forced me always to be "on my toes," and have constantly stimulated my curiosities about the many issues treated in this book.

CHRONOLOGY OF WORLD EVENTS

By Philip M. Soergel and Melanie Casey

1303 Pope Boniface VIII dies a broken man about a month after being beaten up by a gang of toughs sent by King Philip IV of France.

1304 Francesco Petrarch, who will become known as the "Father of Humanism," is born.

1309 The pope moves the capital of his government to the French border town of Avignon, beginning the so-called "Babylonian Captivity" of the church.

1316 The Great Famine strikes much of Europe.

1321 The poet Dante, author of the epic poem *Divine Comedy*, dies.

c. 1325 The Aztecs settle in the area around modern Mexico City.

1337 Edward II is crowned king of England and begins the Hundred Years' War with France.

1340 Defeat of the Moors in Spain leaves the kingdom of Granada as the only Arab possession in Iberia.

The English attack the French fleet off the coast of the Netherlands in order to secure the English Channel for an invasion of France.

1341 Petrarch is crowned with laurel at Rome, a ceremony that imitates the ancient Roman custom of naming poet laureates.

1346 The Battle of Crécy is fought in the ongoing war between England and France. It is the first battle to use cannons, and is a decisive victory for England.

1347 The Black Death strikes Europe. Over the next three years it will claim perhaps as much as a third of the entire population, and the disease will recur many times over the following three centuries.

1348 Giovanni Boccaccio begins to write his *Decameron*.

1349 Pogroms (organized massacres) against Jews rage in Germany and France in the wake of the Black Death. Jews are blamed for causing the disease, either through magic or through poisoning wells.

1350 War breaks out between the two Italian powers of Venice and Genoa over their rights to navigate in the Black Sea.

Sixteen-year-old Javan ruler Hayam Wuruk takes the throne of the Hindu state of

Majapahit when his mother, Tribhuvana, abdicates. Along with his powerful minister Gajah Mada, he extends Javan control throughout Indonesia.

Ramathibodi I, a Utong (Thai) general, becomes king and moves the capital to Ayutthaya, a settlement on an island north of Bangkok. He engages in warfare against the Cambodians—who are defeated, but they introduce Khmer culture into that of their conquerors—and establishes coded laws. He becomes a Buddhist priest and rules until his death in 1369.

1352 The Ottoman Turks establish a settlement on Gallipoli, near Tzympe.

Arab traveler Ibn Battutah crosses the Sahara and visits the Mandingo Empire.

1353 Fa Ngum unites the Laotian people and introduces Khmer civilization. He leads his country until he is exiled in 1371.

Chinese general Hsü Ta and rebel Hung-wu join their forces and fight against the Mongols, eventually leading to the downfall of Mongol control and the start of a new Chinese dynasty.

1354 Forces of the Ottoman Turks capture the Byzantine province of Thrace in the Balkans.

1355 Chu Yüan-chang becomes leader of rebel forces in China, after the death of Kuo-Tzu-hsing.

1356 The English Black Prince attacks the French at the Battle of Poitiers, capturing the French king John the Good. England demands much of southwestern France and the port of Calais, in addition to a large ransom, to return John. A temporary lull in the hostilities begins.

Yüan-chang's forces take the city of Nanking.

Mobarez od-Din Mohammad, son of southern Iranian ruler Sharaf od-Din Mozaffar, captures Tabriz in northwest Iran.

1358 In France, the peasant rebellion of the *Jacquerie* begins.

Od-Din Mohammad is deposed by his sons Qotb od-Din Shah Mahmud and Jalal od-Din Shah Shoja', who divide the kingdom between themselves.

1359 At London, a treaty signed between France and England forces the former to give control over a large portion of its territory. The following year the English king Edward III will fail in his attempt to try to capture the French throne during an unsuccessful campaign on the continent.

Angora (later Ankara) is captured by the Ottomans. It will become the capital of modern Turkey.

1360 The Ottoman Turks seize the important city of Adrianople from the Byzantine Empire. In the same year Murad I assumes the throne of the empire, establishing the powerful force of troops that will become known as the Janissaries. The Janissaries are made up of prisoners of war and Christians, and they remain a powerful Turkish force until the nineteenth century.

Mari Jata II becomes the mansa of the Mali Empire in West Africa. He rules until 1374.

1362 Adrianople (now Edirne, Turkey) is captured by the Ottomans under Murad I.

1364 Javan minister Gajah Mada dies, possibly after being poisoned by Hayam Wuruk, who may have feared the influence of his powerful subordinate.

1365 Indonesian poet Prapanca writes *Nāgarakertāgama,* an epic poem featuring the rule of Wuruk.

1368 The Yüan dynasty in China, a period of Mongol control initiated by Kublai Khan in 1260, ends. It is replaced by the Ming dynasty, founded by the monk Chu Yüan-chang, whose forces capture Khahbalik (later Beijing). Ashikaga Yoshimitsu becomes a shogun in Japan. He serves in

many government posts, reorganizes civil service and suppresses piratical activities.

1369 The peace that has reigned between England and France ends with the outbreak of renewed hostilities in the Hundred Years' War between the two countries.

1370 King Timur or Tamerlane assumes the throne of the state of Samarkand (in modern Uzbekistan). During his reign he will subdue much of Central Asia and the Middle East.

c. 1371 Arab jurist ad-Damīrī writes the *Hayāt al-hayawān,* an encyclopedia of animals that appear in the Koran.

1373 Sam Sene Thai becomes the ruler of the Lan Xang kingdom of Laos and rules for forty-four years of peace and prosperity.

1375 Suleiman-Mar wins independence for the Songhai, who controlled the western Sahara, from the Mali Kingdom.

1377 Islamic traditionalist theologian al-Jurjānī arrives to teach in Shīrāz, where he stays for ten years. He is best known for his dictionary *Kitāb at-ta' rifāt.*

1378 In Florence, members of the guilds rebel against the great masters and seize control of the city government in the Revolt of the Ciompi.

Pope Gregory XI dies in Rome while preparing the way for the return of papal court to its ancient capital. Competition between Avignon and Rome, however, gives rise to the Great Schism.

1381 English peasants revolt under the leadership of Wat Tyler. During their brief rebellion, they slay the archbishop of Canterbury and other British nobles.

1382 The Mongols are decisively expelled from China, making way for the rise of the Ming dynasty.

1385 Japanese poet Kanami, who is credited with transforming primitive dance into Nō drama, dies.

1386 Serbian prince Lazar Hrebeljanović defeats the Turks at the battle of Pločnik.

1389 Hrebeljanović is killed, and his forces are crushed by the Turks at the battle of Kosovo. Also killed, however, is the Ottoman sultan Murad I, who is replaced by Bayazid I.

1390 Bayazid I captures Anatolia.

1391 A massacre of Jews in Seville in Iberia claims as many as 4,000 lives.

1392 Korean general Yi Sŏnggye overthrows the Koryŏ dynasty, names his kingdom Chosŏn, and establishes his capital at Hanyang (Seoul). The Yi dynasty rules Korea until 1910, when Japan annexes the country.

1393 The Thais invade Cambodia, capturing Angkor and ninety thousand people. The policy of seizing and subjugating whole populations, often removing them to the home state, leads to much intermixing of peoples in the region.

1394 King Charles VI expels all Jews from France.

Turkish ruler Timur captures Baghdad and controls Mesopotamia.

1395 Thai king Ramesuan dies and is replaced by his son Ramraja. Fourteen years of peace follow.

1397 The Ming law code is introduced in China, reinforcing traditional authority and the responsibility of the paterfamilias along hereditary groupings. A system of social organization (ten-family groups organized into one-hundred-family communities) is developed to regulate and indoctrinate the populace.

1398 Timur's Turkish troops invade India, destroying the province of Delhi and massacring more than one hundred thousand Hindus before capturing the city of the same name.

1399 Faraj becomes ruler of Egypt. He allows a defensive alliance with the Turks to lapse and is later captured by the Turks while trying to regain Syria.

c. 1400 Five Iroquois nations (Mohawk, Oneida, Onondaga, Cayuga, and Seneca) emerge as distinct tribal entities in North America.

1400 Damascus and Aleppo in Syria fall to Timur's armies.

1402 Bayazid is defeated, and later dies in captivity, by Timur at the Battle of Angora.

1403 Prince Paramesvara founds Malacca (Melaka) on the west coast of the Malay Peninsula. The area will become a major supplier of spices.

1405 Chinese explorer Cheng Ho (Zheng He) begins the first of seven expeditions, which will last until 1433, to Asia, India, East Africa, Egypt, Ceylon, and the Persian Gulf.

Timur dies during an expedition to conquer China. Shah Rokh, his son, begins his reign of Persia (Iran) and Central Asia, which lasts until 1447.

1406 The city of Florence conquers nearby Pisa, granting it an access to the Mediterranean.

1407 Civil conflicts rage among the nobility of France.

1408 The king of Ceylon is taken to China as a prisoner.

1409 Thai prince Nakonin overthrows Ramraja and takes the Intharaia.

1410 Sultan Ahmad Jalayir of Iraq is killed in a dispute with the chief of the Black Sheep Turkmen tribal confederation from eastern Anatolia.

1411 The once powerful Teutonic Knights are forced to relinquish control over much of their Eastern European territory after defeat by an alliance of Polish, Lithuanian, Russian, and other ethnic groups' forces.

1412 Faraj is killed by the Turks in Damascus while trying to recapture Syria.

1413 Henry V begins to press his claim to the throne of France.

1414 Khizr Khan, former governor of the Punjab, becomes ruler of the Delhi sultanate, beginning a reign known as the Sayyid dynasty, because the leaders claimed to be descendants of the Prophet Muhammad. North India is divided among military chiefs for half a century.

1415 The Great Schism is brought to an end through the work of the Council of Constance.

Although his forces are outnumbered four to one, Henry V defeats the French at the Battle of Agincourt.

1416 A revolt begins in Iznik, Turkey, initiated by the communalistic social theories pushed by Moslem theologian Bedreddin, who had been exiled to the city. He is captured and hanged after the rebellion is crushed by Mehmed I.

1418 Le Loi begins a Vietnamese independence movement in the Red River basin against the Chinese.

1419 In Portugal, Prince Henry begins to support voyages of exploration down the coast of West Africa.

Sejong becomes the king of Korea. His reign, which lasts until 1450, is known for cultural achievement, development of a phonetic alphabet, and reduction of the power of the Buddhists.

1420 The Duchy of Burgundy supports Henry V as king of France. The southern part of the kingdom remains loyal to the heir of Charles the Mad.

1421 Murad II becomes the Ottoman sultan.

China establishes its capital at Beijing.

1422 Indian Bahami Shihāb-ud-Dīn Ahmad I becomes sultan of the Deccan and expands

the territorial holdings of his country during his reign, which lasts until 1436.

1423 Mongol leader Aruqtai, chief of the As, declares himself khan of the Mongols and attacks North China.

1425 The lands and rule of the Mentese Dynasty of the Mugla-Milas region of southwestern Anatolia are annexed by the Ottomans.

1427 In Florence, a census is undertaken of all the population, and an income tax is introduced.

1428 Joan of Arc's visions begin to play a vital role in French opposition to English occupation.

 Aztec ruler Itzcóatl begins his reign, which lasts until 1440.

1429 Charles VII is crowned King of France with Joan of Arc at his side.

1430 Philip the Good of Burgundy founds the Order of the Golden Fleece on the occasion of his marriage. The order's aims are to defend the code of chivalry and the church.

1431 Joan of Arc is burned at the stake after being captured by Burgundian forces and sold to the English.

1432 The Kara Koyunlu destroy remnants of the Jalayirid dynasty of Iraq, which had fled to areas around Basra.

1435 Chu Ch'i-chen, son of Chu Chan-chi, begins his rule of China.

1438 In France, the Pragmatic Sanction of Bourges limits the rights of the pope in that country.

 Pachacuti begins his 33-year reign, expanding and reorganizing the social and political system of the Inca Empire. His domain stretches from present-day Ecuador to southern Peru.

1440 The Praquerie, a rebellion of nobles against the French king, fails in France.

Venice and Florence combine to defeat the Duchy of Milan.

Aztec ruler Montezuma I begins his reign, which lasts until 1469. He extends the control of his people over what will become known as Mexico.

1442 The Portuguese begin trading in Berber slaves they capture in North Africa.

1444 The Ottomans, led by Murad II, who had been coaxed out of retirement from public life, defeat Christian Hungarians, led by János Hunyadi, at Varna.

1446 A revolt of the Janissaries, who opposed a planned attack on Constantinople, calls Murad II back to Edirne from a second retirement because of the weakness of his fourteen-year-old son Mehmet's rule.

1447 Tartar prince Ulugh Beg becomes ruler of Turkestan. His short reign, which lasts until 1449, marks the transition of Central Asia, as after his death the Timurid Empire breaks up.

1450 The French defeat English forces at the Battle of Formigny, paving the way for France to reclaim its possessions in Normandy.

1451 Ottoman sultan Mehmed II (Mehmed the Conqueror) succeeds his father, Murad II. He is considered the true founder of the Ottoman Empire.

 Afghan king Bahlul Lodī begins his reign, initiating the Lodī dynasty.

1453 Constantinople falls to the Turks and is renamed Istanbul.

 The English are defeated in the Hundred Years' War and withdraw from France.

1454 The Greek Orthodox Patriarchate is restored to Istanbul by Mehmed, who also allows a Jewish rabbi and Armenian patriarch into the city.

1455 Johann Gutenberg von Mainz perfects the first press with movable type and prints the first book, the Bible.

The War of the Roses breaks out between the Houses of York and Lancaster in England.

1456 Tun Perak, the chief minister of Malacca, leads his forces to a victory over the invading Siamese.

1457 Chu Ch'i-chen returns as emperor of China, remaining on the throne until his death in 1464.

1458 Herāt, an ancient town on the trade route through Afghanistan, is captured by Jahān Shān of Azerbaijan.

1460 The Portuguese prince Henry the Navigator, supporter of that country's explorations, dies.

Le Thanh Tong becomes ruler of Vietnam. He institutes Chinese-style government, develops an efficient provincial system, employs centrally appointed officials, institutes new taxes, and promotes education.

1462 The Portuguese found a colony on the Cape Verde Islands.

In Russia, Ivan III assumes the title of Grand Prince of Moscow. He will be a strong ruler committed to expelling foreign influences in the country.

1464 Sonni 'Alī (Alī the Great) becomes king of Gao and Songhai, beginning an expansion of territory that leads to the development of the Songhai Empire.

1468 Mengli Giray begins nearly half a century of rule as Khan of the Crimean Tartars.

Sonni 'Alī drives the Tuaregs out of Timbuktu.

1469 The two Medici brothers, Lorenzo the Magnificent and Giuliano, assume control of government in Florence.

1471 The conquest of Champa by Le Thanh Tong, who establishes military colonies in the southern parts of Vietnam, is completed. This victory allows the Vietnamese the freedom to take border areas from the Cambodians.

Topa Inca Yupanqui, son of Pachacuti, assumes the Incan throne.

1472 Chinese Ming philosopher Wang Yangming is born. Trained as a Taoist, he brings new interpretations to Confucianism, advocating the philosophy of subjectivism. He serves as a governor and war minister in the Chinese government.

1474 Isabel of Castile seizes the throne of her native kingdom from her sister. As ruler of Castile, Isabel is also married to Ferdinand of Aragon. Their union begins the process of forging a united Spanish kingdom in Iberia.

1476 Japanese painter and art critic Nōami compiles a catalogue of Chinese artists, titled the *Kundaikan sayu.*

1478 The Pazzi Conspiracy at Florence fails. The conspiracy had been planned by enemies of the Medici and was timed to occur during a Mass in Florence's Cathedral. One of the Medici brothers, Giuliano, is killed, but Lorenzo survives and puts down the plot by executing a number of conspirators and their supporters, including Florence's bishop. These executions cause disputes between Florence and the papacy that last for several years.

1479 The Spanish claim the Canary Islands.

1481 Sultan Mehmed II dies, possibly from poisoning, and is replaced by his elder son Bayezid II, despite the dead leader's wish that his favorite son, Cem, get the throne. Cem attempts a revolt, but is defeated and exiled to Rhodes. Bayezid rules until 1512.

1482 The Portuguese begin to develop trade links with the African state of the Congo.

The mouth of the Congo River is located by Portuguese navigator Diogo Cāo, who soon finds the Kongo people. Trade be-

tween Kongo and Portugal commences, and the Kongo people become Christianized and Europeanized.

1483 Bābur (Zahīrud-Din Muhammad), founder of the Mughal dynasty in India and its first emperor, is born. He rules until 1530.

1485 King Richard III is killed at the Battle of Bosworth Field, and the Earl of Richmond, his attacker, assumes the throne of England as Henry VII. Henry thus establishes the Tudor dynasty that will last until 1603.

Saluva Narasimha begins a new dynasty in India, opening ports on the west coast to trade, revitalizing the army, and establishing centralized rule.

1486 Japanese poet Ike Sōgi, a Buddhist monk and master of linked verse, writes *Minase Sangin Hyakuin*.

1487 The Fugger family of Augsburg founds an international banking empire that soon competes successfully against the Medici Bank.

The Court of Star Chamber is established in England to hear cases against the nobility in secret.

Chu Chien-shen's son Chu Yu-t'ang begins his rule, a mostly peaceful reign, of China. He controls the throne until his death in 1505.

1488 King Trailok dies and is replaced by his son and deputy Boromaraja III, who leads the Thais for only three years.

The True Pure Land Sect in northern Japan rebels against a local lord and kills him, leading to a series of uprisings by this group.

1492 Columbus sails west in hopes of finding a route to India. Instead, he discovers the Caribbean.

The Jews are expelled from Spain.

1494 The Treaty of Tordesillas is signed between Spain and Portugal. It establishes a line approximately 1,200 leagues west of the Cape Verde Islands. Portugal is to be allowed to colonize east of the line in modern Brazil and Africa, while Spain is to control the area west of the marker.

France invades Italy, touching off the "Italian Wars" that will last intermittently until 1559 and produce a bitter rivalry between the Hapsburgs and the French Valois for territory in the peninsula.

1497 The Italian explorer John Cabot sets sail on a voyage underwritten by King Henry VII of England. His intentions are to find a route to India, but he finds lands in modern Labrador and Newfoundland instead.

1498 The Portuguese explorer Vasco da Gama discovers a route to India by sailing around the Cape of Good Hope in Africa.

1499 War between Venice and the Ottoman Turks begins, and a Venetian fleet is defeated in the same year.

Switzerland's independence from the Holy Roman Empire is recognized.

c. 1500 The Aztec empire has by this date grown into a vast and powerful force in Central America.

The Portuguese explorer Pedro Alvares Cabral claims Brazil for his king.

For approximately forty years, two queens, Rafohy and Rangita, successively rule the island nation of Imerinanjaka, located on Madagascar.

1501 The French conquer the kingdom of Naples.

The enslavement of Africans is introduced into the West Indies to replace the rapidly dying off Native American population, which had been pressed into service. Nicolás de Ovando of Hispaniola imports some Spanish-born blacks for the purpose of using them as slaves.

1505 Emperor Chu Yu-t'ang dies, leaving the throne in the hands of his son, Chu Hou-chao, whose reign is marked with rampant corruption, dominance by the eunuchs, and internal strife.

 Ozolua (the Conqueror) dies after a twenty-three year reign as king of Benin (Nigeria). He expanded the size of his kingdom and traded with the Portuguese.

1506 The king of the African Kongo, Alfonso I, converts to Christianity.

1507 Martin Waldseemüller publishes his imposing atlas, *Cosmographie Introductio*, naming the continents of the Western Hemisphere "America," after the Italian navigator, Amerigo Vespucci.

1509 An Arab-Egyptian fleet is destroyed off Diu (northwest of Bombay, India) by a Portuguese navy led by Francisco de Almeida, who had established forts along the Indian coast.

1510 The Portuguese establish trading colonies at Calcutta and Gao in India, thus establishing their powerful position in the European spice trade.

1512 Selim I (the Grim) becomes sultan upon the abdication of his father, Bayezid II. He doubles Ottoman territory, moves the capital to Istanbul, brings the Arab world into the Ottoman Empire, and becomes an Islamic caliph (or protector) of the Sunni Muslims. He rules until 1520.

 Afonso I of Kongo signs a treaty with Manuel I of Portugal.

1513 The Spanish explorer Balboa crosses Panama, discovering the Pacific Ocean.

1515 The Turks capture Anatolia and Kurdistan.

1516 King Ferdinand of Aragon dies in Spain, and Charles I assumes the throne.

 Ang Chan becomes the king of Cambodia, resists Thai dominance, and rules until 1566.

 Syria is annexed by the Ottoman Empire.

1517 Martin Luther's 95 Theses begins to excite controversy in Germany.

 Spain allows the importation of slaves from Africa in its New World colonies.

1519 The Spanish conquistador Cortés conquers Mexico, making the once powerful ruler Montezuma into a puppet.

 Charles I of Spain is elected Holy Roman Emperor. Charles now controls a vast empire that includes Spain, the New World, the Netherlands, Austria, and parts of Italy.

1520 Cuauhtémoc becomes the last emperor of the Aztecs, but is hanged in 1522 by Cortés.

 Babur invades northern India.

 Photisarath becomes ruler of Lan Chang (Laos), builds monasteries and temples, and promotes Buddhism. He rules until 1547.

1521 After a short revolt, the Aztec capital Tenochtitlan falls to the Spanish.

 Magellan is the first European to sight one of the Polynesian Islands, that of Puka-puka.

1522 Ferdinand Magellan completes his circumnavigation of the globe.

1526 The Muslim Moguls, rulers of an empire centered at Kabul (in modern Afghanistan), invade India, subduing a large part of the subcontinent.

 The Turks defeat Hungarian forces at the Battle of Mohács.

1527 Imperial forces of Charles V sack Rome and take the pope hostage.

 Somali chieftan Ahmed Gran, a Moslem, invades Ethiopia.

1529 Spain names Mexico City, built on the site of the former Tenochtitlán, capital of the viceroyalty of New Spain.

The Turks attack the city of Vienna in Austria.

1530 Atahualpa assumed the throne of the Incan Empire in Peru.

1531 Tabinshweti becomes the king of Burma.

1533 Francisco Pizarro conquers Cuzco, capital of Peru, and secures a large quantity of gold from the former empire.

Four-year-old Prince Ratsadatiratkumar becomes ruler of Siam, but is killed by his half brother Prince Prajai.

1534 The French explorer Jacques Cartier sails to the Gulf of St. Lawrence in modern Canada.

1535 The first printing press in the Western Hemisphere is established in the colony of Mexico.

1536 The Spaniard Pedro de Mendoza leads an expedition into modern Argentina.

1537 A period of peace and stability in China begins with the ascension to the throne of Chu Tsai-kou, son of Chu Hou-tsung.

1539 In Ghent in the Low Countries, a revolt begins against the rule of the emperor Charles V. It fails, but Charles stations a permanent garrison of troops in the city.

Tabinshweti conquers the kingdom of Pegu (Myanmar).

1543 Portuguese naval ships arrive in Japan, the first time Europeans visit these islands.

The English perfect the iron cannon, a weapon that is stronger and cheaper to produce than those made out of bronze.

Altan Khan becomes chief of the eastern Mongols. His army breaches the Great Wall of China in 1550.

1544 The city of Lima is named the capital of the Spanish province of Peru.

Hindu religious reformer Dādu, founder of the Dādupanthīs sect, is born.

1545 Spanish conquistadors discover a large lode of silver at Potosi in modern Bolivia.

1548 Sinan, considered the greatest Ottoman architect, builds the Sehzade Mosque in Istanbul. He is credited with designing more than three hundred buildings.

1549 Spanish missionary Francis Xavier, who helped found the Jesuit Order and preached in Gao and India, arrives in Kagoshima, Japan, where he works for two years. He returns to India in 1551 and dies on Sancian Island.

1550 Jón Arason, a prelate of Iceland who resists the expansion of Lutheranism into his country, is beheaded.

Arab traveler Leo Africanus's *Descittione dell' Africa,* the only source of information on the Sudan, is published.

1555 The Peace of Augsburg in Germany resolves religious tensions between Protestants and Catholics and establishes the principle, "He who rules, his religion," a settlement that will hold until 1618 when hostilities once again break out between the two factions. At the end of that conflict, the so called Thirty Years' War in 1648, the principles of the Peace of Augsburg ("He who rules, his religion") are reiterated.

Turkish poet Bâkî gains the favor of Sultan Süleyman I, helping to revitalize lyric poetry in Turkey.

1556 Abu-ul-Fath Jalāl-ud Din Muhammad Akbar (Akbar the Great) becomes the Mughal emperor of India. He reigns until 1605, conquers most of India, and promotes reforms, learning, and art.

1557 Spanish troops defeat the French at the Battle of Saint-Quentin, forcing them to abandon Italy.

Shaybanid ruler 'Abd Allāh ibn Iskandar conquers Bukhara in Central Asia, as well as several regional kingdoms, and attacks Persia (1593–1594, 1595–1596).

1559 King Henri II of France dies as a result of a wound he received in a jousting tournament.

The Treaty of Cateau-Cambrésis ends hostilities between France and Spain and allows the latter to remain dominant in the peninsula.

1562 The Wars of Religion between Protestants and Catholics commence in France. They will last until 1598.

A cargo of African slaves is deposited in Hispaniola by Englishman John Hawkins, the first of three such voyages, initiating English participation in the trade.

1563 Burmese king Bayinnaung invades Siam, assaulting the capital of Ayutthaya.

1564 England surrenders its claim to the port of Calais.

1566 Selim II becomes sultan of the Ottoman Empire.

1568 The Azuchi-Momoyama period begins in Japan, an era of unification under military rule that lasts until the turn of the century.

1569 The Flemish mapmaker Gerardus Mercator perfects the Mercator Projection map.

c. 1570 The Iroquois League is established between various tribes of Oneida, Mohawks, Onondaga, Cayuga, and Seneca in the modern northeastern United States and Canada.

1571 Forces of Venice and Spain combine to produce a navy of about 200 ships. They capture an Ottoman navy at the Battle of Lepanto, thus stopping for a time the advance of the Turks into the Mediterranean.

The Spanish conquer the Philippine Islands.

The Ottomans capture Cyprus.

Safavid philosopher-author Mullah Sadra is born; he will lead the Iranian cultural renaissance into the early seventeenth century.

1572 The Dutch declare their independence from Spain, thus precipitating a long conflict between the two countries.

1574 Murad III, the son of Selim II, becomes the sultan of the Ottomans.

Rās Dās becomes the fourth Sikh Guru and founds Amritsar (in Punjab, India).

Hindu poet Tulsīdās writes *Rāmcaritmānas* (Lake of the Acts of Rama), one of the greatest Hindi literary works.

The Spanish are pushed out of Tunis by the Turks. While the Spanish are losing in Tunis, they are establishing a settlement in Angola.

1576 In an attempt to destroy a rebellion in the Netherlands, Spanish forces advance on Antwerp. There they wreak devastation on the city when Spain is unable to pay them.

1578 The Jesuit missionary Matteo Ricci journeys to China and works to promote Christianity. In 1601, he founds a mission in Beijing.

1580 Chinese dramatist Liang Ch'en-yü, whose K'un-shan style of singing dominates Chinese theater for nearly three centuries, dies.

1581 King Bhueng Noreng of Burma, who had conquered the Thais, is succeeded by his son Nanda Bhueng.

1582 Pope Gregory XIII establishes the Gregorian Calendar in place of the older Julian styled one that had been used in Europe since the first century C.E. It will be adopted in Portugal, Germany, and Spain the following year.

1584 Queen Elizabeth I authorizes Sir Walter Raleigh to undertake an expedition to the New World. The colony that Raleigh establishes at Roanoke Island fails the fol-

lowing year, and another settlement will fail in 1587.

1586 Japanese dancer Izumo Okuni, considered the founder of Kabuki, begins performing works inspired by Buddhist prayers.

1587 An expedition of Spaniards visits Japan. The Inquisition is established in Portugal.

1588 Elizabeth I's navy defeats the Spanish Armada after a storm comes to the aid of her forces. More than half the Spanish navy is destroyed in the conflict.

Abbās I (Abbas the Great), the son of Shāh Soltān Mohammad, begins his reign in Persia. He rules the empire, defeating the Uzbeks and Ottoman Turks and regaining Persian lands, until 1629.

1589 King Henri III of France is assassinated by a monk, thus paving the way for the Protestant Henri of Navarre to come to the throne as Henri IV. Civil war again breaks out in France.

1590 Japan, including the islands of Shikoku and Kyushu, is united under the leadership of Hideyoshi Toyotomi. He brings peace and infrastructural improvements, and will lead his nation (though he relinquishes his official title), until his death in 1598.

1591 The kingdom of Aragon rebels against King Philip II of Spain.

1592 Ming troops defending Korea battle Hideyoshi's Japanese army in its unsuccessful attempt to capture the country.

1593 Henri IV renounces his Protestant faith, and is crowned the following year as King of France.

1596 Mexican historian Agustin Dávila Padilla publishes *Historia de la fundación de la provincial de Santiago de México de la Orden de predicadores.*

1597 Hugh O'Neill leads an uprising against the English in Ulster; Irish forces will eventually be reinforced by Spanish armies, but the uprising will be finally subdued in 1603.

1598 Henri IV of France promulgates the Edict of Nantes, granting a limited degree of toleration to French Protestants. King Philip II of Spain dies.

Abbās I defeats the Uzbeks near Herāt.

Trade between Ayutthaya and Spain begins.

1599 Manchurian chief Nurhachi begins conquering the Juchen tribes in his quest to unite the Manchu, which will become the Ch'ing dynasty starting in 1644.

1600 The East India Company is founded to regulate England's trade with India.

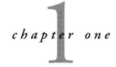

chapter one

ARCHITECTURE AND DESIGN

Philip M. Soergel

IMPORTANT EVENTS
in Architecture and Design

c. 1300 Work begins on the Cathedral of Florence. When completed, the building will be the largest church in Europe.

1334 The painter Giotto is appointed to oversee the construction of Florence's cathedral.

c. 1350 Work is temporarily halted on the cathedral at Florence. It soon resumes and during the 1350s the structure's bell tower or campanile is completed.

1377 The future founder of the early Renaissance style in architecture, Filippo Brunelleschi, is born.

1401 The competition to create new doors for the Baptistery of Florence's cathedral is announced.

c. 1420 In Florence, Brunelleschi designs the orphanage known as the *Ospedale degli Innocenti*, the Church of San Lorenzo, and the dome of the cathedral.

1433 The Pazzi Chapel, one of Brunelleschi's important masterpieces, is begun.

1434 The humanist architect Leon Battista Alberti arrives in Florence.

1436 The dome of Florence's cathedral is completed.

c. 1443 Giuliano da Sangallo, the first of a dynasty of Florentine architects, is born.

1445 The Medici Palace, designed by Michelozzo di Bartolommeo, is begun at Florence.

Bernardo Rossellino designs a classically-styled tomb for the Florentine chancellor Leonardo Bruni.

1447 The humanist Tommaso Parentucelli is elected pope and takes the name Nicholas V. Nicholas will support public works and construction projects in Rome during his eight-year pontificate.

c. 1450 The humanist Alberti writes his *Ten Books on Architecture*, a work that is influenced by the ancient Roman architect Vitruvius. Around this time he also designs at Rimini the Malatesta Temple for the tyrant Sigismondo Malatesta.

c. 1455 Alberti plans several important buildings in Florence that will be imitated by other architects over the coming decades.

1458 The Pitti Palace is begun at Florence.

1459 Pope Pius II commissions Bernardo Rossellino, a follower of Alberti, to redesign the core of the city of Pienza.

c. 1460 A great age of palace building begins in Florence. The wealthiest families of the town try to outdo each other to build the most sumptuous family residence.

c. 1465 Federigo da Montefeltro commissions Luciano Laurana to design a classical courtyard in his palace at Urbino.

1470 Alberti designs the Church of Sant'Andrea in Mantua.

c. 1475 The artist Piero della Francesca paints his *Vision of an Ideal City*.

1481 Leonardo da Vinci leaves Florence to work in Milan. There he serves the dukes of Milan for almost twenty years, undertaking the design of many important military and civil engineering projects.

1484 Francesco di Giorgio designs the Church of Santa Maria del Calcinaio at Cortona.

1499 The architect Donato Bramante is forced to flee Milan after French forces capture the city. He travels to Rome where Popes

Alexander VI and Julius II will keep him busy designing many projects.

1502 Bramante designs the little *Tempietto* for King Ferdinand and Queen Isabella of Spain. When eventually built, the small domed structure will commemorate the site where, according to legend, St. Peter was crucified, as well as influence many later designers.

1505 Michelangelo completes his first plans for Julius II's massive tomb.

1506 Pope Julius II orders the original St. Peter's Basilica demolished at Rome, and Bramante designs its replacement as a central-style church in which all the radiating wings will be of the same size.

1508 The central-style Church of Santa Maria della Consolazione is begun at Todi. The popularity of this style derives, in part, from the vogue for Renaissance neoplatonism.

Andrea Palladio is born.

c. 1510 Bramante designs the facade for Palazzo Caprini in Rome.

c. 1515 The painter Raphael designs the pleasure palace called Villa Madama at Rome. A great age of palace building commences within the city, as the town's major families and important church officials compete against one another to build ever more imposing structures.

1519 Michelangelo designs the New Sacristy at the Church of San Lorenzo in Florence.

The Château de Chambord is begun in France.

c. 1520 Antonio da Sangallo, younger brother of Giuliano da Sangallo, receives the commissions for a number of important churches and urban palaces in Florence and Central Italy.

1524 The Laurentian Library, designed by Michelangelo, is begun at Florence.

1527 The Mannerist Palazzo del Te, designed by Giulio Romano, is begun near Mantua.

Rome is sacked by forces of the imperial armies of Charles V.

1528 The royal palace of Fontainebleau is begun in France.

1532 The High Renaissance architect Baldassare Peruzzi designs the Palace of the Monumental Columns at Rome, a work that is influenced by the developing taste for Mannerism in architecture.

c. 1535 Jacopo Sansovino plans classical buildings to house Venice's mint and the Library of San Marco.

1538 Michelangelo's Campidoglio, a complex of public buildings on the Capitoline Hill in Rome, is begun.

1546 The Renaissance-styled Square Court of the Louvre, designed by Pierre Lescot and Jean Goujon, is begun.

c. 1550 Andrea Palladio designs a number of important palaces and churches in and around the cities of Vicenza and Venice.

1556 A classical facade is begun for part of the Heidelberg castle in Germany.

c. 1560 Giorgio Vasari designs the Mannerist-styled Uffizi Palace in Florence, home of the future famous gallery of paintings.

1563 The Escorial, a royal palace and monastery combined in the same complex, is begun outside Madrid in Spain.

c. 1575 Il Gesù, the church of the Jesuit order in Rome, is begun. The design will be widely imitated in Jesuit churches throughout Europe.

1580 Andrea Palladio dies. His last important design is for the Olympian Theater at Vicenza.

Wollaton Hall is begun in England.

1583 The Renaissance-styled St. Michael's Church is begun at Munich.

OVERVIEW
of Architecture and Design

TRADITION AND CHANGE. In 1300 most Europeans lived in cities that resembled fortresses more than the spaces modern people would associate with urban life. Long-standing warfare and insecurity in medieval Europe had caused people to huddle together closely within the confines of towns protected by walls and battlements. Inside these fortifications, functional houses and tenements crafted from rustic stone, timber, or brick were built close to the street, choking out light and the flow of air from above. Poor or inadequate sanitation was usually the norm, and smoke from family hearths filled the cities. The largest public buildings in a medieval city were almost always churches, and around 1300, the Gothic style—notable for its height and intricate complexity—dominated their construction. These buildings, the largest architectural monuments of the Middle Ages, were not only centers of worship and Christian ritual, but also objects of local civic pride, and towns avidly competed to outdo each other in their construction. Three hundred years later the situation had changed dramatically in many places, as Renaissance Europeans built churches, public buildings, broad squares, and urban palaces that expressed new and strikingly different attitudes towards urban space and design. In creating these projects architects found inspiration in the buildings of classical Antiquity. The revival of knowledge about ancient styles, proportions, and construction techniques deepened tremendously during the Renaissance as architects studied the buildings and urban spaces of ancient Rome more systematically than before. The birthplace of this revolution in architecture was Italy, and as in many other areas of Renaissance life, it was in Florence that the new classicism first developed. There the new projects that architects built in the early fifteenth century made use of the language of classical Roman architecture, while developing a native style that would be imitated elsewhere. As the fifteenth century progressed, architectural innovations appeared in a number of other cities throughout the peninsula.

THE HIGH RENAISSANCE. By 1500, Italy's architects, drawn mostly from the guilds of sculptors and carpenters in the cities, had achieved a remarkable mastery of the elements of ancient design. They had used ancient inspiration to create buildings that functioned well under the quite different circumstances of life in Renaissance cities. During the first quarter of the sixteenth century, architecture, like painting and sculpture, underwent another rapid transformation. This period, known as the High Renaissance, saw painters like Leonardo da Vinci, Donato Bramante, Raphael Sanzio, and Michelangelo Buonarroti entering into the planning of buildings with increasing frequency. As painters trained in the Florentine tradition of *disegno*, that is, draftsmanlike design, each brought with them a new sophistication about the use of light, line, and mass in the construction of buildings. Although natives of Tuscany and central Italian towns, each of these figures worked in Rome at different points in their careers, and that city benefited from the construction of most of the grand projects of the High Renaissance. This style was notable for its great simplicity, harmonious proportions, and unified design. Julius II, the commanding "Warrior Pope," employed Michelangelo, Bramante, and Raphael, among many other artists, to fashion his grand rebuilding and renewal projects in the church's capital. By far the greatest of the pope's ambitions was his plan to demolish and rebuild the ancient Basilica of St. Peter's, a building originally constructed by the emperor Constantine in the fourth century. The scale of this project was unprecedented in European history, and in Bramante, Julius found an architect whose designs were equal to his goals. Bramante designed the new structure to be a central-style church that radiated from a commanding dome. Like many of the projects that Julius began, however, the rebuilding of St. Peter's was too immense to be completed in a single lifetime. The pope accepted Bramante's designs and had his workmen begin the demolition of Constantine's basilica. He also ensured that the central piers that were to support Bramante's dome were begun before his death in 1513. Thus Julius laid down the proportions for a truly grand structure that later consumed the energies and creativity of the finest artists and architects of the sixteenth and seventeenth centuries. The High Renaissance in Rome was also a time of creative and often frenzied building projects undertaken throughout the city. In domestic architecture, Bramante, Raphael, and others created new edifices notable for the complete integration of classical decoration as well as their harmonious beauty. Toward the end of the period the sculptor-painter Michelangelo began to turn to architecture as well, applying the skills that he had acquired

in the planning and execution of Julius II's massive tomb project. During the 1510s he returned to Florence, where he designed several projects for the Medici family. Increasingly these designs took on a willful nature, that is, Michelangelo violated certain tenets of classical design in order to create structures of greater imaginative creativity. In his Laurentian Library at Florence, in particular, the artist created spaces that inspired later Mannerist architects to search for new and innovative ways to use space and decoration.

THE LATER RENAISSANCE IN ITALY. Rome had been the great stage on which High Renaissance architects had designed their new monumental and heroic structures. It had been Julius II's aim, and that of his successors Leo X and Clement VII, to remake the city into an imposing showpiece that celebrated Rome as the very center of the Christian world. Even as this monumental rebuilding of the city was underway in the High Renaissance, Rome's position on the international political scene grew more precarious. In 1527, the great period of creative activity in the city came to an abrupt halt with the Sack of Rome carried out by imperial forces of Charles V. Almost all of the artists and architects who had been active in the High Renaissance fled to work in other cities, carrying with them the skills they had acquired while working in the church's capital. During the 1530s and 1540s Rome experienced a slow recovery from the massive destruction and psychological distresses the Sack had caused. Construction resumed on the new St. Peter's, but not until the 1560s was the building of another large church, the Gesù, begun. During the brief pontificate of Sixtus V (r. 1585–1589) Rome again became a great center of architectural and artistic endeavors. Like Julius before him, Sixtus employed an army of designers, painters, and sculptors to beautify the city. He brought new sources of public water to the town; forged broad, straight avenues through Rome's ancient maze of streets; and built public spaces with attractive architectural focal points. Rome became a model for urban planning and renewal that would be imitated throughout Europe in subsequent centuries. Elsewhere in Italy the sixteenth century was a time of great architectural vitality. In Florence, the Mannerist painters and designers of the mid- and late century created new projects characterized by a style of intricate complexity and repetition. Many of the city's artists worked for the Medici, who now ruled the city as dukes. For inspiration, these figures turned to the architectural works of Michelangelo at the Church of San Lorenzo, notable for its willful violations of classical design tenets. Their projects inspired other designers in Rome and central Italian cities, although their influence rarely spread

into the world of northern Italy and Venice. Here a refined and elegant classicism, best articulated in the architecture of figures like Jacopo Sansovino and Andrea Palladio, continued to dominate both public and private construction. This classicism, characterized by a greater lightness and delicacy and balanced symmetry, was eventually widely imitated throughout Europe, but most notably in England during the seventeenth and eighteenth centuries. Palladio's illustrated architectural treatises even influenced American architecture such as the graceful structures that Thomas Jefferson and other colonials designed for the new Republic.

THE ARCHITECTURAL RENAISSANCE THROUGHOUT EUROPE. Around 1500, European architecture outside Italy remained traditional. The first buildings inspired by the Renaissance of architectural design occurring in Italy were not in Western Europe, but at the continent's eastern fringes. In the second half of the fifteenth century King Matthias Corvinus encouraged the development of humanism in Hungary, and brought to his kingdom a small group of Italian artists and architects to remodel his castles and to build several new projects. In Russia, Grand Prince Ivan III did likewise when he lured a group of Italian craftsmen and architects to Moscow to beautify the Kremlin complex. In Western Europe the spread of humanism similarly encouraged patrons and designers to adopt elements of Renaissance classicism, but this process of integration occurred slowly throughout the sixteenth century. In Western Europe, Spain was among the earliest places to show signs of a classically influenced architectural Renaissance. In Northern European countries, building in the early sixteenth century usually proceeded along late-Gothic lines. In its late phase, Gothic architecture embraced a highly ornate and decorative style, with highly elaborate piers and vaulted ceilings being among its most distinctive elements. As the Renaissance affected styles throughout the region, Northern Europeans often borrowed ancient decorative elements to create highly ornate decorations that were more Gothic than Renaissance in their overall effect. The presence of Italian architects and painters in France, Germany, and Spain, as well as the journeys of craftsmen to Italy, gradually helped to develop a more complete understanding of classical architecture, its design elements, and its uses, as did the spread of architectural treatises written by Italians like Serlio, Palladio, and Vignola. These works, with their engraved illustrations, deepened the appreciation of classicism among European architects working outside Italy. One notable holdout, though, was England, where a native style of Gothic architecture continued to be popular throughout

much of the sixteenth century, with very few attempts at Renaissance classicism. In most of Northern Europe, a shift in the type of building was also evident. In France, the Netherlands, and England, religious controversy between Catholics and Protestants had a dampening effect on the building of new churches in the sixteenth century. At the same time the era was one of great achievement in the building of royal palaces, country châteaux, and public buildings. These structures illustrate the gradual appropriation of Renaissance classicism that occurred throughout the region. At the beginning of the century most projects continued to be built in native and traditional styles with classical and Gothic elements appearing on the same structure. As the sixteenth century progressed, a new sophistication and rigor developed in the uses of ancient design, sponsored by changing tastes, a deepening knowledge of antique architecture, and the spread of humanistic ideas. By 1600, all Western European countries, with the exception of England, had developed vigorous new patterns of building that combined native traditions with Renaissance classicism. These edifices played an important role in expressing the power of the church and state, even as they expressed a new longing for balance, harmony, and order.

TOPICS
in Architecture and Design

THE BIRTH OF THE RENAISSANCE STYLE

ENVIRONMENT. The development of a uniquely Renaissance style centered on the city of Florence, the town often called the "birthplace of the Renaissance." While the citizens of Florence did not single-handedly create the revival of culture and learning that occurred in Europe during the period, they did nevertheless pioneer new architectural styles imitated first in Italy and later abroad. This revival was evident to visitors to the city in the fifteenth century, as they saw the town's urban fabric being transformed through the building of a host of new architectural monuments, most of them created in a style that imitated the buildings of Antiquity. During this period the building of Renaissance Florence was a significant industry, and one whose foundations can be traced to the peculiar circumstances of the town's history in the later Middle Ages and early Renaissance.

POPULATION. During the thirteenth and early fourteenth centuries Florence's population expanded rapidly,

more rapidly than most European cities at the time. Around 1200, for example, the town was smaller than nearby Pisa. A little more than a century later in the time of Dante and Giotto, its numbers had increased at least fourfold. The city's population was then probably around 90,000. Although small by modern standards, the city ranked among the largest in Europe. This great expansion created a building boom, beginning with the new walls constructed to defend the town. A new system of fortifications had been built around Florence in the late twelfth century, but a century later, another was already necessary. These new walls, begun around 1284, were not completed until the mid-fourteenth century. When complete, they increased by five times the area enclosed within the city's fortifications. Such ambitious plans proved unnecessary, however. Between 1347 and 1351 the Black Death struck Florence hard, as it did other European cities at the time; Florence experienced a sudden and dramatic decline in its population as the disease moved quickly through densely packed streets and overcrowded dwellings. Florence's population may have fallen by as much as one-half after the Black Death, and the city's numbers remained depressed from their pre-plague levels in the late fourteenth and early fifteenth centuries, in part because of renewed outbreaks of the disease.

CAPITALISM. Although the Black Death produced sudden economic dislocation in Europe's towns and countryside, it is more difficult to generalize about the epidemic's long-term economic effects. The population decline affected Europe's various industries differently. Activities that required a great deal of labor, for instance, tended to experience a rise in the real wages of their workers, since there were fewer laborers than before the Black Death. In many parts of Europe nobles and peasants converted their lands to pastoral purposes, raising sheep and other animals that required less manpower than other kinds of farming. The increase in the production of wool this transformation provided presented producers in towns like Florence with a steady source of cheap raw materials to refine into finished cloth. While many wealthy families had died out during the epidemics of the fourteenth century, those that survived now faced ideal circumstances in which to consolidate their control over the local economy. By 1400, all evidence suggests that an extraordinary amount of wealth had accumulated in the hands of Florence's wealthy merchants, bankers, and industrial producers. Over the coming years a large part of this wealth funded the construction of buildings designed to glorify and immortalize the city's most prominent families. As a result, the building trades wit-

nessed unprecedented expansion, as cities throughout Italy—but most particularly in Florence—devoted significant capital resources to construction.

LURE OF ANTIQUITY. Florence, like many Italian cities in the early fifteenth century, was a republic that had long been dominated by an oligarchy comprised of prominent families. During the fifteenth century the Medici family, in particular, increased its control over Florence's political structure, while at the same time upholding Florence's pretensions to being a republic. The town's control extended into the surrounding countryside, and during the fifteenth century Florence continued to conquer many neighboring towns in Tuscany, bringing them under its control. These conquests, which had been occurring for years, were now increasingly necessary to protect the town from the threat of outside invasion. Around 1400, Florence narrowly averted a major threat to its independence from the duchy of Milan when a sudden outbreak of plague struck the enemy's armies. A decade later another threat loomed, this time from the Kingdom of Naples to the south. Disease again prevented the town's conquest. In this situation of constant endangerment the image of the city as a David that stood up against the greater Goliaths of Italy became a potent symbol in the town's mythology. At the same time the town's humanist philosophers, artists, and architects were studying the antique worlds of Rome and Greece, finding a kinship with the urbane sophistication and republican values of Greek, Etruscan, and early Roman civilizations. In the decades after 1400 Florence's wealthy families surrounded themselves with the trappings of Antiquity, not only in their intellectual culture but in their art and architecture as well. While this taste for Antiquity was certainly a distinctive element of Florence's Renaissance, it was also at the time becoming a general phenomenon throughout Italy. Even in towns and cities ruled by despotic princes, rulers and ruled were coming to a deeper understanding and appreciation of the ancient world. In Florence, though, the revived classicism of Renaissance architecture played a vital role in expressing the values of independence, civic involvement, and local identity.

MEDIEVAL PROJECTS. Despite the falloff that had occurred in Florence's population as a result of the Black Death, many public building projects had continued in the fourteenth century unabated. Some of these projects were still under construction even as the new architecture of the Renaissance transformed the cityscape. Around 1300, the city's government had begun construction on a new town hall. Today known as the Palazzo Vecchio (or Old Palace, to distinguish it from another civic complex dating from the sixteenth century), the building was constructed in a thoroughly medieval style, with heavily rusticated walls and a crenellated tower. Toward the end of the fourteenth century the town had also opened a new square outside this town hall by demolishing medieval houses that had stood at the site. Florence's governmental square was notable for its size and attractive shape, and although medieval in origin, the plaza displayed sculptural works by the town's most prominent artists throughout the Renaissance, a practice that has continued to the present day. A second major project of the fourteenth century, the town's grain market, began in 1336. When completed, the covered market of Orsanmichele was the most elaborate in Europe. Constructed in stone, the building was over 120 feet high and had two floors of vaulted space for merchants' sales. Even prior to the structure's completion, Florence's town fathers converted the building, allowing it to be used by the city's confraternities and guilds as a center for their charitable works and religious devotions. The decoration of the new religious complex consumed the energies of many Florentine artists and sculptors during the early Renaissance. Although their design was still medieval in nature, the scope of Orsanmichele and the Palazzo Vecchio went far beyond the scale of other projects built in Florence in previous centuries. They, in turn, were soon to be dwarfed by the building of the town's cathedral, the single largest project ever undertaken in the city and still one of the world's largest churches.

CATHEDRAL. Although work began on the Florence cathedral in 1296, it took over a century and a half to complete the mammoth structure. From the first, the cathedral's creators conceived it as a public monument, rather than an ecclesiastical project. The town's government and the local guilds, for instance, financed the church's construction, and Florence's archbishops had little say in how the structure was built. Over time the city's most powerful guild, the Arte de Lana or "woolmaker's guild," controlled the cathedral's construction, establishing a special Board of Works of the cathedral charged with supervising all matters concerning the building. This board appointed many of the city's famous artists and sculptors to decorate the project, including Giotto Bondone (c. 1277–1337), who has long been credited with designing the cathedral's graceful campanile or bell tower, to serve as the director of the work during the final years of his life. Most European cities with similar projects underway at the time of the Black Death abandoned or radically pared down their plans in the years following the epidemic. This was not

a PRIMARY SOURCE *document*

MASTERING ANCIENT BUILDING PRACTICES

INTRODUCTION: The Florentine scholar Antonio Manetti (1423–1491) was the first to write a life of the great early Renaissance architect Filippo Brunelleschi. In it, he lauds Brunelleschi for his innovation. The following excerpt from that biography describes the way in which the architect gained mastery over the process of building by examining the structures of ancient Rome.

Having perceived the great and difficult problems that had been solved in the Roman buildings, he was filled with no small desire to understand the methods they had adopted and with what tools [they had worked]. In the past he had made, for his pleasure, clocks and alarm clocks with various different types of springs put together from a variety of different contrivances. All or most of these springs and contrivances he had seen; which was a great help to him in imagining the various machines used for carrying, lifting, pulling, according to the occasions where he saw they had been necessary. He took notes or not, according to what he thought necessary. He saw some ruins, some still standing upright, and others which had been overthrown for various reasons. He studied the methods of centering the vaults and of other scaffolding, and also where one could do without them to save money and effort, and what method one would have to follow. Likewise, [he considered] cases where scaffolding cannot be used because the vault is too big and for various other reasons. He saw and considered many beautiful things which from those antique times, when good masters lived, until now had not been utilized by any others, as far as we know. Because of his genius, by experimenting and familiarizing himself with those methods, he secretly and with much effort, time and diligent thought, under the pretense of doing other than he did, achieved complete mastery of them, as he afterwards proved in our city and elsewhere …

During this period in Rome he was almost continually with the sculptor Donatello. From the beginning they were in agreement concerning matters of sculpture more particularly … [but] Donatello never opened his eyes to architecture. Filippo never told him of his interest, either because he did not see any aptitude in Donatello or perhaps because he was himself not sure of his grasp, seeing his difficulties more clearly every moment. Nevertheless, together they made rough drawings of almost all the buildings in Rome and in many places in the environs, with the measurements of the width, length and height, so far as they were able to ascertain them by judgment. In many places they had excavations done in order to see the joinings of the parts of the buildings and their nature, and whether those parts were square, polygonal or perfectly round, circular or oval, or of some other shape … The reason why none understood why they did this was that at that time no one gave any thought to the ancient method of building, nor had for hundred of years.

SOURCE: Antonio Manetti, *The Life of Filippo di Ser Brunellesco*, in *A Documentary History of Art*. Vol. I. Ed. Elizabeth G. Holt (New York: Doubleday Anchor, 1957): 177–178.

the case in Florence where construction continued on the cathedral despite the decline that occurred in the city's population after the Black Death. During the 1350s builders completed the structure's campanile, and soon after Florentines laid down the piers of the church's massive crossing, the area between the nave and the choir. The massive scale laid out for these piers committed Florence to the construction of a building of truly enormous size. For years the project continued, even though no one had any idea how the structure's crossing—more than 130 feet in diameter wide—was to be roofed over.

BRUNELLESCHI'S DOME. In the years after 1400 the architect Brunelleschi worked to solve this puzzle. Originally trained as a sculptor, Brunelleschi had been a finalist in a competition to create new doors for Florence's cathedral baptistery in 1401. The judges were unable to decide between Brunelleschi's and his competitor Lorenzo Ghiberti's submissions, and awarded the commission to be shared by both. Brunelleschi, according to a long-standing legend, refused to accept this plan, and from this point onward he turned away from sculpture to devote himself to architecture. He traveled to Rome where he studied the buildings of the ancient world, measuring their proportions and analyzing their structural elements. By 1420, he had perfected his skills as an architect. His designs for a dome to complete the city's cathedral had been accepted and work began on his novel conception. The existing structure, a Gothic-styled cathedral, shaped Brunelleschi's plans for this work, and except for the lantern that sits atop the structure, there are few classical influences in the architect's dome. The ingenuous solutions that Brunelleschi developed to cover this enormous space, though, point to his great skill as an engineer, skills that he would put to use later in a series of churches, chapels, and public buildings he designed in Florence. Brunelleschi directed the cathedral

project for a number of years, supervising work crews and resolving thorny issues of design and building on a daily basis. His solutions to the practical problems of building show the strongly inventive strain of his mind. One of the problems of constructing a dome of this magnitude proved to be the issue of scaffolding. It had been estimated that it might consume the wood from several forests to build a scaffold large enough to construct the structure's dome. Brunelleschi instead devised an innovative system in which the scaffolding positioned at the top of the dome's drum could be moved up as new sections of the structure were completed. He also created a device whereby building materials could be hoisted up to these scaffolds as needed, an invention that reduced the number of workmen needed to ferry materials. The dome's structural elements consisted of eight ribs that supported both an outer and inner skin. Patterned brickwork between the ribs added strength to the structure, allowing the two elements—the stone ribs and brickwork—to support the dome's interior skin. A series of buttresses arranged around the base or drum of the dome also gave further support to the entire project's mass. This solution allowed the structure to soar with commanding simplicity almost 40 stories over the skyline of Florence. Since its completion in 1436, Brunelleschi's dome has become the most famous and readily recognizable symbol of the city.

OTHER PROJECTS. As construction on Brunelleschi's dome reached completion, the city of Florence witnessed a building boom of unprecedented proportions. For the architect Brunelleschi, managing the cathedral project was a full-time job that required his presence on a day-to-day basis. Even though the demands of this work were considerable, Brunelleschi still found time to design a number of structures elsewhere in the city. These projects helped forge a distinctive Renaissance architectural style imitated by later architects. In these designs Brunelleschi put to even greater use the classical language he had learned from his study of ancient architecture in Rome. The architect's plans for the Ospedale degli Innocenti show the artist's first attempts to develop a complete style influenced by classical proportions and design elements. Founded in 1410, the Ospedale was a foundling hospital or orphanage—one of the first European institutions to deal with the problem of abandoned children. The design that Brunelleschi crafted for the institution's orphanage was similarly innovative. In it, he created an arcade of eleven slender columns that supported rounded Roman arches. One of the most significant things about the architecture the artist created here was its use of a geometrically regular system of propor-

tions. Each column, for instance, was as high as the width of the arch it supported and equal, too, to the distance between the outer colonnade and the interior wall. Brunelleschi made similar use of regular proportions throughout his plans, thus producing a work that was simple, elegant, and visually balanced. The only decorative elements he included in his original plans were the acanthus-leafed Corinthian capitals that crowned the colonnade's columns. Thus in contrast to the complexity of Gothic architecture being constructed at the time in most of Europe, his designs for the Ospedale were a model of restraint, clarity, and simplicity. A key feature of Brunelleschian architecture was its use of numerical relationships. On the building's façade the proportions he relied upon made use of the relationships one to two, one to five, and two to five. Brunelleschi repeated these same numerical relationships in the building's interiors. These numbers were not haphazardly chosen, but were religiously significant: one being the number associated with God the Father, two with Jesus Christ, and five with the number of wounds the Savior suffered during his crucifixion. Further, the multiple of two and five equals ten, the number of the Commandments, which were an important set of strictures used in raising the orphanage's children. In this way Brunelleschi's mathematical relationships, which were readily intelligible to the astute fifteenth-century observer, expressed certain underlying religious ideals, a feature of his architecture that became one of the hallmarks of Renaissance design. In both the fifteenth and sixteenth centuries architects would use numerical relationships, proportions, and shapes not only to create harmonious designs but to express underlying philosophical and religious truths.

CHURCHES. In a series of churches and chapels designed throughout Florence the architect perfected his new classical idiom. Work on Brunelleschi's plans for the Church of San Lorenzo commenced in 1421. The Medici family, which was rising to prominence at the time, financed much of the construction of this project, and their ties to the church remained strong throughout the fifteenth and sixteenth centuries. In his designs for San Lorenzo, Brunelleschi pioneered the first use of an architectural system of single-point perspective. Looking down the church from the high altar back to the end of the nave, the church's lines and columns are designed so that they diminish and converge at one point in the rear of the structure. In place of the mystery of a Gothic church, Brunelleschi here expressed an architectural system in which the interplay of light on simple refined surfaces recalled the grand interior spaces of ancient Rome. In place of the traditional Latin cross usually relied upon

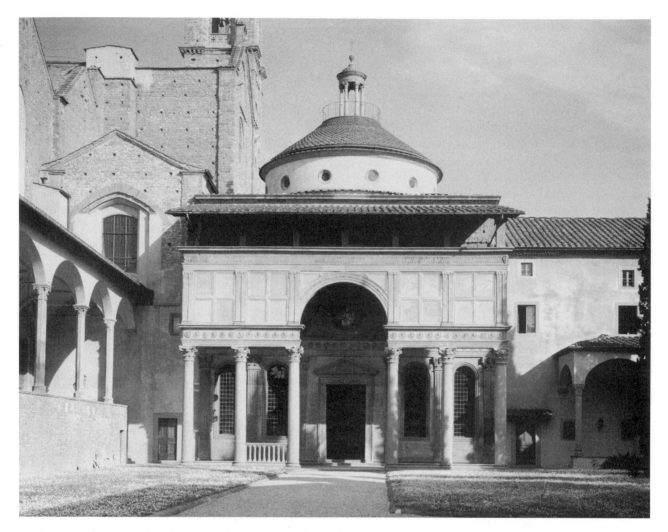

The Pazzi Chapel, Church of Santa Croce in Florence, Italy, designed by Filippo Brunelleschi. © ANGELO HORNAK/CORBIS. REPRODUCED BY PERMISSION.

in Western church architecture, the architect substituted the T-shape of the ancient Roman basilica. On both sides of the nave, a colonnade of Corinthian columns supporting Roman arches sets off side aisles, in which the church's chapels are recessed again into Roman arches. Above these arches round windows known as *oculi* admit light into the space. Throughout the structure Brunelleschi restricted his use of materials to the gray stone known in Italy as *pietra serena* and white plaster. Although the resulting effect is severe, it is also rational, harmonious, and altogether appealing. The use of the two-tone palette of gray and white, found in Brunelleschi's earliest creations, became a long-standing feature of Tuscan design, surviving well into the nineteenth century. The architect perfected this new classical style of church architecture further in his plans for a new Church of Santo Spirito, a building that eventually replaced an older medieval structure on the spot. Here Brunelleschi

relied on a different set of proportional relationships to produce a structure that appears more massive and imposing than the lighter and more elegant San Lorenzo. In the case of both churches Brunelleschi planned to situate the structures within impressive piazzas that would serve as a focus for civic life. Unfortunately, neither design was executed in the way in which the artist had wished, although later architects studied his plans. Thus they had an indirect impact upon developing ideas about urban design in the Renaissance. For the Church of Santa Croce in Florence, Brunelleschi designed a third architectural masterpiece, the small Pazzi Chapel that is a freestanding structure on the church's grounds. In this building the contrast between the late-medieval architectural world and that of the developing Renaissance becomes even more evident. In contrast to the complexity and mystery of Gothic spaces, Brunelleschi's plans for the chapel are at once clear, graceful, and har-

monious. They give expression as well to the developing sensibilities of the humanist movement, with its emphasis on the notions of a universe filled with divinely inspired harmonies and proportions that could be understood by the human mind. At the Pazzi Chapel, the artist again relied on the color scheme he chose for Santo Spirito and San Lorenzo: cool gray and white. Yet within this space, touches of blue—from the terracotta medallions designed for the chapel by the sculptor Luca della Robbia—relieve the severity inherent in the earlier structures. In addition, Brunelleschi altered his proportions so that he diminished the scale of each of the chapel's three stories. The result makes the Corinthian pilasters, which serve as a decorative element upon the chapel's walls, take on an even greater visual importance.

MICHELOZZO. All Brunelleschi's completed buildings in Florence were public in nature. At the same time a revolution was also underway in domestic architecture led by the architect's younger competitor, Michelozzo di Bartolommeo (1396–1472). Michelozzo and his studio designed numerous chapels, churches, and monastic buildings in and around the city of Florence, along with urban palazzi (palaces) and country villas. The quality of domestic architecture in medieval Florence had been low, consisting mostly of medieval tenements filled with crowded apartment-styled dwellings. Even the wealthiest families in the town had long clung to fortress-like houses, which in the uncertain and insecure world of the Middle Ages had often been sited around a massive defensive tower. During the 1440s Cosimo de' Medici, the head of the wealthy banking family and the backdoor manipulator of Florence's politics, commissioned the architect Michelozzo to design a new family palace or palazzo. At that time, as now, the word "palazzo" in Italian referred to all kinds of substantial urban buildings. The Medici Palace that Michelozzo designed became the nerve center of the Medici banking and business concerns as well as the family's domestic residence. At the time the Medici was a family of comparatively new wealth that lacked a noble title. Cosimo de' Medici consequently wanted to use his new palazzo to project the right image. We know, for instance, that he had originally approached Brunelleschi to design the building, but he rejected the architect's plans because he felt that they were too ostentatious and elaborate. Since Florence was a republic (although ostensibly one largely controlled by Cosimo) he desired a palace that would bolster the image of his family as cultured and substantial private citizens of the city. The Michelozzo design he chose has been somewhat altered over the centuries. It consisted of three floors. The first floor, which was the center of the

The Medici Palace in Florence, Italy. © PHILIPPA LEWIS/CORBIS.

Medici bank during the Renaissance, originally had large Roman-styled arches that were open to the street so that merchants and businessmen could gain free access to the structure. The exterior walls of this floor are finished with rustic blocks of stone, while above on the second and third floors, the masonry becomes progressively more refined. At the top of the structure a classical cornice crowns the building. Although the Medici Palace is more than 70 feet high, the overall effect is not one of grandeur, but of squatness. The interior courtyard fills the structure with light and relieves the fortress appearance of the exterior. The colonnade that surrounds this courtyard shows the influence of Brunelleschi's designs for the Ospedale, although Michelozzo used columns that were shorter and more massive to support the heavy weight of the floors above. To modern minds, the appearance of the Medici Palace appears far from homey since its high ceilings and forbidding rusticated exterior seem to connote more the appearance of public rather than domestic spaces. Such distinctions, however, played little role in the overheated commercial world of fifteenth-century

a PRIMARY SOURCE *document*

BEAUTY IN BUILDING

INTRODUCTION: Leon Battista Alberti's *On the Art of Building* closely followed the ideas of the ancient Roman designer Vitruvius. Later architects and patrons read Alberti's treatise, and many of Alberti's ideas were to shape the aesthetic values of the later High Renaissance. The scholar's definition of beauty was often repeated in the evolution of Renaissance thought.

In order therefore to be as brief as possible, I shall define Beauty to be a harmony of all the parts, in whatsoever subject it appears, fitted together with such proportion and connection that nothing cou'd be added, diminished or altered, but for the worse. A quality so noble and divine that the whole force of wit and art has been spent to procure it; and it is but very rarely granted to any one, or even to Nature herself, to produce any thing in every way perfect and complete. How extraordinary a thing (says the person introduced in Tully) is a handsome Youth in Athens! This Critick in Beauty found that there was something deficient or superfluous in the persons he disliked, which was not compatible with the perfection of beauty, which I imagine might have been obtained by means of Ornament, by painting and concealing anything that was deformed, trimming and polishing what was handsome; so that the unsightly parts

might have given less offence, and the more lovely, more delight. If this be granted, we may define Ornament to be making of an auxiliary brightness and improvement to Beauty. So that then Beauty is somewhat lovely which is proper and innate, and diffused over the whole body, and Ornament somewhat added or fastened on rather than proper and innate. To return therefore where we left off. Whoever wou'd build so as to have their building commended, which every reasonable man would desire, must build according to a justness or proportion, and this justness of proportion must be owing Art. Who therefore will affirm that a handsome and just structure can be raised any otherwise than by the means of Art? and consequently this part of building, which relates to beauty and ornament, being the chief of all the rest, must without doubt be directed by some sure rules of art and proportion, which whoever neglects will make himself ridiculous. But there are some who will by no means allow of this, and say that men are guided by a variety of opinions in their judgment of beauty and of buildings, and that the forms of structures must vary according to every man's particular taste and fancy, and not be tied down to any rules of Art. A common thing with the ignorant to despise what they do not understand!

SOURCE: Leon Battista Alberti, *On the Art of Building*, in *A Documentary History of Art*. Vol. I. Ed. Elizabeth G. Holt (New York: Doubleday Anchor, 1957): 230–231.

Florence, as most families lived and worked in the same space. The Medici Palace, by contrast, offered the family a greater degree of privacy and comfort than was usually present in the dark and damp homes in which even many of the city's wealthiest citizens lived. The building's rusticated exterior, too, duplicated the surviving monuments of ancient Rome rather than medieval models, in order to give the Medici family a degree of greater respectability. To the fifteenth-century observer, the palace's exterior likely conveyed an impression of dignity and solidity. Observed from this direction, it is not difficult to see why the palace exercised an influence over the construction of many similar structures for Italy's notable families.

ALBERTI. Leon Battista Alberti (1404–1472) was the finest fifteenth-century architect to follow Brunelleschi in Florence. One of the great "universal men" of the Renaissance, Alberti was a humanist by training who worked in Florence during the mid–1430s. Although he was a member of one of the town's most distinguished families, the young Alberti had been born illegitimate

and was brought up in Venice during one of the periods of his father's exile from the city. His father died during Alberti's student years, ultimately leaving the young scholar without sufficient resources to support himself. Thus Alberti sought patrons in the wealthy, cultivated families of Italy, numbering among his distinguished supporters the Este of Ferrara, the Gonzaga of Mantua, at least two popes, and the Rucellai family in Florence. He designed a number of structures for these patrons, and in 1450 he finished his *Ten Books on Architecture*, a work that revived the ideas of the ancient Roman scholar Vitruvius about architectural proportions. While his architectural ideas were not widely influential among Florentine builders in the fifteenth century, architects elsewhere in Italy imitated his design tenets.

DESIGNS. At the invitation of Pope Nicholas V (1459–1557), a scholarly pope whom Alberti met during his student days, the architect completed the first plans for the rebuilding of St. Peter's Basilica in Rome. Although that project stalled for almost another half cen-

tury, Bramante, Raphael, and Michelangelo—the Vatican's chief sixteenth-century builders—all studied his plans. Alberti's ideas about architecture maintained that beauty was a truth, and that buildings must be designed rationally to provide people with space that was harmonious and beautiful. At the same time he was conscious of the functionality of the spaces he created, insisting that buildings must serve practical uses and consequently be designed for their inhabitants. Alberti's theories on architectural beauty are evident in the palace he designed for the Rucellai family during the mid–1440s. The architect rejected the heavy fortress style of Michelozzo's slightly earlier Medici Palace, and instead created a façade that was altogether more refined. Unlike Brunelleschi who used columns to support his graceful colonnades and arches, Alberti liberated the column and the pilaster to become mere decorative elements. The arch itself, he insisted, was an opening in a wall, and most of his designs preserved its essential nature. Alberti, for instance, did not create colonnades of columns that supported Roman arches in the way that Brunelleschi had done before him. He developed these ideas in a number of commissions he completed for Italian princes, amassing a distinctive list of creations that influenced the development of the later High Renaissance style. One of the most unusual buildings he designed was for the notorious despot Sigismondo Malatesta, at the time lord of Rimini. Alberti was then working within the papal household and was also a member of a religious order, but this did not dissuade him from helping Malatesta in his plans to build a temple that glorified pagan learning and humanist scholars. Originally, Malatesta had planned to remodel a local church to suit his ambitions for a pagan shrine. At Alberti's instigation, though, the tyrant began to completely encase the former church within an entirely new skin of marble. Unfortunately, Malatesta's fortunes changed before the shrine's completion, and work on the structure ceased. The exterior of this structure, though, shows Alberti's successful assimilation of classical elements of design, an assimilation that was also expressed in the architect's plans for the Church of Sant'Andrea in Mantua. The architect finished designing this project in 1470, shortly before his death, and most of its construction occurred following his death. Here he relied on a traditional Latin cross layout for the structure, although in his writings he advocated the use of central style, in which none of a church's radiating wings was larger than another. Instead of the rows of columns that Brunelleschi and other fifteenth-century architects had used to support their vaulted ceilings, Alberti created a single-aisle church with side chapels recessed into the walls within gigantic Roman

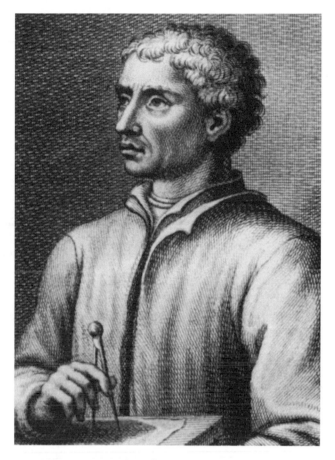

Engraving of Leon Battista Alberti. **THE LIBRARY OF CONGRESS.**

arches. Further he designed the ceiling of this church as a single rounded barrel vault that moves toward the crossing and is met by similar barrel vaults in the transepts and choir. The overall effect of the design produced is at once harmoniously proportioned and majestically beautiful. It is little wonder, then, that elements of Sant'Andrea's barrel-vaulted style had numerous imitators, most notably in both Bramante's plans for the new St. Peter's Basilica and the Jesuit Church of Il Gesù, important sixteenth-century projects in the city of Rome.

AFTER ALBERTI. The impact of Alberti's harmonious creations inspired many designers in the second half of the fifteenth century. In Rome, Alberti's work for Pope Nicholas V created a new urban design for the city centered on St. Peter's and the Vatican complex. A number of buildings constructed after 1450 seem to be influenced by his ideas and designs, although their architects are unknown. These nameless figures copied Alberti's plans for the façade of Santa Maria Novella in Florence at several Roman churches during the 1470s and 1480s. In addition, Alberti's architectural ideas are evident in the courtyard built for the Palazzo Venezia in

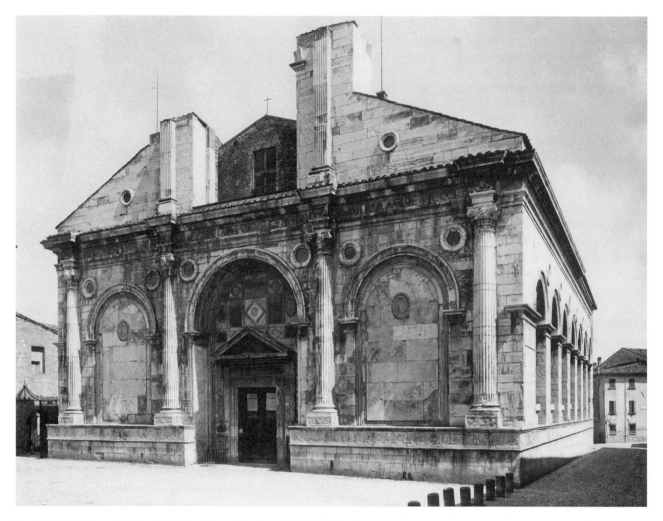

The Malatesta Temple in Rimini, Italy, designed by Leon Battista Alberti. ALINARI-ART REFERENCE/ART RESOURCE, NY. REPRODUCED BY PERMISSION.

Rome sometime after 1455. Although the architect's influence upon subsequent designers was profound, innovators also continued to appear on the Italian scene. One of these, Giuliano da Sangallo, was the first of a distinguished family of architects. Like Brunelleschi and Alberti, Sangallo studied the buildings of ancient Rome, recording a number of buildings that have since disappeared. In Prato, a suburb outside Florence, he designed the Church of Santa Maria dell Carceri that drew imaginatively on elements from Alberti and also from Brunelleschi's plans for the Pazzi Chapel. In this structure he placed a ribbed dome similar to those Brunelleschi had designed in Florence. Sangallo designed the church itself in the central style, a departure from the traditional Latin cross used throughout most of the Middle Ages. Alberti's theoretical writings on architecture had stressed that the central style—in which the radiating transepts of the building were of equal size—was

more harmonious and beautiful. Sangallo's integration of Albertian and Brunelleschian styles continued throughout the interior and exterior of the building. Inside he decorated the structure with the palette of *pietra serena* and white plaster typical of Brunelleschi. On the exterior of the church, however, the architect played off brilliant white and green marbles, similar to the façades that Alberti had crafted for his structures. Sangallo established a popular design practice in Florence, and during the late fifteenth century he produced plans for a number of charming structures, including a new country villa for the Medici at Poggio a Caiano.

PALACE BUILDING. The years between 1450 and 1500 saw a great boom in the construction of urban palaces for the wealthy merchants and nobles of Italian cities. In Florence the town's patrician class rushed to imitate the Medici and other families who had already constructed domestic palaces during the first half of the

fifteenth century. The façades of these structures were either constructed from rusticated stone or finished with rough plaster known as *intonaco*. In a few cases both materials were combined on the same façade. Like the Medici Palace, the impression most Florentine palaces made from the street was not one of opulence or grandeur, although such buildings would have stood out in a cityscape filled with monotonous and undistinguished medieval houses. Inside, though, the interiors were flooded with light from the stylish courtyards that usually served as the central focus of the building. The contrast between the dark spaces typical of medieval houses and those of the Renaissance was probably striking to fifteenth-century observers. Over time, the palazzi grew larger and more elaborate, as families competed to outdo each other. In the 1490s, for instance, the prominent Strozzi family began construction on a palace that they hoped would outshine all others in the city. Not completed until 1507, the Palazzo Strozzi was, like many of these palace projects, an early exercise in urban renewal that necessitated the demolition of many pre-existing structures. The family demolished a huge city block that included a massive medieval tower that belonged to a noble count, several shops, and at least four other houses in order to build its new home. While the interiors of these dwellings offered definite improvements in comfort over most medieval structures, a palace's walls were frequently plain and unadorned. The amassing of collections of art, a custom that grew more popular at the time, did much to relieve the monotony of Florence's new interior spaces. Even with these great collections, though, a palace was not a homey structure in a modern sense.

CONSEQUENCES. The construction of so many great structures within such a short time transformed the Florentine cityscape. Palace construction displaced huge numbers of people from their residences, as wealthy families bought up large tracts of land within the city and demolished former tenements. As poor residents were dispersed into other areas of town, fashionable and unfashionable neighborhoods emerged. The city's wealthiest families crowded into particular areas and even certain streets, while the poor sought housing at the boundaries of the town's developed areas. The result produced more notable distinctions between rich and poor in the city. Writing about 1470, a prominent Florentine observed that thirty imposing urban palaces had been constructed during his lifetime. A half century later another observer noted an additional twenty structures that had been added to the city, but he also remarked that anyone who would want to list all of the town's major

palaces would have a difficult job indeed. The construction of such a large number of imposing structures required an equally large number of designers and tradespeople. Among the architects who frequently designed and supervised construction of these buildings were Giuliano da Sangallo, his brother Antonio, and their nephew Antonio. The Sangallos maintained a popular and profitable business constructing domestic palaces. But Florence also produced a number of competent designers at this time, men who met the demands of wealthy citizens for new accommodations. Most of these figures had risen in their respective guilds—goldsmithing, carpentry, and stonecutting—and had acquired notable expertise in the arts of construction. Around 1500, painters, too, ranked among those who designed urban buildings, and the long list of sixteenth-century artists who planned such buildings included Raphael Sanzio, Michelangelo, and Giorgio Vasari. But in most cases architecture was not a self-sustaining profession, as in the modern world. Most designers practiced other crafts besides designing buildings, and many merely designed one or two structures at the request of their patrons.

URBAN PLANNING. From Brunelleschi's days onward, architects had often envisioned plazas and squares surrounding the structures that they built; but like the oft-unfinished façades of Renaissance churches, few of these plans ever came to fruition during the fifteenth century. The experience of seeing the Roman forum, even in its dilapidated and ruined state, suggested to Renaissance scholars, architects, and artists, the public vitality of ancient life. In an effort to recover this kind of use of urban space, architects in the fifteenth century increasingly turned to study the ancient designer Vitruvius as well as the works of Polybius. They often envisioned entirely new cities planned along lines suggested by these antique writers. Although they rarely produced results, these plans had avid students in the artists and designers who came later. The fifteenth century, though, did produce one fine example of a planned city. During the 1460s Pope Pius II had his native village south of the city of Siena rebuilt along the lines suggested by contemporary Renaissance architects. Eventually named Pienza in his honor, the town featured a plan in which streets and subsidiary squares radiated out from a central plaza. Within Pienza, different architectural proportions established a visible hierarchy among the city's various structures. Architects and artists admired this kind of centralized, rational planning. The Urbino court artist Luciano Laurana designed one of the most famous plans for an ideal city of this sort. In a plan from around 1475 the architect grouped all structures in a large city

around a central square in which he placed a classically styled round "temple" inspired by the architectural writings of Alberti. The central Italian painter Piero della Francesca immortalized Laurana's visually appealing plans in a famous panel painting, *Vision for an Ideal City*. Most fifteenth-century architects, Laurana included, had to be satisfied with far more limited successes, such as the design of the small squares that surrounded their architectural creations.

THEORY. The fifteenth century also witnessed a revival in interest in the theory of architecture. Brunelleschi and other architects had studied the buildings of ancient Rome, measuring their proportions and analyzing their structural and design elements. This initial interest gave rise to a heightened interest in architectural theory. The humanist scholar and artist Alberti had been among the first to comb the pages of the ancient builder Vitruvius' works on architecture. In his *On the Art of Building*, completed around 1450, he had codified the ancients' ideas about decoration and proportion into a set of architectural "laws." Vitruvius had insisted that the human body was the primary model for architectural design, and he had based the building of his structures on proportions and design elements drawn from the body. Alberti similarly argued that beautiful buildings arose from principles that were similar to those of the human body's design. According to Alberti, beauty arose from the interplay of design elements within a building so that, like the human body, no part could be taken away without diminishing the effect of the whole. Alberti's treatise, however, was primarily a literary work. He provided, in other words, no illustrations to make clear just exactly how buildings designed with these principles might look. For clues to the application of his ideas, his later students studied the many he had planned throughout Italy.

FILARETE AND DI GIORGIO. Shortly after the completion of Alberti's treatise, *On the Art of Building*, the Florentine sculptor and architect, Antonio Averlino (1400–1469), who was widely known as Filarete, completed a similar work of theory. Unlike Alberti's work, though, Filarete illustrated his *Treatise on Architecture* with examples of the buildings he envisioned. The architect wrote the work for the duke of Milan and, although it was not printed in the next generations, it was widely circulated in manuscript form. Filarete wrote his theory with an evangelical tone, trying to convert his readers to the Florentine way of construction. He celebrated the revival of Antiquity that had recently occurred in his hometown and tried to convince his readers of the supremacy of antique styles of building. Along the way he advised on topics about ornament, decoration, pro-

portions, and urban design. He did not write his work, though, with designers in mind, since he addressed his comments not to architects and artists but to princes and nobles. He hoped to encourage these figures to patronize the new architecture. He used a complex and contrived style throughout the work that included a narrative plot in which a court architect educates a young prince in the arts of building. By contrast Francesco di Giorgio (1439–1501), a Sienese painter, sculptor, and architect, was more systematic in his *Treatise on Civil and Military Architecture*, which he probably wrote sometime during the 1480s and later revised in a completely new manuscript edition. As a painter, di Giorgio laid great emphasis both on the inventiveness and drafting skills that were necessary for those who hoped to practice architecture. Like Filarete, di Giorgio illustrated his work, but he did so more systematically than the earlier theoretician. His illustrations, in other words, elaborated upon issues he had discussed in the text, even as they conveyed additional technical information necessary to the practitioner. This technical strain recurs in the text as well, since di Giorgio included a great deal of practical information on methods for measuring heights and depths, military engineering, and hydraulics. Like many artists of the period, di Giorgio also desired to elevate the practice of his discipline and to promote it as an endeavor equal in intensity and seriousness to the liberal arts. His treatise praised the skills that were necessary in the architect, including sophistication in geometry and arithmetic. These he celebrated as signs of the nobility of the calling. Together with Filarete's and Alberti's works, di Giorgio's treatises helped establish a body of architectural theory studied by later sixteenth-century practitioners in Italy and throughout Europe.

ACHIEVEMENT. Fifteenth-century Italian Renaissance architects had many accomplishments. Early in the century Filippo Brunelleschi had made the pilgrimage to Rome to study the structural elements of Antique buildings and to measure their proportions. Returning to his native Florence, he had used the insights gained there, as well as his own skills as a sculptor and stonecutter, to create a dome of stunning beauty for the town's cathedral. In works undertaken throughout the city, he had also relied on his new knowledge of classical Antiquity to design buildings notable for their graceful harmonies and proportions. The success of his initial structures had inspired other figures to create monuments that made use of the visual language of classical buildings. These architects, at first drawn mostly from the stonecutters', goldsmiths', and carpenters' guilds, produced works for the ever-intensifying building boom that occurred in

Florence during the later fifteenth century. The results of this swell in construction clothed the town in new marble-clad churches, domestic palaces, and civic buildings notable for their size and elegance. Florence, in other words, developed from a medieval town filled with monotonous, fortress-like buildings, into a city punctuated by great squares, imposing churches, and dignified residences. These developments did not go unnoticed elsewhere in Italy. Throughout central and northern Italian towns, architects observed the elements of Florentine design and imitated some of its innovations. While the influence that the city cast was great, designers native to other cities—figures like Luciano Laurana and Francesco di Giorgio—point to the growing vitality and originality of centers outside Florence. By the end of the fifteenth century, this productivity had prepared the stage for an even greater era of architectural accomplishment that unfolded in the following century.

SOURCES

R. Goldthwaite, *The Building of Renaissance Florence* (Baltimore: Johns Hopkins University Press, 1980).

F. Hartt and D. Wilkins, eds., *A History of Italian Renaissance Art: Painting, Sculpture, and Architecture.* 4th ed. (New York: Abrams, 1994).

R. King, *Brunelleschi's Dome* (London, England: Chatto and Windus, 2000).

J. T. Paoletti and Gary M. Radke, *Art in Renaissance Italy* (New York: H. N. Abrams, 1997).

R. Tavernor, *On Alberti and the Art of Building* (New Haven, Conn.: Yale University Press, 1998).

P. Walker, *The Feud that Sparked the Renaissance: How Brunelleschi and Ghiberti Changed the Art World* (New York: Harper Collins, 2002).

SEE ALSO *Visual Arts: The Early Renaissance in Italy*

THE HIGH RENAISSANCE

ACHIEVEMENT. By the end of the fifteenth century Italian designers had developed a new sophisticated architectural language that relied on elements culled from the monuments and buildings of Antiquity. They had used this knowledge to create daring new structures that were unparalleled in the centuries that preceded the Renaissance. In Florence and other Italian cities, the new knowledge of classical style had also been used to create imposing urban palaces for wealthy families. For most of the fifteenth century architecture had been a craft largely practiced by sculptors, masons, and carpenters. Around 1500, though, painters began to design buildings with increasing frequency. Painters brought new skills to the practice of architecture, including a surer sense of draftsmen's skills acquired in their craft. They also used light and mass in building in bold new ways. Although none of his structures were ever built, Leonardo da Vinci's plans for several buildings point to the vibrancy of this new trend. Both his imagined designs as well as the writings and buildings of Alberti—all of which emphasized harmonious beauty and elegant refinement—were major influences on the development of High Renaissance architects. This period, which began around 1500 and ended abruptly with the Sack of Rome, produced many fine designs for buildings planned on an enormous scale. As in painting and sculpture, the High Renaissance in architecture produced new structures that were more heroic and grand than those of the fifteenth century. Unfortunately, the relatively slow progress of building construction doomed many of the High Renaissance's monumental architectural plans to incompletion. Some builders abandoned projects altogether; other builders truncated their projects or modified them to fit changing tastes. The High Renaissance in architecture, then, frequently presents us with a picture of great promises, but promises that were often left unfulfilled.

SHIFT TO ROME. Around 1500, the center of architectural innovation also shifted in Italy from Florence to Rome. The pace of construction in the city had already picked up during the second half of the fifteenth century, but with the election of Pope Julius II in 1503 a great period of expansion began. Julius was an impetuous and fiery personality. Known as the "Warrior Pope" he faced friends and foes alike with equal determination. Abroad, Julius marched into battle with his troops, pronounced public curses against his enemies, and beat recalcitrant cardinals who refused to march into battle with him with his cane. At home in Rome, he turned his steely will upon the face of the city, razing whole districts and rebuilding them to suit his desires for a grand capital. The tentative renewal plans of previous Renaissance popes paled in comparison with the building campaigns he waged during his ten-year pontificate. Julius called a host of artists to work in the city and refused to live in the papal apartments that had been recently refurbished by his predecessors. Instead he commissioned Raphael to provide him with new monumental frescoes that might equal the forcefulness of his personality. He hired Michelangelo to work on his enormous tomb, and then only a few years later, redirected the artist to painting the ceiling frescoes of the Sistine Chapel. His greatest endeavor of all, though,

Portrait of Pope Julius II by Raphael. © **NATIONAL GALLERY COL-LECTION; BY KIND PERMISSION OF THE TRUSTEES OF THE NATIONAL GALLERY, LONDON/CORBIS.**

was his decision to rebuild St. Peter's Basilica, a structure originally constructed by the Roman emperor Constantine in the fourth century. To create the new church, which he stipulated must outshine every other church in Christendom, he demolished one of the largest surviving buildings from the ancient world. Summoning the architect Bramante, he soon began the greatest building project of the sixteenth century. Along the way to completion, the new St. Peter's Basilica consumed the efforts of the greatest architectural minds of the age, not to mention enormous sums of money. The project also lasted for more than 175 years, long beyond the scope of the pope's life. Before his death in 1513, Julius oversaw the partial destruction of the old basilica and the construction of the piers of the new building's crossing in order to commit future popes to follow through with his ambitious plans, even when those plans ran counter to the best interests of the church. During the reign of his immediate successor, Leo X (1513–1523), the demand for money to continue St. Peter's construction actually contributed to the great crisis of the Protestant Reformation when Leo arranged for the sale of an indulgence in Germany to finance the building's construction. Similar crises throughout the sixteenth

century threatened the building's completion, although it was, and it remains, an indubitable testimony to Julius' initial inspiration.

BRAMANTE. Donato d'Agnolo, who was better known as Bramante, (1444–1514) became the chief aid to Julius in attaining his greatest architectural ambitions. A native of a small town near the central Italian city of Urbino, Bramante had a successful career as a painter before beginning to practice architecture in his forties. At that time he worked for the Sforza duke Lodovico il Moro and he designed several churches in their capital Milan. The architecture of Alberti (particularly in its use of Roman barrel vaults) and the architectural drawings of Leonardo, with their emphasis on the use of the central style and geometric shapes, both influenced Bramante's style. In 1499, French forces conquered Milan, however, and Bramante was left without employment. He traveled to Rome, where he soon found work because of his connections with the Sforza dynasty. In the city a member of the family, Ascanio Sforza, commissioned him to build his tomb, and over the following years Bramante designed and supervised the construction of a cloister in the city. In 1502, he created the small *Tempietto*, a memorial commissioned by King Ferdinand and Queen Isabella of Spain to mark the site upon which St. Peter supposedly had been crucified. This small domed structure, considered one of the finest of High Renaissance architectural creations, perfects the central style of construction to a point of high finesse. Everything in the small building radiates outward from the memorial's center point, and shows that Bramante had now taken full advantage of his recent viewing of ancient Roman monuments firsthand. Although more severe than the architect's earlier designs, the work points forward toward his plans for the new Basilica of St. Peter's, a commission he won in 1506.

ST. PETER'S. For that great construction project the artist may have considered several possible plans, although he settled eventually on a central-style church, created in the shape of a Greek cross. The architectural drawings of Leonardo da Vinci, which Bramante had studied years before in Milan, influenced his plans for a building constructed as a Greek cross in which each of the church's four radiating wings were of exactly equal size. Eventually, the church's later architects abandoned the Greek cross in favor of a more traditional Latin cross design in which the nave was longer than the other three wings. Bramante's plan, however, called for each of the four corners of the building to be crowned with a large tower, and a dome—envisioned from the very first—was to sit atop the central crossing. Inside the structure Ro-

a PRIMARY SOURCE *document*

A PAPAL ARCHITECT

INTRODUCTION: The architect and painter Giorgio Vasari wrote a famous series of biographies of Italy's greatest artists, which were first published in 1550. In his life of Bramante, Vasari carefully catalogues the changes that were made up to his day in the architect's plans for the new St. Peter's Basilica. The following excerpt illustrates the dangers of later alteration, to which most of the great architectural projects of the High Renaissance fell prey. By Vasari's time, Michelangelo, then the papal architect, was at work to restore key elements of Bramante's original design.

But the work we are here alluding to was conducted after a much altered fashion on his death and by succeeding architects; nay, to so great an extent was this the case, that with the exception of the four piers by which the cupola is supported we may safely affirm that nothing of what was originally intended by Bramante now remains. For in the first place, Raffaelo da Urbino and Giuliano da San Gallo, who were appointed after the death of Julius II to continue the work with the assistance of Fra Giocondo of Verona, began at once to make alterations in the plans; and on the death of these masters, Baldassare Peruzzi also affected changes when he constructed the chapel of the king of France in the transept which is on the side towards the Campo Santo. Under Paul III the whole work was altered once more by Antonio da San Gallo, and after him Michael Angelo, setting aside all these varying opinions, and reducing the superfluous expense, has given the building a degree of beauty and perfection, of which no previous successor to Bramante had ever formed the idea; the whole has indeed been conducted according to his plans, and under the guidance of his judgment, although he has many times remarked to me that he was but executing the design and arrangements of Bramante, seeing that the master who first founded a great edifice is he who ought to be regarded as its author. The plan of Bramante in this building does indeed appear to have been of almost inconceivable vastness and the commencement which he gave to his work was of commensurate extent and grandeur; but if he had begun this stupendous and magnificent edifice on a smaller scale, it is certain that neither San Gallo nor the other masters, not even Michael Angelo himself, would have been found equal to the task of rendering it more imposing, although they proved themselves to be abundantly capable of diminishing the work: for the original plan of Bramante indeed had a view to even much greater things.

SOURCE: Giorgio Vasari, *Lives of Seventy of the Most Eminent Painters, Sculptors, and Architects.* Vol. 3. Trans. E. H. and E. W. Blashfield and A. A. Hopkins (New York: Charles Scribner's Sons, 1913): 52–53.

man barrel vaults, drawn from the architecture of Alberti, were to cover each of the wings, a design feature that was also later achieved. The dome Bramante designed was innovative by Renaissance standards, and shows his growing mastery of the architectural forms of Antiquity. Until Bramante's time architects had relied on the ribbed-style dome first used by Brunelleschi at the cathedral of Florence. In that structure, floating ribs of stone had supported panels of masonry. Bramante's plans for the new St. Peter's stipulated a circular structure, an exact hemisphere based upon the still-standing ancient Pantheon in Rome. To give the dome's unusual shape greater height, Bramante placed the structure atop a drum, a structure that was one of the Renaissance's chief design innovations in constructions of this nature. In sum, the plans Bramante crafted for the new St. Peter's were monumental, and befit the enormous ambitions of the "Warrior Pope" Julius II. At the same time the design was too large to be completed in a single person's lifetime. At the time of Julius' death only the eastern portion of the ancient Roman structure at the site had been cleared away. Many of the features of Bramante's design never came to fruition, including his plans for a perfectly hemispherical dome and other elements of his interior and exterior plans for the church. The imaginative design that he envisioned can best be seen not in Rome but in the small central Italian town of Todi. Here in 1508 Bramante designed the much smaller Santa Maria della Consolazione, a small pilgrimage church, which made use of the ideas he was developing for the new St. Peter's around the same time. The building sits on a small plain and is not surrounded by any other structures, a site that provides an excellent vantage point to observe the harmonious aspects of its design. Like many of Bramante's other plans, the structure functions organically, almost as if it were a sculptural, rather than an architectural creation. It is here that one can observe the Renaissance's desire to develop an architecture based upon the design principles of the human form.

OTHER PROJECTS. Even as he was at work upon the designs for the new St. Peter's, Julius II deployed Bramante to plan other projects. One of these was the

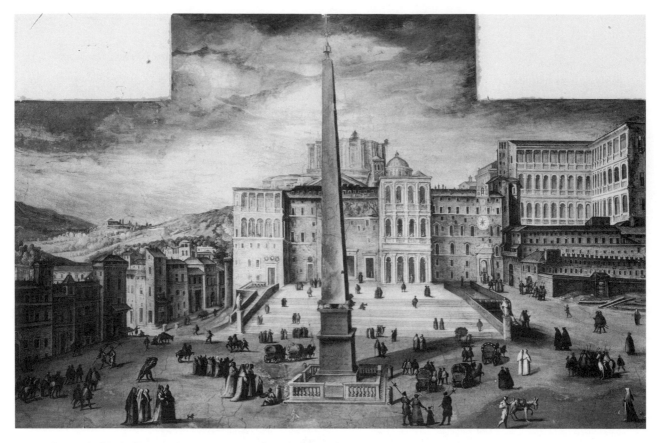

Sixteenth-century fresco showing the construction of St. Peter's Basilica at Rome. **PUBLIC DOMAIN.**

rebuilding of the Vatican Palace. Julius wished to join two structures—the small hilltop house known as the Belvedere and the Vatican Palace—which stood more than an eighth of a mile apart across undulating terrain. Bramante planned two enormous corridors that were more than a thousand feet long and two hundred feet wide. These corridors enclosed three garden terraces filled with fountains and grand staircases designed to follow the rolling shape of the site's hills. The scale of the project was immense, and like many of Bramante's buildings it was left unfinished at his death. Subsequent alterations changed the face of those parts of the work that Bramante designed, destroying the grand vistas that the architect had envisioned for the Vatican complex. Not until Louis XIV's building program at Versailles in the seventeenth century, though, did another monarch attempt anything quite so grand as Bramante's design, and the partial realization of the surviving plans for the gardens of the complex influenced garden planning for several centuries to come. A similarly important work from the architect's later years in Rome was his design for the Palazzo Caprini, a structure that is sometimes referred to as the House of Raphael, since the artist purchased it in 1517. In that building Bramante made full use of the concept of a screen or decorative façade filled with classical elements that masked the building's underlying structural elements. The ground floor of this structure was heavily rusticated and contained a succession of Roman arches. Above this, the living quarters featured decorative balustrades and grouped columns that supported a classical cornice. None of these elements played a structural role, but were design touches that evoked Roman Antiquity and granted an air of refinement to the building. The elegance of the design (the house itself has long since been demolished) affected later architects, including the Venetian Andrea Palladio. Palladio so admired Bramante's Roman buildings that he observed that the artist had single-handedly brought "the light of architecture" back into the world. This hyperbole was far from correct, since a number of great and innovative designers had preceded Bramante. Nevertheless, his grand Roman designs instituted and continued to shape architecture in the style of the High Renaissance throughout the sixteenth century.

DOMESTIC BUILDING. The first decades of the sixteenth century witnessed a dramatic surge in the building of great urban palaces and suburban villas for Rome's

a PRIMARY SOURCE *document*

ASSESSING ANCIENT ROME

INTRODUCTION: With the death of Bramante, Pope Leo X appointed Raphael to serve as his chief architect. One of the tasks given to the artist was to complete a survey of the surviving ancient monuments in Rome. Raphael was a poor writer, so it appears that he wrote his report with the aid of his friend, Baldassare Castiglione. Castiglione was the author of the *Book of the Courtier*, one of the greatest prose works in sixteenth-century Italian. The following excerpt from the report shows the deep feelings of wonder that ancient architecture inspired in Raphael, and he laments the decay of the city.

For, if one considers what may still be seen amid the ruins of Rome, and what divine gifts there dwelt in the hearts of the men of ancient times, it does not seem unreasonable to believe that many things which to us would appear to be impossible were simple for them. Now I have given much study to these ancient edifices: I have taken no small effort to look them over with care and to measure them with diligence. I have read the best authors of that age and compared what they had written with the works which they described, and I can therefore say that I have acquired at least some knowledge of the ancient architecture.

On the one hand, this knowledge of so many excellent things has given me the greatest pleasure: on the other hand the greatest grief. For I behold this noble city, which was the queen of the world, so wretchedly wounded as to be almost a corpse. Therefore I feel, as every man must feel, pity for his kindred and for his country. I feel constrained to use every part of my poor strength to bring to life some likeness, or even a shade of that which once was the true and universal fatherland of all Christians ...

May your Holiness, while keeping the example of the ancient world still alive among us, hasten to equal and to surpass the men of ancient days, as you even now do, by setting up magnificent buildings, by sustaining and encouraging the virtuous, by fostering talent, by rewarding all noble effort—thus sowing the fruitful seeds among the Christian princes. For, as by the calamities of war are brought to birth the destruction and the ruin of the arts and sciences, so from peace and concord are born the happiness of men and that highly-prized serenity of spirit that may imbue us with strength to accomplish work reaching to the heights of achievement.

SOURCE: Raphael in *A Documentary History of Art*. Vol. I. Ed. by Elizabeth G. Holt (New York: Doubleday Anchor, 1957): 290, 292.

wealthiest citizens and foreign dignitaries. This boom, similar to the great construction bonanza that occurred in fifteenth-century Florence, resulted in the erection of a number of new and innovative domestic structures. The finest painters and architects of the age worked on these projects, including Raphael, Baldassare Peruzzi, Antonio da Sangallo the Younger, and Giulio Romano. By contrast to the solidity and weight of most Florentine palaces of the previous century, an elegant refinement characterized these Roman structures. In the years after Bramante's death in 1514, Raphael entered the arena of Roman architecture. He became director of the construction of St. Peter's Basilica, a project on which he accomplished little since the building program slowed in the years after 1515 because of lack of funds. His most ambitious design program, outside of his involvement in the great basilica, was the construction of the Medici Villa or, as it is now known, the Villa Madama, a large suburban house near the Vatican intended for the use of Cardinal Giulio de' Medici. Raphael designed the structure with a number of intriguing and fantastic details, including circular courtyards and domed ceilings. He made use of the sloping hillside site and planned to set

the villa within a series of delightful gardens. As in the case of many ambitious Renaissance projects of this nature, circumstances forced Giulio de' Medici to divert his attentions from the project, and little of Raphael's ambitious design saw completion. One section of the villa, the Great Hall, still stands today, allowing us to observe Raphael's skills as an architect. He designed the room with a series of arches that supported a dome; the room's arches also frame the exterior gardens. Both the interior and exterior space thus work as part of a harmonious whole; later sixteenth-century architects imitated Raphael's design at the Villa Madama.

SANGALLO. Another domestic project from the early sixteenth century merits mention. In 1517, the influential Cardinal Alessandro Farnese commissioned Antonio da Sangallo the Younger to remodel a palace he had bought in Rome. Sangallo, a member of the Florentine dynasty of builders and designers, had originally served as a carpenter at the building of St. Peter's Basilica in Rome. The majestic structure he crafted for Farnese established Sangallo's reputation; he received numerous commissions and even served as the chief architect of St. Peter's during the years between 1539 and 1546. The

architect planned a huge masonry palace for the cardinal that abandoned the long-standing use of rusticated stone on its façade. Rough stone appears only at the arches that grant entrance into the building's massive interior courtyard. On the first floor he used low-rising windows, similar to ones that Michelangelo had designed to be installed a few years before on the façade of the Medici Palace in Florence. On the story above he relied on the Corinthian columns to frame the windows, which are alternately topped by rounded and triangulated pediments. Above on the structure's final floor, he mixed elements from the lower two floors before capping the entire structure with a cornice. Michelangelo, who supervised the later years of the building's long construction period, made this element grander and more prominent. The Palazzo Farnese was a huge building, massive in size, severe, yet refined in its effect. It influenced the design of many public and private buildings in European cities for years to come. The Palazzo Farnese also shaped American architecture. With the Renaissance architectural revival that occurred in North America in the late nineteenth century, numerous buildings resembling Italian palaces appeared in American cities. The style of the Farnese became popular. Perhaps it is for this reason that, in 1944, the United States purchased the Palazzo Margherita, another palace closely constructed upon the model of the Farnese, to serve as its embassy in Rome.

PLEASURE PALACES. The sixteenth century in Rome also produced a spate of pleasure palaces, buildings designed as retreats for their owners and as the backdrop for impressive banquets and other entertainments. The artist Raphael, who had already designed the suburban Villa Madama, also played a role in the decoration of one of these projects, a pleasure palace constructed for Agostino Chigi, the pope's banker. This structure is now known as the Villa Farnesina (since the Farnese family later bought it and connected it to their town Palazzo by a suspended walkway). Originally, the villa stood in a quiet country setting on the outskirts of the city. Chigi chose Baldassare Peruzzi as the project's architect. The building has two stories with a large façade of Roman arches in the center facing the surrounding gardens. Originally, delicate ornamentation carved into the stucco plaster or *intonaco* decorated the façade. Today, these decorative details survive only on the building's frieze, the others having been covered up since the sixteenth century. The delicacy of these decorations suggested the building's role as a pleasure palace, a building intended for the amusement of Chigi, his wife, and their guests, as opposed to a dwelling. The villa had only a few ma-

jor rooms, but these were sumptuously decorated and used to entertain. At Chigi's banquets, guests were said to have imitated the customs of ancient Rome by throwing their gold plates out the villa's windows (although Chigi's servants soon reclaimed them below). The interior walls of the villa were filled with ornate and sumptuous decorative cycles painted by Peruzzi, Raphael, and other artists in a style that imitated ancient Roman frescoes. The illusionistic details of the frescoes suggested the architecture of ancient Rome, and their erotic and classical imagery impressed Chigi's guests not only with the size of his fortune but the depth of his learning. The example of Chigi's pleasure villa inspired other members of Italy's ruling classes to build similar structures in the decades that followed.

MICHELANGELO. The artist Michelangelo had the longest and most varied career of any figure of the Renaissance. He lived until 1464 and his art underwent a progression from the idealized, heroic forms of the High Renaissance to the more willful and turbulent creations that inspired Italian Mannerism. As the greatest artistic genius of the age, his development affected other figures who avidly imitated his design innovations. Originally trained as a painter in the studio of the prosperous Florentine artist Domenico Ghirlandaio, Michelangelo also studied sculpture, and throughout his life he felt most at home in this medium. It was as a sculptor that the artist made his first decisive marks on Renaissance art. The carving of his Roman statues *Bacchus* and the *Pietà* established his reputation. Following these masterpieces, Michelangelo returned to Florence to complete, among many other works, his colossal *David*, the largest freestanding statue since Antiquity. Michelangelo continued to work in Florence, but with the accession of Julius II to the papacy, he was soon called to Rome to work on the pope's tomb project. The plans for the Julian tomb called for a massive independent structure that would contain scores of sculptures, architectural niches, and a bronze frieze. The tomb was never completed on this ambitious scale and it took more than thirty years for a greatly scaled-down memorial to be finished. But in the years between 1505–1508, Michelangelo was at work on the project, and from these initial experiences he began to acquire the skills necessary to be a successful architect and project supervisor. The tomb project required the quarrying of enormous amounts of marble and the supervision of large work crews. Although Michelangelo worked on the project for several years full time, Julius II soon moved him to work on the famous Sistine Chapel ceiling frescoes, a commission he completed in the years between 1508 and 1512. The election of the Medici

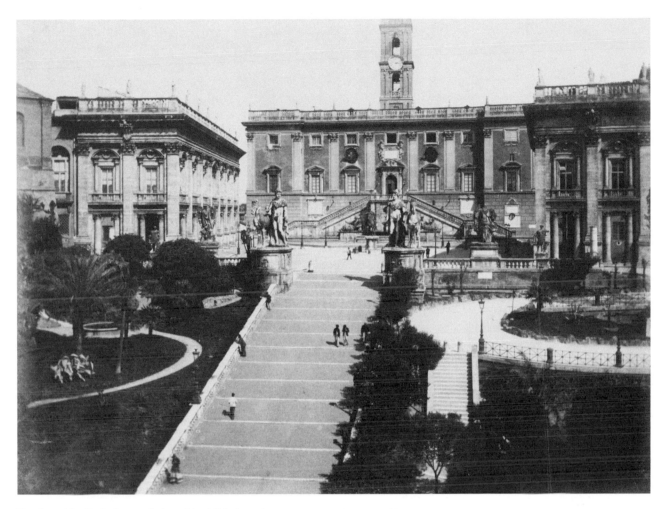

The Campidoglio in Rome, designed by Michelangelo. © MICHAEL MASLAN/CORBIS

pope Leo X in 1513 confirmed Michelangelo's papal patronage, and by 1517 the artist was back in Florence, undertaking an important project for the pope: the construction of a new façade for the Medici's family church of San Lorenzo. During the fifteenth century the family had richly showered this site with patronage. By the time that Michelangelo worked there, the Medici had weathered several challenges to their control over Florence and they had now allied themselves through marriage to the kings of France. The family now turned again to San Lorenzo, to shower it with new projects that underscored their rising status. Just before Michelangelo had arrived in Florence the venerable architect Giuliano da Sangallo, the uncle of the Roman architect Antonio, had made several drawings for plans for the project, although he had died before progressing further on the project. One of Sangallo's designs created an imaginative solution to the problem of the façade. Sangallo created a two-story Roman temple flanked by enormous towers to hide certain of the unattractive exterior elements of Brunelleschi's

original design. In this drawing he planned to mass classically-styled sculptures of the saints atop the façade's upper story, in effect creating a screen similar to that with which Baldassare Peruzzi was experimenting in Rome at the Palazzo Caprini around the same time.

SAN LORENZO. The Medici chose Michelangelo's plan for the church's façade instead. In keeping with the grand pretensions of the church's patron family, Michelangelo intended his design to be a "mirror of architecture and sculpture of all Italy" and he labored on the plans for over three years. The design he formulated was also for a two-story structure, although Michelangelo designed his structure without towers to cover the entire area of the church's edifice. Like the earlier project for the building of Julius' tomb, the San Lorenzo project was overly ambitious; it included eighteen statues in bronze and marble as well as fifteen carved reliefs. A surviving model of the façade shows shallow niches, from which the planned statues were to have projected

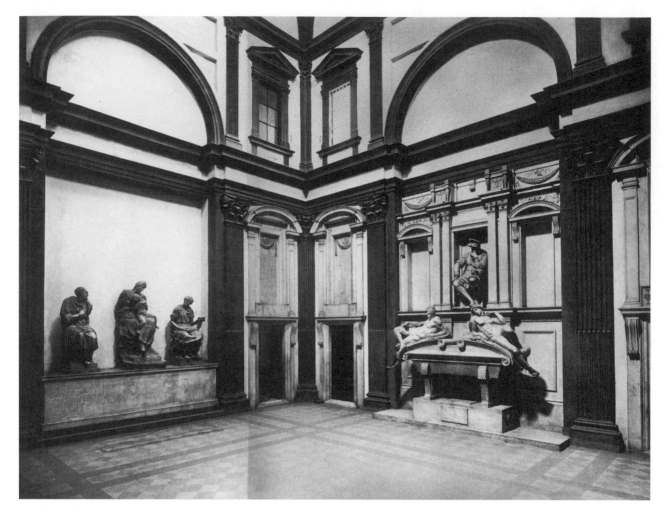

The New Sacristy at the Church of San Lorenzo in Florence, designed by Michelangelo. **ALINARI-ART REFERENCE/ART RESOURCE, NY. RE-PRODUCED BY PERMISSION.**

outward. The use of marbles and bronze together would have created a dramatic interplay of color. Michelangelo set himself to the task quickly, supervising the quarrying of stone, a project that eventually required him to build a road through a portion of the Apennine Mountains outside Florence. But although the artist worked feverishly on the project for several years, the Medici cancelled the commission for the façade abruptly in 1520, deciding to expend the family's resources on a chapel and family tomb at the church instead. They chose Michelangelo again to direct this commission, and the chapel he designed was made to harmonize with a sacristy Brunelleschi had built for the opposing side of the church in the fifteenth century. Work was frequently interrupted on the tombs, and the chapel was never finished as it had been designed. But among Michelangelo's architectural creations it ranks as one of his most completely realized creations. To secure better lighting for the tombs, Michelangelo raised the roof of the chapel by

adding a third story that brought the structure's roofline above those of surrounding houses. In other respects he relied on the traditions of Brunelleschian architecture, including the use of gray *pietra serena* set against white stucco. In this structure Michelangelo's carved tombs, with their more delicate and refined High Renaissance architectural frames, seem out of place with the surrounding fifteenth-century style of the chapel.

LAURENTIAN LIBRARY. Michelangelo was soon to develop a more unified style, one that was notable for its willful violations of the traditional canons of classical design. In 1524 the Medici pope Clement VII (r. 1523–1534) awarded the artist the commission to design a new library for San Lorenzo. This site was intended from the first to be dedicated to the use of humanist scholars and was to house the Medici's large collection of rare manuscripts. Michelangelo planned an entire complex at the site, including an Entrance Hall, Reading Room, and a

rare-book chamber, although he never lived to see the structure completed. The site itself was problematic since it was irregularly shaped, and the building had to be made to fit overtop and in between other structures that already stood on the church's grounds. Michelangelo's design solved these problems brilliantly, although the building was not executed completely in the manner in which he had planned. He designed a stately entrance to the library with a high staircase set in an imaginative architecture that bent the rules of traditional classical design. Michelangelo lined the walls of these spaces with pilasters that appear to support the ceiling, but which are instead set in niches, so that on second glance they appear like mere decorative sculptures that taper as they move downward. Below these niches the architect placed classical stone scrolls that again serve, not as traditional supports, but as mere sculptural or decorative elements placed on the walls. The effect of these design elements seems to make the room cave inward, although other features counteract this effect. The architect, for instance, divided the large staircase—the focal point of the room—into three sections and he bowed the stairs of the central section outward in a bold hemispherical shape. These hemispheres wage battle against the downward tapering pilasters that are placed within the wall's niches. Once above within the Reading Room the first impression is at once more traditional. The columns that line the room actually appear to support the ceiling, and its other elements seem to be drawn from a traditional classical architectural language. On closer inspection, though, Michelangelo seems to repeat the elements of the room's design *ad infinitum*, so that the windows and transepts that are above them, as well as the endless rows of reading desks and the patterned floor, take on the same dimension of a Herculean struggle as occurred outside in the entry hall. One appears, for instance, to be caught in a cage in which the room's design elements are constantly being repeated without relief. Unfortunately, the last element of Michelangelo's Laurentian Library design was never built. The architect had planned a final culmination to the architectural battle he had presented in the library's first two spaces: a dramatic triangular-shaped rare-book room designed to fit inside the spaces between buildings on the library's exterior. This conclusion to the Laurentian Library's strange and challenging architecture might have presented one of the most unusual spatial solutions of the Renaissance. But like many architectural plans of the period it was not constructed when the patron's interests shifted elsewhere.

CHANGING TASTES. The Laurentian Library reveals a new taste for creative experimentation, a taste shaped by artist and patron alike. As the High Renaissance pe-

riod drew to its conclusion at the end of the first quarter of the sixteenth century, architectural design came to be affected by changes similar to those underway in painting, sculpture, and literature. During the course of the fifteenth century architects had fastidiously studied classical Antiquity, and in the High Renaissance had achieved a mastery over ancient styles that allowed them to produce designs and structures notable for their complete assimilation of classicism. These details had been used to grant a human scale to projects that were heroic and monumental in nature. In his Laurentian Library complex Michelangelo showed a new direction, and the structure influenced later architects who used the language of classical Antiquity in a boldly willful and creative way. The violations of the canons of ancient design that Michelangelo displayed at the Laurentian were intentional, and they helped to give rise to the new movement in Renaissance architecture known as Mannerism.

SOURCES

J. S. Ackerman, *The Architecture of Michelangelo* (London, England: Zwemmer, 1961).

A. Hopkins, *Italian Architecture from Michelangelo to Borromini* (London, England: Thames and Hudson, 2002).

P. Murray, *Renaissance Architecture* (New York: Electa, 1985).

J. T. Paoletti and Gary M. Radke, *Art in Renaissance Italy* (New York: H. N. Abrams, 1997).

M. Rivosecchi, *Art in Rome: From Michelangelo to Bramante* (Rome: Ediralia, 1977).

SEE ALSO *Visual Arts: The High Renaissance in Italy*

THE LATER RENAISSANCE IN ITALY

MANNERISM. The High Renaissance of the early sixteenth century was notable both for its amazing level of artistic achievement and its brevity. By 1520, artists and architects were already in search of new styles that made the heroic and idealized paintings, sculptures, and buildings of the early years of the sixteenth century appear to many connoisseurs as dated. In architecture, Michelangelo had shown a new willful creativity that inspired later designers, particularly in Rome, Florence, and Central Italy. Even here, though, High Renaissance architectural styles persisted alongside the new Mannerism. The path of architectural development in Venice was slightly different. There, figures like Jacopo Sansovino and Andrea Palladio created a classical style notable for its elegance and refinement as well as its faithful use of the elements of ancient design. The very multiplicity of styles that

coexisted at the time provided a wealth of inspiration as Renaissance design moved from Italy into other parts of Europe.

ROME. Although the first two decades of the sixteenth century had been a time of incredible productivity, artistic activity and construction in Rome slowed dramatically in the later 1520s and 1530s. This falloff in production was largely the result of the Sack of Rome that occurred in 1527. During the 1520s the Medici pope Clement VII had tried increasingly to maintain the autonomy of the city of Rome and the Papal States he controlled in Central Italy. These policies had brought him increasingly in conflict with both the Habsburg emperor Charles V and the king of France. In May of 1527, a force comprised of mostly German, French, and Italian soldiers laid siege to Rome and conquered the city within a day. The army's commander soon died, and his successor was unable to control the force. Over the next few months the invading armies raped local women, tortured and ransomed citizens, and plundered Rome's villas and palaces. Many of the attacking soldiers were Germans who acted on anti-Italian sentiments fueled by the rise of the Reformation and its distaste for religious art. They desecrated the city's most venerable churches, plundering their gold and silver and destroying their religious art. Forced to take refuge in the papal fortress, the Castel Sant' Angelo, Clement VII was completely unable to stop this wanton destruction and carnage. Eventually, he surrendered, and to regain control over the city he paid a ransom of more than 400,000 ducats, an enormous sum that required him to melt down papal crowns and other ornaments. As a result of the Sack, Rome's ambitions to be an autonomous and powerfully independent state ended. A spate of prophecies that interpreted the crisis as signs both of God's judgment on papal immorality and warnings of the coming end of the world followed the attack. At the same time scholars in both Protestant and Catholic camps throughout Europe expressed regrets about the event since numerous libraries and important monuments had been destroyed. Rome gradually regained political and economic strength during the reign of Paul III (1534–1549), but most of the artists and architects who had worked in Rome during the golden years of productivity before the Sack packed up and left to work in other Italian centers. Slowly new artists and architects arrived, while others returned. Michelangelo was the most notable of those who returned to Rome. He arrived even in the relatively dark days of 1534, and he stayed in the city for the rest of his life. In part from his inspiration, as well as the arrival of other enormously creative figures, Rome's culture flow-

ered again in the second half of the sixteenth century. Yet even then, a growing realization of the city's dependence upon other major European powers helped to breed a kind of nostalgic longing for the early years of the sixteenth century. This nostalgia can be seen reflected in many of the grand and monumental church and secular projects that were undertaken at the time. These late sixteenth-century monuments, impressive in their grandeur, formed the foundations for the flowering of the Baroque in the first half of the seventeenth century in Rome.

MICHELANGELO. The first commission Michelangelo undertook upon his return to Rome was the project for his famous *Last Judgment*, which he painted on the wall behind the High Altar of the Sistine Chapel between 1534 and 1541. While he was involved at the Sistine, the artist also began to take on architectural projects. In 1538 he won the commission to redesign Rome's Capitoline Hill, the center of the ancient city. Although the Capitoline was not completed until after his death, it reflects the intentions of Michelangelo's late style. During the late 1530s the artist made several tentative steps toward refurbishing the famous plaza on the Capitoline Hill, and in 1561, shortly before his death, he returned to the plaza's designs. At this time he planned a dramatic square, and in the pavement to this plaza, he created a circular pattern filled with trapezoids, triangles and diamonds, at the center of which he placed an ancient Roman equestrian statue of the emperor Marcus Aurelius. At the time Romans believed that this statue was of the emperor Constantine, the figure who had converted the empire to Christianity. It had long stood nearby at the Church of St. John Lateran, the pope's cathedral church within the city of Rome. Although Michelangelo resisted moving the statue to the Capitoline, he eventually relented and created his dramatic plans for the square to frame the sculpture. His new design glorified Rome's position as the center of the world, a position that by the time was only symbolic, since the city's political powers had grown increasingly circumscribed by the greater European states of France and Spain. Michelangelo designed two palaces for the site that served as the center of Rome's civil government, and he sited these structures so that they radiated outward at angles from the pre-existing Palace of the Senate at the back of the plaza. The result produces a trapezoidal-shaped courtyard notable for its warm and enveloping feel. Despite poor eyesight and bad health, Michelangelo managed to keep up an astonishing level of productivity during his later years in Rome. During the 1540s, he undertook the decoration of the Pauline

a PRIMARY SOURCE *document*

TROUBLE AT ST. PETER'S

INTRODUCTION: In 1557, Michelangelo wrote the following letter to his friend Giorgio Vasari at Florence, explaining his dissatisfactions with the pace of the building's construction, and explaining his reasons for staying in Rome.

Messer Giorgio, Dear Friend,

God is my witness how much against my will it was that Pope Paul forced me into this work on St. Peter's in Rome ten years ago. If the work had been continued from that time forward as it was begun, it would by now have been as far advanced as I had reason to hope, and I should be able to come to you. But as the work has been retarded the fabric is much behindhand. It began to go slowly just when I reached the most important and difficult part, so that if I were to leave it now it would be nothing less than a scandal that I should let slip all reward for the anxieties with which I have been battling these ten years. I have written this account in reply to your letter because I have also received one from the Duke which fills me with astonishment that His Lordship should deign to write to me in such kindly terms. I thank both God and His Excellency with all my heart. I am wandering from my subject, for both my memory and my thoughts have deserted me and I find writing most difficult, being, as it is,

not my profession. What I wish to say is this: I want you to understand what would happen if I were to leave the aforesaid work and come to Florence. Firstly, I should give much satisfaction to sundry robbers here, and should bring ruin upon the fabric, perhaps causing it to close down for ever: then also I have certain obligations here, as well as a house and other possessions which are worth several thousand crowns, and if I were to depart without permission I do not know what would happen to them: and finally, my health is in the condition, what with renal and urinary calculi, and pleurisy, that is the common lot of all old people. Maestro Eraldo can bear witness to this, for I owe my life to his skill. You will understand, therefore, that I have not the courage to come to Florence and then return once more to Rome; and that if I am to come to Florence for good and all it is imperative that I should be allowed sufficient time in which to arrange my affairs so that I should never again have to bother about them. It is so long since I left Florence that Pope Clement was still alive when I arrived here, and he did not die until two years later. Messer Giorgio, I commend myself to you, begging you to commend me to the Duke and to do the best you can on my behalf, for there is only one thing left that I should care to do— and that is to die.

SOURCE: Michelangelo Buonarroti, "Letter to Giorgio Vasari, May 1557," in *A Documentary History of Art*. Vol. II. Ed. Elizabeth G. Holt (New York: Doubleday Anchor, 1958): 19–20.

Chapel, a private papal chapel, within the Vatican with two large frescoes. At the same time Pope Paul III appointed him to serve as the official architect for the rebuilding of St. Peter's Basilica in 1546, and in 1547, he took on supervision of the final stages of the Farnese Palace's construction. On this building he added a massive decorated window above the palace's central entrance and increased the size of the cornice, two features that softened the severe effects of the original architect Antonio da Sangallo's design. In the interior courtyard his revisions inspired later seventeenth-century Baroque architects. On the courtyard's third story, for instance, he superimposed pilasters on top of each other and added broken moldings and lions' heads to the windows, features that played an important role in the language of seventeenth-century architecture.

ST. PETER'S. At St. Peter's Michelangelo's innovations removed many of the innovations that Antonio da Sangallo had made in the project, and he reinstated features of Bramante's original plans. Sangallo had added a series of loggias, galleries, and towers that, had they been

built, might have doubled the already colossal size of the building. Michelangelo swept away these planned additions and returned the design to a more harmonious High Renaissance style in tune with Bramante's original plans. At the dome the architect abandoned Bramante's idea of a simple hemispherical dome and instead adopted a shape that was more ovoid. To achieve the greater height necessary for this shape, Michelangelo's design required the Florentine ribbed style of construction, a system that Bramante had avoided. But although most of Michelangelo's design for the dome was realized, the wooden model he created for the structure shows that even his plans were not carried out completely in the way he wished. The huge drum that supports the dome was later lengthened and the dome itself was stretched into an even more oval shape than he had originally planned; both these features added even more height to the design than Michelangelo's already soaring plan stipulated. Michelangelo's designs, like Bramante's before him, tried to make the dome the central architectural feature so that it would dominate all views of the church. During the seventeenth century the Greek style of

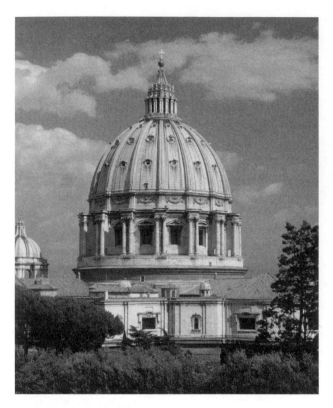

The dome of St. Peter's Basilica, designed by Michelangelo.
© ARALDO DE LUCA/CORBIS.

construction that both he and Bramante had advocated was abandoned. St. Peter's was made into a more traditional Latin cross by the addition of several bays of arches to the nave. This change increased the size of the church to truly enormous proportions, its total length from the rear of the church to the edge of the choir being almost 700 feet in length. At the same time these alterations obscure views of the dome to those who stand directly before the entrance to the church. Despite the change, the overall effect of the structure bears Michelangelo's indubitable stamp, and the architect returned clarity and coherence to a construction that might have turned out dramatically different had Sangallo's plans been realized. In the rich decorative elements that the architect designed for the church, which included grouped pairs of Corinthian columns and pilasters on the dome and exterior of the church, his plan also anticipated the complexity and grandeur of the later Baroque period.

THE GESÙ. For many years following the Sack of Rome in 1527, the construction of large churches in the city of Rome dropped off. The largest religious building program underway in the years between the Sack and 1560 had been the ongoing reconstruction of St. Peter's, a project that proceeded by fits and starts. After 1560, the construction of new churches picked up again in the

city and the most important building of the time was the new Church of the Gesù. This structure was designed to be the center of the new Jesuit order in Rome. In 1540 the pope had recognized the Jesuits, who soon became a major force in the reform of the church and in opposing the spread of Protestantism. Officials of the order sought a structure to express their organization's rising status within the church and to present their ideas about the reform of Christian worship they believed was a necessary precondition for the reform of the church to be successful. Their plans for a Roman church proceeded slowly during the 1540s and 1550s. Finally in 1561, they secured funding from Cardinal Farnese, with the stipulation that he was to be the only person allowed a tomb within the structure. Several architects, including Michelangelo, had already created plans for the church, although construction of the interior followed a plan laid down by Giacomo Vignola. A student of Michelangelo, Giacomo della Porta, later assumed responsibility for the façade and the church's dome, and under his supervision, the Gesù became a showpiece for the developing aesthetic sensibilities of the Counter Reformation. Inside the Gesù a single massive barrel vault, similar to Alberti's Church of St. Andrea in Mantua, leads to the domed crossing and high altar of the church. Throughout the structure nothing detracts from the centrality of the High Altar, a demand that had recently been made explicit in the decrees of the Council of Trent. The exterior that Giocomo della Porta fashioned for the church was similarly innovative. As in Michelangelo's later designs, della Porta paired Corinthian pilasters upon the church's two-story façade, but he also incorporated fluid lines into his design above the central entrance and in the consoles that hid the vaults of the church's side chapels. These fluid lines inspired later Baroque designers in the seventeenth century, but already in the sixteenth a number of imitations of the Gesù were begun throughout Italy and Europe. During the 1580s, for instance, the plans for the church were already being copied in Munich, where the Jesuit order used the new St. Michael's Church to express the architectural ideas of the Counter Reformation. The heightened emphasis on visual unity and the centrality of a church's main altar became a feature in other churches throughout Europe that imitated the design of the Gesù. Constructed elaborately in marble and often decorated later in the less restrained and sumptuous style of the Baroque, these had a profound effect on early-modern Catholicism.

ROME RESURGENT. During the reign of Pope Sixtus V (r. 1585–1590) the gathering strength of Rome's

artistic and architectural wealth came to fruition in dramatic new plans for the city's renewal. The sixteenth century had already seen enormous changes in Rome, first through the offices of the High Renaissance popes Julius II, Leo X, and Clement VII. All three figures had attracted an army of artists and designers to the city with the intention of remaking the town into a truly Renaissance capital. The Sack of the city had cut this first spate of activity short in 1527. Around mid-century, Michelangelo had aided the designs of the popes for urban renewal, but even his projects paled in comparison to the great energy displayed during the reign of Sixtus V. This Counter-Reformation pope set his hand to creating a grand capital that was to make Rome the envy of European cities. During his short pontificate he set in motion the forces that transformed the town into a model early-modern capital. Sixtus concentrated his efforts on restoring the great churches of the city and on joining these ancient monuments together with the construction of a series of broad and straight streets. These new thoroughfares linked Rome's major points of religious interest together in a circuit that was easily comprehensible for the many pilgrims who came to the city. Despite enormous expense and technical problems, he arranged for ancient Egyptian obelisks captured by Roman armies to be moved to the new squares and plazas his designers created, adding architectural focal points to the cityscape he was creating. He capped Roman columns, with their historical reliefs narrating the exploits of ancient emperors, with new bronze figures of the saints. Many of his new axis streets, broad squares, and monuments still exist as defining features of Rome today, and during the seventeenth century successive popes elaborated upon his basic plans. Sixtus, too, provided new sources of water to the city by restoring ancient Roman aqueducts and building a series of fountains throughout the city. These new projects resolved a long-standing shortage of fresh water in the city that had plagued inhabitants throughout the Middle Ages and which had often forced citizens to bring their water daily from the polluted Tiber. In all these projects Sixtus employed a group of accomplished architects and designers. Most prominent among these was Domenico Fontana, who aided the pope in his plans to construct straight streets through the city and to beautify the urban landscape. Fontana also provided technical solutions for the pope's plans to relocate Egyptian obelisks and to make them prominent landmarks in the city, and he aided the pope by restoring the interiors of many of the city's ancient churches. Another architect who won papal favor in the reign of Sixtus V was Giacomo Della Porta, who had already designed the new façade for the Gesù. Della Porta supervised the final stages of the construction of the dome at St. Peter's Basilica, adding even more height to the already towering structure. The completion of the project proved to be a symbolic victory for the papacy, demonstrating to Romans and Europeans alike the power of the Roman pontiff to conquer seemingly insoluble problems of design. It is no wonder, then, that during the seventeenth century urban planners elsewhere throughout Europe looked favorably upon the Rome that Sixtus and his architects had helped to fashion. Throughout the continent architects avidly copied features typical of Rome's renewal plan, and thus even as the city's political power weakened on the European landscape, it took on a new role as a force for urban planning and renewal.

FLORENCE. In the course of the sixteenth century the Medici rule increasingly dominated both the visual arts and architecture in Florence. The family had long been the most influential citizens of the town. In the fifteenth century they had at first used back-room manipulation to dominate the town's politics, although later they increasingly abandoned these subtle measures in favor of a more overt management of Florence's political affairs. In 1537, the family's elder statesman Cosimo de' Medici, known as Cosimo I, became a duke, which officially ended Florence's long-standing republican pretensions. Cosimo secured the often unstable Medicean dominance of the city and he ruled over both Florence and its surrounding territory Tuscany until his death in 1574. During Cosimo's long reign Florence's major artists and architects came increasingly to serve the court. These figures—men like Giorgio Vasari (1511–1574), Francesco Salviati (1510–1563), Bartolommeo Ammanati (1511–1592), and Angelo Bronzino (1503–1572)—had either studied with the great master Michelangelo or with one of his pupils. They were often described as *maniera* (meaning "mannered" or "stylish"). In English, long-standing usage has referred to these figures as Mannerists. At its best Mannerism became known for its great elegance, profound intellectual and allegorical content, formalism, and linear complexity. At its worst, art critics through the ages have criticized the Mannerists for being artificial, intellectually arid, overly elaborate, and slavishly imitative of Michelangelo and earlier masters. In the sixteenth century, however, the principle of imitation of previous models was a venerable one. At their core, most of the arts and scholarly activities practiced in the sixteenth century proceeded from the principle of imitation, whether it was the imitation of Antiquity, or of more recent models. In verse and prose, the works of the Renaissance authors Dante and Petrarch were highly

venerated models. In art, the achievements of Leonardo and Michelangelo fulfilled a similar role. Most theoreticians of the arts assured their audience that only through imitation of an acknowledged master was one really able to acquire the sure style that would harness human creativity and allow for truly great expression. Criticisms of the Mannerists' art as derivative and unimaginative, then, represent modern, and not Renaissance, notions about taste and creativity. In architecture, as in painting and sculpture, Mannerist designers often paid homage to Michelangelo, Bramante, and Raphael, figures they placed at the pinnacle of artistic achievement. Florence was the leading center of Mannerism in sixteenth-century Italy, although the style appeared in many Italian courts and was prized for its elegance and sophistication. By the second half of the sixteenth century Mannerist styles were also influencing the arts and architecture of Northern Europe, particularly in the Netherlands. The foundation of the Florentine Academy in 1563 helped to establish Mannerism's dominance within Tuscany's capital and in the surrounding region. Cosimo I patronized and sponsored this institution, which his chief artist and architect Giorgio Vasari had helped to organize. The Florentine Academy nurtured the development of new styles and themes in the arts along the lines favored by the Mannerist artists who participated in the institution. Its members also nourished an interest in art theory and aesthetics. In the second half of the sixteenth century the two important members of the academy, its founder Giorgio Vasari and Bartolommeo, were the town's most important architects.

VASARI. Giorgio Vasari is better known to the modern world for his *Lives of the Most Eminent Artists*, a collection of biographies of the most prominent sculptors, painters, and architects of the Renaissance. He was himself an accomplished painter and architect, and his greatest construction design was for a new civic palace, the Palazzo Uffizi, in Florence. The Uffizi, as it is commonly known today, was intended to house all the offices of Florence's civil government, as well as those of the guilds, and of the court artists who served the Medici. Vasari designed an enormous U-shaped complex whose exterior shows a clear influence from Michelangelo's Laurentian Library. Four stories tall, the building's three sides enclose a space that is narrow, more like a street than a city square. Throughout the building Vasari achieves a grand effect by the seemingly endless repetition of details. At the street level two columns and a pier continually alternate along the two parallel sides of the building. Above, at the second floor, decorative consoles inspired by those in Michelangelo's Laurentian Entrance

Hall demarcate triplets of simple square windows. At the third floor, groups of three windows are again repeated, but this time with rounded and triangular pediments governed by a strict A-B-A pattern. On the top floor, an open loggia (now glassed in) repeats the columns of the street level. The only break in this constant pattern of repetition comes at the perpendicular wing at the end of the complex. Here three arches at the street level—the center one rounded—serve to relieve the seeming monotony of the other two façades. To build this massive government complex, Vasari made use of pre-existing buildings at the site. These various structures are visible from the rear of the complex, but are masked by the massive edifices Vasari designed for the façade. To join these disparate structures together and to build to such a height, Vasari reinforced parts of the Uffizi with steel supports. Thus, his building was one of the first in European history to rely upon a metal skeleton.

BARTOLOMMEO AMMANATI. The sculptor Bartolommeo Ammanati, a close associate of Michelangelo, also completed two notable architectural projects in Florence in the second half of the sixteenth century. First, he created designs for a remodeled Palazzo Pitti, a fifteenth-century palace purchased by Cosimo I to serve as his official residence. The original design of the palace had been massive, and included seven bays of Roman arches on the ground floor. It eventually grew to more than three times its original proportions, but the sixteenth-century remodeling plan of Ammanati consisted of lengthening the structure's façade and in creating a beautiful interior courtyard, now known as the Cortile dell' Ammanati (Ammanati's courtyard). In this interior space the architect again relied on the principles of repetition inspired by Michelangelo's Laurentian Library. The chief elements he used included Roman arches and rusticated stonework, which appeared on all three of the building's floors. An interesting innovation that Ammanati made at the Pitti was his use of rusticated columns and arches. On all three floors the architect relied upon rustic stonework to outline both the arches of the courtyard's ground floor colonnade and those of the windows on the second and third floors. Despite the palace's monumental scale Ammanati's use of decorative stonework tamed the colossal spaces of the interior courtyard. Rustication had traditionally been used in Florence's palaces to grant an impression of weight and solidity. In Ammanati's hands, however, he transformed the traditional design element into a kind of decorative ornament, a breakthrough typical of the often creative aesthetics of Mannerism. The second of Ammanati's great architectural contributions in Florence was his Bridge of the

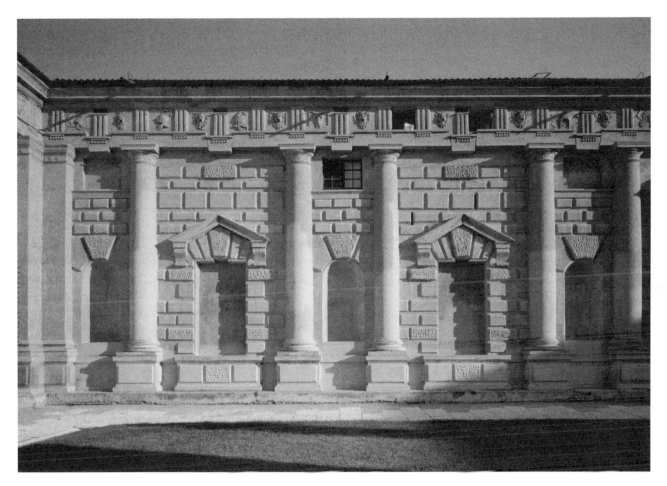

Façade of the Palazzo del Te in Mantua. © MASSIMO LISTRI/CORBIS.

Holy Trinity (Ponte Santa Trinita), which was begun in 1566. Here he relied on triangular pylons and flattened Roman arches to support a delicate roadway over the River Arno. He created this elegant construction after showing his original designs to Michelangelo, shortly before the elder artist's death. Michelangelo made several suggestions that improved upon Ammanati's original designs, and the result was a structure of great beauty. Tragically, the original structure did not survive the Second World War, falling victim to the retreating German army as they destroyed bridges to hinder the advancing Allied forces. It was, however, rebuilt according to its original plans shortly after the war's end.

GIULIO ROMANO. Rome and Florence did not have a monopoly on architectural innovation in sixteenth-century Italy. Throughout the peninsula designers of merit produced plans for buildings that shaped architectural tastes in Europe in the decades that followed. One influential figure was Giulio Romano, a native Roman who had originally worked as a painter in the studio of Raphael as a young man. In 1527 he moved to Mantua

in Northern Italy, where he became a court artist to Duke Federigo Gonzaga. The duke deployed Giulio on a variety of projects, including the design and construction of a new pleasure palace to be situated in a meadow known as the Te outside Mantua. Duke Federigo was a breeder of horses, and the plans for the Palazzo del Te, as it is known today, situated a banqueting hall beside his stables. Soon the duke decided to expand the structure at the site to build a larger palace in which he could entertain his guests while on retreat in the country. The grand exterior that Romano designed for the palace makes the structure appear far larger than it is in reality, and similar illusions recur throughout the structure. On the structure's façade the artist played willfully with the traditional classical orders in a way that was similar to the somewhat later structures built by the Florentine Mannerists. Doric order columns and heavily rusticated blocks of stone finished the exterior of the building, while inside a series of luxurious rooms are filled with rich illusionism. In the Salon of the Giants, for instance, the walls of the entire room have been painted without

any kind of framing device, so that the viewers enter a room in which they are totally surrounded by illusion. Columns snap under the exertions of heaving Giants, clouds roll by, and everywhere Romano surrounds his viewers with a rich panoply drawn from the artist's imagination and its interpretation of classical myth. Similar illusionistic devices occur throughout the palace, so that the façade and the interior function as one of the most fantastic creations of the later Renaissance. The dukes of Mantua entertained many visiting dignitaries with their playful palace, including the Hapsburg emperor Charles V. It is not hard to understand, then, why other designers throughout Europe turned to the structure for inspiration as they crafted similar pleasure palaces for their noble patrons.

VENICE. Like other Italian cities Venice in the fifteenth and early sixteenth centuries had seen a construction boom, still visible today through the many churches and palaces that survive from this period. These early Renaissance buildings were craftsman-like without being innovative masterpieces. Venetians in the fifteenth and early sixteenth centuries indulged a taste for the elaborate Gothic ornamentation still in fashion in much of Northern Europe. Architects hired from other Italian regions—most notably the northern Italian province of Lombardy around Milan—had designed many of these structures. In the sixteenth century Venice continued to import its architects, and no native school of designers developed in the city until much later in the seventeenth century. By the mid–1500s, though, two architects of unsurpassed skill practiced in the city: Jacopo Sansovino and Andrea Palladio. Together they created new and innovative plans for Venice's renewal influenced by the lessons they had learned in Rome, Florence, and other centers of the Italian architectural Renaissance. Given its enviable position as the City of the Lagoons, Venice provided a safe haven in the turbulent world of sixteenth-century Italy. Sansovino (1486–1570) was just one of many great figures who found refuge there after the disturbing Sack of Rome in 1527. Palladio was a resident of nearby Vicenza and he settled in Venice late in life, when he assumed the position of architectural adviser to the Republic after Sansovino's death. By this time Palladio had already designed several churches in Venice as well as many country villas within Venice's mainland territories. Together both figures helped to forge a distinctively northern Italian Renaissance style different from the Mannerist creations to the south in Florence, Rome, and central Italian towns.

SANSOVINO. When Sansovino arrived as a refugee in Venice, he was already 41 years old. He intended only to stay for a few months, but remained in the city for the rest of his life. Over this considerable span of years, his plans largely reshaped the Venetian cityscape. Trained in Florence during his youth, he had also worked in Rome during the High Renaissance, and the works of Bramante, Raphael, and Michelangelo had shaped his designs. The grand architecture of ancient and High Renaissance Rome affected him deeply, but in his years in Venice, he developed a new style well-suited to the broad vistas and brilliant light of this city literally on the sea. At the time of his arrival, Venice's Doge and the Venetian Senate intended a renewal of the city that was to symbolize the town's claim to be a second Rome. Outside forces had threatened Venice since the early sixteenth century, but at the conclusion of the first phase of the Italian Wars in 1530, the town could boast, unlike most other Italian powers, to having retained its independence relatively unscathed. Sansovino was an ideal architect for the grand plans that were underway in Venice at this time. Unlike Florence or Rome with their cramped streets and tiny plazas, Venice was a city of broad canals. Sansovino designed buildings that were not only functional, but a delight to the eye. He altered his styles and ornamentation to fit different projects and the spaces in which they were located. His first great masterpiece of design in the city was the *Zecca*, a building that housed the town mint. In the sixteenth century Venice's currency, the ducat, was among the most respected in Europe. Sansovino labored to create a structure worthy of the eminent currency produced inside. A rusticated first floor, similar to those of Rome and Florence at the time, is crowned by a second and third story more delicate in design. On the façade he included banded Doric columns, similar to those in use among some Mannerist designers at the time. The elegant and overall classical effect of the building, though, differs greatly from the repetitive formalism typical of Mannerist designs. Despite the building's gentle appearance, particularly in the upper stories, Sansovino claimed that the structure was fireproof. The structure he designed proved to be a venerable tribute to the distinguished city and its highly respected coinage.

ST. MARK'S LIBRARY. In the fourteenth and fifteenth centuries, Venetians had often evidenced a taste for richly ornamented gothic façades. In Sansovino's greatest work, the Library of St. Mark's, he translated this traditional idiom into the world of the Renaissance. He designed two arcades, one atop the other, that made use of rich and graceful classical ornamentation in a way that fit in with the pre-existing architecture of St. Mark's Square. The building had been necessary to house,

a PRIMARY SOURCE *document*

CHURCH ARCHITECTURE

INTRODUCTION: In his *Four Books on Architecture*, Andrea Palladio discussed how the insights of antique temple builders could be used to create more beautiful Christian churches. Since the time of Alberti, architects had argued that churches should be constructed in the central style, that is, in the form of a Greek cross where the radiating wings are of equal length or that they should be built in the round. Palladio, too, was fascinated by the possibility of a round church. The long-standing use of the Latin Cross style was too deeply ingrained in contemporary practice and prevented the great popularity of round churches, although a few attempts were made during the Renaissance to build structures in that shape. Palladio admits that even he had been forced to adopt the traditional style in his Church of St. George Major in Venice.

We, therefore, who have no false Gods, should, in order to preserve a decorum about the form of Temples, choose the most perfect and excellent; and seeing the round form is that (because it alone among all figures is simple, uniform, equal, strong, and most capacious) we should make our Temples round, as being those to which this form does most peculiarly belong: because it being included within a circle, in which neither end nor beginning can be found nor distinguished from each other and having all its parts like one another, and that each of them partakes of the figure of the whole: and finally the extreme in every part being equally distant from the center, it is therefore the most proper figure to shew the Unity, infinite Essence, the Uniformity, and Justice of God. Over and above all this, it cannot be deny'd that strength and durability are more requisite in Temples than in all other Fabrics; in as much as they are dedicated to the most Gracious and Almighty God, and that in them are preserved the most precious, famous, and authentick records of towns: for which very reasons it ought to be concluded that the round figure, wherein there's no corner or angle, is absolutely the most suitable to Temples. Temples ought likewise to be as capacious as may be, that much People may conveniently assist in them at divine service; and of the figures that are terminated by an equal circumference, none is more capacious than the round. I deny not but those Temples are commendable, which are made in the form of a Cross, and which, in that part making the foot of the Cross, have the entry over against the great Altar and the Quire, as in the two aisles, which extend like arms on each side are two other entries or two Altars; because being built in the form of the Cross, they represent to the eyes of those who pass by what wood on which our Savior was crucified. In this form I built myself the Church of Saint George the Great in Venice.

SOURCE: Andrea Palladio, *The Architecture of A. Palladio, in Four Books.* Trans. G. Leoni (London, 1742); Reprinted in *A Documentary History of Art.* Vol. II. Ed. Elizabeth G. Holt (New York: Doubleday Anchor, 1958): 61–62.

among other things, the great collection of manuscripts given to the city by the Greek humanist Cardinal Bessarion. Like other Venetian buildings, St. Mark's Library glitters in the brilliant sun reflected from the light blue waters of Venice's lagoons. Sansovino's Library and Mint, which form part of the large civic and Cathedral plaza of St. Mark's Square, grant a dignified yet human scale to the surrounding plaza, considered one of the finest in Europe. It is interesting to note that part of the vaulting of Sansovino's Library collapsed shortly after it was built during an unusually cold winter. Authorities blamed the artist and imprisoned him for producing shoddy designs. Sansovino's friend, the painter Titian, eventually negotiated his release and the restoration of his reputation and fortunes. While the architect maintained a successful career designing public buildings for the Venetian Republic, he also took on commissions for domestic palaces in the city. Among these, the Palazzo Corner dell Ca Grande, commissioned by the wealthy Corner family, ranks among his greatest works. Here

Sansovino introduced rigorous classical detailing drawn from the ancient architectural theoretician Vitruvius. Although thoroughly classical in design, Sansovino ensured that the palace fit in visually with the other older structures that surrounded it on its canal. For the ground floor, he designed a heavily rusticated façade and included elements of the severe Doric order. The three bays he placed in the façade served to admit merchants and businessmen into the interior courtyard, much as the arched colonnades in Roman and Florentine palaces did at the same time. On the two floors above, Sansovino used first the Ionic order and then the Corinthian. While the exterior of the structure fit neatly into the unusual canals of Venice, Sansovino also included an immense interior Roman-styled courtyard. This was an unprecedented luxury in a city in which dry land was a dear commodity.

PALLADIO. The architect Andrea di Pietro is better known today by the classical Latin name he took in middle age, Palladio. The precise place of his birth remains

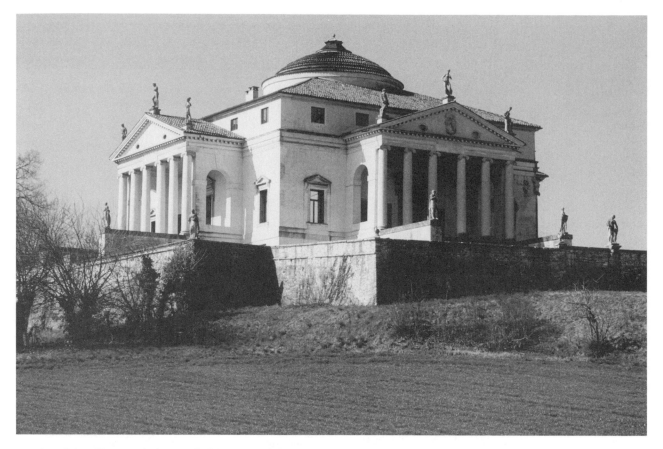

Exterior of the Villa Rotonda (once called the Villa Capra) near Vicenza, Italy, designed by Andrea Palladio. © SANDRO VANNINI/COR-BIS. REPRODUCED BY PERMISSION.

an uncertainty but he first served as an apprentice to a Paduan stonemason. By 1524, he had moved to Vicenza, the site of many of his architectural masterpieces. He joined a local workshop, but by his mid-thirties he had come to the notice of a nobleman residing in Vicenza, the humanist scholar Gian Giorgio Trissino. Trissino took Palladio into his scholarly circle, exposed him to the rudiments of a humanist education and to Vitruvius' treatise on architecture. It was under the influence of Trissino, too, that the architect adopted his classical name. With the elder humanist's patronage, Palladio traveled to Rome many times during the 1540s. On one of these trips he met Michelangelo, and on all of his journeys he spent a great deal of time in Rome's ruins, studying and drawing their design elements. Even as he was developing his taste for classical Antiquity, Palladio was also at work designing structures for Vicenza's wealthy inhabitants. His first independent creation seems to be the designs for the Villa Godi in a small town near Vicenza. Within the city he also created plans for two domestic palaces as well as another country villa. These works do not yet show the secure integration of classi-

cal design elements, while one of them, Palazzo Thiene, shows that the architect toyed with some elements of central Italian Mannerism. He later rejected Mannerism of a thoroughly classical idiom. By 1549, the architect had been appointed by Vicenza's town council to restore the city's Basilica, or town hall. In the fifteenth century this large complex of separate buildings had been joined into a single structure surrounded by Gothic-styled arcades. One of these arcades had collapsed in 1496, and the Vicenza council had long searched for an architect who could remodel the complex along the lines of the new Renaissance classicism. In the structure that Palladio designed he displayed a thorough knowledge of Roman styles of building, and the ingenuous solution that he created for this problematic structure helped to establish his reputation as a designer of merit.

DOMESTIC ARCHITECTURE. Palladio continued to design new palaces in Vicenza during the 1550s and 1560s, and much of the city still bears his indubitably elegant stamp. He also filled the countryside in and around Vicenza with numerous villas. The most influential of these was Villa Rotonda (sometimes referred to

as Villa Capra). Later it would become the model for Thomas Jefferson's Monticello. The Rotonda, so called because of its central dome, sits atop a hill with a view of Vicenza. The villa is a square building with a hemispherical dome shaped like that of the Roman Pantheon at the center. Each of the building's four sides is framed with a portico whose columns and pediments show the influence of ancient temple architecture. Each portico frames a different view of the attractive countryside and distant city, and at the same time these structures provide shelter from the elements and from the harsh summer sun. In this way Palladio created a building that allowed inhabitants to spend a great deal of time outdoors at all times of the year. Palladio's porticoes have continued to be an important design feature in houses since his day, and they are to be found not only in Europe but also in many hot regions of North and South America. Here these structures provide shelter from the elements and the sun, allowing people to spend greater time out of doors. Palladio decorated each of his structures with an arcade of Ionic columns and classical pediments. Statues atop these pediments and at the corners of the stairs leading to each portico are among the only decorative elements placed upon the structure. The window pediments, often a place upon which Renaissance designers showered great decorative attention, are restrained. The structure is elegant, yet severe, with simple unadorned plaster facing the exterior walls rather than expensive stonework. Perhaps this restraint explains the great popularity the Palladian style had for the colonial settlers of North America and for rapidly expanding eighteenth-century towns like London and Philadelphia. In these circumstances the building techniques of Palladian architecture provided structures that were pleasing to the eye, yet relatively inexpensive since they could be constructed with materials that were close at hand.

VENICE. Most of Palladio's architectural commissions were for domestic structures, and, unlike other great Italian architects of the Renaissance, he designed churches only infrequently. As he matured and his fame spread, however, he did complete designs for two famous churches in the city of Venice. The first of these, the Church of St. George Major, stands on an island away from the main center of Venice but still visible from the Doge's Palace in St. Mark's Square. Built for a Benedictine monastery at the same site, the church has been one of the most beautiful landmarks of Venice's cityscape since its completion. In his architectural writings Palladio, like other sixteenth-century architects, advocated a central-style church as the most visually pleasing and harmonious space. He believed that such a shape stressed

the unity and power of God. At St. George, however, he bowed to the pressure of the local church authorities and instead created a traditional Latin cross plan with a long nave. Palladio filled these spaces with light from the dome at the crossing, as well as a row of windows placed just under the vault. He crafted an arcade of Roman arches set off with columns in gray stone, and above this he included a large entablature that was among the most prominent decorative elements in the church. Designed after the conclusion of the Council of Trent (1545–1563), Palladio also complied with the new dictates of the church for simple unobstructed views of the High Altar. The effect of St. George Major is at once simple, rational, and harmonious. Together with another Church of the Redeemer that the architect designed a little more than a decade later, Palladio's church architecture inspired several generations of English designers, including Sir Christopher Wren (1632–1723), who relied on its appealing visual language in the churches he created in seventeenth- and eighteenth-century London. A final important design from the late period of Palladio's life was his plan for the Olympian Theater, the construction of which was overseen by his student Vincenzo Scamozzi in the city of Vicenza after his death. The architect's designs for the theater had been influenced by architectural theory about the size and shape of ancient Roman theaters, and the building was intended for recreations of classical dramas. Fixed scenery was included in Palladio's design, and after his death Scamozzi added perspectival street scenes. These are stepped up so that they appear to vanish at a great distance from the front of the stage. In reality, these are only tricks of perspective, for the depth of the stage from front to back is only a few feet, rather than the vast distance that it appears to be. The Olympian Theater was one of several attempts in Italy to reconstruct a historically accurate version of a Roman theater, an effort in which both humanist scholars and artists participated. Most other attempts involved temporary structures in wood or plaster, while Palladio's more elaborate stage and theater has survived over the ages.

THEORY. Palladio was also an important figure in the history of architectural theory. In 1556, Palladio created a series of illustrations for a new printed edition of Vitruvius' ancient architectural text. Slightly later, the author published his own *Four Books on Architecture,* a work that he also illustrated and used to inform his readers about many of the practical problems of building in the classical style. He treated the preparation of building sites, the practical design elements of the ancient architectural orders, and discussed what types of rooms

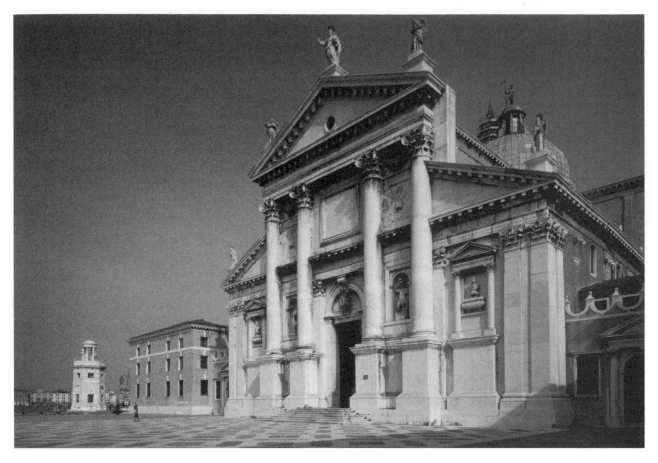

Exterior of the Church of San Giorgio Maggiore in Venice. © ARALDO DE LUCA/CORBIS.

were best suited to which activities. Palladio also discussed public works and civic buildings, even as he surveyed ancient Roman designs. He also assessed and criticized the most prominent structures of his own times. The architect's writings advocated the styles of Antiquity, not from a doctrinaire perspective, but as the most practical forms for the contemporary situation. He showed, in other words, how classical elements and designs could be profitably adapted to current realities to provide city and country dwellers alike with spaces that were visually pleasing, yet functional. Palladio's prominent pupil Vincenzo Scamozzi, later updated and expanded upon this pragmatic dimension of Palladio's work in a treatise entitled *The Idea of a Universal Architecture* (1615). In sixteenth-century Italy, Palladio's work shared an audience with the *Rules of the Five Orders of Architecture* (1563), a treatise written by the papal architect Giacomo Barozzi da Vignola. Elsewhere in Europe Palladio's work traveled farther and acquired a greater following, a following that eventually stretched from England to Croatia, from Scandinavia to the Americas. In these widely diverse cultures the *Four Books of Architecture* kept alive High Renaissance classicism, de-

spite the simultaneous popularity of Mannerism in many of these regions. Even centuries later, Palladio's treatise produced new revivals of classicism. The work was particularly admired in Georgian England, and one disciple, the colonial revolutionary Thomas Jefferson, relied on its canons as he planned the buildings and grounds of the University of Virginia in the new American Republic. Thus it is difficult to overestimate the importance that Palladio's treatise on classical design exercised upon the minds of Europeans, both in the Renaissance and in the centuries that followed.

IMPLICATIONS. The sixteenth century in Italy was an era of amazing architectural productivity. The century opened with the ambitions of Julius II for the rebuilding of St. Peter's Basilica and the renewal of the ancient city of Rome, plans that came abruptly to an end with the Sack of the city in 1527. In Florence, Michelangelo's first architectural works, notable for their willful individualism and creative use of ancient design elements, inspired Mannerist artists and architects in the decades that followed. Dissatisfied with Medicean rule in his native city, though, Michelangelo returned to

Rome in 1534. His later Roman works, while monumental and influential in inspiring later Baroque designers, did not continue along the path that he had laid out in his Florentine buildings. Mannerism persisted in Italy, and became a significant influence throughout Europe in the decades following 1550. The emphasis of Mannerist artists on designing complex spaces and on repeating classical elements in new formations inspired many projects in Florence, Rome, and Central Italy, and slightly later in Northern Europe. At the same time the allure of Palladio's classicism, and of High Renaissance forms generally, survived in the second half of the sixteenth century. This rich diversity in sixteenth-century Italian design presented architects working in other European regions with a wealth of examples, styles, and possibilities upon which to draw as they integrated the new architecture of the Renaissance into buildings constructed in their own countries. While they reached out to Italy for inspiration, European designers also created their own ways to give native expression to the Renaissance's taste for the world of classical Antiquity.

SOURCES

S. Borsi, *Giuliano da Sangallo* (Rome: Officina, 1985).

B. Boucher, *Andrea Palladio: The Architect in His Time* (New York: Abbeville Press, 1994).

M. Fossi, *Bartolommeo Ammanati, Architetto* (Naples: Morano, 1968).

M. Furnari, *Formal Design in Renaissance Architecture* (New York: Rizzoli, 1995).

P. Murray, *Renaissance Architecture* (New York: Electa, 1985).

N. Pevsner, *The Architecture of Mannerism* (London, England: Routledge and Kegan Paul, 1946).

SEE ALSO *Visual Arts: Late Renaissance and Mannerist Painting in Italy*

THE ARCHITECTURAL RENAISSANCE THROUGHOUT EUROPE

SPREAD OF CLASSICISM. The adoption of the classical style that had flourished in Italy since the early fifteenth century appeared only slowly throughout Europe. Even within Italy, the spread of classicism had been uneven in the 1400s, and had often been governed by the presence of vigorous local circles of humanists. With its love of Roman and Greek texts, humanism tended to support the revival of classical architecture, as scholars and patrons pursued an interest in all aspects of life in the ancient world. In Northern Europe, the fondness for the intricacies of Gothic style persisted everywhere during the fifteenth century, and buildings constructed in the classical style appeared first, not in Western Europe, but in Hungary and Russia. Hungary's despotic King Matthias Corvinus (r. 1458–1490) was among the first European monarchs to import Renaissance humanists and architects to his court. He subdued his country's nobles and established a firm but tenuous hold over the country. At Buda he rebuilt the city's castle in the Italian Renaissance style and provided space for a library, the Biblioteca Corvina. The library housed Corvinus' large collection of manuscripts, a collection that at the time was about the same size as that of the popes' Vatican Library in Rome. At several other places throughout the country he deployed his Italian architects to remodel or build anew structures in the Renaissance styles of contemporary Italy. Far from the centers of Western Europe, the Grand Prince Ivan III did much the same when he called several Italian designers to plan projects for his rebuilding of the Kremlin in Moscow. One of the structures he built, the Palace of the Facets, was the first secular building to be located within the walls of the ancient fortress upon its completion in 1491. Ivan's Italian architects also aided him in strengthening the fortifications of the Kremlin by constructing defensive works similar to those being built in Italy at the same time. In Western Europe, though, patrons and architects proved more resistant to the new style, and it was not until the early sixteenth century that a great number of buildings based on the newly revived classicism began to appear. As in Italy, the spread of humanism furthered these developments, and royal and aristocratic patrons, as well as wealthy merchants and townspeople desired buildings that expressed their newfound fondness for classical Antiquity. The political chaos of the Italian scene in the first decades of the sixteenth century also created a supply of architects available for commissions and positions as court designers in France, Spain, and elsewhere throughout the continent.

ORNAMENTATION AND INTEGRATION. Local artists, though, designed most of the Renaissance buildings constructed outside Italy in the sixteenth century. Kings and princes were usually the only figures who possessed resources considerable enough to import their designers from Italy, the wellspring of Renaissance neoclassicism. Oftentimes the new fashion for Antiquity of the early sixteenth century produced buildings that were not notably ancient in their feel or design, but which were merely decorated classical elements. The fondness for elaborate ornamentation characteristic of the late phases of Gothic architecture thus persisted, and designers produced many buildings that were a forest of classical

a PRIMARY SOURCE *document*

A ROYAL PATRON

INTRODUCTION: Francis I of France was one of the great sixteenth-century royal builders and connoisseurs of art. In a relatively long reign, he beautified the Palace of Fontainebleau, began rebuilding the Louvre, and created a string of country châteaux. Francis also called artists from Italy and Flanders to work for him, among them the swashbuckler, Benvenuto Cellini. In his *Autobiography*, Cellini reported how he received one commission from Francis to build a new fountain at Fontainebleau in a casual almost offhand manner. Whether the story is true or not, Cellini usually engineered his accounts to throw himself into the best possible light.

For my great King, as I have said, I had been working strenuously, and the third day after he returned to Paris, he came to my house, attended by a crowd of his chief nobles. He marvelled to find how may pieces I had advanced, and with what excellent results. His mistress, Madame d'Etampes, being with him, they began to talk of Fontainebleau. She told his Majesty he ought to commission me to execute something beautiful for the decoration of his favourite residence. He answered on the instant: "You say well, and here upon the spot I will make up my mind what I mean him to do." Then he turned to me, and asked me what I thought would be appropriate for that beautiful fountain. I suggested several

ideas, and his Majesty expressed his own opinion. Afterwards he said that he was going to spend fifteen or twenty days at San Germano del Aia, a place twelve leagues distant from Paris; during his absence he wished me to make a model for that fair fountain of his in the richest style I could invent, seeing he delighted in that residence more than in anything else in his whole realm. Accordingly he commanded and besought me to do my utmost to produce something really beautiful; and I promised that I would do so.

When the King saw so many finished things before him, he exclaimed to Madame d'Etampes: "I never had an artist who pleased me more, nor one who deserved better to be well rewarded; we must contrive to keep him with us. He spends freely, is a boon companion, and works hard; we must therefore take good thought for him. Only think, madam, all the times that he has come to me or that I have come to him, he has never once asked for anything; one can see that his heart is entirely devoted to his work. We ought to make a point of doing something for him quickly, else we run a risk of losing him." Madame d'Etampes answered: "I will be sure to remind you." Then they departed, and in addition to the things I had begun, I now took the model of the fountain in hand, at which I worked assiduously.

SOURCE: Benvenuto Cellini, *The Autobiography of Benvenuto Cellini* Vol. 31 of *The Harvard Classics*. Trans. John Addington Symonds (New York: Collier, 1965): 292–293.

ornamentation, but in which the overall effects lay closer to medieval than to Renaissance sensibilities. Eventually the growing body of books treating architectural theory and practice aided architects in Northern Europe and Spain, as designers and patrons were now able to read about the design principles and rationale that underlay classical architecture. Many of these works' illustrations, along with the independent prints that circulated of classical buildings, helped to produce purer forms of architectural classicism, although the development was not without difficulty. In Northern Europe the sixteenth century was also a time of great religious and political upheaval. The protracted religious crisis had a dampening effect everywhere on the construction of new churches, one of the chief kinds of monuments upon which Italian designers had displayed their newfound fondness for Antiquity. The Religious Wars in France and the Netherlands delayed or caused patrons to abandon the completion of many secular projects as well. In England, the Reformation similarly dampened enthusiasm for church building. Despite these difficul-

ties Northern European and Spanish architects learned many lessons from ancient and Renaissance architectural designs, and by 1600, they had developed their own forms of classicism tempered by their native traditions.

FRANCE. France proved to have one of the most innovative climates for pioneering new architectural forms in the era. Although the period was not one of great achievement in church building, the country produced a wealth of new châteaux, palaces, townhouses, and civic structures during the sixteenth century. The taste for Italian design influenced many of these buildings. In the early stages of the French Renaissance, Italian designers—at first drawn from the Duchy of Milan conquered by the French at the very end of the fifteenth century—planned and executed many ambitious projects for the French crown. Among the Italians lured to France was Leonardo da Vinci, who experienced a stroke shortly after his arrival, and produced little in the last years of his life in France. Da Vinci did design a new royal château to be built at

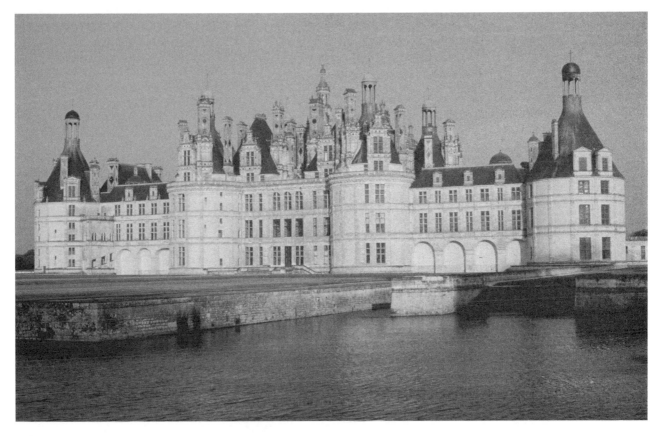

Château de Chambord, France. MICHELLE GARRETT/CORBIS.

Romorantin, and although the project did not begin until after the artist's death, it was soon given up to build the larger, still-standing Château de Chambord. Leonardo's design ideas, nevertheless, seem to have left their impact on French design. While the artist was still living in Milan, he had developed plans for interlocked double staircases, built in a structure that resembled a double helix. These structures allowed one staircase to be used by those ascending and another for those who were descending. His designs seem to have encouraged a series of interlocked staircases in sixteenth-century French châteaux, a type of construction that was springing up on the French landscape with increasing frequency at the time.

CHÂTEAUX. Although the sixteenth century proved to be a time of religious warfare and chaotic political rivalries in France, the period actually opened on a note of optimism. This optimism is evident in the large number of construction projects undertaken for new and rebuilt châteaux. The English equivalent for this French word is "castle," and originally medieval châteaux had been heavily fortified, their role being defensive. Certainly, most sixteenth-century French châteaux for the

nobility and the king retained their defensive elements, but now they also took upon a refined elegance more in keeping with their residential nature. Francis I (1515–1547) was an avid builder of these country châteaux, and during the early years of his reign, he concentrated his efforts on his castles at Blois, Chambord, and Amboise. One of the most unusual of the many structures he built was a loggia at Blois, modeled closely upon Donato Bramante's famous plans for the Belvedere Palace at the Vatican. At Chambord, he built the most imposing of his country castles, using a plan that melded French Gothic ideas with the newer design features of the Italian Renaissance. Built over a period of twenty years, the castle was notable for the layout of its central keep (the most heavily fortified part of the château). Francis had the keep designed in the shape of a Greek cross, an innovation that showed the influence of Italian ideas about the superiority of the central style of design. At Chambord, he also included paired ascending and descending staircases made popular by Leonardo's designs, and at Chambord their construction shows a new concern with privacy, since no one is able to see those who are on the opposing staircases. But although this, the largest and most impressive of Francis' châteaux,

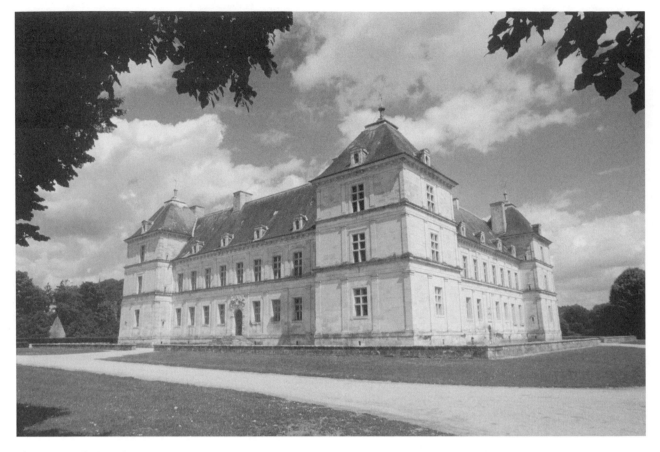

Château Ancy-le-Franc in France. © BOB KRIST/CORBIS.

included some of these Renaissance details, it continued to display the traditional French Gothic taste for dormers, spires, and fanciful roof decorations. These tended to overwhelm the building's classical details. At the same time as Francis beautified his castles, similar structures built for the country's notable families dotted France's countryside. While the Loire Valley contained the greatest number of châteaux as France's nobles congregated there in hopes of being close to the king, construction of châteaux in the more refined and elegant style of the times occurred throughout the country—albeit on a distinctly smaller scale than the royal castles at Chambord and Blois. One of the most beautiful structures that traces its origins to this early boom in Renaissance châteaux construction is Chenonceaux. It was picturesquely sited above a river, where it replaced a mill that had stood upon the same spot. Later in the century, Henry II (r. 1547–1559) purchased it for his mistress, Diana of Poitier, who gave the original castle greater classical detailing and connected it to the opposite shore by the construction of a new Renaissance-styled wing. Significant additions over the centuries have altered the appearance of the castle, which today still ranks as one of the most delicate and beautiful of European buildings. The châteaux at Azay-le-Rideau, Villandry, and Le Rocher Mézanger also present examples of the various styles that were popular during the first half of the sixteenth century, and show the taste for mingling of Renaissance and Gothic ornamentation.

ITALIAN ARTISTS. Besides Leonardo, three other prominent Italian artists—Rosso Fiorentino, Primaticcio, and Serlio—spent significant portions of their careers in France. They were among the most influential Italian émigrés who settled in the country in the sixteenth century. Rosso Fiorentino and Primaticcio had begun their careers in Italy as painters during the development of early Mannerism. While they continued to paint in France, they also designed and decorated rooms for the royal palace at Fontainebleau as well as for a string of royal châteaux located mostly in the Loire River valley and in the Île de France, the countryside surrounding the city of Paris. This tradition of imported Italian designers continued in the 1540s when Sebastiano Serlio (1475–1554) took up residence in the country. Serlio was an architect, sculptor, and painter whose designs

attracted a wide following through his publication of his architectural treatise. In France he designed several works, including the new Château Ancy-le-Franc. The building's plan was C-shaped and enclosed a central courtyard guarded on the open side by a low rising wall. This style of construction grew popular in France over the coming centuries, as French patrons generally disregarded the central enclosed courtyards that were popular in Renaissance Italy.

FONTAINEBLEAU. Throughout his long reign Francis showered his greatest attentions on the royal palace of Fontainebleau. He commissioned a number of Italian artists to decorate the palace's chambers, including Rosso and Primaticcio. In the rooms they decorated for the king both artists developed a highly ornamental style that made use of the design techniques that Raphael and Giulio Romano had developed in Rome at the Villa Farnesina, but which extended that pattern of decoration to an almost baroque complexity and elegant finesse. From 1528 onward, Francis also began to transform parts of the palace's façade, relying on the native architect Gilles Le Breton as his designer. With the premature death of Rosso in 1540, Francis also coaxed Sebastiano Serlio to France. By this time Serlio's reputation had already been established by the publication of his architectural treatise in 1537. The work was popular and appeared in French and Italian editions during the following years. Serlio's design tenets included impressive classical colonnades similar to those Bramante had designed for the Belvedere Palace in the Vatican. His influence was widespread and gave encouragement to the construction of similar structures at Fontainebleau and at the Louvre in Paris as well as in other noble houses constructed throughout France.

LOUVRE. The greatest achievement of sixteenth-century French architecture was the rebuilding of the Louvre Palace in Paris, a project planned and executed by mostly French, rather than Italian designers. The project began in 1546 under the direction of Pierre Lescot (1510–1578), and the rebuilding continued for centuries. Francis began by demolishing the medieval keep that stood in the center of the palace, and building on its site a series of buildings arranged around a courtyard. Lescot was unusual by the standards of many Northern European architects of the time. In France, in particular, most sixteenth-century designers came from stonemason backgrounds. By contrast, Lescot was from a prosperous legal family, and he had received a broad education. Unlike many native French architects of the time, he did not learn his craft by traveling to Italy. Instead he applied the mathematical, painting, and archi-

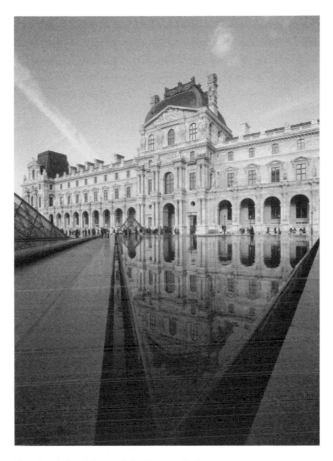

Façade of the Palace of the Louvre in Paris. © PHILIP GOULD/ CORBIS.

tectural lessons he had learned at home in France. His chief achievement at the Louvre was the building of the Square Court. In the designs he crafted for this part of the palace, Renaissance architecture in France reached a high expression of classical finesse. Lescot's plan shows a mastery of all the details of the classical orders, and at the same time the building's appearance is refined and unified. It is also an elegant structure when compared against the massive palaces of Florence and Rome. Lescot also skillfully incorporated details that were typically French. In the cold climate of Northern Europe, steeply sloped roofs were a necessity, and thus the imitation of the Italian example was never to be complete. Lescot's steeply pitched roof, however, manages to fit nicely with the other details of his design. His use of small decorative statues to ornament the façade was a design element rarely used in Italy, and points to the greater taste for ornamentation that continued to live on in France even under the guise of the classical revival. In total, though, Lescot's classicism was more assured than any work designed by a French designer to this point. Yet at the same time he developed a native French Renaissance idiom

that was free from tutelage to Italian models. It is not surprising, then, that later designers were to build upon his example.

SPAIN. The architectural Renaissance in Spain followed a path similar to that of France. Like its northern neighbor, Spain dominated political developments in Italy in the early years of the sixteenth century, and many of its artists traveled there to learn firsthand about the new styles in painting and architecture. Three phases occurred in the integration of Renaissance elements into the native architecture of Spain. In the first phase, a decorative style known as the Plateresque (for its affinities to work in silver and gold plate (in Spanish known as *plata*), incorporated classical elements as highly decorative ornaments on tombs and altars in churches. Soon this classical detailing spread to use on wall surfaces and façades, too. By the end of the first quarter of the sixteenth century, in the second phase of classical integration, a more thorough adoption of Italian influences resulted in the construction of projects that were more outrightly Renaissance in their design and construction methods. Finally, an austere classicism, known as the Herreran style (for the architect Juan de Herrera), began to appear around 1560. As in all regions in Renaissance Europe, elements of older styles continued to co-exist alongside newer innovations. Decorative Plateresque buildings, in other words, continued to appear at the same time as the more austere forms of Herreran classicism were growing popular.

ROYAL PATRONAGE. The greatest architectural projects in sixteenth-century Spain were undertaken on a grand scale with royal patronage, as befitted the country's status and the enormous wealth its government derived from New World silver and gold. Among the classically styled monuments erected under the patronage of the crown, the Royal Hospital at Santiago de Compostela was one of the first examples of Renaissance classicism in Spain. Santiago de Compostela was the site of an important pilgrimage church to which Europeans from throughout the continent came, and the hospital was intended to care and provide lodging for these pilgrims. Spain, like France, had no formal capital in a modern sense during the sixteenth century, and the monarch regularly moved from place to place, supervising the administration of the country. This annual circuit brought the king to Spain's most important cities. Taking up residence in various parts of the country was even more important in Spain than in France or England, for the country was really an amalgamation of many kingdoms and provinces, many with very distinct customs, laws, and languages. During the later Middle Ages,

two kingdoms—Castile and Aragon— had conquered much of the peninsula, and they had been linked in an uneasy alliance through the marriage of the dual monarchs Ferdinand and Isabella. Granada, Toledo, Madrid, and Seville were just a few of the cities the sixteenth-century Spanish kings regularly visited as they conducted their annual tour of Spain. The itinerant nature of the Spanish monarchs during much of the sixteenth century thus necessitated the construction of palaces, churches, and other governmental buildings throughout the country. After 1560, the center of royal administration of the two kingdoms became situated in the central Spanish city of Madrid, thus setting off a building boom in and around that town. Besides these royal construction projects, the crown in Spain was also a fervent supporter of universities, and in the sixteenth century Spain's major educational centers acquired many new buildings in the various Renaissance styles flourishing throughout the peninsula. Among these, the campuses of the University of Salamanca and the new University of Alcalá acquired some of the finest Renaissance structures in Spain. In both cases, these buildings utilized the more ornate Plateresque style, rather than the severe Herreran classicism that became popular later in the sixteenth century.

THE ESCORIAL. The greatest, and at the same time most unusual, architectural project undertaken in sixteenth-century Spain was the construction of the Escorial near Madrid. King Philip II's favorite architect, Juan de Herrera (c. 1530–1597), designed this building, which was constructed between 1563 and 1584 as a combination church, monastery, mausoleum, and royal palace. The complex expresses the fervent, unbending Catholicism of its patron, Philip, who presided over the country's internal affairs and vast colonial empire between 1556 and 1598. The king acquired a reputation, even in his own lifetime, for being an overly scrupulous religious fanatic and a meddling absolutist ruler. In reality, Philip exercised a great deal of restraint and was far from being a zealot, but the religious wars of the sixteenth century were chiefly to blame for developing a "Black Legend" about Spain and his rule, particularly in Protestant countries where fear of the forces of the Counter-Reformation ran high. The king was an avid connoisseur of art and he maintained a long friendship with the great Venetian artist Titian. Both his taste for Italian art and his own austere religious temperament influenced his distaste for the ornamental Plateresque style of Renaissance architecture that flourished in much of Spain at the time. Herrera became the perfect architect to give expression to Philip's tastes. Undertaking the great project of the Escorial, the king wrote to his architect, advising him that

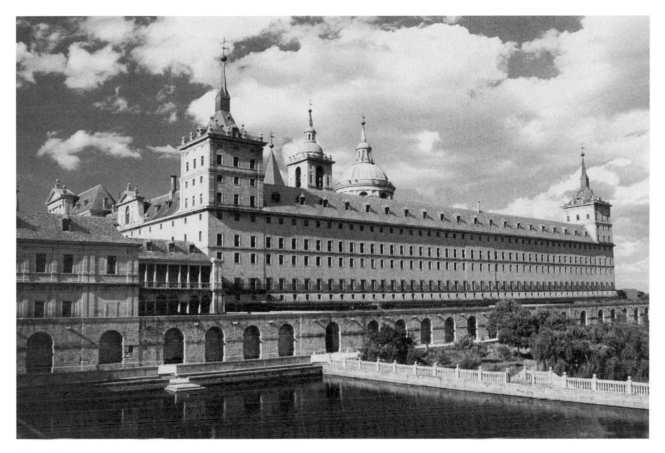

El Escorial, Spain. © VANNI ARCHIVES/CORBIS. REPRODUCED BY PERMISSION.

the building should have "simplicity of form, severity in the whole, nobility without arrogance, majesty without ostentation." Herrera gave brilliant expression to these demands in the plans he completed for the building, although a change in the purpose of the building likewise necessitated a radical change to the architect's original plans. In 1558, Philip's father, the emperor Charles V, died, and his son decided to transform his palace, still in the design stages, into a tomb for his father. He added a monastery, where monks were to pray continually for the soul of his father. The church at the center of the new palace was to become Charles' mausoleum. Herrera designed a great gray granite mass of a building with its prominent domed church for a plot at the edge of the mountains outside Madrid. Until he received the commission for the Escorial, Herrera had been living in Naples, at the time a Spanish possession in Italy. While in Italy he had studied the plans for the new St. Peter's Basilica, and the influence of Michelangelo's designs can be seen in his subsequent plans for the Escorial. He designed the central domed church as a simplified, even puritanical version of Michelangelo's St. Peter's dome. Around this he built a series of square courtyards, the sur-

rounding wings of which house the royal palace and monastery complex. The façade of the entire structure is largely undecorated, and where ornamental elements appear, they are in the simplest of classical forms. Herrera used the Doric, rather than the more ornate Corinthian order, and on the palace's many rectangular windows he placed mere square pediments, the only decorations that penetrated the otherwise unending granite wall surfaces. Four large spires at the four corners of the structure repeat the motif of the two central spires of the palace's church; the overall effect of the palace bears more resemblance to the grand churches of sixteenth-century Rome than to any kind of domestic structure. Detractors have long criticized the structure as cold and monotonous, while its admirers have defended it as simple and grand. Its influence on subsequent designs in Spain was considerable, as the Escorial paved the way for a new Spanish architecture characterized by a rigid use of classical forms and massive, relatively undecorated spaces.

GERMANY. The influence of Italian Renaissance architecture can be seen at work in Germany from the first decades of the sixteenth century. Religious turbulence, though, characterized life in the region during much of

the sixteenth century, and the disputes of the Reformation initially cast a pall over the construction of new churches. These were once the largest building projects of the German Middle Ages. In the first half of the sixteenth century, though, church building ground to a halt before reviving in the second half of the century. As in France and somewhat later in England, the greatest architectural projects that made use of Renaissance classicism were castles, palaces, and civic buildings. But in contrast to France and Spain, most German projects were on a decidedly smaller scale because of political realities. The area comprising modern Germany and Austria was part of the Holy Roman Empire, a loosely knit confederation of more than 350 states, ruled over in theory—if not always in practice—by an emperor chosen from the Habsburg dynasty. In the sixteenth century this powerful family had amassed significant territories outside the region, including the kingdoms of Spain, the counties of the Netherlands, and the New World colonies. These more prosperous territories became far more important to the dynasty than the traditional seats of Habsburg power in Austria and the German southwest. Although Charles V (r. 1519–1558) ruled over the Holy Roman Empire for much of his life, his positions as king of Spain and ruler of the Netherlands consumed more of his time than the rural and undeveloped territories of Central Europe. He visited Germany only occasionally, and centuries of feudal development in the region limited his power, allowing small territories and cities to become, in effect, semi-autonomous states. Thus court life on the massive scale typical of France or Spain was largely unknown in Germany. Before his death Charles divided his massive empire into two parts, splitting off his Spanish and Italian possessions as well as the Netherlands from the ancient German heart of Habsburg power. Charles' Spanish heir was Philip II, while his son Ferdinand (r. 1558–1564) succeeded him as Holy Roman Emperor; during his relatively short reign, Ferdinand concentrated his energies on resolving Germany's religious crisis, on his role as king of Hungary and Bohemia, and on his struggles against the incursion of the Turks into his Eastern European possessions. Despite these problems Ferdinand and his successors began to devote significant attention to the development of the court at Vienna. But this was a local phenomenon that affected only Austria and the other centers of Habsburg power in Eastern Europe. Ferdinand called several Italian artists to his court and he patronized a small circle of German masters. His successors followed this pattern, although the great age of the Austrian Habsburgs' patronage of art and architecture lay ahead in the seventeenth century. At this time Vienna and the surrounding Austrian countryside became

a great stage upon which the Habsburgs displayed their absolutist pretensions through the construction of monumental and imposing edifices. There was, in other words, no sixteenth-century Austrian Fontainebleau or Escorial, although the Habsburg emperors constructed several projects in their homelands on a decidedly more modest scale.

COURTS. For most of the sixteenth century Germany may have lacked the central state authority typical of France and Spain which inspired monumental architectural projects. More than 300 territories ruled by members of the feudal aristocracy and the Roman Church produced hundreds of courts, in which German princes were increasingly concerned to safeguard their power and to demonstrate their control over the small lands they held. Architectural projects were thus a visible result of the trend toward heightened local control. To imitate the greater princes of Europe, Germany's territorial rulers relied on building projects to express their increasingly grand pretensions. In the first half of the sixteenth century relatively few projects relied upon the innovative styles of the Renaissance. One notable exception was the remodeling of the Wittelsbach's Residence in Landshut. Landshut today is no more than a respectably sized town about an hour's train ride north of Munich. In the sixteenth century, though, it was an important center of the duchy of Bavaria's government. In 1536, the local duke visited Italy, where he saw the imaginative designs that Giulio Romano had crafted for the pleasure Palace of the Te. The duke recruited a small circle of Italian craftsmen and painters to come to Landshut, where they constructed and decorated a series of rooms in the city's palace that strongly resembled the Te. Such fervent devotion to Italian design, though, was rare among the German princes of the first half of the sixteenth century.

RELIGIOUS CONTROVERSY. The ideas of Protestant Reformers like Martin Luther and Ulrich Zwingli spread through German cities and the surrounding countryside quickly during the 1520s. Outlawed by imperial edict, Luther's views continued to attract significant support, particularly in the empire's towns and among some of its most prominent nobility. Growing tension between Protestant and Catholic factions of towns and the nobility produced brief, but vicious religious wars followed by attempts at reconciliation between both sides. In 1555, leaders crafted a compromise between the two opposing religious factions. Known as the Peace of Augsburg, this treaty stipulated that German rulers possessed the power to sanction either Lutheranism or Catholicism within their territories. Although most combatants in the religious disputes that had gripped Germany over the

previous decades thought of the treaty as a temporary truce, its solution to the problems of religious diversity proved to be particularly long lasting. The Peace of Augsburg forestalled religious war in Germany until 1618, introducing a period of stability that was unusual in Northern Europe at the time. One of the stipulations of the treaty had the unintended effect of producing a great flowering in church building. The Peace of Augsburg forbade Protestants from appropriating additional property belonging to the Roman Catholic Church. As a result, Protestant cities and princes constructed a number of new churches in the years after 1555.

PROTESTANT CHURCHES. While many important church-building projects had been underway in Germany during the early sixteenth century, new construction had generally ceased with the rise of the Reformation. Protestants had found the late-medieval trend to create ever larger and more elaborate side-aisle chapels within churches wanting, believing that such structures detracted from the central messages of the altar and the pulpit. These, their leaders intoned, were more suitable foci for the laity's devotion. Although they initially avoided new church construction, Protestants still placed their indelible stamp on existing structures. In many places the Reformers removed side-aisle chapels, and introduced more elaborate main altars and pulpits to underscore the change in church teachings. With the conclusion of the Peace of Augsburg, and the realization of its prohibitions against the further appropriation of Roman Church property, Protestants began to build new churches. At first no single style dominated, as designers searched for a distinctive style that might express their new religious convictions. By the end of the sixteenth century, though, a new style of construction began to appear. Designers adopted Renaissance classical elements to create spaces characterized by simpler sight lines, less ornate decoration, and better-lighted, vaulted spaces for the purpose of throwing into greater relief the central messages conveyed from the altar and the pulpit. The Marian Church in Wolfenbüttel, in a town today near the northern industrial city of Braunschweig, and the City Church in the Black Forest town of Freudenstadt in southwest Germany are typical examples of this new style. Both structures date from around 1600.

CATHOLIC CONSTRUCTION. Between 1580 and 1600 more church construction began in Germany than in all the other regions of Northern Europe combined. In contrast to the traditional designs of the later Middle Ages, those of the later sixteenth-century Catholic Church evidenced innovative new designs, designs that answered the calls of religious reformers, both Catholic and Protestant, for renewal in the church's teachings and worship. These included St. Michael's Church in Munich, the headquarters of the new Jesuit order in the Bavarian capital. Modeled closely on the designs that Giocoma Vignola had perfected for the Gesù in Rome, the St. Michael's Church gave prominence to the High Altar by eliminating side aisles and truncating the normally long transepts that radiated from the church's crossing. While side chapels did not disappear altogether, they were tucked inside the walls of the church, so that all sight lines in the structure led eyes inexorably to the church's main focal point in the choir. In this way the designers of the church, and the Jesuit patrons who commissioned it, hoped to answer the call of the Counter-Reformation Catholic Church for greater focus on the centrality of the Eucharist in the Mass. In Münster in northwestern Germany, the Jesuits began the Peter's Church around 1590, a structure very much influenced by St. Michael's. During the seventeenth century the order continued to rely on a similar style throughout Northern Europe, which they hoped might focus the attention of their worshippers closely on the important features of Roman Catholic ritual.

CASTLES. As in other regions of Europe, the sixteenth century in Germany was a great age in the construction of palaces and castles. Like the châteaux of sixteenth-century France, the German *Schloss*, (meaning literally "keep") was more refined and elegant than the castles of the Middle Ages. They appear today more like grand homes than the fortress-like structures of the late-medieval period. Most were constructed of stucco and refined stone masonry, rather than the heavy and rustic stonewalls of the past. Although produced on a smaller scale than buildings of the kings of France or Spain, German palaces and castles often made imaginative use of the design tenets of the Renaissance, and merged the new classicism with older native styles of buildings in ways that were similar to trends in France and Spain.

PROJECTS. The boom in construction was particularly vigorous between 1560 and 1580. Among the Renaissance projects constructed at this time were a new castle for the Dukes of Brunswick-Wolfenbüttel in the town of Wolfenbüttel and a grand new section of the Palatine Electors' castle at Heidelberg. At Heidelberg, the local Duke Ottheinrich used his offices to try to introduce humanist learning into his small, but politically important territory. The new wing he constructed for his palace made use of ancient architectural forms, as well as design tenets drawn from Sebastiano Serlio's famous architectural treatise. Further south and east in Munich, the reigning Wittelsbach dynasty set itself to

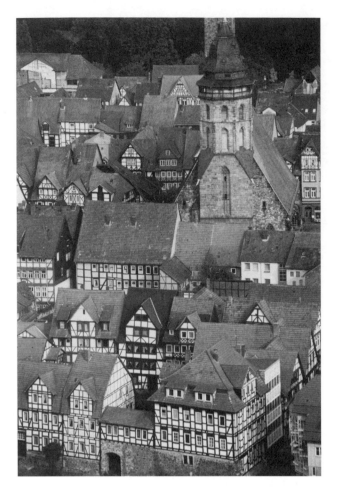

Aerial view of Weser Renaissance houses in Hannoversch Münden. © BOB KRIST/CORBIS.

CITIES. Besides the presence of numerous courts throughout Germany, there were scattered throughout the country about eighty imperial cities that were relatively independent since they owed allegiance only to the rather distant figure of the emperor. It was in these towns that Germany's most vigorous circles of humanists had appeared in the early sixteenth century. As elsewhere in Europe, urban life proved to be one of the factors encouraging the adoption of Renaissance architecture. Germany's wealthy merchants, bankers, and patricians favored the new styles as an expression of their solidity and their embrace of humanism. Here the imperial city of Augsburg was the leader. There the wealthy banking family, the Fuggers, had a chapel built in the Church of St. Anna around 1510. They also remodeled three existing patrician houses on an important market square in the city, adopting new classical façades for their project. The inspiration for these projects came from the family's close association with Italy, particularly its trading contacts with Venice, although the designers for the Fuggers' Augsburg projects were Germans. Many other notable families in towns and cities throughout Germany imitated the architectural attentions the Fugger family had showered on their native city. From Augsburg's early embrace of classical design, Renaissance architecture spread quickly in all directions throughout southern Germany. By 1550, classically styled public buildings and houses decorated with ancient elements had appeared in Regensburg, Nuremberg, Basel, and Strasbourg, among many other cities in the region. Thereafter the taste for buildings in the Renaissance style spread even further afield throughout Germany. During the years between 1570 and 1620, for example, the towns of the Weser River valley in north central Germany experienced a building boom, and many of the new structures constructed at the time made use of the new fashion for Antiquity. While many projects undertaken during this "Weser Renaissance" had styles affected by the classicism of Renaissance architecture, older medieval patterns of building persisted, as they did elsewhere in Germany. Half-timbered houses continued to be constructed alongside the classical masonry styles favored by Renaissance designers. We would like to know more about the many architects who practiced in the Weser Renaissance, but, like most of the designers active in sixteenth-century Germany, their identities are rarely mentioned in contemporary documents. Most seem to have come from the stonemason and construction trades, and the buildings they constructed were often eclectic, mixing elements of the new classicism with those drawn from native traditions. Steep stepped roofs, a design style popular in the later Middle Ages, persisted in newer build-

remodeling their residence. Among the many important monuments they constructed at this time on the grounds of the residence was an Antiquarium, a new hall built under the family's library and intended from the first to house their collection of antiquities. Painted by the Netherlandish artist Peter Candid, the hall became the first museum to be built in Germany. These projects in Wolfenbüttel, Heidelberg, and Munich represent only a tiny fraction of the many princely projects undertaken in the later sixteenth century. Throughout the country the second half of the sixteenth century proved to be one of particularly vigorous building on the parts of Germany's nobles, as the country's princes made use of the relative domestic stability to indulge a taste for construction. The aristocratic embrace of refined palace architecture continued over time. Although initially dampened by the Thirty Years' War (1618–1648), the German princes' support of architecture survived to become one of the defining features of the court life of the later seventeenth and eighteenth centuries.

ings that made use of Renaissance design elements. Many houses built at the time made use of Gothic and Renaissance elements simultaneously. During the Weser Renaissance, as elsewhere throughout Germany at the time, designers often built houses that ran perpendicular to the street on which they were situated. Thus in many cases the longest part of the house faced inward and was not visible to passersby, a contrast to Italy where architects had designed most domestic palaces since the fifteenth century to face the street with an impressive façade oriented to foot traffic. Urban vistas were rare in Renaissance Germany, and few great squares dotted the cityscape, as people huddled into the cramped spaces enclosed by a town's walls. Open-air markets, often sited in front of a city's major churches or town hall, were among the largest places in which people congregated out-of-doors. It was not until the late seventeenth and eighteenth centuries that many German towns began to realize plans for broader public squares and avenues like those envisioned in the works of Italian Renaissance architects.

NETHERLANDS. The outlines of architectural development in the Low Countries (today the areas making up modern Belgium and Holland) followed closely developments in Germany and France, although the heavily urbanized region allowed for the construction of fewer great castles. No new churches appeared in the region between the Reformation and the 1590s, the first major structure for the new Dutch Calvinist Church being the *Zuiderkerk* begun around that time in Amsterdam. Although Calvinism generally discouraged the building of large and elaborate church structures, the Zuiderkerk and the structures that imitated it were truly monumental structures filled with elaborate and often ornate decorations, when compared against other Calvinist-inspired churches throughout Europe. The great age of church building in Amsterdam and other cities throughout the Netherlands lay more in the Baroque than the Renaissance period. Netherlandish designers were particularly innovative in their planning of town halls, if not in their construction of castles, palaces, or churches. In 1561 the harbor city of Antwerp in Flanders began construction of an immense town hall based upon plans by Cornelis Floris de Vriendt (1514–1575). De Vriendt had studied in Rome and published books of engravings based upon his study of classical buildings. In comparison with many Northern European buildings at the time, de Vriendt's town hall is relatively restrained and has a simpler and more harmonious appeal. Its classical decoration shows a thorough understanding of antique building practices, and displays de Vriendt's

conscientious attempt to adapt that style to the very different climate and situation of Northern Europe. Antwerp's new town hall was an influential building as well. Even prior to its completion, designers from other towns in the region began adapting its plans in the construction of similar town halls throughout the Netherlands.

ENGLAND. The classicism typical of Renaissance architecture played little role in early sixteenth-century England where a vigorous tradition of building in the late Gothic style persisted. When antique elements appeared in the architecture of the island at this time, they were almost always treated as mere decorative elements to be elaborated upon in ways drawn from the Gothic tradition. A few notable exceptions to the almost universal love of Gothic architecture may have been built in the early sixteenth century. Recent theories suggest that Cardinal Thomas Wolsey's massive estate at Hampton Court, a property later given to Henry VIII (r. 1509–1547) when its owner was disgraced, may have originally been constructed in a style imitative of Italian Renaissance palaces of the time. A coffered ceiling and other details that survive at the site point to an original style influenced by Italian designs, albeit with rather poor craftsmanship. Whatever Hampton Court's original style, though, Henry VIII soon set about modifying its design to fit with more native traditions of palace building. The remodeling of the massive palace, then the largest in England, continued for almost a dozen years. At Nonesuch, another royal palace later destroyed, Henry allegedly entertained his taste for a palace in the Italian style, although the images that survive of the building suggest that he based his designs instead on fairly traditional models drawn from France and the Low Countries, rather than Italy. Throughout the sixteenth century Nonesuch remained one of the most popular of English royal palaces, although it had originated in a game of one-upsmanship played against King Francis I of France. No great Renaissance classical churches survive from the sixteenth century, and the few churches and ecclesiastical building projects undertaken in the period were usually on a small scale and relied on the architecture of the past. The Reformation in England produced the same stultifying effects on church building that it did in France and the Netherlands, although in other respects Protestantism aided in the creation of a building boom. Soon after pushing his divorce from Catherine of Aragon through England's Parliament and contracting his ill-fated marriage to Anne Boleyn, Henry imitated the actions of some German princes by seizing the property of England's convents and monasteries. Henry's Lord Chancellor Thomas

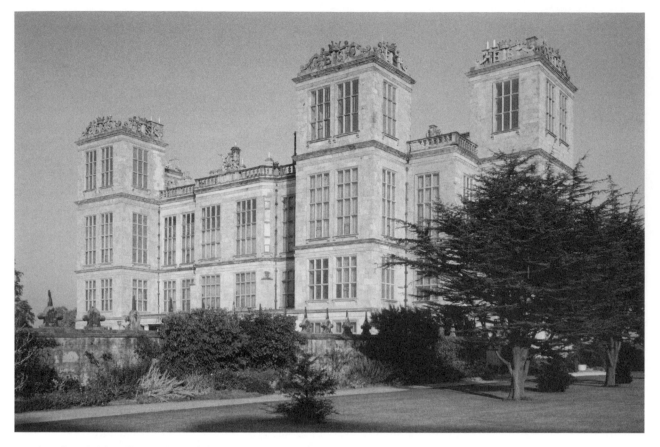

Exterior of Hardwick Hall near Chesterfield, England. © ERIC CRICHTON/CORBIS.

Cromwell realized great gains for the crown by selling these lands to English aristocrats and wealthy merchants. These, in turn, were made wealthy by their newly gotten gains, and they built a number of great country houses throughout England during the rest of the sixteenth century. Most of these structures followed traditional lines, although several magnificent exceptions stand out. At Longleat, Sir John Thyme designed a house constructed around 1572 that is noteworthy for its elegance and restraint. Built in Somerset, the house contained a number of beautiful bay windows, a typically English feature used at Longleat to accentuate the vertical lines of the great house. Inside the house Thyme moved the traditional English Great Hall to the structure's side, thus allowing for a central entrance hall and a symmetrical placement of the front door and many luxurious glass windows, a ridiculously expensive commodity at the time. This harmonious rationality had a number of imitators. At Hardwick Hall and Wollaton, two houses designed by Robert Smythson at the very end of the century, central entrance halls imitative of continental examples recurred. At Hardwick the design made the traditional Great Hall the center of the house, approached as it was by the building's colonnaded entrance and interior hall. The growing importance of Netherlandish and German styles throughout Northern Europe influenced the designs of both Hardwick and Wollaton. In many respects, in other words, these houses seem to owe little to the Italian Renaissance. It was not until the seventeenth century, with the rise of figures like Inigo Jones (1573–1652) and the great designer Christopher Wren (1632–1723), that English architecture integrated fully the lessons of Italian Renaissance classicism. In buildings such as Jones' Banqueting Hall (1619), once a part of the royal palace complex at Westminster but now a venerable monument in the governmental quarters of Whitehall in London, Jones fully integrated the lessons of Renaissance classicism in a way similar to the Louvre rebuilding projects of Lescot. He repeated this successful formulation several years later in his Queen's House in Greenwich, a structure that demonstrates his increasing mastery of the tenets of Renaissance design, and at the same time still preserves some native elements of English architecture. Jones, a figure of the very late Renaissance, also laid out the great market square of Covent Garden along lines that many Italian fifteenth- and sixteenth-century designers might

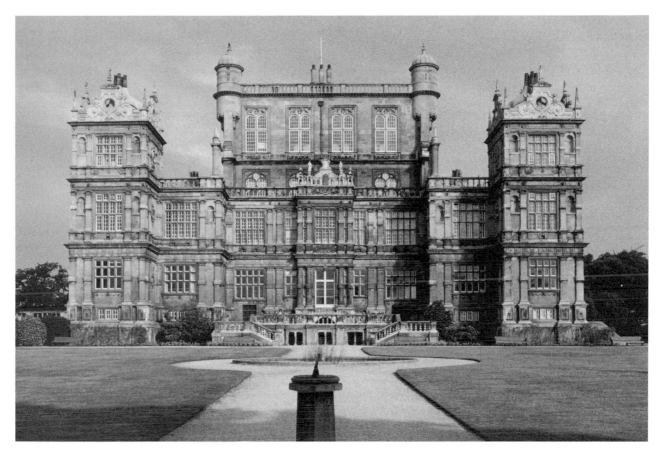

Exterior view of Wollaton Hall in Nottingham, England, designed by architect Robert Smythson. © FARRELL GREHAN/CORBIS.

have envied. His innovative plans were to be followed a generation later by Sir Christopher Wren, who revived the architectural models of Andrea Palladio in England, and, in turn, created a native English style that today is popularly referred to as "Georgian," in reference to the Hanoverian kings who ruled England in the eighteenth century. The origins of this widely popular style, which influenced British colonial design in the Americas, had their roots in sixteenth-century Northern Italy. Thus while the classical revival of the fifteenth and sixteenth centuries had little immediate impact on the architecture of England, its influence reappeared to shape British construction in the centuries following the Renaissance.

IMPLICATIONS. Throughout the continent the classicism that had first been born in Renaissance Italy in the early fifteenth century helped to reinvigorate native styles of architecture and to inspire new construction projects, notable for the inclusion of classical details, harmonious designs, and rationalistic proportions. The process of integrating the classical heritage into the very different circumstances of life that prevailed throughout Renaissance Europe was a long one. The rising popularity of humanism as a scholarly movement helped to encourage the adoption of classical designs, and in the first stages—as in Hungary, Russia, and France—kings and princes who had a passing familiarity with the movement imported Italian architects to design new structures and supervise their construction. Over time, though, native architects dedicated themselves to mastering the tenets of the new Renaissance modes of construction. Architectural treatises and engravings helped to broaden knowledge of the buildings of Antiquity, as did the journeys of local craftsmen to Italy. In Northern Europe until about 1550, architects merely added Renaissance elements to buildings that were more traditional and Gothic in their feel and flavor. The fashion for classicism produced buildings in which ancient columns and orders combined to create a thicket of ornamentation similar to the highly decorative styles of the later Middle Ages. In Spain, the highly decorative Plateresque style made use of classical elements to form architectural filigrees more similar to the works of silversmiths than to those of ancient architects. Over time, as knowledge of the ancient world deepened, an increasing sophistication and appreciation of the classical uses of space, mass, and

ornament appeared. In France, this sophistication can be seen in the façade of Pierre Lescot's Square Court at the Louvre; in Spain, it found expression in the austere and severe Escorial; and in Germany, it was articulated in scores of castles and churches constructed in the second half of the sixteenth century. The quest to integrate the architectural forms of the ancient world into contemporary life proved to be more than just mere fad or fashion. In the new styles of churches that Renaissance classicism inspired, a rational, harmonious attitude toward space became an essential tool for both Protestants and Catholics to enhance the worship of ordinary Christians. Similarly, the new town hall projects constructed throughout Northern Europe with designs inspired by Antiquity gave expression to notions of order and the public good that prevailed when cities were ruled by long-standing traditions of civic involvement and self-government. And finally, for Renaissance kings and princes who were increasingly jealous of their power, monumental classical buildings revived the purposes of the temples and ancient public spaces of imperial Rome. The new structures showed subjects the necessity of submitting to the growing central authority of the state.

SOURCES

M. Airs, *The Making of the English Country House, 1500–1640* (London, England: Architectural Press, 1975).

A. Blunt, *Art and Architecture in France, 1500–1700* (New Haven, Conn.: Yale University Press, 1999).

H. R. Hitchcock, *German Renaissance Architecture* (Princeton, N.J.: Princeton University Press, 1981).

J. F. Millar, *Classical Architecture in Renaissance Europe, 1419–1585* (Williamsburg, Va.: Thirteen Colonies Press, 1987).

P. Murray, *Architecture of the Renaissance* (New York: H. N. Abrams, 1971).

SEE ALSO *Visual Arts: The Arts in Sixteenth-Century Northern Europe*

SIGNIFICANT PEOPLE
in Architecture and Design

LEON BATTISTA ALBERTI
1404–1472

Humanist
Artist

IMPACT. Leon Battista Alberti has long been considered one of the finest examples of the Renaissance "universal man." During his relatively long life he mastered an enormous number of arts, made important contributions to humanist scholarship, and fulfilled administrative roles within the papal government and the noble courts of Italy. In the history of architecture he played a key role as a designer and in deepening contemporary understanding of the buildings of classical Antiquity. His treatise, *On the Art of the Building* (1452), had a great impact on later fifteenth- and early sixteenth-century designers.

EARLY LIFE. Alberti's early life had been filled with problems. He had been born illegitimate, the son of Lorenzo Alberti, a member of a powerful Florentine banking family. At the time Alberti's family was in exile from Florence, and as a young boy, he grew up in Genoa and Venice. He received his early schooling in Padua before attending the University of Bologna, then Europe's premier center for the study of church law. His father intended for Alberti to have a career in the church bureaucracy, but he died during Alberti's student days, and members of the Alberti clan appropriated his inheritance. Alberti was drawn to the ancient philosophy of Stoicism, which taught disregard for fortune and worldly cares, as a solace for these problems. One of his closest associates in his student days was Tommaso Parentucelli, a figure whom Alberti later served. Parentucelli became Pope Nicholas V (r. 1447–1455), the first humanist scholar to hold the office. As Alberti completed his law degree, he took holy orders and accepted a position within the church bureaucracy. In 1432, he finally visited his family's native Florence, where he remained for several years. His exposure to Florentine humanism and the vigorous artistic culture of the city left a profound mark on his subsequent development. The quality of Alberti's written work deepened. He wrote his famous *Book of the Family*, a work that analyzes the strategies that preserve great families over time, during this first period in the city. The work is a lively dialogue in Italian, an unusual innovation for a humanistic work of the time. Alberti's display of the possibilities of literary Italian helped to encourage other humanists to use the language. In Florence, Alberti also befriended the architect Filippo Brunelleschi, and in 1435, he composed a Latin treatise entitled *On Painting*. The work included a technical method for artists who wished to use linear perspective. Alberti likely learned these techniques from his friendship with Brunelleschi. He soon saw the need for a translation of his work into Italian since many of the artists of the time could not read Latin. A year after

completing the Latin version he issued his new Italian version. Alberti followed his treatise on painting with other works on artistic theory and practice, including his *On Sculpture* and *On the Art of Building*. This latter work dates from 1452 and its ten books written in Latin treat many aspects of the theory and practical application of architecture. Alberti relied on the ancient Roman architectural treatise of Vitruvius, but the views expressed in his work did not support a slavish imitation of antique designs. Instead he showed how classical symmetry, ornament, and proportion could be mined to solve contemporary design problems in new and imaginative ways. Alberti had acquired much of the obvious architectural sophistication evident in *On the Art of Building* while serving in the 1440s in the church government at Rome. One of the tasks he undertook in these years was the survey of the city's ancient monuments, and when his friend Parentucelli became pope, he took on many planning projects for the renewal of Rome.

BUILDINGS. Despite his professional duties and his scholarly interests, Alberti was also a practicing architect in his spare time. His first important design was for the Malatesta Temple, a project he undertook for the ruthless despot Sigismondo Malatesta at Rimini around 1450. Alberti was an official of the papal government, but he seems to have had few qualms about desecrating an existing church in Rimini by transforming it into a Roman-style temple intended to glorify pagan virtues. He clothed the existing church with a new skin of marble and planned a classical arched façade for the exterior. A change in Malatesta's fortunes left the building unfinished. Among Alberti's subsequent architectural plans, several works had broad influence. These included his plans for a new Rucellai family palace in Florence and his Church of St. Andrea in Mantua. Alberti's palace design successfully adapted classical elements to the building of a contemporary palace; his façade, harmonious and more elegantly refined than was the custom in Florence at the time, inspired later designers from other parts of Italy to adopt his style in similar projects. At the Church of St. Andrea in Mantua he forged massive barrel vaults to cover the church's nave, transepts, and choir, and for the crossing he designed an attractive dome. His design dispensed with the side aisles traditional in most Italian churches to this point. He recessed the lesser chapels of the church into the building's walls. In this way he created clear sight lines that focused on the church's central altar, at once creating a structure that was symmetrical and harmonious. In his architectural treatise Alberti had described beauty in building as an organic phenomenon that arose from the balanced interrelationships of a structure's constituent parts. At St. Andrea, Alberti achieved his ideal, and elements of the structure can be found in many later Renaissance church designs, including that of St. Peter's Basilica and the famous Jesuit Church of the Gesù in Rome. This latter structure became, in turn, the model for many Baroque churches throughout Europe. Even in Alberti's lifetime, his architectural ideas bore fruit in new structures from the hands of other designers. Although his buildings were not particularly influential among Florentine builders, who preferred the more severe style first developed by Brunelleschi, figures working in Central Italy and Rome, in particular, relied heavily upon Alberti's designs in the decades that followed his death.

SOURCES

M. Baxandall, *Painting and Experience in Fifteenth-Century Italy* (Oxford: Oxford University Press, 1972).

J. Kelly, *Leon Battista Alberti; Universal Man of the Early Renaissance* (Chicago: University of Chicago Press, 1969).

C. Smith, *Architecture in the Culture of Early Humanism* (New York: Oxford University Press, 1992).

FILIPPO BRUNELLESCHI

1377–1446

Sculptor
Architect

EARLY TRAINING. The future architect Filippo Brunelleschi was born the son of a notary who worked for the city of Florence. His mother was from a prominent local family. Brunelleschi spent most of his life in Florence. As a child, Brunelleschi received a thorough education, including training in the reading of Latin, in the hopes that he might follow in his father's footsteps and become a notary. Early on, he took great pleasure in drawing, and in 1398, he joined Florence's Silk Guild, membership of which also included goldsmiths. Brunelleschi soon became a master of the goldsmith's trade. He completed his first commissioned sculptures in silver for the cathedral of the nearby town of Pistoia. By 1401, after having completed several other major sculptural projects, he entered the competition to create new bronze baptistery doors at the cathedral of Florence. The subject chosen was the "Sacrifice of Isaac," and Brunelleschi completed a highly dramatic and moving panel for the doors that still exists today. The judges of the competition were unable to decide between his submission and that of the sculptor Lorenzo Ghiberti. They asked the two to share the project, although Brunelleschi

allegedly refused. Disheartened, he turned now away from sculpture to study architecture. In the first decade of the fifteenth century he made several journeys to Rome, where he measured and studied the proportions of ancient buildings. He also became one of the first Renaissance figures to excavate ancient buildings so that he could examine their foundations. During these years he studied mathematics and geometry. Even in this early stage of his development as an architect, he became fascinated with problems of numerical proportions and perspective. Contemporaries in Florence credited him with solving the riddles of linear perspective, and his system for working out geometric relationships on a picture plane allowed artists to represent three-dimensional space in their paintings and sculptures more rigorously than previously. Up to this time artists had used perspective only intuitively. Brunelleschi's breakthrough permitted paintings and sculptures to be constructed with a single vanishing point in the background. This system found expression in the Florentine frescoes of the great painter Masaccio, and the theoretical treatise of the humanist Leon Battista Alberti on painting codified and communicated it to artists throughout Italy. Later in life, Brunelleschi used his knowledge of linear perspective in the creation of his architecture. In his designs for the Church of San Lorenzo he constructed the interior much like a three-dimensional pictorial space so that the lines of the building converged at a single vanishing point in the rear of the church.

THE DOME. Brunelleschi's first great achievement as an architect was his successful design of the dome over the crossing in Florence's cathedral. The construction of this massive church had continued throughout the fourteenth and early fifteenth centuries, even though no one knew at the time how a roof might be constructed between the enormous piers that stood at the central crossing of the structure. Florence's foremost builders had estimated that it might consume the wood of several forests to construct scaffolding sufficient enough to build a roof over the structure. Previous designers feared that any structure that covered this space could not stand without some kind of central support that rose from the cathedral's floor, thus obstructing the view of the altar. Brunelleschi turned to the problem and realized that a central support was unnecessary. The building might be covered with a freestanding dome made up of an inner and outer shell. In designing the dome he created a huge octagon drum, which added height to the structure and dispersed the dome's weight. He buttressed this drum with hemispherical constructions at its base. Over this, he created a huge conical structure supported by eight

stone ribs on its outer shell. Between these ribs, Brunelleschi devised a pattern of brickwork that added great strength to the dome's outer shell. Consequently the inner shell—in effect the ceiling of the church— hung from the outside ribs and masonry. Brunelleschi's accomplishments in building the dome were far more than a mere design marvel. The dome was the greatest practical construction feat of the fifteenth century. A key problem to contemporaries had been the issue of scaffolding, which Brunelleschi resolved by designing hanging platforms that could be moved up as the construction progressed and the dome grew higher. To bring materials to workmen who were hundreds of feet in the air, the architect built a system of sturdy winches that hoisted the stone, brick, and mortar to the scaffolds. Brunelleschi duplicated this system in the great projects he designed throughout Florence in the years after 1420.

PUBLIC PROJECTS. Brunelleschi's dome, completed in 1436, established his reputation as an architect of great merit. Despite the punishing schedule of his duties as master builder at the cathedral, the architect also undertook many commissions in Florence. These works form the foundation of the early Renaissance in architecture, and include his designs for the Orphanage of the Innocents (in Italian, *Ospedale degli Innocenti*), the churches of San Lorenzo and Santo Spirito, and the gemlike Pazzi Chapel on the grounds of the Church of Santa Croce. Key elements in Brunelleschi's classicism, which was not nearly as rigorous as that of later fifteenth- and sixteenth-century Italian architects, were the construction of graceful colonnades that supported Roman arches. The designer was the first European architect to rely on a system of clear mathematical relationship in his buildings. These are readily distinguishable to the astute observer, and in the fifteenth century these numerical proportions were intended to convey underlying religious and philosophical truths. The interiors of many of Brunelleschi's structures appear to many today as severe, since his buildings are less highly decorated than those constructed in later Renaissance styles. All his public buildings relied on simple gray *pietra serena*, a stone quarried near Florence, set against white stucco. The result was harmonious and elegant, and it was a style that Florentines embraced enthusiastically. Until the nineteenth century, buildings modeled on Brunelleschi's early Renaissance achievements were built in Florence and the surrounding region of Tuscany. The architect himself lived to see few of his creations completed, since the painstaking building processes of the time meant that their construction usually lasted over many decades. Lack of funds, too, sometimes dogged the construction of his

great public buildings in Florence, and changing tastes and demands altered some of his designs. Still, Brunelleschi has long been credited with being the "father of Renaissance architecture," and his key position in the creation of the early Renaissance style is even now maintained, although more recent scholarship has located many of the designer's seeming innovations within the contemporary context of widespread building practices in the Florence of his day.

SOURCES

E. Battisti, *Filippo Brunelleschi: The Complete Work.* Trans. R. E. Wolf (New York: Rizzoli, 1981).

F. D. Prager and G. Scaglia, *Brunelleschi: Studies of His Technology and Inventions* (Cambridge, Mass.: MIT Press, 1970).

H. Saalman, *Filippo Brunelleschi: The Buildings* (London, England: Zwemmer, 1980).

FRANCIS I

1494–1547

King of France

UPBRINGING. Francis I was born the cousin of King Louis XII of France. His father Charles was a Count of Angouléme and his mother was a member of the princely house of Savoy in northwestern Italy. When it appeared that he was to succeed his elder cousin as king, the young Francis and his sister Margaret moved to court so they could be trained to assume royal duties. During this time, however, their mother, Louise of Savoy, continued to supervise her children's education, which appears to have been remarkably advanced for the time. Francis' sister, the future Marguerite of Navarre, became an important advocate for reform in the church and an author of unusual distinction. Francis, on the other hand, led a spirited life that seemed to bear more resemblance to that of an itinerant and carefree knight than a man of state affairs. Early on in his reign he challenged the growing power of Spain, opposing its conquests in Italy and waging his own battles to achieve supremacy in the peninsula. On one of these campaigns during 1525, he was captured by Charles V at Pavia, and taken as a hostage to Spain. Later his sister, Marguerite of Navarre, successfully negotiated his release, in exchange for which Francis renounced his claims to his Italian possessions. He was twice married, first to the daughter of his cousin, King Louis XII, Claude de France, and later to Eleanor of Portugal, who was a sister of the emperor Charles V. Never faithful to either wife, Francis kept a long string of mistresses, some of whom played important roles in court politics.

RULE. Francis was a competent, if not astute monarch. His foreign policy brought him continually into conflict with Spain and involved him in constant intrigues with Italy, England, and the papacy. Domestically, his policies were often authoritarian, but ineffective. During his reign the Reformation swept through France. At first Francis' policies against the new religious ideas vacillated between toleration and condemnation. Toward the middle part of his reign he began to persecute Protestants, who multiplied despite his prohibitions. Under Francis' rule, corruptions in the system of taxation and royal fiscal system worsened. Francis attempted to deal with these problems by creating a system of public debt that was secured by the taxes levied on the city of Paris. Corruption, nevertheless, persisted.

PATRONAGE. Francis compensated for his deficiencies in governing with his avid connoisseurship of the arts and architecture. From his earliest youth the king was a great lover of art, and early in his reign he built three stunning châteaux at Blois, Chambord, and Amboise. At this time the royal court moved from palace to palace on an annual progress. The itinerant nature of the court thus made necessary a large number of stately palaces and castles, but the progress was more than just a sign of royal extravagance. Through these annual circuits through the countryside French kings conducted royal business in the various regions of their large kingdom. The progress was often attended by elaborate royal entries, in which particular towns welcomed the king with elaborate processions and musical and theatrical performances. During the sixteenth century these entries grew more elaborate, and they often imitated Roman triumphs in keeping with the French taste for Renaissance classicism. The increasingly elaborate scale of court life in France necessitated an almost continual program of palace decoration. To undertake these projects, Francis brought Italian artists to France and he hired native craftsmen, too. He began by attracting Leonardo da Vinci to his court in 1516. Although the artist spent the last three years of his life there, he produced little in France beyond several drawings for a new royal château at Romorantin. The artist suffered a stroke shortly after his arrival, and his slow recovery affected his productivity. Several years after Leonardo's death, Francis also lured the Italian painters Rosso Fiorentino and Francesco Primaticcio to France, where they worked on decorating a series of new rooms at the royal palace of Fontainebleau. As Francis' reign progressed this great palace became the focal point for his most ambitious

artistic and architectural programs. Among the architects who left their stamp upon the Fontainebleau were Sebastiano Serlio, Giacomo da Vignola, and the sculptor Benvenuto Cellini. Later in his reign Francis focused greater attention on his plans for rebuilding the Louvre, the medieval royal palace within Paris. In 1528, he added a royal chateau that became known as the Madrid in the Bois de Boulogne, the woods just outside the Louvre. And in the 1540s, the native French architect Pierre Lescot began construction on a new central section of the palace, the Square Court, which replaced the old medieval structure that had stood at the spot. Lescot's façade for the new palace has long been judged the first truly Renaissance construction by a French artist. The Louvre rebuilding project was massive and lasted over many generations. While Francis' tastes in art and architecture were generally Italian, he favored portraitists in the Flemish tradition. Among these, Jean Clouet and his son Francis most often painted members of the royal court.

ASSESSMENT. In the sixteenth century Francis was known as one of the country's great kings. Since that time assessments of this larger-than-life figure have changed. Modern judgments have sometimes cast the king in a harsh light, pointing to his extravagance as well as the corruption that reigned in his government. At the same time even the most critical of assessments of Francis have had to take account of the great cultural legacy of his reign. In the construction of palaces, the amassing of a royal collection of art, and the support of humanistic scholarship, Francis outshone almost every other European prince of the time.

SOURCES

R. J. Knecht, *Renaissance Warrior and Patron* (New York: Cambridge University Press, 1994).

P. Murray, *Architecture of the Renaissance* (New York: H. N. Abrams, 1971).

J.-M. Pérouse de Montclos, *Fontainebleau* (London, England: Scala, 1998).

ANDREA PALLADIO

1508–1580

Architect

TRAINING. Palladio, the greatest architect of sixteenth-century Northern Italy, was probably born in Padua in 1508. At birth his name was Andrea di Pietro; he did not take the classical name Palladio until he was middle-aged. Around the age of 13 he worked as an apprentice

to a local stonemason, but he apparently did not stay in this workshop long. By 1524, records show that he had enrolled in the stonemasons' guild in nearby Vicenza, where he joined a local workshop. Eventually, his talents came to the attention of the local aristocrat, Gian Giorgio Trissino. Trissino was a humanist scholar and he soon became the young stonemason's patron. Under Trissino's influence, the future architect acquired some knowledge of Latin and studied Vitruvius' ancient treatise on architecture. At Trissino's urging, Andrea di Pietro changed his name to the Latin, Palladio, and with the elder aristocrat's support the designer made several study trips to Rome during the 1540s. On one of these journeys he met Michelangelo, and during all his stays in Rome he spent a great deal of time in the ancient center of the city, studying and drawing the monuments of the ancient Roman Empire.

ARCHITECTURE. Around 1540, Palladio had already begun to design buildings in and around Vicenza. His earliest commissions were for domestic palaces in the city and country villas. These works do not yet show a secure understanding of ancient Roman architecture. During the course of the 1540s, though, his mastery of classicism grew more assured. The most important commission Palladio received at this early stage in his career as an architect was for the reconstruction of Vicenza's Basilica. This complex, a series of local government offices, had been joined together in the later Middle Ages with a series of Gothic arcades. In 1496, one of these structures had collapsed, and during the following decades the government at Vicenza searched for an architect who might rebuild the structures on a more secure footing. Palladio won the commission, and the resulting building he created established his reputation as an architect of merit. Palladio continued in the 1550s to design domestic palaces, government buildings, and country villas in and around Vicenza. In his country villas especially, Palladio's works display his certain mastery over classical building styles and his ability to adapt those elements to contemporary situations. His structures were notable as well for the great harmony they achieved between interior spaces and the surrounding exterior gardens. Before his death in 1580, the architect had populated the region around Vicenza and the Veneto (Venice's mainland possessions) with a number of graceful and harmonious structures. Palladio's classicism was restrained and, in contrast to the great Venetian architect Sansovino, he used relatively little ornament. Porticos that made use of the region's gentle climate were one common feature, as was the so-called Palladian window, a structure in which side columns supported a hemi-

spherical shaped arch. In later years Palladio used his relatively severe but graceful style in two churches he designed in the city of Venice.

THEORY. Trissino had introduced Palladio to circles of humanists in Northern Italy, and Palladio nourished his scholarly interests even as he was busy designing his many domestic and public projects. His career testifies to the rising status that was accorded Italian architects in the sixteenth century. When his friend Trissino died in 1550, Palladio began to develop his own contacts among Northern Italian humanists. One of the most avid friendships of his later life grew to become a fruitful collaboration. In the years following Trissino's death, the humanist Daniele Barbaro influenced Palladio, and the two cooperated to produce an Italian translation of Vitruvius' ancient architectural work. Palladio wrote a commentary for this new edition and prepared a number of illustrations of the works that Vitruvius had discussed in his text. Both the illustrations and the translation were of undeniable importance in spreading knowledge of Vitruvius' architectural ideas. Few architects at the time had the advantage of Palladio's Latin education, and thus the edition became an indispensable tool for those hoping to design classically styled buildings. In his later years, the friendship with Barbaro, a member of a distinguished Venetian family, also helped to gain Palladio several commissions in the city of Venice. At this time Palladio also published his own work on theoretical treatise, the *Four Books on Architecture.* Palladio's work was just one of many produced by sixteenth-century designers. Its author had written sections of the work over a long period of time, and then in 1570 he rushed to get the book into print. As a result, the work contained numerous internal contradictions, and its illustrations sometimes defy the canons that the author sets out in the text. Later the artist's most accomplished student, Vincenzo Scamozzi, expanded the work and clarified its arguments. But even in its imperfect state, Palladio's text influenced architects throughout Europe, and somewhat later in America. In England, the famous designers Inigo Jones and Christopher Wren were disciples of Palladio's elegant style of building. Their influence, in turn, spread knowledge of his systems of design everywhere where English was spoken. Elsewhere in Europe, interest in Palladio's architectural treatises and in his villa projects gave rise in the seventeenth and eighteenth centuries to structures that continue to show his influence. It is for this reason that some scholars have argued that Palladio was the single most important architect in spreading the ideas of Renaissance classicism to the rest of Europe.

SOURCES

J. Ackerman, *Palladio* (Harmondsworth, United Kingdom: Penguin Books, 1977).

R. Tavernor, *Palladio and Palladianism* (London, England: Thames and Hudson, 1991).

R. Wittkower, *Architectural Principles in the Age of Humanism* (Chichester, United Kingdom: Academy Editions, 1998).

DOCUMENTARY SOURCES
in Architecture and Design

Leon Battista Alberti, *On the Art of Building* (1452)—This humanist attempt to come to terms with the ancient architectural treatise of Vitruvius cast a wide influence over subsequent building in fifteenth-century Italy. Alberti argued that beauty was an organic phenomenon. Harmony between the constituent parts of a building was similar to the functions of the limbs and various parts of the human body. Take away one element and, Alberti warned, disaster might result. An architect who added too much ornamentation might similarly violate Alberti's canons of classical beauty.

Filarete, *Work on Architecture* (c. 1460)—Antonio Averlino, known popularly as Filarete, originally circulated this treatise on building among noble and wealthy urban patrons in Italy in many manuscript editions. The text recounts the education of a prince by his architect, thus encouraging noble patrons to support the architecture of the Renaissance. It is illustrated, although many of Filarete's building prescriptions are drawn from the medieval past and are not in sync with the innovations of Renaissance design occurring at the time.

Andrea Palladio, *The Four Books on Architecture* (1570)—A major architectural treatise by one of Italy's most accomplished Renaissance designers, this work treats many practical problems arising from construction and presents illustrations of Palladio's classically inspired buildings. Inaccuracies and disagreement between the illustrations and the text did not prevent this book from exercising a major influence on later designers, particularly in seventeenth- and eighteenth-century England and America.

Sebastiano Serlio, *Treatise on Architecture* (1537)—The famous architectural theorist Sebastian Serlio served in many sixteenth-century courts, including that of the opulent King Francis I in France. His architectural treatise went through several editions, published in Italy, France, and the Low Countries, and was to have a wide

influence, particularly in Northern Europe. Serlio's books defined subsequent treatments of Vitruvian-inspired architecture, as later writers came to terms with the categories that Serlio had developed to treat the classical revival of the Renaissance.

Giorgio Vasari, *Lives of the Most Eminent Painters, Sculptors, and Architects* (1550)—This work is one of the first attempts to write a history of art and architecture from a biographical perspective. Vasari was himself a painter and he treats Italian artists from the time of Giotto until Michelangelo. He is frequently opinionated, and his work gave rise to a number of legends about various artists. He stresses that the development of Italian art occurred as an organic process. According to Vasari, the arts first began to bud in Italy in the time of Giotto.

Later, the bud turned to a bloom in the years after Masaccio, before coming to full flower in the time of Leonardo and Michelangelo. As a result, his assessments of contemporary architectural achievements placed great emphasis on the buildings of the High Renaissance and Mannerist artists.

Vitruvius, *Ten Books on Architecture* (1st century B.C.E.)—The most influential of ancient writings on building in the Renaissance, this work became the Bible for many designers anxious to revive the classical style. Alberti relied upon it in the fifteenth century to write his *On the Art of Building*. In the sixteenth century it was given an important new edition, labored over by the architect Palladio and his friend the Venetian humanist Daniele Barbaro.

chapter two

DANCE

Philip M. Soergel

IMPORTANT EVENTS
in Dance

c. 1420 A Burgundian manuscript preserved at Brussels outlines the steps necessary to perform the *bassedance*.

c. 1445 Domenico da Piacenza, dance master to the D'Este family at Ferrara, completes the dance handbook, *The Art of Leaping and Dancing*. Piacenza's work is the first to discuss the theory of dance.

1459 The lively Italian dance known as the *chiarentina* is performed before Pope Pius II. The chiarentina is full of hops and jumps and elaborate reel constructions.

1488 The anonymous book, *The Art and Instruction of Good Dancing* appears in print in Paris. It is the first dancing manual to be written for use in urban, rather than aristocratic society.

1499 A total of 144 performers are needed to stage the *moresca* dances that are performed in the intervals between the acts of four comedies staged in Ferrara. Throughout the following years the practice of staging elaborate *intermedi* between the acts of plays will steadily intensify throughout Italy.

1512 Henry VIII introduces the Italian practice of *masquerie* into the English court.

1528 In his important conduct book, *The Book of the Courtier,* Baldassare Castiglione celebrates dance as an essential skill necessary for the cultivated courtier.

1531 Thomas Elyot's *The Book of the Governor* recommends dance to gentlemen as a virtuous and civilizing pursuit.

1533 The first ordinances governing dance schools are enacted in London.

1539 Elaborate *intermedi* or interludes, which include dances, are staged during a comedy produced at Florence, which is presented to commemorate the wedding of Cosimo I de' Medici to Elenore of Toledo.

1545 The office of Master of the Revels is established within the Tudor Court to supervise entertainment.

c. 1550 The *allemande* emerges as an independent dance form in France and spreads in the later sixteenth century throughout Europe.

1557 The term "suite" is first used to describe a grouping of dances.

1559 Catherine de' Medici becomes regent of France, giving important support to the development of the ballet in France.

1570 The Academy of Poetry and Music is founded by Jean de Baïf in France. The institution works to revive ancient Greek meters in French poetry and music, and leads to experiments in dance.

1572 The City of London grants a monopoly to three expert dancing masters to teach dance within the city limits.

c. 1580 The *camerata,* a loose-knit organization of scholars and musical amateurs, supports the revival of ancient poetry, music, and dance in and around Florence.

1581 Fabrizio Caroso publishes his dance instruction manual *Il Balarino.*

 In France, the first *ballet de cour* is performed in the French court.

1583 The sexually suggestive dance known as the *sarabande* is prohibited in Madrid.

1588 Thoinot Arbeau completes his *Orchésographie,* a late-Renaissance dance manual

that outlines a variety of dances just coming into fashion at the time.

1589 Catherine de' Medici, an avid supporter of dance and particularly of the French court form known as the *ballet de cour*, dies.

c. 1590 Shakespeare begins to write his plays in London. These will make use of rich metaphors about dance's role in the cosmos.

1594 The English poet John Davies' poem "Orchestra. A Poem of Dance" praises the art for its ability to enhance people's sociability and argues that the universe it-self is organized around principles that mirror the dance's harmonious choreography.

1600 Fabrizio Caroso's dancing manual *On the Nobility of Ladies* appears in Italy.

c. 1601 The *chaconne* and *sarabande* are the two most popular dances in Spain.

1602 Cesare Negri publishes his important dance manual, *The Charms of Love*, which he dedicates to Philip III, king of Spain.

1606 Ben Jonson and Inigo Jones stage the influential *The Masque of Blackness* in King James' court in London.

OVERVIEW
of Dance

DEVELOPMENT. By the early Renaissance dance had flourished in Europe for more than a thousand years. Evidence for medieval dance, though, comes to us primarily from literature and art. With the coming of the Renaissance, new dance manuals appeared in both Italy and Burgundy, the two major centers of courtly dance of the period. In Burgundy, the first of these works was written around 1420, and in Italy somewhat later, in the 1440s. The Italian examples, in particular, show that there was already a high degree of choreographical sophistication in Renaissance dance by this time. The authors of these books were courtly dance masters who lived in the houses of Italy's nobles and who were charged with training noble children and courtiers in the dance steps. These dancing masters also staged elaborate spectacles for Italy's counts and dukes that expressed the rising taste of the period for pageantry and ritual. The dance masters considered their art to be an athletic exercise that displayed a courtier's intellect through his ability to subject the body to the mind. Italy's dance theorists reached back to ancient philosophy—particularly to Aristotle's *Nichomachean Ethics*—to elevate the status of dance into an art, rather than just a mere pastime. By contrast, Burgundian *bassedance* was an elegant form of processional dance that consisted of a rigid vocabulary of walking steps, performed either sideways, backwards, or in a forward direction. Popular at the court of Burgundy, it also spread to England, France, and other northern European regions, its diffusion aided by Burgundy's enviable position as one of the most brilliant courts of fifteenth-century Europe.

HIGH AND LATE RENAISSANCE DANCE. The development of dance as a social entertainment continued to expand during the sixteenth century, the period of the High and Late Renaissance. New forms of choreographed dances flourished in the elegant court societies of Italy and Northern Europe, notable now for their complex footwork and relatively rigid upper body positions. The styles, epitomized in the popularity of the

branle in France or the Italian *galliard* and *pavan,* owed much to changing fashions in court dress. Men and women now wore corsets that constricted the movements of the torso and the upper body. By contrast, tight leggings for men and women's bell-shaped skirts allowed the feet relatively more freedom to move than had the older long-flowing gowns of the fifteenth century. New types of shoes equipped with soles and heels allowed dancers a greater degree of flexibility on the floor. The dance manuals published at the time reveal an increasingly complex and elaborate language of steps. Jumps, skips, lifts, twirls, stomps, and hops, which had previously been avoided as unseemly and inelegant, came now to play a vital role in social dance. In their manuals, too, dance theorists argued that dancers were reviving the movements of the ancients and experiencing again the dance's power to unite the force of poetry and music to movement. They celebrated dance in ever more elaborate metaphors and imagery and promoted the art as a force for ennobling the human spirit.

THEATER. Dance also played a vital role in Renaissance theater, particularly in the spectacles staged in Europe's courts. In Italy, the *intermedi,* or interludes that occurred between the acts of plays, included dances. Since the humanist-influenced theater of the period favored five-act comedies based upon ancient Roman models, there were plenty of opportunities in an evening for dancers to display their skills. Often members of the court danced in these productions, but professional dancers also flourished in Italy's wealthy courts. During a festival of four comedies staged at Ferrara in 1499, more than 140 performers danced the sixteen *intermedi* that occurred between these plays' acts. Throughout the sixteenth century these interludes grew even more complex, mixing together song, poetry, dance, and music in ways that influenced later dramatic forms like the opera and the ballet. In France, the inspiration of Italian *intermedi* combined with older forms of court spectacle to produce the *ballet de cour,* a dance and musical entertainment staged in the royal court. Patronized by the queen regent Catherine de' Medici, the *ballet de cour* made use of a story line and a libretto text, and it enlisted members of the court as its dancers. It included recited poems, musical airs, and a succession of mimed and danced scenes. The English equivalent of the *ballet de cour* and the *intermedi* was the court masque, a form of entertainment that Henry VIII introduced into England from Italian examples in 1512. At these masques, disguised courtiers and professional entertainers rode into a palace's great hall atop an elaborate pageant wagon, and proceeded to present a series of dances and

songs to the court. Even Queen Elizabeth, notable for her restraint in expenditure, paid out generous sums for the celebrations of these masques. During her reign, the genre adopted some of the features of the French *ballet de cour* and the Italian *intermedi*, including the use of a unified story line and of complex and expensive stage machinery. The greatest masques to be celebrated in England were those written by the playwright Ben Jonson and staged by the architect Inigo Jones, which were performed in the early years of the seventeenth century.

FOLK DANCE. As the Renaissance matured in the sixteenth century, urban elites developed a dance culture similar to that which flourished in Europe's great courts. Wealthy merchants and political figures in the towns avidly studied the dance manuals of the time, and dance schools allowed them to learn the complex steps that had previously only been taught by resident dance instructors in the palaces of the nobility. As a result, dance became a mark of social distinction among gentlemen and gentlewomen. At the same time the sixteenth century records a rising chorus of complaints about the dances of the lower orders, the urban poor and peasants. Many of the charges made against their dances—that they promoted sexual immorality, that they wasted time, and that they were generally lascivious—had long been leveled against folk dances throughout medieval Europe. It was not until the Reformation and Counter Reformation, however, that religious reformers joined forces with civil magistrates in an effort to try to curb, and sometimes even to prohibit, such dancing. These officials tried to reform the celebration of Carnival, an occasion that frequently erupted into raucous dancing, and to curb the excesses associated with the celebration of the wedding feast, although these efforts were generally unpopular and produced few long-term results. Attitudes towards Europe's folk dances present us with a paradox. On the one hand, civil authorities and religious moralists feared that the dancing of the people was a source of disorder and sexual immorality. On the other hand, nobles and cultivated elites adopted many dances from popular culture, and thus folk forms played a vital role in dance's elevation to one of the "fine arts."

TOWARD THE FUTURE. By the conclusion of the Renaissance dance had benefited from at least two centuries of attention from dance masters, theorists, and cultivated elites who perceived in its practice an art form that might ennoble performers and audiences alike. The results of Renaissance innovation had raised the status of dance beyond the role that it had played as a sociable pastime in the Middle Ages to a point from which dance now competed against other art forms, like mu-

sic and the theater, for the attentions of noble patrons. Dance had found its way into the spectacles of court, and in art forms like the intermedi, the ballet de cour, and the masque, dance had come to play a key role in Renaissance pageantry. These developments paved the way for the rise of the professional ballet in the seventeenth century, an art form that has persisted since that time as a display of beauty, intellect, and sheer athleticism. Dance also had entered into the European imagination as a model of how social relationships might function in an ideal world. In courtesy books, like Thomas Elyot's *Book of the Governor* (1531), European social commentators recommended dance for its ability to teach its participants the disciplines and behaviors necessary for conducting life in a civilized society. Dance also played an important role in the fictions of the era, as dramatists like Shakespeare frequently relied on dance to emphasize key observations in their literary masterpieces. In his popular tragedy *Romeo and Juliet*, Shakespeare never let his star-crossed lovers share a dance, foreshadowing their dismal fate, while in his comedy, *Much Ado about Nothing* he underscored the successful resolution of the drama's many plot twists with a dance that began just as the curtain fell. Like Shakespeare, the Elizabethan poet John Davies glorified dance in his popular poem "Orchestra" (1594) as "love's proper exercise," and he described the movements of the planets themselves as a heavenly dance, with the sun, earth, moon, and stars progressing through an elaborate choreography in the heavens to the music of the heavenly spheres. In these ways dance entered into the Western imagination during the Renaissance as a force of civility, sophistication, and human inventiveness, and from this vantage point, the art continued to flourish for centuries to come.

TOPICS
in Dance

COURTLY DANCE IN THE EARLY RENAISSANCE

MEDIEVAL DANCE. Dance is one of the oldest and most universal of human art forms. European cave art from the Stone Age depicted dancing figures, and dance flourished in the ancient societies of Greece and Rome. The ancient Greek word for poetry, *mousike*, referred to a series of stanzas that were delivered in song while dancing. The art form of dance is unique from the other

Renaissance arts in that the church did not dominate its development, and largely failed in its attempts to regulate it. Although there were some religious dances—particularly as part of the Good Friday celebrations that occurred prior to Easter—dance was largely a secular pastime by the thirteenth century, and every segment of the society participated: peasants, urban townspeople, and courtly societies. Another unique feature of dance was its inability to exist apart from music as an essential part of performance. Changing musical fashions have served to inspire new dance forms on the one hand, but dances have just as easily given rise to new tastes and fashions in music. Medieval sources testify to the vast popularity of dance, although before the fifteenth century no instructional or theoretical manual survives in Europe that allows us to reconstruct medieval dance steps. Our knowledge of the medieval forms of dance that existed in Europe on the eve of the Renaissance comes to us from paintings and frescoes and from literary sources. Two basic forms of dance seem to have been generally performed throughout the Middle Ages, of which there were a number of variations. The first, known as the *carole,* was common in folk and elite society alike, and was a kind of line dancing in which groups of men and women formed linear or circular patterns. Jumps and hops were common to the caroles, although some involved nothing more than a series of relatively peaceful steps. In addition, singing often accompanied the carole, and these songs were either sung in unison or in response to the chants of a leader. The most common kinds of songs to accompany the carole in the later Middle Ages and the early Renaissance were the *virelais,* the *rondeaux,* and the *ballades.* The second form, often referred to in the documents with the French word "danse," was more elevated and consisted of groups of two or three dancers walking and making a series of elegant steps, struts, and glides. The possibilities of variation were limitless in such dances, and it is for this reason that this form of entertainment flourished in elegant court societies. Many courtly dances appear to have been international and spread from country to country through the efforts of professional entertainers who moved between courts. In France these entertainers were known as *jongleurs* (jugglers) and in German, *spielleute* (players). Jews often played a special role as well, since Jewish entertainers known as *letzim* were prized at court for their knowledge of dance steps. All these figures were itinerant. Traveling from place to place, they entertained nobles with dances, pantomimes, and song, often teaching those in court the latest dance steps. Medieval folk dancing, by contrast, seems to have been subject to a greater degree of regional variation.

DANCE MASTERS. The appearance of dance masters in Renaissance Italy reveals a new attitude toward dancing in the great courts of the region. Just how and when the dance masters of the Renaissance appeared cannot be determined, but by the mid-1400s many of Italy's wealthiest, most powerful noble and merchant families already had a resident dance master. In contrast to the medieval entertainers who had traveled from court to court, the dance masters were permanent members of noble and merchant households. They trained the family in the latest dance steps as well as instructed them in a variety of other skills. They might be best thought of as a kind of physical education instructor, charged with teaching members of the household, not only dance but gymnastics, fencing, riding, and every kind of athletic endeavor. Beyond physical training, dance masters taught the children about manners and deportment (the proper carriage of the body), and they staged entertainments and choreographed dances and spectacles for the court. The variety of their tutoring duties mandated that the dance masters be highly educated figures skilled in the arts of music, painting, sculpture, poetry, mathematics, philosophy, and aesthetics. The appearance of these masters points to a key change between medieval and Renaissance attitudes toward dance. In the Middle Ages dance had been a relatively straightforward pastime that had flourished in court and village societies, usually at the end of the day as a social entertainment that concluded a festival, a hunt, the harvest, or a tournament. Steps had been so simple that most people probably learned them on the spot. In the Italian Renaissance court, though, dance grew more complex, becoming an art form that must be mastered through careful study. In addition, the dance master's role in teaching skills besides dancing demonstrates the increasingly ritualized and formal character of Renaissance courtly life. Proper manners, good carriage or deportment, and the mastery of a variety of athletic skills were now important signs of social distinction.

PROMINENT FIGURES. A lineage of distinguished masters in fifteenth-century Italy flourished from the training of the early dance theorist and master Domenico da Piacenza (c. 1400–c. 1476). Piacenza served for many years in the urbane, sophisticated court of the D'Este family at Ferrara, where he not only taught dance to members of the court, but also choreographed a number of special dances for the family's entertainments. He was also much in demand elsewhere in Italy, and frequently staged important dance entertainments for the peninsula's wealthiest families. Sometime around 1445, Piacenza completed his dance manual, *On the Art of*

a PRIMARY SOURCE *document*

THE GOLDEN MEAN

INTRODUCTION: Domenico da Piacenza began his *On the Art of Dancing* (1445), the oldest surviving Renaissance dance manual, by treating the theory of dance before outlining its contemporary practices. His opening chapter defended dance against the charge that it wasted time by pointing to Aristotle's *Nichomachean Ethics*, an ancient work that outlined the doctrine of the "golden mean," the notion that human beings should avoid actions and emotions that are extreme, and instead search for the moderate position. Aristotle also treated dance in the *Ethics* as a way to harness the mind's power over the body, a position that Piacenza also relies upon in his defense.

Thanks to the great and glorious God for the intellects that by his grace are inspired. To Him belongs the honor and glory in all things intellectual and moral. The respectable and noble knight Mister Domenico da Piacenza wishes to petition with great reverence Him who, because of his holy humanism, has always blessed the said practitioner to treat this material to a good end. Although many object to this agile and elegant motion made with great subtlety and effort as one which is a waste of time, the practitioner cites the second [book] of *Ethics*. The author states that all things spoil or go bad if they go astray, that is, to extremes. Being moderate saves one. The wise Aristotle discusses movement well quite a bit in the tenth of *Ethics*. In other parts, even with his sensitivity, he could not draw forth the implications of his bodily motion through space. With *misura* [measure], *memoria* [memory], *agilitade* [agility], *maniera* [grace], *misura di terreno* [balance], aided by placing the body with *fantasmate* [imagination], he argues well that this art is a refined demonstration of as much intellect and effort

one can find. Not that if you perform this motion in the way that you do not go to extremes, I say that this refined art has natural goodness and many things because of its delicateness in its execution.

Note that no creature who has natural defects is capable of this refined motion. He [Aristotle] states that lame, hunch-backed, or maimed people of all callings will not succeed in this. One needs good fortune—which is beauty. The proverb goes, "The one made beautiful by God is not all poor." Nature must grace and sculpt from the foot to the head the practitioner of this art form. But beauty alone is not all required for this refined art.

Note that aside from being blessed by God with a good mind and body, one has to learn to discern the underlying structure of this refined art. He states that the foundation is *misura*, which governs everything quick or slow according to the music. Aside from this, it is necessary to have a large and deep *memoria*, which stores all of the corporal movements—natural and incidental—that are required by all performers depending upon the composition of the dances. Note that aside from all these things, it is necessary to have a refined *agilitade* and physical *maniera*. Note that this *agilitade* and *maniera* under no circumstances should be taken to extremes. Rather, maintain the mean of your movement, that is— not too much nor too little. With smoothness appear like a gondola that is propelled by two oars through waves when the sea is calm as it normally is. The said waves rise with slowness and fall with quickness.

SOURCE: Domenico da Piacenza, *On the Art of Dancing* in *Fifteenth-Century Dance and Music. Twelve Transcribed Italian Treatises and Collections in the Tradition of Domenico da Piacenza.* Trans. A. W. Smith (Stuyvesant, N.Y.: Pendragon Press, 1995): 11, 13. Annotations by Philip M. Soergel.

Dancing, the first theoretical and instructional handbook for the art of dance. For his theory of dance, he drew upon the *Nichomachean Ethics* of Aristotle, the text that outlined the doctrine of the "Golden Mean" and whose Tenth Book discussed beauty and pleasure in movement. Similarly, Piacenza advised his readers that dance provided a "refined and delicate demonstration of … intellect and effort" and he counseled against extremes or jerks in movement. After treating the theory of dance along these Aristotelian grounds, he proceeded to outline the musical meters commonly used in Italy at the time and the various steps needed to perform dances. Piacenza's manner of treating first the theory of dance and then its practice had imitators in the many dance manuals that followed his early hand-

book. Two of these came from the hands of his students, Guglielmo Ebreo da Pesaro (William the Jew of Pesaro) (c. 1420–1484) and Antonio Cornazano (c. 1430–1484), both of whom were active in courts throughout Italy in the second half of the fifteenth century. Guglielmo Ebreo was much sought after as a dance master. Born a Jew, he converted to Christianity and took the name Giovanni Ambrosio, perhaps to increase his prospects at court. He spent most of his career working as a dance master at the court of the Malatesta family in Pesaro and Rimini, although he also worked for the ruling dynasties of Milan, Ravenna, Naples, Ferrara, Urbino, and Camerino, and for the Medici family at Florence. Ebreo earned special recognition for the quality of dance spectacles he choreographed for weddings, entries, and the

visits of state dignitaries, and his skill in the construction of elaborate entertainments meant that he was very much in demand. In 1463, he completed his own instructional manual on dance, a work that was less theoretical than that of his teacher, Piacenza. Antonio Cornazano, by contrast, was born a nobleman at Piacenza near Milan. Early on, he studied dance with Domenico da Piacenza before joining the Sforza family as a secretary around 1454. In the years that followed he also served as dance master to the young Sforza princess Ippolita, dedicating his first edition of the *Book on the Art of Dancing* to her in 1455. This work, like Ebreo's shows a great debt to the ideas of Cornazano's teacher, Domenico da Piacenza. Together these three treatises inspired many similar works over the following years that discussed both the theory and practice of dance.

BALLO AND BASSADANZA. Each of these manuals outlined two types of dance: the *bassadanza* and the *ballo*. The *bassadanza* was the Italian version of the French and Burgundian *bassedance,* although it was significantly different from this Northern European style. In a dance of this type lines or circular groups of dancers performed a series of steps in procession. The word "bassa," meaning "low," reveals one feature of the bassadanza: the feet stayed close to the floor. There were, in other words, no leaps or hops worked into the steps and the bassadanza was an elegant, if somewhat severe dance. A *ballo* or *balleto*, by contrast, was a highly choreographed dance with a more playful dimension, in which a couple or several couples performed a series of dances involving changes of speed and steps. Oftentimes, *balli* followed a story line, which required a higher level of choreography. A key difference between the bassadanza and ballo at this time seems to have lain in the music available to each. Balli were choreographed for a specific piece of music that fit with the steps of the dance master's choreography. A bassadanza, on the other hand, was more often performed with any piece that had a suitable tempo, meter, and length for the steps chosen. Although the dance manuals recommended that all dancers develop a fluid and beautiful line, displays of mere technical prowess on the dance floor were generally discouraged in these manuals. These styles of dance constituted courtly entertainment, and thus the authors advised their aristocratic readers to avoid unseemly movements or specific dances that might tarnish their reputations. The dancer's body should become, these writers observed, an expression of beauty and of the dancer's own intellect. Courtly dance was thus a restrained art, different from the athletic proficiency displayed by professional performers. At the same time all three writers allowed men a greater degree of flexibility on the dance floor than women. A male dancer's jumps were to be higher and his steps could be ornamented more vigorously. A woman's conduct on the dance floor was expected to be more modest, and although she was always to stand tall, she was expected to keep her eyes downcast as a sign of modesty.

BURGUNDY. Unlike Italian court dances of the fifteenth century, which were characterized by great complexity, difficult choreographies, elegant footwork, and other bodily disciplines that expressed the taste of the Renaissance for a language of movement that was refined and difficult to achieve, the styles of dance that flourished in Northern Europe at the time were heavily influenced by the tastes of the court of the Duchy of Burgundy, a powerful territory in the center of Europe. While Burgundian dance was very refined, its steps were simpler and its choreography less difficult to master than the Italian models. It is perhaps for this reason that we find evidence of the appearance of dance masters in Northern Europe much later than in Italy. Burgundy was a territory that was officially subject to the French king, but which had by the end of the fourteenth century acquired a vast amount of land in central and northwestern Europe, including Lorraine, large parts of northern France, and the Netherlands or Low Countries (modern Belgium, Luxembourg, and Holland). These areas included some of the wealthiest commercial centers of Europe, and in the early fifteenth century, Burgundy's style of court life influenced many other European regions. Courts throughout Europe sought out Burgundy's music and musicians, and its dance form—the *bassedance*—affected tastes in dance in places far from the center of Burgundian power.

BASSEDANCE. The *bassedance* was a line dance that consisted of only five steps: single steps, double steps, branle, reverence (a bow or curtsey), and reprise. Very strict rules governed the ways in which these steps could be arranged, and dances that followed all these rules were known as common dances. Others that slightly altered these conventions were known as uncommon forms. It is difficult to reconstruct these steps precisely from the few technical descriptions that survive, although artistic evidence does provide some clues. Burgundian dance did not emphasize the technical display of skill, but slow and graceful movements of the feet and the upper body. Like the early Italian bassadanza, which had originally been inspired by the Burgundian bassedance, this form was to be performed "low," that is, without hops and skips. The elegant, controlled steps allowed the lines of the dancers' bodies and the folds and drape of their clothes to be brilliantly displayed.

a PRIMARY SOURCE document

FEMININE MODESTY

INTRODUCTION: All writers of dance manuals firmly insisted on a distinction between the sexes in dance. William the Jew, who converted to Christianity and changed his name to Giovanni Ambrosio, was one of the great fifteenth-century Italian dance masters. In his dance treatise, *The Art of Dancing*, he gave these rules to his female readers.

For the young, virtuous woman who delights in learning and understanding such exercise and art, it is necessary to have a rule and manner with much more modesty and honesty than for the man ... Her *moviemiento corporeo* [bodily movements] should be humble and controlled, with a worthy and noble body carriage, agile in the feet, and with well-formed gestures. Her eyes should not be arrogant or flighty, looking here or there as many do. Most of the time, they should be honestly glancing at the floor, though the head should not be lowered in the chest, as some do, but should be straight up and corresponding to the body, as nature herself would teach. Her moving should be agile, graceful, and moderate, because when performing a *sempio* [single step] or a *doppio* [double step] she needs to be well adapted. Also for the *riprese* [sideways movements], *continentie* [sideways steps], *riverentia* [curtseys], and *scossi*

[rises] she needs to have a human, gentle, and sweet manner. Her mind should always remain attentive to the harmonies and *misure* [beat of the music] so that her actions and sweet gestures are well composed and correspond to them. At the end of the *ballo* [dance] when left by the man, she turns entirely around to him and with a sweet glance at him performs a compassionate and honest *riverentia* [curtsey] to that of the corresponding man. Then, with a modest attitude she goes to rest, noting the actual defects of others, the correct actions, and the perfect *movimienti* [movements]. If these things are well noted and prudently observed by the young woman, she will be notably adept in the aforesaid art of dancing, worthy of virtuous and commendable fame. So much more, because it is most rare for women to perfectly understand such virtue and art. They use such exercise as a random practice rather than as a science. Some of them often commit errors and oversights and are reprimanded by one who understands. With devoted disposition for their comfort let all attentively read this little work of mine. It will offer them very refined and virtuous fruit.

SOURCE: Guglielmo da Pesaro or Giovanni Ambrosio, *The Art of Dancing* in *Fifteenth-Century Dance and Music: Twelve Transcribed Italian Treatises and Collections in the Tradition of Domenico da Piacenza.* Trans. A. W. Smith (Stuyvesant, N.Y.: Pendragon Press, 1995): 141–142. Italian terms translated by Philip M. Soergel.

Since it was a highly stylized, dance-like procession, its steps involved simple, short movements of the feet, the raising and lowering of the body, and gentle sideways motions. In the final step—the reprise—dancers moved backwards, and great care needed to be taken so that the women did not trip on the elaborate trains popular in Burgundy at the time. The shoes worn at Burgundy's court at the time were known as *poulaine*, and they were long constructions in felt that ended with a high-rising point at the toe. While preventing a great freedom of movement, the *poulaine* allowed the graceful stepping movements typical of the bassedance, and they also accentuated the line of the foot, thus adding to the impression of the dancer's elegance. The range of steps was limited, yet at the same time, modern reconstructions of the Burgundian bassedance have shown that it can be a remarkably expressive form. Like Italian dances, the bassedance inspired its own manuals of instruction, including an anonymous fifteenth-century manuscript written at Brussels around 1420 and a later anonymous dance manual published in Paris in 1488. This later book, *The Art and Instruction of Good Dancing*, con-

tained instructions about the music that should accompany these dances. It stipulated a tenor line for the music above which up to three layers of instruments might improvise harmonies to accompany the dance. Typically, the *sackbut* (an early trombone) played the tenor, while *shawms* (the Renaissance counterpart of the modern oboe) performed the improvised lines.

OTHER REGIONS. The Burgundian style of bassedance was already well developed as a form in the early fifteenth century and maintained its popularity in many of the courts of Northern Europe throughout the century. It was performed in France, England, and in certain parts of Germany and Spain at the time. Certainly, other forms of dances may have flourished in Northern European court societies, but the lack of documentation makes it difficult for us to reconstruct many of the precise details of dance in Western Europe during the fifteenth century. In the sixteenth century an increase in sources reveals the rising popularity of dance as a form of entertainment as well as its steadily increasing repertory of forms.

SOURCES

I. Brainard, *The Art of Courtly Dancing in the Early Renaissance*. 2 vols. (West Newton, Mass.: I. G. Brainard, 1981).

———, "Italian Dance Documents of the Fifteenth Century," *Dance Chronicle* 21 (1998): 285–297.

A. Michel, "The Earliest Dance-Manuals," *Medievalia et humanistica* 3 (1945): 117–31.

A.W. Smith, *Fifteenth-Century Dance and Music* (Stuyvesant, N.Y.: Pendragon Press, 1995).

D. R. Wilson, *The Steps Used in Court Dancing in Fifteenth-Century Italy* (Cambridge: Cambridge University Press, 1998).

SEE ALSO *Fashion: Early Renaissance Styles*

HIGH AND LATE RENAISSANCE COURTLY DANCE

FASHION. The styles of courtly dance popular in fifteenth-century Italy and Northern Europe favored restraint in the use of the body. The Burgundian bassedance was intended to be an elegant dance procession that displayed the rich splendor of courtly costumes. Sudden jerks, quick steps, and hops were avoided in favor of an understated repertory of subtle footwork that showed off the long, flowing lines of dancers' bodies and their costumes. Despite the greater complexity of Italy's courtly dance, the Italian dancing masters of the time similarly urged restraint in their dance manuals. Changing fashions, both in clothing, shoes, and dance itself, altered the types of movements used in courtly dancing in the sixteenth century. For much of the fifteenth century Burgundian and Italian women's fashions had favored a long flowing gown under which was worn a simple white chemise. The trains of these creations restricted sideways and backward movements because of the great lengths of material that trailed behind a woman as she moved on the dance floor. At the outset of the sixteenth century the corset came into use and was adopted by both men and women. In women's dress, its rise to popularity inspired new styles in which the bust line was flattened and the bodice tapered toward the waist in a funnel-like shape. Bulky skirts then flowed from the waist to the floor, often flaring outward into a bell-like shape. The upper portions of both men's and women's dress, with their whale-boned corsets, restricted the movements of the torso. The fashion that developed later in the century for ruffled starched collars similarly constricted head movements.

At the same time, the broad, bell-shaped skirts allowed women's feet to move with relative freedom, as did the tights favored by fashionable courtly men. New styles of shoes, too, allowed greater flexibility in steps. Shoes with soles and heels became common among the nobility, allowing dancers to stomp and stamp their feet and protecting them from splinters and other debris on the floor. Thus while the upper body grew more rigid, the feet at the same time could explore a greater range of movement than before.

REFINEMENT. Italian courts continued to lead the way in creating complex social dances in the sixteenth century, and Italy's dances spread to many Northern European courts. At the very end of the Renaissance three technical manuals published by the great Italian dance masters Fabrizio Caroso (c. 1527–c. 1605) and Cesare Negri (c. 1535–c. 1604) allow us to gauge the changes that had occurred in attitudes toward courtly dance since the fifteenth century. Both Negri and Caroso laid incredible stress on the proper execution of steps, setting down a large number of rules for the proper performance of each. Caroso continually warned his readers about the possible pitfalls that existed in each dance step, and he spent a large amount of his treatise cautioning his readers about proper deportment at a ball. In addition, he prescribed how men and women should treat their dance accessories—swords, gloves, handkerchiefs, fans and so forth—so that all their movements at a ball were closely choreographed. This increasing emphasis on social refinement was partially inspired by the humanist fashion for Antiquity, as writers like Negri and Caroso argued that modern dance revived the virtues of movement of the ancient Greeks and Romans. In his dance manual, *Love's Graces*, published in 1602, Cesare Negri contrasted the art of dancing with another popular courtly pursuit: jousting. Jousting, he argued, was the provenance of the ancient god Mars, while the goddess Venus ruled over the dance floor. In his two popular treatises on dancing, *The Ballerina* (1581) and *The Nobility of Ladies,* Caroso gave ancient Latin names—drawn from the poetry of Ovid and Vergil—to the new dances he created. The styles outlined in Caroso's and Negri's works were more elaborate than ever before and were now choreographed for groups of up to four couples. Many new steps, too, had been added to the dancing repertoire. In addition to the traditional walking and running steps, bows and reprise steps (which were performed backwards) new foot crossings, leg raisings, and swings flourished, as did vigorous foot stompings. Single-sex dances and solo dances thrived in the period, and many of the new complex

a PRIMARY SOURCE *document*

BEHAVIOR ON THE DANCE FLOOR

INTRODUCTION: Fabritio Caroso published *The Nobility of Ladies*, a dance manual, in 1600 at Venice. The work expanded upon another manual he had published about two decades before. In the *Nobility*, he included dialogues between a dance master and a gentleman disciple in which he set out rules for conduct at balls. His style was lively, and he left nothing to chance, as this exchange over the matter of a man's gloves and cape shows.

Disciple: Please Master, I pray you to teach me the gentleman's comportment at a party.

Master: I will do so, if you are patient. Let me say, then, that there are some gentlemen who go to parties wearing gloves so tightfitting that, upon being invited to dance by the ladies, and preparing to take hands, they must take more time than an *'Ave Maria'* to remove [them]; and if they do not succeed with their hands, they even use their teeth! When they do this some accidentally drop their capes (or riding cloaks). This also pays little honour to the lady who has invited one, by making her wait so long. It is better, then, to wear gloves that are fairly loose rather than too tight, for on occasion I have seen [a gentleman] on trying to remove them with his teeth, who has had one finger of the glove left in his mouth, while all in attendance at the party laughed at this behaviour.

Disciple: Is there anything else you wish to advise me of, Sir?

Master: Yes, of course. Let me say, then, that there are others who, while dancing a grave dance, or promenading with a lady, take one side of their cape in their left hands and put it over their left shoulders, leaving the other [end] hanging down so far that it trails along the ground, which is awkward and doesn't look well; for though ladies are permitted to trail their dresses, or trains (if you will), this is not suitable for a gentleman. There are still others who wear their [cloaks] even more improperly while dancing, for they wrap themselves up as if swaddled, which has two unfortunate consequences; first, that they cover their swordhilts; and the other is that the swords are so obstructed that if they should be needed, they could not be [got at], thereby endangering their lives, which is a bad and perilous habit. So I advise you to wear your cape, or any mantle with which you cover yourself, in the style I have shown you above, and always to shun this bad behaviour since it displeases everyone, and could cause the entire company to ridicule you.

SOURCE: Fabritio Caroso, *The Nobility of Ladies*. Trans. J. Sutton (Oxford and New York: Oxford University Press, 1986): 135–136.

creations choreographed by the dancing masters of the High Renaissance bore elaborate titles and were dedicated to noble patronesses.

NEW FORMS. One of the most popular dances to flourish in the sixteenth century was the *branle*, a couple's dance that had originated in France, but which soon spread to most of Europe. Branles developed out of the sideways steps that were prescribed in fifteenth-century *bassedances*. In his dance treatise, *Orchesographie* (1588), Thoinot Arbeau outlined three kinds of branles that were practiced at the time. These included the simple branle, which consisted of either single or double sideways steps; the mixed branle, which included hops on one leg; and the mimed branle, which incorporated the steps of the other two but also required that performers mime facial gestures and hand movements. Here the *Washerwoman's Branle* and the *Maltese Branle* were among the most popular forms. The boisterousness of the branle form, which evolved over time to include foot stomping, hand clapping, and other exaggerated pantomimes, helped to sustain the dance's popularity throughout the sixteenth century. Not all observers, though, found the style worthy of inclusion in court balls. In his famous conduct manual, *The Book of the Courtier* (1528), Baldassare Castiglione warned courtiers and princes against performing the branle in public, arguing that its extremes of motions were not compatible with the decorum necessary for court life. The branle style seems to have been resisted in England for a time, where its English term— the brawl—suggests some of the noisome and "peasant" qualities associated with the dance. In both Italy and England, though, the branle established itself as a popular court entertainment throughout Europe after 1550. In his dance treatises written in 1602, Cesare Negri included several late sixteenth-century examples of branle or *brando* as they were known in Italy, that had been performed in some of the most elevated court circles of the peninsula.

GALLIARD AND PAVAN. By far one of the most difficult dances that flourished in the sixteenth-century court was the *galliard*. Of Italian origin, it quickly spread to almost every corner of the continent. Within the

a PRIMARY SOURCE *document*

A PERFECT UNION

INTRODUCTION: The English gentleman Thomas Elyot modeled his conduct book, *The Book of the Governor* (1531), on Baldassare Castiglione's famous *The Book of the Courtier*. While Elyot wrote for an elite reader, his work was notable for disseminating the ideas of civility and courtly manners among the English gentry (a wealthy, but non-aristocratic class of wealthy landowners and commercial figures). Elyot's book also included one of the most enthusiastic endorsements of the art of dance in the sixteenth century. For several pages he catalogued the virtues that accrued to those who mastered its complexities, showing the gravity with which Renaissance thinkers considered the art form. In the following excerpt, he celebrates dance's power to achieve a perfect marriage of the contrasting natures of men and women. In dance, he argued, the ideals of the sacrament of matrimony were actually achieved. Each sex on its own is incomplete before the dance, but when joined in its artful motions, their natural qualities are brought into the perfection of the "golden mean."

But now to my purpose. In every dance of a most ancient custom, a man and a woman dance together, holding each other by the hand or the arm, which betokens concord. Now it behooves the dancers, and also their audience, to know all the qualities incident to a man, and also all the qualities that also pertain to a woman.

A man in his natural perfection is fierce, hardy, strong in opinion, covetous of glory, desirous of knowledge, hungers to reproduce his likeness. The good nature of a woman is mild, timorous, tractable, benign, with a good memory, and modest. Certainly, many other qualities of each [of the sexes] might be identified, but these are the most apparent, and for our purposes sufficient.

Therefore, when we behold a man and a woman dancing together, let us suppose there is a concord of all these said qualities, being joined together, as I have set them here in order. And the moving of the man is more vehement, while the woman is more delicate, and she moves with less advancing of the body. These [qualities] signify the courage and strength that ought to be in a man, and the pleasant soberness that should be in a woman. And in this wise fierceness, joined with mildness, severity is formed. Audacity with temerity produces magnanimity; willful opinion and tractability (which is to be shortly persuaded and moved [by the dance]) makes constancy a virtue. [Man's] search for glory adorned with [a woman's] benign nature produces honor. [His] desire for knowledge combined with woman's good memory procures Wisdom. [Women's] modesty joined to the [male] appetite for generation makes continence, which is a mean between Chastity and inordinate lust. These qualities, in this wise being knit together, and signified in the personages of man and woman dancing, do express or set out the figure of very nobility, which in the higher estate it is contained [there], the more excellent is this virtue's estimation.

SOURCE: Thomas Elyot, *The Boke Named the Gouvernor* (London, 1531): L1v–L2r. Text modernized by author.

galliard, the male dancer makes a series of five jumps, shifting his weight back and forth from side to side. This feat must be performed within a musical interval of six beats. More complex and difficult jumping patterns were also common in the galliard, allowing dancers at court to demonstrate their prowess on the dance floor in a way that had generally been avoided in the more restrained fifteenth century. In his *Orchesographie* (1588) Thoinot Arbeau included a number of variations on the basic galliard as well as some choreographies that linked together two five-jump variations into an even longer eleven-step variation. By contrast, the *pavan* was more restrained and dignified. It consisted of two single steps walked forward, followed by a double step. Of Italian origin, the pavan was first mentioned in texts in the early sixteenth century. Its name may derive from the Latin word for the city of Padua, or from the Spanish word for a peacock's tail. The pavan was in many respects similar to the bassedance styles that had flourished in fifteenth-century northern Europe in its restraint and use of staid and grand music.

ALLEMANDE. Little is known about the origins of this form, although the dance's name, the French word for "German," suggests that its origins may lie in Germany. Some have suggested that it developed as a German form of the bassedance. By 1550, the *allemande* was considered its own independent dance form. In this dance a group of couples stand beside one another and fall into a procession that moves across the dance floor. At the other end of the floor each male partner turns his female partner, and the progress is repeated in the opposite direction. By the end of the sixteenth century the allemande had grown more complex with small jumps or leg lifts worked into some of its surviving choreographies. The allemande's music witnessed a long life. The surviving music composed for the dance in the sixteenth

Arts and Humanities Through the Eras: Renaissance Europe (1300–1600)

Dancers performing the galliard, from Thoinot Arbeau's *Orchesographie*. HULTON ARCHIVE/GETTY IMAGES. REPRODUCED BY PERMISSION.

century shows that the form was innovative in its exploration of changes in tonality as well as tempo. It is perhaps for this reason that allemandes continued to be written as music long after the popularity of the dance had faded on the ballroom floor.

OTHER FORMS. The great popularity of dance as an entertainment in the High and Late Renaissance court gave rise to an almost infinite number of styles. There were couple's dances like the *volta* in which the dancers held themselves in a tight embrace, moving around the dance floor. At regular intervals in the volta the man thrust his female partner high into the air by grabbing her firmly at the back, and the couple then performed a series of turns in this position. Considered obscene by some authorities, the dance was banned for a time in early seventeenth-century France during the reign of Louis XIII. Its freedom of movement and athleticism, however, inspired its popularity, and the dance spread far from its origins in the southern French region of Provençale. The *chiarentana*, by contrast, was an elaborate figure dance preceded by a staged chase in which men picked their female partners. The dance that followed made use of complex patterns of line dancing, reels, and figure eights that some authorities, including the great dance expert Fabrizio Caroso, found confusing and difficult to perform. Simpler and easier to learn were the "country dances," figure dances that flourished in the courts and noble households of France and England at the time and which harked back to rural line dances and earlier bassedance forms. Similar to modern square dancing, the country dances might be learned quickly,

since only the first couple that stood at the head of the line needed to be certain of the various steps that were to be performed for the dance to begin. Others might learn the dance merely by imitating the actions of the first couple.

DANCE MUSIC. The writers of dance manuals had usually informed their readers about the kinds of musical meters used to perform particular dances, often even including tunes in their guidebooks for performance. Printed music became more popular in the sixteenth century, giving us a clearer glimpse of the kinds of dance music that flourished at the time. The first printed collections of dance music issued from the houses of Ottaviano de Petrucci at Venice and Robert Attaignant in Paris in the early sixteenth century. Printed music was an expensive commodity and thus was likely only to have been used in the wealthiest noble houses and merchant families of the time. Most collections were scored for lute (the most common household instrument), for the keyboard, or for small ensembles of wind and brass instruments. Throughout the sixteenth century printed dance music grew more popular, and toward the end of the century printed dance music popularized dance suites that had been recently performed in some of Europe's greatest households. These dance suites were often specially written to accompany highly choreographed "ballets" created by dance masters in these courts.

IMPLICATIONS. The wealth of dance forms that flourished in the sixteenth century points to the rising

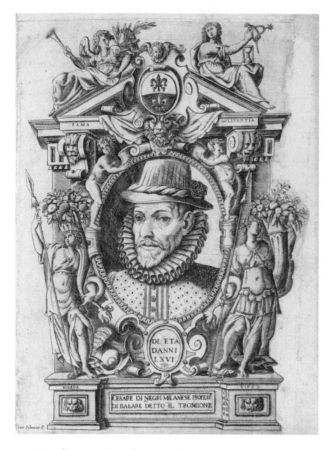

Portrait of Cesare Negri from the frontispiece of his dance manual *Nuove inventioni di balli*. **AMERICAN MEMORY/THE LIBRARY OF CONGRESS.**

importance that dance played as a marker of social distinction and cultivation in courtly societies at the time. In the dance manuals of Italy and France, theorists like Negri, Caroso, and Arbeau celebrated the art as a sign of the era's kinship with classical Antiquity, and they left little to chance in the choreographies and recommendations that they prescribed to their readers. Dance as an art form had clearly come of age in Renaissance courts, and the clear distinctions of genres and forms that developed at the time expressed the era's determination to mold the actions of the body to the creative impulses of the human mind.

SOURCES

T. Arbeau, *Orchesography.* Trans. M. S. Evans (New York: Dover Publications, 1967).

Fabrizio Caroso, *Nobiltà di Dame.* Trans. J. Sutton (New York: Dover, 1986).

M. Dolmetsch, *Dances of England and France from 1450 to 1600* (New York: Da Capo Press, 1976).

————, *Dances of Spain and Italy from 1400 to 1600* (London, England: Routledge and Kegan Paul, 1954).

S. Howard, *The Politics of Courtly Dancing in Early Modern England* (Amherst, Mass.: University of Massachusetts Press, 1998).

SEE ALSO *Fashion: High and Late Renaissance Fashion; Music: Sixteenth-Century Achievements in Secular Music*

THEATRICAL DANCE

TYPES. Dance played a vital role in Renaissance theater. In Italy, troupes of *Commedia dell' Arte* performers relied on songs and dances to break up the action of their improvised comedies. Dances and musical interludes became a feature of the intermissions of the early professional theaters common in Europe's largest cities during the sixteenth century. The surviving sources, though, give little information about the kinds of dances that were performed in these circumstances. In aristocratic society, by contrast, dance flourished as an important component of court spectacles and was well recorded in the documents of the period. The fifteenth and sixteenth centuries saw a steady increase in the theatricality of these entertainments, as kings and princes competed with each other to create ever more elaborate spectacles. Such entertainments were almost always undertaken with the purpose of demonstrating a prince's power and wealth to foreign visitors. Diplomatic visits, dynastic marriages, and ceremonies of royal entry were just a few of the many important political occasions for which elaborate spectacles were mounted. Dance played a key role in these celebrations, and its popularity in the Renaissance provided a constant source of employment for the prominent dance masters of the day who choreographed these productions.

BANQUETS. During the fifteenth century Europe's nobles marked important occasions with "theme" banquets. The rise of these great feasts can be traced to the Duchy of Burgundy, which influenced aristocratic tastes throughout Europe in these years. Philip the Good, who served as Duke of Burgundy between 1423 and 1467, established a court life notable for its lavish display and intricate rituals. In 1430, Philip founded an order of nobility on the occasion of his marriage to Isabella of Portugal. This Order of the Golden Fleece was intended to promote chivalry and to mediate disputes between nobles. With the fall of Byzantium to the Turks in 1453, however, Philip devised a plan to use the order to promote a new crusade that might wrest the Holy Land from Islamic control. At his famous "Feast of the Pheasant," held in 1454, Philip announced his vow to un-

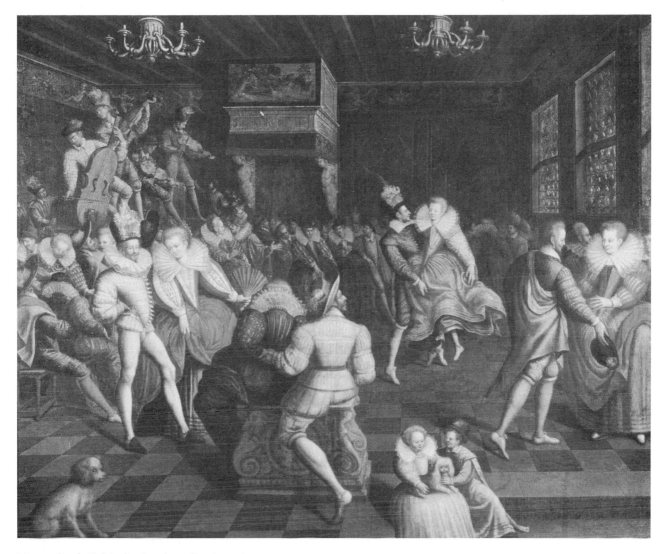

Marguerite de Valois dancing the volta at court. © GIRAUDON/ART RESOURCE, NY. REPRODUCED BY PERMISSION.

dertake the campaign and encouraged other members of the Golden Fleece to follow suit. The evening's festivities soon became famous throughout European aristocratic society and set a bar that later Renaissance princes tried to surpass. As Philip's disguised guests arrived in the hall, they encountered elaborate *entremets* or sculpted concoctions of food that adorned the tables. Originally, such platters had consisted of nuts and other lighter fare that guests consumed between the feast's courses. Philip's ingenuous chefs, though, had created entremets in which ships sailed, a working pipe organ played music to accompany a celestial choir, and animals engaged in combat. As the banquet proceeded, living entremets, consisting of acrobatic acts, dances, and musical performances, also entertained the guests between the feast's courses. At the end of the banquet Philip announced his vow to retake the Holy Land in a highly staged manner,

and he encouraged his fellow members of the Order to follow suit. A ball concluded the festivities.

INTERMEDI. Pantomime, dances, and songs performed in the space between a banquet's courses flourished in the wake of the *Feast of the Pheasant*. In Italy these interludes, known as *intromesse* (the origin of our modern English word "intermission") or *intermedi* soon came to be used not only in banquets but in theatrical performances in the space between the acts of plays performed in Italian courts. The dancing of a *moresca* was among the most common type of interlude used at the time. The moresca was an exotic dance that took its name from the Italian word for "moorish." Often participants blackened their faces and attached bells to their clothing in imitation of the North African and Spanish Moors. Morescas often had a loose plot narrative in which a Moor threatened a fool dressed as a woman. Sexual

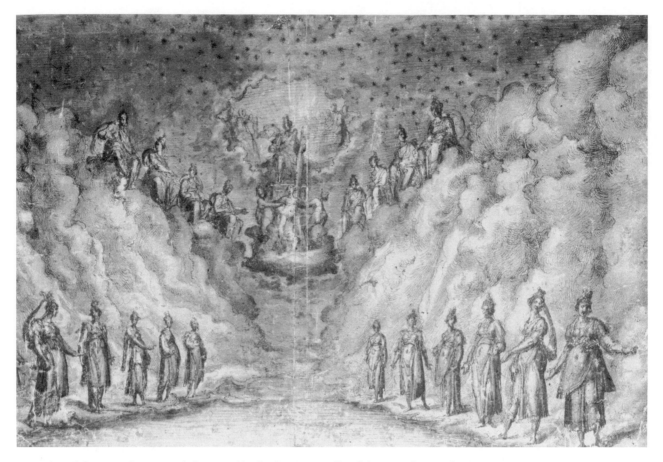

Engraving of the set and costume designs used in the first intermedio of the comedy *La Pellegrina*. ART RESOURCE.

overtones and whirling, seemingly ecstatic movements were common to the morescas, and for this reason, the dance was often entrusted to professionals, who would not be embarrassed by performing such exotic actions. In his *Book of the Courtier*, for instance, Baldassare Castiglione recommended that no prince be seen dancing a moresca in public since its suggestive movements and themes were incompatible with his dignity. By 1500, the popularity of the moresca as a form of theatrical dance was well established throughout Italy, and the rising fashion for Antiquity prompted dancers to adopt the seductive imagery of the moresca to story lines that they drew from ancient mythology and pastoral poetry. At Ferrara, these dance interludes first flourished in the last quarter of the fifteenth century. At the time the D'Este family who ruled the city favored five-act comedies written in the style of the ancient Latin dramatists Plautus and Terence, thus providing four opportunities between the acts for dancers to perform. These interludes usually bore little relationship to the plays themselves, and the dances and other entertainments that occurred between the acts were intended to be mere diversions while the actors prepared for the next act. Over time, intermedi were some-

times added before and after the performance and there were attempts to rely upon the interlude to establish an atmosphere for the play itself. The purpose of the intermedi, though, was always to entertain, and their popularity soon rivaled that of the plays themselves. During 1499, for example, 133 actors performed four plays staged at the court of Ferrara, while 144 performers danced the sixteen moresca interludes that occurred between these plays' acts. During the sixteenth century the great popularity of dance in court life encouraged the custom's rapid adoption in palaces throughout Italy and Europe.

DEVELOPMENT. The dancing of moresca continued to flourish in the interludes popular in sixteenth-century Italy, but a great variety of musical forms and pantomimes also developed. The singing of madrigals was soon to be adopted in these interludes, and in Florence and other Italian cities the most extravagant stagings of intermedi were usually reserved for the celebration of important dynastic weddings. For the marriage celebrations of Cosimo de' Medici to Elenore of Toledo in 1539, specially composed madrigals and dance music were used

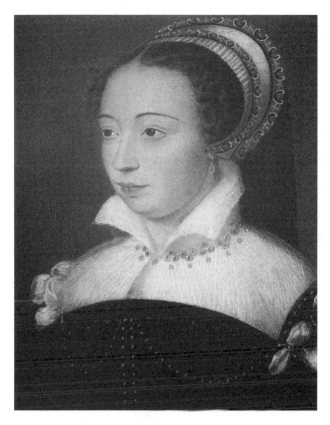

Portrait of Catherine de' Medici, queen of France.
© BETTMANN/CORBIS.

to stage six interludes for a comedy: four for the spaces between the acts and one each at the beginning and end of the play. Each of the interludes was carefully crafted to enhance the evening's overarching message: that the union of Cosimo and his bride Elenore was to give birth to a new Augustan Golden Age in Florence. That evening, though, the play came to a quiet and serene ending, and the producers of the entertainment feared that its conclusion might disappoint the audience. Thus the final concluding intermedi of the performance consisted of 20 performers who entered the stage to sing and dance an elaborate Bacchanalian rite. Experiments with interludes like these, then, contributed to the development of the modern musical theater, and they continued in Florence during the rest of the sixteenth century. The genre had an important impact on the development of opera, a form that emerged in the city during the final years of the sixteenth century. Concluding "ballets," similar to that staged at the performance marking the marriage of Cosimo de' Medici, became a popular feature of these early performances.

BALLET DE COUR. In France, the popularity of these interludes combined with a native tradition of court *fêtes* or festivities that had long been staged around

a central theme. Together the two forms of the intermedi and fête inspired a new genre that came to be known as the *ballet de cour* or "court ballet." The ballet de cour became a popular dance entertainment in the royal court during the final decades of the sixteenth century. Members of the royal family commissioned the poetry and music for these events, and the productions made use of elaborate stage machinery and sumptuous costumes. The court ballet was very much influenced by the ideas of the French Academy of Poetry and Music, which had been established in 1570 by Jean-Antoine de Baïf. De Baïf was interested in reviving the powerful union he believed had existed in the ancient world between poetry and music. Members of the academy strove to write poetry and music that made use of the ancient metrical modes, thus hoping to deepen music's power to influence the human spirit. The curiosity the academy bred also inspired investigations into ancient dance, and members of the academy soon experimented with performances staged to their rhythmical songs. Catherine de' Medici, the regent of France and later Queen Mother, supported these innovations, and frequently included choreographed dances in the festivities she staged at court. Under her influence and patronage, the ballet de cour flowered in the years around 1580. The genre wedded fantastic stage effects with instrumental and vocal music, poetry, and dancing. The first *ballet de cour* to rely on an integrated and dramatically effective libretto was *Circe, or the Comic Ballet of the Queen*, which was produced in Paris in 1581. The story retold the ancient tale of Circe, daughter of Perseus and the Sun, who lured men to ruin through their passions. In the end, though, human reason triumphs over the weaknesses of passion, and rationality succeeds in destroying Circe's power. It is because of this plot, a story in which order is brought out of chaos, that the ballet was termed a "comedy." The subject matter—the relative power of reason and the passions—was to recur many times in sixteenth- and seventeenth-century French literature. Yet as it was conceived in the *Comic Ballet of the Queen*, the triumph of reason was also intended to glorify the French monarchy. The work's poetry and art drew frequent parallels between rationality and its French champion, the reigning monarch Henri III, and it glorified the harmony his rule bred in France. In the coming years the optimism of such sentiments proved misplaced as France descended ever deeper into the malaise of religious civil war at the end of the sixteenth century. Despite these troubles, ballets de cour remained popular in these years, but none of the successive works rose to the artistic level of the early *Comic Ballet of the Queen*. As the seventeenth century approached, though, the

a PRIMARY SOURCE *document*

A MASQUE

INTRODUCTION: In the Tudor and Stuart court in England masques often marked the Christmas celebrations, especially the final concluding or "Twelfth Night" of those festivities. Ben Jonson and Inigo Jones mounted the most sumptuous of these masques in 1605, *The Masque of Blackness.* Jones, an architect, designed the sets for the masque, which made use of innovations in stage machinery and set design of the French *ballet de cour.* Jonson included this description of the sets in his prologue to the printed edition of the masque. The masque is notable for its rich mixture of poetry, song, and dance, a development inspired by the revival of antiquity that the Renaissance initiated.

First, for the scene, was drawn a landscape consisting of small woods, and here and there a void place filled with huntings; which falling, an artificial sea was seen to shoot forth, as if it flowed to the land, raised with waves which seemed to move, and in some places the billows to break, as imitating that orderly disorder which is common in nature. In front of this sea were placed six tritons, in moving and sprightly actions, their upper parts human, save that their hairs were blue, as partaking of the sea-color: their desinent parts fish, mounted above their heads, and all varied in disposition. From their backs were borne out certain light pieces of taffeta, as if carried by the wind, and their music made out of wreathed shells. Behind these, a pair of sea-maids, for song, were as conspicuously seated; between which, two great sea-horses, as big as the life, put forth themselves, the one mounting aloft, and writhing his head from the other, which seemed to sink forward; so intended for variation, and that the figure behind might come off better: upon their backs, Oceanus and Niger were advanced. Oceanus presented in a human form, the color of his flesh blue; and shadowed with a robe of sea-green; his head gray, and horned, as he is described by the ancients: his beard of the like mixed color: he was garlanded with algae, or sea-grass; and in his hand a trident. Niger, in form and color of an Æthiop; his hair and rare beard curled, shadowed with a blue and bright mantle: his front, neck, and wrists

adorned with pearl, and crowned with an artificial wreath of cane and paper-rush.

These induced the masquers, which were twelve nymphs, negroes, and the daughters of Niger; attended by so many of the Oceaniæ, which were their light-bearers. The masquers were placed in a great concave shell, like mother of pearl, curiously made to move on those waters and rise with the billow; the top thereof was stuck with a chevron of lights, which indented to the proportion of the shell, struck a glorious beam upon them, as they were seated, one above another: so they were all seen, but in an extravagant order.

On sides of the shell did swim six huge sea-monsters, varied in their shapes and dispositions, bearing on their backs the twelve torch-bearers, who were planted there in several graces; so as the backs of some were seen; some in purfle, or side; others in face; and all having their lights burning out of whelks, or murex-shells.

The attire of the masquers was alike in all, without difference: the colors azure and silver; but returned on the top with a scroll and antique dressing of feathers, and jewels interlaced with ropes of pearl. And for the front, ear, neck, and wrists, the ornament was of the most choice and orient pearl; best setting off from the black.

For the light-bearers, sea-green, waved about the skirts with gold and silver; their hair loose and flowing, garlanded with sea-grass, and that stuck with branches of coral. These thus presented, the scene behind seemed a vast sea, and united with this that flowed forth, from the termination, or horizon of which (being the level of the state, which was placed in the upper end of the hall) was drawn by the lines of perspective, the whole work shooting downwards from the eye; which decorum made it more conspicuous, and caught the eye afar off with a wandering beauty: to which was added an obscure and cloudy night-piece, that made the whole set off.

SOURCE: Ben Jonson, *The Masque of Blackness*, in *The Works of Ben Jonson*. (Boston: Phillips, Sampson, and Co., 1853): 660–661.

conventions that governed these ballets' performances became ever firmer. Members of the court danced in the productions and played characters in the various scenes, while in the final choreographed dance, the *grand seigneurs* or "peers of the realm" participated. At least once each year the king danced in the finale of a ballet de cour, establishing a tradition of royal performance that lasted into the early years of the reign of Louis XIV

(r. 1643–1715). The genre, with its mixture of music, poetry, and dance, had a profound impact on the emergence of both opera and ballet as independent art forms in seventeenth-century France.

MASQUES. Dance figured prominently in a final category of court entertainments popular in England, which became known as "masques." The development of masques was long and complex. In late-medieval Eng-

land professional actors and dancers known as mummers regularly visited the houses of the nobility in disguises to perform for members of the household. These mummers performed elaborate dance pantomimes, and while festive social dances sometimes concluded these events, the professionals did not mingle or dance with the noble audience. In 1512, Henry VIII introduced a new kind of *masquerie* into England that was inspired by Italian examples. The king and revelers—all in disguise—surprised members of the court, danced and sang, and, in a break with tradition, recruited volunteers from the audience to participate with them. In the course of the sixteenth century, these masques at court grew increasingly formalized. One force that aided in their rising popularity was the establishment of the Master of the Revels in 1545, the chief Tudor official responsible for supervising entertainments at court. The Master appointed the poet George Ferrars to serve as the court's official "Lord of Misrule," and during his tenure, Ferrars staged a number of fantastic masques with odd-sounding titles, including *The Masque of Covetous Men with Long Noses* and *The Masque of Cats*. Mounting such productions was costly. At first, masques only required an elaborate pageant wagon, which served as their principal set. The performers rode atop this wagon as it was wheeled into the hall in which the masque was to be performed. Over time, though, English spectacles adopted the expensive costumes and elaborate stage machinery typical of Italian intermedi and French ballets de cour. Despite Queen Elizabeth I's thriftiness, she doled out large sums for the celebration of the masques, and she participated in them on many occasions. They often marked Twelfth Night, the concluding festivities of the annual Christmas celebrations. During Elizabeth's reign (r. 1559–1603), the English court masque also adopted the unified themes and high quality literary texts that were typical of the intermedi and ballets de cour. Masques were also celebrated, not only at court, but in the Inns of Court, the four legal societies in London. The greatest English masques—notable for their high literary quality, fusion of music and dance with poetry, and elaborate architectural stage effects—were mounted in the first decades of the seventeenth century during the reign of Elizabeth's successor James I (1603–1625). The playwright Ben Jonson (1572–1637) and the architect Inigo Jones (1573–1652) joined forces in these years to produce high-quality works that influenced all court entertainments during James's reign. Jones served as set designer, importing innovations in stage machinery from the continent and adapting them for use in the masques. The production that Jones and Jonson mounted in 1605, *The Masque of Blackness*, influenced the style of a number of

other Stuart-age poets who wrote for the masque, including Thomas Campion, Thomas Middleton, and William Rowley.

SOURCES

S. Howard, *The Politics of Courtly Dancing in Early Modern England* (Amherst, Mass.: University of Massachusetts Press, 1998).

M. M. McGowan, *L'art du ballet de cour en France, 1581–1643* (Paris: CNRS, 1963).

J.-P. Pastori, *La Danse* (Paris: Gallimard, 1996).

C. M. Shaw, *'Some Vanity of Mine Art': The Masque in English Renaissance Drama.* 2 vols. (Salzburg, Austria: Institut für Anglistik und Amerikanistik, 1979).

R. Strong, *Splendor at Court; Renaissance Spectacle and the Theater of Power* (Boston: Houghton Mifflin, 1973).

SEE ALSO *Theater: Theater in the Later Middle Ages; Theater: The Renaissance Theater in Italy*

FOLK DANCING IN EUROPE

PROBLEM. The development of the office of dance master and the circulation of dance manuals in the fifteenth and sixteenth centuries aided the rise of courtly dance as an art form. Court pageants, ballets de cour, masques, and intermedi were all well documented in the artistic records of the period, allowing for the reconstruction of these festivities in which dance played a central role. These increasingly complex and highly choreographed events spurred dance's rise to one of the "fine arts" in the seventeenth century, as ballet and other forms of cultivated dance eventually became professional endeavors for which long periods of training and athletic development were necessary. We are less informed, however, about the kinds of dances that were performed by the lower orders of urban people and rural peasants. Certainly dance played a crucial function in these strata of society. It was a vastly popular entertainment, recorded in literary and artistic sources. Fifteenth- and sixteenth-century engravings as well as the paintings of artists like Pieter Bruegel frequently depict dancing at peasant festivals and weddings. The sermons and moral tracts of both Catholic and Protestant religious reformers constantly criticized this popular dancing, attacking it as an evil that led to lasciviousness and sexual promiscuity. Europe's princes and magistrates often tried to limit the lengths of wedding feasts, which sometimes included up to three days of dancing and revelry. At the same time the dances of the countryside inspired dancing masters and courtiers as they fashioned new dances

Dance

a PRIMARY SOURCE document

A PLEA FOR RULES

INTRODUCTION: The dance masters of the Renaissance frequently criticized the absence of rules in popular dance. Thoinot Arbeau wrote his *Orchesography* for cultivated urban people, hoping to foster a strict understanding of the rules of the dance. The text was written, like many of the dance manuals, as a dialogue between the master, in this case Arbeau, and the student, named Capriol or Caper. Capriol at one point asks about the proper performance of the galliard, a court dance that sprang from folk roots. Arbeau criticizes the way in which the dance is being practiced in the cities of his time, and instead makes a plea for a strict interpretation of the dance's traditional courtly rules. In point of fact, however, the free-flowing way in which he describes the dance being performed in his own time may lie closer to the dance's true roots. While Arbeau is critical of popular practice of the dance, and tries to foster a "courtly style," his comments are interesting because he realizes that all dances change over time.

Arbeau: In the towns nowadays the galliard is danced regardless of rules, and the dancers are satisfied to perform the *five steps* and a few passages without any orderly arrangement so long as they keep the rhythm, with the result that many of their best passages go unnoticed and are lost. In earlier days it was danced with much more discernment. When the dancer had chosen a damsel and led her to the end of the hall, after making the *revérence*, they circled the room once or twice together simply walking. Then the dancer released the damsel and she went dancing away to the other end of the hall, and once

there, continued to dance upon the same spot. In the meanwhile, the dancer having followed her presented himself before her to perform a few passages, turning at will now to the right, now to the left. This done the damsel danced her way to the opposite end of the hall and her partner, dancing all the while, pursued her thither in order to execute more passages before her. And thus, continuing these goings and comings, the dancer kept introducing new passages and displaying his skill until the musicians stopped playing. Then, taking the damsel by the hand and thanking her, he performed the *revérence* and returned her to the place from whence he had led her forth to dance.

Capriol: This manner of dancing the galliard seems to me more laudable than the slipshod way in which I usually see it performed because when the dancer all but turns his back to the damsel she retaliates by doing the same thing to him while he is performing the passages.

Arbeau: For some time now the galliard has been danced in a manner known as the Lyonnaise, in which the dancer, giving way to another takes his *congé* of the damsel and withdraws. She, thus left alone, continues to dance a little while and then goes to choose another partner, and after they have danced together she takes her *congé* of him and withdraws. And these changes continue to take place as long as the galliard lasts.

SOURCE: Thoinot Arbeau, *Orchesography*. Trans. M. S. Evans (New York: Dover Publications, Inc., 1967): 76–77.

throughout the Renaissance. The *branle*, or brawl as it was known in English, had originally been one of the steps of the Burgundian *bassedance*. During the sixteenth century, though, it was expanded to include a number of elements drawn from the dancing of French peasants, including hand-clapping, facial gestures, hops, skips, and jumps. Even though cultivated aesthetes like Baldassare Castiglione implicitly criticized the dancing of the lower orders of society as rambunctious and lacking in refinement, the court society longed for the livelier rhythms and forthright gestures of popular dance.

CITIES. Perhaps nowhere were the dancing styles more varied and complex than in Europe's cities. Here elites imitated the dances of the European courts, while the lower orders of society continued to use dance forms that were popular in the countryside. Accounts from ur-

ban society, too, point to a great innovation in the cities, as urban dancers experimented with new forms that were often perceived by moralists to be sexually suggestive. Courtly patterns of dance first influenced urban elites through printed dance manuals. In 1488, an anonymous dance manual, *The Art and Instruction of Good Dancing*, was printed in Paris. Unlike the elaborate theoretical manuals of dance that were being written for Italian aristocrats at the time, this manual was more pragmatic than theoretical and was designed for urban burghers who were interested in mastering the techniques of dance. Other practical manuals intended for city elites anxious to develop their skills on the ballroom floor soon followed in England, Germany, and Italy. While the great dancing masters of the Renaissance worked primarily in courtly society, dance schools began to appear throughout Europe during the sixteenth century for anyone who

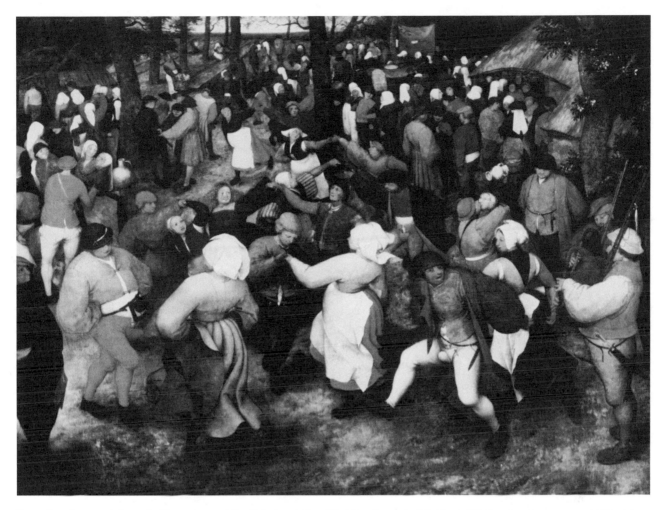

Examples of peasant dance in Pieter Bruegel the Elder's painting *Wedding Dance in the Open Air.* © FRANCIS G. MAYER/CORBIS. RE-PRODUCED BY PERMISSION.

could afford the tuition. By 1533, the first laws were enacted in England to regulate the new dancing schools. Somewhat later, the City of London granted a monopoly over the instruction of dance within its boundaries to three dancing instructors. At about the same time, two types of dance schools flourished in Lisbon, Portugal: those that taught the whirling, ecstatic style of the morescas, and others that instructed in the more restrained courtly forms. A number of Spaniards also flocked to Italy to learn dancing technique from figures like Cesare Negri. Returning home, they opened their own schools in cities throughout the peninsula, but especially in the capital Madrid and the important provincial city of Seville, which were populated with a large number of dance schools by the late sixteenth century. In his important dance treatise, *The Charms of Love* (1602), Negri mentioned more than forty men who had trained in Italy before establishing their own schools or winning court positions throughout Europe. Through

these new dance schools the techniques and forms of elegant dancing that had flourished in Europe's courts during the fifteenth and early sixteenth centuries spread far beyond the confines of castles and palaces. In the late Renaissance this refined style now became a mark of social distinction among the upper and middle ranks of urban society as well.

PEASANT DANCES. The artistic evidence that survives of rural society suggests that different patterns of dancing prevailed in the countryside and among many of the lower orders in the cities. The French engraver, Théodore de Bry, completed a series of engravings documenting the styles of dance in use in sixteenth-century Europe. His *Dance of Lords and Ladies* showed cultivated couples arranged in the stylized poses recommended in the elite dancing manuals of the period. By contrast, his *Peasants' Dance* showed wild and raucous movements, with couples hopping and springing, men lifting their women high off the ground, and couples

a PRIMARY SOURCE *document*

THE EVILS OF DANCE

INTRODUCTION: During the sixteenth century both Catholic and Protestant reformers stepped up attacks on dance and even tried to eliminate dancing, particularly the kind of folk dance that occurred in connection with weddings and peasant festivals. In 1581, Thomas Lovell, a Puritan minister in London, published a short dialogue about the evils of dance, entitled *A Dialogue Between Custome and Veritie Concerning the Uses and Abuses of Dance.* It was typical of the many pamphlets that circulated in sixteenth-century Europe attacking dance. In the dialogue, the figure of Custom continually defends dance by recourse to traditional arguments, i.e., dance increases sociability, it provides a way for men and women to meet one another, and so on. Verity, on the other hand, launches bitter attacks like that which follows on the evils of dance.

Custom: But some reply what fool would dance
if that when dance is done
He may not have at lady's lips
What dance hath for him won.

Verity: By this their minds they utter plain:
To feed their fancy and their lust
Not God in mind to keep.
Such dancing where both men and maids
together trace and turn,
Stirs up the flesh to Venus' games,
causes men with lust to burn.
If we the living God do fear,
and dread his laws to break,
what so might move us until evil
we should nay do nor speak.
So if the causes we cut out,
the effect we take away.
Our holy life our loving Lord,
better serve we may.
Lest I alone with dance do fight
this battle should be thought,
out of the works of worthy men
let's see what may be brought.
Sirach, that sage in chapter ninth
this counsel doth he give:
In company with dancing dame,
see that thou doth not live,
Gaze not upon her beauty brave,
hear not her mermaid's noise,
Lest thou be snared, and lest that she
enchant thee with her voice.

Bishop (Saint) Augustine were wont
vain dances to reprove.
But they are now so far from it,
they that to dance do love.
Better (he saith) that on Sabbath's rest,
if were all day to ditch,
Then on that day to be defiled
with dancing as with pitch.
Dancing is a flattering devil,
a poison fire, destroying them
that take delight therein.
Oh, would that men their sins could see,
how dance do them defile:
Though pricked in pride and garnished gay,
and they like wanton's smile.
And Chrysostom, that golden mouth,
for so his name may spell,
where he of Jacob's wedding writes
this doth he plainly tell:
Weddings, thou hearest that thou might
no wanton dancing hear,
might it which dances diabolical
he plainly calleth there,
The bride and ere the bridegroom is with
dance (saith he) beguiled,
and the whole house and family
therewith also defiled.
And writing of Herodias
her daughter's dancing nice,
before the king to which her gave
John Baptist's head of price.
Ye saith that many nowadays whom
Christians men do judge
Not half their kingdoms for to give,
nor others heads do grudge.
But their own souls most dear of all,
they give to be destroyed.
While by their devilish dancing
they are daily sore annoyed.
Yea where that wanton dancing is
erected, he doth say,
The devil himself doth dance with them
in that ungodly play.
I wish that dancers then would weigh
the author of their sport,
which is the devil, and that he doth
with them in dance resort.

SOURCE: Thomas Lovell, *A Dialogue between Custom and Veritie Concerning the Use and Abuse of Dancing and Minstrelsie.* (London: John Allde, 1581): C4v–D1v.

engaged in close tight embraces. The hops, lifts, and tight embraces that de Bry depicted were also found in the artistic depictions of peasant dances of Albrecht Dürer, Hans Sebald Beham, and Pieter Bruegel. These movements had long raised the ire of moral reformers throughout Europe. The popular fifteenth-century preachers St. Bernard of Siena and St. John Capistrano had frequently railed against the immodesty of popular dances. When they preached in towns and villages, their audience sometimes tossed the musical instruments and other frivolities used to celebrate dances into massive "bonfires of the vanities." Other more cautious individuals packed musical instruments and other dance paraphernalia away, waiting for the religious fervor to subside before bringing their items out of hiding. During the sixteenth century, though, the attacks on dancing from Protestant and Catholic reformers grew more severe, and in many places attempts were made to prohibit the custom. A pamphlet published in Augsburg in 1549, *A God-fearing Tract on Ungodly Dancing*, criticized peasant dances for their overt sexuality. The author attacked the custom of "fore" and "after" dances. After couples danced a serious "fore-dance," the author railed, they then proceeded to perform a "less disciplined dance, with nudging, romping about, secretive hand touching, shouts, other improper things, and things about which I dare not speak." Moralists feared such "improper" mixing of the sexes, and civil authorities tried to curb the popularity of such spirited movements by limiting opportunities for dances or by prohibiting these customs altogether. In spite of the efforts to censure dance, it continued to be a part of wedding celebrations as well as the long church festival of Carnival. While authorities attempted to segregate the young, unmarried men from women at these occasions, these festivals and celebrations provided an important avenue for socializing in country and town societies. At dances many men met their future wives through the courting rituals during which men often sat on ladies' laps, caressing and fondling them. Such open displays were perceived by Christian moralists and governing officials alike as an easy entree into premarital sex. Sixteenth-century government officials responded by enacting ever-tighter regulations against dance and by sending magistrates into the countryside to punish offenders. Sometimes the magistrates seized and smashed the instruments that had been used to accompany such dancing. But despite such draconian efforts, the popularity of dance persisted.

NEW FORMS. The association of the dances of peasants and the urban poor with immorality and disorder was reinforced in the sixteenth century by the rise of several new dance forms, including the *sarabande* and the *chaconne*. Legends linked both dances to the New World Indians, although each derived inspiration from native Spanish folk traditions as well. The sarabande was first mentioned in a manuscript poem written by Fernand Guzmán Mexía in 1539 in Panama, but was not recorded in a Spanish document until 1583, when it was prohibited at Madrid. The sarabande was performed in groups with castanets and tambourines and was explicitly sexual in its movements. It was denounced as a "national disgrace," and described by one Spanish moralist as a "dance and song so lascivious in its words, so ugly in its movements, that it is enough to inflame even very honest people." In 1599, Swiss observer Thomas Platter witnessed a group of fifty men and women performing the sarabande in Barcelona, making "ridiculous contortions of the body, the hands, the feet." Still others condemned the dance as a devilish creation. From Spain the dance spread into France, Germany, and England, where it flourished in the early seventeenth century. As the dance moved throughout Europe, it developed different styles. Some of the forms of the dance were lively and suggestive, while others were grave and mannered, suitable to be performed in the ballrooms of the aristocracy and the rich. The rhythm of the dance, which was similar to the later Baroque minuet, inspired new native sarabande steps. In time, the original daring element of the dance disappeared, and it became one of the more staid of seventeenth-century dances. The chaconne, like the sarabande, developed in Spain, emerging in the final years of the sixteenth century. The songs that accompanied it were frequently filled with anticlerical sentiments and sexual innuendo, and the movements of the dance were thought to be similarly suggestive. The refrains to its songs frequently began with phrases like, "Let's live the good life! Let's go to Chacona!" Chacona may have been associated at the time with a colonial outpost in Mexico, but the precise derivation of the dance's name is still a matter of conjecture. The dance grew popular in Spain's cities around 1600, and chaconnes together with sarabandes were the two most popular urban dances in the country during the first quarter of the seventeenth century. No one was said to be able to resist the call to dance the chaconne, and its feverish popularity soon spread to other European regions. Its adoption in courtly societies toned down its more overt sexuality, as had happened with the sarabande before it.

FOLK DANCES. The examples of the chaconne and sarabande illustrate the ongoing and important influence that European folk dance had on the more elevated and

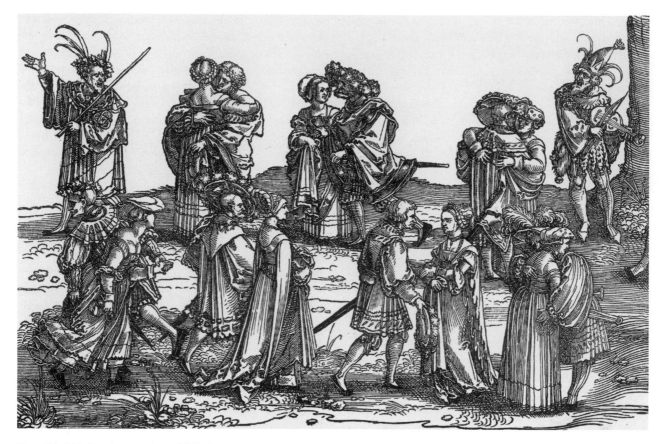

Hans Sebald Beham's engraving of folk dance steps. **MARY EVANS PICTURE LIBRARY.**

highly choreographed styles of the continent's great ballrooms. A distinguished lineage of ballroom styles in France, Italy, England, and Germany developed out of the folk dances of the European Renaissance. The *gavotte, bourrée, passepied,* and *jig* (or *gigue*) were just a few of the many folk dance forms that entered the repertory of social dances practiced in aristocratic and upper-class European societies during the period.

CONCLUSION. As one of the fine arts, dance experienced a long period of apprenticeship in the Renaissance under the direction of courtly dance masters and European aristocrats. The widespread love for dance gave birth to scores of new styles, choreographies, and spectacles that were characterized by complexity and grace of movement. For inspiration, Europe's dance theorists turned to the ancients, trying to recapture the power they believed had flourished in ancient Rome's poetry, dance, and music. They revived neoplatonic ideas about the nature of the universe as a dance, believing that the harmonies on the dance floor mirrored those of the cosmos. And they also combed through the native styles of their regions and adapted folk dances to the new demands of the ballroom. Dance as an art form of the Renaissance

court flourished, even as moralists and civic authorities attacked the spirited dances of the countryside and the urban landscape. Dance played an important role as a marker of social distinction, a sign of cultivated upbringing. As the end of the Renaissance approached, new court forms of theatrical dance like the ballets de cour, masques, operas, and intermedi were being performed throughout Europe. Dance played a key role in court spectacle, and the stage was set in these developments for the emergence of the independent professional ballet in the seventeenth century, a form which has since delighted audiences with its combination of stagecraft and highly choreographed movements.

SOURCES

L. A. Armstrong, *Window on Folk Dance* (Huddersfield, United Kingdom: Springfield Books, 1985).

J. Cass, *Dancing Through History* (Englewood Cliffs, N.J.: Prentice Hall, 1993).

J.-M. Guilcher, *La tradition populaire de danse en Basse-Bretagne* (Paris: Mouton, 1963).

W. Hilton, *Dance and Music of Court and Theater* (Stuyvesant, N.Y.: Pendragon Press, 1997).

N. A. Jaffé, *Folk Dance of Europe* (Skipton, United Kingdom: Folk Dance Enterprises, 1990).

R. Stevenson, "The Sarabande, A Dance of American Descent," *Inter-American Music Bulletin* 30 (1962): 1–13.

T. Walker, "Ciaccona and Passacaglia: Remarks on Their Origin and Early History," *Journal of the American Musicological Society* 21 (1968): 300–320.

SIGNIFICANT PEOPLE
in Dance

THOINOT ARBEAU

1520–1595

Cleric
Dance theorist

A CLERIC. Thoinot Arbeau was born Jehan Thauburot in 1520 in Dijon, once a center of fifteenth-century Burgundian court life. He received his schooling in Dijon and Poitiers and may have also attended the University of Paris. He took a degree in law before entering holy orders. By 1542, he became treasurer of the chapter house at Langres, and five years later was named a cathedral canon. He held a number of important church positions throughout his life, rising to the post of vicar-general, an important diocesan office. Late in life he wrote his dance treatise, *Orchesography*, a work that provides a vital glimpse of the styles of dance practiced in late sixteenth-century France, and which subscribes to the prevalent Neoplatonic notion about the importance of dance as a reflection of the cosmos.

TONE. Arbeau's dance manual was the only such work to appear in France in the late sixteenth century, although works of this kind were relatively common in Italy. It is a text comparable to the works of Fabrizio Caroso and Cesare Negri, and it records a similar number of dances. Arbeau, though, writes for an urban clientele, in contrast to the "courtly" tone of Caroso and Negri, and his dances are simpler and more direct. At the same time he includes even more important information about musical accompaniments to the dances. Arbeau developed, for example, a precise system for mapping out the steps to the accompanying musical passages he includes. Thus there can be no doubt about how he wanted the dance steps to follow the music, and for this reason, his work has been an invaluable tool to modern scholars wishing to recreate sixteenth-century dances. Among the many dances he relates, Arbeau includes 25 different branles, perhaps the most popular dance of the time in France. The branle, known as the brawl in English, had originally developed out of one of the steps of the Burgundian bassedance of the fifteenth century. In the sixteenth century, though, ingenuous dance masters and dancers had added a number of choreographed movements and innovations to the dance, which Arbeau carefully catalogues. One of the colorful branles he relates is the *washerwomen's branle,* in which dancers clap their hands like washerwomen beating clothes on the banks of the Seine. Another is the *hermit's branle,* in which participants mime the hand gestures that religious hermits made in greeting. Fancy footwork was a hallmark of such dances, and Arbeau recounts these with care as well. Beyond his numerous branle variations, he includes choreographies for the pavan, 15 different galliards, the volta, allemande, canary, as well as many others. The entire tone of the book is good-natured and charming; it is written, for instance, in the form of a dialogue between the teacher Arbeau and his disciple Capriol (meaning "step" or "caper"). As a cleric, Arbeau was one of an increasingly rare breed that actively pursued secular pursuits like the dance, and he recommended it in a strikingly modern way as good exercise. The changing spirit in the church, fueled by the severe tastes of the Counter-Reformation, took an increasingly dim view of priests like Arbeau who danced. The Jesuits and other religious orders of the time included dance instruction into their school curricula for children destined for marriage and secular careers, but dance was quickly becoming a pursuit too worldly for the rectory and the chapter house.

SOURCES

Thoinot Arbeau, *Orchesography*. Trans. M. S. Evans (New York: Dover, 1967).

J. Sutton, "Arbeau, Thoinot," in *The International Encyclopedia of Dance* (New York: Oxford University Press, 1998).

———, "Arbeau, Thoinot," in *The New Grove Dictionary of Music and Musicians.* 2nd ed. (New York: Norton, 2001).

K. H. Taubert, *Höfische Tänze, Ihre Geschichte und Choreographie* (Mainz: B. Schott, 1968).

FABRIZIO CAROSO

c. 1530–c. 1605

Dance master
Dance theorist

EARLY LIFE. Little is known about the circumstances of Caroso's life, except that he was born in Sermoneta, a small town near Rome, sometime between

1527 and 1535. Long-standing legends have alleged that he was a peasant taken into the household of the Caetani family, dukes of Sermoneta and Rome, and provided with an education. In his treatises Caroso dedicates a number of his dances to members of the Caetani and Orsini families, and it is likely that he probably served as the dance instructor in these households for a time. Both families kept large palaces in Rome during the sixteenth century, and besides the Orsini and Caetani, Caroso mentions other powerful Roman nobles of the day, including the Farnese and Aldobrandini Duke and Duchess of Parma and Piacenza, to whom he dedicates his second dance book, *The Nobility of Ladies* (1600). Torquato Tasso, the accomplished late Renaissance poet, also wrote a sonnet dedicated to Caroso, which is included in *The Nobility*. Like most of the prominent dance masters of the period, though, he probably spent much of his life moving in princely circles in Italy, teaching dance and mounting spectacles and other entertainments for court circles. Little more, though, can be determined about his life.

WORKS. Caroso is remembered today for two dance manuals he published late in the sixteenth century: *The Dancing Master* (1581) and *The Nobility of Ladies* (1600). Both are informative sources about the kinds of dances that were popular in the later Renaissance and together include information on about 100 different dances. Among these dances, Caroso includes a number of *balletto*, which were specially choreographed dances that consisted of multiple parts and specially composed music. While Caroso's works include a few simple dances that could be easily mastered, most of them were highly complex constructions that even expert amateurs might have had to spend many hours practicing. His books also include music intended to accompany these dances, and thus his work has been of great value to scholars and modern dance enthusiasts anxious to recover Renaissance styles of dance. In his *Nobility of Ladies* Caroso also included two dialogues between a dance master and his student that outline ballroom etiquette and a series of hard-and-fast rules for dancers to observe. His prescriptions on etiquette are notable for their extreme courtliness. He advises his readers on such subjects as how to wear a cape, how to sit and stand, when and how to remove gloves, and so forth. New editions of Caroso's book *Nobility of Ladies* continued to appear in Italy until 1630, demonstrating its continued role in the seventeenth century as an authority on dance techniques and ballroom behavior.

SOURCES

Fabrizio Caroso, *Nobiltà di Dame*. Trans. J. Sutton (Oxford: Oxford University Press, 1986).

A. Feves, "Fabritio Caroso and the Changing Shape of the Dance, 1550–1600," in *Dance Chronicle* 14 (1991): 159–174.

P. Gargiulo, ed., *La danza italiana tra Cinque e Seicento: studi per Fabrizio Caroso da Sermoneta* (Rome: Bardi, 1997).

J. Sutton, "Caroso, Fabrizio," in *The New Grove Dictionary of Music and Musicians*. 2nd ed. (New York: Norton, 2001).

CATHERINE DE' MEDICI

1519–1589

Queen of France

CULTURED BEGINNINGS. Catherine de' Medici was one of the most powerful women of the sixteenth century. She was the daughter of Lorenzo de' Medici, duke of the Italian city of Urbino, and the French princess Madeleine de la Tour D'Avergne, but was completely orphaned by the age of one. Her upbringing was entrusted to nuns in the city of Florence and later in Rome. Her marriage to the heir to the French throne, Henri, the duke of Orléans (king of France from 1547–1559), was negotiated by her uncle, Pope Clement VII. This wedding took place in Paris in October 1533. According to long-standing legend, Catherine made a sensation in her first appearance at the wedding ball by wearing a new style of high-heeled shoe that gave a swaying undulation and grace to her dance steps. Shoes with soles and heels were just coming into use in the early sixteenth century, and they had a definite effect on dancing, since they allowed performers to stomp and stamp their feet and to perform more intricate steps than was possible in the older fifteenth-century styles. Whether or not Catherine introduced these shoes to France cannot be determined, but she has long been credited with raising the standards of civility and culture in France's noble courts. Her cuisine was widely admired, and noble families searched for Italian cooks that could make the kinds of dishes that Catherine served at state festivities. Italians have long been fond of crediting the subsequent glories of French cooking to the advances that this Italian princess introduced into the royal kitchens in the sixteenth century.

COURT FESTIVITIES. Catherine's years in political life were tumultuous ones, dominated by the ongoing controversies and civil conflicts between French Protestants, known as Huguenots, and Catholics. One way in which Catherine escaped the stress of these difficulties was through the development of the genteel and ordered

art of dance in her court. Like dance enthusiasts elsewhere in Renaissance Europe, Catherine saw in the art a way of teaching the harmony and order that should prevail in the social and political world. Dance was, in her mind and in the minds of other cultivated Europeans, a model for properly ordered social relationships. In the many festivities she staged at court during the troubled years of her reign, she relied upon dance to express these ideas. She staged a series of "magnificences," grander than any that had yet been seen in France. These costly spectacles were attacked at the time as a source of ruination and poverty to the French crown, although Catherine saw them as an essential way to unify the French monarchy's quarrelling noble factions. As Catherine wooed other European kings and states and as she tried to mediate between her restive nobles, she imported ideas from the Italian dances and *intermedi* of the day. The "magnificences" relied extensively on dance choreography to express the faith in dance's powers to teach peaceful and harmonious living. Out of her efforts the *ballet de cour* emerged, a royal art form that joined together artistic stage designs, poetry, music, and dance. This genre influenced both the rise of the opera and the seventeenth-century ballet. Thus although Catherine's years as regent of France were troubled, her political career has long been credited with being an important stimulus to the development of the *beaux arts*, or "fine arts" in France.

SOURCES

J. Héritier, *Catherine de' Medici.* Trans. C. Haldane (New York: St. Martin's Press, 1963).

M. M. McGowan, *L'art du ballet de cour en France, 1581–1643* (Paris: CNRS, 1963).

R. Strong, *Spectacle at Court: Renaissance Spectacle and the Theater of Power* (Boston: Houghton Mifflin, 1973).

R. Williamson, *Catherine de' Medici* (New York: Viking Press, 1973).

CESARE NEGRI

c. 1535–c. 1604

Dance master
Dance theorist

MILAN. Cesare Negri's *The Graces of Love* (1602) was the most complete and detailed of all the great Renaissance works on dance theory and practice, and it provides a great deal of information about the dance life of the Italian upper classes in the late Renaissance. In this work Negri also informs us about his own life, allowing

us to reconstruct the career of one of the Renaissance's most important dance masters. Born in Milan around 1535, he served the city's Spanish governors as dance master until 1599. Between 1555 and 1600 he also directed a number of spectacles for major Italian ducal families. His list of distinguished clients included the Visconti, the Medici, the Gonzaga, and D'Este. One of his most impressive productions was a spectacle celebrating the naval victory of the Italian admiral Andrea Doria against the Turks in 1560. Another was his direction of the festivities marking the visit of Queen Margarethe of Spain to Milan in 1598. In his capacity as dance master, Negri also traveled extensively with Milan's noble rulers, performing dances for them on journeys to Malta, Genoa, Naples, Florence, Mantua, and Saragossa. Negri's *Graces of Love* is also a rich source of information about the major dancing masters of the later Renaissance. He includes the names of over forty dance masters who practiced at the time and gives details about their training and where they traveled to practice their art. His work thus points to the development in Italy of a group of professional male dancers, many of whom opened dancing schools in Europe's cities or who taught dance to their noble patrons.

DANCES. Negri's dance manual includes some of the typical information on ballroom etiquette that is to be found in many similar books from the period. He also discusses dance's role in aristocratic processions and *intermedi*, two of the most common occasions for theatrical dance in Renaissance Italy. By far, though, the largest portion of *The Graces of Love* is given over to a technical discussion of dance steps. The dances that he treats in the work are extremely complex, among the most difficult to survive from the Renaissance. In particular, he treats extensively the upper-class forms of the galliard and outlines a number of variations on the dance's footwork. He also shows that dances, just like the music of the time, were often improvised and that dancers loved to practice variations on the basic steps, joining different steps and footwork together to create ever more difficult choreographies. He includes 43 choreographies for dances, a number of which are figure dances similar to those that are still performed in American square dances. Like other dance manuals of the period, Negri's also included music to accompany these forms.

SOURCES

O. Chilesotti, *Danze del secolo XVI: trascritte in notazione moderna* (Bologna: Forni, 1969).

A. Feves, "Fabritio Caroso and the Changing Shape of the Dance, 1550–1600," in *Dance Chronicle* 14 (1991): 159–174.

J. Sutton, "Negri, Cesare," in *The International Encyclopedia of Dance* (New York: Oxford University Press, 1998).

———, "Negri, Cesare," in *The New Grove Dictionary of Music and Musicians.* 2nd ed. (New York: Norton, 2001).

DOCUMENTARY SOURCES
in Dance

Anonymous, *The Art and Instruction of Good Dancing* (1488)—This text was printed in Paris and was the first dance manual written for urban townspeople, rather than the nobility. It inspired a host of similar texts written in the native languages of European countries.

Thoinot Arbeau, *Orchesography* (1588)—Written in a dialogue between the dance master Arbeau and his student Capriol or Caper, this dance treatise provides invaluable evidence for many of the dances that flourished in late Renaissance Europe. It is important, too, because it includes many of the melodies and rhythms to which dances were performed.

Fabritio Caroso, *The Nobility of Ladies* (1600)—Caroso's second edition of his *Il Ballarino* or *The Dancing Master* includes a greater range of choreographies than his first work. It also outlines the rules of deportment that are essential to men and women on the dance floor. Dedicated to the Duke and Duchess of Parma, it was printed in Venice in an impressively produced edition.

Robert Davies, "Orchestra, or a Poem of Dancing" (1596)—Davies' Elizabethan verse celebrates the power of dance and in its many stanzas also informs about many of the customs of the dance floor in Renaissance England.

Thomas Elyot, *The Book of the Governor* (1531)—A Tudor conduct book modeled on Castiglione's *Book of the Courtier* (1528), Elyot's book outlines the behaviors necessary for a man to be considered a "gentleman" in sixteenth-century England, and devotes a large amount of space to the subject of dancing. He recommends the art as a way for a gentleman to display his civility.

Cesare Negri, *The Charms of Love,* (1602)—A late-Renaissance dance manual, this work provides a complete look at the social dance and theatrical spectacle that flourished in Italy during the period.

Domenico da Piacenza, *Of the Art of Dancing* (1445)—The first Italian dance treatise to survive from the early Renaissance, this work demonstrates Piacenza's vast reading on the history and theory of dance as well as his general theoretical knowledge of the arts. He relies on Aristotle's *Nichomachean Ethics,* particularly its outlining of the law of the "golden mean," to evaluate what steps nobles should perform on the dance floor.

chapter three

FASHION

Philip M. Soergel

IMPORTANT EVENTS
in Fashion

1311 The Council of Ravenna repeats a traditional medieval requirement that Jews wear a distinguishing sign on their clothes. These measures continue to be unpopular and largely disregarded by populations throughout Italy.

1348 The bubonic plague, also known as the Black Death, strikes Europe.

c. 1350 The hemlines of men's *jupons* or doublets begin to rise in France to scandalous levels; women's bust lines, on the other hand, start to plunge.

1373 The city of Florence passes stricter sumptuary laws (laws designed to curtail luxury in dress) aimed at women.

1405 In her *Book of the City of Ladies*, Christine de Pizan praises women's love of fashion.

1416 Giacoma della Marca takes clerical orders in Italy. Della Marca's fiery sermons delivered over the next sixty years are typical of the fifteenth-century Franciscans, who favored restraint in dress and the adoption of a strict system of dress codes to identify Jews, prostitutes, and other marginal groups.

1427 Bernard of Siena conducts a hugely successful preaching tour in Italy that encourages men to discard their gaming boards, dice, and cards, and women to throw their finery into "bonfires of the vanities."

1434 The humanist Leon Battista Alberti completes his *Book of the Family*, an impor-tant work in promoting styles of feminine beauty for women, and one that encourages men to adopt a gravity in dress.

c. 1450 The rich court of the Duchy of Burgundy dominates fashions in courtly societies in Northern Europe.

c. 1460 The codpiece begins to grow, both in popularity and size, in male fashions.

1463 A series of sumptuary laws are passed in England that aim to define the status of various classes of society through distinguishing dress.

1464 Pope Paul II passes a series of vestment laws at Rome that exert greater control over the dress of the clergy.

1469 Galeazzo Maria Sforza, duke of Milan, gives his wife a pair of earrings, a style of jewelry long associated with Jewish women. Over the next half century earrings will be increasingly adopted by Christian women.

1477 A fashion for "slashed" and puffed styles in court dress develops in Germany.

c. 1485 Italian court dress becomes fashionable in aristocratic circles throughout Europe.

1493 The popularity of the *poulaine*, long and pointed footwear, fades in favor of new soled and heeled shoes.

1494 The fiery Dominican Girolamo Savonarola begins to preach in Florence after the expulsion of the Medici. Over the following years, his sermons will encourage many Florentines to abandon their sumptuous clothing styles, but his preaching will remain controversial.

1498 Savonarola, recently excommunicated by the pope, is deposed following a counterrevolution in Florence.

1501 Catherine of Aragon marries Prince Arthur of England, introducing the style of the *farthingale*, a large hoop skirt, to the country.

1510 German styles reign in court dress fashions adopted throughout Europe, spreading the popularity of "slashing," in which overgarments are cut away to reveal rich undergarments.

Many aristocrats adopt the richly jewelled and decorative patterns of clothing popular in Italy.

1512 While Venice is under attack from the League of Cambrai, its Senate deliberates for a month about the kinds of ornaments that are to be permitted on clothing.

1527 In England, the German painter Hans Holbein begins to immortalize the clothing styles of many of the most famous English aristocrats and courtiers of the Tudor period through his minutely accurate and richly opulent portraits.

1530 The Medici family is restored to power after a brief interlude of republicanism at Florence. They will adopt a richly elegant style of dress in contrast to the severe republican styles that flourished in the city during the fifteenth century.

c. 1535 The Italian sculptor Benvenuto Cellini is active at the court of Francis I. Besides his many duties as a sculptor, Cellini designs a great deal of jewelry for the French king Francis I.

1539 Cosimo I de' Medici celebrates his wedding to Elenore of Toledo at Florence. Elenore will become known in the city for her lavish gowns.

Henry VIII sends his court painter Hans Holbein to Flanders to paint the image of his prospective bride Anne of Cleves. Although the marriage is never consummated because of Henry's personal distaste for her physical appearance, Anne gains a reputation in England for her richly decorated clothes, which establish new styles in the English court.

c. 1540 In Italy the Mannerist painters' portraits of the upper classes are notable for their richly jewelled and elaborately decorated women's dresses.

1541 Protestant leader John Calvin establishes control over the Reformation at Geneva and begins to promote tougher sumptuary laws. During his more than two decades in the city over 800 people will be arrested for violations, and 58 will be put to death for excesses in clothing.

c. 1550 The upper-class dress of Spain begins to affect courtly styles throughout Europe.

Henry II of France forbids the wearing of clothes made of silk and velvet and of styles that are trimmed in silver and gold in order to prevent the flow of money outside France.

1553 Marguerite de Valois, the future wife of King Henry IV (r. 1589–1609) and an important originator of many upper-class feminine styles, is born.

1558 Queen Elizabeth I ascends the throne of England. During her more than forty-year reign she will influence the styles of her court and will, according to legend, commission more than 3,000 costly dresses.

c. 1560 Pocket watches begin to appear in France.

Huge pants known as "Plunder" trousers are popular in Germany, although preachers attack the style as wasteful and sinful.

1564 The use of starch is introduced in England, allowing for the development of complex pleats and ruffles.

1569 The Flemish painter Pieter Bruegel paints his famous *Peasant's Wedding*, a source for information on rural styles at the time.

c. 1570 The ruffled collar becomes popular as an upper-class style favored throughout Europe.

c. 1580 In Germany, the style of women's clothes grows increasingly severe and restrained. Religious changes in both Catholic and Protestant regions as well as the popularity of Spanish dress at the time encourage the new style.

1581 The French court witnesses the production of a *ballet de cour* entitled *The Comic Ballet of the Queen* which is notable for its rich costuming and its elaborate use of gold, silver, and jeweled decoration on the characters' costumes.

1589 William Lee invents the knitting machine in England. Elizabeth I denies him a patent for his invention because she fears it will put people out of work.

1590 Men begin to wear "love locks" at court in England. These locks are long shocks of hair that fall over one side of the collar.

1599 The Tudor court in England spends approximately £10,000 on clothes this year at the same time many professionals (lawyers and government officials) live on less than £100 per year.

1600 Marie de' Medici becomes queen of France. She establishes a court notable for its luxury and acquires a reputation as the most expensively dressed woman in Europe.

1603 Elizabeth I dies in England. Her successor, James I of Scotland, ascends the throne. During the initial years of his reign James will quadruple the amount spent on clothing in the English court.

OVERVIEW
of Fashion

A CLIMATE OF RESTRICTION. Renaissance society depended upon the production of cloth and clothing as one of its key industries. As a time-consuming and labor-intensive process, the production of textiles kept as much as a third of urban populations employed, often in servile and brutal conditions. Despite the immense amount of energy that went into the production of clothes, there was a prevalent mistrust of clothing as "fashion" at the dawn of the Renaissance; the majority of the population still adhered to the medieval belief that such displays contributed to the sin of vanity. This attitude lost some ground during the fourteenth century, however, as court and urban fashions in Europe became more changeable and daring. The tension between moralists who denounced changing fashions as sinful and the upper-class obsession with clothes became a hallmark of this period. Renaissance moralists particularly zeroed in on a perceived association of style's fickleness and mutability with women, even though little evidence exists to suggest women's passion for clothes exceeded that of men. In fact, the advice books of the Renaissance written by humanists frequently encouraged men to pay more attention to their clothing than women. The association of women as the "fashion horses" of the time, though, arose from complex causes and transformations in the exchange of property that, by the Renaissance, had become established throughout society. The system of inheritance excluded women from inheriting property from their husbands, and they received their share of their father's estate when they married in the form of a dowry and a trousseau (a gift of clothing that was intended to see women through the first few years of marriage). The husbands, in turn, had to give a complex set of gifts to their wives that rivaled the trousseau and dowry she had received from her own family or face the loss of status. During the fourteenth and early fifteenth centuries the cost of establishing a household rose quickly in Europe as a result of inflation touched off by the Black Death and subsequent outbreaks of the plague.

As a result, men began to marry later, and dowry and trousseau expenses rose. The cost of a man's "counter-trousseau," the gifts he gave his wife at marriage, consequently rose to keep apace with this inflation. Thus in the minds of Renaissance men, women's taste for fashion was one of the chief evils of the age. Civic officials tried valiantly to contain the costs of this luxury, while the popular preachers of the age denounced it. Still, fashion had penetrated into Renaissance society, and over the following centuries its steady advancement knew no retreat.

FASHION AS INDUSTRY. Although moralists and town and state officials tried to contain fashion's excesses, the style industry was a significant portion of a Renaissance city's economy by the early fifteenth century. In many parts of Europe tailors had their own guilds that regulated production and fixed prices. Elsewhere this group existed within pre-established guilds. In Florence, tailors became associated with several guilds, but gained a greater reputation as part of the relatively low status "clothing resellers" guild. By the standards of the fifteenth century tailoring was still only a middling occupation, but the increasing emphasis on clothing and appearance increased the status of the best tailors. Beyond tailors, however, an entire battery of professions satisfied the Renaissance demands for style. Milliners, cobblers, lace makers, leather workers, and furriers were just a few of the myriad professions who served the fashion industry. The boundaries between all these various occupations were often strikingly clear, although at the bottom rung of the clothing market independent suppliers sometimes poached these professions' livelihood. The clothing market was highly competitive, with the high cost of materials offset by the relatively cheap labor. To take advantage of these realities, families bought their own cloth from retailers and producers before commissioning a tailor to construct a garment. Many families did their own sewing at home or gave it to a family member who had entered a convent. Still, the cost of clothing was dear, and patterns in dressing drew a clear line of demarcation between social classes; servants, the lower classes, and the poor dressed in clothes that were considerably more threadbare, and made over patterns that required far less material than those of the wealthy.

EARLY RENAISSANCE STYLES. In Florence an ethos of republicanism in the fourteenth and fifteenth centuries bred restraint in clothes. The humanist literature of the age counseled wealthy men of affairs to dress in a magnificent, but severe fashion that reflected favorably on their lineage and their city. Although this literature advised women from the same class to think less about

their clothes and more about their husband's desires, wives often dressed in elaborate styles at ceremonial occasions attended by other members of the upper classes as reflections of their husbands' wealth and status. The greatest of the many occasions that called for finery was the wedding. Brides and grooms planned for months and sometimes years the clothes that they were to wear on these occasions, and an ever-escalating climate of competition among families is evident in Renaissance cities throughout the period. Governments frequently tried to control the expenditure of these events, but despite these prohibitions urban dress continued to grow more sumptuous, elaborate, and ornate as the fifteenth century drew to a close. At this time urban fashions, particularly in Italy, reflected the increasingly elegant styles popular in court circles throughout Europe. While the elites in cities tried to ape court societies, they could never come close to rivaling the expense and magnitude of styles favored by Europe's aristocrats.

THE SIXTEENTH CENTURY. As the sixteenth century approached, styles in Europe were largely regional. Around 1500, however, a wave of styles that emanated from Germany and somewhat later from Italy affected European court dressing. The new dress was elaborate, many-layered, and given to patterns that reshaped the body, sometimes into profoundly distorted shapes. A case in point is the Spanish-inspired *farthingale,* or wide hoop skirt, which made it difficult for women to sit in chairs and even to pass through doorways. It became popular in France, England, and Germany in the sixteenth century, although moralists attacked it for deforming the human body. Despite such attacks, fashion's ever-changing whims persisted. The corset, an undergarment adopted by both men and women, achieved strikingly different effects in each gender. For men, it allowed tight-fitting, heavily tailored doublets, while for women it flattened the bust and tapered the waist into an "hour glass" shape. In the styles of the first half of the sixteenth century, this tendency to distort the human form gave birth to eccentric fashions like slashing, in which elaborate cuts in an outer garment's material allowed the many-layered undergarments to show through. Around 1550, upper-class fashions changed again rather quickly. The new styles came from the Spanish court and favored heavily tailored, more restrained appearances. High ruff collars and capes were also elements of Spanish style adopted by courtiers and urban elites at the time. The continued criticism of fashion's ever-changing bazaar failed to blunt the reality that style had become a fundamental feature of European life.

THE REGULATION OF CLOTHING

CONSUMPTION. The Commercial Revolution that began in Europe around 1000 C.E. rested on a firm foundation of cloth and clothing production. As Europe's cities increased in population during the High Middle Ages, fabric weaving became a lucrative business, and by the early Renaissance Italy was Europe's preeminent center of cloth production, exporting fine silks and woolens throughout the continent. The production of cloth—an item for which there was universal need—was the foundation upon which great Renaissance economies relied, and the spinning of fabric produced much of the enormous wealth that allowed the era's elites to indulge their tastes for art, fine buildings, and sumptuous fashions. The guilds that controlled the milling of wool and the weaving of textiles were usually the most important commercial organizations in Europe's cities, and they often dominated local politics. In Florence, perhaps as many as a third of the city's population worked in the woolen industry, and Florentine cloth had a reputation throughout Europe for its fine quality. Spun from English wool, it had captured a place as a luxury commodity of the highest distinction. In the course of the Renaissance the wealth that Florence's looms produced funded many of the city's building projects, including the construction of the city's cathedral. In the 150 years it took to complete the massive edifice, the town's Arte della Lana, or Wool Guild, controlled the building's construction, even as it dominated the city's economy and government.

LABOR PROBLEMS. The medieval and Renaissance guilds have often been compared to modern trade unions, but in one crucial respect they were vastly different. The goal of modern unions is to better the living standards and wages of workers, while in pre-modern Europe, great masters dominated the guilds and acted to keep costs low. As a result, many guilds were far from harmonious organizations, as journeymen and small producers resented the actions of the great masters who controlled the guilds' structures. At Florence, for example, the master weavers responsible for the final stages of production of the town's luxurious woolens sat at the apex of a vast pyramid of woolen workers. Their high-handed tactics frequently angered those who performed simpler, less skilled tasks associated with cloth production. Tensions erupted in the Arte della Lana, sometimes threatening the city's social fabric. In 1378, for instance, the

a PRIMARY SOURCE *document*

LABOR TROUBLES

INTRODUCTION: Like many large European cities in the later fourteenth century, Florence experienced major conflicts in its guilds. After the population decline caused by the Black Death and subsequent outbreaks of the plague, labor grew comparatively more expensive in the towns, although the demands for better wages and working conditions sometimes fell on deaf ears in the guilds, many of which were controlled by the wealthiest masters. In his *History of Florence,* the famous sixteenth-century humanist Niccolò Machiavelli recounted the history of Florence's bitter revolt of the *Ciompi,* or wool carders, in 1378. As this relatively powerless group within the wool guild clamored for a greater voice in their guild and in urban government, they were joined by many of the minor artisans of the city. Machiavelli was not unsympathetic to the workers' plight and the interesting observations that he places in the mouth of one of the rebels show us the fundamental role that dress played in the mentality of the Renaissance.

When the companies of the arts were first organized, many of those trades, followed by the lowest of the people and the plebeians, were not incorporated, but were ranged under those arts most nearly allied to them; and, hence, when they were not properly remunerated for their labor, or their masters oppressed them, they had no one of whom to seek redress, except the magistrate of the art to which theirs was subject; and of him they did not think justice always attainable. Of the arts, that which always had, and now has, the greatest number of these subordinates is the woolen; which being both then, and still, the most powerful body, and first in authority, supports the greater part of the plebeians and lowest of the people.

The lower classes, then, the subordinates not only of the woolen, but also of the other arts, were discontented from the causes just mentioned; and their apprehension of punishment for the burnings and robberies they had committed, did not tend to compose them. Meetings took place in different parts during night, to talk over the past, and to communicate the danger in which they were, when one of the most daring and experienced, in order to animate the rest, spoke thus:

If the question now were, whether we should take up arms, rob and burn the houses of the citizens, and plunder churches, I am one of those who would think it worthy of further consideration, and should, perhaps prefer poverty and safety to the dangerous pursuit of an uncertain good. But as we have already armed, and many offenses have been committed, it appears to me that we have to consider how to lay them aside, and secure ourselves from the consequences of what is already done ... We must, therefore, I think, in order to be pardoned for our old faults, commit new ones; redoubling the mischief, and multiplying fires and robberies; and in doing this, endeavor to have as many companions as we can; for when many are in fault, few are punished; small crimes are chastised, but great and serious ones rewarded ... Be not deceived about that antiquity of blood by which they exalt themselves above us; for all men having had one common origin are all equally ancient, and nature has made us all after one fashion. Strip us naked, and we shall all be found alike. Dress us in their clothing, and they in ours, we shall appear noble, they ignoble—for poverty and riches make all the difference.

SOURCE: Niccolò Machiavelli, *History of Florence.* (Washington: M. Walter Dunne, 1901): 128–129.

Ciompi, or the wool carders, revolted against the control over production held by the weaving masters and retailers. The carders did not possess a vote within the guild so they demanded their own guild to represent them against the wealthier weavers and exporters of fabric. Eventually, many of the city's less-skilled workers or "little people" (*popolo minuti*) joined the carders in their demands and succeeded in briefly seizing control of the town's government. Although eventually suppressed, the Revolt of the Ciompi left a legacy of bitter faction and enmity in Florence's government and cloth industry that persisted in the early fifteenth century.

LUXURY GOODS. Florence was not alone in its guild tensions, as a demographic crisis had long aggravated problems within Europe's cities. By 1300, three centuries of unparalleled population growth had outstripped the towns' ability to provide employment for the thousands of new immigrants who flooded into them each year. This population boom depressed wages and made widespread poverty a fact of life in Renaissance towns. While the numbers of the poor varied widely from place to place, as many as one-third of a town's population might be impoverished. They survived on occasional day labor, begging, and thievery. The problem of overpopulation encountered a devastating solution between 1347 and 1350 when the bubonic plague decreased the population of many of Europe's cities by as much as one-half. Repeated outbreaks of the disease throughout the fourteenth and fifteenth centuries effectively prevented population numbers from replenishing. The dramatic falloff in population in the towns initially deflated the

demand for the goods produced in cities, but as equilibrium returned to the urban scene the population decline bred inflation. While the Black Death and subsequent plagues often destroyed entire families, those wealthy producers who survived faced relatively less competition than before the epidemic. As a result, the concentration of wealth allowed the great families who had long dominated town governments and the urban economy to achieve even greater dominance. While this dominance fueled urban revolts like the Ciompi, it also inspired a new taste for luxury consumption. In Italy, especially, the cities' great families embraced fashion as a way to demonstrate their status and standing within urban society.

FASHION: A FEMININE PROBLEM. By 1400 the rise of an opulent world of fashion in the Renaissance city was indisputable. This trend did not go unnoticed at the time, and criticisms of the love of luxury were common. In contrast to earlier medieval commentators who had frequently attacked men for their role in sustaining the taste for rich display, the moralists and civic fathers of the Renaissance more often blamed women for the insatiable appetite for sumptuous clothing. In truth, men were just as often guilty of sartorial excess as women, but the notion that fashion was a "women's disease" was common and had its origins in certain customs and legal practices of Renaissance society. The patrilineal system of inheritance (in which property passed through the father's line of descendants) made women legal outsiders in the families they joined when they married. While a married woman might produce heirs for her husband's family, Renaissance law gave her no claim to his wealth upon his death, and even the children she bore her husband belonged, not to her own but to her husband's lineage. A woman, then, effectively borrowed her status from her husband, and the high mortality rate of the time meant that the identification with her husband's lineage might be only a temporary one. Widowhood and remarriage thus threatened the stability of the family, as widows might take a new husband and leave their children to be raised by their deceased spouse's family. Thus many Renaissance men made bequests in their wills to their wives, stipulating incomes and property they might enjoy if they stayed within their adopted families and continued to raise their children. As these practices became ever more fixed in the society of the High Middle Ages and the Renaissance, the symbolic role of a wife's clothing and jewelry increased dramatically. Her dress became, in other words, a potent symbol of her husband's power over her and of her ties to his lineage. From queens to the ranks of humbler women who en-

tered marriages, women adopted the styles of dress favored by their husbands' families. Those who used their dress, by contrast, to express an individual identity or to satisfy a mere desire for fashionable display could be attacked for defying their husband's authority.

TROUSSEAUX AND DOWRIES. In the mid-fourteenth century the humanist Giovanni Boccaccio concluded his famous collection of tales *The Decameron* with the story of Griselda, a woman who suffered trials in her marriage similar to those of the Old Testament figure Job. Boccaccio celebrated Griselda's patient suffering as the highest expression of Christian womanhood, and his story shows the vital role that clothing played in Renaissance marriage and family life. Born of peasant stock, the virtuous Griselda rose to become the wife of a king. At the couple's marriage, her husband richly adorned her with fine jewels and costly garments, only to take these away from her soon after the wedding guests had departed. In the years that followed, Griselda bore her husband children, but he turned her out of the house to live in poverty. Despite these and other trials, she preserved her honor, lived in acute need, and refused to take a lover to support herself. Her constancy convinced her royal husband of her virtue, and he eventually restored her to an honored position in the family, clothing her again in rich finery. The exchanges that Boccaccio detailed in Griselda's story were very much a part of Renaissance family life. While no peasant ever rose to become the wife of a king, marriage was, in fact, preceded by a highly complex system of gift exchanges in which clothing and jewelry figured prominently, underscoring a bride's entrance into a new family and her willingness to live, like Griselda, under the control of her husband. At marriage, for example, a woman received her dowry from her own family as her share of her father's wealth. These sums, often consisting of cash payments, property, and household items, transferred to her husband to offset the expenses of the new couple's household. In addition, none but the poorest of families ever sent their daughters off to begin marriage without an opulent trousseau (a set of sumptuous clothes and gifts intended to help the young woman establish her household) that expressed their ability to provide her with a suitable entrance into married life. To match the finery that her own family provided, the groom and his family also presented the future bride with many gifts of clothing, jewels, and luxurious household items that matched and even surpassed those provided by her birth family. These exchanges—of rings, gowns, silver, and gold—thus played a symbolic role in underscoring that a woman was leaving her own lineage, and taking up a new position within her husband's family. At the

a PRIMARY SOURCE *document*

CLOTHING A BRIDE

INTRODUCTION: The fourteeth-century humanist Giovanni Boccaccio concluded his *Decameron* with the tale of patient Griselda, a peasant woman who rose to become the wife of a king. Stripped of all her possessions, her husband Gualtieri clothed her in rich finery for the wedding, but soon afterwards stripped her of her possessions and subjected her to many trials. Withstanding these, she convinced her husband of her true nobility of spirit and at the story's conclusion he restored her finery to her. The story shows the way in which Renaissance men perceived clothes as a means for fashioning their wives' identities. First dressed in her wedding finery, Griselda seems to take on a new noble appearance and to shed her peasant identity. Yet Boccaccio undermined these sentiments at the tale's end, because he argued that true nobility of spirit had nothing to do with birth but with a person's spirit. Centuries after the completion of the *Decameron*, Griselda's story was still being repeated in plays, short novels, and even in the opera. It ranks as one of the most powerful fictional narratives to come out of the Renaissance.

Whereupon Gualtieri, having taken her by the hand, led her out of the house, and in the presence of his whole company and of all the other people there he caused her to be stripped naked. Then he called for the clothes and shoes which he had specially made, and quickly got her to put them on, after which he caused a crown to be placed upon the dishevelled hair of her head. And just as everyone was wondering what this might signify, he said:

"Gentlemen, this is the woman I intend to marry, provided she will have me as her husband." Then, turning to Griselda, who was so embarrassed that she hardly knew where to look, he said: "Griselda, will you have me as your wedded husband?"

To which she replied:

"I will, my lord."

"And I will have you as my wedded wife," said Gualtieri, and he married her then and there before all the people present. He then helped her mount a palfrey, and led her back, honourably attended, to his house, where the nuptials were as splendid and as sumptuous, and the rejoining as unrestrained, as if he had married the King of France's daughter.

Along with her new clothes, the young bride appeared to take on a new lease of life, and she seemed a different woman entirely. She was endowed, as we have said, with a fine figure and beautiful features, and lovely as she already was, she now acquired so confident, graceful and decorous a manner that she could have been taken for the daughter, not of the shepherd Ginnùcole, but of some great nobleman, and consequently everyone who had known her before her marriage was filled with astonishment. But apart from this, she was so obedient to her husband, and so compliant to his wishes, that he thought himself the happiest and most contented man on earth. At the same time she was so gracious and benign towards her husband's subjects, that each and every one of them was glad to honour her, and accorded her his unselfish devotion, praying for her happiness, prosperity, and greater glory. And whereas they had been wont to say that Gualtieri had shown some lack of discretion in taking this woman as his wife, they now regarded him as the wisest and most discerning man on earth. For no one part from Gualtieri could ever have perceived the noble qualities that lay concealed beneath her ragged and rustic attire.

SOURCE: Giovanni Boccaccio, *The Decameron*. Trans. G. H. McWilliam (Harmondsworth, England: Penguin Classics, 1972): 786–787.

same time, family honor hung in the balance of gift-giving, and the exchange of rich goods often became a competition that demarcated each family's standing in the urban hierarchy. Among the wealthiest families of Italian cities, specially constructed and elaborate caskets known as *cassoni* carried these items on ceremonial processions that wended through a town's streets in the days and weeks before a marriage occurred. Thus the exchanges of clothing, jewelry, and household items that occurred in the critical days before a wedding played a vital role in publicizing a family's wealth and status in cities, and the size of a woman's dowry, her trousseau, and her husband's gifts became a matter for local commentary and record.

INFLATION. Such displays of family status were costly and could threaten the financial well being of all but the wealthiest families. Amassing a daughter's trousseau was an expensive and time-consuming process, and the husband's counter-gifts of clothing and finery represented a similar effort. By the 1400s, husbands often offset the exorbitant cost associated with celebrating a marriage by renting the elaborate wedding costumes with which they clothed their brides from other families who had recently undergone the same event. Those who actually purchased the gowns might, after the wedding, cut off the gold, silver, pearls, and precious gems affixed to the fabric, or even sell the dresses to other

TROUSSEAUX

The trousseaux of those who married were normally quite extensive, including not only clothing but sewing and writing supplies and items such as chests, baskets, basins, and ewers [broad-spouted pitchers used to carry water to the bedroom for face- and hand-washing]. Andrea Minerbetti's *ricordanza* [ledgers] itemized each of his three wives' trousseaux, which run many pages in length, distinguishing between items assigned a monetary value (noted in the margin) and those left unestimated. Upon the betrothal of his eldest daughter Ghostanza in 1511 (at the age of eighteen) to Carlo di Tommaso Sassetti, Andrea provided her with a dowry of 1,200 florins ... and a trousseau of 275 florins *di suggello*. In his records, Minerbetti detailed every piece of clothing in her trousseau, as was usual, noting the type of garment, fabric, color, and specific styles of gowns and sleeves. Andrea had previously sent this daughter to a convent on two occasions before her espousal, the first time being the day after her sixth birthday, when her mother died on December 19, 1499. The second time was eight years later, at the age of sixteen, after his second marriage also ended in a death, this time that of her stepmother ... Emerging from her convent in February 1511, Ghostanza was finally readied for marriage and provided with the elaborate ritual clothing that would equip her for public display. In addition to her "official" detailed trousseau, worth around 280 florins, her father gave her another 520 florins, which was listed directly under the amount paid for her dowry and the trousseau. The Minerbetti were part of the Florentine elite, and this marriage would have strengthened their alliance with the illustrious Sassetti family, so the additional amount was in all probability added for more clothing for the requisite ritual festivities.

The first impression of the written description of her official (*stimate*) wedding trousseau is one of luxurious silk pastel gowns, fur linings, jewelry, and extra detachable sleeves to mix and match. Besides the requisite ornate silver overgown—her's of a carnation pink, (*gherofanato*) lined and bordered with fur—Ghostanza had in her trousseau three other gowns (*cotte*), including two of fabric called *ciambellotto* in light yellow and white. The third cotta was of damask in a color designated as *sbiadato*, possibly a pale, watered blue. She also had three pairs of detachable sleeves, one of heavy silk chermisi, another of crimson velvet, and a third simply designated as *lavorato*, or embroidered. These garments were only seven of her many clothing items, which ran two full pages in her father's logbook, including other gowns (lilac blue silk with flounced sleeves, green wool with lined sleeves of tan silk damask); as well as headdresses, belts, head scarves, aprons, linens, slippers, undergarments, and an appropriate Santa Margherita doll "dressed in brocade with pearls," which had undoubtedly been passed down to her by her mother, a doll of the same description being listed in the mother's trousseau some sixteen years earlier in 1493.

The second, unassessed part of Ghostanza's trousseau was even more extensive, and contained dozens of other items whose worth was left unestimated, although they were of no mean value. More clothes, linens, and accessories were listed, including detachable sleeves, gold-embroidered stockings, and two pairs of wooden platform shoes (*zoccoli*) for wearing in the street. Included also were ribbons, purses, and gloves, as well as sewing and embroidery supplies (scissors, pins, silk pin cushions, and embroidery thread "of many colors"), silk appliqués of doves and flowers, and an angel embroidered in gold.

SOURCE: C. C. Frick, *Dressing Renaissance Florence* (Baltimore, Md.: Johns Hopkins University Press, 2002): 139–141.

prospective grooms. Only the wealthiest families or the most generous husbands allowed their wives to keep the finery that they provided for the wedding indefinitely, particularly since sumptuary regulations mandated that women put away these lavish clothes several years after marriage and adopt a reserved and matronly style of dress. Such practices made these wedding customs affordable to a broader range of the populace, but the cost of celebrating a couple's wedding was still considerable. By the early fifteenth century even bourgeois women came to their new homes laden with many changes of clothes, numerous slippers and shoes, a wide selection of hats and jewels, and a variety of purses and accessories.

By the fifteenth century a prospective husband might invest as much as one-third of the money he received from a woman's dowry in wedding gifts of clothing and jewelry, a development that caused, in turn, the price of dowries to rise and inspired some cities like Florence to introduce municipal bonds that allowed the parents of daughters to invest in a publicly funded bond market to amass the sums needed to see their daughters installed in marriage. Out of fear that this rising tide of consumption would make marriage too expensive for all but the wealthiest Italians, many towns tried to limit the values of the gifts that a groom's family could shower upon a bride, even as they tried to pare down the size of a

woman's dowry and the number of items that might be included in her trousseau. Despite laws passed to outlaw these excesses, the costs of trousseaux and marriage gifts continued to rise. Women's elaborate consumption of clothing, town authorities feared, discouraged many men from marrying. In Florence and other towns, they introduced new taxes that discriminated against men who had failed to wed by a certain age in an effort to prod them into marriage. At the same time fears of male homosexuality grew in some cities as civic officials suspected that a perceived increase in sodomy resulted from male anxieties about the enormous costs of marriage. And finally, fears of population decline emerged as a result of the debate over women's fashions. In 1512, for example, the Republic of Venice faced the threat of an attack from the powerful forces of the League of Cambrai. That year in the midst of these troubles the Venetian Senate spent a month debating the cut of women's clothes and the finery that was permissible on their dresses in order to limit the costs of female fashions. Like civic officials elsewhere, Venice's town fathers perceived women's opulent dress as a barrier to marriage. Their line of reasoning ultimately linked the city's costly fashions with the military crisis, since they credited women's excesses with lengthening the age at which men might marry and thus with depressing the birth rate and ultimately limiting the number of men who might be recruited to serve in the city's army and navy.

MORAL ATTITUDES. Prospective husbands and town authorities detested fashion as a costly excess that threatened family and the home front. The attitudes of the friars—members of the Franciscan and Dominican orders within the church—were even more uncompromising, and arose from long-standing interpretations of Christian teaching. In the fifteenth century a distinguished lineage of Franciscan and Dominican preachers, including St. Bernard of Siena and St. John Capistrano, toured Italy denouncing women's fashions, gaming, prostitution, and Jewish money lending as vain practices that encouraged sexual depravity. In Italian cities the preaching of these figures concluded with huge "bonfires of the vanities" into which men threw their cards, dice, and gaming boards, and women tossed their ruffles and frills. In the wake of these rituals of purification Italy's towns redoubled their efforts to confine the activities of the Jews, often insisting that Jewish men and women wear some distinguishing sign on their clothing to make their identity plain for all to see. They linked Jewish money lending with luxury consumption, and banished prostitutes from cities in the days and weeks that followed the friars' preaching missions. In all cases, the

Engraving of Girolamo Savonarola. © ARCHIVO ICONOGRAFICO, S.A./CORBIS.

prostitutes returned within a few months, but they faced closer scrutiny and limited activity for a time after the friars' missions. The relationship between Jewish money lending, prostitution, and women's finery was close in the friars' perceptions. As they explained in their sermons, women's seemingly insatiable appetite for fashion encouraged single men to spurn marriage for sodomy or sexual relations with a prostitute, even as it forced the married man to Jewish money lenders to support his wife's consuming habits. One of the most vicious and extreme outbreaks of these sentiments occurred in Florence at the end of the fifteenth century, as the Dominican preacher Girolamo Savonarola attracted a following in the city and tried to establish a "Godly" republic. In daily sermons he preached from December 1494 until his downfall and execution in 1498, Savonarola encouraged Florentines to establish a "New Jerusalem" free from the vices of avarice and ostentation. Frequent religious processions and "bonfires of the vanities" popularized the rise of a new holy republic, as many Florentines tried to rid themselves of every hint of immodesty, including their rich finery and games. At the same time, Savonarola's puritanism remained unpopular

a PRIMARY SOURCE document

THE EVILS OF APPAREL

INTRODUCTION: Attacks on clothing styles as a symptom of pride stretched back to the Middle Ages. Even in the late sixteenth century, the Puritan minister Philip Stubbes continued to denigrate fashion in ways similar to many medieval preachers. His *Anatomy of Abuses*, published in London in 1583, recounted a dialogue between a philosopher and a student concerning the evils of pride, in which the philosopher identified pride as a threefold sin that included pride of the heart, of the mouth, and of apparel. Stubbes claimed that pride of apparel was the worst of the vainglorious sins. His claim that his own country England was most given to "newfangledness" and innovation in style might have been vigorously disputed by the many critics of fashion who wrote at the time in all European countries. Each critic seemed always to be convinced that their own nation was most affected by the disease of fashion.

S[tudent]: How is Pride of Apparel committed?

P[hilosopher]: By wearing of Apparel more gorgeous, sumptuous, and precious than our state, calling, or condition of life requires, whereby, we are puffed up into Pride, and forced to think of ourselves more than we ought, being but vile earth and miserable sinners. And this sin of apparel (as I have said before) hurts more than the other two [sins of pride], for the sin of the heart, hurts none but the Author in whom it breeds, so long as it hurts not forth into the exterior action: And the Pride of the Mouth, which consists, as I have said, in offending and bragging of some singular virtue, either in oneself or in his kindred, and which he arrogates to himself (as it were by hereditary possession, or lineal descent from his progenitors) though it be mere ungodly in its own nature, yet it is not permanent. ... But this sin of excess in Apparel remains as an example of evil before our eyes, and it is provocative to sin, as experience daily proves.

S: Would you not have men to observe a decency, a comeliness, and a decorum in their visual Attire?

Does not the word of God command all things to be done ... decently and after a civil manner?

P: Yes truly, I would wish that a decency, a comely order, as you say, a decorum were observed, as well in attire, as in all things else. But would God the contrary were not true. For do not most of our novel inventions and newfangled fashions, rather deform us, than adorn us, disguise us, than become us? Making us rather to resemble savage beasts ... [rather] than continent, sober and chaste Christians?

S: Hath this contagious infection of Pride in apparel infected and poisoned any other countries besides Ailgna [England], suppose you?

P: No doubt but this poison of Pride hath shed forth his influence, and poured forth his stinking dregs over all the face of the earth, but yet I am sure, there is not any people under the Zodiac of heaven ... so poisoned with this ... Pride ... as Ailgna (England). ...

S: But I have heard them say that other nations ... [wear] exquisite finery in Apparel, the Italians, the Athenians, the Spaniards, the Chaldeans, Helvetians, Zuitzers, Venetians, Muscovites, and such like. ...

P: This is but a ... cloak to cover their own shame ... The Egyptians are said never to have changed their fashion, or altered the form of their attire from the beginning to this date ... The Greeks are said to use but one kind of Apparel without any change, that is to wit, a long gown, reaching down to the ground. The Germans are thought to be so precise in observing one uniform fashion in apparel as they have never receded from their first original ... The Muscovites, Athenians, Italians, Brasilians, Africans, Asians, Cantabrians, Hungarians, Ethiopians ... are so far behind the people of Ailgna (England), in exquisiteness of Apparel that they esteem it little or not at all.

SOURCE: Phillip Stubbes, *The Anatomy of Abuses*. (London, 1583): fol. cir–ciir. Text modernized by Phil Soergel.

with the aristocratic and wealthy element in Florence, who taunted him at his public sermons. Thus while the Dominican developed a significant following in the city, members of the government were not always as enthusiastic about adopting his policies as the law of the town. Excommunicated for his anti-papal views, Savonarola was eventually arrested in Florence, tried, and burnt at the stake for heresy. Although his plans for a "Godly Re-public" failed, his extreme puritanical views about the relationship between clothing and morality survived, and religious figures as different as the English Puritans and the Catholic Counter Reformers expressed similar views in the sixteenth century.

SUMPTUARY LEGISLATION. While moral and social reasons prompted Renaissance Italians to regulate dress, sumptuary laws—laws aimed to curtail extravagance in

a PRIMARY SOURCE document

SUMPTUARY LAW

INTRODUCTION: Cities and kingdoms throughout Europe passed frequent sumptuary laws between the fourteenth and the eighteenth centuries to restrict the consumption of fashionable clothing. England's sumptuary laws were typical of Northern European states in that they set out categories of clothes that could be worn by different classes of people. Elizabeth I (r. 1558–1603) did so by setting out a model of what clothes were permissible to be worn by the categories of people who comprised her own household and then enjoining her subjects to hold to the same rules in the country. This excerpt from a 1577 proclamation of one such law explains patiently that previous laws have had little effect on curbing waste in clothing. Elizabeth, in fact, republished these laws at least five times in her reign, and each subsequent proclamation noted that her subjects were not heeding the restrictions. The higher members of her court, though, enthusiastically consumed the articles that were permitted to them, and Elizabeth herself cut a daring sartorial figure as she matured in her office.

Whereas the Queen's Majesty has by sundry former Proclamations notified unto her loving Subjects of this Realm, the great inconvenience and mischief that hath grown to the same by the great excess of apparel in all states and degrees, but specially in the inferior sort, contrary to divers laws and statutes of the Realm, whereof notwithstanding there hath followed no redress or very little at all; whereby hath appeared no less contempt in the offenders, than lack of dutiful care in those to whom the authority to see due execution of the laws and orders provided in that behalf was committed, which thing might give her Majesty just cause (were it not that of her own gracious disposition she is naturally inclined rather to clemency than severity, so long as there is any hope of redress otherwise) to commit the execution of the said laws, to such persons as would have proceeded therein with all

extremity. Notwithstanding her Majesty meaning to make some further trial, before we have recourse to extreme remedies, and finding upon conference had with the Lords and others of her privy counsel, for the redress of so grievous and pernicious a sore in this commonwealth, the chief remedies for the same, to be example, and correction. Her Majesty therefore for the first, which is example, thinks it very meet and expedient that the due execution in her Majesty's most honorable house, of such orders and articles as are annexed to this Proclamation, should serve for a pattern throughout the whole Realm, and therefore her Majesty hath already given, and by these presents doth give special charge to all those that bear office within the said house, to see due observation of the same, which she trusts will be duly observed. And further her Majesty doth generally charge all Noblemen, of what estate or degree so ever they be, and all and every person of her privy counsel, all archbishops, and bishops, and the rest of the clergy, and all other persons, according to their degrees that they do respectively see the same speedily and duly executed in their private households and families. And likewise does [she] charge all mayors and other head offices of cities and towns corporate, the chancellors of both the universities, governors of colleges, readers, ancients and benchers in every Inns of Court and Chancery, and generally all that have any superiority or government over and upon any society or fellowship, and each man in his own household for their children and servants, that the likewise do cause the said orders to be straightly kept by all lawful means that they can.

SOURCE: Elizabeth I of England, Proclamation entitled *By the Queene: Whereas the Queen's Majesty hath by sundry former proclamations notified unto her loving subjects of this realm, the great inconvenience and mischief that hath grown to the same, by the great excess of apparel in all states and degrees.* (London: Richard Jugge, 1577). Text modernized by Philip M. Soergel.

dress—were a common feature of life everywhere in Renaissance Europe. While maintaining a common base in Christian morality, these laws varied from region to region. In France and England, Renaissance sumptuary laws served to reinforce social distinctions and status, with certain items being reserved for the exclusive use of the nobility. In England, a series of Tudor sumptuary laws detailed the kinds of fur, fringes, and cloth that were appropriate for each class. While such regulations eventually spread to Mediterranean Europe, the far greater inspiration for Italian sumptuary regulation lay in the

climate of intense competition that existed within the peninsula's cities. Towns feared that the rivalries in gift-giving and lavish clothes surrounding marriage squandered resources and discouraged men to marry. In Germany, cities and territories also had a long tradition of sumptuary legislation, and they relied on various codes of dress to make obvious distinctions between different categories and classes of people. In particular, Germany's urban sumptuary laws upheld differences in the patterns of dress among guild masters, journeymen, and apprentices. While in most places sumptuary violations merely

resulted in fines, from time to time offenders received more extreme punishments. In 1541, for example, the Protestant reformer John Calvin gained control over the church in the city of Geneva in Switzerland. Among the many moral reforms that Calvin instituted were a stricter prosecution of those who violated the traditional prohibitions against luxury, ostentation, and display. He also tried to curb immodesty by bans on the display of women's busts. During the almost quarter century that Calvin dominated the city, sumptuary violations resulted in more than 800 arrests and as many as 58 death sentences. The rigor of Geneva's sumptuary laws was extreme, however. Most Protestants and Catholics differed little in their attitudes toward sumptuary laws, favoring fines rather than death sentences for violations.

SOURCES

D. O. Hughes, "Earrings for Circumcision: Distinction and Purification in the Italian Renaissance City," in *Persons in Groups.* Ed. R. C. Trexler (Binghamton, N.Y.: Medieval Institute Publications, 1985).

———, "Regulating Women's Fashion," in Vol. II of *A History of Women in the West* (Cambridge, Mass.: Harvard, 1992): 139–168.

———, "Sumptuary Laws and Social Relations in Renaissance Italy," in *Disputes and Settlements.* Ed. J. Bossy (New York: Cambridge University Press, 1983): 69–99.

A. Hunt, *Governance of the Consuming Passions; A History of Sumptuary Regulation* (New York: Macmillan, 1996).

Christiane Klapisch-Zuber, *Women, Family, and Ritual in Renaissance Italy* (Chicago: University of Chicago Press, 1985).

D. Nicholas, *The Later Medieval City, 1300–1500* (London, England: Longman, 1997).

FASHION AS AN INDUSTRY

CLOTHING. While moralists and city officials perceived ostentation and display as a threat to urban society, a large class of wealthy consumers in Renaissance towns admired fashion for its innovations and its ability to express individual tastes. By the fifteenth century a category of wealthy consumers no longer feared ostentatious dress as a sign of concupiscence, the chief evil the friars had identified in lavish clothes. In medieval and Renaissance terminology concupiscence was any strong desire that might lead one to the even greater sins of avarice and sexual depravity. As wealthy Renaissance men and women shed their fears of ruffles and finery, the fashion market expanded in towns like Florence and Venice. By the fifteenth century a vast number of tailors, seamstresses, accessory producers, furriers, glove makers, cobblers, and leatherworkers produced the daily wear and grand costumes consumed in Italian cities. The clothing industry was by this time as varied and complex as the modern "rag trade" is today, and while most of the men and women who toiled in the industry earned low wages, great and middle ranks of tailors who catered to the whims and demands of the city's rich became increasingly common. Their presence in a town like Florence—a city lacking a court and a hereditary aristocracy—points to the development of a style-conscious elite who relied on fashion to express their wealth and family position as well as their individual preferences. Honorable men, Florentines frequently repeated, were created out of "cloth and color." Thus the first glimmers of the modern consumer society can be found in a Renaissance city like Florence, where fashion emerged as an important expression of one's individual identity.

SILKS AND WOOLENS. In Italy, the standard measure for cutting cloth was the *braccio,* a length that differed from city to city but which usually was about 22 to 26 inches long. In Rome, though, the standard was considerably longer, measuring almost thirty inches. In those towns where the cloth trade was a vital part of the local economy, a bronze measuring stick was often affixed on the exterior of the town hall or on the cloth guilding's offices, so that merchants might be sure that they were receiving the correct length of material from local suppliers. Shorting on the weights and measures of raw materials used in the construction of clothing was a serious offense. The cost of fine fabric of the type used in the upper classes' gowns, doublets, and robes fluctuated dramatically, but began at around three florins per braccio for woolens and escalated to twenty florins for the finest silks. Since the grandest men's robes and women's gowns might consume up to 20, 30, or even 35 braccio of material, the cost of fabric used in these garments was enormous. A family of four, for example, could live in Renaissance Florence at a minimal standard in the fifteenth century for sixty or seventy florins annually. Many gowns and robes of the period thus consumed in fabric alone far more than most people's annual incomes. Cloth was expensive for a number of reasons. First, the weaving of wool or silk was a time-intensive project. It required more than 25 steps to produce a length of woolen cloth and nine steps to produce a similar length of silk. Wool had first to be carded and spun into yarn before it was woven, bleached, and stretched. The dying of most fabric occurred after it had been formed into cloth and subjected to more than twenty separate production steps. The cost of dyes varied enormously, with red being the favored color for men's cloth-

WOOL
Imports

The great merchant Francesco Datini presided over the weaving of wool in the Tuscan town of Prato, just outside Florence. Datini was a pious man whose more than 140,000 letters provide one of the great collections of evidence concerning Renaissance commerce. He was also fiercely competitive and amassed a considerable fortune. A relatively self-made man, he often kept his suppliers waiting for months for payment. In her classic biography of Datini, the twentieth-century historian Iris Origo describes the shrewd way in which Datini imported English wool, buying up the raw material from abbeys throughout the island even before the sheep had been shorn. At the same time, Datini was a pioneer in outsourcing, for he also bought up woolen cloth that had been woven in England because it could be sold more cheaply in Italy and throughout Europe than what he could have woven in his own workshops.

It was, of course, exceedingly important to avoid any delay in buying up the clip. At the beginning of the century the papal tax-collectors who purchased English wool from the great abbeys often reserved the amount of the clip they wanted, even before the sheep were shorn, and this custom apparently still survived in some places, for there is a letter to Datini from Francesco Tornabuoni and Domenico Caccini and Co. of London apologizing for some wool from Cirencester which had proved unsatisfactory by saying that he had been obliged to buy up the clip before seeing it. "For one must buy in advance from all the Abbeys, and especially from this one, which is considered the best ..."

The wool—which was classified as "good," "middle," or "young," was exported either in sacks of shorn and wound wool from the clip or as wool-fells (i.e., sheepskins with the wool still on them, collected after the Martinmas slaying)—240 wool-fells, for purpose of taxation, being considered equal to one sack. The wool was brought in to the great barns of the sleepy Cotswold villages, weighed and valued and packed and carded and sold, after much hard bargaining, to the highest bidder, and was then loaded on pack-horses and brought to London, where it was weighed for custom and subsidy, and shipped off with the next merchantman who set sail for the Mediterranean ...

Datini imported to Tuscany not only wool but cloth—which may at first sight seem surprising, since he had a cloth-manufacturing company of his own. It must, however, be remembered that English cloth was not only good, but cheap, since English manufacturers had the great advantage over their Italian or Flemish competitors of first-rate raw material on the spot, and since the English export tax on cloth was then only about 2 per cent, while that on wool was about 33 per cent. Moreover, fine English cloth seems also already to have been fashionable, for we find Datini ... buying "6 scarlet *berrette*, dyed in England" for his own use. The types of cloth he imported were Essex cloth ... in various colours, Guildford cloth ... in various colours, and unbleached cloth ... from the Cotswolds and Winchester, while there is also one record of two bales of "Scottish cloth" sent from Bruges to Majorca.

SOURCE: Iris Origo, *The Merchant of Prato*. (New York: A. A. Knopf, 1957): 57–58.

ing of the time. A wide array of red dyes was available, and the discriminating consumer could distinguish quite easily between those colors that were expensive and cheaper hues. Other colors favored by Renaissance elites included black, purple, and a deep blue violet. Although the weaving of wool was labor- and time-intensive, the industry's returns were far less than those in silk production. Because of the great profits generated by the silk industry, the weaving of this fabric eventually outpaced the production of woolens in Renaissance Italy in many cities. Florence and Venice gave important tax incentives to spur the production of silk, realizing the important revenue that might be generated from the industry. By the mid-fifteenth century Florence's government encouraged the planting of mulberry trees throughout Tuscany, from which the precious cocoons that provided silk's raw material might be grown. Silk

required only nine steps to produce, but the finer thread necessitated a complex, time-consuming weaving process. It might take up to six months to weave a length of luxury silk suitable for making two gowns. Beyond the higher returns of silk production, other factors made it a desirable industry for cities. The higher incomes of the silk weavers made them generally more satisfied and less contentious than wool weavers, and the bigger profits from silk allowed a city to tax it more lucratively than wool. In Italy, the production of many different kinds of luxury silks became popular. These included an array of velvets, taffetas, damasks, and cloth of gold. This last kind of fabric had gold or silver threads woven into them in a number of stunning patterns that caught the light. Sumptuary laws enacted throughout Europe restricted its use; in England regulations permitted it only for nobles of the highest rank, and in Renaissance Italy it could

only be used on women's sleeves. At twenty florins per braccio it was the highest priced fabric of the age.

CLOTHING PRODUCERS. Renaissance men and women usually purchased their cloth directly from producers in the cities before taking these materials to a tailor to be sewn. In many European cities tailors had their own guilds that defined training requirements and set prices for garments. In other towns, those who produced clothing worked in many guilds, depending upon which kind of clothing they produced. In Florence, for instance, some tailors and seamstresses had originally belonged to the city's luxury retail guild before moving into the silk guild. Over time, however, only the producers of the most luxurious garments like male doublets (an elaborate vest worn under a man's robes) maintained their affiliation in these guilds. Eventually most Florentine tailors worked within the guild of secondhand clothiers, men and women who bought up the linens and clothing of the deceased in order to resell them. This guild organized the first "ready-to-wear" marketplace within Florence, and its members also sold silk hats, purses, gloves, and a variety of other fashion accessories. Most of the tailors who belonged to this group ranked among the middle level of artisans in the city, while the most successful had considerable fortunes. Generally, tailors earned only modest incomes in spite of their high level of skills, although the status of the profession increased during the fifteenth century. Female tailors earned less than their male counterparts since they generally served less distinguished clients. The greatest tailors—admittedly a small circle within the guild—moved easily within the cultivated palaces of the time and sometimes became trusted confidantes of their most important clients. Most of these artisans, though, spent their days in less rarefied surroundings.

SUPPLIERS AND CRAFTSPEOPLE. Besides tailors, a complex web of craftspeople also served the clothing industry in all cities. Milliners, cobblers, hosiers, purse makers, furriers, and goldsmiths were just a few of the many categories of artisans who produced clothing and accessories. The labor market was highly stratified, with the makers of slippers falling under different regulations than those who produced shoes or clogs. The guilds carefully monitored the activities of each, ensuring that one group did not stray into another's territory. In addition, the guilds supervised with minute detail just exactly how much each kind of artisan might charge for its work, and they defined the kinds of materials each was to use in production. Beret makers, for instance, were distinguished from those who made hats out of wool or silk, while those who made clasps and buckles were further

separated from those who produced buttons. While a tailor might be responsible for the final sewing of a garment, he sewed the final gown or doublet only after extensive work had been done on the materials by embroiderers, furriers, or goldsmiths. Beyond work performed by guildsmen, a variety of other clothiers worked outside these structures, producing lace, veils, scarves, and other items that were part of a complete dressing ensemble. Many of those producers who worked outside the guilds were independent vendors who crowded into a city's back alleys or sold their wares by going door to door. They were usually female, with reputations for being aggressive salespeople. At Florence, these women vendors were notorious for their brash manners and for encouraging the women to whom they sold to buy more than they needed.

SEWING AT HOME. More sewing was done at home—even in the houses of the very wealthiest families—than in modern times. Some seamstresses did not sew but merely cut material for clothes that could then be sewn by women in the home, thus keeping the costs of daily dress down. In the fourteenth and fifteenth centuries the popularity of underwear was on the rise, and the records and letters of great families show that it was the mistress of the household's job to see that her husband, children, and servants had the proper undergarments. To do so, even many of the wealthiest women usually visited a linen retailer to purchase a bolt of the cloth before she and her daughters set to sewing the chemises, undergarments, and nightcaps for the household. Even high-ranking women acquired skill with the needle and thread, and great families with a daughter in a convent frequently sent her sewing projects to fill the day. Although nuns only wore plain habits, many of them spent their time sewing for others. Lace- and purse making as well as embroidery were crafts that were frequently practiced in the Renaissance convent.

OCCASIONS. As in modern times, Renaissance urban life required different kinds of clothes, depending on the occasion. The men who governed Florence, Venice, and other cities dressed in a dignified, yet magnificent style when in public or conducting affairs of state. Advice books written by humanists counseled men to have their clothes made of the finest fabrics and grand materials in order to prolong their wear and to reflect favorably on their family and city. They cautioned women, on the other hand, to be restrained in choosing clothes to wear at home, although the wives of great men dressed in grand splendor when accompanying their husbands at public occasions. There were many such events annually in Florence and other important Renaissance

a PRIMARY SOURCE document

WOMEN'S DRESS

INTRODUCTION: In the early fifteenth century the Venetian humanist Francesco Barbaro wrote his treatise *On Wifely Duties*. Besides doling out a great deal of advice to women on how to get along with their husbands, Barbaro treated the manner in which the wife should dress. In many humanist treatises of the time, the man of affairs was urged to adopt a magnificent, yet restrained attire. Barbaro, on the other hand, encourages women to avoid waste and to avoid dressing to give pleasure to other men. The only judge of a woman's clothes that mattered was her husband.

This is the point at which to discuss dress and other adornments of the body, which when they are not properly observed, lead not only to the ruin of a marriage but often to the squandering of a patrimony as well. All authorities who have studied these matters bear witness to this fact. If indeed one is pleased by the always praiseworthy rule of moderation, women will be recognized for modesty, and care will be taken for personal wealth and, at the same time, for the city as a whole. Here this fine precept should be followed: wives ought to care more to avoid censure than to win applause in their splendid style of dress. If they are of noble birth, they should not wear mean and despicable clothes if their wealth permits otherwise. Attention must be given, we believe, to the condition of the matter, the place, the person, and the time;

for who cannot, without laughing, look upon a priest who is dressed in a soldier's mantel or someone else girdled with a statesman's purple at a literary gathering or wearing a toga at a horse race. Hence, we approve neither someone who is too finely dressed nor someone who is too negligent in her attire, but, rather, we approve someone who has preserved decency in her dress. Excessive indulgence in clothes is a good sign of great vanity...

Julia, the daughter of Caesar Augustus, imagined that her fine attire was sometimes offensive to her father, so one day she put on a plain dress and went to pay him a visit. When Caesar greatly approved of her new attire, she acknowledged that she was now wearing clothes that would please her father while before she had been dressing to please her husband Agrippa.

One may believe whatever he wishes. But still I think that wives wear and esteem all those fine garments so that men other than their own husbands will be impressed and pleased. For wives always neglect such adornments at home, but in the market square "this consumer of wealth" cannot be sufficiently decked out or adorned. Indeed, a great variety of clothes is rarely useful and often harmful to husbands, while this same variety is always pleasing to paramours for whom such things are invented.

SOURCE: Francesco Barbaro, "On Wifely Duties," in *The Earthly Republic*. Trans. and Ed. B. G. Kohl and R. G. Witts (Philadelphia: University of Pennsylvania Press, 1978): 206–208.

cities. Florence, for example, celebrated at least twenty important feast days each year, in addition to weddings and those affairs demanded by public offices. In this last category, royal visits, the arrival of ambassadors, and state banquets called for those who held urban office and their wives to don their finest clothes. In Italy, most great families kept a logbook that recorded their major purchases, and these included entries for cloth and dress accessories as well as notes about when a tailor had been hired to complete an outfit. These records show that the greatest merchant families of the Renaissance paid endless amounts of attention to their dress throughout the year as the cycle of public festivities and state occasions demanded a steady influx of new garments for public life.

COSTS. Generally, the enormous costs of the wealthy's garments resulted from the high price of materials. The clothes of kings, nobles, and merchant princes consumed an inordinate amount of costly silks, velvets, and woolens, and they were generally bulkier than those worn by society's lower orders. Servants and slaves wore clothes that were shorter and made over patterns that consumed relatively little material. By contrast, the huge, bulky folds of men's robes and women's skirts represented wealth and often slowed the steps of the wealthy to a crawl, lending dignity to the important person's gait. Stories abounded of women who appeared to be weighted down under the dresses they wore on important occasions, and in at least one case a young Renaissance bride had to be carried to her wedding because her dress was too heavy to walk in. The expenditures of Renaissance patricians and merchants differed widely across the spectrum of the upper classes. Prosperous, but not enormously wealthy merchant families spent more each year on clothing than the annual salaries of many venerable professions, including accountants, university professors, and tax collectors. Above this, the inventories conducted at death from some of the wealthiest members of the Renaissance urban elite show that as much as one-third to forty percent of a family's wealth might be invested in clothing.

Portrait of Lucrezia Borgia. © LEONARD DE SELVA/CORBIS.

Yet nowhere in the cities were expenditures comparable to the enormous amounts spent on clothing in Renaissance courts. The records of these courts indicate an enormous increase in clothing costs during the fifteenth and sixteenth centuries. In 1502, Pope Alexander VI married his illegitimate daughter, Lucrezia Borgia, to Alfonso I, duke of Ferrara. She came to Ferrara with a total of more than 80 gowns, 200 day dresses, 22 head-dresses, 20 robes and cloaks, 50 pairs of shoes, and more than 30 pairs of slippers. One of her dresses alone was worth the princely sum of 15,000 ducats. Her jewelry collection included almost 2,000 pearls and 300 gemstones, and in addition, she packed in her trunks another 2,500 yards of precious satins, silks, gold cloth, and velvet to be made into dresses at a later date. To transport her luggage from Rome to Ferrara her father the pope had to have a number of wagons specially constructed, and more than 150 mules were necessary to pull this caravan. Lucrezia Borgia was certainly an extraordinary case, yet as the Medici family in Florence rose to become dukes in the sixteenth century, they, too, emulated such expenditures. Duke Lorenzo de Medici's personal clothing expenses for the year 1515 alone totaled more than 5,100 florins, a truly unbelievable sum when one considers that many respectable professions had incomes of less than 100 florins annually.

WEDDINGS. Renaissance families lavished the greatest care on the creation of gowns for a bride's wedding and the garments that were part of her trousseau. Two ceremonies—one of betrothal, the other of the formal wedding—marked the couple's entrance into married life. The betrothal usually took place some months or years before the actual wedding. At this ceremony, the couple exchanged the words of consent ("I take you to be my lawfully wedded wife") that established marriage. The church's teachings dictated, however, that unions be sexually consummated before they were legally binding, and consummation occurred at a distinctly later date, that is, after the formal exchange of marriage vows at the wedding. During the intervening period, both the bride and groom's family completed the financial exchanges necessary for the marriage to occur. In this period, a great deal of effort went into the creation of the bride's gown for the wedding feast as well as the items that made up her trousseau. During these months the groom also prepared for the coming celebrations by seeing to the creation of the bride's "counter-trousseau," that is, the gifts of clothing, jewelry, and items that he was to offer his bride at the time of the wedding. Of all the preparations, families of brides showered the greatest attention on the actual creation of the wedding gown itself. Sisters, mothers, cousins, aunts, and uncles all weighed in with their opinions about the dress, but in most cases the father of the bride took the active role in determining what kind of dress his daughter wore and in choosing its fabric and decorations. While no Renaissance merchant's daughter ever approached the level of luxury accorded a royal princess, the costs of these gowns was nevertheless enormous, with prosperous, but not wealthy merchants sometimes spending several hundred florins on the gown itself. Pearls and other gems frequently decorated these dresses that grew more complex and magnificent the further up the social ladder one went.

CONCLUSIONS. While preachers and civic officials castigated women throughout the Renaissance for their costly wardrobes, the evidence suggests that men lavished just as much attention on their clothes as women did. The life of a public figure in the Renaissance required careful dressing to project the right image. The preparation of outfits worn at civic events consumed a family's time and money. In fifteenth century Florence, great families might spend as much as forty percent of their wealth on clothing. These upper-class styles favored bulk and ostentatious display, and a complex web of suppliers served this clientele. Tailors and seamstresses represented just one segment of those involved in the clothing

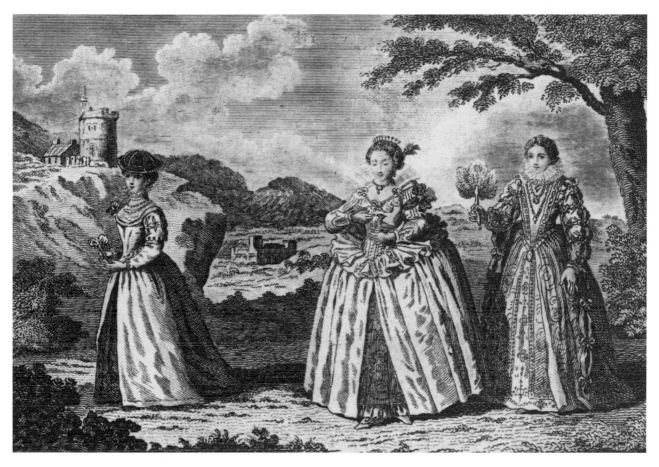

Late eighteenth-century French fashion plate depicting fashions of Renaissance England. HULTON ARCHIVES/GETTY IMAGES. REPRO-
DUCED BY PERMISSION.

industry, as many small suppliers churned out the ac-
cessories, trims, buttons, and other items needed for
dress. Guilds mostly controlled workers in these profes-
sions, but small independent suppliers sometimes carved
out niches in the trade in certain accessories, much to
the guilds' chagrin. Tailors themselves were among the
middle ranks of a town's artisans, less prosperous than
goldsmiths and other master craftsmen. While their sta-
tus was lower than those in the great trades, the fond-
ness of Renaissance men and women for clothing helped
to boost their position within the urban hierarchy. The
greatest of these figures, those who clothed great mer-
chant princes like the Medici and Strozzi families at Flo-
rence, mingled with elites and sometimes became trusted
figures within great Renaissance households.

SOURCES

C. Frick, *Dressing Renaissance Florence* (Baltimore, Md.:
Johns Hopkins, 2002).

L. Molà, *The Silk Industry in Renaissance Florence* (Balti-
more, Md.: Johns Hopkins, 2000).

EARLY RENAISSANCE STYLES

REGIONAL VARIATIONS. Urban and courtly cloth-
ing differed greatly from region to region throughout the
Renaissance, with the styles favored in England vastly
different from those of southern France or Italy. One
factor that sustained this regional variation was the nu-
merous sumptuary laws enacted in various European
cities and states. Whereas a law in one place might for-
bid an item to be used in dressing, another place might
allow it, and the highly specific laws designed to contain
fashion's excesses frequently inspired new styles. Floren-
tine law, for instance, forbade the use of embroidery and
decoration on women's clothing for many decades, ex-
cept at the sleeves. Thus sleeves were often one of the
most complex parts of women's outfits, and Florentine
tailors began to create detachable sleeves that might be
adapted for wear on several different gowns. While tai-
lors often devised cleverly ingenuous fashion solutions
to circumvent the letter of the law, they had to be care-
ful in doing so since tailors and seamstresses who vio-
lated sumptuary legislation were liable for the same fines

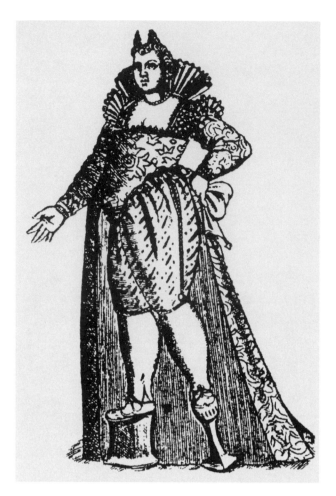

Engraving of a woman wearing chopines, platform shoes. **THE GRANGER COLLECTION, NEW YORK.**

these laws form part of the largest body of legislation to survive from the Renaissance, with thousands of such laws surviving from a region like Germany alone.

COURTLY STYLES. While fashion tended to differ greatly throughout Europe, certain international patterns influenced the courtly styles favored in the fourteenth and fifteenth centuries. For most of the fourteenth century clothing fashions emanated from the royal court in France to be adopted by nobles in England and other Northern European regions. In this period, patterns of dress in Germany, Italy, and Spain, however, continued to evidence strong regional variations. Men in the fourteenth-century French court adopted a close-fitting padded garment known as the *jupon*, which they wore beneath elaborate robes. The popularity of the jupon spread to many regions throughout the course of the fourteenth and fifteenth centuries, inspiring the later fashion of the doublet, a fitted vestcoat that became a highly decorated expression of status. The fourteenth century witnessed the development of new more elastic hosiery fabrics, and men laced these new hose to ever shorter, tighter jupons. Outer robes grew ever shorter to show off the line of a man's legs, leaving a man's buttocks, thighs, and groin relatively exposed under the thin hosiery's material to the dismay of moralists. The clothing styles favored by both French men and women made extensive use of buttons as a sign of wealth and status, with close-fitting, many buttoned sleeves becoming a favorite fashion of women. An innovation of the mid-fourteenth century was the growing tendency for women's bodices to be sewn separately from their skirts, a fashion that opened up new possibilities for decorating each along different lines. At the same time necklines plunged deeper and sleeves grew longer. The dominant style of shoe at the French court, the *poulaine*, was a long pointed-toe construction. The poulaine was particularly well-suited to Northern European styles of dancing known as the *bassedanse* as it elegantly extended the line of the foot.

CITIES. By contrast the styles worn in the early Renaissance cities were distinctly more practical and egalitarian. The vast artistic legacy of the period has left us with a great wealth of depictions of contemporary urban dress. During the fourteenth and early fifteenth centuries, a tradition of sumptuary legislation gave Italian fashions a distinctly republican flavor that downplayed extravagance in favor of a restrained use of ornament and clothes that had relatively simple lines. This style of dress expressed an egalitarian consciousness that was common in the cities among artisans and merchants, and which frequently had an anti-aristocratic edge. Even patri-

that might be levied on a woman or man who wore an offending style. Thus both those who bought and those who created clothing set their minds to creating fashion that might be accommodated within the law's restrictions. Towns, for instance, frequently prohibited the sewing of dresses and robes with stripes made out of pieced cloth since these fashions wasted material. But if a regulation forbade vertical stripes, tailors might create similar daring effects by running the pieced materials horizontally or by demanding that weavers produce new fabric to achieve similar effects. In this way the repertory of fashion continued to be enlarged despite the seemingly draconian regulations designed to contain it. At the same time the ingenuity of tailors and consumers sustained an ongoing climate of restriction throughout the Renaissance as civic and state "fashion police" kept abreast of the latest styles. The result produced a constant flow of fashion regulations, with a town like Florence producing eighty revisions of its laws governing fashion between roughly 1300 and 1500. As a group,

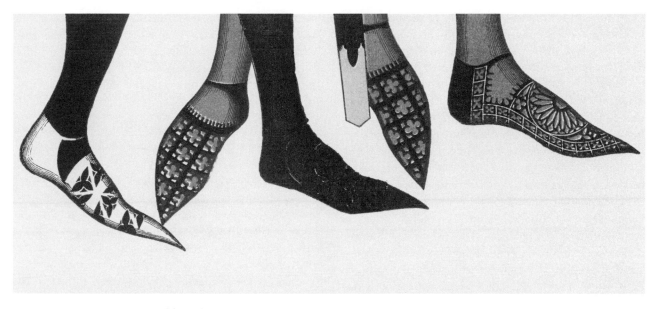

Detail from a painting showing fifteenth-century poulaines, spiked-toe footwear. **MARY EVANS PICTURE LIBRARY.**

cians—nobles who lived within the cities—usually adopted this reserved pattern of early Renaissance dress. Male artisans clothed themselves in simple belted tunics and hose that had soles at the feet, while the civic officials of the Renaissance city wore bulky gowns and robes with rolled hoods. Generally, these garments were not decorated, although the quality of the cloth distinguished upper classes from those of the poorer classes. Women of the time wore woolen gowns or long-sleeved day shifts that covered the body from head to toe. Over these, the working woman wore an apron to protect her garments from soiling. Since all clothing was expensive, working-class women patched their garments or remade them into new styles. Both the skirts of the upper and working classes contained a large amount of material at the front, and the depictions of women in Renaissance paintings often feature them holding these shocks of material artfully to one side. The extra material served the purpose of allowing working women to use the same clothes during pregnancy and upper-class women to disguise whether they were pregnant or not at any given time. Upper-class women seldom showed themselves on the streets of a Renaissance city. Instead they hid themselves from the "prying" eyes of common people and only appeared at events among members of their own class. Thus while the ceremonial outfits of these women were often ostentatious and highly decorated, they were not for public display. One fashion innovation readily adopted by upper-class Renaissance women was the wearing of *chopines,* a form of tall platform shoe first introduced in Venice. Made of cork, wood, or leather, the chopines' platforms could be as high as 18 to 24 inches. Since sumptuary legislation often prohibited women from wearing long trains that consumed inordinate amounts of cloth, the chopines' extreme elevation permitted women to consume more fabric in their dresses while also allowing them to avoid the effects of mud puddles and garbage in the street. The custom was controversial, and as the style spread among wealthy women in Italy and Spain it prompted increasing criticism. In Venice, moralists attacked it as a custom similar to the Chinese binding of feet, and in Spain, royal officials and priests claimed that the chopines' enormous platform soles would destroy the country's cork oak forests. Others charged that prostitutes had introduced the style, and in some cities laws limited the wearing of chopines to women of that profession. Civic officials contended that the hobbling gait such shoes produced was better suited as a sign of "distinction" to these women than it was to those from respectable families.

GROWING SPLENDOR. As Italians developed their more severe fifteenth-century public styles, the lavish life of the court of Burgundy dominated court dress in Northern Europe. Officially a French territory, the duchy's counts began a meteoric rise to European prominence at the end of the fifteenth century by conducting astute marriage alliances and military conquests. The troubles of the Hundred Years' War had diverted the attention of their feudal overlords, the kings of France, who were powerless to prevent the duchy's increasingly enviable position. By the early fifteenth century Burgundy had captured a large area of European territory, including much of northern France, the Netherlands or

Low Countries (modern Belgium, Luxembourg, and Holland), and Lorraine. Enriched by the Flemish cities' cloth industry, the dukes of Burgundy developed the most brilliant court in Europe, noted for its music, dance, poetry, and fashion. At Burgundy, the fashion for many elegant styles reached new, often eccentric extremes, with high-pointed and multi-peaked headdresses becoming common for women. The elongated poulaines, the pointed shoe that was French in origin, reached new fashionable excesses, as their toe peaks sometimes had to be tied to men's knees. Like fifteenth-century Italians, Burgundy's courtiers favored sumptuous reds, from which we take the modern term "Burgundy" to describe the color's deeply tinged shades. Gowns at the Burgundian court and among the Flemish burghers who fueled the territory's prosperity were richly decorated and fashioned from brocade, damask, and other luxuriously patterned fabrics. Cloth of gold, too, was widely used at court as well as elaborate jewelry. Men's styles continued to creep northward, so that the jupons or doublets of the period now only rarely covered a man's buttocks. Toward the end of the fifteenth century, long-standing legend alleges, Burgundy may have also played a role in the development of one of the Renaissance's most puzzling fashions. After Swiss and German mercenaries defeated the duchy's forces at Nancy in 1477, they stormed the duke's tents, which had been hastily left behind in the retreat. The soldiers tore the rich fabrics and tapestries that they found there and tied them through the slashes and holes that had been made in their clothes during the preceding battle. Returning home, this penchant for slashing and slitting clothing was said to have spread in Germany and Switzerland before becoming one of the fashion rages throughout Europe after 1500. While a fascinating tale, the rage for slashing clothes and decorating them with richly contrasting fabrics probably did not arise from a single source. Yet the elaborate display, sumptuous fabrics, and oddly exaggerated styles that were typical of Burgundian taste seem to have captivated the imaginations of wealthy Europeans everywhere as the fifteenth century came to a close. In Italy, where the public dress of wealthy merchants had often been restrained in the city republics, a new trend of purely luxurious consumption became popular. In Florence and other wealthy cities, a taste for elaborate, detachable, and merely decorative sleeves, ornate headdresses, casually unlaced bodices, and a number of other purely decorative items like berets and caps for men swept through wealthy urban society. The once reigning ethos that stressed dignified restraint as a way to create an aura of magnificence now disappeared in favor of patterns of dressing that emphasized the ability of the wealthy merchant class to rise above merely utilitarian considerations. In this way the clothing of the wealthy, but non-aristocratic Italians resembled more closely patterns of court dress popular at the same time in European principalities.

PEASANT CLOTHING. Historians are best informed about the patterns of dressing that predominated in Europe's cities and courts. The rich artistic legacy as well as the many inventories that survive from these quarters of society have left us with rich testimony of the vital importance that clothing played among the nobility and wealthy elites in the continent's cities. Surprisingly less is known about the ways in which peasant society dressed. In the nineteenth century, those that were interested in the history of costume often turned to the countryside and found certain regional or peasant patterns of dress. They reasoned that these were "traditional" costumes that had existed from many centuries. In truth, the terms "fashion" or "costume" to describe the clothing of peasants in the Middle Ages or the Renaissance is inappropriate, and although there were regional variations in traditional Europe, the clothing of the peasantry seems everywhere to have displayed more similarities than differences. One of the most distinctive differences between city and country in the Renaissance, in fact, was in clothing. While in the city one could witness a great variegation in the ways in which people dressed—with patricians and great merchants adopting clothing that displayed their status and wealth—the clothing of peasants was primarily functional. In the countryside men and women rarely had more than two or three changes of clothing, and styles altered relatively slowly over time. The difference between rural and urban dress is all the more surprising when we bear in mind that many in the countryside possessed significant financial resources. Not all peasants were, after all, poor, although many did live at the subsistence level. Whereas powerful urban elites and aristocrats came in the course of the Renaissance to adorn themselves with costly fabrics, gold jewelry, and other precious materials, life in the countryside admitted no such extravagances. The gold that a peasant earned as a result of selling his goods at market very often went into hiding—that is, it was hoarded as a hedge against future crises—rather than spent on finery. Those peasants that were better off still circulated goods, clothing, and other valuable items at the marriages of their sons and daughters, although on a far less grand scale than in the countryside. Daily wear for rural peasants at the beginning of the Renaissance

seems to have showed a considerable similarity across European regions. In the fourteenth century long tunics were still popular for both men and women. By the sixteenth century, simple, ankle length skirts for women had replaced the medieval tunic. Over this peasant women often worn an apron. For men, hose or leggings were donned separately for each leg, while a simple jerkin was worn as outerwear over the torso. By this time, underwear of rough linen had become the rule, even in the countryside. The fabric used for peasant clothes was either homespun, or was purchased cheaply in urban markets. Fabrics constructed from hemp and beaten tree bark were used in regions where the wool trade was undeveloped. Elsewhere coarse, rather than finely spun wool and roughly woven linens were common materials as well. The clothing of the more than 90 percent of peasants was considerably more monochromatic than in the cities, too. Grey, black, white, ivory, and brown were favored over other more brilliantly colored cloth, although rural dress was not without color. Those reared in the cities would have been readily able to distinguish the costly dyes used to give color to the clothes of the wealthy in the cities from the cheaper dyes worn in the countryside. Although leather-soled shoes came into use in Europe at the end of the fifteenth century, wooden clogs and wooden-soled shoes were more popular among peasants than in the city. If peasant outfits were generally constructed from rougher materials, they were not necessarily less comfortable than those worn by courtly and urban elites. Wool provided warmth, a consideration in the cold and damp climate of Europe, and if the character of peasant clothing was more roughly hewn than in aristocratic or merchant societies, it may have all the same been even more comfortable. Peasants did not wear corsets or farthingales, two of the more uncomfortable and constricting garments of the age. Nor were starched collars, known as ruffs, an item of country dress throughout the Renaissance.

SOURCES

M. Davenport, *The Book of Costume.* Vol. 1. (New York: Crown, 1972).

C. Frick, *Dressing Renaissance Florence* (Baltimore, Md.: Johns Hopkins, 2002).

D. O. Hughes, "Regulating Women's Fashion," in Vol. II of *A History of Women in the West* (Cambridge, Mass.: Harvard University Press, 1992): 139–168.

J. Laver, ed., *Costume of the Western World* (London, England: Harrap, 1951).

HIGH AND LATE RENAISSANCE FASHION

COURT FASHION. During the first half of the sixteenth century most courts throughout Europe adopted successive waves of styles in both male and female dress. Around 1500, a taste for German styles became evident, but fashions that were Italian in origin soon superseded them. As a result of these trends, courtly dress tended to shake off many older regional styles and instead become more international in appearance. Similar changes refashioned the dress of bourgeois urban society as well, so that by the mid-sixteenth century the clothes of the most urbane city dwellers in Flanders appeared roughly similar to Italians of the time. This internationalization of style, though, held only in courtly and upper-class urban societies, and even there, an elite foreigner might be embarrassed by the cut of his clothes when he visited another country. Peasant dress and the styles of most artisans and the urban proletariat still continued to differ greatly from region to region. One factor that helped establish the new international styles at court was aristocratic marriage alliances. A case in point is the rise of the *farthingale* throughout sixteenth-century Europe. *Farthingales* were broad hoop skirts that extended the lines of women's hips through a contraption made of wood, hoops, and rope. The style originated in Castile in Iberia (modern-day Spain and Portugal), but spread throughout Europe as the ambitious marriage policy of the Castilian dynasty sent its princesses to other countries. Catherine of Aragon was the first to wear the skirt in England, and at about the same time it appeared in France at the court of Francis I (r. 1515–1547). In both places attacks on the farthingale were common, and moralists charged that it so deformed and accentuated a woman's childbearing parts that it was impossible to tell whether a woman who wore it was pregnant or not, and thus it might promote sexual depravity. Despite such attacks the style continued to make headway in court circles, and by the second half of the sixteenth century its perceived dangers had by and large been dismissed. It became a favorite of Elizabeth I (r. 1559–1603), and was worn widely throughout her court in England, as well as in France, Germany, and Italy.

ATTITUDE TOWARD THE BODY. The farthingale excited public opinion by distorting the body's contours, a trend that affected many sixteenth-century styles, particularly those popular in aristocratic circles up to 1550. Clothes of this period remade the human form by pushing, squeezing, pulling, or in some other

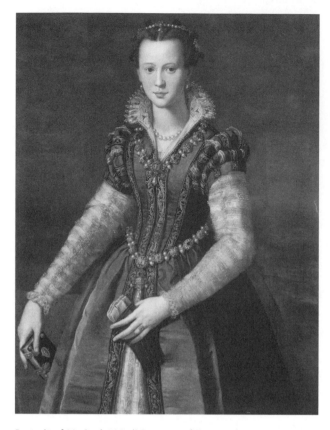

Portrait of Marie de' Medici, queen of France. © ALI MEYER/ CORBIS.

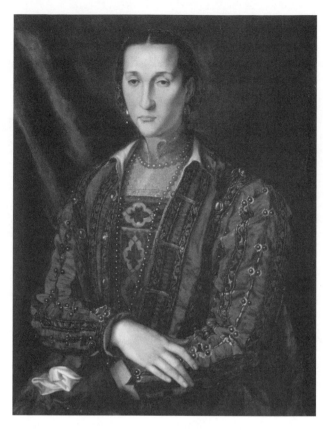

Portrait of Elenore of Toledo. © FRANCIS G. MAYER/CORBIS.

way exaggerating the body. Among the fashion accessories of the age, the corset was an important innovation worn by both men and women. For men, these tight-fitting, whale-boned undergarments shaped the upper body for the form-fitting doublets popular at the time. For women, they were used at first to flatten the bust, and somewhat later in the century to taper the body toward the waist so that women's torsos took on a the shape of an inverted funnel. Another item of dress that came to be greatly elaborated and increasingly important at the time was the codpiece, an accessory that had originally been developed to hide men's crotches as doublet hemlines rose in the later Middle Ages. By the mid-sixteenth century, however, the codpiece took on a heightened importance as an expression of male virility. It was enlarged and frequently covered with decorative touches, including sequins, striped fabric, and other ornaments. Reaching its height of decoration around 1550, the codpiece soon became more restrained, but not after exciting considerable commentary from sixteenth-century preachers and moralists. Codpieces, like farthingales, point to some of the underlying attitudes about style in the first half of the sixteenth century. Unlike the free-flowing, relatively unconstrained robes of the later Middle Ages and the

early Renaissance, the stylish man and woman of this period perceived the body as badly in need of enhancement. The human form required discipline and had to be transformed into what it was not in order to appear stylish. Similarities exist between these attitudes and the roughly contemporaneous Mannerist movement among artists. Mannerist painters, in both Italy and Northern Europe, promoted a "stylish style" notable for its artificiality, elongation, and distortion. Similarly, the clothes that were popular in elite society at this time distended and constricted the human body, making some body parts appear larger, longer, or smaller than they were in reality. In these distortions the stylistic mentality of the first half of the sixteenth century proclaimed a taste for the exotic and the exaggeratedly elegant.

FASHION SHIFTS. Around 1550, aristocratic styles shifted in court circles throughout Europe rather quickly to favor new influences from Spain. German fashions had given birth to a craze for slashing fabric and for making exotic cuts that allowed the undergarments to show through. Italy's contribution to court style had consisted in the elegant juxtaposition of costly materials. The cut of Spanish clothes, however, was altogether different. Often restrained and given to long lines, Spanish tailoring

was widely admired for its excellent fit, which closely followed the lines of the upper body. While Spanish court women favored the farthingale (known in Spain as the *verdugado*) and the elaborate ruffed collar for formal occasions, they also chose clothes that were more severe and restrained than those that had been common in courtly circles in the first half of the sixteenth century. Both men's and women's choices of colors were more limited, favoring deep reds, greens, and black, rather than the bright colors of the earlier period. Indeed a taste for black often became synonymous with the notion of "Spanish style," although the court originally adopted this color in large part because of the protracted period of mourning that Philip II (r. 1556–1598) observed after the death of his first wife, Maria of Portugal, in 1545. Philip II's marriage to Mary I of England in 1554 helped to establish the Spanish style in England, and Spain's dominance in the international arena during the second half of the sixteenth century ensured that its court fashions were imitated almost everywhere in Europe. Besides the high starched ruff at the neckline of men's and women's clothes, the use of a limited color palette, and an emphasis on restrained, yet grand tailoring, another fashionable innovation associated with the Spanish Habsburgs and their noble courtiers was the hooded cape.

ELIZABETHAN AND THE EARLY STUART COURT.
By the end of the century the surviving records of the court of Elizabeth I provide us with a unique glimpse of how the monarch and her court dressed. Elizabeth had a reputation for thriftiness, but she spared little on her dress and that of her court. A number of her portraits show the care she obviously put into choosing her wardrobe. In fact, these portraits are usually far more detailed and accurate representations of her costume than they are of the monarch herself. Following the sixteenth-century court custom, an artist only hastily sketched Elizabeth's image, but took her clothes back to the studio to faithfully copy every element of their finery. As a young monarch, Elizabeth was not known for the quality of the clothes she wore, although as she matured she developed an inimitable style. She favored the drum farthingale and the high starched ruff that developed in imitation of Spanish court dress. Her clothes were heavily embroidered and beautifully produced. Fragments from at least one of Elizabeth's outfits survive, a heavily embroidered jacket and other items she presented to Sir Roger Wodehouse of Norfolk after spending an evening in his house during 1578. This custom was common since clothing had a recognized worth, and Elizabeth's courtiers often used items of dress to settle their debts. The Norfolk outfit shows that she was a small person,

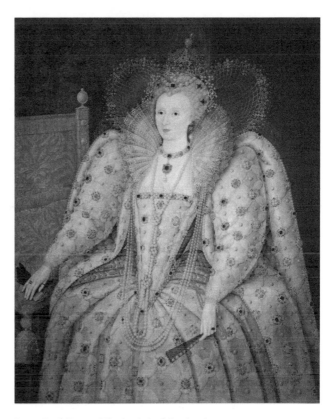

Portrait of Queen Elizabeth I of England. © CORBIS.

and it is richly embroidered with silver and gold sequins. During the 1570s and 1580s Elizabeth favored many-colored gowns, and in her old age her style grew only slightly more restrained. While the finery of the Elizabethan court was considerable, Elizabeth frequently reused embroidered finery, gems, and adapted them into the succeeding years' styles. Still, estimates of Elizabeth's dress collection alleged that she may have had as many as 3,000 gowns made while queen, and that 500 of these were still in her wardrobe near the time of her death. These were apparently left to Queen Anne, wife of her successor James I, who had many of them refashioned for her own use. James I generally increased the splendor of dress at English court in the first years of his reign. Where Elizabeth had spent around £10,000 a year to clothe herself and ranking members of her court in the last years of her reign, the first years of James' ascendancy saw a fourfold increase in the cost of court clothing. Thereafter James' enormous expenditures on court finery grew, reaching a high point of £66,000 during 1612. At the time the humble profession of a wool spinner earned less than £6 annually, and a London craftsman less than £20 per year. Those that James appointed to the post of Master of the Wardrobes continually tried to introduce greater economy into the court's clothing,

a PRIMARY SOURCE *document*

TAMING A SHREW

INTRODUCTION: William Shakespeare, like many Renaissance authors, relied on clothing as a metaphor for the fashioning of the self. In his *Taming of the Shrew*, the hero Petruchio tames Katherina, his restless wife, in part, by breaking her taste for the latest fashion. He presents her with a dress and tailor to clothe her to attend her sister's wedding and then proceeds to rip the gown to shreds in front of her. The scene is also notable for its many mentions of different fashions of the late sixteenth century.

Petruchio: ... And now, my honey love,
Will we return unto thy father's house
And revel it as bravely as the best,
With silken coats and caps, and golden rings,
With ruffs and cuffs and farthingales and things,
With scarfs and fans and double change of brav'ry.
With amber bracelets, beads, and all this knav'ry.
What, hast thou din'd? The tailor stays thy leisure,
To deck thy body with his ruffling treasure.
[Enter Tailor]
Come, tailor, let us see these ornaments;
Lay forth the gown. [Enter Haberdasher]
What news with you, sir?

Haberdasher: Here is the cap your worship did bespeak.

Petruchio: Why, this was moulded on a porringer;
A velvet dish. Fie, fie! 'tis lewd and filthy;
Why, 'tis a cockle or a walnut-shell,
A knack, a toy, a trick, a baby's cap.
Away with it. Come, let me have a bigger.

Katherina: I'll have no bigger; this doth fit the time,
And gentlewomen wear such caps as these.

Petruchio: When you are gentle, you shall have one too,
And not till then.

Hortensio: [Aside] That will not be in haste.

Katherina: Why, sir, I trust I may have leave to speak;
And speak I will. I am no child, no babe.
Your betters have endur'd me say my mind,
And if you cannot, best you stop your ears.
My tongue will tell the anger of my heart,
Or else my heart, concealing it, will break;
And rather than it shall, I will be free
Even to the uttermost, as I please, in words.

Petruchio: Why, thou say'st true; it is a paltry cap,
A custard-coffin, a bauble, a silken pie;
I love thee well in that thou lik'st it not.

Katherina: Love me or love me not, I like the cap;
And it I will have, or I will have none. [Exit Haberdasher]

Petruchio: Thy gown? Why, ay. Come, tailor, let us see't.
O mercy, God! what masquing stuff is here?
What's this? A sleeve? 'Tis like a demi-cannon.
What, up and down, carv'd like an appletart?
Here's snip and nip and cut and slish and slash,
Like to a censer in a barber's shop.
Why, what a devil's name, tailor, call'st thou this?

Hortensio: [Aside] I see she's like to have neither cap nor gown.

Tailor: You bid me make it orderly and well,
According to the fashion and the time.

Petruchio: Marry, and did; but if you be rememb'red,
I did not bid you mar it to the time.
Go, hop me over every kennel home,
For you shall hop without my custom, sir.
I'll none of it; hence! make your best of it.

Katherina: I never saw a better fashion'd gown,
More quaint, more pleasing, nor more commendable;
Belike you mean to make a puppet of me.

Petruchio: Why, true; he means to make a puppet of thee.

Tailor: She says your worship means to make a puppet of her.

Petruchio: O monstrous arrogance! Thou liest, thou thread, thou thimble,
Thou yard, three-quarters, half-yard, quarter, nail,
Thou flea, thou nit, thou winter-cricket thou-
Brav'd in mine own house with a skein of thread!
Away, thou rag, thou quantity, thou remnant;
Or I shall so bemete thee with thy yard
As thou shalt think on prating whilst thou liv'st!
I tell thee, I, that thou hast marr'd her gown.

SOURCE: William Shakespeare, *The Taming of the Shrew,* Act IV, Scene 3.

but with few long-term effects. Graft and corruption significantly inflated the costs that James' court paid for its wardrobe. But even when this is taken into account, the finery must have been striking. James' level of expenditure was enormous, particularly so when one considers that England was, by European standards, a relatively poor country at the time.

COMMON PEOPLE. Throughout the Renaissance, fashion had been largely a game in which only aristocrats and wealthy city dwellers might participate due to the exorbitant cost of handwoven cloth. The vast majority of society—from craftsmen, to the urban proletariat and peasantry—remained largely unconcerned about the cut of their clothes. Hand-me-downs were a common fact of life, and patching or remaking clothes to suit new circumstances was an everyday event for most people. Fashion played no role in these societies. Toward the very end of the sixteenth century evidence points to the growth of consumption among broader segments of the population. Still, it was to be at least another century before a majority of the population developed the kind of fashion consciousness that wealthy merchants and nobles evidenced during the Renaissance. A key invention in this development was William Lee's perfection of a knitting machine in 1589. Lee, a clergyman in London, applied for a royal patent for his efforts, but Elizabeth I denied his request because she feared the invention would put large numbers of people out of work. The Renaissance's technological base thus continued to prove too rudimentary to provide luxury goods like finely woven or knitted cloth to the majority of the population. Without automation, the lavish display typical of upper-class clothing continued to have the whiff of immorality and luxury for vast portions of the population. Upper-class innovations in dress had long been criticized for its excess and senseless patterns of change, and as the Renaissance approached its conclusion, fashion's critics continued to charge that the ever-changing bazaar of style deformed the body and made it into an object of rampant sexual desire. Critics also blamed fashion's constant patterns of change for contributing to the squandering of family and state resources. Even so, a barely perceptible but undeniable change in attitude during the sixteenth century made comfort and luxury more acceptable in the eyes of the general population, an attitude that solidified with the emergence of a consumer society in Europe around 1700. In 1530, the humanist moral philosopher Desiderius Erasmus wrote a little tract entitled *On Good Manners,* to teach civility to young male students. Much of Erasmus' advice seems strikingly modern, while other parts express the traditional atti-

tudes of his age. Erasmus counseled his readers on how to stand, sit, walk, and even blow one's nose. But when he considered dress, he cautioned young men from thinking too much about their clothes. Instead they should ensure they were clean and tidily presented. Erasmus further advised his readers to avoid innovations at all costs: "Slashed garments are for fools; embroidered and multicolored ones for idiots and apes." In his opinion, fashion was an affectation of the rich which did little more than flaunt magnificence and bring before the eyes of the less fortunate their own wretchedness. As a result, its offspring were jealousy and hatred. Within a generation or two after Erasmus wrote, Jesuit missionaries made their way to the New World and the Far East. In their letters and journals some of these figures noted the absence of changing styles of dress among the Indians and the Japanese. Fashion, long attacked and criticized throughout the later Middle Ages and the Renaissance, had thus entered into the warp of the European mentality. It was to remain there as an important part of the economy and as a symbol of cultural vitality, imagination, and decadence until modern times.

SOURCES

F. Braudel, *The Structures of Everyday Life: The Limits of the Possible* (Berkeley, Calif.: University of California Press, 1992).

M. Davenport, *The Book of Costume.* Vol. 1. (New York: Crown, 1972).

D. O. Hughes, "Regulating Women's Fashion," in Vol. II of *A History of Women in the West* (Cambridge, Mass.: Harvard University Press, 1992): 139–168.

A. R. Jones and P. Stallybrass, *Renaissance Clothing and the Materials of Memory* (Cambridge: Cambridge University Press, 2000).

J. Laver, ed., *Costume of the Western World* (London, England: Harrap, 1951).

SIGNIFICANT PEOPLE
in Fashion

BERNARD OF SIENA
1380–1444

Franciscan preacher

NOBLE BIRTH. Bernard of Siena was born, not in the town of Siena but in the seaport of Massa Maritima,

where his father, a Sienese noble, was living at the time. He was orphaned at an early age and decided on a religious life after spending time caring for the sick and dying during an outbreak of the plague in 1400. He joined the Franciscan order in 1402, becoming a member of a strict Observant monastery in the order. At the time the Observant movement within the Franciscans championed an austere and disciplined interpretation of the rules of the order, emulating St. Francis' initial asceticism and poverty. Bernard soon developed skill as a preacher and began to conduct missions in and around his convent, which was near Siena, and in other cities throughout northern Italy. His fame as a preacher spread far and wide through a hugely successful mission he undertook during 1417. Transcripts of some of Bernard's surviving sermons illustrate his colorful style. He ranged over a broad variety of topics, including sexuality, heresy, domestic life, and clothing. He spiced these sermons with a common touch, including the use of bawdy sexual humor. The paintings that survive of his missions show that his audience was largely women, and those who heard him recorded that he often grew exasperated when his listeners grew restless.

BONFIRES OF THE VANITIES. Bernard of Siena's preaching missions made skillful use of religious ritual as well. He designed an emblem that included a seal made from the letters "YHS," which stood for the Holy Name of Jesus. After whipping his audience into a frenzy of enthusiasm through his skillful rhetoric, he often concluded his sermons by holding up the emblem to the roars and cheers of the crowd. Like Catherine of Siena and other figures revered for their pious lives, he also engaged in peacemaking, mediating disputes in the Italian cities and encouraging combatants to adopt the YHS seal to replace their factional banners. His heavy reliance on the "Holy Name of Jesus" worried some clerical officials at the time because they feared that it led his audiences into idolatry. While Bernard was known for his peacekeeping skills among Christians, he was not so sanguine with those that stood outside the church's fold. His sermons frequently attacked the Jews for their money lending and pawn brokering, and prostitutes were also a frequent target as well. On the positive side, he did help to inspire movements that redeemed women out of prostitution by providing them with dowries so that they might marry. Later fifteenth-century preachers imitated his preaching missions, and elements of his style can be found in the sermons of St. John of Capistrano and the fiery rebel Girolamo Savonarola. These missions sometimes included dramatic public exorcisms, and they stirred weeping and intense displays of emotion from the

audience. They usually concluded with a huge "bonfire of the vanities," into which men threw their cards, dice, and gaming boards, while women cast off their lace, ruffles, and other finery. Given this level of emotion, prostitutes and Jews often temporarily left town when word of Bernard's impending visit spread.

SAINTHOOD. Bernard was already revered by many during his life for the saintliness of his behavior. He died during a preaching mission, and his cult quickly developed following his death. Reports of miracles associated with these relics were frequently broadcast in the years immediately after his death, and his canonization—that is his rise to an official saint of the church—had already occurredby 1450. In this role, his memory continued to live on since he was frequently a subject for religious altarpieces. His fiery sermons, which often forged a link between vain display and contemporary styles in clothing, also long outlasted his death.

SOURCES

C. L. Polecritti, "Bernardino of Siena," in *Encyclopedia of the Renaissance* (New York: Scribner 1999).

I. Origo, *The World of San Bernardino* (New York: Phaidon, 1962).

LUCREZIA BORGIA
1480–1519

Italian noblewoman

OTHERS' AMBITIONS. Lucrezia Borgia was one of the most notorious of Italian noblewomen of the Renaissance. Her fame arose, not from her own ambitions but from those of her brother and father. Her father was a member of the Borgia, a noble family of mixed Spanish and Italian heritage, and in 1492, he became Pope Alexander VI. Her mother, Vannozza Cattanei, was her father's longtime mistress, and she bore him four children, including the famous Cesare Borgia, who became his father's right-hand man in the papal states during the 1490s.

THREE MARRIAGES. Lucrezia was married three times to suit the changing course of the Borgia's political ambitions. The first marriage was to Giovannia Sforza, lord of a small territory of Pesaro. In 1498, when the opportunity presented itself, Lucrezia's father annulled this marriage and wed her to Duke Alfonso of Busceglie. Alfonso was the illegitimate son of the king of Naples, but in 1501, as a new opportunity beckoned, Lucrezia's brother Cesare had Alfonso assassinated. Finally, Lucrezia wed Alfonso D'Este, the powerful duke of Ferrara. In her capacity as duchess of Ferrara, Lucrezia presided over a

brilliant court. Among those who were affiliated with Ferrara during her rule as duchess were the poets Pietro Bembo and Ariosto and the humanist and printer Aldus Manutius. Despite her previous marital difficulties, Lucrezia made her husband an admirable wife and bore him seven children. The people of Ferrara, too, affectionately held her in high regard because of her numerous charitable activities in the small state. She died young, though, as a result of complications from childbirth.

STYLE. Long-standing rumors once linked Lucrezia with the suspicious deaths, not only of her second husband but of several other Italian nobles. Her notoriety, however, was largely the result of her relation to the ruthless figures of her father, Pope Alexander VI, and her grasping brother, Cesare. In her own time, though, Lucrezia was widely recognized in court circles for her style, and her dowry and trousseau were among the largest for a noblewoman of the early sixteenth century. Lucrezia came to Ferrara with one of the largest trousseau ever recorded up to this time, worth the princely sum of 15,000 ducats. While Lucrezia's impressive wedding ensemble was extraordinary, it points to the enormous role that clothes played in defining status and rank in the Renaissance world.

SOURCES

M. Bellonci, *The Life and Times of Lucrezia Borgia.* Trans. B. Walls (New York: Harcourt, 1953).

R. Erlanger, *Lucrezia Borgia: A Biography* (New York: Hawthorn Books, 1978).

J. Haslip, *Lucrezia Borgia* (Indianapolis, Ind.: Bobbs-Merrill, 1953).

M. Mallett, *The Borgias* (Chicago: Academy Chicago, 1987).

FRANCESCO DATINI

c. 1335–1410

Cloth merchant

CORRESPONDENCE. Francesco Datini's life is one of the best documented merchant stories in all European history. At his death he left behind almost 140,000 letters and a collection of more than 500 account books. His career may not have been extraordinary, but the degree of records his businesses produced have provided a rich mine for scholars anxious to reconstruct the history of one of Europe's most vigorous commercial centers in the early Renaissance.

HUMBLE BIRTH. Datini came from humble origins and lost his parents during the Black Death in 1348. When he was about fifteen he left Florence and traveled to Avignon, which at the time was the capital of the Roman Church. There he began work in a Florentine business in the city. Like many later capitalists he shepherded his resources, eventually investing in the business. Within eight years of his arrival in Avignon, he had already acquired a significant fortune, although his success later in life was to outstrip vastly these early successes. In Avignon, Datini dabbled in all manner of business, including the selling of salt, dyes, gemstones, works of art, and military equipment, such as armor and daggers. When he was 47 he returned to Tuscany and took up residence in Prato, a small, but important trading center just outside Florence. Like other merchants of the day, he patronized scholarship, providing financial support for Lapo Mazzei's university studies. These two figures conducted an extensive correspondence, the letters of which revealed that Datini's business interests had become a significant burden in his later life that required him to spend a great deal of each day managing his enterprises. By the end of the fourteenth century, for example, Datini's interests had branched out from his early dabbling in retail and small trade. He now controlled a vast number of banking interests in trading companies. From Prato, his ties stretched out to firms in England, Flanders, Spain, the Near East, as well as the major Italian societies. By this time, Datini was also a major figure in the woolen industry, and he regularly imported huge amounts of fine English wool and finished English cloth to Italy. He kept a small portion of the wool he imported for his own woolen workshops, but also resold a great deal of the raw product to weavers throughout Tuscany. English cloth, while widely respected at the time, could also be sold cheaper in Italy because of its lower cost structure. Thus Datini was one of Europe's first outsourcers. Beyond these interests in the wool industry, the Merchant of Prato, as he came to be known, had a large amount of real estate at the time of his death, including more than seventy properties in and around Prato.

TRENDS. Datini's life and career shows the possibilities and limitations that existed within Renaissance society. Born relatively poor, he climbed the social and economic ladder in the urban world through a shrewd understanding of the new realities of trade. Like the Medici and other major Italian merchants of the time, Datini arranged all of his interests into an organization that resembled the modern industrial holding company. The branches of his business that stretched throughout Europe each constituted a separate company, although Datini retained controlling interest in their governance. In these ways he limited his liability, since if one of his business or banking interests failed, it did not threaten

his still healthy companies. He was also extremely pious, supporting charitable organizations and founding the *Casa del Ceppo* to aid poor children. Generally, he did not involve himself in politics, though he did spend a brief period as a civic official in Prato. Shrewd, high-handed, and arbitrary, he, like many other merchants of his time, often strung along his small suppliers, many of whom performed steps in the production of wool for his shop. Datini kept these poorer artisans and craftspeople in a servile position, often refusing to pay them for months on end for their work. His curious combination of religious sentiment, corrupt practices, business acumen, and entrepreneurial risk taking, though, is strikingly modern.

SOURCES

E. Baselli, *Francesco di Marco da Prato; notizie e documenti sulla mercatura italiana del secolo XIV* (Milano: Fratelli Treves, 1928).

Giovanni Caselli, *Un mercader florentino* (Barcelona: Molino, 1987).

I. Origo, *The Merchant of Prato* (London, England: Jonathan Cape, 1957).

ELIZABETH I

1533–1603

Queen of England

EARLY TROUBLES. The early years of Elizabeth's life were fraught with problems, largely brought about by the tempestuous marital career of her father, Henry VIII. Daughter of Henry's second wife, Anne Boleyn, Elizabeth had been conceived officially out of wedlock, and with the execution of her mother she grew up in the company of governesses and tutors, largely ignored by her father. Her early life was troubled, and during the reign of her sister, Mary Tudor, she was even suspected of treason. These problems left her ill-prepared for assuming the throne, but in 1558 Mary's death put Elizabeth in control of the state nonetheless, and despite ongoing problems she fashioned an enormously effective domination of her country.

RELIGION AND POLITICS. The advances that Elizabeth made in English government are too complex to be all but suggested here. In place of the religious factionalism and infighting that had dominated court and parliament during the previous 25 years, Elizabeth gradually achieved a mediating settlement that became styled as the *via media* or "middle way." In a famous statement she was alleged to have said that she had no intention of

"making windows onto men's souls," and so she cautiously reintroduced the Protestant *Book of Common Prayer*, with conciliatory nods toward Catholics. As her policy matured, she threatened those who questioned her moderate religious policy with fines, rather than death, although a number of staunch and prominent Catholics were indeed executed during her reign. During the Elizabethan period, too, the Puritans grew as an opposition party in Parliament. Although Elizabeth I skillfully maintained power despite their demands for increasingly definite Protestant reforms, she left her successor James I with many issues unresolved in this regard. At court, Elizabeth often played nobles against one another, but she was criticized for her pattern of favoring a succession of male courtiers. Some of these, like Robert Dudley, were married, inspiring rumors about her sexual depravity. At home, Elizabeth tried unsuccessfully to curb the changing styles and expensive fashions of her subjects. On many occasions she reissued her sumptuary laws, which were designed to designate status by limiting the consumption of rare and expensive items to the upper nobility. The constant reissuing of these royal edicts, however, demonstrates their ineffectiveness, although their prohibitions against imported items stand as evidence of the growing mercantilist spirit of her day. Mercantilism promoted the economic self-sufficiency of a country by trying to drastically reduce a country's imports.

COURT CULTURE. Although Elizabeth cut a rather austere figure at the outset of her reign, she adopted a fashion of dress that was increasingly grand as her reign progressed. An inventory conducted of her clothes before her death showed she had more than 500 gowns, and it was rumored that she had more than 3,000 of these elaborate dresses created during her reign. Tudor dress, like all sixteenth-century court clothing, was complex and many layered. Numerous items that made up an ensemble were reused year after year in new guises, thus much of the gem-embroidered finery in which Elizabeth was often depicted in her portraits were reusable. At the end of a season her maids carefully trimmed away the beads and other precious gems to be used in the next year's fashionable creations. Her clothing also had added use as costumes for the immensely popular court masques of the time or her dresses were passed on to courtiers for favors rendered. Thus while the scale of Tudor life was grand—clothing costs totaled almost £10,000 annually in the final years of Elizabeth's reign—the tenor of court life in England was more reserved than elsewhere in Europe.

ACHIEVEMENT. Elizabeth I came to power in England at a time when feminine monarchy was controver-

sial throughout Europe, and yet she managed in the 35 years of her reign to place her indelible stamp on the Tudor court and on her nation. She was more than adept at skillfully handling her opponents and in using faction to her own advantage. Internationally, Elizabeth largely kept England out of many continental intrigues, but in the defeat of the Spanish Armada in 1588 she placed a powerful imprint on the politics of the sixteenth century. That victory, although only momentary since England fought Spain for another ten years, provided an enormous boost to the morale of Protestant states in Northern Europe. Under Elizabeth's guidance, a Protestant prince had succeeded in taking on the greatest Catholic power of the age. Her period also coincided with an unprecedented growth in English literature and the rise of the professional theater in London. Both institutions benefited from the relative peace and stability that Elizabeth provided as well as from her tangible patronage. At the same time, the queen was also imperious, stubborn, and vain. In her old age, for example, she dismissed the Earl of Essex from her patronage after he surprised her in her chambers and saw her without her makeup and wig. By this date the bloom of Elizabeth's reign had long since faded, and her popularity had waned, both among her courtiers who rarely received financial advantage from her, and among her subjects, who were by this time heavily taxed to pay for the golden aura of her court.

SOURCES

P. Johnson, *Elizabeth I* (New York: Holt, 1974).

C. Levin, *The Heart and Stomach of a King* (Philadelphia: University of Pennsylvania Press, 1994).

W. McCaffrey, *Elizabeth I* (London, England: 1993).

MARIE DE' MEDICI

1573–1642

Queen of France

ART AND FASHION. The propulsion of Marie de' Medici into the arena of high politics arose from the crisis of the French monarchy at the end of the sixteenth century. With the kingdom of France under a heavy burden of debt after more than thirty years of civil war, the country's new king, Henry of Navarre, divorced his wife, Marguerite de Valois, and married his niece, Marie de' Medici, in 1599. Henry owed Marie's father a lot of money, and as part of these marriage negotiations much of this debt was forgiven in exchange for a large portion of Marie's dowry. While Henry tried to introduce greater economy into the French court, particu-

larly concerning matters of dress, Marie was from the first one of the most fashionable women of Europe. Her early portraits show her obviously sumptuous style. In contrast to the relatively restrained Spanish tailoring that was popular in the late sixteenth century, Marie favored ermine, gem-embroidered gowns, and luxurious high ruffed collars. Her taste for lavish clothes was immortalized in a series of portraits and paintings on royal themes painted by the French artist Pourbus and eventually by the great seventeenth-century Flemish painter Peter Paul Rubens. During Rubens' time as Marie de' Medici's court painter, he completed a series of 25 canvasses that glorified the history of her life and royal mission. The relationship that developed between Rubens and Marie was a close one and gave rise to a correspondence. During her last period of exile Marie also stayed with her artist for a time in Flanders. In short, Marie de' Medici's life shows the close relationship that developed between fashion, art, and political power during the late Renaissance. Marie may have been a woman who played a high stakes political game and lost, but she astutely understood the necessity of fashioning an imposing royal image while she was involved in royal pursuits. Since the seventeenth century, though, the lavish face that she presented to her world has often been used to lend credence to the charge that she was but a mere fashion plate, instead of a woman against whom the forces of her times conspired.

RISE TO POWER. Marie de' Medici's rise to power began with the assassination of her husband, Henri IV, in 1610. On the day following his death, Marie convened a royal assembly, installing her son, the heir to the throne, beside her to show that she intended to exercise power in his name. This disregard for the traditional mourning period that followed a monarch's death scandalized the French court, but Marie persisted all the same in her attempts to dominate French politics. In the years immediately following the death of her husband, Marie recruited Rubens to glorify her role in French politics. In these paintings, which were originally housed in the Luxembourg Palace in Paris, the queen regent was elegantly displayed in all her finery. In her office she continued to pursue many of the same policies of her late husband, although her involvement in state affairs eventually resulted in her own exile from France in 1630, as she fell afoul of her son and his powerful minister, Cardinal Richelieu. Even in exile, though, Marie de' Medici continued to present herself in royal style, making imposing entries into cities in Flanders and Holland, clad in her royal finery. During this bleak period of her life, she spent time in her daughter's court in England, but

as the crisis of royal government worsened in that country she moved on to Cologne in 1641. She died not soon after, impoverished. Her application to her son, the king of France, for permission to be buried in the royal gravesite at St. Denis had been ignored during her life, but in the months following her death, Louis XIII granted her wish.

SOURCES

D. Marrow, *The Art Patronage of Maria de' Medici* (Ann Arbor, Mich.: UMI Research Press, 1982).

Peter Paul Rubens, *Life of Marie de' Medici* (New York: Abrams, 1967).

S. Sarrow, *The Golden Age of Marie de' Medici* (Ann Arbor, Mich.: UMI Press, 1973).

DOCUMENTARY SOURCES
in Fashion

Leon Battista Alberti, *The Book of the Family* (c. 1435)—An advice book written for wealthy urban families, it discusses the different patterns of dressing that men and women ought to adopt.

Bernard of Siena, *Sermons* (c. 1410–1444)—These sermons provide insight into the piety of the later Middle Ages. Bernard links women's fashions of the day, Jewish usury, and prostitution, all in a lively way that held his mostly female audience captivated, and which encouraged them to throw their finery into "bonfires of the vanities" following these sermons.

Francesco Barbaro, *On Wifely Duties* (c. 1410)—This advice manual, intended for women and their husbands, counsels on all sort of problems arising out of marriage. One chapter treats the way in which women should dress themselves.

Giovanni Boccaccio, *Decameron* (c. 1350)—Clothing and the cloth trade figure prominently in this major work of fiction. The final story of patient Griselda Boccaccio gave to the Renaissance a poignant tale about the role that men played in shaping women's dress, and he warned his readers that nobility of spirit was more important than fashionable dress.

Baldassare Castiglione, *The Book of the Courtier* (1527)—This is a major Renaissance advice book that treats the subject of dress and shows the mounting importance that elegant clothing played in the minds of courtiers of the day.

Francesco Datini, *Correspondence* (c. 1380–1410)—This is one of the largest collections of Italian letters to survive from the Renaissance. These detail the activities of Datini in the wool trade of the late fourteenth century.

William Shakespeare, *The Taming of the Shrew* (1594)—In this famous play, Shakespeare's hero uses clothing as one of the ways to tame a wild wife.

Philip Stubbes, *Anatomy of Abuses* (1583)—This is a late Renaissance indictment of fashion from the hand of a Puritan minister. Stubbes repeats many of the charges that had long been made against fashion's vanities over the past centuries and argues that "newfangledness" in fashion is chief among all the permutations of the sin of pride.

LITERATURE

Philip M. Soergel

IMPORTANT EVENTS
in Literature

c. 1300 Humanism, with its emphasis on the works of classical Antiquity, begins to attract disciples in Italy.

1321 Dante Alighieri completes his *Divine Comedy*.

1341 Petrarch crowned poet laureate at Rome.

c. 1350 Giovanni Boccaccio meets Petrarch, and Boccaccio's collection of stories, *The Decameron*, is completed.

1374 Petrarch dies, having achieved widespread fame through his literary works.

Coluccio Salutati is called to Florence to become the town's first humanist-trained chancellor. In that capacity he will support the arts and humanities.

1375 Boccaccio dies.

1385 Chaucer writes *Troilus and Cryseide*.

c. 1387 Geoffrey Chaucer begins the *Canterbury Tales* in Middle English. In the coming century, the language will evolve into its early-modern form.

1391 Salutati completes his *On the Labors of Hercules*, a study of the poetry related to Hercules. One year later he will discover letters written by Cicero in a library at Verona.

1396 Manuel Chrysoloras begins to teach Greek in Florence to the city's humanist scholars.

1400 Chaucer dies and is buried in Westminster Abbey, London.

1405 Christine de Pizan writes her classic *Book of the City of Ladies*, a work influenced by Giovanni Boccaccio's *On Famous Women*.

1427 Leonardo Bruni, an accomplished humanist and historian, accepts the post as Chancellor of the City of Florence.

1431 François Villon, greatest of France's fifteenth-century poets, is born.

1434 Leon Battista Alberti uses Tuscan Italian to compose his humanist tract *On the Family*.

1440 The Italian humanist Flavio Biondi completes his *Decades of History since the Decline of the Roman Empire*, a great contribution to medieval history.

1458 Aeneas Silvius Piccolomini becomes the first humanist pope. An active author, he will support scholars and build the Vatican Library as Pope Pius II.

1462 Lorenzo de' Medici appoints Marsilio Ficino to translate the works of Plato from Greek into Latin. Ficino's own mixture of Christian theology and Platonic teaching will have a tremendous impact on literature, particularly in its notion of Platonic Love.

1470 First printing press is established in the city of Paris. Two years later the technology will appear in Spain and by 1473, in Lyon, a city destined to become a center of humanist publishing.

1491 Froben publishing house is established in Basel; the Froben press will eventually become dominant in editions of humanist works in sixteenth-century Europe.

1492 Marguerite of Navarre, author of the *Heptameron*, is born.

c. 1493 Fernando de Rojas writes *La Celestina* as a sixteen-act play; in novel form the *Celestina* will eventually become the

sixteenth-century's best-loved piece of fiction.

1494 Sebastian Brant's satire, *Ship of Fools* is published.

Hans Sachs, author of more than 6,000 poems, dialogues, and plays is born at Nuremberg.

1495 Aldine Press established by Aldus Manutius, a scholar. The press will maintain publishing houses in Rome and Venice and will become famous for its pocket size books and its publication of many Greek classics.

1496 John Colet arrives in Italy for three years of study with Renaissance Platonists, including Ficino and Mirandola. He will help to popularize Platonism in England upon his return in 1499.

1502 The German humanist Conrad Celtis publishes his *Four Books of Love Poetry*, the only one of his many writings that will be printed during his life.

1503 Sir Thomas Wyatt, the most accomplished poet of King Henry VIII's age, is born.

1505 Polydor Vergil, an Italian scholar who will become the best historian of the English Renaissance, arrives in England on an assignment from the pope.

1509 Desiderius Erasmus dedicates his *Praise of Folly* to his friend Thomas More.

c. 1513 Baldassare Castiglione begins his *Book of the Courtier*.

1516 Sir Thomas More completes the second book of the *Utopia*. The first book and a complete edition of the work will be published two years later in Basel.

In Italy, Ludovico Ariosto's *Orlando Furioso* (*Mad Roland*) is published.

1528 The first edition of Castiglione's *Book of the Courtier* appears. It soon becomes a model for many similar conduct books throughout Europe.

1529 Pietro Bembo, a great Italian and Latin stylist, is named official historian of the city of Venice.

1531 Beatus Rhenanaus completes his *History of German Affairs* from documentary research and oversees the work's publication at Basel.

1532 François Rabelais publishes *Pantagruel*, a satirical novel.

1538 Pietro Aretino, an Italian who writes in the vernacular, begins publishing the first of six volumes of his personal letters. The popularity of these works encourages many similar editions of personal letters.

1539 First New World printing press is established.

1540 Francesco Guicciardini, historian and statesman of Florence, dies.

1547 The great Spanish author Miguel de Cervantes is born.

Vittoria Colonna, the greatest Italian woman poet of the sixteenth century, dies with her friend, Michelangelo, at her side.

1549 The first Book of Common Prayer is required for use within the Church of England. The work's lofty language will influence the development of Elizabethan English in the later sixteenth century.

The Pleiades, a group of seven French poets who adopt a strict classical style, is formed. The group takes its name from the Greek myth that surrounds this famous constellation. According to that legend, seven great Greek poets were transformed into the seven stars of the Pleiades upon their deaths in order to make them immortal.

1553 The French novelist François Rabelais dies.

1555 The *Works* of Louis Labé, greatest woman poet of the French Renaissance, are published.

c. 1571 Michel de Montaigne begins his *Essays* in seclusion at his country home.

1577 Ralph Holinshed publishes his *Chronicles of England, Scotland and Ireland*, while Sir Francis Drake sails around the globe.

1580 The first edition of Montaigne's *Essays* are published.

1590 Edmund Spenser completes his *Faerie Queene*.

OVERVIEW
of Literature

EARLY RENAISSANCE LITERATURE. Two developments shaped literature in fourteenth-century Italy. First, the humanist revival of the classics encouraged writers to adopt a new cultivated style in their writings and to develop new literary genres. Second, the works of Dante, Petrarch, and Boccaccio in the Tuscan dialect—the language used in and around the city of Florence—laid the foundations for early-modern Italian as a literary language. The masterpieces each of these three great literary figures wrote would provide models for later Renaissance writers.

THE FIFTEENTH CENTURY. By 1400, most Italian writers had come to favor the gracious and elegant Latin and Italian style of Boccaccio and Petrarch, rather than the now seemingly dated Dante. During the course of the fifteenth century, the fashion for classical rhetoric, grammar, and vocabulary would inspire new efforts to revive a pure classical Latin, and humanist writers would criticize with increasing vehemence the barbarity of the medieval Latin used by the scholastics. Knowledge of Greek, too, would extend the Italians' understanding of the classical past, and would also deepen their vision of history. Humanist works of history would contribute to the literature of the age and would become a genre in which many scholars displayed their cultivated Italian and Latin prose. After 1450, literary tastes changed in Italy rather quickly. In place of the civic humanist attention to the arts of government, many writers in the second half of the century devoted their attention to lyric poetry, the pastoral, and chivalric romances. Numerous factors contributed to this change in tastes. In Florence and other Italian cities, a new longing for privacy and inwardness made the reading of literary works one of the chief recreations of the age. Literary endeavors were also more generously funded by Italy's urbane princes. And the spread of the printing press throughout the peninsula meant that writers could read and imitate successful texts more quickly than before. By the end of the fifteenth century a new self-assurance had emerged in

Italian literature. Writers no longer felt bound to imitate classical models, but instead experimented and often created new genres.

THE HIGH AND LATER RENAISSANCE IN ITALY. The sixteenth century opened with a brilliant episode in artistic and cultural life known as the "High Renaissance." In art, this movement coalesced around the stunning achievements of Leonardo da Vinci, Raphael Sanzio, and Michelangelo Buonarroti. By 1520, the first two of these figures were dead and Michelangelo had begun to experiment with an altogether more personal and distorted style that would eventually become known as Mannerism. In literature a similar progression can be seen as writers imitated ancient models, particularly Cicero and Vergil in Latin prose and poetry, and Petrarch and Boccaccio in their Italian writings. Ciceronianism and the Italian literary movement known as Bembismo (after its chief proponent Pietro Bembo) stressed that the emulation of older literary models could provide artists with a sure style in which to express their individuality. Others, like Machiavelli, Guicciardini, Erasmus, and Castiglione, rejected the principle of literary imitation. The "question of language," as it came to be known, became a burning issue for Italy's literary theorists. Writers debated which genres were suited to Latin and which to Italian and what style should be used when writing in these languages. Court culture also left its mark on many of the classic works of the period. Courts favored a "stylish style" that demonstrated writers' technical proficiency and their mastery of the principles of elegant ease or *sprezzatura*. Finally, Petrarchism, a poetic movement that emulated Petrarch's fourteenth-century verse, appeared in Italy and quickly spread throughout Europe. Over the coming generations proponents of Petrarchism would produce an enormous quantity of verse, particularly of sonnets.

THE NORTHERN RENAISSANCE. After 1450, humanism began to spread to areas outside Italy. Although Northern European universities often resisted the New Learning at first, humanists had established themselves in many places by 1500. The first impact of the new movement was a revival of classical Latin and the study of ancient languages. Most Northern Renaissance humanists did not turn immediately to write in their native languages. Over time, humanists adopted their vernacular, helping to produce a great flowering in sixteenth-century literature and the study of history.

WOMEN WRITERS. Literacy increased in the fifteenth and sixteenth centuries, and with this rise came an expansion in the number of women writers. Around

1400, Christine de Pizan set out many of the issues that women would discuss in their writings over the coming generations. In her *Book of the City of Ladies*, she desired to rehabilitate women's virtues against the criticisms of men. The early feminism of her attack upon male attitudes would be evidenced in the work of later Renaissance writers like Laura Cereta, Veronica Franco, and Marguerite de Briet. Many Renaissance women authors, though, accepted male domination as part of the God-given order of the world. As the educational levels of wealthy city and noble women rose in the sixteenth century, women wrote enormous quantities of love poetry, religious commentary, and fiction. By the end of the sixteenth century these achievements had set the stage for the even greater participation of women in literature that occurred during the early-modern period.

TOPICS
in Literature

EARLY RENAISSANCE LITERATURE

GROWTH OF ITALIAN. During the fourteenth century Dante Alighieri (1265–1321), Francesco Petrarch (1304–1374), and Giovanni Boccaccio (1313–1375) laid the foundations for Italian as a literary language. Around 1300, Dante became one of the first Europeans to discuss a subject that would become increasingly important during the Renaissance. In his *On the Vulgar Tongue* he considered what style was most appropriate for writers who decided to compose their works in their own native language, rather than in Latin. Dante advocated his own "sweet new style," an elegant form of medieval Italian that was intended to please both the mind and the ear. In his great masterpiece, *The Divine Comedy*, Dante used the "sweet new style" to record his imaginary pilgrimage through hell, purgatory, and paradise. He intended this masterpiece, which he completed shortly before his death in 1321, to be a summation of everything he had learned in his life about philosophy, theology, and science. The *Comedy* expressed its author's profound faith that everything in the world operated according to the designs of God's will. Throughout the work humanity is caught in a divinely-controlled drama it cannot hope to influence, and human beings are ultimately powerless when judged against God's omnipotence. Dante's bleak and personal vision of the afterlife still ranks as one of the greatest masterpieces of world literature, and its influence in establishing Dante's own

language—the Tuscan Italian used in and around Florence—as a literary language was considerable. But by 1400, the new philosophical and literary movement known as humanism had altered literary tastes. To many of Italy's authors, Dante's "sweet, new style" seemed dated and old-fashioned. For inspiration, Italy's growing number of humanists would now turn to Petrarch and Boccaccio, the other two literary geniuses of the fourteenth century.

HUMANISM. Petrarch and Boccaccio were the two acknowledged geniuses among early Renaissance humanists. Humanism had begun to appear as an educational movement within the Italian cities during the late thirteenth and early fourteenth centuries. In place of the scholastic curriculum of Europe's universities, which stressed logic and the disciplined proof of theological and philosophical principles, the humanists advocated study of the language arts, moral philosophy, and history. Petrarch, who is sometimes called the "Father of Humanism," was the first of many of these scholars to achieve an international fame through his literary works. In a life devoted to writing and study, he tried to create a relevant personal philosophy guided by the works of classical Antiquity. In place of the austere vision of Dante and many medieval writers, Petrarch's works stressed that there was a place for the enjoyment of literature and the other good things that the world had to offer. Although he remained deeply traditional and Christian in his outlook, his philosophy emphasized that graceful writing and speaking might have a good end if used to encourage its audience to lead a virtuous life. Petrarch was not a systematic thinker; he frequently contradicted himself and at times adopted points of view that were in conflict with his earlier positions. But in both his Italian and Latin writings, Petrarch devoted himself to the cause of eloquence, making it the basis for a career that spread his fame throughout Europe.

POETRY. Petrarch wrote his philosophical works largely in Latin, while composing his poetry mostly in Italian. In some of his philosophical works, though, Petrarch argued that the art of poetry might have a philosophical function, an idea that would have puzzled most medieval thinkers. While poetry had not been neglected in the Middle Ages, it was seen more often than not as a kind of literary enjoyment and recreation that was incapable of conveying the profound truths of philosophy. In his *Divine Comedy* Dante had used poetry to address deep religious truths, but he had placed the ancient Roman poet, Vergil, within his creation to represent the limits of human reason. His choice of the acknowledged master of ancient poetry to personify

a PRIMARY SOURCE document

PETRARCH CONSIDERS THE NATURE OF POETRY

INTRODUCTION: Petrarch, one of the Renaissance's foremost humanist writers of poetry and literature, was also an avid philosopher and theologian. But like most of his endeavors, it is through the written word that Petrarch delved into these topics in order to gain a higher and fuller understanding. In the following letter to his brother, Gherardo, Petrarch makes a case for the importance of poetry in understanding religion and theology. He references not only the allegorical and poetic nature of biblical texts, but also refers to Aristotle's *Poetics*, revealing his love of the antiquity as well as his need to rectify antique text with modern Renaissance religious ideals. Petrarch sees poetry as one of the many ways that humans can pay homage to higher powers, and equates the nature of writing poetry with such activities as building religious structures, such as temples, and going through religious orders to become priests and nuns. Petrarch's goal in this letter is to convince his brother that all poetry, regardless of the surface subject matter, is truly directed to God, and it is only the intelligent, patient person who is willing to take the time to read and understand the poetry that will truly understand its true purpose and in doing so, will become closer to God.

On the Nature of Poetry, to his Brother Gherardo

I judge, from what I know of your religious fervour, that you will feel a sort of repugnance toward the poem which I enclose in this letter, deeming it quite out of harmony with all your professions, and in direct opposition to your whole mode of thinking and living. But you must not be too hasty in your conclusions. What can be more foolish than to pronounce an opinion upon a subject that you have not investigated? The fact is, poetry is very far from being opposed to theology.

Does that surprise you? One may almost say that theology actually is poetry, poetry concerning God. To call Christ now a lion, now a lamb, now a worm, what pray is that if not poetical? And you will find thousands of such things in the Scriptures, so very many that I cannot attempt to enumerate them. What indeed are the parables of our Saviour, in the Gospels, but words whose sound is foreign to their sense, or allegories, to use the technical term? But allegory is the very warp and weft of all poetry. Of course, though, the subject matter in the two cases is very different. That everyone will admit. In the one case it is God and things pertaining to him that are treated, in the other mere gods and mortal men.

Now we can see how Aristotle came to say that the first theologians and the first poets were one and the same. The very name of poet is proof that he was right. Inquiries have been made into the origin of that word; and, although the theories have varied somewhat, the most reasonable view on the whole is this: that in early days, when men were rude and unformed, but full of a burning desire—which is part of our very nature—to know the truth, and especially to learn about God, they began to feel sure that there really is some higher power that controls our destinies, and to deem it fitting that homage should be paid to this power, with all manner of reverence beyond that which is ever shown to men, and also with an august ceremonial. Therefore, just as they planned for grand abodes, which they called temples, and for consecrated servants, to whom they gave the name of priests, and for magnificent statues, and vessels of gold, and marble tables, and purple vestments, they also determined, in order that this feeling of homage might not remain unexpressed, to strive to win the favour of the deity by lofty words, subjecting the powers above to the softening influences of songs of praise, sacred hymns remote from all the forms of speech that pertain to common usage and to the affairs of state, and embellished moreover by numbers, which add a charm and drive tedium away. It behooved of course that this be done not in every-day fashion, but in a manner artful and carefully elaborated and a little strange. Now speech which was thus heightened was called in Greek *poetices*; so, very naturally, those who used it came to be called poets.

SOURCE: Petrarch, in *Petrarch: The First Modern Scholar and Man of Letters.* Ed. and Trans. J. H. Robinson (New York: G. P. Putnam, 1898): 261–263.

earthly knowledge expressed the traditional medieval judgments about the limits of poetic wisdom. By contrast, Petrarch argued that poetry could, through its use of metaphor, simile, and other literary devices, convey truths that were more profound than those derived from arid logic. Poetry could also appeal to the senses and captivate the imagination, and in these ways spur the mind and the human will to try to achieve virtue. While Petrarch developed this defense of poetry in his philosophical works, most of his poetry celebrated human love. When he was 23, Petrarch was to have met his love Laura, the woman who would serve as his poetic muse for the remainder of his life. Whether Laura was real or imagined has never been definitely determined, but Petrarch always emphasized that his love for her went unrequited. For Petrarch, Laura became the subject of his most lyrical and influential poetry, the *Canzoniere* or *Songbook*. This collection would eventually

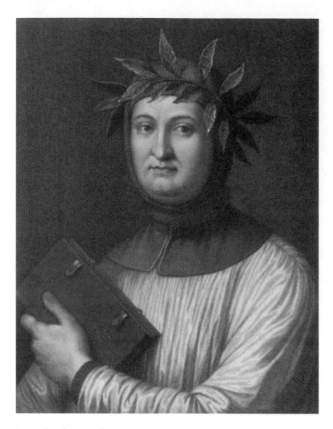

Portrait of Petrarch. ©BETTMANN/CORBIS.

THE TRIUMPHS. Petrarch's collection of six poems treating triumphs also influenced later writers and artists, although their influence upon the art of the Renaissance was more profound than on literature. The *Triumphs* were written in rhymed triplets around 1355, when Petrarch was in his middle age. They depict a series of six victories that occur in a sequence. Petrarch richly describes symbolic battles between Love, Chastity, Death, Fame, Time, and Eternity. Each of these abstract nouns is personified, and each in turn experiences its own victory, but every one but the last, Eternity, is conquered in turn by another, more powerful figure. Through this sequence the *Triumphs* lead Petrarch to a final consoling realization. In the first poem, for example, the God of Love is victorious, as he leads famous historical lovers in bondage to the island of Cyprus. Soon, though, the figure of Chastity rises in the figure of Petrarch's Laura. She rescues Love's captives and steals the god's bow and arrow, which she places in the Temple of Chastity at Rome. Chastity's victory, too, is short-lived, as Death arrives to steal her and her ransomed lovers. In his grief Petrarch consoles himself that Fame triumphs over Death, since reputation and accomplishments outlive mortal life. But even Fame's conquest is ephemeral because in the fifth poem, the God of Time's decaying effects on human memory conquers Fame. In the final poem the God of Eternity conquers Time, a victory that reassures Petrarch. He realizes that in the infinity of Eternity, he will be able to enjoy the beauty and love of his Laura. Because of their rich visionary description, Petrarch's *Triumphs* were frequently exploited by artists throughout the fifteenth and sixteenth centuries in paintings, tapestries, and even on furniture. Depictions of the *Triumphs* were most prominent on Renaissance dowry chests, which were the ceremonial caskets used to carry a woman's dowry from her family's house to her husband's in the weeks that preceded her wedding. The *Triumphs* were usually included in the many manuscript and printed editions of the *Songbook* that circulated in the Renaissance. Although Petrarch downplayed their importance as he had the poems of the *Songbook*, he also returned to revise them many times, even in the months leading up to his death.

include 366 poems, more than 300 of which would be written in the sonnet form Petrarch perfected. He wrote about two-thirds of these poems while Laura was living, and the other third after her death, but he often returned to polish the collection. Although Petrarch would discredit his Italian poetry later in life as youthful indulgence, he seems to have realized that it would form one of the foundations of his reputation. In them, Petrarch made use of the long tradition of love poetry from Ovid and Vergil, to the medieval troubadours, and to the Italian poets of the "sweet new style." Petrarch transformed these influences, though, to create poems that were stunningly lyrical and profound in their psychological depth. They ranged over a variety of topics—love, death, politics, and religion—but somehow their most important subject emerges as Petrarch himself. He uses the poems, in other words, to present himself to his readers as a thoughtful and unique personality. Time and again Renaissance writers would return to these poems, and they would eventually be seen as setting the highest standard for verse treating love. During the sixteenth century, the style of the *Songbook* would even give rise to a literary movement known as "Petrarchism" in Italy that would spread throughout Europe.

LATIN WORKS. Petrarch's Italian verse would rank among his most important contributions to the literary traditions of the Renaissance. The impact of his Latin works, by contrast, would be felt most keenly among the humanist moral philosophers who followed him, and these works were generally less important in inspiring new literary themes and genres. His *The Secret, or the Soul's Conflict with Desire*, an important philosophical

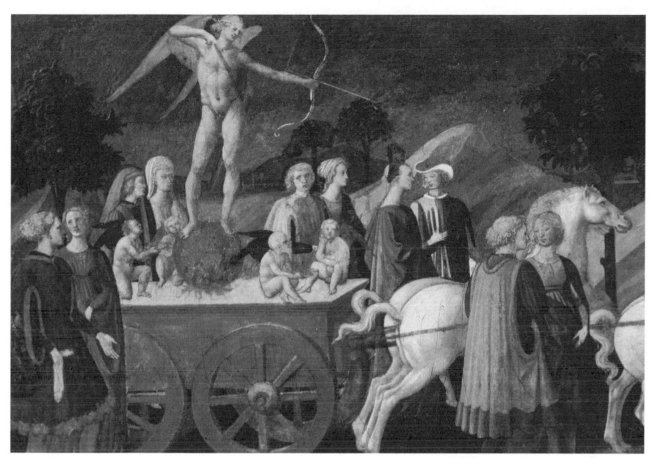

Il Pesellino's "The Triumphs of Love, Chastity, and Death," based on Petrarch's work. © BURSTEIN COLLECTION/CORBIS. REPRODUCED BY PERMISSION.

work written in dialogue form, inspired many subsequent Renaissance dialogues. There were also some other notable exceptions among Petrarch's Latin works that would prove influential to later Renaissance authors. In his monumental poem, *Africa*, Petrarch turned to the history of the Punic Wars between Rome and Carthage and he treated the life and deeds of the Roman hero Scipio Africanus. Petrarch admired this work above all his other poetry, and its praise of Roman valor and the virtues of patriotism helped popularize the study of history among his humanist followers. He continued to praise Roman virtues in his collections of biographies entitled *The Lives of Illustrious Men* and his *Letters to the Ancient Dead*. But perhaps Petrarch's most important contribution to Latin literature during the Renaissance was his collections of letters; these helped establish the art of letter writing as one of the literary techniques favored by later humanists. In 1345, Petrarch discovered at Verona a collection of letters written by the ancient Roman philosopher and orator Cicero. These letters encouraged Petrarch to collect and edit his own communications in a series of manuscript editions. By the time

of his death in 1374, he had compiled three volumes of his Latin letters. These would circulate during the fifteenth and sixteenth centuries in both manuscript and printed editions and would inspire other collections of letters written by famous political dignitaries, scholars, and literary figures.

BOCCACCIO. Petrarch's relationship with Giovanni Boccaccio also helped to shape the course of early Renaissance literature. In 1350, these two figures met for the first time, and struck up a friendship that would last for the rest of their lives. Petrarch continually worried about his own posterity and the reputation that his works would achieve after his death. Boccaccio, on the other hand, was more humble about his literary achievements, and he allowed his ideas to be shaped by his older friend Petrarch. For example, Petrarch's defense of poetry, his love for the classics, and his insistence that literature and eloquence must serve the cause of virtue all influenced Boccaccio. In his *Genealogy of the Gods* (written over many years but finished shortly before his death), Boccaccio displayed the influences that he had derived from

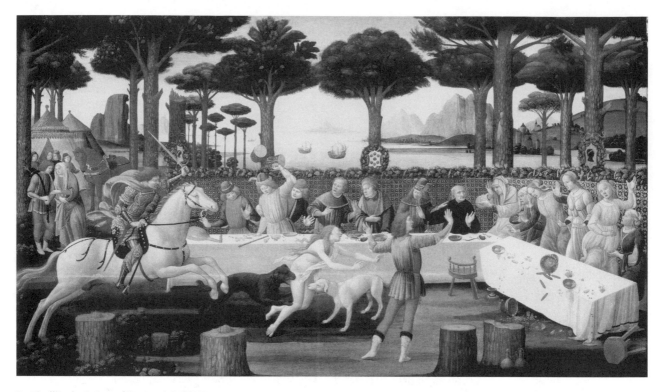

Botticelli's depiction of Boccaccio's *Decameron*. © ARCHIVO ICONOGRAFICA, S.A./CORBIS. REPRODUCED BY PERMISSION.

his relationship with Petrarch. This work catalogued pagan mythology and would be widely used as a textbook for students of literature and by artists composing works on mythological themes during the next four centuries. When they had turned to consider ancient myths, medieval writers had usually granted these stories Christian interpretations. Boccaccio's *Genealogy* strove instead to present Greek and Roman mythology from their literary sources without extensive commentary or Christian philosophizing. In the final two sections of *The Genealogy* Boccaccio also defended the study of pagan literature and the writing of poetry and fiction along lines consistent with his mentor Petrarch. Boccaccio insisted that poetry's purposes were far more profound than mere literary enjoyment. Poetry could convey truths concealed in beauty, and the poet's gift consisted in "exquisitely discovering and saying, or writing, what you have discovered." Poetry was not, according to Boccaccio, an earthly enjoyment that led away from divine truth, as many medieval commentators had argued. It was instead a craft that brought glory to God, since He was the ultimate source of the poet's inspiration. Importantly, the *Genealogy* also defended the writing of fiction, insisting that fables and stories possessed the power both to entertain and to instruct their readers in morality.

DECAMERON. While Petrarch's influence on the development of Boccaccio's humanist ideas was great, he shares little of the credit for directly shaping Boccaccio's great masterpiece, *The Decameron*. Boccaccio had begun that work in 1348, shortly after the Black Death struck Florence. He completed it in 1352, only shortly after his first meetings with Petrarch. The work's prologue recounts the horrors of the bubonic plague as it winnowed down the city's population during 1348 and 1349. Few descriptions of epidemics are more chilling than this, as Boccaccio describes the swiftness with which the plague moved through the city, the variety of ways in which Florentines responded to the disease, and the gruesome manner in which many met their deaths. In the midst of this carnage a group of ten wealthy men and women decide to flee the city. They take refuge in the countryside outside Florence and begin to tell tales to pass the time. Each day, the group elects a king or queen from among their members to preside over their storytelling, and during the ten days that they stay in the countryside, each of the group's members tells a tale. Boccaccio relates the resulting 100 tales in a short story form known as *novella*, a literary form popular in Italy at the time. Some of the stories are written for pure literary and comic enjoyment; others convey a message. To underscore these messages, Boccaccio identifies themes for most of the days' storytelling. Day One, for example, treats tales of villainy and deceit, while Day Ten recounts stories in which virtue triumphs over vice. Between these two ex-

a PRIMARY SOURCE *document*

OBSERVATIONS ON THE BLACK DEATH

INTRODUCTION: The bubonic plague (better known as the "Black Death") wiped out a third of the European population in the years between 1300 and 1500, leaving a devastating mark on the continent. The swift, gruesome, and certain death associated with the disease was all the more terrifying because no one knew how it began or how it spread. In the prologue to his *Decameron*, Giovanni Boccaccio chillingly described the course of the Black Death as it made its way through Florence.

I say, then, that the sum of thirteen hundred and forty-eight years had elapsed since the fruitful Incarnation of the Son of God, when the noble city of Florence, which for its great beauty excels all others in Italy, was visited by the deadly pestilence. Some say that it descended upon the human race through the influence of the heavenly bodies, others that it was a punishment signifying God's righteous anger at our iniquitous ways of life. But whatever its cause, it had originated some years earlier in the East, where it had claimed countless lives before it unhappily spread westward, growing in strength as it swept relentlessly on from one place to the next.

In the face of its onrush, all the wisdom and ingenuity of man were unavailing. Large quantities of refuse were cleared out of the city by officials specially appointed for the purpose, all sick persons were forbidden entry, and numerous instructions were issued for safeguarding the people's health, but all to no avail. Nor were the countless petitions humbly directed to God by the pious, whether by means of formal processions or in all other ways, any less ineffectual. For in the early spring of the year we have mentioned, the plague began, in a terrifying and extraordinary manner, to make its disastrous effects apparent. It did not take the form it had assumed in the East, where if anyone bled from the nose it was an obvious portent of certain death. On the contrary, its earliest symptom, in men and women alike, was the appearance of certain swellings in the groin or the armpit, some of which were egg-shaped whilst others were roughly the size of the common apple …

Against these maladies, it seemed that all the advice of physicians and all the power of medicine were profitless and unavailing. Perhaps the nature of the illness was such that it allowed no remedy: or perhaps those people who were treating the illness … being ignorant of its causes, were not prescribing the appropriate cure. At all events, few of those who caught it ever recovered, and in most cases death occurred within three days from the appearance of the symptoms we have described—some people dying more rapidly than others, the majority without any fever or other complications.

But what made this pestilence even more severe was that whenever those suffering from it mixed with people who were still unaffected, it would rush upon these with the speed of a fire racing through dry or oily substances that happened to come within its reach. Nor was this the full extent of its evil, for not only did it infect healthy persons who conversed or had any dealings with the sick, making them ill or visiting an equally horrible death upon them, but it also seemed to transfer the sickness to anyone touching the clothes or other objects which had been handled or used by its victims.

SOURCE: Giovanni Boccaccio, *Decameron*. Trans. G. H. McWilliam (London: Penguin, 1972): 5–6.

tremes of hellish wickedness and heavenly virtue, Boccaccio tells a number of other tales that presented a variegated portrait of human nature. In many of these, women get the better of men because of their cunning nature or superior intelligence. Other characters redeem themselves from imminent catastrophe because of a witty reply or sheer human inventiveness. And still others are able to confront harsh fortune successfully because of their ability to master their will and overcome human passions. These last themes—the passions and the human will—are elements that run throughout the tales. Some people, Boccaccio shows, are able because of their superior intelligence and will power to shape the world to their needs and desires, while those who succumb to their passions are rarely ever able to rise above the blows of ill fortune. The clergy are prominent among those Boccaccio criticizes as victims of their own desires, and a number of the tales recount the clergy's sexual antics. At other times he presents Jews and Moslems as more virtuous than Christians. Finally, he records many of the tensions of fourteenth-century Italian life, particularly those that existed between the new merchant class and the older nobility. In all these ways Boccaccio's work presents an extraordinary tapestry of Mediterranean life, and one which found a wide readership during the following centuries, both in Italy and throughout Europe.

OTHER WORKS. The *Decameron* was Boccaccio's undisputed masterpiece, but the author's literary output was enormous, both in Latin and Italian. Like Petrarch, Boccaccio styled some of his works self-consciously to

Giovanni Boccaccio. THE LIBRARY OF CONGRESS.

resemble ancient literary styles and genres, hoping to revive these forms. In his *Country Songs,* or *Buccolicum carmen* Boccaccio wrote in Latin and used the ancient Roman form of the eclogue, a kind of pastoral poetry that had been developed by the ancient poet Vergil. Boccaccio, like Petrarch who also wrote eclogues, used these poems to discuss ethical, political, and religious themes. And like Petrarch, Boccaccio also devoted himself to writing biographical studies. Two of these, *The Fates of Illustrious Men* and *On Famous Women,* continued to debate an issue that Boccaccio had identified in the Decameron: the role of fortune in human affairs. In the *Fates of Illustrious Men* Boccaccio examined the lives of men from the Garden of Eden to contemporary times and argued that the fall of powerful historical figures was most often the result of moral failings, rather than mere bad fortune. Sometimes, though, he admitted that pure misfortune could prove disastrous. In his catalogue of women's lives, *On Famous Women,* Boccaccio became the first European author to create a collection of biographies devoted exclusively to women. The examples that Boccaccio treated in this work were all drawn from pagan Antiquity, and he praised these women for their learning, their writing, their political skill, and even their military prowess. While Boccaccio presented this work

as a tribute to a famous Florentine woman, his comments throughout the book show that he intended it to be read by both men and women. He often criticized men for allowing women to outdo them in scholarship and other endeavors. *On Famous Women* appeared during the early Renaissance, and inspired at least one other collection of feminine biographies: the more famous *Book of the City of Ladies* written by Christine de Pizan in the early fifteenth century.

GREEK LANGUAGE AND LITERATURE. Boccaccio exercised a significant impact on later Renaissance literary tastes through his support of the study of the Greek language and literature. Although he was usually self-deprecating, he did stress in his *Genealogy of the Gods* his role in establishing the first professorship of Greek at the University of Florence. He called Leontius Pilatus, a southern Italian Greek scholar, to this position and asked him to translate works of Homer and Euripides into Latin. Boccaccio became Pilatus' student, and he was the first Renaissance European to learn Greek for the expressed purpose of reading classical literature. He circulated the translations that Pilatus had completed of Greek texts, sending copies to Petrarch and other humanists. In this way, he helped to encourage the revival of the study of Greek, a language that had been virtually unknown in Western Europe over previous centuries.

IMPACT. Both Petrarch and Boccaccio's literary endeavors provided models for later Renaissance writers. Each figure had conducted extensive studies of ancient prose and poetry, and they had often self-consciously used their works as a way of reviving classical style and literary genres among their fellow humanists. While dedicated to the study of ancient literature, and using it as a guide, both Petrarch and Boccaccio were also original and innovative artists. In his Italian lyrics, for example, Petrarch perfected the sonnet and expressed psychological insights that would inspire later writers. For his part, Boccaccio created a fictional universe in his *Decameron* that made use of the medieval genre of the novella. Boccaccio breathed new life into this form by weaving his own consistent perspective as well as the philosophical insights of early humanism into the work. These features helped to raise his work to the level of a masterpiece.

SOURCES

W. J. Kennedy, *Authorizing Petrarch* (Ithaca, N.Y.: Cornell University Press, 1994).

P. O. Kristeller, *Renaissance Thought and the Arts* (Princeton, N.J.: Princeton University Press, 1965).

G. Mazzotta, *The Worlds of Petrarch* (Durham, N.C.: Duke University Press, 1993).

J. P. Serafini-Saulfi, *Giovanni Boccaccio* (Boston: Twayne, 1982).

C. E. Trinkaus, *The Poet as Philosopher: Petrarch and the Formation of Renaissance Consciousness* (New Haven, Conn.: Yale University Press, 1979).

SEE ALSO *Theater: The Renaissance Theater in Italy*

THE FIFTEENTH CENTURY IN ITALY

CIVIC HUMANISM. During the first half of the fifteenth century humanists in Florence and elsewhere in Italy wrote mostly prose treatises and dialogues. They did not immediately develop the fictional possibilities that Boccaccio's *Decameron* presented. Nor did they devote themselves to the writing of love lyrics or other poetry in the style of Petrarch. Florence's first humanist chancellor, Coluccio Salutati (1331–1406), had been a disciple of both Boccaccio's and Petrarch's humanism, and he continued to defend the study of poetry in his writings in ways similar to his mentors. In the first half of the fifteenth century the humanist circle that Salutati was largely responsible for assembling in Florence devoted itself to other concerns. These scholars turned instead to study ancient philosophy, history, and the classical languages, rather than pursue purely literary pursuits. Their writings were not without literary merit or importance, but they often used their treatises and dialogues to discuss the arts of good government and the importance of a life of civic engagement. A perennial theme of their works considered how one might achieve virtue while living an active life in society. For these reasons, the humanists of this period have often been called "civic humanists." Other achievements of the humanists in this period would prove decisive for the later development of Italian and Latin literature in subsequent generations. The humanists recovered a thorough knowledge of classical Latin's structure, style, and rhetoric, providing the basis upon which later Renaissance writers would successfully imitate the style of the ancients. The recovery of the knowledge of Greek, too, continued to expand in Florence and elsewhere in Italy, and with it, came a deeper understanding of the classical literary and historical past. Humanist writers like Leon Battista Alberti also expanded the use of Italian in this period by adopting it as the language for their dialogues and treatises. Alberti wrote his massive dialogue *The Book of the Family* in Tuscan Italian rather than Latin during the 1430s, and he circulated the work among educated Florentines. *The Book of the Family* presented a conversation between members of the Alberti family about the strategies that could best ensure a family's survival, and it advised readers about ways to achieve marital harmony. It was practical concerns like those that Alberti demonstrated in this dialogue that most often dominated the humanists' attentions at the time.

IMPORTANCE OF HISTORY. The study of history was also an area in which the humanists distinguished themselves. Leonardo Bruni, another of Florence's humanist chancellors, ranks among the finest of Italy's many fifteenth-century historians. In his *History of the Florentine People*, completed between 1415 and 1429, Bruni used his knowledge of ancient Greek and Roman history to debunk many long-standing myths about Florence's and Europe's history. His work defended republicanism as the best mode of government, against medieval notions that the monarchical Roman Empire was the supreme political achievement of the ancient world. Until Bruni's time, legend had located Florence's origins in the days of the Roman Empire. Bruni's *History of the Florentine People* relied on documentary evidence to disprove those myths. He pushed back the city's origins into the days of the Roman Republic, arguing that Florence's greatness was a product of her republican past. Medieval thinkers had admired the Roman Empire because they believed that it had played a providential role in the establishment of Christianity in Europe. Bruni, by contrast, stressed that the earliest forms of governments in Greece and Rome had been republican, and these societies had valued the free debate and circulation of ideas. He established a link, in other words, between these free political systems and the cultural greatness of these ancient civilizations. The Roman emperors had destroyed these long-standing traditions of civic liberty, and in this process classical civilization itself had decayed. Thus by locating Florence's founding within the Republic, Bruni aimed to prove that the city's greatness was a product of its long fidelity to the traditions of civic liberty. At the same time Bruni was no modern democrat; most of his works reveal an essentially conservative political thinker. He accepted that aristocratic dominance was a necessary part of government, even in the government of a republic. It was natural for those who possessed greater wealth and status to have a greater say in a state's government. He also defended imperial expansion, so long as a republic, and not a dictatorial empire conducted it. His histories celebrated Florence's conquest of neighboring cities in Tuscany. Importantly, their popularity helped encouraged a new disciplined study of local history throughout Italy,

a PRIMARY SOURCE *document*

ADVICE TO A YOUNG LADY ON THE STUDY OF LITERATURE

INTRODUCTION: The humanist chancellor of Florence, Leonardo Bruni, sent a letter to Baptista Malatesta, a noblewoman, advising her on her intentions to study literature. Like many Renaissance letters, this one would have been circulated in the humanist circles that were growing increasingly common in fifteenth-century Italy.

I am led to address this Tractate to you, Illustrious Lady, by the high repute which attaches to your name in the field of learning; and I offer it, partly as an expression of my homage to distinction already attained, partly as an encouragement to further effort. Were it necessary I might urge you by brilliant instances from antiquity: Cornelia, the daughter of Scipio, whose Epistles survived for centuries as models of style; Sappho, the poetess, held in so great honour for the exuberance of her poetic art; Aspasia, whose learning and eloquence made her not unworthy of the intimacy of Socrates. Upon these, the most distinguished of a long range of great names, I would have you fix your mind; for an intelligence such as your own can be satisfied with nothing less than the best. You yourself, indeed, may hope to win a fame higher even than theirs. For they lived in days when learning was no rare attainment, and therefore they enjoyed no unique renown. Whilst, alas, upon such times are we fallen that a learned man seems well-nigh a portent, and erudition in a woman is a thing utterly unknown.

For true learning has almost died away amongst us. True learning, I say: not a mere acquaintance with that vulgar, threadbare jargon which satisfies those who devote themselves to Theology; but sound learning in its proper and legitimate sense, viz., the knowledge of reali-

ties—Facts and Principles—united to a perfect familiarity with Letters and the art of expression. Now this combination we find in Lactantius, in Augustine, or in Jerome; each of them at once a great theologian and profoundly versed in literature. But turn from them to their successors of today: how must we blush for their ignorance of the whole field of Letters!

This leads me to press home this truth—though in your case it is unnecessary—that the foundations of all true learning must be laid in the sound and thorough knowledge of Latin: which implies study marked by a broad spirit, accurate scholarship, and careful attention to details. Unless this solid basis be secured it is useless to attempt to rear an enduring edifice. Without it the great monuments of literature are unintelligible, and the art of composition impossible. To attain this essential knowledge we must never relax our careful attention to the grammar of the language, but perpetually confirm and extend our acquaintance with it until it is thoroughly our own. We may gain much from Servius, Donatus and Priscian, but more by careful observation in our own reading, in which we must note attentively vocabulary and inflexions, figures of speech and metaphors, and all the devices of style, such as rhythm, or antithesis, by which fine taste is exhibited. To this end we must be supremely careful in our choice of authors, lest an inartistic and debased style infect our own writing and degrade our taste; which danger is best avoided by bringing a keen, critical sense to bear upon select works, observing the sense of each passage, the structure of the sentence, the force of every word down to the least important particle. In this way our reading reacts directly upon our style.

SOURCE: "Leonardo Bruni" in *Vittorino da Feltre and Other Humanist Educators.* Ed. by W. H. Woodward (Cambridge: Cambridge University Press, 1912): 119–120.

even as they nurtured the republican sentiments of many Italians against the despotic princes who were growing more powerful at the time. Bruni's works would eventually be read elsewhere in Europe, where they helped to establish history as an important humanist literary genre. Because of his disciplined reliance upon the sources, his revisionism, and his use of history to defend liberty, Bruni has sometimes been called "the first modern historian."

REVIVAL OF CLASSICAL LATIN. Bruni had located the cultural greatness of ancient Rome in the time of the Republic. At the same time as his histories were appearing, humanists were actively engaged in recovering and

studying the literature and language of this period. While most humanists were concerned with recovering the entire classical heritage, they were often especially interested in the literature of the late Republic, the so-called "Golden Age" of classical Latin. In particular, they were fascinated by unearthed copies of the letters and other works of Cicero (d. 43 B.C.E.), who had been identified even in Antiquity as the finest master of the language. In Florence, two figures were particularly important in these attempts to recover classical texts: Poggio Bracciolini and Niccolò de Niccoli. Through his letters to friends and associates, Niccoli tracked down the locations of many works and he purchased a number of these manuscripts for his personal library. Upon his death he

Engraving of the city of Florence, late sixteenth century. HULTON/ARCHIVE. REPRODUCED BY PERMISSION.

left this collection to Florence, and his close friend Cosimo de' Medici built facilities within the town's Dominican monastery of San Marco so that scholars could study his library. Poggio Bracciolini surpassed even Niccoli's exhaustive efforts. Besides conducting a voluminous correspondence to track down texts, he ransacked many German monastery libraries while he was serving as a Florentine delegate to the Council of Constance (1413–1417). Among the treasures that Bracciolini discovered were several unknown orations of Cicero as well as many works of history and philosophy in ancient Latin. As a result of his efforts, scholars studied the classical heritage more intently than ever before, and subjected antique Latin to critical scholarship. During the 1430s, for instance, Lorenzo Valla (1407–1457) devoted his attentions to studying the language of classical texts. His research resulted in the foundation of a new discipline: philology. Valla discovered that languages changed and developed over time. Until Valla's time, the humanists had tried to emulate the style of ancient writers intuitively. From Petrarch and Boccaccio's time, humanist authors had labored to acquire a voluminous knowledge of Latin literature, and they had tried to write in a classical Latin style merely by pulling phrases and other literary devices from their reading. Valla warned his fellow humanists that Latin had changed greatly over

time. One could not, for example, draw phrases and stylistic devices from texts that had been written several centuries apart. If a writer hoped to write in a classical Latin style, he must confine himself to imitating the works of a certain period. Like most fifteenth-century humanists, Valla preferred the Latin of the Golden Age, and in his *Elegances of the Latin Language* he guided his readers through the style, usage, and grammar that characterized the Latin of this period.

CODICOLOGY. By the mid-fifteenth century humanist students were carefully learning the lessons that Lorenzo Valla had taught. They paid close attention to mastering the grammar and rhetoric of ancient Latin and many tried to emulate the elegant and polished style of ancient writers using the disciplined methods Valla had outlined. Valla himself had preferred the Latin of the ancient Roman Quintillian to Cicero, but later authors more often followed the example of Cicero. The Roman works of Horace, Livy, Ovid, and Vergil also provided important models. Among the many humanists who distinguished themselves as students of ancient style, Angelo Poliziano (1454–1494) was acknowledged as the master. A precocious student, Poliziano had translated Homer's *Iliad* into classical Latin verse by the time he was 19. The depth of his knowledge of Latin and Greek impressed

a PRIMARY SOURCE document

STANZAS FOR A JOUSTING MATCH

INTRODUCTION: In his "Stanzas for a Jousting Match," Angelo Poliziano imagined Florence in a classical landscape for the setting of a romance between his pupil Giulio de' Medici and a young noblewoman. Poliziano was widely recognized for the beauty and clarity of his style, as testified in these lines.

My daring mind urges me to celebrate the glorious
pageants and the proud games of the city
that bridles and gives rein to the magnanimous
Tuscans, the cruel realms of the goddess who
adorns the third heaven, and the rewards merited
by honorable pursuits; in order that fortune,
death, or time may not despoil great
names and unique and eminent deeds.

O fair god: you who inspire through the eyes
unto the heart sweet desire full of bitter
thought, you nourish souls with a sweet venom,
feeding yourself on tears and sighs, you ennoble
whatever you regard, for no baseness can exist
within your breast; Love, whose subject I am
forever, now lend your hand to my low intellect.

Sustain the burden that weighs so much upon me,
rule, Love, my tongue and hand; you are
the beginning and the end of my lofty endeavor,
yours will be the honor if this prayer is not in
vain; say, my Lord, with what snares you captured
the noble mind of the Tuscan baron, the
younger son of the Etruscan Leda, what nets
were spread out for so great a prey?

And you, well-born Laurel, under whose shelter
happy Florence rests in peace, fearing neither
winds nor threats of heaven, nor irate Jove in
his angriest countenance; receive my humble voice,
trembling and fearful, under the shade of
your sacred trunk; o cause, o goal of all my desires,
which draw life only from the fragrance of
your leaves.

SOURCE: Angelo Poliziano, "Stanzas for a Jousting Match," in *The Stanze of Angelo Poliziano*. Trans. David Quint (Amherst: University of Massachusetts Press, 1979): 3.

ily tutor wrote a vivid account of the event, one that was touching for its pathos. Eventually, Poliziano became a professor of rhetoric and poetry at the University of Florence, and in that position he published a study of texts that would have far-reaching impact. Poliziano's *Miscellanea* was a collection of essays about certain problems in textual editing and interpretation. Humanist scholars had long been aware of many variations in the texts that they studied. Over the centuries, scribes had introduced errors into later manuscripts and medieval scholars had sometimes written variant forms of texts willfully to defend their own principles. Until Poliziano's time, scholars had dealt with this problem intuitively. When faced with several variations in different manuscript versions, they had chosen the reading that seemed to fit with the style of the entire work. Poliziano showed that the use of intuition was insufficient, and his *Miscellanea* provided a method for establishing which manuscript version of a text was the oldest, and therefore, likely to be the most accurate. In his brief life Poliziano examined many variant versions of ancient texts in circulation, and the dates that he assigned to many of these manuscripts continue to be accepted even now. His most important contribution to Renaissance literary study, though, was his method, which became known as codicology. Codicology became in the following centuries an essential tool for philologists and historians, who used its critical methods to weed out erroneous texts and even to debunk forged manuscripts.

NEW GENRES. The developments in the study of language that were occurring in Florence and elsewhere throughout Italy point to a growing literary sophistication, a sophistication that would produce an undeniable flowering of Italian poetry and prose in the later fifteenth century. Emboldened by their new knowledge of classical literature, authors from throughout Italy would revive ancient genres and develop new ones to express their ideas. They were supported in these endeavors by the princely patrons of the period. Literary achievement became an important marker of social distinction at the time, and Italy's many princes encouraged inventiveness and experimentation in the authors they supported. Finally, the spread of the printing press in Italy in the second half of the fifteenth century helped stimulate the rise of new literary forms since it allowed writers and scholars to circulate numerous copies of both ancient texts and their own works more quickly than ever before. Writers, in other words, could imitate successful works in their own writing. Lyric poetry, pastoral literature, and chivalric romances were the most common literary forms favored by late fifteenth-century Italian

Lorenzo de' Medici, who became his patron and soon asked Poliziano to tutor his children. Poliziano developed an especially profound attachment to Giuliano Medici, who was murdered in the Pazzi Conspiracy in 1478, an unsuccessful coup directed against the Medici. The fam-

a PRIMARY SOURCE *document*

THE PAZZI CONSPIRACY

INTRODUCTION: Renaissance writers were well-acquainted with the political intrigues of their time, enjoying the patronage of wealthy, political families for their livelihoods. Often writers used their pen in service to their patrons' careers, producing propaganda against their enemies, or stirring public support with sonnets of praise. The humanist Angelo Poliziano wrote this contemporary history in which he described the death of his beloved pupil, Giuliano de' Medici, in a conspiracy that occurred in Florence in 1378. In the plot, members of the Pazzi clan joined with Florence's Archbishop Salviati and others discontented with the Medici rule to kill the family's two male heirs at a mass in Florence's cathedral. Although Giuliano was killed, his brother, Lorenzo, survived.

The state of this city was then that while all the good people were on the side of the brothers Lorenzo and Giuliano and the rest of the Medici family, a branch of the Pazzi family and some of the Salviati began, first in secret and then even openly, to oppose the existing government...

The Pazzi family was hated by citizens and common people alike. Moreover, they were all extremely greedy, and none could stand their outrageous and insolent nature ...

As soon as the communion of the priest was over and the signal had been given, Bernardo Bandini, Francesco Pazzi, and other conspirators surrounded Giuliano in a circle. First Bandini struck the young man, forcing his sword through his chest. Giuliano, dying, fled a few steps; they followed. Gasping for breath the youth fell to the ground. Francesco stabbed him again and again with his dagger. ...

Meanwhile, the chosen assassins attacked Lorenzo, and Antonio, first laying a hand on his left shoulder, aimed his dagger at Lorenzo's throat. The latter, undaunted, let his mantel fall and wrapped it around his left arm, drawing his sword out of its scabbard at the same time; however, he received one more blow, and as he freed himself, was wounded in the neck. Then, as a man both astute and brave, he turned upon his murderers with his unsheathed sword, watching carefully and guarding himself. ...

The panic of the people was something to be seen: men, women, and children fleeing everywhere, wherever their feet took them. The whole place was filled with roaring and groaning, yet you could not hear anything clearly that was said, and there were some who thought the church would collapse. ...

I went straight to the house by the shortest route and came across Giuliano's body wretchedly lying there, fouled with the blood of many wounds. Trembling, and hardly in possession of myself for the grief, I was supported by some friends and taken home. ...

The people, meanwhile, were gathering at the Medici palace with incredible excitement and demonstration of support. They demanded that the traitors be handed over to them for punishment and spared no threat or abuse until they forced the criminals to be arrested. The house of Jacopo Pazzi was barely defended from plunder, and Francesco, naked and wounded, was taken almost half dead to the hangman ... for it was not easy, or even possible, to control the fury of the crowd.

SOURCE: Angelo Poliziano, "The Pazzi Conspiracy" in *The Earthly Republic*. Trans. Elizabeth B. Welles. Eds. B. G. Kohl and R. G. Witt (Philadelphia: Pennsylvania University Press, 1978): 315–316.

writers. Most lyric poetry treated love, and would now be influenced by Petrarch's *Songbook*, as well as the more thorough knowledge of ancient love poetry that had recently been acquired. In his *Books of Love*, for example, Matteo Maria Boiardo relied on Petrarch's example as well as the ancient Roman poet to tell of the problems that his love for a young woman caused him. A similar sensibility about the pains of love shaped the Italian poetry of cultivated figures like Angelo Poliziano and Lorenzo de' Medici. In Florence, the love poetry of these all figures would also be shaped by Neoplatonism, which downplayed the importance of erotic attraction, and instead stressed the intellectual character of love as a meeting of minds.

PASTORAL. Poliziano and others also encouraged a new attention to an ancient literary form: the pastoral. In the fourteenth century Boccaccio had written pastoral poems that were set in the countryside and featured bucolic conversations between shepherds, sprites, and nymphs. He had been inspired to compose these poems after discovering the beautiful pastoral lyrics of the ancients, and he hoped his compositions would bring about a revival of the genre. His lead, however, was not followed until long after his death, as Poliziano and other late fifteenth-century writers now turned to champion pastoral imagery to give shape to their poems, plays, and novels. Pastoral literature often recounted tales of those who discovered wise and noble circles of shepherds and

Angelo Poliziano. THE LIBRARY OF CONGRESS.

nymphs in the countryside. The genre expressed a nostalgic longing for the simpler pleasures of rural life. Poliziano set his *Stanzas Begun for the Jousting Match of the Magnificent Giuliano di Piero de' Medici* (1478) within a pastoral setting, a classical landscape he placed around the city of Florence. In this country landscape he placed the love affair of his pupil, Piero de' Medici and Simonetta Cattaneo. He mixed themes that he derived from his study of history, classical mythology, and the Bible. And his work was freely tinged with the Neoplatonism popular among Florentine humanists at the time. Poliziano's shift to tales set in an idyllic rural setting was also symptomatic of the cultural transformations that were underway in Florence and other Italian cities in the second half of the fifteenth century. Before 1450, most of Florence's humanists had favored issues of government and civic engagement in their philosophical and historical works. Or in their treatises they had outlined programs for the liberal arts, the revival of ancient rhetoric, and the development of eloquence as part of a philosophy designed to encourage men and women to virtuous living. After 1450, in Florence and somewhat later elsewhere in Italy, many humanists became disciples of Neoplatonism, a philosophical move-

ment that favored meditation and a solitary life spent in the pursuit of individual perfection. These changes were also reflected in the architecture and art of the time. In the early part of the century great public monuments were constructed throughout the city of Florence, while later in the century, the town's great families built new, private family palaces and country villas in the areas surrounding the town. These changes were occurring elsewhere in Italy, and in these imposing structures Italy's reigning princes, nobles, and wealthy merchants achieved the privacy to cultivate the arts and their literary pursuits—recreations Neoplatonism advocated. The longing for the countryside and the isolation and simplicity of rural life then expressed in pastoral literature was yet another symptom of this shift toward privacy and inwardness. Eventually, these sensibilities became popular throughout Europe, and pastoral literature became one of the most widely read genres of the sixteenth century. In England, the taste for pastoral themes produced the famous rural scenes of Spenser's *Faerie Queene* as well as the forest images of Shakespeare's *A Midsummer Night's Dream*.

ARCADIA. The most accomplished work of pastoral fiction to appear in late fifteenth-century Italy was Jacopo Sannazaro's *Arcadia*, which was first published in 1502. Sannazaro set his rural vision in a shepherd's world, and he mixed poetry and prose together throughout the work. He recounts the tale of an autobiographical figure named Sincero, whose entrance into the idyllic Arcadia province of Greece becomes a vehicle for the author to consider the nature of poetry and art. Sincero is only gradually accepted into the company of shepherd poets he finds in this new world. The local shepherds share their wisdom, poetic skills, culture, and customs with him, but ultimately Sincero cannot be completely assimilated into their company. He leaves Arcadia and returns to Naples to find that his former love has died, and the poem ends with Sincero cursing his decision to leave the peaceful tranquility he had once experienced in Greece. The return to his native world has exposed him to the sorrow attendant upon all human attachments. The outlines of this plot, with its story of a wayfarer who learns poetic wisdom in a peaceful Paradise, would often be repeated in later pastorals.

CHIVALRIC ROMANCE. In another genre known as chivalric romance, writers forged together influences from many different literary traditions and periods, including works drawn from the classical period, the Middle Ages, and the more recent Renaissance. During the 1480s and 1490s Matteo Boiardo (1441–1494) pub-

lished his *Orlando innamorato* or *Orlando in Love*, a masterpiece of chivalric romance. Boiardo was a member of the brilliant D'Este court at Ferrara, a place in which a cultivated knowledge of literature and history was prized. His story drew upon Carolingian history and Arthurian legends, medieval romances, and the literature of courtly love. The epic poem recounts the life and deeds of Roland, the nephew of the emperor Charlemagne, and of Roland's love for the Saracen Princess Angelica. The plot is complex, involving numerous twists of fate that keep Roland apart from his Lady. But in the process of relating the complex tale, Boiardo transforms the rude and rough manners of the Carolingians into a courtly culture similar to the D'Este. While acknowledged as a masterpiece, the work was left incomplete at the author's death. In the sixteenth century the brilliant poet Lodovico Ariosto continued the poem, carrying the story to its conclusion as *Orlando furioso* or *Mad Roland*. Over time, Ariosto's *Furioso* enjoyed an even wider fame than the original that inspired it. Another chivalric romance, *Il Morgante* (1483) by Luigi Pulci, reveals a similar tendency to merge literary traditions drawn from the classical and medieval periods. Pulci was a member of the cultivated circle that surrounded the Medici family in late fifteenth-century Florence. His subject matter is similar to Boiardo's *Roland in Love*; his tale relates, in other words, events at the court of Charlemagne. While the tale is epic in proportion and complexity, Pulci lightens his story by narrating the tale from the perspective of the mock hero and giant Morgante. Along the way, the ponderous action is punctuated with many comic episodes. In France, the novelist François Rabelais read Pulci's work and relied upon it as one source of inspiration for his comic novels, *Gargantua* and *Pantagruel*.

IMPLICATIONS. During the fifteenth century Italy's literary figures moved to assimilate fully the traditions of classical Antiquity. At the beginning of the century, humanist writers, particularly in the city of Florence, devoted themselves to the study of history and to writing philosophical works that dealt with the ethics of government and an active life in society. By mid-century, though, new styles and fashions had helped to inspire a taste for Neoplatonism. In art, architecture, and literature, Italy's cultivated elites expressed a fondness for privacy and inward contemplation. In literature especially, these new sensibilities produced a number of new genres. Through these new literary forms Italy's literati demonstrated their intense classical learning, their mastery of rhetoric and stylistic devices, and their sheer imaginative inventiveness.

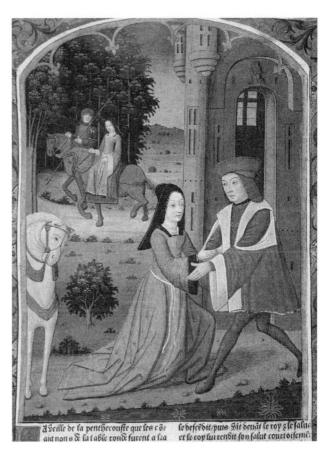

Fifteenth-century French manuscript illumination of "Lancelot Embracing a Lady." ARCHIVO ICONOGRAFICO, S.A./CORBIS. REPRODUCED BY PERMISSION.

SOURCES

H. Baron, *The Crisis of the Early Italian Renaissance* (Princeton, N.J.: Princeton University Press, 1966).

M. Ciliberto, *Giordano Bruno* (Rome: Laterza, 1990).

M. P. Gilmore, *The World of Humanism, 1453–1517* (New York: Harper, 1952).

P. O. Kristeller, *Renaissance Thought: The Classic, Scholastic, and Humanist Strains* (New York: Harper, 1962).

C. Nauert Jr., *Humanism and the Culture of Renaissance Europe* (Cambridge: Cambridge University Press, 1995).

E. F. Rice Jr., and A. Grafton, *Foundations of Early Modern Europe, 1460–1559* (New York: Norton, 1994).

R. Weiss, *The Renaissance Discovery of Classical Antiquity* (Oxford: Oxford University Press, 1969).

THE HIGH AND LATER RENAISSANCE

THE STYLISH STYLE. At the very end of the fifteenth century the artistic and literary achievements of Italy reached their apex in the movement known as the High

Baldassare Castiglione. THE LIBRARY OF CONGRESS.

Renaissance. In art, an impressive merger of the knowledge of classical art and technical brilliance produced the serenely beautiful works of Leonardo da Vinci, Michelangelo Buonarroti, and Raphael Sanzio. In the visual arts this High Renaissance synthesis emphasized classical proportions, balance, naturalism, rationality, and harmony. These accomplishments began with Leonardo's *Baptism of Christ* and *Annunciation* in the 1480s and concluded with Raphael's frescoes in the papal apartments in the Vatican and the early stages of Michelangelo's Sistine Ceiling paintings. By 1520, the High Renaissance style, which had been favored for only a generation, was already beginning to give way. By that time, Michelangelo was the sole surviving genius of the movement, and he was moving to develop a new style that would become known as Mannerism. Mannerism has often been called the "stylish style," because it was often exaggerated and contorted and its spirit was tenser and more disturbed than the peaceful, harmonious compositions of the High Renaissance. Mannerism survived into the later sixteenth century and affected artists throughout Europe. At the same time Mannerism was also symptomatic of more general cultural trends in the age. In literature, we can see the development of a similar "stylish style" occurring in Italy around the same

time. These changes resulted, in part, from the rise of refined court culture throughout Italy. Many of the peninsula's finest sixteenth-century authors lived and worked in this new refined environment. Members of a court, or courtiers for short, were expected to have mastered the Renaissance ideal of universality; that is, they were to have achieved competence in many different areas of endeavor. In literature, the refined courtier was expected to display a cultivated knowledge of classical literature, mythology, and the ancient rhetorical forms. Writing was also conceived of as a craft, and every refined courtier was expected to be able to write at least a passable sonnet or an elegant letter. The distinguishing signs of literary genius consequently shifted in this period to prize ingenuity and invention as signs of individuality. In the visual arts, the rise of this heightened sense of individuality extended the boundaries of pre-existing styles and genres. So, too, did writers strive to display their unique character, their refinement, and their individuality to their readers.

SPREZZATURA. Another value that was prized in the court culture of Italy at this time was known as *sprezzatura*. It can best be described as grace under pressure. To demonstrate *sprezzatura*, a courtier was expected to undertake difficult tasks—whether they be in writing, acrobatics, or horsemanship—and to perform them with an effortless ease. For writers, achieving *sprezzatura* often meant the ability to write about difficult themes and subjects in ways that seemed artless. In practice, reaching this goal sometimes proved beyond many writers' skills. At its best, the fashion for displaying one's *sprezzatura* produced stunning and original literary creations, but at its worst, it resulted in literature that could be overwrought, obscure, and merely difficult to understand.

BOOK OF THE COURTIER. Nowhere can the emerging values of late Renaissance court culture be observed more brilliantly than in the *Book of the Courtier*, a work begun by Baldassare Castiglione (1478–1529) around 1510. Castiglione was a nobleman who was related to the Gonzaga dukes of Mantua. In his youth he enjoyed the best education available in Italy and when he reached maturity he served as a diplomat in the courts of the dukes of Mantua and Urbino as well as in the papal government. He knew the life of a courtier firsthand, and in his guide to court life he tried to encapsulate the perfect mix of qualities necessary for someone to survive and prosper in this environment. *The Book of the Courtier* is written in dialogue form, a genre that the humanists had favored since the fourteenth century. The conversation it relates is set within the court at Urbino in Northern

Italy, reputedly one of the most elegant and refined in sixteenth-century Europe. The text is divided into four books, each treating a different dimension of the ideal courtier. The portrait that emerges from the dialogue is complex and multi-faceted. The ideal courtier must be of noble birth, skilled in the arts of war, but at the same time a master of all the liberal arts. His outward appearance must be pleasing, and in his speech and all his behavior he should be moderate and avoid any affectation. He must be a good conversationalist, witty, and able to crack a good joke. And since he serves as an adviser to a prince, he must always speak the truth. In this way, he can gain the trust and admiration of his lord, and having done so, he should speak his mind freely to prevent his master from erring. The *Courtier* also deals extensively with the role of the court lady, and the participants in the discussion at Urbino are similarly idealistic about this figure. While she should have many of the same qualities as her male counterparts, she must also cultivate discretion, generosity, grace, and purity. To this list, Castiglione also adds likability, liveliness, and a kind nature. Importantly, he supports women's education and argues through his courtiers' conversations that women are in many cases the intellectual equals of men. But in these discussions of women's capabilities, the female members of the Urbino court only rarely contribute to the dialogue.

INFLUENCE. The impact of Castiglione's work was two-fold. Written in an elegant Italian, *The Book of the Courtier*'s style was imitated by Italian writers in the decades that followed its publication. More importantly, though, Castiglione championed an ideal of a truly liberal and wide-ranging education for those who participated in court life. In Italy, the standards of behavior and intellectual life had risen in these societies during the fifteenth and early sixteenth centuries. Elsewhere in Europe, though, court life often remained rude and unsophisticated, and many courtiers at the dawn of the sixteenth century, particularly in Northern Europe, were illiterate. Castiglione's work championed a higher standard of education and conduct. Although it has often been criticized for placing too much emphasis on outward appearances, it did have a civilizing effect on courts throughout Europe. It was widely published throughout Italy in the sixteenth century, and was soon translated into Spanish, French, English, and Latin. In Northern Europe, it inspired an entire genre of conduct books. And in England, as wealthy but non-aristocratic gentry came to play a more dynamic role in the political life of the country in the seventeenth century, "gentlemen's books" promoted an ideal of civilized behavior similar

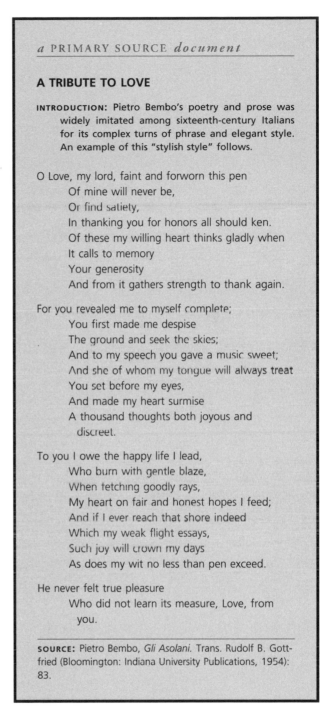

a PRIMARY SOURCE *document*

A TRIBUTE TO LOVE

INTRODUCTION: Pietro Bembo's poetry and prose was widely imitated among sixteenth-century Italians for its complex turns of phrase and elegant style. An example of this "stylish style" follows.

O Love, my lord, faint and forworn this pen
 Of mine will never be,
 Or find satiety,
 In thanking you for honors all should ken.
 Of these my willing heart thinks gladly when
 It calls to memory
 Your generosity
 And from it gathers strength to thank again.

For you revealed me to myself complete;
 You first made me despise
 The ground and seek the skies;
 And to my speech you gave a music sweet;
 And she of whom my tongue will always treat
 You set before my eyes,
 And made my heart surmise
 A thousand thoughts both joyous and
 discreet.

To you I owe the happy life I lead,
 Who burn with gentle blaze,
 When fetching goodly rays,
 My heart on fair and honest hopes I feed;
 And if I ever reach that shore indeed
 Which my weak flight essays,
 Such joy will crown my days
 As does my wit no less than pen exceed.

He never felt true pleasure
 Who did not learn its measure, Love, from
 you.

SOURCE: Pietro Bembo, *Gli Asolani.* Trans. Rudolf B. Gottfried (Bloomington: Indiana University Publications, 1954): 83.

to Castiglione among members of this rising class. In short, Castiglione's work proved to be an important chapter in what some historians have called the "tilt toward civility" in early-modern Europe.

CICERONIANISM. Questions of style took on renewed importance in another area of sixteenth-century literary life, this time concerning issues of rhetoric. During the fifteenth century the humanist campaign to

Pietro Bembo. THE LIBRARY OF CONGRESS.

emulate the classical Latin of the ancients had focused on recovering the language of the "Golden Age," that era believed to encompass roughly the century before and after the birth of Christ. Most scholars had insisted that Cicero represented the best model for prose, while for poetry they had usually turned to Vergil or Ovid as models. Lorenzo Valla had been a dissenting voice in the early debate over Latin style, as had the prolific Latinist Angelo Poliziano. In a famous letter to one Ciceronian disciple, Poliziano had pronounced "I am not Cicero; I express myself." Still, the example of Cicero prevailed. In the early sixteenth century the issue of which Latin style should be emulated took on renewed and now heated importance among the humanists. In 1513, Pietro Bembo, a philologist and literary theorist, defended the principle of literary imitation in a highly influential treatise written against those who attacked over-dependence on Cicero's model. Bembo showed that only by emulating a single example could an author hope to produce a work in a unified style. Imitation, in other words, was not stifling to creativity, but it allowed authors to achieve a unified voice that they could use to express their own individuality. Like many before him, Bembo promoted Cicero as the best model for Latin prose and Vergil for Latin poetry. At the same time that he was at work on his defense of Cicero and Vergil, Bembo devoted his attentions to literary Italian, too. Like

many, he realized that Italian would eventually triumph as a mode of written expression over Latin. In his *Prose* Bembo considered what form written Italian should take. Should literary Italian emulate the fourteenth-century Tuscan works of Dante, Petrarch, and Boccaccio? Should writers adopt the language of the Italian court? Or should they aim to express themselves in a generalized form of the language that everyone might understand? Bembo debated these questions and advised authors again to adopt the principle of literary imitation. For poetry, he insisted Petrarch's fourteenth-century Italian provided the best model, while for prose, Boccaccio was the best source for emulation. Bembo's many disciples followed his advice, and imitated the already archaic forms of Italian written by Petrarch and Boccaccio. The style that Bembo outlined in his *Prose* quickly became known in colorful Italian as "Bembismo," or "in the manner advocated by Bembo." Characteristics of Bembismo included complex turns of phrase, veiled meanings, and finely carved and chiseled lines, all of which writers in this vein saw as an attempt to revive the literary Italian of Petrarch and Boccaccio. Poetry and prose written in the style that Bembo advocated was often beautiful to the ear, but its critics charged that it was overly difficult and precocious as a literary language. But over time, Bembo's position would triumph. The long-term consequence of his support of the archaic usage of Petrarch and Boccaccio would mean that literary Italian tended to diverge increasingly from spoken forms of the language.

REVOLT. Bembo's victories in defining Latin and Italian style did not go unquestioned. In Northern Europe the humanist Desiderius Erasmus was widely recognized as the best Latinist of the age. On his travels to Italy, Erasmus had wearied of the devotion to Cicero that he found among scholars there, and he had been horrified to learn of the path taken by one of his Dutch countrymen, Christophe Longueil. With Bembo's encouragement, Longueil had dedicated himself to becoming a kind of living Cicero. In 1528, Erasmus published a bitter satire of Longueil and the Italian Ciceronians entitled *The Ciceronian*. The central character of this dialogue is Nosoponus, a pedant, who is cured of his disease of Ciceronianism through the ministrations of Bulephorus, the character in the dialogue that represents Erasmus's point of view. Throughout *The Ciceronian* Erasmus attacked the notion that Cicero's language could be an appropriate vehicle for communicating the very different circumstances of sixteenth-century European life. As the battle raged over literary Italian, other authors expressed their disapproval. In Flo-

rence, Niccolò Machiavelli, an important literary figure as well as political theorist, advocated that contemporary Florence's language should be the basis for literary Italian, and he dismissed Bembo's attempts to revive the archaic form of the language written by Boccaccio and Petrarch. Baldassare Castiglione, a champion of yet a third perspective, advocated the use of the language of Italian courts because it made free use of words drawn from many Italian dialects and even incorporated words from non-Italian languages.

PETRARCHISM. The imitation of Petrarch's poetry advocated by Pietro Bembo in his *Prose* also gave rise in Italy to a poetic movement known as Petrarchism. In the course of the sixteenth century Petrarchism became truly international, spreading to almost every corner of Europe. Among those who wrote poetry in the style of Petrarch were the Italians Baldassare Castiglione, Vittoria Colonna, and Michelangelo Buonarroti, the Frenchman Pierre de Ronsard, and the English poets Thomas Wyatt and William Shakespeare. At its best, Petrarchism's emulation of the language and style of the fourteenth-century poet produced many beautiful lyrics. In his *Songbook* Petrarch had written mostly in the sonnet form which, because of its relatively few lines and tightly controlled scope, was a suitable candidate for mimicry. But in the hands of lesser artists and amateur poets the fashion for Petrarch would also produce much mediocre verse.

HISTORY. In the sixteenth century Italian humanists continued to nourish their fascination for local history. Niccolò Machiavelli and Francesco Guicciardini (1483–1540) produced notable works in this genre that treated the history of their native Florence. In his *History of Florence* Machiavelli used the past as a mirror to support his republican political assumptions. He drew heavily upon older works, including those of Leonardo Bruni. Bruni had drawn strong links between republicanism and human creativity, and Machiavelli, too, used history to confirm such assumptions. At the same time he believed that the past repeated itself in cyclical patterns. Thus the astute observer could hope to predict coming events through a thorough knowledge of history. As in his *Prince*, Machiavelli's Florentine history also celebrated the virtues of the ancient Romans of the Republic. He found the valor they displayed sorely missing among contemporary Italians. Through his writing of history he hoped to reinvigorate this spirit among his readers, encouraging them to emulate Roman virtues. Machiavelli was a writer of unusual brilliance, creativity, and verve. After 1512 he lived in exile from government in Florence. During this time writing proved both a so-

a PRIMARY SOURCE *document*

A SONNET LAMENTING ART

INTRODUCTION: In addition to his numerous works of art and architecture, Michelangelo wrote a distinguished body of poetry, many written in the sonnet style popularized by Petrarchism at the time. In this poem, written late in his life, Michelangelo reevaluates his youthful devotion to art.

My course of life already has attained,
Through stormy seas, and in a flimsy vessel,
The common port, at which we land to tell
All conduct's cause and warrant, good or bad,

So that the passionate fantasy, which made
Of art a monarch for me and an idol,
Was laden down with sin, now I know well,
Like what all men against their will desired.

What will become, now, of my amorous thoughts,
Once gay and vain, as toward two deaths I move,
One known for sure, the other ominous?

There's no painting or sculpture now that quiets
The soul that's pointed toward that holy Love
That on the cross opened Its arms to take us.

SOURCE: Michelangelo Buonarroti, "Sonnet (1554)," in *Complete Poems and Selected Letters of Michelangelo.* Trans. Creighton Gilbert (New York: Random House, 1963): 159.

lace and a tangible means of support. He wrote in a colloquial Florentine Italian different from the highly stylized forms favored by other Italians. His use of the contemporary spoken language distinguished his writing and probably enhanced its popularity. Like many of Machiavelli's literary endeavors, the ideas contained in his *History of Florence* were neither new nor particularly insightful. His historical writing fit with his political philosophy, which favored both strong republican government when possible, and dictatorship when necessary to serve the common good. The strength of Machiavelli's history and the admiration that it drew resulted primarily from its literary style which, like most of Machiavelli's works, was clear, forceful, and capable of inspiring readers through its immediacy.

GUICCIARDINI. The Florentine statesman Francesco Guicciardini, on the other hand, was more sophisticated as an historian. He has long been seen, in fact, as the greatest historian of the Renaissance. In his *Florentine*

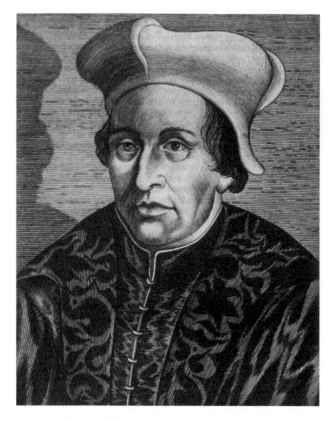

Francesco Guicciardini. THE LIBRARY OF CONGRESS.

History he wrote in the same contemporary Florentine Italian that Machiavelli had used, but he relied more heavily upon documentary evidence than Machiavelli had. In fact, before the modern world few historians evidenced a dedication to the documents deeper than Guicciardini's. His narrative covered the period of Florence's history from the late fourteenth to the early sixteenth century. It retold events clearly and evaluated the actions of the key players in Florence's government fairly. Guicciardini was not content merely to construct this history on the basis of past works, or documents he had seen while working on behalf of the state. Instead, as a member of Florence's government, he gained access to the city's secret files. At one point he even moved the city's wartime archives to his villa, where he carefully combed through thousands of documents. As a result, he constructed a relatively unbiased picture of this decisive period in the city's past. His efforts anticipated the development of historical objectivity pioneered by the great German historian Leopold von Ranke in the nineteenth century. The results of this research produced a history that was more thorough and objective than Machiavelli's, but one that was sometimes ponderous and slow reading. It was also no more optimistic in its conclusions than Machiavelli's had been. Like Machi-

avelli, Guicciardini was pessimistic about the course of Florence's development and about its citizenry's moral virtues. He presented the period following the death of the capable Lorenzo de' Medici in 1492 as a story of persistent decline in the city's fortunes.

ARETINO. One of the most unusual of Italy's sixteenth-century literati was Pietro Aretino (1492–1556), a native of the city of Arezzo near Florence. Aretino was the son of a shoemaker, but despite his humble origins and little formal schooling, he rose to play a role on the literary and political scene in Rome, and later in Venice. Above all, Aretino was a satirist, and the defamatory letters that he circulated about candidates for the papacy in 1523 influenced the election of Giulio de' Medici to the office. In his years in Rome, Aretino wrote pornography and used literal "blackmail" to extort money from the city's powerful. He threatened to expose the hypocrisy of these figures in published letters if they did not pay him off. Eventually, Aretino's intrigues forced him to flee Rome, and he wandered through Italy for a time before finding a home in Venice. There he wrote for the popular press, but he also produced a remarkable range of literary works. These included sonnets, plays, mock predictions, dialogues, and even biographies of saints known as hagiographies. His satires mocked the rich and the powerful as well as contemporary trends in the arts and learning, including Petrarchism and Neoplatonism. Aretino's greatest achievement, though, was the publication of his correspondence. He became the first Renaissance figure to publish his letters in Italian, and the witty and sometimes salacious contents of these letters inspired a fashion for the great and near-great to publish gossipy correspondence. These documents show Aretino advising princes, cursing his enemies, and holding forth on subjects in literary and artistic criticism. Together with Venice's famous painter, Titian, and the architect, Jacopo Sansovino, Aretino formed a kind of triumvirate that judged artistic taste in the city. Aretino's chief goal in life seems always to have been to tend his own fame, and in this profession, he was an astute master. He realized many of the promotional opportunities that the printing press offered and he used these to his advantage to become one of Europe's first modern celebrities.

TASSO. The last major literary genius the Italian Renaissance produced was Torquato Tasso (1544–1595). His life and work show the influence that the increasingly puritanical tastes of the Counter Reformation produced upon literary fashions in the second half of the sixteenth century. Tasso was born in Sorrento near the city of Naples in Southern Italy, where his father Bernardo served as a courtier to the Baron of Salerno.

Bernardo's opposition to the establishment of the Inquisition in nearby Naples forced his departure from that position. During the 1550s, Torquato traveled with his father, who had to take a series of insecure court positions in Northern and Central Italy to support the family. While on these travels, Tasso acquired an excellent education, but he also became familiar with the uncertainties that could plague a courtier's life if he failed to please his prince. In 1560, he entered the University of Padua, where his father wanted him to pursue a legal career that would free him from the need to secure literary patronage. Young Tasso, though, preferred poetry and philosophy to the law, and in these years, he began some of the poems that eventually established his fame. He began the chief of these works, *Jerusalemme liberata* or *Jerusalem Delivered*, at this time, although he did not finish it until many years later. He conceived the poem as a chivalric epic similar to those of Ariosto, Boiardo, and Pulci. Its tastes, though, were more moral and religiously profound than these earlier works. While Tasso did not completely abandon the complex plot twists, eroticism, or adventure of the chivalric romance, he sublimated these features to the higher themes of love and heroic valor. Completing *Jerusalem Delivered*, though, proved to be a lifelong, tortuous task. After leaving university, Tasso received patronage from a wealthy and influential cardinal. He had few duties except to write and amuse the cardinal's court in the city of Ferrara. In this environment Tasso circulated his poems, realizing that his works might cause offense in the heightened moral climate of the day. Over time, Tasso grew suspicious of his critics, and he feared that he would be denounced to the Inquisition. He went to confess his wrongdoings to the body when he had not even been summoned. Eventually, he stabbed a household servant whom he suspected of spying on him and he fled Ferrara. He left behind his manuscripts for *Jerusalem Delivered* and spent several years wandering through Italy. Later he returned to Ferrara where he denounced his former patrons, who imprisoned him, believing him to be mad. After seven years spent in an asylum, Tasso was finally released and had his writings returned to him. He regained his sanity and completed his masterpiece. His exaggerated, often paranoid fears of being persecuted by the Inquisition colored *Jerusalem Delivered*, and Tasso seems to have practiced a thorough self-censorship to avoid giving offense. Nevertheless, in his capable hands he still raised the chivalric tale he told to the level of high art.

SOURCES

A. Bevilacqua, *Pietro Aretino* (Rome: Instituto Poligrafico, 2002).

C. Cairns, *Pietro Aretino and His Circle in Venice* (Florence: Olschki, 1985).

F. Gilbert, *Machiavelli and Guicciardini* (Princeton, N.J.: Princeton University Press, 1965).

D. Looney, *Compromising the Classics: Roman Epic Narrative in the Italian Renaissance* (Detroit: Wayne State University Press, 1996).

C. Nauert Jr., *Humanism and the Culture of Renaissance Europe* (Cambridge: Cambridge University Press, 1995).

C. Raffini, *Marsilio Ficino, Pietro Bembo, Baldassare Castiglione: Philosophical, Aesthetic, and Political Approaches in Renaissance Platonism* (New York: P. Lang, 1998).

J. Shearman, *Mannerism* (Harmondsworth, United Kingdom: 1967).

SEE ALSO *Music: Sixteenth-Century Achievements in Secular Music*

THE NORTHERN RENAISSANCE

SPREAD OF HUMANISM. In the final quarter of the fifteenth century humanism's influence began to spread beyond Italy, into France, Germany, Spain, the Netherlands, and England. The timing of the arrival of this New Learning differed from place to place. In most countries pockets of scholars active in the first half of the fifteenth century had tried to revive ancient Latin grammar and rhetoric and to imitate the ancients' style in their work. Many of these proto-humanists were teachers, and their interests nourished in their students a hunger to learn about the *studia humanitatis*. By the 1460s and 1470s, an increasing number of northern European scholars journeyed to Italy to learn firsthand about the Italians' textual scholarship and their historical discoveries. As these figures began to return home, they frequently faced resistance from more traditional faculties in the universities. By 1500, though, the dogged persistence of this first generation of humanists had paid off and the movement was now established in many places outside Italy. As humanism matured in the sixteenth century, it helped to inspire a literary Renaissance. Inspired by the study of the classics, humanist scholars labored to revive ancient Latin and to reinvigorate their own native literary traditions. Their efforts resulted in a brilliant flowering of poetry and prose in sixteenth-century Europe.

LATIN. Latin had long been the *lingua franca* of Europe, a shared language that had allowed literate people from every corner of the continent to communicate with each other. During the Middle Ages the language had never ceased growing, as theologians, philosophers, and

government officials had constantly coined new terms and phrases in Latin to fit changing realities. Over the centuries, the native languages spoken in Europe had influenced medieval Latin, as writers often latinized terms drawn from their own spoken vocabulary. But Latin's influence on the development of the vernacular languages—that is, on French, German, English, and the other languages spoken in Europe—was even greater. As these native languages developed more and more into literary languages in the later Middle Ages, Latin provided a constant well from which writers drew words and phrases that had no equivalent in their own tongue. By contrast, the Renaissance humanists bypassed medieval Latin and worked to revive the language of ancient Rome, a Latin that differed enormously from the many medieval forms in use throughout Europe. Ancient Latin was an extremely precise language with a rich vocabulary and a complex and highly structured grammar. Latin now had to be mastered as a foreign language and it required years of instruction and practice to become fluent. Sixteenth-century intellectuals proved more than equal to this task. During this period more Latin literature would be written in Europe than at any other time in history, and while many works were of a mediocre quality, much of this writing was also distinguished by its technical brilliance and learning. The roll call of distinguished Latinists included Desiderius Erasmus, Thomas More, Juan Luis Vives, Philipp Melanchthon, Huldrych Zwingli, John Calvin, and Michel de Montaigne. Many Latin writers translated or arranged to have their works translated into vernacular languages, and in this process classical Latin enriched the style and vocabulary of the vernacular languages, as medieval Latin had once done. There were few signs of any decline in Latin's importance throughout the sixteenth century. The period was instead a great autumn harvest in the uses of Latin. Most intellectuals were bilingual, and while the language was used for every kind of writing, its precision and literary sophistication were seen as absolutely essential to those who wished to discuss theological, scholarly, or technical issues in their writing.

VERNACULAR LANGUAGES. At the same time as the revival of classical Latin was occurring throughout Europe, the continent's rich variety of spoken dialects were more and more coalescing into the forms we recognize today as modern national languages. Spoken dialects persisted in European countries until modern times, and the gulf between many of these spoken dialects and the national written language continues even now to be enormous. Yet by the end of the Middle Ages, vernacular French, German, English, Italian, and Spanish began to

challenge Latin's dominance as a literary language. At least three factors had stimulated the development of these languages as written forms of expression. First, in the high Middle Ages Europe's aristocracy had evidenced a taste for chivalric themes and epic literature written in their own languages. The literary traditions that had been born in this period—epic poetry, chivalric romances, and ballads, to name just a few—continued to live on in the later Middle Ages. The language used to retell these tales was the vernacular, a written approximation of the spoken dialect of a region. Government was a second force that stimulated the rise of the vernacular. By the end of the Middle Ages, government documents, court records, and wills were being kept in many parts of Europe in native languages rather than Latin. These practical uses created a demand for notaries, secretaries, and other officials who were trained in both Latin and the native language. Governmental usage helped elevate the importance of the vernacular language, which had long been seen as a form of expression inferior to Latin. The final factor that aided the rise of vernacular languages was the invention of the printing press. In the first generation of the press, most printers devoted their attentions to printing copies of ancient classics, theological works, and other texts useful to scholars, typically published in Latin. Though less common, vernacular works printed during this early period of the development of the press resulted in the circulation of hundreds of copies, influencing later writers to adopt the vernacular. The press, moreover, played an important role in standardizing the form of the national languages. In Germany, Luther's translation of the Bible into German helped establish the reformer's own Saxon German as the dialect many later German writers preferred. In England, the publication of the Great English Bible and the Book of Common Prayer played similar roles in standardizing English. While great regional variations in usage and vocabulary persisted in written forms of the national languages, the economies of printing tended to fix the style, vocabulary, and spelling of the early-modern national languages. Authors and printers concerned with maximizing their earnings favored the emerging standard forms of English, French, and German used in the press at the expense of other regional dialects. In adopting these standard vernacular forms their works could be read by the broadest possible audience.

FRENCH LANGUAGE. The French language possessed the longest literary tradition of all the vernacular languages of Europe and its influence spread across a great area of the continent. As a result of the Norman Conquest, French had been established in Britain, where

it shaped the development of Middle English. Even in the sixteenth century, many of the English and Scottish aristocracy continued to write and speak French rather than the native languages of their countries. French was also a language used in diplomacy in Northern Europe, and it was spoken in parts of Flanders (a province of modern Belgium), in Burgundy (an important duchy located between France and Germany), and in regions of Germany and Switzerland. Thus a large portion of Northern Europe was French-speaking in the later Middle Ages, although there were considerable regional variations in the language. Over the course of the sixteenth century these differences diminished within France itself, in part because of a royal edict of 1539 requiring all court proceedings within France to be conducted in the French language. This decision sounded the death knell for Provencal, a widely spoken and written form of French in the southern part of the country. Now attorneys, judges, and royal officials needed to adopt the northern French dialect favored by the royal government.

LITERARY TRADITIONS. Medieval French authors had written a vast body of lyric poetry, historical chronicles, epics, and romances. In the course of the sixteenth century Renaissance humanism affected these older literary traditions, in most cases causing writers to abandon the older genres in favor of new classical forms. Enlivened by these classical examples, writers produced some of the language's finest poetry, and in the works of François Rabelais and Michel de Montaigne, France made two undeniably great prose contributions to world literature.

INFLUENCE OF ERASMUS. Literary achievement, though, was far from the minds of the first French thinkers to develop their skills as humanist scholars. Instead religious issues stimulated the growth of humanist studies, as France's first humanists aligned themselves with the movement because of its support of Christian reform. The example of Erasmus was particularly important to many of France's early humanists. In his many satires Erasmus had mocked the sterile theology taught by scholastic theologians in the universities. Erasmus had acquired this distaste for traditional theology, in fact, while he was a student at the University of Paris during the 1490s. As his ideas developed in the first decade of the sixteenth century, he promoted a revival of primitive Christianity as the only sure way to enliven the reform of the church. Guillaume Budé (1467–1540) and other early French humanists took interest in these ideas and they became avid students of Greek and Latin so they could deepen their understanding of the scriptures and

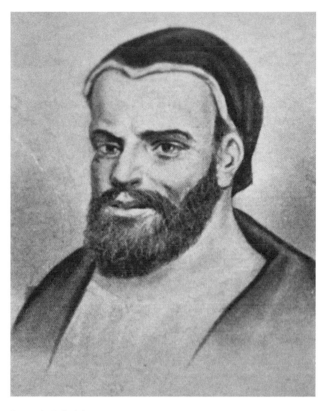

François Rabelais. **THE LIBRARY OF CONGRESS.**

the early history of the church. This sure and certain understanding of primitive Christianity, though, could not be achieved without a thorough knowledge of the Greek and Roman classics. And so, like Erasmus, many French humanists argued that classical eloquence and ancient moral philosophy could play a role in helping to shape the reform of the church. Budé, Jacques Lefèvre d'Étaples, and other French humanists of this first generation developed this form of "Christian humanism" during the first decades of the sixteenth century.

INITIAL LITERARY DEVELOPMENTS. Humanism's impact on literary developments in France was already evident by the 1530s. At this time the first generation of Renaissance fictional writers and poets relied on the critique of the church and of medieval traditions that humanist philosophers like Erasmus, Budé, and Lefèvre d'Étaples had developed. Three figures stand out in this early period of the French Renaissance: François Rabelais, Marguerite of Navarre, and Clément Marot. Of the three, François Rabelais (1494–1553) was the undisputed genius. In two novels, *Pantagruel* (1532) and *Gargantua* (1534), he wove together fantastic comic tales about a race of giants into an enormous tapestry that attacked traditional medieval religious life and learning. He had developed his disdain for the monastic life firsthand.

a PRIMARY SOURCE *document*

AN ATTACK ON MONKS AND SCHOLASTIC THEOLOGIANS

INTRODUCTION: In his novels *Gargantua* and *Pantagruel*, the French humanist François Rabelais often mocked monks and scholastic theologians. At the end of the second book, Rabelais defended himself against these figures, and he defends the role that laughter plays in his work and in living generally.

Do I hear you saying: "Master, it scarcely seems sensible of you to be writing such jocose twaddle!" My reply is that you are no more sensible to waste your time reading it.

But if you do so as a gay pastime—which was the spirit in which I wrote—then you and I are less reprehensible than a rabble of unruly monks, critters and hypocritters, sophists and double-fists, humbugs and other bugs, and all folk of the same water and kidney who skulk under religious robes the better to gull the world. For they seek to persuade ordinary people that they are intent solely upon contemplation, devotion, fasts, maceration of their sensualities—and that merely to sustain the petty fragility of their humanity! Whereas, quite to the contrary, they were roistering, and God knows how they roister! As

Juvenal has it *"Et Curios simulant sed bacchanali vivant,* they play the austere Curius yet revel in bacchanalian orgies." You may read the record of their dissipation in great letter of illuminated script upon their florid snout and their pedulous bellies unless they perfume themselves with sulphur.

As for their studies, they read only Pantagrueline books, not so much to pass the time merrily as to hurt some one mischievously. How so? By fouling and befouling, by twiddling their dry fingers and fingering their dry twiddlers, by twisting wry necks, by bumming, arsing and ballocking, by devilscutting, in a word by calumniating. Rapt in this task, they are like nothing so much as the brutish village clods who in the cherry season stir up the ordures of little children to find kernels to sell to druggists for pomander oil.

Flee these rascals at sight, hate and abhor them as I do myself, and by my faith, you will be the better for it. Would you be good Pantagruelists? That is, would you live peaceful, happy, healthy and forever content? Then never trust in people who peep through holes, especially through the opening of a monk's hood.

SOURCE: François Rabelais, *The Five Books of Gargantua and Pantagruel.* Trans. Jacques LeClercq (New York: Modern Library, 1936): 289–290.

In his youth he had been a member of a Franciscan monastery. There, Rabelais frequently came to loggerheads with his superiors, and he soon left the convent to join a more liberal group of Benedictines. Eventually, he left the religious life altogether to pursue his classical studies and to complete a medical degree. Rabelais promoted his *Gargantua* and *Pantagruel* as mere trivialities he had created to lighten the sufferings of his sick patients. While the two books contain much buffoonery and grotesque humor, a deeply serious vein runs through these comic tales. Their satire mocks contemporary hypocrisy, popular superstitions, and religious intolerance, faults that Rabelais saw as being in abundant supply during his times. Beyond his Christian humanism, Rabelais did not subscribe to a set of religious orthodoxies or to a single philosophical perspective in his work. Instead he preached the enjoyment of life, the value of study, and a tolerant understanding of human foibles and shortcomings. Rabelais wrote two more installments to the series in the 1540s, and in these he stepped beyond the stylistic confines of the medieval chivalric epic in which he had begun the tales. He moved to develop instead a classical heroic narrative that was

more consonant with the story's underlying humanist ideology. Throughout the entire series, though, the tales were freely tinged with a frank and open sexuality, a great deal of coarse and scatological humor, and the language of the street. These factors helped to stimulate their enormous popularity, which was immediate and stretched far beyond France. Rabelais' works were translated into other European languages, and eventually influenced Cervantes' *Don Quixote* in seventeenth-century Spain as well as novel writers in eighteenth-century England and France. At home, though, the scholastic theology that litter the tales were not fondly received by the theologians of the University of Paris, who routinely condemned Rabelais' works as subversive.

MAROT AND MARGUERITE OF NAVARRE. Christian humanist and Protestant ideas shaped the poetic works of Marguerite of Navarre (1492–1549) and Clément Marot (1496–1544). Marguerite of Navarre was one of the most brilliantly educated women of the sixteenth century. She was the sister of King Francis I of France and, following her first husband's death, she married the King of Navarre, a small but important king-

it shaped the development of Middle English. Even in the sixteenth century, many of the English and Scottish aristocracy continued to write and speak French rather than the native languages of their countries. French was also a language used in diplomacy in Northern Europe, and it was spoken in parts of Flanders (a province of modern Belgium), in Burgundy (an important duchy located between France and Germany), and in regions of Germany and Switzerland. Thus a large portion of Northern Europe was French-speaking in the later Middle Ages, although there were considerable regional variations in the language. Over the course of the sixteenth century these differences diminished within France itself, in part because of a royal edict of 1539 requiring all court proceedings within France to be conducted in the French language. This decision sounded the death knell for Provencal, a widely spoken and written form of French in the southern part of the country. Now attorneys, judges, and royal officials needed to adopt the northern French dialect favored by the royal government.

LITERARY TRADITIONS. Medieval French authors had written a vast body of lyric poetry, historical chronicles, epics, and romances. In the course of the sixteenth century Renaissance humanism affected these older literary traditions, in most cases causing writers to abandon the older genres in favor of new classical forms. Enlivened by these classical examples, writers produced some of the language's finest poetry, and in the works of François Rabelais and Michel de Montaigne, France made two undeniably great prose contributions to world literature.

INFLUENCE OF ERASMUS. Literary achievement, though, was far from the minds of the first French thinkers to develop their skills as humanist scholars. Instead religious issues stimulated the growth of humanist studies, as France's first humanists aligned themselves with the movement because of its support of Christian reform. The example of Erasmus was particularly important to many of France's early humanists. In his many satires Erasmus had mocked the sterile theology taught by scholastic theologians in the universities. Erasmus had acquired this distaste for traditional theology, in fact, while he was a student at the University of Paris during the 1490s. As his ideas developed in the first decade of the sixteenth century, he promoted a revival of primitive Christianity as the only sure way to enliven the reform of the church. Guillaume Budé (1467–1540) and other early French humanists took interest in these ideas and they became avid students of Greek and Latin so they could deepen their understanding of the scriptures and

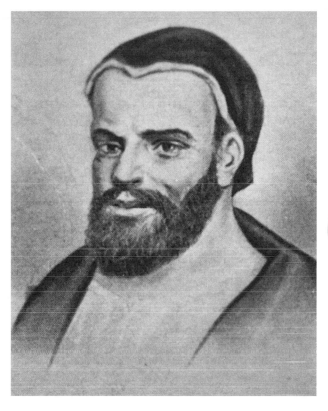

François Rabelais. THE LIBRARY OF CONGRESS.

the early history of the church. This sure and certain understanding of primitive Christianity, though, could not be achieved without a thorough knowledge of the Greek and Roman classics. And so, like Erasmus, many French humanists argued that classical eloquence and ancient moral philosophy could play a role in helping to shape the reform of the church. Budé, Jacques Lefèvre d'Étaples, and other French humanists of this first generation developed this form of "Christian humanism" during the first decades of the sixteenth century.

INITIAL LITERARY DEVELOPMENTS. Humanism's impact on literary developments in France was already evident by the 1530s. At this time the first generation of Renaissance fictional writers and poets relied on the critique of the church and of medieval traditions that humanist philosophers like Erasmus, Budé, and Lefèvre d'Étaples had developed. Three figures stand out in this early period of the French Renaissance: François Rabelais, Marguerite of Navarre, and Clément Marot. Of the three, François Rabelais (1494–1553) was the undisputed genius. In two novels, *Pantagruel* (1532) and *Gargantua* (1534), he wove together fantastic comic tales about a race of giants into an enormous tapestry that attacked traditional medieval religious life and learning. He had developed his disdain for the monastic life firsthand.

a PRIMARY SOURCE *document*

AN ATTACK ON MONKS AND SCHOLASTIC THEOLOGIANS

INTRODUCTION: In his novels *Gargantua* and *Pantagruel*, the French humanist François Rabelais often mocked monks and scholastic theologians. At the end of the second book, Rabelais defended himself against these figures, and he defends the role that laughter plays in his work and in living generally.

Do I hear you saying: "Master, it scarcely seems sensible of you to be writing such jocose twaddle!" My reply is that you are no more sensible to waste your time reading it.

But if you do so as a gay pastime—which was the spirit in which I wrote—then you and I are less reprehensible than a rabble of unruly monks, critters and hypocritters, sophists and double-fists, humbugs and other bugs, and all folk of the same water and kidney who skulk under religious robes the better to gull the world. For they seek to persuade ordinary people that they are intent solely upon contemplation, devotion, fasts, maceration of their sensualities—and that merely to sustain the petty fragility of their humanity! Whereas, quite to the contrary, they were roistering, and God knows how they roister! As

Juvenal has it *"Et Curios simulant sed bacchanali vivant,* they play the austere Curius yet revel in bacchanalian orgies." You may read the record of their dissipation in great letter of illuminated script upon their florid snout and their pedulous bellies unless they perfume themselves with sulphur.

As for their studies, they read only Pantagrueline books, not so much to pass the time merrily as to hurt some one mischievously. How so? By fouling and befouling, by twiddling their dry fingers and fingering their dry twiddlers, by twisting wry necks, by bumming, arsing and ballocking, by devilscutting, in a word by calumniating. Rapt in this task, they are like nothing so much as the brutish village clods who in the cherry season stir up the ordures of little children to find kernels to sell to druggists for pomander oil.

Flee these rascals at sight, hate and abhor them as I do myself, and by my faith, you will be the better for it. Would you be good Pantagruelists? That is, would you live peaceful, happy, healthy and forever content? Then never trust in people who peep through holes, especially through the opening of a monk's hood.

SOURCE: François Rabelais, *The Five Books of Gargantua and Pantagruel.* Trans. Jacques LeClercq (New York: Modern Library, 1936): 289–290.

In his youth he had been a member of a Franciscan monastery. There, Rabelais frequently came to loggerheads with his superiors, and he soon left the convent to join a more liberal group of Benedictines. Eventually, he left the religious life altogether to pursue his classical studies and to complete a medical degree. Rabelais promoted his *Gargantua* and *Pantagruel* as mere trivialities he had created to lighten the sufferings of his sick patients. While the two books contain much buffoonery and grotesque humor, a deeply serious vein runs through these comic tales. Their satire mocks contemporary hypocrisy, popular superstitions, and religious intolerance, faults that Rabelais saw as being in abundant supply during his times. Beyond his Christian humanism, Rabelais did not subscribe to a set of religious orthodoxies or to a single philosophical perspective in his work. Instead he preached the enjoyment of life, the value of study, and a tolerant understanding of human foibles and shortcomings. Rabelais wrote two more installments to the series in the 1540s, and in these he stepped beyond the stylistic confines of the medieval chivalric epic in which he had begun the tales. He moved to develop instead a classical heroic narrative that was

more consonant with the story's underlying humanist ideology. Throughout the entire series, though, the tales were freely tinged with a frank and open sexuality, a great deal of coarse and scatological humor, and the language of the street. These factors helped to stimulate their enormous popularity, which was immediate and stretched far beyond France. Rabelais' works were translated into other European languages, and eventually influenced Cervantes' *Don Quixote* in seventeenth-century Spain as well as novel writers in eighteenth-century England and France. At home, though, the scholastic theology that litter the tales were not fondly received by the theologians of the University of Paris, who routinely condemned Rabelais' works as subversive.

MAROT AND MARGUERITE OF NAVARRE. Christian humanist and Protestant ideas shaped the poetic works of Marguerite of Navarre (1492–1549) and Clément Marot (1496–1544). Marguerite of Navarre was one of the most brilliantly educated women of the sixteenth century. She was the sister of King Francis I of France and, following her first husband's death, she married the King of Navarre, a small but important king-

a PRIMARY SOURCE *document*

ADVICE ON WORLDLY ENGAGEMENTS

INTRODUCTION: Marguerite of Navarre's *Heptameron* was closely modeled on Boccaccio's *Decameron*. In the prologue, the characters discuss the purpose of life, and in their deliberations they are guided by an old woman who warns them to avoid worldliness and engage in the study of the scriptures.

"You ask a thing of me, my children," replied the old lady, "which I find very difficult. You want me to invent an amusement which shall dissipate your ennui. I have been in search of such a remedy all my life long, and I have never found but one, which is the reading of Holy Writ. It is in such reading that the mind finds its true and perfect joy, whence proceed the repose and the health of the body. If you ask me what I do to be so cheerful and so healthy at so advanced an age, it is, that as soon as I rise I read the Holy Scriptures. I see and contemplate the will of God, who sent his Son on earth to announce to us that holy word and that good news which promises the pardon of all sins, and the payment of all debts, by the gift he has made us of his love, passion, and merits. This idea affords me such joy, that I take my psalter, and sing with my heart and pronounce with my lips, as humbly as I can, the beautiful canticles with which the Holy Spirit inspired David and other sacred authors. The pleasure I derive from them is so ravishing, that I regard as blessings the evils which befall me every day, because I have in my heart through faith Him who has suffered all these evils for me. Before supper I retire in like manner to feed my soul with reading. In the evening I review all I have done in the day; I ask pardon for my faults; I thank God for his graces, and lie down in his love, fear, and peace, assured against all evils. This, my children, is what has long been my amusement, after having searched well, and found none more solid and more satisfying. It seems to me, then, that if you will give yourselves every morning for an hour to reading, and say your prayers devoutly during mass, you will find in this solitude all the charms which cities could afford. In fact, he who knows God finds all things fair in him, and without him everything ugly and disagreeable. Take my advice, therefore, I entreat you, if you wish to find happiness in life."

"Those who have read the Holy Scriptures," said Hircan, "as I believe we have done, will confess, madam, that what you have said is true. But you must also consider that we are not yet so mortified but that we have need of some amusement and corporeal pastime. When we are at home we have the chase and hawking, which make us forget a thousand bad thoughts; the ladies have their household affairs, their needlework, and sometimes dancing, wherein they find laudable exercise. I propose then, on the part of the men, that you, as the eldest lady, read to us in the morning the history of the life of our Lord Jesus Christ, and of the great and wondrous things he has done for us. After dinner until vespers we must choose some pastime which may be agreeable to the body and not prejudicial to the soul. By this means we shall pass the day cheerfully."

SOURCE: Marguerite of Navarre, *The Heptameron*. Trans. Walter K. Kelly (London: 1855). Available online at http://digital.library.upenn.edu/women/navarre/heptameron/introduction.html.

dom between Spain and France. Marguerite's interests were wide-ranging, and included Neoplatonic philosophy and the cause of church reform. While she remained outwardly loyal to Rome, her court harbored a number of Protestants, and those suspected of Protestant sympathies. She was a prolific writer, although most of her works were not published during her lifetime. In many of these she develops a consistent theme, first outlined in the *Mirror of the Sinful Soul.* In that long work she describes the soul as constantly in danger from temptation, but still moving along toward the path of salvation. Many of Marguerite's poems were allegories that described her own religious turmoil and the consolation she received from Christ. She modeled her greatest work of fiction, the *Heptameron*, on Boccaccio's *Decameron.* In it, a flood traps a group of ten French noble men and women. While they wait to be rescued, they tell tales to pass the time. After each of these, the group considers the moral message of the fable. Like Rabelais, Marguerite's tales are often marked by a frank sexuality, which caused some scholars to discount its value. More recent examinations of the *Heptameron* have shown that it is filled with dynamic female characters, complex observations, and a subtle morality. For a time Marguerite of Navarre was also patron of Clément Marot, a figure that influenced much later sixteenth-century French verse. Marot fell under suspicion of Protestant sympathies at more than one point in his life, and his persecution became the subject for several of his poems. When he was not yet thirty, he abandoned the traditional medieval style of verse that he had used until that point, and adopted a lighter and more elegant style. At Marguerite of Navarre's urging, he translated the Old Testament Psalms into French verse, and these soon became

wildly popular. They were used at the royal court and adopted by congregations of French Protestants. During the sixteenth century French presses published more than 500 editions of Marot's poetic versions of the Psalms, even though the theological faculty at the University of Paris had condemned them. Fears about his religious orthodoxy forced Marot into exile later in his life, and he died in the Northern Italian city of Turin. Importantly, Marot became the first French poet to learn of the Italian movement of Petrarchism, the imitation of Petrarch's style. He wrote the first sonnet in the French language, and his other verses, which included a number of short poems and epigrams, influenced poets in the second half of the sixteenth century.

THE PLEIADES. Around 1550, a group of seven poets known as the Pleiades self-consciously tried to separate themselves from France's medieval traditions of verse. In the place of native verse forms, they adopted a strictly classicizing style based on poetic models found in Greek and Roman literature. The group took its name from the heavenly constellation, which according to Greek myth had been formed to immortalize the memories of seven great poets. The Pleiades rejected France's medieval poetry as barbaric, and instead they wanted to endow literary French with the same kind of elegance that was to be found in the works of Homer, Vergil, Horace, and other ancient figures. They fashioned the manifesto for the movement after Joachim Du Bellay's treatise *Defense and Illustration of the French Language*, which he published in 1549 along with thirteen odes written in the style of Horace. Du Bellay's friend Pierre de Ronsard soon followed with the publication of a much larger collection of odes, and over the course of the next two decades the other members of the Pleiades worked to perfect classical style in French verse. Around 1570, the movement began to die out as fashions changed. By this time the members of the Pleiades had succeeded in introducing a number of ancient poetic forms into French verse, and writers continued to return to many of these forms during the early-modern and modern periods.

MONTAIGNE. In the final decades of the sixteenth century religious wars broke out in France. As the disruptions of these conflicts grew, the dream of reviving a classical Golden Age seemed increasingly unrealistic. Now Renaissance writers experimented with more personal styles, making many of their works difficult to classify within the existing French or the newly adopted classical genres. Such is the case with the greatest author of the period, Michel de Montaigne (1533–1592). He was at one and the same time a classical humanist of distinction, a critical and literary theorist, a political philosopher, and a skeptical figure of some subtlety (see Philosophy: Trends in Sixteenth Century Thought: Montaigne). Disgusted by the violence and intolerance that was becoming increasingly common in France, Montaigne retired from public life to his country chateau when he was not yet forty. For the rest of his life he devoted himself to his *Essays*, a collection of internal thoughts, debates, and trials of ideas which he recorded and expanded upon over a number of years. From his earliest youth Montaigne had been trained in the traditions of Renaissance humanism and he had grown up speaking classical Latin. While his mastery of that language was prodigious, he chose to write his *Essays* in French, a sign of the growing dominance of the language among writers in sixteenth-century France. The beauty of his style, his depth of classical knowledge, and the fine literary distinctions he made in recording his thoughts and feelings expanded the boundaries of literary French even farther. They would also make the *Essays* one of the milestones in the history of the language. As the sixteenth century drew to a close, Montaigne's *Essays* came in their final form to reflect the increasingly pessimistic cast of the humanist movement in France. The century had opened in high optimism, as a new generation of scholars like Budé had seen in the imitation of classical Antiquity a force that would revitalize morality and reform Christianity. Inspired by Erasmus and other Christian humanists, French humanists had labored to revive the antique ideal of eloquence in speaking and writing. But now as religious intolerance and violence punctuated the final years of the sixteenth century, figures like Montaigne questioned the civilizing effects of these efforts. "Between ourselves," he wrote, "these are the things that I have always seen to be in remarkable agreement: supercelestial thoughts and subterranean conduct."

SPANISH LANGUAGE. In Spain, Renaissance humanism did not produce the great flowering of Latin works that the movement did elsewhere in Northern Europe and Italy. In the second half of the fifteenth century the humanist Antonio de Nebrija helped to establish the study of classical Latin in Spain by publishing a textbook about the language in 1481. Queen Isabella of Castile soon encouraged Nebrija to translate the work into Spanish so that a wider audience could study his text. By 1500, small groups of Spanish humanists wrote literature in a revived classical Latin, and some of these scholars worked on the great Polyglot Bible project that began at the University of Alcala in 1506. But Spanish humanists wrote largely in their own language, and despite the intensely orthodox character of religious life in Spain at the time, they adopted many of the ethical and

moral teachings that humanists did elsewhere in Europe. Erasmus was a key figure in the Spanish Renaissance—so key, in fact, that humanism came to be known in parts of Iberia as Erasmianism. As elsewhere in Europe, written Spanish was being standardized during the sixteenth century, its vocabulary, spelling, and phonetic structure acquiring its modern elements. In the creation of this national language, the Castilian dialect grew to be dominant. The expansion of Castilian hastened in the sixteenth century as the union of Castile and Aragon that had first been forged by the marriage of King Ferdinand and Queen Isabella grew tighter over time. Like France, Spain had a distinguished medieval tradition of chivalric romances, epic poetry, and love lyrics. In the course of the sixteenth century, these native traditions would be influenced by Petrarchism, which popularized the writing of sonnets, and by the revival of knowledge of ancient poetry.

THE NOVEL. In the writing of novels, the sixteenth century in Spain was a distinguished prelude to the Golden Age of Spanish literature in the seventeenth century. As in France, the traditions of chivalric romance had been strong in medieval Spain. Novels about knightly love affairs formed a widely popular genre in Renaissance Spain. The most successful of these was *Amadis de Gaula*, a tale which had been written by several authors before being given its final form by Garci Rodríguez de Montalvo and published in 1508. *Amadis* recounted the tale of an idealized knight and his love for an equally idealized lady. The success of the work gave rise to an entire genre of knightly romance in which military figures embodied Christian virtues. But by the end of the sixteenth century, the popularity of these tales had begun to wane in favor of new kinds of fiction. Tragicomedy, as evidenced in the success of Spain's greatest sixteenth-century novel *La Celestina*, also attracted new readers. Published in 1502, Fernando de Rojas's great masterpiece relates in dialogue form the love interests of the noble Calisto, who tries to seduce the lovely, but lowborn woman Melibea. She rebuffs his advances, and Calisto, offended by this assault to his honor, appeals to the sorceress Celestina for aid. After many twists and turns, the novel ends uncharacteristically with Celestina's gruesome murder, the accidental death of Calisto, and the suicide of the deflowered Melibea. The picaresque novel was another important form of fiction that emerged in sixteenth-century Spain. Instead of recounting the heroic deeds of great lovers or knights errant, these stories treated society's downtrodden and outcasts. These novels are notable for their moral ambiguity since their heroes are,

in reality, anti-heroes. Vagabonds, thieves, and other deviants populate the pages of these works, and writers often used the genre to satirize society's absurdities. The first novel in this vein, *The Life of Lazarillo of Tormes* is often judged the best. It was published in 1554, and by the end of the century many authors had imitated its formula. As a genre, the picaresque novel proved important in the seventeenth century in forging more realistic kinds of fiction. A final fictional form that was popular in sixteenth-century Spain was the pastoral romance. In 1559 Jorge de Montemayor published the first of these works in Spanish entitled *Diana*. Modeled after the *Arcadia* of Jacopo Sannazaro, *Diana* included scenes in which nymphs and shepherds engaged in airy discussions of Platonic love. By century's end, Spanish authors had published a number of other pastoral romances; most notable among these was Miguel de Cervantes' *Galatea*, first published in 1585.

VIVES. Spain's most accomplished sixteenth-century humanist philosopher, Juan Luis Vives (1492–1540), was also a literary figure of distinction. When he was only seventeen Vives left Spain for the University of Paris. He soon attracted the attention of Erasmus, Budé, and other humanists in northern Europe, and he lived for a time in Louvain in Flanders before moving on to England where he was appointed a lecturer at the University of Oxford. He remained in England for several years, but eventually fell out of favor when King Henry VIII wanted to divorce his Spanish wife, Catherine of Aragon. He moved on to Bruges, the home of his wife, and spent the remainder of his life there. He continued in these years to nourish a correspondence with Thomas More and other humanists, both in England and throughout Europe. Vives made powerful contributions to the study of philology and philosophy, but he was also an advocate of social and educational reform. In 1526, for instance, he wrote a tract entitled *On Aid to the Poor* which he sent to the magistrates of his wife's city Bruges. Vives recommended that the increasingly large number of refugees present in Europe should be treated as natives in those places in which they settled, a visionary plan when judged against the restrictive citizenship requirements common at the time. In his educational tracts he outlined plans for the education of children and women. One of these, *On the Right Method of Instruction for Children,* was written for Princess Mary of England, the daughter of Henry VIII and Catherine of Aragon. In *On the Education of the Christian Woman,* Vives advocated the education of women in the classics. These tracts influenced court societies throughout Europe in the sixteenth century, and where the advice of

Literature

On the Education of Women was followed the status accorded women's education was elevated. Vives today is best remembered for one of his early works, *The Fable of Man*, a parable that expounds the Christian humanism and Neoplatonism that were popular at the time.

GERMAN LANGUAGE. In comparison to France, Italy, and Spain, the development of a national language proceeded more slowly in Germany and England. The Holy Roman Empire, the political confederation that governed Germany, Austria, and much of Central Europe, was comprised of more than 300 individual territories loosely joined together under the rule of an elected monarch. Most people within this complex political entity were German-speaking, although there were large minorities that spoke other languages. In addition, enormous differences characterized the German spoken and written in the various regions of the empire, so that the language of one area was often unintelligible to people from another area.

WRITTEN GERMAN. Many different written forms of German developed from these local dialects, and this complex variety did not give way decisively to a single standard literary German until the late seventeenth century. Spoken dialects, on the other hand, have persisted in Central Europe ever since to confound natives and travelers alike. The origins of written forms of German stretched back to the High Middle Ages. In the thirteenth century, some German states began keeping their records in native forms of their language, rather than in Latin. During the fourteenth century the emperor Charles IV (1346–1378) helped to stimulate the growth of the empire's first shared form of written German. Charles ruled from Prague, but his officials adopted both a new form of Latin based upon the writings of the early Italian humanists and a standard German. They based this written German on the spoken dialects of Austria and South Germany and the eastern and central parts of the empire. Johannes von Tepl used this language, known as "Common German," around 1400 to write *The Ploughman of Bohemia*, one of the first literary classics of early-modern German. In the fifteenth century the imperial court continued to develop a standard form of written German, but the Austrian Habsburg emperors who ruled at this time now favored their own local South German dialects in comparison to the more broad-based "Common German" that had been used in the fourteenth-century court. Around 1500, another form of written German developed and began to compete against the Habsburg court's language. The powerful electors of Saxony developed a new literary form of German based upon their own dialect. The use of this form

of written German was greatly expanded during the sixteenth century as a result of the rise of Protestantism, since Martin Luther used it to write his tracts condemning the pope and the Roman Church. As Luther's career continued, he translated the Bible into this same Saxon German. Eventually, Luther's German Bible became the most powerful tool in establishing a standard written language throughout Germany. By the time of his death in 1546, more than three hundred editions of the Luther Bible had been printed and as many as three million copies of the German Bible may have been in circulation throughout the empire. During the remainder of the sixteenth and seventeenth centuries, Luther's idiom, ensconced in this biblical translation, became the dominant force in establishing a standard form of written German throughout the empire. While he did not single-handedly create modern German as some might suppose, his forceful and colorful use of the language exerted a powerful influence on shaping the language's style, vocabulary, and grammar. At the same time, vast regional differences in written German persisted, and while the press had originally aided in the dissemination of a standardized form of literary German through the publication of books like the German Bible, it also kept alive regional differences. Local printers, concerned to satisfy their readership, continued to use written forms of local dialects for years to come.

RENAISSANCE STYLES. Humanism appeared in Germany slightly earlier than in France and Spain and, by 1500, it had established itself in a pattern similar to other places in Northern Europe. The movement was present in small circles throughout the country, where it often faced the opposition of the scholastics. The first German humanists of distinction, Rudolph Agricola (1444–1485) and Conrad Celtis (1459–1508) devoted themselves to writing poetry in the style of Petrarch as well as mastering the languages and literary styles of Antiquity. Celtis became the most accomplished poet of early humanism, although he wrote most of his important creations in Latin, rather than German. One undisputed classic of the early German Renaissance was *Das Narrenschiff* or *The Ship of Fools* written by Sebastian Brant (1457–1521) and published in 1494. The work was a long allegorical poem that mocked the foibles of humankind. It served as a prelude to Erasmus' great Latin oration, *The Praise of Folly* of 1509, a work which also criticized human stupidity. Although Brant was less thorough and biting in his attacks than Erasmus, a similar spirit animates his long work, which is divided into 112 chapters each devoted to mocking a different kind of human fool. Satire was one of the genres in which

German humanists excelled during the Renaissance. Among the many achievements in this vein, *The Letters of Obscure Men* of Ulrich von Hutten were particularly brilliant and influential. Written in a mock scholastic style, they poked fun at the absurd conventions of Germany's university theologians. Composed to defend the German humanist Johann Reuchlin during the height of a controversy over the study of Jewish books, von Hutten's works became the model for a truly widespread genre of satirical tracts and polemics that would be published during the Protestant Reformation. Later Protestant and Catholic writers made use of the broad humor and satirical techniques that von Hutten perfected in his *Letters*, spawning one of the most universally consumed literatures of sixteenth-century Germany.

RELIGIOUS CRISIS. The controversies of the Reformation and Counter Reformation often dominated sixteenth-century German literature. Critical analysis has only begun to digest the enormous amount of pamphlet literature published during the period. Although most of these tracts were not of high literary quality, one does find fine allegorical poems and humanist-inspired dialogues amidst the thousands of short tracts defending the Roman Church or promoting the ideas of the Protestant Reformation. The Protestant reformers, including Thomas Müntzer and Martin Luther, also wrote some of the finest lyric poems of the period and these often served as hymns in the developing Protestant churches. Another genre that arose in Lutheran territories was the funeral sermon, of which more than 100,000 printed copies survive from the sixteenth and seventeenth centuries. Originally, the Protestant reformers had been reluctant to allow eulogies to accompany the sermons preached at the burial of the dead. Over time, however, eulogies treating the life of the deceased crept into these sermons, which were printed in the days and weeks following a funeral and circulated as a memorial to the dead. While many of these texts show that the task of writing and delivering a funeral sermon was frequently a perfunctory one, in some cases and in the hands of some gifted preachers these Lutheran funeral sermons could rise to the level of high art. In addition, the tradition of the Meistersinger continued unabated in sixteenth-century Germany, and in Protestant towns this late-medieval form of singing was placed into the service of the Reformation. The Meistersinger, immortalized in Richard Wagner's famous opera, *The Meistersinger from Nuremberg* were usually members of local guilds who met at certain times to perform musical works they had written. They performed their works as unaccompanied solos, and their compositions were judged according to strict rules that had long been laid down by their society. The city of Nuremberg was the most famous center of this art, and during the sixteenth century as the town became a center of Protestantism, the Meistersinger focused increasingly on using their songs to promote Lutheran ideas. The most fertile of all the Meistersinger at Nuremberg was Hans Sachs, (1494–1576), a dramatist and poet, and the central character of Wagner's opera. During his long life Sachs wrote more than 4,000 of these songs, and an additional 2,000 other short verses, dramas, and dialogues.

FICTION. The excitement that religious disputes created in sixteenth-century Germany helped to increase the number of readers throughout the population. As the German audience grew, new forms of fiction appeared to satisfy an increasingly diverse public of readers. By mid-century collections of short, humorous stories, written either in prose or verse, appeared. The most popular of these were *Humor and Seriousness*, written by the Franciscan monk Johannes Paul, and *The Carriage Booklet*, by Jörg Wickram. Wickram, from Colmar in the far western province of Alsace, was illegitimate and had little more than a rudimentary education. He did read widely in German works, but was apparently unschooled in Latin. In several fictional works he pioneered the form of the novel in the German language. These longer narratives had central characters, more involved plots, and better character development than the short German fiction that had been written up to his time. His most fully developed work was *Of Good and Bad Neighbors*, a tale of a merchant family across several generations. The values that he praised in his works included hard work, thrift, respect for authority, and kindness to one's neighbors. Another great achievement of late sixteenth-century German fiction was the *History of Dr. Johann Faustus*, a short anonymous book published at Frankfurt in 1587. It was an overnight success and was soon translated into a number of other languages. In its original form the plot of *Dr. Faustus* treats the story of a young theologian who turns from his studies to take up magic. To strengthen his knowledge of the new art, he concludes a pact with the devil to enjoy 24 years of prosperity and mastery of magic. At the conclusion of this period the devil returns to take him to hell. *Dr. Faustus* soon became the basis upon which other writers constructed more complex plots in other fictional and dramatic works. The most famous Renaissance adaptation of the tale of Faustus was Christopher Marlowe's *Doctor Faustus*, which he apparently wrote within just a few years of the original. The story of Faustus is one of the most enduring tales in European history; it survived long

a PRIMARY SOURCE *document*

A STATESMAN IMAGINES A PERFECT SOCIETY

INTRODUCTION: In his *Utopia*, Sir Thomas More imagined a tightly controlled society that was free from many of the vices common in Europe at the time. In this passage, he describes how his imaginary Utopians are all engaged in useful occupations, thus avoiding the poverty that is common among Europeans.

The chief, and almost the only business of the syphogrants, is to take care that no man may live idle, but that every one may follow his trade diligently: yet they do not wear themselves out with perpetual toil, from morning to night, as if they were beasts of burden, which, as it is indeed a heavy slavery, so it is everywhere the common course of life among all tradesman everywhere, except among the Utopians; but they dividing the day and night into twenty-four hours, appoint six of these for work; three of them are before dinner, and after that they dine, and interrupt their labor for two hours, and then they go to work again for the other three hours; and after that they sup, and at eight o'clock, counting from noon, go to bed and sleep eight hours. And for their other hours, besides those of work, and those that go for eating and sleeping, they are left to every man's discretion; yet they are not to abuse that interval to luxury and idleness, but must employ it in some proper exercise according to their various inclinations, which is for the most part reading. ... After supper, they spend an hour in some diversion: in summer, it is in their gardens, and in winter it is in the halls where they eat, and they entertain themselves in them, either with music or discourse. They do not so much as know dice, or any such foolish and mischievous games: they have two sorts of games not unlike our chess; the one is between several numbers, in which one number, as it were, consumes another: the other resembles a battle between the virtues and the vices, in which the enmity in the vices among themselves, and their agreement against virtue, is not unpleasantly represented; together with the special oppositions between the particular virtues and vices; as also the methods by which vice either openly assaults or secretly undermines virtue, and virtue on the other hand resists it ... But this matter of the time set off for labor is to be narrowly examined, otherwise you may perhaps imagine, that since there are only six hours appointed for work, they may fall under a scarcity of necessary provisions. But it is so far from being true, that this time is not sufficient for supplying them with a plenty of all things, that are either necessary or convenient, that it is rather too much; and this you will easily apprehend, if you consider how great a part of all other nations is quite idle. First, women generally do little, who are the half of mankind; and if some few women are diligent, their husbands are idle: then consider the great company of idle priests, and of those that are called religious men; add to these all rich men, chiefly those that have estates in land, who are called noblemen and gentlemen, together with their families, made up of idle persons, that do nothing but go swaggering about. Reckon in with these all those strong and lusty beggars that go about pretending some disease, in excuse for their begging; and upon the whole account you will find that the number of those by whose labors mankind is supplied, is much less than you perhaps imagined. Then consider how few of those that work are employed in labors that Men do really need; for we who measure all things by money [and] give occasion to many trades that are both vain and superfluous, and serve only to support riot and luxury. For if those who are at work were employed only in such things as the conveniences of life require, there would be such an abundance of them that the prices of them would so sink that tradesmen could not be maintained by their gains; if all those who labor about useless things were set to more profitable employments, and if all that number that languishes out their life in sloth and idleness, of whom every one consumes as much as any two of the men that are at work do, were forced to labor, you may easily imagine that a small proportion of time would serve for doing all that is either necessary, pleasure being still kept within its due bounds.

SOURCE: Sir Thomas More, *Utopia* (London: Richard Chiswell, 1685): 81–84. Spelling and punctuation modernized by Philip M. Soergel.

after the Renaissance to become the subject for operas, plays, and novels. While the original work warned of the dangers of magic and curiosity, the Faustian tale has come to be seen since then as symptomatic of the dangers that lurk in humankind's search after knowledge.

ENGLISH LANGUAGE. The reception of humanism followed a similar path in England as elsewhere in Northern Europe. Toward the end of the fifteenth century a group of scholars, inspired by Italian examples, devoted themselves to the study of Latin and other ancient languages. Over time Neoplatonism and the Christian humanism popularized by figures like Erasmus in the early sixteenth century developed in circles of scholars throughout the island. The greatest member of this group, Sir Thomas More, produced a number of works

that inspired later generations of English writers. Until 1550, though, most humanists in England wrote in Latin. Even More's immensely popular work of political philosophy, *Utopia* did not have an English translation until a quarter century after its Latin publication. In England, Latin was usually the language of scholarship, while most of the country's nobles preferred to speak and write in French. This situation, though, began to alter quickly and dramatically in the first half of the sixteenth century. At the same time as humanism was maturing in England, the use of written forms of English was also expanding greatly. Long thought by English aristocrats and intellectuals to be an inferior form of expression, English gradually replaced Latin in the course of the sixteenth century as the preferred written language. These developments occurred at a time of rapid change for the English language. Chaucer completed his *Canterbury Tales* around 1400 in a form of Middle English, and in the century that followed English changed dramatically. By 1600, the English vocabulary underwent a serious expansion, aided by the publication of William Tyndale's English New Testament in 1525, by the English Great Bible in 1539, and by the Protestant *Book of Common Prayer* adopted throughout England in 1549.

QUESTIONS OF STYLE. By 1550, it had become increasingly clear that English would eventually triumph over Latin, and humanist-trained intellectuals now debated what direction English style should take. During the so-called "Inkhorn Controversy" opponents of Latin style and eloquence like Thomas Wilson argued that English possessed a clear and forceful style and that it should be kept free of Latin, Greek, and French words and phrases. Against this purist pose, others supported borrowing phrases from Latin and other languages for which there was no ready English equivalent. Over the remainder of the century, the practice of adapting words from other languages gradually won out over the purist perspective, although purists continued to defend native words and styles into the seventeenth century. Despite the purists' opposition, borrowing from other languages continued, and a tremendous expansion in vocabulary transformed the language into an elegant and malleable vehicle for written and spoken expression. The masters of sixteenth-century English who had helped to expand the language included Sir Thomas Wyatt (1503–1542), who was influenced by Italian Petrarchism and introduced the sonnet into English; Sir Thomas Elyot (1490–1546), who was a prolific writer and whose courtesy book, *The Book of the Governor*, helped to establish standards of civility in English aristocratic life; and

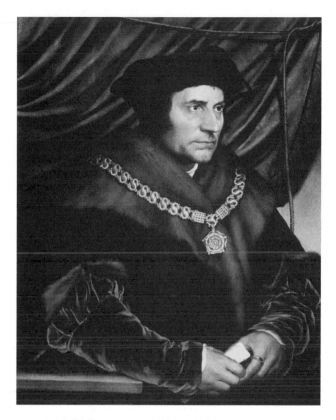

Portrait of Sir Thomas More by Hans Holbein the Younger. © FRANCIS G. MAYER/CORBIS.

Henry Howard, the Earl of Surrey (1517–1547), who among his other literary accomplishments translated Vergil's *Aeneid* into English. These figures had laid the foundation for the incredible flowering of English verse and prose that would occur in the final years of the Elizabeth period, the era of Marlowe and the early Shakespeare.

STUDY OF HISTORY. Outside Italy, Renaissance scholars also devoted themselves to the study of history. Humanist historiography varied greatly in quality and sophistication throughout Europe. Nationalistic concerns often dominated the writing of history, as humanists from England, Germany, France, and Spain became interested in treating the glories of their nations' past. Other authors saw in the central characters of history morality lessons; they stressed that certain figures were worthy of emulation. As a rule, though, humanist historiography in Europe downplayed the role of God in shaping human events, and instead saw history as the product of great men working with and against fortune. Toward the end of the sixteenth century a more objective, less moralistic spirit began to prevail among some scholars, particularly in France. The standards of proof these historians applied laid the foundations for a more

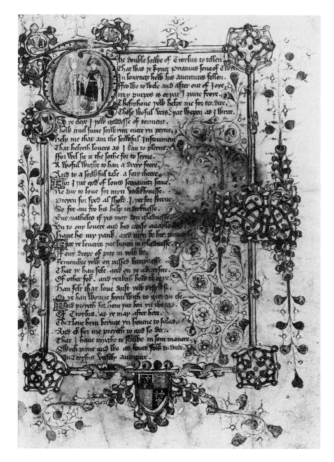

Fifteenth-century English manuscript from Geoffrey Chaucer's *Troilus and Criseyde*. PUBLIC DOMAIN.

modern and unbiased writing of history in the seventeenth and eighteenth centuries.

GERMAN TRENDS. History was a central concern of the German humanists. In the early sixteenth century these scholars began to form a recognizable group within the court of the emperor Maximilian I, and many of these figures wrote histories. In the fifteenth century Italian humanists had frequently pointed to the works of Latin Antiquity to confirm their dark judgments about German culture—that is, that Germans were barbaric and their learning was inferior to Italians. As a result, the early German humanists frequently focused on rehabilitating their own heritage. Their histories celebrated the bravery and independence of the early German tribes and these writers posed Germanic valor against effete Italian culture. They pointed to the early Christianization of the German tribes, a sign of the depth of German piety and religious sentiments. But humanists also devoted themselves to writing local histories, as Italians had done in the fifteenth century. In scores of works like Johannes Aventinus' *Bavarian Chronicle*, Germany's new

historians tried to reconstruct the history of Germany's many regions. Much of this work was uncritical, merely relying on ancient myths that had long circulated in older chronicles. But every now and then, a new critical spirit sometimes shone through. The Strasbourg historian Beatus Rhenanus (1486–1547) was a friend of Erasmus who questioned the uncritical tactics of many of his fellow humanist historians. Rhenanus constructed more reliable histories of the German past by examining the surviving documents. One of the insights that Beatus Rhenanus had—his suggestion that the Franks were also a Germanic tribe—would spark a great deal of controversy in France. Longstanding myths about French history had traced the French to the descendants of Francus, a refugee from the destroyed city of Troy. Beatus Rhenanus debunked these myths, instead interpreting the early history of the Germanic tribes according to the documents and artifacts that survived from the early-medieval period. Even though Beatus Rhenanus helped to debunk myths about France and Germany's past, new legends developed in the sixteenth century. The Protestant Reformation had a profound influence on shaping ideas about the German past. Many German historians at the time had been trained as humanist scholars, and as Protestants, men like Martin Bucer at Strasbourg and the Lutheran theologians Philip Melanchthon and Matthias Flacius Illyricus developed the notion of a medieval "Roman yoke." In their works they celebrated the Protestant Reformation for freeing Germany from the weight of Roman oppression. This Protestant view of history interpreted the Middle Ages as a dark period of decay and degeneration in which the Roman papacy had tyrannically ruled over the human conscience. The revival of the New Learning and the Reformation's restoration of true Christian teaching in Germany had rescued the nation from the oppression of a thousand years of medieval history.

HISTORY IN FRANCE. In France, the fifteenth and sixteenth centuries also saw a revival of interest in history. Philippe de Commines (1445–1509) was one of the first of a new breed of historians in France who applied a more distanced and objective spirit to his retelling of the past. He was not a humanist scholar, but he served as a member of the court of Duke Charles the Bold of Burgundy. At the time Burgundy was one of the most powerful territories in Europe, and Commines recorded many of the great events he had witnessed in his *Memoires* in a relatively unbiased way. As humanists devoted themselves to writing history after Commines, they downplayed the role of divine providence in shaping history. Instead they stressed the role that human actors had

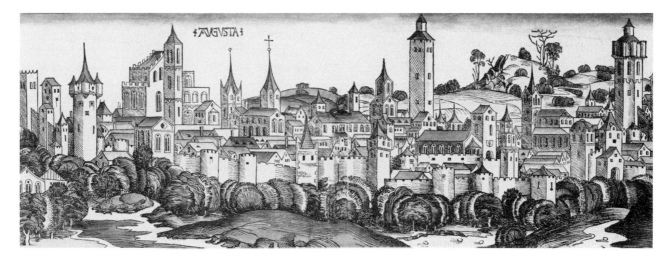

Woodcut illustration of the city of Augsburg from Hatmann Schedel's *World Chronicle* (1493). © HISTORICAL PICTURE ARCHIVE/CORBIS. REPRODUCED BY PERMISSION.

played in shaping their countries' history, and like many Italian Renaissance historians, they identified virtuous individuals in history who were worthy of emulation. Among the many humanist scholars who practiced history in the sixteenth century, Jean Bodin, Étienne Pasquier, and Jacques Auguste de Thou stand out. In his works treating history, Jean Bodin (1530–1596) tried to develop a theory for interpreting the past and for undertaking study in the discipline itself. He stressed the importance of acquiring a broad knowledge of the past before specializing one's study in a particular era. By contrast, Étienne Pasquier (1529–1615) was a lawyer who adopted legal methods of proof in his histories. He worked in the royal government in France and, like Guicciardini before him, had unprecedented access to state documents. Through this experience he acquired a critical understanding of France's past as well as a broad picture of how government had developed over time. When he was thirty years old, he began his *Researches on France*, a work he did not complete until forty years later. The *Researches* eventually comprised ten thick volumes. Pasquier intended his work to stir an admiration in his readers for the glories of French history, but he applied a judicious standard to do so, carefully documenting his conclusions. In constructing his French history he did not rely on past chronicles, but went instead to the primary legal and court documents that contained more reliable information about developments. His work did much to advance notions about documentary proof and the necessity for an historian to adopt an unbiased spirit. The last great genius of French sixteenth-century historical writing was Auguste de Thou (1533–1617). De Thou was also a trained lawyer, and in his works he strove for a similarly objective presentation of the past.

He wrote his works in a commanding and eloquent Latin. As Pasquier had been before him, de Thou was also a Gallican—that is, he supported the notion that the French Church should develop as a national church and be kept free from papal intervention. He believed that this tradition of relative French independence had deep roots, and he attempted to demonstrate the origins of Gallicanism in medieval history. These sentiments did not endear him to church authorities outside France. Although the histories he wrote of sixteenth-century France were erudite and largely objective, his judgments about Gallicanism resulted in the placing of at least one of his histories on the *Index of Prohibited Books*, the organ of censorship in the Roman Catholic Church.

MARTYRS. While Pasquier and de Thou favored a distanced objectivity, the religious crises of the second half of the sixteenth century in France, England, and other parts of Europe stimulated the popularity of another more emotional historical work: the martyrology. Martyrologies treated the lives and deaths of those who had sacrificed themselves for their faith, and these sometimes gruesome books had both Catholic and Protestant versions throughout the sixteenth century. Among the most astute authors in this genre were the English historian John Foxe and the French Protestant Jean Crespin. Crespin published his *Book of Martyrs* in 1554, and the work continued to be edited and re-issued after his death, becoming an enormously popular text among French Calvinists at the end of the sixteenth century. Since the publication continued over time, new editions of the work added accounts of those who had been killed for their faith during the Wars of Religion. In England, John Foxe drew upon Crespin's example for his *Actes*

and Monuments of These Latter and Perilous Days first printed in 1563. Foxe included many stories of European martyrs drawn from Crespin's text, but, in particular, he focused on those recently executed in England during the reign of Mary I. Together both Crespin and Foxe hoped that these tales of suffering would invigorate readers to defend the Reformation against those who would subvert it. Martyrologies like these remained a tremendously popular genre throughout the sixteenth and seventeenth centuries. Foxe's *Book of Martyrs* as it came to be popularly known, would be published many times, and influenced later writers, including the seventeenth-century authors John Bunyan and John Milton.

TRENDS IN ENGLAND. In England it was the Italian Polydor Vergil (1470–1555) who established the genre of humanist historical writing. Vergil was a native of Urbino and he had been sent to England in 1502 on a minor diplomatic mission. He stayed on in England, eventually publishing his *English History* in Latin in 1534. Vergil cast doubt on the traditional myths of Britain's origins which traced England's kings to Brutus the Trojan, a figure who had reputedly liberated England from the rule of giants. Vergil's history served Tudor purposes, since throughout his history he did celebrate the "great deeds of England's kings and those of this noble people," and these included the deeds of the ruling Tudor dynasty. But the skeptical eye he cast on some of the legends of English history irritated native scholars, and his humanist-styled history of England and the "great deeds" of its people would not be imitated until very late in the sixteenth century. Another humanist work of history was Sir Thomas More's *History of Richard III*, a book that More wrote in both English and Latin editions about the same time. The picture he drew of this hated king has largely persisted until the present, although recently some have questioned Richard's villainy, and historians have never conclusively decided whether Richard was a hunchback, as More treated him. More had been a child when many of the pivotal events of Richard III's reign had occurred, and he probably based his accounts on the testimony of his father and others who had been adults at the time. As a literary work, though, More shaped his account of the king's life relying on Roman history, particularly the works of Tacitus. He injected imaginary dialogue into the account, and he made maximum tragic use of Richard's alleged slaying of the "little princes," the two sons of Edward IV. His version of events became canonical, and survived to be read by William Shakespeare and immortalized in the playwright's masterpiece *Richard III.*

SPANISH HISTORY AND THE NEW WORLD. In Spain, a country recently unified from separate kingdoms, history took on a special importance during the Renaissance. Both the monarchy and the scholars hired to write histories of the country were keenly interested in the distant past, as they searched for a source of Spain's sixteenth-century greatness and imperial expansion. In the early sixteenth century King Ferdinand hired several historians to undertake historical studies. He desired to justify his expansionist policies, but unfortunately most of these projects, although undertaken by capable scholars, were left unfinished. Similar problems dogged later monarchical histories, too. The most important literary histories to emerge in sixteenth-century Spain were not those that dealt with Iberia's distant past, but with more recent events. Spain produced a distinguished lineage of humanist and non-humanist scholars who turned their attentions to Spain's conquests in the New World. These writers produced a record of events, which if not always factual, was of a consistently high literary quality and was often characterized by profound human insight. Christopher Columbus had helped to stimulate this attention to the New World discoveries by publishing accounts of his voyages. Peter Martyr D'Anghiera, an Italian, studied Columbus' accounts intently and published the first historical treatment of his journeys. It was Martyr who actually coined the term, "New World," through using it as the title of a history he published in several stages between 1511 and 1530. Bartolomeo de Las Casas built upon these efforts with his *History of the Indies*, which he finished around 1550. De Las Casas based his work on documentary evidence, and upon his own firsthand observations of conditions in Spain's American possessions. His account still proves useful today for the insights it offers concerning native peoples and their treatment at Spanish hands. The greatest historian of the period, though, was Gonzalo Fernández de Oviedo, who lived for a decade in the New World, undertaking various jobs before being appointed official historian of the Indies. Oviedo amassed a valuable collection of documents about the conquest and he used them to write a history of the early conquest and settlement of Mexico and Peru. His career as a professional historian of the Spanish territories inspired a lineage of later sixteenth-century New World historians, who often treated in detailed fashion the establishment of Spanish rule within the various regions of Central and South America. Many of these turned in particular to treat the establishment of Spain's control over the Aztecs in Mexico and the Incas in Peru. While these later accounts often celebrated the conquistadors' bravery in subduing native populations, some were more critical. Some of

Spain's New World historians, particularly those that treated the history of Peru, attacked the Conquest for unleashing the unbridled individualism of the conquistadors and for destroying the Incas' basically peaceful and orderly way of life.

SOURCES

E. Cameron, ed., *Early Modern Europe* (Oxford: Oxford University Press, 1999).

J. Cruickshank, ed., *French Literature and Its Background.* Vol. 1: The Sixteenth Century (London: Oxford University Press, 1968).

J. F. D'Amico, *Theory and Practice in Renaissance Textual Criticism: Beatus Rhenanus Between Conjecture and History* (Berkeley, Calif.: University of California Press, 1988).

A. B. Ferguson, *Clio Unbound: Perceptions of the Social and Cultural Past in Renaissance England* (Durham, N.C.: Duke University Press, 1979).

B. S. Gregory, *Salvation at Stake; Christian Martyrdom in Early Modern Europe* (Cambridge, Mass.: Harvard University Press, 2001).

G. Knowles, *A Cultural History of the English Language* (London: Arnold, 1997).

J. Kraye, ed., *The Cambridge Companion to Renaissance Humanism* (Cambridge: Cambridge University Press, 1996).

I. D. McFarlane, *Renaissance France, 1470–1589* (London: E. Bonn, 1974).

C. Nauert, *Humanism and the Culture of Renaissance Europe* (Cambridge: Cambridge University Press, 1995).

R. Pascal, *German Literature in the Sixteenth and Seventeenth Centuries: Renaissance, Reformation, Baroque.* 2nd ed. (Wesport, Conn.: Greenwood Press, 1979).

C. J. Wells, *German; A Linguistic History to 1945* (Oxford: Oxford University Press, 1985).

SEE ALSO *Philosophy: New Trends in Sixteenth-Century Thought*

RENAISSANCE WOMEN WRITERS

WOMEN'S LIVES. Social class and wealth were the chief determinants of the path a woman's life would take in the Renaissance. At the bottom of the social ladder the poorest women often faced bleak prospects, and daily life could become a quest for survival. High social status and family wealth, not unsurprisingly, enhanced a woman's choices, and also granted her greater leisure. An increasing number of women learned to read and write their native languages during the Renaissance, although female literacy continued to be rare. Literacy was prized in the cities, where it was necessary for both men and women from certain sectors of society to be able to read. Merchants who were frequently away on business needed wives who could manage their business interests while they were away from home. In cities, then, many merchants' wives could read and write. Reading was also important to artisans, and since many women helped their husbands in their businesses, there were also many artisans' wives who could read as well. While many urban women probably possessed basic literacy during the later Renaissance, most women as a rule had little time to indulge in reading or studies. They were usually far more interested in their account ledgers than in literature. Only a few women, moreover, were ever taught Latin, the dominant language of scholarship until the late Renaissance. Widespread male prejudice and even Renaissance medical wisdom taught that women were not cut out for a life of scholarship, their intellect being of a more delicate and sensitive nature than men's. Despite these enormous barriers to women's literary and scholarly careers, the fifteenth and sixteenth centuries saw an increasing number of women writers, many of whom left behind subtle and refined works of fiction, poetry, and scholarship. This trend first appeared in the fifteenth century in Italy and France. During the sixteenth century women writers appeared in every major European country, and although the career of a woman author was still extraordinary, there were more women who wrote in this period than at any other time in the past. Humanism was one important force in producing this change; many humanists elevated the importance given to women's education. The list of humanists who advocated a more thorough education for women was long, and included Giovanni Boccaccio, Leonardo Bruni, Baldassare Castiglione, and Juan Luis Vives. At the same time even the most enlightened Renaissance men continued to think that women's capabilities as writers and scholars were distinctly inferior to men. A woman who wrote and recorded her thoughts and who did so elegantly was often described as "surpassing her sex." Still, the groundwork was being laid in Renaissance Europe for women to compete in the arena of literature, philosophy, and the humanities. By the end of the sixteenth century, although women still wrote far less than men, they had begun to take their place beside their male counterparts, a trend that would persist and expand further in the seventeenth and eighteenth centuries.

CHRISTINE DE PIZAN. Although Christine de Pizan (1364–1430) is known today primarily as a French writer, she was an Italian who was born in Venice and whose family was originally from Pizano, a village outside the

a PRIMARY SOURCE *document*

ON WOMEN'S VIRTUES

INTRODUCTION: Christine de Pizan's *Book of the City of Ladies* was written in the early fifteenth century and was one of the earliest feminist statements of women's worth. In this passage, Christine is instructed in women's virtues by the figure of Rectitude.

[Christine:]"My lady, you have given me a remarkable account of the marvelous constancy, strength, endurance, and virtue of women. What more could one say about the strongest men who have lived? Men, especially writing in books, vociferously and unanimously claim that women in particular are fickle and inconstant, changeable and flighty, weak-hearted, compliant like children, and lacking all stamina. Are the men who accuse women of so much changeableness and inconstancy themselves so unwavering that change for them lies outside the realm of custom or common occurrence? Of course, if they themselves are not that firm, then it is truly despicable for them to accuse others of their own vice or to demand a virtue which they do not themselves know how to practice."

[Rectitude replies:] "Fair sweet friend, have you not heard the saying that the fool can clearly see the mote in his neighbor's eye but pays no attention to the beam hanging out of his own eye? Let me point out to you the contradiction in what these men say concerning the variability and inconstancy of women: since they all generally accuse women of being delicate and frail by nature, you would assume that they think that they are constant, or, at the very least, that women are less constant than they are. Yet they demand more constancy from women than they themselves can muster, for these men who claim to be so strong and of such noble condition are unable to prevent themselves from falling into many, even graver faults and sins, not all of them out of ignorance, but rather out of pure malice, knowing well that they are in the wrong. All the same, they excuse themselves for this by claiming it is human nature to sin. When a few women lapse … then as far as these men are concerned, it is completely a matter of fragility and inconstancy. It seems to me right, nevertheless, to conclude—since they claim women are so fragile—that these men should be somewhat more tolerant of women's weaknesses and not hold something to be a crime for women which they consider only a peccadillo for themselves. For the law does not maintain, nor can any such written opinion be found that permits them and not women to sin, that their vice is more excusable. In fact these men allow themselves liberties which they are unwilling to tolerate in women and thus they—and they are many—perpetrate many insults and outrages in word and deed. Nor do they deign to repute women strong and constant for having endured such men's harsh outrages. In this way men try in every question to have the right on their side—they want to have it both ways!

SOURCE: Christine de Pizan, *Book of the City of Ladies.* Trans. E. J. Richards (New York: Persea Books, 1982): 164–165.

Italian city of Bologna. When she was five, Christine's family moved to Paris where her father had been appointed as the astrologist to the king. She was schooled alongside her brothers, a common Italian custom of the day. She married early and became a widow by the time she was 25. There followed a hard period in Christine's life, as she lost her money because of bad advice. Gradually, she created a new life based around literature, study, and writing. In these endeavors she was largely self-taught. At first she wrote a great deal of conventional poetry, but she gradually broadened the scope of her literary work. Around 1400, she wrote *The Letter of the Goddess Othea to Hector* in which she theorized about the proper education that should be given to young men. Christine de Pizan became aware of humanism's development in Italy, and she seems, in particular, to have come into possession of copies of at least two of Boccaccio's important works: his *Genealogy of the Gods*, the textbook of classical mythology he had written late in life; and his *On Famous Women*, his catalogue of great women of classical Antiquity. Knowledge of these is reflected in Christine's most famous work, her *Book of the City of Ladies*, a long allegory in which the author set forth a new positive view of the role of women in history. As her career as a writer continued, Pizan also treated a number of political themes in her works, advising the French queen and members of the court on matters of social policy. Many of these works dealt with the problems that France's wars with England caused throughout the country. As a result of these troubles, Christine de Pizan gradually despaired, and she withdrew from public life, although shortly before her death she did write *The Tale of Joan of Arc*, commemorating the arrival of this French heroine on the contemporary scene. Although Christine de Pizan was the first independent female writer in European history, her career would not be immediately emulated in France. It was instead in Italy that female scholars and authors began

to grow more common during the remaining years of the fifteenth century.

WOMEN HUMANISTS. The two women who achieved the greatest notoriety as scholars in fifteenth- and early sixteenth-century Italy were Laura Cereta (1469–1499) a native of Brescia, and Cassandra Fedele (1465–1558), a Venetian. Fedele became the most famous female humanist of her time, learning Latin at a young age and, slightly later, Greek. Fedele went on to master philosophy and Aristotelian logic. Early on, her father promoted her as a prodigy. When she was not yet an adult, she delivered Latin addresses to the faculty of the University of Padua and to the Senate of Venice. She published her first book at 22, but spent most of her life writing letters to a distinguished circle of intellectual and political figures. Angelo Poliziano, the great Florentine Latinist of the late fifteenth century, admired her writing, and Fedele was even offered a post as a professor in Spain. She refused, was eventually widowed, and was forced by hardship to live with her sister. The pope learned of her plight and offered her a position in a local orphanage so she could be independent. In her letters and the small surviving body of other texts she wrote, Fedele made clear that she accepted the inferiority of women as part of the pattern of nature. She often criticized her own weaknesses of style and intellect. This self-deprecating strain endeared her to her elite readers. Laura Cereta's disposition, on the other hand, was not nearly so modest. Cereta was the daughter of a Brescian attorney from a family that had noble pretensions. After being educated at home and in a nearby convent, she married, but was quickly widowed. She spent her widowhood alone writing lengthy and urbane letters to notable humanists, political figures, and churchmen, and of these a number survive. In her letters she develops a number of themes that would be pursued by later Renaissance and early-modern women, and many of her ideas have a distinctly feminist cast. Unlike Fedele, she was not content to see herself as a mere decorative ornament in Italy's learned society. Instead she assaulted traditional stereotypes about women; her letters painted marriage as enslavement and the chores of women's lives as drudgery. This early brand of feminism would influence later Renaissance women writers.

POETS. Prepared by the examples of Cereta and Fedele, women entered into the arena of public letters in sixteenth-century Italy. Among those who achieved notoriety for their cultivated learning and literary endeavors, most were members of noble families. Vittoria Colonna, a member of the Roman aristocracy, was happily married to a marquis, and cultivated her literary and

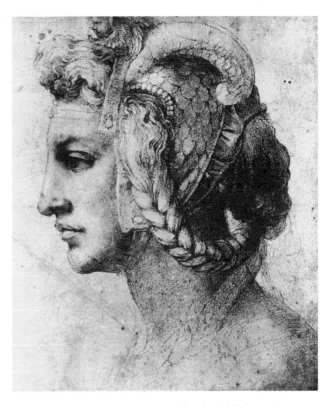

Vittoria Colonna, after a chalk drawing by Michelangelo. THE LIBRARY OF CONGRESS.

artistic ambitions during his frequent absences. She became friends with such important members of the Italian literati as Jacopo Sannazaro (author of the pastoral *Arcadia*) and the artist Michelangelo. For many years at Naples she transformed her home into an early version of the salon, inviting visiting intellectuals there and cultivating local talents. When her husband died, she was grief stricken. She eventually left Naples and spent the remaining twenty years of her life living in convents. While staying in Rome, she befriended a number of Catholic religious reformers who were known as the "Spirituals." Their religious beliefs emphasized an interior pious devotion, and even made use of the concept of justification by faith that was being promoted at the time in northern Europe by the Protestant reformer Martin Luther. Colonna devoted herself to these religious pursuits, but she also became one of the premier Italian poets of the sixteenth century, developing her sonnets and other literary inventions in the Petrarchan mode that had become popular at the time. She wrote some of her most beautiful lyrics to her beloved deceased husband. For several generations of sixteenth-century noblewomen in Italy she represented the highest standard in piety and learning. The poetess Gaspara Stampa (1523–1554), by contrast, followed a different path. She wrote about the

a PRIMARY SOURCE *document*

LOVE'S FIRE

INTRODUCTION: Louise Labé was a poet know for her passionate poetry on the nature of love as well as the nature of madness. Labé often equated the two with one another and saw them as two sides to the same coin. In *Love's Fire*, Labé plays out this duality by personifying love as an unruley master whose only purpose is to switch the speaker from joy to pain in a single instant to symbolize its control, causing the speaker to sound unstable and on the brink of madness.

I live, I die: I burn and I also drown.
I'm utterly hot and all I feel is cold.
Life is too soft and too hard for me to hold;
my joy and my heavy burden are mixed in one.
I laugh at the same time that I weep and frown;
the tarnish of grief has marred my pleasure's gold;
my good flies away, but stays until it's old;
I wither just as I find out that I've grown.
This is how love guides me, so changeably
that when I think the pain has me controlled,
with my very next thought I find that I am free.
Then, just as I trust in joy so certainly
that the peak of a yearned-for hour makes me bold,
he shows me my familiar grief unfold.

SOURCE: Louise Labé, *Love's Fire*. Trans. Professor Annie Finch, Department of English, Miami University, Oxford, OH.

same time as Colonna, but her works were frequently filled with erotic and passionate imagery rather than religious inspiration. Her mother had brought her to Venice so that she might pursue a career as a musician. She entertained Venice's cultured elite with her musical renditions of her poetry and soon came to the notice of the best poets in the city. They admitted her to their literary academy and cultivated her talents. Although she did not live long, Stampa wrote more than three hundred poems that were published soon after her death. She wrote her verse in a Petrarchan style and was influenced by Italy's arbiter of literary taste at the time, Pietro Bembo.

NOTORIOUS CELEBRITY. Since Petrarch's time authors had been concerned with cultivating their fame. In the sixteenth century self-promotion reached new heights in Italy with figures like Pietro Aretino, whose celebrity derived from his scandal-filled letters and his connections to other famous people. A similar strain of fame can be seen in the career of a Venetian courtesan, Veronica Franco (1546–1591). Franco became an "honest courtesan" after separating from her husband; this category of woman in sixteenth-century Venice was seen as standing above the level of the common prostitute. They were often literate and educated, and in their homes they nourished their male companions' desires for intellectual stimulation, as well as erotic love. Franco, like many educated Italian women, had received her education at home by sharing tutors with her brothers. She became an important literary figure on the Venetian scene by compiling and publishing collections of poems she received from members of Venice's male elite. She was herself a poet and released a volume of her own poetry in 1575. In these works she was honest about her profession and sometimes even candid about sexual matters, in contrast to the Platonic love poses that many men took at the time. Like Aretino and a number of sixteenth-century Italian authors, she also printed her letters and these displayed her as conversant with the ideas of ancient authors. Franco's life came to a tragic end, however, when she was brought before the Inquisition on charges she practiced love magic. Although she was exonerated, the trial cast a shadow over her reputation and, as she had already experienced financial losses, she died an impoverished and lonely figure.

WOMEN POETS IN FRANCE. Outside Italy, the largest group of accomplished women authors appeared in sixteenth-century France. Here the example of the powerful and dynamic figure Marguerite of Navarre (1492–1549) helped to foster a literary climate receptive to female authors. Marguerite was not only the author of the cultivated prose *Heptameron*, but also of a number of poetic allegories that expressed her powerful religious sentiments as well as her passionate emotions. Two other figures, Marguerite de Briet and Louise Labé, would build upon and expand Marguerite's example of the feminine author. Marguerite de Briet was a noblewoman who separated from her husband and took up residence in Paris. There she fashioned a literary career that attacked male misogyny and defended female virtues. Under the pseudonym "Hélisenne de Crenne," she published a collection of her letters that became popular and were reprinted a number of times. These provide insights into sixteenth-century life, but they also dissected male prejudices against women in a way that had not been done in French letters since the time of Christine de Pizan. Marguerite de Briet pointed out the logical inconsistencies in men's attitudes toward women. Women took the blame for tempting men with their beauty, but men, who were sup-

posed to be "wiser than women should not deal with anything they know to be harmful or dangerous." De Briet was also a novelist and her romance *The Painful Anxieties that Proceed from Love* treated her literary creation Hélisenne de Crenne's passionate and disastrous devotion to her lover. Marguerite intended this fiction to serve as a warning to her women readers of the dangers that lurked in a love that was not tempered by reason. The second of France's great female authors was Louise Labé, who came from the country's second largest city, Lyon. She was not a noblewoman, but the daughter of a wealthy rope maker. The extensive education she acquired in languages, music, and art was extraordinary for the time. She married a much older man, also a rope maker, and possessed leisure to pursue her studies and writing. She struck up an acquaintance with a member of the Pleiades, a group that sought to revive classical styles in French verse. In 1555, she published a collection of her poems, which she wrote largely as sonnets and elegies. Labé also composed a prose work, *The Debate Between Madness and Love*, that was a dialogue between Folly and Cupid. Like writers elsewhere in Europe at the time, her works were influenced by the fashions of Neoplatonism and Petrarchism, but her poems in particular were notable for their passionate imagery.

OTHER EUROPEAN DEVELOPMENTS. The works of Marguerite of Navarre and Louise Labé represent only the best known surviving works of sixteenth-century women writers in Northern Europe. Throughout Europe, the sixteenth century produced an enormous increase in the number of women writers. In the course of the century the spread of the press throughout Europe, the religious controversies of the age, and the diffusion of humanist educational ideas resulted in an enormous expansion of the sixteenth-century reading public. Not everyone who could read and write chose to leave behind a written record. The writing of poetry and prose fiction was still a rare art, usually practiced only by those who possessed sufficient leisure to do so. But among the educated elites of Europe, literary achievement was becoming an increasingly important sign of one's cultivation. It was recommended by courtesy books like Baldassare Castiglione's *Book of the Courtier* and humanist educational treatises like those written by Erasmus and Vives. Women, particularly those from the wealthy urban classes and the nobility, benefited from this attention to literature, even if they were not nearly so great beneficiaries as men. Outside the cultured and urbane circles of Italy and France, women who were instructed in Latin, Greek, and classical literature remained rare. In England, for instance, only the very highest ranks

of ladies at court and Henry VIII's daughters Mary and Elizabeth received classical educations. But in time the rise of the vernacular languages made classical instruction increasingly irrelevant to those women who wanted to write. The growing body of women who wrote about their ideas and emotions in the later sixteenth century thus helped to lay the foundations for the even greater literary achievements of European women in the centuries to come.

CONCLUSIONS. Beginning with Petrarch in the fourteenth century, Renaissance writers identified literary achievement as a way to achieve fame and immortality after death. In the fourteenth and fifteenth centuries humanists in Italy devoted themselves to the study of ancient literature, to perfecting classical Latin style, and to incorporating these insights into their own letters, histories, and poetry. By 1500, the methods they had perfected were being adopted elsewhere in Europe, where they often joined with demands for the reform of Christianity. Many members of this first generation of Northern Renaissance humanists shared a common desire to revive the moral standards of the church. They studied the literary forms of Antiquity with a mind toward imitating ancient style and applying the moral insights they discovered in classical Antiquity. Over the course of the sixteenth century they created an enormous body of Latin literature, even as they devoted themselves to perfecting and expanding their own native languages. The rise of the vernacular and the increasing demands of a non-specialist, non-Latin reading public helped to produce an enormous flowering of literature in French, Spanish, German, and English. Many of those who wrote in these native languages adopted styles drawn from the classics. Yet as the sixteenth century progressed an increasing sophistication and innovation can be seen in the vernacular literature that was being written throughout Europe.

SOURCES

D. L. Baker, *The Subject of Desire: Petrarchan Poetics and the Female Voice in Louise Labé* (Lafayette, Ind.: Purdue University Press, 1996).

M. King, *Women of the Renaissance* (Chicago: University of Chicago Press, 1991).

M. King and A. Rabil Jr., eds., *Her Immaculate Hand; Selected Works by and about the Women Humanists of Quattrocento Italy* (Binghamton, N.Y.: Medieval and Renaissance Texts and Studies, 1983).

D. Robin, *Collected Letters of a Renaissance Feminist* (Chicago: University of Chicago Press, 1997).

R. Warnicke, *Women of the English Renaissance* (Westport, Conn.: Greenwood Press, 1983).

SIGNIFICANT PEOPLE
in Literature

PIETRO ARETINO

1492–1556

Italian author

HUMBLE ORIGINS. Pietro Aretino was born the son of a cobbler in Arezzo, a small town in Tuscany that was subject to the city of Florence. His mother grew estranged from Aretino's father and moved in with a local nobleman, taking her children with her. At eighteen the young Aretino left Arezzo and moved to Perugia to become a servant in the home of the humanist Francesco Bontempi. Here he met the city's circle of humanists, painters, and authors, and he acquired his taste for writing and painting. In Perugia he published a book of his poetry, in which he described himself as a painter, and he also became acquainted with Agostino Chigi, a prominent Sienese banker who kept a villa in Rome. Chigi became Aretino's patron, inviting him to move to the papal capital, where he broadened his circle of friends and acquaintances. At the time Rome was emerging as the capital of the High Renaissance. Long a dusty and dirty city when compared to Florence and the other Northern Italian centers of the time, Rome was in transformation, becoming the center of artistic and intellectual life at the time. In this brilliant atmosphere Aretino became constantly embroiled in scandals.

POLITICAL INVOLVEMENTS. In Rome, Aretino soon became known for his skills as a satirist when Giulio de' Medici hired him to write propaganda for him supporting his case for election to the papacy in 1521. Besides writing pamphlets praising the Medici candidate, Aretino also wrote a series of scathing satires that mocked Medici's rivals, and when one of these candidates won election instead of Giulio, Aretino fled the city. Two years later, though, Giulio de' Medici finally secured his election as pope and Aretino returned to Rome. However, he irritated his powerful friend when he wrote a series of pornographic sonnets that attacked Bishop Giberti, one of Giulio's close advisers. These sixteen *Lascivious Sonnets* recounted Giberti's bizarre sexual tastes, and resulted in Aretino's second banishment from the city. He made his way to the French court and tried to secure the patronage of Francis I, although his reconciliation with the pope soon allowed him to return to Rome. His taste for scandal, though, prompted him to write *A Comedy about Court Life*, a biting satire of the debauched sexual lives of those in the papal court. Aretino fell out of favor again, and when he tried to seduce the wife of a powerful Roman citizen, an assassination attempt nearly ended his life. Although unsuccessful, the attack damaged Aretino's hand and he never painted again. He traveled to Mantua in northern Italy where he continued to write satires and plays that attacked the papal court, but a second assassination attempt in 1527 forced him to flee yet again. He traveled to Venice, a more congenial place for his scathing wit, and he remained there for the rest of his life.

VENICE. Venice was widely known throughout Europe for its tolerant atmosphere and its anti-papal politics, and Aretino prospered in this setting. He quickly became a close friend of the artist Titian and the architect Jacopo Sansovino. Together the three figures formed a kind of triumvirate that established the tastes and fashions in the city. Aretino wrote for the popular press in Venice on a whole range of subjects, including Petrarchism, Neoplatonism, and other philosophical topics, but he became wealthy from his satires of the pope, of court life, and of the high-born's sexual peccadilloes. His prose and poetry were vigorous, and captured the spirit of *sprezzatura*, the art of seeming artlessness that Castiglione and other prominent writers recommended as the best style. He became a friend of Italy's literary arbiter, the Cardinal Pietro Bembo who was also a Venetian and who supported and promoted Aretino's work. His satires and plays made him wealthy, as did his custom of sending "blackmail" to European princes and nobles. These figures often paid Aretino off with large donations rather than allow him to publish works that mocked them. In Venice, Aretino also became the first to publish his letters in Italian rather than Latin, which increased his readership since much of Italy's literate population was not schooled in scholarly Latin. Aretino's gossipy and frequently earthy letters gave readers throughout Italy an insider's glimpse into the lives of the rich and famous. He published more than three thousand of them during his life, and their subjects range over the most diverse areas, including minutiae of fashions, politics, and daily life. In Venice, Aretino's fortunes became so well established that he was able to promote the careers of many young artists and writers whose works ran counter to prevailing taste. But throughout his life his success continued to be tinged with controversy. In 1542 he earned the English king Henry VIII's favor when he dedicated a book of his letters to him, but a few years later, he had so enraged the court in England that an ambassador of the country made a third at-

tempt on Aretino's life. While he became known as the "scourge of princes," he kept a large townhouse in the city of Venice that overlooked the city's Rialto Bridge on the Grand Canal, where he established a kind of court of admirers. Here his literary collaborators, mistresses, male lovers, and friends came to pay him homage. By 1550, Aretino had again won favor with the papal court so that he was granted a pension from Rome, but just a few short years after his death, his works would be placed on the *Index of Prohibited Books*. Such extremes of favor and disfavor and of controversy and celebrity had long been a fact of this fascinating figure's life.

SOURCES

C. Cairns, *Pietro Aretino and the Republic of Venice* (Florence: Olschki, 1985).

T. C. Chubb, *Aretino, Scourge of Princes* (New York: Reynal and Hitchcock, 1940).

J. Cleugh, *The Divine Aretino* (New York: Stein and Day, 1966).

R. B. Waddington, *Aretino's Satyr: Sexuality, Satire, and Self-Projection in Sixteenth-Century Literature and Art* (Toronto: University of Toronto Press, 2004).

GIOVANNI BOCCACCIO

1313–1375

Humanist
Author

EARLY LIFE. Giovanni Boccaccio was born in the small town of Certaldo south of Florence to an employee of the Bardi bank. His father intended that he would pursue either a career in the church or in banking, but from an early age Boccaccio preferred the study of literature. When Boccaccio was a teenager, his father traveled to Naples on business, and there Boccaccio became an apprentice banker, but he also met many literary figures in the local university and court. He was a friend of the royal librarian and several other men, one of whom was a close friend of Petrarch's and who introduced Boccaccio to the poet's works. While in Naples, Boccaccio began to write, and his works in this period show a mixture of contemporary Italian styles with idioms he drew from classical Antiquity. Boccaccio clearly admired Dante, who would be a lifelong influence on his work. His Italian poem *Diana's Hunt* imitated the medieval poet's style, but it also made use of Boccaccio's knowledge of Ovid and other classical works. Another work from this Neapolitan period, the *Filostrato*, related the tragic love story of a Trojan prince and his love for Cri-

seida, and would become the model for the Englishman Geoffrey Chaucer's masterpiece *Troilus and Criseyde*. Many of the poems he composed at this time show his affection for classical literature, but they did not step very far outside the confines of contemporary styles in Tuscan poetry.

FLORENCE. In 1341 the Bardi bank suffered a disastrous failure, and Boccaccio returned with his father to Florence in search of work. There, the young author wrote his *Ameto*, a work that criticizes the drab commercial nature of Florence when compared to the brilliant court at Naples. Other poems and Italian works gave evidence to Boccaccio's growing literary mastery, including his *Elegy of Madam Fiammetti* written sometime around 1343. That work has often been judged as one of the first novels because of its central character, longer narrative development, and its emphasis on the psychological examination of its heroine. It relates the tale of Fiammetta, who becomes increasingly miserable in contemporary Naples and attempts suicide before comparing her fate to famous women from classical Antiquity. It became an important source of literary inspiration to Renaissance women writers, including Marguerite de Briet (pen name Hélisenne de Crenne), the French sixteenth-century feminist author. Boccaccio's later collection of short feminine biographical portraits entitled *Of Famous Women* (1361), would also inspire later authors, including Christine de Pizan who based *The Book of the City of Ladies* on it.

DECAMERON. Boccaccio's greatest fictional achievement was his *Decameron*, a collection of 100 tales told during the outbreak of the Black Death in Florence in 1347–1348. Collections of novella, which were short stories with morals, had been popular in Florence and Tuscany since the late thirteenth century. Boccaccio's work revolutionized the genre by linking these tales together into a single narrative construction. His prologue sets out a premise for the entire collection and states Boccaccio's stoic perspective on life. As many Europeans did at the time, he pondered the underlying causes for the recent catastrophe of the Black Death, and the subsequent stories present Boccaccio's point of view concerning the perennial question of whether the plague was a divine judgment upon human sinfulness. The will of God, Boccaccio counsels his readers, is inscrutable and trust in God's grace provides the only consolation in times of trials. At the same time the stories celebrate human ingenuity, even as they warn readers that human life is governed by fortune and the passions. Those who succumb to these forces will fail, but the ingenuous can triumph over their desires and use their intellects to

succeed in life. Boccaccio began this work sometime around 1348 as the plague had just receded in Florence, and he completed it about four years later. During this same period he met Petrarch, the figure he had long admired. The two eventually became close correspondents, with Petrarch playing the mentor to the slightly younger Boccaccio. The *Decameron*, though, seems to have been largely formed and shaped before Boccaccio struck up his friendship with the humanist and is thus a testimony to the literary skills he had acquired over the previous years.

LATER WORKS. In the last two decades of his life, Boccaccio came increasingly under Petrarch's influence, and the relationship with his mentor caused him to devote his efforts to literary scholarship rather than the writing of fiction. After the *Decameron*, he wrote only one more fictional work, the *Corbaccio*, a misogynistic tale about a lusty widow. During these years he retired to his family home at Certaldo, outside Florence, and spent the largest portion of his efforts writing the enormous *Genealogy of the Gods*, a work that would eventually comprise fifteen massive volumes. In it, Boccaccio treated Latin and Greek mythology from a literary perspective, rather than from the Christian moralizing traditions that had long commented upon ancient myth. Boccaccio's *Genealogy* was also important for its defense of the study of pagan literature and of poetry. Until the eighteenth century the work continued to be the main scholarly reference work on ancient mythology, and it was widely used by authors and painters when they composed works on mythological themes. In his later years Boccaccio also wrote verse in Latin, including his *Country Songs (Buccolicum carmen)* through which he tried to encourage the revival of ancient pastoral poetry. Written in the ancient form of the eclogue, these poems did not immediately produce any great flowering of pastoral literature, but they did become important in fostering a renewal of the pastoral in Florence a century later.

IMPACT. Boccaccio was generally an appealing and self-deprecating figure on Florence's literary scene in the mid- and late-fourteenth century. In later years he was chiefly responsible for spreading Petrarch's brand of literary scholarship and humanistic philosophy among the educated circles of Florence. The esteem which his admitted masterpieces like the *Decameron* brought him allowed him to influence intellectual developments in the city. Although his works became a major milestone in the creation of Italian as a literary language, Boccaccio felt that his chief accomplishment in life was his encouragement of the establishment of a Greek professorship at the University of Florence. He himself studied

Greek with Leontius Pilatus, the man who filled this position, and he did so with the expressed and revolutionary purpose of studying ancient Greek literature. Boccaccio's scholarly and literary connections were broad, and they helped to spread knowledge of his works throughout Europe. His efforts encouraged the formation of a humanist circle within Florence, and after Boccaccio's death, this circle grew to dominate the city's civic life by the early fifteenth century.

SOURCES

Giovanni Boccaccio, *The Decameron*. Trans. and ed. G. H. McWilliam (New York: Penguin, 1996).

V. Branca, *Boccaccio: The Man and His Works*. Trans. R. Monges (New York: New York University Press, 1976).

J. P. Serafini-Saulfi, *Giovanni Boccaccio* (Boston: Twayne, 1982).

MARGUERITE OF NAVARRE

1492–1549

Queen
Author

UPBRINGING AND EARLY LIFE. Marguerite was the sister of King Francis I of France and as a young child she received extensive tutoring in the classics from her mother. She mastered French, Latin, Greek, Hebrew, German, and Spanish and had also read the scriptures widely by the time she married Charles, the Duke of Alençon, in 1509. When her brother ascended the throne in 1515, she moved with him in his court, exercising an influence on his policies. In 1525, French forces lost the battle of Pavia in Italy, and the Spanish army took Francis captive, imprisoning him at Madrid. Marguerite traveled there and negotiated her brother's release in exchange for an enormous ransom payment. In this same year her husband died, and two years later Marguerite married Henri d'Albret, king of Navarre, a small but important territory in the Pyrenees between France and Spain. While Marguerite continued her public role in her brother's court, she had already become active in the campaign for the reform of the church, too. In 1521, Guillaume Briçonnet, a French bishop, introduced Marguerite to evangelical ideas, and the two continued a long and fruitful correspondence. Briçonnet, together with the humanist Jacques Lefèvre d'Étaples, had a profound influence on her religious ideas. Although Marguerite remained loyal to Rome, she supported reform movements within the church in France. At the same time the court she kept at various châteaux throughout France and

Navarre sheltered a number of authors and religious figures that were suspected of heresy. These included Briçonnet and Lefèvre d'Etaples, who fell under the umbrella of suspicion of heresy at various points in their careers, and the poet Clément Marot. For a time she even harbored John Calvin, the future reformer of Geneva. In touch with powerful men and women throughout Europe, including the reform-minded women Vittoria Colonna and Renée of Ferrara, Marguerite lobbied for religious change for a time, but she gradually isolated herself over time and devoted herself to her writing.

POETRY. During her life Marguerite wrote an enormous body of works, little of which was printed while she lived. In 1531, she did publish her *Mirror of the Sinful Soul,* a 5,000-line poem that would eventually be condemned as heretical by the theological faculty of the University of Paris. The *Mirror* is typical of many of the themes that Marguerite developed in her plays and poetry. The soul is depicted as constantly embattled by worldly temptations but, aided by the grace of Christ, moves toward a final happy resolution in its salvation. A collection of her poems were published two years before her death in a work entitled *Pearls from the Pearl of Princesses,* and although these works were long judged inferior to other French poetry of the time, they have more recently been re-evaluated. Scholars now find in Marguerite the expression of a deeply tormented conscience, but one that strives to find joy in its relationship with Christ.

HEPTAMERON. The queen's most ambitious project, the *Heptameron,* was left incomplete at her death. She modeled this collection of tales on Giovanni Boccaccio's *Decameron.* The premise behind this work of storytelling is similar to Boccaccio's masterpiece: a flood traps ten noble men and women, and to pass the time they tell stories. After each of these the men and women deliberate upon the moral messages in the fables they have just recounted. Like Boccaccio's masterpiece and the nearly contemporaneous *Gargantua* and *Pantagruel* series of François Rabelais, these tales are frequently filled with a great deal of frank sexuality. In comparison with the earlier *Decameron,* though, Marguerite's use of sex is frequently violent and less playful. The mood of the piece is somber, and the storytellers debate the morality of the tales they tell with a subtle, finely tuned discrimination.

ASSESSMENT. Long dismissed as pornographic, Marguerite's *Heptameron* has recently been the subject of a number of studies, as scholars have seen in it unusual feminine characters, a complex narrative, and a subtle and ambiguous moral message. While it may never

rank among the great monuments of sixteenth-century French literature, as Rabelais' and Montaigne's works do, it is nevertheless a significant achievement and displays Marguerite's depth and breadth of learning. Marguerite's other works, particularly her poetry, have also witnessed resurgence in popularity since the late nineteenth century. At that time a number of her poems were rediscovered and published, and these have re-established her justified reputation as perhaps the best educated woman of the Renaissance and certainly one of its finest writers.

SOURCES

M. Cerati, *Marguerite de Navarre* (Paris: Sorbier, 1981).

R. D. Cottrell, *The Grammar of Silence: A Reading of Marguerite de Navarre's Poetry* (Washington, D.C.: Catholic University of America Press, 1986).

Marguerite, queen, consort of Henry II, king of Navarre, *The Heptameron.* Trans. Paul Chilton (New York: Penguin, 1984).

G. Mathieu-Castelani, *La conversation conteuse: les nouvelles de Marguerite de Navarre* (Paris: Presses universitaires de France, 1992).

THOMAS MORE
1478–1535

Statesman
Humanist

EDUCATION. More was the son of a prominent lawyer in late fifteenth-century London who gave his young son the best education available in England at the time. More went to school early and he entered the household of English cardinal John Morton at the age of twelve. Morton was not only a churchman, but he also served the Tudor king Henry VII as Lord Chancellor of England, and thus he helped to introduce Thomas More to the life of high politics that would play such an important role in his later life. After leaving Morton's household, More entered the University of Oxford where he was tempted for a time to pursue a career in the church, but his father's wishes prevailed. After completing his studies at Oxford, More entered the Inns of Court in London to begin his legal education. While he was a law student, he came under the influence of John Colet, the prominent humanist who served at the time as the dean of St. Paul's Cathedral and who influenced many English intellectuals to take up humanist studies. In 1499 More met Erasmus and the two struck up a friendship that would last the rest of their lives. Both men studied the comedy of Lucian together during this

period, and their later mastery of ancient comedy punctuated the letters they exchanged as well as the humanist works they dedicated to each other. During the first decade of the sixteenth century More continued his humanist studies, but he was also actively involved in furthering his career. He married Jane Colt and had four children with her, but she died in 1511. A month later More married Alice Middleton, who would later be criticized by one of More's humanist biographers as "blunt" and "rude." Like most humanists, More believed that education helped produce virtue and so he saw to it all that all his children were well educated. His daughters were famous in sixteenth-century England for their mastery of Latin and the classics.

AMBITIONS. By his middle age Thomas More had established himself as a lawyer of distinction in London, and he had begun to play a role in local and later national politics. He was first chosen as undersheriff of London, before becoming a member of the Royal Council. Later he served as speaker of Parliament, and finally, with the embarrassment of Cardinal Wolsey in 1529, he was elevated to become Lord Chancellor. He used his positions to foster the New Learning in England and to defend humanism against scholastic traditionalists who aimed to stamp the new movement out. At the same time More was hardly a worldly and liberal figure in the Italian mold. He was reputed to wear a hair shirt and to practice self-flagellation, and when Luther's ideas began to acquire admirers in England during the 1520s, More advocated the swift and sure punishment of these heretics.

WORKS. Like many humanists More was an active letter writer and he used his letters to discuss all manner of issues with his friends and associates. One of his most famous letters defended his friend Erasmus' *Praise of Folly* against its detractors. Erasmus had dedicated this work to More, and the title was actually a play on words. The work's Latin title *Moriae Encomium* could be read as either "In Praise of Folly" or "In Praise of More." Today, More is chiefly remembered for two works, his *History of Richard III* and *Utopia*. The first of these works was unusual for the time since it was prepared about the same time in both English and Latin versions. The English version is longer, which has led some authorities to conclude that it was actually written before the Latin. The use of English at the time was highly unusual, since most scholars in the island relied on Latin or French. More's work was thus an important literary milestone in the creation of modern English. The history that More constructed about the evil king Richard III was not objective in a modern sense, but was nevertheless an advance from the largely legendary chronicles that passed for history in England at the time. Like other humanist historians More believed that the study of the past could ennoble readers by providing them with moral lessons from the lives of good and evil figures. In the *History* More created the image of the evil king Richard that Shakespeare was to use as the basis for his masterpiece *Richard III*. More relied on eyewitnesses to Richard's reign and although he may have created the notion that Richard was a hunchback, historians have for centuries confirmed his picture of the king as a ruthless tyrant. Much of *The History of Richard III* was written around the same time as Machiavelli was completing his *Prince* in Italy. A comparison of the two works is revealing. Where Machiavelli embraced the ability of rulers to enforce their will with determination and at times even ruthlessness, More linked Richard's destruction to his tyrannical and amoral behavior. The second and even more widely known of More's works, *Utopia*, was first published at Basel in 1516. More came up with the idea for the work while he was on a diplomatic mission to the court of Burgundy. It is one of the first pieces of European fiction to be inspired by the discovery of the Americas. It records the experiences of Raphael Hythloday, a voyager who has just returned from a journey to the New World with Amerigo Vespucci, the famous Italian geographer. Hythloday is a philosopher of sorts and he praises every place he has seen on his journeys at the expense of contemporary Europe. One of these is the island of Utopia, and the remainder of the book treats the strange customs of the inhabitants of this newly discovered world. Many of Hythloday's statements mock contemporary mores, including his attacks on contemporary penal practices and capital punishment in Europe. The work was exceptional primarily for its economic theories. More pointed out that privation was the cause of enormous suffering and lawlessness in European society, and the perfect society that he imagines is consequently one in which private property is banned. The Utopians do not pursue the creation of wealth or the production of goods for mere luxury's sake, but each has enough for his or her own needs. They spend part of each day working, but since everyone has a task and there are no leisured elites like in Europe, there is greater time for everyone to enjoy the good things of the world. Many have seen in More's vision a bleak and darker side, that is, of a society in which most human freedoms have been abolished. Certainly his identification of an imaginary society that serves as a critique of contemporary Europe was popular. It gave rise in the sixteenth and seventeenth centuries to an entire genre of Utopian literature in which social theorists imagined their own perfect society.

LATER PROBLEMS. Although More's rise to power had been swift throughout the 1520s, he exercised little influence on government following his appointment as Lord Chancellor because of his disapproval of Henry VIII's plans to divorce Catherine of Aragon. More eventually retired from public life, writing polemical works against Protestantism. When he refused to swear a loyalty oath in 1534 to Henry VIII, he was first imprisoned in the Tower of London and later tried and convicted for treason. He was executed on 1 July 1535.

SOURCES

P. Ackroyd, *The Life of Thomas More* (London: Chatto and Windus, 1998).

A. Kenney, *Thomas More* (Oxford: Oxford University Press, 1983).

R. Marius, *Thomas More, A Biography* (New York: Knopf, 1984).

J. B. Trapp, *Erasmus, Colet, and More: The Early Tudor Humanists and Their Books* (London: British Library, 1991).

HANS SACHS

1494–1576

Poet
Playwright
Cobbler

EARLY LIFE. Born the son of a tailor in Nuremberg, Hans Sachs attended local Latin school before being apprenticed to a cobbler at age 15. Like other journeymen, he traveled for a time before returning to set himself up in his trade at Nuremberg. He married, had seven children, and eventually became a staunch supporter of the Protestant Reformation. He continued to practice his trade throughout his life, only leaving Nuremberg for brief trips to trade fairs in Germany. In short, his life was relatively without incident or disruption, but as a local poet and author in Nuremberg he wrote more than 6,000 works.

SUPPORT OF REFORMATION. Like many literate townspeople at the time, Sachs was fascinated with Martin Luther's campaign against the church, and he read all of the reformer's available works. Soon after the outbreak of the Reformation, he published *The Wittenberg Nightingale*, an allegory of 700 verses in which Sachs denounced the Roman Church and its financial exploitation of the German people. Published in numerous editions over the next years, the poem made Sachs something of an instant celebrity throughout the country.

Sachs' support for the Reformation never wavered and he published other short pamphlets that praised Luther's teaching in a lively idiom. These were written as dialogues, the most famous being the autobiographical work *A Dialogue between a Canon and a Shoemaker*, in which a Bible-verse-spitting cobbler takes on a cleric to reveal the evils of the Roman religion.

MEISTERSINGER. In the modern world Sachs has long been known to opera lovers as the hero of Richard Wagner's famous work, *The Meistersinger of Nuremberg*. In that work Wagner immortalized Sachs as the cheerful and beloved master of the art of *Meistergesang* or *Master Song*. This tradition had grown up in Germany in the later Middle Ages, and Nuremberg was the primary center of its art. A strict set of rules governed *Meistergesang* and those who practiced it were members of trade guilds in southern German cities. They met regularly to perform the works they authored and they were judged according to strict criteria. Between 1524 and 1560, Sachs was the undisputed leader of Master Singing or *Meistergesang*, and during these years he wrote over 4,000 lyric poems that he performed in the Nuremberg competitions. These covered an enormous variety of topics, including subjects that he drew from the Bible, from classical literature, and from medieval German traditions. Some were light farces, others Protestant propaganda. His literary output as a master singer was so enormous that not all of his songs have yet been studied.

PLAYS. Sachs was also a dramatist, and he particularly excelled in writing Carnival Plays or *Fastnachtspiele*. These were light and short farces that were performed in Nuremberg immediately before the beginning of Lent, and Sachs cast his dramas with a rich variety of characters. Grasping merchants, country bumpkins, simpletons, and an enormous range of human types play off each other in these short comedies, and are given a humane cast by Sachs' light touch. Many of these dramas are still performed today. Less well known are Sachs' 130 other tragedies and comedies which were intended to play a moral and didactic function. In all these works Sachs transformed his characters—whether they were drawn from ancient or medieval models—into contemporary Nurembergers, and the values that he celebrated were those of the emerging European bourgeoisie. He praises hard work, thrift, and religious faith, while condemning self-interest, greed, and envy. Similar themes, too, emerge in the more than 2,000 poems he also wrote. While Sachs was a widely recognized talent of his age, he was largely forgotten after the sixteenth century. In the eighteenth century the great German poet, Johann

Wolfgang von Goethe, studied his lyrics and promoted his works. Restored to his rightful place among German authors, Sachs inspired a number of dramas, poems, and operas in the nineteenth century, including Wagner's famous and idealized portrait. Since that time scholars have also been devoted to reviving a truer picture of this admitted genius of sixteenth-century German literature.

SOURCES

Eckhard Bernstein, *Hans Sachs* (Rheinbek, Germany: 1993).

B. Könneker, *Hans Sachs* (Stuttgart, Germany: Metzler, 1971).

Hans Sachs, *Werke.* Ed. A. von Keller and E. Goetze. 26 vols. (Stuttgart, Germany: 1870–1908).

DOCUMENTARY SOURCES
in Literature

Boccaccio, *The Decameron* (c. 1350)—A collection of 100 stories told by a fictional group of wealthy Florentines while awaiting the recession of the Black Death away from their homes, this pioneering work of fiction in the Renaissance inspired many later writers.

Michelangelo Buonarroti, *Poems* (c. 1550)—These beautiful lyrics show the influence of Petrarch as it was developed in the later Renaissance among Italian writers.

Baldassare Castiglione, *The Book of the Courtier* (1528)—This work is a dialogue between members of the cultivated court of Urbino about the qualities of a perfect courtier. The book was translated into a number of European languages and became read as an advice manual for courtiers in the later Renaissance. It also spawned a host of imitators who wrote similar courtesy books.

Niccolò Machiavelli, *A History of Florence* (1532)—Published after his death, this work ranks among the greatest literary achievements in historical studies in the Renaissance. It carries on the tradition of history as a republican duty, which had been begun by Leonardo Bruni a century earlier in Florence.

Marguerite of Navarre, *Heptameron* (c. 1547)—The famous French noblewoman and queen of Navarre's unfinished collection of short novella was inspired by Boccaccio's *Decameron.* The work, long thought to be scandalously erotic, has more recently been shown to be filled with subtle moral insights.

Michel de Montaigne, *Essays* (1595)—The final edition of Montaigne's famous work includes the expansions that the author continued to make in these works throughout his later life. The *Essays* are an unprecedented journey of one man's search through his psyche and his attempts to establish a meaningful personal philosophy. The *Essays* are also a literary milestone in the creation of modern French.

Sir Thomas More, *Richard III* (c. 1510)—This is a pioneering work of contemporary history by the famous Northern Renaissance humanists. This work helped to establish the stereotypical image of one of history's most famous villainous kings.

Francesco Petrarch, *Canzoniere* or *Songbook* (1373)—This is a collection of Petrarch's lyric poetry dedicated to his illusory love Laura. Renaissance writers continued to return to the work, particularly to the sonnets, as inspiration for their poetry.

François Rabelais, *Gargantua* and *Pantagruel* (c. 1534)—These two novels were written in several installments throughout the writer's life and recounted the fabled exploits of a race of giants. They are the greatest fictional works of the French Renaissance and were widely copied by other satirical writers.

MUSIC

Philip M. Soergel

IMPORTANT EVENTS
in Music

1308 The pope takes up residence at Avignon on the Italian-French border. During the fourteenth century French composers working in Avignon will nourish the development of secular and religious music inspired by their native styles.

1321 The French mathematician Jehan des Murs completes his treatise *Ars nove musice* (On the New Art of Music), a work that defends innovations in the writing of sacred music.

1322 The French poet, composer, and bishop Philippe de Vitry (1291–1361) writes an important treatise on music entitled *Ars Nova* (The New Art).

1325 Jacques de Liège attacks the *Ars nova* style in his *Mirror of Music*.

Francesco Landini, the leading fourteenth-century Italian composer of secular ballads, is born at Florence.

1377 The papacy returns to Rome from Avignon, giving rise to the Great Schism that lasts until 1415. The return of the capital of the church to Rome brings an influx of French musicians and composers to Italy, inspiring innovation in music.

c. 1390 The composer Johannes Ciconia, a native of the French city of Liège, becomes a resident of the city of Padua. He will influence the musical life of his adopted town and nearby Venice.

1404 Duke Philip the Bold of Burgundy, an enthusiastic supporter of church music, dies.

Philip's successor, Philip the Good, will continue Burgundian patronage of church music until his death in 1467.

c. 1420 Guillaume Dufay composes a series of songs and motets while working for the Malatesta family in the Italian city of Pesaro. These works are often cited as the first to express a distinctly "Renaissance" musical style.

1422 The Duke of Bedford, an English nobleman, becomes regent of France. One of the members of his court is John Dunstaple, whose use of new harmonies and rhythms in his compositions influences French musicians.

1436 Guillaume Dufay composes the motet *Nuper rosarum flores* for the dedication of the Cathedral of Florence's dome, designed by Filippo Brunelleschi.

1440 The "English Style" becomes popular in masses composed in France and the Low Countries.

1450 Pipe organs become increasingly common instruments used throughout large churches in Western Europe; at the same time, the harpsichord and clavichord grow in popularity.

1460 Gilles Binchois, a Burgundian court musician and avid composer of songs or *chansons*, dies.

1467 Charles the Bold becomes Duke of Burgundy and establishes his courts in the north of the Burgundian lands, rather than in the traditional French province of Dijon. An amateur musician, Charles continues the tradition of Burgundian support for musical composition and performance and supports the development of an important school of musical composition in Flanders.

c. 1470 The Platonic philosopher Marsilio Ficino champions music in his philosophical works for its ability to inspire poetry and to heal body, mind, and soul.

c. 1472 Josquin des Prez, called the "father of musicians" and praised by Martin Luther as "the master of the notes," enters into the service of the Sforza dukes at Milan.

1474 Composer Guillaume Dufay dies in Cambrai, a town in modern Belgium. Dufay's music will continue to influence the development of a Burgundian style after his death.

1477 Johannes Tinctoris' important theoretical treatise *A Book on the Art of Counterpoint* appears. Tinctoris is a Flemish composer active at the royal court in Naples.

c. 1480 Lorenzo de Medici grants rich patronage to the choir of the cathedral of Florence and recruits Flemish musicians to serve there.

1497 Johannes Ockeghem, an important Flemish composer, dies.

1501 Oattaviano dei Petrucci becomes the first to print music through the publication of a collection of motets and chansons in Venice.

1519 Maximilian I, the Habsburg Holy Roman Emperor, and an enthusiastic supporter of court music, dies.

1520 Pierre Attaignant develops a new method for musical printing that drastically cuts the time needed to prepare an edition. Music printing begins to spread quickly throughout Europe as a result, arriving in London apparently in the same year.

1522 Francesco Gaffurio, an important Italian musical theorist, dies.

1524 The Protestant Martin Luther embraces the chorale, a hymn form which will be used in Reformation churches.

1534 Music printing begins in Germany.

1543 William Byrd, the last great Catholic composer of church music in England, is born.

1547 Edward VI succeeds to the throne of England and begins reforming the country's worship and religious music along severe lines.

Thomas Tallis, once a composer in Henry VIII's chapel, now adopts a more severe and measured style emphasizing texts.

1558 Gioseffi Zarlino's important treatise *The Art of Counterpoint* is published at Venice.

1562 John Dowland, a composer of popular English lute songs, is born.

1563 The Council of Trent concludes its deliberations. Although music was not a central issue, the Council's decrees begin to inspire a reaction in the church against complicated polyphony, causing a more restrained style of religious music to eventually prevail.

1567 Claudio Monteverdi, master of the Italian madrigal and composer of early operas, is born at Cremona in Italy.

c. 1570 A major controversy erupts in Italy between supporters of Francesco Zarlino and Vincenzo Galilei over the precise contours of ancient Greek music.

Michael Praetorius, an important musical theorist and early Baroque composer, is born in Germany.

c. 1573 Groups of local musicians and academics organize to form the *camerata* in Florence, which will champion the revival of Greek performance practices and influence the development of the early opera.

1588 Nicholas Yonge publishes a collection of Italian madrigals translated into English in London. This and other works will inspire a fury of English madrigal writing at the end of the sixteenth and beginning of the seventeenth centuries.

1594 Orlando di Lasso, perhaps the greatest of sixteenth-century European composers, dies after a long career in service to the dukes of Bavaria.

Giovanni da Palestrina, greatest of Italian Counter-Reformation composers, dies at Rome.

1597 The opera *Dafne*, with words written by Ottavio Rinuccini and music composed by Jacopo Peri, is the first opera to be produced at Florence.

1600 A second Rinuccini-Peri opera, *Euridice* is performed at the wedding of Henry IV of France to Marie de' Medici of Florence.

OVERVIEW
of Music

ACHIEVEMENT. In the modern world, rich musical traditions have so long affected the ear that it is difficult for modern listeners to imagine the musical styles that were common in Western Europe 700 years ago. For centuries, the Western musical tradition has made extensive use of harmony, rhythm, melody, and lyrics, and it has embraced innovation and experimentation in sound. But while the modern musical universe is constantly evolving, a tradition of musical experimentation was also a feature of the musical landscape of the Renaissance. The music of the Middle Ages, while often of great expressive beauty, possessed dynamic and harmonic possibilities that were considerably more limited than the art form known today. The Renaissance helped to open up those possibilities by embracing new rhythms and harmonies, developing new genres like the madrigal and opera, and exploring the musical colors of instruments and the human voice. The art of counterpoint—the combination of independent melodies to create an overarching harmonic structure—also matured as an important foundation of Western music at this time. If the Renaissance produced no universal musical genius that is revered in modern times throughout the world like Bach, Mozart, or Beethoven, the period, nevertheless, saw the rise of the professional composer, a figure who expressed his own individualistic and creative musical vision. The ranks of distinguished musical composers of the period include Claudio Monteverdi, who experimented with the madrigal form and the early opera; Orlando di Lasso, whose vocal compositions influenced musical styles throughout Europe; and Giovanni da Palestrina, who defined the Catholic Church's sacred music to fit with the emerging religious sensibilities of the Counter-Reformation. New musical styles and forms flourished everywhere in Europe during the Renaissance. In Germany, Martin Luther and other early Protestant reformers embraced the singing of chorales as part of the new religious services adopted in their churches. These hymns were performed with rich harmonies and drew their tunes from a variety of sources. In other quarters new types of national song flourished, like the German lieder, the English carols, and the French chansons. If the sounds of the Renaissance sometimes seem strange and foreign to modern ears when judged against the still widely revered music of the Baroque, classical, or romantic periods, the period's music stands far closer to these modern eras than it does to the often severe and unadorned music of the Middle Ages. As Renaissance composers experimented with new ways of pleasing their audience, they acquired an innovative and inventive musical spirit. It was this spirit of dynamic innovation that produced the great musical masterpieces of the time, even as it helped to lay the foundations for the profound period of musical achievement that occurred in Europe between the seventeenth and the twentieth centuries.

THE EARLY RENAISSANCE. During the first half of the fifteenth century, European music experienced a major stylistic shift. Harmonies and rhythmic patterns imported from England broadened the range of compositional possibilities open to composers in France and the Netherlands. Throughout the fifteenth century these two regions were to remain Europe's premier centers of musical innovation. In the Duchy of Burgundy—a large and wealthy territory that stretched over eastern France, Lorraine, Burgundy, and the Low Countries (modern Belgium, Luxemburg, and Holland)—composers developed a distinctive style characterized by a broader range of harmonies, tighter structural unity, and greater rhythmic complexity. Chief among the early exponents of this new style was Guillaume Dufay who, together with Gilles Binchois, found inspiration in English patterns of composition as well as native French and Flemish secular song and sacred plainsong. The frequent travels of Burgundian composers throughout the fifteenth century helped spread the new style to Italy and other parts of the continent. By the end of the century the foremost exponents of this Franco-Flemish school of composers—figures like Jacob Ockeghem and Josquin des Prez—influenced musical tastes almost everywhere in Europe.

HUMANISM. The revival of Antiquity championed by the humanists in Italy was also a significant factor in changing musical tastes. The humanists advocated the study of ancient literature as a road to virtue, and, among composers, one of its chief results was to foster a new emphasis on the texts of vocal music. As the sixteenth century approached, composers became more concerned than ever before with finding musical forms of expression that expanded their audience's understanding of a piece's lyrics.

MUSICIANS' WORLDS. While the knowledge of performance practices and the training of musicians in the Renaissance is comparatively less than in later centuries, the evidence suggests that a sophisticated audience for music was developing at the time and that more professional musicians were being employed in important churches, cathedrals, and courts than ever before. Most musicians likely acquired their first musical training in the home from their parents or tutors or from someone in the neighborhood who was skilled in singing or in the playing of a musical instrument. Many young boys probably honed their skills in music by serving for a time as a choirboy in a cathedral or major church, the incubators that produced most of the period's accomplished composers. In France, Flanders, England, and Italy, major choir schools were already training a number of musicians by 1500, and the skills of French and Flemish musicians, in particular, were widely prized and admired throughout Europe. The choir schools taught a number of musical skills beyond just singing. They familiarized their male students with harmony and instrumentation and they included extensive training in how to improvise, perform, and ornament music. While young girls were barred from attending these schools or performing in these important choirs, many women did receive a musical education. In court society, in particular, the ability to play an instrument and to accompany oneself while singing was prized as a sign of refinement for both men and women alike. Most cultivated women of the Renaissance acquired these skills, and even outside the great courts, female amateur musicians were common. In sixteenth-century Italy a number of female professionals also entertained audiences with song concerts. The increasing number of books published about performing music also testifies to the swelling ranks of both professional and skilled amateur musicians.

INSTRUMENTS. By the sixteenth century the categories of instruments in use throughout Western Europe already resembled those common in the modern world. Strings (either of the violin or the viol family), woodwinds, brass, and percussion and keyboard instruments were popular throughout the West, and although these instruments differed greatly from place to place, new innovations were expanding the sounds available to composers and musical ensembles. The range of woodwind instruments—the ancestors of our modern flutes, oboes, and clarinets—did not alter in the period. Yet these instruments came to be combined into new groups or "courses" that were of three sizes—such as the soprano, alto, and tenor recorders that were common in the period. Each type of instrument's pitches were set about a

fifth apart, and thus the recorder sound was able to be produced over a broader range. By the end of the fifteenth century, these changes meant that similarly voiced woodwind instruments could play a far broader harmonic spectrum than before. The brass instruments—trumpets, trombones (known as sackbuts at the time), and cornets—were not only constructed of brass, but of wood and silver. Like the woodwinds, they, too, were combined into new groupings or consorts to achieve greater ranges of color and pitch in the period. While violins were popular, the use of the viols—stringed instruments that were supported in the lap or held between the knees, rather than at the chin—were more popular. A great deal of music was played on the string instruments generally, because of the high status they had in approximating the character of the human voice. Perhaps no other instrument underwent a more fundamental transformation at this time than the organ. At the beginning of the Renaissance, small portable organs that sat on a table or in the player's lap were popular. While this style of organ continued to be used throughout the Renaissance, the modern pipe organ, characterized by its fixed location and massive structure, became popular in the largest churches and cathedrals of Europe during the fifteenth and sixteenth centuries. Like most of the instrumental developments of the Renaissance, the new fashion for these large organs reflected the taste of the age for increased volume and a broader range of pitch and sounds. But while organs were one of the signs of the new technological bent of the period—a bent that was to produce great changes in instruments during the seventeenth and eighteenth centuries, the most popular domestic instrument of the time was the lute. Originally of Middle Eastern origins, the lute had long flourished as a household instrument in medieval Europe, prized for its compatability with the human voice. During the Renaissance the range of the instrument was extended, at first by the inclusion of a fifth string in the fifteenth century, and then, by the addition of another in the sixteenth. By that time most Western Europeans played the instrument with their fingertips, rather than with a plectrum, a small piece of bone or wood used to pluck strings. The lute continued to be among the most popular instruments in Europe long after the Renaissance, surviving as perhaps the most important amateur and household instrument until the eighteenth century.

HIGH RENAISSANCE ACHIEVEMENTS. During the sixteenth century skill in musical performance and discernment in listening became an increasingly important marker of good taste and sophistication. In Italy, the madrigal emerged as a kind of chamber music performed

in educated circles that gave musical expression to some of Italian's finest poetry. Written in four- and five-part harmony, madrigals spread rapidly and influenced choral music through the rise of musical printing. New national styles of secular songs flourished as well, including the Parisian chanson and the German Lied. The development of centers of musical printing, particularly in Paris, the Low Countries, Venice, and Nuremberg, played a key role in establishing the European-wide reputations of some of the age's greatest composers, including figures like Orlando di Lasso and Giovanni Pierluigi da Palestrina. In addition, the popularity of printed music spread knowledge of musical innovations then occurring in Italy and elsewhere to other parts of the continent. While vocal and choral forms remained dominant in the music published in the Renaissance, instrumental music came to be printed, too. The importance of memory and improvisation in instrumental music had long necessitated a dependence on the skill of musicians, who had learned to embellish and play their works from tunes that had their origins in songs and dances. Now as instrumental music came increasingly to be written down, composers became more definite about the ways in which their music should be played. Thus heightened technical virtuosity became important for professional musicians who hoped to succeed in the new, highly competitive market.

CHANGES. The sixteenth century may have seen the rise of more sophisticated patterns of musical consumption, but it also produced a number of new musical genres and, in the spread of humanism and Protestantism as well as the rise of the Counter-Reformation within the Catholic Church, the period saw fundamental transformations in the uses of music. During both the Middle Ages and the Renaissance, music was a practiced art as well as an important branch of the "mathematical sciences" taught in the seven liberal arts, the dominant secondary school curriculum used throughout Europe. From the beginning of the Middle Ages this curriculum had developed a considerable body of theory about music as the "science of pitch." Much of this theorizing about music had speculated about its role in the structure of the universe, and this body of highly technical knowledge continued to be debated in the sixteenth century. At the same time the rise of humanism also sent these musical scholars into the libraries to investigate more closely the precise contours of ancient music. In doing so, these figures hoped to be able to recover the power that ancient philosophers had associated with music's performance. In turn, Renaissance musical investigations gave birth to several attempts to imitate ancient

music, including the first operas that were performed in and around the city of Florence at the very end of the sixteenth century. In these first performances Italian composers and their poetic librettists relied on a new form of musical performance known as the recitative, in which the work's text was highlighted by being recited against an accompanying instrumental background. While the great age of opera's development was to lie outside the Renaissance, the pioneering of these secular musical dramas was just one way in which the sixteenth century enlarged the European musical universe. The religious controversies of the age similarly acted as a leaven in the musical world, producing new musical forms. In the German-speaking heartland of Europe, Martin Luther and other Protestant reformers embraced the chorale, which was a form of melodic hymn that was harmonized in several parts. In Switzerland, by contrast, the stricter, uncompromising Calvinist tradition of Protestantism avoided such elaborate and showy uses of church music, and instead relied on severe, unison psalm singing. In Italy, other reassessments of music's role in the church were underway. As the Counter-Reformation came to maturity, it prompted both religious leaders and composers to rethink the role that polyphony—the simultaneous performance of many musical lines—should play in sacred music. Giovanni da Palestrina and other church musicians led a reform in music that made use of a new grand and restrained style that was to affect Catholic religious composers in the centuries to follow.

TOPICS
in Music

MUSIC AND THE RENAISSANCE

PROBLEMS OF DEFINITION. In art, architecture, and literature, long-standing definitions of Renaissance style have stressed the importance of the recovery of ancient models and their impact upon the artists and writers of the period. To speak of a "musical Renaissance," however, is more problematic. In the three centuries following 1000 C.E., European composers and musicians had developed distinctive national styles and musical forms that continued to shape the achievements of the Renaissance long after the recovery of Antiquity had begun in other arts during the fourteenth and fifteenth centuries. While knowledge of ancient styles proved often to be crucial for the creation of "Renaissance" paintings, sculptures, and architecture, the application of such

knowledge to music presented a special problem to the scholars, composers, and musicians of the time. The improvisational, performance-based music of Antiquity yielded very few documents or records that could be studied by later generations; as a consequence, Renaissance scholars did not focus on ancient musical theory or performance practices until comparatively late in the period—not until the later fifteenth and sixteenth centuries. The absence of scholarship concerning Antique music prevented most attempts by Renaissance musicians to imitate ancient practices; as a result, the ancient world had a comparatively lesser impact on the great changes that occurred in music during much of the Renaissance than it did in the other arts. For these and other reasons, historians of music, in contrast to those of art, architecture, and literature, have long dated the emergence of a distinctive Renaissance style in music only after 1450, roughly a century and a half later than in other media.

MUSIC AS A SCIENCE. During both the Middle Ages and the Renaissance a clear line existed between music's role as a branch of the sciences on the one hand and musical composition and performance on the other. What modern scholars consider music theory was in both the Middle Ages and the Renaissance known as "speculative" or "scientific" music (in Latin *musica speculativa* or *musica scientia*). From the early Middle Ages philosophers had included music within the "mathematical" sciences, four distinctive branches of the seven liberal arts. These disciplines together were known as the Quadrivium, and anyone who hoped to gain entrance into a university needed to acquire knowledge of the mathematical relationships that existed in musical pitches, intervals, and harmonies. In this way the academic study of music developed as the "science of sound" and a great deal of theory was written during the Middle Ages that treated the physical properties of music. Philosophers speculated upon music's abilities to produce changes in the characters of its listeners as well as to generate alterations in the external world. This body of theory grew immensely during the Renaissance, too, largely as a result of the contact of intellectuals with the works of ancient writers that treated music as an important aid to philosophy. At the same time, the great philosophers of the ancient world, although they had prized music for its ability to speak to the human soul, had had little definite to say about musical practices per se. Thus the discussions of music as a science that continued during the Renaissance were not an abrupt break with medieval tradition. One figure whose work continued to be widely read and discussed was Boethius (480–524), a late antique figure who had

transmitted the musical knowledge of his day and of the ancient world to the Renaissance. While important as a transmitter of knowledge, Boethius was also a major figure in the history of musical theory and science in his own right. He treated music as one of the four branches of mathematics, a view that continued to be shared in both the Middle Ages and the Renaissance. Yet he also insisted that music had a special role among these sciences because it might breed both ethical virtue and reason.

MUSICAL PERFORMANCE. Performers, by contrast, were largely unaffected by these rarefied discussions of music as the "science of sound," or of music's role as one of the mathematical sciences. In fact, the evidence suggests that while many musicians may have been able to read music, they were not able to read the written word. They learned their skills by being taught in the home, or from someone nearby who could already sing or play an instrument, or by serving for a time as a choirboy in a local church or cathedral. Musical performance was a practical art, and most accomplished musicians were by and large unaware of the complexities of musical theory or of the scientific and philosophical discussions about music. The performance of music was instead governed by long-standing traditions, by the role that music played in the church, and by the secular songs and ballads that were performed in medieval society. While the music of the church often bore a resemblance across regions, secular music differed greatly from place to place, with the popular or "folk" music of France making use of traditions, sounds, and instruments that were often very different from those of Italy or Germany. By the fourteenth and fifteenth centuries a wealth of these native kinds of music existed everywhere in Europe, although most music was still performed from memory or through improvisation of a well-known tune. Far less music was "composed"—that is written down—than was to be the case in later centuries. Even many cathedral choirs improvised their harmonies according to generally accepted conventions, rather than reading the parts from a score. During the Renaissance quickening changes in musical tastes helped to popularize the practice of writing down a greater range of music than previously. As composers gained reputations in places far from their homeland, a fashion for "new music" emerged, and written scores were more necessary than ever before to satisfy the demands of audiences for the admired works of the age.

ROLE OF THE CHURCH. During the fifteenth century, the writing of sacred vocal music for the rituals of the church continued to be the most important outlet for those who composed music. While a current of in-

novation is discernible by the 1300s, the music of the church had long been defined by the primary importance of plainsong, a form of unison or chant-style singing. Since early Christian times plainsong had been the dominant form of music performed in the European church. Modern listeners popularly refer to plainsong as Gregorian chant, a term that is technically a misnomer, since it associates one form of early medieval chant sanctioned by Pope Gregory I (540–604) with the rich variety of plainsong that flourished in medieval Europe. Plainsong involved the singing of texts, prayers, and biblical readings that were used in the church's rituals, thus elevating their performance above mere spoken recitation. The simplest forms of plainsong used only a single tone, sometimes with a falling pitch on the last note of a phrase. But several thousand plainsong melodies survive from the Middle Ages, showing a considerable diversity and complexity in the form's development. Medieval plainsong did not have "keys" like most Western music has had since the seventeenth century. Instead plainsong was based around a system of eight scales known as modes; these modes governed the progression of tones and semi-tones used in a piece's scale. While some of the medieval modes sounded remarkably similar to the modern system of major and minor keys, music written in some other modes has a very different character than that written in the modern system of tonality. Plainsong developed during the Middle Ages in close connection with monasteries and cathedrals, and their performance occurred during a series of daily religious prayers known as the Offices and in tandem with the celebration of the Mass. The Offices began with *Matins*, a service that occurred in the middle of the night, and they continued with *Lauds* at sunrise. Thereafter they followed at intervals of about every three hours during the day and concluded with Vespers and Compline at sundown. At these services, monks and clerics chanted prayers, hymns, Psalms, and lessons from the Scriptures with matins, lauds, and vespers generating the most complex musical forms. The Office of Vespers was particularly important, since it was the only ritual that initially allowed monks and clerics to perform music that was polyphonic, that is, in which multiple melody lines or harmonies were sung simultaneously. As such, musical innovations tended to develop around the Office of Vespers.

THE MASS. The rituals of the Offices occurred in cathedrals and monasteries throughout Europe and were performed only by the monks and priests who resided in these institutions. By contrast, the Mass was a universal religious rite, separate from the Offices, in which

a PRIMARY SOURCE *document*

MUSICAL DIVERSIONS

INTRODUCTION: In his famous work *The Decameron*, Giovanni Boccaccio described the entertainments of a group of ten noble men and women who fled Florence during the outbreak of the Black Death in 1348. For ten days, the company told stories, each day electing a king or queen to preside over their efforts. In his introduction to the work, Boccaccio describes how music enlivened this aristocratic circle's time in exile.

Thus dismissed by their new queen the gay company sauntered gently through a garden, the young men saying sweet things to the fair ladies, who wove fair garlands of divers sorts of leaves and sang love-songs.

Having thus spent the time allowed them by the queen, they returned to the house, where they found that Parmeno had entered on his office with zeal; for in a hall on the ground-floor they saw tables covered with the whitest of cloths, and beakers that shone like silver, and sprays of broom scattered everywhere. So, at the bidding of the queen, they washed their hands, and all took their places as marshalled by Parmeno. Dishes, daintily prepared, were served, and the finest wines were at hand; the three serving-men did their office noiselessly; in a word all was fair and ordered in a seemly manner; whereby the spirits of the company rose, and they seasoned their viands with pleasant jests and sprightly sallies. Breakfast done, the tables were removed, and the queen bade fetch instruments of music; for all, ladies and young men alike, knew how to tread a measure, and some of them played and sang with great skill: so, at her command, Dioneo having taken a lute, and Fiammetta a viol, they struck up a dance in sweet concert; and, the servants being dismissed to their repast, the queen, attended by the other ladies and the two young men, led off a stately carol; which ended they fell to singing ditties dainty and gay. Thus they diverted themselves until the queen, deeming it time to retire to rest, dismissed them all for the night. So the three young men and the ladies withdrew to their several quarters, which were in different parts of the palace. There they found the beds well made, and abundance of flowers, as in the hall; and so they undressed, and went to bed.

SOURCE: Giovanni Boccaccio, "Introduction to Day One," in *The Decameron*. Trans. J. M. Rigg (London: Routledge, 1921).

Medieval choir-book illumination. © HISTORICAL PICTURE ARCHIVE/CORBIS.

all medieval Christians participated. Priests celebrated the ritual, although lay people attended it and played a role in its celebration. While the Offices were relatively short religious observances, the Mass was the church's most important, and therefore, elaborate religious rite. Sacred music accompanied the Mass very early in the history of the church. The Mass was celebrated in Latin and although there were variations in the ritual throughout Western Europe, it proceeded with a text that was largely fixed according to custom. Often the celebration of the Mass was a relatively humble affair, with priests merely chanting the text of the ritual before those who were in attendance. Yet "high" masses accompanied by choirs, music, and instruments were also celebrated in both the Middle Ages and the Renaissance, and were especially common in Europe's most important churches on particularly solemn occasions.

CIVIC MUSIC, SACRED FORMS. By the end of the Middle Ages, Europe's cathedrals were vital centers of musical production, a trend that was to persist in the Renaissance and beyond. The quality of music performed in a town's cathedral or major churches was already an important element of civic pride by this time. Town governments helped to fund the establishment of choral schools, choirs, and instrumental groups to ac-

company the singing that occurred within their churches. In Italy, where great commercial wealth came to be amassed during the later Middle Ages and the early Renaissance, choirs were a major preoccupation of town governments and not just church officials. At first, the great Italian cities—places like Florence, Siena, and Milan—imported many of their singers from northern Europe, particularly from Paris and throughout northern France, the great centers of musical composition and performance in the later Middle Ages. Over time, though, these towns nurtured their own home-grown talent, so that by the fourteenth century, a city like Siena or Florence already had its own widely admired musical establishment. At the same time not all music that was performed in Europe's cities was liturgical in nature. Civic music—music that was intended to accompany the rituals of government such as the reading of public announcements and proclamations—the processions of city officials and of visiting dignitaries, and important feast days were all major occasions for musical performances.

SOURCES

H. Chadwick, *Boethius: The Consolations of Music, Logic, Theology, and Philosophy* (Oxford, England: Oxford University Press, 1981).

Frank D'Accone, *The Civic Muse: Music and Musicians in Siena during the Middle Ages and the Renaissance* (Chicago: University of Chicago Press, 1997).

D. J. Grout and C. V. Palisca, *A History of Western Music.* 5th ed. (New York: Norton, 1996).

Ann Moyer and G. Reaney, *Musica Scientia: Musical Scholarship in the Italian Renaissance Guillaume de Machaut* (Ithaca, N.Y.: Cornell University Press; London, England: Oxford University Press, 1992).

C. V. Palisca: "Boethius in the Renaissance," in *Music Theory and its Sources.* Ed. A. Barbera (Notre Dame, Ind.: University of Notre Dame Press, 1990): 259–280.

RENAISSANCE INNOVATION

THE LATE MEDIEVAL INTERNATIONAL STYLE. Like late Gothic sculpture and painting throughout much of Europe, the surviving musical texts of the late fourteenth and early fifteenth centuries display the prominence of an "international style" that flourished over large expanses of Europe, particularly in France, Italy, and the Netherlands. This style was already making use of a number of innovations in musical composition, rhythm, and harmony that had been pioneered in fourteenth-century France, particularly in Paris at

mid-century, and somewhat later in Avignon, the capital of the papacy at the time. With the eventual return of the capital of the church to Rome in the early fifteenth century, Avignon faded as a center of musical innovation, and instead new centers of experimentation began to emerge in other places. For inspiration, composers began to turn to the music of England, an island that had been relatively isolated from many continental musical traditions during the Middle Ages. This isolation had caused English composers to follow a slightly different course from the courtly, chivalric styles and rigid plainsong melodies that had flourished in France or those favored by the civic musicians of Italy. The Mass in use in much of later medieval England—known as the Sarum Rite after its origins in Salisbury Cathedral—made use of melodies and scales in its chants that differed from those favored in continental Europe. Generally, English musicians used major keys rather than the varied and often minor-sounding modal scales that were employed on the Continent. The polyphony that developed from such a tradition, too, was different from the French and French-influenced sacred music popular in much of Europe during the fourteenth century. In most of continental Europe, for example, intervals of the fourth, the fifth, and the octave had long been favored as the most perfect harmonies. The third and the sixth—while they had begun to make inroads throughout the Continent at this time—were sometimes controversial. Much medieval musical theory taught that the harmonic relationship between these two intervals was too close and consequently dissonant. To modern Western ears, however, both the third and the sixth have long been heard as the most perfect or consonant of intervals, the very basis upon which much harmony rests. It is sometimes difficult for modern listeners to imagine a time when these intervals were heard as dissonances, but they were only gradually accepted in the fifteenth century, prompted largely by English examples. It is for this reason that scholars have often identified the reception of these harmonies as "consonant" as one of the first markers of the birth of a true Renaissance style.

DUNSTAPLE. One of the key figures in popularizing the new harmonies and in pioneering new settings of the Mass and sacred music generally was John Dunstaple (1390–1453), the greatest fifteenth-century English composer. Dunstaple was a member of the household of the Duke of Bedford, a powerful commander in the English army of the time. England's engagement in the Hundred Years' War against France resulted in military victories that gave Bedford practical control over a large portion of French territory in the

Hans Memling's *Virgin and Child with Two Angels Playing Music.* © ARTE & IMMAGINI SRL/CORBIS.

1420s. Dunstaple may have spent the years between 1422 and 1435 living in France in Bedford's household, although the evidence for this French residency is slight. His works, however, must have had many admirers on the Continent since they exist in many manuscript collections throughout Europe. Seventy of his compositions survive, demonstrating his taste for the full sound and major tonalities favored by English composers of the late fourteenth and fifteenth centuries. In addition, he made frequent use of thirds and sixths in his work, helping to popularize their use by later composers in France and Burgundy especially. Like the French medieval composer Guillaume de Machaut (c. 1300–1377) before him, Dunstaple also set the Mass in choral music. These settings were, like Machaut's earlier French example, artistically unified, but in a new, bold way. Dunstaple constructed many of the individual parts of his masses on pre-existing church melodies, but he granted to these settings a new lyricism as well as the harmonies of English music of the time. Dunstaple also wrote numerous carols, a type of song structure that was distinctly English, yet similar to the French songs known as rondeaux and the Italian form of the rondeau, the ballate. The

carol had its origins, like these continental forms, as accompaniments for dances and made use of contrasting stanzas set against choral refrains. By Dunstaple's time, however, composers increasingly used the genre to set religious poems to music. In writing carols, English composers like Dunstaple gave primacy to their texts, which they set from poems written in Latin, English, or sometimes in a lively mix of the two languages. Most carols had two- or three-part harmonies with colorful texts, and while these songs were not truly "folk music," they did have a popular and distinctively English flavor.

BURGUNDY. No other place in fifteenth-century Europe surpassed the musical achievements and innovations of Burgundy. Although the heartland of this powerful duchy lay within France and was officially subject to the French king, the dukes of Burgundy had by 1400 surpassed him in the wealth and splendor of their court, particularly as France became mired in the Hundred Years' War. To their homelands in eastern France, the dukes had added through skillful marital alliances the rich Low Countries of Europe (that is modern Belgium, Holland, and Luxembourg), a large portion of northeastern France, as well as the province of Lorraine. In the early fifteenth century they maintained their capital at Dijon, but Burgundy's dukes began to spend more time in their northern possessions, particularly in Flanders or modern Belgium, than in the original seat of their power. The Burgundian territories that they ruled were diverse in language and culture, and so each year the court spent a great deal of its time traveling through these various lands. This annual progress bred sophistication in Burgundian standards of musical performance, as accomplished musicians flocked to this court from throughout the dukes' possessions to receive patronage. Through their travels, too, the dukes learned of musical forms and innovations in the far corners of their vast lands. Thus the rise of Burgundian power was a force that aided further developments in an International Style in music throughout the Continent, as rulers elsewhere imitated the tastes of the rich Burgundian court. Rising to prominence around 1400, the Burgundian court became an important center of art, culture, and music under Duke Philip the Good (1419–1467). Philip, an enthusiastic supporter of church music, retained a large choir and the most elaborate armory of musical resources in Europe. Beyond his ranks of singers, Philip also employed trumpeters, bagpipers, drummers, organists, and a vast array of other instrumentalists. The attention he showered on music was surpassed by his successor Charles the Bold, whose rule began in 1467. He was to be the last of the Burgundian dukes, however, as the duchy of Burgundy reverted to France and the northern possessions in the Low Countries came under the control of the Habsburg dynasty upon his death in 1477.

DUFAY. During Burgundy's heyday, a number of composers of distinction flourished. Generally, those favored at the Burgundian court made use of the new inspirations from the composer John Dunstaple and other English figures to enliven their musical traditions. Among the most accomplished of these figures was Guillaume Dufay, a figure of the first importance in fashioning a distinctively new musical style. Dufay was born near Brussels around 1397, and became a choirboy at the Cathedral of Cambrai, an important bishopric within the Burgundian lands. As he reached maturity, he traveled to Italy, where he found employment at first in the household of the powerful Malatesta family before serving for a time in the papal choir at Rome. In 1432 Dufay left Rome to serve the duke of Savoy on the northwestern frontier of Italy. Thereafter, he lived in his native Cambrai until his death in 1474, except for a brief four-year return to Savoy in the 1450s. Dufay is often associated with the Burgundian style and its innovations in music, but he was truly an international figure, as at home in the world of Italy and Savoy as he was in his native Cambrai. He was also highly educated, an unusual status for a musician by the standards of the time. He had received a degree in canon law from the prestigious University of Bologna, and his education allowed him to acquire a number of offices in the church. The works that Dufay composed while in Cambrai proved to be particularly fruitful in inspiring other composers, including Gilles Binchois (1400–1460), the second great Burgundian composer at the time. Dufay's output included a number of masses, motets, and secular songs or chansons, while Binchois was notable, in particular, for the quality of his chansons.

THE MASS. Although the duchy of Burgundy disappeared as a political force following the death of Charles the Bold in 1477, its musical styles survived into the late fifteenth and early sixteenth centuries throughout much of Europe. The Burgundian chanson (song) style developed by Binchois and Dufay relied on free flowing melodies, frequent use of triple meter, and a gentle, sometimes melancholic sound. These features of the style survived to be deployed in many of the masses which composers in the former Burgundian lands and elsewhere in Europe wrote at the time. Before the early fifteenth century there had been relatively few attempts to craft a single unified musical service around the ordinary parts of the Mass, that is, those sections of the Mass that were unchanging and occurred in every celebration

MUSICAL
Forms

The forms in which Renaissance composers wrote their music differed greatly from those of the modern world. The most popular musical genres are summarized below.

Allemande: From a French word meaning "German." The term was given to a popular dance of the sixteenth century that was written in double meter and believed to be German in origin. Allemandes survived in dance suites, and were even used in the early symphonies of the eighteenth century.

Caccia: From the Italian for "hunt" or "chase." A popular Italian song of the fourteenth century in which two vocal parts appear to be chasing one another.

Canon: Meaning "rule" or "law," a canon was a musical form in which composers originally wrote out a musical theme and then devised a series of rules by which the other voices in a choir were to sing the theme in polyphonic patterns. Canons became increasingly complex in the late fifteenth century and came to include counter themes. As a result of their rising difficulty, all the parts of a canon came to be written down. Canons played a major role in the development of the art of counterpoint, the combination of polyphonic lines into a single artistic unity.

Carol: Originally, a song that was used to accompany ring and line dances. During the Renaissance, English composers embraced the carol and made it into a distinctly native style that played the same role in English music as the chansons did in France or the Lied in Germany.

Chanson: One of the longest lived native song styles in French-speaking Europe. Their popularity spread to almost every corner of Renaissance Europe, and under the influence of the period's foremost composers the form often became a remarkably complex art song that was performed in court and cultivated urban societies.

Chorale: A hymn form originally embraced by Martin Luther and other early Protestant reformers in Germany. Chorales were originally performed in unison. Quite quickly, though, rich harmonies were created around these hymns' melodies, which were usually carried in the uppermost vocal part. The chorale inspired the greatest sacred music of the German Reformation and survived into the age of Bach to be transformed into a high musical art form.

Frottola: A verse song much performed and published in Italy in the sixteenth century. The melody was usually carried in the top voice with three parts harmonized below. In performance, all four parts could be sung, or the lower three harmonies could be played by a small ensemble as an accompaniment to a solo performer.

Lied: German for "song." The earliest Lieder that survive from Renaissance Germany date from the fifteenth century, and show that this form was then written either as a simple single-line or homophonic song or that it was set in three-part harmony.

Madrigal: Originally a popular medieval Italian song that contained a refrain (known as a *ritornello*), the madrigal was embraced by and transformed into a high art form. Madrigals became an important form of vocal chamber music and were written in four, five, six, and even more parts. Italian madrigal composers like Gesualdo and Monteverdi set to music some of the finest Italian poetry of the period.

Mass: From the fourteenth century European composers began to compose masses that set to music the unchanging parts of this religious ritual's texts (the Kyrie, Gloria, Credo, Sanctus, and so forth). By the fifteenth century the writing of masses provided an important opportunity for a composer to demonstrate his skill in linking the work's various parts together into a single artistic unity.

Motet: Originally a musical form that was performed outside the rituals of the Mass or the Offices of the church, but which usually, but not always, made use of sacred texts. The first motets had contrasting vocal lines and texts given to various voices in a choir. These lines were sung simultaneously, and thus the motet played a key role in the development of polyphony. The motet is one of the longest-lived choral forms in European history, with its origins stretching back to the High Middle Ages.

Plainsong: Also known as plainchant or Gregorian chant. By the time of the Renaissance this form of unison or chant singing already had a history that was more than a thousand years long. Plainsongs were not composed in keys like modern music, but within a system of eight modes, some of which sounded similar to modern major and minor keys, and others of which had completely different characters.

Rondeau: A lively French song with contrasting themes that was used to accompany dances.

Virelais: A popular French song of the fourteenth and fifteenth centuries that was preceded and followed by a refrain.

of the ritual. In the fifteenth century, though, such attempts soon grew common. To give their works artistic unity, composers often relied on older plainsong melodies, sometimes using a different plainsong in each of the separate movements they wrote, a practice that has sometimes been called "plainsong mass." The custom also developed of choosing a musical motif from one plainsong and building it into each of the five movements of the Mass, a development that has often been referred to as the *motto mass*. Another fifteenth-century development was the appearance of the *cantus firmus* Mass, in which a single melody, often adapted from a secular song, appeared at the beginning of each movement in the tenor voice. *Cantus firmus* masses had first been written in England in the early fifteenth century, but after 1450, they became the customary way to set the Mass to music. Among the most beautifully integrated masses of this time were those of Dufay, who drew upon his own musical ballads to craft artistically integrated and aesthetically pleasing sacred music for the service. In the sixteenth century the fashion for *cantus firmus* masses soon evolved into the Imitation Mass. In this form even popular songs were inserted into the various movements of a Mass, and the polyphony imitated the source of inspiration, often in a highly original way. Such ingenuous works fascinated many sixteenth-century composers, and the form, in fact, soon became dominant throughout Europe at mid-century. Yet the fondness that imitation masses expressed for secular music was criticized by the Council of Trent (1545–1563), the church council that met to consider ways of reforming Catholicism in the wake of the Protestant Reformation.

OCKEGHEM. Another standout among the many competent composers of the fifteenth century was Johannes Ockeghem (c. 1420–1497). Ockeghem was born in the French-speaking province of Hainaut, at the time part of the duchy of Burgundy. He began his career apparently as a member of the Cathedral choir at Antwerp, but soon entered into service in the household of Charles I, duke of Bourbon in France. In 1452, he became a member of the royal chapel of the king of France, and during the remainder of his long life he served three French kings. By the time of his death he was celebrated in verse and song as one of the founders of a new musical style, and he has long been revered, together with Guillaume Dufay and Josquin des Prez, as an important developer of a distinctive Renaissance style. Unlike Dufay and des Prez, however, his surviving body of works is somewhat small, consisting of ten motets, thirteen settings of the Mass, and twenty chansons. In contrast to Dufay, who preferred to set his chansons using two and

three voices, Ockeghem most frequently used four separate vocal parts. The lines of his works are longer and are often complex. One of the most distinctive features of his style is his use of an expressive bass voice, a departure from previous compositions in which comparatively little importance had been granted to this part of the harmonic range. Ockeghem also extended the range of the bass voice downward four or five tones lower than had been common previously. The result was a harmonic texture with more gravity, but with a broader range of sound, and his emphasis on the lower sonorities opened up new possibilities for later composers. In his settings of the Mass, Ockeghem sometimes relied on a familiar, pre-established melody to serve as a *cantus firmus* throughout his setting. At other times he avoided the use of a cantus firmus and instead developed the individual movements of the Mass as a canon, a contrapuntal form in which successive vocal parts imitated the line that had been set out by the first voice. Ockeghem was a master of the canon, a style of composing that took its name from the Latin word for "rule" or "law." Up to this time composers had not usually written out all the various parts of their canons. Instead they often wrote down the first voice and then set out a set of rules or canons by which the other voices in the choir should follow or imitate the first voice. The voices were usually to proceed through principles of strict imitation. Ockeghem vastly extended these possibilities by writing canons in which the voices moved at different speeds while reproducing essentially the same vocal line. He also created double canons in which several vocal parts proceeded in canonical form, while several more wove independent lines around their harmonies. These innovations established Ockeghem as an early master of the art of counterpoint, making his compositions vital to later sixteenth-century students and masters who mined their intricacies for inspiration. At the same time the very complexities of his creations tended to make later composers assess his works as mere products of technical finesse. Recently, his compositions have been more adequately studied, however, and Ockeghem has been restored to his position as a master of expressive vocal lines as well as contrapuntal invention.

OBRECHT. As the life of Johannes Ockeghem illustrates, the musical innovations occurring within the duchy of Burgundy in the fifteenth century soon spread farther afield through the migrations of composers and musicians. Jacob Obrecht (1452–1505) was one important figure who developed compositions using the broader ranges of harmonies and new musical forms on the rise in Flanders and France. His surviving opus in-

cludes thirty masses and about an equal number of chansons. He also composed songs in Dutch and instrumental music, although comparatively little of this music has survived. Unlike Ockeghem, Obrecht usually relied on *cantus firmus* melodies to grant structure to most of his masses, adopting popular, well-known secular songs as well as Gregorian plainsong melodies to serve in this role. He opened up new imaginative vistas, though, in the use of *cantus firmus*. In some compositions, for instance, he repeated the borrowed theme at the outset of each movement of the Mass, as was customary at the time; at other times he relied on the first phrase of the melody in the mass's first movement, while using the second phrase in the next, the third in the following, and so on. Or in still other compositions he based his masses around two or three cantus firmus melodies simultaneously. Obrecht also wrote various movements of his mass settings in canon style, although his use of the form was not exact, with the various voices sometimes subtly altering the original melody that had been set out by the first voice. Obrecht's modulations and violations of received forms thus presented followers with new ways of envisioning vocal music. In his travels to Italy, moreover, he brought to that country a knowledge of the new styles and forms emerging in Northern Europe at the time.

JOSQUIN DES PREZ. Josquin des Prez, a composer born sometime around 1450 in northern France or within the Flemish province of Hainaut, ranks as the greatest musical genius of the later fifteenth and early sixteenth centuries. He gained recognition as a genius in his lifetime, and his reputation as the "father of musicians" survived long after his death. Even in the late sixteenth century commentators continued to compare his achievements to those of Michelangelo in the visual arts. As with the creations of Michelangelo, contemporaries found des Prez's compositions remarkably expressive, noting his ability to forge a complete union between music and the chosen text. Further comparisons between the two men include their ability to solve complex aesthetic problems in a way that seemed effortless, and their willful individuality coupled with occasional bouts of moodiness.

DES PREZ'S MUSIC. Josquin des Prez's surviving compositions include some eighteen masses, fifty motets, and about seventy chansons. His masses are masterful creations, although they are not ranked among his most innovative works. In these, Josquin des Prez usually relied on a cantus firmus melody to grant structure to his works, often choosing these themes from popular secular songs of the day. Sometimes he paraphrased these tunes, and in his most skillful creations he relied on all

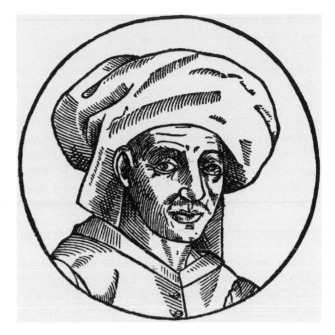

Josquin des Prez. © BETTMANN/CORBIS.

the voices that had appeared in the original chanson to create a free-flowing expansion of the original's themes. In this way his masses extended the boundaries of the *cantus firmus* mass, and were the origins for the imitation or parody masses that flourished in the later sixteenth- and early seventeenth-century Catholic Church. In these parody or imitation masses, composers sometimes used the initial theme quite explicitly and at other times they played with it extensively, constructing variations that disguised the theme's origins through elaboration and ornamentation. In this way Josquin des Prez helped to solve a central problem that revolved around setting the Mass to music: how to keep an audience captivated over a long period of time by using music to outline the various distinct parts of the Mass's ritual. While Josquin's masses are artistically notable, his motets are even more accomplished demonstrations of his skills as a composer. The Mass may have still been a major vehicle for demonstrating an artist's inventiveness at the time of his life. But his skill in the motet, and his far greater output in this genre, shows the increasing importance that non-liturgical music—music that was not to be performed within the Mass per se—was to have in the sixteenth century. The unchanging nature of the Mass's text gave a composer relatively little freedom to explore the relationship between words and music, since church tradition narrowly prescribed the acceptable text. In a motet, by contrast, a composer could set poems and other texts of greater variety to music since the motet was performed outside the regular structure of the Mass and thus did

not have to conform to the ritual's restrictions. Des Prez's work in the humanist-influenced courts of Italy caused him to focus on the imaginative possibilities that music offered for conveying literary meaning. To do this, he abandoned the involved, complex lines of the type of French and Flemish music exemplified by Ockeghem and his followers, and instead he tried to forge a union between the chosen words and notes so that the lines of the poems and other texts he set to music could be consumed as thoughts. The example that he left behind in his motets inspired several subsequent sixteenth-century composers of vocal music who relied on rhythm, harmony, pitch, and tonalities to suggest the meanings of their texts.

IMPORTANCE OF EARLY RENAISSANCE INNOVATIONS. During the course of the fifteenth century an international style of musical composition flourished throughout much of continental Europe. This style was at first enlivened by the examples of harmony and rhythm of English composition and later inspired by the complex lines and intricate counterpoint harmonies of the Burgundian composers. Harmonies of thirds and sixths in many musical compositions were relative innovations, and writers of masses and motets borrowed melodies for their works from the church's plainsong and the secular chansons. Through the influence of Johannes Ockeghem and others the harmonic possibilities of fifteenth-century music expanded to include a wider range of pitches and in many cases to subject the construction of harmony to the bass, rather than the tenor voice. In this process the once-dominant tenor voice began to fade in favor of a more equal construction of harmony between all the voices. In Ockeghem's work, in particular, the bass became the entire foundation upon which the upper harmonic relationships were created. In this way a more resonant sound began to flourish. While the Mass remained the primary vehicle through which composers demonstrated their imaginative finesse, the motet became increasingly important as a vehicle for expressing the complex meanings of texts. As the century drew to a close the genius of Josquin des Prez opened up a new flexibility for forging relationships between texts and the musical forms in which they were conveyed. During the sixteenth century composers were to build upon this new sophistication to create a distinctive Renaissance mixture of polyphony, harmony, and melodic exploitation.

SOURCES

H. M. Brown, *Music in the Renaissance* (Englewood Cliffs, N.J.: Prentice Hall, 1976).

D. J. Grout and C. V. Palisca, *A History of Western Music.* 5th ed. (New York: Norton, 1996).

Gustave Reese, ed., *The New Grove High Renaissance Masters: Josquin, Palestrina, Lassus, Byrd, Victoria* (New York: Norton, 1984).

E. Sparks, *Cantus Firmus in Mass and Motet, 1420–1520* (Berkeley, Calif.: University of California Press, 1963).

SIXTEENTH CENTURY ACHIEVEMENTS IN SECULAR MUSIC

HUMANISM. As the dawn of the sixteenth century approached, humanism's influence on music grew increasingly important. Humanism was a complex literary movement that had its origins in the works of fourteenth-century intellectuals like Francesco Petrarch and Giovanni Boccaccio. The term itself is a nineteenth-century creation crafted to describe those in the Renaissance who practiced the *studia humanitatis* ("humane studies"). Thus humanism, the source for modern notions of the humanities, was not a philosophy, but a curriculum. As such, it differed greatly from the scholastically influenced studies that were dominant in most European universities at the time. The university system based its curriculum on logic, Aristotelian natural philosophy, and theology. By contrast, the humanists championed training in rhetoric (graceful speaking and writing), history, moral philosophy, and the languages. These disciplines, they argued, were better suited to creating virtuous human beings than were the logic and reasoned argumentation favored by the scholastics in medieval universities. The works of the humanists who followed Petrarch and Boccaccio persistently recommended the cultivation of the language arts and the study of Antiquity, and humanism sponsored a revival of ancient culture and learning that has long been synonymous in many people's minds with the very idea of the Renaissance itself. Throughout most of the fourteenth and fifteenth centuries the primarily literary concerns of the humanists had little impact on music, but in the final decades of the fifteenth century the links between humanism and composition became more important. As the humanists studied a broader range of ancient texts throughout the fifteenth century, they learned of the importance that ancient philosophers had attached to music. The importation of many ancient Greek treatises on music into Italy from the ailing Byzantine Empire in the Eastern Mediterranean as well as forays into Western European monastic libraries aided their studies. By the end of the century most of the vast and variegated musical theory of Antiquity had been recovered and translated into Latin. Somewhat later, many of these texts were also to be translated into

Italian. From this vantage point, ancient theoretical and aesthetic works that treated music could be read and studied by a broader range of educated men, and even by a small minority of cultivated women. From their reading, both humanists and educated composers like Josquin des Prez came to learn that the ancients had prized music for its power to ennoble the human spirit, inspire poetry, and change the soul. In a more general sense, humanist culture's emphasis on rhetoric and language expressed a fondness for good poetry; thus its influence came to be felt upon music in a deepening attention to the texts that composers set to music. These trends can be seen in the works of Josquin des Prez, the figure that has long been attributed with developing a distinctively Renaissance musical idiom.

PRINCELY PATRONAGE. In the fifteenth century most humanists were only able to realize the ideal of the detached study of literature, history, and ancient philosophy through finding employment in Italy's burgeoning governments or through attracting the patronage of powerful princes and wealthy merchants. Similarly, as the taste for Antiquity flourished among elites, Italy's humanist-educated princes and wealthiest merchant, banking, and patrician families sought out the best composers and musicians to create works that expressed their love of the ancients and of the humanist creed of literary study. It was in Florence that a musical culture first began to flourish that made use of the philosophical insights drawn from the works of the ancients. During the 1470s and 1480s the city's wealthy merchants joined the backdoor manipulator of Florence's political life, Lorenzo de' Medici, in seeking out the best Flemish musicians of the day. Lorenzo was an avid supporter of the philosopher Marsilio Ficino (1433–1499), one of the most important scholars of the day who was actively engaged in the translation and study of Plato's entire body of work. Ficino himself was a musician and physician, and his studies of Plato frequently recommended music's power to influence the cosmos. From Ficino, humanists and musicians alike began to adopt Plato's notion of poetic inspiration to defend musical composition. This idea—that poets were seized with divine inspiration when they wrote—could also be applied to musicians and composers, even as it came to be used in the High Renaissance by painters and sculptors in a similar fashion to defend their arts. Modern scholars have sometimes credited Ficino with founding the discipline of musical therapy, an interest that derived from his interests as a musician and physician. The practice of musical therapy was often undertaken in the hospitals of the later Renaissance and was recommended in the philoso-

pher's works. Among the many other accomplished musicians that Lorenzo de' Medici invited to his court were Heinrich Isaac, Alexander Agricola, and Johannes Ghiselin. Medici patronage of the art was important, but almost every major court in late fifteenth-century Italy awarded employment to a sizable contingent of musicians and composers. At Ferrara, for example, the d'Este dukes patronized Jacob Obrecht, Antoine Brumel, and Adrian Willaert, among many others. In Rome, the papal household, as well as the many courts of the church's cardinals, maintained sizable contingents of musicians and composers. And in despotic Milan, the Sforza dukes stocked their chapel with 22 singers and their palace chamber choir with another eighteen. The composers among these ranks experimented with achieving the new Renaissance ideal of a music that stirred the emotions and purified the soul. Until 1550, those active in the great households and courts of Italy were predominantly from Northern Europe, and the taste for Franco-Flemish musical practices was strong. Still, Italians made inroads in these years, although the international character of the peninsula's musical life was constantly enriched and strengthened by the migrations of Europeans from beyond the Alps.

FROTTOLA. The emergence of a new, distinctly Italian genre of popular song in the second half of the fifteenth century points to this vitality. In the Renaissance the Italian term "frottola" had both a narrow and a broad meaning. In its broadest sense it came to be applied to any of a number of secular song types that were popular throughout the peninsula in the years between 1470 and 1530. This genre included a number of more specific song types, including odes, sonnets, capitoli, strambotti, and canzoni. In a narrow sense, the frottola also referred to a song that was written for four vocal parts with its melody usually placed in the uppermost voice. Underneath this melody, the other voices often provided an accompaniment of chords. Usually, frottola were written in 3/4 or 4/4 time. The origins of this form, which came to set much ancient and Renaissance lyric poetry to music, lay in the traditions of the early Italian Renaissance, when poetry had often been recited against a musical accompaniment. Over time, a tradition of extemporized singing of lyrics emerged, and became a popular form of entertainment, notably in the Medici household in Florence, but in a number of other courts throughout Italy as well. Lorenzo de' Medici greatly admired an artist's ability to extemporize vocally *ad lyram* ("on the lyre"), and many of Florence's humanists developed this skill. Among those that were particularly noted for the ability to perform such frottola were

a PRIMARY SOURCE document

THE COURTIER AND MUSIC

INTRODUCTION: In his *Book of the Courtier*, a conduct manual describing the arts necessary to succeed at court, the accomplished Italian writer Baldassare Castiglione singled out music for special consideration. The book was written as a dialogue, and in it, one character defends knowledge of music and skill in performance as befitting to those in refined society. He defends the art, moreover, from the charge that it is effeminate and stresses music's role in ancient philosophy, a defense that is distinctively Renaissance in nature.

And the count, beginning afresh:

"My lords," he said, "you must think I am not pleased with the Courtier if he be not also a musician, and besides his understanding and cunning upon the book, have skill in like manner on sundry instruments. For if we weigh it well, there is no ease of the labors and medicines of feeble minds to be found more honest and more praiseworthy in time of leisure than it. And principally in courts, where (beside the refreshing of vexations that music brings unto each man) many things are taken in hand to please women, whose tender and soft breasts are soon pierced with melody and filled with sweetness. There no marvel that in the old days and nowadays they have always been inclined to musicians, and counted this a most acceptable food of the mind."

"I believe music," [another] said, "together with many other vanities is appealing to women, and peradventure for some also that have the likeness of men, but not for them that be men indeed; who ought not with such delicacies to womanish their minds and bring themselves in that sort to dread death."

"Speak it not," answered the Count. "For I shall enter into a large sea of the praise of music and call to rehearsal how much it hath always been renowned among them of old and counted a holy matter; and how it hath been the opinion of most wise philosophers that the world is made of music, and the heavens in their moving make a melody, and our soul framed after the very same sort, and therefore lifts up itself and (as it were) revives the virtues and force of it with music. Wherefore it is written that Alexander was sometimes so fervently stirred with it that (in a manner) against his will he was forced to arise from banquets and run to weapon, afterward the musician changing the stroke and his manner of tune, pacified himself again and returned from weapon to banqueting. And I shall tell you that grave Socrates when he was well stricken in years learned to play upon the harp. And I remember I have understood that Plato and Aristotle will have a man that is well brought up, to be also a musician; and declare with infinite reasons the force of music to be very great purpose in us, and for many causes (that should be too long to rehearse) ought necessarily to be learned from a man's childhood, not only for the superficial melody that is heard, but to be sufficient to bring into us a new habit that is good and a custom inclining to virtue, which makes the mind more apt to the conceiving of felicity, even as bodily exercise makes the body more lusty ..."

SOURCE: Baldassare Castiglione, *The Book of the Courtier*, Trans. Thomas Hoby (London, 1561), in *Source Readings in Music Theory: The Renaissance*. Ed. Oliver Strunk (New York, W. W. Norton, 1965): 91–92. Text modernized by Philip M. Soergel.

Raffaele Brandolini (1465–1517), a native Florentine who spent much of his life as a scholar in Rome, and who wrote an important treatise entitled *On Music and Poetry*. Two other performers of merit were Baccio Ugolini and Serafino dall'Aquila, but the custom for extemporizing songs was so popular that even Lorenzo de' Medici himself sometimes performed this way. By 1500, Mantua had become the most brilliant center of frottola performance; the city's duchess, Isabella d'Este (1474–1539) supported this popular song form by seeking out the best poetry from Italian authors, and then turning it over to musicians to be set to music. These departures from the genre's extemporaneous roots have provided music historians with manuscripts and printed editions of the works her composers wrote, an invaluable source for reconstructing the popular song trends of the age. In contrast to the many musical genres of the period that were heavily influenced by Franco-Flemish styles, the *frottola* style was a native art form, with its poetry and music written by Italians. Nurtured by Isabella d'Este and in a number of Italian cities, the form was a significant source of inspiration for Italian musical creativity in the sixteenth century.

IMPROVISATIONAL VERSUS WRITTEN MUSIC. The vigorous musical culture that flourished at the time created an almost insatiable demand for compositions that might be presented at the many ceremonial occasions, festivities, and court entertainments at which music was demanded. Most musicians were schooled in the techniques of musical improvisation, although the degree to which they relied on these skills depended upon the type of music that was being performed. Italian song tradi-

a PRIMARY SOURCE document

THE SOUND OF MUSIC

INTRODUCTION: The Renaissance humanist Raffaele Brandolini wrote one of the first serious treatises about musical performance. In his *On Music and Poetry* (1513) he argued that music and poetry were disciplines that arose from the same creative impulse, an argument that supported music's claim to a high status among the arts, rather than in its traditional place as one of the sciences. Brandolini's statements were typical of many discussions about the relative merits of specific arts at the time, and his ideas came to have an impact in raising the importance accorded to music by the thinkers that followed him.

If you rebuke music, which nature herself instituted with the first elements of the world for lightening labors, for calming and stimulating affections, and for expressing happiness and enjoyment, I do not plainly see what liberal art you would find very worthy of praise. Or do you not accept the great literary tradition that the world is composed of musical ratio? For Pythagoras, studying with divine diligence the rhythms, modes, and inflections of the various pitches from the blows of hammers, established this ratio according to the model of heaven. His school of thought presented this opinion as transmitted from ancient times; and, not satisfied with merely the concord of dissimilars which they call harmony, that school also attributed its varied symphony to the diverse motions of the heavenly spheres. But we will leave these matters, all too obscure as they are, to be debated by natural philosophers; let us now lay out carefully those which are both easy to see and consistent with the qualities of popular knowledge.

What is it that urges oarsmen, laborers in the field, and artisans in the city to persevere in their work as much as does song? Nor does it encourage only those labors where many strive together, led by some pleasant voice; the fatigue of individuals is also assuaged by any simple song. For while some fight back savage tempests and gusts of wind with all their strength of body and soul, while others eagerly wield their hoes, mattocks, and axes to cultivate a field in good time, and while still others exert themselves in various and complex works for human benefit, they render labor lighter by means of song. In the camp, workers and soldiers too soften their labors day and night with the beauty of song, while they build palisades, dig trenches, and raise bulwarks, and keep their watches or vigils. There is no need to confirm all this with examples, since it is accepted in constant and everyday practice.

By the sound of music, moreover, an army itself is armed, drawn into formation, and led headlong against the enemy, as is shown by the experience and efforts of many kings and nations. The Lacedaemonians, not the least among Greek warriors, are remembered for their use of the music of the tibia when they joined in hand-to-hand combat—not, in brief, as a religious rite or for the sake of worship, but in order to moderate and modulate their souls. The Cretans, as tradition has it, were accustomed to go into battle with the cithara sounding beforehand, setting the pace of their march. The Amazons, excelling beyond their female sex in battle skill, were accustomed to wield arms to the sound of the reed-pipe, the Sybarites to the tibia ... Indeed many others everywhere, though especially the Romans, have done so, as they were roused up for battle by the sounding of the horn and the clarion. For the louder it was than all others, the more the glory of Rome surpassed the others in warfare.

SOURCE: Raffaele Brandolini, *On Music and Poetry*. Trans. Ann E. Moyer (Tempe, Ariz.: Arizona Center for Medieval and Renaissance Studies, 2001): 13, 15.

tions, in particular, had long had a vigorously creative and sophisticated set of improvisational and extemporizing techniques, while other kinds of music—polyphonic motets and settings of the Mass—were often more thoroughly composed or written down. In Italy, entire evenings of entertainment were sometimes constructed from extemporaneous song. But the most complex polyphonic music of the period, performed in church on solemn occasions or as part of civic festivities, required more disciplined performance practices and written music, since these compositions made use of many different and contrasting lines of counterpoint. They could not, in other words, be executed unless performers paid strict attention to written music. In addition, the increasing numbers of musical manuscripts that survive from the period reveal an emerging demand for music that might be readily replayed or sung time and again. The circulation of these manuscripts beyond the point at which they had first been written down and their extensive recopying in subsequent editions reveals as well the emergence of a sophisticated culture of musical consumption.

PRINTING. With the invention of the printing press, new technology afforded musicians and composers a process that might make the hand copying of music less laborious. The first printed musical edition

appeared in Venice in 1501, when Ottaviano Petrucci released a collection of 96 chansons, mostly written in French. While printed editions of music were cheaper than those compiled and copied by scribes in hand-written manuscripts, they were still enormously expensive by sixteenth-century standards and only available to the wealthy, cultivated few. To print his early musical editions, Petrucci had to process each page three separate times. First he had to print the staff lines on the page, then he printed the words that flowed under the lines, and the notes were added in the final impression. In 1520, Pierre Attaignant simplified the process when he developed a way to print music through a single impression in Paris; the new process quickly spread to Italy, Germany, and the Netherlands. By mid-century, Europe's primary centers of music publication included Rome, Venice, Antwerp, Paris, and Nuremberg. The rise of these centers greatly increased the flow of knowledge about recent musical developments. By the late sixteenth century, for example, printed music traveled from Rome or Venice to the farthest corners of the European continent in a matter of months, and printing became a way for composers to establish their reputations on a European-wide scale. Figures like Orlando di Lasso and Giovanni da Palestrina enjoyed widespread renown throughout the continent by virtue of the printed editions of their works. Printed music, too, allowed new compositions to be played in many places quickly. Thus the press could play a role in establishing musical tastes. Orlando di Lasso, for example, was among the first composers whose printed music helped to establish certain common tastes throughout Europe rather quickly. At the same time the importance of printed editions of music should not be overemphasized. They were still an expensive rarity when compared to the vast amount of music that circulated in hand-copied editions. Much Renaissance music, moreover, continued to be improvised from pre-existing melodies, chansons, and other musical forms, or as in the tradition of the frottola, it was often by its very nature designed to be an extemporaneous exercise. Although many songs of this sort were not written down, such singing was often governed and judged according to complex conventions and rules.

NATIONAL STYLES. During the late fifteenth and early sixteenth centuries French and Netherlandish composers and musicians practiced in many of the most important courts and religious institutions of Europe. By 1500, their dominance in Italy was particularly great. At the same time, all European regions had long had their own native musical cultures and idioms distinct from those of the Franco-Flemish composers who held the continent's most important musical posts. These national styles gained a higher profile in the sixteenth century, in part due to the increase of published manuscript editions. Not long after he released his first edition of mostly French chansons, for instance, the Venetian printer Petrucci devoted his attention to printing eleven vast collections of frottole. His editions helped in spreading the popularity of this style of performance, particularly at court, where the frottole could be played and sung by performers with vast differences in ability levels. Both hired players and amateurs could join in their performance. Their simplicity, too, meant that they were open to free extemporizing on the one hand, or that they might be accompanied only by a lute on the other. The growth of musical styles like the frottola gradually undermined the dominance of French and Flemish composers and musicians in Italy, as did the training of Italians at the hands of northerners like Adrian Willaert, the organist and music director of the Cathedral of St. Mark's in Venice, the most important musical post in Italy. In turn, the printing of these native songs and dances and their circulation throughout Europe eventually expanded the musical language of all countries as well.

MADRIGALS. The most important genre of secular music to flourish in Italy during the sixteenth century was the madrigal, a form that eventually became popular in many countries throughout Europe and which established Italy as the undisputed musical center of the later sixteenth century. The Renaissance madrigal was a musical setting of a short poem that bore little resemblance to the earlier madrigals that had flourished in thirteenth- and fourteenth-century Italy. In the earlier period madrigals had been performed with verses that alternated with refrains. In keeping with the new influence that humanism exerted on sixteenth-century Italian taste, however, the later madrigal gave primacy to the text. It was a thoroughly composed form of music, with none of the connections to the popular and folk forms that had originally inspired the medieval style. Writers of madrigals chose to set poems that were written by the foremost poets of the age, and they expressed a preference above all for the fourteenth-century sonnets of Francesco Petrarch (1304–1374). During the time that the madrigal appeared, disputes were common among poets and literary critics concerning the direction literary Italian should take. The preference for Petrarch evidenced in the early madrigal writers, in particular, fit neatly with the aims of Pietro Bembo, one of Italy's most important arbiters of aesthetic taste and

an important author. He argued that Petrarch's Italian was particularly musical in nature. Among the qualities that Bembo identified in Petrarch were rhythm, melody, dignity, sweetness, and magnificence, and he recommended the author's poetry to composers as particularly fitting for music. From the earliest development of the madrigal, then, Petrarch's creations played a central role in the musical genre, inspiring Adrian Willaert and other early writers in the genre to adapt styles in their compositions that mirrored the music of Petrarch and other major Italians' verse. In their remarkable settings these composers labored to fit their music to the moods and sounds of the poetry, crafting musical imagery that was harsh and grave or light and sweet as the text demanded. Besides Petrarch, some of the poets whose works were most frequently set in madrigals were Lodovico Ariosto, Pietro Bembo, Jacopo Sannazaro, and Torquato Tasso. While comic and satirical madrigals certainly appeared during the great Italian outpouring of madrigal writing that occurred between 1530 and 1600, most madrigals dealt with serious themes of love and eroticism. Many drew upon the popularity of pastoral poetry as well. The enormous fondness of the Italian elite for madrigals at the time cannot be disputed. More than 2,000 printed editions of these works survive from the sixteenth century alone, and the form remained one of the most popular in secular music well into the seventeenth century. Originally written for four voices, most madrigals after 1550 had five voices, and somewhat later, works written for six or more voices appeared. Composers intended each written part to be sung by only one voice, and thus the madrigal played a role in cultivated Italian circles as an early form of chamber music. The genre's appearance and rapid development thus point to a sophisticated, although mostly amateur, culture of musical consumption. Madrigals, in other words, were performed within Italian court circles by courtiers who were relatively well educated in reading and executing musical scores.

GESUALDO AND MONTEVERDI. The two greatest composers of madrigals were Carlo Gesualdo (c. 1561–1613) and Claudio Monteverdi (1567–1643). Gesualdo was an Italian nobleman, notorious for having murdered his wife and her lover in 1586 after he caught them in the act of adultery. He outlasted the scandal, however, and in 1593 married the prominent Leonora d'Este, niece of the powerful ruler of the duchy of Ferrara. Like other composers of the later sixteenth century in Italy, Gesualdo employed chromatic scales and harmonies in his work, a fashion at the time that was prompted through the study of Greek musical trea-

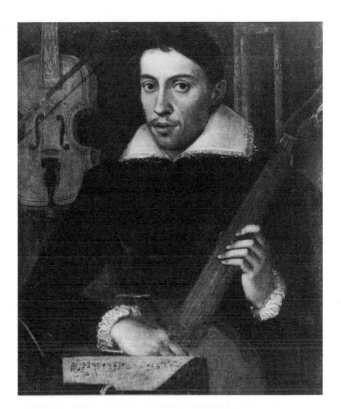

Claudio Monteverdi. © BETTMANN/CORBIS.

tises. While the fad for chromaticism was considerable in Italy at the time, Gesualdo relied on it as more than a mere imitation of ancient style. In his beautiful madrigal settings, he employed chromatic melodies together with root chords that were a third apart. The result produced music that was frequently a touching response to his emotion-laden texts. By contrast, the late Renaissance composer Claudio Monteverdi was a master not only of madrigal composition but a pioneer in the writing of opera and a composer of sacred works as well. Born in Cremona, he served the Duke of Mantua, eventually attaining the rank of music master in his chapel. In the last thirty years of his life he gained prominence as the choirmaster at St. Mark's Cathedral in Venice. In 1587, Monteverdi began to publish his madrigals, and by 1605 he had produced five printed collections. His settings mixed contrapuntal and homophonic sections, and he freely employed the chromatic scales and dissonant harmonies that had grown popular in response to Greek theory. His settings were lively and sensitive responses to the texts he chose. In addition, his works were innovative and point to some of the trends that developed as important features of seventeenth-century Baroque music. Monteverdi, for instance, relied on the recitative style in many of his madrigals, allowing the voices to declaim certain important parts of the

poetic text. The composer also wrote embellishments into his scores rather than allow performers to improvise these freely as was the sixteenth-century custom. Through their wide circulation in printed editions Monteverdi's madrigals had an enormous influence on the development of musical tastes and fashions, not only in Italy, but throughout Europe.

CHANSONS. The madrigal, a courtly and elite form of musical entertainment, was prized by the musically sophisticated circles that had sprouted in Italy during the sixteenth century. Elsewhere in Europe, native styles of song and choral music underwent a similar development. In France the chanson, a native medieval genre, had become one element of the international European musical landscape by 1500. During the first half of the sixteenth century the chanson reacquired many native French elements, and in the vicinity of Paris, in particular, a style of chanson composition, frequently referred to as "Parisian chanson," emerged. The new form made use of distinctive French poetry, and was encouraged by the chivalric tone of Francis I's court. Another spur to the popularity of the Parisian chanson lay in the publication efforts of Pierre Attaingnant, who published some fifty books of chansons in the years between 1528 and 1552. Attaingnant was an innovator who perfected the process of single-impression musical printing, thus greatly reducing the cost and effort needed to print music. His chanson collections included more than 1,500 musical creations, and other French printers soon imitated their success. The earliest printed chansons were similar in many respects to the frottole popular in Italy around the same time. They were light confections that moved quickly and rhythmically, scored for four voices with the highest voice most often carrying the melody. Somewhat later, hundreds of the most popular of these songs were transcribed for the lute or for the voice with lute accompaniment. Among the most popular compositions Attaingnant published were the songs of Clément Janequin (c. 1585–c. 1560). Janequin's chansons made use of sounds that imitated the birds, calls to the hunt, battle cries, and street noises, and they had a dominant melodic line. Outside Paris, printers in sixteenth-century Lyons and Antwerp continued to publish chansons that were true to the genre's original polyphonic origins. And after 1550, French fascination with the polyphonic madrigal exerted an influence on the traditional chansons. At this time some composers experimented with inserting madrigal elements into the production of their chansons, including the madrigals' polyphonic and contrapuntal texture. As the seventeenth century approached, though, the homophonic Parisian style of chanson tended to dominate throughout France.

MUSIQUE MESURÉE À L'ANTIQUE. Another sign of the creative ferment that the alliance between Renaissance and humanism was producing throughout Europe lies in the development of the *musique mesurée à l'antique*. This French form developed in the second half of the sixteenth century in a series of experiments undertaken by members of the Pléiade, a group of poets concerned with applying the metrical lines of ancient Greek and Latin poetry to the writing of sixteenth-century French verse. Underlying the concerns of the members of the Pléiade—most notably Jean-Antoine de Baïf—was the notion that music and poetry should be reunited, as he and others believed they had been in the ancient world. De Baïf soon enlisted a number of musical colleagues to achieve this reunification of the two arts. The composers that participated in this effort to set French texts, based on classical metrical models, to music included Thibault de Courville, Guillaume Costeley, and, perhaps most importantly, Claude Le Jeune. Just as in the spoken performance of these poems, musique mesurée à l'antique proceeded through a combination of long and short sounds, intended to heighten the difference between the accented and unaccented syllables that were fundamental to the endeavor of creating French lyrics based on classical models. The result produced an austere, somewhat severe style of music, but one that fascinated French humanist intellectuals and many educated musicians and composers during the 1570s. In developing musique mesurée à l'antique, de Baïf worked in tandem with Thibault de Courville to set out a theory for the new music, and in 1570 enough interest in the project had developed to found the Académie de Poésie et de Musique, an institution that soon received a royal charter. Like many humanist-inspired experiments in music, the Académie de Poésie et de Musique had a philosophical agenda: to revive the power of music to achieve ethical virtua, a power that humanists believed had existed in Antiquity, but had long since been corrupted. Through concerts, de Baïf and other members of the Académie hoped to spread their new art form among a small cadre of intellectuals and members of Paris' political elites, who might then work for the reform of all music in France along the lines advocated by the Académie. Thus membership in the organization included both professional musicians and a second category of listeners, who were learned and often wealthy musical fans. This second group of members were expected to support the institution financially,

in large part by paying expensive yearly fees for admission to its concerts. Despite such grand intentions the Académie was not a success, but points rather to the perennial appeal that the revival of classical musical forms had on the musical figures of the later Renaissance.

LIEDER. The *Lied*, a distinctively German song form, experienced a development similar to the madrigal in Italy and the chanson in France. The earliest collections of *Lieder* survive from the mid-fifteenth century, and show that these songs were performed either as simple monophonic melodies or they were set in three voices with the tenor singing the melody. Like the madrigal and chansons, the singing of Lieder flourished and developed in tandem with courtly musical life. One of the most accomplished sixteenth-century composers of these songs was Paul Hofhaimer (1459–1537), who served as organist to the Emperor Maximilian I (r. 1489–1519). Hofhaimer relied on traditional German melodies that he set in harmony according to the contrapuntal techniques popularized by the French and Flemish composers of the day. Through the efforts of composers like Ludwig Senfl, too, the Lied became a highly artful genre that was similar in many ways to the complex choral motets sung throughout Northern Europe at the time. At the same time Senfl and others composed shorter Lieder that imitated folk melodies and which often had a bawdy quality. With the rise of music printing in the first half of the sixteenth century, the wealthy city of Nuremberg became Germany's primary center of Lieder publication, and many collections of the songs issued from the city. Later in the century, however, Lieder publication fell off in Germany as the taste for the more complex Italian madrigal grew. The melodies that had been popularized in the earlier printed Lieder collections, however, formed the basis upon which many late sixteenth- and seventeenth-century composers constructed Protestant chorales, hymns that were sung in Germany's newly reformed Lutheran churches.

MADRIGALS AND SONGS IN ENGLAND. The printing and performance of secular songs written in parts developed in England somewhat later than in the rest of Europe, and was intricately connected to the Italian madrigal's rising popularity in the late sixteenth century. Nicholas Yonge's 1588 *Transalpine Music* (*Musica transalpina*) represents the first collection of madrigals published in England. Yonge merely translated and adapted these works from Italian models, and in his preface he explained that he had been meeting regularly with a group of gentlemen to perform these works. His anthology became popular, and by the 1590s it inspired a

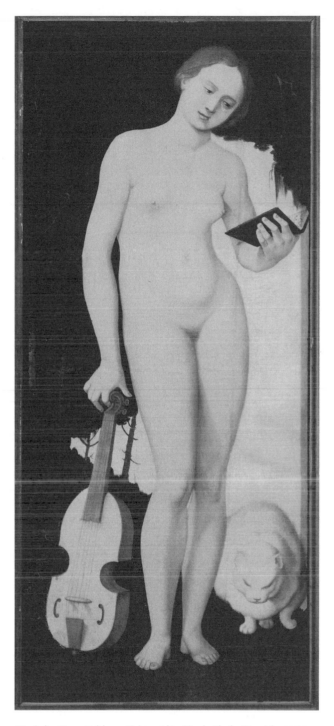

Music by Hans Baldung Grien, Alte Pinakothek, Munich. ART RESOURCE.

number of composers to produce their own madrigals. Among the most prolific of these English madrigal composers were Thomas Morley (1557–1602) and John Wilbye (1574–1638). Great variety characterized the many English madrigals that were written between the 1590s and the 1630s. Generally, though, their musical

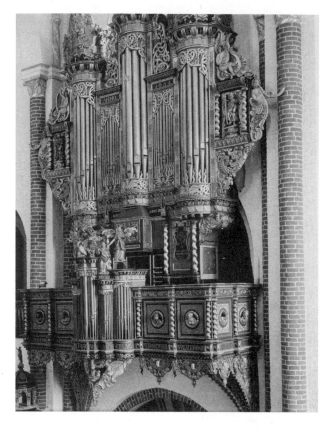

Sixteenth-century organ, designed by Hermann Raphael Rottensten-Pock, Roskilde Cathedral, Denmark. © ARCHIVO ICONOGRAFICO, S.A./CORBIS.

phrases were longer than those that originated in Italy at the same time. And while Italian composers granted primacy to the setting of the texts, English composers tended to pay greater attention to the overall musical and aesthetic structures of their works. As the sixteenth century drew to a close in England, collections of lute songs became popular, too. In these solo songs with lute accompaniment composers set to music some of the best English poetry of the period, and the literary quality of these works is usually consistently better than the texts used at about the same time for madrigals. The two most prominent composers of lute songs were John Dowland (1562–1626) and Thomas Campion (1567–1620). Dowland's "Flow, my tears" was among the most successful and well known of the lute songs. Published in 1600, it inspired a number of variations and arrangements.

INSTRUMENTAL MUSIC. Music intended to be played only by instruments had long existed in Europe as accompaniment to dances, or as incidental pieces at courtly banquets and other entertainments. Because most of this music was improvised or played from memory, very little instrumental music had ever been written down be-

fore the later fifteenth century; the surviving manuscripts and sixteenth-century printed editions we possess record only a small portion of Renaissance instrumental music. These written works, too, are rarely reliable guides to the actual performance of the pieces since, until very late, written music did not stipulate the embellishments that performers should include. Performers made these enhancements to the written text according to certain commonly accepted conventions, and at the same time they often freely improvised on the text's theme. The increasing number of musical instructional books common in Renaissance Europe points to the growing importance Europeans attached to the proper performance of instrumental music. Many of these books taught their readers how to embellish a musical line as well as how to tune their instruments. The first of such works, Sebastian Virdung's *A Summary of the Musical Sciences in German,* appeared in 1511. Many similar books followed that were of a practical nature and addressed both the professional and amateur musician. Consequently, they were written in the national languages rather than in the Latin preferred by writers of musical theory. The ensemble instruments preferred by the composers of sixteenth-century instrumental music were the viol, the harp, the flute, the shawm (an early double-reeded form of the oboe), the cornet, trumpet, and sackbut (an early version of the trombone). The keyboard instruments of the day consisted of the portable organ or organetto, the pipe organ (which by the sixteenth century had acquired the massive size and fixed position in churches similar to the modern instrument), the clavichord, and the harpsichord. The most popular domestic instrument in use throughout Europe was the lute, an instrument that by the sixteenth century already had more than five centuries of history. In Spain the lute resembled the modern guitar, while elsewhere it was shaped more like a pear.

PERFORMANCE PRACTICE. Despite the growth in forms of instrumental music, vocal music continued to be dominant in the written music of sixteenth-century Europe, and its importance influenced many instrumental performance practices. In accompanying the Mass or in the performance of other choral pieces, instruments typically served to double or substitute for voices in the choir. Instrumental and organ interludes were played between the various sections of the Mass or they were used as intermezzi within one of its sections. In addition, a number of musical forms developed that were based around vocal compositional models. In Italy, for instance, composers wrote pieces for ensembles and instruments that were termed *Canzone da sonar* ("songs

to be played"). At first, these pieces imitated the fast-moving chanson vocal style, with its strong rhythms and straightforward counterpoint based around a central theme. Over time, however, composers broke these works into sections and often employed different themes in each of the work's movements. The sixteenth century, too, saw a great elaboration in instrumental dance music, much of it written for the lute, the keyboard, or small ensembles. Most dance music at the time still tended to be improvised, but printers also released collections of dances. Written and printed forms of dance music grew more complex, and while many pieces retained the rhythms originally associated with a dance, they were not intended to accompany dancers, but to serve as diversions in well-heeled or aristocratic households. Over time, too, composers tended to group these stylized, diversionary dances into suites comprised of several different types of pieces in contrasting meters. In the dance suites slow movements usually alternated with faster ones. Fashions for dances changed greatly over time. Around 1550, the most popular dance throughout Europe was the *allemande,* a dance in double meter that continued to be included in the dance suites written in the seventeenth and eighteenth centuries long after its popularity had waned. *Pavanes* and *galliards,* too, while popular in the sixteenth century, survived as musical forms long after their popularity had faded in the ballroom. In the Baroque era, for example, the widespread popularity of dance suites extended the life of many Renaissance dances. Although many forms like the pavane or the galliard came to be danced less and less over time, their rhythms and styles of musical composition lived on in instrumental music of that later period.

VARIATIONS. By the Renaissance, improvisation already had a long history throughout Western Europe. Improvised variations on tunes, for instance, had a venerable tradition as the accompaniment to social dancing. With the advent of printing, some variations began to be written down. In 1508, Joan Ambrosio Dalza published a series of Italian tunes for which he included variations suitable for accompanying dances on the lute. The custom of crafting variations continued to flourish in the sixteenth century, particularly in Spain, where composers for the lute and keyboard developed the genre of variation to a high level. Of all the sixteenth-century variations that survive, however, the most technically brilliant were those created by a group of English composers known as the Virginalists, who composed variations for the keyboard. The leading figure among the Virginalists was William Byrd (1543–1623), who composed a series

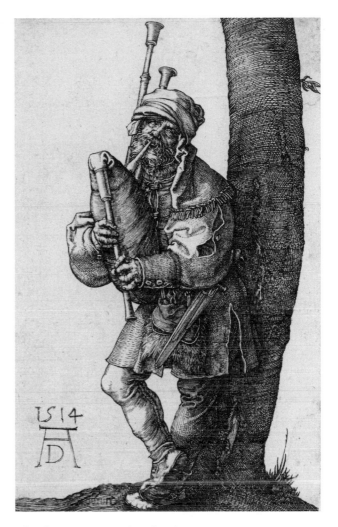

Albrecht Dürer's engraving of a piper. **ART RESOURCE.**

of keyboard variations notable for their brilliant song-like character. Other Virginalists included John Bull (c. 1562–1628) and Orlando Gibbons (1583–1625). The art of variation that flourished in England at the time did not always place great emphasis on displaying the technical brilliance of the player, but instead composers tried to play ingenuously with the themes they selected from the lute songs and other melodies popular in England at the time.

CHANGES. Sixteenth-century achievements in music began with the great masses and sacred motets of Josquin des Prez, and the legacy of achievement continued unbroken throughout the century. In these developments, though, secular music played an increasingly important role. Humanism's influence on music could be felt in the revival of Greek and Roman theory concerning the art, and in a new attention to song texts. Chromatic and harmonic inventiveness were

a PRIMARY SOURCE document

A GUIDE TO PERFORMANCE

INTRODUCTION: The sixteenth century produced a great number of practical guides to music that were intended for musicians. These treatises were largely practical and without a great deal of theory. The accomplished English musician and composer Thomas Morley wrote one of these works entitled *A Plain and Easy Introduction to Practical Music.* In it, he described the various forms of dances and songs that were in use at the time, and advised his readers about the practice of "composing fantasies," many of which were not written down at the time, but improvised.

The slightest kind of music (if they deserve the name of music) are the *vinate*, or drinking songs, for as I said before there is no kind of vanity whereunto they have not applied some music or other, as they have framed this to be sung in their drinking, but that vice being so rare among the Italians and Spaniards, I rather think that music to have been devised by or for the Germans (who in swarms do flock to the University of Italy) rather than for the Italians themselves.

There is likewise a kind of songs (which I had almost forgotten) called *Giustinianas* and all are written in the Bergamasca language. A wanton and rude kind of music it is and like enough to carry the name of some notable courtesan of the city of Bergamo, for no man will deny that Giustiniana is the name of a woman.

There be also many other kinds of songs which the Italians make, as *pastorellas* and *passamezos* with a ditty and such like, which it would be both tedious and superfluous to relate unto you in words. Therefore I will leave to speak any more of them and begin to declare unto you those kinds which they make without ditties.

The most principal and chiefest kind of music which is made without a ditty is the fantasy, that is, when a musician taketh a point at his pleasure and wresteth and turneth it as he list, making either much or little of it as shall seem best in his own conceit. In this way more art be shown than in any other music, because the composer is tied to nothing but that he may add, diminish, and alter at his pleasure. And this kind will bear any allowances whatsoever tolerable in other music, except changing the air and leaving the key, which in fantasy may never be suffered. Other things you may use at your pleasure, as bindings with discords, quick motions, slow motions, proportions, and what you list. Likewise this kind of music is with them who practice instruments of parts in greatest use, but for voices it is but seldom used.

SOURCE: Thomas Morley, *A Plain and Easy Introduction to Practical Music* (London, 1597), in *Source Readings in Music History: The Renaissance.* Ed. Oliver Strunk (New York: W. W. Norton, 1965): 86–87.

also another direct result of the revival of knowledge of antique music. In Italy, the great courts, cathedrals, and wealthy merchant families expanded their patronage of musicians and composers, attracting many French and Flemish immigrants during the first half of the century. Eventually Italians trained by the greatest of these figures established Italy as the undisputed center of European musical life, a position that it retained over the next two centuries. Italian forms, like the madrigals, frottole, and balleti, became popular throughout Europe, competing against native musical styles that were also being enriched and creatively reassessed at the same time. Instrumental music, too, became increasingly important during the later Renaissance, as exemplified by the many musical handbooks and written instrumental pieces that survive from the period. The tendency to commit more music to written and printed scores placed a higher emphasis on the technical virtuosity of performers, since a written text could now be compared against the actual performance. In turn, this new tendency to "fix" later Renaissance music in printed and written scores gave birth to many manuals that treated proper performance techniques and the arts of ornamentation and elaboration. The rising fashion for instrumental music at the time inspired the development of new instruments that often shared the traits of increased volume and tonal range. The innovations of Renaissance instrumental and vocal music, largely centered in Italy, spread quickly to all corners of the continent through travel and the printed page.

SOURCES

F. Blume, *Renaissance and Baroque Music* (London, England: Faber & Faber, 1969).

H. M. Brown, *Music in the Renaissance* (Englewood Cliffs, N.J.: Prentice Hall, 1967).

D. J. Grout and C. V. Palisca, *A History of Western Music.* 5th ed. (New York: Norton, 1996).

J. Haar, ed., *Chanson and Madrigal, 1480–1530* (Cambridge, Mass.: Harvard University Press, 1961).

W. Prizer, "The Frottola and the Unwritten Tradition," in *Studi musicali* XV (1986): 3–37.

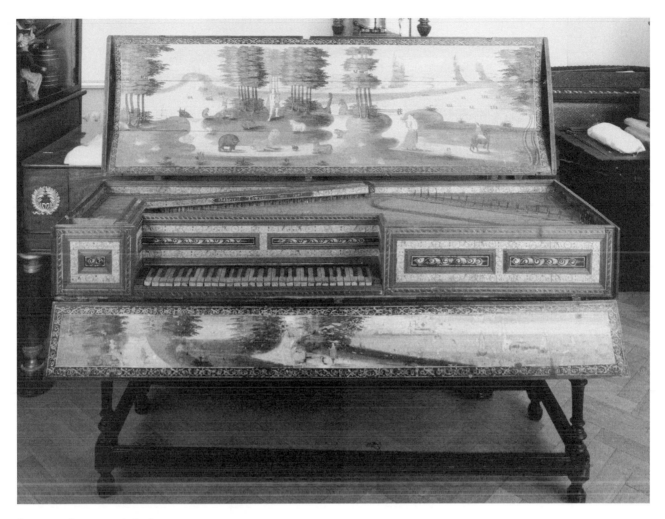

Seventeenth-century virginal. © MICHAEL BOYS/CORBIS.

F. A. Yates, *The French Academies of the Sixteenth Century* (London, England: Warburg Institute, 1947).

RELIGIOUS MUSIC IN THE LATER RENAISSANCE

PROTESTANTISM. If the sixteenth century represented a great age of secular musical achievement and innovation, religious music was to be equally transformed by the enormous religious changes that occurred at the time. The Reformation began with Martin Luther's attack on the sale of indulgences in 1517, and, over the decade that followed, a number of groups with teachings focused on reforming the Catholic Church appeared throughout Northern Europe. While some Reformation figures—notably Ulrich Zwingli in Zürich—aimed to purify the church of music altogether, most retained some place for it in the new Protestant services. The develop-

ing Lutheran Church was the most accepting of medieval musical practices. Throughout Germany many of the territorial churches reformed along the lines of Luther's model kept a great deal of the musical tradition of the medieval church alive. Often new German texts conformed to the old melodies of the Middle Ages, but innovations occurred as well. Luther himself had been a singer, and he composed many vivid new hymns for the Reformation movement that stirred the imagination, deepened the piety, and inspired musical creativity for centuries. A great age in the writing of hymns, or "chorales" in the German Lutheran tradition, resulted from the relatively accepting and fluid attitude of the Lutheran Church toward music. Elsewhere the situation was not so tolerant. The reformed churches that followed the religious ideas of John Calvin and other more extreme reformers permitted music in church life, but often in a new, severe way. The leaders of Reformed congregations usually insisted on a spare and unadorned style

a PRIMARY SOURCE *document*

LUTHER DEFENDS MUSIC

INTRODUCTION: The Protestant reformer Martin Luther (1483–1546) was an avid music lover and singer. In 1524, he published the first of a series of spiritual songs and motets for the developing Lutheran Church, which he followed with several more editions of chorales or hymns. During the sixteenth century this sacred music grew to a large repertoire. In his foreword to the first of his hymnals, the *Wittenberg Song Book*, he made clear his reasons for his generally tolerant attitude toward music's role in the church.

That it is good, and pleasing to God, for us to sing spiritual songs is, I think, a truth whereof no Christian can be ignorant; since not only the example of the prophets and kings of the Old Testament (who praised God with singing and music, poesy and all kinds of stringed instruments), but also the like practice of all Christendom from the beginning, especially in respect to psalms, is well known to every one: yea, St. Paul doth also appoint the same (I Cor. xiv) and command the Colossians, in the third chapter, to sing spiritual songs and psalms from the heart unto the Lord, that thereby the word of God and Christian doctrine be in every way furthered and practised.

Accordingly, to make a good beginning and to encourage others who can do better, I have myself, with some others, put together a few hymns, in order to bring into full play the blessed Gospel, which by God's grace hath again risen: that we may boast, as Moses doth in his song, (Exodus xv) that Christ is become our praise and our song, and that, whether we sing or speak, we may not know anything save Christ our Saviour, as St. Paul saith (I Cor. ii).

These songs have been set in four parts, for no other reason than because I wished to provide our young people (who both will and ought to be instructed in music and other sciences) with something whereby they might rid themselves of amorous and carnal songs, and in their stead learn something wholesome, and so apply themselves to what is good with pleasure, as becometh the young.

Beside this, I am not of opinion that all sciences should be beaten down and made to cease by the Gospel, as some fanatics pretend; but I would fain see all the arts, and music in particular, used in the service of Him who hath given and created them.

Therefore I entreat every pious Christian to give a favorable reception to these hymns, and to help forward my undertaking, according as God hath given him more or less ability. The world is, alas, not so mindful and diligent to train and teach our poor youth, but that we ought to be forward in promoting the same. God grant us His grace. Amen.

SOURCE: Martin Luther, "Luther's First Preface," in *The Hymns of Martin Luther.* Ed. Leonard Woolsey Bacon (New York: Charles Scribner's Sons, 1883): xxi.

in musical performance, and they resisted great musical embellishments and elaboration in performance. The chief musical achievements of this tradition lay in the Psalters, collections of tunes that set to music the poetic texts of the Old Testament Psalms. With the penetration of reformed ideas into late sixteenth-century England and the growth of Puritanism, the music of the new Anglican Church grew more restrained as well. In Anglicanism, a musical tradition developed that placed a greater emphasis on music that did not obscure the sacred texts, but which made their meanings obvious to worshipers. Similarly, a new stress on making religious lyrics intelligible to the laity dominated the music of the Roman Catholic Church over the course of the sixteenth century. Composers in the Counter-Reformation Church downplayed the intricate simultaneous vocal lines and complex polyphony that had flourished in the later Middle Ages. This new sensibility, which favored the primacy of the text in the composition of vocal music, was one of the hallmarks of the age for both Catholics and Protestants.

LUTHERAN CHORALES. The Lutheran Church's most distinctive musical contribution to sacred music was the chorale, a verse hymn set to a tune. The first Lutheran hymnals appeared in 1524 in Luther's hometown of Wittenberg and also at Nuremberg and Erfurt. Luther himself wrote many of the texts for these early collections, and he and a close composer friend Johann Walther set them to music. The first chorales were to be sung without accompaniment and in unison. Luther's own hymn, "A Mighty Fortress is Our God," illustrates some of the musical properties that developed early on in this tradition. Most of the words of the hymn are set to music using a single tone for each syllable, although *melisma*—the singing of a word or syllable on more than one tone—added emphasis to words like "fortress," "sword," and "bulwark" that convey the poem's central ideas. Luther, unlike more severe Protestant Reformers, also approved of polyphony in church music, calling it a "heavenly dance." In the collections upon which he and Walther collaborated, they included a number of

a PRIMARY SOURCE document

A CAUTIOUS ACCEPTANCE

INTRODUCTION: The French Reformer Jean Calvin was considerably more cautious than German or English religious authorities concerning the role that music should play in the Church. He was one of the most important founders of Reformed Christianity, and in his preface to the *Geneva Psalter* of 1543, he explained his position on sacred music. Calvin's reference to Plato's ideas about music in this paragraph betrays his early training as a humanist.

Now among the other things which are proper for recreating man and giving him pleasure, music is either the first, or one of the principal; and it is necessary for us to think that it is a gift of God deputed for that use. Moreover, because of this, we ought to be the more careful not to abuse it, for fear of soiling and contaminating it, converting it our condemnation, where it was dedicated to our profit and use. If there were no other consideration than this alone, it ought indeed to move us to moderate the use of music, to make it serve all honest things; and that it should not give occasion for our giving free rein to dissolution, or making ourselves effeminate in disordered delights, and that it should not become the instrument of lasciviousness nor of any shamelessness. But still there is more. there is scarcely in the world anything which is more able to turn or bend this way and that the morals of men, as Plato prudently considered it. And in fact, we find by experience that it has a sacred and almost incredible power to move hearts in one way or an-

other. Therefore we ought to be even more diligent in regulating it in such a way that it shall be useful to us and in no way pernicious. For this reason the ancient doctors of the Church complain frequently of this, that the people of their times were addicted to dishonest and shameless songs, which not without cause they referred to and called mortal and Satanic poison for corrupting the world. Moreover, in speaking now of music, I understand two parts: namely the letter, or subject and matter; secondly, the song, or the melody. It is true that every bad word (as St. Paul has said) perverts good manner, but when the melody is with it, it pierces the heart much more strongly, and enters into it; in a like manner as through a funnel, the wine is poured into the vessel; so also the venom and the corruption is distilled to the depths of the heart by the melody. What is there now to do? It is to have songs not only honest, but also holy, which will be like spurs to incite us to pray to and praise God, and to meditate upon his works in order to love, fear, honor and glorify him. Moreover, that which St. Augustine has said is true, that no one is able to sing things worthy of God except that which he has received from him. Therefore, when we have looked thoroughly, and searched here and there, we shall not find better songs nor more fitting for the purpose, than the Psalms of David, which the Holy Spirit spoke and made through him.

SOURCE: John Calvin, "Epistle to the Reader," in *The Origins of Calvin's Theology of Music: 1536–1543.* Trans. Charles Garside, Jr. (Philadelphia: The American Philosophical Society, 1979): 32–33.

Latin motets written in five-part harmony. Although the chorale texts originally written in Lutheran hymnals had a simple unison tune, by the late sixteenth century harmony had become an essential part of the chorale tradition. In the numerous hymnals published at the time, four-part settings with the melody carried in the highest voice dominated. It is difficult to overestimate the popularity of hymns in the Lutheran Church. Throughout the sixteenth century Lutheran pastors, musicians, and composers combed through the medieval tradition in search of tunes in sacred and secular music that were appropriate for the new chorales. They adopted texts and music from traditional plainsong, composed new texts that they set to the music of popular secular songs, and wrote many hymns from scratch. Luther himself termed these spiritual songs "sermons in sound," and he believed they possessed the power to purge the soul of evil thoughts and to prepare it to commune with God. The force of "A Mighty Fortress is Our God" was so widely

revered throughout the Lutheran confession that it was sometimes even used to exorcize those who were believed to be demonically possessed. In Reformation Germany, a distinctly vibrant culture of chorale singing was one of the results of Luther's and other early Protestant reformers' admiration for the power of music. In the seventeenth and eighteenth centuries the Lutheran tradition's major musical figures, from Heinrich Schütz to Johann Sebastian Bach, elaborated and embellished the Reformation chorale tradition, elevating it to the level of high art.

THE PSALTERS. The tradition of church music that developed in Switzerland, France, and other regions of Europe where Reformed Protestantism took hold differed greatly from the harmonic complexity and embellished elaboration of the Lutheran tradition. Reformed Christianity, a second wing of the Protestant Reformation, began to emerge first in Switzerland and

along the Rhine River in southwestern Germany around the same time as Luther attacked the traditional church. A key figure in defining this tradition was Ulrich Zwingli (1484–1531), who banned all music from the churches of Zürich in spite of his background as a humanist, musician, and lover of the arts. Sacred music did not return to the city until the very last years of the sixteenth century. Elsewhere, Reformed Christians did not oppose music so completely, although they limited its use and development far more than Lutherans did. At Geneva in French-speaking Switzerland, John Calvin (1509–1564) helped to codify the Reformed tradition's teachings during his more than twenty years' tenure in the city as its chief minister. He opposed many of the elaborate ceremonial elements of the traditional church, and sought to restrict the use of music by insisting that all texts sung in church have biblical foundations. Thus throughout most of the Reformed churches in Europe, the greatest achievements in sacred music consisted largely of the Psalters, collections of translations from the Old Testament Book of Psalms that were set to music with melodies drawn from medieval plainsong, from popular secular songs, and from some newly written tunes. Although some harmonized versions of the Psalters were published for private use in Reformed homes, these hymns were originally sung in unison in church. Eventually some simple four-part harmonies did make their way into Reformed practice. The first of the many Psalters that appeared in sixteenth-century Reformed Christianity was the Geneva Psalter of 1542, which was followed by several later editions in the city. This first Geneva Psalter made use of fifty of Clément Marot's translations of the Psalms, which had been rendered in an elegant metrical French verse. Marot's translations, although condemned by the theological faculty of the University of Paris, were wildly popular in France at the time. More than 500 editions of his Psalm translations were published in French during the sixteenth century, and their inclusion as the texts in the first Geneva Psalter helps to explain part of the book's popularity and its constant republication. The book also spread to other non-French speaking regions of Europe, including the Netherlands, England, Scotland, and Germany. In some of these places, the popularity of the Geneva Psalter, with its sophisticated metrical renderings, encouraged the replacement of previously existing Psalters. In other places, like England, Scotland, and the New England colonies, the Geneva Psalter inspired new native versions of the Psalms. While the Reformed Psalms never rivaled the Lutheran chorales for musical inventiveness, they were a devotional music that was prized for generations in their own tradition.

ENGLAND. England's long, sometimes torturous Reformation greatly affected religious music. Although England's music had inspired the innovations of the Flemish composers of the early fifteenth century, the country was largely a musical backwater by the late fifteenth and early sixteenth centuries. At this time musical currents on the island were relatively isolated from the innovations in Renaissance style that were occurring on the continent. This situation began to change slowly under Henry VII (r. 1485–1509), and during the reign of his son Henry VIII (r. 1509–1547) English music began to flower. Both Henry VII and Henry VIII were music lovers, and during their reigns, the religious music of the English court acquired greater sophistication. By the mid-sixteenth century a number of native composers were at work in service to the court and the country's major religious institutions. The most important of these was Thomas Tallis (c. 1505–1585), whose long and varied career illustrates some of the implications that England's "long Reformation" had for the musical scene. Tallis entered into royal service under Henry VIII, the monarch who severed ties to Rome to achieve his divorce from Catherine of Aragon. Henry, however, remained a religious conservative, and the pieces that Tallis wrote for the English church at the time were largely traditional in nature. During the reign of Henry's minor son, Edward VI, Protestant forces at court achieved ascendancy over religious practices, and in the king's short reign, they attempted to introduce the severe style of Reformed worship in the English church. As part of this goal, they required Tallis to write service music to be used in tandem with the *Book of Common Prayer*, and he wrote a number of austere, yet beautiful anthems on biblical texts in English translation. In 1553, the premature death of Edward, however, resulted in the re-introduction of Catholic practices throughout the land at the instigation of Queen Mary I. In response, Tallis returned to writing Latin hymns, motets, and masses. The Catholic Restoration proved equally short-lived, with the ascendancy of Elizabeth I in 1558, who soon re-introduced the *Book of Common Prayer* and Protestant reforms throughout the Church of England. Tallis now returned to writing works in English, although under the generally tolerant attitude of Elizabeth, he continued to compose works in Latin. Among the greatest achievements of his maturity in Elizabethan times were two settings of the Old Testament *Lamentations* of Jeremiah. Another of his greatest works was the motet *Spem in alium*, a work that was scored for a remarkable forty voices, each carrying a different melodic line. Both the *Lamentations* and *Spem in alium* are noteworthy for their intricate interplay of vocal lines. They are dramatic tour

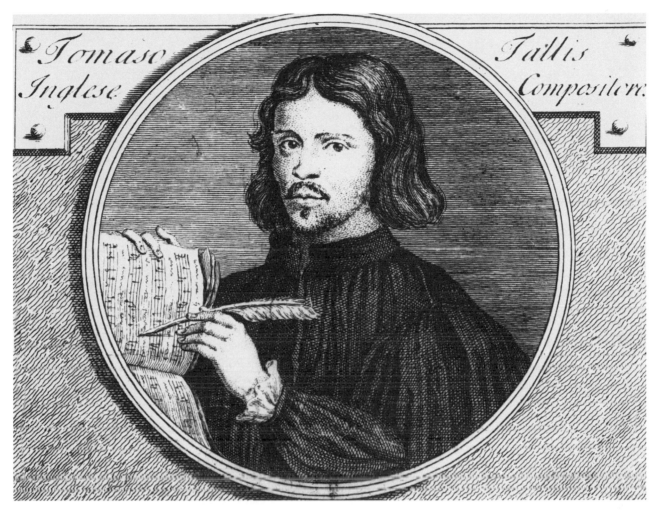

Portrait of composer Thomas Tallis. HULTON ARCHIVES/GETTY IMAGES. REPRODUCED BY PERMISSION.

de forces of Renaissance polyphony, yet at the same time, the composer always managed to find a pleasing balance in his work between the texts that he set to music and the use of counterpoint and harmony. Despite their complexity, they beautifully portray the spirit of the lyrics they convey.

MUSIC IN ANGLICANISM. As the life of Tallis suggests, the Reformation in England had major implications for composers of sacred music. A chief aim of Edward VI's introduction of the *Book of Common Prayer* was to introduce the celebration of the liturgy in the native language, and he and his Protestant officialdom desired to eliminate the elaborate traditional music of the Roman Church. In its place, these figures wanted to sponsor a new kind of religious music notable for its textual clarity and simplicity. Catholic restoration brought yet another series of short-lived changes to the sacred music favored in England, although Elizabeth I's ascendancy to the throne in 1558 signaled a new "middle

path." During her long reign she took a generally accepting attitude toward the traditional Latin motets and masses of the medieval past, allowing these services to be celebrated in some of the island's venerable religious institutions. At the same time the composers favored at court—figures like William Byrd, Thomas Tallis, and Orlando Gibbons—created new forms of Anglican service music that survived over the following centuries. Chief among the services of the English *Book of Common Prayer* were the Offices of Morning Prayer, Evening Prayer, and Holy Communion, reformed celebrations of two of the medieval Offices and the Mass. Since Holy Communion was celebrated less frequently than it had been in the medieval church, the composition of masses played a less important role in Anglicanism than it did in Roman Catholicism. Choral evensongs and anthems composed for the celebration of Morning Prayer tended to replace the once dominant choral mass. At the same time the custom of composing Great and Short Services

a PRIMARY SOURCE *document*

CATHOLIC REFORMS

INTRODUCTION: The Council of Trent, which met in Northern Italy during the years between 1545 and 1563, deliberated on many issues in the church. Although concerns for the reform of church music came to play a major role in Roman Catholicism during the later sixteenth century, the Council only rarely gave mention to music in its canons and decrees. The following text shows, though that the removal of "lascivious" melodies, by which sixteenth-century commentators usually had in mind the popular melodies of the street, was as important for the Catholic church fathers as it was for John Calvin and Martin Luther.

What great care is to be taken, that the sacred and holy sacrifice of the mass be celebrated with all religious service and veneration, each one may easily imagine, who considers, that, in holy writ, he is called accursed, who doth the work of God negligently; and if we must needs confess, that no other work can be performed by the faithful so holy and divine as this tremendous mystery itself, wherein that life-giving victim, by which we were reconciled to the Father, is daily immolated on the altar by priests, it is also sufficiently clear, that all industry and diligence is to be applied to this end, that it be performed with the greatest possible inward cleanness and purity of heart, and outward show of devotion and piety. Whereas, therefore, either through the wickedness of the times, or through the carelessness and Corruption of men, many things seem already to have crept in, which are alien from the dignity of so great a sacrifice; to the end that the honour and cult due thereunto may, for the glory of God and the edification of the faithful people, be restored; the holy Synod decrees, that the ordinary bishops of places shall take diligent care, and be bound to prohibit and abolish all those things which either covetousness, which

is a serving of idols, or irreverence, which can hardly be separated from impiety; or superstition, which is a false imitation of true piety, may have introduced. And that many things may be comprised in a few words: first, as relates to covetousness:—they shall wholly prohibit all manner of conditions and bargains for recompenses, and whatsoever is given for the celebration of new masses; as also those importunate and illiberal demands, rather than requests, for alms, and other things of the like sort, which are but little removed from a simonical taint, or at all events, from filthy lucre.

In the next place, that irreverence may be avoided, each, in his own diocese, shall forbid that any wandering or unknown priest be allowed to celebrate mass. Furthermore, they shall not allow any one who is publicly and notoriously stained with crime, either to minister at the holy altar, or to assist at the sacred services; nor shall they suffer the holy sacrifice to be celebrated, either by any Seculars or Regulars whatsoever, in private houses; or, at all, out of the church, and those oratories which are dedicated solely to divine worship, and which are to be designated and visited by the said Ordinaries; and not then, unless those who are present shall have first shown, by their decently composed outward appearance, that they are there not in body only, but also in mind and devout affection of heart. They shall also banish from churches all those kinds of music, in which, whether by the organ, or in the singing, there is mixed up any thing lascivious or impure; as also all secular actions; vain and therefore profane conversations, all walking about, noise, and clamour, that so the house of God may be seen to be, and may be called, truly a house of prayer.

SOURCE: The Council of Trent, *The Canons and Decrees of the Sacred and Oecumenical Council of Trent*. Ed. and Trans. J. Waterworth (London: Dolman, 1848): 159–161.

developed. In a Great Service, composers like William Byrd created elaborate choral responses that relied on counterpoint and all the devices common to the musical life of Renaissance Europe at the time. The more common Short Service, though, made use of far simpler unison responses, which could be sung to simple chordal music, chanted, or merely spoken. In the most elaborate Anglican ceremonies the anthem played a role similar to that of the Catholic motet in the Roman Church as a musical interlude within the service, or as part of a solemn occasion external to the church's ritual. And as with the Catholic motet, the anthem became one of the most important avenues for composers to demonstrate their technical finesse during the sixteenth century.

COUNCIL OF TRENT. Protestants were not alone in making major reforms in church music during the sixteenth century. The criticisms of the elaborate, overly ornate worship of the fifteenth- and early sixteenth-century church struck a chord within the Catholic Church, too. Between 1545 and 1563 the Council of Trent met in several sessions to answer the charges that Protestants had made against the church and to refine church discipline, theology, and religious practices. The church fathers who met in Trent, a city on the northern Italian border with Austria, did not consider religious music in much depth or detail. Instead they insisted that churches should be houses of God in which nothing "impure or lascivious" occurred, and that they wanted to rid the church of

worldly music, including the longstanding practice of composing imitation masses that were based on popular songs. The Council also insisted that the texts of sacred music should be readily intelligible, since the liturgical text was the focus of worship. Beyond these prescriptions, however, the Council gave composers little concrete guidance, although a new more severe style of religious music soon began to flourish in Italy, prompted in part by the spirit of the age and also by the peninsula's bishops and major religious institutions who favored greater clarity and less ornamentation in music. Eventually, this style influenced Catholic music throughout Europe. Giovanni Pierluigi da Palestrina (c. 1525–1594) was the chief exponent of this new, more serious style. He had been born in Palestrina, a small town near Rome, and received his musical education in the church's capital. He began to compose early, publishing his first masses when he was only nineteen. His musical idiom fit the developing contours of the Counter-Reformation in the city, and he held a number of important posts in Rome as choirmaster. As part of Palestrina's duties, he was also responsible for revising the church's official chants, a task that he did not complete during his lifetime because of its enormous complexity. According to the directives given to him by Pope Gregory XIII, he was expected to purge the church's chants of "barbarisms" and "superfluities" so that the teachings of the Mass and of the other Christian rituals might stand out in greater relief. The composer also wrote more than 100 masses and almost 250 motets. A master of the developing madrigal style, he composed about 50 of these works based on religious themes. Palestrina's music brilliantly fit with the serious tone of Catholic reform, and although he relied on polyphony, his compositions gave greater primacy to the text. To achieve this union between music and sacred message, Palestrina generally reduced the number of voice parts, usually only writing for four voices, rather than the five, six, or even more parts that filled the works of his contemporaries. To this economy of harmony, Palestrina also brought gentle rhythmic lines that enhanced the music's message.

Lasso. While Palestrina's most masterful achievements were in his settings of the Mass, Orlando di Lasso (1532–1594), a composer in the Franco-Flemish tradition, brought his considerable talents to bear on the perfecting of the motet to fit within the changed circumstances of Counter-Reformation taste. Though the composer spent his youth publishing books of madrigals, chansons, and motets, he eventually concentrated in his later years solely on the production of sa-

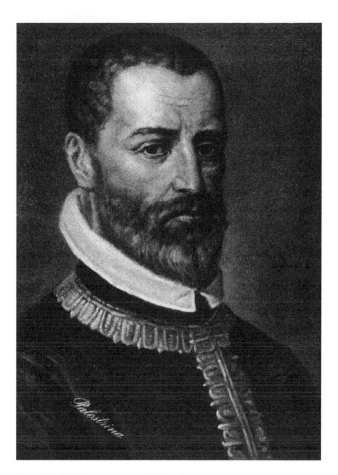

Portrait of Italian composer Palestrina. © MICHAEL NICHOLSON/ CORBIS.

cred motets, leaving behind 500 of these works at his death. Like Palestrina, his later works (published by his sons a decade after his death), reveal a dynamic association between textual rhetoric and musical interpretation. Yet Lasso's temperamental and tempestuous nature is reflected in his music, which varies freely, includes rich harmonies and intricate vocal lines, and is governed by sudden changes in tempo, rhythm, and harmony. Only rarely did Lasso make use of the contemporary fashion for chromatic scales, but when he did, he always wedded its use to the piece's words. Lasso was one of the first composers to establish his reputation largely through musical printing, gaining a reputation during his years in Italy in the 1540s and 1550s for his numerous published musical pieces. From 1556 onward, he lived in the relative isolation of Munich, the capital of the Duchy of Bavaria. Here he had access to the considerable musical establishment and resources amassed by the Bavarian dukes over previous decades. Even in this relative backwater, Lasso continued to publish his pieces, which were enthusiastically studied by composers

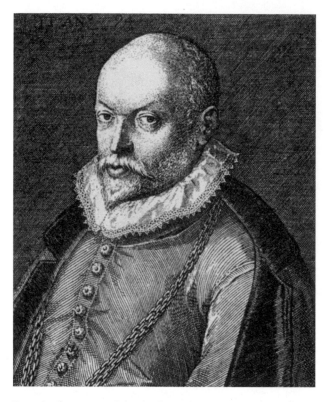

Portrait of composer Orlando di Lasso. MARY EVANS PICTURE LIBRARY.

throughout Europe and performed by ensembles soon after they came into print. From this vantage point, they had an enormous influence on sacred musical conventions, not only in Catholic Europe but in some Protestant centers as well.

IMPLICATIONS. The dynamic events of the Protestant and Catholic Reformations left their imprint on the sacred music of sixteenth-century Europe. The most radical centers of Protestantism removed music altogether from the church. Other branches of Protestantism—particularly the Genevan Reformed tradition—allowed music to flourish only within rigid confines. In Lutheranism and Anglicanism, a greater tolerance, even approval, for sacred music inspired new forms like the chorale and the anthem. A key feature shared by both Protestant and counter-reforming Catholic composers, however, was a new emphasis on the importance of texts and on fashioning a musical vocabulary to convey religious meaning in a way that was forceful and clearly intelligible to listeners.

SOURCES

F. Blume, *Protestant Church Music* (New York: Norton, 1974).

H. M. Brown, *Music in the Renaissance* (Englewood Cliffs, N.J.: Prentice Hall, 1967).

D. J. Grout and C. V. Palisca, *A History of Western Music.* 5th ed. (New York: Norton, 1996).

P. LeHuray, *Music and the Reformation in England 1549–1660* (New York: Oxford University Press, 1967).

MUSIC THEORY IN THE RENAISSANCE

SCIENCE. For most of the Renaissance, music was also considered a branch of the sciences. From the early medieval period onward music had been designated as one of the four mathematical branches of the quadrivium, the curriculum used by secondary schools as a prerequisite for entrance into the university. The issues that had been identified by the early medieval philosopher Boethius in his treatise, *Fundamentals of Music*, continued in the early Renaissance to dominate questions concerning music as a science. In the *Fundamentals*, written around 500 C.E., Boethius concentrated on the pitches and musical intervals, and he treated knowledge of the mathematical proportions in music as a way to attain virtue. His work transmitted some ancient musical theory to the Middle Ages, and it did so relying, in particular, on the ideas of Pythagoras. Pythagoras had treated the proportions of musical scales as revealing the entire order that underlay the human soul as well as the physical universe. Thus the study of music, as championed by Boethius's treatise, laid great stress on identifying the underlying rationale behind Creation. In 1500 Boethius' treatise was still the essential starting point for any student hoping to undertake the study of music as a part of the quadrivium, although the body of theoretical texts written from the vantage point of music as a science had grown enormously during the fifteenth century.

REVIVAL OF ANTIQUITY. This great flowering of theory had its inspiration in the efforts of humanists working mostly in Italy, who scoured European monastic libraries in search of ancient musical texts and imported many of these works from the Byzantine Empire, the descendant of ancient Rome in the Eastern Mediterranean that fell to the Turks in 1453. Some of the many musical texts that came to be known in new Latin translations were those of Ptolemy, Euclid, Aristides Quintilianus, Aristotle, and Plato. While many theorists in the fifteenth century tried to remain faithful to the Pythagorean tradition, the sheer variety of ideas about music that circulated at the time prompted reassessment. The chief debates among musical theorists continued to

a PRIMARY SOURCE *document*

MUSIC OF THE SPHERES

INTRODUCTION: In 1477, Johannes Tinctoris, a Flemish music theorist, published his *Book on the Art of Counterpoint*, a mostly technical manual that treated harmony and polyphony. In his foreword to the work, however, Tinctoris dressed up his ideas by considering the arguments for and against the music of the spheres. This belief, held by some in the Renaissance from ancient inspiration, taught that there was a relationship between the sounds the heavenly bodies made as they moved through heaven and the harmonies that existed on earth. The most dedicated of this camp believed that music should be studied for the changes that it might accomplish on earth and in the stars. Tinctoris discounts such a position and instead sides with Aristotle, who insisted that heavenly bodies made no sound as they moved through space.

Now, therefore, among other things, I have decided to write out at length, for the glory and honor of His Eternal Majesty, to whom by this counterpoint, as is ordered in the Psalm, is made a joyful and fitting praise, and for the benefit of all students of this noble art, those few things I have learned from careful study about the art of counterpoint, which is brought about through consonances that, according to Boetius, rule all the delight of music.

Before I explain this, I cannot pass over in silence the many philosophers such as Plato, Pythagoras and their successors, Cicero, Macrobius, Boetius, and our own Isidore, who believe that the spheres of the stars revolve under the rules of harmonic modulation, that is, by the concord of different consonances.

But although, as Boetius says, some assert that Saturn is moved with the deepest sound and, taking the remaining planets in proper order, the moon with the highest, while others, however, conversely attribute the deepest sound to the moon and the highest to the stars in their movement, I adhere to neither position. On the contrary, I unshakeably agree with Aristotle and his commentator, together with our more recent philosophers, who most clearly prove that there is neither real nor potential sound in the heavens. For this reason I can never be persuaded that musical consonances, which cannot be produced without sound, are made by the motion of heavenly bodies.

Concords of sounds and melodies, therefore, from whose sweetness, as Lactantius says, the pleasure of the ears is derived, are brought about, not by heavenly bodies, but by earthly instruments with the cooperation of nature. To these concords, also, the older musicians, such as Plato, Pythagoras, Nichomachus, Aristoxenus, Philolaus, Archytas, Ptolemy and many others, even including Boetius, most assiduously applied themselves, but how they were accustomed to arrange and put them together is only slightly understood at our time. And, if I may refer to what I have heard and seen, I have held in my hands at one time or another many old songs of unknown authorship which are called *apocrypha* that are so inept and stupidly composed that they offended our ears rather than pleased them.

SOURCE: Johannes Tinctoris, *The Art of Counterpoint* (1477). Trans. Albert Seay (n.p.: American Musicological Society, 1961): 13–14.

revolve around issues of pitch and tuning, harmony, and how these related to the human mind, the body, and the physical universe. But ancient philosophers like Plato had also taught that the musical forms, particularly the various modes, produced moral effects in their listeners. Renaissance musical theoreticians, then, became fascinated with stories from ancient literature that warned about and celebrated music's effects on the individual. They frequently quoted a legend about Pythagoras, who had allegedly calmed a violent youth by changing a piper's tune, or Alexander the Great who had been stirred to battle by a song written in the Phrygian mode. In trying to understand the power of ancient music, Renaissance theorists soon realized that an insufficient understanding of the pitches and tuning systems of ancient music hampered their efforts. They recognized that medieval musical theory had merely associated the eight modes that had flourished in medieval plainsong—the Dorian, Phrygian, and so forth—with the similarly named modes of the ancient world. Johannes Gallicus (1415–1473), who worked in tandem with humanists in the city of Mantua, was the first to discover that a vast difference separated the Greek systems of music from medieval plainsong. His work inspired a number of subsequent musical theorists to try to recover a firmer understanding of the various scales, modes, and tuning systems that underlay ancient music.

MUSICAL AESTHETICS. Until 1550 much of the musical theory that flourished as a result of these questions was highly technical and mathematical in nature. The scholarly interest in rediscovering the precise pitch relationships or intervals that had existed in ancient music had little impact on musical practice. Most of these

figures pursued the theory that the mathematical study of pitch provided a way to illuminate the universal harmonies they believed inspired music's beauty as well as its power to stir the senses and perfect the soul. But while frequently arid and theoretical, the ferment this scholarship produced can be seen in the debate that occurred between two of the most distinguished theoreticians of the mid-sixteenth century: Gioseffe Zarlino (1517–1590) and Vincenzo Galilei (1530–1590).

ZARLINO CONTROVERSY. Zarlino had been trained by the most distinguished musician in early sixteenth-century Italy: the Flemish composer Adrian Willaert, who was at the time choirmaster of St. Mark's Cathedral in Venice. Zarlino himself succeeded his teacher in that position. In his work, *The Art of Counterpoint* (1558), Zarlino credited Willaert with reintroducing a sophisticated style of musical composition inspired by the ancients, and he rejected the music of the Middle Ages as barbaric. Like those who had come before him, Zarlino associated the relationship of pitches with numerical ratios, and he accepted as a given that the ancients had understood the underlying mathematical nature of music. Although his *Art of Counterpoint* survived as a practical manual on the techniques of counterpoint that composers used well into the seventeenth century, his theoretical perspectives on ancient music were soon to be challenged by one of his most prominent students, Vincenzo Galilei. A patrician, Galilei had studied with Zarlino in Venice during the 1560s, and he continued to nourish his interest in ancient music throughout the rest of his life. Galilei's correspondence with another scholar, Girolamo Mei, undermined his faith in Zarlino's conclusions about ancient music. Mei showed Galilei that Greek music had been single-toned or monophonic rather than polyphonic, and thus it could not serve as a ready guide for modern harmony or counterpoint, the original aim of Zarlino's *The Art of Counterpoint.* As he combed through the historical record, Mei found no evidence that polyphony and counterpoint had existed in European music before the early fifteenth century. The Greeks, Mei showed, had actively rejected polyphonic music because they believed it diluted the emotional effects of a piece to allow several different melodies and pitches to play at the same time. In 1581, Galilei published his *Dialogue on Ancient and Modern Music,* a work in which he publicized many of Mei's historical insights and thus threw into question the suitability of ancient theory in the practice of contemporary music. Galilei also examined the ways in which the instruments of his time were tuned, and he showed that none of the tuning systems then in use followed the numerical relationships advocated in the works of the Greeks. The specific tuning of any instruments, he argued, was subjected not to an underlying set of natural and mathematical laws but to the ear itself, which became used to hearing tones in a certain way. According to Galilei, scales, polyphony, the modes, and tuning systems were all mediated by culture and thus had no relationship to universal or cosmic harmonies. His work thus opened up the possibility of viewing the final arbiter of "good" and "bad" music according to mere considerations of taste, a strikingly relativistic notion among the musical theorists of the day. At the same time Galilei did not question that moderns might learn from the ancients, for he included a plea in his work for music that was monodic, that is, which consisted of a single melodic line accompanied by a simple orchestration.

RECITATIVE. While the debate raged between supporters of Zarlino and Galilei, Galilei played an important role in attempts to revive an historically accurate style of Greek performance. Since the early 1570s, the theorist had been involved in a circle of music connoisseurs and scholars that met in the home of his patron, Vincenzo Bardi in Florence. This group, which later became known as the *camerata* ("circle"), examined many topics in literature, science, and the arts. Out of this coterie developed the first attempts to fashion recitative. At its origins, recitative was intended to be a naturally expressive vocal line with changes in pitch, rhythm, and tempo that mirrored the text being recited. Galilei himself experimented with recitative, setting to monodic lines selections from Dante's *Divine Comedy.* His example inspired the poet Ottavio Rinuccini and the composer Jacopo Peri, who wrote the earliest forms of opera in the final years of the sixteenth century.

IMPLICATIONS. Growing out of the tradition of the quadrivium, the musical science of the Renaissance encompassed the study of the harmonies, intervals, and proportions of music as a branch of the mathematical sciences. Little change was evident in the musical theory produced in Europe until the later fifteenth century, when humanist-trained scholars began to realize that many previously accepted ideas about ancient music were inaccurate. At this time they ransacked libraries in search of ancient musical texts and imported Greek works from Byzantium, translating these works into Latin, and somewhat later into Italian. From this vantage point, they were now more widely read and studied. Questions continued, though, about the precise harmonic intervals and pitches that had governed ancient music, as many Renaissance theorists believed that these might provide some clues to the relationships that underpinned all Cre-

a PRIMARY SOURCE *document*

ON COMPOSING AND SINGING WELL

INTRODUCTION: Gioseffe Zarlino (1517–1590) was the most important musical theorist in Europe before the seventeenth century. In his works he decried the music of the Middle Ages as barbaric and instead insisted that his own period, guided by the ancients, had been successful in recovering true musical practices. For Zarlino, music was comparable to natural law, and aesthetic tastes were to be subjected to certain universal laws that reigned in the cosmos. In the following excerpt he uses such logic to recommend techniques to singers, reminding them that they are to execute the demands and notes set down by the composer.

If music is the science of singing well or of forming good melody ... as St. Augustine defines it, and aims at nothing else, how can we include a composition that contains such errors and is so disordered as to be unsupportable to the eye, not to mention the ear, among those that serve this end? ...

The composer will seek, therefore, to make his parts easily singable and formed of beautiful, graceful, and elegant movements. Then his listeners will be delighted with them rather than offended.

Matters for the singer to observe are these. First of all he must aim diligently to perform what the composer has written. He must not be like those who, wishing to be thought worthier and wiser than their colleagues, indulge in certain divisions ... that are so savage and so in-appropriate that they not only annoy the hearer but are ridden with thousands of errors, such as many dissonances, consecutive unisons, octaves, fifths, and other similar progressions absolutely intolerable in composition. Then there are singers who substitute higher or lower tones for those intended by the composer, singing for instance a whole tone instead of a semitone, or vice versa, leading to countless errors as well as offense to the ear. Singers should aim to render faithfully what is written or express the composer's intent, intoning the correct steps in the right places. They should seek to adjust to the consonances and to sing in accord with the nature of the words of the composition; happy words will be sung happily and at a lively pace whereas sad texts call for the opposite. Above all, in order that the words may be understood, they should take care not to fall into the common error of changing the vowel sounds, singing a in place of e, i in place of o, or u in place of one of these; they should form each vowel in accord with its true pronunciation. It is truly reprehensible and shameful for certain oafs in choirs and public chapels as well as in private chambers to corrupt the words when they should be rendering them clearly, easily, and accurately. For example, if we hear singers shrieking certain songs—I cannot call it singing—with such crude tones and grotesque gestures that they appear to be apes ... are we not compelled to laugh? Or more truthfully who would not become enraged upon hearing such horribly, ugly counterfeits?

SOURCE: Gioseffe Zarlino, *The Art of Counterpoint.* Trans. G. Marco and C. Palisca (New Haven: Yale University Press, 1968): 110–111.

ation and which governed music's relationships to the human body, mind, and spirit. At the same time a definite shift in emphasis is evident in many of the works of musical theory published in the later sixteenth century. In the debate between Gioseffe Zarlino and Vincenzo Galilei, aesthetic questions, rather than mathematical issues, dominated the discussion. In these disputes Galilei promoted the notion that ancient music's power had resided in simple melodic lines, lines that emphasized the text and that possessed the power to move people's hearts and emotions, rather than in mathematical harmonies. He and other thinkers promoted a new art, the recitative, that gave greater weight to words than to harmony, and they attacked many of the polyphonic forms like the madrigal that were then in use. Galilei's own work, however, had set up the human ear as the final arbiter of taste in music, and thus supporters of the madrigal and other polyphonic forms popular at the time were able to counter that these genres were capable of stirring the emotions and of ennobling their listeners. Polyphony did not die out as a result of the innovations of later Renaissance theorists like Galilei and Mei, but recitative and other monodic forms were to be integrated into the early Baroque opera and other musical forms and consequently to enrich the musical choices available to later European composers.

SOURCES

D. J. Grout and C. V. Palisca, *A History of Western Music.* 5th ed. (New York: Norton, 1996).

A. E. Moyer, *Musica Scientia: Musical Scholarship in the Italian Renaissance* (Ithaca, N.Y.: Cornell University Press, 1992).

C. V. Palisca, *Humanism in Italian Renaissance Musical Thought* (New Haven, Conn.: Yale University Press, 1985).

SIGNIFICANT PEOPLE
in Music

WILLIAM BYRD

c. 1540–1623

Composer

TRAINING. Like many others who composed music during the Renaissance, William Byrd probably began his training as a chorister in the Royal Chapel in London. At the time, Thomas Tallis was the most important English composer in England, and Byrd studied with him. During 1563, Byrd became organist and choirmaster at the Cathedral of Lincoln. He developed a successful career in Lincoln before being recalled to London to serve as organist and singer in the Chapel Royal. He shared the position of organist with Tallis and together both men received a royal patent (in effect, a monopoly) to publish all music in England for a period of 21 years. Elizabeth I regularly granted such patents to revered members of the court, allowing them to reap generous financial benefits for service to the crown. Byrd thanked the queen with the composition of his *Sacred Songs*, a work he dedicated to Elizabeth in 1575. During the 1570s and 1580s Byrd regularly composed service music for the new Anglican rite, although his family's Catholic background caused them to be targeted as recusants—those who celebrate Catholic rituals in secret. Sometime during the early 1590s, Byrd went into an early retirement in Essex, where he continued to compose music. He completed three masses, which he published between 1592 and 1595, and two other books of graduals (responses for the Mass) appeared in 1605 and 1607. A few years later Byrd published a collection of his songs. During the long period of his retirement he also instructed students, including the English composers Thomas Morley, Thomas Tomkins, and John Bull.

COMPOSITIONS. Besides his church music Byrd composed in almost every genre popular in late sixteenth- and early seventeenth-century England. In his Latin church works, Byrd became the first Englishman to master the continental style of contrapuntal motet. In these, he developed the continental style of imitation—in which the voices mirrored each other—to a high point of finesse. At the same time his music granted imaginative and often emotional intensity to the text. Many of his Latin compositions were destined to be performed in private, rather than public, since England as a Protestant country was moving more and more to service music written in the English language. The book of Graduals that he wrote in the early seventeenth century was intended, not just for the Anglican service, but also for the Catholic Mass, making Byrd the last major composer in England to write for the Roman rite. These liturgical works have long been judged to be the finest sacred music written by an English composer. Beyond his output of music intended for church ritual, much of which had to be performed secretly in the houses of great Catholic families in England, Byrd wrote a large number of sacred and secular songs. He scored these for vocal parts, with the melody in the upper line. These works could also be performed by solo voice together with lute accompaniment. It was this versatility that contributed to the success of Byrd's music in the printed music market of the day. Their adaptability, moreover, helped to sustain their popularity, and many of Byrd's songs have been performed in England over the centuries, even to the present day. In the area of keyboard works, the composer was also a master. Well known as a virtuoso on the organ, Byrd also printed some of his keyboard pieces, and these compositions show a great development of the musical form of variation. He also relied on contrapuntal invention and his typically brilliant conception to give structure to his work.

SOURCES

J. Harley, *William Byrd: Gentleman of the Chapel Royal* (Aldershot, U.K.: Scolar Press, 1997).

C. A. Monson, "Byrd, William," in *The Encyclopedia of the Renaissance* (New York: Scribner, 1999).

GUILLAUME DUFAY

c. 1397–1474

Singer
Composer

UPBRINGING. Born near Brussels, Dufay was educated in the school of the Cathedral of Cambrai in what is now modern Belgium. He completed his education around 1414, took holy orders, and set off for the Council of Constance, which was then meeting in the north of Switzerland. After 1420, Dufay became a member of the Malatesta court, which ruled the cities of Pesaro and Rimini in Italy. Several compositions survive from these early years of his career. Like many fifteenth-century Burgundian musicians and composers, Dufay spent most of his life moving from court to court, accepting

short stints of patronage and working in important choirs. By the mid-1420s he was in León in France, but he soon returned to Italy. In this period he first served a cardinal at Bologna, then moved on to become a member of the papal choir. Later he became a member of the Duke of Savoy's household, the head of an important state on the northwestern border of Italy, before joining the papal household once again. Between 1435 and 1437, Dufay spent most of his time in Bologna and Florence, where he continued to serve the pope. In this period he wrote his famous mass, *Nuper rosarum flores*, a work commissioned for the dedication of the dome of the Cathedral of Florence. Gianozzo Manetti, a Florentine humanist, attended this celebration, and later described the piece as "filled with such choruses of harmony and such a concert of diverse instruments that it seemed ... as though the symphonies and songs of the angels and of divine paradise had been sent from Heaven to whisper in our ears an unbelievable celestial sweetness." Dufay returned to work for the Duke of Savoy for a short time in the late 1430s, and again for a longer six-year stay during the 1450s. But he spent most of his middle and older years at Cambrai, near the place of his birth.

IMPORTANCE. Dufay's career coincided with the rise of the Burgundian musical style throughout Europe, and he achieved recognition during his life as one of the greatest of its composers. Like other Burgundian composers, he made use of the innovations that had recently been imported into Northern Europe from England. From John Dunstaple and other Englishmen, the composers active in France and the Netherlands during the fifteenth century adopted more complex rhythms and the use of the closer harmonies of the *fauxbourdon*. *Fauxbourdon* made use of intervals of thirds and sixths to set the harmony against a plainsong tune that continued to reside in the tenor voice. Eventually, the musical writing that flourished as a result of the popularity of the *fauxbourdon* tended to become more homophonic, that is, it sounded more like a melody with harmonic accompaniment. In addition, the works of composers like Dufay helped to win acceptance for the use of the third and the sixth, intervals that until this time had often been avoided as dissonances. Dufay was one of the fifteenth-century figures who tamed these intervals, helping to train the Western ear so that these sounds appeared more consonant than previously. As a composer he wrote a wide variety of music, including masses, magnificats, chansons, and motets, much of which survives in important manuscript collections throughout Europe.

SOURCES

D. Fallows, *Dufay* (London, England: Vintage, 1987).

C. Reynolds, "Dufay, Guillaume," in *Encyclopedia of the Renaissance* (New York: Scribner, 1999).

JOSQUIN DES PREZ

c. 1450–1521

Composer
Musician

CONFUSION. Little is known about many key details of Josquin des Prez's life, the indisputable genius of High Renaissance musical composition. It had long been thought, for example, that he had been born sometime around 1440, although research conducted in recent years has thrown his date of birth into grave doubt. The composer's family name was actually Lebloitte, and he was born in Northern France, where he served as a choirboy in Saint-Quentin. Part of the confusion about Josquin's early career has arisen from the fact that he shared the name "des Prez"—the name he adopted in adulthood—with another musician active in Italy who was a decade or two older. A date of birth of around 1450 for Josquin des Prez now seems likely, because his first positions seem to have been in the employ of the Sforza dukes of Milan in the mid-1470s.

CAREER. While the early circumstances of this composer's life are still shrouded in some mystery, Josquin's quick rise to prominence allows scholars to track his career as it progressed. After leaving the court of Milan, he entered into the service of King René of Anjou, who maintained a residence at Aix-ex-Provence near Marseilles in southern France. By 1486, he had resumed his affiliation with the Sforza, having become a member of the Sforza Cardinal Ascanio's household. In these years he spent most of his time in Rome, where he was occasionally associated with the pope's chapel. In 1501, he traveled to France, where he likely worked in the king's court for a few years before returning to Italy to take a position in the court of the dukes of Ferrara. For his services Josquin was offered an enormous salary, although he only stayed in Ferrara for a little over a year. In 1504, Josquin des Prez left Italy, this time for his ancestral homeland in Northern France, where he served as an official in the Cathedral of Notre Dame at Condé-sur-L'Escaut until his death in 1521.

MUSIC. Josquin des Prez's compositional output was considerable and included about eighteen masses, fifty motets, and some seventy secular pieces. Many other

works from the time have long been attributed to him, although ongoing research is still separating spurious compositions from those actually from Josquin's hand. His chief importance lay in his ability to fashion new techniques and styles that heightened the understanding of his music's text. Although he still continued to be affected by the French and Flemish musical traditions of the fifteenth century, Josquin des Prez simplified his work's musical phrases, bringing his compositions into alignment with the humanist demands for a music that expressed ideas and words and did not just impress the ear with complex harmonies. While he made use of canons and cantus firmus melodies in his masses, Josquin also expanded the boundaries of these compositional techniques by freely varying and re-interpreting the melodies that were repeated in these compositions. Josquin des Prez was known for being a willful individualist, and was sometimes compared to Michelangelo in this regard. His career was similar to the great sculptor and painter in that he established a standard in music that those who came after him tried to emulate and surpass. His works continued to be widely admired in the first half of the sixteenth century. For many years they were played at the court of the Habsburg emperor Charles V. Notably, the Protestant reformer Martin Luther dubbed Josquin des Prez the "master of the notes," and he stressed the composer's ability to bring all the compositional devices to bear in his works so that a single artistic unity and a deeper understanding of the text developed after one listened to them.

SOURCES

P. Macey, "Josquin des Prez," in *Encyclopedia of the Renaissance* (New York: Scribner, 1999).

R. Sherr, ed., *The Josquin Companion* (Oxford, England: Oxford University Press, 2000).

ORLANDO DI LASSO

c. 1530–1594

Composer

EARLY LIFE. The Flemish composer Orlando di Lasso was born in Mons in what is today modern Belgium, where he received his early musical training and served as a choirboy. Lasso's beautiful voice resulted in him being kidnapped on three occasions by wealthy families desiring his services; after the third incident, his parents finally relented and allowed him to stay in the household of the viceroy of Sicily. As part of the viceroy's household he traveled to Palermo, and over the next ten years, he also spent time in Milan, Rome, and Naples. His years in Italy were critical for his later development as a composer, and while there, he adopted the Italian name that he continued to use for the rest of his life. Following the death of his parents in 1554, he took a position in Antwerp, but several years later became a chorister in the chapel of Albert V, duke of Bavaria. He remained in the duke's household at Munich for the rest of his life. Although Munich was a small and rather provincial capital at the time, Bavaria was a large and important state, a center of the Counter-Reformation in Northern Europe. In his Munich years, Lasso published a number of his compositions, and he became, in fact, the first composer in European history to establish his reputation primarily on the basis of his printed work. In the last forty years of his life Lasso printed more than 600 works, and usually a new composition appeared in the press about once each month. He favored musical printing houses in France, Italy, and the Netherlands, as well as those in Germany.

WORKS. Lasso wrote more than 1,000 works and he was a master of most of the musical forms of the period. He produced a number of excellent compositions in all genres except instrumental music. His Latin motets form his largest group of compositions, totaling more than 500. He also composed almost sixty masses and about 100 magnificats. Most of the motets have sacred themes, and were likely performed within church rituals, at public ceremonies, or for the private devotions of the duke of Bavaria and his family. A few celebrate secular events, while an even smaller number are humorous. Lasso was also a writer of madrigals based on Italian texts and chansons that set some of the finest sixteenth-century French poetry to music. Finally, he wrote German lieder as well.

IMPORTANCE. Lasso was widely admired in his own day. Referred to as the "prince of music" or "the divine Orlando," he earned praise for his ability to bring the subject of his chosen texts to life through his music. Like other sixteenth-century composers, he relied on changes in melody, harmony, and rhythm to suggest essential elements of the text, and sometime subtle musical innuendos lie hidden in his works. A consummate technician, Lasso did not care for many of the musical innovations of his own period. The chromatic style so popular among writers of Italian madrigals as a bow to the music of Antiquity only rarely is employed in his works. By the time of his death, his musical language had been superseded by other developments, but Lasso's works continued to be prized in Germany well into the seventeenth century.

SOURCES

Peter Bergquist, "Lasso, Orlando di," in *Encyclopedia of the Renaissance* (New York: Scribner, 1999).

J. Roche, *Lasso* (London, England: Oxford University Press, 1982).

CLAUDIO MONTEVERDI

1567–1643

Composer

LONGEVITY. In a long and illustrious career Claudio Monteverdi established himself as one of the great musical geniuses of the Western tradition. His music gave expression to late Renaissance tastes while eventually helping to establish the characteristics of early Baroque style. Monteverdi's career occurred at a pivotal point in the history of Western music, as a melodic line supported against an instrumental background replaced the relatively equal polyphonic lines and harmonies of the sixteenth-century madrigal. Monteverdi helped to establish this style in a career that lasted more than sixty years.

MADRIGALS. Until the early seventeenth century Monteverdi's most important compositional work was in the madrigal form, then popular as a kind of vocal chamber music in elite societies throughout Italy. These were written for five voices, with complex interwoven lines, as was the popular custom of the day. In the years following 1600, though, Monteverdi also experimented with some of the most innovative forms to develop in the later Renaissance. One of these was the opera, and Monteverdi's earliest contributions to this genre are performed to this day. These include his *Orfeo* written in 1607, which gave expression to the then contemporary desire to recreate the music of ancient Greece. The early opera had grown out of the discussions and experiments of the Florentine camerata, which under the influence of such theorists as Girolamo Mei and Vincenzo Galilei, had begun to piece together scattered evidence of the kinds of music that had been used in Greek tragedy. The most fervent supporters of this revival argued that ancient Greek tragedy had been completely sung in monodic or single-toned expressive lines. The first attempts to recreate this form of drama had occurred in the city of Florence in the final years of the sixteenth century, and had been supported by the wealthy merchant and patrician families of the city as well as members of the Medici dynasty. These early entries had relied almost solely on recitative, a new form of monody that imitated, yet heightened the patterns of human speech. Monteverdi patterned his *Orfeo* along the lines of what had been developed in Florence, but beyond making use of the new recitative, he also introduced solo airs, duets, and madrigal-like portions into the action of the opera. In this way he joined many of the contrapuntal techniques that had flourished in the late Renaissance to the emerging fashion for a monodic line.

IMPORTANCE. Even in his own day Monteverdi was credited with founding a "modern" style in music, a position within the history of the Western repertory that he has retained even to the present day. Besides his important innovations in opera and the madrigal, he served from 1613 until his death as choirmaster at St. Mark's Cathedral in Venice. From this, the most important musical position in Italy, he also influenced contemporary tastes in sacred music. At the same time, late Renaissance musical theorists attacked his work for its disregard of the craftsman-like techniques and traditions of counterpoint. They criticized his new experiments with melodies that were supported against a backdrop of choral and instrumental harmonies. Certainly, Monteverdi rebelled against many of the traditions that governed Renaissance music, but at the same time he never completely abandoned the style of his youth. While long judged one of the founders of the early Baroque style, he continues to be classified by most scholars as a "late Renaissance" composer. In a long and distinguished career the experiments he made in madrigal form, opera, and sacred music continued to inspire subsequent generations.

SOURCES

M. Ossi, "Monteverdi, Claudio," in *Encyclopedia of the Renaissance* (New York: Scribner, 1999).

G. Tomlinson, *Monteverdi and the End of the Renaissance* (Berkeley, Calif.: University of California Press, 1987).

GIOVANNI PIERLUIGI DA PALESTRINA

1525–1594

Composer
Musician

TRAINING AND LIFE. The composer Giovanni Pierluigi da Palestrina was born in the small village of Palestrina outside Rome and by the 1530s he was serving as a choirboy in the Church of Santa Maria Maggiore in Rome. By 1551 he had risen to the rank of the "master of the choirboys" and somewhat later Pope Julius III appointed him a member of the Capella Giulia at St.

Peter's. Unlike the Sistine Chapel, the Capella Giulia's ranks of choristers were drawn from Italians and not from the numerous professional Flemish musicians who flourished in Italy at the time. Julius III had hired Palestrina without the customary vote of the other members of the choir, and his appointment remained controversial. Soon after his taking on the duties of a papal chorister, Palestrina released his first printed book of masses. This was the first Italian collection of masses to be dedicated to a reigning pope, and it was a sign of the rising status of native Italian musicians in Rome. In 1555, Palestrina lost his position after Paul IV cleared the Capella Giulia's choir of all married choristers. During the following years Palestrina found employment as master of choirs at a number of Rome's most important religious institutions, and by 1565 he had regular commissions to write music for the papal chapel, eventually becoming its official composer. In 1571 he returned to the Capella Giulia at St. Peter's and spent the rest of his life as choirmaster. When his wife died in 1580, Palestrina considered for a time entering the priesthood, although he decided to remarry instead. The composer died on 2 February 1594, and was buried at St. Peter's; his funeral was an important occasion attended by all of Rome's musicians and many dignitaries, too.

COMPOSITIONS. Although many of Palestrina's works were published while he was still alive, his son also supervised the printing of a number of works following the composer's death. Palestrina wrote an enormous amount of music for the Catholic Mass, and these compositions expressed the developing religious sensibilities of the Counter-Reformation. He produced more than 100 masses and about 250 motets. In addition, hymns, Magnificats, offertories, litanies, and lamentations make up his opus. While his religious works gave expression to the severe Catholic piety of the age, he was perhaps more revered for his madrigals, publication of which began in 1555. Later in life when Palestrina's own religious convictions had grown more serious, he was embarrassed by these early sensual creations. Besides his work as a composer, he was also an influential trainer of musicians and composers. While important on the late sixteenth-century musical scene, he attained an almost mythic status after his death. By the seventeenth century a legend credited Palestrina with "saving" music in the church during the reign of the severe pope Marcellus II (r. 1555). Palestrina's *Pope Marcellus Mass* was said to have so pleased the short-reigning pope that he gave up his plans to ban music in the church. More recent research, though, has dated this mass to around 1562, rather than

1555, thus undermining the legend of Palestrina's rescue of music.

IMPORTANCE. In 1577, Pope Gregory XIII chose Palestrina and his colleague Annibale Zoila to sift through the church's bewildering variety of chants and responses. Palestrina was expected to reform the use of liturgical music along the lines necessitated by recent reforms in the Mass. The composer did not complete this enormous project before his death, although the work that he began helped to define the project as it was carried to fruition in the seventeenth century. At this time, too, Palestrina had an important role. Seventeenth-century composers recommended study of Palestrina's works to their students, who were interested in mastering the techniques of Renaissance counterpoint. His reputation as an authority on contrapuntal technique survived even into the eighteenth and nineteenth centuries. As a result Palestrina was one of the first Renaissance composers to be granted significant modern scholarly attention.

SOURCES

L. Lewis and J. A. Owens, "Giovanni Pierluigi da Palestrina," in *The New Grove High Renaissance Masters* (New York: Norton, 1984): 93–156.

R. Sherr, "Palestrina, Giovanni Pierluigi da," in *Encyclopedia of the Renaissance* (New York: Scribner, 1999).

DOCUMENTARY SOURCES
in Music

Boethius, *The Fundamentals of Music* (500 C.E.)—This early medieval musical theory textbook remained indispensable to those who studied music as a branch of the mathematical sciences in the Renaissance. Boethius transmitted the ancient Pythagorean notion that proportionate intervals or musical harmonies underlay Creation and that music was thus a source for understanding natural laws.

Raffaele Brandolini, *On Music and Poetry* (1513)—This important humanist treatise opened up the possibility for music to be understood as a kin to poetry, rather than as a branch of mathematics.

Vincenzo Galilei, *Dialogue on Ancient and Modern Music* (1581)—This pathbreaking work argued that music's power derived, not from its mathematical relationship, but from the ear as it was trained to accept certain sounds and sensations. Galilei also promoted the

monodic (single-lined) music of Greek Antiquity as the style that was most capable of stirring the emotions.

Thomas Morley, *A Plain and Easy Introduction to Practical Music* (1597)—One of many sixteenth-century guidebooks, this work informed its readers about the various musical forms, tuning systems, and arts of embellishment necessary to succeed as a musician at the time.

Gioseffo Zarlino, *The Art of Counterpoint* (1558)—This work was both a theoretical and practical guide to the art of writing counterpoint (two or more musical lines heard simultaneously). Zarlino's ideas about ancient polyphony were subsequently disproved, but his influence on later students of musical composition continued to be strong even in the seventeenth century.

PHILOSOPHY

Philip M. Soergel

IMPORTANT EVENTS
in Philosophy

c. 1300 Circles of humanists begin to appear in Italy.

1304 Francesco Petrarch is born.

1308 John Duns Scotus, the "subtle doctor," dies.

c. 1310 Dante Alighieri completes his *On Monarchy*, a work praising the universal state.

1323 William of Ockham resigns his professorship at the University of Paris, and dedicates himself to political philosophy. His works will attack the church's interference in secular affairs and will lay the foundation for nominalism, the most important movement of scholastic philosophers in the later Middle Ages.

1324 Marsilius of Padua writes his *Defender of the Peace*, a treatise that argues for the separation of secular and religious powers.

1327 John Buridan, a nominalist philosopher trained by William of Ockham, becomes rector or head of the University of Paris.

1341 Petrarch is crowned "Poet Laureate" at Rome.

1360 Leontius Pilatus is called to serve as professor of Greek at the Studium Generale of Florence.

1375 Pierre d'Ailly publishes his commentaries on the Sentences of Peter Lombard.

Coluccio Salutati becomes the first humanist chancellor of Florence.

1380 Political theory of conciliarism, which advocates the superiority of the church's councils over the power of the pope, emerges as a solution to heal the Great Schism.

1396 Manuel Chrysoloras becomes professor of Greek at the University of Florence and begins to train the town's civic humanists in the reading of ancient Greek.

c. 1400 Civic humanism begins to develop in Florence and other Italian cities.

1410 Leonard Bruni is elected as second humanist chancellor of Florence.

1440 Lorenzo Valla uses philological techniques to show that the *Donation of Constantine* is a forgery.

c. 1450 Nicholas of Cusa relies on his knowledge of astrology and advances the notion that the world is infinite and the earth is a star, similar to the other stars in the heavens.

1458 Nicholas V, the church's first humanist pope, expands the church's role in the world of learning by founding the Vatican Library.

1462 Cosimo de Medici appoints Marsilio Ficino to translate Plato.

c. 1466 Desiderius Erasmus is born at Gouda in the Netherlands.

1474 Marsilio Ficino completes his *Platonic Theology*, a work that tries to join an accurate understanding of Plato's philosophical ideas to Christianity. The work's emphasis on Platonic Love as a communion between two minds will have a major impact on philosophers during the coming century.

1486 The Renaissance Platonist Giovanni Pico della Mirandola publishes his *900 Theses*, which outlines the fundamental truths all religions seem to share. Its preamble, *The Oration on the Dignity of Man* praises humankind's dignity as a virtue of its creation

in God's likeness and serves as a call to debate the author's Platonic philosophy.

c. 1500 Printing begins to spread humanist texts in Northern Europe.

1503 Erasmus publishes his *Handbook of the Militant Christian*, a work that instructs its readers in piety and the "Philosophy of Christ." The book will become popular quite quickly and establish Erasmus's fame as a Christian philosopher throughout Europe.

1506 Johannes Reuchlin publishes his Hebrew grammar and supports the study of medieval Jewish philosophy and theology.

1509 Desiderius Erasmus publishes *The Praise of Folly*, which pokes fun at the foibles of Europeans, but criticizes the learning of the scholastic theologians, in particular. Erasmus argues that Christianity is a religion that surpasses the limits of human reason.

1513 Niccolò Machiavelli writes *The Prince*, a work praising the role of a strong prince in unifying his kingdoms. The book is published in 1532, five years after Machiavelli's death, and placed on the church's *Index of Prohibited Books* in 1559.

1516 Thomas More publishes his *Utopia*, a vision of an ideal society.

The humanist and Aristotelian philosopher Pietro Pomponazzi completes his *On the Immortality of the Soul*, a work that calls into question the eternal nature of the human soul.

c. 1525 Philip Melanchthon, a close associate of Martin Luther, begins to reform the university curriculum at Wittenberg. Melanchthon's mix of scholastic and humanist methods will dominate universities in much of Protestant Northern Europe over the coming centuries.

1527 Rome is sacked by troops of the emperor Charles V and for a time the city falls into an economic recession and declines as a center of learning.

1530 Ignatius Loyola studies philosophy and theology at the University of Paris.

Apparently influenced by Renaissance Platonism, Nicholas Copernicus completes his *On the Revolution of the Heavenly Planets*, which argues that the sun is the center of the universe and that the stars travel around the sun in circular orbits. The treatise is published in the year of Copernicus's death, 1543.

c. 1545 The Council of Trent begins its deliberations. During the two decades in which the council meets it relies on the scholastic philosophy of Thomas Aquinas and other medieval theologians as the basis for creating the modern orthodoxy of the Catholic Church.

1547 The Jesuits found their first secondary school at Messina in Southern Italy. This college, as Jesuit institutions come to be known, adopts a humanist curriculum. It will be widely copied by other Jesuit institutions in Europe.

1553 The astrologer and metaphysician John Dee, an expert in the learned magic that has become popular in the wake of Ficino's *Platonic Theology*, is imprisoned in England for conjuring "evil spirits." He is later released, but Queen Elizabeth seizes his library in 1583.

1584 The Renaissance Platonist Giordano Bruno publishes *On the Infinity of the Universe*, while serving as an Italian ambassador to London.

1592 In his *Essays* Michel de Montaigne argues for the superiority of human experience over ultimate truths.

OVERVIEW
of Philosophy

SCHOLASTICISM. At the dawn of the Renaissance, philosophy in Western Europe continued to be dominated by the scholastic method, and philosophical examination occurred primarily within Europe's universities. Because philosophy was largely pursued in faculties of theology, theological issues were of primary importance. Scholastic philosophy relied on a method for examining questions logically by weighing opposing viewpoints, propositions, and evidence. In the thirteenth century the scholastic method had reached a high watermark of development, particularly at the hands of thinkers like St. Thomas Aquinas, Albertus Magnus, and St. Bonaventura. Aquinas's achievement, in particular, still ranks as one of the great intellectual edifices of European history, and his *Summa Theologiae* or *Theological Summation* remained influential in the later Middle Ages. Thomism proceeded from the assumption that human knowledge might, in large part, be harmonized with divine revelation. In the Renaissance many scholastics continued to examine theological and philosophical questions in a manner that was consistent with Thomas Aquinas, but Thomism's dominance was only unquestioned within the Dominican Order. Elsewhere new movements arose that criticized the Thomists' faith in human reason, and bitter disputes occurred in the late medieval universities between the "old way" of Aquinas and the "new way" comprised of nominalists and Scotists.

NOMINALISM. It was the issue of philosophical universals that separated the new nominalist philosophy most decisively from thirteenth-century scholasticism. To explain why humans agreed on the meanings of certain terms, earlier scholastics had relied on the concept of universals, their interpretations of which they had drawn from Platonic philosophy. Universals, Platonists had taught, were ideas imprinted upon the human mind. For this reason, much thirteenth-century scholasticism had shared an underlying realism, i.e. the notion that earthly terms and concepts existed in a perfect form in a realm of universals. Realism had allowed scholastic philosophers to argue that the human mind contained imperfect but nevertheless reliable representations of these universals. During the thirteenth century the concept of universals had grown more controversial, with some scholastic philosophers continuing to hold to an "ultra-realist" position, while others insisted that the precise nature of these ideals was unknowable. In a third position, scholastics like Thomas Aquinas upheld the reality of universals within the mind, while insisting that the human senses still provided reliable knowledge of the world. Relying upon this reasoning, Aquinas had argued that human reason and divine revelation (sacred scriptures and the authoritative sources that explained its meaning) could provide true answers to questions about God and the Christian religion. Around 1300, though, nominalist critics began to attack the concept of universals altogether. They expressed a new skepticism about the human mind's ability to establish truths about the nature of God. William of Ockham, an English scholastic, was most prominent among this new school, and he argued that philosophical terms were not expressions of universals. They were instead but mere names that humans beings had given to things they had observed in the world. In place of the confidence that thirteenth-century scholastics had placed in human reason, then, the nominalists argued that philosophers should confine their speculations to what they could prove reasonably from their own observation. As a result, the nominalist school increasingly separated scientific truths from religious ones. Because of their skepticism about the mind's ability to understand God rationally, the nominalists also reduced the scope of questions a theologian might treat. They argued, for instance, that the truths of the Christian religion could not be proven rationally through logical proofs. Instead theology consisted in examining the scriptures and the traditions of the church to reveal the nature of the promises God had made with humankind.

HUMANISM. Three main schools of scholastic theology persisted in the fourteenth and fifteenth centuries: Thomism, nominalism, and Scotism, a theology derived from the ideas of the Duns Scotus (1265/66–1308). While fundamental differences of interpretation separated these theological systems, all three schools proceeded with certain common assumptions about method. The scholastics embraced logic and the weighing of arguments from traditional authorities to prove their points on rationalistic grounds. While the nominalists attacked traditional scholasticism for its heavy reliance upon human reason, they shared a conviction with all medieval philosophers that truth should be established through log-

ical examination. In the fourteenth century humanists began to attack scholasticism generally for having favored logical analysis. They argued that scholasticism's heavy reliance upon logic was ineffectual in the true goal of philosophy: the pursuit of virtue. Petrarch was the first humanist to attain an international reputation, and the patterns he set in his writings were imitated throughout Italy over the next century. Petrarch believed that rhetoric, the art of persuasion, appealed to the human will, and might prompt human beings to virtuous living more effectively than scholasticism's appeal to logic and the intellect. Graceful writing and speaking and study of the literary works of the ancients could all be used to encourage human beings to live virtuous lives. Thus, humanists like Petrarch shared a passionate devotion to Antiquity, and during the fifteenth century members of the movement dedicated themselves to recovering the knowledge of the classics. A deepening understanding of the ancient languages and a new critical sophistication in the study of texts emerged during this period as a result.

RENAISSANCE PLATONISM. Florence was the first city in which humanism emerged to dominate public life. Around 1400, the town produced a circle of civic humanists, who considered issues of politics, civic ethics, and history in their works. As a group, they advocated an active life engaged in public duties. During the first half of the fifteenth century this political philosophy became the creed of Florence's growing humanist circle. As the Renaissance matured in the city and knowledge of ancient philosophers grew, Platonism became increasingly attractive to Florence's intellectual elite. Renaissance Platonism, in contrast to earlier civic forms of humanism, advocated a life lived in contemplation and relative isolation from society. The figure of Marsilio Ficino was important in spreading this new creed, first in Florence and somewhat later throughout Italy and Europe. The leading Platonic scholar of his day, Ficino completed authoritative translations of Plato's surviving works. During the 1460s and 1470s, he also dedicated himself to the creation of a *Platonic Theology*, a huge theological summation that tried to merge Plato's philosophy with Christianity. A popular form of Renaissance Platonism became part of the intellectual creed of the later Renaissance. The doctrines of the movement, including its emphasis on Platonic Love, on the soul as a spark of the divine flame, and on human creativity as a divine attribute, affected many areas of art and cultural life during the High Renaissance.

HUMANISM BEYOND ITALY. As a new philosophical and educational movement, humanism did not remain solely within Italy. During the fifteenth century scholars from throughout Europe began to journey to Florence and other Italian intellectual centers to learn the new scholarly methods promoted by the humanists. As they returned home to Northern Europe and to Iberia, they brought with them knowledge of the humanists' achievements in translation and in rediscovering the ancient classics. A key impetus in spreading the New Learning beyond Italy was, as it had been in Italy, the need for properly trained secretaries, royal officials, and diplomats. But humanism spread throughout Europe within the secondary schools and universities, too. Although they were at first resistant to what became known as the New Learning, most universities had accommodated themselves to it by 1500. They were encouraged by the changing tastes of their students, who hungered for the humanist training that had become popular in Italy over the previous century. As humanism left Italy, its practitioners often devoted themselves to harmonizing classical wisdom with Christianity. Platonism was one movement that had an appeal in this vein. But the Renaissance outside Italy also produced strikingly original thinkers like Desiderius Erasmus, who promoted Christian reform and whose ideas cannot be neatly classified into any category. Erasmus' ideas acquired many admirers in the early sixteenth century, from England to Germany and Spain. Yet as the sixteenth century progressed, both Catholic traditionalists and reform-minded Protestants distanced themselves from the gentler reforms of Christian culture that he had advocated.

NEW TRENDS IN SIXTEENTH-CENTURY THOUGHT. In the sixteenth century a new breed of intellectuals began to alter the course of debate in European philosophy. Many of these new thinkers turned to politics and presented new ideas about political power. These political thinkers included Niccolò Machiavelli, who presented a strikingly amoral portrait of the astute ruler in his *Prince*; Jean Bodin, who laid the foundations for political absolutism; and Theodore Beza, who defended a subject's right to resist a monarch's tyranny. In a more personal vein the French humanist Michel de Montaigne gave his readers an internal journey through his most intimate thoughts in his *Essays*. Montaigne's pessimism about contemporary society was at odds with the traditional humanism that had shaped his early development. And his skepticism about the ability of human beings to establish absolute moral truths was not shared by most of his contemporaries. His intense search for a relevant personal philosophy, free from traditional religious dogma and intolerance, would recur among thinkers in later centuries.

TOPICS
in Philosophy

SCHOLASTICISM IN THE LATER MIDDLE AGES

TERMINOLOGY. The term *scholasticism*, a word invented by sixteenth-century humanist critics, has long been used to describe the dominant intellectual movement of the Middle Ages. The humanists used the term to attack the verbose style and arid intellectualism they perceived to be the defining features of medieval intellectuals. Humanists criticized the scholastics for concentrating on legal, logical, and rationalistic issues at the expense of genuine moral and ethical problems. In truth, the thought of the schoolmen possessed considerable variety and depth. These thinkers often engaged in debating complex moral and intellectual issues in ways that were far from arid and which dealt with realistic considerations. There was not, moreover, a single set of assumptions about philosophical issues within the scholastic movement. Instead it possessed great variety and witnessed continued vitality and development throughout the later Middle Ages. But humanist philosophers came to contrast their own method of discussing and writing about philosophical problems against those of the scholastics and to argue that their ideas were more original and morally relevant than those of the medieval schoolmen. At the same time humanist thinkers were often indebted to the ideas of the scholastics, and the gulf that separated the two movements was less profound than many humanists often imagined.

UNIVERSITIES. Scholasticism first developed in schools attached to Europe's cathedrals in the twelfth century. By 1200, the most successful of these schools had emerged as universities. These first universities—places like Oxford in England, Bologna in Italy, and Paris in France—shared a common educational outlook, even though each specialized in different kinds of learning. These institutions were carefully nourished, both by the church and their local states, since the students that they trained provided a pool of eligible talent to assume positions of authority in secular and religious governments. The medieval universities enjoyed special legal status as largely autonomous bodies, free from local control. As a result, "town and gown" rivalries often erupted, even at this early point in their development. The curriculum taught in the universities changed little over time. Students began their instruction at the universities in their mid-teens after completing their preparatory work at home or in the secondary schools in Europe's cities. Since all instruction within the universities was in Latin, most students required years of elementary and secondary instruction, either formally or informally, before they could enter a university. The course of primary and secondary education differed from place to place, as did the number of schools available to educate young boys in the basic instruction that they would need before they entered the university. While there were a few notable exceptions of talented, young women who attended universities in the Middle Ages, women were prohibited from taking degrees. And as a rule, women received no instruction in Latin, so that in all but extraordinary cases, this prevented them from pursuing higher learning. Before a student entered university, he needed a basic knowledge of the seven liberal arts: the *trivium* (which included rhetoric, grammar, and logic) and the *quadrivium* (astronomy, geometry, arithmetic and music). A university's curriculum was more systematic, though, and during the four or five years a student was enrolled in the Bachelor of Arts curriculum he was expected to master logic and the other tools of the scholastic method. At the end of this course, a student usually took the degree. The fourteenth and fifteenth centuries were a great period in the expansion of university education throughout Europe. University education still was a rare thing, but universities spread in this period to almost every corner of the continent. In 1300 there were only 23 universities in Europe. During the fourteenth century, an additional 22 were founded, and in the fifteenth century 34 new institutions appeared. This growth was strongest in Germany, Eastern Europe, and Spain. As new universities appeared throughout the continent, the number of individual colleges within these institutions also grew, as nobles, wealthy burghers, kings, and princes moved to endow new schools within the framework of existing universities. Medieval universities also specialized, as universities do today, in particular areas of expertise. Until the sixteenth century, Paris remained Europe's premier theological university, while Bologna in Italy was known for its legal studies. It trained many of the lawyers who practiced in the church's courts. Salerno, in Sicily, was Europe's first medical school. As university specialization increased in Europe at the end of the Middle Ages, a new kind of itinerant scholar appeared. Many fourteenth- and fifteenth-century students migrated from university to university, spending only a year or two in each place, before taking the B.A. at one institution. In this way students took advantage of the lectures given at particular places by the most expert of professors. Rising complaints of students who lacked direction and seriousness, though, also accompanied these

changes, and the European system of degrees allowed students to remain in school for many years. For those who desired the academic life and who possessed the resources to pursue education, the Masters of Arts degree could be attained with another two to three years of study. At this point the most dedicated students usually became teachers for several years before pursuing the doctoral degree, which required another seven or eight years to complete.

SCHOLASTIC METHOD. A common way of teaching known as the scholastic method dominated in most universities. The scholastic method—often attacked by later humanists for its verbose style—was, in reality, a logical way of examining problems from contrary points of view. The scholastic thinker set out a proposition to be debated and then he proceeded to present arguments on both sides of this question. He carefully answered each argument in support of this proposition and each in opposition before coming to a final conclusion about the matter. To practice this method, students relied upon a highly technical form of Latin, one which humanists attacked as barbaric in the fifteenth and sixteenth centuries. A thorough knowledge of the ideas of previous authorities was also a key skill needed by those students who hoped to succeed in mastering the method. The accomplished scholastic was expected not only to be able to deal with problems in their discipline logically, but to recall and manipulate the ideas of previous authorities on a subject. These skills were put to the test in oral debate, as students were called upon to demonstrate mastery of the material through engaging their peers in verbal matches.

PERVASIVENESS OF THE SCHOLASTIC METHOD. This style of examining intellectual questions was common in all the disciplines that were taught in the medieval university and was particularly important in the development of law, theology, natural philosophy (that is, those studies concerned with matter and the physical world), and medicine. Philosophy itself was not an independent discipline in the medieval university, as it is today, although its methods of rational analysis and its logic pervaded all studies. Much of what we would identify today as "philosophy" was concerned with theological issues, although in every area of academic endeavor, medieval scholars wrote works that were philosophical in nature. The importance of philosophy in the medieval curriculum, especially in theological studies, had grown during the course of the high Middle Ages (the eleventh to the thirteenth centuries). In the eleventh century, for instance, many of those who taught in Europe's cathedral schools had been wary of the use of an-

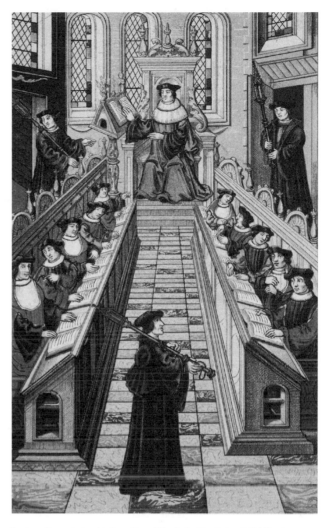

Instruction at the University of Paris in the later Middle Ages. © LEONARD DE SELVA/CORBIS.

cient philosophy within theological studies, but over time the rational and logical analysis that philosophy offered influenced theological study more and more. In the twelfth century Peter Abelard (1079–1142) compiled his *Sic et non,* a work that presented the conflicting statements of the scriptures and of early church fathers concerning doctrinal issues. Although Abelard was a Platonist as were many scholastics of his day, he relied on Aristotle's dialectical method as a means to analyze and harmonize contradictory statements. Peter Lombard (c. 1100–c. 1160) built upon his efforts to construct his *Sentences,* a work that examined the sum of the church's theology, and which attempted to harmonize the contradictory statements of the ancient church fathers concerning the key teachings of Christianity. In many cases, however, Lombard's *Sentences* left the contradictions that existed between early Christian authorities unresolved, and thus his work became

an important textbook for those theological students who followed him. Students were expected to weigh the contradictory statements of ancient church authorities and the Scriptures the *Sentences* contained, and to construct their own theological judgments by confronting and harmonizing those contradictions through reasoned and logical analysis. As the *Sentences* became more popular the dialectical method of Aristotle and the teachings of ancient philosophy concerning the science of logic became increasingly important to European theologians, many of whom wrote commentaries on Lombard's work. By the thirteenth century, in fact, logic had a pre-eminent position in the theological curriculum of universities throughout Europe.

INCREASING IMPORTANCE OF ARISTOTLE. Aristotle's increasing prominence in medieval theology arose, not just from his expertise in logic or the dialectical method, but because the philosopher came to be accepted as a pre-eminent authority on science, nature, and ethics. Early scholastics like Peter Abelard and Peter Lombard had advocated the adoption of Aristotelian forms of reasoned argumentation, but they had remained Platonic in their theological outlook and often wary of Aristotle's ideas. During the twelfth century, though, Western thinkers had begun to re-acquire a firmer understanding of Aristotle's works. They were aided in their efforts by the studies of Aristotle that had been undertaken by Jewish and Muslim scholars in previous centuries, since firsthand knowledge of Aristotle's texts had largely disappeared in medieval Europe. As more and more European scholastics studied the philosopher's works, Aristotle's influence grew, and the sense of uneasiness that had once existed regarding his "pagan" philosophy disappeared. Aristotle became a powerful ally in the attempt to construct a reasoned defense of the Christian faith. By the thirteenth century key aspects of Aristotle's ideas, including his system of logic, his science, and his moral philosophy, helped to fashion a new Golden Age of scholastic theology. Theologians saw in Aristotle's science and metaphysics—particularly in his emphasis on a Prime Mover—new ways to prove the existence of God. They embraced his ethics because they saw in it ways to defend Christian moral imperatives. Aristotle also provided a set of logical tools that allowed theologians to systematize the doctrines derived from the Bible and church tradition. They also relied on these tools to make the church's system of the sacraments rationally coherent. During the thirteenth century, then, the philosopher's largely secular-spirited philosophy served as a foundation for theologians' attempts to interpret the Bible and to explain the workings of the Christian religion and its sacraments. This new marriage between theology and ancient philosophy also played an important role in defining the limits of secular and ecclesiastical authority.

REASON AND REVELATION. At the high point of scholasticism's development in the thirteenth century many scholastic philosophers were convinced that human knowledge could be harmonized with divine knowledge. They believed, in other words, that faith and human reason were complementary and that human reason could be used to prove the tenets of the Christian religion. This confidence in the compatibility of human reason and the Christian religion was nowhere more profoundly displayed than in the works of St. Thomas Aquinas (1225–1274). Aquinas was an Italian by birth who entered the Dominican Order, and eventually studied at the University of Paris, then Europe's pre-eminent theological institution. After spending some time in Cologne, he returned to teach in Paris before retiring to Italy in his later years. His career thus exemplifies the international nature of university education in the thirteenth-century world. An indefatigable scholar whose literary output was vast, he was sometimes observed writing one work while dictating another. One of his greatest achievements was his *Summa Theologiae*, or *Theological Summation.* In this work Aquinas argued that many of the truths of the Christian religion were beyond rational explanation and that they must, by their very nature, be treated as mysteries of a "divine science." At the same time, he applied Aristotelian logic, metaphysics, and ethics to theological problems to make the intellectual issues of the faith readily intelligible and rationally coherent. Almost invariably in the *Summa,* each article follows a set form. Its title asks whether something is true, such as "Is the Existence of God Self-Evident?" This question is then followed by the words "It seems that" as well as a series of objections that refutes the initial question. These objections include statements from the scriptures, the church fathers, the saints, and other Christian authorities, although in some cases they present purely philosophical statements about logic or nature. The side of the argument Thomas wants to defend is then introduced with the words "but on the contrary," and is accompanied by the quotation of the same kinds of authorities previously presented under the objections. Then Thomas turns to the heart of the article with the words "I answer that" in which he shows by logical argument and the citation of authorities that "what seems" is incorrect, and that what he has stated following the words "on the contrary" is, in fact, correct. He then disposes of the initial "objections," most

often by showing that if one interprets them correctly, they actually do not support the erroneous side of the argument. The *Summa* in its entirety—in its four parts and hundreds of questions—is always built upon these same balanced and orderly principles of argumentation. Aquinas's *Summa Theologiae* is thus a work of theology, but one that nevertheless relies on philosophical methods and ideas to defend many Christian teachings. In other writings, particularly his *Commentaries on Aristotle*, he treated subjects that were more purely philosophical in nature, but most of Aquinas's works are best described as works of theology that make use of philosophy's tools. As a theologian, Aquinas was well aware of the problems that might arise from a too heavy reliance on logic and reason to prove Christianity's premises. At the same time, a confidence existed in his work that the mind of man mirrored the mind of God, and thus human beings might strive to understand the Christian faith aided both by divine revelation (the sacred Scriptures and those authorities that had commented upon them) and human reason.

UNIVERSALS. In the decades following Aquinas's death a number of scholastic theologians criticized what they felt was a too heavy reliance on reason in his and other thirteenth-century theologians' works. The issues that precipitated this debate involved the nature of universals, an issue that had been debated by theologians since ancient philosophy had begun to make inroads into scholasticism in the twelfth century. The issues surrounding universals seem to modern minds to be erudite and removed from practical considerations, but to thinkers in the high and later Middle ages, the debate over universals was part of a broader set of discussions about the science of epistemology, that is, the science of how human beings can establish the truth of what they know. These epistemological debates became fundamental to theologians' considerations of their discipline and to their treatment of Christian truth, the church's sacraments and institutions, and even to their considerations of the relationships between religious and secular authority. Until the thirteenth century many scholastics had relied on Platonic realism to explain why human beings shared certain ideas and concepts. Plato had taught that the human mind had been imprinted at birth with knowledge of archetypes or universals that existed in a perfect realm, and this knowledge allowed human beings to recognize and react to the ideas and objects they observed on earth. As a human being saw the elements that made up the world, in other words, each particular object or idea forced the mind to recall its correspondence to a perfect universal. When the hu-

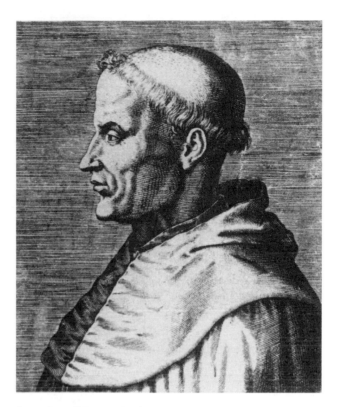

Engraving of Thomas Aquinas. **NEW YORK PUBLIC LIBRARY PICTURE COLLECTION.**

man eye turned to look at a chair, for example, the mind recognized it as a chair because of its relationship to the pre-existing universal idea of chair. This way of interpreting earthly reality as a shadowy emanation of a realm of pure forms or universals has often been called realism. It proved particularly amenable to the needs of some early scholastics desirous of proving the Christian faith using reasoned arguments. In the eleventh century, for example, St. Anselm of Canterbury (1033–1109) had relied on realism to prove the existence of God. According to Anselm's proof, if God was conceived in the mind as that "being which nothing greater could be conceived" then the very presence of this notion in the mind proved God's existence. As a realist, in other words, Anselm believed that certain concepts were imprinted on the mind at birth that pointed to the reality of their existence in the realm of universals. As scholastic theology matured, however, new positions on the subject of universals had multiplied. Some thirteenth-century thinkers had remained faithful to realism and had even become "ultra-realist" in their attitudes toward universals. Others insisted that the precise nature of universals was unknowable and they refused to pronounce any opinion on the matter. Still others, like Aquinas, forged positions on universals that were somewhere in between both alternatives.

AQUINAS'S REFORMULATION OF UNIVERSALS. While Aquinas insisted on the reality of universals, he argued at the same time that human knowledge derived from sensory experience working in tandem with these ideas in the mind. The eyes, ears, and hands provided the mind with a reliable picture of the world, even though universal knowledge shaped and gave meaning to sensory perceptions. With this notion of universals, Aquinas was able to treat concepts like the existence of God in new ways. He avoided the old means of proof based upon *a priori* notions imprinted upon the mind at birth, notions that had once played such an important role in the work of figures like St. Anselm. Instead he looked to the natural world and argued that the senses might provide human beings with some reliable proofs for God's existence. Aquinas argued that wind, the flow of water, and the life cycle of flora and fauna all pointed to the presence of a prime mover, a planner that had set these processes in motion. Thus Aquinas's reformulation of the concept of universals allowed him to forge a new kind of theology that linked science, human reason, and divine revelation together, even if he continued to insist that neither nature nor human reason could provide sufficient proofs for the Christian religion on their own. The theologian, according to Aquinas, still had to rely on a detailed and logical study of sacred scriptures and the church's authorities to arrive at religious truth. Although Aquinas's formulations concerning these problems continued to be influential among many later medieval scholastics, particularly in the Dominican Order, his concepts were soon challenged after his death. By 1300, a new group of thinkers began to attack the concept of universals altogether, and in a skeptical vein they insisted that there were clear limits to human reason's ability to understand God and religious truth. As they attacked the concept of universals, they insisted that their precise nature was indeterminable and that each and every object in the world was endowed with its own peculiar, unique qualities. The terms that human beings used to describe these things, in other words, did not have their origin in universals imprinted on the mind, as earlier scholastics had argued. Instead they insisted that philosophical concepts were mere names that arose from human attempts to categorize and comprehend what they observed in the world.

OCKHAM'S RAZOR. This philosophy eventually became known as nominalism, taking its name from the Latin word for "name" (*nomenus*). The nominalists generally tried to limit the use of human reason in understanding the Christian faith. In place of the trust that Aquinas and other thirteenth-century thinkers had placed in logic and the mind's ability to comprehend the Christian religion, they argued that faith could not be proven by strictly rational means. Instead there were truths of faith that were not reliant on human reason, and truths of science that were independent of religion. The nominalist critique of the notion of universals was made most cogently by William of Ockham (1285–1349), a brilliant English philosopher and theologian. Ockham had a diverse and interesting career as an academic, a political theorist, and a campaigner for reform in the church. His impact on philosophy, though, proved to be his most enduring contribution. He denied the nature of universals and instead insisted on a simpler explanation for human knowledge. The concept he pioneered, today known as "Ockham's Razor," proposed that the simplest explanation for a phenomenon should win out over a more complex one. Ockham divided all human knowledge into intuitive and abstract categories. Intuitive knowledge is by far the more common, since it is the basis upon which all human understanding of the world is constructed. Intuitive knowledge is acquired through experience and from discussing one's experiences with others. Through their intuition human beings discover that the sky is blue, water is wet, and wood is hard. These intuitive conclusions, though, are nothing more than names which human beings use to describe the realities that they observe in the world. The second category of human knowledge, abstract knowledge, arises from human beings' ability to imagine. Here Ockham cites the example of the unicorn as a typical invention of humankind's abstract knowledge. A fantastic and concocted being, the unicorn is not an expression of a heavenly archetype, but is instead a completely imaginary animal created within the human mind out of the intuitive knowledge of horses and horned animals. From their ability to think in abstract terms, human beings possess the ability to create, but Ockham cautioned that abstract knowledge can also err and, as in the case of the unicorn, create ideas that are completely imagined. In this way Ockham argued for a dramatic reduction of the role of universal truths, one of the fundamental building blocks of scholastic philosophy up to his time. Instead of insisting that universals were pre-existing archetypes in the mind of God, Ockham argued that they were little more than ideas that human beings created to name the things that they observed while living together in the world. This denial of universals or archetypes had a profound effect on philosophy and theology. Fueled with his new understanding of how the mind operated, Ockham argued that the truths of religion could not be understood using human reason. The human mind, in fact, could not establish the reality of

a PRIMARY SOURCE document

AN ACADEMIC ATTACKS PAPAL POWER

INTRODUCTION: Marsilius of Padua's *Defender of the Peace* was written in 1324 while controversy raged concerning the pope's recent decision to condemn the teachings of the Spiritual Franciscans, a group of the order who held to a strict interpretation of their founder St. Francis's ideas concerning poverty. Marsilius attacked the foundations of papal authority by insisting that the authority of the state should be supreme over the church. Marsilius also included an early theory of representative government in his work, arguing that all government's power derived from the people, but in the fourteenth century, most readers focused on his attack upon the power of the church.

Now we declare according to the truth and on the authority of Aristotle that the law-making power or the first and real effective source of law is the people or the body of citizens or the prevailing part of the people according to its election or its will expressed in general convention by vote, commanding or deciding that something be done or omitted in regard to human civil acts under penalty or temporal punishment ...

On the other side we desire to adduce in witness the truths of the holy Scripture, teaching and counseling expressly, both in the literal sense and in the mystical according to the interpretation of the saints and the exposition of other authorized teachers of the Christian faith, that neither the Roman bishop, called the pope, nor any other bishop, presbyter, or deacon, ought to have the ruling or judgment or coercive jurisdiction of any priest, prince, community, society or single person of any rank whatsoever. ... For the present purposes, it suffices to show, and I will first show, that Christ Himself did not come into the world to rule men, or to judge them by civil judgment, nor to govern in a temporal sense, but rather to subject Himself to the state and condition of this world; that indeed from such judgment and rule He wished to exclude and did exclude Himself and His apostles and disciples, and that He excluded their successors, the bishops and presbyters, by His example, and word and counsel and command from all governing and worldly, that is, coercive rule. I will also show that the apostles were true imitators of Christ in this, and that they taught their successors to be so. I will further demonstrate that Christ and His apostles desired to be subject and were subject continually to the coercive jurisdiction of the princes of the world in reality and in person, and that they taught and commanded all others to whom they gave the law of truth by word or letter, to do the same thing, under penalty of eternal condemnation. Then I will give a section to considering the power or authority of the keys, given by Christ to the apostles and to their successors in offices, the bishops and presbyters, in order that we may see the real character of that power, both of the Roman bishop and of the others....

SOURCE: Marsilius of Padua, *Defender of the Peace* in *The Early Medieval World.* Vol. V of *The Library of Original Sources.* Ed. Oliver J. Thatcher (Milwaukee, Wisc.: University Research Extension Co., 1907): 423–430.

God's existence, nor could the truths of religion be defended using an abstract system of logic. Human knowledge existed in a realm completely separate from the majesty of God, and it could only establish the absolute truth of the things that it witnessed through its own observations.

IMPLICATIONS. Despite his criticisms of the limits of human reason, Ockham remained a devout Christian. As a result, he and his followers stressed the absolute power of God on the one hand, and the necessity for philosophers to confine their speculations to what they could prove through their observation on the other. His nominalist philosophy was particularly important in the University of Paris, Europe's leading theological institution. A second group of philosophers, known as Scotists, elaborated the positions of John Duns Scotus (1266–1308), a Scottish scholastic who had emphasized the will over human reason in his works. Scotus's thought had been complex and had merged elements of both Aristotle's and Plato's philosophies. Because he was so adept in harmonizing these two conflicting figures, Scotus became known as the "subtle doctor." Scotus's followers emphasized freedom of the will and the necessity of both good works and divine grace in the process of human salvation. Their theory of knowledge differed from the nominalists because the Scotists continued to affirm the role of universals in human thought. Scotism was most widely developed as a philosophical movement among members of the Franciscan Order. While Scotism was a more conservative movement in some ways than nominalism, Scotists often joined forces with nominalists in the later Middle Ages to oppose Thomists, and together the two philosophies became known as the *via moderna* or "the modern way." While the gulf that separated both traditions was pronounced, both Scotists and Nominalists were skeptical about the mind's ability to fathom the truths of the Christian faith rationally. Despite the

growth of these two movements, Thomism continued to attract supporters in the fourteenth and fifteenth centuries, but outside the Dominican Order its influence was slight. In contrast to the *via moderna*, Thomism was known as the *via antiqua* or the "old way." Like Thomas Aquinas, followers of the "old way" continued to express a confidence in the human mind's ability to understand sacred things. Within university faculties generally, bitter disputes often raged between followers of the "old" and "new" ways. Scotism and Thomism continued to attract support throughout the Renaissance, but nominalism would be the most definite force for change on the scholastic horizon. It helped to shape new ways of conducting theological study and new modes of asking philosophical questions. The simplifying effects of Ockham's teaching, in particular, have long been seen as laying the groundwork for the ideas of later Protestant Reformers. Martin Luther began his career as a scholastic theologian within the tradition of the "modern way." That philosophy also helped to shape John Calvin's theology, with its emphasis on the majesty of God and the importance of understanding the covenants that He had established with humankind in the scriptures. Beyond its religious implications, many have seen in Ockham's defense of empirical truths over abstract logic a development that helped to influence the course of Western science.

POLITICAL THEORIES. William of Ockham also involved himself in the political issues of his day, including the long-standing controversies that revolved around church and state power. Ockham became embroiled in these matters while defending the concept of Franciscan poverty against Pope John XXII (r. 1316–1324), who had declared a radical interpretation of the order's teachings on poverty to be heretical. In 1324, the pope summoned Ockham to Avignon, and Ockham, displeased with the papal behavior he witnessed, quickly became an opponent. After leaving Avignon, he joined forces with radical leaders in the Franciscan Order who had taken up residence at the court of the German emperor Louis the Bavarian. From there, Ockham wrote several works defending the outcast Franciscans and attacking John XXII as a heretic. These tracts argued that the pope should be deposed and they defended the power of church councils and the state over the papacy. Ockham's political philosophy was unusual in its arguments concerning the nature of church truth. Theologians had long argued that the church, guided by the Holy Spirit, could not stray from the truth. Ockham, for his part, noted that while truth always prevailed in the church in some quarters, the papacy and even church councils could err and stray

from true Christian teaching. While his ideas shared certain affinities with later Protestant attacks, most late-medieval theologians and philosophers did not support them. Ockham's more limited defense of church councils to resolve the issues facing the church would be influential later in helping to resolve the crisis of the Great Schism (1378–1415). (See Religion: The Church in the Later Middle Ages.)

MARSILIUS OF PADUA. Ockham's radical political philosophy had been partly influenced by the ideas of Marsilius of Padua, who had completed his influential *Defender of the Peace* in 1324. Although Italian by birth, Marsilius rose to become the rector of the University of Paris and, like Ockham, became an outspoken opponent of Pope John XXII. Eventually, he, too, left his position to join the court of the emperor Louis the Bavarian. In the *Defender of the Peace* Marsilius stressed that the will of the people was the basis for all government. Power did not flow from God to the pope and into secular rulers, as many political philosophers had long supposed. Instead it rose from the people, who established governments in order to live by the rule of law. At first glance, these ideas might seem a democratic manifesto, but Marsilius still envisioned that kings, princes, and nobles would play a greater role in defining government than common people. The importance of his work lay in its strong support of the secular power of princes over that of the church. Throughout this political treatise Marsilius criticized the power of the clergy by insisting that they were only one part of society, and as such, bound by the laws the entire community enacted. As he turned his attention to papal power, he argued that the pope was merely a humanly appointed executive, responsible to the Christian community in the same way that all rulers were. The members of the church acting in a general council could, when circumstances warranted, depose him. While Marsilius's *Defender of the Peace* was an early defense of the principles of representative government, it did not influence political philosophy until much later. In the fourteenth century those secular rulers who prized it did so because it supported their power against the pope.

CUSA. These strains of political theorizing continued in the fifteenth century, too. They can be seen in the works of the scholastic philosopher Nicholas of Cusa (1401–1464), a German and a cardinal. In his *Catholic Concordance* Cusa examined the history of the church, including the long-term relationships between the German Empire and Rome. Cusa showed that the *Donation of Constantine*, one of the foundations of papal authority, had left no trace in historical documents through-

a PRIMARY SOURCE document

A SCHOLASTIC DELIBERATES UPON RELIGION AS ART

INTRODUCTION: The scholastic philosopher Nicholas of Cusa was also a cardinal and a tireless campaigner for the reform of the church. In this capacity he gave hundreds of sermons throughout his life. This excerpt from one of these entitled "Where is He that is Born the King of the Jews?" makes the following interesting observations about religion as art. According to Cusa, one of the purposes of religion is to help human beings live better, more fulfilled lives.

Now everyone has one entrance into this world, but not all men live equally. For even though men are born naked like the other animals, still they are clothed by men's art of weaving so they may live in a better state. They use cooked foods and shelter and horses and many such things which art has added to nature for better living. We possess these arts as a great service and gift or favor from their inventors.

And so when many live wretchedly and in sadness and in prisons and suffer much, but others lead lives of abundance joyfully and nobly, we rightly infer that a human being can with some favor or art attain more of a peaceful and joyful life than nature grants. Even though many have discovered the various arts of living better by their own talent or with divine illumination, as those who discovered the mechanical arts and the arts of sowing and planting and doing business. And others have gone further, as those who wrote the rules of political life and of economic activity, and those who discovered the ethical life of habituating oneself through mores and customs even to the point of taking delight in a virtuous life and thus of governing oneself in peace. Nonetheless all these arts do not serve the spirit, but hand on conjectures how in this world a virtuous life worthy of praise can be led with peace and calm.

Thereupon religion based on divine authority and revelation is added to these arts that prepare a human being for obeying God through fear of him and love of him and one's neighbor in the hope of attaining the friendship of God who is the giver of life so that we may attain a long and peaceful life in this world and a joyful and divine life in the world to come. Nonetheless, among all the ways of religion which fall too short of true life, a way to eternal life has been revealed to us through Jesus, the Son of God. He handed over to us what the heavenly life is which the sons of God possess, and revealed that we can reach divine sonship and how to do so ... Jesus is the place where every movement of nature and grace finds rest. The word of Christ or his teaching and his command or the paradigm of his movement is the way to vision or the taking hold of eternal life that is the life of God who alone is immortal. It is a more abundant life than the life of a created nature. Therefore, no one can reach on his own the way of grace which leads to the Father, but must proceed to that way through the gate.

SOURCE: Nicholas of Cusa, "Where is He that is Born the King of the Jews?" Trans. by Professor Clyde Lee Miller, State University of New York at Stony Brook.

out the ages, thus calling into question one of the foundations of the pope's secular authority in Western Europe. Like Marsilius of Padua, his *Concordance* argued that the basis of all government lies in the will of the people, although Cusa would take his conclusions farther than Marsilius. As the monarch of the church, Cusa argued, the pope should be elected by a body of cardinals that was truly representative of the entire church. Church councils, moreover, were the ultimate arbiters of Christian teaching because they derived their powers directly from Christ.

LEARNED IGNORANCE. Even as he devoted himself to writing political philosophy, Cusa was also an academic philosopher who embraced mysticism in other works. His *On Learned Ignorance* displayed a skepticism about the human mind's ability to understand God rationally and instead argued that God could be best understood through the way of negation. The deity, in other words, was most easily comprehended in terms of what He was not, rather than in terms of what He was. This small treatise advocated a mystical path toward union with God, a God that Cusa perceived as present everywhere in an infinite universe. *On Learned Ignorance* demonstrates another keen interest of the late-medieval scholastics: their fascination with mathematics and the natural sciences. In this work Cusa relied upon geometry to demonstrate the infinitude of the universe, a realm he described as having no center or circumference. As a result, his theory denied the traditional notion that the earth was at the center of the universe. For Cusa, the center of the universe was everywhere, a space that God alone occupied. He admitted that his concepts were difficult for the human mind to grasp, and he often relied on difficult mystical terms to present his ideas. At the same time his work was one of the first Renaissance philosophical documents to present a notion of the shape

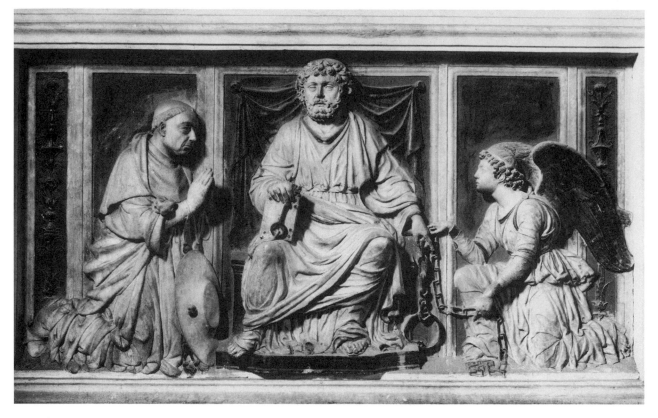

Detail from Nicholas of Cusa's tomb, showing the philosopher venerating St. Peter. **ALINARI-ART REFERENCE/ART RESOURCE, NY. REPRODUCED BY PERMISSION.**

of the world that was different from the traditional "earth-centered" models that had long been accepted as orthodoxy.

NATURAL PHILOSOPHY. Cusa's interest in considerations about the shape of the universe illustrates another dimension of late-medieval philosophy: its continuing interest in nature and metaphysics. Before the Scientific Revolution of the seventeenth century, universities treated the physical sciences largely as branches of natural philosophy, an important part of the philosophical curriculum in both the Middle Ages and the Renaissance. Aristotle's ideas concerning matter and the physical universe had largely shaped the development of medieval natural philosophy, and Aristotelian ideas continued to be important in Renaissance natural philosophy, too. Over the centuries, though, some Christian, Neoplatonic, and Islamic commentaries had been added to the corpus of works treated in the universities' natural philosophical instruction. But as a discipline, natural philosophy continued to be dominated largely by Aristotle. Two of his commentaries were especially important: the *Physics* and *De Anima* (*On the Soul*). These provided the discipline with many of its underlying assumptions. Natural philosophy was concerned chiefly with understanding natural bodies—their form, motion, shape—and the causalities that altered or affected these bodies. Motion had been introduced into the world by a Prime Mover, and now everything in the world that moved contrary to its natural course did so because of the force being applied to it. Following Aristotle and other Antique writers on nature, natural philosophers accepted that there was an inherent purpose or potential in every created thing, for nothing had been created by chance or without a reason. Matter tended to fulfill these natural purposes and in doing so, it came to a state of rest. Natural philosophers debated these questions of purpose through intellectual speculation and by studying previous writings in their discipline. They only rarely observed or experimented with matter. Aristotle's influence, too, prevented them from stepping outside traditional ideas. Although some experiments disproved Aristotle's physics in the fourteenth century, his authority tended to survive unquestioned. In the fifteenth century this began to change, as natural philosophers embraced alternative theories about nature. The revival of Plato was of key importance in questioning Aristotelian ideas about natural philosophy as Plato's works became better known through more accurate Latin trans-

lations and Greek editions. Nicholas of Cusa had relied upon Platonic ideas about nature when he created the infinite universe of his *On Learned Ignorance.* But Cusa was not alone, and fifteenth-century natural philosophers now investigated other ideas in the works of ancient authorities, including those of Pythagoras, the Stoics, the Epicureans, and the Hermetic tradition. The rise of knowledge of these alternative systems of physics complicated the natural philosophy taught in the Renaissance, and opened up the possibility of new hybrid approaches to the discipline. Over time, too, observation and the testing of the assumptions contained in natural philosophical texts through experiments became more common. But until the advent of Galileo's modern scientific method after 1600, the observation of nature was not seen as a means of establishing a truth, but as a way to confirm what one had read in the works of other authorities. Renaissance thinkers, in other words, remained wedded to the notion of "textual" truth.

SCHOLASTIC SURVIVALS. Although scholasticism is typically thought of as a medieval phenomenon, the movement survived long after the Middle Ages. Scholasticism's vitality persisted in the sixteenth century, helping to shape the teachings of both Protestantism and Catholicism. In Spain many of those who became leaders within the Society of Jesus had trained as scholastic philosophers, and they mixed Thomist teachings with humanism in their educational schemes. Of the Jesuits' many philosophers, the most influential in shaping the development of the society's teaching was Francisco Suarez (1548–1617), who taught a version of Thomism that nevertheless included powerful theological and philosophical arguments drawn from Scotism and nominalism. As a result of the Council of Trent (see Religion: The Council of Trent and the Catholic Reformation), Thomism increasingly became the position of the official theology of the Roman Catholic Church, helping to sustain scholastic instruction into the seventeenth and eighteenth centuries. Scholasticism, too, affected the development of early-modern Protestantism. Protestants like Martin Luther may have criticized medieval philosophy, but Protestant universities soon welcomed the scholastic method. In Germany, Philip Melanchthon and others re-introduced Aristotelian logic and metaphysics into the university curriculum. They adopted the scholastic method in university instruction as well. Elsewhere, in Protestant England, Scotland, and the Netherlands, scholastic philosophy continued to play a role in the early-modern period. And by virtue of the planting of new universities by missionaries and settlers in North and South America, scholasticism exercised an influence in Europe's colonies overseas.

SOURCES

M. Colish, *Medieval Foundations of the Western Intellectual Tradition* (New Haven, Conn.: Yale University Press, 1997).

F. C. Copleston, *Aquinas* (Baltimore, Md.: Penguin Books, 1965).

D. Hay, *Europe in the Fourteenth and Fifteenth Centuries.* 2nd ed. (New York: Holt, 1989).

S. Ozment, *The Age of Reform, 1250–1550* (New Haven, Conn.: Yale University Press, 1980).

C. Schmitt, *Studies in Renaissance Philosophy and Science* (London, England: Variorum Reprints, 1981).

W. A. Wallace, *The Modeling of Nature: Philosophy of Science and Philosophy of Nature in Synthesis* (Washington, D.C.: Catholic University of America Press, 1996).

HUMANISM IN THE EARLY RENAISSANCE

DEFINITION. While scholasticism was dominant in Europe's universities during the fourteenth and fifteenth centuries, humanism also appeared at this time as the primary intellectual innovation of the Renaissance. Humanism first developed in Italy's cities in the fourteenth century, and underwent a process of maturation before affecting intellectual life throughout Europe around 1500. The word "humanism," though, is a modern term created to describe a broad and diffuse movement. There was no intellectual manifesto for humanism, no set of beliefs that all humanists shared, as in modern Marxism or existentialism. Instead humanism describes an intellectual method and a pattern of education that Italy's *umanisti* or humanists embraced in the fourteenth century. These humanists practiced the *studia humanitatis,* the origin of the modern humanities. They believed that an education rooted in the classical texts of ancient Greece and Rome would help to bring about a rebirth of society. Their interests in Antiquity were wide ranging, embracing both the writers of the pagan and the early Christian world. Humanists desired to revive classical literary style and to create graceful speakers and writers who would encourage their audience to pursue virtuous living. The incubator for these ideas was the Italian city, and throughout humanism's long life, the movement often treated the problems that arose from Europe's rapidly urbanizing society. The specific disciplines the humanists stressed in their studies differed across time and place, but an emphasis on rhetoric (the art of graceful speaking and writing), grammar, moral philosophy, and history was usually shared as a common vision. Thus in place of the university's scholastic method

with its emphasis on logic, the humanists' vision of education stressed the language arts. From the first, the humanists distinguished themselves from the scholastics. They attacked the scholastics for their "barbaric," uncultivated Latin style, and for emphasizing logic over the pursuit of moral perfection. This rivalry at first made the universities resistant to humanist learning. In Italy, the movement developed in the cities, in ducal courts, and in monasteries and other religious institutions before it eventually established a foothold within the universities in the fifteenth century. As humanism spread to Northern Europe in the later fifteenth century, it experienced similar resistance. Universities continued to be dominated by the scholastic study of theology and philosophy. By 1500, though, most of Europe's distinguished centers of learning had begun to establish training in the "New Learning," a signal for the adoption of humanist patterns of education. In early-modern Europe the emphasis on the Classics and the humanities became signs of intellectual and cultural distinction and helped to create the modern vision of liberal arts instruction within the universities.

ORIGINS. The first humanist to achieve international renown was Francesco Petrarch (1304–1374), and his interests and ideas shaped the humanist movement for several generations. Petrarch gave up the study of law when he was young and instead devoted himself to literature, particularly the literature of classical Rome. He took the example of the ancient poet Vergil as the model for his poetry, while Cicero was important in shaping his prose. Petrarch self-consciously styled his letters to other humanists to be read by an audience, and in one of these he set forth a new idea of Western history. In place of the traditional periodization, which had stressed the birth of Christ as a key date, Petrarch saw the collapse of Roman authority in Western Europe as decisive. Constantine's abandonment of the Western Empire had given rise to an era of barbarism, from which Petrarch believed that European civilization was only beginning to recover in his time. Thus Petrarch helped to shape the notion of European history as divided into ancient, medieval, and modern periods. In 1341, Petrarch became the first of the humanists to accept the poet laureate's crown, an event that humanists over the following centuries considered the highlight of their revival of letters. Petrarch staged this ceremony himself as a way of self-consciously identifying with the poets of classical Antiquity. His coronation as poet laureate, though, helped spread his celebrity throughout Europe, and for the remainder of his life Petrarch continued to extend his fame through his writing. In these works he expressed a love

for St. Augustine, particularly the autobiographical *Confessions*. Petrarch took this work as a model for his *The Secret, or the Soul's Conflict with Desire*, a work that was unprecedented since Augustine's time in revealing the internal psychological dimensions and tribulations of its author.

THOUGHT. Petrarch's thought lacks a systematic current, but is instead characterized by several recurring themes. Petrarch was deeply Christian in his outlook, but because of his admiration for Antiquity, his Christianity was broad and inclusive. His love for classical literature, too, meant that he was often critical of the scholastics. He disliked intensely the logically structured arguments of medieval philosophers like St. Thomas Aquinas, and he berated the scholastics' style as mere "prattlings." Petrarch argued instead that the chief end of philosophy should be to help human beings to attain moral perfection, not the logical understanding of philosophical truths. These truths were ultimately unknowable and they did not prompt human beings to live virtuous lives. He expressed this position in his famous and often quoted dictum, "It is better to will the good than to understand truth." Petrarch realized that harnessing the human will was essential in any effort to achieve virtue, and so his writings often contained deeply introspective passages in which he recorded his efforts to overcome human passions and to lead a more virtuous life. Petrarch's emphasis on the will in his writings gave rise as well to his argument that rhetoric—the art of persuasive and graceful writing and speaking—inspired morality more profoundly than the study of logic or ethics. The ancient Roman rhetoricians Cicero and Seneca, for instance, prompt their readers to live virtuous lives. By contrast, Aristotle's *Ethics* may promote an intellectual knowledge of morality, but it is incapable of making its readers into better human beings. These ideas together with Petrarch's life and literary corpus provided a powerful example to humanists of his own generation and those that followed. Later humanists emulated Petrarch's love for classical literature and learning, his powerful individuality, and his advocacy of the study of rhetoric in place of traditional scholastic logic.

FLORENCE. It was in Florence that a distinctly humanist culture first emerged in Renaissance Italy. Coluccio Salutati (1331–1406), a disciple of Petrarch, was a key figure in the development of humanism within the city. Salutati served the city as its chancellor or chief administrator in 1375 and he remained there until his death. His success in this post helped to quiet Florence's long-standing tradition of factional infighting among its powerful families, and in the quieter years after Salutati's

a PRIMARY SOURCE *document*

A HUMANIST DECIDES HOW TO ACHIEVE VIRTUE

INTRODUCTION: Petrarch's career exemplified many of the dimensions of learning that would become associated with Renaissance humanism: a love for poetry, an insatiable taste for the works of the classical philosophers, and a desire to create a personal philosophy that would treat the despair and disappointments that arise from living. Petrarch's letters were particularly important in spreading his ideas among other humanists and they helped to produce a new fashion for letters as a way of treating philosophical issues. Sometime in his middle age, Petrarch sent a letter to his friend Dionisio da Borgo San Sepolocro, a monk and professor of philosophy at the University of Paris. In it, he described a journey that he had taken up Mt. Ventoux in southeastern France; the climb became a symbol for Petrarch's journey through life. In the following passage Petrarch engaged in an intense self-examination, scrutinizing his desire for worldly fame. He concluded his letter to Dionisio with the realization that the search for notoriety in this world could not compare in magnitude and importance with the pursuit of moral perfection that leads to eternal happiness.

While I was thus dividing my thoughts, now turning my attention to some terrestrial object that lay before me, now raising my soul, as I had done my body, to higher planes, it occurred to me to look into my copy of St. Augustine's Confessions, a gift that I owe to your love, and that I always have about me, in memory of both the author and the giver. I opened the compact little volume, small indeed in size, but of infinite charm, with the intention of reading whatever came to hand, for I could hap-

pen upon nothing that would be otherwise than edifying and devout. Now it chanced that the tenth book presented itself. My brother, waiting to hear something of St. Augustine's from my lips, stood attentively by. I call him, and God too, to witness that where I first fixed my eyes it was written: "And men go about to wonder at the heights of the mountains, and the mighty waves of the sea, and the wide sweep of rivers, and the circuit of the ocean, and the revolution of the stars, but themselves they consider not." I was abashed, and … I closed the book, angry with myself that I should still be admiring earthly things who might long ago have learned from even the pagan philosophers that nothing is wonderful but the soul, which, when great itself, finds nothing great outside itself. Then, in truth, I was satisfied that I had seen enough of the mountain; I turned my inward eye upon myself, and from that time not a syllable fell from my lips until we reached the bottom again. Those words had given me occupation enough, for I could not believe that it was by a mere accident that I happened upon them. What I had there read I believed to be addressed to me and to no other, remembering that St. Augustine had once suspected the same thing in his own case, when, on opening the book of the Apostle, as he himself tells us, the first words that he saw there were, "Not in rioting and drunkenness, not in chambering and wantonness, not in strife and envying. But put ye on the Lord Jesus Christ, and make not provision for the flesh, to fulfil the lusts thereof."

SOURCE: Petrarch, "Letter to Dionisio da Borgo San Sepolocro," in *Petrarch: The First Modern Scholar and Man of Letters.* Trans. James Harvey Robinson (New York: G. P. Putnam, 1898): 316–318.

arrival, learning began to flourish in the city. Salutati encouraged the development of humanism in Florence by inviting scholars to come to the town. Of the many immigrants who took up residence during Salutati's years in Florence, Poggio Bracciolini (1380–1459) was important in deepening knowledge of classical Antiquity. Salutati had hired Bracciolini to copy important classical manuscripts so that their insights might be made available to other scholars at work in the city. But Poggio did far more than merely serve as a scribe. He combed through Florence's rich monastery libraries and those in surrounding Tuscany. He used his trips outside Tuscany to deepen his knowledge of classical literature, too. While attending the Council of Constance (1414–1417), he spent his free hours searching for texts in the libraries of Southern Germany and Switzerland. The result of his research there uncovered many of Cicero's orations as

well as ancient rhetorical manuals, which became guides to Florence's humanists as they tried to recover a purer classical Latin style. Knowledge of these texts circulated quickly through Florence's growing humanist contingent, in part through the efforts of Niccolò Niccoli (1363–1437), who collected these texts and founded Europe's first lending library to serve the city's scholars.

REVIVAL OF GREEK. Humanists of Petrarch's generation had confined their efforts to the study of classical Latin texts, but around 1400 knowledge of the Greek classics began to expand dramatically. In this regard, Florence led the way by establishing the first European professorship of Greek in 1360. Of those who held this position, Manuel Chrysoloras (c. 1350–1415) was chiefly responsible for creating a resurgence in the study of Greek. He arrived in Florence in 1397 at Salutati's

a PRIMARY SOURCE *document*

LIBERAL EDUCATION

INTRODUCTION: In 1404, the humanist Pier Paolo Vergerio wrote one of the first humanist treatises on education. The ideas that he sets forth in the book—that liberal education is necessary for the formation of men capable of governing—link him to the civic humanist tradition that was developing in early fifteenth-century Florence. The work was widely read and shaped the training of young men in Florence and throughout Italy in the fifteenth century.

We call those studies *liberal* which are worthy of a free man; those studies by which we attain and practise virtue and wisdom; that education which calls forth, trains and develops those highest gifts of body and of mind which ennoble men, and which are rightly judged to rank next in dignity to virtue only. For to a vulgar temper gain and pleasure are the one aim of existence, to a lofty nature, moral worth and fame. It is, then, of the highest importance that even from infancy this aim, this effort, should constantly be kept alive in growing minds. For I may affirm with fullest conviction that we shall not have attained wisdom in our later years unless in our earliest we have sincerely entered on its search. Nor may we for a moment admit, with the unthinking crowd, that those who give early promise fail in subsequent fulfillment. This may, partly from physical causes, happen in exceptional cases. But there is no doubt that nature has endowed some children with so keen, so ready an intelligence, that without serious effort they attain to a notable power of reasoning and conversing upon grave and lofty subjects, and by aid of right guidance and sound learning reach in manhood the highest distinction. On the other hand, children of modest powers demand even more attention, that their natural defects may be supplied by art ...

We come now to the consideration of the various subjects which may rightly be included under the name of 'Liberal Studies.' Amongst these I accord the first place to History, on grounds both of its attractiveness and of its utility, qualities which appeal equally to the scholar and to the statesman. Next in importance ranks Moral Philosophy, which indeed is, in a peculiar sense, a 'Liberal Art,' in that its purpose is to teach men the secret of true freedom. History, then, gives us the concrete examples of the precepts inculcated by philosophy. The one shews what men should do, the other what men have said and done in the past, and what practical lessons we may draw therefrom for the present day. I would indicate as the third main branch of study, Eloquence, which indeed holds a place of distinction amongst the refined Arts. By philosophy we learn the essential truth of things, which by eloquence we so exhibit in orderly adornment as to bring conviction to differing minds. And history provides the light of experience—a cumulative wisdom fit to supplement the force of reason and the persuasion of eloquence. For we allow that soundness of judgment, wisdom of speech, integrity of conduct are the marks of a truly liberal temper.

SOURCE: Pier Paolo Vergerio, "The Qualities of a Free Man," in *Vittorino Da Feltre and Other Humanist Educators.* Ed. William H. Woodward (Cambridge: Cambridge University Press, 1921): 102–110.

instigation, and during his three-year tenure in the city, he taught Greek to many outstanding humanists, including Salutati, Poggio Bracciolini, Leonardo Bruni (1370–1444), and Pier Paolo Vergerio (1370–1444 or 1445). Chrysoloras's tenure at Florence produced great enthusiasm for the study of Greek, and knowledge of the language steadily grew among humanists during the fifteenth century. After leaving Florence in 1400, Chrysoloras taught in a similar fashion in Milan and Pavia, and his activities in these places produced similar results. In the next few decades as humanists throughout Italy devoted themselves to recovering antique texts, knowledge of the Greek tradition expanded apace with the recovery of Latin sources. In 1418 Ciriaco D'Ancono traveled to Greece to collect classical texts, and in 1423 Giovanni Aurispa returned from a journey there laden with more than 230 volumes of classical Greek manuscripts. As a result of his reception in Italy during the Council of Ferrara-Florence (1438–1445) the Greek Cardinal Bessarion later left his collection of more than 800 Greek works to the city of Venice, where they became the foundation for the city's Marciana Library. While knowledge of Greek grew in the fifteenth century, many humanists were still unable to master the language. Translations out of the Greek and into Latin continued to feed the desire of many scholars for a more direct knowledge of the Greek classics. Of the many translation projects undertaken by the humanists in the fifteenth century, none was more important than Marsilio Ficino's translation of all the surviving works of Plato into Latin during the 1460s. With the completion of this project, Italy's humanists finally possessed a detailed knowledge of the entire scope of Plato's ideas, something that scholars had longed for since the days of Petrarch.

The city of Florence. CORBIS. REPRODUCED BY PERMISSION.

CIVIC HUMANISM. The humanist culture that Salutati and others introduced into Florence matured during the period between 1400 and 1440. A lineage of humanist chancellors succeeded Salutati, of whom Leonardo Bruni was the most notable. Bruni served as chancellor during the period between 1427 and 1444, continuing the tradition that had by then developed of civic support for the arts and humanist scholarship. A number of artistic projects undertaken during Bruni's period as chancellor gave Florence the veneer of a classical Roman city. These included the doors of the baptistery, the dome of the cathedral, and a number of churches, public buildings, and patrician palaces. These new movements evoked the antique past and were largely designed and executed by the Renaissance artists Filippo Brunelleschi, Leon Battista Alberti, and Michelozzo Michelozzi. Artists established ties with Florence's circle of humanists. Alberti, for instance, was both a practicing architect and a humanist, and he spent his time writings treatises on marriage and family life even as he codified the rules of visual perspective and revived ancient architectural style. Although Bruni's day-to-day government work consumed his time, he continued to nourish his scholarly interests. He completed Latin translations of works of Aristotle, Plato, Plutarch, and other Greek writers, which became models of cultured style imitated by other Florentines. His *History of the Florentine People* was a widely popular work among the city's humanist circle, and although written in Latin, each volume's immediate translation into the local Tuscan dialect reached the broadest possible audience. In the work, Bruni argued that Florence had been founded during the Roman Republic, and not, as had been previously thought, in the era of the empire. The work, together with other monuments of Florence's artistic and literary life, glorified Florentine patriotism for its defense of civic liberty. More generally, an emphasis on civic values and the arts of good government was a subject that the Florentine humanists frequently took up in the works written in this period. The "civic humanism" that appeared in these years advocated an active life engaged in government and society as the most conducive to virtue. The town's civic humanists also celebrated the republican virtues of ancient Rome and they saw Florence as the modern heir to the ancient arts of good government.

a PRIMARY SOURCE *document*

ON THE WILL

INTRODUCTION: In his *Dialogue on Free Will* Lorenzo Valla considered a perennial philosophical question: What part does God play in the creation of evil? The work was fashioned as a conversation between Valla and his friend Antonio Glarea. The two debated the nature of free will and predestination, considering the age-old question, Did God create Judas Iscariot, the betrayer of Christ, knowing that he would be damned for his treachery? In the *Dialogue* Valla held to an extreme interpretation of predestination, one that would mirror the position later developed by Luther and Calvin during the sixteenth century. Toward the end of the dialogue, Lorenzo Valla delivers his own conclusions on predestination, stressing that God's will is inscrutable and that all the Christian can do is to have a simple faith in the promises that Christ has made in the gospels.

I said that the cause of the divine will which hardens one and shows mercy to another is known neither to men nor to angels. If because of ignorance on this matter and on many others the angels do not lose their love of God, do not retreat from their service, and do not consider their own blessedness diminished on that account, should we for this same reason depart from faith, hope, and charity and desert as if from a commander? And if we have faith in wise men, even without reason, because of authority, should we not have faith in Christ who is the Power and Wisdom of God? He says He wishes to save all and that He does not wish the death of the sinner but rather that he be converted and live. And if we loan money to good men without a surety, should we require a guarantee from Christ in Whom no fraud may be found? And if we entrust our life to friends, should we not dare to entrust it to Christ, who for our salvation took on both the life of the flesh and the death of the cross? ...

What is more arrogant or mad than this, or how could God by more manifest judgment condemn his cleverness and that of others like him than by letting him be turned into a madman by immoderate greed for knowledge and thus bring his own death on himself, a death, I say, far more horrible than that of the most wicked Judas? Let us therefore shun greedy knowledge of high things, condescending rather to those of low estate. For nothing is of great avail for Christian men than to feel humble. In this way we are more aware of the magnificence of God, when it is written: "God resisteth the proud and giveth grace to the humble." To attain this grace I will no longer be anxious about this question lest by investigating the majesty of God I might be blinded by His light.

SOURCE: Lorenzo Valla, *Dialogue on Free Will* in *The Renaissance Philosophy of Man.* Ed. E. Cassier, P. O. Kristeller, and J. H. Randall, Jr. (Chicago: University of Chicago Press, 1948): 180–181.

HUMANISM BEYOND FLORENCE. In part because of the success of the humanists at Florence, elites in northern and central Italy embraced humanism as the preferred means of preparing men to enter into government service. Often, students who had trained with Salutati, Bruni, and other Florentine scholars spread the new learning to cities throughout the peninsula. By 1450, humanists were active as civil servants, diplomats, and secretaries in most of Italy's important city governments, and humanist training became more and more essential as preparation for those who wished to undertake careers in government. Outside urban governments, humanists also worked in the courts of Italy's dukes and in the governments of church officials, including those of the pope. In addition, many who had received humanist training served as private tutors in the households of the elite, while humanists also taught in Italy's secondary schools and universities. The most fortunate of humanist scholars sometimes became "scholars-in-residence" at the courts of Italian dukes, in the church at Rome, or in the households of merchant princes. In these positions a scholar received a salary merely in exchange for pursuing his studies. Marsilio Ficino (1433–1499) was one such humanist, who was singled out by the Medici family in Florence for patronage. The son of the family's physician, Ficino exhibited precocious scholarly talents at an early age. When not yet thirty, the Medici set him up with a pension and a town house and a villa outside Florence in which he pursued his studies and translations of Plato. Lorenzo Valla (1405–1457), one of the outstanding humanists of the fifteenth century, received similar appointments, first in the household of the king of Naples and later at the papal court at Rome. Most humanist scholars, though, struggled to pursue their love of learning while working in government positions or teaching their craft.

INTENSIFICATION OF LITERARY STUDIES. As humanism spread from Florence throughout Italy, an increasing sophistication developed in the movement's critical study of languages. The career of Lorenzo Valla exemplifies this trend. Valla was the most distinguished

of the many students trained by Leonardo Bruni at Florence and early in his life he displayed a keen understanding of classical Latin and Greek. When he was not yet thirty he had written a grammar of classical Latin entitled *The Elegancies of the Latin Language*. During the next century the *Elegancies* became the dominant Latin grammar used by students of the language. Valla's nature was impetuous, though, and the criticisms that he made of scholasticism's barbaric Latin style offended his colleagues at the University of Padua. Soon after he completed the *Elegancies*, Valla fled Padua for Naples. There he enjoyed the most productive period of his career, devoting himself to perfecting the philological method. As Valla developed philology, it became a tool for studying the original meanings of words in texts. With the disciplined techniques that he developed, he was able to authenticate or deny the originality of documents that historians had long relied upon. He found many of the texts that had long been used to justify historical developments to be forgeries. His studies disproved the authenticity of *The Donation of Constantine*, a document that had long been a foundation of papal authority. Valla examined the text, which reputedly ceded secular control over Western Europe to the Roman pope. He found words, phrases, and concepts used in the document that had not existed during Constantine's life, and he demonstrated that the *Donation* was probably written in the late eighth or early ninth century, hundreds of years after the Roman emperor's death. Other philological studies that he undertook in this period denied the authenticity of the Apostle's Creed and pointed out inaccuracies in St. Jerome's Latin translation of the Bible, the *Vulgate*, that had long been used in Western Europe. Valla's critical scholarship raised the suspicions of the Inquisition at Naples, but although they questioned him, they allowed him to continue his studies. In the final years of his life he took up a position at Rome under the patronage of Nicholas V, the first humanist-trained pope.

EPICUREANISM. Until Valla's time most humanists had been attracted to those ancient philosophies that stressed self-denial and the pursuit of moral perfection. In the generations following Petrarch the humanists had often argued that mastering the human will through self-examination and self-denial was key if one hoped to attain a virtuous life. Lorenzo Valla's life and ideas, though, point to the growing philosophical variety of fifteenth-century humanism. Early in life he had been drawn to the ideas of the ancient Greek philosopher, Epicurus, who had argued that the pursuit of pleasure was humanity's life-giving principle. Valla made use of Epicurus's insights concerning the importance of pleasure to

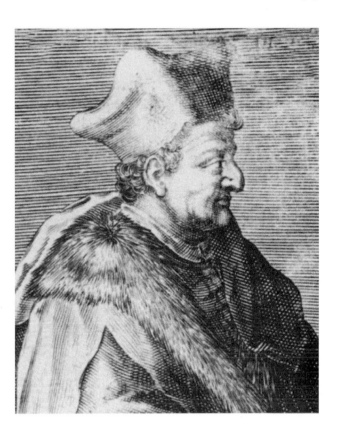

Lorenzo Valla. **MARY EVANS PICTURE LIBRARY.**

create a surprisingly original philosophy. In *On Pleasure*, a work completed during Valla's final years at Rome, he outlined a synthesis of ancient Greek Epicureanism with Christianity. On its surface, the text seemed to praise the joys and pursuits of the ancient pagans. But beneath this surface, Valla presented a highly moral Christian philosophy that would later be echoed in the works of sixteenth-century Protestants like Martin Luther and John Calvin. Only Christianity, according to Valla, offered a way out of the cycle of human sinfulness. The sinful human will, according to Valla, could not be overcome, nor could human beings hope to achieve moral perfection. But Christianity, through its pursuit of the higher aim of love, offered a means for human beings to substitute the pursuit of God's love for earthly pleasure. In this way the Christian religion presented humankind with a genuine way out of the dismal cycle that the pursuit of pleasure created. While these ideas were highly original, Valla's Christian Epicureanism found few admirers during his lifetime. His critical scholarly methods, though, inspired humanists in the late fifteenth and early sixteenth centuries.

SOURCES

De Lamar Jensen, *Renaissance Europe* (Boston: Heath, 1992).

C. Nauert, *Humanism and the Culture of Renaissance Europe* (Cambridge, United Kingdom: Cambridge University Press, 1995).

A. Rabil, Jr., ed., *Renaissance Humanism: Foundations, Forms, and Legacy.* 3 vols. (Philadelphia: University of Pennsylvania Press, 1988).

C. Trinkaus, *In Our Image and Likeness. Humanity and Divinity in Italian Humanist Thought* (Chicago: University of Chicago Press, 1970).

R. G. Witt, *In the Footsteps of the Ancients; Italian Humanism from Lovato to Bruni* (Leiden, Netherlands; Boston: Brill, 2000).

RENAISSANCE PLATONISM

ORIGINS. Medieval scholastic philosophers had often revered Plato, even though very few of his works were directly known to them. Plato's dualism (the notion that the spiritual was inherently superior to the physical) and his realism (the notion that the realm of ideas shaped our sensory perception of the world or that the things that we see are only dim reflections of universal ideals or forms) seemed to fit with Christian ideas about the world. Very few of Plato's works, though, had survived in the Middle Ages. Some were available in Greek, but knowledge of Greek was almost non-existent in medieval Europe. Most scholastics knew of Plato's ideas only secondhand. They were known, in other words, from the writings of St. Augustine, the late antique Platonic philosopher Plotinus, and the early medieval scholar Boethius. Francesco Petrarch had collected some of Plato's works in their original Greek, but he struggled unsuccessfully to learn the language. With the revival of the knowledge of Greek that occurred in Florence and other Italian cities after 1400, scholars began to read Plato and other Greek philosophers in their original texts. By the mid-fifteenth century knowledge of Greek expanded even further because of the political situation in the Eastern Mediterranean. By 1450, the Byzantine Empire, the descendant of ancient Rome, faced conquest at the hands of Islamic Turks. Although Byzantium had long been wealthier and more sophisticated than Western Europe, the empire building of Islamic states, particularly the Turks in the Eastern Mediterranean, had caused the empire's power and dominions to shrink over the last few centuries. Italy now became home to many cultivated scholars fleeing Islamic domination in the East. Among these, George Gemesthis Plethon (c. 1355–1450 or 1452) and Cardinal Bessarion (1403–1472) were important in helping to spread a detailed knowledge of the Greek classics and to advance the study of

Plato in Italy. Both Plethon and Bessarion attended the Council of Ferrara-Florence in 1439, where they exercised a profound influence on humanist scholars.

NEW TRANSLATIONS. In 1462, Cosimo de Medici, patriarch of the merchant banking house, asked Marsilio Ficino to complete a translation of Plato's works from a collection of manuscripts he had recently purchased. Even by the cultured standards of fifteenth-century Florence, Ficino was an extraordinary figure. The son of the Medici family physician, he had entered the University of Florence at an early age to study Latin grammar and rhetoric. He received training in Aristotelian physics and logic, too, but his father had intended that he pursue a career as a physician, and so he completed medical training. Healing became an important concept, both in his writings on medicine and in those that treated philosophy. His philosophical works, in other words, frequently aimed to heal the human soul. Ficino's interests were wide ranging. From his medical training he was also well versed in pharmacology and astrology (an important science to those who practiced medicine). He was a practicing alchemist, nourished an interest in music and music theory, and was an accomplished poet. He was also ordained a priest, wrote theological treatises, and was even considered at one point in his life for election as a bishop.

PLATONIC ACADEMY. It was long supposed that the Medici had supported the development of a formal academy in Florence to study the works of Plato, in which Marsilio Ficino served as the director. This myth of the Florentine Academy as a school seems, in part, to have been created by the sixteenth-century Medici to bolster their reputation for long-standing patronage of the arts. While a group of scholars seems to have coalesced around Ficino from the 1460s, they were a loosely knit society who met to discuss philosophical issues and to learn from Ficino's encyclopedic knowledge of Plato. The kind of philosophy that arose from this group was eclectic, and stressed privacy and contemplation. The Florentine Platonists placed a high value on meditation and mysticism with the goal to become God-like, something they thought was possible to humankind because of the race's creation in the likeness of God. The Florentine interest in Platonism during the second half of the fifteenth century marked a turning away from the active life of public duty that the civic humanists had advocated in the early 1400s. This transformation was part of a general shift away from civic involvement in the later Italian Renaissance to more personal modes of mystical contemplation. Renaissance Platonism became one of the most important intellectual fashions of the age, and its teach-

ings spread throughout Europe to shape religious beliefs, the visual arts, and learned culture over the next century and a half.

FICINO'S PLATONISM. During the 1460s Ficino completed most of his translations of Plato's works from the manuscripts supplied to him by the Medici, but he continued to revise his translations until their publication in 1484. While working on the Platonic translations, Ficino received a request from Cosimo de Medici to complete a Latin translation of the *Corpus Hermeticum*. These were mystical and magical texts that survived in fragmentary form from ancient Egypt and which ranged over a variety of occult subjects, including alchemy, astrology, and numerology. These texts treated the knowledge of the occult as branches of practical science. Ficino interrupted his studies of Plato to complete the translation of these hermetic works, and influences from his readings of these magical texts found their way into his most important work, his *Platonic Theology*. Ficino began this work in 1469 and completed it five years later. He intended the *Theology* to be a philosophical summation, like the medieval summas of figures like Aquinas, that would merge Plato's teachings with Christianity. The work's length, not to mention its repetitive and difficult nature, prevented a thorough examination of its ideas by most students of philosophy, including most of Ficino's own fifteenth-century disciples. While many of his followers adopted its ideas concerning the soul's divine nature, they were less rigorous in emulating Ficino's complex metaphysics. Some disciples popularized smatterings of the text's metaphysical ideas, but few understood all of Ficino's complex notions. Ficino saw his role as being one of harmonizing Christianity with Platonism. To be sure, Christian thinkers had long relied on Platonic concepts to make Christianity intelligible as a philosophic system. But Ficino was the first Western thinker to understand Plato's ideas and those of his commentators in their entirety. Harmonizing true ancient Platonism with Christianity was considerably more of a challenge. Like Plato, the most important dimensions of Ficino's thought were his strong dualism and realism. Ficino thought that the realm of universals or Platonic forms shaped all human life on earth and all human perceptions. In addition, his thought stressed that the physical world was inherently inferior to the spiritual, or internal world. Ficino and other Florentine Platonists championed the doctrine of Platonic love that became immensely popular in the sixteenth century. The term today describes non-sexual attractions between the sexes. For Ficino and other Renaissance Platonists, Platonic love meant a great deal

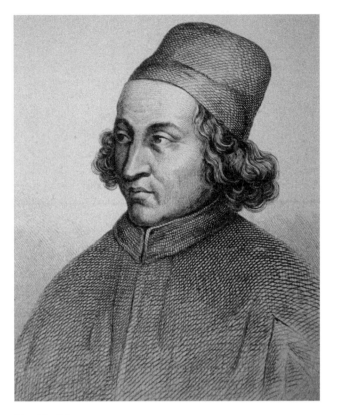

Marsilio Ficino. **THE LIBRARY OF CONGRESS.**

more than this. This form of attraction was a true meeting of the minds on the highest plane of reality, that is, in the realm of universals. Since the Platonists were usually men, Platonic love occurred within the male sex. According to Platonists like Ficino, this intellectual love was inherently superior to erotic attraction. Ficino and some of his disciples consequently advocated chastity just as vigorously as had medieval monks.

METAPHYSICS. According to Ficino, human beings inhabit a cosmos filled with spheres and intelligences. In the highest or supercelestial sphere one finds God, and beneath God is a many-storied universe consisting first of the angels and intelligences (ideas and semi-animate beings that motivate actions in people), the planets and fates, the souls of men, and finally the realm of the natural world. According to Ficino and later Platonists, every realm above humankind has the power to shape and influence human life, thought, and actions. The realms of God, the angels, intelligences, and fates affect human beings' mind, soul, and intellect. In addition, however, human beings are governed from below by their instincts. The human creature, then, is distinct among all Creation because it occupies an intermediate position between the realms of higher ideas, intelligences, and so forth, and the physical world. Human beings can

a PRIMARY SOURCE *document*

THE HUMAN MIND

INTRODUCTION: Marsilio Ficino wrote his little tract called *Five Questions Concerning the Human Mind* in 1476, shortly after he had completed his monumental synthesis of Christianity and platonic philosophy entitled *Platonic Theology*. As in many of Ficino's works, he argues that the aim of the soul is the search after truth, which ends in God. To accomplish this journey, the soul's appetite must be whetted for divine perfection. In this passage Ficino also argues that the universe is infinite, one of the contributions of Platonism to the intellectual landscape of Europeans.

It is indeed necessary to remember that the universe, which we say is the end of the soul, is entirely infinite. We reckon to be peculiar and proper to each thing an end for which that thing characteristically feels a very strong desire, as if this end were the highest good for it; an end, moreover, for whose sake it desires and does everything else; and in which at length that thing rests completely, so much so that it now puts an end to the impulses of nature and desire. Surely, the condition natural to our intellect is that it should inquire into the cause of each thing and in turn, into the cause of the cause. For this reason the inquiry of the intellect never ceases until it finds that cause of which nothing is the cause but which is itself the cause of causes. This cause is none other than the boundless God. Similarly, the desire of the will is not satisfied by any good, as long as we believe that there is yet another beyond it. Therefore, the will is satisfied only with that one good beyond which there is no further good. What can this good be except the boundless God? As long as any truth or goodness is presented which has distinct gradations, no matter how many, you inquire after more by the intellect and desire further by the will. Nowhere can you rest except in boundless truth and goodness, nor find an end except in the infinite. Now since each thing rests in its own especial origin, from which it is produced and where it is perfected, and since our soul is able to rest only in the infinite, it follows that that which is infinite must alone be its especial origin. Indeed, this should properly be called infinity itself and eternity itself rather than something eternal and infinite. Certainly, the effect nearest to the cause becomes most similar to the cause. Consequently, the rational soul in a certain manner possesses the excellence of infinity and eternity. If this were not the case, it would never characteristically include toward the infinite. Undoubtedly this is the reason that there are none among men who live contentedly on earth and are satisfied with merely temporal possessions.

SOURCE: Marsilio Ficino, "Five Questions Concerning the Human Mind," Trans. J. Burroughs. In *The Renaissance Philosophy of Man*. Ed. E. Cassirer, P. O. Kristeller, and J. H. Randall, Jr. (Chicago: University of Chicago Press, 1948): 201–202.

decide which realm—spiritual or physical—they want to inhabit. For Ficino, though, the central task of philosophy became to wean oneself away from attachment to earthly or physical things and to find ways to return to God. Thus much of his *Platonic Theology* dealt with learned magic or the "occult sciences" which Ficino believed could aid the human soul in returning to its origins in God. The soul's reunion with God could also be accomplished through cultivating poetry, prophecy, and meditation, or occur in the dream world of sleep, the unconsciousness of comas, and in certain psychological states.

ANCIENT THEOLOGY. Renaissance Platonism had its origins in humanism's hunger for knowledge of classical Antiquity. It is hardly surprising, given Ficino's bent toward philosophical synthesis, that he adopted a new stance concerning ancient religion and philosophy. Throughout his works he frequently argued that God had granted the ancient pagans a line of religious teachers who had taught philosophical insights that ran parallel to those he had supplied to the Jews through the Hebrew prophets. Ficino called this notion *prisca theologica*, meaning that a divinely inspired ancient theology ran through all pagan religions. The fountainhead of this wisdom had been the Persian teacher Zoroaster, but Ficino insisted that the tradition of the ancient theology had achieved its full and final expression in the works of Plato. Thus Christians could profitably study the religious works of antique pagans as divinely inspired wisdom that mirrored the truths God had also given to Moses. In this way Ficino moved to christianize the works of the ancient philosophers.

PICO. Many of Ficino's ideas reached a broader audience through the brief but notable career of Giovanni Pico della Mirandola (1463–1494). Pico was a nobleman, born to an ancient family of counts, but he renounced his inheritance in exchange for money to underwrite his studies. At fourteen he left home to study law in Bologna, but soon moved on to the universities at Ferrara and Padua. In the last institution, Pico became familiar with the works of Marsilio Ficino, and he soon began to correspond with Lorenzo de Medici and

a PRIMARY SOURCE *document*

HUMANISM ON HUMAN DIGNITY

INTRODUCTION: The widely-read scholar, Giovanni Pico della Mirandola was an admirer of Platonism and believed that there was a certain common foundation to all human religions. In his *Oration on the Dignity of Man* Pico praised the dignity of humankind because of its creation in the image and likeness of God. Sparked with the divine spark that God's creation gave to the species, human beings could achieve great things. They could also, as this passage shows, act as the great chameleons of the universe, modulating their behavior to various purposes.

O supreme generosity of God the Father, O highest and most marvelous felicity of man! To him it is granted to have whatever he chooses, to be whatever he wills. Beasts as soon as they are born ... bring with them from their mother's womb all they will ever possess. Spiritual beings, either from the beginning or soon thereafter, become what they are to be forever and ever. On man when he came into life the Father conferred the seeds of all kinds and the germs of every way of life. Whatever seeds each man cultivates will grow to maturity and bear in him their own fruit. If they be vegetative, he will be like a plant. If sensitive, he will become brutish. If rational, he will grow into a heavenly being. If intellectual, he will be an angel and the son of God. And if, happening in the lot of no created thing, he withdraws into the center of his own unity, his spirit, made one with God, in the solitary darkness of God, who is set above all things, shall surpass them all. Who would not admire this our

chameleon? Or who could more greatly admire aught else whatever? It is man who Asclepius of Athens, arguing from his mutability of character and from his self-transforming nature, on just grounds says was symbolized by Proteus in the mysteries. ...

Are there any who would not admire man, who is, in the sacred writings of Moses and the Christians, not without reason described sometimes by the name of "all flesh," sometimes by that of "every creature," inasmuch as he himself molds, fashions, and changes himself into the form of all flesh and into the character of every creature? For this reason the Persian Euanthes, in describing the Chaldaean theology, writes that man has no semblance that is inborn and his very own but many that are external and foreign to him; ... Let a certain holy ambition invade our souls, so that, not content with the mediocre, we shall pant after the highest and (since we may if we wish) toil with all our strength to obtain it.

Let us disdain earthly things, despise heavenly things, and finally, esteeming less whatever is of the world, hasten to that court which is beyond the world and nearest to the Godhead. There as the sacred mysteries relate, Seraphim, Cherubim and Thrones hold the first places; let us, incapable of yielding to them, and intolerant of a lower place, emulate their dignity and their glory. If we have willed it, we shall be second to them in nothing.

SOURCE: Giovanni Pico della Mirandola, *Oration on the Dignity of Man*, in *The Renaissance Philosophy of Man*. Ed. E. Cassirer, P. O. Kristeller, and John Herman Randall, Jr. (Chicago: University of Chicago Press, 1948): 225–227.

other Florentine humanists. Pico left Italy for the University of Paris in 1485, and he returned a year later. Upon his return he circulated and had printed a collection of *900 Theses* he had culled from his studies of ancient religions and philosophies. Like Ficino, Pico believed in a shared unity of religious and philosophical truths across the ancient religions, and he intended his *Theses* to be a definitive statement of these shared truths. He drew these from the works of pagans, Muslims, Christians, and Jews, and he intended to have his *Theses* debated at a conference to be held at Rome. But Pico's adventurous reading of texts from various religious traditions and his assertion that all religions shared in the same truths as Christianity caused the pope to examine the *Theses*. A commission appointed by Pope Innocent VIII declared thirteen of the work's assertions to be heretical, and when Pico refused to recant, the pope responded by condemning the entire document. The

philosopher left for Paris shortly afterward, although he reconciled with the church shortly before his untimely death. Despite his short life, Pico's fame continued to live on, primarily through the document that has long been known as his *Oration on the Dignity of Man*. That work, which Pico circulated to stir debate for his *Theses*, extravagantly praised human dignity because of its spiritual descent from the mind of God. It argued that the highest calling of the human race was to seek the communion of the angels and higher intelligences that populated the celestial spheres. But it admitted that human beings were often "chameleon-like," and were more interested in emulating the beasts of the field than they were in rising to the heavens.

INFLUENCES ON THE ARTS AND SCIENCE. Renaissance Platonism praised creativity as a sign of humankind's creation in God's likeness. It became a widely popular philosophy, particularly in Florence, during the

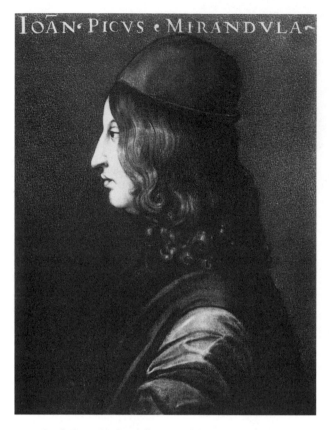

Portrait of Giovanni Pico della Mirandola. **PUBLIC DOMAIN**.

Lorenzo de' Medici. **PUBLIC DOMAIN**.

second half of the fifteenth century. There its ideas helped to shape the artistic world that would soon be known as the High Renaissance. The Platonists celebrated human creativity as evidenced in poetry and literature as divine attributes and they searched for ways in which the soul could return to commune with God. Artists relied on these and other ideas from the movement to argue that, like the poet, their creations were the product of humankind's divine genius. In this way they helped begin the process that elevated the artist's status above the medieval notion of a craftsman. Although he was not a humanist, Michelangelo Buonarroti was influenced by the vogue for Renaissance Platonism in his native Florence, and its ideas found expression in his poetry and other writings. Even during his lifetime, he was frequently interpreted as someone sparked with the flame of divine inspiration, an interpretation that would have been largely unthinkable without Platonism's celebration of creativity as a sign of humankind's creation in God's likeness. Michelangelo's sonnets also praised the skill of the sculptor to liberate Platonic forms that lay hidden and pre-existent in the marble he sculpted. And his painted compositions made use of Renaissance Platonism's ideas about the importance of

shapes; he frequently relied on circles and triangles to give his compositions form, shapes that had been praised by Renaissance Platonists for their strength and mystical meanings. Elsewhere in Italy, the philosophical movement's influence helped inspire the popularity of central-style churches. Within these buildings—constructed either as a Greek cross or in the round—the most distant worshiper could be no farther from the altar than another in the remaining three wings of the church. The architect Bramante had originally planned the new St. Peter's Basilica (begun after 1506) in this way, but the plan was later altered to make the building conform to the more traditional pattern of a Latin cross. Architects also used the harmonies and proportions that Platonic philosophers insisted lay hidden within the universe, and this emphasis on the importance of shape and mathematical proportion influenced the sciences, too. Renaissance Platonism taught that the heavenly spheres, intelligences, and angels that populated the celestial realms influenced life on earth. Through Natural Magic the Platonist hoped to use these relationships to best advantage in one's daily affairs. Thus astrology and other occult sciences were often profoundly important to the Platonist. In spite of this strikingly non-scientific way

of thinking about the world, some Renaissance Platonism ideas proved important in the shaping of a more modern scientific mentality. For the Platonist, mathematical laws governed all natural processes and the numerical relationships that were in evidence in Creation were part of the hidden mysteries of the universe that might be unlocked through mathematical investigation. Platonism thus helped to promote a growing arithmetical sophistication in Europe, as disciples of the movement frequently searched for the harmonies and numerical relationships they perceived as underlaying Creation. Nicholas Copernicus and Johannes Kepler, promoters of the sun-centered or heliocentric universe, were just two of many Renaissance scientists whose thinking about the natural world was, in part, shaped by Platonism.

SPREAD OF RENAISSANCE PLATONISM. In the second half of the fifteenth century Florence had been the center of Renaissance Platonism. By 1500, though, disciples of the movement appeared in every country in Europe. In Germany, the Christian Hebraist Johannes Reuchlin was one of the first to be attracted to the movement. Through his friendship with Ficino and Pico he became convinced of the profound spiritual insights that Platonism offered. He devoted himself especially to studying the collection of Jewish mystical writings known as the Cabala, an interest he shared with Italian Platonists. Through two treatises he popularized their study within Germany's growing group of humanists. His taste for Jewish wisdom eventually embroiled him in international controversy, and led to his condemnation by Rome (see Religion: Humanism: Reuchlin Affair). In France, Jacques Lefèvre D'Etaples (1450–1536) was also a disciple of Pico and Ficino, and he nourished an interest in mystical writers. He published Ficino's translations of the hermetic texts and continued to pursue the studies of the Jewish Cabala that Pico and Reuchlin had begun. In England, Renaissance Platonism took root earlier than in many parts of Northern Europe thanks to a group of English scholars who had traveled to study with Ficino and Pico in the 1460s and 1470s. By the early sixteenth century the movement produced the brilliant scholar John Colet, who served as the dean of St. Paul's Cathedral in London. In a series of famous lectures on the Epistles of St. Paul, Colet inspired a generation of English humanists with his dedication to Christian reform and the Platonic ideals of scholarship. His lectures also deeply affected Desiderius Erasmus. Platonism survived in England as a philosophical movement longer than in most European countries. It produced scholars like John Dee in the sixteenth century, who

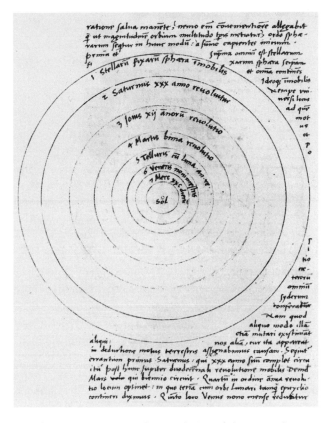

Page from Copernicus' *On the Revolution of the Heavenly Spheres* (1543). © HULTON/ARCHIVE. REPRODUCED BY PERMISSION.

practiced the occult sciences in the court of Queen Elizabeth I, and the physician Robert Fludd, whose career stretched into the mid-seventeenth century. A revival of Platonism in seventeenth-century Cambridge produced a group of scholars who became known as the Cambridge Platonists and who professed a metaphysical worldview that had its origins in Ficino's *Platonic Theology*.

SOURCES

M. J. B. Allen, et al., ed., *Marsilio Ficino: His Theology, His Philosophy, His Legacy* (Leiden, Netherlands; Boston: Brill, 2002).

Paul Oskar Kristeller, *Marsilio Ficino and His Work after 400 Years* (Florence, Italy: Oschki, 1987).

C. G. Nauert, *Humanism and the Culture of Renaissance Europe* (Cambridge, England: Cambridge University Press, 1995).

C. Trinkaus, *In Our Image and Likeness: Humanity and Divinity in Renaissance Thought* (Chicago: University of Chicago Press, 1970).

C. Wirszubski, *Pico della Mirandola's Encounter with Jewish Mysticism* (Cambridge, Mass.: Harvard University Press, 1989).

SEE ALSO *Architecture: The High Renaissance; Visual Arts: The High Renaissance in Italy*

HUMANISM OUTSIDE ITALY

ORIGINS. In the fifteenth century humanism spread beyond the boundaries of Italy, first to Spain and Portugal and somewhat later to Northern Europe. In the Iberian Peninsula humanists often wrote in Spanish and Portuguese, adapting the literary style of Petrarch, Boccaccio, and other Italian humanists to their own local languages. Northern European humanists continued to rely on Latin, although there were notable exceptions of humanists who dedicated themselves to using and expanding their local languages. Outside Italy, humanists promoted notions about their movement similar to those already expressed in Florence and other Italian cities. They celebrated their movement as the birth of a new "Golden Age" in which religion and learning would be invigorated by the examples of Antiquity and a renewal in moral philosophy. In Northern Europe and Spain, humanism became associated with plans for Christian reform and placed less emphasis on the rhetoric of Cicero and other ancient writers. For this reason humanism outside Italy has sometimes been called "Christian humanism." The philosophers and writers of this movement advocated a renewal of Christianity that would be illuminated by the new knowledge of Latin, Greek, and Hebrew and envisioned a reform of the church that would rely on the knowledge of Antiquity and the study of the scriptures in their original languages. They emphasized the importance of moral philosophy rather than scholastic logic, and were often just as critical of the scholastics as their Italian predecessors had been. But as in Italy, the gulf that separated humanism from scholasticism was not so deep as many humanists claimed. Some humanists, for instance, studied both scholasticism and the newer forms of learning, but their anti-scholastic rhetoric made many universities initially resistant to the humanists. By 1500, though, humanists had gained a foothold in many institutions of learning north of the Alps and in Spain and Portugal.

GERMANY AND THE NETHERLANDS. In both Germany and the Netherlands, the humanist movement exhibited signs that were similar to the Renaissance elsewhere in Northern Europe. Like its Italian version, humanism here owed a great debt to the classics of Greek and Roman Antiquity. Rediscovering and studying classical texts became a burning desire of humanists in Germany and the Netherlands; these scholars argued that literary study was more conducive to human virtue than the arid logical considerations of scholasticism. For these reasons, the humanists initially encountered opposition as they tried to assume positions in Dutch and German schools and universities. Eventually, these barriers were overcome, and by 1500, the humanists had gained a foothold. In the educational institutions in which they taught, the humanists argued for a reformed curriculum based upon the study of the classical languages. But as the movement developed in Germany and the Netherlands, they also advocated religious reform and an ideal of learned Christian piety. In Germany, the first great scholar of humanism was Rudolph Agricola (1444–1485). Like many later German and Dutch humanists, Agricola had been schooled by the Brethren of the Common Life, the lay monastic movement that had developed in the Netherlands and Germany from the Modern Devotion movement. When he was 25, Agricola traveled to Italy, studying the Classics at Ferrara and Pavia. After ten years he returned to Germany, where he spent the remainder of his life encouraging the development of humanistic studies from his post at the University of Heidelberg. Agricola's religious ideas were conservative and traditional, but he laid great emphasis on the study of the scriptures, something that later Dutch and German humanists embraced enthusiastically. Although he died relatively young, he had by the time of his death developed a group of disciples that included Conrad Celtis and Jakob Wimpheling, two scholars who expanded the cause of humanism in Germany. Their efforts saw humanism embraced in the imperial court, as the emperor Maximilian I appointed a number of classical scholars to serve as secretaries, historians, and astrologers in his government. One of the greatest of these was Johannes Reuchlin, who accepted several imperial appointments during the 1490s and 1500s. Reuchlin was one of the most widely traveled scholars of the fifteenth and sixteenth centuries. He studied at the universities of Orlèans, Basel, Paris, Tübingen, and in Rome and Florence, before devoting himself to the study of the Hebrew language and Jewish literature. He authored the first grammar of Hebrew intended for Christian students of the language, and he published several monumental studies of the Jewish Cabala. Because of these involvements, Reuchlin was eventually drawn into a controversy over the study of Jewish books (see Religion: Reuchlin Affair). Many of the imperial humanists that Germany produced in these years were advocates of German nationalism. In their historical works these court humanists tried to address a sense of cultural inferiority. They attempted to show in their works that Germans had not been barbarians (an interpretation of German history

a PRIMARY SOURCE *document*

CHRISTIAN HUMANISM

INTRODUCTION: In his *Handbook of the Militant Christian*, Desiderius Erasmus outlined a program of Christian ethics based upon the life of Christ. In the following passage he recommends his readers seek invisible and spiritual things rather than material ones. Renaissance Platonism here influences Erasmus's arguments, especially in his argument that humankind occupies an intermediary position between the visible and invisible worlds.

I am now going to add a fifth, subsidiary rule. You will find that you can best maintain this piety if, turning away from visible things, which are for the most part either imperfect or of themselves indifferent, you seek the invisible. ... I am going to stress the difference between the visible and invisible because I find so many Christians, either out of neglect or sheer ignorance, as superstitious as the pagans. Let us suppose that there are two worlds, the one intelligible, the other visible. The intelligible or angelic world is that in which God dwells with the blessed. The visible world embraces the circle of heaven, the planets, the stars, and all that is included in them.

Now let us imagine that man is a third world participating in both of the others, the visible referring to his corporeal part, the invisible to his soul. In the visible world, since we are, as it were, mere sojourners, we ought to consider all that we perceive through our senses in terms of its relationship to the intelligible world. The sun, for example, in the visible world might be compared to the divine mind. The moon might be thought of in terms of the whole assembly of the angelic hosts and of the elect whom we call the Church Triumphant. These ce-lestial bodies operate in relation to the earth as God does in relation to our soul. It is the sun that quickens, produces, matures, purges, softens, illuminates, brightens, and gladdens. When you are delighted by the beauty of the rising sun, consider the joy of those in heaven upon whom the divine light shines eternally ... If the darkness of night is oppressive to you, then think of how destitute is the soul without the light of God. If you find any darkness within your soul, then pray that the Sun of righteousness may shine upon you.

The things that we can see with our physical eyes are mere shadows of reality. If they appear ugly and ill formed, then what must be the ugliness of the soul in sin, deprived of all light? The soul, like the body, can undergo transformation in appearance. In sin it appears as completely ugly to the beholder. In virtue it shines resplendently before God. Like the body the soul can be healthy, youthful, and so on. It can undergo pain, thirst, and hunger. In this physical life, that is, in the visible world, we avoid whatever would defile or deform the body; how much more, then, ought we to avoid that which would tarnish the soul? I feel that the entire spiritual life consists in this: That we gradually turn from those things whose appearance is deceptive to those things that are real ... from the pleasures of the flesh, the honors of the world that are so transitory, to those things that are immutable and everlasting. Socrates had this in mind when he said that the soul will leave the body at the time of death with little fear if, during life, it has rehearsed death by despising material things.

SOURCE: Desiderius Erasmus, *Handbook of the Militant Christian* in *The Essential Erasmus.* Ed. and Trans. J. P. Dolan (New York: Penguin, 1993): 60–63.

that Italian humanists had kept alive through their knowledge of Tacitus and other ancient Latin writers). The Dutch humanists did not share this focus on national identity. But like their German counterparts, they took an interest in the study of traditional mystical texts and in the newer metaphysical ideas of Renaissance Platonism.

ERASMUS. The Dutch-born Desiderius Erasmus (c. 1466–1536) was the commanding figure produced by the Renaissance in Northern Europe. Erasmus was a religious thinker of profound depth, a writer of some of the sixteenth century's most brilliant and cultivated prose, and a philosopher of some sophistication. Like Agricola and other German and Dutch humanists, he had been trained in youth in the traditions of the Brethren of the Com-mon Life, and the concept of the imitation of Christ advocated by the Modern Devotion had shaped his early life. To these early interests, Erasmus added training in the methods of both humanism and scholasticism. Erasmus's writings fall into three categories. First, he produced works of critical scholarship, editing important classical works and translations, including his definitive translation of the New Testament. Second, Erasmus published a number of comic and satirical works, including his famous *Colloquies.* He wrote the *Colloquies* as a series of conversational dialogues, and teachers used them to train young men in the knowledge of Latin. The works mocked the foibles and superstitions of people, most especially of monks and scholars. Finally, a third category of Erasmus's works aimed for a re-establishment of early Christian teachings in Europe. In this last kind of work,

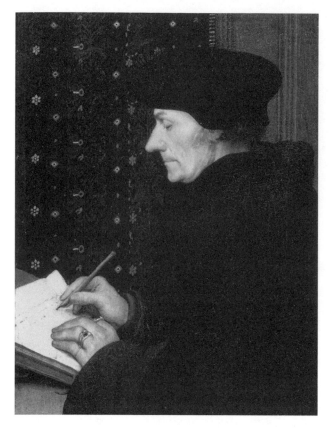

Portrait of Desiderius Erasmus. THE ART ARCHIVE/DAGLI ORTI. RE-PRODUCED BY PERMISSION.

Erasmus frequently outlined his "Philosophy of Christ," a set of teachings he believed were revealed in the gospels, particularly in the Sermon on the Mount. Among the several works that Erasmus wrote in this vein, his *Handbook of the Militant Christian* (1503) was the most influential in attracting disciples to his ideas and plans for Christian reform. The work argued that the kernel of all Christ's teachings consisted in love, charity, and respect exercised toward one's neighbors. "Wish for good, pray for good, act for good to all men" is how he summarized this great rule in the *Handbook*. Erasmus's beautiful literary style and his engaging summation of the core of Christian teachings attracted numerous admirers throughout Europe in the sixteenth century. To many educated humanists, his works presented a middle path between the extremes of traditional Catholicism and the newer and more radical forms of Protestantism. Vestiges of his reform ideas survived in the works of many humanists, many of whom served in Christian reform efforts throughout Europe. His ideas, for instance, were particularly important in shaping the course of the Reformation's teachings in England, and had admirers at the same time in the Catholic reformers in Spain and Italy. As the sixteenth century progressed, though, and

religious positions hardened on both sides of the Protestant and Catholic divides in Europe, Erasmus attracted increasing criticism from many quarters. Catholic traditionalists identified in Erasmus's emphasis on the spiritual nature of Christianity a set of teachings that was subversive to the sacraments and religious discipline. By the end of the century, a number of his works had been placed upon the *Index of Prohibited Books*, a list of books which Catholics were forbidden to read. For committed Protestants, too, Erasmus's denial of the concept of justification by faith and his loyalty to Rome helped limit his appeal.

ENGLAND. Renaissance humanism attracted significant support from English intellectuals at the end of the fifteenth century, despite the conservative character of intellectual life in the country at the time. Many aspects of English learning remained tied to medieval scholasticism, and chivalric ideals still dominated English elite society in the late fifteenth century. Still, during the 1460s and 1470s a group of English scholars traveled to Italy to study with humanists and several were students of Giovanni Pico della Mirandola and Marsilio Ficino. These included Thomas Linacre, William Sellyng, and William Grocyn. This last figure was particularly important in building a circle of humanist scholars in England. Grocyn served as court physician and a royal tutor during the time of Henry VII and Henry VIII. While he did not write a great deal, like Rudolph Agricola in Germany, he helped to popularize humanistic studies among England's intellectual elite. The first undeniably accomplished English humanist, though, was John Colet (1466–1519), who was a member of the clergy and dean of St. Paul's Cathedral in London. Colet had spent four years in Italy during his youth, much of it in close affiliation with Giovanni Pico della Mirandola. When he returned to England, he helped to spread knowledge of Ficino and Renaissance Platonism. Like Erasmus and other Northern Renaissance humanists, he was critical of the corruption of the church and the popular superstitions of the people, and his sermons argued for a reform of ecclesiastical abuses. His great achievement, though, lay in fostering the study of the humanities in England through his foundation of St. Paul's School in London. This cathedral school opened the way for the training of members of the English elite in the classics and it exerted a significant influence on English intellectual life during the following centuries.

MORE. Sir Thomas More (1478–1535), an admirer of John Colet, exemplifies a different path taken by some English humanists. He was a layman and a lawyer who occupied the highest political positions in the court of

Henry VIII. More received his Bachelor of Arts at Oxford before studying law at the Inns of Court in London. By 1510, he had become an official in the City of London and he soon rose to serve in Henry VIII's diplomatic service. It was while on a diplomatic mission to Flanders that More wrote part of his famous *Utopia*, a work that has since his time been the model for many imaginary visions of a perfect society. The *Utopia*, one of the best examples of sixteenth-century literature, also reflects More's personal philosophy (see Literature: Utopia). He was skeptical of humankind's ability to achieve virtue, and the society he imagined in his work was tightly ordered and highly disciplined so that its people could avoid their natural inclinations toward wrongdoing. More was well read, and an excellent stylist in Latin prose; he was also well connected among humanists in England and in Europe. Among his correspondents, he maintained a close friendship with Erasmus throughout his life, and Erasmus dedicated his *Praise of Folly* to him. Religiously, though, More was more conservative than the Dutch humanist. He engaged in prayer vigils and practiced ascetic disciplines like the wearing of a hair shirt. While he enthusiastically supported charities, he was also an unswerving opponent of heresy. As a royal official, he supported the persecution of heretics, including those who were drawn to the new Protestant ideas that began to circulate in England in the 1520s. The same sword of royal authority that More wielded to eradicate Protestants in England would eventually be turned against him. Because of his loyalty to the Roman Church, he refused to recognize Henry VIII's divorce from Catherine of Aragon, and he was condemned and beheaded in 1535.

FRANCE. In France, humanism developed within the same time frame as it did in Germany, the Netherlands, and England. While the country's intellectual centers, particularly the University of Paris, were resistant to the new studies, humanists had established themselves at Lyon and Paris by the late fifteenth century. Both towns were important printing centers, and they played a key role in spreading the new humanistic knowledge throughout Europe. Robert Gaguin (1433–1501) was the first in a distinguished lineage of French humanists. In his works he tried to harmonize classical philosophy with Christian teaching, a goal that would be pursued by a number of French Renaissance thinkers. Gaguin's influence upon his students at Paris helped to permanently establish the humanities within the university. His influence, though, was soon to be eclipsed by Giullaume Budé (1467–1540) and Jacques Lefèvre D'Etaples (1450–1536), the two most accomplished scholars of the French Renaissance. By train-

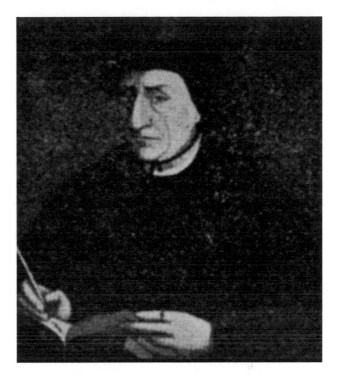

Guillaume Budé. THE LIBRARY OF CONGRESS.

ing, Budé was a lawyer, and found no university appointment until he established his own college late in life. He was a particularly astute philologist, who translated the Greek works of Plutarch and wrote treatises in Greek even in his youth. Of the many honors that Budé received during his lifetime, one was to prove particularly important for posterity: his appointment as the head of the king's library enabled him to purchase a number of important Greek manuscripts. Jacques Lefèvre D'Etaples, by contrast, took a different turn in his scholarship. Inspired by the example of Giovanni Pico della Mirandola, Lefèvre became convinced of the unity of philosophical truth. As a result he ranged broadly in his studies, dedicating himself to the works of Italian Renaissance Platonists, the medieval scholastics and mystics, the Jewish cabalistic writers, and hermeticism. As he matured, though, he concentrated his efforts on biblical scholarship, and in his studies of the New Testament he developed ideas that were similar to many German Protestants. Lefèvre remained a devout Catholic, but as a consequence, his scriptural studies shaped the ideas of some of France's early Protestant reformers.

SPAIN AND PORTUGAL. Humanist influences can be seen in both Spain and Portugal from the early fifteenth century as the works of Petrarch and Boccacio became popular in the peninsula. In both countries, as elsewhere in Europe, the demand for properly trained

secretaries and diplomats helped to fuel the popularity of humanism. The presence of an increasing number of skilled Latinists within the region in the fifteenth century encouraged the study of classical texts, as well as the importation of works by the Italian humanists and their translation into Spanish and Portuguese. During the reign of the married monarchs, Ferdinand and Isabella, humanist study within the two kingdoms of Castile and Aragon expanded. The project for a new polyglot Bible at Alcalá, which became known as the Complutensian Polyglot, brought many humanists to Spain in the early sixteenth century. But it was not until the reign of the Spanish emperor Charles V (r. 1516–1556) that a true Renaissance in Spanish learning occurred. During the early part of Charles' reign Spain's humanists revered the works of Erasmus, including the *Handbook of the Militant Christian*, which for a time became the country's most widely read devotional book. Its influence persisted even after its placement on the *Index* in 1559. In Charles' Spain, a number of distinguished humanists were actively engaged in the king's service. These included Diego Hurtado de Mendoza, Juan de Valdés, and Antonio de Guevara. The greatest of Spain's humanists, Juan Luis Vives, was also from a family of recent converts to Christianity. Known as *conversos*, these former Jews or descendants of Jews were particularly receptive to the ideas of Erasmian humanism. Vives studied in Spain until his teenage years, when he moved to the University of Paris. When still young, he distinguished himself through the publication of his *The Fable of Man*, a work tinged with Renaissance Platonism. As a result of his literary successes, Vives became a professor of literature at the University of Louvain, and eventually served as the royal tutor in the court of Henry VIII. When he failed to endorse Henry's divorce of Catherine of Aragon, he was forced to emigrate, and he settled in Bruges in Flanders where he spent the remainder of his life. Vives' death came before a great change in attitude toward humanism began to sweep across his native Spain. At home, fears of Protestantism gave rise after mid-century to attempts to suppress the Erasmian humanism that had circulated in Spain relatively freely during the first half of the century. Humanists came to be suspected of heresy, and followers of Erasmus, together with Spanish mystics (known as the *Alumbrados*) became victims of persecution. In Portugal, the rise of counter-reforming sentiments similarly discouraged a nascent humanist culture.

SOURCES

C. G. Nauert, Jr. *Humanism and the Culture of Renaissance Europe* (Cambridge, England: Cambridge University Press, 1995).

E. Rummel, *The Humanist Scholastic Debate in the Renaissance and Reformation* (Cambridge, Mass.: Harvard University Press., 1995).

J. S. Ruth, *Lisbon in the Renaissance* (New York: Italica Press, 1999).

Domingo Ynduráin, *Humanismo y renacimiento en España* (Madrid, Spain: Cátedra, 1994).

SEE ALSO *Religion: The Spread of Protestantism in Northern Europe*

NEW TRENDS IN SIXTEENTH-CENTURY THOUGHT

NEW QUESTIONS. The character of intellectual life in sixteenth-century Europe was traditional and not given to dramatic reassessments or change. Nevertheless, in many areas of life new questions arose that could not be easily answered by the wisdom that had been received from Antiquity or the Middle Ages. The discovery of other parts of the globe, for instance, raised questions about cultures and histories that had apparently not been mentioned in the Bible or in ancient authorities. Most thinkers continued to try to fit their new knowledge of these societies and exotic lands into the textual knowledge they had received from tradition. The authority of the church came under attack in the sixteenth century, too. The Protestant Reformation began with dramatic blows against the power of the clergy and the pope, yet during the remainder of the century, Protestant leaders recreated political authority in ways that were essentially traditional and conservative. Most intellectuals opposed radical change and revolutionary ideas, and even the most radical religious and social reformers of the century usually argued that they were restoring, not destroying, tradition. At the same time there were truly revolutionary thinkers at work within the sixteenth century whose ideas eventually altered the course of intellectual debate. While their scholarship was not completely integrated into the fabric of sixteenth-century intellectual life, they raised questions that Europe's intellectuals returned to again in early-modern and modern times. These thinkers had been trained in the traditions of medieval scholasticism and Renaissance humanism, but they broke the mold of these traditions to ask new questions and to answer them in ways that eventually led to more dramatic change.

ARISTOTELIANISM. At the same time as Platonism became one of the intellectual fashions of the later Renaissance, a revival of Aristotle was also underway, particularly in Italy at the University of Padua, an institution

long associated with the ideas of the great Greek philosopher. In Northern Europe scholasticism had relied on Aristotle's philosophy and logic to support the teachings of the church. At Padua, though, scholars had been more concerned with the study of Aristotle's *Physics* and with the insights that his philosophy offered in natural philosophy (the branch of knowledge concerned with nature and matter) and medicine. Padua's Aristotelians had long developed a venerable tradition of commenting upon the works of Aristotle. They were also largely responsible for transmitting knowledge of the great Aristotelian Averroës among Europeans. The twelfth-century Averroës was a Spanish Arab, and his works had emphasized the superiority of reason over faith. While the tradition of studying and commenting upon Aristotle and Averroës remained strong in fifteenth-century Padua, it was now to be affected by the revival of knowledge of Greek. Now enlightened by their knowledge of Aristotle's original language, Paduans re-examined his works. The results produced a reassessment of Aristotle's philosophy similar to that which was occurring with Plato among Florence's Platonists.

POMPONAZZI. The greatest thinker this new scholarship produced was Pietro Pomponazzi (1462–1525), a native of Mantua who had studied at Padua and later became a professor there. Pomponazzi treated many subjects in his popular lectures at Padua since his interests ranged across natural philosophy, psychology, and logic. His most famous published work was *On the Immortality of the Soul*, which denied that philosophy could prove the soul's eternal existence. Pomponazzi's position was not entirely new, but the methods that he used to prove the mortal nature of the human soul were innovative. They fascinated his students, even as they sparked controversy. Pomponazzi identified the human soul with the intellect, and he argued that a human being's intellect was a mere organic phenomenon that perished with the body. Pomponazzi realized that his ideas were a challenge to morality. For if the soul did not survive death, why should someone lead a moral life? To this question, Pomponazzi responded that virtuous living was its own reward. A person who leads a good life, in other words, need never suffer guilt. But many intellectuals throughout Italy responded to Pomponazzi's challenge to human immortality by denouncing his work, publishing tracts against him, and, at Venice, even by burning his book. In 1514 at the Fifth Lateran Council, the church reaffirmed the concept of the immortality of the soul against Pomponazzi's challenge. For his part, Pomponazzi defended his denial of the soul's immortality by insisting that he had come to those conclusions, not on

religious grounds, but through the logical methods of philosophy. Philosophy, in other words, could not prove the soul's immortal existence; that truth must be accepted through faith. And faith, Pomponazzi had already pointed out toward the end of his *On Immortality*, is a realm that is superior to philosophy. Whether Pomponazzi actually believed that the Christian faith transcended human reason remains an open question. In the remaining years of his life he continued to devote himself to daring philosophical studies, publishing two more important treatises before his death in 1525. The first of these, *On Fate*, was strongly deterministic and largely denied the freedom of the human will, while the second, *Of Incantations*, explained away miracles by using naturalistic explanations. Pomponazzi's naturalistic philosophy, while popular in some quarters in the early sixteenth century, did not produce a long-lasting circle of followers. In the era of heightened religious controversy that occurred as a result of the Protestant Reformation, the church discouraged attempts like those of Pomponazzi to explain away concepts like human immortality. In the seventeenth and eighteenth centuries, though, European philosophers resurrected for discussion the questions he had posed.

MACHIAVELLI. Another challenge to traditional morality appeared in late Renaissance Italy in the political ideas of Niccolò Machiavelli (1469–1527). Machiavelli was born in a Florence that had been tightly controlled by Lorenzo de' Medici. Very little is known about his early life. He received a humanist education, but did not learn Greek. His father was an impoverished lawyer, and so Machiavelli entered public life in 1498 as a member of the Florentine government. Machiavelli's career in Florentine politics occurred during the Republican period that followed the expulsion of the Medici and which lasted until 1512. As a member of the government Machiavelli was soon charged with important diplomatic missions, and these allowed him to witness the treachery that occurred in Italian foreign relations. In 1512, Machiavelli's career was cut short when the Medici returned to power and removed those who had served the Republic. He retired to his country home and spent the remaining years of his life writing plays, satires, poetry, and other literary works. Some of the most important works completed in this period include *The Prince*, *Florentine Histories*, and *Discourses on the First Ten Books of Livy*. In 1526, the Medici government of Florence once again recalled Machiavelli to public life, but within a few months the family was expelled again. The officers of the new Republic removed Machiavelli from office, and he died several months later.

a PRIMARY SOURCE *document*

ESTABLISHING A REPUBLIC

INTRODUCTION: The Florentine Niccolò Machiavelli has long been famous for his portrait of the ruler contained in *The Prince*. Machiavelli spent his youth and middle age, though, working for the Republic of Florence as a civic official and when he had been banished from power he wrote his *Discourses*, a work that analyzes the reasons for the initial successes and later failures of the Roman Republic. In the following extract, Machiavelli discusses and approves of the murder of Remus by his brother Romulus (mythological twins considered to be the founders of Rome), because it gave rise to an effective state—a state that, in other words, achieved the greatest good for the greatest number of its subjects. The justification of murder for a greater political good is an example of Machiavelli's amorality.

We must assume, as a general rule, that it never or rarely happens that a republic or monarchy is well constituted, or its old institutions entirely reformed, unless it is done by one individual; it is even necessary that he whose mind has conceived such a constitution should be alone in carrying it into effect. A sagacious legislator of a republic, therefore, whose object is to promote the public good, and not his private interests, and who prefers his country to his own successors, should concentrate all authority in himself; and a wise mind will never censure any one for having employed any extraordinary means for the purpose of establishing a kingdom or constituting a republic. It is well that, when the act accuses him, the result should excuse him; and when the result is good ... it will always absolve him from blame. For he is to be reprehended who commits violence for the purpose of destroying, and not he who employs it for beneficent purposes.

The lawgiver should, however, be sufficiently wise and virtuous not to leave this authority which he has assumed either to his heirs or to any one else; for mankind, being more prone to evil than to good, his successor might employ for evil purposes the power which he had used only for good ends. Besides, although one man alone should organize a government, yet it will not endure long if the administration of it remains on the shoulders of a single individual; it is well, then, to confide this to the charge of many, for thus it will be sustained by the many. Therefore, as the organization of anything cannot be made by man, because the divergence of their opinions hinders them from agreeing as to what is best, yet, when once they do understand it, they will not readily agree to abandon it. That Romulus deserves to be excused for the [murder] of his brother and that of his associate, and that what he had done was for the general good, and not for the gratification of his own ambition, is proved by the fact that he immediately instituted a Senate with which to consult, and according to the opinions of which he might form his resolutions. And on carefully considering the authority which Romulus reserved for himself, we see that all he kept was the command of the army in case of war, and the power of convoking the Senate. This was seen when Rome became free, after the expulsion of the Tarquins, when there was no other innovation made upon the existing order of things than the substitution of two Consuls, appointed annually, in place of an hereditary king; which proves clearly that all the original institutions of that city were more in conformity with the requirements of a free and civil society than with an absolute and tyrannical government.

SOURCE: Niccolò Machiavelli, *The Prince, and the Discourses.* Trans. Christian Detmold (New York: Modern Library, 1950): 138–140.

POLITICAL THEORY. While most famous for *The Prince*, Machiavelli developed a consistent theory of the state in several of his works that was novel for its insight. He wrote these works during one of the low points of Italian political history, as French, German, and Spanish forces invaded the peninsula and used Italy's disunity to play one state against the other. Machiavelli dealt with these issues in his works and tried to present solutions to Italy's problems. But he also theorized in his political tracts about government in general. He argued that immutable laws ruled politics, laws that did not operate according to the considerations of personal morality. He advocated secular government, kept free from all interference from the church. Although he believed that organized religion was necessary in a society, he saw it as little more than a mysterious force that bound a state's subjects together in a common set of beliefs. He also supported a strong military, even in a republic, as a necessary protector of public welfare. Machiavelli has often been accused of amorality, of justifying in his works any and all means to achieve an end. This charge has most frequently been levied against *The Prince*, the work Machiavelli intended as a manual to inspire an Italian ruler to build a unified coalition that would expel Italy's foreign invaders. Even in *The Prince*, though, Machiavelli does not advocate that a ruler use any and all means to obtain and maintain his power. Instead he observes that when faced with certain circumstances, he must put aside his own morality and act in a way that accomplishes the greatest good for the greatest number. This

same argument appears in Machiavelli's treatise on republican government, *The Discourses on the First Ten Books of Livy*. There he approves of ancient Romulus' decision to murder his brother Remus, because it allowed for the creation of a strong republic, a task that must be completed by one person. During the rest of his life Romulus vindicated the murder by dedicating himself to building an effective state that secured the liberty of its citizens. Passages like these celebrated the valor and bravery of the ancient Romans, values Machiavelli often saw as lacking in his own time. But while he was sometimes pessimistic about his contemporaries' ability to achieve the virtues of the ancient Romans, he was more often cautiously optimistic. His works expressed a fervent desire that a revitalized Italy, animated by the ancient spirit of military valor, might successfully expel its foreign invaders.

RESISTANCE. *The Prince* had advocated strong government under the authority of a determined monarch as the solution to Italy's political woes. In the sixteenth century "Machiavellianism," as the political philosophy of *The Prince* came to be known, became synonymous with evil and amorality in public life, and thus political philosophy did not immediately follow the lead that Machiavelli had laid out in his work. In Germany, France, the Netherlands, England, and Scotland, religious controversies fostered a new critical examination of the power of governments, and theories of resistance to state tyranny were the result. Protestantism was largely the incubator for these new attitudes toward government, and it was in Germany that these ideas first began to appear. Martin Luther had always been careful in his career as a religious reformer to stress the Christian's duty to submit to the power of the state. Political authority was part of the divinely established realities that the pious must accept. His essentially conservative attitude had helped to protect his reform movement from the charge of political subversion, particularly in the 1520s and 1530s when other more radical groups like the leaders of the Peasants' War of 1524–1525 and the Anabaptists had argued for more extreme social and political changes (see Religion: Radical Reformation). By the mid-sixteenth century, though, a group of Lutheran conservatives encountered a dilemma. Their states began requiring them to profess teachings that ran counter to their conscience and their theological interpretations. Meeting at Magdeburg in 1550–1551, the group wrote its own manifesto. Known as the Magdeburg Confession, the document soon circulated throughout Europe, where its strains of resistance to governmental authority inspired a number of groups. Supporters of this "resis-

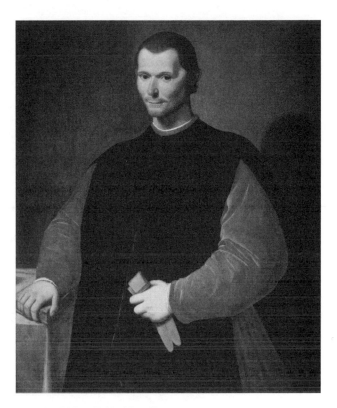

Portrait of Niccolò Machiavelli. © **ARCHIVO ICONOGRAFICO, S.A./CORBIS.**

tance theory" soon produced a spate of tracts and pamphlets that outlined under what circumstances subjects might disobey their rulers. In France, Protestant writers, including Theodore Beza (1519–1605) and Philippe du Plessis Mornay (1549–1623), were particularly active in developing this political theory, especially after the slaughters of Protestants that occurred during the St. Bartholomew's Day Massacres of 1572. John Knox, the Calvinist reformer of the church in Scotland, the Dutch Calvinists who revolted against Spain in the later sixteenth century, and English Puritans all developed resistance theories, too. Beza's works, though, had an especially wide appeal because he was careful to outline precisely how, when, and why subjects might oppose their rulers. His works did not argue that everyone had the right to resist the will of a monarch. Instead he concentrated on the French nobility, who had long shared power with the king in France's national assembly, known as the Estates General. Many of France's nobles were Calvinists, and Beza hoped to invigorate them to oppose royal plans to suppress Calvinism. His works emphasized that obedience to God was more important than obedience to a king, and that natural law granted subjects the right to depose a monarch who acted contrary to the will of God. Beza's reading of biblical and

a PRIMARY SOURCE document

CULTURAL RELATIVISM

INTRODUCTION: In his famous essay "Of Cannibals," Michel de Montaigne recounted having seen Brazilians while on a trip to the French city Rouen. Montaigne criticizes the fantastic accounts that have circulated about these peoples, and tries to establish a true picture of their behavior. His work is unusual as an early statement of the concept of cultural relativism. He argues, in other words, that culture and historical developments produce differences between peoples, and at times he extols the greater simplicity and virtue of the New World natives when compared against the barbarism of Europeans.

We ought to have topographers who would give us an exact account of the places where they have been. But because they have over us the advantage of having seen Palestine, they want to enjoy the privilege of telling us news about all the rest of the world. I would like everyone to write what he knows, and as much as he knows, not only in this, but in all other subjects; for a man may have some special knowledge and experience of the nature of a river or a fountain, who in other matters knows only what everybody knows. However, to circulate this little scrap of knowledge, he will undertake to write the whole of physics. From this vice spring many great abuses.

Now, to return to my subject, I think there is nothing barbarous and savage in that nation, [Brazil] from what I have been told, except that each man calls barbarism whatever is not his own practice; for indeed it seems we have no other test of truth and reason than the example and pattern of the opinions and customs of the country we live in. *There* is always the perfect religion, the perfect government, the perfect and accomplished manners in all things. Those people are wild, just as we call wild the fruits that Nature has produced by herself and in her normal course; whereas really it is those that we have changed artificially and led astray from the common order, that we should rather call wild. The former retain alive and vigorous their genuine, their most useful and natural, virtues and properties, which we have debased in the latter in adapting them to gratify our corrupted taste. And yet for all that, the savor and delicacy of some uncultivated fruits of those countries is quite as excellent, even to our taste, as that of our own. It is not reasonable that art should win the place of honor over our great and powerful Mother Nature. We have so overloaded the beauty and richness of her works by our inventions that we have quite smothered her.

SOURCE: Michel de Montaigne, "Of Cannibals," in *The Complete Essays of Michel de Montaigne.* Trans. Donald M. Frame (Stanford, Calif.: Stanford University Press, 1958): 152.

ancient history was broad, and his works pointed to numerous instances in which lower officials like the French nobles had resisted the authority of a tyrant.

POLITIQUES. Beza's opponents saw his attempts to sanction resistance as a prescription for anarchy, and the second half of the sixteenth century saw numerous attempts to defend the sovereign power of the monarch against those who supported resistance. The political tide of the period was on the side of those who supported the strong central authority of the monarch over the state, although Beza and other Protestant resisters continued to inspire readers and rebels in seventeenth- and eighteenth-century Europe. Wracked by internal civil conflicts born of the country's religious disunity, some French legal scholars downplayed the role that religion should play in public life. They argued instead that the survival of the state was more important than religious differences between Catholics and Protestants. For this reason, their opponents mocked them at the time as *politiques*, because they emphasized political goals at the expense of spiritual issues. Jean Bodin (1530–1596) was one of the most important of this group, and his ideas would have an impact, not only in France, but also across Europe. They helped to form the foundations of the later seventeenth-century theory of absolutism, but, when he wrote, Bodin saw his ideas as a solution to the political and religious intrigues common in his times. He pleaded with his countrymen—both Catholic and Protestant—to respect the power of the monarch. In his *Six Books of the Commonwealth*, first published in 1576, he argued that the king's authority over the state must be respected. The survival of the state—an entity that could do the greatest good for the greatest number—was more important than the goal of enforcing religious uniformity. Similar pleas for a limited tolerance of religious differences to foster civil peace appeared in the works of other *politiques*, including the famous late sixteenth-century essayist, Michel de Montaigne. While the political program advocated by the group fell in and out of royal favor in the last two decades of the sixteenth century, the program of monarchical unity amidst religious disunity that the *politiques* envisioned would eventually be established by Henry IV (r. 1594–1610). A Catholic convert, Henry eventually granted a limited degree of religious toleration to his

former Protestant compatriots, the Huguenots, helping to lay the foundations for the strong centralized monarchy that developed in seventeenth-century France.

MONTAIGNE. Politics had initially shaped the strikingly original insights of Michel de Montaigne (1533–1592), one of the greatest minds of the late sixteenth century. Montaigne had been trained as a humanist, and as the son of a prosperous nobleman he had been brought up to assume a role in public life. He practiced law and became a member of the royal court, but he was horrified by the Wars of Religion and retired from public life to his country estate. There he soon began the task that would consume the rest of his life: the writing of his *Essays*, a collection of internal thoughts and debates he conducted with himself over two decades. The *Essays* show that Montaigne was not a systematic thinker, even though the works are rich in moral insight. In them, Montaigne ranged over his thoughts about the most diverse of subjects. He found the ideological dogmatism of both contemporary Catholics and Calvinists wanting, and was skeptical generally about all attempts to establish moral absolutes. Instead his sermons counseled tolerance of divergent opinions. Montaigne was one of the most important spokesmen for the positions of the *politiques*, the party who argued that religious differences were less important than the need to preserve the peace of the state. Montaigne's ideas as recorded in his *Essays* seem to bear little imprint from his own Catholic upbringing. He solves the intellectual dilemmas and problems that he treats in these short pieces in a completely secular way, with little recourse to traditional Christian morality or church teaching. Montaigne was also a liberal thinker, able to train his penetrating glance upon the behavior of his countrymen, to criticize their barbarity, and to express his distaste for their extremism in all its forms. He was also intellectually curious about those areas of the globe recently discovered by explorers. One of his most famous essays, *Of Cannibals* subjects the customs that have been discovered among Indians in the New World to searching questions and compares it to the behavior of Europeans. Montaigne concludes that all cultures are relative and are produced by a combination of history, religion, and environment. He concludes, moreover, that there is a hint of barbarism in all peoples, and there is little to suggest that Europeans are more civilized than the inhabitants of the New World. In this and many ways, Montaigne questioned the received wisdom long accepted by most European intellectuals, and he began the process of questioning the underlying assumptions of intellectual culture in ways that would be continued by later seventeenth-century philosophers.

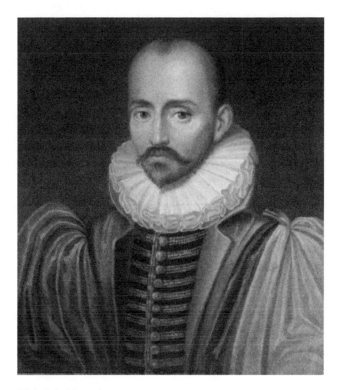

Michel de Montaigne. © BETTMANN/CORBIS.

IMPLICATIONS. While the character of religious and intellectual life remained conservative in sixteenth-century Europe, thinkers like Montaigne, Beza, Machiavelli, and Bodin posed new questions that extended the boundaries of intellectual debate. Their ideas were not completely integrated, nor were the issues they raised exhausted by the controversies they inspired in their own times. During the following two centuries European philosophy returned to the skepticism that Montaigne expressed in his penetrating *Essays*. Thinkers examined the claims that Machiavelli, Bodin, and the *politiques* made for the central authority of the state. And they revisited the criticisms that resisters made of the unfettered authority of monarchs over the human conscience. The sixteenth century, then, presents us with a time in which a new breed of intellectuals set the agenda for the intellectual debate to be pursued during the early-modern period.

SOURCES

E. Cameron, *Early Modern Europe* (Oxford, England: Oxford University Press, 1999).

R. Dunn, *The Age of Religious Wars, 1559–1715* (New York: Norton, 1970).

D. Frame, *Montaigne: A Biography* (New York: Harcourt, 1965).

J. Franklin, *Jean Bodin and the Rise of Absolutist Theory* (Cambridge: Cambridge University Press, 1973).

P. French, et al., eds., *Renaissance and Early Modern Philosophy* (Oxford, England: Blackwell, 2002).

I. D. Macfarlane and I. Maclean, eds., *Montaigne* (Oxford, England: Clarendon Press, 1982).

S. Ozment, *The Age of Reform, 1250–1550* (New Haven, Conn.: Yale University Press, 1980).

SEE ALSO *Literature: The Northern Renaissance; Religion: The Reformation's Origins*

SIGNIFICANT PEOPLE
in Philosophy

DESIDERIUS ERASMUS

c. 1466–1536

Scholar
Philosopher
Religious reformer

LIFE. The early life of Desiderius Erasmus remains shrouded in some mystery, a situation that Erasmus helped foster. He was the illegitimate son of a priest, and he remained acutely sensitive about his illegitimacy throughout his life. For this reason he left little testimony behind about his youth, and some of what he did leave was deceptive. We know that he attended the Brethren of the Common Life schools at Deventer and Hertogenbosch in Holland, and that Erasmus and his brother were eventually orphaned. Their guardians suggested that they enter the Augustinian Order. Later in life Erasmus admitted that he had never felt much calling to the religious life, but instead of abandoning his monastic vows completely as Luther and other Protestants did, he sought papal dispensations that relaxed his observance of his order's rule. He was ordained a priest in 1492 and began to work in the household of the bishop of Cambrai, in modern Belgium. The bishop paid for Erasmus to attend the University of Paris where he studied theology. There he developed his strong dislike for scholasticism, nourishing instead his interest in classical literature. In 1499, Erasmus made his first journey to England where he met many scholars, including Sir Thomas More, who became a lifelong friend. At this time, too, John Colet, the dean of St. Paul's Cathedral in London, encouraged Erasmus to begin biblical studies. He returned to the continent, and by 1506 he was in Italy, where he received a doctorate in theology from the University of Turin. A few years later Erasmus returned to England, where he took a lectureship at Cambridge and continued his biblical studies. In 1514, he took up a post in the household of the Hapsburg Prince Charles (who later became the emperor Charles V). By this time Erasmus had already achieved considerable fame from his written works, and his several pensions from church appointments allowed him to set up a household at Louvain where he finished his Greek and Latin New Testament. These works established him as an authority on biblical matters, although some criticized his translations for inaccuracies in the first few years after they appeared. Erasmus himself admitted that he had rushed to complete the work, and he made numerous corrections to later editions. His discipline paid off as his versions became the standard critical edition of the New Testament used by scholars in the sixteenth and seventeenth centuries. Because of the depth of learning, the 1520s saw Erasmus participating in the religious debate of the early Reformation. At Louvain, Erasmus was credited with having inspired Luther, and as his situation there grew increasingly untenable, he moved on to Basel in Switzerland in 1521. When that town converted to Protestantism in 1529, Erasmus moved again, this time to Catholic Freiburg in southwestern Germany. In the last years of his life both Protestants and Catholics attacked him—Catholics because they doubted his orthodoxy and Protestants for his failure to support Luther. At the same time his supporters, sometimes known as Erasmians, continued to be an influential group within the Roman Church, demanding reform of its institutions and working to further classical studies. While en route to the Netherlands in 1536, Erasmus died at Basel.

WORKS. Erasmus was one of the most broadly educated figures of the Renaissance and one of its most creative and productive writers. Erasmus himself published a catalogue of his enormous body of works in 1523 and he divided these into nine categories. These categories ranged over educational treatises and textbooks, collections of proverbs and wisdom, devotional books, polemics, biblical studies, critical editions of Latin texts, and works of church history and theology. In addition to this voluminous output, more than 3,000 of his letters survive and these show that Erasmus was constantly in contact with the most politically important and brilliant minds of his age. He published many of these letters while he was living, often in annual installments, and students avidly studied them to imitate their author's elegant style. Although he was primarily a literary figure of unusual distinction and was known even while living as the "Prince of the Humanists," his works reveal a great deal of subtle philosophy.

POLITICAL IDEAS. In his *Education of a Christian Prince*, published in 1516, Erasmus revealed many of his political ideas. In contrast to the roughly contemporary portrait of Machiavelli's *The Prince*, Erasmus portrayed the monarch as a divinely appointed figure. He stressed that God established kings and princes to personify goodness and justice before their peoples, and his vision of the good prince was strongly patriarchal. The benevolent and effective prince, in other words, should serve as a father to his people, correcting those that err, but dispensing justice with mercy. In his *Complaint of Peace* Erasmus attacked war as a tool of international relations. Although he did not deny that there were times and places that wars might be justified, the tone of his *Complaint* was undeniably pacific. War provided an inadequate solution to nations' problems, and instead he advocated a system of mediation to resolve diplomatic issues. In many other works he outlined a vision for a highly structured Christian society under tight control by authorities. In this way his social ideas were similar to those of his close friend, Sir Thomas More, whose *Utopia* imagines the perfect society as an organized and disciplined community under the watchful eye of state authorities.

CHRISTIAN HUMANISM. Erasmus's text also outlined a program of Christian humanism designed to reinvigorate European societies' ethics and morality. Here Erasmus's most influential work was his *Handbook of the Militant Christian*, a manual of edification that he first published in 1503. The work was immediately influential and drew disciples to Erasmus's ideas of reform from throughout Northern Europe, Italy, and Spain. The *Handbook* outlines a system of Christian ethics based upon the teachings of the New Testament, particularly those that Christ preached in the Sermon on the Mount and the parables. It is a clear and elegant work that also supports the study of the classics to cultivate the moral insights and eloquent style of the ancients. Erasmus advocates the study of the scriptures together with the classics of Antiquity as the basis for a program of moral reform throughout society. The *Handbook* also argues that the rituals of the church are of little use without an internal spirit that enlivens one's devotion and leads to piety, good works, and the practice of charity. The entire law of Christianity or as Erasmus termed it "the philosophy of Christ" is to be understood in the law to love one's neighbors. While many found this work a vital aid to their devotional lives, others responded that Erasmus's teachings undermined the institutional church and that they transformed Christianity into a mere system of ethics. After his death, Erasmus's celebrity waxed and waned over the seventeenth and eighteenth centuries. More recently, modern commentators have found in his works a perennially attractive set of teachings and have sometimes called him "the first modern."

SOURCES

Erika Rummel, *Erasmus and his Catholic Critics*. 2 vols. (Nieuwkoop, Netherlands, 1989).

James Tracy, *Erasmus of the Low Countries* (Berkeley, Calif.: University of California Press, 1996).

MARSILIO FICINO

1433–1499

Translator
Philosopher

EARLY LIFE. Marsilio Ficino was born at the time when the revival of knowledge of the classics was expanding greatly in Renaissance Florence. His father was the Medici family's physician, and Ficino was to follow in his footsteps. Ficino did pursue a career as a physician, but he also mastered a number of other fields. By the time he was thirty he had come to the attention of Cosimo de' Medici, who began to support his scholarly endeavors. Cosimo had recently acquired collections of Plato's manuscripts as well as of the *Corpus Hermeticum* that he asked Ficino to translate from Greek into Latin. The *Corpus Hermeticum* was a collection of mystical and magical texts that had long been attributed to the ancient Egyptian figure Hermes Trismegisthus (meaning literally "Thrice Great Hermes"). During the 1460s Ficino involved himself in these projects, and he continued to win rich patronage from the Medici family. Eventually, the family set Ficino up in a townhouse and also gave him one of their country villas so that he could pursue his work without interruption. By 1469, Ficino had largely completed his Platonic translation, and he began an ambitious new project. He would write a theological *summa* or summation that would harmonize Christianity with the new insights he had acquired from his study of Plato and other ancient works. He completed this *Platonic Theology* in 1474, but along the way he gave lectures in Florence and discussed his ideas with many of the city's intellectuals, helping to popularize his Platonism among them. His ideas helped to seal the shift of the town's humanists away from the "civic humanism" that had been popular in the first half of the fifteenth century. That movement had discussed issues of good government and public involvement. Ficino's philosophy, by contrast, stressed inwardness, quiet contemplation, and the cultivation of the arts.

METAPHYSICS. Metaphysics, the study of the underlying and unseen properties of matter, was also an important dimension of Ficino's ideas. Ficino had trained as a physician and he was as interested in astrology, alchemy (the science of transforming matter), and the other "occult sciences" as he was in philosophy. In his *Platonic Theology* he joined these interests to his philosophical concerns, creating a difficult and often mysterious intellectual broth. Many ascribed to his ideas, but few understood them in all their complexity. They are only now coming to be completely studied by scholars, and they have also recently received attention from some "New Age" philosophers. But in the Renaissance, Ficino was responsible for fostering the dissemination of several ideas that became important in the sixteenth-century intellectual world. First, he promoted the notion of a *prisca theologica* or *ancient wisdom*. From his enormous range of reading, Ficino realized that there were certain underlying similarities among the ancient religions. He identified a wisdom that began with the ancient Egyptians, Persians, and other Near Eastern religions and which culminated in the ideas of the Greek and Roman philosophers. This knowledge, he argued, had been divinely inspired and was a second path of illumination God had granted to the human race alongside the revelations of the Jewish and Christian traditions. In pointing to an underlying similarity in their religious ideas, Ficino gave a great stimulus to the study of ancient philosophies and religious cultures. One of his more important disciples was Giovanni Pico della Mirandola, who collected an enormous number of ancient texts and in his *900 Theses* tried to summarize the teachings of the *prisca theologica*. A second idea Ficino help popularize was the notion of Platonic love, the belief that in an intellectual, non-erotic relationship human beings can commune with one another on a higher celestial plane. Much of his writing focused on how the human soul could be liberated from the body and ascend to its true home in heaven. Some of the techniques for cultivating the divine nature of the soul Ficino stressed were celibacy, poetry, ascetic self-denial, and contemplation. Platonic love, a relationship that could be engaged in by those striving for illumination, gave the usually intensely private Neoplatonism a social dimension. In addition to these ideas, Ficino's Platonism stressed the notion of an infinite, many-storied universe controlled by celestial intelligences, spheres, and planets. To identify the underlying proportions that existed in this infinite world, the Platonists who followed Ficino devoted themselves to the study of mathematics and music, believing that these could reveal the spatial and harmonic relationships that governed creation. Although these ideas were meta-physical rather than scientific, scholars have long debated the extent to which they shaped the insights of the seventeenth-century Scientific Revolution.

SPREAD OF HIS IDEAS. Ficino's interpretation of Plato and his attempts to fashion a new Christian theology that made use of ancient wisdom grew to be tremendously popular in Florence at the end of the fifteenth century. It soon spread throughout Europe, sparking an intensified concern among philosophers with metaphysics and the occult sciences. Traces of Ficino's influence can be seen in the works of Desiderius Erasmus, Jacques Lefèvre d'Étaples, John Colet, and Thomas More, and this tradition persisted into the late sixteenth and early seventeenth centuries. Neoplatonism also influenced the artistic culture of the High Renaissance. The artist Michelangelo came to be admitted into the Platonic circle that surrounded the Medici family and which included Angelo Poliziano and Giovanni Pico della Mirandola as well as Ficino. Michelangelo promoted the use of certain shapes, numerical proportions, and the personification of ideas in his works that were drawn from his knowledge of Platonism. The Sistine Chapel frescoes, for example, make use of Neoplatonic ideas about the ancient wisdom, showing as they do Cumaean sibyls and other antique figures alongside the Old Testament biblical history. Others resisted the movement. In his *Notebooks* Leonardo da Vinci was frequently critical of the Florentine Platonists, often attacking the group for their difficult, unintelligible ideas that lacked empirical evidence. In Padua, a group of humanist scholars began to promote Aristotle as an alternative to the popularity of Plato. The most prominent of these figures was Pietro Pomponazzi (1462–1525), who in 1516 shocked the Platonists and the church with a work denying the immortality of the soul. Pomponazzi relied on a penetrating logic to show that philosophy could not prove the existence of the soul as an eternal spark of the divine flame.

SOURCES

A. Field, *The Origins of the Platonic Academy of Florence* (Princeton, N.J.: Princeton University Press, 1988).

P. O. Kristeller, *The Philosophy of Marsilio Ficino.* Trans. Virginia Conant (New York: Columbia University Press, 1964).

A. Moyer, *Musica Scientia: Musical Scholarship in the Italian Renaissance* (Ithaca, N.Y.: Cornell University Press, 1992).

D. P. Walker, *Spiritual and Demonic Magic: From Ficino to Campanella* (London, England: Warburg Institute, 1958).

NICCOLÒ MACHIAVELLI

1469–1527

Humanist
Historian
Political theorist

LIFE. Like other Florentine children of his age and class, Niccolò Machiavelli's education included the humanist study of the classical authors. Very little, though, is known about Machiavelli's life before he entered the world of politics in 1498. At this time he was almost thirty years old, but he managed to rise quickly in Florence's government. The Medici family had been expelled several years before from the city, and a republic had been established which had fallen under the influence of the puritanical preaching of Giralamo Savonarola. Machiavelli came into the Florentine chancery immediately after Savonarola had been executed, a time of significant upheaval in the republic. His first job involved the supervision of the city's relationships with its subject towns in Tuscany. Machiavelli was soon responsible for other tasks, and on several occasions he carried out diplomatic missions. While he was never actually a diplomat, he conducted a number of visits to other Italian courts as an "envoy." These missions allowed Machiavelli to witness firsthand the ruthless political deeds of Italy's despotic princes and dictators, including the actions of Cesare Borgia, the son of Pope Alexander VI, who serves as one model for the ruler in Machiavelli's later classic *The Prince.* As a result of the successes he attained in these years, Machiavelli's star rose higher in the republic's administration, and by the time of the abolition of this government in 1512, he was one of the republic's senior officials. Once the Medici returned to power, though, Machiavelli lost his posts and for a time he even fell under suspicion of treason in the new government. He retired to his country home, where he spent the next years writing *The Prince* and a number of other works of history, political philosophy, and literature.

THE PRINCE. Machiavelli wrote this work and circulated it in 1513, although it was not published until 1532. He dedicated it to the Medici princes who had recently taken over government in Florence, and in a letter to a friend, he expressed the hope that it would secure him a place in the new government. In this little book he strives to present his readers with a theory of politics, a relatively novel idea at the time. Previous writers had stressed that the uncertainties of fortune made theorizing about the fates of states impossible, but Machiavelli insisted that the reasons for the successes and failures of kings, princes, and republics could be understood through careful observation. This idea would recur in Machiavelli's *Florentine Histories.* There he argued that history operated according to cycles, and an astute observer could predict the future and perhaps avoid past mistakes by acquiring a detailed knowledge of the past. Although Machiavelli seems always to have believed that a republican government was best suited to achieving human virtue, he was willing to accept dictatorship and despotism, provided it served higher ends. Italy's political disunity and the jockeying of its petty despots had marked the peninsula as easy prey to its more powerful neighbors, France and Spain. In *The Prince* he wanted to identify the virtues and behaviors necessary in an Italian leader who could unify the country sufficiently to expel its foreign invaders. While much of the work analyzes political successes and failures drawn from incidents in classical and recent Italian history, it is the later part of the book that has proven most troubling to its readers ever since the sixteenth century. Here he identifies the behaviors that are necessary in an effective prince. In these chapters Machiavelli argues that power requires a prince to forsake the normal bounds of morality to ensure the stability of his position. The effective prince must not be afraid to exercise cruelty when it is warranted. And although it is good for him to seem to be kind, benevolent, religious, and compassionate before his subjects, he need not practice these virtues when circumstances demand more ruthless behavior. To be feared is frequently a better goal of the prince than to be loved, but above all he must not be hated, for out of hate arises all manner of challenges to a prince's authority. In the final chapter of the work he raises a call for a prince who will exercise the strengths of political character he has identified throughout the book and work to expel Italy's foreign invaders.

REPUBLICAN WORKS. Like Florentine humanists of the early fifteenth century, Machiavelli also devoted his attention to questions of civic involvement and republicanism. Around 1518 he completed his *Discourses on the First Ten Books of Livy.* By this time he realized that he had little prospects for finding employment in the Medici regime and he now turned to questions of political liberty and republicanism, subjects that were generally not in favor in a Florence that was ruled by the Medici dukes. The *Discourses* affected the development of later European writing about republicanism, particularly among seventeenth- and eighteenth-century English political theorists. In them, Machiavelli argues that a balance of power between the various interests that comprise society is the surest defense of human liberty.

Strong governments may be created through the efforts of a single ruler, but it requires the actions of many within a society to preserve their institutions. These insights hark back to Marsilius of Padua's early theory of representative government contained in the *Defender of the Peace*, although Machiavelli defended the power of the people in an even more vigorous way.

IMPACT. In both his *Discourses* and *The Prince* Machiavelli insisted that the moral conventions that governed normal private interactions between human beings did not apply to the realm of government. Politics occurred in a completely different sphere in which the considerations of human ethics did not apply. These insights were troubling to most sixteenth-century political theorists, who identified Machiavelli as a great source of evil, and who produced at the time a significant body of anti-Machiavellian works that argued for the compatibility of Christian morality with good government. At the same time even Machiavelli's enemies admitted that there were times when "reason of state" demanded certain actions from a ruler. Since the sixteenth century interpretations of Machiavelli have often shifted. In the nineteenth century Italian writers found in him a source for their nationalist movement aimed at unifying the disparate states of the peninsula into a single state. And in the twentieth century scholars treated Machiavelli in a variety of ways. Some have seen him as a political opportunist who used *The Prince* to try to ingratiate himself with the Medici regime, while others have argued that he was a political realist who astutely judged the character of Italian politics at a difficult time in the country's history.

SOURCES

F. Gilbert, *Machiavelli and Guicciardini* (Princeton, N.J.: Princeton University Press, 1965).

J. Najemy, "Machiavelli, Niccolò," in *Encyclopedia of the Renaissance* (New York: Scribner, 1999).

MICHEL DE MONTAIGNE

1533–1592

Essayist

EARLY LIFE. Born in Bordeaux in southern France, Michel de Montaigne's father oversaw his early education by hiring tutors to teach the child Latin at an early age. Allowed only to speak this language until the age of six, Montaigne then entered the Collège de Guyenne, a secondary school in Bordeaux and a center of the humanist movement in France. He stayed there until he

was 16, at which point he moved on to attend the University of Toulouse, another center of French humanism and a place of fervent religious debate at the time.

RELIGIOUS WARS. Like other humanistically-educated sons of prosperous fathers, Montaigne soon made a political career. In 1554 he took a legal post at Perigeaux and a few years later he became a member of the *parlement* (a local court of appeals) at Bordeaux. While a member of the *parlement* Montaigne traveled to Paris and took part in several important missions for the king. On one of these to Rouen he witnessed the consequences of the Wars of Religion, the great civil war that afflicted France at the time. In Rouen he also saw Brazilian natives recently brought to Europe, a subject that he later exploited in his famous essay *Of Cannibals*. In 1565 he married a wealthy heiress, and the large fortune that she brought to their marriage made Montaigne a rich man. He had six children with his wife, but only one survived infancy. In his writings he only rarely mentions his family. His closest personal attachments seem to have been with other leading humanists and scholars. Among these, his closest friend was Étienne de la Boétie, a French humanist with whom Montaigne worked in the *parlement* at Bourdeaux. Boétie's premature death in 1563 had a lasting impact on Montaigne, and in later life, he composed his famous essay "Of Friendship" in memory of him. Another of Montaigne's friends was the female scholar Marie de Gournay, whom Montaigne considered like an adopted daughter. Gournay edited one version of the *Essays*. By 1570, Montaigne had grown increasingly disillusioned with public life and he resigned his duties. A year later he took up residence at a country estate where he shut himself off for a great part of each day in a tower of the chateau to devote himself to reading, study, writing, and contemplation. Except for only brief interruptions, Montaigne remained there for the rest of his life, producing the *Essays* for which he became justifiably famous.

ESSAYS. At the time in which he wrote these works, the French word *Essai* meant "trial" or "attempt." Essays were a form of short, reflective prose that had developed out of the genre of Renaissance letters. Montaigne used this form and raised its literary value to a high level. He wrote his works over a number of years and revised them many times so that they eventually became one of the milestones in the history of the French language. In France his thoughts affected later thinkers like René Descartes, Blaise Pascal, Jean-Jacques Rousseau, and Montesquieu, among others, and the works enjoyed wide readership outside their native country, too. In his play, *The Tempest*, William Shakespeare quotes from the *Es-*

says. Certainly, one reason for their broad appeal was their diversity of subjects. Montaigne ranges over a number of areas, including friendship, cannibalism, cruelty, presumption, the enjoyment of food and wine, and even the human imagination. To these various subjects Montaigne brings a depth of insight and often a cool detachment to dissect human emotions, thoughts, and fears. He is also strikingly relativistic in his judgments; in *Of Cannibals,* the essay recounting his seeing of Brazilian natives at Rouen, Montaigne concludes that Europeans are crueler than New World natives. Unlike the so-called savages of the New World who live relatively peaceful lives in harmony with nature, Europeans inhabit a social order filled with intolerance, inequality, filth, and violence.

DEVELOPMENT. Traditionally, scholars have seen three stages in the development of Montaigne's ideas in the *Essays.* More recently, others have called attention to the eclectic and free-ranging nature of his ideas, stressing that elements of many different schools of thought can be found in all periods in which he wrote the essays. While Montaigne was eclectic, there is still a definite change of tone in each of the three volumes. In the first book Montaigne appears to be applying the ancient ideas of the Stoics to the problems he analyzes. Stoicism taught that an ascetic self-discipline and disregard for the world was the best way to face harsh fortune. In the second volume Montaigne's intellectual development embraces an increasingly skeptical and relativistic creed. Truths, his insights taught him, were not to be found in religious orthodoxy or in moral absolutes. These were instead merely cultural ideas that one inherited from being brought up in a particular place and time. Catholic children were the result of Catholic parents, while Protestants and Muslims were the products of a different upbringing. No amount of philosophizing could ever prove that the assumptions that each group doggedly held were, in fact, true. In the final section of the essays, Montaigne shifted his stance yet again to develop his thoughts in an Epicurean mold. The Epicureans, an ancient Greek philosophical sect, taught that the purpose of life consisted in enjoying the good things the world had to offer. As he concluded his *Essays* Montaigne seems to have come to peace with the world, realizing that in the embrace of its pleasures lay one of the mysteries of existence. Although he remained an orthodox Catholic throughout his life, his thoughts contained many ideas upon which later seventeenth- and eighteenth-century writers would build more skeptical philosophies, philosophies that eventually challenged theistic religions altogether. For this reason his works would eventually be placed on the *Index of Prohibited Books,* the

organ of Roman Catholic censorship throughout Europe. In their own time, though, they were a stunning testament to the insights that classical scholarship helped breed among Renaissance thinkers. And they continue to provide unparalleled insights into sixteenth-century life and customs.

SOURCES

C. B. Brush, *From the Perspective of the Self: Montaigne's Self Portrait* (New York: Fordham University Press, 1994).

D. Frame, trans. and ed., *The Complete Works of Montaigne* (Stanford, Calif.: Stanford University Press, 1957).

D. Frame, *Montaigne: A Biography* (New York: Harcourt, 1965).

M. A. Screech, *Montaigne and Melancholy; The Wisdom of the Essays* (London, England: Gerald Duckworth, 1991).

FRANCESCO PETRARCH
1304–1374

Poet
Philosopher

EARLY LIFE. Petrarch was born into an impoverished family at Arezzo in Tuscany. Although his father was from Florence, the family had been banished from the city as a result of one of its many factional disputes. In 1312, Petrarch's father secured employment with the papal court in Avignon, and the family moved there. Petrarch studied law at the University of Bologna, Europe's foremost center for teaching church law, but in 1326 his father's death forced him to return to Avignon. While in Avignon the following year, Petrarch was to have met Laura, the woman who would serve as his poetic muse for much of the rest of his life. Scholars have never been able to determine whether Laura was real or imaginary. Petrarch always stressed that his love for Laura was unrequited, and the poems he dedicated to her had profound psychological insights. In order to secure employment Petrarch took Holy Orders, although he was never ordained a priest. His entrance into the church provided him with a secure income, but he continued to live much as a layperson. In this period in his life he traveled widely, visiting the Netherlands, Germany, France, and many parts of Italy. While reading in monastery libraries throughout Europe, he acquired his taste for classical literature, and he came to see Italy as the heir to the greatness of ancient Rome.

POET LAUREATE. Petrarch gained recognition throughout Italy, and eventually Europe, for his poetry.

Besides the poems that he wrote to Laura in his *Songbook* (in Italian the *Canzoniere*), Petrarch also tried to write poems in classical Latin. His efforts in this vein were largely intuitive, based upon his readings of ancient texts. The recovery of ancient Latin, which the humanists would come to champion, was a full century away, although Petrarch's attempts to revive a classical Latin style encouraged greater study among his humanist followers. For his poetic attempts in Latin and Italian, Petrarch received the poet laureate's crown at a special ceremony staged in Rome in 1342. Although he craved fame and celebrity, Petrarch tended by the mid-fourteenth century to live a life of isolation in which he could devote himself to study. During this period of his middle age, he made many contributions to the humanist movement.

HUMANISM. The word "humanism" is a modern expression coined to describe those who practiced the *studia humanitatis*, or "humane studies." Humanism championed the study of literature, moral philosophy, and history as the disciplines that could best ennoble the human spirit. Petrarch has often been called the "Father of Humanism," but he was preceded in his efforts by several generations of Italian scholars who were interested in classical Antiquity. He is better described as the first Italian to attract European-wide attention to this brand of scholarship. In Petrarch are to be found many of the tendencies that the humanist movement would evidence over the next 200 years. He was passionately concerned with recovering knowledge of classical Antiquity. He believed that eloquent speaking and writing were more effective means of promoting virtue than the logical scholastic philosophy that was common at the time. In many of his works he strove to create a relevant personal philosophy, in which he relied on the works of Cicero, the ancient Stoics, and St. Augustine as his primary sources of inspiration. Realizing that the difficulty of mastering the human will was the greatest barrier to achieving virtue, Petrarch focused his efforts on trying to identify ways in which human nature might be overcome. His dictum, "It is better to will the good than to understand the truth," expresses much of the core of his thought. Still, Petrarch was eclectic, drawing inspiration from many different sources, and he was not always logically consistent. A final dimension of Petrarch's humanism defended the study and uses of poetry, a form of literature that had not been held in high esteem by medieval scholastic philosophers. Petrarch insisted that the scriptures were, in fact, forms of poetry and that the study of poetic literary forms could serve virtuous purposes. The consequences of his enthusiastic embrace of poetry helped to inspire many later discussions of poetry among the humanists and gave inspiration as well to later Renaissance poets.

LITERARY OUTPUT. Petrarch's literary output was enormous. Among his most important works were his *Songbook*, in which he perfected the use of the sonnet form, his *Familiar Letters*, which were a collection of letters he wrote to friends and associates on philosophical subjects, and his *The Secret or the Soul's Conflict with Desire*, a dialogue in which he debated St. Augustine on how to master his will. At many points in the Renaissance, though, scholars continued to consider the themes he had first identified in other writings. His discussion of the solitary life, *De vita solitaria*, inspired later humanists to emulate his cultivation of the classical ideal of studious, isolated leisure. And his attempts to revive ancient styles of poetry also gave rise to new literary genres in the later Renaissance. In short, Petrarch helped to establish many later patterns evidenced among the humanists. He was a philosopher of some insight, a literary figure of celebrated acclaim, and a voracious student of classical Antiquity.

SOURCES

H. Baron, *Petrarch's Secretum: Its Making and its Meaning* (Cambridge, Mass.: Harvard University Press, 1985).

M. Bishop, *Petrarch and His World* (Bloomington, Ind.: Indiana University Press, 1962).

C. Trinkaus, *The Poet as Philosopher: Petrarch and the Formation of Renaissance Consciousness* (New Haven, Conn.: Yale University Press, 1979).

DOCUMENTARY SOURCES
in Philosophy

Jean Bodin, *Six Books of the Commonwealth* (1576)—This response to the religious crises of the Wars of Religion advocates respect for the absolute sovereignty of the prince as the way out of France's troubles. It became an important text justifying the absolutist pretensions of seventeenth-century monarchs.

Marsilio Ficino, *Platonic Theology* (1474)—A major work of Renaissance Platonism, this treatise tries to synthesize Plato's philosophy with the Christian religion. Its heavy reliance on metaphysics was not widely understood, although many tried. Certain concepts, like the notion of Platonic Love, were to catch on as a result of Ficino's works.

Niccolò Machiavelli, *The Prince* (1513)—The author thought that this portrait of the amoral prince was necessary to end the chaos of Italy's politics. Notorious in the sixteenth century for its amorality, the work was one of the first realistic portraits of politics.

Marsilius of Padua, *Defender of the Peace* (1324)—This important political treatise argues for the separation of the powers of church and state and sets out an early theory of representative government.

Michel de Montaigne, *Essays* (1595)—One of Montaigne's longest life projects, this work presents his philosophical musings on an extraordinary array of subjects. It shows his search for a relevant personal philosophy free from the intolerance of traditional religion.

Nicholas of Cusa, *On Learned Ignorance* (c. 1350)—A difficult philosophical treatise that combines medieval mysticism with Neoplatonism, this work posits that God is everywhere present in the world, that he is the universe's center, and that the world is infinite. It is the first Renaissance statement of a limitless universe and was followed by many more in the coming centuries.

Francesco Petrarch, *Familiar Letters* (1374)—Written throughout his life, these letters by Petrarch on a multitude of themes provide an insight into the early philosophical ideas of humanism.

Giovanni Pico della Mirandola, *Oration on the Dignity of Man* (1486)—One of the Renaissance's most enthusiastic endorsements of the concept of human dignity, this oration was written as an introduction to Pico's *900 Theses*, a work that argued that all religions share an underlying core of truths.

Pietro Pomponazzi, *On the Immortality of the Soul* (1516)—An Aristotelian and a humanist, Pietro Pomponazzi argues in this treatise that the soul's immortality cannot be proven on philosophical grounds.

Lorenzo Valla, *Dialogue on Free Will* (1439)—An important Renaissance dialogue that argues against the traditional position that human beings have free will to participate in their salvation; this work presents a position that anticipates the later Protestant principle of salvation by faith.

chapter seven

RELIGION

Philip M. Soergel

IMPORTANT EVENTS
in Religion

1300 Pope Boniface VIII calls for the celebration of the first Jubilee year at Rome, granting indulgences to those European pilgrims who visit the city. The rise of the Turks in the Mediterranean has made pilgrimage to Palestine increasingly difficult for Europeans, leading to Rome's emergence as Europe's pilgrimage capital during the Renaissance.

1302 In his ongoing rivalry with King Philip of France, Boniface VIII publishes his bull, *Unam Sanctam*, the most extravagant medieval statement of papal authority ever written. One year later, he is captured by a mob outside Rome, tortured, and released, dying a broken man a few months later.

1309 Through the king of France's influence, the administrative capital of the church is moved from Rome to Avignon, on the southeast border of Italy and France. The change in the church's administrative center will become known as the Babylonian Captivity, in reference to the captivity of the Jews at Babylon in the Old Testament.

1320 The poet Dante Alighieri finishes his great religious and allegorical poem, *The Divine Comedy*.

1323 The spiritual Franciscans, or Fraticelli, are condemned for their literal interpretation of St. Francis's notion of poverty.

 Pope John XXIII declares in a bull of November of that year that the Apostles and Jesus had owned private property.

1327 The mystic Meister Eckhart dies at Cologne.

1342 The pontificate of Clement VI, widely known for his corruption and decadence, begins at Avignon.

c. 1350 Tensions resulting from the Black Death cause Jews to be blamed for the disease's outbreaks in many parts of Western Europe. Pogroms (organized massacres of Jews) erupt in Southern France and Germany.

 More than one million Europeans visit the city of Rome during the second Jubilee.

1351 The Statute of Provisors in England establishes the king's right to appoint bishops and archbishops within his kingdom.

1353 English Statute of Praemunire forbids subjects to appeal their legal cases to Rome. Tighter restrictions follow in 1365 and 1393.

1378 Pope Gregory XI returns the capital of the church to Rome, but soon dies; rival popes are elected, beginning the period of the Great Schism in the church.

1380 The mystic Catherine of Siena dies.

1381 Peasants kill the archbishop of Canterbury during the English Peasants' Revolt.

1382 John Wycliffe begins to translate the Bible into English.

1409 The Great Schism worsens when a third pope is elected at the Council of Pisa.

1415 The Council of Constance is convened to heal the breach in the church caused by the Great Schism; the Council also condemns the Bohemian heretic John Huss, who is sentenced to be burnt at the stake.

1417 The Council of Constance concludes by deposing Benedict XIII and electing a new pope, Martin V, thus ending the Great Schism.

c. 1430 The Hussite heresy grows in Bohemia and the church undertakes several crusades to

suppress the movement. By 1436, concessions are made to the Hussite Church in Bohemia, which is allowed to retain its liturgy and celebration of communion with both bread and wine.

1438 Pragmatic Sanction of Bourges limits the power of the pope in France.

1439 The Council of Ferrara-Florence is convened in Italy.

1440 Lorenzo Valla proves that the Donation of Constantine is a forgery. The document had alleged that the fourth-century emperor Constantine had ceded control over Western Europe to the Roman pope.

c. 1450 The Vatican Library is founded at Rome. Pope Nicholas V, a humanist, strengthens the church's support of the arts and scholarship.

1456 Johann Gutenberg of Mainz publishes the first Bible using movable type.

1460 Pope Pius II declares conciliarism a heresy. The conciliarists had argued that church councils were superior to the judgments of the pope.

1472 The first printed edition of *The Imitation of Christ* appears; more than seventy additional editions will be printed before 1500.

c. 1480 Humanism begins to spread to Northern Europe; biblical studies intensify in Italy and elsewhere in Europe under the influence of humanism.

1483 Martin Luther is born at Eisleben in Saxony, Germany.

1492 Spain begins to expel Jews who will not convert to Christianity.

1499 Desiderius Erasmus makes his first journey to England where he befriends Sir Thomas More and John Colet.

1503 Cardinal Francisco Ximénes des Cisneros founds the Polyglot Bible project at Alcala in Spain.

1506 Pope Julius II has St. Peter's Basilica in Rome demolished and begins to formulate plans for an enormous replacement.

1509 Under the influence of Johann Pfefferkorn, a converted Jew, the Holy Roman Emperor Maximilian I orders all Jewish books critical of Christianity to be seized and burnt. The plan is denounced by the Christian Hebraist Johann Reuchlin, and the resulting controversy, known as the Reuchlin Affair, pits Germany's humanists against scholastics.

1516 Desiderius Erasmus publishes his Greek and Latin New Testament. The Concordat of Bologna grants the kings of France the right to appoint hundreds of officials to high posts in the French Church.

1517 Martin Luther distributes his *95 Theses*, a protest against the church's sale of indulgences.

1519 Martin Luther debates papal authority and other issues with Johann Eck in a staged disputation held at Leipzig.

Ulrich Zwingli takes up the post of city preacher at Zürich and introduces biblical preaching.

1520 Martin Luther publishes three major treatises defending his views: *The Address to the Christian Nobility of the German Nation*, *The Babylonian Captivity of the Church*, and *On Christian Liberty*.

1521 Pope Leo X condemns Luther as a heretic.

1522 Luther is called to the imperial diet at Worms to answer the charges of heresy; he is placed under the imperial ban, a death sentence, but leaves the diet on a safe conduct. He is kidnapped and taken into seclusion at the Wartburg place near Eisenach, where he continues his translation of the New Testament into German.

Ulrich Zwingli violates the church's teachings against eating meat in Lent and convinces Zürich's town council to begin to reform the local church.

1524 The Peasants' War begins in southwestern Germany and spreads into central and eastern Germany. As many as 100,000 of the movement's supporters are slaughtered during the suppression of the revolt that occurs in the spring of 1525.

1527 Saxony stages the first Visitation of its churches, causing Luther to formulate his *Small Catechism of 1529*, a document intended to indoctrinate children in the Reformation's teachings.

German imperial forces sack the city of Rome.

1528 The pope recognizes the Capuchins, an order of reformed Franciscan brothers.

A league of states and cities sympathetic to Martin Luther stage a protest at the imperial diet at Augsburg. After walking out of the meetings, they become known as Protestants, a name which eventually encompasses all those who reject the authority of Rome.

1534 Luther completes his translation of the Bible into German.

Anabaptist forces seize control of the city of Münster in northwest Germany. They abolish private property and introduce polygamy into the city, prompting a coalition of church and state forces from throughout the region to lay siege to the city, eventually crushing the Anabaptist revolution.

To secure his divorce from Catherine of Aragon, Henry VIII obtains from Parliament the Act of Supremacy, a document that establishes his supremacy over the church in England.

1535 The Ursulines, a religious order that will specialize in the education of young women, is founded in Italy.

1536 The French reformer John Calvin prints the first edition of the *Institutes of the Christian Religion*, a document that will help to spread the Calvinist form of Protestantism throughout Europe in the second half of the sixteenth century.

In England, Henry VIII begins to dissolve Catholic monasteries.

1540 Pope Paul III officially recognizes the Society of Jesus or the Jesuits, who soon begin their missionary work in India and the Far East.

1541 John Calvin returns to the city of Geneva in French-speaking Switzerland after a period in Strasbourg and consolidates his power over the Reformation in the town.

1545 The Council of Trent begins its deliberations on the reform of the Roman Church.

1548 The first Jesuit college is founded at Messina in Southern Italy.

After the defeat of the Protestant Schmalkaldic League, the emperor Charles V establishes the Interim, a religious plan to re-catholicize Protestant areas of Germany.

1549 Thomas Cranmer, the archbishop of Canterbury, issues the first *Book of Common Prayer* in England. The book, influenced to an extent by the Reformed theology of Zwingli and Martin Bucer, prescribes regular English liturgies that are obligatory for all members of the Church of England.

c. 1550 Calvinism begins to spread throughout Europe as a result of the missionary efforts of those who are trained at Geneva.

1555 The Peace of Augsburg in Germany establishes the principle "He who rules, his religion." Territorial rulers are allowed to decide whether Catholicism or Lutheranism will be practiced in their territories.

1559 Pope Paul IV establishes the *Index of Prohibited Books* to identify and publish a regular listing of books that are dangerous to Catholic truth.

1563 The Council of Trent concludes its deliberations.

1572 During August, massacres of Protestants break out in Paris and other provincial cities in France. Within several weeks perhaps as many as 5,000 French Calvinists are dead.

Revolt against Spanish rule of the Netherlands begins in the Dutch provinces.

1595 The Protestant Henry of Navarre successfully pursues his claim to the throne of France, becoming the first of its Bourbon monarchs. To subdue Paris, Henry renounces his Protestantism and converts to Catholicism.

1598 The Edict of Nantes grants French Calvinists a limited degree of religious toleration.

OVERVIEW
of Religion

INTOLERANCE. Renaissance Europe was an overwhelmingly Christian society where the teachings of the Roman Church exercised an influence on all areas of life. The hold of this Catholic or universal religion was profound, but at the same time, it frequently bred intolerance. Over the centuries Europe had become a persecuting society, and intolerance of religious minorities mounted during the fourteenth and fifteenth centuries. In Spain, the last Islamic communities were banished in the final stages of the Spanish Reconquest of the peninsula. And at the same time Christian treatment of Jews, which had never been good, grew harsher. In the wake of the Black Death (1347–1352) Jewish pogroms occurred throughout Southern France and Germany, as locals accused Jews of poisoning wells to bring on the disease. Jewish persecution persisted in the fifteenth century, with Austria expelling its Jews in 1421, Spain and Sardinia in 1492, and Portugal in 1497. Europeans may have directed considerable violence at religious outsiders, but they were no less accepting of those Christians who taught unorthodox ideas. In Renaissance Europe, the deadly persecution of heresy continued. In the fourteenth century the church struggled to contain the teachings of the Spiritual Franciscans and of John Wycliffe. The Spiritual Franciscans held to a literal interpretation of St. Francis's notions about religious poverty—teachings that were a challenge to the wealth and worldly prestige of the church. A similar note echoed in the writings of the Oxford theologian John Wycliffe, who attacked the secular authority of the pope and the church's doctrines concerning the sacraments. In England, both church and state tried to root out Wycliffe's followers, but a small, underground group, known as the Lollards, persisted. Wycliffe's teachings, moreover, escaped from England, and in the early fifteenth century, they inspired the theologian John Huss in Bohemia (a part of the modern Czech Republic). Following his execution at the Council of Constance in 1415, Huss's ideas inspired a rebellion that produced a new Utraquist

Church. The Utraquists violated orthodox teaching by giving both bread and wine to lay people during communion. Since the high Middle Ages the church had withheld the Chalice or consecrated wine from the laity and reserved this portion of the Eucharist only to priests. By the 1430s, the Hussite movement had grown in Bohemia and now threatened to spill over into other areas of Central Europe. Rome mounted five largely unsuccessful crusades to wipe out Hussitism. The movement splintered into factions and civil war broke out. In 1434, the Utraquists were successful in subduing the more radical Taborites, and they entered into negotiations with Rome. Rome eventually recognized their liturgy, allowing the Utraquist Church to survive in Bohemia, where it would eventually provide an example to sixteenth-century Protestants of a successful secession movement from Rome.

CRISIS IN THE CHURCH. In the fourteenth century long-standing rivalries between church and state over the election of bishops and archbishops and other details of church administration heated up. In 1303, King Philip IV of France inspired a Roman mob to attack Pope Boniface VIII, who died a broken man several months later. Philip succeeded in obtaining the election of a friendlier pope, and by 1309, the administrative capital of the church had been moved from Rome to Avignon, within southern France. The papacy remained there for slightly more than 70 years, a period that became known in the later Middle Ages as the "Babylonian Captivity," a reference to the seventy years of Jewish captivity in ancient Babylon recorded in the Old Testament. The return to Rome in 1378, however, brought new problems. Rival factions from within the College of Cardinals elected their own popes: Urban VI, who remained at Rome, and Clement VII, who continued to administer the church from Avignon. This era of dual papacies became known as the Great Schism and it grew more complicated in 1409, when the Council of Pisa elected Alexander V to replace the rival Roman and Avignese popes. In both of the church's capitals, factions refused to accept the election, and for a time, three popes ruled in Western Christendom. By 1417, the Council of Constance had successfully resolved the crisis by eliminating all three popes and electing Martin V in their place. As a result of the council's success, however, a new conciliar movement had grown up in the church. The conciliarists argued that a permanent council within the church—in effect a kind of parliament—should supervise the papacy. Although conciliarists grew progressively weaker throughout the fifteenth century, they did call for reform in the church. But re-established in the city of

Rome, the traditional seat of its power, the papacy was generally successful in re-exerting its authority over the church. By 1500, the prestige of the popes was high, despite widespread corruption and abuse within the church.

LAY PIETY. If the administrative problems of the church were profound in the fourteenth and fifteenth centuries, this same period saw a vital and deepening surge of piety among the laity. This surge can be seen in the popularity of confraternities, which were brotherhoods and sisterhoods of lay people who met regularly for prayer, to perform Christian rituals, and to do good works. The religious devotion of the laity also found expression in the many bequests made to churches and religious institutions as well as the endowing of posts for preachers and priests. Much of late-medieval piety focused on the preparation for death, as in the popular *Art of Dying* books that began to appear in the fifteenth century. It also found expression in a devotion to the Eucharist, as the devout came to favor frequent participation in communion. In both the countryside and the cities pilgrimages to venerate the relics of the saints were popular, and a number of new shrines appeared in the period. Indulgences were another important dimension of popular piety. The church granted indulgences as formal pardons for the time one would have to spend in purgatory atoning for sins after death. The popularity of pilgrimages and indulgences points up the continuing vitality of traditional medieval religious life in the Renaissance. At the same time, the increase of new, individual religious practices demonstrated the growing importance of an internalized religion. The spread of *Books of Hours*, collections of prayers for private meditation, points to the appearance of a more internalized and subjective kind of devotional life, as do works like St. Thomas à Kempis's *Imitation of Christ.* Bible reading, a practice supported by heretical groups like the Lollards and Waldensians, began as well to find its way into the mainstream, although it could only be practiced by the small minority of people who were literate. Both the sixteenth-century Protestant and Catholic Reformations would continue to deepen this strain of individual and internalized religious devotion.

THE LUTHER AFFAIR. By the early sixteenth century the church had weathered significant controversies and emerged resilient. Most Europeans still believed that there was no salvation outside the church, beliefs that were soon to be challenged by the sixteenth-century Reformation. Martin Luther, a German monk and theologian, dominated the early history of this movement. Luther's own life had been marked by an intensely personal quest for assurance of his salvation. He had dedicated himself to the study of the scriptures, and by 1516, he had begun to teach radical doctrines about salvation in his post as professor of theology at the University of Wittenberg. Luther's lectures stressed that a person's salvation was a consequence of the gift of faith that one received through God's grace, not one's good works. This radical idea challenged traditional orthodoxy, which stressed that both good works and faith were necessary for salvation. These teachings did not attract much attention until late 1517, when Luther attacked the church's unscrupulous sales of indulgences. Through the circulation of his *95 Theses*, Luther hoped to spur debate among theologians about the teachings of the church. In the years that followed the controversy he unleashed dominated public life in Germany. The new invention of the printing press helped to disseminate Luther's ideas to an audience beyond the confines of the universities. Rome did not stand by quietly while Luther's position attracted admirers. After several quiet attempts to encourage Luther to recant, Pope Leo X condemned his ideas as heresy in June 1520, and the following spring, summoned him to appear before the imperial Diet meeting in the city of Worms. Luther steadfastly refused to deny his teachings, for which the Diet sentenced him to death. At the conclusion of the trial Luther's protector, the elector Frederick the Wise, managed to have him spirited away. In hiding Luther began translating the Bible into German, something that had already been advocated by Renaissance humanists like Desiderius Erasmus. Embraced by Luther and other reformers, lay Bible reading eventually became one of the defining features of Protestantism.

RADICAL REFORMERS. During Luther's enforced confinement, other reformers began to teach even more radical ideas. In Zürich, Ulrich Zwingli convinced the town council to abolish the traditional laws of the church. He established a pattern of reform that was even more extreme than Luther's, advocating the abolishment of all religious practices that did not have direct support in the scriptures. Both Zwingli and Luther desired that the reform of the church proceed along orderly lines and be controlled by state and city authorities. Elsewhere, though, radical reformers like Andreas Karlstadt and Thomas Müntzer began to argue for a complete clearing away of medieval Christianity, and they showed little deference to state authorities. Many radicals preached an apocalyptic message that the world was nearing an end, and they encouraged their followers to take the law into their own hands. Some championed the cause of the poor and downtrodden and became involved in the great Peasants' War of 1524–1525. Their presence in

that movement prompted Luther's condemnation, and helped to produce a bloody repression of the rebellion. Religious radicalism survived, though, and came to be dominated by the Anabaptists, a group that practiced a second adult baptism and advocated a Christian life lived in isolation from "worldly abomination." In 1527, supporters of this movement met at Schleitheim in Switzerland and formulated a simple confession of their faith. Many who followed in this radical path practiced a simple, communal life. But in 1534, one group of Anabaptists seized control of the Northern German town of Münster, where they founded a social revolution that abolished private property and established polygamy. Though suppressed a year after it began, this Revolution of the Münster Prophets inspired widespread fears about the Radical Reformers, prompting their persecution in both Protestant and Catholic states.

REFORMED CHRISTIANITY. In most of Germany and Scandinavia Luther's pattern of reform dominated, and state authorities adopted and controlled the Reformation. In Switzerland, a different pattern of Reformed Protestantism had already begun to develop in Zwingli's Zürich and in the German border town of Strasbourg. Reformed Christianity placed greater emphasis on the remolding of society through the teachings of the Bible and the offices of the church than had Luther's reforms, which were more concerned with establishing the teaching of justification by faith. In the figure of John Calvin, a French Protestant who fled to the city of Geneva in Switzerland, Reformed Christianity found its most coherent exponent, and as a result, the movement came to be known as Calvinism. Calvin's *Institutes of the Christian Religion*, first published in 1536, became the intellectual manifesto of Reformed Christianity, and through the missionaries that Calvin and his associates trained at Geneva, Calvinism spread to the British Isles, the Netherlands, France, and Central and Eastern Europe. Eventually, its teachings dominated much of North America through the settlement of Calvin's English followers, the Puritans. By 1550, the growing popularity of Calvinism made it increasingly difficult for Rome to combat Protestant teachings. At the same time the increasing divergence between Lutheranism and Calvinism helped to breed bitter divisions within Protestantism.

THE CATHOLIC REFORMATION. From the 1520s many loyal to the Roman Church had called for a council to resolve the differences between the reformers and the traditional church. Despite many efforts to heal these differences in the 1530s and 1540s, intractable divisions increasingly separated Catholicism and Protestantism. In 1545, though, the papacy finally convened the long-hoped-for council at Trent, in modern northern Italy. During the next eighteen years, the members of the council met three different times to consider the criticisms that Protestantism had made of the church. They ultimately rejected Protestant teachings, and their definition of Catholic orthodoxy prevailed in the church until the Second Vatican Council of 1962. Trent also laid out a plan for the reform of the church that concentrated on raising the standards of the clergy. Its highly negative decrees condemning Protestantism gave rise to the term "Counter Reformation." At the same time a widespread revival of Catholicism was already underway, prompted not by Protestantism, but by the deepening surge of piety that had characterized the later Middle Ages. This Catholic Reformation gathered steam in the sixteenth century. Its effects can be seen in the birth of new religious orders, the development of early baroque art and architecture, and in renewed expressions of popular piety such as confraternities, processions, and pilgrimages.

CONCLUSION. The Renaissance was a period of momentous change in the history of Christianity in Europe. The period began with the calamities of the Avignon papacy and the Great Schism, events precipitated by long-standing competition between church and state. Heresy, too, was a problem in the late-medieval church, and the patterns that emerged to deal with it shaped the church's reaction to the Protestant Reformation. That movement—the most significant development within the period—produced new churches controlled by the secular state. The intolerant attitude that grew out of these new religions was not new, but the intensified effect these new exclusive creeds exercised on the arts and humanities would be profound.

TOPICS
in Religion

THE LATE-MEDIEVAL CHURCH

COMPLEXITIES. The late-medieval church was vast and complex, the single largest and most diverse political institution of the Renaissance. In theory, the church's governmental structure was a pyramid in which the papacy sat at the top. The pope and his officialdom at Rome supervised the activities of scores of bishops and archbishops throughout Europe, who, in turn, oversaw thousands of priests and their parishes. Numerous religious orders of monks, nuns, and friars scattered

throughout Europe often stood outside the structure of the provinces of the church known as diocese. Over the centuries, these orders had amassed significant wealth, and many enjoyed exemptions from the control of Europe's bishops and archbishops. Most owed allegiance to their order, which the papacy ultimately supervised; that tie could be tenuous when hundreds of miles separated an abbey or a monastery from the church's capital. The administrative complexities of the Roman Church may have been considerable, but so were the numerous roles the institution fulfilled in society. In the spiritual realm, the church provided a necessary link between God and humankind by virtue of its performance of the sacraments and rituals. For the orthodox, there was no salvation outside the church. In the political realm, the institution was an international force that jealously maintained its power against the encroachment of kings and princes. And locally, the church performed numerous practical functions in society. It administered an effective and sophisticated judicial system to which, in theory, all Europeans could bring cases. As Europe's largest landholder, it was a financial powerhouse, levying taxes and collecting revenues that were the envy of many princes. Its monasteries and convents produced rich storehouses of agricultural goods that were sometimes sold on the urban market; many of these institutions ran breweries and distilleries that could compete more successfully against private concerns because of the church's widespread exemption from local taxation. And finally, religious orders like the Carthusians and the Cistercians were important breeders of sheep and livestock who influenced the international market in wool.

ANTICLERICALISM. Its worldly wealth and power, though, subjected the church to criticism. Little evidence exists to suggest that corruption was more widespread within the Renaissance church than it had been in previous centuries, but high-profile crises like the Babylonian Captivity and the Great Schism made the church more vulnerable to critics. A more general anticlerical spirit, motivated by the hatred of the clergy's special rights and privileges, grew as well. The corruptions people identified—sexual immorality among the clergy, the holding of multiple offices by clerics, and the selling of dispensations from church law, to name just a few—had long existed. Rising dissatisfaction with these centuries-old problems, though, can be seen in the attacks on the wealth and sexual immorality of the clergy that litter great works of Renaissance literature like Giovanni Boccaccio's *Decameron* or Geoffrey Chaucer's *Canterbury Tales*. These criticisms also came from famous preachers like St. Bernard of Siena (1380–1444) and St. John of

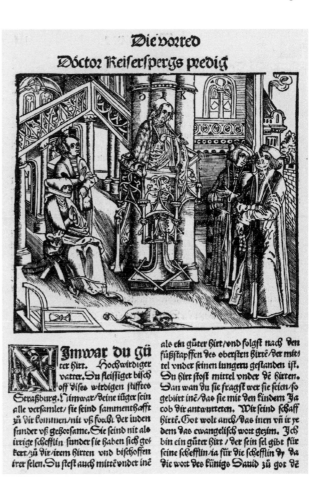

Late-medieval preaching as depicted in a 1513 printed sermon of Johannes Geiler von Kaysersberg. THE LIBRARY OF CONGRESS, ROSENWALD COLLECTION.

Capistrano (1386–1456), who rode a high tide to popularity, in part, by criticizing the immorality of the church. And more generally, an anticlerical spirit rested just below the surface of late-medieval society, where political circumstances might bring it to life. In the frequent peasant revolts that erupted in Europe after the Black Death, hatred of the clergy sometimes boiled over to produce spectacular attacks on priests, bishops, and archbishops. In 1381, for example, English peasants seized and decapitated the archbishop of Canterbury Simon Sudbury who, as England's Lord Chancellor, fulfilled both important clerical and secular functions. Anticlerical violence seems always to have been most pronounced in those places where, as in the case of Sudbury, clerics exercised both important secular and religious powers, proof that the mingling of worldly and religious power so in evidence within the Renaissance church could be an uneasy mix for Europeans.

AVIGNON. For most of the fourteenth century both the possibilities and limitations of papal power were

a PRIMARY SOURCE *document*

HERETICAL CRITICISM

INTRODUCTION: John Wycliffe was among many medieval heretics who denied transubstantiation, the notion that in communion the bread and wine is changed into the actual body and blood of Christ through the priest's consecration. This belief was later to be rejected as well by sixteenth-century Protestants. His *Trialogus* was a discussion between the figures Alithis, Pseudis, and Phronesis in which Wycliffe pointed out the illogicality of transubstantiation, because the bread used in the Eucharist could not be in the same place as the Body of Christ at the same time.

Alithis: I must request you, brother, to show still farther, from reason or Scripture, that there is no identification of the bread with the body of Christ ... For I am no means pleased with the spurious writings which the moderns use, to prove an accident without a subject, because the church so teaches. Such evidence should satisfy no one.

Phronesis: As to identification, we must, in the first place, agree on what you mean by the term. It signifies God's making natures which are distinct in species or number, one and the same—as though, for instance, he should make the person of Peter to be one with Paul... For if A is identical with B, then both of them remain; since a thing which is destroyed is not made identical, but is annihilated, or ceases to be. And if both of them remain, then they differ as much as at first, and differ consequently in number, and so are not, in the sense given, the same ...

Pseudis: In the first place, you cannot escape from this expository syllogism: First, This bread becomes corrupt, or is eaten by a mouse. Second, The same bread is the body of Christ. Third, Therefore the body of Christ does thus become corrupt, and is thus eaten;—and thus you are involved in inconsistency.

SOURCE: John Wycliffe, *Trialogus,* in *Tracts and Treatises of John de Wycliffe.* Ed. Robert Vaughan (London: Blackburn and Pardon, 1845): 150, 152.

brilliantly displayed, not in Rome, but in the city of Avignon, just inside the southern borders of France. The period in which the papacy ruled from Avignon lasted from 1309 until 1378 and was known even in the fourteenth century as the "Babylonian Captivity," a phrase that likened the papacy's relationship to France with Israel's bondage in Babylon. It was not a very accurate portrayal of the Avignon Papacy. It is true that Pope Clement V (r. 1305–1314) moved there at the instigation of the French king, but the city was not technically a French possession. It belonged to the kingdom of Naples, and the church purchased it before setting up its capital there. The town did lie within France's boundaries, but the king was still several hundred miles to the north, unable to exert day-to-day influence over church administration. Instead France's dominance over the church was more subtle. All seven of the Avignon popes were French, and the College of Cardinals—the body charged with electing the pope—had a large contingent of Frenchmen, too. Still, except for the first Avignon pope, Clement V, the pontiffs elected in the city were bright and energetic, and they administered the church more effectively than it had been for some time. During this period the cost of papal government steadily rose. To create sufficient revenue to meet their expenses, the popes moved to centralize their administration of the church and to identify new sources of revenue. The papacy, for instance, reclaimed its rights of reservation, that is, the power to appoint clerics to key offices in the church. While vacant, the income from these offices flowed to the popes, and the papacy began to levy fees on those who wished to be appointed to them. To manage this system, a large bureaucracy developed in Avignon, and bribes became commonplace. For these reasons, Avignon became synonymous in the minds of Europe's rulers with corruption. Such feelings produced measures like the Statutes of Provisors (1351) in England, an act of Parliament that prohibited the pope from appointing non-English subjects to church offices. At Avignon, the church's dependence on revenues from the sale of indulgences grew, too. All these innovations in papal finance and government caused a decline in papal prestige and a growing distaste for the rising flow of wealth into the church's coffers.

THE GREAT SCHISM. These problems paled in comparison to the dilemmas that arose after the papacy's return to Rome in 1378. Soon after he re-established papal government in the city, Pope Gregory XI died, and the College of Cardinals elected an Italian to assume the office as Urban VI. Within months, Urban's attacks on the worldliness and corruption of the church's cardinals had alienated many, and a faction of the college met to depose him. In his place they elected Cardinal Robert of Geneva who took the name Clement VII. Urban, for his part, refused to resign, and instead he excommunicated the rebel cardinals and their pope. He created a number

MILESTONES
in the Renaissance Papacy

1309: The papacy moves to Avignon.

1350: A Jubilee is celebrated at Rome after the disaster of the Black Death.

1378: Gregory XI returns the papacy to Rome; after his death in the same year, the Great Schism begins.

1415: The Council of Constance deposes rival popes and resolves the crisis of the Great Schism.

1450: The first humanist pope, Nicholas V, founds the Vatican Library.

1492: Pope Alexander VI is elected pope. One of his three children will die suspiciously. His daughter, Lucrezia, will be married off to a series of important noblemen, and his son, Cesare, will conduct wars of conquest for the pope.

1503: Alexander VI dies and Cesare Borgia tries to take over the papal territories in central Italy; Julius II is elected pope and captures him.

1506: Pope Julius tears down St. Peter's Basilica and makes plans for a larger and more splendid building.

1513: Leo X, a member of the Medici family, assumes the office of the pope and continues construction of the Vatican.

1520: Leo X denounces Luther's teachings as heresy.

1527: Rome is sacked by imperial forces of Charles V. The destruction of the city is widespread and sends shock waves through Europe.

1541: The papacy grants official recognition to the Society of Jesus or Jesuits.

1545: Pope Paul III convenes the Council of Trent to reform the church and consider Protestant doctrines.

1559: Pope Paul IV establishes the Index of Prohibited Books, an organ of censorship in the Catholic Church.

1575: The pope pronounces a Roman Jubilee at Rome that is widely attended by Catholics from throughout Europe and symbolizes the resurgence of Catholicism following the Reformation.

1585: Sixtus V ascends to the papal throne. During his brief five-year reign, a number of major public works and church construction projects will be completed, including the dome of St. Peter's Basilica, the Lateran Palace, and the new acqueduct, the Acqua Felice, which provides the city with a secure source of water. These projects will help to prepare the way for the great age of Rome's expansion that occurs in the Baroque era.

of new, mostly Italian cardinals to replace them. Clement VII now refused to step down, and he left Rome for Avignon, where he and the majority of the original College of Cardinals set up a rival papal court. For almost forty years this Great Schism prevailed in the European church, with international politics determining which pope a specific nation recognized. England, Ireland, parts of Germany, and most of Italy remained loyal to the pope at Rome, while France, Castile, Aragon, Portugal, and Scotland recognized Avignon. The resulting confusion eroded the notion of the church as the sacred instrument of God on earth. Instead more and more people saw the church as a human institution. The schism thus helped to create an audience for the teachings of figures like John Wycliffe in England and John Huss in Bohemia, both of whom attacked the wealth and secular power of the church and instead insisted that Rome would do better to concentrate on its spiritual mission.

CONCILIARISM. The way out of the crisis of the Great Schism gradually appeared in the form of a new political theory that developed within the church known as conciliarism. The conciliarists taught that the decisions of a church council could override those of the popes. In the past the popes had convened church councils, but neither the Avignon nor the Roman popes could be expected to call a council that might depose them of their office. Thus conciliar theorists at the University of Paris began to make the convincing case that a church council might be convened independently of the pope under extraordinary circumstances. In 1409, representatives of both papal governments and church officials from throughout Europe met in the Italian city of Pisa to consider ways of healing the breach in the church. After deliberating, the council decided that both papal governments were invalid and it called for the resignations of the Avignon and Roman popes. When neither would resign, it declared them antipopes and elected a new pope, Alexander V. For a time both Avignon and Rome held out against the new Pisan pope, and factions throughout Europe supported each of the three papal governments. Thus the Council of Pisa, which had been called to heal the breach, inadvertently worsened the

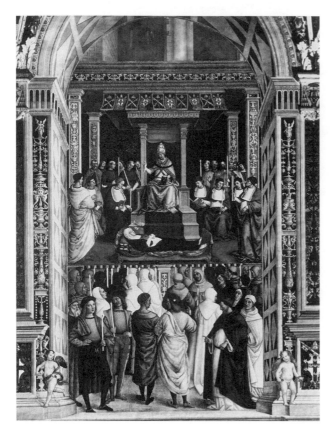

Pope Pius II Canonizes St. Catherine of Siena by Pinturicchio.
PUBLIC DOMAIN.

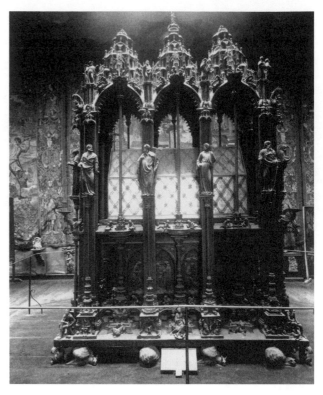

Shrine of St. Sebald by Peter Vischer, in St. Sebald's Church,
Nuremberg. **MARBURG-ART REFERENCE, ART RESOURCE, NY. REPRO-
DUCED BY PERMISSION.**

crisis for a time. In 1413, a second council convened at Constance in Germany. There church officials successfully obtained resignations from the Pisan and Roman popes, and deposed the Avignon pope when he refused to resign. They elected Martin V to serve as the indisputable leader of the church, who now enjoyed loyalty from all parts of the church. In the decades that followed, many conciliarists continued to argue that the church needed a permanent resident council to advise and supervise the activities of the pope, an innovation that, had it been established, would have transformed the church into something similar to a constitutional monarchy. Although conciliarists remained powerful in the first half of the fifteenth century, one tenet of their teachings—that church councils were superior to the judgments of the pope—was declared heretical by Pope Pius II in 1460. After that date, conciliarism declined rather rapidly as a challenge to papal authority.

INDULGENCES. Indulgences were an important feature of the late-medieval church. They had first been used to encourage soldiers to participate in the Crusades, but by the fourteenth century, they were being applied to all kinds of good works in the church. The theolog-

ical definition of indulgences was subtle. They were not licenses to sin, nor did they release souls automatically from purgatory. They were instead pardons that substituted for penances, those penitential acts assigned by priests at confession. In practice, though, the indulgence's popularity developed from the growing importance of purgatory in the later Middle Ages. Purgatory was believed to be that realm of the afterlife where Christians would be purged of the unconfessed sins they had committed in life. By the fourteenth century, most Europeans believed that only the saints, those sinless Christians, would go immediately to Heaven after their deaths. Others would have to spend some time in purgatory suffering for their sins. Indulgences substituted for this penance in the afterlife by granting a specific number of days off the time that would be spent in purgatory. There were many ways to attain indulgences. Contributing to church building projects, making pilgrimage to certain shrines, venerating a saint's relic, or saying certain prayers were just a few of the many good works that Christians could perform to gain access to the indulgence's pardon. In the fifteenth century the evidence shows that the market in indulgences went into an "inflationary spiral." At Rome, local church officials lobbied and bribed church officials to secure indulgence letters, which they often

sold at home in exchange for mere money payments. The funds indulgences generated became a vital source of revenue, both at Rome and in the church's provinces. Toward the end of the fifteenth century the market for indulgences expanded once again, when the church began awarding the documents, not only to the living, but also for the benefit of the dead already suffering in purgatory. Certainly, these abuses in the indulgence trade were one of the most glaring ills of the late-medieval church, and they inspired the sixteenth-century reformer Martin Luther to speak out against the church's teachings on salvation. But both Protestant and Catholic reformers criticized these glaring abuses. The custom of granting indulgences as pardons would play no role in Protestantism. Among Catholics, though, a reformed notion of indulgences continued to serve as an accompaniment to good works after the Council of Trent.

SOURCES

D. Jensen, *Renaissance Europe; Age of Recovery and Reconciliation* (Boston: Heath, 1992).

S. Ozment, *The Age of Reform, 1250–1550* (New Haven, Conn.: Yale University Press, 1980).

R. W. Southern, *Western Society and the Church in the Middle Ages* (Harmondsworth, England: Penguin Books, 1970).

R. N. Swanson, *Religion and Devotion in Europe, c. 1215–c. 1515* (Cambridge, England: Cambridge University Press, 1995).

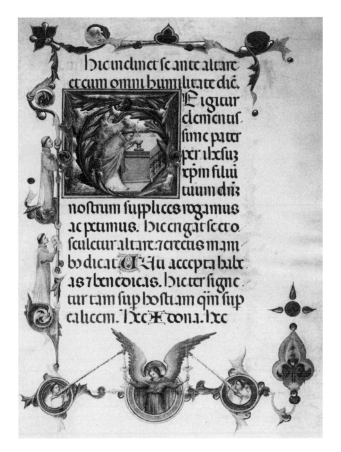

Illumination from a late fourteenth-century missal showing a priest consecrating the host in the Mass. PUBLIC DOMAIN.

RENAISSANCE PIETY

VITALITY. Despite the political and administrative problems of the church, popular religion witnessed a dramatic surge in the Renaissance. This surge can be seen in the many bequests the laity made to support masses, to found new monasteries and convents, and to build new churches. The authority of the church as an institution that controlled people's salvation was still widely respected, and late-medieval religion often evidenced a ritualistic flavor. The Mass and the other sacraments were seen as effective forces that aided in the salvation of an individual's soul. One of the most common priests at the time was the chantrist, who did nothing more than repeat the Mass many times each day for the benefit of people's salvation. Many people tried to amass as many indulgences as possible, holding fast to the notion that salvation could be accomplished through the routine channels the church provided. At the same time a deeper kind of piety was intensifying that pointed to the growth of more internal religious beliefs. Confraternities increased dramatically in importance among the laity. These brotherhoods and sisterhoods practiced many of the same prayers and rituals that had long been used in Europe's monasteries, but, in addition, they dedicated themselves to pious works that were practical and beneficial to society. They fed the poor, tended the sick, and even accompanied the condemned to the gallows. This search for a practical piety found expression, too, in the numerous endowments the laity made to support preachers in Europe's towns. And the new subjective religious spirit can be seen in the great surge in the writing and circulation of devotional literature. New classics appeared at the time, works like Thomas à Kempis' *Imitation of Christ* or the *Books on the Art of Dying* that would help Christian readers shape their devotion, not only in the Renaissance, but in the centuries that followed. Finally, these sensibilities were displayed as well in the rising attention Europe's scholars and lay people gave to the scriptures.

SACRAMENTS. The system of the seven sacraments had grown up in Europe during the medieval centuries, and it remained a source of Christian discipline and consolation during the Renaissance. The seven sacraments were Baptism, Confirmation, Penance, Holy Orders,

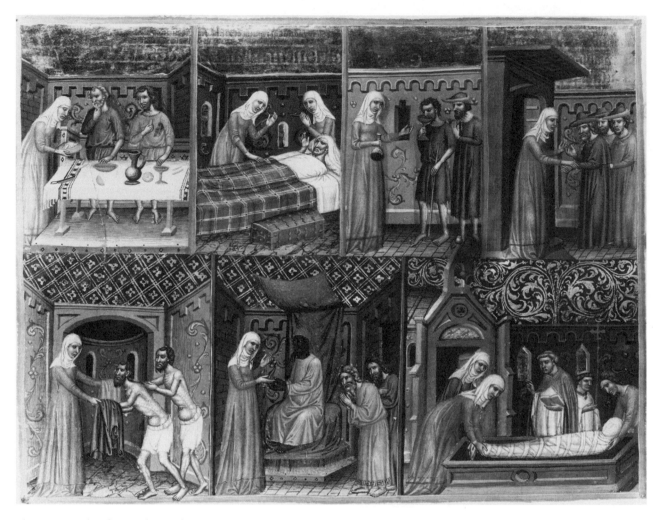

The Seven Works of Mercy from a fourteenth-century Italian psalter. **PUBLIC DOMAIN.**

Marriage, Holy Communion or the Eucharist, and Last Rites or Extreme Unction. The church taught that the sacraments were outward signs that brought grace to the faithful and thus they were the most important rituals of the church. The sacraments were not mere symbols, but acts that helped heal a human being's sinful nature. The system of sacraments, moreover, functioned to discipline Christians. The sacraments could be withheld through excommunication, and since people feared death without Penance and Last Rites, the sacramental system functioned as a force of control. Every Christian did not receive all the sacraments during his or her life. Those who married, for instance, generally could not take Holy Orders, which required sexual abstinence. Everyone, though, participated in Penance and the Eucharist at least once each year. For most lay people, they did so in the days and weeks immediately preceding Easter, giving rise to the custom of "Easter duties." The Eucharist occurred in the final

part of the Mass, and it was the most ritually potent event within the Renaissance church. Most people accepted the church's doctrine of transubstantiation— that is, that the bread and wine used in the sacrament become the actual body and blood of Christ through the priest's consecration. The popularity of the Eucharist in the later Middle Ages can be seen in the spread of the Feast of Corpus Christi throughout Europe. Corpus Christi was a eucharistic celebration that occurred in late spring, and it became one of the liturgical year's most important festivals. In England and France especially, the celebration of Corpus Christi included impressive processions and dramatic play cycles that sometimes lasted over several days. The Eucharist was also displayed in every church, often in elaborately carved or silver monstrances which could be quite large. At the end of the fifteenth century, for example, the late Gothic sculptor Adam Krafft (1455–1509) created a soaring 64-foot tall stone tabernacle for the Church

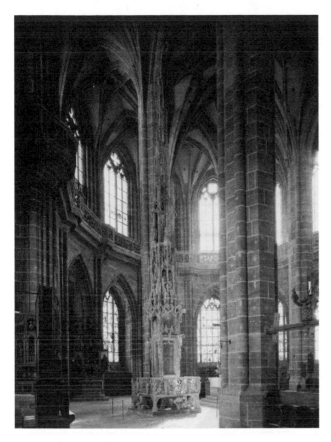

"Sakramentshaus" by Adam Kraft, Church of St. Lawrence, Nuremberg, early sixteenth century. ART RESOURCE.

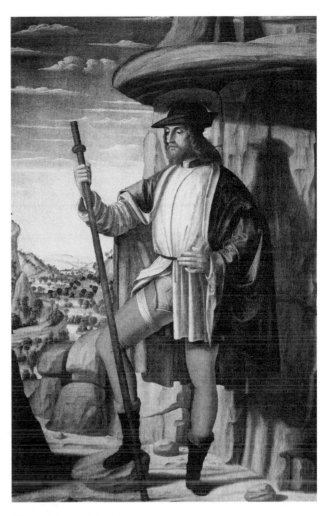

Giovanni Santi, *Saint Roch.* © ARCHIVO ICONOGRAFICO, S.A./ CORBIS. REPRODUCED BY PERMISSION.

of St. Lawrence in Nuremberg, a monument that became a source of local civic pride.

IMPORTANCE OF RITUALS. Beyond the sacraments, a rich life of rituals and observances was an important feature of Renaissance religion. Fasting, for example, was a common sign of religious devotion, but also a requirement imposed by the church at particular times. Fasting was prescribed for the 40 days of Lent, for the four weeks of Advent before Christmas, and on a number of other days throughout the year. At these times the eating of all animal products and sexual intercourse were forbidden. Prolonged fasts were also considered signs of saintliness. For women saints, in particular, fasting had a special significance. Long-standing religious teachings condemned women as "daughters of Eve," and the view that women were more highly sexed than men also ran through much medical and scientific literature in circulation in the Renaissance. While the biographies of Renaissance male saints sometimes stressed their asceticism, the ability to survive without food was usually a necessary precondition for becoming a female saint. The ability to fast demonstrated a woman's victory over her body, that she had successfully conquered her flesh. For most

Christians, though, the church stressed that fasting should be practiced in moderation, as but one part of a program of self-denial and discipline. Most people were more eager to celebrate the numerous "feast days" that occurred throughout the church's calendar than they were to fast. Although the precise dates and reasons for these holidays differed from place to place, feast days were usually times for parish festivals, for processions, and for other events that helped to relieve the monotony of daily life. Many religious rituals also occurred outside the church, and often without the participation of the clergy. People practiced a lush variety of prayers, benedictions, and ceremonies at the time and saw ritual as possessing an almost magical effectiveness to protect one's self or family. Women in childbirth, for example, relied on talismans, charms, and prayers to ensure their safety. Farmers used similar measures to try to increase their yields of livestock and crops. Specific prayers existed for almost any circumstance. Some were believed

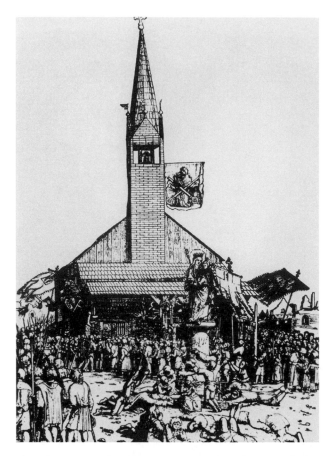

The Pilgrimage to the Fair Mary at Regensburg by Michael Ostendorfer, 1520. PUBLIC DOMAIN.

Early seventeenth-century engraving of the Altötting pilgrimage shrine in Bavaria. PUBLIC DOMAIN.

to be effective in winning lawsuits, others for curing nosebleeds, and still others for avoiding sudden death, robbery, or specific illnesses. The church had long condemned this attitude toward prayer as magic, but it survived nonetheless.

PILGRIMAGE. Society's love of ritual and the church's desire to promote the veneration of the saints combined to inspire a great age of pilgrimage in the later Middle Ages. In 1300 the papacy had initiated the practice of the Roman Jubilee, a year-long religious festival held in the church's capital. Journeys to Palestine had become unfeasible for most Europeans because of the spread of Islamic power in the Western Mediterranean. Now Rome became Europe's undisputed pilgrimage capital, and the papacy supported its development by awarding rich indulgences to those who made the journey. During the second Jubilee held in the city during 1350, more than a million Europeans journeyed there, their journeys inspired by indulgences and the desire to demonstrate their devotion to God in the wake of the Black Death that had recently afflicted Europe. Individuals and communities often relied on pilgrimage in

this way to secure the saints' aid in solving their problems. Church teaching stressed that the saints could not perform miracles, but they could offer people aid by interceding with God, encouraging him to grant a miracle. If plague threatened a town, civic leaders often promoted communal pilgrimages to try to obtain the saints' aid. Those suffering from disease, or in fear of dying, promised to make journeys to local shrines, too. By the fourteenth century, thousands of pilgrimage shrines dotted the European landscape, and new shrines added to their number constantly. Some were quite small, but Europe also had many impressive centers for long-distance pilgrimage. Like Rome, these places drew the faithful from throughout the continent. In Spain, Santiago di Compostella, a shrine possessing the relics of St. James, drew pilgrims from everywhere in Europe, as did Canterbury in England, and Mont St. Michel in France. The pilgrimage industry brought with it the rich donations of Europe's faithful, and by the fifteenth century, local church leaders and civic boosters were often anxious to see the development of shrines within their

provinces. In Germany, places like Wilsnack, Grimmental, and Regensburg were enthusiastically advertised to draw as many pilgrims as possible. In Regensburg, for example, the shrine developed in the wake of miracle reports during 1519, and during the next two years, it had drawn several hundred thousand pilgrims. But the excitement could fade just as quickly as it arose. By 1522, Regensburg had largely been forgotten. This enthusiasm inspired criticism from many in the church and state who feared these spontaneous outbursts of religiosity. Crowds might turn dangerous, as at Niklashausen in Germany during 1476. Pilgrims traveled to a shrine there because of the anticlerical sermons of an itinerant preacher. When the church prohibited their pilgrimage, the faithful revolted, marching on the local bishop's palace and staging riots along the way. Other critics of late-medieval pilgrimage attacked it as nothing more than a ploy to raise money. Humanists like Desiderius Erasmus poked fun at the popular beliefs in the saints. In his short dialogue, *A Pilgrimage for Religion's Sake,* Erasmus used bitter satire to mock those who believed their problems could be solved merely by journeying to a saint's relic. It would be better, he advised, for people to stay at home, say their prayers, and do their work.

MODERN DEVOTION. Erasmus's pragmatic attitude had been shaped by a different set of religious values, values that had been formed by his education and early upbringing within the schools of the Brethren of the Common Life. The Brethren practiced a disciplined religious life that was known as the Modern Devotion. The movement's founder, Gerd Groote, had been destined for a brilliant career in the church when, in 1370, he renounced his worldly ambitions and entered a monastery. After several years spent as a monk, Groote embarked on a preaching career that lasted until his death in 1384. During this time he turned over his house and belongings to a group of laywomen, who became known as the Sisters of the Common Life. These women took no formal religious vows, nor did they wear any special dress. They were free to leave the group when they wished, but while serving as members of the community they were to share their possessions. Within a short time, a male wing of the movement, the Brothers of the Common Life, had developed, and during the next century, scores of houses of the Brothers and Sisters had been founded in the Netherlands and Germany. The life of the Brothers and Sisters stressed prayer and introspection. They frequently expressed distaste for the ritualistic formalism they saw in the church, but they did not reject Catholic teachings. They insisted instead that the sacraments and other rituals of the church must be

A sixteenth-century Northern European wood panel painting showing the profession of the faith and vestiture of a nun. © ARCHIVO ICONOGRAFICO, S.A./CORBIS. REPRODUCED BY PERMISSION.

practiced with a spirit of fervent internal devotion. To support themselves, many of the Brothers undertook scribal work, copying manuscripts for scholars. Others ran boarding schools that provided their students with an elementary knowledge of Latin and the Christian classics. The Sisters, on the other hand, served as nurses and ran hospitals. Church leaders had long distrusted lay movements like the Brothers and the Sisters because they feared they might teach heresy. Over time, though, this group ingratiated itself with the church leadership in most of the places in which it founded communities, in part because the Brothers and Sisters resembled other orders of monks and nuns. By the late fifteenth century, the number of their lay members had shrunk as Brothers and Sisters took permanent vows and followed disciplines similar to other religious orders. Even at this time, though, the Brothers continued to exert an influence over learning and scholarship in Northern Europe through their primary schools. From their scribal endeavors, many of the Brothers of the Common Life were also aware of the inaccuracies that had crept into manuscripts over the centuries. With the coming of the Renaissance to Northern Europe in the late fifteenth century, the schools of the Brothers of the Common Life helped to

disseminate knowledge of the textual studies of the Italian humanists in their schools. The largest of these institutions at Deventer had more than 2,000 students in 1500, and counted among its pupils Desiderius Erasmus. Elsewhere the alumni of the Brethren of the Common Life schools were just as distinguished, and included such figures as the Protestant reformer Martin Luther.

THE IMITATION OF CHRIST. The teachings of the Modern Devotion were broad and eclectic, despite a firmly orthodox flavor. One work, *The Imitation of Christ*, became particularly important in spreading the ideas of the movement. The work has long been ascribed to Thomas à Kempis, a member of a religious house associated with the New Devotion, but evidence to prove his authorship is slight. The Brothers and Sisters of the Common Life enjoyed works like the *Imitation* which was essentially a collection of adages, proverbs, and spiritual admonitions drawn and paraphrased from other spiritual writings. One phrase in the work, though, manages to sum up much of its teaching: "It is better to feel sorrow than it is to understand it." When he used the word "understand," the author of the *Imitation* had in mind the intense intellectual efforts that theologians used to understand sorrow as a necessary part of the sacrament of Penance. The Brothers and Sisters of the Common Life believed that these attempts to comprehend how the sacraments worked were meaningless. The sacraments, they taught, were not mere exercises in ritual; they needed to be combined with an internal change of heart. As such, the *Imitation* was typical of a rising strain of piety in the later Middle Ages which advocated a greater internalization of religious experience. The immediate impact of the work is evident from the more than 700 handwritten manuscripts that survive from the fifteenth century. The *Imitation* was also printed in 1472, and by the end of the century, more than 85 printed editions were in circulation. During the sixteenth century another 200 printings appeared. Eventually, the *Imitation* had translations in all European languages, and from its almost unchallenged vantage point as a manual of the Christian life, it continued to inspire the religious devotion of both Catholics and Protestants until modern times. Its effect can be seen on figures as diverse as Desiderius Erasmus, Martin Luther, Ignatius of Loyola, and John Wesley.

THE ART OF DYING. The fifteenth century witnessed a number of new theological handbooks and practical guidebooks that treated the subject of death. The surge in the production of texts on these themes was part of a more general preoccupation with death in the later Middle Ages. Preparation for death, concentration on its inevitability, and attention to the final hours of those who were dying had long been important themes in the Christian religion. Since the early church, in other words, Christians had written numerous texts about the final moments of life and how the Christian should approach that time. The grim realities of living in the fourteenth and fifteenth centuries heightened people's fascination with these themes. Many of the new works used the word "art" in their titles. By art, their writers had in mind "skill." The authors of these books treating the art of dying intended to teach the skills that the still-healthy would need as they approached their final hours. The theologian Jean Gerson (1363–1429) wrote the first of these works entitled *On the Art of Dying*. Another twenty similar theological handbooks appeared on the subject during the fifteenth century. The primary aim of Gerson's work was to keep sick and dying people confirmed in their faith in the period between their last Confession and the moment of death. These moments were particularly important in the medieval mind. Sins committed after a person's final Confession would need to be atoned for in purgatory. More serious mortal sins, like denying one's religion or cursing God, would result in one's damnation. Gerson tried to provide his readers with prayers, admonitions, and meditations that would keep the Christian true to his religion on his deathbed. Other theologians imitated his success, but the genre of books treating the art of dying also included two works intended for a popular readership. The first of these was a text version and it was more widely circulated. The second was an illustrated handbook that consisted of a series of pictures outlining the stages the dying would experience before their last breath. More than 300 handwritten manuscripts of both works still survive, and 75 printed editions appeared in Latin and other European languages between 1468 and the end of the fifteenth century. Both works recommended that family members and friends accompany the dying on their deathbeds. This custom had been used in the medieval monastery and it now came to be practiced by laypeople relying on the books of the art of dying for advice. The works gave those gathered at the deathbed tools to help their loved ones avoid the temptations that approaching death might bring. Overall, the tone of these books was not morbid, but cautiously optimistic. Every death, the books taught, is a drama, but armed with the proper tools of the faith, the dying can be committed to the afterlife successfully. The art of dying was one of the most popular religious themes treated in the early press, with scores of editions being printed in the late fifteenth and early sixteenth centuries.

RENAISSANCE MYSTICISM. Mysticism was a form of religious experience that became increasingly popular

a PRIMARY SOURCE document

THE IMITATION OF CHRIST

INTRODUCTION: The third book of Thomas à Kempis's devotional classic is written as a dialogue between Christ and a Christian. In this, the 43rd of its chapters, Christ advises the faithful on the proper use of learning and study.

MY CHILD, do not let the fine-sounding and subtle words of men deceive you. For the kingdom of heaven consists not in talk but in virtue. Attend, rather, to My words which enkindle the heart and enlighten the mind, which excite contrition and abound in manifold consolations. Never read them for the purpose of appearing more learned or more wise. Apply yourself to mortifying your vices, for this will benefit you more than your understanding of many difficult questions.

Though you shall have read and learned many things, it will always be necessary for you to return to this one principle: I am He who teaches man knowledge, and to the little ones I give a clearer understanding than can be taught by man. He to whom I speak will soon be wise and his soul will profit. But woe to those who inquire of men about many curious things, and care very little about the way they serve Me.

The time will come when Christ, the Teacher of teachers, the Lord of angels, will appear to hear the lessons of all—that is, to examine the conscience of everyone. Then He will search Jerusalem with lamps and the hidden things of darkness will be brought to light and the arguings of men's tongues be silenced.

I am He Who in one moment so enlightens the humble mind that it comprehends more of eternal truth than could be learned by ten years in the schools. I teach without noise of words or clash of opinions, without ambition for honor or confusion of argument.

I am He Who teaches man to despise earthly possessions and to loathe present things, to ask after the eternal, to hunger for heaven, to fly honors and to bear with scandals, to place all hope in Me, to desire nothing apart from Me, and to love Me ardently above all things. For a certain man by loving Me intimately learned divine truths and spoke wonders. He profited more by leaving all things than by studying subtle questions.

To some I speak of common things, to others of special matters. To some I appear with sweetness in signs and figures, and to others I appear in great light and reveal mysteries. The voice of books is but a single voice, yet it does not teach all men alike, because I within them am the Teacher and the Truth, the Examiner of hearts, the Understander of thoughts, the Promoter of acts, distributing to each as I see fit.

SOURCE: Thomas à Kempis, *Imitation of Christ* (Milwaukee, Wisc.: Bruce Brothers, 1940): 164–166. Christian Classics Ethereal Library. Available online at http://www.ccel.org/k/kempis/imitation/imitation.html; website home page: http://www.ccel.org (accessed January 8, 2004).

in the later Middle Ages. Mystics came from many different social classes and educational backgrounds, and they were both male and female. Great variety characterized late-medieval mysticism, making it difficult to generalize about the movement. All mystics attempted to achieve a direct, unmediated union with God, but the methods they relied upon to achieve this relationship differed dramatically. Still, trends can be discerned in the history of mysticism in medieval and Renaissance Europe. By the fourteenth century, European writers wrote more mystical texts than ever before. Laymen and laywomen, too, played roles in mysticism, as they did in other dimensions of late-medieval piety. Finally, mysticism influenced other areas of late-medieval and Renaissance intellectual life. In Italy, the movement affected humanist scholars from Francesco Petrarch (1304–1374) to Giovanni Pico della Mirandola (1463–1494), who studied mystical texts for the insights they offered concerning human nature and its relationship to the Creator. Northern European scholars similarly combed through the mystical heritage. Renaissance humanist Jacques Lefevre D'Etaples (d. 1536) in France and scholastic theologian Martin Luther were just two of the many Northern European intellectuals whose ideas were in part shaped by mystical texts. Although mysticism's influence stretched to these different spheres of Renaissance life, both the church and society at large were distrustful of mystics. The mystic claimed to have direct knowledge of God, a knowledge that was more personal and subjective than the insights the scriptures and church theology offered. Many mystics experienced visions, and their pronouncements could veer into prophecies that were a challenge to the church and state. As a consequence, church authorities often carefully scrutinized the writings of mystics to see if they conformed to church teaching or if they threatened medieval institutions.

AFFECTIVE MYSTICISM. Two broad categories of mystical experience have long been identified in late-medieval Europe, with considerable overlap between the

a PRIMARY SOURCE *document*

MYSTICAL VISIONS

INTRODUCTION: In his *Life of St. Catherine*, Raymond of Capua recorded St. Catherine's rich visionary life. This excerpt describes one of Catherine's most famous visions. It occurred the day after Catherine first drank human pus and Christ rewarded the saint by allowing her to drink from the wound in his side.

On the night following ... a vision [of Christ with his five wounds] was granted to her as she was at prayer ... "My beloved," [Christ] said to her, "You have now gone through many struggles for my sake ... Previously you had renounced all that the body takes pleasure in ... But yesterday the intensity of your ardent love for me overcame even the instinctive reflexes of your body itself: you forced yourself to swallow without a qualm a drink from which nature recoiled in disgust ... As you then went far beyond what mere human nature could ever have achieved, so I today shall give you a drink that transcends in perfection any that human nature can provide ..." With that, he tenderly placed his right hand on her neck, and drew her toward the wound in his side. "Drink, daughter, from my side," he said, "and by that draught your soul shall become enraptured with such delight that your very body, which for my sake you have denied, shall be inundated with its over-flowing goodness." Drawn close ... to the outlet of the Fountain of Life, she fastened her lips upon that sacred wound, and still more eagerly the mouth of her soul, and there she slaked her thirst."

SOURCE: Raymond of Capua, *Life of St. Catherine*, in Caroline Walker Bynum, *Holy Feast and Holy Fast*. Trans. C. Kearns (Berkeley and Los Angeles: University of California Press, 1987): 172.

two. The first, known as "affective mysticism," involved the mystic adopting certain behaviors to try to achieve union with God. Affective mystics desired to conquer their wills as a necessary pre-condition for uniting with God. Many practiced acts of self-denial and subjected their bodies to tortures so that they could triumph over their human needs. Affective mystics described their journey to union with God using metaphors drawn from the writings of monasticism. They treated the mystical union as a marriage, or they pictured Christ as a mother who fed them from His breasts or the wound in His side. One affective mystic, Catherine of Siena (d. 1380),

used these metaphors in her *Dialogue On Divine Providence*, one of the major mystical texts of the later Middle Ages. Catherine was the daughter of a large Sienese family who had spent her youth in conflict with her parents. They disapproved of her desire to become a nun and her extremes of religious devotion. From a young age, Catherine had fasted regularly and subjected her body to regimens of sleep deprivation so that she could spend more time in prayer. Because of her deep feelings of unworthiness, Catherine never became a nun, but instead joined an auxiliary order of laywomen attached to a local Dominican convent. There she performed the most menial of tasks and tended the sick and dying. For much of her life she was said to have lived only on the communion wafer she received each day and pus she drained from those she nursed. Following the first of these episodes of drinking filth Catherine reported a vision of Christ, who came to feed her from the wounds in his side, and from this point forward she developed a rich visionary life. She died at 33 as a consequence of her fasting, but her ability to conquer her human needs and her success in achieving mystical union with Christ gave her a great deal of influence while she was alive. In the many letters she wrote to kings, queens, and popes, she doled out praise and blame. Other women followed a path similar to Catherine's. St. Birgitta of Sweden (1303–1373) told of her many visits from Christ in her *Revelations*, as did Julian of Norwich (1342–c. 1416) in her *Revelations of Divine Love*. Margery Kempe (1373–1438), a laywoman, recounted her visions in a widely read spiritual autobiography in English. And at the end of the Middle Ages, St. Catherine of Genoa (1447–1510) published her fascinating visionary accounts of purgatory, which reached a large audience. The affective mystical tradition persisted in the sixteenth century, particularly in Spain where St. Teresa of Avila (1515–1582) and St. John of the Cross (1542–1591) informed their readers of their visions through their writings. St. Teresa wrote her autobiographical *The Interior Castle* in 1577, a book that found a ready audience in both the women of her religious order and members of the Catholic devout. John of the Cross' *The Ascent of Mt. Carmel* and *Dark Night of the Soul* were equally popular and provided early-modern Catholics with an orthodox theology of mysticism. John's writing, in particular, stressed that the Christian's soul needed to be emptied and purified in order to be filled by the spirit of God. Teresa of Avila's mysticism, on the other hand, shows less influence from the scholarly and theological traditions; it is instead an often highly personal and emotional account of the visitations she received from God while in prayer.

SPECULATIVE MYSTICISM. A second kind of mystical experience was important in late-medieval Europe. It was less emotional and less ascetic than "affective" mysticism and is sometimes referred to as "speculative" mysticism because of the importance that intellectual issues had for its practitioners. Speculative mysticism flourished in Germany and Northern Europe in the later Middle Ages, and Meister Eckhart (c. 1260–c. 1327) was among its most important exponents. Many speculative mystics drew upon Neoplatonism in their writings. Neoplatonic thought had allowed Christian theologians like St. Thomas Aquinas (1225–1275) to argue that human ideas were dim reflections of universal truths that pre-existed in the mind of God. Neoplatonism also stressed that human nature, which had been created in God's likeness, possessed a spark of divinity. As a consequence, speculative mystics often stressed that mystical union with God was but a return to humankind's original oneness with God, a teaching that, when overstated by Meister Eckhart, led to the condemnation of his ideas as heretical. Speculative mysticism also found inspiration in the newly discovered works of Pseudo-Dionysius. Pseudo-Dionysius was actually a sixth-century writer, but he alleged to be Dionysius the Areopagite, the associate of St. Paul spoken of in the New Testament. In his works Pseudo-Dionysius had tried to communicate a special "gnosis," that is, a secret wisdom he alleged had been given to him by the apostles. This special wisdom, Pseudo-Dionysius argued, surpassed human reason, and thus those mystical writers who relied upon his texts stressed that union with God was an experience that was incomprehensible according to rational, intellectual standards. Besides influencing Meister Eckhart, Dionysian ideas can be seen at work in a number of late-medieval mystical writers. *The Cloud of Unknowing*, an anonymous fourteenth-century English mystical text, was among the first to apply these sober insights about the limits of the human intellect to understanding the divine mind. But the ideas of Pseudo-Dionysius continued to have perennial appeal. *On Learned Ignorance*, a treatise written by the late-medieval theologian Nicholas of Cusa (1401–1464), went to great lengths to demonstrate the finite limitations of human reason when applied to the infinitude of God. Cusa's treatise argued that the true mystic needed to cultivate an awareness of the limitations of his own intellect, a first step toward developing a higher knowledge of the divine mind.

OTHER TRADITIONS. Other mystical texts appeared in late-medieval Europe that cannot neatly be fit into "affective" and "speculative" traditions. The *Theologia Germania*, or *German Theology*, a compilation of mystical texts that circulated in Northern Europe in the fifteenth century, shows influences from all the Christian mystical traditions—affective, speculative, monastic, Dionysian, Neoplatonic, and so forth. The publication of that text in 1516 by the German reformer Martin Luther (1483–1546) granted medieval mysticism renewed life in the early-modern period. It also ensured that mystical ideas would continue to be discussed and debated, not only among Catholics, but among Protestants, too. Mystics were often eclectic, drawing upon a variety of texts, metaphors, and allusions in their quest to express the union with God. These metaphors were adaptable, and could be used not only by other mystics but by non-mystical devotional writers in search of vocabulary and rhetoric to portray the indescribable character of God and the Christian's relationship to Him.

SOURCES

C. Bynum, *Holy Feast and Holy Fast; The Religious Significance of Food to Medieval Women* (Berkeley, Calif.: University of California Press, 1987).

B. Gordon and P. Marshall, eds., *The Place of the Dead: Death and Remembrance in Late-Medieval and Early-Modern Europe* (Cambridge: Cambridge University Press, 2001).

F. Oakley, *The Western Church in the Later Middle Ages* (Ithaca, N.Y.: Cornell University Press, 1979).

S. Ozment, *The Age of Reform, 1250–1550* (New Haven, Conn.: Yale University Press, 1980).

T. Tentler, "Ars Moriendi," in *New Catholic Encyclopedia* (Detroit: Gale Group, 2002).

THE REFORMATION'S ORIGINS

PHILOLOGY. The maturing of Christian humanism in Northern Europe around 1500 preceded the rise of the Protestant Reformation. Like the followers of the Modern Devotion, many Christian humanists criticized the ritualism of religion at the time, and instead argued for the importance of an internal change of heart among Christians (see also Philosophy: Christian Humanism). The humanists also devoted themselves to the study of the classics and ancient languages. One important innovation of fifteenth-century humanism was its perfecting of philological techniques. Philology, the historical study of languages, taught the humanists that the meanings of words used in ancient documents, particularly in the scriptures, had changed over the centuries. One of the most important demonstrations of fifteenth-century philological technique had come from the Italian humanist philosopher Lorenzo Valla. In 1440, Valla had

a PRIMARY SOURCE *document*

THE ROLE OF THE SCRIPTURES

INTRODUCTION: In 1516, Erasmus published his edition of the New Testament in parallel Greek and Latin versions. The work soon became popular among scholars and was used by translators throughout the sixteenth century as they translated the Bible into Europe's native languages. In his "The Paraclesis," an introduction to his translation, Erasmus advocated the revolutionary idea of lay Bible reading, and his final words from that work argued that the message of the scriptures was clear to anyone who wished to examine them.

Let all those of us who have pledged in baptism in the words prescribed by Christ, if we have pledged sincerely, be directly imbued with the teachings of Christ in the midst of the very embraces of parents and the caresses of nurses. For that which the new earthen pot of the soul first imbibes settles most deeply and clings most tenaciously. Let the first lispings utter Christ, let earliest childhood be formed by the Gospels of Him whom I would wish particularly presented in such a way that children also might love Him. For as the severity of some teachers causes children to hate literature before they come to know it, so there are those who make the philosophy of Christ sad and morose, although nothing is more sweet than it. In these studies, then, let them engage themselves until at length in silent growth they mature into strong manhood in Christ. The literature of others is such that many have greatly repented the effort expended upon it, and it happens again and again that those who have fought through all their life up to death to defend the principles of that literature, free themselves from the faction of their author at the very hour of death. But happy is that man whom death takes as he meditates upon this literature [of Christ]. Let us all, therefore, with our whole heart covet this literature, let us embrace it, let us continually occupy ourselves with it, let us fondly kiss it, at length let us die in its embrace, let us be transformed in it, since indeed studies are transmuted into morals. As for him who cannot pursue this course (but who cannot do it, if only he wishes?), let him at least reverence this literature enveloping, as it were, His divine heart. If anyone shows us the footprints of Christ, in what manner, as Christians, do we prostrate ourselves, how we adore them! But why do we not venerate instead the living and breathing likeness of Him in these books? If anyone displays the tunic of Christ, to what corner of the earth shall we not hasten so that we may kiss it? Yet were you to bring forth His entire wardrobe, it would not manifest Christ more clearly and truly than the Gospel writings. We embellish a wooden or stone statue with gems and gold for the love of Christ. Why not, rather, mark with gold and gems and with ornaments of greater value than these, if such there be, these writings which bring Christ to us so much more effectively than any paltry image? The latter represents only the form of the body—if indeed it represents anything of Him—but these writings bring you the living image of His holy mind and the speaking; healing, dying, rising Christ Himself, and thus they render Him so fully present that you would see less if you gazed upon Him with your very eyes.

SOURCE: Desiderius Erasmus, "The Paraclesis," in *Christian Humanism and the Reformation: The Selected Writings of Erasmus.* Ed. John C. Olin (New York: Fordham University Press, 1987): 107–108.

demonstrated that one of the foundations of papal power, the Donation of Constantine, was a forgery. This document had allegedly been written by the Roman emperor Constantine in the fourth century, and transferred power in the West to the Roman pope. Valla's detailed examination of the language used in the text demonstrated conclusively that it was a fake written around 800 C.E. Inspired by the example of Renaissance philologists like Valla, the humanists began to study the ancient Classics to revive an accurate ancient knowledge of Greek, Latin, and Hebrew. Nowhere were their insights to produce more profound changes in Christianity than in the corrections they made in the Bible. Until 1500, the most important version of the scriptures used in Europe was the Vulgate, a fourth-century translation of the Greek and Hebrew books of the Bible into Latin by St. Jerome. Humanists began to use their new sophisticated knowledge of Greek and Hebrew to examine this text and they found that it contained numerous inaccuracies. Medieval scribes had also compounded the Vulgate's problems by miscopying the text. Consequently, humanists undertook a great project to ensure the accuracy of the Bible's translation. Their new translations into Latin and other European languages produced powerful reassessments in Christian teaching. In 1516, for example, the humanist Desiderius Erasmus published his translation of the New Testament. Corrections Erasmus made in the text undermined traditional church teachings, and Erasmus pointed out that the sacrament of Penance had no clear scriptural foundation. While this Dutch humanist remained a loyal follower of the church, Protestant preachers and theologians made use of his scholarly insights to reform Christian teachings.

PRINTING. The development of the printing press aided the new studies undertaken by humanists in the late fifteenth century, as it promoted the circulation of texts throughout Europe. The printing press, traditionally attributed to the German Johann Gutenberg of Mainz, was a complex development to which many contributed ideas and techniques. The new technology spread quickly throughout Europe after 1450. In the first half-century of its existence, the press largely published editions of the Classics and medieval theology. It helped scholars by providing them with cheaper versions of important works for their libraries. In 1490, Aldus Manutius founded a publishing house in Venice that pioneered the use of italic print. This Aldine press issued many important classical works in Greek editions, and it helped spread the new textual scholarship throughout Europe. Even in 1500, though, some humanists and theologians still desired to circulate their texts in manuscripts copied by scribes because they were more beautiful. Publishers like Aldus Manutius, however, successfully weaned Europe's scholars away from manuscripts because they produced cheaper books that were as pleasing to the eye and easier to use than handwritten manuscripts. The press, too, helped make the scholarly insights the Renaissance had produced a permanent feature of the intellectual scene as the identical copies of a particular work ensured that a scholar working in England had access to the same authoritative text as one who worked in Italy. The fact that printed books had editions of several hundred to several thousand meant that a text could never be lost again, as many had been in the Middle Ages. In its first decades, then, printing proved to be an invaluable boon to scholarship. But by the early sixteenth century another possibility of the press became evident to people as well: its ability to transmit knowledge quickly. The press allowed the lecture notes of a famous Greek professor in Venice to be printed and sent to Northern Europe within a matter of weeks, and it fostered intellectual debates and controversies as scholarly opponents sparred off with printed defenses of their positions. Protestantism made brilliant use of these possibilities, but it also used the press as a mass medium that could spread ideas throughout society.

REUCHLIN. Another dispute that helped to shape the early course of the Reformation was the Reuchlin Affair, a controversy that erupted over Hebrew books in Germany after 1506. Johannes Reuchlin (1455–1522), one of the most distinguished scholars in Renaissance Europe, had spent his early years studying at the universities of Freiburg, Paris, and Basel before turning to study law at Orléans and Poitiers. He made two trips to Italy where he impressed Italian humanists with the depth of his knowledge. Although Reuchlin's interests were wide-ranging, he applied himself increasingly to the study of Hebrew, and one of his chief achievements was the popularization of the study of Hebrew among humanists in Germany. He published a Hebrew grammar for students in 1506. A few years later Reuchlin became embroiled in controversy with the converted Jew Johann Pfefferkorn, who had received the emperor's permission to seize and destroy Jewish books. Reuchlin immediately opposed Pfefferkorn's plan, and advocated that Christians study Hebrew texts for the insights they might offer for their own religion. The debates over these issues lasted more than a decade, with first Pfefferkorn's position winning the upper hand, then the balance shifting in Reuchlin's favor, and finally back to Pfefferkorn. Generally, Germany's Dominican Order and scholastic theologians tended to side with Pfefferkorn in favor of the destruction of Jewish works, while the empire's humanists supported Reuchlin's position and condemned Pfefferkorn's plan as an assault on academic freedom. During the high tide of the controversy around 1515, two of Reuchlin's humanist supporters, Ulrich von Hutten and Crotus Rubeanus struck a successful blow against Pfefferkorn and his Dominican and scholastic supporters with the publication of their *Letters of Obscure Men*. This biting and hilarious work berated the intentional "obscurity" of theologians and churchmen and was one of the Renaissance's most successful satires. In the bitter disputes that resulted, charges leveled at Reuchlin for the biting tracts he had written against Pfefferkorn resulted in his condemnation by the church in 1520.

INDULGENCE CONTROVERSY. The bitter divisions the Reuchlin Affair caused between Germany's humanists and scholastic theologians helped to shape the responses of Germany's intellectuals to Martin Luther's attacks upon the sale of indulgences. The Dominican Order and traditional scholastics tended to oppose his ideas; while many humanists supported them. Martin Luther had assumed the post of professor of biblical theology at the University of Wittenberg in Saxony in 1516, but his radical ideas did not attract much attention until the following year, when he attacked the sale of indulgences. At this time his attacks on the practice collided with German politics and the church hierarchy. To secure his election as archbishop of Mainz, Albert of Brandenburg had incurred enormous debts from bribes and fees that he paid to the church's officials in Rome. To pay these off, he and Pope Leo X came up with a plan to sell a new indulgence in Germany. Leo planned to use his share of the indulgence sales to support the construction

a PRIMARY SOURCE *document*

HUMANISM VS. SCHOLASTICISM

INTRODUCTION: In the *Letters of Obscure Men*, a series of satires, several German humanists rose to defend Johannes Reuchlin, who advocated the study of Hebrew texts. The satires mocked the intentional obscurity of scholastically-trained theologians. The first of this collection was typical of the vigorously critical tone taken throughout. In it, Thomas Langschneider writes to his former teacher for advice on a minute point of terminology.

Since as Aristotle hath it, "To enquire concerning all and singular is not unprofitable"; and, as we read in *The Preacher*, "I purposed in my soul to seek and ensearch wisely of all things that are made under the sun," so I, therefore, am purposed to propound to your worship a question about which I have a doubt.

But first I call the Lord to witness that I seek not to craftily entangle your excellence or your reverence: I do but heartily and sincerely crave of you that you will instruct me on this perplexful matter. For it is written in the Evangel, "Thou shalt not tempt the Lord thy God," and *Solomon* saith, "All wisdom is of God." ...

Now, the aforesaid question arose after this manner:— The other day a *Feast of Aristotle* [a banquet traditionally given for members of the university by newly promoted Masters of Arts students] was celebrated here—the Doctors, the Licentiates, and the Magisters were in high feather, and I too was present. ...

Then began the Doctors over their cups to argue canonically concerning profundities. And the question arose, whether "magister nostrandus" or "noster magistrandus" is the fitter to denote a candidate eligible for the degree of Doctor in Divinity ...

Forthwith made answer Magister Warmsemmel, my compatriot—a right subtle Scotist, and a Master of eighteen years' standing ...

He knoweth his business right well, and hath many pupils, high and low, young and old; and speaking with ripeness of knowledge, he held that we should say "nostermagistrandus"—in one word—because "magistrare" signifies to make Master and "baccalauriare" to make Bachelor, and "doctorare" to make Doctor ... Now Doctors in Divinity are not styled "Doctors," but on account of their humility and sanctity, and by way of distinction are named and styled "Magistri Nostri" because in the Catholic Faith they stand in the room of our Lord *Jesus Christ*, who is the fount of life, and the "Magister" of us all: wherefore are they styled "Magistri Nostri" because it is for them to instruct us in the way of truth—and God is truth.

Rightly, he argued, are they called "our masters," for it is the bounden duty of us all, as Christians, to hearken to their preachments, and no man may say them nay— wherefore are they the masters of us all. But "nostro-trastrare" is not in use, and is found neither in the vocabulary *Ex Quo*, nor in the *Catholicon*, nor in the *Breviloquus*, nor even in the *Gemma Gemmarum* notwithstanding that this containeth many terms in art.

Thereupon uprose Magister *Andreas Delitsch*, a very subtle scholar—on the one hand a Poet, and on the other, an Artsman, Physician, and Jurist—who lectureth in ordinary upon *Ovid* in his *Metamorphoses*, and explaineth all the fables allegorically and literally ... and he held, in opposition to Magister *Warmsemmel* that we should say "magister-nostrandus"; for, as there is a difference between "magisternoster" and "noster magister," so there is a like difference between "magisternostrandus" and "nostermagistrandus." Because "magisternoster" signifieth a Doctor of Divinity, and is one word, but "noster magister" consisteth of two words, and is used for a Mastery in any Liberal Science, whether it concern handicraft or braincraft. And it booteth not that "nostro-tras-trare" is not in use, for we may devise new words—and on this point he quoted *Horace*.

Then the company marvelled greatly at his subtlety, and a tankard of Naumburg beer was handed to him ...

Then all the Magisters waxed merry, till at last the bell rang to Vespers.

I beseech your excellence, therefore, to set forth your opinion, seeing that you are mightily profound, and, as I said at the time, "Magister *Ortwin* will easily unfold the truth of the matter, for he was my teacher at *Deventer*, when I was in the third class."

SOURCE: Ulrich von Hutten, et al, *Letters of Obscure Men*. Trans. F. G. Stokes (Philadelphia: University of Pennsylvania Press, 1964): 5–7.

of a new St. Peter's Basilica in Rome, which had been demolished in 1506 but not yet rebuilt. During the autumn of 1517 Luther became aware of the unscrupulous methods that the indulgence's chief salesman, Johann Tetzel, used to boost sales of these letters in Germany. Luther wrote to the archbishop, warning him to keep the indulgence salesmen away from Saxony, and at the same time he prepared his famous *95 Theses* against indulgences. Luther may have posted the theses on the door of the university's church in Wittenberg, an act that

has legendary status as the beginning of the Reformation. But that act cannot be definitely established from the surviving documents. Such public postings were a common way to inspire debate in the university among scholars. The sale of indulgences offended Luther for several reasons. First, the techniques of Tetzel and others active throughout Germany suggested that salvation could merely be bought in exchange for money payments. Second, salesmen taught that the indulgence letters could be applied not only to one's own wrongdoings, but also to those of dead relatives and friends suffering in purgatory. For Luther, salvation was always a personal matter between God and a human being, and thus Luther saw the indulgences as a fraud, a way to dupe innocent men and women out of their hard-earned money.

95 THESES. Luther had probably hoped to discuss his criticisms of the sale of indulgences only among scholars. He sent copies of his *Theses* to friends and colleagues elsewhere in Germany, and one of these contacts arranged for their printing without Luther's permission. During the coming months editions of the work appeared in several cities in Germany. Luther's attacks on indulgences became controversial, and Johann Tetzel and other German Dominicans called for his condemnation. The archbishop of Mainz referred the case to Rome, and the pope responded by sending an emissary to Germany to discuss the matter with Luther. In several meetings during October 1518, the pope's ambassador tried unsuccessfully to get Luther to retract his statements. Other initiatives followed, since church leaders wanted desperately to avoid making a martyr of the scholar. Luther, for his part, agreed to take part in a staged debate the following June with the Dominican Johann Eck at Leipzig. In this debate Luther generally defended his ideas skillfully. But at one point in the three-week deliberations, Luther admitted that he admired some of the ideas of the heretic John Huss. This outburst would later be used to condemn the reformer. In this sense Luther emerged partially bruised by the Leipzig experience, although a transcript of the deliberations there were printed and circulated throughout Germany. This printed account expanded Luther's notoriety throughout Europe. In the wake of the Leipzig debate, Luther became more and more convinced that the problems with the church's teachings ran deeper than mere clerical corruption and indulgence sales. These problems had developed over centuries and they necessitated a more complete reform of the church. In the months that followed Luther began denying the authority of the pope.

THREE TREATISES. In spite of his many problems with church authorities, Luther continued in these busy

Martin Luther. **NEW YORK PUBLIC LIBRARY.**

months to work out the many implications of his new ideas. Three of the works he published in 1520 became important manifestoes for the Reformation. In the first, *The Address to the Christian Nobility of the German Nation,* Luther argued that corruption had become so entrenched in the church that it was unrealistic to expect reform to come from the clergy. He appealed instead to the German princes and nobles to take up the task of reforming the church within their lands. This call for state-directed reforms would prove important to the Lutheran cause in subsequent years. Luther was always careful to argue that his ideas and reforms must be adopted through the lawful measures of the states, and Germany's territorial princes found Luther's ideas attractive because they sanctioned a state-directed church. The second of the three important 1520 tracts, *The Babylonian Captivity of the Church,* presented a new theology of the sacraments. Luther denied that the sacraments helped in human salvation. He insisted instead that sacraments were signs of promises God had made with humankind and thus they must be clearly commanded in the scriptures. This definition caused Luther to reduce the number of sacraments from seven to two, although he held out the possibility that a reformed Penance might play some role in the church. For Luther, only baptism and the Eucharist had clear scriptural foundations. While Luther's teaching on baptism remained close to that of the medieval church, his ideas about the Eucharist differed

Title page of Martin Luther's German edition of the Bible, 1585. **THE UNIVERSITY OF MICHIGAN LIBRARY. REPRODUCED BY PERMISSION.**

from traditional orthodoxy in two ways. Like John Huss, Luther believed the laity should celebrate communion with both bread and wine, and he denied transubstantiation. Luther taught instead that the body of Christ was present everywhere in the world, and the words of consecration uttered in the communion service brought Christ's body to the bread. This doctrine became known as consubstantiation. In the third of the treatises, *On Christian Liberty*, the reformer presented his mature theory concerning salvation. Luther stressed that human beings received justification by faith alone, which was a gift of God's grace. Since God gave this gift to some and not others, Luther upheld the doctrine of predestination. In order to stress the primary, initiating role that faith played in salvation, Luther went to great lengths in this short work to show that good works were not the cause of a sinner's justification, but the result. At one point, he even insisted that the experience of justification was similar to a marriage between Christ and a prostitute: "Who can comprehend the riches of the glory of this grace? Christ, that rich and pious Husband, takes as a wife a needy and impious harlot, redeeming her from all her evils and supplying her with all His good things." *On Christian Liberty* also insisted that those who had been saved in this way had no need for a special category of priests to intercede for them with God; they were, in other words, their own priests. Luther did believe that there was still a need for ministers within the church, but that this office should not be seen as radically separate from the laity. All three treatises were widely published throughout Germany and translated into other European languages. By 1525, more than a quarter of a million copies of these three tracts alone had been printed throughout Europe. Luther had become a bestselling author, and the press had aided the spread of his ideas among the German people.

THE DIET OF WORMS. Certainly, Luther's dramatic treatment at the hands of imperial and ecclesiastical authorities also helped to create an audience for his work. The church had originally tried to deal with Luther quietly, but by June 1520, the papacy was losing patience, and Leo X issued a bull (an official papal document) condemning 41 of his teachings. The pope gave Luther two months to retract his statements or face excommunication. When Luther received his copy, he staged a bonfire, placing medieval theological works, church laws, and the papal bull on the flames. By the following year the emperor Charles V was anxious to see the entire affair put to rest, and he summoned Luther to an imperial diet (a national parliament) in the city of Worms. Luther had prudently asked for a safe conduct while he attended the meetings. At the diet the emperor and the parliament's representatives interviewed him twice. When pressed at the end of his second audience to recant his errors, Luther responded with a speech that became famous for its defense of conscience: "Unless I am convinced by the testimony of Scripture or by clear reason … I am bound by the Scriptures I have quoted and my conscience is captive to the Word of God. I cannot and will not retract anything, for it is neither safe nor right to go against conscience. I cannot do otherwise, here I stand, may God help me. Amen." Despite his stirring rhetoric, the diet responded by placing Luther under an imperial ban, in effect a death sentence. The decree stipulated, however, that the punishment would not go into effect for another month to allow Luther time for prayer and reflection. This sentence plagued Luther for the rest of his life, since it meant that he could not travel outside Saxony and a few neighboring friendly territories in Germany where he was under the protection of local princes.

THE WARTBURG. While Luther was on his way back to Wittenberg from Worms, he was "kidnapped"

a PRIMARY SOURCE *document*

LUTHER'S TOWER EXPERIENCE

INTRODUCTION: In his latter autobiography Martin Luther described his experience of the realization of justification by faith. The insight he received was to have occurred in his monastery's tower or study one day while he was preparing his lectures. Luther dates this event as occurring in 1519, but other sources disagree on the date. Luther always described the event as a sudden realization in which he became aware of the futility of the medieval church's doctrine of works.

Meanwhile in that same year, 1519, I had begun interpreting the Psalms once again. I felt confident that I was now more experienced, since I had dealt in university courses with St. Paul's Letters to the Romans, to the Galatians, and the Letter to the Hebrews. I had conceived a burning desire to understand what Paul meant in his Letter to the Romans, but thus far there had stood in my way, not the cold blood around my heart, but that one word which is in chapter one: "The justice of God is revealed in it." I hated that word, "justice of God," which, by the use and custom of all my teachers, I had been taught to understand philosophically as referring to formal or active justice, as they call it, i.e., that justice by which God is just and by which he punishes sinners and the unjust.

But I, blameless monk that I was, felt that before God I was a sinner with an extremely troubled conscience. I couldn't be sure that God was appeased by my satisfaction. I did not love, no, rather I hated the just God who punishes sinners. In silence, if I did not blaspheme, then certainly I grumbled vehemently and got angry at God. I said, "Isn't it enough that we miserable sinners, lost for all eternity because of original sin, are oppressed by every kind of calamity through the Ten Commandments? Why does God heap sorrow upon sorrow through the Gospel and through the Gospel threaten us with his justice and his wrath?" This was how I was raging with wild and disturbed conscience. I constantly badgered St. Paul about that spot in Romans 1 and anxiously wanted to know what he meant.

I meditated night and day on those words until at last, by the mercy of God, I paid attention to their context: "The justice of God is revealed in it, as it is written: 'The just person lives by faith.'" I began to understand that in this verse the justice of God is that by which the just person lives by a gift of God, that is by faith. I began to understand that this verse means that the justice of God is revealed through the Gospel, but it is a passive justice, i.e. that by which the merciful God justifies us by faith, as it is written: "The just person lives by faith." All at once I felt that I had been born again and entered into paradise itself through open gates. Immediately I saw the whole of Scripture in a different light. I ran through the Scriptures from memory and found that other terms had analogous meanings, e.g., the work of God, that is, what God works in us; the power of God, by which he makes us powerful; the wisdom of God, by which he makes us wise; the strength of God, the salvation of God, the glory of God.

I exalted this sweetest word of mine, "the justice of God," with as much love as before I had hated it with hate.

This phrase of Paul was for me the very gate of paradise. Afterward I read Augustine's "On the Spirit and the Letter," in which I found what I had not dared hope for. I discovered that he too interpreted "the justice of God" in a similar way, namely, as that with which God clothes us when he justifies us. Although Augustine had said it imperfectly and did not explain in detail how God imputes justice to us, still it pleased me that he taught the justice of God by which we are justified.

SOURCE: Martin Luther, Preface to *The Complete Edition of Luther's Latin Works (1545) by Dr. Martin Luther, 1483-1546.* Trans. Bro. Andrew Thornton. Internet Christian Library. Available online at http://www.iclnet.org/pub/resources/text/wittenberg/luther/tower.txt; website home page: http://www.iclnet.org (accessed February 13, 2004).

in a plan hatched by his protector Frederick the Wise. Frederick arranged to have Luther taken for safekeeping to the Wartburg Castle. He remained there for over a year, studying, reflecting, and beginning one of his most important works: the translation of the Bible into German. When completed in 1534, Luther's German Bible was a significant literary milestone. It affected the development of written German over the coming centuries in a way similar to the King James Version of the Bible's influence over literary English. German writers, just like their English counterparts, pulled phrases, metaphors, and allusions from the scriptures as knowledge of the Bible expanded dramatically among Protestant readers. Medieval translations of the Bible into native European languages had existed, to be sure. But Luther's program to translate the scriptures into his native German had proceeded from a key principle of his teaching: that the scriptures, and not the teachings of the church, should be the prime foundation of Christianity. Here Luther's ideas had been shaped in part by the humanists, who

had criticized the medieval church for insisting that only trained and skillful theologians could interpret scripture. At this early stage in his career as a reformer, Luther believed that the truths of the scriptures were self-evident. His ideas were similar to Desiderius Erasmus, who had dreamed of a day when farmers would chant the scriptures at their plows and women recite them at their spinning wheels. For Luther, the Word of God would accomplish the job of reforming the church by itself. Events soon demonstrated, though, that not everyone who read the scriptures shared Luther's interpretation. Even as he was deep in the work of his translation of the Bible in 1522, news reached him that some former associates in Wittenberg had begun teaching ideas that were more radical than his own. Andreas Karlstadt, for example, advocated iconoclasm, that is, the violent destruction of religious art, and Thomas Müntzer hoped to radicalize Saxony's poor and downtrodden. After Luther's return to Wittenberg, the events he saw unfolding there helped convince him that clear authority and decisive teaching was necessary to ensure the Reformation's survival. Although he often insisted that he had no special authority to define the Bible's meaning, Luther struggled for the remainder of his life to ensure that his interpretation of the Bible prevailed among his evangelical disciples.

PEASANTS' WAR. The theological quarrels that Luther had with Karlstadt and Müntzer, though, soon paled in comparison to the outbreak of revolt among the peasants during 1524. In June of 1524, rebellion broke out among the peasants of the Upper Rhine in southwest Germany. During the year that followed, this revolt became known as the Peasants' War and spread into central and eastern Germany, affecting Swabia, Franconia, Thuringia, Saxony, and Austria. Peasant revolts had grown increasingly common in the Holy Roman Empire during the fifteenth and early sixteenth centuries. Fourteen rural rebellions occurred in the half-century between 1450 and 1500, and in the quarter century leading up to the great Peasants' War of 1524–1525 another eighteen rebellions are recorded. This tradition of peasant rebellion grew out of the great demographic changes occurring in Europe. After the dramatic mortality caused by the Black Death (1347–1351) and the recurrence of the plague in the fourteenth and fifteenth centuries, Europe's population had fallen off by almost forty percent. It began to grow again after 1450, though, and this increase made agricultural land more expensive and produced inflation. Because land was usually let on long-term leases, Europe's nobility faced shrinking incomes. To deal with this crisis, many of Germany's nobles had

moved to revive taxes and payments that had long since passed away. They had also begun enclosing lands that had once been commonly owned by village communities. These changes had inspired many of the sporadic revolts that had occurred in the period before the Reformation. The causes of the great Peasants' War, the largest of these rebellions, were more complex than these previous rural rebellions. The momentous changes in Germany's economy attracted supporters to the peasants' movement, not only from the countryside, but from the urban poor and the artisans' guilds. Radical religious reformers, too, joined it. In March 1525, representatives from these various factions met at Memmingen in Swabia, and produced the "Twelve Articles" as their manifesto. Tens of thousands of copies of the document circulated in the following months. The Articles called for the return of common lands and the abolition of serfdom as well as the new exactions and laws that the nobility had been enforcing in the countryside. They demanded the establishment of biblical preaching and "godly law." By "godly law," the Memmingen assembly had in mind the establishment not only of Christian principles in society but a return to the customs that had governed people's lives before the nobility had begun to exact the new, harsher feudal duties. As the revolt spread, its death toll rose. By April of 1525, Luther feared the Peasants' War might destroy the developing Reformation in Germany, and he published an *Admonition to Peace*. That work blamed the nobility for causing the revolt because of their harsh rule, but it also counseled the revolt's supporters to give up on their rebellion. Luther's counsel proved futile, and as the revolt continued, he reissued the *Admonition*, in June 1525, together with a new postscript entitled *Against the Robbing and Murderous Hordes of the Peasantry*. Now Luther advised the nobility to put down the rebellion immediately, using all the armed force necessary. Germany's nobles probably did not need much encouragement. While the precise death toll is unknown, as many as 70,000 to 100,000 peasants may have been slaughtered in the campaign to suppress the rebellion.

AFTEREFFECTS. The suppression of the Peasants' War had a major and lasting impact on the Reformation. Luther had taken no direct role in inspiring the rebels, and had always been critical of their violent actions. But the presence of religious reformers like Thomas Müntzer within the movement fed the fears of many that the Reformation would lead to full-scale revolution. For his part, Luther's denunciations of the peasants helped condemn his Reformation movement to widespread unpopularity among the poorer classes of

Germany. Luther and state leaders in Saxony realized that discipline and control were necessary if the Reformation was going to survive. In the wake of the Peasants' War, a number of measures appeared to ensure that Lutheran teachings were established in an orderly fashion in ways that were sanctioned by the government. Indoctrination of the population in the evangelical doctrines became particularly important to the state, too. State and religious authorities undertook an inspection of the territory's religious life, investigating the level of religious knowledge among Saxony's ministers and its laity. Known as a Visitation, this practice became a key vehicle for establishing the Reformation in Germany and elsewhere in Europe. Investigators were often disheartened with the results of their fieldwork. The first Saxon Visitation revealed widespread ignorance of the Reformation's teachings in the countryside. As a consequence, Saxony became one of the first territories to require mandatory primary education of the young. To accomplish this, Luther prepared a *Small Catechism* in 1529 designed to teach evangelical principles to children. Each week parents were required to bring their children to church to receive religious instruction, much of which was accomplished merely by rote memorization. This Lutheran practice of instructing children in doctrine would be widely imitated in both Protestant and Catholic countries in the following generations and would become one of the primary ways in which children learned the substance of religious teachings. The emphasis on mere memorization of religious principles, though, would often make these programs unpopular.

LUTHERANISM IN GERMANY. The Peasants' War temporarily slowed the speed with which Luther's teachings spread throughout Germany. After the revolt Lutheranism competed, too, against the rising popularity of Zwingli's reform program, particularly in southern Germany's cities (see also Spread of Protestantism: Zwingli). Eventually, many of Germany's towns and territories favored Luther's brand of religious reform over Swiss Reformed Protestantism, in part because of its clear respect for state authority over religion. Within Germany's Lutheran states, the church became almost a department of the state. Unlike England or France, Germany was not a unified monarchy, but a loose confederation of more than 350 states presided over by an emperor. Politics affected the spread of the Reformation in this loose-knit empire deeply, at times halting the spread of Lutheranism and at other times encouraging it. By the 1540s, a recognizable group of cities and territories known as the Schmalkaldic League had emerged. In 1546, the emperor Charles V defeated this alliance,

and introduced a plan to re-catholicize all German territories. The consequences of Charles V's arbitrary decisions, though, inspired a resurgence of Protestant forces, which defeated the emperor's armies in 1552. In 1555, both Protestant and Catholic states met at the imperial diet at Augsburg to forge a peace. This Peace of Augsburg recognized Lutheranism as a legal religion, and gave Germany's princes the power to decide which religion would be practiced within their territories.

SOURCES

E. Cameron, *The European Reformation* (London, England: Oxford University Press, 1991).

G. R. Elton, ed., *New Cambridge Modern History II: The Reformation 1520–1559* (Cambridge, England: Cambridge University Press, 1990).

H. Oberman, *Luther: Man Between God and the Devil* (New Haven, Conn.: Yale University Press, 1989).

S. Ozment, *The Age of Reform, 1250–1550* (New Haven, Conn.: Yale University Press, 1980).

G. Strauss, *Luther's House of Learning. The Indoctrination of the Young in the German Reformation* (Baltimore, Md.: Johns Hopkins University Press, 1978).

SEE ALSO *Philosophy: Humanism Outside Italy; Philosophy: New Trends in Sixteenth-Century Thought*

THE SPREAD OF PROTESTANTISM IN NORTHERN EUROPE

SCANDINAVIA. Luther's teachings became the dominant form of Protestant Christianity, not only in Germany, but throughout Scandinavia. In the later Middle Ages, the cultural ties between these two regions, which were linked by trade and similarities in language, had been strong. Scandinavia was sparsely populated, and had only a few universities. Many Scandinavian scholars regularly enrolled in German universities and thus became familiar with the Reformation teachings in the early sixteenth century. When they returned to their homelands, they brought with them knowledge of Luther's ideas, and encouraged the monarchs of Sweden and Denmark to adopt evangelical reforms. In 1527, the Swedish Parliament voted to break its ties with Rome, and a council held two years later prepared the way for a reform of Sweden's church. In Denmark the pattern was similar, although the adoption of Lutheranism occurred slightly later. At first, a national parliament meeting at Odense granted recognition to Lutherans, while protecting the rights of Catholics. Denmark's monarch,

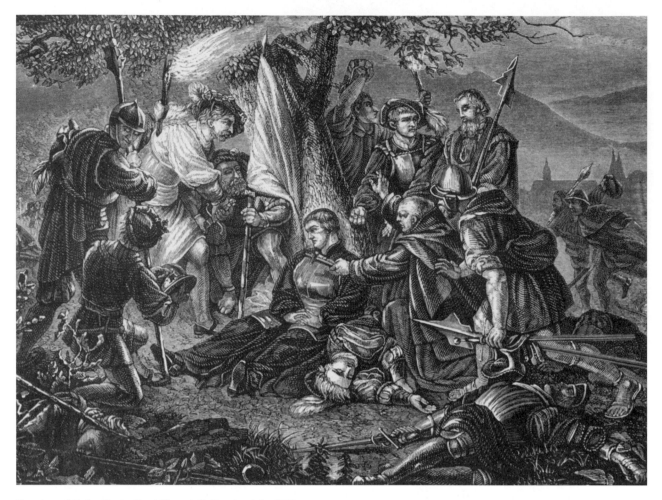

Drawing of Zwingli's death at Kappel, Switzerland, in 1531. © BETTMANN/CORBIS. REPRODUCED BY PERMISSION.

though, favored Lutheranism, as did the nobility, who stood to benefit from the crown's abolition of Catholic monasteries and the sale of their lands. After a brief civil war, Protestantism triumphed in Denmark in 1536, and the king called one of Luther's closest associates, Johann Bugenhagen, to Denmark to advise him on how to institute Lutheran reforms. These new Evangelical churches, the term Lutherans used to describe their institutions, adopted essentially conservative reforms. They preserved much of the character of medieval Christianity, particularly in worship, while adopting the Reformation's teachings concerning justification by faith and the authority of the scriptures.

ZWINGLIANISM. A very different kind of Reformation emerged in Switzerland during the 1520s under the leadership of Ulrich Zwingli at Zürich. Zwingli had been born to a wealthy peasant family and had received a thorough education, both in the Christian humanism of figures like Erasmus and in traditional scholastic philosophy (see also Philosophy). Upon his arrival in Zürich

in 1519, Zwingli began to preach the gospels in a way that was simple and graceful and which won him many admirers among the local population. During the next few years Zwingli's sermons encouraged many in the city to demand church reforms. In 1523, the council agreed to allow Zwingli to debate his positions with supporters of the Roman Church. His performance convinced many on the council of the correctness of his positions, and the council began to institute changes in the church, including the abolishment of clerical celibacy and the closing of the town's monasteries and convents. Zürich used the proceeds from the sale of these properties to fund a community chest that cared for the town's poor. By 1525, the Mass had been eliminated, and a simple service of communion took its place. To underscore Zwingli's rejection of the doctrine of transubstantiation, he insisted that the town's churches get rid of their elaborate silver and gold communion services. In their place he substituted simple wooden bowls and cups. This innovation emphasized that Christ's physical body was not present in communion, and it showed a second key

element of Zwingli's communion teachings: that communion was a symbolic commemoration of Christ's sacrifice. In other words, communion did not confer any special divine grace on those who participated in it. Like Luther, Zwingli denied that the clergy had any special status, although the flavor of many of his church reforms proved to be more radical.

CHURCH AND SOCIETY. Zwingli's more radical ideas resulted largely from a different understanding of the Bible. Luther had insisted that the central teaching of the scriptures was salvation by faith, and his aim had always been to call the church back to the preaching of the gospel. While Zwingli accepted salvation by faith, he also believed that the laws and commandments outlined in the Old Testament should be observed in society. As a result, his reform of worship was severe. In place of the Mass, Zwingli introduced church services that emphasized the scriptures. He considered church music and religious art to be violations of the Ten Commandments, and he ordered that the murals in Zürich's churches be hidden with whitewash. Zwingli looked to the town council to accomplish these reforms, but he also argued that the church must play a key role in reforming society. It is for this reason that his reforms have often been described as theocratic. He taught, in other words, that the church's ministers should share power with civil government, and that they should exercise this influence not only over spiritual matters but over secular issues as well. In this way Zwingli saw the church as playing a dynamic role in the reform of society, an idea he passed on to John Calvin and the Reformed tradition of Protestantism. Like Luther, Zwingli admitted only two sacraments into his reformed church: baptism and communion. He continued to baptize infants and made few changes in the ritual. But his denial of a physical presence of Christ in the communion ritual separated him from Luther, and caused bitter disagreement between the two figures. In the later 1520s Catholic forces amassed in Switzerland against the Reformation in Zürich, and Zwingli decided to enter into negotiations with Luther in an effort to forge a united front against Catholicism. The two figures' conflicting notions of communion, though, proved to be a stumbling block, and no agreement was forthcoming in the meetings that occurred between the two parties at Marburg in Germany in 1529. Two years later Zwingli died while leading Zürich's forces in battle against Catholic armies in Switzerland. Despite his early death Zwingli's ideas lived on to influence the development of both Anabaptism and Calvinism.

ICONOCLASM. Iconoclasm—that is, the destruction of religious images and statues—had accompanied the Reformation since its earliest days. Luther had disapproved of the iconoclasm that some of his more radical colleagues in Saxony had supported. He had insisted that religious images and sculptures were "matters of indifference" to Christians who possessed faith and he had advocated only clearing away those medieval works of art to which people displayed extravagant worship. Zwingli's uncompromising attitude towards public religious sculptures and paintings—a view John Calvin would also share—became a central tenet of the Swiss Reformation. At the same time neither Zwingli nor Calvin ever advocated the violent popular attacks on religious art that sometimes erupted in Northern Europe during the sixteenth century. Each stressed that religious art should be done away with in an orderly fashion. Nevertheless, the Swiss Reformation's more extreme teachings about art led to eruptions of iconoclasm from time to time among Zwinglians and Calvinists. An outbreak of iconoclasm in the Swiss city of Basel during 1529 horrified the humanist Erasmus, who decided to pack up and leave town as a result. And the many Calvinist Protestants of France in the second half of the sixteenth century also actively embraced iconoclasm as a technique to denounce Catholicism. During the Wars of Religion that gripped the country from 1562 to 1598, Calvinist iconoclastic episodes often produced riots and the indiscriminate slaughter of Protestants by their Catholic opponents.

ANABAPTISM. This movement takes its name from the "second baptism" that was given to adult Christians as they joined the sect. The Anabaptists practiced this rebaptism as a rite of entry into their community, which they believed was a gathered body of true adult believers. Since ancient times rebaptism had been seen as a heretical practice. To defend themselves against the charge of heresy, Anabaptists argued that infant baptism was not valid because it was unscriptural. In this and other ways, Zwingli's emphasis on the rigorous observance of the scriptures influenced the Anabaptist's early leaders. The pattern of simplified Christian worship that had developed in Zwingli's Zürich also came to be adopted by the Anabaptists. Whereas Zwingli had insisted that the church had an important role to play in the reform of society, however, Anabaptism was an exclusive movement that tried to separate the church from the "abomination of the world." Only those who had received adult baptism were allowed to take part in the Lord's Supper and participate in the community's life. Anabaptist teachings also advocated pacifism, and members were prohibited from taking vows. Each congregation chose its own minister, and members submitted themselves to

his discipline. In turn, these groups also supervised the moral behavior of their ministers. The movement outlined these teachings in its first statement of faith, *The Schleitheim Confession*, a document adopted by Swiss Anabaptist congregations in 1527. Elsewhere, the precise outlines of Anabaptist teaching and organization were somewhat different, although the movement spread very quickly in the 1520s through many parts of Germany and the Netherlands.

MÜNSTER PROPHETS. Wherever the Anabaptists taught the new doctrines, harsh, repressive measures arose to discourage them. One exception was the northern German town of Münster, but the establishment of an Anabaptist state there in 1534 was to have far-reaching implications for the subsequent history of the movement. The so-called Revolution of the Prophets that occurred in Münster helped condemn Anabaptism to continuing widespread unpopularity. In 1533, the Reformation had just been officially established in the town, when one of the city's preachers, Bernard Rothmann, convinced the council to take in persecuted Anabaptists from the neighboring Netherlands. During 1533, the numbers of Anabaptists at Münster swelled and this encouraged the spread of the religion among the local population. By February 1534, the Anabaptist party seized control of local government, and advised those who were not in agreement with their religious views to leave. Over the next few months, a dictatorship of the Anabaptists emerged, eventually led by one Dutch immigrant, John of Leyden, who tried to establish a godly community through force. The new Münster government was a theocracy, run by the town's religious leaders that carefully controlled every dimension of the town's life. They abolished both private property and the circulation of money within the city because neither of those things had played a role in the ancient church. Leyden also demanded compulsory polygamy from his subjects and he justified the practice because of its use among the Old Testament patriarchs. The intensive regulation that Leyden introduced in Münster was soon unpopular among many in the town, and a reign of terror, complete with horrifying public executions, became necessary to keep the populace in line. While all this was transpiring within the town's walls, a confederation of princes from the surrounding region had joined with the local Catholic bishop of Münster to lay siege to the town. As this siege lengthened, conditions within the city's walls worsened. The Münster Anabaptists desperately pegged their hopes on the arrival of reinforcements from the Netherlands, but although thousands of Dutch Anabaptists marched on Münster, the military forces in the vicinity crushed

them. In June 1535, months after the siege of the town had begun, Münster was retaken and many of its Anabaptists slaughtered. John of Leyden and his associates were tried, displayed in cages for several months, and finally tortured and publicly executed in January 1536. Harsh reprisals against the movement followed the suppression of the Revolution of the Münster Prophets, and persecution of Anabaptists remained the rule almost everywhere in sixteenth-century Europe. Pockets of Anabaptists survived, particularly in the Netherlands, Switzerland, and Moravia, but these groups settled down into a life of quiet pacifism. Nowhere were the dramatic events of Münster to be repeated. It was not until the eighteenth century, and the expansion of the British colonies in North America, that Anabaptism was truly able to prosper. In Pennsylvania, in particular, the radical wing of the Reformation found a home that was more congenial than Europe. And in the nineteenth century many of the descendants of the sixteenth-century radical reformers, including Anabaptist offshoots like the Mennonites and the Amish, spread into the American Midwest and the Canadian plains.

CALVINISM. The emergence of Calvinism in Geneva was one of the most significant developments in the later Reformation. Calvinism was a form of Reformed Protestantism, the movement whose origins lay in the uncompromising biblical and theocratic views of figures like Ulrich Zwingli. Calvinism takes its name from its leader, John Calvin, a French theologian who settled in Geneva. Like Zwingli and other Reformed Protestants, Calvin was much influenced by the Christian humanism of figures like Desiderius Erasmus (see also Philosophy: Christian Humanism). He also trained as a lawyer, and his written work constantly displayed the keen intelligence and clear argument typical of the best legal minds of the sixteenth century. After 1550, Calvinism grew into a vast international movement; its influence spread out from Geneva to affect the British Isles, the Netherlands, France, Germany, and Central and Eastern Europe. By virtue of its disciplined organizational structure and coherent teachings, Calvinism successfully challenged the dominance of the Lutheran Reformation in Northern Europe and it also competed vigorously against a resurgent Catholic Church.

GENEVA. John Calvin had converted to Protestantism in 1533, and soon fled religious persecution in France. He arrived in Geneva in 1536, well aware of the fears that radical religious movements like the Münster Prophets had caused among monarchs and civic leaders. He spent the remainder of his life trying to create a disciplined form of Protestantism to counteract the Refor-

mation's radical wing. He directed many of his most determined efforts toward spreading his teachings in France, as he trained French-speaking preachers to carry Reformed Protestantism back to his homeland. During his first sojourn in Geneva, Calvin worked closely with his associate William Farel, but local officials expelled both from the town because of their uncompromising attitudes towards religious reform. Calvin and Farel retreated to Strasbourg, a town that under Martin Bucer had also become a center of Reformed Protestant teachings, but in 1541, Calvin returned to Geneva where he remained for the rest of his life. The reformation movement he built in the city attracted converts from throughout Europe, eventually doubling the town's population. Among its admirers, Geneva became known as the "most perfect school of Christ," a reference to its role as a training center for Calvinist preachers. Critics of Calvin, however, attacked him for acquiring dictatorial power and sometimes mocked him as "the pope of Geneva."

SACRAMENTS. Like Zwingli and Luther, Calvin retained only two sacraments: baptism (which was performed in infancy) and the Eucharist. In contrast to the symbolic interpretation Zwingli gave to communion, though, Calvin insisted that Christ's spirit was present in the sacrament. He went to great lengths to emphasize the importance of this spiritual communion with Christ in the Christian's life. In Geneva, the Eucharist became the most important ritual of the church. Although Calvin had desired to celebrate the sacrament more frequently, the town's original reform ordinances had been influenced by Zwingli's ideas and they stipulated that communion should not occur more than four times each year. For his part, Calvin went to great lengths to increase the importance of the Last Supper in the religious life of Geneva. A time of collective penance and a period of internal reflection preceded each celebration of the Eucharist that underscored communion's importance in the church and in the Christian's life.

MAJESTY OF GOD. Calvin's teachings also extended and codified many of Luther's evangelical ideas, but with important shifts in emphasis that resulted in a different kind of Protestantism. In all his writing Calvin went to great lengths to emphasize the majesty of God over everything in His Creation. A huge chasm separated God from sinful humankind, and only God could bridge that gap. From this insight, Calvin stressed predestination more than Luther, who had also taught the doctrine. The notion that God pre-ordains human fates had long existed in Christianity, having been discussed in the works of St. Augustine and other early Christian theologians.

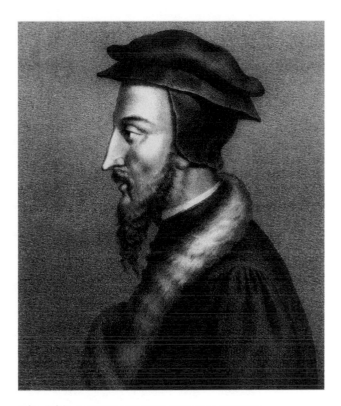

John Calvin. © HULTON-DEUTSCH COLLECTION/CORBIS.

Augustine had taught that a person's election was a gift of God's mercy, while the damned were responsible for their own fate because of their sins. By contrast, Calvin outlined a teaching that has sometimes been called "double predestinarian," because he insisted that God had chosen both the elect and the damned before the Creation of the world. There was nothing a human being could do to influence these judgments. Those whom God had elected would be saved because His grace was irresistible, while eternal punishment awaited as the inescapable fate for those He had chosen to damn. Calvin called predestination the "terrible doctrine," and he spent comparatively little time writing about it in his works for fear that it might lead his followers to become fatalistic. His emphasis on the majesty of God in all human affairs, though, tended to reinforce the notion that human beings had no control over their destiny.

VISIBLE SAINTS. Some found Calvin's emphasis on God's majesty and predestination distasteful because it denied all free will and any human participation in the process of salvation. At the same time Calvin's devoted followers found reassurance in these same teachings. Calvin always assured his followers that they could be relatively certain of their election if they were leading good Christian lives, and Calvinists stressed that good works were the visible signs God produced in His saints.

a PRIMARY SOURCE *document*

THE MAJESTY OF GOD

INTRODUCTION: For John Calvin, true knowledge of God was only possible for those who understood the depths of human depravity and the extent of the divinity's omnipotence. The first book of Calvin's *Institutes of the Christian Religion* treated these themes, of which a small excerpt from the English translation of the work follows.

The entire sum of our human wisdom, in so much as it is to be judged true and perfect wisdom, consists in two parts: the knowledge of God and of ourselves. But since these two sources of knowledge are linked together by many bands it is difficult to discern which of the two precedes and inspires the other. For at first, no man can look upon himself except by turning all his senses to the discerning of God, in whom he lives and moves because it is plainly evident that those gifts we possess do not arise from ourselves. No, in fact, our being derives from the very essence of God. Furthermore, it is through those good things that fall like streams from the heavens that we are led to the fountainhead. And so the infinity of God's goodness shines through our need. The miserable ruin into which the fall of the first man has thrown us compels us to lift up our eyes, not only out of hunger and want because we crave what we lack, but also being stirred by fear to learn humility. For as there is found in man a certain world of miseries, and since we have lost the divine apparel our shameful nakedness discloses an infinite heap of filthy disgraces; [in this way it seems] that every man needs to be stung by his own conscience with knowledge of his unhappiness to make him come at least to some knowledge of God. So by the very understanding of our ignorance, vanity, beggary, perversity and corruption, we are reminded that in no other place but in the Lord abides the light of true wisdom, sound virtue, perfect abundance of good things, and purity of righteousness. And so by our own evils we are stirred to consider the good things of God; and we cannot earnestly aspire to them until we begin to dislike ourselves. For of all men, what one is there that would not willingly rest in himself? Yea, who does not rest as long as he does not know himself, that is to say, so long as he is contented with his own gifts, and ignorant or unmindful of his own misery? Therefore every man is by the knowledge of himself, not only pricked to seek God, but also led as it were by the hand to find him.

SOURCE: John Calvin, *Institutes of the Christian Religion* (London: Eliot's Court Press, 1611): 1. Text modernized by Philip M. Soergel.

Works thus testified to election. But this doctrine of election also bolstered many Calvinists as they defied the authority of the state when its laws and actions contradicted the teachings of the scriptures. Over time, the notion of election spilled over into other areas of Calvinist life. In seventeenth-century Calvinist communities in England, Scotland, the Netherlands, and North America, many followers of the religion saw worldly success, especially in the world of commerce, as a sign of God's favor. In this way the Calvinist notion of election contributed to that complex set of ideas and behaviors that has often been referred to as "the Protestant Work Ethic."

SCRIPTURES. Calvin's attitude toward the scriptures also explains some of the differences that developed between Calvinism and Lutheranism. Luther had taught that the primary purpose of the Bible was to reveal God's gift of salvation by faith, and thus those parts of scripture that treated faith were more important than those that did not. By contrast, Calvin's attitude toward the Bible was more complex and closer to Zwingli's. He believed that the scriptures were a record of two covenants or promises God had established with humankind throughout history: law and grace. The church had a duty to ensure the establishment of biblical laws in society; at Geneva, the town's pastors closely supervised the morality of citizens. Each week a consistory met to hear cases of immorality among the town's inhabitants. The consistory included all nine of Geneva's pastors and twelve elders chosen from the town council, and had the power to excommunicate, expel, and even sentence citizens to death for violating the town's strict moral code. As Calvinism spread beyond Geneva, the consistory was sometimes an appealing feature to local civic leaders and princes as a way to control the morality of their subjects. The consistory could be used as a way to establish greater discipline among citizens. Other monarchs, though, feared the sharing of church and state powers within the consistory as a challenge to their power.

INSTITUTES. Calvin disseminated his ideas and reforms beyond Geneva through his theological masterpiece *The Institutes of the Christian Religion*. That work was first published in 1536 as a thin French primer on the teachings of Reformation Christianity. Until his death in 1564, Calvin constantly edited and expanded the book, so that by the final edition the *Institutes* had grown to four books and 80 chapters. The *Institutes* be-

a PRIMARY SOURCE document

THE MARTYRDOM OF COLIGNY

INTRODUCTION: On August 22, 1572, the tensions between French Catholics and Protestants came to a head when a group of French Catholics, perhaps inspired by the Queen Catherine de' Medici, murdered Gaspard, the Duke of Coligny, a prominent French Huguenot. The event touched off a series of riots and massacres first in Paris and later throughout France, in which as many as 5,000 Protestants may have been killed. Protestant propagandists made use of Coligny's martyrdom to solidify their cause. An excerpt from one of the first histories to describe that event follows.

Meanwhile Coligny awoke and recognized from the noise that a riot was taking place ... when he perceived that the noise increased and that some one had fired an arquebus in the courtyard of his dwelling, then at length, conjecturing what it might be, but too late, he arose from his bed and having put on his dressing gown he said his prayers, leaning against the wall. [After a struggle in which one Swiss guard was killed, the conspirators finally] broke through the door and mounted the stairway ...

After Coligny had said his prayers with Merlin the minister, he said, without any appearance of alarm, to those who were present ... "I see clearly that which they seek, and I am ready steadfastly to suffer that death which I have never feared and which for a long time past I have pictured to myself. I consider myself happy in feeling the approach of death and in being ready to die in God, by whose grace I hope for the life everlasting. I have no further need of human succor. Go then from this place, my friends, as quickly as you may, for fear lest you shall be involved in my misfortune, and that some day your wives shall curse me as the author of your loss. For me it is enough that God is here, to whose goodness I commend my soul, which is so soon to issue from my body." After these words they ascended to an upper room, whence they sought safety in flight here and there over the roofs.

Meanwhile the conspirators, having burst through the door of the chamber, entered, and when Besme, sword in hand, had demanded of Coligny, who stood near the door, "Are you Coligny?" Coligny replied, "Yes, I am he," with fearless countenance. "But you, young man, respect these white hairs. What is it you would do? You cannot shorten by many days this life of mine." As he spoke, Besme gave him a sword thrust through the body, and having withdrawn his sword, another thrust in the mouth, by which his face was disfigured. So Coligny fell, killed with many thrusts. Others have written that Coligny in dying pronounced as though in anger these words: "Would that I might at least die at the hands of a soldier and not of a valet." But Attin, one of the murderers, has reported as I have written, and added that he never saw any one less afraid in so great a peril, nor die more steadfastly. [Coligny's body was thrown into the street, and the head removed.] They also shamefully mutilated him, and dragged his body through the streets to the bank of the Seine ...

As some children were in the act of throwing the body into the river, it was dragged out and placed upon the gibbet of Montfaucon, where it hung by the feet in chains of iron; and then they built a fire beneath, by which he was burned without being consumed; so that he was, so to speak, tortured with all the elements, since he was killed upon the earth, thrown into the water, placed upon the fire, and finally put to hang in the air. After he had served for several days as a spectacle to gratify the hate of many and arouse the just indignation of many others, who reckoned that this fury of the people would cost the king and France many a sorrowful day, Francois de Montmorency, who was nearly related to the dead man, and still more his friend, and who moreover had escaped the danger in time, had him taken by night from the gibbet by trusty men and carried to Chantilly, where he was buried in the chapel.

SOURCE: J. H. Robinson, ed., *Readings in European History.* Vol. 2 (Boston: Ginn, 1906): 179–183.

came Protestantism's most significant systematic theology, and it was translated into a number of European languages. Although the final version of the *Institutes* was an imposing volume, it was, when compared to Luther's massive literary output, a relatively compact and coherent statement of faith. Its clear and forceful language, as well as its logical cast, attracted many, particularly those in the growing educated and urbanized classes of Europe's cities. As a result, Calvinism tended to attract a literate, relatively prosperous and well-educated group of converts.

VIOLENCE. Violence was often the result of the early confrontations between Calvinism and Catholicism. Calvinism taught that many of the traditional rituals of the Catholic Church were not just the products of wrong thinking, but were sources of evil that needed to be eliminated. Calvinist preachers often stressed the similarities between the idolatries God had vigorously punished in the Old Testament and those practiced by sixteenth-century Catholics. Many Calvinists believed that tolerating these modern idolatries would result in divine punishment, and so they staged episodes of iconoclastic

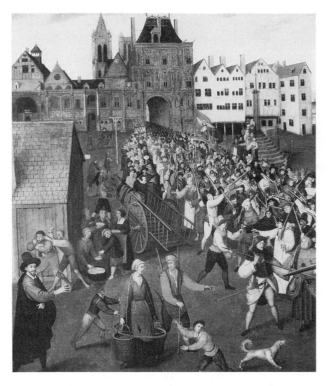

March of the Holy League in the Place de Greve, Paris, late sixteenth-century French painting. © **ARCHIVO ICONOGRAFICO, S.A./CORBIS. REPRODUCED BY PERMISSION.**

destruction upon religious images, relics, and other Catholic objects. Calvinists often timed these demonstrations to occur on particularly important Catholic holidays. They sometimes subjected the Catholic host to mock tortures before destroying it. In this way they hoped to demonstrate to their opponents that Catholicism's ritual objects were merely physical things that could not aid in a person's salvation. Catholics responded with violent counterattacks, and deadly riots often erupted. In the second half of the sixteenth century religious violence between Catholics and Calvinists, particularly in France and the Netherlands, was a frequent threat to public order and claimed many lives. Between 1562 and 1598 civil war raged in France over the question of what would be the state religion. During this time there were many battles between rival noble armies and the forces of the crown. But sporadic outbursts of street fighting and rioting, similar to modern Northern Ireland or Lebanon, occurred throughout the period, too. In the series of massacres that occurred around St. Bartholomew's Day in the late summer of 1572 as many as 5,000, mostly Calvinist French, may have been slaughtered. In 1598, the royal pronouncements of the Edict of Nantes helped to end this violence. The Edict granted Calvinists a limited degree of religious toleration in France, allowing them to fortify themselves for protec-

tion within certain French cities. Calvinists were forbidden to preach their religion outside these cities. The solution of the Edict of Nantes survived until 1685 when Louis XIV revoked it and forced Calvinists to convert to Catholicism or to leave France.

SPREAD OF CALVINISM. Although it had not been officially recognized by the terms of the Peace of Augsburg (the treaty that governed religion in Germany), Calvinism spread in the German Empire in the later sixteenth century as several German princes decided to adopt the religion in their territories. Reformed Christianity's emphasis on moral discipline was attractive to these rulers, but sometimes proved less so to their subjects. In several territories, princes abandoned their plans to convert their territories to Calvinism, as their subjects seemed by now to prefer Lutheranism to the new practices. In the last decades of the sixteenth century, German Calvinist and Lutheran theologians also engaged in bitter polemical disputes with one another. These controversies marred relationships between the two religions, and inadvertently aided the resurgence of Catholicism as Roman Catholic missionaries were quick to contrast the unity of their church's truth against the disunity of Protestants. Despite the growing tensions in Germany between these three religious camps—Lutheran, Calvinist, and Catholic—religious war did not occur in Germany until 1618, when the Thirty Years' War broke out in the country. The conclusion of that conflict recognized Calvinism as a legal religion in Germany, so long as a prince initiated the reforms in his state. The role of Calvinism in the German Empire, though, remained small as compared to Lutheranism and Catholicism. By contrast, Calvinism became the dominant form of Protestantism practiced in the Netherlands, and it played a greater role in Eastern Europe than Lutheranism. In Poland, Bohemia, and Hungary, many Lutherans converted to the new religion in the second half of the sixteenth century, but these Eastern European Calvinist churches did not survive the intensive efforts of rulers to re-establish Catholicism in the seventeenth century. Outside continental Europe, Calvinism's influence was most pronounced in Britain. Through the efforts of John Knox (1505–1572) and other Genevan-influenced reformers, a Calvinist-styled Presbyterian Church prevailed in Scotland, the largest state to adopt the religion officially. Reformed Protestantism also affected the course of the Reformation in England, where Calvinists remained an important religious minority that later became known as Puritans. The migration of Puritans to colonial New England helped establish Calvinism as one of the dominant forms of religion in North America.

ENGLAND. In comparison to other parts of Northern Europe, Protestant teaching made slower progress in England during the first half of the sixteenth century. England was a unified monarchy with stronger central authority than other states, and during the early 1520s King Henry VIII (r. 1509–1547) made his opposition to the teachings of Martin Luther clear. By the late 1520s, though, Henry faced a crisis. His marriage to the aging Catherine of Aragon had produced only one child, Princess Mary, and the rights of women to succeed to the throne in England had not been officially established. Henry began to lobby Rome for a divorce, but because of Catherine of Aragon's powerful dynastic connections as a Spanish princess, Rome prevented the dissolution of the marriage. In 1533, Henry asked Parliament to approve a decree severing England's ties with Rome and naming him as supreme head of the church in England. The decree's approval allowed the archbishop of Canterbury to hear and grant the divorce. By this time, though, Henry had already married his mistress, Anne Boleyn. Some of Henry's ministers, especially his Lord Chancellor Thomas Cromwell, favored the introduction of moderate Protestant reforms in the wake of the divorce controversy. Despite Henry's unwavering support of traditional doctrine, he granted Cromwell the power to begin dissolving England's monasteries and convents in 1536. At first the king's minister proceeded only against the smallest houses in the kingdom, but in 1539, he convinced Henry to abolish all remaining monastic institutions in England. Cromwell ruthlessly arranged the sale of these lands, and through his skillful management he realized an enormous increase in the king's revenues. Henry continued to pursue traditional religious policies throughout the rest of his life. Upon Henry's death, his son, Edward VI (r. 1547–1553), was too young to rule without a regent, and his advisers favored the introduction of greater religious reforms. Edward's archbishop of Canterbury, Thomas Cranmer, invited Protestant theologians from Germany and Switzerland to England. The influx of these Protestant preachers from the continent soon bore fruit in 1549 with the introduction of the first *Book of Common Prayer*, a book that prescribed English-language services in the Church of England. In 1552, a second edition of the book included a celebration of the Eucharist along the severe lines prescribed by Ulrich Zwingli. But Edward VI was to die a year later, and his Catholic sister, Mary, took the book out of circulation upon her succession to the throne. Mary set herself to the task of undoing England's tenuous Protestant reforms and to re-establishing the Catholic Church. At first she proceeded slowly, but with the accession of the anti-Protestant pope Paul IV she pursued more vigorous efforts to rid England of Protestants. During the final years of her reign more than 300 Protestants were put to death, including the archbishop of Canterbury, Thomas Cranmer. Even more Protestants fled to the continent, particularly to Geneva, where they immersed themselves in the teachings of Calvinism. Eventually, they returned to England to demand more extensive reforms in the church.

ELIZABETH I. Mary died childless in 1558, and so her Protestant sister Elizabeth now ascended the throne. Elizabeth's accession boded well for those who had been exiled by the intolerant Catholic measures of "Bloody Mary." The Marian exiles that returned to England in the first years of Elizabeth's reign brought with them the desire to purify the Church of England of its Roman teachings and rituals. For her part, though, Elizabeth I was always a moderate, and the religious settlement she crafted for England was to be a middle path between the extremes of Protestantism and Catholicism. While Elizabeth's international policies favored Protestant states in Northern Europe, the revised *Book of Common Prayer* authorized for use during her reign was vaguely worded, and many of the Protestant innovations that had been included in her brother Edward's prayer book were now removed. Elizabeth's middle-of-the-road religious settlement pleased the majority of the English population, and the policy lasted throughout her reign. Fervent Catholics and Puritans—as English Calvinists had come to be known—were less enthusiastic about the state's religious policies. Through the skillful use of politics, Elizabeth forestalled Puritan demands for greater reform in the English church. Her record with Catholics, though, was not so happy. Fearing that her Catholic subjects might participate in political intrigues and plots to depose her, Elizabeth secured the passage of a loyalty oath from Parliament. Those who refused to recognize her power over the English church could be tried for treason. About 200 of these English recusants (those who refused to swear loyalty to the queen) were put to death during Elizabeth's reign. Despite the climate of persecution, English Catholicism survived to be practiced as a largely underground movement by a small minority of the population.

SOURCES

W. J. Bouwsma, *John Calvin: A Sixteenth-Century Portrait* (London, England: Oxford University Press, 1988).

E. Cameron, *The European Reformation* (London, England: Oxford University Press, 1991).

A. G. Dickens, *The English Reformation* (University Park, Pa.: Pennsylvania State University Press, 1989).

G. R. Elton, ed., *The New Cambridge Modern History: The Reformation, 1520–1559* (Cambridge, England: Cambridge University Press, 1990).

W. P. Stephens, *The Theology of Huldrych Zwingli* (London, England: Oxford University Press, 1986).

SEE ALSO *Philosophy: Humanism Outside Italy*

THE COUNCIL OF TRENT

CALLS FOR A COUNCIL. Political disunity within Germany, the spread of printing, long-standing anticlericalism, and international political rivalries had all aided the rise of Protestantism in Northern Europe. Initially, the Roman Church's response to the movement had been to condemn outright the teachings of Luther and the Protestant reformers who followed him. As the Reformation expanded, both geographically and numerically, these prohibitions proved insufficient. Many began to call for a church council to address the issues Protestantism had raised and to deal with long-standing corruption in the church. There were a number of moderate leaders in the Roman Church during these years that clearly recognized the need for reform, both in the church's administration and its teachings. Liberal Catholic humanists, influenced by figures like Erasmus, often shared many beliefs with Protestants. But the papacy resisted their calls for a council for almost two decades. Conditioned by the history of conciliarism in the later Middle Ages, the popes feared councils as a threat to their authority. They preferred instead to try to negotiate with Protestants in the hopes that they could heal the rifts developing in Christendom, or at the very least, paper over some of the divisions with broad, vaguely-worded statements. There were several such efforts, but the most famous occurred in the German city of Regensburg during 1541. Pope Paul III sent the reform-minded Cardinal Gasparo Contarini to serve as his delegate at the meetings. Luther, who was prevented from traveling to Regensburg because of the imperial sentence pronounced upon him in 1521, sent his closest associate Philip Melanchthon as his representative. The delegates at Regensburg reached agreement over many key issues, but the theology of the Eucharist proved to be a stumbling block. Their meetings broke off without resolving the crisis in the church. During the next few years, though, Pope Paul III grew more confident of his abilities to control a council, and in 1545 he convened a meeting at Trent, a town on the border of Northern Italy just inside lands controlled by the German emperor Charles V. Protestant leaders were invited to

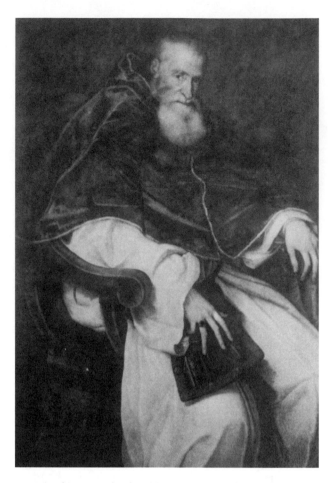

Portrait of Pope Paul III by Titian. THE LIBRARY OF CONGRESS.

attend the meetings, although they were not allowed to speak at them. The debilitating effects of the previous 25 years had by this time dampened enthusiasm for the long-awaited council. Only 35 bishops and archbishops turned up for the first session, and these came mostly from Italy.

THE DEBATES OF TRENT. The number of bishops and archbishops in attendance eventually grew, although Trent's delegation still continued to be dominated by its Italian members. It took almost two decades for the delegates to complete their work, although the council did not meet continuously. A series of sessions occurred during the years 1545–1547, 1551–1552 and 1561–1563. The first sessions of Trent discussed Protestant teachings concerning salvation, and after much debate, the position the delegates formulated denied the Reformation's principle of justification by faith. The Council's statements asserted the traditional medieval doctrine of free will: human beings were free to accept or reject God's grace, and both faith and human works were necessary for salvation. During the next block of meetings in

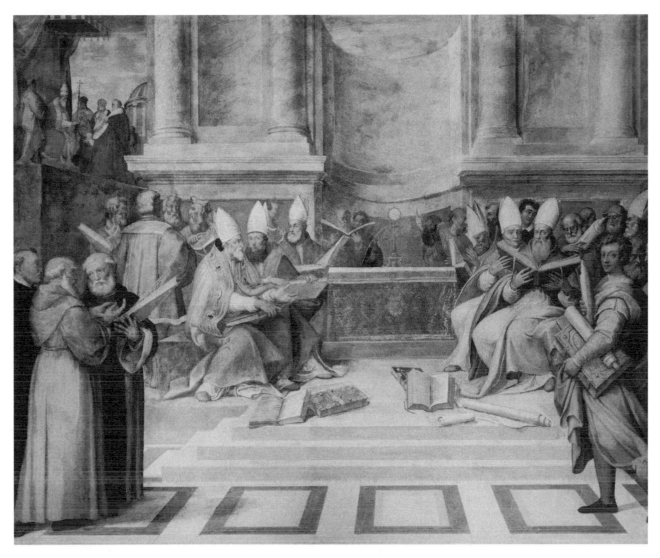

Painting of the Council of Trent by Hermano Zuccarelli. © ARCHIVO ICONOGRAFICO, S.A./CORBIS. REPRODUCED BY PERMISSION.

1551–1552, the council debated the role of the scriptures in the church and they denied the Protestant teaching of the primary authority of the Bible. Instead they asserted the ancient principle that the church's tradition and scriptures were two equal sources of authority. This teaching ensured that the Roman Church would possess the authority to interpret scripture and to define what views would be considered orthodox. The final meetings of the Council during 1561–1563 had far-reaching implications for the development of church discipline. Here the Council strengthened the powers of bishops to oversee local monasteries and the parish clergy. It reinforced older prohibitions against holding multiple offices in the church and stipulated that those who held offices should be resident in the place from which they received their income. Among the more enlightened of the requirements that Trent formulated was the mandate that each

bishop should establish a seminary within his diocese for the training of priests. Although it would take many years for these seminaries to be established everywhere in Europe, this requirement ensured that in the future the Catholic clergy would be trained to certain minimal standards of religious knowledge.

NEGATIVE TONE. The Council of Trent had been called with the expectation that it might heal the developing rift between Protestants and Catholics. Most of Trent's decrees, though, were essentially negative condemnations of Protestantism, and thus the Council helped to widen the gap between the groups. The positions adopted at Trent were often expressed in ways that made the Catholic Church's teachings as distinct from Protestant positions as possible. The Council ignored the moderate Catholic humanism of figures like Erasmus in

favor of theological teachings drawn from the more distant past. The church leaders assembled at Trent adopted many positions from the scholastic theologians, especially those of St. Thomas Aquinas (1225–1275). From the Council of Trent onward, Aquinas' teachings were seen more and more as the foundation of Catholic orthodox theology.

COUNTER-REFORMATION. The conservatism that was developing at Trent and more generally in the hierarchy of the church in these years helped inspire the term "Counter-Reformation," a phrase that calls attention to the essentially reactionary character of many reforms in the church. This growing conservatism can be seen in the actions of the popes who were elected at the time. Perhaps none was so determined a counter-reformer as Paul IV (r. 1555–1559). During his short period as pope, he tried to make Rome into a model Catholic city, adopting many of the same moral reforms that had already been used by Protestants in places like Geneva. Paul outlawed gaming and dancing, banished Rome's prostitutes, and placed severe restrictions on the activities of the city's Jews. He became best known for one innovation that would shape Catholic life for centuries to come: the *Index of Prohibited Books*. He charged the administrators of the index with compiling a list of works that were believed to be subversive to Catholic truth. The list was to be made available to Catholics so that they could know what works were forbidden. The index came to include many works written by Lutherans and Calvinists, but also by moderate Catholic reformers like Erasmus. Paul encouraged Europe's Catholic rulers to enforce the index in their states and to strengthen their efforts to punish Protestants as heretics. Not all Catholic monarchs pursued the harsh counter-reforming campaign he and his successors advocated, but the most fervent did. In Catholic Bavaria, a territory in the German Empire, the duke instructed his officials to conduct house searches and regular inspections of the territories' booksellers for prohibited Protestant books. To try to re-establish Catholic orthodoxy, Bavaria's dukes also required their subjects to attend Mass and confession regularly, and they ensured compliance with an ingenuous system. Priests gave out certificates to their parishioners at Mass, and each year, subjects had to present these proofs of attendance when they paid their state taxes. Those who failed to attend could be fined. Harsh and repressive measures like these became common in those states where staunch Catholic rulers enforced the uniform beliefs that a counter-reforming church demanded.

CATHOLIC REFORMATION. These measures, though, were only a part of the revival that occurred within the Catholic Church in the early-modern period. Many reform movements had also grown up within Catholicism in the years prior to the Protestant Reformation, and for this reason, most historians prefer to use the term "Catholic Reformation" to describe the church's revival. The phrase calls attention to the fact that not all the reforms that appeared in these years were inspired by the battle against Protestantism. Many developments had occurred independent of those controversies. Of the many reforming groups within the church that existed prior to the Reformation, the Oratory of Divine Love was the most famous. The founders of the Oratory of Divine Love had been influenced by the example of Catherine Adorno (1447–1510), who would later be canonized as St. Catherine of Genoa. Although married, Catherine renounced her family's wealth and lived a celibate life in service to Genoa's poor. She drew around her a circle of devoted admirers, who spread her message of penance and good works through the foundation of the Oratory. The confraternity soon spread to other Italian cities, including Rome. There it shaped the thinking of some of the church's most important figures, including Pope Paul IV; Gaetano da Thiene, the founder of the Theatines; and Gasparo Contarini, the papal representative who negotiated with Protestants at Regensburg.

NEW ORDERS. In the first half of the sixteenth century a number of new religious orders appeared in the Roman Church. These included the Theatines founded in 1524, the Capuchins (1528), the Ursulines (1535), and the Jesuits (1540). The Capuchins took their name from the hooded cape (in Italian *capuccio*) that they wore. Their founder Matteo di Bassi (1495–1552) intended the order to observe the Rule of St. Francis in a strict, literal fashion; members devoted themselves to prayer and preaching and a strict adherence to Franciscan poverty. By contrast, the Ursulines' founder, Angela Merici (d. 1540), envisioned that her order of religious women would take vows of perpetual virginity but continue to wear normal clothes and live with their families. The Ursuline was to devote herself to the education of young girls. Eventually, though, the long-standing distrust of unsupervised groups of laywomen led the Ursulines to develop their own convents, from which they ran schools for girls.

JESUITS. The Society of Jesus, or the Jesuits as they came to be known, were by far the most important order to appear in this early stage of the Catholic Reformation. Their founder, Ignatius Loyola (1491–1556), exercised a profound influence on Catholic spirituality in the early-modern period, particularly through the widespread diffusion of his classic devotional work *The*

Spiritual Exercises. He originally wrote the work as a diary of his own quest for spiritual perfection, but he adapted it for his followers' use. It relied on a technique of mental prayer that Loyola called "meditation." The Jesuits who first practiced the *Exercises* were to keep certain prescribed images from the life of Christ before their eyes. By undertaking these meditations over the course of thirty days, the Jesuits acquired the mental tools they needed to avoid sin. While intended originally for Loyola's followers, the *Spiritual Exercises* eventually became a form of retreat that many members of the Catholic devout practiced in the early-modern period. The practitioners of these devotions thus held ideas that were very different from Protestants, who placed great stress on humankind's wickedness and helplessness outside of God's aid. These devoted Catholics, on the other hand, believed that sin could be conquered through a combination of human effort and God's grace.

JESUITS AS CATHOLIC REFORMERS. Besides their role in fostering a deepened Catholic piety, the Jesuits played a major part in shaping the resurgence of the Roman Church. Loyola had been a soldier, and he molded his society into a military-style organization that culminated in the office of the society's Order General. Local communities of Jesuits did not have the customary rights of religious orders to choose their leader; instead the Order General appointed their superiors. Loyola, moreover, envisioned the society as a highly mobile force that could be deployed to establish schools, to preach and conduct missionary work, and to combat Protestant influences wherever and whenever the church required. The Jesuits had very stringent entrance requirements that included a nine-year probationary period. Despite these requirements, the rapid development of the Society points to its widespread popularity. At the time of Loyola's death in 1556, the Jesuits numbered more than 1,000; by the end of the century, their numbers had surpassed 5,000. One area in which the Society of Jesus exercised a profound influence was in the establishment of secondary schools for young men. After renouncing his military career and experiencing a religious conversion, Loyola himself had entered the University of Paris, where he had been schooled in the traditions of Renaissance humanism. In 1548, as the Jesuits founded their first secondary school at Messina in Sicily, Loyola chose to adopt a humanistic, rather than scholastic, curriculum. Soon Jesuit schools modeled on Messina opened throughout Europe. By 1600, more than 100 such institutions had been founded in Germany alone, and the schools became one of the primary vehicles through which young men from prominent families acquired a classical education.

B. IGNATIVS DE LOIOLA SOC: IESV FVNDATOR.

Omnibus omnia factus est vt omnes lucrifaceret.
Obijt An. Dni 56. Ætatis 65. Conuerf. 35.
Hieronymus Wierx fecit et excudit. Cum Gratia et Priuilegio. Pulchre.

Engraving of St. Ignatius of Loyola. THE LIBRARY OF CONGRESS.

MISSIONS. The Jesuits were also enthusiastic missionaries, as were many of the orders of the Catholic Church in the sixteenth and seventeenth centuries. Jesuits, though, played a particularly important role in the establishment of seminaries that trained preachers who worked for the re-conversion of Protestants to the Catholic religion. In Germany, more than half the lands that had been won over to Protestantism re-converted to Catholicism by the mid-seventeenth century. In this intensive effort of recatholicization the Jesuits played an important role. The Jesuits performed their work by conducting preaching missions, particularly in the cities where Protestantism was strongest. These missions also aimed to keep Catholics confirmed in their faith. Jesuit success elicited Protestant anger, and prompted numerous polemics against the society. In Germany, where the Jesuits were particularly effective in winning converts, Lutheran preachers often attacked the society as a force of Antichrist. Jesuit missions also took on an international dimension. The Jesuits, together with the other

a PRIMARY SOURCE *document*

JESUIT MISSIONS

INTRODUCTION: In the mid-sixteenth century the Jesuit Order published the letters of its missionaries at work in the Far East. The letters, filled with adventures and stories of conversions the order had accomplished in their missionary work, became successful propaganda for the Roman Catholic Church. This 1543 letter from Francis Xavier, a missionary working in India, to the Jesuits is one of the first of this genre of missionary communications.

I and Francis Mancias are now living amongst the Christians of Comorin. They are very numerous, and increase largely every day. When I first came I asked them, if they knew anything about our Lord Jesus Christ? but when I came to the points of faith in detail and asked them what they thought of them, and what more they believed now than when they were Infidels, they only replied that they were Christians, but that as they are ignorant of Portuguese, they know nothing of the precepts and mysteries of our holy religion. We could not understand one another, as I spoke Castilian and they Malabar; so I picked out the most intelligent and well read of them, and then sought out with the greatest diligence men who knew both languages. We held meetings for several days, and by our joint efforts and with infinite difficulty we translated the Catechism into the Malabar tongue. This I learnt by heart, and then I began to go through all the villages of the coast, calling around me by the sound of a bell as many as I could, children and men. I assembled them twice a day and taught them the Christian doctrine: and thus, in the space of a month, the children had it well by heart. And all the time I kept telling them to go on teaching in their turn whatever they had learnt to their parents, family, and neighbors. ...

I take care to make them repeat the Creed oftener than the other prayers; and I tell them that those who believe all that is contained therein are called Christians.

After explaining the Creed I go on to the Commandments, teaching them that the Christian law is contained in those ten precepts, and that every one who observes them all faithfully is a good and true Christian and is certain of eternal salvation, and that, on the other hand, whoever neglects a single one of them is a bad Christian, and will be cast into hell unless he is truly penitent for his sin. Converts and heathen alike are astonished at all this, which shows them the holiness of the Christian law, its perfect consistency with itself, and its agreement with reason. ...

As to the numbers who become Christians, you may understand them from this, that it often happens to me to be hardly able to use my hands from the fatigue of baptizing: often in a single day I have baptized whole villages. Sometimes I have lost my voice and strength altogether with repeating again and again the Credo and the other forms.

The fruit that is reaped by the baptism of infants, as well as by the instruction of children and others, is quite incredible. These children, I trust heartily, by the grace of God, will be much better than their fathers. They show an ardent love for the Divine law, and an extraordinary zeal for learning our holy religion and imparting it to others. Their hatred for idolatry is marvelous. They get into feuds with the heathen about it, and whenever their own parents practice it, they reproach them and come off to tell me at once. Whenever I hear of any act of idolatrous worship, I go to the place with a large band of these children, who very soon load the devil with a greater amount of insult and abuse than he has lately received of honor and worship from their parents, relations, and acquaintances. The children run at the idols, upset them, dash them down, break them to pieces, spit on them, trample on them, kick them about, and in short heap on them every possible outrage.

SOURCE: Francis Xavier, "To The Society at Rome," in *Modern Asia and Africa,* Vol. 9 of *Readings in World History.* Ed. W. H. McNeill and M. Iriye (Oxford: Oxford University Press, 1971): 4–6.

Catholic Reformation orders, helped carry Catholicism to the New World and the Far East. In Spanish and Portuguese South and Central America, Jesuit missionaries shared the mission field with groups of Dominicans, Franciscans, and Capuchins. In India and the Far East, their efforts were at first unchallenged. In 1542, Loyola's close associate Francis Xavier (1506–1552) arrived in the Portuguese colony of Goa on India's west coast. He and a group of Jesuits stayed there for three years, planting the seeds of a Catholic Church in the region. In 1545, Xavier moved on to Malacca and in 1549 to Japan.

Xavier and his followers communicated frequently by letters with their superiors in Europe, and at home the Jesuits published these communications. These printed "Letters from the Far East" became popular reading for devout Catholics, filled as they were with accounts of conversions and adventures the missionaries had experienced in the East. They became, in other words, highly successful propaganda for Rome's renewal. By 1582, the Jesuits estimated that they had established 250 churches in Japan and converted more than 200,000 to the Christian faith. The society advertised similar successes in

a PRIMARY SOURCE *document*

THE INQUISITION INVESTIGATES ART

INTRODUCTION: In July 1573, the Venetian painter Paolo Veronese was called before the Inquisition to defend a painting of the Last Supper he had recently completed. The painting was filled with riot of richly dressed figures, including Germans, court jesters, and serving men and women. The Inquisition was not satisfied with Veronese's defense of his work, which stressed artistic license. They demanded that he paint out the extraneous figures that would not have been present at the Supper. Instead he changed the work's name to *Feast in the House of Levi*, a biblical theme that allowed for his luxuriant depiction. A portion of his testimony before the Inquisition follows.

Q: What is the significance of those armed men dressed as Germans, each with a halberd in his hand?

A: We painters take the same license the poets and the jesters take and I have represented these two halberdiers, one drinking and the other eating nearby on the stairs. They are placed there so that they might be of service because it seemed to me fitting, according to what I have been told, that the master of the house, who was great and rich, should have such servants.

Q: And that man dressed as a buffoon with a parrot on his wrist, for what purpose did you paint him on that canvas?

A: For ornament, as is customary.

Q: Who are at the table of Our Lord?

A: The Twelve Apostles.

Q: What is St. Peter, the first one, doing?

A: Carving the lamb in order to pass it to the other end of the table.

Q: What is the Apostle next to him doing?

A: He is holding a dish in order to receive what St. Peter will give him.

Q: Tell us what the one next to this one is doing.

A: He has a toothpick and cleans his teeth.

Q: Who do you really believe was present at that Supper?

A: I believe one would find Christ with His Apostles. But if in a picture there is some space to spare I enrich it with figures according to the stories.

Q: Did anyone commission you to paint Germans, buffoons, and similar things in that picture?

A: No milords, but I received the commission to decorate the picture as I saw fit. It is large and, it seemed to me, it could hold many figures.

Q: Are not the decorations which you painters are accustomed to add to paintings or pictures supposed to be suitable and proper to the subject and the principal figures or are they for pleasure—simply what comes to your imagination without any discretion or judiciousness?

A: I paint pictures as I see fit and as well as my talent permits.

Q: Does it seem fitting at the Last Supper of the Lord to paint buffoons, drunkards, Germans, dwarfs and similar vulgarities?

A: No, milords.

Q: Do you not know that in Germany and in other places infected with heresy it is customary with various pictures full of scurrilousness and similar inventions to mock, vituperate, and scorn the things of the Holy Catholic Church in order to teach bad doctrines to foolish and ignorant people?

A: Yes, that is wrong; but I return to what I have said, that I am obliged to follow what my superiors have done.

SOURCE: Paolo Veronese, "Testimony before the Inquisition," in *Italian Art, 1500–1600: Sources and Documents.* Ed. Robert Klein (Englewood Cliffs, N.J.: Prentice-Hall, 1966): 31–132.

China. While these numbers may be exaggerated, Jesuit conversions were frequently troubling to local non-Catholic populations. In both Japan and China, sporadic persecutions of Christian converts gave way through time to brutal efforts to suppress Christianity. Local rulers feared the foreign cultural influence of Christianity the Jesuits had sowed among their subjects.

RELIGIOUS ART. Because of their religious teachings, all the Protestant Reformations had favored an aesthetic that drastically reduced, and sometimes eliminated the use of religious art in churches. Of all the forms of Protestantism that developed in the sixteenth century, only Lutheranism retained a prominent place for pictorial images and the plastic arts. The Swiss forms of Protestantism, the Radical Reformers, and the Church of England all moved to curb the use of religious art within the public spaces of churches. The Council of Trent, by contrast, enthusiastically supported the continuing use

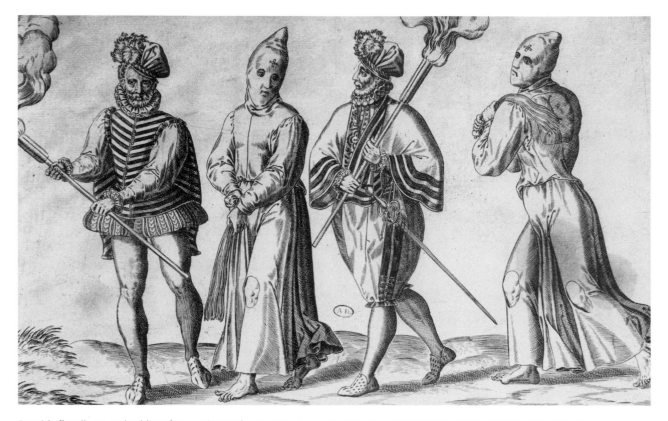

Spanish flagellants and soldiers from a sixteenth-century print. © GIANNI DAGLI ORTI/CORBIS. REPRODUCED BY PERMISSION.

of religious art, insisting that images provided a necessary way to teach the faithful the truths of the church. As the Roman Church's officialdom met at Trent, though, they were well aware of problems in the uses of religious art. Throughout Europe, the contemporary style of many artists favored the movement known as Mannerism, which sometimes distorted religious themes or clouded them in images that were so complex that few could understand the Christian message. Thus Trent tried to reform the uses of religious art in the church, entrusting its decrees on the proper uses of religious art to the church's bishops for enforcement. A key figure in the movement to reform art in the second half of the sixteenth century was Gabriel Paleotti, the bishop of Bologna and a cardinal of the church. Paleotti's *Discourses* became an essential text used by bishops and reformers throughout Europe to discern whether religious art fit within the church's teachings. He insisted that artists must make their messages clear and that religious paintings and sculptures should stir the faithful to piety. In the wake of decrees of the Council of Trent and the reform measures that bishops like Paleotti instituted, artists were sometimes brought before the Inquisition to answer for their compositions. The Council had stipulated that the message of religious art should be clear

and forceful; it should, in other words, communicate Catholic truths to the unschooled in a way that seized upon their emotions and inspired their loyalty to the Roman Church. The most famous case of the censorship of art involved the great Venetian painter Paolo Veronese, who had painted an elegant Last Supper filled with serving men and women, Germans, buffoons, and so forth. When the Venetian Inquisition demanded that he paint over these unscriptural figures, he responded by merely changing the work's name from "The Last Supper" to "The Feast in the House of Levi."

POPULAR RELIGION. The later Middle Ages had witnessed a vital surge in lay piety that had taken many forms. In Northern Europe, the Modern Devotion had deepened the sense of religion as an internal and individual experience. Members of confraternities had also practiced rigorous penitential disciplines that imitated those of monks and nuns. They had displayed their devotion to the sacraments and had helped the poor and downtrodden through good works. A surge in the veneration of the saints had also been evident in the foundation of scores of new pilgrimage shrines. During the Catholic Reformation all these forms of religious devotion were renewed and intensified. Through the efforts of the reforming orders the sacrament of Penance be-

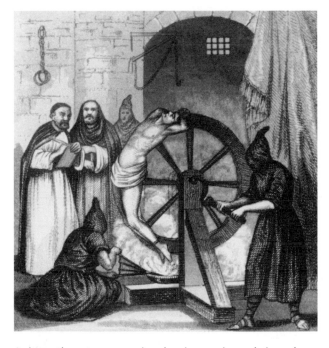

A sixteenth-century engraving showing a prisoner being subjected to the wheel by the Spanish Inquisition. HULTON/ARCHIVE. REPRODUCED BY PERMISSION.

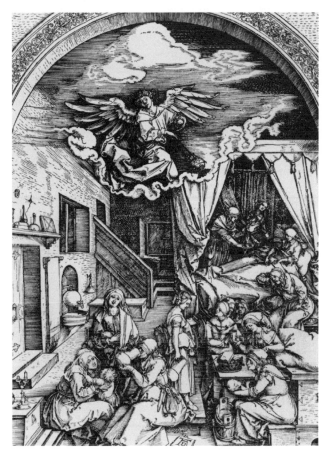

The engraving *The Birth of the Virgin* by Albrecht Dürer. PUBLIC DOMAIN.

came an intense act of self-examination in the sixteenth and seventeenth centuries. In place of the often ritualistic observance of the late-medieval church, the new preachers of the Catholic Reformation taught that Penance needed to be preceded by an internal change of heart and that it should be accompanied by a rigorous inward examination of the conscience. These views show the triumph of religious views that had initially been championed by groups like the Brothers and Sisters of the Common Life and Christian humanists like Erasmus. Confraternal piety lived on in the later period, too. In Northern Europe these traditional religious organizations had been attacked by several generations of Protestant preachers and had fallen into decline. In the second half of the sixteenth century, though, confraternities witnessed a renewal there and everywhere in Europe. The new confraternities of the Catholic Reformation often took the Virgin Mary as their standard bearer since Marian devotion had been widely attacked by Protestants. Many of these organizations imagined themselves as a kind of religious army of lay people that would effectively re-establish Catholicism throughout Europe. Many confraternities spread from their point of original foundation to establish constituent branches throughout the continent, becoming international movements that linked groups of the Catholic laity together across national boundaries thus sustaining the universal character of Catholicism. Some supported the revival of pil-

grimages and renewed devotion to the Catholic saints, practices that had been attacked by the Protestant reformers. Everywhere in Europe, pilgrimage became a vivid symbol of Catholicism and a tool for creating Catholic identity. Luther and other Protestants had attacked pilgrimages and the saints as products of the flawed teachings of the medieval church. But the Catholic reformers of sixteenth- and seventeenth-century Europe embraced these practices as embodiments of Catholic truth since they taught that the Christian life was a journey in search of individual spiritual perfection.

IMPLICATIONS. The Protestant and Catholic Reformations were complex events, so complex indeed that most generalizations about them prove problematic. Important patterns nevertheless emerged in the religious world of the later Renaissance, patterns that had been shaped by the enormous controversies that had occurred between competing religions. This competition between Catholicism and Protestantism helped produce new highly defined religious orthodoxies. In the process of reforming and reordering religion in Europe, long-standing conflicts between church and state were

generally resolved in favor of the secular state. As the Renaissance drew to a close, in other words, it was Europe's princes who now possessed the power to define what religion their subjects would practice. In both early-modern Catholic and Protestant states, indoctrinating people in the principles outlined in a religion's confession (that is, its formal statement of belief) became a central concern of the state. Catholic and Protestant rulers expended considerable energy trying to ensure uniform belief among their subjects. In this offensive, Europe's rulers often relied on the arts—particularly theater, music, and the visual arts and architecture—to express their Protestant or Catholic principles. This campaign also left its marks on European literature, too, as authors published works that both defended and attacked their state's religious principles.

SOURCES

A. Martin, *The Jesuit Mind* (Ithaca, N.Y.: Cornell University Press, 1978).

J. Olin, *Catholic Reform: From Cardinal Ximenes to the Council of Trent* (New York: Fordham University Press, 1990).

J. O'Malley, *The First Jesuits* (Cambridge, Mass.: Harvard University Press, 1993).

SEE ALSO *Visual Arts: Late Renaissance and Mannerist Painting in Italy*

SIGNIFICANT PEOPLE
in Religion

JOHN CALVIN
1509–1564

Protestant theologian

EARLY LIFE. John Calvin was born at Noyon in Northern France, the son of a local official of a bishop. The family was relatively prosperous, and early in Calvin's life his father groomed him to pursue a career in the church. In 1523, he enrolled at the University of Paris where he studied theology within the university's Collège de Montaigu, the college in which thirty years before Desiderius Erasmus had been a student. After Calvin completed his bachelor of arts, his father encouraged him to pursue advanced studies in law, a move that necessitated a move to Orléans and later to Bourges. While he was a law student, Calvin became attracted to the study of literature, particularly the classics, and in 1531, he returned to Paris with the intention of pursuing humanist studies. Although his father disapproved, Calvin came to know the premier French humanist Guillaume Budé closely in this period. In 1532, he published his first work, a commentary on the ancient Stoic Seneca. It showed that he had acquired a very fluent Latin style and that he was capable in Greek. Sometime in 1532 or 1533, Calvin converted to Protestantism, a religion under persecution by the French government at the time. He fled Paris, and thus began a long pilgrimage that eventually established him as one of the leading religious reformers of Europe.

TRAVELS. Over the course of the next several years Calvin traveled throughout Europe in search of a suitable refuge. He stayed for a time in Ferrara, and then in Basel in Switzerland, before deciding to take a position as the pastor to the French-speaking Protestants in Strasbourg. On his way he passed through Geneva, and some local citizens, impressed with his scholarly reputation, asked him to stay. By this time Calvin's fame had already grown through the recent publication of his *Institutes of the Christian Religion*, which had appeared in its first Latin edition in 1536. It explained the essential ideas of Calvin's Protestantism in a way that was forceful and persuasive. During the next two years, Calvin remained at Geneva, where he labored to reform the city along the lines he had revealed in his *Institutes*. His extremism attracted the hatred of some of Geneva's citizens, and they succeeded in having the town council expel him in 1538. Now Calvin moved on to Strasbourg where he remained for several years and where he would marry. Although he was content in Strasbourg, his supporters at Geneva regained control over the town, and they asked him to assume once more his post in the city. Calvin reluctantly returned and he remained in Geneva for the rest of his life.

GENEVA. As Calvin set up residence in Geneva again, he was more cautious about establishing his reformation over the city. He desired to mold Geneva into an example of a reformed Christian town, and in the 1540s and 1550s his influence grew. His admirers celebrated the city as "the most perfect school of Christ," while critics both in Geneva and throughout Europe attacked him for the control he seemed to wield over people's daily lives and consciences. As part of the conditions for his return from Strasbourg, Calvin had already sent the town council his "Ecclesiastical Ordinances" in 1541. He had demanded that they enact these regulations as laws of the city. The ordinances were based upon Calvin's interpretation of the Acts of the Apostles, the

New Testament history that outlines the pattern of government the apostles used in the very earliest days of the church. Calvin's reading of the Acts established four chief offices in the Genevan church: ministers, teachers, deacons, and elders. The most powerful body of the church was the consistory, which functioned like a court, hearing cases of moral infractions reported among the citizens of Geneva. Each Friday during Calvin's tenure in the city, the consistory met to deliberate. It heard marital disputes, conflicts between neighbors, and even tried and sentenced to death heretics (those whose ideas ran contrary to the city's reformed Protestantism). This institution would be widely imitated in other places in which Calvinists established reforms. The Calvinist-inspired Puritans who emigrated from England to North America, for instance, established its use in Massachusetts and elsewhere in their new settlements.

CALVIN'S TEACHINGS. Calvin saw himself as continuing and perfecting the reforms begun by Luther and Zwingli. In the *Institutes* he laid out his Protestant teachings in a way that was clear and intelligible to his mostly urbanized audience. These views placed a great emphasis on the majesty of God. Calvin, for instance, devoted a full quarter of the book to showing his readers how human beings could not comprehend God's omnipotence. He stressed the huge chasm that separated a perfect God from sinful humankind; nothing that human beings could do by themselves could ever bridge this gap. These observations led Calvin to adhere to a strict interpretation of the Christian doctrine of predestination, a doctrine he did not create but instead interpreted in a radically new and extreme way. Predestination was an ancient teaching of many Christian theologians. Many traditional statements of the doctrine had stressed a difference between God's foreknowledge and his election. God chose or elected some to salvation, but at the same time He had only foreknowledge of those who would be damned. He did not, in other words, create some human beings merely to damn them; instead the damned were responsible for their own fates because of their sins. By contrast, Calvin's notion of predestination has often been called "double predestinarian" because he insisted that God chose both to save some and damn others. Critics charged that such an interpretation of predestination led to fatalism and despair, and Calvin himself did not emphasize the doctrine in the *Institutes*. He was more concerned to foster among his followers a sense of their unworthiness when judged against God's omnipotence. The enormous effort he expended on trying to drive home this point to his readers, though, tended to reinforce the sense that human beings were utterly powerless in determining their fate. These were relatively bleak doctrines, but Calvin assured his audience at the same time that they could be reasonably certain they were among the elect if they were leading an upstanding moral life. Thus Calvin's ideas tended to sanctify good works, hard labor, and moral discipline, and although they lacked a general appeal throughout society, they found many adherents, particularly among the growing bourgeoisie of Europe's cities.

SPREAD OF CALVIN'S IDEAS. Through the intensive efforts of dedicated missionaries trained in Geneva, Calvin's ideas spread to France, the Netherlands, England, Scotland, and parts of Central Europe. Scotland became the only country outside Switzerland to adopt Calvinism as its legally recognized religion. In other monarchies Calvinists were a distinct, but often-powerful minority. In France and the Netherlands, the Calvinist movement clashed in the second half of the sixteenth century with a resurgent Catholicism that was fueled by the Counter-Reformation to produce bloody civil wars. In England, Calvin's followers, the Puritans, also lobbied Queen Elizabeth I for greater reform in the Church of England. They were largely unsuccessful in promoting Calvinism's general adoption throughout the English church, but in the seventeenth century, the brief English Civil War succeeded in establishing a Calvinist government throughout the land. The victory of the Puritans proved short-lived, and the monarchy and the Church of England were re-established. In the wake of this crisis, English Puritans often became dissenters from the national church and established their own Presbyterian institutions. Others immigrated to the English colonies in the Americas. There Calvinism shaped the development of American institutions over the coming centuries.

SOURCES

William Bouswma, *John Calvin: A Sixteenth-Century Portrait* (New York: Oxford University Press, 1988).

A. McGrath, *A Life of John Calvin* (Cambridge, Mass.: Harvard University Press, 1990).

J. T. McNeil, *The History and Character of Calvinism* (New York: Oxford University Press, 1954).

CATHERINE OF SIENA

1347–1380

Mystic

EARLY LIFE. Catherine was born in Siena in Western Italy. She was one of 25 children and was also a twin.

When Catherine was an infant her mother was only able to nurse one of her children, and so Catherine's sister had a wet nurse. Although this custom was common in the Renaissance, it often proved disastrous to the child, as it was to Catherine's sister. It may be the death of her twin sister that sowed in Catherine the notion that she had been marked by God for a special destiny. As she grew older, events within the family continued to shape her outlook. Her beloved older sister Bonaventura died in childbirth, and without her company, Catherine turned to religion for solace. When she was still a child, she escaped to isolated caves around Siena to imagine herself as an ascetic saint from the early church. Over time, she spent long periods of the year in fasts and prayer. Her family tried to encourage her to pursue the normal interests of a maturing girl. They wanted her to make herself attractive to men and prepare herself for marriage, but Catherine resisted. She wanted instead to enter a convent, and when her family resisted she tried to make herself unattractive to men. When she came down with the smallpox, for instance, she refused to take any special precautions to protect her complexion, and on another occasion she tried to scald herself. She also practiced flagellation (self-whipping) and wore coarse hair shirts.

CONVENT LIFE. By the time she turned sixteen Catherine's behavior had convinced her family to allow her to enter a religious order. She joined the Sisters of Penance, a group that did not have a regular convent, and Catherine continued to live isolated within her family's home. For three years she saw almost no one and ate only infrequently, spending her time in constant prayer. During this period she began to have ever more intense visions, and by nineteen she experienced a vision of her "mystical marriage" to Christ. These mystical experiences continued, and in another vision several years later she heard a command to leave her parents' house and enter the world. As a result, she left her isolation behind and devoted herself to the world of church politics. Despite her inexperience she exerted a significant influence on the history of the church. At the time, the pope resided not in Rome but in Avignon, a small city just inside France's borders. This "Babylonian Captivity," as it was called, was a significant blow to Italian prestige as well as to the economy of the city of Rome. During the 1370s Catherine put pressure on the pope to return the capital of the church to its ancient home. She also called for him to support a crusade against Islam. While she eventually was successful in obtaining the first of her desires, the second eluded her. Her political involvement brought her fame among the powerful throughout Europe. In the letters she wrote during this period in her life, Catherine took on the role of an adviser to kings, queens, and other powerful figures throughout the continent. She was not always complimentary to her correspondents, castigating and chiding those of whom she disapproved.

POLITICS. Because of her visions and political engagement, the church mounted an investigation into Catherine's life. In 1374 the priest Raymond of Capua received the appointment to serve as her confessor and spiritual advisor. Although Capua was supposed to make sure that Catherine kept quiet, he soon came to respect her and the two developed a close relationship over the coming years. For the rest of Catherine's life, Raymond acted as her confidant. Raymond relieved the doubts of those in the church who had suspected that Catherine's motives were less than pure, and she was now free to pursue her political ambitions. In 1376 the city of Florence asked her to go to Avignon to negotiate a resolution to a dispute between the town and the pope. Catherine agreed, and although she was unsuccessful in resolving Florence's problems, she did succeed while she was in Avignon in finally convincing the pope to return to Rome. When she returned to Florence, she soon became involved in a popular revolt in the city known as the "Ciompi," and at one point she received a death threat. Catherine survived to negotiate a settlement to the political problems in Florence, and afterwards she set down to write her *Dialogue on Divine Providence*, which recounted a conversation between God and the human soul. In this book Catherine set out her religious ideas about the importance of love and service. Although she wanted to retire from her public role, the Great Schism required her diplomatic skills once more in 1378. This breach in the church—caused by the election of rival popes at Avignon and Rome—saddened Catherine, who tried to resolve the issue by writing numerous letters to her correspondents. Catherine also believed that she was somehow responsible for the problems of the church because of her role in encouraging the pope to return to Rome. She soon gave up even the small amount of food and water that she normally consumed and died soon afterwards.

BIOGRAPHY. Fifteen years after her death Raymond of Capua wrote on the life of Catherine of Siena. Although Raymond was convinced of her saintliness, he still managed, in a relatively unbiased way, to present a faithful life of his friend. Fasting and asceticism was not unknown in the Middle Ages, but Catherine carried these religious disciplines to audacious extremes, and they eventually resulted in her death. Catherine's visions

and the mastery she displayed over her body through her fasts and rigorous disciplines demonstrated her spiritual authority to the fourteenth-century world. Besides her *Dialogue of Divine Providence* and several other works, Catherine's letters are an eloquent testimony to the fame and influence she achieved in her own time. In the years following her death her reputation continued to grow, and Catherine became an official saint of the Roman Church in 1461.

SOURCES

Caroline Bynum, *Holy Feast, Holy Fast; The Religious Significance of Food to Medieval Women* (Berkeley, Calif.: University of California Press, 1987).

S. Noffke, *Catherine of Siena: Vision through a Distant Eye* (Collegeville, Minn.: Liturgical Press, 1996).

IGNATIUS LOYOLA

1491–1556

Catholic reformer

EARLY LIFE. Christened as Inigo, this founder of the Society of Jesus (Jesuits) was born into a Basque noble family in Northern Spain. Like other children of his class he was trained in the arts of war and groomed for a military career. In 1521 he was wounded in battle and spent over a year recovering from a crushed leg. During this recovery he had several religious experiences and he realized that he wanted to help other Christians. He entered into a year of isolation, during which he kept a spiritual notebook. This collection of his prayers and spiritual observations would later become the basis from which he wrote his *Spiritual Exercises*, a great classic of devotional literature.

EDUCATION. Once his recovery was complete, Loyola went on pilgrimage to the Holy Land and realized that he needed a better education if he was going to realize his dream of helping his fellow Christians. He enrolled in the university at Barcelona to study Latin and later moved on to the universities of Alcalà and Salamanca before finally ending up as a student at the University of Paris, Europe's premier theological institution. In Paris, he attracted a group of disciples, and this group later formed the core of the Society of Jesus. Among Loyola's earliest followers in his student days were Francis Xavier (1506–1552), who would become a great missionary to the Far East, and Diego Laynez, who was a distinguished theologian of the Catholic Reformation. By 1540, others had joined them, and the group based itself in Rome. In that year the pope approved the order officially, and a year later the group elected Loyola as their leader, a position in which he served the Society of Jesus for the remainder of his life. His tenure oversaw the Jesuits' expansion from the handful of 1540 to more than a thousand members at the time of his death.

CHARACTER. Despite the time he spent at universities in Spain and France, Loyola was never an intellectual. He possessed only a passing familiarity with the educational innovations of humanism and with the fine theological distinctions that were developing at the time as a result of the Council of Trent. His genius consisted in identifying those who could help him in his efforts and in recognizing the talents of those who surrounded him. From the start the Jesuits envisioned themselves as a missionary order that would fulfill Christ's charge to evangelize the world. As a result they stipulated in their first constitution that members were not required to meet daily for common prayers, nor were they required to dress in a common habit. These innovations granted them greater freedom and they attracted many highly educated, highly motivated men to the group. In 1548, the Society took on a new dimension when it founded its first secondary school at Messina in Italy. The Jesuits' educational role grew over the next several decades and established the order at the forefront of Catholic educational trends over the coming centuries.

SPIRITUAL EXERCISES. The core of a Jesuit's religious training consisted in the *Spiritual Exercises*, which was a devotional guidebook to a month-long retreat that all Jesuits undertook once in their life. Ignatius Loyola first published the book in 1548. The prayers and meditations that are outlined in this short book provided a common core of experience for all Jesuits and helped to forge an identity within the group. Loyola's *Spiritual Exercises* also spread outside the order to lay people and members of other religious orders. The central insight of their teachings lay in their notion that a time of isolation and intensive self-examination might provide a person with the defenses needed to avoid sin. Throughout the work Loyola's early experiences in the military shaped the language of the *Exercises* in describing the Christian life as a battle against sin. For each of the thirty days of these devotions, the Jesuit was expected to keep vivid images of Christ's suffering and passion before his eyes. In imagining the lashes that raised Christ's blood or the thorns that pierced his brow, the practitioner was to acquire a lifelong distaste for wrongdoing. Besides participation in the *Spiritual Exercises*, the Jesuits also required that their recruits endure one of the longest probationary periods of any order in the Catholic Church. They desired to weed out those who were unsuitable for

missionary or educational efforts, and their constitution stressed absolute obedience to the authority of the church and to superiors in the order. For this reason they have long been likened to a military force within the Catholic Reformation.

MISSIONS. Ignatius Loyola also identified missions as an important dimension to be pursued by the Society, and the missionary expansion of the Society of Jesus into Asia and the New World began during his tenure. In 1542 he sent Francis Xavier to India where he worked to establish a strong Jesuit presence. Xavier moved on to Japan in 1549, planting the seeds of Christianity on that island. One of the innovations of the Jesuits allowed those they converted in other countries to enter into their society, and Japanese Jesuits soon found their way into the life of the order. In the same year Xavier arrived in Japan, Jesuit missionaries also went to Brazil. By the time of his death, not all the mission fields in which the Jesuits would work had been opened up, but Loyola had led the order into the missionary work he prized.

FINAL TROUBLES. The final years of Ignatius Loyola saw an increasing number of problems. Portuguese Jesuits rebelled against his authority, and the election of Pope Paul IV, an enemy of the order, complicated Loyola's administration. Despite these problems the Society continued to prosper and expand, and Loyola even received recognition in his life as an exemplary Christian. In death his reputation only continued to grow, and he was named an official saint of the Roman Catholic Church in 1622.

SOURCES

J. Delumeau, *Catholicism between Luther and Voltaire* (London, England: Westminster Press, 1977).

W. Meissner, *Ignatius of Loyola* (New Haven, Conn.: Yale University Press, 1992).

J. O'Malley, *The First Jesuits* (Cambridge, Mass.: Harvard University Press, 1993).

MARTIN LUTHER

1483–1546

Protestant reformer

EARLY LIFE. Martin Luther was the son of prosperous peasants, and his father intended him to become a lawyer, the avenue that many upwardly mobile people followed in the fifteenth century. Early in his life he studied at schools run by the Brethren of the Common Life and he eventually attended the University of Erfurt where he earned a master's of arts degree in 1505. Before

he could begin his law studies, however, fate intervened. One day he was caught in a terrible storm and, fearing for his life, he prayed to St. Anne, vowing to become a monk if he was spared. He survived to make good on his promise, despite his father's vehement opposition. He entered an Augustinian monastery and took priestly orders. During this time he continued his studies, earning a doctorate in theology in 1512. A few years later he became professor of biblical theology at the University of Wittenberg in Saxony, one of Germany's newest universities. He stayed in this position for the rest of his life.

ANXIETY. In the 1950s the Danish psychologist Erik Erikson painted a picture of Luther's psychological makeup that was less than flattering. He saw Luther as someone who had suffered from an identity crisis in his early life because of his conflicts with his father over his choice of career. According to Erikson, Luther's quest for certainty of his salvation was a way to resolve these long-standing issues with his father. Historians have long attacked Erikson's version of events, but it is clear that Luther was someone with an anxious nature. Even as he completed his studies in biblical theology, the future reformer continued to try all the remedies the medieval church prescribed for sinful human nature. In the later Middle Ages the church taught that while human beings could not save themselves, they needed to cooperate with God by participating in the sacraments and doing good works. Luther tried this path. He went on pilgrimage to Rome, performing the prayers and rituals that were customarily undertaken in the Holy City to obtain indulgences. He fasted and spent long nights in prayer vigils, but he could not dispel doubts and uncertainties about his salvation. Johann von Staupitz, Luther's superior in the monastery, originally identified Luther's problems, and it was he who suggested Luther undertake biblical studies in the first place. Staupitz thought that reading and studying the Bible would calm Luther's fears, and in his ongoing attempts to keep Luther occupied, he arranged for the scholar to be appointed to his post at Wittenberg. Sometime around the time he took up his new position, though, Luther had a momentous insight. This event would later become known as his "Tower Experience," although it cannot be established with certainty just when it occurred. While gathering his thoughts together for a lecture on St. Paul's Epistle to the Romans, he was struck by the phrase, "The just shall live by faith." Fueled by his powerful new insight, he began to teach that works were unnecessary for salvation. Only faith in the promises of God could redeem sinners. These insights soon clashed with imperial politics. During 1517, members of the Dominican Order began to sell a

papal indulgence in Germany in order to finance the building of the new St. Peter's Basilica in Rome and to retire the debts a German archbishop had acquired in securing his election. Luther became disgusted with the techniques of the chief salesman, Johann Tetzel, and he wrote his *95 Theses* to spur debate. Luther probably did post these propositions on the door of Wittenberg's university church on 31 October 1517, an event that has become legendary as the start of the Protestant Reformation. But it cannot be definitely established whether he decided to publicize his ideas in this way at the time. He did send the *95 Theses* to the church officials responsible for the sale and to close friends and associates. Someone soon arranged for its publication without Luther's knowledge, and although it had been written in Latin, the language of scholars, its translation into German caused great excitement throughout the country.

DEBATE. While Luther's fame grew, Rome made several attempts to quiet his criticisms. These efforts failed, and in 1519 Luther debated his propositions publicly at Leipzig against the Dominican theologian Johann Eck. The reformer defended his positions skillfully, although at several points in the debate Eck drew him into making statements that showed he did not recognize the authority of the pope. Luther also expressed sympathy for John Huss, the leader of the fifteenth-century religious rebellion in Bohemia. These admissions made it clear to Pope Leo X that Luther was a heretic, but they also extended his popularity throughout Germany where the press promoted him as a sort of folk hero. Leo X condemned Luther's positions, but when Luther received his copy of the condemnation in June 1520 he publicly burnt it together with several esteemed theological works of the medieval church. In the months that followed, Luther actively engaged in preaching and writing about his new ideas. Among the many works he wrote in 1520, three treatises stand out in the history of the Reformation because they redefined Christian teachings according to Luther's principle of justification by faith. They presented a plan for the reform of the church and they also reformulated the role of the sacraments in Christianity. Over the following years these three treatises circulated throughout Germany and Europe in thousands of cheaply produced copies. They soon produced such excitement that a number of writers throughout Germany wrote similar tracts condemning the church, and the short Reformation pamphlet became the most popular printed work in Germany.

IMPERIAL DIET. As the controversy over Luther's ideas grew, the emperor Charles V summoned Luther to a meeting of the imperial parliament in the city of Worms. Charles wanted to put the matter to rest, but Luther refused to recant his ideas and he was condemned as an outlaw. Before attending the meetings at Worms, though, Luther had asked for a safe conduct, and he was able to leave the meetings to travel home. While en route, his protector, Frederick the Wise, arranged to have him kidnapped and taken to the Wartburg castle, where Luther hid for ten months. During this period Luther began his translation of the Bible into German, a task that would require another decade to complete. Although Bibles were tremendously expensive, Luther's translation became enormously popular. It was printed in hundreds of thousands of copies and had a major impact on the German language.

UNREST. While Luther was at the Wartburg, the situation at home in Wittenberg was quickly changing. Many of Luther's closest associates began to promote ideas that were even more radical than his own. In 1522 the reformer returned to Wittenberg to try to establish control over the situation. One of the key elements of these radical reformers' program at the time was the condemnation of traditional religious images and sculptures. These figures taught that religious art was a violation of the Bible's teachings about "graven images." Iconoclasm, that is, the destruction of religious art, had broken out in Saxony. Luther responded with a conservative defense of religious art's role in worship. The ideas he formulated at this time fashioned an essentially conservative Reformation in the church.

REFORM OF WORSHIP. Luther insisted that the chief insight of his movement, justification by faith, should be the central teaching of the church. For those who possessed faith, religious art was a matter of indifference. While church and state authorities should see to it that those objects that excited idolatrous affection in the people should be removed, religious art, Luther argued, had a role to play in people's devotions. At this time Luther also translated the traditional Mass and the other services of the church into German. He pruned away those parts of medieval worship that were in conflict with his teachings, but he preserved much from the Middle Ages. With Frederick the Wise's support, Luther abolished monasticism, and at Wittenberg, he arranged for the marriage of the town's monks and priests to nuns. In 1525, Luther himself married Katherina von Bora, a former nun.

PEASANTS' WAR. While Luther reshaped the life of the church in Saxony, unrest continued to brew. In 1524, peasants in Germany's southwest revolted, formulating their demands for religious and social reform in a widely circulated manifesto known as the *Twelve*

Articles. The movement soon spread to the east and north in Germany, threatening to erupt into a full-scale social revolution. Luther had originally supported the peasants' demands. He had himself been born a peasant and knew that Germany's nobles were often harsh and repressive in their dealings with the class. As the peasant rebellion grew more violent, Luther distanced himself from the peasant rebels, and in 1525, he condemned the movement outright. In the years after the bloody suppression of the Peasants' War, the reformer increasingly relied on the power of the state to reform the church. Together with his close associates, especially Philip Melanchthon, Luther developed new plans for the education of the young, instituted an inspection of local churches, and reformed the curriculum of the University of Wittenberg. Luther's reliance on the state, however, coupled with his denunciation of the peasantry during the Peasants' War, condemned many of his reforms to unpopularity, particularly in the countryside.

LATER YEARS. The remaining two decades of Luther's life were times of both success and failure. During the 1520s Ulrich Zwingli had championed a different course of reform in Switzerland and southern Germany, and this movement now rivaled Luther's own. In 1529 Zwingli and Luther met at Marburg in Germany in an attempt to iron out their differences so that they might form a united church. This Marburg Colloquy, as it became known, was a failure, and Swiss Protestantism continued to develop as a separate movement. During the 1530s and 1540s, numerous attempts to reconcile Luther and his followers with the Roman Church also failed. Furthermore, the bigamy of one of his most powerful followers, Philip of Hesse, embarrassed Luther, as Philip's taking of a second wife made it seem to many conservative minds that Reformation was a force of disorder and lawlessness. Still, there were many positive developments in these years. Luther's cause took on a distinctive identity and its message became the religion of many cities and territories. In 1534 Luther also completed his biblical translation. His family multiplied, eventually totaling twelve children, six of whom Luther's wife Katherina bore, and six which they adopted. The loss of Luther's daughter, Magdalena, in 1542 devastated Luther, and he was unusually candid about it. In these years he also continued to suffer from health problems, as he had throughout his life. Some have credited his worsening health with inspiring the violent anti-Semitism of a tract entitled *Against the Jews and Their Lies* which he published in 1543. He wrote increasingly violent diatribes against the papacy in these years, too. At the same time Luther remained a tremendously popular figure in the circle that surrounded him at Wittenberg. He boarded many of his students, who recorded their lunchtime conversations with him. Known as the "Table Talk," these accounts provide us with an unparalleled view into his life, often allowing us to reconstruct his day-to-day activities. His death in 1546 came after he had traveled to a neighboring territory to help settle a dispute between two nobles. Even in death, though, Luther's life produced controversy. His followers circulated an account of his final hours that stressed that he had remained steadfast in his faith until the very end. But rival Catholic propagandists circulated a counter myth that he had recanted in the last moments and returned to the traditional faith.

SOURCES

M. Brecht, *Martin Luther* (Stuttgart: Calwer, 1981).

H. Oberman, *Luther: Man between God and the Devil.* Trans. E. Walliser-Schwarzbart (New Haven, Conn.: Yale University Press, 1989).

R. Marius, *Martin Luther* (Cambridge, Mass.: Harvard University Press, 1999).

ST. TERESA OF AVILA

1515–1582

Mystic
Catholic reformer

FAMILY LIFE. Teresa was the daughter of a merchant in the city of Avila in Spain. Her father was the son of converted Jews, while her mother's family was Old Christian. Old Christians were those who had lived under Islamic rule in medieval Spain. Teresa never had formal schooling but she learned to read and write, practicing both skills voraciously throughout her life. One of ten children, she lost her mother when she was thirteen, and her subsequent misbehavior landed Teresa in a convent school. There she read the letters of St. Jerome and underwent a conversion experience. Despite her father's opposition, she decided to become a nun, entering a Carmelite convent in 1535, and taking her vows two years later. The convent she entered at the time was not a model of religious observance, having a widespread reputation for lax discipline. Inadequate funds forced many of the nuns to spend part of each year visiting their families. To make ends meet, too, the sisters admitted into their orders women from wealthy families in the vicinity, some of whom lacked a sense of vocation. Many of the women in the convent entertained men and indulged a taste for luxurious living. Teresa seems to have initially

done the same, but as she grew older she became more serious about her pursuit of the religious life.

VOICES AND VISIONS. Around the time Teresa was forty she became ill and suffered from paralysis. She also began to experience visions and voices from God which told her she would be damned if she did not repent of her worldly ways. Her priests thought these were really demonic spirits and suggested that she be exorcized. One of her confessors suggested that she record her visions and experiences, and through the resulting enormous written record she convinced her detractors that her visions were divine. In the wake of these mystical experiences, Teresa became convinced of the necessity for reforming local women's convents. In 1562, she left her own convent and founded a new one at Avila, to which she drew a group of like-minded nuns. As a sign of their commitment to live an ascetic and disciplined life, the women became Discalced Carmelites, that is, they refused to wear shoes. In addition, Teresa worked to establish a standard of absolute egalitarianism within the order. No woman could presume that she was superior to any other because of birth or wealth. Teresa also admitted converted Jews and others who would have been ignored by the traditional orders. The establishment of the new monastery in Avila offended a significant portion of the local population. Some doubted the divinity of Teresa's visions, and others were reluctant to contribute to the foundation of another religious institution given the glut of monks, nuns, and priests. Gradually, Teresa obtained royal favor and in the final twenty years of her life she founded another seventeen convents. These Discalced Carmelites lived a disciplined life in intense seclusion, and they counted among their numbers many women who gained a reputation for saintliness. In 1580, the pope granted her order official recognition.

WRITINGS. Teresa was an important figure in the reform of monasticism and the church in sixteenth-century Spain. Her influence lived on as well in the numerous writings she completed during her career as a religious reformer. Many of these texts were explicitly mystical and showed her reading of texts from the medieval past. They were notable, too, for the ways in which Teresa stressed that a mystic must conform to the teachings of the church. Teresa herself was charged with heresy at least six times in her life, although she was never formally tried before the Inquisition. She knew firsthand how dangerous it could be for a woman to speak her mind. In her writings she adopts complex strategies to present her message so that she can protect herself from long-term prohibitions against women preaching and teaching in the church. The most famous of her works

included the *Book of Her Life*, completed around 1565 but later revised, the *Way of Perfection* (1566) and *The Interior Castle* (1577). These form an unprecedented spiritual biography that takes Teresa's readers on a tour of her innermost thoughts, dreams, and aspirations. One task that she set for herself in the years after her visions was to accomplish the re-conversion of Protestants through her prayers. In one of her more vivid visions described in these works, she tells her readers of her ecstasy in 1559. In this mystical event, she saw an angel, who pierced her side with an arrow that was flaming with divine love. The experience left her "aflame with the love of God." During the seventeenth century the Roman architect and sculptor Gian Lorenzo Bernini immortalized Teresa's ecstasy in a famous work he completed in the Church of Sta. Maria della Vittoria in Rome. By Bernini's time, Teresa was an official saint of the Catholic Church, having been raised to that status in 1622.

SOURCES

J. Bilinkoff, *The Avila of St. Teresa: Religious Reform in a Sixteenth-Century City* (Ithaca, N.Y.: Cornell University Press, 1989).

A. Weber, *Teresa of Avila and the Rhetoric of Feminity* (Princeton, N.J.: Princeton University Press, 1990).

DOCUMENTARY SOURCES
in Religion

John Calvin, *Institutes of the Christian Religion* (1536)—This work originally began as a short French text outlining Calvin's teachings on Reformed Christianity. It underwent many changes and revisions, so that by Calvin's death it was an imposing volume that was widely circulated among Reformed Protestants. Today, it still ranks as one of Protestantism's most important texts and has made Calvin "the Protestant Aquinas."

Catherine of Genoa, *Treatise on Purgatory* (1551)—This work recounted Catherine's vivid visions of purgatory, and was widely circulated in the late fifteenth and early sixteenth centuries. It helped to establish in many people's minds an image of purgatory, that realm of the afterlife where Christians suffered for their sins.

Catherine of Siena, *Dialogue of Divine Providence* (c. 1378)—This was one of the most important mystical texts of the later Middle Ages.

Desiderius Erasmus, *Translation of the New Testament* (1516)—Erasmus' new Latin translation also included

an authoritative edition of the Bible in Greek. This work was widely used by scholars in the sixteenth century to translate the Bible into other European languages. Luther relied upon it as he translated the New Testament into German, as did William Tyndale for his English translation.

St. Ignatius of Loyola, *Spiritual Exercises* (c. 1521)—Written as Loyola convalesced from a battle wound, the *Exercises* outlined a detailed plan for harnessing one's mind and body to conquer sin. The exercises were practiced first by Jesuits, but the practice also spread among the Catholic laity in sixteenth-century Europe. These meditations and prayers were performed in retreat over the course of a month.

St. John of the Cross, *Dark Night of the Soul* (sixteenth century)—This is a masterpiece of sixteenth-century Spanish mysticism.

Martin Luther, *On the Freedom of a Christian* (1520)—This was the most widely distributed of the three influential treatises Luther published in 1520. Together with the *Address to the Christian Nobility of the German Nation* and *The Babylonian Captivity of the Church*, these works outlined a plan for the reform of the church as well as a new theology of salvation and the church.

St. Teresa of Avila, *The Interior Castle* (1577)—This work describes the saint's visionary life and Christian spirituality.

chapter eight

THEATER

Philip M. Soergel

IMPORTANT EVENTS
in Theater

c. 1300　The Italians Lovato Lovati and Nicolò di Trevet produce commentaries on ancient tragedies by the Roman Seneca.

1315　Albertino Mussato writes the first Renaissance tragedy, *Ecerinis*, based upon the style of the ancient Roman Seneca. The work is intended to be read, rather than staged, and relates the life of the thirteenth-century Italian despot, Ezzelino da Romano.

1339　The Paris Goldsmith's Guild begins performing a cycle of mystery plays annually.

1376　The first records establish the performance of a mystery play in the English city of York. Over the next century, the annual performance will grow to be one of the most impressive in England.

1384　A mystery cycle begins to be performed in the city of London.

1400　Mystery and Passion cycles grow more popular throughout Northern Europe.

1402　The king of France grants a monopoly to the Confraternity of the Passion to perform mystery plays in the city of Paris.

1429　Nicholas of Cusa, the humanist scholar and cardinal, recovers twelve comedies written by the ancient Roman Plautus.

1440　The French mystery playwright Eustache Marcadé dies.

1444　The humanist Aeneas Sylvius Piccolomini writes a Latin school comedy *Chrysis* in the style of Plautus.

c. 1450　Arnoul Gréban writes his *Mysteries of the Passion,* in Paris. The work consists of over 35,000 lines of verse and must be performed over four days.

1470　The first edition of the plays of the ancient Roman playwright Terence is printed. It will be followed two years later by a printed edition of the comedies of Plautus.

1494　Hans Sachs, Germany's greatest Renaissance poet and most prolific playwright, is born at Nuremberg.

c. 1495　The morality play *Everyman* is first performed in the Netherlands.

c. 1501　Jean Michel, author of French mystery plays, dies.

1508　Lodovico Ariosto completes his play *The Coffer Comedy*, one of the first Erudite Comedies to be written in the Italian language.

c. 1515　The artist Raphael designs stage sets for theatrical productions at Rome.

1516　The poet John Skelton, once tutor to King Henry VIII, produces his play *Magnificence*, a morality play that tries to convince the king to give up his lavish ways.

1517　The Protestant Reformation begins in Germany. Eventually, the movement will discourage the medieval mystery cycles in favor of supporting new kinds of polemical theater that attack the pope and the Roman Church. Extreme Protestants, such as the Calvinists of Switzerland, France, and England, will lobby for restrictions against the theater.

c. 1518　Niccolò Machiavelli completes his comedy *The Mandrake* in a lively Tuscan dialect.

Hans Sachs begins to write plays in Germany. In the course of his long life, his many dramas will come to support Martin Luther and the Reformation.

c. 1525 Alessandro de' Pazzi translates Euripides' *Iphigenia in Tauris* and *Cyclops* as well as Sophocles' *Oedipus Rex* into Italian.

1531 The Intronati, a group of university-educated comics, begin performing at Siena.

1545 The first surviving document records the foundation of a troupe of Commedia dell' Arte players at Padua.

An installment of Sebastian Serlio's *Architettura* includes illustrations and descriptions of a temporary theater inspired by ancient Roman designs.

1548 A theater is built in the former townhouse of the dukes of Burgundy, the Hôtel de Bourgogne, in Paris.

Mystery plays are forbidden by the city's parliament.

c. 1550 The Jesuits begin to stage Latin school dramas at their secondary schools throughout Europe.

1562 The political morality play, *Gorboduc*, is performed at the English court before Queen Elizabeth I. The play encourages her to resolve the problem of her succession.

The Wars of Religion begin in France.

1563 The Council of Trent concludes; over the coming generations reformers will try to curb the "lewd excesses" of the theater in Catholic Europe.

1564 William Shakespeare is born in Stratford-upon-Avon.

Christopher Marlowe is born at Cambridge.

1566 Nicholas Udall's *Ralph Roister Doister*, the first English play to imitate classical Roman comedy, is printed.

1569 The last performance of the York Mystery Cycle occurs.

1571 The first Italian Commedia dell'Arte troupe leaves on a tour of Northern Europe.

1573 Torquato Tasso's pastoral drama *Aminta* is performed in the Este court of the duchy of Ferrara.

1575 The English city of Chester curtails its annual mystery play.

1576 Blackfriars Theater, an exclusive London theater, is founded in the city in a chamber once used by parliament.

James Burbage builds a commercial theater, known simply as The Theater, just outside London.

1579 The commercial theater Corral de la Cruz opens at Madrid in Spain.

1583 A group of twelve actors is selected from the London theaters to serve as players at court. They become known as "Queen Elizabeth's Men."

1587 Christopher Marlowe's innovative drama, *Tamburlaine* is performed in London at the theater of James Burbage.

1588 The Olympian Theater is completed in Vicenza by Vincenzo Scamozzi after plans laid down by his mentor, the famous architect Palladio.

1589 Giovanni Battista Guarini writes his *The Faithful Shepherd*. The work combines the conventions of Renaissance pastoral with a new genre of tragicomedy. It will inspire similar plays throughout seventeenth-century Europe.

1592 The Rose Theatre is rebuilt in London after a fire.

Christopher Marlowe's masterpiece of historical theater, *Edward II*, is staged.

1595 Construction begins on the Swan Theater in London; it will be the only English sixteenth-century theater from which

sketches survive, allowing later scholars to reconstruct its plans.

1598 The first opera, *Dafne* (Daphne), is produced at Florence in the household of the silk merchant Jacopo Corsi. The work sets to music a play that is inspired by Renaissance pastoral.

1599 William Shakespeare's company takes up residence at the Globe Theater in London. Over the next decade the playwright will write most of his finest works.

1600 The Accessi, a Commedia dell'Arte troupe, performs at the marriage of Marie de' Medici to Henry IV of France.

OVERVIEW
of Theater

RELIGIOUS ROOTS. In the Middle Ages drama developed first in the church and consisted of short plays staged on important feast days in the liturgical calendar. By 1500, these dramatic traditions had inspired huge mystery cycles that were often mounted by the guilds and other corporate bodies in Europe's cities. The scope of the mystery cycles was often enormous, with the cycles sometimes taking from several days to weeks to perform. By this time, too, morality plays were also popular. These dramas treated Christian themes from an allegorical perspective, their characters named after the virtues and vices. In the sixteenth century religious drama underwent a transformation, first under the influences of the Protestant Reformation, and later by the Counter Reformation in those parts of the continent that remained loyal to the church at Rome. As a result of these religious developments, the great medieval mystery cycles gradually disappeared in most of the continent, as both Protestants and Catholics developed new forms to teach the principles of their movements. In Catholic Europe, the Jesuits began to rely on the theater around 1550 to teach Latin to students in their secondary schools. Over the next century Jesuit drama grew, and the order staged many spectacular productions that often made use of professional stage equipment and which even came to integrate elements of ballet and opera. In Protestant Europe, by contrast, polemical dramas attacked the papacy and Catholic beliefs in order to popularize the teaching of the Reformation's principles among the people.

SPECTACLE. Another area in which the theater had long played an important role in medieval Europe was in the staging of royal spectacles. Here the ceremonies of royal entry, through which a king received ceremonial admission to his major cities, were one area that witnessed a huge development in the Renaissance. In 1300 these ceremonies had been relatively small in scale, and had involved a procession of civic leaders who met the king at the town's gates. Gradually, the rites grew more elaborate, and living tableaux and other street dramas became part of the festivities. By 1500 the forces of humanism transformed the entries yet again, and these rituals became spectacles replete with ancient triumphal imagery, first in Italy and then somewhat later in Northern Europe. The entry ceremonies staged in France and other Northern European cities celebrated the king as a force for national unity, and processions filled with costumed characters and choreographed productions became highly theatrical celebrations of the growing cult of royalty. In addition, new fashions at court, including massive theme banquets and other entertainments, created a new demand for short dramatic interludes. By 1550 most courts of significant size required troupes of professional players and designers to stage these elaborate productions.

HUMANISM. Humanist interest in drama developed even in the fourteenth century when Italian scholars first turned to study the ancient Roman tragedies of Seneca. Seneca, however, treated tragedy as a primarily literary form, suitable for private and small group reading, rather than as a theatrical genre. His influence produced numerous "closet dramas" in the Renaissance, plays intended to be read rather than performed. It was not until 1541 that a tragedy was actually staged in Italy, but these dramas soon caught on and became popular elsewhere in Europe. In the fifteenth century humanists also turned to study the classical comedies of Plautus and Terence, and in Italy these studies helped to produce a new genre of "erudite comedies" written in contemporary Italian but based upon ancient models. In the course of the sixteenth century the impact of these humanist discoveries broadened greatly the types of dramas staged throughout Europe. In its purest forms, humanist dramas influenced the styles of theater supported by Europe's courts. Here the elaborate plays constructed according to classical models appealed to the tastes of cultivated nobles and courtiers. Elsewhere, though, humanist dramatic innovations made their way in diluted form into plays intended for a more general audience.

COMMERCIALISM. A second factor that revolutionized drama in sixteenth-century Europe was the growth of professionalism in the theater. By the mid-sixteenth century troupes of *Commedia dell'Arte* players had exploded on the Italian scene, and soon they popularized their art form in towns and cities throughout Europe. The *Commedia* appealed to rich and poor, educated and uneducated audiences alike. As a theatrical phenomenon, its importance was far greater than the mere comic relief the *Commedia* provided. The troupes in Italy soon inspired local imitators in all European countries, and these new groups became the first truly professional

acting ensembles. The new professionalism coincided with the disappearance of the older religious mystery cycles, and the professional stage began to replace the traditional forms of drama. The new rise of a commercial theater was most evident in London. Here by 1600, thousands of city dwellers viewed the new professional performances each day. But in Spain and France, vigorous national theaters had also begun to emerge by this time. An air of danger and immorality often surrounded the new commercial theaters. Religious moralists, both Protestant and Catholic, attacked actors' immorality and the secular themes treated in plays as subversive. Town officials, too, found the disorderly crowds that congregated in the theaters troubling. Yet in those places where the new commercial theaters came gradually to find a home, royal licensing permitted their productions. Popular demand, too, made the new theaters financially successful, and these commercial forces had, by the dawn of the seventeenth century, produced a new caste of professional playwrights who churned out hundreds of plays. In these dramas authors frequently made use of the innovations of Renaissance humanist dramas. But at the same time, since the theater was a paying proposition, they carefully geared their plays to a broad audience. The results helped to produce native traditions of theater that shaped the experience of Europeans for centuries to come.

TOPICS
in Theater

THEATER IN THE LATER MIDDLE AGES

RELIGION AND STATE. Medieval drama was religious in nature. Liturgical dramas had long been performed in Europe's churches on the most popular and solemn religious occasions of the year, and many of these religious plays continued to be performed throughout the continent until the seventeenth century. At the same time new dramatic developments became evident in fourteenth- and fifteenth-century Europe. At court, traditional jousts and tournaments grew more elaborate as their functions became more clearly a theatrical celebration of noble prowess. In towns and cities throughout the continent enormous mystery cycles staged by local guilds and confraternities appeared, too. Royal entries, a long-standing ceremony that welcomed a monarch to one of his cities, similarly expanded, taking on new elements of drama and theater. While all these forms traced their roots to medieval precedents, their imposing expansion during the early Renaissance demonstrates the increasing role that ritual played in European society at the time. Out of this fondness for ritual grew some of the new dramatic forms that inspired the even greater developments in the Renaissance theater that occurred during the sixteenth century.

MYSTERY CYCLES. Each year most major European cities held a summer festival that included a trade fair combined with religious festivities. In most towns the guilds of merchants and artisans staged these fairs, which grew to become important expressions of urban pride and religious devotion. In the fourteenth century the guilds often celebrated their fairs with religious processions that included floats decorated with scenes from the Bible. Typically, each guild was responsible for mounting a different scene, and the scenes ranged from the Garden of Eden, through major events in the Old Testament, and culminated with the crucifixion, resurrection, and ascension of Christ. Subjects drawn from the life of the Virgin Mary were also popular. Over time, these pageant wagons grew more elaborate as guilds competed to outdo each other. The guilds hired carpenters, sculptors, and local painters to decorate the floats, and many placed costumed mimes atop them that acted out the events of their float's theme. Soon, spoken dramas became part of the celebrations in many cities, and actors performed short scenes along the parade route or at the conclusion of the procession in an important town square. Thus religious processions like these provided the foundation upon which one of the greatest developments of late-medieval drama—the mystery cycles—appeared. These cycles, like the festivals themselves, also became venerable objects of civic pride, and they grew in many places to enormous lengths. In the city of York in England, 48 separate dramas were performed in the annual mystery cycle during a single day. The action of these dramas consumed so much time that the theatrical performance was begun at 4:30 in the morning. At London, the town staged a mystery cycle that required anywhere between three and seven days to perform, while in Paris the town's annual cycle was 35,000 verses long and required 220 actors to stage. Although these great late-medieval cycles were enormous, and their rehearsals sometimes stretched throughout the entire year, the tendency was for ever larger and grander mystery plays to develop. By the sixteenth century, for example, some towns staged daily performances that stretched over an entire month, thus entertaining those who came to the now greatly extended market fairs each day during the annual festivities.

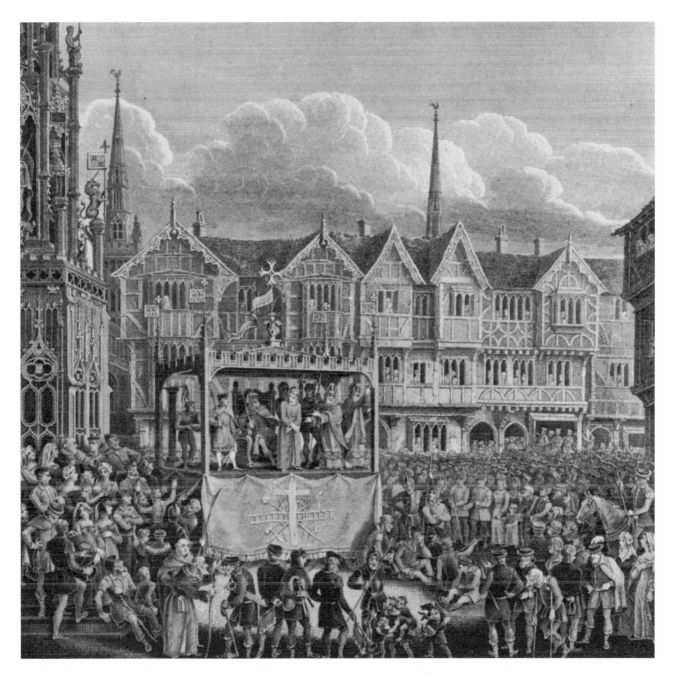

An engraving of a pageant wagon on which theatrical performances were staged in the Renaissance. FOLGER SHAKESPEAREAN LI-BRARY. REPRODUCED BY PERMISSION.

THEMES. Relatively few of the texts for these mystery cycles survive, and those that did survive come mostly from French and English cities. But the popularity of these theatrical performances was great throughout Europe, and the texts that still exist suggest that common themes pervaded most of the plays. The subject of the plays was the salvation of humankind, and the individual scenes wove the tale of human redemption out of the events recorded in the scriptures and the traditions of the church. Most cycles began in Eden with the creation of Adam and Eve, and proceeded to recount the events in the Garden in a vivid way, with Lucifer being embarrassed and made to slither on the ground and Adam and Eve being expelled from Eden in a brutally realistic fashion. The subsequent scenes ranged far and wide over the events of the Old Testament, showing the process by which God eventually came to identify the Jews as his chosen people and then to make salvation a possibility for all humankind in the sacrifice of Christ. Usually, the cycles concluded with Christ's Passion,

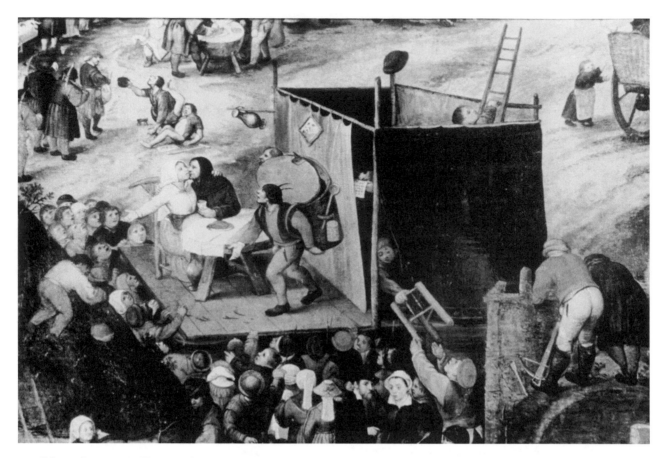

Detail from *Players at a Village Fête* by Peter Balten. THE GRANGER COLLECTION.

Resurrection, and Second Coming. The action was often violent, particularly in the scenes of Christ's torture and Passion, where bloody realism and illusionistic techniques served to entertain the crowds. In scenes like the beheading of John the Baptist or the martyrdom of a saint, the actors went to great lengths to create special effects to enhance the action. Trick limbs, fake heads, and animal guts were often part of these illusions. Although not every play's actions and verses fit with the fine discrimination of the church's theology, the flavor of the cycles was undeniably orthodox. To emphasize the interconnections between the individual scenes and the great culmination in Christ's sacrifice and resurrection, the writers often inserted commentators into the drama who spoke between the scenes. Most mystery cycles similarly opened with a prologue and a conclusion. Prefiguration and recurrent motifs also became devices to tie the entire structure of the cycle together. While blood and gore were a part of the cycles, comic episodes inserted between the greater dramas provided a measure of relief from the generally serious tone of the action.

STAGING. The staging practices used in the mystery cycles evidenced a great variety throughout Europe. Gen-

erally, though, the cycles were not acted upon a single stage, but a scene or a number of scenes were performed in front of a set referred to as a mansion. These mansions were sometimes elaborately constructed, or at other times minimalist and severe. Three different ways of using these mansions seem to have been popular, although local variations were common. In the English cycles pageant wagons carried the mansions around the city to sites where the actors performed their part of the drama several times during the day. The mystery cycle performed annually at York seems to have been the most complicated of these moving dramas, requiring about 50 pageant wagons annually to stage the drama and teams of six to eight men to pull these throughout the town. In other places horses pulled the wagons. While the size of many of these wagons appears to have been generally small, some accounts survive of pageant wagons with elaborate scenery and which carried more than twenty actors. Staging in this way must have been a logistical and scheduling challenge. At York, for instance, there were anywhere from a dozen to sixteen different staging areas scattered throughout the city in various years. To keep local citizens and visitors informed of where the

dramas were to occur, the town placed banners in the squares and streets at the various sites. The second style of staging that flourished at the time placed the different mansions in the round in a city square or open area. This style of presentation seems to have been popular in German-speaking Europe, and in parts of England, too, where round amphitheaters were sometimes built to stage the dramas. Finally, the most popular method seems to have been to build a central platform, with the scenic mansions arranged beside each other in succession on the platform. This method of staging the plays was most popular in France, but also appeared in Spain, Italy, Germany, and in some English towns. In this platform style of staging, towns often built bleachers so that the audience could be elevated to an appropriate height to view the action. Boxes placed atop these bleachers could accommodate local dignitaries and important visitors. The size of these great platform stages differed depending upon the number and complexity of a play's individual mansions, but most platform stages were between 100 to 150 feet long and about thirty feet in depth. Staging in this way had several advantages because it allowed for acting to occur in several different mansions at once. Souls in limbo could be depicted writhing in torment, for instance, while in Heaven another actor pleaded for God's mercy. Thus the presence of multiple stage sets placed several scenes before the audience simultaneously and produced a highly visual art that was not dissimilar to the effects of the modern cinema.

END OF THE MYSTERY CYCLES. In Northern Europe the Reformation of the sixteenth century discouraged the mounting of the great mystery cycles. The teachings of many of the plays conflicted with the new religious ideas of Protestantism. Many, but not all, the cycles had traditionally been performed in connection with a town's celebration of the Feast of Corpus Christi, which had first been approved by the pope at the beginning of the thirteenth century in connection with a series of visions that a Flemish nun had experienced of the Eucharist. Corpus Christi, meaning literally the "body of Christ," celebrated the Eucharist as the key force of Christian salvation, and the day's processions carried a consecrated wafer throughout the town as a kind of blessing to urban space. In many parts of Europe the processions of Corpus Christi grew to enormous heights of popularity at the end of the Middle Ages, and festivities—including the performing of mystery plays—surrounded these events. Protestantism generally found such outpourings of devotion directed toward the Eucharist idolatrous. For the reformers, salvation was a free gift of God's grace, produced not by participating in the

Eucharist, but through faith. In France during the Wars of Religion that raged in the country between 1562 and 1598, Calvinist sympathies ran high, eventually attracting about a third of the country to the movement. Here Corpus Christi often became an occasion for bloody riots as Protestants and Catholics staged riots in protest. Many mystery cycles consequently disappeared, the guilds now unwilling to underwrite the productions any longer. In England and those parts of Europe where Protestantism became the officially sanctioned religion, reformers curtailed mystery cycles. Elsewhere in Catholic Europe the mysteries sometimes survived, but they now came to be known as Passion Plays. These new forms, descendants of the late-medieval mystery cycles, were particularly popular in the rural areas of Central Europe, the most famous being the Passion Play at Oberammergau in the Bavarian Alps. Every ten years since 1634, the play has commemorated the town's deliverance from an outbreak of the plague.

MORALITY PLAYS. The mystery cycles aimed to teach their viewers and participants a history of human salvation by drawing on the traditional accounts of the scriptures and events in the history of the church. Their overall structure followed the lines of Judeo-Christian history, which had begun in Eden, and was one day in the future to end with the Second Coming of Christ. Another kind of drama, which was widely popular throughout the fifteenth century, was the morality play. Morality plays were highly allegorical productions in which virtues and vices were the central characters. Unlike the mysteries or other liturgical forms of drama, they did not have to be performed at a certain time of year. They seem, in fact, to have been popular at all times and were performed by troupes of amateur actors, groups that were increasingly popular at the end of the Middle Ages. The morality plays portrayed a battle between the forces of good and evil, that is, between God and the devil, and they showed their central characters facing great moral dilemmas, often illustrating the disasters that attended those who followed the paths of the Vices and the Seven Deadly Sins. By contrast to the mystery cycles, which retained a relatively static form year after year, the genre of morality plays showed great change and development over time. Playwrights experimented with both shorter and longer forms of drama, and these new dramas were of several different types. Religious morality plays were often almost as long as the mystery cycles themselves. At York, a town with a famous mystery cycle, a new Paternoster play written in the later Middle Ages alternated its performance with the city's long-standing mystery cycle. The York Paternoster play, like the traditional

a PRIMARY SOURCE *document*

EVERYMAN

INTRODUCTION: The play *Everyman* was one of the many popular morality plays staged in the fifteenth and sixteenth centuries. Originally an interlude in the longer play, *The Castle of Perseverance*, it was being performed independently by the late fifteenth century. The drama begins with God lamenting the state of fallen humankind and announcing his plans to chasten the character Everyman with the figure of Death.

I perceive here in my majesty,
How that all creatures be to me unkind,
Living without dread in worldly prosperity,
Of ghostly sight the people be so blind,
Drowned in sin, they know me not for their God.
In worldly riches is all their mind,
They fear not my righteousness, the sharp rod;
My love that I showed when I for them died
They forget clean, and shedding of my blood red;
I hanged between two, it cannot be denied;
To get them life I suffered to be dead;
I healed their feet, with thorns hurt was my head.
I could do no more than I did, truly;
And now I see the people do clean forsake me.
They use the seven deadly sins damnable;
As pride, covetousness, wrath and lechery,

Now in the world be made commendable:
And thus they leave of angels the heavenly company.
Every man liveth so after his own pleasure,
And yet of their life they be nothing sure.
I see the more that I them forbear
The worse they be from year to year;
All that liveth appeareth fast.
Therefore I will, in all the haste,
Have a reckoning of every man's person;
For, and I leave the people thus alone
In their life and wicked tempests,
Verily they will become much worse than beasts;
For now one would by envy another up eat;
Charity they all do clean forget.
I hoped well that every man
In my glory should make his mansion,
And thereto I had them all elect;
But now I see, like traitors deject,
They thank me not for the pleasure that I to them meant,
Not yet for their being that I them have lent.
I proffered the people great multitude of mercy,
And few there be that asketh it heartily;
They be so cumbered with worldly riches,
That needs on them I must do justice,
On every man living, without fear.
Where art thou, Death, thou mighty messenger?

SOURCE: Anonymous, *Everyman* (London: Rycharde Pynson, 1526): 4–6. Spelling modernized by Philip M. Soergel.

mystery cycles, had performances atop moving wagons dispatched to different points in the city. In the morality play at York, the requests that Christ makes in the Lord's Prayer waged battle against the Seven Deadly Sins. In another typical example of the fifteenth-century morality play, *The Castle of Perseverance*, Lust and Folly tempt the figure of Youth. The action shows Youth transported to a castle that is held by the Virtues against the besieging Vices. *The Castle* was a long play of more than 3,500 lines, and a central part of the action—the approach of Death—actually became the independent play, *Everyman*, the most famous of the surviving late-medieval morality plays. In it, Everyman is struck at once by the fickleness and impermanence of all human relations. He places his faith in the figures Fellowship, Kindred, and Goods—characters that represent friendship, family, and material possessions—only to find that each of these desert him as the play progresses. Along the way to the play's conclusions, Everyman tries to embrace the figure of Good Deeds, but even this proves insufficient to survive in the world, although it does encourage him

to call upon the figure of Knowledge, who leads him to the sacrament of penance. As he approaches his final comforting realization, he is also accompanied by the figures of Strength, the Wits, and Beauty, though even they leave him in the end as he comes to prepare for death and his welcoming into Heaven. Thus in this way *Everyman* stylized the Christian's internal battle against doubt, temptation, and worldliness as an external, highly allegorized pilgrimage. In later centuries the moralistic novels of the seventeenth century imitated its forms, particularly in John Bunyan's great *Pilgrim's Progress*.

COMIC AND POLITICAL MORALITIES. The allegorical structure of the morality play was also adaptable to other circumstances, and gave birth to comic and political forms. In the comic morality play *Mankind* from about 1470, the world is depicted as chaotic and disordered—so much so, in fact, that the play serves as a satirical commentary upon the more standard conventions of traditional morality plays. The conflict between the play's central characters Mercy, the Vices, and the Devil remained in the background of *Mankind*, and instead

the actors performed a series of songs, dialogues, and dances intended merely to entertain those in attendance. In these, the figures of the Vices stole the show with their witty repartee and lively use of song and dance. Around the end of the fifteenth century a final form of the morality play became popular: the political morality play. Performed before kings and princes, the plays intended to teach them the virtues necessary for good rule. Just as in the religious morality plays, these political versions showed the figure of the king beset by threats to public order and buffeted between the wise advice of ministers and dangerous sycophants. Early in the reign of Henry VIII about 1516, the poet John Skelton wrote and produced his *Magnificence* before the king. Skelton had been Henry's tutor as a young man, and he intended his drama to encourage his now mature student to abandon his overly extravagant ways, including his involvement in a series of continental wars that threatened the financial well-being of the state. The central character Magnificence represented the king, and in the action the figure of Fancy brings him to ruin by making him abandon Measure. Adversity and Poverty strip him of his worldly goods before Mischief and Despair lead him to the verge of Suicide, but Goodhope arrives and wrests Magnificence's sword from him. At the play's conclusion Redress arrives to lead the king back to Perseverance. Political moralities like *Magnificence* continued to be popular throughout the sixteenth century, particularly in England and Scotland. In 1562, for instance, the lawyers of the Inner Temple in London staged a political morality that aimed to encourage Queen Elizabeth to settle the matter of the succession. Their play, *Gorboduc*, was originally performed in the lawyers' own hall, but later the players staged a performance before the queen in her London palace at Whitehall. The action of *Gorboduc* showed the tragic consequences of an ancient British king's decision to divide his kingdom between his two sons, and it relied on the traditional conventions of the morality play.

ROYAL ENTRIES. The occasions of royal entries into cities also included street theater, living tableaux, and musical performances. Royal entries were a form of royal spectacle that traced their origins to the Middle Ages. At first they had been quite simple and had involved the processions of a town's major officials, prominent burghers, and its guilds, all of which met the king and his entourage and accompanied them into the city. By 1400, a town's guilds mounted pageants similar to those that occurred alongside religious processions to celebrate the entry. The scope of these pageants grew steadily throughout the fifteenth and early sixteenth centuries. By

1500, for example, a king and his courtiers might pause as many as twenty times along a processional route lined with elaborate pageant wagons, triumphal arches, and other kinds of gateways. As the architectural and artistic Renaissance of the sixteenth century spread to the kingdoms of Northern Europe and Spain, these festivals included a greater wealth of decorative and thematic detail drawn from Antiquity. In the fifteenth century, though, their elements were usually traditionally medieval and Christian in flavor. The role of the royal entry was largely ceremonial, but towns still used these occasions to remind their monarchs of their hopes and demands. In 1440, the city of Bruges in the Duchy of Burgundy (now a town in modern Belgium) relied on the entry of their duke to gain pardon for a recent revolt staged in their town. The town fathers processed to meet the ruler with bared heads and feet to show their humility before his authority; as the duke processed with them to enter the city, the local officials had the prince stop before a series of tableaux that reenacted examples of ancient kings who had shown mercy to their rebellious subjects. On other occasions, the royal entry was an occasion for a town to remind the ruler of the traditional laws and local customs that limited the monarch's authority in their city. Great drama rarely arose from these circumstances, but the impact of the royal entry was felt in other areas of the theatrical arts. During the fifteenth century the scenery used for the royal entries grew increasingly elaborate. Castles, pavilions, arcades, arches, and complex façades were among the scenic devices used to suggest times and places, and these rode atop the pageant wagons traditionally used in processions. Of all the major scenery forms, the castle was the most important in the fifteenth century since it suggested the traditional powers of the monarch to subdue his enemies and defend his realm. To enhance the staging of the tableaux before these sets, towns sometimes adopted the use of revolving stages, elevators, and other machinery that enhanced the action. In the sixteenth century, many of the innovations in set design and stage machinery that had developed out of the royal entries made their way into the new commercial theaters. Royal entry sets were particularly important, too, in inspiring the popularity of the proscenium arch in the sixteenth century.

TOURNAMENT DRAMAS. By the later Middle Ages the conventions that governed tournaments had largely become conventionalized and dramatic in nature. While in the past, these occasions had provided knights an opportunity to demonstrate their prowess through jousts and other military feats, the weapons used in the late-medieval tournaments had been blunted, and a series of

rules limited the danger inherent in these displays. At the same time the dramatic and symbolic nature of the tournament grew. Pageantry came increasingly to characterize the late-medieval tournament, and while the combat at these events still titillated the audience, it now tended to pale in comparison to the processions, parades, dances, and poetry that occurred alongside them. The late-medieval tournament usually commenced with a dramatic entry. Spectacle governed these entries, as in a London tournament in 1490 where a total of sixty ladies each led a knight into the arena tethered by a chain. The use of pageant wagons, too, gained favor with the crowd, and the knights who participated relied on fantastic costumes to attract attention from the audience. In the more elaborate late-medieval tournaments a storyline governed the action, and the traditional feats of prowess became embedded into this narrative. In many places the design of the tournament field was similar to a large round amphitheater, and tournaments took place in actual Roman amphitheaters where they survived. In England, the tournaments' popularity among the Tudor monarchs of the late fifteenth and early sixteenth centuries necessitated that the tournament fields be lined with a series of pavilions with elaborate boxes for members of the court, the monarch, and his family. This pattern of building galleries inspired the designers of later Elizabethan theaters, who built several galleries above the stage and floor level pit to accommodate higher paying and ranking patrons. Although the popularity of jousts and tournaments persisted throughout the Renaissance, its dangers came to be ever more circumscribed. In 1559 King Henry II of France died as the result of a tournament accident, and a series of new regulations in France and elsewhere tried to limit the inherent dangers in these events even further.

BANQUETING AND MASQUES. Tournaments were public events, staged in the open air before crowds of nobles and peasants alike. As such, they had a political role in demonstrating the strength and power of the aristocratic classes. In the later Middle Ages drama also found its way into the private life of the court. Medieval banquets at court or in a substantial noble household were long affairs that included many courses. Between these courses it became customary to introduce dramatic interludes, known in Italian as *intermezzi*. European princes sometimes chose a theme for the entire banquet, and these various *intermezzi* thus became linked together in a kind of narrative. One of the most famous occasions that relied upon a narrative occurred at the Feast of the Pheasant in 1453 at the Duke of Burgundy's court. The Duke of Burgundy's nephew, the Duke of Cleves,

threw this banquet as the conclusion to a several-week period of tournaments and entertainments staged for the noble members of the Order of the Golden Fleece. Distressed by the capture of Constantinople by the Turks, he used the occasion to try to enlist support from the Fleece for a new crusade to retake the Holy Land. He had the hall decorated with spectacular caves and forests, and the food lowered to the table with mechanical devices that looked like triumphal carriages. Small scenes and tableaux entertained those at the feast as a way to encourage the men of the order to pledge their support to the crusade. While many apparently did, their enthusiasm seems to have faded relatively quickly after the event since the military campaign was never undertaken. Another entertainment at court, the masque, was just beginning to appear in the later Middle Ages. Masques grew out of the popular medieval custom of mumming, a custom particularly widespread in England. In these performances masked villagers, known as mummers, visited the manor houses of local lords, entertaining the household with short pantomimes, dances, and games. Originally, mumming served as a fund-raiser for local relief efforts in the village, but by the late fourteenth century a variant of the custom, the masque, was quickly developing in the royal court. In 1377, a group of about 130 masked Londoners visited a dance held by King Richard II. Dressed in elaborate costumes that suggested powerful figures in the church and state, these masked entertainers stayed to dance alongside the royal courtiers. Like most court entertainments, these early masques grew more elaborate at the end of the Middle Ages, and the official entry of the king's herald often preceded them, in order to set out an elaborate pretext for the evening's entertainment. Noblemen donned masks to present short dramas that they themselves had prepared, and professional actors, singers, and dancers lent these affairs greater finesse, as did special stage sets constructed about the hall. This combination of amateur and professional court entertainments remained popular throughout the Renaissance, inspiring the elaborate masked balls that became customary in royal courts and noble households in the seventeenth century.

TRANSFORMATIONS. The later Middle Ages was a time of great innovation in the theater. Several new forms—the mystery cycles and morality plays—grew out of the traditional liturgical dramas of the earlier Middle Ages and came to maturity in the fourteenth and fifteenth centuries. The mystery cycles were noteworthy for their dramatic realism, impressive scenery, and narrative complexity, while many of the morality plays of the period were, by contrast, masterpieces of religious allegory.

The other venues in which dramatic forms developed in the era—royal entry tableaux, tournaments, and the early masque—tended toward spectacle. The inclusion of games, songs, and dance in these forms points to the eclectic nature of entertainments favored in Europe's courts. Here the appearance of narrative structures to explain the action as well as the development of new kinds of scenery and theaters inspired later generations.

SOURCES

G. R. Kernodle, *The Theatre in History* (Fayetteville, Ark.: Arkansas University Press, 1989).

C. Molinari, *Theatre Through the Ages* (New York: McGraw-Hill, 1972).

R. Strong, *Splendor at Court: Renaissance Spectacle and the Theater of Power* (Boston: Houghton, Mifflin, 1973).

G. Wickham, *The Medieval Theatre*. 3rd ed. (Cambridge, England: Cambridge University Press, 1987).

SEE ALSO *Dance: Theatrical Dance*

THE RENAISSANCE THEATER IN ITALY

HUMANISM. In Italy humanism was the dominant intellectual movement of the fourteenth and fifteenth centuries, and its methods affected most areas of cultural life. The early humanists Francesco Petrarch (1304–1374) and Giovanni Boccaccio (1313–1375) had been fascinated by the genres and literary style of Latin Antiquity. They envisioned a revival of culture based upon ancient literary models. As the humanist movement developed, it acquired a new sophistication about the role and uses of language. This sophistication gave birth in the fifteenth century to philology, a new discipline that studied the historical and contextual uses of languages in ancient documents. Philology developed rigorously scientific methods that by the second half of the fifteenth century allowed scholars to establish the authenticity of ancient texts. At about the same time, humanism also supported a revival of the study of ancient rhetoric as well as the Greek language. As this snapshot suggests, humanism was from its first a literary, rather than a philosophical, movement. There was no humanist manifesto or creed, but a general conviction that the development of men and women who were critical readers and thinkers as well as elegant writers might ennoble society. This same conviction prompted the humanists to study ancient forms of drama. Their efforts produced a classical revival of the masterpieces of Antiquity, even as they eventually inspired Renaissance playwrights to imitate the ancient genres. In tragedy, however, Italian

dramatists long remained slaves to ancient models. Although many Renaissance Italians wrote Greek and Roman styled tragedies, no masterpiece in this genre appeared until the eighteenth century. Italian scholarship of the ancient classics gave rise to works that today are only of historical interest. At the same time Italian humanist scholarship traveled to the rest of Europe, and in Renaissance England, France, and Spain, great tragic dramas did appear. In comedy, by contrast, Renaissance Italians evidenced greater success, producing a long string of learned or erudite comedies that also inspired playwrights throughout Europe.

REVIVAL OF ANTIQUITY. The rediscovery of the comedies and tragedies of the ancient world gave birth to new editions of the works of Sophocles, Euripides, and the Roman playwrights Seneca, Terence, and Plautus. Seneca, the ancient author of Rome's greatest tragedies, was the first ancient playwright to attract the humanists' attentions. Already in the fourteenth century scholars had turned to study his tragedies. The comic playwright Plautus was the next great classical figure to undergo a revival. In 1429, the humanist Nicholas of Cusa rediscovered twelve plays by Plautus, and in the years that followed, Italy's growing ranks of literary scholars pored over these documents. By the second half of the fifteenth century, the printing press permitted scholars to print editions of the classical plays. A collected edition of the surviving works of Terence appeared in 1470, followed two years later by the works of Plautus. These printed editions allowed hundreds of identical texts to circulate among scholars and authors simultaneously, thus inspiring readers to try their own hand at imitating the ancient forms. The new editions also prompted Italy's wealthy patrons and nobility to commission translations of the works into Italian and to undertake productions of the plays. By contrast, the study of Sophocles, Euripides, and Aristophanes proceeded more slowly since, in the fifteenth century, Greek dramas could only be read by the most erudite of scholars. By 1525, this situation had begun to change when three of the most famous Greek tragedies, Euripides' *Iphigenia in Tauris* and his *Cyclops* as well as Sophocles' *Oedipus Rex*, had translations in Italian. Translations of major Greek dramas appeared throughout the sixteenth century, producing calls for the revival of Greek theater, as well as a more general interest in classical dramatic conventions.

TRAGEDY. Humanist interest in ancient tragedy developed early, as Italian scholars examined the ancient tragedies of Seneca. Around 1300, the early humanists Lovati Lovato and Nicholas di Trevet produced

commentaries on Seneca's tragedies. The critical interest in Seneca was not accidental. Seneca was a Stoic, a member of the ancient philosophical sect that taught that the human passions were the source of evil. Stoicism embraced a world-renouncing creed that was not dissimilar to the Christian philosophy of many medieval figures, nor was it unattractive to the early humanists. Petrarch saw in Stoicism's teachings an effective way to manage one's relations with the world. On balance, the renewed popularity of Senecan tragedy, however, had a dampening effect on the revival of the form as a theatrical drama. Seneca treated tragedy largely as a literary genre, and today most scholars believe that he was, even in Antiquity, a writer of "closet dramas," that is of plays intended to be read rather than performed. In their attempts to understand this writer's works, the early Renaissance humanists also relied on medieval theorists such as the sixth-century philosopher Isidore of Seville or the thirteenth-century poet Dante Alighieri—both of whom had treated ancient tragedy largely as a kind of poetry that dealt with the vile deeds and justified downfall of immoral rulers. Isidore and Dante's attitudes toward the form thus downplayed the richly variegated philosophical, psychological, and visual elements that lay within ancient tragic forms. In the fourteenth and fifteenth centuries Italy's humanists largely agreed with these traditional assessments. The writers of the earliest Renaissance tragedies imitated the literary style of Seneca even as they discounted the genre's theatrical potential. In 1315, Albertino Mussato was among the first to compose a tragedy in the ancient style. In his *Ecerinis* Mussato drew his plot from recent historical events, recounting the wicked deeds and downfall of Ezzelino da Romano, a thirteenth-century Italian despot. Like all Italian writers of tragedies until the mid-sixteenth century, Mussato downplayed the theatrical elements of his story, and instead developed the work's great literary potential. He wrote his drama not for the stage but for a small group of readers who were to recite the play. This notion—that tragedy was best consumed by a small circle of cultivated readers rather than on stage—survived for many generations. It persisted even in the sixteenth century when printed editions of tragedies replaced manuscript versions of these plays. Even the rising popularity of Greek tragedy in the sixteenth century did little to dampen the enthusiasm for "closet dramas" read in private or in small reading circles. In 1515, for example, the humanist Gian Giorgio Trissino became the first Italian to write a play using the conventions of ancient Greek tragedy. His *Sofonisba* employed the ancient Greek elements of chorus, song, and spectacle, and he relied on the solemn unities characteristic of these ancient works.

But like most Italian Renaissance tragedies, *Sofonisba* was read in small groups long before it was performed on the stage. The play went through six printings—a sign of its popularity—but it was not staged until 1562. Another popular tragic drama of the time, Giovanni Rucellai's *Rosmunda* similarly claimed a large readership, but was not performed until the eighteenth century.

STAGED TRAGEDIES. Despite the relatively arid way in which tragedy was consumed during much of the Renaissance, the form retained great popularity as literary entertainment. By the sixteenth century, though, a growing understanding of the conventions of the ancient theater inspired a new realization of the dramatic potential that lay within the genre. Here the rediscovery of an uncorrupted version of Aristotle's *Poetics* was a particularly decisive development. In this ancient treatise on poetry and the dramatic forms, Aristotle showed how tragedy possessed great power to appeal to the human passions. As knowledge of the *Poetics* spread it produced changes in the ways in which playwrights wrote tragedies. Authors addressed their works more and more to the audience for these dramas, and they stressed the visual elements of their dramas. In his *Poetics* written in 1529, the playwright Trissino noted that the first, and consequently one of the most important, elements of a tragedy is its scenery because this might excite pleasure in the audience. A new curiosity, evident in Trissino's statements as well as continuing attempts to track down ancient dramas, inspired the first performance of a Renaissance tragedy in 1541, Giambattista Cinzio Giraldi's *Orbecche*. The great success of this production inspired noble patrons throughout Italy to commission authors to write new tragedies intended from the first to be staged rather than merely read. These included Pietro Aretino's *Orazia* (1546), Gugliemo Dolce's *Marianna* (1565), and Orsatto Giustiniani's *Edipo* (1585). While tragedy never became as popular as other Renaissance dramatic forms—most notably comedy—it still managed to acquire a significant following. Its themes, which were grave and often foreboding, meant that tragedy was a theatrical form that appealed to the relatively educated few. And since tragedies usually treated the lives of noble figures, their staging requirements were costly and elaborate. In the absence of a professional theater dedicated to tragic productions, these costs could only be borne by the occasional noble patron who commissioned such works. While these factors limited tragedy's appeal, significant productions were nevertheless undertaken toward the end of the sixteenth century. At the same time, the knowledge Italian scholars had amassed about the performance standards and structures of ancient tragedies

was transmitted throughout Europe; and in late Renaissance Spain, England, and France, tragic theater found a more congenial home.

ERUDITE COMEDY. The study of ancient comedy and its conventions first developed in the fifteenth century, somewhat later than the initial revival of tragedy. From the first, though, renewed interest in ancient comedy generated theatrical productions, and in turn, the staging of the ancient dramas inspired the new Italian genre of *Erudite Comedy*. These learned comedies influenced dramas written elsewhere in sixteenth-century Europe. The revival of knowledge about ancient comedy began in 1429 when the humanist Nicholas of Cusa rediscovered a dozen previously unknown works by the ancient Roman playwright Plautus. The circulation of these comedies soon produced Italian imitations like the *Chrysis* of the humanist scholar Aeneas Sylvius Piccolomini, written in 1444. At the same time a fashion developed for the works of Plautus. At Ferrara, for instance, the dukes staged both Latin and Italian translations of the ancient playwright's works from the 1570s onward. These performances inspired the great poet Lodovico Ariosto (1474–1533) to compose several widely admired Italian comedies in the first decade of the sixteenth century. In Florence, the development of a genre of theatrical comedies took a somewhat different path. There the great humanist Angelo Poliziano (1454–1494) revived the works of the ancient comic playwright Terence by editing the author's accomplished drama *Andria*. Florentine authors of the late fifteenth and early sixteenth centuries also studied ancient Greek comedies, and discussed these in a sort of salon patronized by the Rucellai family at the time. After his exile from the Florentine political world, Niccolò Machiavelli (1469–1527) began writing political theory and histories as well as comedies to support himself. Of all three kinds of writing the statesman undertook, comedy proved to be the most lucrative. In his dramas he put to work the theoretical and practical literary knowledge he had acquired from living in Florence during the heyday of the comic revival. He produced several plays, of which *The Mandrake Root* (1517) was his most popular and influential. In ways reminiscent of some of the tales of the *Decameron*, it retold the story of an old braggart who is cuckolded by a clever young man.

CHARACTERISTICS. The new plays modeled on the examples of Terence and Plautus were called *erudita*, meaning erudite or learned, because their structures imitated those of ancient Rome. Although the contours of these dramas relied upon some ancient conventions, erudite comedy grew to become far more than a merely im-

a PRIMARY SOURCE *document*

SETTING THE STAGE

INTRODUCTION: Niccolò Machiavelli, author of the famous book, *The Prince*, was also a writer of several popular Renaissance comedies. *The Mandrake Root* was his most successful play. Actors frequently worked on small stages with cramped scenery that inadequately suggested the spaces in which their dramas took place. The Prologue to the *Mandrake*, shows how playwrights sometimes aided in the process of setting the scene.

God bless you, gracious audience,
Since we know that your graciousness
Depends upon our pleasing you.
May your silence let our troupe commence
To Play for you, with some finesse,
A recent case that's something new.
The stage set we've convoked you to,
As you shall presently be shown
Is that dear Florence which you call your own.
Tomorrow Rome or some other setting
Will tickle you till your sides are splitting.

This entrance, on my right-hand side,
Is the door to the house of a doctor of law
Who's learned from Boethius what law he could
And that street there, you've no doubt espied,
Is called Lovers' Lane, where, as you know
He who stumbles falls for good.
You shortly will have understood,
When you have seen the cloak he flaunts,
What sort of monk or abbot haunts
That church there in the other part,
If you don't leave too near the start.

SOURCE: Niccolò Machiavelli, "Prologue to *The Mandrake*," in *The Comedies of Machiavelli*. Ed. and trans. David Sices and James B. Atkinson (Hanover, N.H.: University Press of New England, 1985): 157.

itative form. In several cases playwrights wrote these comedies in verse. But most often they relied on a prose written in the vigorous Tuscan dialect in use throughout northern and central Italy at the time. The dramas often used local dialects or words that were foreign in origin to underscore a character's nature as a simpleton or a foreigner. Most of the comedies followed the five-act format of ancient Roman models. They took place in an Italian street scene populated with wealthy patricians, their servants, and their clients. Courtesans, pimps, innkeepers, peddlers, and soldiers were also frequent

a PRIMARY SOURCE *document*

CIMADOR: CLOWN OF COMMEDIA DELL'ARTE

INTRODUCTION: The great Italian poet and dramatist Pietro Aretino included the following description of Cimador, a Commedia dell'Arte clown, in a letter to a friend.

Nanna:

Ha! ha! ha! I'm still laughing about one they called the son of Giampolo, a Venetian I think, who imitated an assortment of voices while concealed behind a door. He did a porter well enough for anyone from Bergamo to have given him the palm. When the porter enquired of an old woman about a lady, in imitating the old woman he would say, "And what do you want from my lady?" And in reply said to her, "I should like to speak with her," and in just the way such a rascal would do he added, "Madonna, Oh! Madonna, I'm dying, and I can feel my lung bubbling like washed tripe." He could complain like a porter in the most perfect way in the world, and when he began to fondle her he joked away with the sort of re-

marks sure to spoil her Lent and make her break her fast. Then in the midst of this game who should appear but her senile old husband, who at the sight of the porter made an uproar that sounded like a peasant who finds his cherry tree being robbed—and the porter replied "Oh sir! Sir! Ah ha!" and laughed and gestured like an idiot. "Oh, go your way!" said the old man, "You're a drunken ass!" Then having got the servant woman to remove his boots, he would tell his wife a garbled tale about *Sofi* and the Turk, and made everyone collapse with laughter as, farting all the while, he would swear never again to eat food that gave him the wind. When he had been put to bed, and was snoring away in his sleep, this same buffoon became the porter again, and after much laughing and crying with the lady began to shake her fur [...] you'd have howled listening to the noise they made tooing and fro-ing together, the vulgar remarks of the porter nicely counterpointing the lady's cries of "Do it to me!"

SOURCE: Pietro Aretino, *I Ragionamenti*, in *The Commedia dell'Arte: A Documentary History*. Eds. Kenneth Richards and Laura Richards (Oxford: Basil Blackwell, 1990): 24–25.

characters in the plays, showing the taste for real-life situations rather than the fantasy settings that had often been used in earlier medieval forms of comedy. One important development in the history of erudite comedy was the foundation of the *Intronati* at Siena around 1531. A group of university-educated intellectuals and wits, the Intronati extended the boundaries of comedy by bringing romance plots into the genre. Eventually, their innovations attracted a broad readership throughout Europe, and inspired many similar works, including Shakespeare's *Twelfth Night*. Beyond the many plots they developed from medieval romances, the Intronati also made use of stories from Boccaccio's *Decameron*, favoring those tales in which highly intelligent and heroic women get the better of weaker male characters. News of their innovations spread quickly throughout Italy, and new groups in Florence, Padua, Rome, and other cities soon imitated them.

COUNTER REFORMATION. The great comic tradition that was built up in Italy between the late fifteenth and mid-sixteenth century also was affected by the religious controversies of the time. As the Counter-Reformation aimed for reform of both the church and society, the forms of erudite comedy grew increasingly more serious and high-minded in tone. In the second half of the sixteenth century, a new form known as *commedia grave* treated more serious themes. While these

new plays mixed pathos and humor, the *commedia grave* more generally inspired yet a third genre known as tragicomedy toward the end of the sixteenth century. In contrast to ancient and erudite comedies, the messages of tragicomedies were more essentially Christian in nature. In plays like *Il Pastor Fido* (The Faithful Shepherd), the writer Battista Guarini, an early master of tragicomedy, showed the central character facing the sufferings of the world, yet still achieving ultimate redemption through the powers of Divine Providence. This new strain of drama played more to the tastes of the Counter Reformation for high-minded themes that might uplift viewers and teach moral values.

COMMEDIA DELL'ARTE. The audience for the comic art form known as *Commedia dell'Arte* (a name invented after the Renaissance to describe this phenomenon) was broader and more popular than that of erudite comedy. There were at the same time many connections between the two forms. Members of the professional *Commedia dell'Arte* troupes frequently attended erudite comedies in search of inspiration. But in contrast to erudite comedy, the *Commedia dell'Arte* was largely an improvised art form. The transmissions between erudite comedies and the *Commedia*, too, usually worked only in a single direction, since the authors of the more learned comedies generally avoided the slapstick humor and crowd-pleasing effects that were the

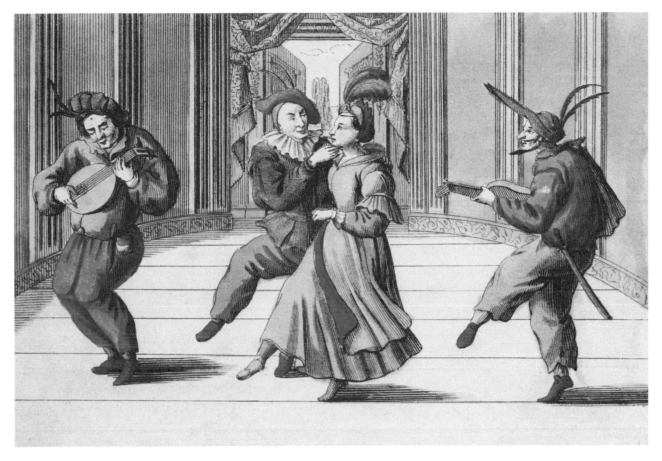

Eighteenth-century engraving of Commedia dell'Arte performers wearing traditional costumes. © BETTMANN/CORBIS.

stock-in-trade of the *Commedia*. There were, however, a few notable cases in which learned writers borrowed characters and gestures from the more popular form. The *Commedia dell'Arte* began to appear in the mid-sixteenth century. At Padua, a contract survives from an eight-man troupe that joined together for the purpose of traveling and acting out comedies. By the 1560s these roving comic troupes were common throughout Italy, and many hastily erected temporary stages in town squares to entertain urban people. At the conclusion of these shows, the performers collected donations from the crowd. Other troupes developed a noble and distinguished clientele, and instead of giving spontaneous street performances, they provided entertainment at the wedding feasts and banquets of princes and wealthy townspeople. There were no scripts for most *Commedia dell'Arte* performances, and the action was spontaneous and quick. Acting in this way required troupe members to develop a great spirit of teamwork, to have a sense of comic timing, and to acquire an enormous reservoir of jokes and stories. The actors seem to have read widely and to have attended the theater regularly in search of inspiration. Most scenarios usually included a central couple that were attractive lovers and well accomplished in the rhetorical forms of the Tuscan dialect. In addition, several characters that played maids to these figures were common features of most troupes. These characters provided the essential comic twist by confounding and commenting upon their master and mistress' love interest. Men usually undertook these roles and they played them unmasked. Beyond the lovers and servants, most troupes had a host of stock characters, many of who were older and who were usually depicted using masks. There was often a doctor from Bologna, a Venetian grandee, as well as groups of clowns and buffoons. Other figures that marched across the *Commedia*'s stages included gypsies, drunkards, Turks, executioners, and innkeepers. Since most of the troupes were small, actors doubled-up on roles to achieve this great variety of characters.

TRAVELS. As the sixteenth century progressed, the most distinguished Italian troupes entertained in courts and cities throughout Europe. By the 1570s, *Commedia* troupes were also making their own journeys to France, Spain, England, and Poland. The popularity of the form,

both among city people and the nobility, was undeniably great. By the end of the century, for example, Italian *Commedia dell'Arte* troupes performed at some of the most important weddings throughout the continent, including that of Marie de' Medici to Henry IV of France in 1600. The comic form survived into the seventeenth century, when it continued to compete successfully against the many new kinds of theater that were common throughout Europe. The popularity of the art inspired some *Commedia* actors to publish their monologues and dialogues in their retirement, and these editions affected later written comedy. Although the Counter Reformation generally found the off-color, even lewd, overtones of the *Commedia* distasteful, the art form's audience was so large and the troupes so vital to local economies that it was never effectively suppressed.

THE PASTORAL. The Renaissance dramatic genre of the pastoral arose from roots in poetry and became a highly original theatrical form that long outlived the Renaissance. In the theater, as in literary pastorals, these plays were set in rustic locales and their characters—shepherds, shepherdesses, and sometimes nymphs—met in cool shade or by clear brooks to sing, dance, and socialize. The happy consequences of faithful love were a frequent theme. The genre, produced by urban people, arose from a nostalgic longing for the simpler pleasures of rural life. The literary roots of pastoral drama stretched back into both Antiquity and the Middle Ages. In the fourteenth century the poets Dante, Petrarch, and Boccaccio all wrote poems that imitated the rustic eclogues of Vergil. Although they mastered the ancient form, each used the style to convey allegorical truths. Over time, though, the pastoral poetry of the Renaissance became less allegorical in tone. At the end of the fifteenth century, for instance, the accomplished Florentine humanist Angelo Poliziano was just one of several Italian authors to try his hand at writing poetic pastorals. Poliziano enriched the genre by working the conventions and storylines of the medieval romance into the traditionally bucolic pastoral form. During the sixteenth century the increasingly sophisticated knowledge of Greek theater also left its mark on pastoral theater. The Greeks had developed "satyr plays" as a genre of theater distinct from tragedy and comedy. Usually, these dramas had been performed as lighter interludes during the staging of long tragedies. The translation of Euripides' play, *Cyclops*, in 1525—the only completely extant example of a Greek satyr play—proved to be the final impetus to the development of a distinctly Renaissance genre of pastoral theater. *Cyclops*, like most of the ancient satyr plays, had been populated with drunken satyrs, subhuman creatures

who were believed to live in the Greek countryside. The drama recounted their lustful exploits and mocked the traditional conventions of mythological stories. It is from the word "satyr" that the modern word "satire" takes its origins. In 1545, Giambattista Cinzio Giraldi completed his *Egle*, the most successful imitation of Euripides' satyr play to appear during the Renaissance. As pastoral theater came of age in the second half of the sixteenth century, it made use of these ancient Greek and Roman models as well as the conventions of medieval romances. Among the greatest Italian dramatists to write pastoral plays was Torquato Tasso (1544–1595), whose *Aminta* became the most influential drama of this type. It was first performed in 1573 at the court of the dukes of Ferrara by the Gelosi troupe, a popular professional theatrical group who also regularly performed *Commedia dell'Arte* productions for distinguished clients. Afterwards the influence of Tasso's work spread throughout Europe and inspired dramatists in England, France, and Spain, including Ben Jonson, William Shakespeare, Lope de Vega, and Cervantes. Another influential work in the pastoral vein was Giovanni Battista Guarini's *Il Pastor Fido* (1580) or *The Faithful Shepherd*, a pastoral play that also helped create the new theatrical genre of tragicomedy. Like Tasso's *Aminta*, Guarini's play became popular in courts throughout Europe and inspired John Fletcher's own version of *The Faithful Shepherd* in England. By the early seventeenth century the pastoral play had appeared everywhere in Europe, inspiring a tradition of pastoral visual art and music that survived for several centuries.

THE OPERA. A final theatrical form, the opera, was just beginning to emerge in the last years of the Renaissance, and was shaped by the developing taste for pastoral drama as well as the conventions of classical Greek theater. Opera's earliest origins lay in the city of Florence, the cultural center from which many innovations issued in the Renaissance. The first dramas to be set to music were performed in the palaces of the city's wealthy merchants and in the Medici court. Thereafter, as opera spread throughout Europe, it remained a form of court entertainment for many years. *Dafne* has long claimed the title of Europe's first opera; it was performed in the Florentine palace of Jacopo Corsi, a local silk merchant, in 1598. Jacopo Peri (1561–1633) wrote the libretto for *Dafne*, which was set to music by Ottavio Rinuccini (1562–1621). Unfortunately, the score of this work has not survived, although Rinuccini and Peri soon collaborated on a second work, *Euridice*, which was performed before the Medici court in Florence in 1600. The music from this opera does survive, and the score shows that

a PRIMARY SOURCE *document*

THE MAKING OF ILLUSION

INTRODUCTION: Sebastiano Serlio was a highly respected architect, who, in the normal course of his duties, designed theatrical productions for his aristocratic patrons. In his treatise on architecture, a section of which was published at Paris in 1545, Serlio treated the ways that a designer could make any and all kinds of illusions.

Now let us speak of some other things which bring great delight to the spectator. For these times when the actors are not on the scene, the architect will have ready some processions of small figures, of an appropriate size, cut of heavy cardboard and painted. These are fastened to a strip of wood and pulled across the scene at some arch, in a swallow-tail runway. In the same way can be shown musicians playing instruments or singing, and some one behind the scene will supply the music softly. At other times a troop of people passing over, some on foot, some on horseback, with the muffled sound of voices and drums and trumpets, will greatly please the spectators.

To make a planet or other heavenly body pass through the air, it is painted well on cardboard and cut out. Then far back in the scene, at the last houses, a soft iron wire is stretched across the scene with small rings attached to the back of the cardboard figure, which may be drawn slowly across, by a dark thread. But all must be so far back that neither the thread nor the wire can be seen.

Thunder, lightning, and thunderbolts will be needed on occasion. Thunder is made by rolling a large stone ball on the floor above the hall used for the theatre. Lightning is made by some one in a high place behind the scenes holding a box of powdered resin. The top of the box is full of holes and in the center is a lighted candle. When the box is raised, the powder is thrown out and set on fire by the candle. A thunderbolt is made by letting down a rocket or ray ornamented with sparkling gold on a wire stretched at the back of the scene. Before the thunder has stopped rumbling, the tail of the rocket is discharged, setting fire to the thunderbolt and producing an excellent effect.

But if I were to discuss all the things I know about stage setting, I would never be done; therefore I shall say no more.

SOURCE: Sebastiano Serlio in *The Renaissance Stage. Documents of Serlio, Sabbattini and Furttenbach.* Ed. Barnard Hewitt (Coral Gables, Fla.: University of Miami Press, 1958): 35-36.

the libretto dominated the performance, with words sung in simple recitative. There were as yet no arias or grand musical flourishes. Instead Peri and Rinuccini, like the composers of other early operas, were affected by the late sixteenth-century discussions of the Florentine Camerata, a group of scholars that had coalesced as an informal academy in the city to investigate ancient Greek music. Although little evidence existed to suggest the performance practices of the classical period, the group believed that the music of that time had possessed a great power to ennoble its listeners because it was monodic, that is, it consisted of a single melodic line. The Camerata also idealized ancient Greek music because they perceived that its performers had given greater weight to the texts they had sung. The members of this Florentine group often discounted contemporary music, particularly the popularity of the Renaissance madrigal, because of these forms' polyphony, that is, the presence of many different melodies superimposed atop each other. Polyphony, they charged, confused listeners and lacked any power to spur its audience to virtuous living. For these reasons, the recitative style—the simple recitation of text set to music—dominated the early operas performed in and around Florence. The recitative

opera, though, was short-lived. Already in 1607, Claudio Monteverdi introduced the more intensive form of arias into his work *Orfeo* in order to underscore the most important parts of the libretto. The reliance on arias and the somewhat later return of polyphony to the opera moved the art form away from the severity its pioneers had intended, a severity they believed might recreate the grandeur of the original Greek drama.

THEATERS. Except for the survival of ancient Roman amphitheaters, few permanent theaters existed anywhere in medieval Europe. During the sixteenth century the building of permanent theaters increased, first in Italy and later in Spain and England. Still, there were far more temporary theaters in the period than there were permanent ones—usually set up in the halls and courtyards of public buildings or in the palaces and villas of the nobility. In one part of his *Architettura*, which was published in 1545, Sebastiano Serlio treated the subject of theater design and included illustrations for the construction of a temporary theater similar to one he had already built in Italy. At that time Renaissance artists and architects also functioned as designers of sets, stages, and theaters for their noble patrons. Leonardo da Vinci,

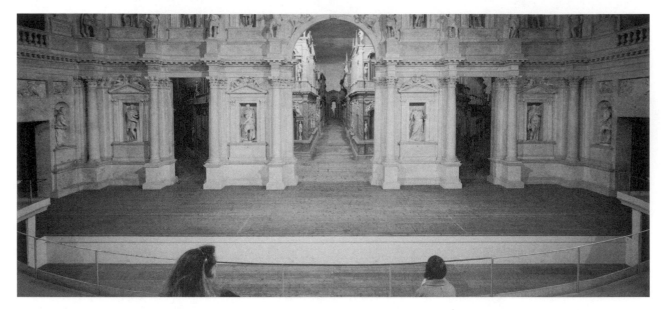

Stage of the Teatro Olimpico in Vicenza, Italy. © DENNIS MARSICO/CORBIS.

Baldassare Peruzzi, Raphael, and Andrea del Sarto were just a few of the many distinguished artists who undertook these tasks for their noble and princely patrons. Serlio's design for a temporary theater attempted to compress as much of the architecture of an ancient Roman theater as he could into the background of his stage. This formal architectural screen had five doorways that opened on to a central acting space. Prompted by the popularity of the comedies of Plautus and Terence, this style of production was popular in the temporary theaters erected in Rome and other cities throughout Italy at the time, particularly those built for noble households. Serlio designed a temporary structure that might be assembled and taken down as needed, yet several permanent sixteenth-century theaters in Italy made use of some his elements. These included the Venetian architect Vincenzo Scamozzi's design for the Teatro Olimpico at Sabbioneta (which was built around 1588) and a similar structure at Piacenza from 1592. A more complete attempt to recreate the designs of an ancient Roman theater also occurred at Vicenza, where the Olympian Theater was constructed according to plans originally set down by the great architect Andrea Palladio. This structure transformed Serlio's pattern by adding stepped-up amphitheater seating. Palladio also placed a two-story portico of columns on the stage, which he decorated with classical statuary. Beyond the five entrances that punctuated his façade, deep perspective vistas of Italian city scenes were later added to fill the spaces behind Palladio's original screens. These created the illusion of great depth in the theater, despite the fact that the stage was relatively shallow.

INFLUENCE. The culture of humanism, with its taste for all things ancient, deeply affected the development of the Italian theater during the Renaissance. Although older styles of religious dramas did not disappear in Italy during the period, the theater of ancient Greece and Rome inspired a new taste for secular themes and subjects. An initial fascination with the works of Seneca, Plautus, and Terence gave rise to new genres of recited tragedy and erudite comedies written in the Italian language. Somewhat later, the revival of Greek drama exerted an influence on the tragedies of the period. Still, the dramatists of Renaissance Italy were not slavish in their devotion to classical genres. While inspired by the enormous achievements of the classical world, they also created new forms like the opera, the pastoral, and the tragicomedy. Although some of the elements of these new genres were classical in inspiration, Renaissance playwrights developed them in ways that were uniquely contemporary in expression. Finally, a vigorous popular theater that was secular in spirit developed in the *Commedia dell'Arte,* an art form that spread rapidly throughout the peninsula in the mid-sixteenth century. This street theater, like many of Italy's theatrical innovations, traveled widely in Europe, thus enriching the continent's national theaters in the final years of the Renaissance and in the generations that followed.

SOURCES

M. Banham, ed., *The Cambridge Guide to World Theatre* (Cambridge, England: Cambridge University Press, 1988).

P. C. Castagno, *The Early Commedia dell'Arte: The Mannerist Context* (New York: P. Lang, 1994).

S. DiMaria, *The Italian Tragedy in the Renaissance* (Lewisburg, Pa.: Bucknell University Press, 2002).

P. L. Ducharte, *The Italian Comedy* (New York: Dover Publications, 1966).

G. R. Kernodle, *The Theatre in History* (Fayetteville, Ark.: Arkansas University Press, 1989).

C. Molinari, *Theatre Through the Ages* (New York: McGraw-Hill, 1972).

SEE ALSO *Dance: Theatrical Dance; Literature: Early Renaissance Literature; Music: Sixteenth-Century Achievements in Secular Music*

THE RENAISSANCE THEATER IN NORTHERN EUROPE

TRENDS. At the dawn of the sixteenth century, humanism gradually gained popularity among educated townspeople and court circles in Northern Europe. At court, the fashion for Antiquity left its mark on spectacles and in the dramatic interludes that were regularly performed at banquets and other entertainments, as they had already done several generations earlier in Italy. At the same time religious mystery plays continued, but the impact of the Protestant Reformation discouraged their staging. In Germany the falloff in production of the mystery cycles that Protestantism caused encouraged development of other dramatic forms, including village farces and polemical plays designed to popularize either Protestant or Catholic sympathies. The traditional *Fastnachtspiele*, or Shrove Tuesday plays staged before the onset of Lent, continued under both Lutheran and Catholic auspices and became a new vehicle for moralistic teaching. A new feature of the sixteenth-century theater in Northern Europe was its increasing professionalism. As in Italy, the mid-sixteenth century in the north of the continent saw the rise of small traveling theatrical troupes who made their way through the country to stage short farces and comic interludes. In the largest cities of the region such as Paris and London, the increasingly professional nature of the theater came to inspire new permanent theaters with repertory companies that aimed to entertain a broad swath of the urban population. In Paris, the commercial theater took on a new importance as the religious mystery cycles were forbidden by an edict of the city's parliament in 1548. In England, the mystery cycles survived somewhat longer, but their popularity waned under the new teachings of the Reformation. The foundation of the Hôtel de Bourgogne in Paris in 1548

and the slightly later appearance of professional theaters in London satisfied the demands of city people for entertainment. The commercial theaters also quickened the development of a reservoir of national dramatic literature in these countries that was aimed at a truly popular urban audience. In both England and France the Golden Age of national theater lay ahead in the early seventeenth century, but a number of admirable plays appeared even in the years before 1600. In the productions that were mounted for these new commercial theaters, playwrights used the knowledge of Antiquity they had acquired from Renaissance sources. At the same time, commercial pressures caused them to address their plays to as broad an audience as possible. As a consequence, the imitation of Antiquity that dominated much of sixteenth-century Italian drama was not as extensive in the new commercial theaters of London and Paris. Playwrights tailored their productions to fit popular tastes, and the evidence of rising attendance shows that in both countries they proved more than astute in satisfying audience demands.

ENTRIES. The medieval custom of staging elaborate royal entries into cities throughout a monarch's realm continued unabated in sixteenth- and seventeenth-century Northern Europe. The taste for spectacle, imposing processions, and solemn rituals connected with these ceremonies grew and reflected the tastes of the Renaissance for the ancient world. During the fourteenth and fifteenth centuries the burgeoning knowledge of ancient history in Italy inspired new entries there that were staged in imitation of the imperial triumphs of ancient Rome. In 1326, the despot Castruccio Castracane entered his subject town of Lucca like a Roman emperor driving a chariot and prisoners through the streets. A century later, the trend to style the entrance of Italian rulers into their towns as Roman triumphs had grown even more complex. Italian Renaissance entries now often elaborately melded Christian and ancient imagery together, such as in the entrance of Borso D'Este into the town of Reggio around 1450. A figure dressed like the town's patron saint bore the keys of the city atop a heavenly cloud. Angels and cherubs claimed the keys and presented them to Borso. A pageant wagon crowned by an empty throne approached to bear the duke into the town, while figures representing the classical virtues showed the benefits that accrued from the duke's rule. The procession concluded in front of the town's cathedral, where Borso d'Este reviewed again the classical and Christian characters that had marched in the procession from atop a golden throne. Finally three angels swooped down from a nearby building and presented the duke with a palm

of victory. Spectacles like these grew increasingly commonplace in Italy toward the end of the fifteenth century, their popularity fueled, in part, by the poetry of Petrarch. In his poetic *Triumphs*, the fourteenth-century humanist had celebrated the myths and victorious imagery of ancient Rome in a series of poems that showed the conquests of the figure of Love by the figures of Chastity, Death, Fame, Time, and Eternity. The poems were popular, and by 1500 they inspired a number of artistic portrayals that, in turn, shaped the taste for the entry's pageantry.

NORTHERN EUROPEAN CHANGES. As the fashion for antique imagery spread to Northern Europe after 1500, royal entries were transformed into events similar to those being undertaken at the time in Italy. While the taste for the new classically styled triumphal entries was theatrical, it produced subtle, yet important shifts, particularly in France, that underscored the new grand role that kings expected to play in the governing of their realms. In the fifteenth century monarchs had paused along the route of the entry to observe symbolic tableaux and to listen to short dramatic interludes staged by local townspeople. These short dramas had often been pointed, with messages that underscored local liberties and the limits of royal authority over the town. For cities that had recently evidenced signs of a rebellious spirit, the tableaux and short dramas had often been used to remind the king to practice justice tempered with clemency. As the taste for classical spectacle grew more elaborate after 1500, these dramatic elements were crowded out of the entry in favor of processions that took on ever more the nature of a juggernaut. The key symbol of the new entries celebrated in sixteenth-century Northern Europe was the triumphal arches or, in many cases, a series of triumphal arches through which marched a panoply of elaborately decorated pageant wagons, Roman gladiators and centurions, bound captives, and classically clad figures of the Virtues. The scope of the celebrations that surrounded the entry itself grew similarly grand, with ancillary spectacles and entertainments surrounding the festivities and lengthening the time needed to undertake a royal entry to days, and in some cases, weeks. In these later Renaissance entries, particularly those that occurred around the mid-sixteenth century in France, traditional religious imagery was downplayed in favor of new classical symbols. Slightly later, chivalric elements played an important role as well in the spectacles. The new style of entry developed most definitely in France, and entries elsewhere did not always take on the same level of fantastic elaboration. In England, the rituals continued to be relatively small and tra-

ditional until the accession of the Stuart kings in the early seventeenth century. But in most places the tendency to eliminate medieval street theater from the festivities developed, and for the entry to become a mute, yet imposing testimony to the central authority of the monarch.

RELIGIOUS DRAMA. Religious dramas along the lines of the great mystery and morality plays of the later Middle Ages survived in Renaissance Europe. In France, an edict of the Parliament of Paris forbade the performance of the great mystery cycles in the city in 1548. The action was precipitated both by Protestant attacks upon the theological errors the cycles contained and because of a growing sentiment among Catholics that the plays were an inappropriate vehicle for conveying religious truths. Despite the moves in Paris against the plays, mysteries continued to be performed in some parts of the country. As new forms of drama competed against these cycles, though, the mystery cycles' audience became increasingly circumscribed to the poor and largely uneducated rural population. In Germany, the fate of the mystery cycles, there known as Passion Plays, was largely similar. Although these great productions lasted in Catholic regions into the seventeenth century, they disappeared in the new Protestant territories. By the mid-seventeenth century Passion Plays had increasingly become a kind of Catholic "folk art," confined to largely rural regions throughout the countryside. In England, no state action was taken against the mystery cycles until the years of Elizabeth I's reign (r. 1558–1603). It is difficult to gauge just exactly when most of the plays ceased to be performed in England, given the sketchy nature of the documentation. In the northern English town of York, the great medieval cycle was last performed in 1569, and abandoned the following year after an abortive rebellion by pro-Catholic earls in the region. Chester's play was performed until 1575. By this time, though, the evidence suggests that many of the cycles had already disappeared.

POLEMICAL DRAMA AND LENT. At the same time, new kinds of religious drama proliferated in Northern Europe. In Protestant Germany, the traditional vehicle of the interlude, a short dramatic sketch performed at banquets and other entertainments, became ripe for polemical condemnation of the Catholic Church. Short Protestant interludes performed on feast days in the cities attempted to popularize the Reformation and to teach its new doctrines to the people. These Protestant polemical plays were quite long-lived, surviving in some Lutheran regions into the mid-seventeenth century. Protestants imitated the custom in England, where sim-

a PRIMARY SOURCE *document*

REFORMATION DRAMA

INTRODUCTION: The Protestant Reformation in Germany produced hundreds of short dramatic interludes designed to popularize the new teachings among the people. Some of these were performed, while others circulated as dialogues in cheap pamphlets. The greatest of sixteenth-century German dramatists was Hans Sachs (1494–1576). In his *A Pleasing Disputation between a Christian Shoemaker and a Popish Parson* he defended Protestant teachings. Like some other German Reformation dramas, this text was translated into English. In England, as in Germany, texts like these inspired a vogue for polemical dramas that supported the Reformation. The emphasis of the following passage upon Christianity as a system of moral ethics is found in many of Sachs's works.

Shoemaker: When you do sincerely and purely teach God's Word, then men are bound to hear you, even as Christ himself. But when you preach your own imagination ... then ought no man to give ear to you. For all that is not planted of God shall the Heavenly Father pluck up by the roots.

Parson: Are the Councils then the teaching of men?

Shoemaker: If a man should say the truth, the Councils have done great damage in Christendom ...

Parson: What hurt or damage have they done, I pray thee heartily?

Shoemaker: First through their commandments, which as you yourself know are innumerable and unmeasurable, and these they have confirmed through many excommunications ... Such people, Paul has declared, would in the latter times depart from the faith with their commandments and give heed to error and devilish doctrine ...

Parson: What then are the right and true works of the Christian Man?

Shoemaker: Christ says: All that thou would have men to do unto you, do even the same unto them and that is the fulfillment of the whole law and prophets. And he doth teach us to feed the hungry, to give drink to the thirsty, to harbor the harborless, to clothe the naked, to visit the sick, and to comfort the prisoner.

Parson: Are these the only works of the Christian man?

Shoemaker: Yea. A true and faithful Christian man who is born of the water and the Spirit ... serves God alone in spirit and in truth, and he serves his neighbor also, which is the whole sum of a Christian life.

SOURCE: Hans Sachs, *A Goodly Dysputacion Between a Christen Shomaker, and a Popysshe Parson.* Trans. Anthony Scoloker (London, 1548): 14–15. Text modernized by Philip M. Soergel.

ilar kinds of sketches promoted the Reformation among urban populations. The religious issues of the time also left their mark on the traditional *Fastnachtspiel* or "Shrove Tuesday Plays," which had long heralded the onset of Lent. Journeymen members of the guilds, who were enjoined to be celibate and forbidden to marry, had originated this form of drama. In Nuremberg, where the genre became particularly popular, the plays became a way for guildsmen to let off steam in the revelries that occurred before Lent. Filled with lewd language and salacious imagery, the *Fastnachtspiel* turned the normal sexual and moral conventions of urban life upside down. By the mid-sixteenth century, the moralizing of Nuremberg's Protestant reformers had clearly exerted an influence upon these productions. In the many Shrovetide plays that he wrote to be performed in his hometown, the accomplished poet Hans Sachs (1494–1576) transformed traditional carnival lewdness into mild horseplay, and he used his short dramas to teach proper bourgeois values.

JESUIT DRAMA. The origins of another kind of religious theater, the Jesuit school play, lay in the fifteenth-century revival of ancient drama that had occurred in Italy. Toward the end of the fifteenth century, university professors there had begun to stage Latin revivals of the ancient comedies of Terence and Plautus in order to perfect students' use of classical Latin. In the secondary schools that the Jesuit Order founded throughout Europe in the mid-sixteenth century they relied on a standardized curriculum, closely modeled on humanist examples. As a consequence, they adopted the custom of staging Latin school dramas. The first performance of a school play seems to have occurred at the Jesuits' first institution at Messina in Sicily during 1551. By 1555, the first Jesuit play had been produced in Vienna, and by 1560, many schools the order now ran in Germany and Northern Europe staged these dramas. In its early stage of development the Jesuit Theater produced classical and biblical stories with ennobling content. Popular themes included the stories of Hercules, Saul, and David. Gradually,

however, the Jesuits adopted stories in which female hero-ines like Judith, Esther, and St. Catherine were the cen-tral characters. The choice of these materials forced the order to relax the prohibition against young boys play-ing female parts. Latin remained the dominant language used in the plays for most of the sixteenth century. The first example of a non-Latin Jesuit play, *Christus Judex*, originated in Spain, but schools in Italy and Germany soon had translations. Over time, the Jesuit productions grew more elaborate. Around 1600, the Jesuit dramas al-ready had large casts of characters, and in the course of the following century operatic arias, *intermezzi*, and even ballet became components of the productions. Similarly, their staging became more elaborate, with lighting effects, costumes, and scenery machinery adopted from those used on the professional stage.

FRENCH THEATER. Although the tone of most me-dieval mystery plays was often solemn, short farces had sometimes served as relieving interludes within these dra-mas, the performance of which sometimes stretched across several days. As in Germany, comic carnival plays, too, provided a safety valve through which people pre-pared for the self-denial and rigorous disciplines of Lent. Between 1450 and 1600, these traditional comic forms became the basis for the establishment of a popular the-ater in France. Broad segments of the French urban pop-ulation, rich and poor, educated and uneducated alike attended productions staged in this popular theater. In contrast to other forms of drama, then, the subjects treated in these plays by necessity had to have broad ap-peal and general intelligibility. The comic farce was thus one of the most common staged dramas in the French popular theater of the time. Its characters were, by and large, drawn from daily life. A parade of ordinary fam-ily members, scheming servants, priests, and tradespeo-ple marched through these plays. In contrast to the morality plays still popular at the time, which had char-acters with names like Avarice, Hope, and Charity, the farce aimed to represent real-life situations, albeit with a comic twist. French farces were usually written in eight-syllable (octosyllabic) verses. Their plots attacked gulli-bility, misplaced trust and idealism, and human faithlessness in ways akin to comic traditions stemming from the days of Chaucer and Boccaccio. The stories were often predictable, as characters became embroiled in cases of mistaken identity or tangled in webs that grew from deceit or seemingly harmless lies. In some cases the line of plot development was relatively thin, and witty verbal games dominated the action.

FAMOUS PLAYS. The two most famous farces to sur-vive from this period are still performed today: *Le Cu-*

vier, or *The Tub* (c. 1500) and *Master Peter Pathelin,* (c. 1460). In *The Tub*, a shrewish wife dominates her hus-band and keeps him busy with a long list of chores. While he is thus occupied, his wife falls into the tub and can-not get out. The husband checks to see if helping his wife out of the tub is included on his list of duties. It is not, and so the play concludes with his proposition to help her, so long as he becomes master of the house, a Renaissance happy ending that reinstated male domi-nance. In *Master Peter Pathelin*, the play's hero is a shady legal type who tricks a local merchant out of cloth by offering to pay for it later. When the merchant arrives at his house to collect the payment, Pathelin has taken to his bed in a feigned and hilarious delirium that lasts for weeks. Later a local shepherd who works for the same merchant comes to Pathelin, asking him to protect him from his employer—the very same merchant Pathelin has already tricked—because he has eaten the flock he was supposed to be guarding. Pathelin advises him to say merely "Baa" to any questions that are asked of him. In court, the merchant becomes confused about the two crimes in which he is a victim, and a comic scene ensues before the judge. As a result Pathelin is momentarily vic-torious in defending the young shepherd, but when he tries to collect his fee, the shepherd merely responds with a "Baa." Among the many popular farces staged at the time, *Pathelin* stands out because of its sophisticated plays on words, its comic timing, and plot development. The play is almost twice as long as any other farce pro-duced in fifteenth- or sixteenth-century France, yet the author manages to sustain the protracted schemes of Pathelin over this enlarged scale. Plays like *Pathelin* ac-quired a broad audience in France and earned the re-spect of both intellectuals and ordinary people. Several translations of French farces into English played a role in shaping later comedies.

FRENCH LEARNED COMEDY. By the second half of the sixteenth century the effects of humanism grew more visible in French theater. The play *Eugène* has long been seen as the first truly "Renaissance" comedy to appear in the country, meaning that its author Étienne Jodelle made use of the classical conventions of Roman comic form by dividing his play into five acts. Jodelle was a member of the Pleiades, a group of authors who labored to revive classical poetic and dramatic forms in France in the mid-sixteenth century. The group took its name from the ma-jor constellation, which according to Greek myth, had been formed from the remains of seven prominent Greek poets. The sixteenth-century Pleiades' fashioning after the famous constellation expressed their hope to revive clas-sical forms in French literature. Like Jodelle's *Eugène*,

many early efforts of this group still relied on elements of traditional French poetry and drama. *Eugène*, for instance, is composed in the octosyllabic verse typical of the older farces, rather than the prose typical of comedies of the Latin revival. Its plot also combines some elements of the traditional farce with newer dimensions drawn from the more recently rediscovered comedies of Terence and Plautus. Like the ancient forms, it makes use of power struggles and sexuality in a more direct way than the traditional farces. The play's conclusion is also morally ambiguous since the central love interest is adulterous and the conflict is resolved in the couple's favor at the drama's conclusion. Despite these innovations inspired by ancient comedy, the play's characters, language, and Parisian setting are undeniably French.

OTHER COMEDIES. The bourgeois world that Jodelle created in his *Eugène* was the favored setting of other humanist-influenced comedies written in the years that followed. These dramas adopted the five-act structure typical of ancient Roman comedies, but until 1573 none was written in prose, each retaining the octosyllabic verse that seems to have been much prized by French writers and audiences alike. In some cases the new comedies took their plots directly from earlier works of Terence and Plautus. The theme of the adulterous spouse who manages one or several affairs simultaneously was a popular one, and the characters that populated these dramas were largely those who might appear in upper-class urban life. Doctors, lawyers, military officers, and both helpful and scheming servants were common figures in the play. In the wake of Antoine de Baïf's *The Braggart* (1567), a series of plays appeared in which the central character or characters were boasting and rambunctious fools. De Baïf was a member of the Pleiades group, and he based his play on Plautus's *Miles gloriosus*. Although he did not surpass his source, his drama is almost as appealing as the original. Another theme popular in the humanist comedies of the time was impersonation, and the central heroes' disguises as peasants, fatherly figures, and so forth became the linchpin around which the plot revolved. Another sign of innovation at the time was the revival of Greek comedy. In his *Cloud-cuckoo City*, Pierre Le Loyer relied on the ancient Greek Aristophane's *Clouds* to create a comedy that was more informally structured than previous examples. His work also made use of verses of varying forms. A final milestone in the development of humanist comedy in France was the publication of Pierre de Larivey's first set of six comedies in 1579. These works were very similar to Italian comedies of the period, although their language was a lively French. Despite certain similarities in plot, the humanist comedies of the later sixteenth century in France display considerable variety. Although their characters are often selected from a stock repertory, French humanist playwrights drew their characters so that their foibles and strengths elicit the admiration of readers and audiences alike. Not all of these dramas found life on the stage, however, since many were likely exercises in language and the application of new dramatic theory. But later playwrights seem to have read and learned from them, and the quality of their drama still retains a great freshness and vitality.

FRENCH TRAGEDY. While French humanists wrote many comedies, their output of tragedy was even more extensive. In many of these works dramatists imitated the conventions of the ancient tragedies of Euripides and Seneca. Some French humanists relied on the dramatic form to propagandize for their Catholic or Protestant sympathies, as in the Calvinist Théodore De Bèze's play *Abraham's Sacrifice* from 1550. Others, like Étienne Jodelle, used the forms of classical tragedy to enlarge French literature. Jodelle crowded his *Cleopatra in Prison* (c. 1552) with verses of varying lengths and a wealth of rhetorical flourishes designed to expand the literary possibility of the language. Others viewed the writing of tragedies more as an intellectual exercise befitting to men of letters. A few French tragedies drew their subjects from the Bible, but the vast majority treated classical themes. While some adapted Greek themes, most were Roman in nature. The greatest French writer of tragedies from the second half of the sixteenth century was Robert Garnier, who published seven tragedies between 1568 and 1583. They relied on the classical forms of the genre, including the use of a chorus, monologues, and dialogues. All of Garnier's plays treated classical themes, although the author saw the political rivalries and wars that his dramas recounted to be applicable to the contemporary situation of France. During the Wars of Religion that raged in the country between 1562 and 1598, staged tragedy became a vehicle for commenting upon and lamenting the country's civil conflicts. French tragedies from the period are filled with much pathos as well as moralistic pronouncements about the danger of tyrannicide, political ambitions, and human desires. Like the similar dramas written in Italy at the same time, they are largely concerned with rhetoric and ethics, and they appear to modern scholars to be more a form of literature than staged drama. The number of plays read as social commentary by an elite audience probably outweighed the number performed on the stage.

IMPLICATIONS. In the second half of the sixteenth century French dramatists began to mold classical comedy

a PRIMARY SOURCE document

INFLUENCES FROM ARISTOTLE

INTRODUCTION: At the end of the fifteenth century, scholars began to rediscover Aristotle's *Poetics*, a treatise on dramatic and poetic theory that had been known in the Middle Ages only in extremely corrupt versions. At this time new editions of the work were published, and knowledge of Aristotle's ideas about drama began to spread relatively quickly throughout Europe. Nowhere were they to have more profound effect than in France. Here during the Wars of Religion, dramatists began to rely on Aristotle's tragic theory to create works that lamented upon the course of contemporary politics via the mirror of classical tragedy. Aristotle's influence persisted, and in the seventeenth century a wave of neoclassical tragedies, best exemplified in the works of Corneille and Racine, was produced for the French court. In contrast to the ancient theories of the Roman Seneca, which had stressed the literary dimension of tragedy, Aristotle dealt with the form as a theatrical genre able to move and inspire the human passions.

We have already spoken of the constituent parts to be used as ingredients of tragedy. The separable members into which it is quantitatively divided are these: Prologue, Episode, Exode, Choral Song, the last being divided into Parode and Stasimon. These are common to all tragedies; songs sung by actors on the stage and "commoi" are peculiar to certain plays.

A prologue is the whole of that part of a tragedy which precedes the entrance of the chorus. An episode is the whole of that part of a tragedy which falls between whole choral songs. An exode is the whole of that part of a tragedy which is not followed by a song of the chorus. A parode is the whole of the first utterance of the chorus. A stasimon is a choral song without anapaests or trochaics. A commos is a song of lament shared by the chorus and the actors on the stage.

The constituent parts to be used as ingredients of tragedy have been described above; these are the separable members into which it is quantitatively divided.

Following upon what has been said above we should next state what ought to be aimed at and what avoided in the construction of a plot, and the means by which the object of tragedy may be achieved. Since then the structure of the best tragedy should be not simple but complex and one that represents incidents arousing fear and pity—for that is peculiar to this form of art—it is obvious to begin with that one should not show worthy men passing from good fortune to bad. That does not arouse fear or pity but shocks our feelings. Nor again wicked people passing from bad fortune to good. That is the most untragic of all, having none of the requisite qualities, since it does not satisfy our feelings or arouse pity or fear. Nor again the passing of a thoroughly bad man from good fortune to bad fortune. Such a structure might satisfy our feelings but it arouses neither pity nor fear, the one being for the man who does not deserve his misfortune and the other for the man who is like ourselves—pity for the undeserved misfortune, fear for the man like ourselves—so that the result will arouse neither pity nor fear.

SOURCE: Aristotle, *The Poetics.* Trans. W. H. Fyfe (Cambridge, Mass.: Harvard University Press, 1960): 43, 45.

and tragedy into forms suitable for their own native expression. While they wrote many new plays in these genres, relatively few of the works inspired by Renaissance humanism had audiences outside the royal court and noble households, beyond those intended for use as school exercises. For most of the sixteenth century, the French theater continued to be dominated by royal spectacles and court entertainments and street performances of farces, morality plays, and other popular forms of drama that could be performed in towns and cities throughout the country on hurriedly constructed makeshift stages.

HÔTEL DE BOURGOGNE. The Parisian theater was an exception. Paris was the largest city in sixteenth-century Europe and developed one of the continent's first professional stages. In 1548, the Confraternity of the Passion built a theater on the second floor of a townhouse that had once belonged to the Dukes of Burgundy. In 1402, the French king had awarded the Confraternity, an organization that grew out of the city's guilds, a monopoly over the performance of all religious dramas in the city. Their new hall was long and narrow (45 feet wide by 108 feet deep). The platform stage was only 35 feet deep and 25 feet wide with a secondary stage above its main floor. The theater's pit was for standing spectators, while above, ranks of boxes filled the sides. At the rear stepped up benches faced the stage. With this scheme the Hôtel probably accommodated an audience of more than a thousand spectators. The construction of the confraternity's new theater coincided with the Parisian parliament's decision to outlaw the traditional mystery cycles in the city. As a result, the confraternity became a troupe of actors who staged secular dramas and

farces far different from the mysteries and passions for which they had originally been chartered. These plays were performed before paying audiences with as much spectacle as could fit onto the facility's small stage. The confraternity's theater relied on the medieval style of simultaneous staging, with five or six different sets displayed on the stage at the same time. During the 1550s the theater was successful, but with the ills of the French Wars of Religion (1562–1598) audiences at the house shrank. By the 1590s the guild began to rent out their space to other French and foreign troupes; the confraternity's continued monopoly over theatrical production in Paris forced other professional troupes to negotiate with the guild to perform in the city. The problem of negotiation coupled with the climate engendered by the civil conflicts of the Wars of Religion doomed most foreign or French troupes to failure. This situation began to change around 1600, as the company of Valleran le Conte visited the theater annually. Le Conte developed a highly profitable relationship with the playwright Alexandre Hardy (c. 1575–1632), who in his relatively short life wrote hundreds of comedies, tragedies, tragicomedies, and pastorals. His plays were notable for their coarse language, sexual suggestiveness, and violence, as well as their short scenes and sudden plot twists. Like the medieval spectacles of the mysteries, limbs were severed, eyes plucked out, and characters beheaded. The results proved to be crowd pleasing, and the Hôtel de Bourgogne finally attracted a reliable clientele. Eventually, Valleran's troupe, known as the "Royal Comedians," took up permanent residence at the Bourgogne, and Alexandre Hardy became, from 1611, the group's official dramatist. By the mid-seventeenth century, the continuing monopoly of the Confraternity of the Passion over theatrical productions in Paris angered many playwrights. Dramatists attacked the Confraternity, a one-time religious organization that was now a force over the secular stage, as a symbol of archaic decadence. In their great masterpieces, the seventeenth-century masters of the French stage—Corneille, Racine, and Molière—also aimed to distance the French drama from the blood and gore of the days of Hardy and Valleran at the Hôtel de Bourgogne.

SOURCES

M. Banham, ed., *The Cambridge Guide to World Theatre* (Cambridge, England: Cambridge University Press, 1988).

R. Hsia, *Social Discipline in the Reformation, Central Europe: 1550–1750* (New York: Routledge, 1989).

B. Jeffrey, *French Renaissance Comedy, 1552–1630* (Oxford: Oxford University Press, 1969).

G. R. Kernodle, *The Theatre in History* (Fayetteville, Ark.: Arkansas University Press, 1989).

C. Molinari, *Theatre Through the Ages* (New York: McGraw-Hill, 1972).

D. Stone, *French Humanist Tragedy: A Reassessment* (Manchester, England: University of Manchester Press, 1974).

THE COMMERCIAL THEATER IN ENGLAND

FROM PARTICIPANTS TO AUDIENCE. As religious sensibilities changed in sixteenth-century England, styles of participation in drama altered. In the later Middle Ages many English men and women had taken part in the mounting of the great mystery cycles, but as these plays came gradually to be abandoned, and later to be suppressed, the vigorous traditions of community participation in drama disappeared. Where once English men and women had been active participants in staging local theater, they now became a receptive audience for plays that were performed by professional troupes of actors. London, far and away the largest city of the realm, became the great center in which a national theater emerged at the end of the sixteenth century. The playwrights who wrote for the new commercial theaters in London were, by and large, highly educated men. They possessed the advantages of humanist education, with its attention to the ancient dramas of Greece and Rome. From their boyhood days, most of these figures had likely participated in the classical dramas regularly staged in secondary schools throughout the country. At the same time, London's commercial theaters were always paying propositions, and those who wrote for them needed to take account of the educational level and middlebrow tastes of urban people. London's theater survived on the penny admissions paid by the city's day laborers, shopkeepers, and servant class. Thus the thorough imitation of Antiquity that was to be found in dramas staged in urbane courts throughout Europe never played a role in the public theater of England. Late Tudor drama had no wealthy patrons to underwrite production, so it had to appeal to an audience that was truly broad. This called for fast-moving, adventurous productions filled with elements of spectacle, song, and even occasional outbursts of violence. The evidence of attendance at these dramas as well as the steady proliferation of new theaters in the capital point to the growing popularity of the theater during the later years of Elizabeth I's reign. This popularity steadily mounted under the early Stuart kings in the seventeenth century.

a PRIMARY SOURCE *document*

A LEWD PLAY

INTRODUCTION: In August of 1597, a play performed at the new Swan Theater in London caused a great uproar and excited the wrath of the queen's Privy Council. Exactly what was in the play *The Isle of the Dogs* has remained a mystery, since all copies were seized and destroyed. Its authors, Thomas Nashe and Ben Jonson, were soon forced to leave town. The following order of the Council shows that it was frequently dangerous to write plays in late sixteenth-century London.

Upon information given us of a lewd play that was played in one of the playhouses on the Bankside, containing very seditious and slanderous matter, we caused some of the players to be apprehended and committed to prison, whereof one of them was not only an actor but a maker of the said play. [That was Ben Jonson.]

For as much as it is thought meet that the rest of the players or actors in that matter shall be apprehended to receive such punishment as their lewd and mutinous behaviour doth deserve, these shall be therefore to require you to examine those of the players that are committed, whose names are known to you. Mr. Topcliffe, what is become of the rest of their fellows that either had their parts in the devising of that seditious matter, or that were actors or players in the same; what copies they have given forth of the said play and to who, and such other points as you shall think meet to be demanded of them, wherein you shall require them to deal truly as they will look to receive any favour.

We pray you also to peruse such papers as were found in Nashe his lodgings which Ferrys, a Messenger of the Chamber, shall deliver unto you, and to certify us the examination you take …

SOURCE: "The Privy Council Orders the Arrest of the Other Members of the Company and the Other Co-Author, Thomas Nashe, for Interrogation, 15 August 1597," in *English Professional Theatre, 1530–1660.* Ed. Glynne Wickham, Herbert Berry, William Ingram (Cambridge: Cambridge University Press, 2000): 102.

LEGAL CONSIDERATIONS. Yet before the professional theater could flourish, certain legal considerations and controversies had to be resolved. As elsewhere in Europe, city governments in England feared the itinerant troupes of players and entertainers who increasingly set up shop in the streets and market squares. Vagrancy, perceived as a great social ill at the time, caused urban governments in many places to look upon the spontaneous performances of street players as a form of beggary, since troupes regularly "passed the hat" to underwrite their expenses. They also perceived such spontaneous productions as a threat to public order because actors or plays might express dangerous political or religious sentiments that could foment rebellion. In London, like many cities throughout Europe, local officials might have preferred to legislate the theater out of existence altogether, if the actions of Parliament and the queen had not intervened. In 1572, an act of Parliament specifically exempted "players" from the list of people considered vagrants, so long as they worked in noble households or were employed by other persons of high degree. Two years later, Elizabeth granted one of her court favorites, the Earl of Leicester, a royal license that allowed his own players to perform in the city of London, so long as the royal censor, known as the Master of the Revels, first observed the troupe's plays. While London's officials tried to countermand the queen's will, Leicester's troupe set up shop in the town in 1574 and began performing regularly on weekdays.

LONDON THEATERS. Despite royal sanction the players still faced the determined opposition of London's leadership, and two years later the troupe's leader, James Burbage, decided to build a company outside London's city walls in the northern suburb of Shoreditch. Here in the area known as the Liberties of London, the troupe might be free from interference from the city's officials. Long tradition had identified these fringe suburbs as areas of license, sexual immorality, and disease. The city's lazarettes, the place of isolation for those with leprosy and other contagious diseases, had long been located there, as were many brothels. Initially, then, the move to the Liberties bolstered the shady reputation of theaters in many Londoners' eyes, and the theaters were widely condemned—perhaps nowhere more vigorously than in the sermons of the city's Puritan preachers. At the same time, the sense of danger and the forbidden proved to be a popular draw for those in search of excitement. Burbage had grasped that the freewill gifts of his audiences were never going to provide sufficient income for the new scale of his enterprise, and so he introduced the paid admission. For just a few pennies, Londoners could indulge their longing for spectacle and drama to relieve the tedium of daily existence. Burbage called his new structure simply the Theater, and the design he chose was for a simple polygonal structure with three tiers of galleries that surrounded the stage. Later in 1598, as the lease on the land on which the Theater was

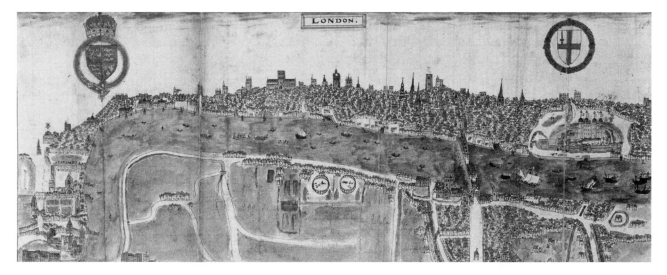

Sixteenth-century London. The location of the Globe Theatre is shown, together with a nearby bear-baiting pit that competed for patrons. THE ART ARCHIVE/BRITISH LIBRARY.

built expired, the company had the building dismantled. They carted the timbers across the Thames and constructed the new Globe Theater, the site that in the seventeenth century was to see some of Shakespeare's greatest triumphs. But in the months and years that immediately followed the building of Burbage's original Theater in Shoreditch, other acting troupes copied the structure, and soon Leiceister's original company had considerable competition. A few months after Burbage's house had opened in Shoreditch, a rival company erected another theater known as the Curtain in the same area. A few years later, two financiers, Philip Henslowe and John Cholmley, built the Rose at Bankside, on the southern shores of the River Thames. With the construction of the Rose, a small theatrical district began to grow in Bankside. By the end of the century the Swan and the rebuilt Theater of James Burbage (now the Globe) had also taken up residence there. Finally, to the north of the city, the Fortune was the last of the great sixteenth century houses to be constructed. But even it was to be followed in the seventeenth century by a series of new theaters constructed like a ring around the city.

RESTRICTIONS ON ACTORS. English law prohibited women from appearing on the stage, thus making it necessary for female roles to be portrayed by men. In the late sixteenth and early seventeenth centuries boy troupes were popular in the city as well. One of these, the "Children of Pauls," was a group of young boys originally drawn from the ranks of choristers at St. Paul's Cathedral. Another troupe, the Children of the Royal Chapel, served the Tudor court as choristers and performers. A series of able playwrights wrote for both boy

companies, and by the end of the 1570s these troupes were competing successfully against the adult companies in London's new commercial theaters. The Children of the Royal Chapel, sometimes called merely the Chapel Boys, had by this time actually blazed a trail in occupying a theater within the city walls in London. At Blackfriars monastery, an institution whose religious mission had been abolished by the Tudor monarch Henry VIII, the boys' impresario Richard Farrant decided to convert a series of rooms into an indoor theater. The City of London opposed his designs, but since the boys were royal choristers and Blackfriars' monastery possessed liberty from the City of London's control, town officials were unable to stop his plans.

CONTROVERSY. At the end of the 1580s the star of the adult troupes moved in the ascendant. Between 1587 and his death in 1593, the great playwright Christopher Marlowe wrote a series of widely admired tragedies that were generally unsuited to being performed by boys. Marlowe relied on the commanding skills of the actor Edward Alleyn, a figure who was larger than life, to play his Faustus and other major roles. At the same time opinion in London also turned against the boys, as the managers of the troupes involved themselves in religious controversy. Puritanism, a fervid religious opponent of the theater, was at the time coming to influence the city's ministers and officials, despite the growing opposition to the movement on the part of the queen and court. In the Marprelate Controversy of 1588–1589, the archbishop of Canterbury John Whitgift attempted to silence this Puritan opposition by a strict application of his authority to censor the press. Widespread indignation

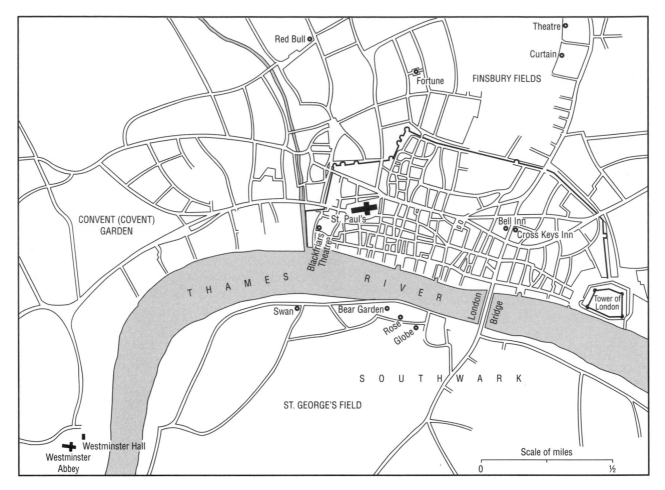

Map of London showing the location of Elizabethan-era theaters. CREATED BY GGS INFORMATION SERVICES. GALE.

inspired pamphleteers to publish furtively a series of satirical tracts under the name "Martin Marprelate," and these, in turn, soon inspired many Londoners to withhold their tithes. As the controversy mounted, the leaders of the boy's troupes supported the archbishop's position, and as a result, public sentiment turned against them. Both the Children of the Royal Chapel and the Boys of Pauls spent the next decade largely touring the countryside, staging their plays for provincials throughout England. By 1599, the situation had cooled off, and the Boys of Pauls returned, to be followed a few months later by the Children of the Royal Chapel. They took up residence in private theaters, the Chapel troupe returning to its former space at Blackfriars. Eventually, there were eight of these private theaters in London and, like the boys' troupes themselves, these theaters appealed to a more cultivated clientele. They were fully enclosed, protected from the elements, and lit with candles. For these luxuries the private theaters charged anywhere from three to six times the admission fees of the much larger public theaters on the city's outskirts. In the early sev-

enteenth century they performed the most up-to-date repertory in London. Blackfriars was always the most successful and exclusive of the private theaters, and in the first decade of the seventeenth century, the Children of the Royal Chapel scored a number of successes in the productions they staged there. At this time, the troupe developed a particularly fruitful relationship with the comic author Ben Jonson. He seems actually to have preferred to write for boy troupes, perhaps because, unlike other playwrights of the time, he was jealous of his texts. The troupes' impresarios tightly managed the actors, thus allowing Jonson to preserve the integrity of the dramas he had written. Buoyed by the success of Jonson's light, satirical fare, the Children of the Royal Chapel staged a string of early seventeenth-century successes.

PRACTICAL CONSIDERATIONS. The early theaters were not always profitable. They were ordered closed during times of epidemic and plays were not permitted during certain seasons of the year, including the 40 days of Lent and periods of royal mourning. An outbreak of

the plague during 1592 also resulted in a long period of closure that forced many playwrights to scramble to find new sources of income. The lack of proper artificial lighting meant that plays could only be performed during daylight hours at the large public theaters. Particularly bad weather cancelled many performances, since the theaters were open to the elements. In order to make them profitable the owners of early theaters sometimes allowed other amusements. The designs of the earliest theaters, with their galleries arranged above a pit for standing spectators, were equally well adapted to bear baiting and cockfighting, both popular amusements at the time. The earliest theaters seem to have alternated their plays with these "sports." But by around 1590, these sidelines were no longer necessary to establish profitability. In 1587, for example, Philip Henslowe remodeled his Rose theater, expanding its seating from around 2,000 to 2,400. His renovations effectively curtailed the structure's adaptability to bear baiting. The building of larger theaters became a trend. Built around 1595, the Swan had a capacity for around 3,000 patrons. The Swan, however, seems always to have been a particularly unlucky theater. In 1597, a performance there found disfavor with the government and the queen's Privy Council banned all theatrical performances around London. The company disbanded, and when the theaters reopened, the Swan proved unable to recover. Amateur groups, several touring professional troupes, and prizefight events rented out the building. By the 1630s, contemporaries noted that it had "fallen into decay." The decor of places like the Swan alternated between the grand and the mundane. The stage and columns supporting the galleries were ornamented with rich carvings, and the stage's roof was usually painted underneath so that it appeared like an elaborate canopy. The floors of the pit, though, were paved with industrial slag, a waste material frequently used on sixteenth-century streets. Above in the galleries, there were benches upon which people might sit, but the space accorded each spectator seems to have been less than twenty inches wide.

DRAMAS. Theater owners and troupes were remarkably pragmatic in choosing the works they performed. They favored authors who could turn out plays quickly and who had a keen eye for the strengths and weaknesses of the players in their particular company. Plays frequently had multiple authors, and actors in the troupes often moonlighted as playwrights. Artistic value was not as important as dramas with a broad popular appeal, and writers who could churn out a great succession of suitable plays had the greatest success. Writers often took advantage of recent spectacular events in the

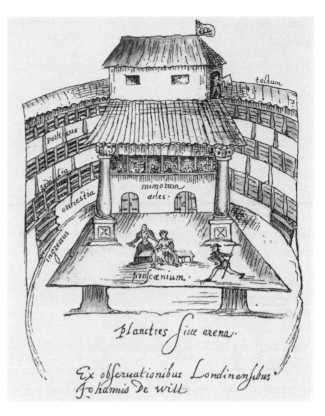

"Sketch of the Swan Theater" by Johann de Witt, c. 1596. THE GRANGER COLLECTION, NY.

city, such as notorious murders and other crimes, for their material. This meant that authors had to work quickly, investigating these tragedies and quickly exploiting them in popular stage productions. Consequently many late sixteenth-century English dramatists were more like modern journalists than literary artists. At the same time, the late sixteenth century did see the appearance of a group of sophisticated playwrights who became known as the University Wits. The term was at first used disparagingly by the actors in London troupes to describe the more sophisticated tastes and elegant style of a group of playwrights who possessed university training. These included John Lyly (1553–1606), Christopher Marlowe (1564–1593), George Peele (1558–1596), and Thomas Nashe (1567–1601). John Lyly was the first of this group to make his mark upon the theater. Trained at both Oxford and Cambridge, he made his way into court circles in London with the aid of powerful patronage. In his prose literary works Lyly established a complex and ornate style which became known as "euphuism," in reference to the author's first romance *Euphues*, published in 1578. His most successful play was *Endimion*, a work in which his central character Cynthia is a flattering portrait of Elizabeth I. Although euphuism had many imitators, by the end of the century

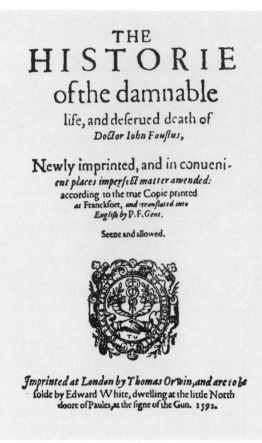

THE HISTORIE of the damnable

life, and deſerued death of
Doctor Iohn Fauſtus,

Newly imprinted, and in conueni-
ent places imperfect matter amended:
according to the true Copie printed
at Franckfort, *and translated into*
English by P.F.Gent.

Seene and allowed.

*Jmprinted at London by Thomas Orwin, and are to be
ſolde by Edward White, dwelling at the little North
doore of Paules, at the ſigne of the Gun. 1592.*

Title page of *The Historie of the Damnable Life, and deserved death of Doctor John Faustus*, the source of Christopher Marlowe's famous play. THE DEPARTMENT OF RARE BOOKS AND SPECIAL COLLECTIONS, THE UNIVERSITY OF MICHIGAN LIBRARY. REPRODUCED BY PERMISSION.

a new fashion for fast-paced dramas made Lyly's ornate verse and stately prose seem old fashioned.

MARLOWE. The greatest of the university-educated playwrights of the time was Christopher Marlowe, who had been born the son of a Cambridge shoemaker and later attended the university in his hometown. The queen's minister Thomas Walsingham recruited Marlowe as an undergraduate to spy for England. He traveled to France where he uncovered evidence of plots being staged against England's monarch. Returning to Cambridge, he received the MA in 1587, but only after a row with his college's administrators, because Marlowe refused to take holy orders, a condition of the scholarly stipend he had received to this point. He settled in London, sharing rooms with the playwright Thomas Kyd and making acquaintances with powerful friends at court, including Sir Philip Sydney and Sir Walter Ralegh. In the very same year that he arrived in the city, he startled London viewers and actors with his innova-

tive play, *Tamburlaine the Great*, the first English drama to be written in blank verse, a form of unrhymed poetry that was immediately hailed for its great strength of expression. He followed the successes of *Tamburlaine* with *The Jew of Malta*, *Edward II*, and *Doctor Faustus*, all three tragedies. Although the last play is among his most famous, many critics consider *Edward II* (1592) to be his most accomplished work. In it, he relates the story of an ill-fated homosexual king murdered by his powerful barons in a plain, but powerful style. Before Marlowe's time, the writing of historical plays had been a relatively crude dramatic genre. In *Edward* he elevated the historical play to a point of high art, one that was to be extended even further in the early seventeenth century by the great histories of Shakespeare. Of the three masterpieces that Marlowe wrote in the final years of his short life, *Dr. Faustus* has been much revived in the twentieth century. It was the most religious of Marlowe's creations, with its personification of the battle between good and evil and its powerful condemnations of the overweening pride of humankind. In 1593, Marlowe came under suspicion of heresy; he appeared in court to answer charges that he had uttered "atheistic" statements. On his way he was killed at the home of Eleanor Bull, apparently in a quarrel, although mystery has long surrounded the precise circumstances. It appears plausible that the playwright's espionage activities doomed him to an act of official assassination.

OTHER PLAYWRIGHTS. Other members of the circle of university-educated playwrights in London—George Peele, Robert Greene, and Thomas Nashe—each produced interesting works that shaped the tastes of lesser dramatists. After graduating from Oxford, George Peele came to London where he at first staged civic pageants and wrote ceremonial verses for the court. After writing several works of middling quality, Peele completed *The Old Wives Tale*. The work satirized contemporary dramatic genres and displayed a warmhearted comedic style. Thomas Nashe, a Cambridge-educated playwright, seems to have been altogether more tempestuous. Seemingly expelled from Cambridge before he took the MA, he came to London around 1587 and began to collaborate with Marlowe on the writing of *Dido, Queen of Carthage*. Several years later he established his literary reputation with the publication of a short pamphlet, *Pierce Penniless*, that told the story of a writer so hard up for cash that he sells his soul to the devil—a fate that Nashe seems to have shared. Several other Nashe pamphlets attacked great figures in the Elizabethan world, and from time to time he fell afoul of the authorities. In 1597, he collaborated

a PRIMARY SOURCE *document*

FAUSTUS' LAMENT

INTRODUCTION: Christopher Marlowe's play, *A Tragical History of Dr. Faustus*, made use of a tale that had recently circulated in Germany about an alchemist who sells his soul to the devil in exchange for magical power and wisdom. Marlowe elevated the original simple story by adding elements of classical tragedy, including the following concluding monologue by Faustus just before he is led off by the devil. For Marlowe, Faustus became symptomatic of humankind's pride and its ambitions of mastering Creation. The play, like Marlowe's earlier and popular work, *Tamburlaine the Great*, helped to establish blank or unrhymed verse's popularity upon the Elizabethan stage.

Ah Faustus,
Now hast thou but one bare hour to live,
And then thou must be damned perpetually.
Stand still you ever moving spheres of heaven
That time may cease, and midnight never come.
Fair Nature's eye, rise, rise again, and make
Perpetual day, or let this hour be but a year,
A month, a week, a natural day,
That Faustus may repent, and save his soul,
O lente lente curite noctis equi:
The stars move still, time runs, the clock will strike,
The devil will come, and Faustus must be damned.
Oh, I'll leap up to my God. Who pulls me down?
See, see where Christ's blood streams in the firmament,
One drop would save my soul, half a drop, ah my Christ.
Ah, rend not my heart for naming of my Christ,
Yet will I call on him, oh spare me Lucifer!
Where is it now? 'tis gone:
And see where God stretches out his arm,
And bends his ireful brows:
Mountains and hills, come, come, and fall on me,
And hide me from the heavy wrath of God.
No, no, then will I headlong run into the earth:
Earth gape, O no, it will not harbour me.
You stars that reigned at my nativity,
whose influence hath allotted death and hell,
Now draw up Faustus like a foggy mist,

Into the entrails of yon' laboring cloud,
That when you vomit forth into the air,
My limbs may issue from your smoky mouths,
So that my soul may but ascend to heaven.
Ah, half the hour is past.

[The clock strikes the half hour]

'Twill all be past anon.
Oh God, if thou wilt not have mercy on my soul,
Yet for Christ's sake, whose blood hath ransomed me,
Impose some end to my incessant pain,
Let Faustus live in hell a thousand years,
A hundred thousand, and at last be sav'd.
O no end is limited to damned souls,
Why wert thou not a creature wanting soul?
Or, why is this immortal that thou hast?
Ah Pythagoras' metempsychosis were that true,
This soul should fly from me, and I be changed
Unto some brutish beast. All beasts are happy, for when
 they die
Their souls are soon dissolved in elements,
But mine must live still to be plagued in hell.
Curst be the parents that engendered me.
No Faustus, curse thy self, curse Lucifer,
That hath deprived thee of the joys of heaven.

[The clock strikes twelve.]

O it strikes, it strikes, now body turn to air,
Or Lucifer will bear thee quick to hell.
Oh soul, be changed into little water drops,
And fall into the Ocean, ne'er be found.

[The devils enter]

My God, my God, look not so fierce on me.
Adders, and Serpents, let me breathe a while.
Ugly hell, gape not, come not Lucifer,
I'll burn my books, ah Mephistopheles!

[Faustus exits with the devil.]

SOURCE: Christopher Marlowe, *A Tragical History of Dr. Faustus* (London, 1604): fol. F2-F3. Spelling and punctuation modernized by Philip M. Soergel.

with the playwright Ben Jonson in writing *The Isle of the Dogs*, a drama produced at the Swan Theater which caused such an uproar, the Queen's Privy Council issued an order for the destruction of all London's theaters. Although the destruction never took place, the theaters remained closed for several months, and the scandal forced Nashe to flee town. The reason for such a violent reaction has long remained a mystery, since the government

immediately seized and destroyed all copies of the text. The author Thomas Kyd (1558–1594) is today remembered for a single masterpiece, *The Spanish Tragedy*, first produced around 1589. Unlike his roommate Marlowe, Kyd was not university-educated although he had received primary and secondary schooling in London. He had studied Seneca's tragic forms, and he adapted these as the structure for his famous tragedy. While the work

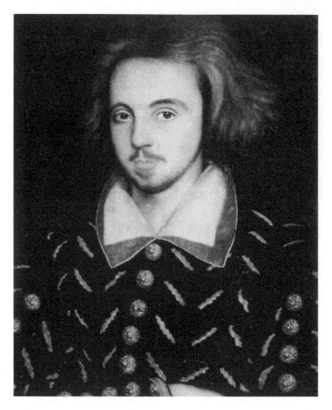

Christopher Marlowe. THE GRANGER COLLECTION, NY. REPRO-
DUCED BY PERMISSION.

is a masterpiece in its own right, it has long been seen
as the model for Shakespeare's even greater and far bet-
ter known seventeenth-century tragedies. Long standing
but unproven theories have speculated that Kyd also
wrote a version of the story of *Hamlet* that has since been
lost, but which influenced Shakespeare in the writing of
his play. He died in 1594 after having been implicated
in heresy together with his roommate Marlowe. Kyd had
been tortured to give evidence against Marlowe, and
never seems to have recovered fully from his wounds.

JONSON. Another great playwright who was per-
fecting his craft as the century drew to a close was Ben
Jonson (1572–1637) Jonson went on to write a series of
brilliant comedies in the years between 1605 and 1614.
This achievement came after a long period of appren-
ticeship, in which he followed a variety of careers and
became embroiled in several controversies. After receiv-
ing a brilliant education at the public school in West-
minster under the direction of the English humanist
William Camden, he served for a time as a bricklayer
with his stepfather. He then became a mercenary who
fought in Flanders, before going to London to try his
fortunes as an actor. In 1597, he worked with Thomas
Nashe on the ill-fated play, *The Isle of the Dogs*, the work

that for a time threatened to extinguish the London the-
ater altogether. A year later he became embroiled in an-
other court trial after killing a fellow actor in a duel, and
he narrowly escaped execution by pleading that he was
a member of the clergy. The independent streak that
Jonson continued to display throughout his life might
easily have snuffed out the life of a lesser soul. Many Tu-
dor playwrights died in brawls or fell afoul of royal and
civic authorities, but Jonson survived to write a series of
fine works, most of which date from the period between
1605 and 1614. King James I frequently recruited him
to produce formal masques for the court.

SHAKESPEARE. England's greatest poet and play-
wright is also in many respects the country's most enig-
matic and least known. Unlike the university wits that
stormed onto the new commercial stage in London in
the late sixteenth century, Shakespeare did not possess a
higher education. Little is known about his early life, in
part, because the author seems to have lacked the desire
for self-promotion typical of the more flamboyant fig-
ures like Marlowe, Kyd, and Nashe. He was born in
Stratford-upon-Avon, the son of a prosperous local glove
maker and one of the town's councillors. He likely at-
tended a local school, but he may not have completed
his education. His father's business soon went bad, and
the future playwright seems to have entered into a hasty
marriage with Anne Hathaway in 1582, just as he turned
eighteen. Six months later the couple had a daughter,
who later married a prosperous local physician. The mar-
riage also produced twins in 1585, one of whom died at
age eleven, the other surviving to live a long life. Be-
tween the births of these children and 1592, nothing is
known of Shakespeare's life. He may have left Stratford
to tour with a troupe of London actors, as some have ar-
gued. But in 1592, the first notice of Shakespeare as a
writer establishes that he was already well known on the
London scene. The university wit Robert Greene referred
to Shakespeare in one of his own plays as an "upstart
crow" and hinted that the author had plagiarized some
of his verses from other dramas.

PLAYWRIGHT. Other evidence suggests that at this
time Shakespeare served a kind of apprenticeship along-
side professional playwrights in the city, and scholars
have identified a long list of plays in which the author
may have played a role. But since many of the texts used
in late sixteenth-century theaters were the products of
players, troupes, and groups of authors, it is impossible
to identify Shakespeare's contributions with any kind of
certainty. In 1594, Shakespeare bought into the com-
pany of the Lord Chamberlain's Men, a popular troupe
in the city. How he earned or received the capital to do

so has never been established, but some evidence suggests that the powerful Earl of Southampton was his patron at the time. By 1594, Shakespeare had already completed three of his famous comedies: *The Comedy of Errors, Two Gentlemen of Verona,* and *The Taming of the Shrew.* Other works from this early period included his famous *Richard III* and *Titus Andronicus.* In this period Shakespeare lived close to the Theater, which was still on its original site in Shoreditch, and in the years between 1594 and 1598 he continued to write plays, usually at the rate of about two each year. *Love's Labour's Lost, A Midsummer Night's Dream, The Merchant of Venice,* and *Romeo and Juliet* are among the best known dramas from this period of Shakespeare's first maturity. As the uproar over the production of *The Isle of the Dogs* threatened London's theaters with permanent closure, Shakespeare began to invest in other businesses, including a brewery. Even though the crisis the play occasioned eventually subsided, the playwright's fears of the uncertainties of theatrical life seem to have persisted. He later bought several properties to secure his future. Besides threats of closure, the examples of many of his fellow playwrights who fell victim to charges of heresy and sedition no doubt deepened his concern. In 1599, the Lord Chamberlain's Men moved into the new Globe Theater in Bankside, a building constructed from the remains of Burbage's original Theater in Shoreditch. In the first decade of the troupe's residency at the facility Shakespeare produced his greatest works. These included his finest comedies, *Much Ado About Nothing, Twelfth Night,* and *As You Like It;* his great Roman historical plays and tragedies, *Julius Caesar* and *Antony and Cleopatra;* and the tragedies *Hamlet, Macbeth,* and *Othello.* By 1613, this extraordinary period of creativity and productivity was largely at an end. In that year the Globe Theater burned down, and the author seems to have retired from any further involvement with his company. It has never been determined whether Shakespeare spent the last years of his life in London or in Stratford.

TUDOR ROOTS OF STUART ACHIEVEMENT. The enormous achievement of Shakespeare, an achievement that belongs more to the seventeenth than the sixteenth century, can easily obscure the other craftsman-like, accomplished, and even brilliant playwrights who plied their craft in the Elizabethan period. While much drama in this period was little more than crowd-pleasing and soon forgotten after its initial performances, many playwrights produced truly great works in Elizabethan London. Had Shakespeare never written his later plays, the achievements of Thomas Kyd or Christopher Marlowe might now loom as large as *Hamlet* or *Macbeth.* The

plays of the late sixteenth century garnered the attention of the urban population and forged an art form that was distinctly middlebrow, aimed as it was at a broad, truly popular audience. Within forms that audiences found pleasing, many of England's most learned playwrights still managed to elevate their dramas and at the same time make their moral, political, and intellectual pronouncements intelligible to a wide swath of the urban population. In this way, learned authors played an important role as transmitters, both of the knowledge contained in older medieval traditions as well as that drawn from the newer humanist learning of the Renaissance.

SOURCES
M. Banham, ed., *The Cambridge Guide to World Theatre* (Cambridge, England: Cambridge University Press, 1988).

E. K. Chambers, *The Elizabethan Stage.* 4 vols. (Oxford: Oxford University Press, 1996).

G. K. Hunter, *English Drama, 1586–1642* (Oxford: Oxford University Press, 1997).

S. Mullaney, *The Place of the Stage: License, Play, and Power in Renaissance England* (Chicago: University of Chicago Press, 1988).

S. Trussler, *Cambridge Illustrated History of British Theater* (New York: Cambridge University Press, 1994).

RENAISSANCE THEATER IN SPAIN

TRENDS. The theater of Renaissance Spain was similar in many ways to the rest of Europe, although it displayed a number of innovative developments. Religious dramas, much like the great mystery cycles of France, England, and Germany, had been important in Iberia in the later Middle Ages. Since Muslim forces had held much of Spain during the Middle Ages, these religious dramas had developed earliest in Catalonia, the northeastern region of the country and the first to expel the influences of Islam. As the Reconquest of the peninsula proceeded, religious dramas developed in those places recaptured from the Muslims. In the absence of a widespread Reformation in the sixteenth century, many of these dramas survived into the seventeenth and eighteenth centuries, and some even into modern times. During the sixteenth century, the Feast of Corpus Christi, long the most important time for theatrical spectacles and dramas, continued to be a force in local religion. While evidencing these conservative elements, new religious forms of drama came to flourish as well, some inspired by the Counter-Reformation. As they did elsewhere in Europe, the Jesuits used school drama in

Spain to perfect their students' Latin, although over time the Jesuit Theater produced plays in Spanish as well. The adoption of Spanish was not so much an innovative element of the sixteenth-century Jesuits, but a bow to long-standing tastes. Latin had not been used extensively in the Spanish religious dramas that flourished in the peninsula during the later Middle Ages. Instead the vernacular or local languages had long been the preferred medium of expression. At court and church festivals in the sixteenth century a genre of *Autos sacramentales*, or religious plays on various themes, came increasingly to be dominated by professional playwrights and producers. A final important trend in the Renaissance theater in Spain, as elsewhere in Europe, was the growth of troupes of itinerant professionals, the first evidence of which comes to us from the 1540s. Both Italian *Commedia dell'Arte* groups and native professionals toured the peninsula in the late sixteenth and seventeenth centuries. As in England and other parts of Europe, these groups often raised the ire of local authorities that complained that the itinerants were little more than thieves and tricksters. Spanish troupes displayed from the very start a love not only of drama but also of dance and song, and the street performances that were common in Iberia were eclectic, mixing elements of all the dramatic arts. While feared as a source of disorder, these very same performers integrated their dancing and theatrics into the celebration of local religious festivals at the request of church and civic officials.

COURT. Politically, modern Spain was a country that was still very much in the process of being created in the sixteenth century. While the two largest kingdoms in Iberia—Castile and Aragon—had been joined in the late fifteenth century by the dynastic marriage of Ferdinand of Aragon and Isabella of Castile, Spain was ruled for much of the sixteenth century as two separate kingdoms, each with their own law code, customs, and civic liberties respected by the Habsburg dynasty. Both Charles V (r. 1516–1558) and Philip II (r. 1556–1598) presided uneasily over powerful noble families who were jealous of their ancient rights. In addition, strong traditions of civic liberty in Spain further limited the authority of these rulers in the towns. Even though Charles V was the grandson of Ferdinand of Aragon, he had been raised in the Burgundian lands in the Netherlands, long one of the most elaborate and spectacular courts in Europe. Although he introduced some elements of Burgundian spectacle into Spanish court life, Charles tread carefully, aware of the envy that these displays might produce in his great nobles and urban patricians. And while Philip II was a great lover and patron of the visual arts

and literature, he found elaborate court spectacle distasteful. For a large part of his reign he isolated himself in the Escorial, a combination monastery, church, and royal palace built outside Madrid as a memorial to his father. In these circumstances the dramatic and imposing forms of court life popular in France and other great sixteenth-century courts—royal entries and spectacles, masques, and elaborate banquets—generally played little role in sixteenth-century Spain. The tenor of Habsburg court life in Spain remained altogether more restrained throughout the sixteenth century.

HUMANIST ELEMENTS. Juan del Encina (c. 1468–c. 1530) was the first Spaniard to integrate humanist elements into his dramas and literary creations. Born the son of a shoemaker, he had been christened Juan de Fremoselle, but later changed his last name to Encina. Educated in law at the University of Salamanca, he entered the service of the powerful Duke of Alba in 1492, where he was appointed the master of revels, a position responsible for ensuring that the duke had a steady stream of musical, dramatic, and poetic entertainments. He held this position until 1500, and during these years he wrote fourteen verse plays and more than sixty songs, the lion's share of his literary and dramatic output. His most important achievement lay in the drama, in which he made use of the Renaissance revival of Vergilian eclogue to create religious plays that were pastoral in their imagery. The first of these were only a few hundred lines long, but he gradually expanded the dramas to more than several thousand lines of verse. Over time, they acquired a surer skill and artistry. Although they did little to inspire the great dramatists of the later sixteenth and early seventeenth centuries, they introduced Renaissance forms into Spain and were notable for their conflicted imagery. On the one hand they displayed Encina's deeply Christian sentiments, and on the other, they showed the realities of a court that had a fondness for the erotic and pagan elements of Renaissance classicism. Encina tried to harmonize these two elements into a refined style, and toward the end of his time with Alba he succeeded in producing works of great elegance. The finesse of these later works came after he had made several trips to Rome, and in these plays he adopted a more forthright eroticism. The most experimental of the fourteen dramas was *Plácida and Victoriano*, which was actually staged in Rome during 1513. That work included parodies on the rituals of the church, invocations of pagan deities, and daringly erotic interludes. In the course of the sixteenth century, however, the rapid development of Spanish literature made his bucolic verses seem outdated, and his frank eroticism put his plays on the *Index of Prohibited Books* in 1559. Even in his own

SEVILLE'S Theater

Authorities suspected social criticism in the entertainments of musicians and acting troupes who traveled from city to city, easily escaping prosecution for blasphemy or libel. Always outsiders, these traveling musicians and players were commonly suspected of theft and prostitution. In addition, they often relied on unwritten lines and impromptu exchanges with the audience, difficult evidence for prosecutors attempting to prove blasphemy. These travelers resembled the vagabonds that city officials distrusted so intensely, except that actors were very clever in persuading their audiences. They delighted their street audiences with ribald imitations of nobles and churchmen. Their bawdy songs poked fun at authority and at those who had money. Townspeople might consider them immoral, but they always gathered an eager, happy audience for their unauthorized street performances.

Drama, music, and dance were usually performed by traveling companies, but all three were also an integral part of religious liturgy. The mixture of theater and religion reached its zenith with the founding of the Jesuits' houses in Seville. Many Jesuits used theater and drama to teach virtue and dramatize the life of Jesus and the saints. Students who were taught in the Jesuits' schools became stars in the acting companies in sixteenth- and early seventeenth-century Spain

Although drama was presented on the streets and in the plazas of Seville, the city also had three famous theaters in the early modern period. The Corral de Doña Elvira, which was built in the sixteenth century, was a patio for performances, covered and surrounded by theater boxes and a gallery in back. The city council decided to build the Coliseo in the early seventeenth century so that it could control the performances and profits of the theater. The first Coliseo, finished in 1607, was a modest wooden building. It was replaced by a second Coliseo that was built much more lavishly in 1614. Rich marble and paintings by Diego de Esquivel and Gonzalez de Campos decorated the theater, and a handsome crest of the city council dominated the entry. This Coliseo burned in 1620 and was rebuilt in greater splendor in 1641. After fire destroyed the Coliseo once more in 1659, the city council lacked funds to rebuild it. It agreed to permit Laura de Herrera and her company to use the Coliseo rent-free for the next forty years in exchange for her financing the reconstruction of the theater. ...

The audience seemed to be as responsible for the scandalous reputation of the theater as the actors were, and the city government's efforts to control the audience failed. Custom dictated that men and women be separated in theaters, but separation had not been enforced. In 1627 a city council member declared that permitting women to sit with men in city theaters had resulted in many "offenses to God." He proposed that the city government require men and women not only to sit in separate sections in the theaters, but also to enter through different doors. These regulations only promoted more scandals, like the uproar in 1654 when one man sneaked into the women's section in La Montería and lifted skirts and "touched legs." Although he was imprisoned and then exiled from the city for two years, the women's gallery (called the *cazuela*, or stewing pan) remained one of the rowdiest sections of the theaters.

People came to the theater for fun and celebration. Customarily they brought fruit and cucumbers, and they pelted the actors who displeased them. They also used rattles, whistles, and metal keys to register their approval and disapproval as noisily as possible. In 1643 an audience in La Montería was outraged when the comedy they had come to see was censored by the Inquisition and replaced by a less offensive comedy. The city chronicler who reported the incident said that "lower and popular" people filled the audience on this feast day. Shouting in protest, they jumped up and began breaking the chairs and benches. They threw the pieces around the theater and tore up all the costumes and scenery they could find. The actors, according to the chronicle, fled from "the rabble."

SOURCE: Mary Elizabeth Perry, *Crime and Society in Early Modern Seville* (Hanover, N.H.: University Press of New England, 1980): 151–155.

lifetime Encina disavowed his embrace of pagan eroticism; in 1500, he left the Duke of Alba to pursue a clerical career. Ironically, later Golden Age dramatists revived his elegant Spanish style in the seventeenth century to suggest the unsophisticated nature of peasant speech.

TORRES NAHARRO. Slightly later in 1517, Bartolomé de Torres Naharro (c. 1485–after 1520) pub-lished a collection of poems and nine plays entitled *Propalladia* or *The First Fruits of Pallas*. These plays made use of the firsthand knowledge of humanism and politics he had acquired while living in Italy. The *Propalladia* plays were notable not only for their classical forms but for the work's Prologue which articulated the first dramatic theory in Spain. Torres Naharro argued that there were only two types of dramas: one based on

actual events and the other on imaginary but still believable forms of fiction. Unlike many dramatic theorists at the time who maintained that drama was primarily a literary art, Torres Naharro insisted that plays needed to be performed so that all their elements could be appreciated and comprehended. Among the best known of the *Propalladia* plays is the *Himenea*, a work that deals with the theme of feminine honor; critics have long seen it as a precursor to the many seventeenth-century Spanish plays treating the same theme. In the work Himenea's brother, a marquis, threatens his sister with death for compromising the family's reputation, but the last-minute arrival of her lover and his reasoned arguments stay the marquis's hand. Two of Torres Naharro's *Propalladia* dramas are satires. One, the *Comedia tinellaria*, treats the less than pious behavior of the servants of a cardinal, and the other the *Comedia soldadesca* satirizes a pope's attempts to raise an army. This latter play was a thinly veiled commentary on Julius II (r. 1503–1513), who was known as the "Warrior Pope" since he marched into battle with his troops. In his relatively brief pontificate Julius aimed to expand the secular territory controlled by the papacy and, in so doing, he embroiled the Papal States in a variety of international intrigues. His policies engendered opposition from Europe's two great powers, France and Spain. Thus while Torres Naharro's choice of theme might appear a daring one at first glance, his satirical jabs at the papacy actually fit with Spain's international aims as an opponent of papal expansionism. These plays introduced a sure understanding of the dramatic structures of the ancient Roman playwrights Terence and Plautus into Spain. At the same time their author also made use of native literary traditions. His works, for instance, evidence an indebtedness to the *Celestina*, a popular novel written in prose dialogue around 1500. The *Celestina*'s author had intended the work to be read out loud rather than staged, and its dramatic, sometimes highly emotional style finds its way into Torres Naharro's plays. Spanish playwrights imitated this lively style in the following decades, although no figure seems to have developed the same finesse or to have acquired a following as large as Torres Naharro in the decades that immediately followed the *Propalladia*. Instead court spectacles staged in the palaces of the country's grand nobles and religious dramas were the dominant theatrical forms of the mid-sixteenth century.

PROFESSIONAL THEATERS. If the mid-sixteenth century produced little in the way of drama that was innovative, it saw at the same time the rise of commercial theaters in Spain's largest cities. In Italy, the ducal courts had largely supported the construction of both temporary and permanent theaters. In France and England, these endeavors had been from their first inception more commercial in nature. At Paris, the late-medieval guild of amateur actors, the Confraternity of the Passion, possessed a royal monopoly over dramatic performances in the city—a right that they were willing to share with other traveling troupes in exchange for money payments. The pattern in England was again slightly different, with the crown granting license patents to companies that fell under the cloak of patronage from nobles and other distinguished subjects of the realm. Spain's commercial theaters evidenced yet a third pattern of development, since from the first they were supported by the charitable confraternities or brotherhoods that ran urban hospitals. These brotherhoods ran the theaters as commercial ventures to support their charitable activities. These theaters first began to appear in Madrid, not long after the city had been chosen as the center of royal government in 1561. Until this time Madrid had been a relatively sleepy provincial town, perched on the high central plain of Spain. After Philip II's decision to build his royal palace, the Escorial, outside the city and to move the offices of royal administration to the town, a period of explosive growth began. By 1600, the population had more than tripled, and twenty years later these numbers were almost seven times the city's size in 1560. This expansion in population produced a corresponding rise in the number of professional theaters located within the city. The first of Madrid's *corrales*—known as such because they were at first merely closed-in yards or "corrals"—was built in 1579. The second came in 1582, and by 1630 there were seven theaters in the city, making Madrid second only to London in the vibrancy of its dramatic life. Each of these theaters contained a large yard surrounded by a U-shaped gallery of boxes arranged in tiers facing the stage. The most visible and desirable of these boxes frequently rented for more than twenty times the admission to the pit-like floor. With this arrangement of space the average Madrid theater could accommodate about 2,000 spectators, about a third smaller than the largest theaters in London at the time but nevertheless an enormous auditorium given Madrid's size (about 130,000 inhabitants in 1620). At their inception these structures were merely functional, quickly erected in yards that surrounded the confraternal hospitals. Over time, however, as the new professional theaters spread to other Spanish cities, more sophisticated designs emerged. By the end of the sixteenth century theaters had been built in every large Spanish town, and although plays were widely popular, the theater was also controversial. As elsewhere in Europe, the new professional the-

aters inspired attacks from Christian moralists, and the Council of Castile, the body charged with regulating actors, granted licenses to only a small number of troupes. Censorship was strict, and a royal official viewed each play before it could be shown to the public. But in Spain, in contrast to most places in Europe at the time, there was no prohibition on women actors. The regulations governing their roles were relatively liberal, allowing them to even dress as men when their parts called for it.

RISE OF GOLDEN AGE. The early years of the new Renaissance professional theater produced no dramatist of distinction, but the rising popularity of the institution attracted a number of great playwrights to the stage after 1600. The seventeenth century in Spanish art and culture has long been known as the Golden Age. This great flowering of the arts came at a time when Spain's international political influence and its national economy were in decline. By 1600, in fact, the great period of Spanish expansion was at an end. Thus the great flowering of Spain's high culture developed, as in High Renaissance Rome, at a time of increasing political tensions and an ever more precarious domestic situation. New immigrants flooded Spain's growing cities, fleeing an increasingly impoverished countryside. In the newly swollen cities, an all-too modern cycle of structural poverty and crime developed. In this new environment the theater provided a welcome and often relatively cheap release from some of the more harrowing aspects of urban life. As in England, the culture of humanism had made its impact on Spain during the Renaissance. Yet in the new commercial realities of Spanish cities, where numbers were increased by thousands of new immigrants from the countryside annually, Golden Age dramatists were never able to adopt Renaissance forms in a pure way. Instead they had to please crowds with dramas that were relatively quick moving and geared to middlebrow tastes. The five-act style of comedy that had been favored in ducal courts in Italy because of its roots in Terence and Plautus did not prevail in Spain. In the summer, performances began in Madrid's corral theaters at 4 p.m.; in the winter when sunlight was more limited they commenced two hours earlier. With these practical considerations in mind there was no place for the elaborate five-act comedies of Renaissance Italy, which had frequently been extended to great lengths through the staging of interludes and other spectacles between the acts. The demands of the new theater were instead for crowd-pleasing, fast-paced action that would leave the audience craving for more.

EMERGING FORMS. Miguel de Cervantes and the other great figures of the early Golden Age thus attempted to adapt classical forms to native traditions and Spanish realities. In the plays that he wrote around 1600 Cervantes relied on a four-act structure, and he drew a clear distinction between tragic and comic forms. One of his earliest successes, *Numancia*, dealt with a tragic event from Spain's ancient past, the destruction of the Celtic Iberian city of Numantia in the second century B.C.E. The play has since seen many revivals at crisis points in Spanish history, as, for instance, during the Napoleonic Wars of the early nineteenth century and in the Spanish Civil War (1936–1939) of the twentieth. It did not produce a wide circle of admirers, though, when first staged in the early seventeenth century. By 1615, shortly before his death, Cervantes tried to adapt to a new style, shifting the directions of his theatrical writing to conform to a quicker paced three-act comic formula. By then, the author's taste for grand themes, carefully and subtly elaborated, had marked many of his earlier plays as outdated. He published eight of his plays in the new three-act formula, a formula that owed its existence to the rising popularity of works by Lope Felix de Vega Carpio (1562–1635). In his plays Lope drew no distinction between comic and tragic forms, dividing each of his plays into a three-act production—a factor that made them relatively easy to stage in the emerging commercial houses. He also relied on quick action coupled with witty, octosyllabic verses—traits that were very different from Cervantes' Renaissance sensibilities, with their tendency toward the gradual elaboration of grand themes. Into his new three-act formula Lope poured historical, religious, and mythological themes, and at the height of his popularity he completed a new play every few weeks. In his lifetime he may have written as many as 1,800 dramas, and the more than 300 of these that survive today show that he had a tremendous talent for creating engaging and appealing works. Still, despite this enormous productivity, great variety exists in his enormous opus—so much variety, in fact, that scholars are still finding hidden treasure in his works today. Lope often started with a scenario drawn from his reading of history, an incident from Spain's past, from the lives of the saints, or from mythology. To each of his creations he brought a fresh perspective, so that even plays that seem to share similar themes are, upon closer inspection, very different from one another. When he died in 1635, his funeral became an event of public mourning in Madrid. By that time, though, his example had inspired many other authors in Spain to undertake writing for the stage. By 1632, for instance, one commentator listed almost eighty contemporary playwrights active in Castile alone. Some of these figures were as prolific as Lope de Vega, and as a result thousands of plays survive from seventeenth-century Spain.

TOWARD THE FUTURE. The enormous outburst of dramatic creativity that appeared in both Spain and England as the Renaissance faded into the new Baroque sensibilities rested on a firm foundation of native tradition and classical models. Like much of the theater of England in the years immediately following 1600, Spain produced many excellent, mediocre, and bad dramas at the same time. The enormous popularity of the new commercial theater reveals important changes that were at work in European society. In place of the community plays staged in the Middle Ages, the tendency appeared for drama to be mounted more and more by a paid cast of professional actors whose primary job was to entertain. Although seventeenth-century society remained vastly poor by modern standards, the increasing division of labor that was appearing in these societies, coupled with rapid urbanization, produced a public with more leisure time, more disposable cash, and a discriminating taste for the drama, indeed for all entertainments. The results of this transformation, rooted in subtle shifts of taste and larger economic realities, helped sustain the theater as one of Europe's most important art forms into modern times.

SOURCES

M. Banham, ed., *The Cambridge Guide to World Theatre* (New York: Cambridge University Press, 1988).

M. McKendrick, *Theatre in Spain 1490–1700* (Cambridge: Cambridge University Press, 1989).

M. Wilson, *Spanish Drama of the Golden Age* (Oxford: Oxford University Press, 1969).

SIGNIFICANT PEOPLE
in Theater

LUDOVICO ARIOSTO

1474–1533

Poet
Dramatist

LIFE. Humanist studies shaped this future poet's early life. Born the son of a count and a scholar, Ariosto received instruction from the humanist Luca Ripa before attending the University of Ferrara in northern Italy. Like many future poets and literary figures, Ariosto originally planned for a career in law, but during his student years he continued to embrace humanist studies, delivering the annual address that commenced the starting of the university's academic year in 1495. By 1500 Ariosto's father's death brought new responsibilities to the young philosopher, who was now responsible for the other members of his family. To deal with the financial responsibilities, he joined the court of Cardinal Ippolito D'Este, a prominent high-ranking church official and a member of the ruling house at Ferrara. In this capacity he fulfilled a variety of roles, among them conducting diplomatic journeys to other courts in Italy. Ariosto stayed with the cardinal until 1517, when he was dismissed for refusing to follow his employer on a trip to Hungary. The poet soon found employment with the cardinal's brother, Alfonso I, who was then ruler of the duchy of Ferrara. Although Ariosto frequently complained about his employment with the D'Este family, he maintained good relations with Ippolito and Alfonso's sister, Isabella D'Este, one of the most cultivated court ladies of the Renaissance. Isabella D'Este, herself a duchess of Mantua, was one of Ariosto's trusted correspondents, and he kept her informed of the progress on his major epic poem, the *Orlando furioso*, or *Mad Roland*. In Alfonso's employment Ariosto was given a position as a remote official in a mountainous region between Ferrara and Florence. Although he dispensed these duties admirably, he disliked life outside the city, and he eventually returned to Ferrara. To further his career, Ariosto had earlier taken holy orders, but in 1528 he secretly married Alessandra Benucci and the two indulged their love for literature during Ariosto's final years. Shortly before his death Ariosto also prepared a final edition of his *Orlando* for publication, lengthening the work to its present state.

DRAMA. By the end of the fifteenth century Ferrara enjoyed an enviable reputation as the most cultivated court in Italy. As a humanistically educated figure, Ariosto was able to read Greek and Latin, and his dramatic works and poetry bear the influence of that early training. At the same time the author was a path breaker who adopted influences not just from the classical past but also from medieval romances and epics and even from the language of the contemporary street. Much of the tone of what he wrote was satirical, and he directed his wit gently against the confines of contemporary court life. To each project he brought a cultivated, yet imaginative perspective. His works did not slavishly imitate Antiquity. Instead he creatively reworked his inspirations into new forms that, in turn, inspired their own imitators. In the generation before Ariosto came to maturity the court at Ferrara had emerged as one center in which the ancient Roman comedies of Plautus and Terence were enthusiastically studied. Since the 1470s the D'Este

family had supported the revival of classical comedy by undertaking an annual festival in which the dramas of Plautus and Terence were performed. To underscore their court's great learning, the comedies were usually performed in their classical Latin, with a separate production staged in Italian translation following the original. Ariosto may have acted in one of these productions during the 1490s, but by 1510, he had produced two works that made use of the conventions of the ancient dramatic form: *The Coffer Comedy* and *The Pretenders*. These plays proved to be influential in establishing Italian erudite comedy, a new genre in which Roman dramatic forms inspired plays about daily life in contemporary times. In the preface to the printed version of *The Pretenders* Ariosto explained his own ideas about the imitation of classical models. He stressed an idea that was popular at the time among Italy's artists and authors, that is, that the imitation of classical models provided a secure form in which one's own native creativity could flourish. This imitation, he warned, should not strive merely to recreate Roman drama. Instead contemporary playwrights should evidence a creativity similar to that of the ancient Romans when they adapted Greek forms for use in their own theater.

IMPACT. In their day Ariosto's comedies were an important force in establishing the new theatrical forms of erudite comedy in Italy. Later writers in Northern Europe and Spain also made use of them for material for plays in their own language. Shakespeare adapted some scenes of *The Pretenders* in his comedy *The Taming of the Shrew*. Ariosto published several of his comedies in both prose and verse versions, and thus his works inspired writers anxious to develop comedy in both forms. While the comedies were important in sixteenth-century Italy, the author's *Orlando furioso* was an even more inspiring work of fiction. A long epic poem that treated the exploits of Roland, a figure in the early medieval court of Charlemagne, was set against the backdrop of Christian-Muslim conflict, a theme that seemed strikingly contemporary to sixteenth-century Europeans as they waged battle against the expansion of the Turks in the Mediterranean and Eastern Europe. The *Furioso* continued to inspire poets, playwrights, and musicians until the nineteenth century. Among the artists who relied upon its vast scope were Lope de Vega in seventeenth-century Spain and the composer Georg Frederich Handel and the painter Fragonard in eighteenth-century England and France, respectively.

SOURCES

L. G. Clubb, *Italian Drama in Shakespeare's Time* (New Haven, Conn.: Yale University Press, 1989).

D. Javitch, *Proclaiming a Classic: The Canonization of Orlando Furioso* (Princeton, N.J.: Princeton University Press, 1991).

D. Looney, *Compromising the Classics: The Canonization of Orlando Furioso* (Detroit, Mich.: Wayne State University Press, 1996).

ALEXANDRE HARDY

c. 1575–1632

Playwright

LIFE. Little is known about the circumstances of the French playwright Alexandre Hardy's early life or education. He was born sometime around 1575, but later attempts by theater historians to construct his biography must be looked at cautiously, since few documents survive that allow us to construct his life. Like the Golden Age Spanish playwright, Lope de Vega, Hardy was similarly prolific, although his crowd-pleasing style has more similarities to the popular commercial theater of the Renaissance than to the greater finesse achieved during the great age of achievement that developed in French theater by the mid-seventeenth century. In a long career Hardy claimed to have written more than 600 plays. Unfortunately, only 34 of these survive, a sampling that allows us to gauge his talents, which most critics have insisted lay in his lyrical poetic style. Hardy's plots, by contrast, were often problematic, although his plays had a wide appeal.

At the time Hardy wrote for the Parisian stage, the medieval Confraternity of the Passion still controlled Paris's chief theater, the Hôtel de Bourgogne. In 1402 the French crown had given the Confraternity a monopoly to stage religious plays in Paris. The organization developed as a guild of amateur actors until 1548, when the local Parliament or town council outlawed the staging of the traditional religious mystery cycles. In the same year, though, the confraternity remodeled a hall inside the former residence of the Dukes of Burgundy in the city, the Hôtel de Bourgogne, and began to stage farces and other light entertainments before a paid audience. The group also rented out their facility to other troupes, and because they still possessed a medieval monopoly, anyone hoping to stage a drama in Paris had to do so under their auspices. In effect, the Confraternity thus became the chief royal censors, charged with inspecting the material that was to be performed before Parisian subjects. The theater in the Hotel de Bourgogne flourished for a while, but during the French Wars of Religion (1562–1598), civil disruption in France exacted a toll on its popularity. Most tragedies written during this period

served as a kind of literary commentary on the bleak course of the wars and never made it to the stage. Light comedies continued to be written and produced, but the 1570s and 1580s produced scores of plays that have long since been forgotten. Around 1600, Alexandre Hardy, working in tandem with Valleran Le Conte, advanced the development of a popular, commercial theater in France. In 1599 Le Conte brought his company of players to the city from the provinces for a three-month term at the Hôtel de Bourgogne. Hardy may have already been connected to the group as an actor or writer at this time, or his connections may have developed somewhat later. But over the next thirty years he wrote for Le Conte's company a series of immensely popular successes. Like many theaters at the time, the Hôtel de Bourgogne was a scene of raucous and bawdy humor and of audiences that might erupt into fistfights at any time. By keeping his audience in rapt attention, Hardy ensured that the fighting was on the stage rather than in the theater's pit. His plays were action packed, with many short scenes and frequent plot twists. They were also graphic and visually spectacular in a way similar to the medieval mysteries. Arms were severed, eyes plucked out, and nothing seems to have been left to the imagination. In addition, his works called for spectacular special effects, all of which garnered for the Le Conte troupe a wide audience in the city of Paris. Hardy drew his subjects from classical Antiquity or from later historical events, and he displayed a fondness for making these events into tragedies and tragicomedies. These dramas show that he must have possessed a smattering of humanist education, but, unlike later French playwrights of the seventeenth century, he did not imitate Aristotle's classical definitions of tragedy. Instead he thrust the action of his dramas forward through a true dramatic sense of how a play should unfold. While Hardy's plays are not important in the modern French repertoire, his career nevertheless advanced the history of the French stage. When Hardy arrived on the scene in Paris around 1600, the French theater was dominated by short farces, interludes, and other genres that were largely traditional. Tragedy had, by and large, made little impact on French drama, outside of the Senecan-styled tragedies that were read by a learned audience. Hardy relied on the form and created an audience for staged tragedies, and in so doing he created commercial successes. He also seems to have been the first French playwright to earn his living exclusively from the theater. Although his plays certainly lacked the finesse and elegance of the later French masters Racine, Corneille, or Molière, it is difficult to imagine how these playwrights could have achieved their successes without the audience that Hardy created for them.

SOURCES

M. Banham, ed., *The Cambridge Guide to World Theatre* (New York: Cambridge University Press, 1988), s.v., Hardy, Alexandre.

S. W. Deierkauf-Holsboer, *Vie d'Alexandre Hardy, poète du roi, 1572–1632* (Paris: Nizet, 1972).

G. Kernodle, *The Theatre in History* (Fayetteville, Ark.: Arkansas University Press, 1989).

CHRISTOPHER MARLOWE

1564–1593

Playwright

EARLY LIFE. Marlowe grew up in Cambridge, the home of England's famous university. His father was a local shoemaker who had settled there after traveling about the country as an itinerant worker, and the young Marlowe was educated as befitted the family's rise in status. At fifteen he received a scholarship set aside for poor children at a secondary school, and a few years later he entered Corpus Christi College at the university. Under the terms of his scholarship Marlowe could receive four years of support, but he could extend this term another three years by promising to enter the clergy, which he did. At the end of his seven years at Cambridge, he took the MA degree, but only after a row in the university caused by his decision to abandon the priesthood. During his later years at Cambridge, Marlowe was also absent for long periods, having been recruited to serve as an agent of the queen by her powerful minister Thomas Walsingham. Walsingham sent Marlowe to the French city of Rheims to investigate rumors of plots being hatched there against Elizabeth. Later these duties undertaken for the queen excited rumors that Marlowe had converted to Roman Catholicism while in France. At the time of the dispute about the awarding of his degree in 1587, however, several members of the Privy Council wrote to the officials at Cambridge to assure them of Marlowe's orthodox Protestant beliefs.

LONDON. Marlowe's first literary endeavor had been a translation of the love poetry of Ovid into English pentameter couplets, a work that he already had undertaken during his days at Cambridge. As he took up residence in London, this capable but sometimes stilted verse can be seen at work in the first play upon which Marlowe worked, *Dido, Queen of Carthage.* In the city Marlowe came into contact with the University Wits, a group of educated and urbane men who were then beginning to write for the London stage. He seems to have worked on *Dido* with one of the wits, Thomas Nashe, and at the

time, he lived with another playwright, Thomas Kyd, author of the wildly popular play *The Spanish Tragedy*. Marlowe's first great success was *Tamburlaine the Great*, a play written late in 1587 and staged early in the next year by the Lord Admiral's Men. In *Tamburlaine* the author demonstrated the powers of simple unrhymed or blank verse. The commanding presence of the Tudor actor Edward Alleyn in the central role also enhanced performances of the play. *Tamburlaine*, however, was a morally ambiguous play by the standards of the time. Most Tudor drama up to this point had sought to defend queen, country, and conventional mores as orthodoxies that needed to be upheld at any cost. The central character in Marlowe's work, Tamburlaine, is a peasant rebel who, while doomed to failure, seizes power and founds his own religion. This attack on authority returned to haunt Marlowe at the very end of his life. But in 1588, the drama inspired a number of imitative plays; encouraged by his success Marlowe explored blank verse's potential and other innovative possibilities in his subsequent dramas. These included *The Jew of Malta* (c. 1589), which drew upon some elements of Thomas Kyd's *Spanish Tragedy*; his bleak *Edward II*, which greatly opened up the possibilities of the genre of the historical play (c. 1592); and *Dr. Faustus* (c. 1588–1592).

LAST YEAR. During the last year of his short life, Marlowe experienced a series of adventures, and these may have ultimately contributed to his murder on 30 May 1593. In 1592 an outbreak of plague in the city closed London's theaters for a long period. Like other playwrights, including Shakespeare, Marlowe tried to support himself during the closure by writing poetry for noble patrons. Unsuccessful, he traveled to the Netherlands where he lived in the house of a counterfeiting goldsmith. Marlowe and the goldsmith found themselves denounced to the local English governor in the Netherlands, Elizabeth's agent Robert Sidney, for their part in the counterfeiting scheme, and the two accused each other of intending to defect to Roman Catholicism. During testimony given to Sidney, Marlowe admitted to being an intimate of two high-ranking English Catholics, rivals to Elizabeth I's throne. Although he escaped condemnation and returned to London, he soon fell afoul of the law and the queen's council again. First arrested for disrupting the public peace by London magistrates, he then faced even more serious charges that he was involved in a plot being hatched both by Catholics and atheists to murder the queen. On 18 May 1593, he was arrested and brought before the Privy Council on charges of espionage and blasphemy; although he posted bail, he reported each day before the queen's officials. When

Queen Elizabeth heard evidence of Marlowe's atheistic pronouncements, she commanded that he be prosecuted to the maximum extent allowed by the law, in effect a death sentence. Marlowe was never able to defend himself against these charges. On his way to court, he died after being stabbed in the eye. The murder of Christopher Marlowe has long remained a mystery. The inquest held a few days later concluded that Marlowe's killer, Ingram Frizer, had acted in self-defense following a quarrel over money. But the playwright's long-term involvement in espionage has long made it plausible that Marlowe was murdered because he fell afoul of certain factions in Elizabeth I's court or because of his intimate knowledge of royal affairs. After Marlowe's death London's playwrights celebrated his poetic genius, and his influence lived on in further explorations of blank verse in later plays. At the same time the city's Puritan ministers continued to attack Marlowe's ideas and dramas as blasphemous and as a sign of the decadence and corruption that the public theater bred in urban society.

SOURCES

L. Hopkins, *Christopher Marlowe: A Literary Life* (New York: Palgrave, 2000).

C. B. Kuriyama, *Christopher Marlowe: A Renaissance Life* (Ithaca, N.Y.: Cornell University Press, 2002).

C. Nicholl, *The Reckoning: The Murder of Christopher Marlowe* (London, England: J. Cape, 1992).

M. J. Trow, *Who Killed Kit Marlowe? A Contract to Murder in Elizabethan England* (Stroud, England: Sutton, 2001).

WILLIAM SHAKESPEARE

1564–1616

Poet
Playwright

EARLY LIFE. Myth and conjecture surround the life of England's greatest poet. Shakespeare's date of birth is relatively certain since he was baptized in the parish church in Stratford-upon-Avon on 26 April 1564, and was thus born in the same year as the innovative Tudor dramatist Christopher Marlowe. Shakespeare's father was a prosperous local glove maker who fell on hard times around 1577. Despite this hardship the young Shakespeare probably attended a "petty" or elementary school, followed by a term at the King's New School in Stratford, where he received a Latin education. Typically, a child entered a school like King's at the age of seven and faced long hours of instruction each day. The

student generally devoted himself to the study of Latin from around six or seven in the morning until five in the afternoon. In this traditional curriculum students read Ovid, Terence, Plautus, and Vergil. It was from these relatively modest beginnings that Shakespeare began to cull his encyclopedic knowledge of the ancients, although, unlike the University Wit playwrights popular in late sixteenth-century London, Shakespeare never attended university. Instead he entered into a hastily arranged marriage with Anne Hathaway, who gave birth to a daughter Susanna six months after the couple exchanged their vows. In the years following his marriage Shakespeare scrambled to find some way to support his growing family. While no documents exist to establish his participation, it has long seemed plausible that he first entered a traveling troupe of actors sometime after 1585. No mention of him, either as an actor or playwright, survives until 1592, when the dramatist Robert Greene attacked Shakespeare as an "upstart crow" in one of his own plays. Greene's accusations allow us to determine that Shakespeare was by then already a rising star in the London theater.

QUESTIONS OF AUTHORSHIP. Shakespeare's explosion onto the London theater scene has puzzled historians ever since the eighteenth century, and some have long doubted that the William Shakespeare of Stratford-upon-Avon could actually have written the plays long ascribed to him. A variety of theories still circulate that try to link these plays with other great literary figures of the age. Usually it is suggested that while Shakespeare was an actor upon the London stage, some high-ranking noble who wished to see his dramas performed used Shakespeare's name. This subterfuge, so-called Anti-Stratfordians have long alleged, was necessary because English nobility considered the stage to be a disreputable career. In all Anti-Stratfordian theories one key issue revolves around the playwright's education, since many have long doubted that a figure such as Shakespeare, who lacked a university education, could have written these brilliant dramas, filled as they are with rich classical allusions, knowledge of contemporary science, and a love of history. Among the many Tudor nobles who have been put forward as possible authors for the plays are Sir Francis Bacon, the earl of Southampton; Anthony Bacon; and Edward de Vere, the earl of Oxford. While some experts have espoused these theories, the majority of contemporary scholars discount them. Although many playwrights in sixteenth-century London were university-educated, that was not universally the case. At the time, university training in England largely served those desiring to undertake careers in the church, and it did not necessarily provide the background in literary studies necessary to write great plays. Shakespeare's early training in his grammar and Latin schools, coupled with his own voluminous reading in the classics, could have provided him with a sufficient education.

CAREER. The plays of Shakespeare's early maturity show rich influences from the Roman stage, particularly in his early comedies produced during the 1590s. In time, he acquired a more independent voice, gradually perfecting the history play to a high point of finesse. The first signs of this brilliant transformation can be seen in his *Richard III* (c. 1594). Here he narrated the conflicts of the fifteenth-century War of the Roses through the figure of Richard III, portraying Richard's inept leadership and savagery within a general environment of political disorder and quarreling. Until Marlowe's day, the Tudor history play had often represented a confused jumble of chronicle-styled scenes. In his *Edward II* (c. 1589), Marlowe had first expanded the genre by adding elements of classical tragedy. Shakespeare raised the history play to high art. He followed the initial success of *Richard III* with a brilliant cycle of plays narrating the life of Henry V, and somewhat later by the great Roman historical tragedies of *Julius Caesar* and *Antony and Cleopatra*. Although Shakespeare's writing was already highly polished from the first performances of his plays, he continued to develop and refine these skills, particularly in the period between 1599 and 1610. In these years he produced his greatest works, including the comedies, *Twelfth Night* and *Much Ado About Nothing* and the tragedies, *Hamlet* and *Macbeth*. But there were many other successes that might be added to this list, successes that made Shakespeare a relatively prosperous man in his later years. Around 1611, he seems to have entered into a period of retirement from which he emerged briefly in 1613 to write with John Fletcher the play *Henry VIII*, treating the life of the famous Tudor king. In 1616 he died at the age of fifty-three.

INFLUENCE. The impact of Shakespeare's plays on the development of the English language can hardly be overestimated. Next to the translations of the Bible into English and the *Book of Common Prayer*, Shakespeare shares a unique place in the history of English. His influence over subsequent literature was similarly enormous. Milton, Keats, Wordsworth, the American Herman Melville, and the Russian Leo Tolstoy are just a few of the scores of authors whose works betray influences from Shakespeare. At the same time, the playwright's impact on the theater was similarly profound, as operas, ballets, and other theatrical works have continued to be inspired by his plays into modern times.

SOURCES

N. Frye, *Fools of Time: Studies in Shakespearean Tragedy* (Toronto, Canada: University of Toronto Press, 1967).

I. L. Matus, *Shakespeare, in Fact* (New York: Continuum, 1994).

R. McDonald, *The Bedford Companion to Shakespeare: An Introduction with Documents* (Boston: Bedford Books, 1966).

S. Schoenbaum, *William Shakespeare: A Documentary Life* (Oxford: Oxford University Press, 1975).

TORQUATO TASSO
1544–1595

Poet

Playwright

The last major literary genius the Italian Renaissance produced was Torquato Tasso (1544–1595). His life and work show the influence that the increasingly puritanical tastes of the Counter Reformation produced upon literary fashions in the second half of the sixteenth century. Tasso was born in Sorrento near the city of Naples in southern Italy, where his father Bernardo served as a courtier to the Baron of Salerno. Bernardo was forced to leave that position when he opposed the establishment of the Inquisition in nearby Naples. During the 1550s, Torquato traveled with his father, who had to take a series of insecure court positions in northern and central Italy to support the family. While on these travels, Tasso acquired an excellent education, but he also became familiar with the uncertainties that could plague a courtier's life if he failed to please his prince. In 1560, he entered the University of Padua, where his father wanted him to pursue a legal career that would free him from the need to secure literary patronage. Young Tasso, though, preferred poetry and philosophy to the law, and in these years, he began some of the poems that would eventually establish his fame. He began the chief of these works, *Jerusalemme liberata* or *Jerusalem Delivered*, at this time, although he did not finish it until many years later. Tasso conceived the poem as a chivalric epic similar to those of Ariosto, Boiardo, and Pulci. Its tastes, though, were more moral and religiously profound than these earlier works. While Tasso did not completely abandon the complex plot twists, eroticism, or adventurism of the chivalric romance, he sublimated these features to the higher themes of love and heroic valor.

TRIALS. Completing *Jerusalem Delivered*, though, proved to be a lifelong, tortuous task. After leaving the university, Tasso received patronage from a wealthy and influential cardinal at Ferrara. He had few duties except to write and amuse the cardinal's court in the city of Ferrara. In this environment Tasso circulated his poems, realizing that his works might cause offense in the heightened moral climate of the day. Over time, Tasso grew suspicious of his critics, and he feared being denounced to the Inquisition. He confessed his wrongdoings to the body when he had not even been summoned. Eventually, he stabbed a household servant whom he suspected of spying on him and then fled Ferrara. He left behind his manuscripts for *Jerusalem Delivered* and spent several years wandering through Italy. Later he returned to Ferrara where he denounced his former patrons, who imprisoned him, believing him to be mad. After seven years spent in an asylum, Tasso finally regained his freedom, his sanity, and his writings. His exaggerated, often paranoid fears of being persecuted by the Inquisition colored *Jerusalem Delivered*, and Tasso practiced a thorough self-censorship to avoid giving offense. Nevertheless, he still raised the chivalric tale he told to the level of high art.

DRAMAS. *Jerusalem Delivered* was Tasso's masterpiece, and was quickly recognized as such. Translations of it appeared in France, England, and Spain relatively quickly, and the work became an important source for later dramas. By 1591, the epic poem had been translated into English, and Shakespeare may be among the many artists who adapted scenes from the work in his *Cymbeline*. In his capacity as a court artist at Ferrara, though, Tasso was responsible for composing intermezzi and other dramatic entertainments for the court. Many of these were short and soon forgotten, although the writer still managed to keep up an enormous output. Two of his dramas were more influential: his *Aminta*, (1573) and *King Torrismondo* (1578). *Torrismondo* was a tragedy, inspired by a work of Sophocles that warned of the consequences of illicit love. *Aminta*, by contrast, was a pastoral play and soon became the most influential drama of its kind in the later Renaissance. The play relates the story of a young shepherd poet, Aminta, and his love for the natural but chaste Silvia. Both the setting and the characters are highly idealized, and the play's beautiful love poetry was widely read and copied. The highly respected Gelosi troupe first performed the play at a country villa outside Ferrara in 1573. The play's popularity was, like *Jerusalem Delivered*, immediate, and inspired the writing of at least 200 similar pastorals by the end of the sixteenth century in Italy. Its influence stretched beyond Italy to embrace all European countries, and its conventions and language have been discovered in several later works by William Shakespeare,

including *As You Like It, Twelfth Night,* and *A Midsummer Night's Dream.* In France and Spain imitators of Tasso's *Aminta* similarly garnered a wide audience for Renaissance pastoral.

SOURCES

C. P. Brand, *Torquato Tasso* (Cambridge: Cambridge University Press, 1965).

G. Getto, *Interpretazione del Tasso* (Naples, Italy: Edizioni scientifiche italiane, 1967).

C. Lanfranco, *Ariosto and Tasso* (Torino, Italy: G. Einaudi, 1977).

DOCUMENTARY SOURCES
in Theater

Aristotle, *Poetics* (350 B.C.E.)—Known only in fragmentary and corrupt versions until the late fifteenth century, the *Poetics* inspired a revolution in drama in Renaissance Europe. Aristotle outlined the classical forms used to stage plays in Greek, treated their underlying logic, and stressed that the drama was a living art form that needed to be performed in order to influence human passions.

Everyman (c. 1495)—Originally a dramatic interlude within the much longer morality play, *The Castle of Perseverance, Everyman* became one of the most popular of sixteenth-century plays. It relies on allegorical conventions to chart the progress of an everyday soul through the trials of this world and to final religious consolation. The first surviving manuscripts of the play were written in Dutch, but the text was popular and translated into many languages. It is still performed today.

Niccolò Machiavelli, *The Mandrake Root* (1517)—A popular comedy in early sixteenth-century Florence, Machiavelli's *Mandrake Root* helped to establish the conventions of erudite comedy in Italy.

Christopher Marlowe, *Dr. Faustus* (c. 1490)—This play was a great Tudor theatrical classic based upon a tale that had originated in late sixteenth-century Germany and which was widely distributed in various translations throughout Europe. Marlowe's realization of the theme—a tale in which a Renaissance alchemist sells his soul to the devil in exchange for wisdom—was among the most successful. It relied on the author's vigorous style of blank verse, and resulted in many subsequent adaptations in opera and theater.

Seneca, *Tragedies* (c. 65 C.E.)—The Renaissance knew of these ancient tragedies as early as the fourteenth century. Seneca's dramatic theory stressed that the tragic form was best treated as a literary genre. As a result, tragedies written in the Renaissance were long "closet dramas," intended to be read rather than performed in public.

Sebastiano Serlio, *Architecture* (1545)—This was a major work by an influential architect that shaped sixteenth-century theater design. Serlio wrote his *Architecture* throughout his life, and the final sections were not published until 1578, long after his death. The 1545 edition published at Paris, however, treated the subject of theater design, and Serlio's treatment of the construction of stages and theaters stressed adapting models from ancient times.

William Shakespeare, *Plays* (c. 1592–1613)—The author's voluminous output still continues to inspire modern readers and audiences everywhere, not only in England but in translations that are staged around the world. The dramas are a gold mine for anyone hoping to recover the history of the most popular commercial theater in Renaissance Europe.

Nicholas Udall, *Ralph Roister Doister* (c. 1534)—This was the first English comedy to make use of the revived knowledge of the ancient Roman dramas of Terence and Plautus. Udall, headmaster of the elite public school at Eton, intended the comedy for performance among his students.

chapter nine

VISUAL ARTS

Philip M. Soergel

IMPORTANT EVENTS
in Visual Arts

c. 1302 The Gothic artist Cimabue dies.

c. 1305 Giotto completes his frescoes in the Arena Chapel at Padua.

1319 The great Sienese painter Duccio dies.

1333 Duccio's pupil, Simone Martine, completes his *Annunciation*.

1334 The painter Giotto is appointed to oversee work on the cathedral at Florence. When completed, the church will be the largest in Europe.

1337 Giotto dies.

c. 1338 Ambrogio Lorenzetti paints his frescoes *Allegory of Good Government* in the town hall at Siena.

 In France, Jean Pucelle produces manuscript illuminations influenced by the naturalism of Italian artists.

c. 1350 Work stops on the cathedral of Florence.

1381 The sculptor Lorenzo Ghiberti is born.

1400 The devout painter Fra Angelico, the "Angelic Brother," is born in Florence.

1401 The great painter Masaccio is born.

1419 A competition is held for bronze doors for the Baptistery of the Cathedral at Florence. Among the seven contestants are Lorenzo Ghiberti and Filippo Brunelleschi; Ghiberti wins the competition.

1421 Gentile da Fabriano, a painter trained in the traditions of northeastern Italy and northern Europe, arrives in Florence.

1424 Ghiberti completes 28 bronze panels for the north doors of the Baptistery at Florence. One year later he begins a second set of doors, which will be named the *Gates of Paradise* by Michelangelo.

1428 Masaccio completes his *Trinity* for the Church of Sta. Maria Novella in Florence.

1430 Donatello casts his bronze *David with the Head of Goliath* for the Medici family at Florence.

1431 The sculptor Lucca della Robbia begins a musicians' balcony for the Cathedral of Florence that makes use of compositional and stylistic techniques drawn from ancient Rome.

c. 1435 Jan van Eyck completes his *Arnolfini Wedding*, a wedding portrait of an Italian merchant and his bride at Bruges that is notable for its extreme realism.

 Alberti writes *On Painting*, a work that codifies the use of single-point perspective for Renaissance artists.

c. 1445 Paolo Uccello makes brilliant use of Alberti's perspective in a group of frescoes for the Church of Sta. Maria Novella in Florence.

 The sculptor Rossellino designs a classical tomb for the humanist Leonardo Bruni at Florence.

1450 A Jubilee is celebrated at Rome. Among those in attendance is Roger van der Weyden, a Flemish painter who will take Italian artistic insights back to his post as court painter at Brussels, at the time in the Duchy of Burgundy.

1452 Ghiberti's bronze *Gates of Paradise* are finished in Florence.

 Leonardo da Vinci is born at Anchiano near Vinci.

c. 1453 Piero della Francesca completes a series of frescoes for the Church of San Francesco in Arezzo.

The sculptor Donatello is at work on his emotional *Mary Magdalene*.

1464 Leon Battista Alberti completes his *On the Statue*, a work that analyzes classical proportions.

c. 1470 Matthias Corvinus, king of Hungary, begins to import Italian Renaissance art and to foster the development of a Renaissance artistic culture in his kingdom.

1475 Michelangelo is born at Caprese, a small Tuscan village. His father, an official of the Florentine government, moves the family back to Florence when Michelangelo is six-months old.

1478 Botticelli completes his *Primavera* or *Birth of Spring* at Florence, a painting that shows the growing fondness for secular and classical themes among the cultured elite of the city.

c. 1480 The painter Domenico Ghirlandaio ranks among the most successful of painters for Florence's wealthy banking and patrician families. Michelangelo will eventually become an apprentice in his studio.

1483 The painter Raphael is born at Urbino.

Leonardo da Vinci leaves Florence to work for the Duke of Milan. In that year he completes his *Madonna of the Rocks*, now in the Louvre in Paris.

1496 Michelangelo arrives in Rome for the first time. During this first period in the church's capital he will complete his *Pietà*.

1498 Leonardo da Vinci finishes his *Last Supper* for the refectory of the monastery of Sta. Maria delle Grazie in Milan.

The German Albrecht Dürer is at work painting his early *Self-Portraits*.

1500 Pope Alexander VI declares a Jubilee at Rome; numerous artistic projects are undertaken as a result of these celebrations.

c. 1503 Leonardo da Vinci is at work on his *Mona Lisa*.

1504 Michelangelo completes his famous *David* at Florence. The work is carved from a long unused piece of marble that contained a large flaw, and is received as a masterpiece.

c. 1505 The painter Hieronymus Bosch is active in the Netherlands.

1506 Pope Julius II decides to rebuild St. Peter's Basilica in Rome and has workmen begin the demolition of the ancient structure upon the site. Julius will enthusiastically support many artistic projects until his death in 1513.

1508 Raphael arrives in Rome to begin work on frescoes for the papal apartments in the Vatican.

Michelangelo begins the ceiling frescoes for the Sistine Chapel.

1511 Albrecht Dürer integrates lessons he has learned from his journey to Italy in his panel painting, *Adoration of the Virgin* completed for a chapel in a home for the elderly in his native Nuremberg.

1512 Matthias Grünewald begins his *Isenheim Altarpiece*, one of the most moving and emotional series of pictures of the Renaissance.

1513 Giovanni de Medici is elected Pope Leo X; he will spend lavishly on artistic projects.

1514 Albrecht Dürer engraves his famous *Saint Jerome in his Study*.

1518 Raphael designs the richly decorated Villa Madama at Rome, a pleasure palace that will be much imitated throughout sixteenth-century Europe.

The painter Titian completes his monumental *Assumption of the Virgin* for the Church of the Frari in Venice.

The painter Pontormo paints his *Joseph in Egypt*, a work that reflects the new style that will become known as "Mannerism."

1519 Leonardo da Vinci dies at the court of King Francis I in France.

Michelangelo begins a series of sculptures for the Medici family tomb in the Church of San Lorenzo at Florence.

1520 Raphael dies at Rome.

1527 Imperial forces of Charles V sack Rome.

1528 Albrecht Dürer composes a manual for artists on classical proportions.

Jacopo Pontormo completes his expressive and emotional *Entombment of Christ* for the Capponi family chapel in Florence.

1535 Michelangelo begins work on the *Last Judgment* in the Sistine Chapel.

1536 The German portraitist Hans Holbein is given an apartment within the royal palace in London to record the lives of the Tudor court and produce art for King Henry VIII's enjoyment.

1538 The Venetian painter Titian completes his famous *Venus of Urbino*, a luxuriant nude.

1540 Parmigianino's *Madonna of the Long Neck* expresses the growing Mannerist taste for elegant and obscure depictions of traditional religious themes.

1547 Michelangelo is appointed the chief builder of the new St. Peter's Basilica in Rome, the largest artistic and architectural project of the sixteenth century.

1550 Giorgio Vasari publishes his large collection of biographies entitled *The Lives of the Artists*.

1555 Gian Pietro Carafa is elected Pope Paul IV at Rome, and begins to introduce strict counter-reforming measures in the church's capital.

1560 Annibale Carracci, one of the founders of the early Baroque style, is born.

1563 The Council of Trent concludes; one of its final sets of decrees addresses the use of religious art. The church fathers at Trent demand that religious art be clear and present a forceful defense of Catholic principles.

1564 Michelangelo dies at Rome.

c. 1565 The Dutch painter Pieter Bruegel paints a number of charming peasant scenes.

1573 The Venetian painter Veronese is called before the Inquisition because of the luxurious style of his *Last Supper*.

1576 Titian, the greatest of Venice's sixteenth-century painters, dies.

El Greco arrives in Spain after training in Venice.

1586 El Greco paints his dark and expressive *The Burial of Count Orgaz* in Toledo, Spain.

c. 1593 Michelangelo Merisi da Caravaggio begins to produce strikingly original paintings at Rome that will form one of the foundations for the new Baroque style.

OVERVIEW
of Visual Arts

IMPLICATIONS. The Renaissance was a time of unprecedented achievement in the visual arts and in no other area of culture was change so readily evident. In 1300 European painters and sculptors composed their works using symbols and styles that had flourished for several centuries. While much of the art they produced was of great beauty, the imitation of nature was not a high priority for most medieval artists. In the fourteenth and fifteenth centuries a new set of visual sensibilities prompted patrons to demand, and artists to produce, works that represented the world in a new, boldly naturalistic way. This revolution in visual perception began first in Italy, but soon appeared in Northern Europe as well. This episode in European history forms an important chapter in what the great nineteenth-century historian Jacob Burckhardt once called the Renaissance's "discovery of man and the natural world." Alongside these developments arose a new set of assumptions about the role that the artist should play in society. In the Middle Ages, artists were considered craftsmen who worked in the guild system. These attitudes died slowly, and artists usually remained guild members throughout the Renaissance. By 1500, though, figures like Leonardo da Vinci and Michelangelo Buonarroti in Italy and Albrecht Dürer in Germany were insisting that the artist was fueled with an extraordinary, divinely inspired creativity. Some patrons agreed. In the sixteenth century the most successful of Europe's greatest artists lived like princes and presided over large and successful studios of assistants charged with setting their masters' stamp upon the works they created.

THE EARLY RENAISSANCE. In the fourteenth and fifteenth centuries artistic styles changed dramatically and quickly in Italy, the center of the early Renaissance. Around 1300, the dominant styles in Italian painting favored Byzantium (the Eastern survivor of the Roman Empire) and its traditions of icon painting. The conventions of icon painting expressed symbolic, rather than realistic, representations of Christ, the Virgin Mary, and the saints. Brilliant colors and intricate precious metal work were also important features of icon painting. During the course of the thirteenth century changes in church ritual gave a new prominence to large altarpiece paintings. These decorated altarpieces, placed directly behind the altar, became more prominent as church law came to require priests to say the Mass standing before, rather than behind the altar. As a result, the size and importance accorded to altarpieces grew throughout the thirteenth century. In Italy, the undisputed master of late thirteenth-century painting was the Florentine painter Cimabue, who strove to achieve a greater naturalism and who tried to introduce depth and solidity into his works —something that had not traditionally been important to the Byzantine-influenced painters of medieval Italy. Cimabue's efforts to introduce a new naturalism into painting were soon eclipsed by Giotto di Bondone, the undisputed genius of fourteenth-century Italian painting. Although Giotto had been trained in the Byzantine manner and many elements of his style remained faithful to those traditions, he surpassed Cimabue's first tentative attempts to introduce weight, solidity, and perspective into his paintings. Giotto's frescoes, in particular, displayed human emotions and attempted to place the human form within spaces that appeared three-dimensional. During the fourteenth century some painters followed his lead, although the Byzantine manner of painting popular in Italy merged also with new influences to forge a new style often referred to as International Gothic. Artists working from this perspective produced paintings and sculptures notable for their religious intensity and stylized, rather than naturalistic presentation.

FIFTEENTH-CENTURY FLORENCE. In the first half of the fifteenth century the efforts of the sculptors Lorenzo Ghiberti and Donatello as well as the painter Masaccio produced dramatic changes in the visual arts in the city of Florence. A competition to create new doors for the Baptistery of Florence's cathedral was the catalyst for the development of a new, more naturalistic style. The winner of that competition, Lorenzo Ghiberti, spent most of the rest of his life completing the doors, and in the process he developed a new naturalistic style, influenced by the art of classical antiquity and the humanist culture of Florence. In the world of painting the short-lived genius Masaccio continued along the realistic lines that Giotto had developed in the early Renaissance, but, in addition, he mastered the art of single-point perspective. The frescoes that he completed in the Brancacci Chapel in Florence shortly before his death served as a textbook for subsequent Florentine artists anxious to develop a more realistic depiction of space. In the

generations that followed Masaccio's death, Florence witnessed the growth of a circle of native artists notable for their finesse and technical brilliance. Although the town emerged as the leading artistic center of fifteenth-century Italy, artists elsewhere also began to adopt the perspective and naturalistic style typical of the Florentine Renaissance. By 1500, an artistic circle in Venice, led by Giovanni Bellini, made great strides in the use of oil paints, a departure from the traditional Italian methods of tempera. The new medium, imported from Northern Europe but enhanced in Venice, allowed for a more brilliant rendering of light as well as finer gradations of color. The use of oils revolutionized painting in Venice and eventually throughout Italy in the sixteenth century.

THE EARLY RENAISSANCE IN NORTHERN EUROPE.
The first tentative movement toward naturalism and a greater freedom of artistic expression occurred in France during the mid-fourteenth century, led by the accomplished manuscript illuminator Jean Pucelle. Most French artists, though, did not widely imitate his example, but instead remained faithful to the canons of International Gothic, a style characterized by a sinuous elegance of line, elaborate folding draperies, and the use of overt symbols. Around 1400, leadership in artistic innovation passed to artists in the Netherlands and Flanders (modern Holland and Belgium). Many of these figures worked in the courts of the Duke of Burgundy or of Duke John of Berry in France. At the end of the fourteenth century, Flanders (a province of modern Belgium) became the dynastic property of Burgundy, and in this region, a burgeoning art market developed. The areas's wealthy trading cities fueled this development. Of the many masters that appeared at this time, Jan van Eyck developed a realistic naturalism characterized by the veiled use of symbols. Van Eyck's works contained deeper meanings that the artist conveyed with items seemingly drawn from everyday life. The artist's almost photographic ability to capture reality inspired several generations of Netherlandish artists. The fifteenth century was a time of artistic brilliance in the Low Countries, and the advances that Flemish and Dutch artists made in recreating the natural world had imitators throughout Northern Europe. Around 1500, though, a variety of new styles emerged throughout the region. In Germany, artists strove to integrate Low Country realism with insights they acquired from Italian examples, while in France various native styles were infused with inspiration drawn from other European traditions. By 1500, the stage had been set for a truly widespread flowering of the visual arts in the many artistic centers of Northern Europe.

THE HIGH RENAISSANCE IN ITALY.
As the fifteenth century drew to a close in Italy, three great masters—Leonardo da Vinci, Michelangelo Buonarroti, and Raphael Sanzio—came to maturity. The works of these three masters helped to forge the conventions long associated with the art of the High Renaissance. Of the three, Leonardo da Vinci was the oldest and the first to develop a new stylistic direction. A restless personality, da Vinci continually experimented with his art and was at the same time a scholar of nature, architecture, and design. His idealization of the human form and his attempts to render the inward personality of his subjects inspired subsequent artists, even though many of his compositions remained unfinished at his death. The second of the High Renaissance masters, Michelangelo Buonarroti, had a long and varied career as a sculptor, architect, and painter. By disposition, he saw himself primarily as a sculptor and his art was influenced by the Neoplatonic ideas popular in Florence at the time. A member of the Medici circle, Michelangelo strove to present an idealized vision of the human form, although he relied on heavily muscled, monumental figures that resembled classical nudes. He was led, like Leonardo da Vinci, to study human anatomy through the dissection of corpses, and in his sculptures and subsequent paintings he displayed an anatomically correct knowledge of the human form. Called to Rome to work for Pope Julius II, Michelangelo's Roman works—including his masterpiece, the ceiling frescoes of the Sistine Chapel—were major landmarks in the history of world art. Works like these also exercised a formative influence on the subsequent art of the sixteenth and seventeenth centuries. The third and youngest of the three masters, Raphael Sanzio, evidenced a completely different character from the restless perfectionist Leonardo da Vinci or the turbulent Michelangelo. Serenity and balance are characteristics of his paintings, and in the many compositions that this short-lived master completed in the city of Rome, he helped to establish a standard of painterly perfection to which many later artists strove.

THE HIGH AND LATER RENAISSANCE IN VENICE.
In Venice, a different pattern of artistic development and stylistic preferences helped to produce an art that was markedly different from that of central Italy or Rome. During most of the fifteenth century the city had been an artistic backwater. Toward the end of the fifteenth century, however, the artists Giovanni Bellini and Giorgione established a distinctive Venetian school of painting. High Renaissance tendencies, too, soon influenced art in the city, and in the course of the sixteenth century Venice became one of Europe's artistic capitals. Its

major painters—Titian, Tintoretto, and Veronese—set new standards in the use of oils on canvas. Their rich use of color, landscape, and urbane settings had imitators throughout Italy and Europe.

MANNERISM AND LATE RENAISSANCE ART IN ITALY. In Florence and Rome, the 1510s saw the culmination of High Renaissance style. By the end of the decade, the art of the late Raphael and of Michelangelo was developing in ways that inspired the new movement known as Mannerism. In contrast to the symmetry of High Renaissance artists, Mannerists preferred intricate compositional interlacing of figures that dispersed the characters in their works to the edges of the painting. Many Mannerist artists found inspiration in the heavily muscled figures of Michelangelo and the late Raphael. Most preferred to elongate and attenuate the human form in order to create elegant, sinuous lines. A tendency to favor difficult and obscure themes and iconography is also evident in their work.

THE VISUAL ARTS IN SIXTEENTH-CENTURY NORTHERN EUROPE. In the first half of the sixteenth century the torch of artistic innovation in Northern Europe passed to Germany. Albrecht Dürer developed the graphic arts to a high degree of perfection even as he laid the foundations for a native style of painting. This style made use of techniques the artist had discovered while on his journeys in the Netherlands and Italy. At the same time Dürer helped to create a definite German style, characterized by rich landscapes, florid line, and a keen observation of nature. Hans Holbein, Albrecht Altdorfer, Lucas Cranach, and a lineage of accomplished artists also contributed to the brilliant renaissance of the visual arts in Germany. In the Netherlands, the traditions of Flemish realism continued in the early sixteenth century, although the region's artistic capital began to shift from Bruges and other centers to the once neglected town of Antwerp. These changes, aided by the economic shifts that were at work in the region, eventually re-invigorated the Netherlandish tradition. At Antwerp, a new group of masters adapted the artistic insights of Italian masters, including mannerist painters, to the production of religious art, portraiture, and landscape painting.

CONCLUSIONS. The period between 1300 and 1600 witnessed unprecedented changes in artistic styles and innovation in the presentation of nature, space, and the human form. The pattern of these developments was not always linear; older styles frequently survived alongside newer ones, although the direction that European art took in the fourteenth and fifteenth centuries inexorably favored artistic realism and the imitation of life models. In the sixteenth century the Mannerist movement struck a somewhat different chord, with its emphasis on the development of a "stylish style." These new sensibilities favored images that embodied contemporary notions of elegance and intellectual sophistication. As the sixteenth century progressed, religious currents, too, affected artistic production. Northern European masters found the market for their religious altarpieces threatened by new Protestant sensibilities that often attacked religious art as idolatrous. Portraiture, landscape painting, and other genres gradually replaced the huge demand that had existed in Northern Europe for elaborate religious altarpiece paintings. By contrast, the Roman Catholic Church retained a vital place for religious art, but as the sixteenth century drew to a close, the religious leaders of the Counter-Reformation were at work trying to reform that art. They insisted that the meaning of religious paintings should be clearly intelligible to the unlearned masses and that paintings and sculpture should try to capture and harness the human emotions in order to deepen the people's piety. The new style that resulted from these notions became known as Baroque, and would be heir to the rich pictorial tradition that had flourished during the Renaissance.

TOPICS
in Visual Arts

THE EARLY RENAISSANCE IN ITALY

ENVIRONMENT. It was in Italy that the artistic values we associate with the Renaissance first began to appear. These values included a new emphasis on naturalistic depiction, on human proportions and human scale in art, and on the rational presentation of observed spaces. During the fourteenth and early fifteenth centuries artists in Northern Italy, particularly in Tuscany, devoted themselves to problems of perspective. Eventually, they mastered techniques that allowed them to reproduce spaces that appeared to have real depth on two-dimensional surfaces. This innovation, known as linear perspective, was not to be perfected until the mid-fifteenth century in the paintings of the Florentine artist Masaccio. Thereafter the humanistically trained artist Leon Battista Alberti codified the methods that Masaccio had used and circulated them in his theoretical treatise *On Painting*, which he wrote during the 1430s. The breakthroughs that fifteenth-century Italian artists made

in the depiction of space built upon the work of several generations of artists and sculptors who had gone before. Another vital feature of the Renaissance in the visual arts was a renewed attention to the style and conventions of ancient art. As the homeland of the ancient Roman Empire in Western Europe, Italy possessed many venerable ancient monuments, and traditions of classicizing art and architecture had persisted in the region during the Middle Ages. Fifteenth-century artists, however, began to study more systematically and rigorously the works of classical Antiquity, and they self-consciously tried to revive its harmonious and balanced proportions. Renaissance painters may never have been wedded to classical styles and idioms to the same degree as humanists and literary figures, but the example of antique painting and sculpture provided potent examples of a human-centered art that shaped their stylistic values. As in many other areas of Renaissance cultural achievement, it was Florence that served as the incubator for many of these innovations, although other cities throughout Tuscany—including Siena, Pisa, Perugia, and Arezzo—produced artists whose works both shaped and reflected the styles of the period.

PATRONAGE. Renaissance art, however, was not created for an open market, but for wealthy and powerful patrons and religious institutions that commissioned it. In the later Middle Ages and the Renaissance most artists were members of guilds in the cities in which they worked and were considered craftsmen. Throughout Italy the precise guilds to which painters and sculptors belonged differed, but these trade associations limited the supply of master craftsmen and thereby indirectly supported the prices artists could charge for their commissions. In Florence, craftsmen artists satisfied the demands of the town's churches, monasteries, confraternities, as well as its large class of wealthy bankers, merchants, and patricians. Thus the taste of patrons often determined matters of artistic style and content. Histories of art have long stressed Italy's importance as the artistic center of Renaissance Europe. Great art and sculpture were produced everywhere in the period, but Italian artists vastly outproduced artists elsewhere in Europe. As the wealthiest region during most of the Renaissance, Italy's merchants, nobles, and church institutions commissioned an enormous amount of art during the Renaissance. Many forces helped to produce this burgeoning market, including the desire of Italy's princes, local governments, and wealthy citizens to display their wealth and power. Patrons relied upon painting and sculpture to express political ideals, to indulge their tastes for fine craftsmanship, and to immortalize themselves

and their families. The deepening piety of the era, too, stimulated the production of much religious art.

IMPORTANCE OF IMAGES. In a world of widespread illiteracy, images took on a special importance. For the illiterate, religious images served as a vital textbook that instructed in the teachings and history of Christianity and the church. For both the learned and unlearned, images conveyed political and religious ideas, and were often tools of propaganda. To express these political positions or religious truths, artists relied upon iconography—a system of symbols that conveyed certain commonly accepted meanings. During the Renaissance the language of iconography expanded greatly, in large part because of the revival of knowledge about ancient religions, philosophy, and mythology. Iconography became an increasingly complex way of communicating meaning, since artists could employ symbols drawn from Christian, Roman, and Greek past as well as from other more obscure traditions. Not every observer understood the sometimes-obscure meanings that artists included in their works. Most contemporaries, though, had some familiarity with the depictions of prominent religious subjects as well as the meanings behind certain artistic conventions and symbols that artists used in their paintings. In the cities preachers often treated the famous historical events of the Bible and the history of the church, recalling to their audience visual images of these incidents. These sermons show us that the visual senses of the inhabitants of a Renaissance city were highly sophisticated. While a large proportion of the population could not read, their knowledge of iconographical symbols was quite broad. The Renaissance painter was expected, then, to visualize the stories that he depicted in ways that fit with people's visual assumptions. Certain conventions of depiction governed the artists' rendition of biblical themes, incidents from the history of the church, or the lives of the saints. Painters did not traverse this sea of artistic creation without guides, however, for there were many iconographical handbooks that prescribed how certain religious themes and subjects should be depicted. For ancient mythological themes, for example, one of the most important guides was Giovanni Boccaccio's *Genealogy of the Pagan Gods*, a multi-volume work used throughout the Renaissance by artists interested in painting mythological themes. Boccaccio's *Genealogy* presents us with a vital example of how the new humanistic culture of the Renaissance shaped the visual arts. Fueled by the insights that humanist writers made in their study of pagan Antiquity, artists gave a visual shape to the concerns of Renaissance humanists. More generally, though, most painting in the fifteenth-century

a PRIMARY SOURCE *document*

CONTRACTS

INTRODUCTION: The painter Domenico Ghirlandaio was one of the most commercially successful artists working in Florence during the second half of the fifteenth century. He ran a large studio where many apprentices learned their craft. Experience had probably taught Ghirlandaio to be careful about his contracts with his patrons, but these contracts show that painters also worked to a large degree at their patron's whims. The following agreement for the creation of a painting—*The Adoration of the Magi*—between the artist and the prior (the church official) in charge of Florence's Orphanage of the Innocents shows the confines in which fifteenth-century artists worked.

Be it known and manifest to whoever sees or reads this document that, at the request of the reverend Messer Francesco di Giovanni Tesori, presently Prior of the Spedale degli Innocenti at Florence [the Orphanage of the Innocents] and of Domenico di Tomaso di Curado [Ghirlandaio], painter, I, Fra Bernardo di Francesco of Florence, Jesuate Brother, have drawn up this document with my own hand as agreement contract and commission for an altar panel to go in the church of the abovesaid Spedale degli Innocenti with the agreements and stipulations stated below, namely:

That this day 23 October 1485 the said Francesco commits and entrusts to the said Domenico the painting of a panel which the said Francesco has had made and has provided; the which panel the said Domenico is to make good, that is, pay for; and he is to colour and paint the said panel all with his own hand in the manner shown in a drawing on paper with those figures and in that manner shown in it, in every particular according to what I, Fra Bernardo, think best; not departing from the manner and composition of the said drawing; and he must colour the panel at his own expense with good colours and with powdered gold on such ornaments as demand it, with any other expense incurred on the same panel, and the blue must be ultramarine of the value about four florins the ounce; and he must have made and delivered completed the said panel within thirty months from today; and he must receive as the price of the panel as here described (made at his, that is, the said Domenico's expense throughout) 115 large florins if it seems to me, the abovesaid Fra Bernardo, that it is worth it; and I can go to whoever I think best for an opinion on its value or workmanship, and if it does not seem to me worth the stated price, he shall receive as much less as I, Fra Bernardo, think right; and he must within the terms of the agreement paint the predella of the said panel as I, Fra Bernardo, think good; and he shall receive payment as follows—the said Messer Francesco must give the abovesaid Domenico three large florins every month, starting from 1 November 1485 and continuing after as is stated, every month three large florins. ...

And if Domenico has not delivered the panel within the abovesaid period of time, he will be liable to a penalty of fifteen large florins; and correspondingly if Messer Francesco does not keep to the abovesaid monthly payments he will be liable to a penalty of the whole amount, that is, once the panel is finished he will have to pay complete and in full the balance of the sum due.

SOURCE: "Contract between Domenico Ghirlandaio and Francesco di Giovanni Tesori for *The Adoration of the Magi*," in Michael Baxandall, *Painting and Experience in Fifteenth Century Italy* (New York: Oxford University Press, 1972). 6.

Italian world remained Christian in nature, and when rendering religious themes, an artist was expected to convey his subject in a way that was appealing to viewers and which did not distort the subject being portrayed.

CONTRACTS. Artists undertook very little painting or sculpture without firm contracts from their patrons. The most successful of Renaissance artists ran studios in which they trained young assistants. They assigned their young apprentices to decorate furniture, paint devotional icons, and undertake other smaller projects. Artists' workshops often sold these creations in much the same way as modern art galleries deal in paintings or sculptures. For the most part, though, artists completed a painting or a sculpture for a client or patron who contracted for a specific work. Hundreds of contracts survive from Renaissance Italy and these show us that the era's wealthy consumers of art were sophisticated consumers who were actively involved in determining the appearance of these creations. Contracts often stipulated that artists use specific pigments in executing their work, and sometimes these stipulations were quite specific as to the precise amount of the painting's surface that various colors should cover. To satisfy their clients, artists usually presented mockup sketches of the proposed finished product. Painters of recognized skill commanded higher prices for their compositions and certain kinds of painting were more expensive than others. Landscape backgrounds, for instance, resulted in extra charges, and the inclusion of these backgrounds was usually stipulated in the original contract commissioning the work. The

vast majority of Renaissance painting and sculpture was undertaken to satisfy the demands of patrons who contracted for specific works, although some princes employed resident artists who received monthly salaries and moved from project to project at their employer's will.

STYLISTIC DEVELOPMENT. The great flowering of Renaissance art that occurred in fifteenth-century Florence and other Italian centers built upon late-medieval traditions. During the early fourteenth century Italian artists had grown increasingly innovative. These changes had occurred within a tradition of painting that had long been influenced by the example of Byzantium, the Eastern Mediterranean survivor of the ancient Roman Empire. The painting of religious icons—devotional images of the Virgin Mary and saints—were important foci of popular piety within the Eastern Orthodox Church. The icon painter depicted his subject using hierarchical proportions: Mary and the saints were presented larger than the other figures that surrounded them. The conventions of Byzantine art were also highly stylized and symbolic as well. During the thirteenth century changes in the teachings and practice of the Roman Church had favored the development of new kinds of art. At this time church law required that the priest stand in front of the altar while celebrating the Eucharist during Mass. This opened up the possibility of decorating the area behind the altar with large panel paintings. In Italy, panel paintings became common during the second half of the thirteenth century, and while they were first produced in the prevailing Byzantine style, artists soon experimented with new ways of conveying their subjects. Among the many unidentifiable and shadowy artists of the time, Cenni di Pepi or Cimabue (c. 1240–c. 1302) was considered the greatest master. Although trained in the Byzantine style, Cimabue endowed his figures with greater weight and solidity than the Greek tradition allowed. He also painted using an intuitive perspective and he was the first Italian artist to develop a technique for rendering *chiaroscuro*, that is, light and dark shading. In the coming decades several Italian artists developed these techniques even further.

GIOTTO. Although Cimabue experimented, he remained a master in the Byzantine tradition. The first painter who definitively broke with that tradition was the Florentine Giotto di Bondone (c. 1267–1337). Giotto earned recognition for his originality and achievement even in his own times. In his *Divine Comedy*, completed around 1321, the poet Dante celebrated Giotto for surpassing the art of Cimabue. And in his chronicles completed around 1338 the Florentine historian Giovanni Villani listed Giotto as one of the great citizens of the town. Although Giotto remained tied to medieval styles of painting in many ways, there can be little doubt about the innovative elements of his style. When his works are compared against the greatest artists of his own period, Giotto's unique contribution becomes evident. In his *Madonna and Child Enthroned*, which he completed around 1310 for the Church of All Saints in Florence, Giotto gave his figures weight and solidity. The work is a panel painting that uses the tempera method favored by central Italian artists throughout the Renaissance. In this medium pigments are suspended in egg yolks, showcasing brilliant colors and a paint capable of producing fine distinctions of line. Giotto used the tempera method to introduce light and dark spaces in his work so that the figures in the composition appeared to be three-dimensional. At the same time, however, Giotto continued to place his subjects within architectural spaces and design motifs that were medieval in nature. His work presented the Virgin and Child sitting on a throne framed with Gothic trefoil arches, and his use of proportion still relied upon scales that were medieval in nature. He painted the Virgin much larger than the angels and saints that surrounded them. His composition, in other words, was hardly naturalistic, since he relied upon proportions that expressed qualitative judgments and that were not naturalistic.

FRESCOES. While the greatest of Giotto's altarpiece paintings contained elements that both harked backward and looked forward, it was in his frescoes that the artist developed a more complete naturalism. The most famous of several fresco cycles Giotto completed was in the Arena Chapel in the northern Italian town of Padua. The subject for this cycle was the lives of the Virgin and Christ, and Giotto painted these frescoes around 1305. Fresco was a technique that had flourished in Italy since ancient times. At the outset of a project the artist prepared the wall with a layer of rough plaster upon which he sketched a mockup of the final composition. Then each day the artist added a finish coat of plaster to a section of the wall and painted that portion of the composition while the surface was still wet. In this way the colors were permanently fused into the wall. In the Arena Chapel frescoes Giotto demonstrated his love of nature and human emotions. Instead of the Byzantine-styled compositional techniques that were popular at the time, Giotto infused his subjects with movement. His hand gestures tell the stories from the New Testament in a way that is lively and true to life. Often within the same panel Giotto tells several parts of a story, giving his work a narrative completeness not found in other paintings of the time. His characters, too, are unique for the level of

emotional depth they express. In his painting of the *Lamentation* the disciples and female followers of Christ express their suffering over the death of Christ through gestural language and facial expressions in a way that is intended to elicit a response from viewers. Even the angels who fly above the dead Christ display their profound suffering.

PAINTING AFTER THE BLACK DEATH. In his great fresco cycles Giotto painted with psychological insight, endowing his figures with emotions and depth. He abandoned as well the traditions of Byzantine stylization and instead tried to capture nature more faithfully. Some of his contemporaries imitated his example, while others who remained faithful to Byzantine traditions rejected it. In Siena, the brothers Pietro and Ambrogio Lorenzetti developed a naturalism similar to Giotto's, helping to establish Sienese painting as a leading artistic force throughout mid-fourteenth-century Europe. In an enormous fresco completed for the interior of the town hall of Siena entitled *Allegory of Good Government*, Ambrogio Lorenzetti catalogued the life of his city with intricate detail and a faithful attention to nature. The Black Death, though, cut short the naturalistic explorations of the Lorenzetti brothers. Both brothers died in 1348 as the plague struck their city. As a result of that catastrophe, painting in Florence, Siena, and other Italian cities seems to have grown more conservative, finding in the traditions of stylized art a vehicle for displaying intense religious emotions. The style that flourished at this time is often called International Gothic, because it was common throughout much of Europe at the time. In Italy, confraternities and religious institutions commissioned many works in this manner during the second half of the fourteenth century. Intricate lines, rhythmically folded draperies, and an intense emotionalism characterized the works of International Gothic artists. In Central Italy, the most famous of these artists were Andrea di Cione, known as Orcagna (1308–1368); Francesco Traini (active 1321–1363); and Giovanni da Milano (active from 1346–1366). The last of these figures created the first Pietà, an image of the dead Christ, which was designed to elicit an observer's devotion and compassion. The work inspired many artists' subsequent efforts, including the famous Pietà of Michelangelo Buonarroti. New developments in fifteenth-century Italy, however, soon superseded the emotionalism and fervent religiosity typical of the International Gothic style.

MASACCIO. During the first half of the fifteenth century Florence was a great center of artistic innovation in Central Italy. Among the many remarkable artists who practiced there during this period of intense activity,

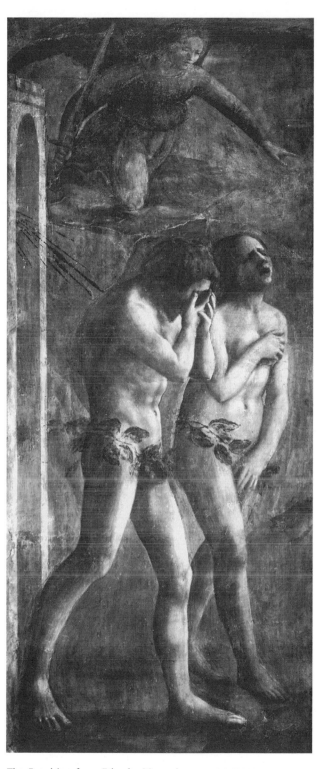

The Expulsion from Eden by Masaccio. **PUBLIC DOMAIN.**

Tommaso di Giovanni (1401–1428), better known as Masaccio, was among the most important. Despite his short life Masaccio exerted a profound influence on Florentine painting, in large part through a series of frescoes he painted during 1425 in the Brancacci family

a PRIMARY SOURCE *document*

ON PAINTING

INTRODUCTION: The humanist Leon Battista Alberti was also a practicing artist and architect who considered the nature of art in several theoretical treatises. In his *On Painting*, Alberti defined painting according to the standards that were typical in Florence. He placed a strong emphasis on *disegno*, the draftsman's drawing of a picture, which was then colored in through the use of paints, the core of most Florentine artists' techniques. Alberti also emphasized the necessity of a painter applying the techniques of perspective and geometry to his works, and he stressed that learning in literature was essential to the artist's craft. The adoption of his program by artists in Italy was one factor that aided in the rise of the artist's status that began to occur in the later fifteenth century.

I would say the business of a painter is this: to draw with lines and dye with colors, on whatever panel or wall is given the like[nesses of the] visible surfaces of any body, so that viewed from a certain distance and central position their bodies seem to be in relief and very similar. The end of painting: to acquire favor, good will, and praise for the artist, rather than wealth. And the artists will achieve this when their painting holds the mind and eye of those who look at it ...

But it would please me that the painter, to grasp all these things, should be a good man and versed in literature. Everyone knows how a man's goodness helps more than his industry or skill in acquiring good will from the citizens, and no one doubts that the good will of many

people greatly helps the artist to praise as well as earnings. It often happens that the rich, moved more by good will to a person than by wonder at someone's art, sooner give work to a modest and good person, casting aside that other painter who may be better in art but not so good in his ways. Therefore it is good for the artist to show himself well behaved, and especially polite and good-natured. Thus he will get good will, a firm help against poverty and earn excellent aid toward the mastery of his art.

I like a painter to be as learned as he can be in all the liberal arts, but primarily I desire him to know geometry. I like the saying of Pamphilus, an ancient, most noble painter, with whom the noble youths began to learn of painting. He held that no painter could paint well if he did not know a great deal of geometry. My rudiments, which explain the perfected self-contained art of painting, will be easily understood by a geometrician, but one who is ignorant of geometry will understand neither those nor any other method in painting. So I maintain that a painter has to undertake geometry. And for their mutual delight he will make himself one with poets and orators, for they have many graces in common with the painter and a plenteous knowledge of many things. So they will greatly assist in the fine composing of narrative pictures, whose whole praise consists in the invention, which often has such an effect, that we see a fine invention is pleasing alone without painting. ...

SOURCE: Leon Battista Alberti, *On Painting*, in *A Documentary History of Art.* Vol. I. Ed. Elizabeth G. Holt (Garden City, N.Y.: Anchor Books, 1957): 215–216.

chapel in the Church of Sta. Maria del Carmine. Their subject—the life and works of St. Peter—is told in several scenes, the most famous being *The Tribute Money*. The subject for this painting is taken from Matthew 17:24–27, the story of a miracle Christ worked in paying tribute to the Romans. In that fresco the apostles are gathered around Christ, who directs Peter to retrieve coins from the mouth of a fish and present them to the Roman tax collector. Like Giotto before him, Masaccio endows the subjects he paints in this fresco with volume and weight, but his mastery of the skills of linear perspective and lighting is now more secure. Masaccio illuminates his frescoes with light that comes from a single source, throwing the actors in these dramas into light and dark so that they appear to inhabit real space. The naturalism of Masaccio's portrayal, the volume and weight with which he endowed his subjects, as well as his use of perspective had many imitators in other Re-

naissance artists, including Michelangelo and Raphael who both studied and copied his Brancacci frescoes in the fifteenth century.

GHIBERTI. At roughly the same time as Masaccio was completing his frescoes in the Brancacci Chapel, the art of sculpture was also undergoing a profound transformation in Florence. Throughout Tuscany, sculpture had had a long and venerable medieval tradition, having grown up in close connection with the building of the region's major churches and cathedrals. Around 1400, a number of sculptors of distinction were at work throughout the region, including Niccolo and Giovanni Pisano and Jacopo della Quercia. The first sculptor to develop a uniquely Renaissance style, though, was Lorenzo Ghiberti (1378–1455). In 1401, Ghiberti won Florence's competition for new bronze doors for its Cathedral baptistery, a competition that had drawn entries from the city's most distinguished artists. Ghiberti spent much of

the remainder of his life designing and executing these doors. He completed his first set of doors in 1424, and immediately received the commission to complete a second set for the Baptistery's eastern portal. He worked on these panels for another two decades. When finished, these eastern doors depicted ten scenes from the Old Testament and they were heavily influenced by the revival of classical Antiquity that was underway in Florence at the time. The doors themselves were more than eighteen feet tall, and in the bronzes Ghiberti created for them he relied upon the shallow technique of bas-relief. He depicted these scenes in a lively way, making use of the classical proportions and architectural details that had recently become important markers of Renaissance style. In addition, Ghiberti relied upon the painterly techniques of linear perspective to give these scenes depth. Even at the time of their creation, the doors gained recognition as a supreme sculptural achievement, and in the sixteenth century the sculptor Michelangelo gave the doors the name by which they have been known ever since. He remarked that Ghiberti's creation was suitable to guard the gates of heaven, thus dubbing them "The Gates of Paradise."

SCULPTURE. Two other remarkable sculptors practiced in early and mid-fifteenth-century Florence: Donatello (1386–1466) and Luca della Robbia (1399–1482). Donatello had been trained in the workshop of Lorenzo Ghiberti, where he mastered the art of carving narrative reliefs. As a master sculptor, however, Donatello's prime achievements were in the creation of freestanding statues, which he carved in stone or cast in bronze, although he did not limit himself to practicing a single kind of art. Like his close friend, Brunelleschi, Donatello indulged a passion for the arts of Antiquity, and together the two figures explored the classical monuments of Rome and Central Italy. He measured these works' proportions and applied this knowledge to his own work, thus creating statues notable for their harmonious balance. Until the time of Michelangelo, no other Italian sculptor created such noble sculptures as Donatello's *St. George,* his *David* or his massive equestrian figure, *Gattamelata.* A similar classicism is to be found in the best works of Luca della Robbia, especially in the *Cantoria* or "Musicians' gallery" he created for the Cathedral of Florence during the 1430s. In that work della Robbia relied upon his knowledge of ancient Roman sarcophagi to create a masterpiece of classicism. During the remainder of his life, though, della Robbia's reputation rested on his creation of terra-cotta reliefs, which he glazed and fired according to a secret process. These reliefs proved particularly suitable as decorations for the

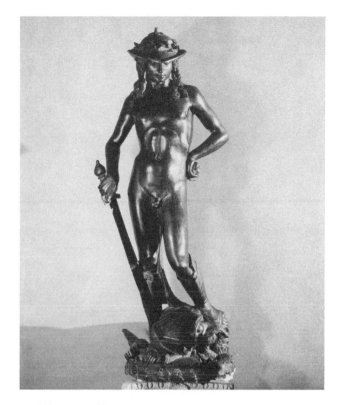

David by Donatello. © **DAVID LEES/CORBIS. REPRODUCED BY PERMISSION.**

classically styled palaces and churches that were being constructed throughout fifteenth-century Florence.

ALBERTI. The arts of sculpture and painting were also affected by the studies of Leon Battista Alberti (1405–1472), one of the great universal geniuses of the Renaissance. Alberti was the illegitimate son of a merchant who had been exiled from Florence. He received a humanist education, although his father died as he came to maturity, and Alberti's relatives laid claim to his inheritance. Forced to work for a living, Alberti entered the papal chancery at Rome, before returning to Florence once the exile pronounced against his family had been lifted. In Florence, Alberti became associated with the humanist circle that had grown up in the town, as well as with the city's growing circle of artists. Even before coming to Florence, the humanist had already befriended Masaccio and Brunelleschi, and once in the town, he extended this circle of friends. A painter, sculptor, musician, poet, philosopher, mathematician, and architect, Alberti also set himself the task of codifying theoretical knowledge about the various arts. His *On the Art of Painting,* first completed in Latin in 1435 and translated into Italian a year later, codified the problem of linear perspective in a way that was easy for later artists to master. In addition, his treatise *On Sculpture* informed

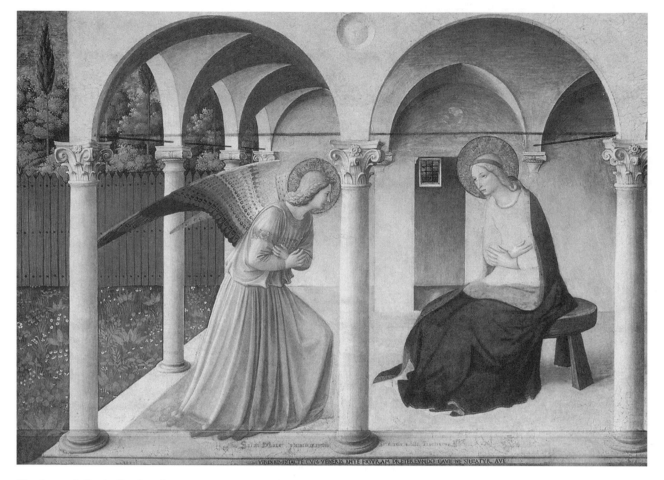

The Annunciation by Fra Angelico. © ARTE & IMMAGINI/CORBIS. REPRODUCED BY PERMISSION.

sculptors about the proportions of antique art and, like his other works on architecture and painting, set out a general theory behind the practice of this art. In this way Alberti's work began the process of raising the status of the artist beyond the realm of the craftsman. Since he knew both humanist scholars and artists, Alberti brought together the various artistic and intellectual circles of Florence. His treatises also attempted to establish a scientific basis for the study of the arts, even as they revived classical knowledge about their practice. In this way Alberti's works were essential to later artists who argued that the techniques they practiced in their trade were both ancient and difficult to master.

PAINTING IN MID-FIFTEENTH-CENTURY FLORENCE. In the first half of the fifteenth century the insights of Masaccio, Brunelleschi, and Alberti provided artists with techniques to present their compositions with depth, solidity, and harmonious proportion. In Florence and elsewhere in Central Italy, artists quickly learned these lessons. In the generation following Masaccio's death, many artists appeared in Florence to serve the

city's religious institutions and wealthy patrons. These included Fra Angelico (c. 1400–1455), Fra Filippo Lippi (c. 1406–1469), Paolo Uccello (1397–1475), Domenico Veneziano (1410–1461), and Andrea Castagno (c. 1417–1457). Of these, Fra Angelico was among the most prolific. Although he had been trained as a painter, he entered the Dominican Order when still a young man. Eventually, he rose to become the prior of Florence's Monastery of San Marco, although throughout his life he continued to produce both panel paintings and frescoes throughout the city. These included a series of frescoes he painted in the cells of his own monastery. While some critics denigrated him as a conservative painter, Fra Angelico was, in truth, a considerable innovator, who had assimilated the legacy of Masaccio and Giotto and used their work as a vehicle for developing an art of great religious intensity. His landscapes were among the most sophisticated of the time, and throughout his works he relied on color and light to create paintings that were models of serene beauty. The art of Fra Filippo Lippi (c. 1406–1469), another Florentine monk, shows a similar

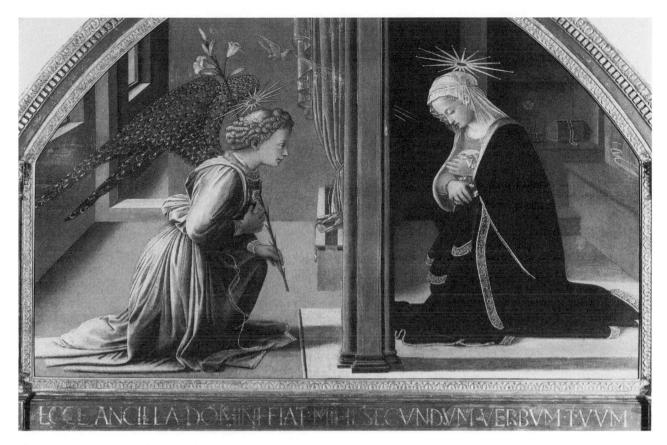

The Annunciation by Fra Filippo Lippi. CORBIS. REPRODUCED BY PERMISSION.

grace and refinement. In contrast to the saintly Fra Angelico, Lippi was a more restless figure who was eventually defrocked because of his sexual escapades. Like most Florentine painters working in the wake of Masaccio, Lippi was fascinated by perspective, but he also relied on elegant flowing lines in his paintings. His envisioning of the Christ child, too, as a chubby cherub has long endeared viewers to his art. Lippi became the favorite painter of the Medici family, and his pupil, Sandro Botticelli (1445–1510), kept alive this tradition of elegance and delicacy in the second half of the fifteenth century. A different direction is discernible in the works of Paolo Uccello, an artist who originally served as an apprentice to the great sculptor Lorenzo Ghiberti, before developing an intense fascination with perspective in painting. During the 1430s and 1440s Uccello painted a number of frescoes and panel paintings that presented imaginative solutions to problems of depth in his paintings. Among these, his *Deluge* and *Battle of San Romano* are arranged so completely according to the laws of linear perspective that viewers often find them disturbing. Two other accomplished painters, Andrea Castagno and Domenico Veneziano, were long thought to have nourished a violent enmity toward each other. According to

a legend retold in the works of the biographer Giorgio Vasari, Castagno was to have murdered Veneziano. Subsequent research has shown that Veneziano outlived Castagno by four years. Whether the two were enemies cannot be established with certainty, although both presented Florence's mid-century artistic culture with different, yet strikingly new artistic insights. In his paintings Veneziano relied on brilliant sunlike lighting and intense colors to present human figures that appeared much like polished marble. Castagno, by contrast, populated his compositions with earthy, muscled characters and endowed these figures with greater movement. His art reveals a more restless temperament than that usually seen in the works of the more serene masters of mid-fifteenth-century Florence.

PAINTING OUTSIDE FLORENCE. Florence may have been the primary center of artistic innovation during much of the fifteenth century, but great artists were active everywhere in Italy. One of the most accomplished figures of the period was Piero della Francesca (1420–1492), who lived largely in isolation in provincial centers for most of his life. It has not been until modern times that Piero's achievement has been truly appreciated. During 1439 Piero served as an assistant to

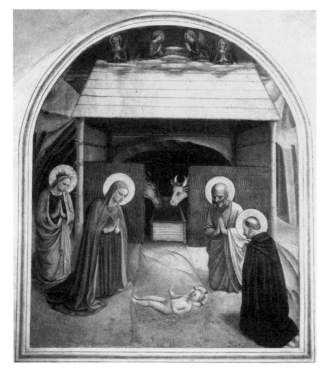

The Nativity of Jesus Christ by Fra Angelico. **CORBIS. REPRODUCED BY PERMISSION.**

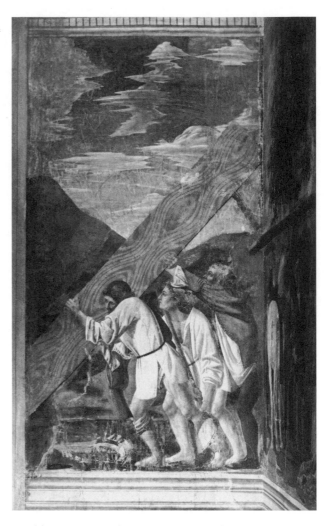

The fifteenth-century fresco cycle *Legend of the True Cross* by Piero della Francesca, Church of San Francesco in Arezzo, Italy. **ALINARI-ART REFERENCE/ART RESOURCE, NY. REPRODUCED BY PERMISSION.**

Domenico Veneziano in Florence, where he observed the advances that had occurred in depiction by figures like Masaccio, Castagno, Fra Angelico, and Veneziano. Returning to his native town, Borgo San Sepolcro, Piero spent the rest of his life undertaking commissions there and in Arezzo and Urbino. Piero integrated his Florentine lessons to create compositions that made use of the solid forms typical of the paintings of Masaccio and Castagno, while at the same time building upon the experiments in color and light typical of the works of Fra Angelico, Lippi, and Veneziano. His style is best exemplified in a series of frescoes he completed for the Church of St. Francis in Arezzo or in his *Resurrection* fresco completed for the town hall of Borgo San Sepolcro. In both paintings a calm and motionless air suffuses the composition, which Piero envisions with geometric regularity and simplicity. Throughout he relies upon colors that are cool and luminous, making the effect of these compositions all the more grand. Piero endowed his subjects with a monumental character, but the artist Pietro Perugino from Perugia in the region known as Umbria was, by contrast, a painter of definite grace and charm. Perugino gave his subjects a gentle majesty and he was among the best fifteenth-century masters of the atmospheric painting technique known as *sfumato*. In his *Christ Giving the Keys to St. Peter*, a fresco painted for the Sistine Chapel in Rome, Perugino presented the scene of Christ granting power over the church to St. Peter before a symbolic landscape—a domed church that suggests the Cathedral of Florence and Roman triumphal arches. While Peter kneels to accept the keys in the foreground, the background of the painting opens into an immense courtyard with enveloping hills in the distance, all of which is seen through the filmy atmosphere.

NORTHERN ITALY. Piero della Francesca and Perugino worked in regions that were relatively close to Florence. Further afield in Northern Italy artists proved more reluctant to abandon native styles in favor of Renaissance naturalism. A few notable exceptions were Andrea Mantegna, Antonello da Messina, and Giovanni Bellini. Andrea Mantegna (1431–1506) worked at Padua and for the Gonzaga family in Mantua. In his student days in Padua Mantegna had been affected by the great

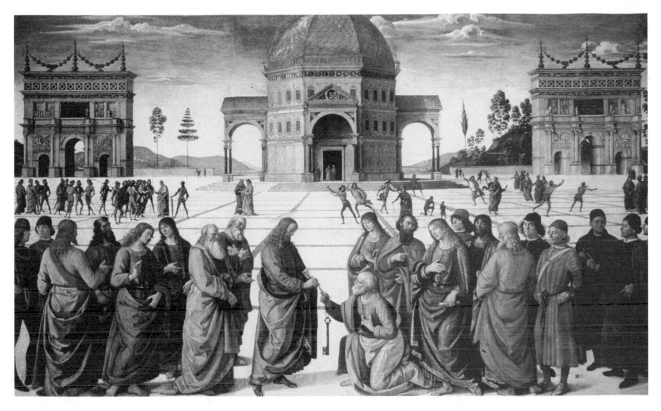

The Consigning of the Keys fresco by Perugino and Luca da Signorelli for the Sistine Chapel, Rome. AP/WIDE WORLD. REPRODUCED BY PERMISSION.

Florentine sculptor Donatello who had been undertaking a commission in the city. In a series of frescoes he completed during the 1450s for the Eremites in Padua, Mantegna showed his mastery of Florentine perspective. His painting *Saint James Led to Execution* relied on illusionistic devices so that the bottom portions of the fresco appeared to disappear as onlookers approached the work. In his later career as a court painter for the Gonzaga lords at Mantua, Mantegna painted a series of frescoes for the *Camera degli Sposi* or "Bridal Chamber" of the family's palace. While Mantegna's early paintings were often noted for their marble-like aloofness, here the artist shows a more playful streak. Besides including a number of scenes that include portraits of members of the family and local dignitaries, the Bridal Chamber's ceiling includes a trick painting in which members of the local court and cherubs appear to be looking down upon the room. Another innovator, Antonello da Messina (c. 1430–1479), was a Sicilian who had worked in the Netherlands before taking up residence in Venice. There Messina introduced the technique of oil painting to the conservative and somewhat old-fashioned circle of Venetian artists, helping to set the stage for the great age of Venetian oil painting that dawned in the sixteenth century. At the end of the fifteenth century Venice be-

gan to shed its reputation as an artistic backwater by providing a home to an increasingly large number of artists. Among these figures, the most accomplished certainly was Giovanni Bellini (1430–1516). In his *Transfiguration of Christ* Bellini relied on the newly imported technique of oil painting to envision the New Testament scene. He set his composition in a lush landscape of alpine foothills that was unprecedented in Italian art to this time. The painting's completion when the artist was around 50 years old shows that Bellini continued to retain his lead as one of the most innovative of fifteenth-century North Italian painters.

SECULAR THEMES. More than eighty percent of all fifteenth-century artistic commissions were religious in nature. The prominence of the church, religious institutions, and private families as commissioners of religious art meant that all artists needed to be fully versed in the stories of the Old and New Testaments and in the lives of the saints—the most prominent themes treated in religious art. Still as the fifteenth century progressed secular themes became more popular among patrons. In Florence and other Italian centers, the prominence of the intellectual movement of humanism helped to stimulate a taste for subjects drawn from Roman and Greek mythology. Sandro Botticelli ranks among the

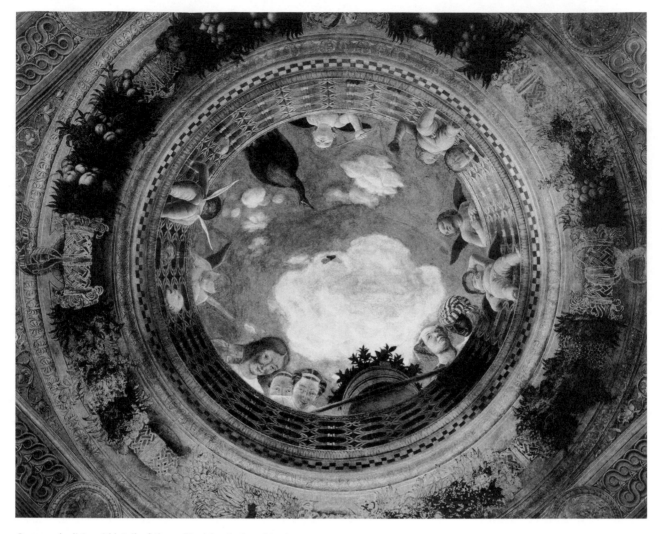

Camera degli Sposi (detail of the ceiling) by Andrea Mantegna. **THE ART ARCHIVE/DAGLI ORTI.**

greatest of artists to paint secular themes in the fifteenth century. Two of his works—the *Birth of Spring* and the *Birth of Venus*—illustrate the growing importance of secular themes among the cultivated elite of a Renaissance city like Florence. Members of the Medici family commissioned both works, and the philosophical movement known as Neoplatonism that was then popular among Florence's intellectuals influenced their subject matter. The first, the *Birth of Spring*, is an allegory that may symbolize the return of learning to Florence under Medicean patronage, although disputes about its precise meaning have continued until modern times. The second, the *Birth of Venus*, has also been variously interpreted. The graceful Venus may actually represent the figure *Humanitas*, a patron of learning and the arts. Or as some have argued, she may have been conceived as a kind of talisman that could bring Venus's favorable influence to the spot where the image was placed, a belief

that Neoplatonism helped to encourage among later fifteenth-century intellectuals.

PORTRAITURE. Another kind of secular art—the portrait—also grew in importance throughout the fifteenth century. The first portraits appeared in religious paintings, as prominent patrons often paid artists to insert themselves into the religious subjects they painted. This practice persisted throughout the Renaissance. The late fifteenth-century Florentine painter Botticelli, for example, used it in his famous painting of the *Adoration of the Magi.* Here he painted the images of prominent members of the Medici family and citizens of Florence into the story of the wisemen's worship of the infant Christ. Even as this custom persisted, Renaissance patrons demanded independent pictures and sculptures of themselves from the era's artists. The earliest independent portrait paintings, commissioned in the mid-fifteenth century, were often stiff and bore resemblance

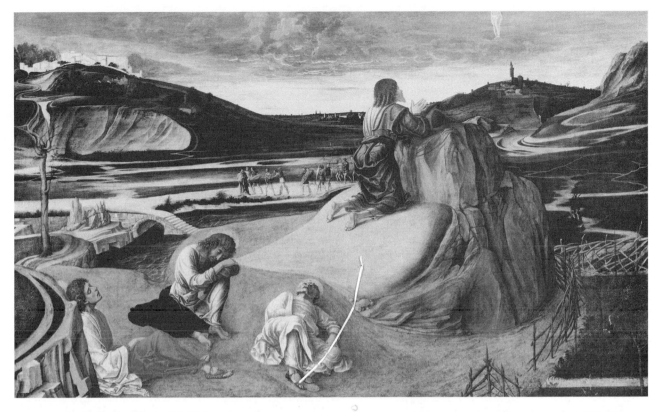

Agony in the Garden by Giovanni Bellini. © NATIONAL GALLERY COLLECTION. BY KIND PERMISSION OF THE TRUSTEES OF THE NATIONAL GALLERY, LONDON/CORBIS. REPRODUCED BY PERMISSION.

to antique portrait busts. Usually painters showed their subjects in profile view. Family members sometimes commissioned these portraits to commemorate a family member who was already dead, or who was of considerable age at the time. One of the oldest surviving portraits from the early fifteenth century—a picture of the Florentine gentleman Matteo Olivieri—depicted the subject as a young man, even though he was at the time of very advanced years. Portrait paintings like these were intended to preserve a positive memory of the subject after death. Over time, portraiture grew more imaginative and portraits fulfilled a broader variety of functions. Around 1480, the successful Florentine artist Domenico Ghirlandaio painted a more realistic portrait known as *An Old Man and a Young Boy* (now in the Louvre, Paris). The painting shows the elderly man, probably the boy's grandfather, sick and diseased with a growth on his forehead. Nevertheless, the senior stares tenderly into the eyes of the youth. Like earlier portraits, this picture may have been based upon a deathbed drawing of the old man, but Ghirlandaio and his patrons no longer found it necessary to give the old man eternal youth. Instead the artist depicted the man as he really was in his final days, while endowing the man with an inner strength and gentleness that makes the viewer look past his de-

formity. In the background a river landscape adds visual interest to the picture, a symbol suggesting the passage of time. Landscape backgrounds like these were becoming increasingly important in portraits at the time. Around 1500 Leonardo da Vinci developed the use of landscape to a high degree of sophistication. At the same time da Vinci perfected the portrait as a vehicle that expressed something about the subject's own individual nature. The artist worked in an environment in which portraits were coming to play ever more roles in elite society. These paintings were now important tools of noble and princely matchmaking. Ambassadors charged with conducting marriage negotiations usually carried with them small portraits or painted miniatures of the princes and princesses on whose behalf they acted.

RISING STATUS OF THE ARTIST. During the course of the fifteenth century the innovations that occurred in painting and sculpture in the Italian Renaissance city-states helped to confer a greater status upon artists than previously. While still considered mostly craftsmen throughout Europe, the presence of a humanist-sponsored artistic culture in Florence and other Italian Renaissance cities endowed artists with a new, more vital position in urban society. Humanist-trained intellectuals like Leon Battista Alberti mingled with artists, practiced

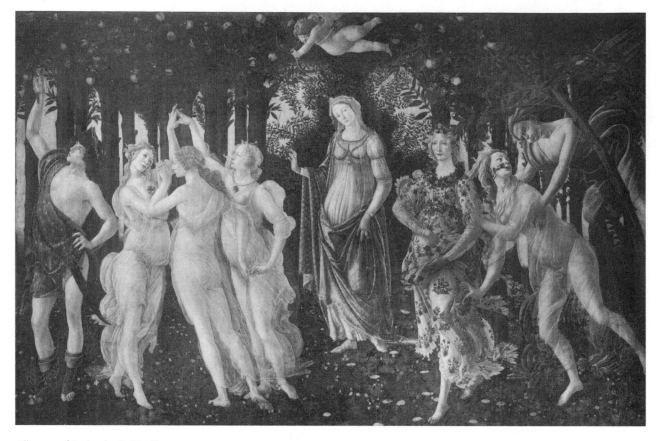

Allegory of Spring by Botticelli. **CORBIS-BETTMANN. REPRODUCED BY PERMISSION.**

architecture, sculpture, and painting themselves, and wrote theoretical treatises about the arts that helped elevate their status. Artists, too, mixed in the circles that surrounded great patron families like the Medici. By the end of the fifteenth century artists were not yet considered the equals of scholars and poets, but their position had risen in society. At this time Leonardo da Vinci stressed in his *Notebooks* the superiority of his knowledge as a painter because it came from experience rather than books. These claims were unthinkable without the steady rise in the artist's status that had occurred during the fifteenth century. During the sixteenth century this trend in Italy continued, particularly as a result of the careers of towering figures like Leonardo, Michelangelo Buonarroti, and Raphael Sanzio.

SOURCES

D. C. Ahl, *The Cambridge Companion to Masaccio* (Cambridge: Cambridge University Press, 2002).

M. Baxandall, *Painting and Experience in Fifteenth-Century Italy* (New York: Oxford University Press, 1972).

M. Chiellini, *Cimabue* (Florence, Italy: Scala Books, 1988).

R. Fremantle, *Florentine Gothic Painters from Giotto to Masaccio: A Guide to Painting in and near Florence,* 1300 to 1450 (London, England: Secker and Warburg, 1975).

C. Ginzburg, *The Enigma of Piero* (London, England: Verso, 1985).

N. Mann and L. Syson, *The Image of the Individual: Portraits in the Renaissance* (London, England: British Museum Press, 1998).

J. Pope-Hennessy, *Angelico* (Florence: Scala, 1983).

P. R. Walker, *The Feud that Sparked the Renaissance* (New York: Harper Collins, 2002).

J. M. Wood, *The Cambridge Companion to Piero della Francesca* (Cambridge: Cambridge University Press, 2002).

F. Zöllner, *Botticelli: Images of Love and Spring.* Trans. F. Elliott (New York: Prestel, 1998).

SEE ALSO *Architecture: The Birth of the Renaissance Style*

THE EARLY RENAISSANCE IN NORTHERN EUROPE

DYNASTIC CONNECTIONS. In Northern Europe, the Renaissance, with its emphasis on literary studies and

the revival of classical Antiquity, made few inroads before the late fifteenth century. Although the literary works of Petrarch, Boccaccio, and other humanists penetrated beyond Italy's borders, there were only few and scattered attempts to imitate the urbane Latin style championed by the early Renaissance humanists in Northern Europe. In the world of architecture Northern Europeans similarly continued to build on the medieval Gothic style during the fourteenth and fifteenth centuries, only hastily adopting the classicism typical of Italian Renaissance architecture in the sixteenth century. The history of the visual arts, by contrast, presents a different picture than other areas of cultural achievement. Although there were few attempts to adopt the classical proportions and ancient trappings that became important in Italian Renaissance painting and sculpture, a new naturalism nevertheless became evident in the art of fourteenth-century Northern Europe. This naturalism first found expression in the art of the French painter Jean Pucelle (active between 1320 and 1350) and the circle that surrounded him in Paris, before spreading to other parts of Northern Europe. It was in the opulent court of the Duchy of Burgundy that naturalism took root to produce its greatest artistic achievements. This curious state had been formed over the previous centuries through a series of marriage alliances, inheritances, and gifts. In 1363, the Duchy's ruling family died out, and because of feudal claims, the territory became the possession of the king of France, who bestowed it upon his youngest son, Philip the Bold. Within a short time Philip succeeded in extending Burgundy's territories to include all of Flanders (modern Belgium), most of Holland, and large parts of eastern France. By 1400, his territory rivaled and now threatened France. Philip chose Dijon to become the center of his state, and the duke called many artists there to create rich trappings for his court. At the same time Philip the Bold's brother, John of Berry, established a similarly opulent court in central France. Both Philip the Bold and John of Berry found their artistic masters not in France but in the Low Countries (modern Belgium and Holland), as leadership in innovation in the visual arts passed to this region in the late fourteenth century. During the following century Philip the Bold's grandson, Philip the Good, continued the tradition of Burgundian artistic patronage. He reigned in Burgundy from 1419 until 1467, and in 1430, transferred the capital of his domain to Brussels. The city now became home to the most luxurious court in Europe. The development of the Low Countries' wealthy trading cities—Bruges, Ghent, and Antwerp—supported the brilliant spectacle of Burgundian court life. In these cities, too, a rich market in art, comparable to that which was developing in Renaissance Italy, also appeared under the patronage of nobles and wealthy merchants. In painting, a vivid realism and the use of rich oil colors were two distinctive attributes of the early Renaissance in the Low Countries. But while painting matured in the Burgundian Low Countries, the fate of the Duchy of Burgundy itself darkened. In 1477 the death of Philip the Good's son and successor Charles the Bold in battle against France resulted in the carving up of the once great duchy, its possessions within France reverting to the French crown while those in the Low Countries became the property of the Hapsburg dynasty. In the Netherlands, however, the artistic marketplace that had developed during the fifteenth century survived into the sixteenth century, and Low Countries masters continued to rival their Italian counterparts in productivity and inventiveness.

JEAN PUCELLE. Among the first artists in Northern Europe to be aware of the artistic innovations occurring in Italy was Jean Pucelle, who was active between the 1320s and around 1350. Little is known about Pucelle's life, although for a time his large studio dominated artistic life in and around the city of Paris. Pucelle was a manuscript illuminator who enjoyed the patronage of the French crown. As a result, he commanded high prices for his works. The illustrations that he created for manuscripts show that he had probably traveled extensively when still young in Italy and the Low Countries. In the works he completed between 1320 and about 1350, Pucelle joined the spatial sense of Italian painters like Giotto and Duccio to the rich colorism that was typical of the art of the Netherlands. He moved to enclose his human subjects within a stage-like frame, in the same manner as Giotto and Duccio had done before him. In this way he suggested the three-dimensionality of space in his works. At the same time many conservative elements persisted in the works of Pucelle and his studio, and painters in Paris were not quick to imitate Pucelle's colorism or his naturalism in the second half of the fourteenth century. The dominant style, often referred to as the International Style, remained popular in France and in many Northern European courts as well. In contrast to the naturalism and spatial experiments of figures like Pucelle, International Style artists produced works in a stylized and elegant fashion, with flowing movements of drapery and a rich symbolic imagery. Contacts between France and Italy continued throughout the second half of the fourteenth century, though, as Italian masters visited French cathedrals and witnessed the majesty of the country's Gothic architecture firsthand. Italian artists, too, worked at the papal court in Avignon. The truly

revolutionary developments in Northern Renaissance art, however, did not come from imitation of Italian examples, but from native developments in style that were occurring among artists in the Low Countries.

CLAUS SLUTER. One of these revolutionary figures was the sculptor Claus Sluter, who was active between 1380 and about 1405. Sluter was from the Netherlands, a native of the Dutch city Haarlem near Amsterdam. Around 1385, Sluter immigrated to Dijon, capital of the rich Duchy of Burgundy, where he became an assistant sculptor at a monastery that Philip the Bold was constructing outside the city. Another Netherlandish sculptor, Jean de Marville, had already planned many of the sculptural works at this site, the Chartreuse de Champmol, and Sluter merely executed those plans. Between 1395 and 1403, Sluter carved his own masterpiece *The Well of Moses*, a large sculptural fountain that originally culminated in a gigantic crucifix. In comparison to the sculptural conventions common in Northern Europe at the time, Sluter's *Well* was a truly revolutionary work. In it, the artist gave primacy to the human form, and carved the figures that adorned the well in a dramatic, natural style. Sluter dispensed with the Gothic canopies that had long been used to encase Northern European sculptures, and instead presented his creations as lifelike individuals projecting out from the sculptural plane on which he carved them. His work also showed that he was a thoughtful and observant student both of human nature and the effects of time. His figures display a variety of psychological states, even as Sluter carved into their faces the wrinkles produced by time.

DIJON. In the years that Claus Sluter was at work at Dijon's Chartreuse de Champmol, the city emerged as one of the great centers of Northern European art. In 1384, Duke Philip the Bold had expanded his Burgundian territories to include wealthy Flanders (most of modern Belgium) and then used his increased revenues from the large and prosperous towns of this region to decorate his new capital at Dijon. The monastery Chartreuse de Champmol was a chief beneficiary of Philip's largesse, as the duke used the site to display his new wealth. One of the undeniable masterpieces created at the Chartreuse at this time was the altarpiece of the *Annunciation and Visitation* by Melchior Broederlam. The artist was a native of Ypres (now in modern Belgium) and he painted the work around 1400. Like other Flemish artists of the period, Broederlam favored a realistic attitude toward nature, rather than the stylized grace that was common among French artists at the time. His work on the altarpiece of the *Annunciation and Visitation* also displays influences from fourteenth-century

Italian art, particularly in its use of the craggy rock shapes that dot the landscape backgrounds. These seem to be drawn from firsthand knowledge of Giotto and his follower Duccio. Other works by Broederlam have never come to light, and his masterpiece did not produce any immediate change in the patterns of painting at Dijon or elsewhere in France. A decade or so after its completion, several works seemed to draw influences from Broederlam's famous altarpiece, but the artist's work represents largely a dead end in the history of Northern European art.

THE LIMBOURG BROTHERS. The creative impulses that were at work in the Burgundian court of Philip the Bold around 1400 were soon to be matched in the court of Philip's brother, John, the Duke of Berry. Around 1400, the duke engaged the services of the Limbourg brothers, Paul, Herman, and John. Natives of the city of Nijmegen in modern Holland, all three brothers died before they were barely thirty years old. In their short lives they managed to complete some of the most brilliant manuscript illuminations in European history. One of the earliest works that survive from the brothers' hand is a Bible from around 1410. In this work the Limbourg brothers sketched their illustrations and then used washes of color to define the characters in these drawings. Over the next few years, however, their technique was perfected, while their style and sense of color deepened. The late perfection of their work can be seen in the *Très Riches Heures* or *Very Rich Hours* manuscript undertaken for the Duke of Berry after 1413. The *Very Rich Hours* was a book of hours, a collection of prayers prescribed to be said at certain times of the day and throughout the year. During the fifteenth century the popularity of praying the hours, a custom originally adopted from monks and nuns, became increasingly widespread among lay people. A great range in quality of books of hours existed at the time, but those created for the nobility often included rich ornamentation and evocative visual images meant to enhance their user's piety and enjoyment. The Duke of Berry's *Very Rich Hours* ranks among the most beautiful of all the works of this kind that survive. In it, the Limbourg brothers gave a primary place to the monthly calendars that outlined the prayers. The illustrations the Limbourg brothers completed for these calendars richly catalogued the life of the Duke of Berry's court and of peasants on his estates. Like other Netherlandish painters the Limbourgs relied upon the realism that was the trademark of their countrymen's art as well as a brilliant sense of color. While these works influenced other masters at work in and around the Duke of Berry's court, they did not produce a complete shift in the patterns of painting

favored in France. The taste for stylized elegance and iconographical symbols that had long been favored by French painters persisted after these artists' untimely deaths, which may have occurred in the same epidemic that killed their patron, the Duke of Berry, in 1416. The *Very Rich Hours* was left tragically unfinished and was never used by the Duke of Berry who had commissioned it.

PANEL PAINTING. Illuminated manuscripts like the *Very Rich Hours* were consumed only by aristocratic patrons and those with whom their owners shared a glimpse of their rich works. By contrast, altarpiece paintings were public monuments, displayed in the open spaces of churches where people of all ages and social classes could view them. The fifteenth-century Netherlands witnessed a dramatic increase in the production of altarpieces. Their numbers grew from the 1420s, so that by the end of the century thousands of churches throughout the region possessed panel paintings treating religious themes. Many of these works were of middling quality, but some rose to the level of high art. During the fifteenth century the Netherlands produced several generations of artists who painted altarpiece paintings of rare quality. These works were executed using the new technique of oil painting, a medium that Netherlandish artists did not create, but perfected for novel use in their altarpieces. Most everywhere else in fifteenth-century Europe, artists relied on tempera painting. In this medium pigments were suspended in a mixture of egg yolk and water. Since the pigments could be easily dissolved with water, artists relied on varnishes to protect their colors from moisture. But in order for tempera colors to stand up to the effect of these varnishes, artists had to use brilliant, gem-like tones. Oil painting, by contrast, offered artists a greater range and depth of color. To create oil colors, artists in the Netherlands perfected a technique that suspended their pigments in hard resins that were then diluted with oil. On the panels he painted, the artist first applied a rough coat of gesso, a plaster-like substance, over which he drew a sketch of the work to be painted. Then he applied oil paints over this sketch. To enhance the paintings, the artist painted glazes over the work. These glazes were a mixture of oil, turpentine, and colors and they gave the painting a luminous effect. Finally, the artist also applied varnishes that were mixed again with colors to protect the work. In this way the painted surface took on an almost magical ability to refract light, thus conveying a broader range and depth of color than possible in the tempera medium.

CAMPIN. Mystery often shrouds the lives and careers of the earliest panel painters from the Low Countries (modern Holland and Belgium). Such is the case with Robert Campin (c. 1378–1444), a figure who is believed to have taught the accomplished Flemish artist Rogier van der Weyden, and who is now often credited with having painted many works long attributed to the so-called "Master of Flémalle." Great disagreement rages over the precise works that Campin painted, and some scholars have even attributed many of these to the young Rogier van der Weyden. Still documentary evidence establishes Campin's existence and further proves that this artist enjoyed a reputation in the early fifteenth century as the most accomplished master of the city of Tournai (now in Belgium). Other details about the painter's life are sketchy. From what can be established, it is obvious that Campin's works made a definitive break with the traditional style of International Gothic painting favored throughout Europe around 1400. International Gothic was particularly popular in the courts of Northern Europe. It was decorative and elegant, with its intricate visual rhythms gently shaped by the flowing and folding lines of the draperies, clothing, and other matter that artists placed in their compositions. By contrast, Robert Campin and his followers broke from these traditions to create a native kind of Netherlandish painting. In place of the stylized elegance favored by International Gothic artists, Campin, Rogier van der Weyden, and Jan van Eyck forged a style notable both for its realism and its use of veiled symbols. This new trend can be seen in a small *Nativity* Robert Campin painted for a monastery near Dijon, possibly the famous Chartreuse de Champmol. It is also to be seen in the famous Mérode altarpiece long attributed to the Master of Flémalle, but now increasingly thought by experts to be Campin's work. The Mérode altarpiece is now in the collection of the Metropolitan Museum in New York. In this work the artist faithfully catalogued a host of details that appeared to be drawn from everyday life, but which were in reality iconographical signs with religious meaning. One panel of the altarpiece treats the subject of the *Annunciation* and shows the Virgin sitting before a table on which a vase of lilies are present, a sign of her purity. A smoking candle, a sign of the Incarnation of Christ, lies beside this vase. To the left of the central panel, the donors of the altarpiece kneel in an enclosed garden, a sign of Mary's virginity. In ways like these Campin packed his works with symbols taken from the realities of everyday life.

VAN EYCK. The greatest master of the new Flemish realism was Jan van Eyck (c. 1385–1441). Like Campin, many of the details about van Eyck's life are sketchy, and many of his works, particularly those completed early in his career, are disputed. According to a sixteenth-century

a PRIMARY SOURCE *document*

ITALIAN ADMIRERS

INTRODUCTION: The Italian humanist Bartolommeo Fazio wrote a collection of *Lives of Illustrious Men* in 1456 in which he granted a surprisingly important place to artists. Among those he praised were the Netherlandish painters Jan van Eyck (here referred to as Jan of Gaul) and Rogier van der Weyden. Fazio lists van Eyck's virtues in the following excerpt and considers his key accomplishments. He stresses, in particular, the artist's ability to endow his objects with the appearances of reality.

Jan of Gaul has been judged the leading painter of our time. He was not unlettered, particularly in geometry, and such arts as contribute to the enrichment of painting, and he is thought for this reason to have discovered many things about the properties of colors recorded by the ancients and learned by him from reading Pliny and other authors. His is a remarkable picture in the private apartments of King Alfonso [Fazio's patron] in which there is a Virgin Mary notable for its grace and modesty, with an Angel Gabriel, of exceptional beauty and with hair surpassing reality, announcing that the Son of God will be born of her; and a John the Baptist that declares the wonderful sanctity and austerity of his life, and Jerome like a living being in a library done with rare art: for if you move away from it a little it seems that it recedes inward and that it has complete books laid open in it, while if you go near it is evident that there is only a summary of these. On the outer side of the same picture is painted Battista Lomellini, whose property it was—you would

judge he lacked only a voice—and the woman whom he loved, of outstanding beauty, and she too is portrayed exactly as she was. Between them, as if through a chink in the wall, falls a ray of sun that you would take to be real sunlight. His is a circular representation of the world, which he painted for Philip, Prince of the Belgians, and it thought that no work has been done more perfectly in our time; you may distinguish in it not only the places and the lie of continents, but also, by measurement, the distance between places. There are also fine paintings of his in the possession of that distinguished man. Ottaviano della Carda: women of uncommon beauty emerging from the bath, the more intimate parts of the body being with excellent modesty veiled in fine linen, and of one of them he has shown only the face and breast but has then represented the hind parts of her body in a mirror painted on the wall opposite, so that you may see her back as well as her breast. In the same picture, there is a lantern in the bath chamber, just like one lit, and an old woman seemingly sweating, a puppy lapping up water, and also horses, minute figures of men, mountains, groves, hamlets, and castles carried out with such skill you would believe one was fifty miles distant from another. But almost nothing is more wonderful in this work than the mirror painted in the picture, in which you see whatever is represented as in a real mirror. He is said to have done many other works, but of these I have been able to obtain no complete knowledge.

SOURCE: Bartolommeo Fazio, *Lives of Illustrious Men*, in *Northern Renaissance Art, 1400–1600: Sources and Documents.* Ed. Wolfgang Stechow (Englewood Cliffs, N.J.: Prentice-Hall, 1966): 4–5.

tradition, the painter was born in Maaseyck in northeast modern Belgium. Documentary evidence establishes that he entered the service of John of Bavaria, a count of Holland, sometime after 1422, and that he decorated the count's palace at The Hague. With the death of John of Bavaria in 1425, he took an honorary appointment in the court of Philip the Good of Burgundy, a position he retained until his death. He traveled to Italy where he most likely observed the revolutionary paintings of Masaccio in Florence and by 1430 he had settled in Bruges where he started to sign and date his works. Van Eyck carried Flemish realism to its highest point of development in both religious and secular paintings. The human subjects and objects that he catalogued appear to be actually real, his observation and recreation of nature being flawless. Like Campin, van Eyck also wed a copious use of veiled symbols to his paintings, as can be seen in one of van Eyck's most famous works, the *Arnolfini*

Wedding. As a sacrament of the medieval church, the marriage ritual was fraught with religious meaning. Marriage was at the same time the only legitimate avenue for bearing and raising children. In his *Arnolfini Wedding* van Eyck aimed to present an accurate vision of the real world, even as he included a number of symbols drawn from everyday life to convey both the religious and sexual meanings behind marriage. The painting depicts the union of Giovanni Arnolfini and Jeanne Cenami, both Italians living in Bruges at the time. To signify that this is a wedding portrait, van Eyck shows the couple clasping hands, a traditional symbol of betrothal, while Giovanni Arnolfini raises his right hand, as if making an oath. In the foreground of the picture van Eyck places a scampering dog, the animal a traditional symbol of fidelity, while the off-cast shoes show that the wedding chamber is a holy site. At the windows fruit is ripening, a sign of fertility, while in the chandelier a single candle

burns, signifying the nuptial candle that was traditionally the last to be extinguished on a couple's wedding night. Behind the couple a carved image of St. Margaret, patron saint of childbearing, decorates the back of a chair. The mirror, which van Eyck inserted at the rear of the room, had long been used as a symbol of the Virgin Mary, and around its circular frame the artist painted ten scenes from the passion of Christ. Van Eyck's mastery of realistic detail is remarkable. In the mirror's reflection can be seen the backs of the wedding couple and a man who stands before them, a figure that may be Jan van Eyck himself. Van Eyck brought this same realism to other portraits as the genre became more important in the Netherlands during the fifteenth century. His *Man in a Red Turban*, painted around 1433 and now in the National Gallery in London, was the first painting in which the subject is presented in a frontal pose, that is, looking at the observer. Van Eyck painted his subject, which may be the artist himself, with a calm and controlled gaze, a gaze that nevertheless suggests something of the subject's individual personality. In this way van Eyck's portraits anticipate the great achievements that Flemish artists like Rembrandt made in portraiture during the seventeenth century.

ROGIER VAN DER WEYDEN. Painting continued to flourish in the Low Countries after van Eyck's death in 1441. While no artist matched the brilliance of his realistic mastery of nature, painters of indisputable genius flourished in the region throughout the fifteenth century. Rogier van der Weyden (c. 1400–1464) was the greatest artist of the generation that followed in van Eyck's footsteps. In place of the earlier artist's placid emphasis on light and color, van der Weyden's religious panel paintings were altogether more emotional and tempestuous. In his early career the artist abandoned the realistic landscapes and surroundings popular with other Netherlandish artists. At the same time he nevertheless continued to paint his human subjects realistically. Van der Weyden lit his works with a brilliant, sometimes harsh light that threw his subjects' wrinkles and flaws into greater relief. The artist's tendency to develop a dramatic and intense art increased throughout his career, and his works grew more monumental following a visit to Italy during the Jubilee year of 1450. From the Italians, too, van der Weyden drew inspiration for the lyrical landscapes he used in his later works. In these paintings, the human form seems to dominate the landscape in the same way that was common among Italian artists of the time.

SECOND GENERATION. A spirit gentler than Rogier's pervades the art of the two greatest Netherlandish

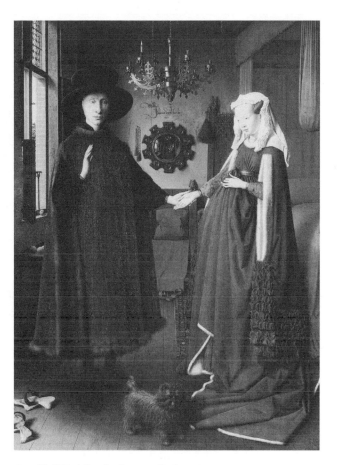

Arnolfini Wedding by Jan van Eyck. THE ART ARCHIVE/EILEEN TWEEDY. REPRODUCED BY PERMISSION.

painters, Dirc Bouts (c. 1415–1475) and Hugo van der Goes (c. 1440–1482) of the second half of the fifteenth century. Both artists continued in the traditions of Flemish realism established by Campin, van Eyck, and van der Weyden. Bouts achieved great notoriety as a portrait painter in the city of Louvain near Brussels. While he painted his early religious works very much in the style of Rogier van der Weyden, Bouts eventually developed his own idiom. This style was less dramatic and more emotionally impassive than Rogier. It has been described as almost primitively naïve. After his death, his sons carried on his workshop, keeping alive his style until the end of the century. Hugo van der Goes, who settled in Ghent, has often been described as the greatest Netherlandish painter of the second half of the century. Little is known about the artist's early life. At 27 he became a member of Ghent's painters' guild, eventually rising to become an official in that organization. The number of van der Goes' works is comparatively small—owing, it seems, to the artist's periodic bouts with depression and his short life. In addition, van der Goes did not sign his works and so it has often been difficult to establish the

a PRIMARY SOURCE document

STRANGE FANTASIES

INTRODUCTION: Carel van Mander (1548–1606) is often called the "Northern Vasari." Like his Italian predecessor, van Mander was the first to treat the lives of artists systematically in a collection of biographies. But unlike Vasari, van Mander was also a theorist who wrote treatises on the more general nature of art and aesthetics. In his life of Hieronymus Bosch, van Mander finds the artist's work filled with strange fantasies.

Manifold and strange are the inclinations, artistic habits, and works of the painters; and each became the better master in the field to which Nature drew and guided his desire. Who can relate all the wondrous and strange fantasies which Jeronimus Bos conceived in his mind and expressed with his brush, of spooks and monsters of Hell, often less pleasant than gruesome to look at? He was born at Hertogenbosch, but I have not been able to establish the dates of his life and death except that it must have been at a very early period. Nonetheless, in his draperies and fabrics his manner differed greatly from the old-fashioned one with its manifold creases and folds. His manner of painting was firm, very skillful, and handsome; his works were often done in one process yet remain in beautiful condition without alterations. Also, like many other old masters, he had the habit of drawing his design upon the white ground of the panel and covering it with a trans-parent flesh-colored priming, often allowing the ground to remain effective. One finds some of his works in Amsterdam. Somewhere I saw his *Flight into Egypt* in which Joseph, in the foreground, asks a peasant the way and Mary rides a donkey; in the distance is a strange rock in an odd setting; it is fashioned into an inn which is visited by some strange figures who have a big bear dance for money, and everything is wondrous and droll to look at. Also by him, [in a house] near De Waal, is a representation of how the patriarchs are redeemed from Hell and how Judas, who thinks he can escape with the others, is pulled up by a rope and hanged. It is amazing how much absurd devilry can here be seen; also how cleverly and naturally he rendered flames, conflagrations, smoke, and fumes … At Haarlem, in the house of the art-loving Joan Dietringh, I saw several of his pictures; among these were a disputation with several heretics. He had all their books, together with his own, put in a fire; he whose book did not burn should be in the right, and one can see the saint's book flying out of the fire. In this picture, the fiery flames as well as the smoking pieces of wood, burnt and covered with ashes, were painted very cleverly. The saint and his companion looked very solemn, and the others had funny and strange faces.

SOURCE: Carel van Mander, *Life of Hieronymous Bosch*, in *Northern Renaissance Art, 1400–1600: Sources and Documents.* Trans. Wolfgang Stechow (Englewood Cliffs, N.J.: Prentice-Hall, 1966): 20–21.

authenticity of many paintings long attributed to him. One undisputed masterpiece which can be securely fixed as Hugo's own is the famous *Portinari Altarpiece*, now in the Uffizi Gallery in Florence. Tomasso Portinari, an Italian merchant, commissioned this painting for the Church of Santa Maria Novella in Florence. The painting exercised an important influence among Italian artists, who were inspired by the artist's subtle mastery of the oil painting technique. In the *Portinari Altarpiece*, van der Goes also handled the painting's subject, the adoration of the shepherds at the birth of Christ, with a fine discrimination of psychological detail.

MEMLINC. In the second half of the fifteenth century the once great port of Bruges in Flanders entered a period of economic decline. Once the greatest trading center of the Low Countries, the town's river, the Zwin, began to silt up the city's excellent harbor. Few signs of the decline that eventually gripped Bruges, however, are evident in the sumptuous art of Hans Memlinc, the city's greatest late fifteenth-century painter. Memlinc combined influences from all the great Flemish painters of the century, including the compositional style of Jan van Eyck and the luxurious details typical of the works of Hugo van der Goes and Dirc Bouts. The greatest influence upon Memlinc, however, seems to have been Rogier van der Weyden, as he modeled many of his human figures and compositions on those of this earlier accomplished artist. Memlinc had a prolific career, painting mostly for Bruges' wealthy religious houses. His many works, which still can be seen in the city today, exhibit a narrative charm and beauty that few artists of the period achieved. Also a superb technical craftsman, Memlinc completed a reliquary in 1489, the *Shrine of St. Ursula*, that was less than three-feet high. Despite this diminutive scale, the artist decorated this casket with a series of paintings that are noteworthy for their astonishing detail, successful decoration, and narrative unity.

HIERONYMUS BOSCH. The fifteenth century was an age of extraordinary achievement in Netherlandish painting. Fueled by the commercial wealth of the region's cities, the artists of Flanders explored issues of light, space, and color to depict the human form and the

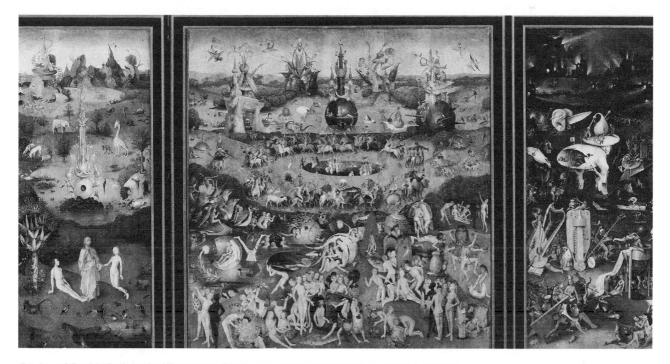

Garden of Earthly Delights by Hieronymus Bosch. THE ART ARCHIVE/MUSEO DEL PRADO MADRID.

landscape in ways that were strikingly realistic. They developed a keen sense of iconography, subtly veiling the use of symbols in their works. A craftsman's precision also characterized the many altarpieces, religious paintings, and portraits they produced. While this lineage of distinguished artists learned from each other, they each displayed an individual temperament in their works that differed subtly from one another. As the fifteenth century came to a close in the Netherlands, Hieronymus Bosch (c. 1450–1516) painted a series of fantastic works that were noteworthy both for their striking originality and individuality of expression. Little is known about this mysterious figure, and tracking the course of his development as an artist is difficult because, of the many works attributed to him, only seven are signed. Bosch was apparently born and worked mostly in the southern Dutch town of 's-Hertogenbosch. Both his father and grandfather appeared to have been painters. If the chronologies that have been constructed of Bosch's works are correct, his earliest paintings were awkward in design and execution. Over time, however, he showed a growing certainty of technique and an increasingly complex iconography. As Bosch's career developed, he created works that gave expression to his own inexhaustible imagination.

GARDEN OF EARTHLY DELIGHTS. This fertile personal vision is most evident in the artist's mature paintings like the triptych, *The Garden of Delights*, apparently completed sometime between 1505 and 1510. The sub-

ject of this three-fold panel painting is a moralistic sermon on the Garden of Eden and the Fall of Man. In the first panel on the left, God appears to Adam and Eve to present them with the garden, a place which the artist populates with a broad array of animal life, some of it only dimly known to Europeans around 1500. He includes images of giraffes, elephants, and countless species of unusual birds. Not all is bliss in this paradise, however, as Bosch suggests the forces that will render the Fall inevitable: a serpent winds itself around a tree, while a cat captures a mouse for its dinner. In the center panel, Bosch depicts the state of humankind after the expulsion from Eden's paradise. In it, the human race has come to follow Satan, who will lead them to the perdition that waits in the final panel, a vivid pictorial description of Hell. In both works, Bosch presents the human form as pale and weak, that is, as incapable of stemming the tide of lust to which it has fallen prey. The singularity of the artist's imagery still manages to amaze viewers five centuries after its creation. In the center panel treating the state of fallen humankind, Bosch sets the images in a landscape with rocky outcroppings and a lake. In the center of the lake a huge egg-like structure appears as a kind of monster from which dolphin-like creatures appear to sprout. Throughout the rest of the panel Bosch presents thinly veiled erotic imagery. His humans frolic, ride livestock, emerge from egg-like structures, and caress strawberries and other fruits, each activity a play on phrases used in many European languages to connote sexual

intercourse. In the final panel, Bosch concludes this sermon on the consequences of erotic attraction: his inferno is a place of mechanical precision lit only by the firelight that serves to punish humankind. The artist does not include a traditional picture of Satan as a beguiling or fearsome demon, but instead shows him as a monstrous being, his body again a broken egg out of which and into human beings crawl like wretched rats. Bosch may have intended the *Garden of Delights* to condemn human sexuality, eroticism, and luxury as the vices that brought damnation. His audiences over the past centuries, however, have more often come to enjoy, and even be titillated by the fertility and seductiveness of his imagination. In the final years of the artist's life, Bosch's development as an artist continued. In place of distanced erotic visions set in meadows or hellish visions set in dimly lit infernos, the artist presented his human figures in close-up position, as in his *Christ Carrying the Cross*, a work completed shortly before Bosch's death in 1516. Still here Bosch returned to the same themes he had moralized about throughout his career: the battle between good and evil. He presented Christ as the archetype of good, surrounded by tightly packed human figures with ghoulish faces.

PAINTING IN EARLY FIFTEENTH-CENTURY GERMANY. The realism developed by Netherlandish artists affected painting produced elsewhere in Europe in the fifteenth century. While artists of great individuality were common in the Netherlands throughout the entire fifteenth century, the early fifteenth century in Germany produced few masters with such fertile imagination and pictorial skill. There were, however, several exceptions. At Cologne, Stefan Lochner (c. 1415–c. 1451) produced a number of charming works, which, although they adopted some of the compositional innovations of Netherlandish art, remained wedded to many medieval conventions. Lochner had learned these techniques, apparently firsthand from Robert Campin. In his *Presentation in the Temple*, completed around 1447, the artist relied on the perspective techniques perfected by Netherlandish artists. But while he set his work within a seemingly three-dimensional space signified by the work's floor, he did not make use of the interior spaces or landscapes common to the Netherlandish art of the time. Instead Lochner painted the background of his work in goldleaf, a medieval technique meant to suggest the glories of Heaven. He also adopted the medieval practice of relying upon several different sets of proportions in his work so that its most important figures appeared far larger than less important ones. Lochner was an artist of great charm. The *Presentation* includes a small procession of choir boys who are arranged according to their

size and who are led by the youngest and seemingly most endearing figure of the artist's imagination. By contrast, Konrad Witz (c. 1400–c. 1445) was born in the German southwest but eventually moved to Basel in Switzerland, and probably died there after a relatively short, but prosperous career as a painter in the city. Witz dealt with perspectival problems in his paintings, developing techniques for rendering both interior and exterior spaces so that they appeared to be real. In this regard he was not always successful, but his attempts show the curiosity common among fifteenth-century artists with mastering space and the depiction of the natural world. One of the artist's most successful works, the *Miraculous Draught of Fish*, is a painting that relates a fishing miracle performed by Christ and recorded in the Gospel of Luke. Witz set this narrative within a glorious subalpine landscape and played the red tones of Christ and the apostles' robes off against rich greens in the surrounding landscape. Despite his short life, Witz seems to have had a prolific career. Unfortunately, sixteenth-century Protestants destroyed many of his works in their staged attacks of iconoclasm on Basel's churches during the Reformation.

LATER FIFTEENTH-CENTURY GERMANY. A greater freedom from Netherlandish models began to appear in certain German centers in the second half of the fifteenth century. The artist Michael Pacher (c. 1435–1498), a native of Bruneck in Tyrol (then, as now, in Austria), was one figure who exemplified this new originality in German art. Pacher was a wood sculptor who carved in the notoriously difficult medium of limewood. Limewood was a species of the linden tree known for its great hardness. His limewood altarpieces were similar in many respects to those of the great German late Gothic sculptors Tilman Riemenschneider (c. 1455–1531) and Veit Stoss (c. 1455–1533). All three men carved numerous wood altarpieces across southern Germany and Central Europe in the late fifteenth century, and Riemenschneider and Stoss continued this tradition after Pacher's death. The figures in a typical limewood altarpiece were carved as separate sculptures and then were placed within a kind of stage-like box. Perhaps because of his background in this kind of sculpture, Michael Pacher experimented with problems of perspective in his paintings. While he continued to make use of northern techniques of realism, Pacher traveled to Italy, visiting Padua and Venice. In Italy, he became a close associate of Andrea Mantegna, an artist who was also interested in problems of perspective. He applied the lessons that he learned in Italy in his subsequent works, but perhaps nowhere more brilliantly than in his *Pope Sixtus II Taking Leave of Saint Lawrence,* a panel from an altarpiece painted in

the 1460s. In this work, Pacher's perspective, solid human forms, and even the flows of drapery seem to be very much influenced by his Italian associate Mantegna. At the same time he handles the play of light and color in his works in much the same way as other Northern European artists influenced by Netherlandish examples.

PRINTING. Copper engraving was one area in which German artists excelled in the second half of the fifteenth century. Artists elsewhere in Europe practiced engraving at this time, but it was in Germany that this particular art form reached its high point of development during the Renaissance. In the second half of the fifteenth century Martin Schongauer (c. 1450–1491) helped to lay the foundations for these later achievements. Schongauer developed techniques upon which sixteenth-century engravers like Albrecht Dürer relied. The artist was born and practiced in Colmar in Alsace (a predominantly German-speaking region now in France). He was an accomplished painter whose works were within the traditions of Netherlandish realism and were heavily influenced by Rogier van der Weyden. As an engraver, however, Schongauer excelled. He relied on hatching, stippling, and all sorts of techniques to produce a subtle range of coloration and detailing in his printed works.

PAINTING IN FRANCE. The first half of the fifteenth century was a time of crisis in France, as the Hundred Years' War moved to its conclusion. The French monarchy, badly bruised by these conflicts, also faced challenges to the east from its powerful cousins, the Dukes of Burgundy. Since much art was produced in Northern Europe within the confines of royal and noble courts, France's international problems had a dampening effect on artistic patronage in the first half of the fifteenth century. Nevertheless, the country still produced artists of sensitivity and some sophistication, but styles of painting differed enormously throughout the country. The International Gothic, with its stylized, swaying draperies, continued to be popular in many parts of France throughout the fifteenth century, while in the north of the country the examples of Flemish and Dutch artists created a preference for the realism and coloristic techniques of Netherlandish artists. Elsewhere other native traditions flourished. If France did not experience the kind of artistic Renaissance that the Low Countries did during the fifteenth century, the country still produced a number of artists of merit. The greatest of the country's fifteenth-century painters was Jean Fouquet (c. 1420–c. 1481), a native of the central French city of Tours. Fouquet worked for Charles VII, the king whose throne had been saved by the visionary Joan of Arc. While undertaking commissions for religious panel paintings, Fouquet also continued to practice the art of manuscript illumination, a medium that had been abandoned by the foremost painters of Italy and the Netherlands by this time. During the 1450s he completed a set of sixty brilliant miniatures for a *Book of Hours* for the king's finance minister, Etienne Chevalier, a patron whom he had already immortalized in a portrait included in a panel painting now known as the *Melun Diptych*. Fouquet was unusual among French artists because he had traveled to Italy, where he likely derived some inspiration from Fra Angelico and other Florentine artists. In general, though, his painting remained true to native French traditions. Late in life, the French monarchy awarded Fouquet the title of "Royal Painter," but the evidence suggests that he had long been the leading painter at court before the conferring of this title. In the southern French region of Provence, Duke René of Anjou supported a brilliant court in the city of Aix that produced several accomplished artists. These included the unknown master who painted the *Annunciation of Aix* sometime around 1445. This "Master of the Annunciation of Aix," as he has come to be known, drew inspiration from the works of Jan van Eyck, although his realism and his use of color and of light and shade are not as sophisticated as that of contemporary Netherlandish artists. At the same time his works show a great simplicity and forcefulness of expression. The greatest panel painter at work in southern France in the fifteenth century was Enguerrand Quarton or Charonton (c. 1410–1466). This artist worked in and around the city of Avignon, producing a celebrated *Pietà* around 1460 that is noteworthy for its somber and haunting qualities. At the same time Quarton could also be an exuberant artist, as in the *Coronation of the Virgin* he completed for a hospital in Avignon. The stipulations of this work's contracts survive and show that the prior of the hospital heavily defined its appearance. He required Quarton to use a number of medieval stylistic traits, including a gold background and differing scales for the various subjects depicted in the work. The resulting project, though, rises to the level of great art because of its stunning detail and use of color.

TOWARD THE FUTURE. The chief development in Northern European art in the fifteenth century had been centered in the cities of Flanders. These had begun with the attempts of Robert Campin and his followers to represent the world realistically. In the art of Jan van Eyck and his followers a Flemish tradition of painting developed that rejected the stylized grace and overt iconographical symbols once common among the Gothic painters of the fourteenth century. In place of these older

artistic canons, Flemish artists advocated a use of veiled symbols, so that the deeper religious icons of their paintings appeared as the objects of everyday life. These insights had imitators in many places in Northern Europe, although in some centers the traditions of the International Gothic survived throughout the century. By 1500, new artists and new artistic centers challenged the dominance of the Netherlandish style, and made way for a more widespread Renaissance in Northern European art.

SOURCES

M. Baxandall, *The Limewood Sculptors of Renaissance Germany* (New Haven, Conn.: Yale University Press, 1980).

H. Belting, *Hieronymus Bosch: Garden of Earthly Delights* (New York: Prestel, 2002).

C. D. Cuttler, *Northern Painting; From Pucelle to Bruegel* (New York: Holt, Rinehart and Winston, Inc., 1968).

C. Harbison, *Jan van Eyck: The Play of Realism* (London, England: Reaktion Books, 1991).

R. Mellinkoff, *The Devil at Isenheim* (Berkeley, Calif.: University of California Press, 1988).

J. Snyder, *Northern Renaissance Art: Painting, Sculpture, the Graphic Arts from 1350 to 1575* (New York: Harry N. Abrams, 1985).

THE HIGH RENAISSANCE IN ITALY

ACHIEVEMENT. At the end of the fifteenth century most of the goals toward which Italian painters and sculptors had long been striving had been achieved. As a result, Italian artists produced works that represented nature and the human form more faithfully than in previous centuries. In painting, the lineage of accomplishments from the time of Cimabue and Giotto to Masaccio had established techniques for rendering space in ways that appeared three-dimensional. And in Florence and elsewhere throughout Italy fifteenth-century artists had continued to master the techniques of *chiaroscuro* (the painting of light and shade that gave solidity and weight to pictures) and *sfumato* (the rendering of atmosphere). In sculpture, the fifteenth century had been one of undeniable achievement, from Ghiberti's doors of the Baptistery at Florence to the bronze and stone carvings of Donatello, Lucca della Robbia, and others. The early Renaissance had also witnessed a revival of knowledge about the art of classical Antiquity, as Brunelleschi, Alberti, and others had studied and begun to apply the proportions and conventions of ancient Roman art. Now at the end of the fifteenth century the results of this research and of the techniques generations of artists had perfected gave rise to a great flowering of art known as the High Renaissance. This period, which lasted until about 1520,

was a brief, but undeniably profound period of artistic achievement. Three great artistic geniuses dominated the style of the High Renaissance: Leonardo da Vinci, Michelangelo Buonarroti, and Raphael Sanzio. Each earned recognition during his lifetime as an enormously gifted creator, whose works were sought after by kings, princes, and popes. As a result of the achievements of the period, the status of the artist continued to rise in Italian society, and the ability to create art came to be seen among intellectuals as a divinely inspired attribute. The High Renaissance in art coincided with the popularity of Neoplatonic philosophy in Florence, Rome, and the other humanist centers throughout Italy. Neoplatonism taught that creativity was a sign of humankind's creation in God's likeness. The Neoplatonic philosophers Marsilio Ficino and Giovanni Pico della Mirandola originally identified this spark of divine creativity with literary achievements, particularly with poetry. But the artists of the High Renaissance came to be influenced by these ideas. Michelangelo, a student of Neoplatonism in his youth, was particularly quick to point to his achievements in sculpture and painting as the products of divine inspiration. Many patrons agreed, and the notion of the artist as a figure filled with an almost superhuman ability to create became one of the underlying themes of the age.

POLITICAL DISUNITY. The High Renaissance, the period of Italy's greatest artistic achievement and productivity, coincided with tensions on the peninsula's political scene. During the course of the fifteenth century despots dominated many of Italy's small states, while the larger powers in the peninsula conquered many smaller territories. By 1500, five great powers—Milan, Florence, the papacy, Venice, and Naples—overshadowed the smaller territories throughout Italy. Constantly shifting alliances and treacherous diplomatic dealings became the rule between these great states, none of which was powerful enough to subdue the others. This lack of political unity, as well as diplomatic treachery, left open the door for outside invasion. In 1494, France became the first major European power to seek conquests in Italy, and this French invasion touched off a long series of conflicts that became known as the Italian Wars (1494–1530). Eventually every major European power became involved in these wars, as European dynasties tried to press ancient feudal claims to rule parts of Italy. Thus Italy's period of greatest cultural achievement occurred simultaneously with a dismal period of warfare.

LEONARDO DA VINCI. Born the earliest of the three giants, Leonardo da Vinci (1452–1519) was a remarkable and unusual man. Unlike other artists of the time,

a PRIMARY SOURCE document

ARTISTIC PRECOCITY

INTRODUCTION: In his famous *Lives of the Most Eminent Painters, Sculptors, and Architects,* the biographer Giorgio Vasari stressed the inventiveness and skill that Leonardo da Vinci displayed from an early age.

Truly admirable, indeed, and divinely endowed was Leonardo da Vinci; this artist was the son of Ser Piero da Vinci; he would without doubt have made great progress in learning and knowledge of the sciences, had he not been so versatile and changeful, but the instability of his character caused him to undertake many things which having commenced he afterwards abandoned. In arithmetic, for example, he made such rapid progress in the short time during which he gave his attention to it, that he often confounded the master who was teaching him, by the perpetual doubts he started, and by the difficulty of the questions he proposed. He also commenced the study of music, and resolved to acquire the art of playing the lute, when, being by nature of an exalted imagination and full of the most graceful vivacity, he sang to that instrument most divinely, improvising at once the verses and the music …

Leonardo, with his profound intelligence of art, commenced various undertakings, many of which he never completed, because it appeared to him that the hand could never give its due perfection to the object or purpose which he had in his thoughts, or beheld in his imagination; seeing that in his mind he frequently formed the idea of some difficult enterprise, so subtle and so wonderful that, by means of hands, however excellent or able, the full reality could never be worthily executed and entirely realized. His conceptions were varied to infinity; philosophizing over natural objects; among others, he set himself to investigate the properties of plants, to make observations on the heavenly bodies, to follow the movements of the planets, the variations of the moon, and the course of the sun.

Having been placed then by Ser Piero in his childhood with Andrea Verrocchio, as we have said, to learn the art of the painter, that master was engaged on a picture the subject of which was San Giovanni baptizing Jesus Christ; in this Leonardo painted an angel holding some vestments; and although he was but a youth, he completed that figure in such a manner that the angel of Leonardo was much better than the portion executed by his master, which caused the latter never to touch colours more, so much was he displeased to find that a mere child could do more than himself.

SOURCE: Giorgio Vasari, *Lives of Seventy of the Most Eminent Painters, Sculptors, and Architects,* Vol. 2. Trans. and Eds. E. H., E. W. Blashfield, and A. A. Hopkins (New York: Scribner, 1902): 371 and 376.

da Vinci completely rejected ancient Roman models for his art and instead painted in a natural style. He was born the son of a notary and a peasant woman. Eventually, his father built a prosperous career, and in his youth da Vinci became an apprentice to the Florentine artist Verrocchio. He earned early recognition as a painter, but da Vinci's restless genius led him to practice sculpture, architecture, in addition to his studies in mechanics and design. While none of the artist's buildings was ever constructed, he was widely recognized as a master of invention and problem solving. The lifelong *Notebooks* that he kept included designs for an amazing number of machines, including an early vision of the helicopter. At times da Vinci worked as a military engineer, designing battlements and siege machines for his clients, which included the despot Cesare Borgia, the dukes of Milan, and the Republic of Florence. Although he was a man of little formal schooling, da Vinci embodied the Renaissance concept of the "universal man." Besides these many achievements, the artist also wrote music, experimented in physics, and was a student of botany, geography, optics, anatomy, and geology.

EARLY WORKS. After completing his training in Florence, da Vinci's first independent commission seems to have been the *Adoration of the Magi,* a composition undertaken for a monastery for Florence. This work, like many of Leonardo's, was left unfinished when the artist left for Milan two years later, but it shows a highly adventurous use of organizational techniques. In the foreground of the panel the Virgin and three kings worship the Christ child, while around them a great circular group of onlookers forms an arch in the background. In this, the first of his mature masterpieces, Leonardo displays his fascination with facial expressions and with balance and harmony. In 1483, the artist traveled to Milan to paint his *Virgin of the Rocks* for a local confraternity, a work long admired for the sweetness of expression on its subjects' faces. It shows the Virgin Mary raising her hand to protect the Christ child, who confers a blessing on the kneeling figure of the infant John the Baptist. An angel, otherworldly in its extreme beauty, points to John the Baptist. The entire drama appears before a mysterious crag-filled landscape that is illuminated by two different sources of light, one in the distance and another

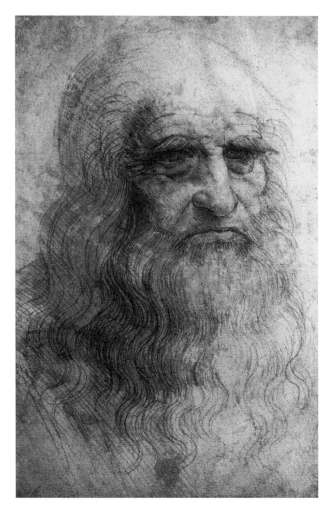

Self-Portrait by Leonardo da Vinci. **PUBLIC DOMAIN.**

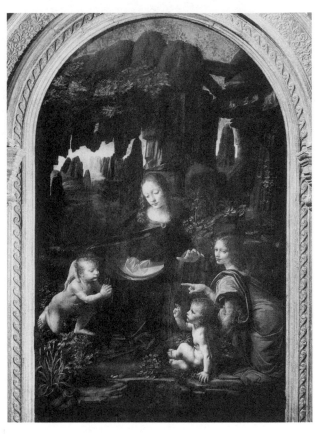

Madonna of the Rocks by Leonardo da Vinci. **THE ART ARCHIVE/DAGLI ORTI.**

that throws an ethereal glimmer upon the faces of the subjects in the foreground. While at work in Milan, Leonardo offered his services to Lodovico Sforza, a despot who had recently seized control of the Duchy of Milan. Sforza sat at the head of a cultivated court, and da Vinci fulfilled many roles within the ducal household. He decorated the Sforza apartments, provided stage sets and costumes for many theatrical productions, and painted portraits of members of the court. During this period the artist completed a number of his most famous portraits, including the *Portrait of a Lady with an Ermine*, the *Portrait of a Musician*, and the *Portrait of a Woman in Profile*. The largest and most important project of these years in Milan, though, was his *Last Supper*, a commission undertaken for the refectory or dining hall of the monastery of Santa Maria delle Grazie. Leonardo da Vinci's plan for the picture was innovative. He divided the group of twelve disciples into four groups of three and through the eyes of these characters and their subtle gestures and facial expressions he endowed these ac-

tors with a kind of superhuman grandeur. Through a skillful use of perspective, too, the artist expanded the space of the refectory illusionistically so that the room appeared to be much larger. Da Vinci's *Last Supper* set a new idealized standard for artists hoping to visualize religious themes. Sadly, the artist also experimented with the use of a new technique of painting and the work began to decay almost as soon as it was finished. Over the centuries it has been badly treated as well at the hands of restorers. Still some of the work's grace and beauty has survived over the years. The invasion of Milan at the hands of the French and the expulsion of Lodovico Sforza, however, cut Leonardo's time in the city short, and in 1499 the artist fled first to Venice and later returned to Florence.

FLORENCE AND LATER YEARS. Upon his return to the city where he had been trained, da Vinci was offered a number of commissions, although at first he completed only studies for these projects. In 1502, the notorious general and despot Cesare Borgia, illegitimate son of Pope Alexander VI, offered Leonardo employment as an architect and engineer. At the request of his patron da Vinci traveled through central Italy, making plans for

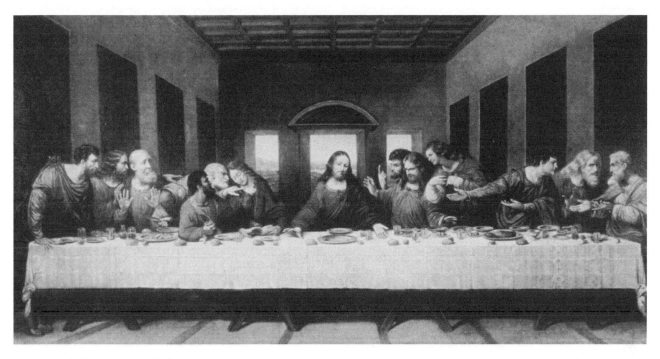

Last Supper by Leonardo da Vinci. THE GRANGER COLLECTION LTD. REPRODUCED BY PERMISSION.

siege engines, model cities, and battlements. He returned to Florence in 1503, and received a commission to paint a fresco for the Chamber of the Republic, a meeting room in Florence's Palazzo Vecchio or town hall. The subject was the *Battle of Anghiara,* a fifteenth-century Florentine military triumph. Again Leonardo relied on experimental methods, and the commission had to be abandoned prior to its completion. Around this time the artist also painted his most famous work, the *Mona Lisa,* a portrait of the wife of a wealthy Florentine. As a portraitist, da Vinci produced notable works. In contrast to the rigid profile portraits of many fifteenth-century artists, da Vinci painted his subjects in relaxed positions. The *Mona Lisa* sits calmly before a rich and mysterious landscape, one in which the artist has made great use of the technique of *sfumato* or atmospheric painting. The *Mona Lisa* is one of the only surviving later works from da Vinci's hand. He did not complete most of the painting projects he began in the years after 1508. Two notable exceptions were the artist's *Saint John the Baptist,* which da Vinci completed during his second residency in Milan between 1508 and 1513, and his *Virgin and Child with Saint Anne,* a work begun in 1508, but not finished until many years later when the artist was in Rome. In these later years Leonardo devoted himself to scientific studies rather than to painting, the record of which are to be found in his voluminous *Notebooks.* In 1516, King Francis I invited him to France to work at the French court. He received a country château and a wide range of projects to complete, including set designs for courtly theatrical productions and plans for a new royal palace. But like so many of the projects he undertook, this last project was never completed.

SIGNIFICANCE. Da Vinci was never satisfied with being merely an artistic craftsman. In contrast to the artists of the fifteenth century he presented himself as an individual on an intensely personal quest for self-expression in his art. Even art, though, was an insufficient taskmaster for Leonardo, who followed many professions simultaneously. This is evident in his *Notebooks.* Leonardo considered himself a painter, and he argued that painting was a science because it proceeded from empirical observation and was based upon the mathematical laws of perspective. At the same time he worked as an engineer, a designer, a writer, a draftsman, builder, anatomist, and contemplative theologian. He was particularly well versed in the arts of war (including the construction of siege machines, defensive battlements, and so forth), and he earned far more from these skills than he did from his art. In his *Notebooks* Leonardo frequently argues that he is not a learned man in the ways of the humanists or scholastics, but that his experience makes him superior to those who have much book learning. His statements often attack the pretentiousness of scholars. Instead he argues that painters practice skills that are superior to other crafts because they rely upon their eyes and are masters of observation. This aspect of Leonardo's thought—the value of empirical

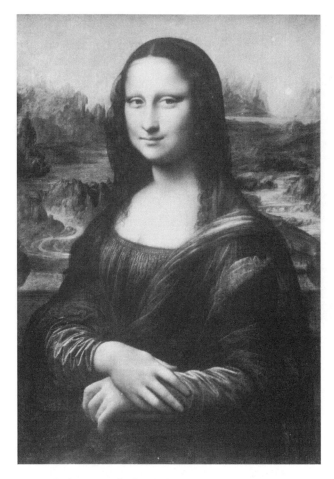

Mona Lisa by Leonardo da Vinci. NEW YORK PUBLIC LIBRARY PIC-TURE COLLECTION.

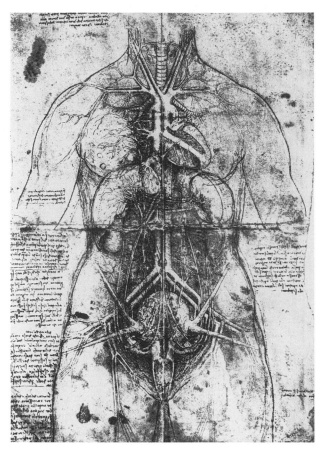

"Anatomical Study" by Leonardo da Vinci. © BETTMANN/CORBIS. REPRODUCED BY PERMISSION.

observation—always shows through in his paintings. He realized that the eyes took in images through a haze produced by dust and humidity in the air, and he relied on *sfumato* (the painting of filmy atmosphere) to demonstrate this in his work. Da Vinci also painted the horizons in his pictures so that they sloped—recognition that the earth was round. Leonardo often remarked in his writings that mortal beauty was ephemeral. While it faded and disappeared, the artist's contribution was to make beauty eternal: "A beautiful object that is mortal passes away, but not so with art." Further, art is a window on the human soul that stirs the senses and provides human beings with a vision of eternal beauty. In contrast to the devotion that scholars evidenced to texts in the Renaissance, da Vinci's emphasis on observation and experimentation was an innovation. While contemporary humanists advocated literary studies and rhetoric as the best way to establish truth, da Vinci insisted instead that the eyes were the most important arbiters of proof. His attitude was forward looking. It had more in common with the Empiricism of seventeenth-century

scientists like Descartes, Bacon, and Newton, than it did with the textual attitudes toward truth that were embraced by fifteenth-century intellectuals.

MICHELANGELO BUONARROTI. The second undisputed genius of the High Renaissance in Italy was Michelangelo Buonarroti (1475–1564). Like Leonardo da Vinci, Michelangelo also strove to develop himself as a "universal man" of the Renaissance. He was interested in a vast array of fields and became an expert on human anatomy and engineering, besides practicing the arts of painting, sculpture, and architecture. Michelangelo also became a poet whose sonnets are notable for their intensity and beauty of expression. His personality, though, differed strikingly from Leonardo da Vinci. Where Leonardo was passionately interested in nature and rarely discussed God or religious issues in his writings, Michelangelo was intensely religious and received inspiration from a deep sense of his own personal unworthiness and of his sinful nature. In his art Michelangelo often sought to give expression to his search for divine love. Both men left many of their compositions unfinished at their deaths. For Leonardo, his reluctance

to finish projects was a by-product of his perfectionism and his realization that his completed compositions rarely matched the ideal beauty of his internal vision. Michelangelo, on the other hand, was driven by a powerful desire to create, and he often neglected his own health and appetites to devote more time to work on his commissions. His patrons frequently moved him from project to project, which prevented him from finishing works he had already begun.

EARLY LIFE. Michelangelo was born the son of a minor Florentine official who was stationed at Caprese, a small Tuscan town subject to Florence. When he was only a few months old, Michelangelo returned to Florence with his family following the completion of his father's term of office. They settled in the small suburb of Settignano, just outside the city, and here Michelangelo learned his first lessons in stone carving when he was just a boy. When he was thirteen, he became an apprentice to the Florentine artist Domenico Ghirlandaio, who ran a large and successful studio. Later he studied sculpture with Bertoldo di Giovanni, a local sculptor who had been a student of the great artist Donatello. Michelangelo never completed the terms of his apprenticeship, but thanks to his father's good offices he gained entrance to the Medici family circle, where he studied the family's large collection of ancient sculptures. Within the Medici circle he also became associated with Marsilio Ficino, Angelo Poliziano, Giovanni Pico della Mirandola, and other Florentine humanists. At this time Neoplatonism was the intellectual vogue of the city, and during the two years that Michelangelo spent as a member of the Medici household between 1490 and 1492, he received the foundations of a humanist training. Although he never became fluent in Latin, his time with the Medici familiarized him with the major intellectual disputes and issues of the age. He also acquired his love for the verse of Dante and Petrarch, and throughout his life, Michelangelo continued to write sonnets and other verse, despite his punishing load of artistic commissions. The desire for social status and distinction also motivated Michelangelo. Throughout his life he was convinced that his family was descended from an ancient line of Italian nobility. Michelangelo adopted the dress and behavior of a nobleman, and through his artistic successes he tried to enhance his family's social position.

SCULPTURE. The artist's first stunning successes came in the field of sculpture, and throughout his life, Michelangelo felt most at home in this medium. His first masterpiece was the *Pietà*, an image of the dead Christ resting upon the lap of his mother. Michelangelo created the statue for the French cardinal Jean Villiers dur-

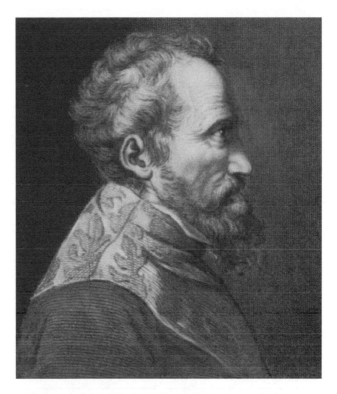

Michelangelo in profile. CORBIS-BETTMANN. REPRODUCED BY PERMISSION.

ing his first period of residence in Rome (1496–1501). Michelangelo carved the *Pietà* from a single block of marble, and the work was immediately recognized for its extreme delicacy and accomplished technique. In his subsequent sculptures Michelangelo adopted a more powerful and heroic style, as for example in his famous *David* completed in 1504. For almost a century the Old Testament figure of David had been a symbol of the Republic of Florence. The imagery of the biblical story of the tiny David victorious against Goliath had been seen as a metaphor of Italian politics. Florence, a small state, had flourished in an Italy dominated by Goliaths. Many Florentine artists had created works that immortalized the youthful figure as a symbol of their city. Michelangelo's work, too, had its own fascinating history. The marble out of which it was crafted had been quarried in the 1460s for the sculptor Donatello and had been partially worked. Following Donatello's death, though, it had lain unused for more than forty years. Most sculptors insisted that the block of stone had a flaw that rendered it unusable. After examining it Michelangelo devised a plan for carving a figure from the stone. In comparison with the serene and youthful *David* that Donatello had cast in bronze in the first half of the fifteenth century, Michelangelo's biblical colossus is no longer a child, but a youthful, heavily muscled

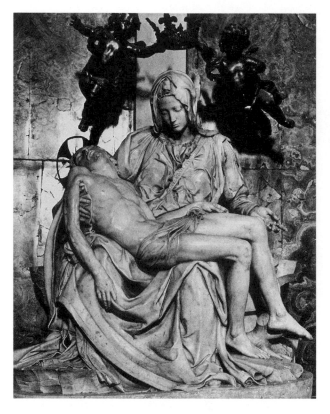

Pietà by Michelangelo. © BETTMANN/CORBIS. REPRODUCED BY
PERMISSION.

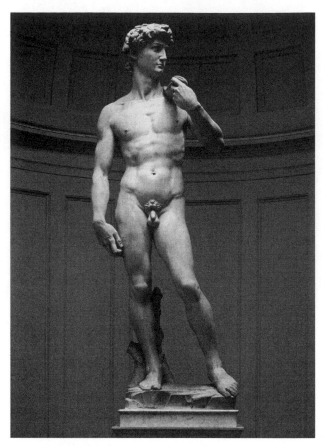

David by Michelangelo. SCALA/ART RESOURCE, NY. REPRODUCED
BY PERMISSION.

adolescent with oversized hands and feet. He stands assured, yet alert with every sinew and muscle in his body ready to do battle. A close examination of the statue shows that it is the product of the artist's studies of anatomy since the muscles and veins of the work are closely modeled upon human models. The work was originally intended for a prominent position atop the Palazzo Vecchio, the town hall, in Florence and was accordingly more than fourteen feet high. It was immediately hailed as a masterpiece, the greatest freestanding sculpture completed since Antiquity. As a consequence Florence's town fathers gave it a position of honor in front of the town hall so that it could be admired more closely. In the nineteenth century the city placed a copy there and moved the original indoors to the Galleria dell' Accademia, a museum of Tuscan sculpture.

JULIUS II. Both the *Pietà* and the *David* established Michelangelo's reputation as an artistic genius, and from this point until his death he received numerous commissions, both in Florence and Rome, the two developing centers of High Renaissance style. In 1505, Pope Julius II (r. 1503–1513) called Michelangelo to Rome to undertake a massive project, the building of an enormous tomb. This project consumed the artist's attention

off and on for over forty years and was complicated by the complex relationship between pope and artist, both of whom were extremely strong-minded personalities. As it was originally conceived in 1505, the tomb was to include more than 40 statues, although when finished four decades later, only three statues were completed. In 1505, Michelangelo set to work on the project immediately. He left Rome to supervise personally the quarrying of the marble for the project. Soon after his departure, Julius' ardor for the tomb cooled, and when Michelangelo returned some months later, the pope had turned to his plans to rebuild St. Peter's Basilica in Rome, a building that was at the time more than a thousand years old. Displeased with the pope's plans to abandon the tomb project, Michelangelo left Rome for Bologna; the two reconciled months later, after the artist asked the pope's forgiveness. Julius lured him back to Rome, and in 1508, he gave Michelangelo the contract for perhaps his most famous work: the Sistine Chapel ceiling. Until this point, most of the artist's most important commissions had been sculptures. The Sistine ceiling was a project to which the artist was by training

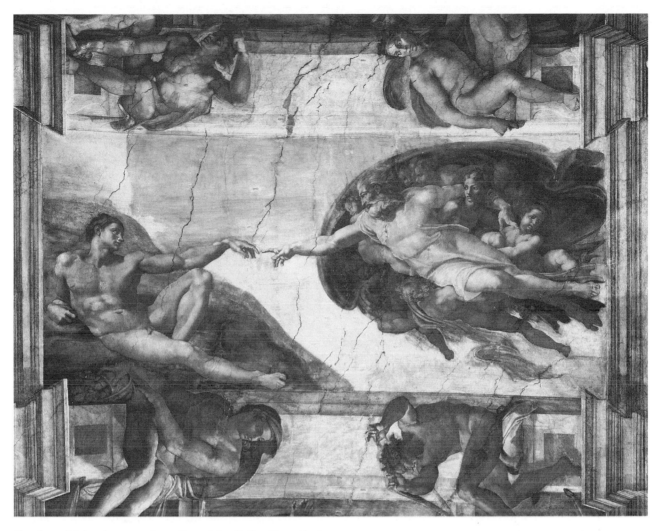

Creation of Adam fresco on the ceiling of the Sistine Chapel in Rome. SCALA/ART RESOURCE, NY. REPRODUCED BY PERMISSION.

and inclination ill-suited. But like so many other projects that Michelangelo undertook, he rose to the occasion once he had set his mind to the task.

SISTINE CHAPEL. The Sistine Chapel, named after Pope Sixtus IV who had it built between 1473–1484, was the private chapel of the popes, and has long been the place in which the College of Cardinals elects new popes. Soon after its completion the artists Domenico Ghirlandaio, Cosimo Roselli, Perugino, and Sandro Botticelli decorated the chapel's sidewalls. In the early sixteenth century the ceiling, which was more than 60 feet high, was still bare plaster. To undertake this project, Michelangelo planned a grand design that mixed decorative elements from Antiquity and the Bible. The major scenes in the center of the ceiling are from Genesis and are framed with alternating images of the ancient Cumaean sibyls and the Old Testament prophets. The narrative Michelangelo created begins with the Creation of the World and of Man and Woman and progresses through the events in the Garden of Eden. The program culminates with the story of the Flood. Michelangelo painted these scenes in reverse order, and after completing the first two scenes he adjusted the scale on which he painted them to take account of the enormous size of the room. As he progressed, his compositions grew simpler and more monumental so that they could be viewed more easily from the floor. The artist also filled the later images with dramatic and swirling elements to suggest movement. Painted over a span of less than four years, the result was one of the wonders of the age, a creation that since the sixteenth century has never ceased to instill admiration in its observers. In Michelangelo's time his Sistine Chapel frescoes were a perennial source of inspiration for other artists, who relied upon the work for elements of design in similar decorative cycles and who tried to imitate the heroic and

a PRIMARY SOURCE *document*

ESPIONAGE AND INTRIGUE

INTRODUCTION: Creative differences between Michelangelo and his patron, Pope Julius II, often erupted into colossal misunderstandings. Such was the case during the time in which Michelangelo worked on the Sistine Chapel ceiling. During one of their disagreements, Michelangelo fled Rome and returned to Florence. According to the biographer Vasari, the architect Donato Bramante used this occasion to show Michelangelo's work secretly to Raphael. Vasari thus explained a change that occurred in Raphael's later style, as the artist added more drama and monumentality to his work. These attributes, Vasari alleged, came directly from the artist's imitation of Michelangelo.

Raphael had at this time acquired much fame in Rome, but although he had the graceful manner which was held by every one to be most beautiful, and saw continually before his eyes the numerous antiquities to be found in that city, and which he studied continually, he had, nevertheless, not yet given to his figures that grandeur and majesty which he always did impart to them from that time forward. For it happened at the period to which we now refer, that Michelangelo, as we shall fur-thermore set forth in his life, had made such clamours in the Sistine Chapel, and given the Pope such alarms, that he was compelled to take flight and sought refuge in Florence. Whereupon Bramante, having the key of the chapel, and being the friend of Raphael, permitted him to see it, to the end that he might understand Michelangelo's modes of proceeding. The sight thus afforded to him caused Raphael instantly to paint anew the figure of the prophet Isaiah, which he had executed in the Church of Sant'Agostino, above the Sant'Anna of Andrea Sansovino, although he had entirely finished it; and in this work he profited to so great an extent by what he had seen in the works of Michelangelo, that his manner was thereby inexpressibly ameliorated and enlarged, receiving thenceforth an obvious increase of majesty.

But when Michelangelo afterwards saw the work of Raphael, he thought as was the truth that Bramante had committed the wrong to himself of which we have here spoken, for the purpose of serving Raphael, and enhancing the glory of that master's name.

SOURCE: Giorgio Vasari, *Lives of Seventy of the Most Eminent Painters, Sculptors, and Architects*, Vol. 3. Trans. and Ed. E. H., E. W. Blashfield, and A. A. Hopkins. (New York: Scribner, 1896): 161–162.

idealized forms that he created on the ceiling. A long-term campaign of restoration undertaken during the 1980s returned the paintings to their sixteenth-century brilliance and allowed observers to view the works minus centuries of accumulated dirt and soot. This restoration also revealed that Michelangelo used a vibrant, and sometimes even garish color palette to create the frescoes. These dramatic colors were yet another feature that Michelangelo's imitators focused on when trying to imitate the style of this great sixteenth-century master.

LEGACY. In the wake of the Sistine Chapel ceiling Michelangelo returned for a time to his first love, sculpture. In 1515 he completed the grand *Moses*, a work in his ongoing tomb project for the now deceased Pope Julius II. Here, as in the Sistine frescoes, Michelangelo presented a higher vision of reality, an image of the biblical prophet that is distinguished by his fiercesome power and the statue's vigorous and piercing gaze. Like Leonardo da Vinci, Michelangelo's High Renaissance style presented an idealized and higher vision of reality. Yet unlike the often placid and cerebral quality of da Vinci's art, Michelangelo's works suggested movement, heroism, and dramatic intensity, qualities that his contemporaries widely emulated. The longest-lived of all the great High Renaissance masters, Michelangelo experimented with new styles in the years after 1520. His later art, significantly different from his early sixteenth-century works, helped to supplant the idealized artistic synthesis of the High Renaissance, and to give rise to yet a new creative artistic movement known as Mannerism.

RAPHAEL SANZIO. In place of the serenity of da Vinci or the intense heroism of Michelangelo, the third great master of the High Renaissance, Raffaelo Sanzio (1483–1520) (or Raphael, as he is known in English) gave expression to a harmonious and balanced vision in the High Renaissance. Raphael was born in the northern Italian town of Urbino, the son of a painter. Initially trained by his father, the young Raphael became a member of the studio of the Central Italian artist Perugino at Perugia. Always able to adapt and learn from other artists, Raphael soon mastered Perugino's sweet and lyrical style with such excellence that contemporaries were frequently unable to distinguish whether a work from Perugino's studio came from the hand of the master or of his student. As his reputation grew, he received commissions from the duke of his native Urbino before moving on to Florence around 1504. There Raphael studied the High Renaissance style of Leonardo and

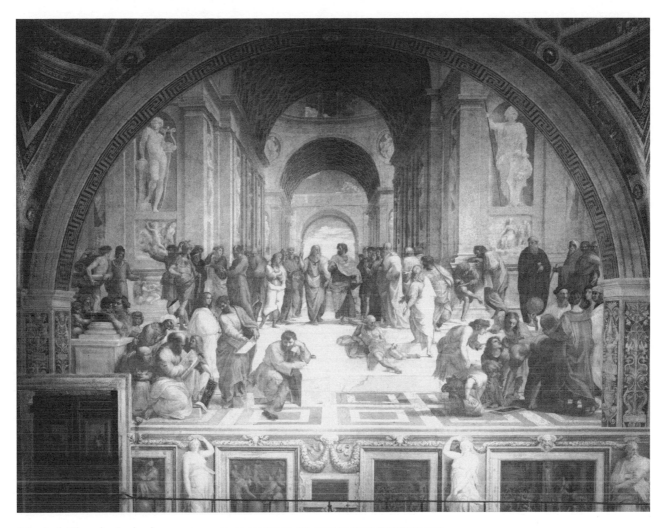

School of Athens by Raphael. ERICH LESSING/ART RESOURCE, NY. REPRODUCED BY PERMISSION.

Michelangelo, who were both in Florence at the time. Both these elder artists were now highly successful figures who served the city of Florence and other princely patrons. The price of their commissions had outstripped the means of most wealthy Florentines. Raphael soon filled a gap in the local art market by producing works in the High Renaissance style for the town's merchants and noble families. During his three years in Florence the artist successfully executed a large number of commissions, including his famous *Madonna of the Meadows*. That work shows the influence that Raphael derived from Leonardo. Its composition is dominated by a pyramidal grouping of Madonna, Christ child, and John the Baptist in a way similar to Leonardo's *Madonna and St. Anne*. At the same time Raphael's work has none of the mysterious *chiaroscuro* of Leonardo's. It shines with brilliant, gemlike colors. Nor does Raphael reveal much interest here in anatomical studies, a chief concern of both Leonardo and Michelangelo. Instead the artist demonstrates a love of harmony and balance through his counter-poising of oval and circular shapes throughout the picture.

ROME. In 1508 Raphael traveled to Rome to work for Pope Julius II. The artist remained there for the rest of his life, painting commissions for the popes and members of the church's government. The first project that the artist undertook in Rome was a series of frescoes for the papal apartments, which happened to coincide with Michelangelo's work on the Sistine Chapel ceiling. As Raphael worked on his frescoes in the nearby apartments, his compositions acquired a more monumental scale suitable to the grand environment in which he was working. The *School of Athens* is typical of the refinement and monumental character of these works. In this work Raphael depicts the ancient Greek philosophers Plato and Aristotle as well as members of the intellectual elite of Greece. To link the past and present he depicted many of these figures as contemporary members on the

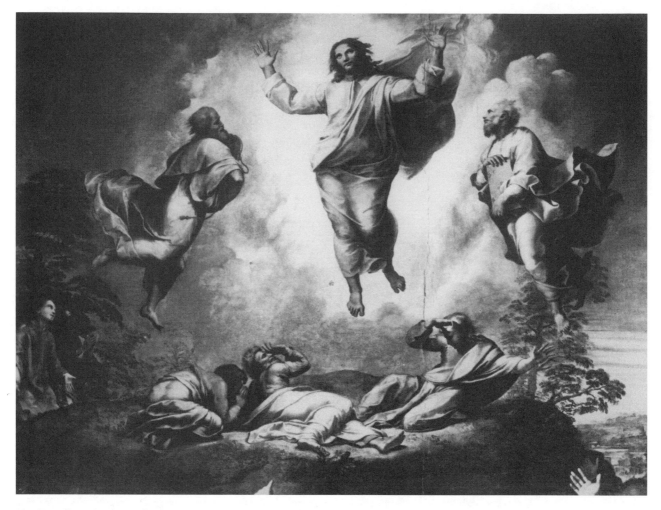

The Transfiguration by Raphael. AP/WIDE WORLD PHOTOS. REPRODUCED BY PERMISSION.

Roman scene, so that his Plato is a portrait of Leonardo da Vinci and his ancient Heraclitus of Michelangelo. The entire composition is set, too, before an architectural backdrop that bears resemblance to the plans for the new St. Peter's Basilica that was just beginning to take shape around the time that Raphael painted his work. For the recognized successes that he achieved in frescoing the papal apartments Raphael was richly rewarded with other commissions. During the five years before his premature death in 1520, the artist served as architect on a number of projects under construction in Rome at the time, including the new St. Peter's Basilica. He also served Pope Leo X, a member of the Medici family, as a supervisor of Roman antiquities. He completed a major decorative cycle for the Villa Farnesina, a palace that overhung the Tiber River in Rome and which was being built by Agostino Chigi, then the pope's banker. For this project Raphael and his assistants painted a large number of rooms in a style that imitated classical Roman frescoes. The subject matter of the Farnesina frescoes was entirely drawn from pagan Antiquity, and unlike many earlier uses of pagan mythology, they were devoid of Christian moralizing. One of the most famous paintings that Raphael completed for this project was the *Galatea*, in which the ancient pagan figure rides on the waves atop a scallop shell, while cupids try to stir her passion for the Cyclops by shooting love arrows at her. In this painting Raphael shows the influences that he derived from observing the art of Michelangelo. The figures in the fresco writhe with a greater heroic tension and movement than in the more placid works of just a few years before. They are now heavily muscled, and their bodies resemble the marble-like creations of Michelangelo's Sistine ceiling frescoes. In these and other works in the Villa Farnesina Raphael brought the synthesis between classical Antiquity and High Renaissance style to its highest level of achievement. In one of his last great masterpieces of painting, the *Transfiguration*, (1517) Raphael adapted his mixture of classical grace and harmony to a Christian theme. Contemporaries seem to have admired this late

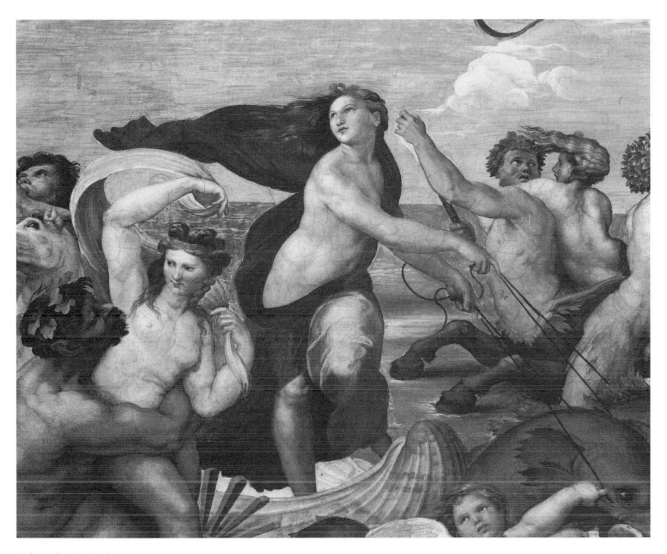

Galatea by Raphael. © ARALDO DE LUCA/CORBIS. REPRODUCED BY PERMISSION.

work above the many that the artist produced in Rome. At Raphael's funeral in 1520, it was displayed alongside the funeral bier.

INFLUENCE. Although his life was short, Raphael continued to cast a long influence over Italian art in the later sixteenth century. During his brief time in Rome the artist had maintained a large studio, in which he had trained a number of painters who were to keep his style alive throughout the peninsula in the decades following his death. In the seventeenth century, too, European academies lauded Raphael's art as the most appropriate style for study and emulation, particularly in France. Raphael's subsequent influence on "academic" art was one cause for the decline of the artist's reputation in the nineteenth and twentieth century. Raphael became connected in the mind of many artistic connoisseurs with the dull repetition and monotony that was frequently

the fate of art produced in the early-modern and modern academies. In truth, Raphael's creations were never repetitive and he evidenced a highly innovative approach to his compositions throughout his career. If his compositions sometimes lack the emotional intensity or intellectual depth of Michelangelo or da Vinci, it must be remembered that the artist died before even reaching the age of forty.

SOURCES

K. Clark, *Leonardo da Vinci: An Account of His Development as an Artist* (Cambridge: Cambridge University Press, 1939).

H. von Einem, *Michelangelo.* Trans. R. Taylor (London, England: Methuen, 1973).

S. J. Freedberg, *Painting of the High Renaissance in Rome and Florence.* 2 vols. (Cambridge, Mass.: Harvard University Press, 1961).

N. Harris, *The Art of Michelangelo* (New York: Excalibur Books, 1981).

H. Hibbard, *Michelangelo* (Boulder, Colo.: Westview Press, 1998).

M. Kemp, *Leonardo da Vinci* (Cambridge, Mass.: Harvard University Press, 1981).

J. Pope-Hennessy, *Raphael* (New York: New York University Press, 1970).

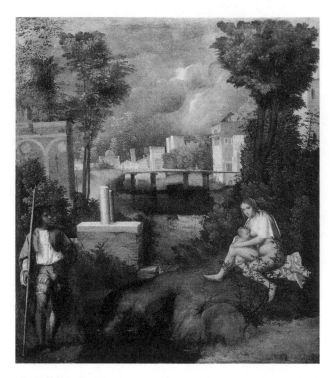

The Tempest by Giorgione. THE ART ARCHIVE/DAGLI ORTI. REPRO-DUCED BY PERMISSION.

THE HIGH AND LATER RENAISSANCE IN VENICE

PECULIARITIES. In Venice and Northern Italy a High Renaissance style developed that was notably different from that of Florence and Rome. Venice, an artistic backwater for most of the fifteenth century, gradually took a leading position in producing artists of merit during the sixteenth century. A fundamental difference of technique separated Venetian artists from those of Central Italy. In the latter region, the principle of *designo* or "design" dominated the style of painting. In their compositions artists sketched their subjects with the precision of a draftsman before adding colors to their panels. The results produced artistic creations with sinuous lines and clear compositional logic. By contrast, Venetian artists from the time of Bellini developed a painterly tradition in which they built their compositions up through the use of color. In place of the precision and dominant lines of Central Italian style, the impression produced by much Venetian art was filmy and indistinct since its compositional logic arose from the juxtaposition of contrasting colors, rather than from the fine lines of a draftsman's design. Venice's painters also became masters of the medium of oil painting, a method originally imported toward the end of the fifteenth century from Northern Europe. Venetian masters perfected new resins that allowed them to paint on canvas rather than panels, an innovation that gave their coloristic techniques greater depth and luminosity. This great flowering of painterly technique developed at a time of political stress in the Venetian Republic. In the early sixteenth century the city faced a crisis. Forces from throughout Italy and Europe massed against the state and temporarily cut the city off from its possessions on the Italian mainland. Venice's political problems persisted, and by the 1520s, its influence in Italy and the Mediterranean was in decline. Economically, Venice remained rich, a great trading center strategically positioned between the east and west. Still, during the course of the sixteenth century her economic and strategic importance diminished in the face of the rise of the great northern European trading

centers in the Low Countries (modern Belgium and Holland). Despite these stresses, however, the sixteenth century was a Golden Age for the city. In literature, art, and architecture, Venice's greatest figures produced works that influenced European styles over the coming centuries.

GIORGIONE. Giorgione da Castelfranco (1475–1510) was among the first Venetian painters to develop a distinctly High Renaissance style. Little is known about Giorgione's career, and few surviving documents exist to date his compositions. These works show influences from the great fifteenth-century Venetian painter Bellini, but Giorgione introduced a greater monumentality into his paintings, and, like High Renaissance artists elsewhere in Italy, he strove to present his subjects on a higher idealized plane. Giorgione, too, developed the painting of landscape in his works to a point where it acquired independent interest. He set both his religious and secular works against seemingly magical appearing backgrounds, and the artist's most famous work, *The Tempest*, has long been credited with granting landscape paintings independence from religious or mythological themes. Here Giorgione made landscape the subject of the picture itself. In the foreground the artist presents a soldier who looks upon a mostly nude woman who is nursing a child. The real interest at work

a PRIMARY SOURCE document

AN ART CRITIC

INTRODUCTION: After a number of early scandals, Pietro Aretino took up residence in the city of Venice, where he gradually established himself as an arbiter of local tastes. In his many letters, which he published while still living, Aretino held forth on all sorts of subjects. In the following letter to his close friend Titian, the writer compares a recent sunset—a work of God—to the landscapes of his dear friend. Throughout the short letter Aretino extravagantly praises his friend's ability to create and to immortalize what in nature is only a fleeting display.

Signor compare, having, contrary to my custom, dined alone, or rather in the company of the discomforts of that quartan fever which never lets me enjoy the taste of food any longer, I walked up from the table sated with the same despair with which I had sat down to it. And then, leaning my arms, my chest, and almost my whole body against the window sill, I started to look at the admirable spectacle made by the innumerable barges which, laden with foreigners as well as natives, entertained not only the onlookers but the Grand Canal itself, that entertainer of all who plough its waves. And as soon as it offered the diversion of two gondolas with famous gondoliers having a race, it was a great pleasure to watch the crowd of people who had stopped, to look at the regatta on the Rialto Bridge, on the Riva dei Camerlinghi, in the Fish Market, on the landing-stage of Saint-Sophia, and in the Casa da Mosto. When these crowds had gone on their way with joyful applauses, then, like a man bored with himself who does not know what to do with his mind or his thoughts, I turned my eyes towards the sky; this had never since God's creation shown such a beautiful picture of shadows and light. And it was such as those who envy you, because they cannot approach you, would like to render. You should see, by means of my description, first the buildings which, although of real stone, seemed made of some unreal material. And then, imagine the sky, which I perceived in some places pure and bright in others dim and livid. Think also how I marveled at the clouds of condensed humidity; in the principal view they were partly close to the roofs of the buildings, partly receding far back [to the left], for the right hand side was all veiled with a darkish gray. I was really amazed by the various colors which they showed; the closest were burning with the flames of the sun's fire; and the farthest were red with a less burning vermilion. Oh, with what beautiful strokes the brushes of Nature pushed the azure into the distance, setting it back from the buildings the same way that Titian does in his landscapes! In some places there appeared a green-blue and in others a blue-green which really seemed as if mixed by the errant fancies of nature, master of the masters. With lights and shadows she hollowed and swelled whatever she wanted to swell and hollow; so that I, who know that your brush is the very soul of her soul, burst out three or four times with: "Oh, Titian, where are you now?"

On my honor, if you had painted what I described, you would amaze people as I was amazed, but while watching what I have described to you, I had to fill my soul with it since the splendor of a painting of this kind was not to last.

SOURCE: Pietro Aretino, "Letter to Titian" in *Italian Art, 1500–1600: Sources and Documents.* Ed. Robert Klein and Henri Zerner (Englewood Cliffs, N.J.: Prentice Hall, 1966): 54–55.

in the picture is the force of nature. In the background an approaching storm makes the landscape come alive, casting patches of light and dark on the stream and cityscape that stretch toward the horizon. Again the beauty of the *Tempest* presents us with evidence of that discovery of the natural world that was common to the visual artists of the Renaissance. Through this work Giorgione granted a new independent importance to the observation of nature since the human figures do little more than establish proportion for the fascinating vision of the natural world that he presents in the rest of the picture.

TITIAN. The greatest painter of sixteenth-century Venice was Tiziano Vecellio (c. 1490–1576), who has long been known in English as Titian. The artist came to Venice from the remote Alpine town of Pieve di Cadore, where he had been born to an important aristocratic family. Legend long taught that Titian had lived to be 100 years old, but more recent research has now fixed his birth date much later than originally presumed. While the artist lived to a venerable age, he likely died at some point between 85 and 90 years of age. Trained originally in the studios of several Venetian painters, Titian's major influences were his teacher Giovanni Bellini and later his close associate Giorgione. When the latter artist died around 1510, Titian undertook to complete a number of his compositions. Giorgione's lyrical influence upon Titian's style can be seen in one of the artist's first masterpieces, *Sacred and Profane Love*, completed sometime around 1516. Like Giorgione's *The Tempest*, the actual subject matter of this piece has never been identified, although it may be an allegory that symbol-

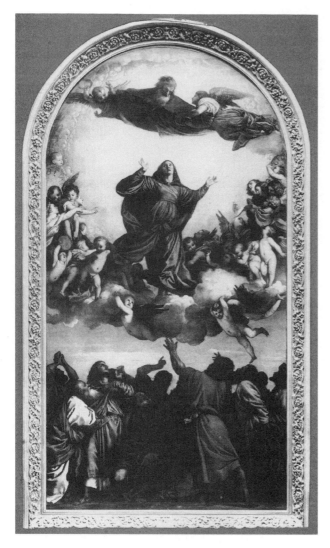

Assumption of the Virgin by Titian. **PUBLIC DOMAIN**.

was the first in a distinguished line of masterworks produced by the artist during the 1510s and 1520s. These works were portraits or they treated mythological and religious themes. One of the most undeniably important works of this period was the artist's *Assumption of the Virgin,* a massive work completed for the Church of Santa Maria dei Frari in Venice around 1518. In that work the Virgin rises from a group of writhing apostles and is supported upon her path to God the Father by groups of struggling child angels. Titian heightened the drama of the work through the use of strong dramatic colors set against a neutral background, as well as by the enormous size of the panel. The work towers more than 22 feet high above the central altar of the Church of the Frari.

MIDDLE AND LATER YEARS. In 1530 Titian lost his wife, and a change in his artistic vision became evident. During the 1530s his use of color grew more restrained. In place of the dramatic juxtaposing of colors that had dominated many of his early works, Titian now drew his palette from related, rather than contrasting colors. This change can be seen in the famous *Venus of Urbino* which the artist completed around 1538. This work is the most famous of several Venuses that Titian painted in these years. In it, the ample form of a woman lies reclining on her bed, while a servant rummages through a chest in the background. An inlaid marble floor and wall hangings grant the scene an atmosphere of cultivated ease, which is further reinforced by the use of rich golds, greens, and brownish reds. Works like these were widely admired by the Italian nobility of the period, and helped to grant the artist a great renown throughout Italy and Europe in these years. He became court painter to the emperor Charles V, and his portraits of popes, kings, princes, and other nobles served to catalogue the lives of the most important figures of the day. In 1545 Titian left Venice on his only journey to the city of Rome, then the acknowledged artistic center of Europe. The monumental works of Michelangelo, including his Sistine Chapel frescoes and *Last Judgment* with their heavily muscled figures, greatly influenced Titian as did the works of Antiquity that had come to light in the previous decades. In the artist's later years he strove to develop a more dramatic and expressive style characterized by broad brushstrokes and a brilliant use of colors. Among the most outstanding of many images painted in this period are the *Rape of Europa* (1562) and the *Crowning with Thorns* (c. 1570). In the *Rape of Europa* Titian brought dramatic swirling brushstrokes to bear on the subject, a rape performed by the god Jupiter in the

izes the passage of a woman from maiden virginity into a life of erotic love. Two women, appearing to be twins, sit on an ancient sarcophagus, which is in reality a fountain. One of the figures is clothed and gloved and touches a black bowl with her left hand, while holding a bunch of roses in the other. To her right an almost completely nude figure holds up a lamp, while between the two women, a cupid stirs the water of the fountain, and water pours from a golden bowl perched on the sarcophagus to fall upon a white rose bush. The background mirrors the difference between the two women. Behind the clothed figure the landscape rises and is crowned by a fortress set in a dark landscape. On the other side of the painting in the space behind the naked figure the view opens into a vast panorama bathed in light and dominated by a hunter's pursuit of a hare and a village crowned with a church spire. *Sacred and Profane Love*

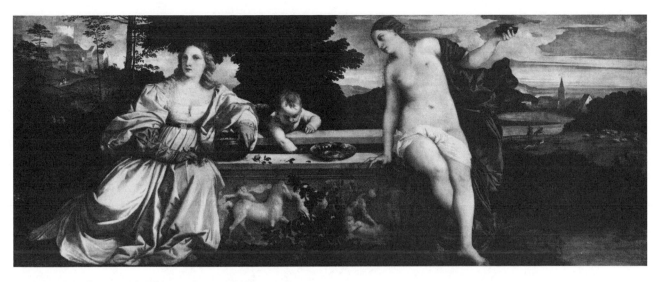

Sacred and Profane Love by Titian. **PUBLIC DOMAIN**.

disguise of a white bull. Throughout the canvas the impression that he produced was filmy and indistinct and did not recur until the eighteenth-century landscapes of the French painter Watteau. In a similar vein the *Crowning of Thorns* suggested the dramatic, intense suffering of Christ through its use of thick masses of paint and torrents of broad strokes. Here, however, the overall effect was of a somber and dramatic composition, rather than of the fanciful spirit of the *Rape of Europa*. Through works like this Titian dominated the development of a distinctive sixteenth-century Venetian tradition of painting. Together with his close friends—the architect Jacopo Sansovino and the poet Pietro Aretino—Titian influenced the artistic and cultural life of his adopted city. The three figures became known as the "Triumvirate" and were admired as arbiters of local tastes and fashion. Titian also maintained a large studio in the city where he trained a number of pupils and supervised works produced under his direction. Through these enormous efforts the artist grew wealthy and became a princely figure among the many painters of northern Italy at the time.

TINTORETTO. Although Titian remained the dominant force in developing a distinctly Venetian Renaissance style in the first half of the sixteenth century, he faced competition after 1550 from two other great masters, Tintoretto (1518–1594) and Veronese (1528–1588). Each of these artists developed unique styles that differed greatly from each other and from Titian. Tintoretto, whose given name was actually Jacopo Robusti, has long been known by his nickname, which means literally "little dyer," a reference to his origins as the son of a cloth dyer. Of all the great Venetian artists of the sixteenth

century, Tintoretto was the only painter who was actually a native of Venice. Although he occasionally painted works for patrons and projects outside Venice, most of his paintings today are to be found in the churches and public buildings of his hometown. Little reliable information exists about his early training. A legend has long alleged that Tintoretto studied with Titian, but was expelled from his studio when the elder artist grew jealous of his talent. His early style, however, suggests that the artist was not Titian's student, but received his training in the workshops of other minor and more conservative Venetian artists. By 1539, Titian is noted in the records of the city as an independent master, and in 1548, the artist completed his first acknowledged masterpiece, a canvas painting of *Saint Mark Freeing a Christian Slave*. Tintoretto undertook the work for a confraternity dedicated to St. Mark. The subject of the painting arose from a legend about a Christian slave who fled his home in France to travel to Alexandria to see the relics of St. Mark. Upon his return, his master condemned him to have his eyes plucked out and his legs broken. St. Mark, however, miraculously appeared from Heaven to free the captive. Tintoretto executed this story with great drama by placing a dramatically foreshortened figure of St. Mark suspended in mid-air about to break the captive's bonds. The saint's body projects out from the picture plane so that his feet attract the eyes of the viewer. Elsewhere throughout the canvas the swirling motions of the figures create a dramatic sense of movement, a sense that is reinforced by Tintoretto's quick brushstrokes and bold use of color. Many of the characters, including the figure of St. Mark, are merely suggested through the use of rapid brushstrokes set against the priming colors of the

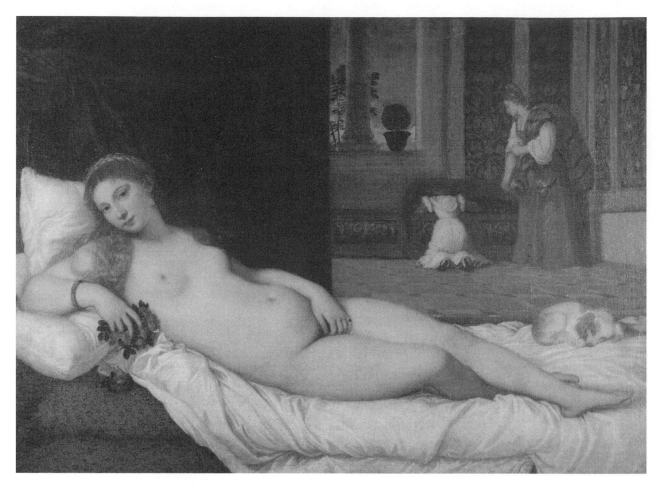

The Venus of Urbino by Titian. ERICH LESSING/ART RESOURCE. REPRODUCED BY PERMISSION.

work's background. In this way Tintoretto astutely used light and dark to suggest his figures and to bring great energy to his canvases.

LATER CAREER. Tintoretto was by temperament dramatically different from Titian. Titian had established himself as a kind of prince among the artists of the city, eventually leading a life of financial ease and refinement. Tintoretto, on the other hand, was enormously prolific but less desirous of worldly position. He was also religiously devout and painted many of his religious subjects for the local confraternities of the city, often accepting payment only for the costs of his paint and canvas. One of these projects, the walls of the Scuola di San Rocco, eventually consumed an enormous amount of his time. This organization was a religious confraternity dedicated to St. Roch, a patron against the plague, which performed charitable works throughout the city. For 25 years, Tintoretto labored to finish more than fifty paintings to decorate the organization's meeting rooms in the city. Eventually the artist accepted only a small salary for completing the works, and when

finished they ranked among one of the great artistic projects of the Renaissance. The works formed an artistic monument as important in Venice as Michelangelo's Sistine Chapel ceiling frescoes were in Rome. These works allow us to trace Tintoretto's artistic development over a course of more than two decades. Among the more famous of these images is the artist's *Crucifixion*, a gigantic work more than 40 feet long. Here Tintoretto relied on light and dark spaces to create a gripping rendering of the tortures of Christ. In it, the onlookers at the scene on Calvary seem to be caught up in an event that they can scarcely comprehend, and which they certainly cannot control. Through his rendering of the religious immediacy of the moment, Tintoretto helped to pave a way in his *Crucifixion* and his later works for the development of a distinctly Counter-Reformation style of art. This Counter-Reformation style was intended to be clearly intelligible to its observers. It aimed, in addition, to harness the power of the observer's emotions in order to deepen his or her own piety.

IMPORTANCE. Although Tintoretto died impoverished the large studio that he had built in Venice continued as a family workshop run by his son Domenico. In a city dominated by a guild structure of production, Tintoretto's workshop lived on after his death to influence artistic styles in the city. It was the artist's bold and defining brushwork, though, that attracted imitations from many later artists. Tintoretto had promoted his own painting as a union between the forces of Michelangelo's strong design and the coloristic tradition of Venice and Titian. Subsequent generations, though, have not always been charitable to Tintoretto's art. In the nineteenth century the great English art historian and critic John Ruskin pronounced that Tintoretto had painted his works with a broom. Like Titian and other Venetian artists, Tintoretto ran a large studio that supplied Venice with many religious paintings, and not all the works produced in this workshop were of the same high quality. Yet in paintings like the *Crucifixion* or *St. Mark Freeing a Christian Slave* Tintoretto's artistic vision rises to a level comparable to the greatest works of the High and Later Renaissance.

VERONESE. The third genius of sixteenth-century Venetian painting was Paolo Caliari (1528–1588), who was known as Veronese because he was a native of the mainland Italian city of Verona. Veronese's paintings were more outrightly opulent than Tintoretto's, filled as they were with signs of luxury. They were also marked by a controlled brushwork and a brilliant compositional presentation. Today Veronese's reputation results chiefly from his painting of gorgeous banqueting scenes like the *Wedding Feast at Cana*, a canvas painting that he completed for the refectory or dining room of the Monastery of San Giorgio Maggiore at Venice. The son of a family involved in the stonecutting trade, Veronese apparently discovered the canons of classical architecture through his acquaintanceship with the architect Michele Sammicheli. His lush banqueting scenes are set against the background of the opulent classically styled architecture that was then becoming popular in and around Venice. The elegant works of the painter Parmigianino also influenced these presentations. While Tintoretto's work gave expression to the growing spiritual forces of the Counter Reformation, Veronese fell under suspicion from Venice's Inquisition. One of his most famous paintings, a *Last Supper* painted for the refectory of the Dominican monastery of Saints John and Paul in Venice during 1573, resulted in the painter's summons to appear before the Inquisition. Besides filling the canvas with the Apostles and Christ, Veronese had included jesters, German soldiers, dwarfs, and dogs. The emerg-

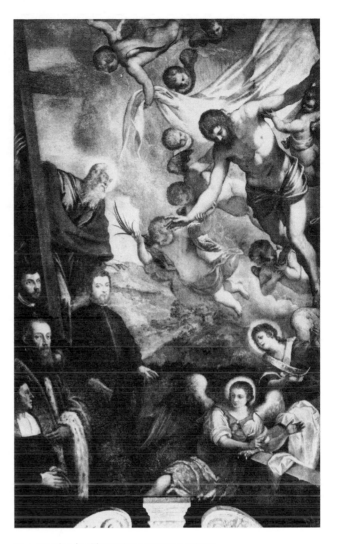

Resurrection by Tintoretto. PUBLIC DOMAIN.

ing Counter Reformation spirit bred distaste among the clergy for such artistic license, and the Inquisition commanded Veronese to paint over these ahistorical figures. The artist responded, however, by merely changing the name of his work to the *Feast in the House of Levi*, a biblical subject more in keeping with the work's luxury. Besides his painting of banqueting scenes, Veronese executed commissions for Venice's city government. Among his most important compositions was a ceiling for the Library of St. Mark, for which he won a citywide competition in 1557. The judges, Titian and the architect Jacopo Sansovino, chose Veronese's work—an allegorical depiction of *Music*—over the submissions of seven other talented Venetian painters. In his later life the artist also decorated the Halls of the College and the Grand Council, two important meeting rooms in the city's ducal palace. Veronese maintained a large studio staffed by members of his family, including his brother

a PRIMARY SOURCE *document*

COUNTER REFORMATION

INTRODUCTION: The Council of Trent (1545–1563) insisted that the meaning of religious art should be clear, and it entrusted the supervision of religious art to the church's bishops. In the later sixteenth century, Gabriele Paleotti, the bishop of Bologna, devoted his attentions to the reform of religious art according to the tenets set out by the council. In one of his works, he outlined the necessity for a painting's meaning to be clearly understood by observers. When he talked about pictures with "obscure and difficult meanings," Paleotti probably had in mind those composed by Italian Mannerists as well as luxurious Venetian artists like Paolo Veronese.

One of the main praises that we give to a writer or a practitioner of any liberal art is that he knows how to explain his ideas clearly, and that even if his subject is lofty and difficult, he knows how to make it plain and intelligible to all by his easy discourse. We can state the same of the painter in general, all the more because his works are used mostly as books for the illiterate, to whom we must always speak openly and clearly. Since many people do not pay attention to this, it happens every day that in all sorts of places, and most of all in churches, one sees paintings so obscure and ambiguous, that while they should, by illuminating the intelligence, both incite devotion and sting the heart, in fact they confuse the mind, pull it in a thousand directions, and keep it busy sorting out what each figure is, not without loss of devotion. Thus whatever good intention that has been brought to the church is wasted, and often one subject is taken for another; so much so that instead of being instructed, one remains confused and deceived.

To obviate such a great ill, one must look carefully for the roots of that error, which we shall find comes from one of three things; either the painter or the patron that commissions the work lacks will, or knowledge or ability; and in this we take an example from the writers, in so far as their art is on this point comparable to the painters' …

But such obscurity can also come from or be increased by the restriction of the space where the painting is located, as the space would not actually contain the multitude of things that should be represented, unless mixed and pressed together; on the other hand, the restriction shrinks the drawing, which by nature would require a larger field, as is the case of a painter who had painted a running horse with the bit in its mouth on a tiny panel; when the patron who had commissioned the work complained that the painter had added the bit, he answered that in such a tiny space it had been necessary to put the bit in the animal's mouth lest it should burst out.

We do not, however, deny that an excellent artist could express whatever he wants effectively in a minute space, as we read of one … who made a picture of Alexander hunting on horseback and wounding a beast, no larger than a fingernail; nevertheless, his face inspired terror and the horse itself, refusing to stop, seemed to be in motion by the strength of art. And Pliny tells of other astonishing examples. But we mention this only as a notable exception, because it can not be accomplished by everybody, and because a proportionate space makes things more successful.

SOURCE: Gabriele Paleotti, "Pictures with Obscure and Difficult Meaning," in *Italian Art, 1500–1600: Sources and Documents*. Eds. Robert Klein and Henri Zerner (Englewood Cliffs, N.J.: Prentice Hall, 1966): 125, 128–129.

and two of his sons. Upon the artist's death in 1588, this family workshop continued to produce art for the city's wealthy patrons. Scholarly opinion long dismissed Veronese's work as merely luxurious and opulent. More recently, however, judgments of the artist's achievement have taken a more positive turn, stressing the artist's skill in the use of color, his deepening use of light and dark coloration in his later years, and his iconographical sophistication.

IMPLICATIONS. The Venetian tradition of painting in the High Renaissance demonstrated a different path from the design-dominated schools of Central Italian and Roman art at the same time. The use of oils and the rich colorism that they helped Venetian artists create fostered a luxuriant and sensual art different from the in-

tellectual, sinuous forms of artists to the south. In contrast to the achievements of the High Renaissance in Rome, Venice's sixteenth-century painting has sometimes been dismissed as mere pictorial opulence. Closer study has shown, though, that a depth of compositional and iconographical sophistication is to be found among Venice's great artists similar to that shown in other Italian Renaissance traditions of painting.

SOURCES

J. Anderson, *Giorgione: The Painter of "Poetic Brevity"* (Paris: Flammarion, 1997).

R. Goffen, *Giovanni Bellini* (New Haven, Conn.: Yale University Press, 1989).

C. Hope, *Titian* (New York: Harper and Row, 1981).

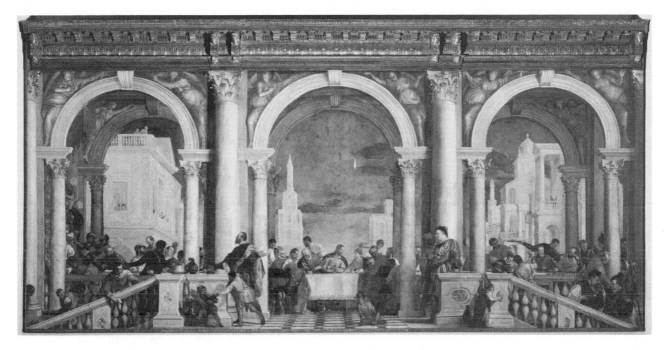

The Feast in the House of Levi by Paolo Veronese. SCALA, ART RESOURCE, NY.

W. R. Rearick, *The Art of Paolo Veronese, 1528–1598* (Washington, D.C.: National Gallery of Art, 1988).

D. Rosand, *Painting in Sixteenth-Century Venice* (Cambridge: Cambridge University Press, 1997).

———, *Titian* (New York: Abrams, 1978).

LATE RENAISSANCE AND MANNERIST PAINTING IN ITALY

TERMINOLOGY. While the High Renaissance was a time of brilliant artistic achievement, the idealized and harmonious style that it bred soon fell into disfavor, particularly in Central Italy and Rome. After 1520, artists began experimenting with new conventions. This new style, often referred to as Mannerism, found its origins in the works of the late Raphael and of Michelangelo's middle and old age. The term "Mannerism" was coined in the seventeenth century to describe those who followed in the patterns established by these two artistic geniuses. By that time scholars used the word Mannerism as a criticism of the artificiality and distortion they observed in the art of the later sixteenth century. These unfavorable assessments of Mannerism persisted even into the twentieth century as critics considered the movement to be an artistic crisis that destroyed the beauty of the High Renaissance synthesis. That synthesis had emphasized classical proportions, ideal beauty, harmony, and serenity. By contrast, critics charged Mannerist art with being artificial, overly emotional, vividly coloristic, effetely elegant, and contorted. Newer artistic tastes in the twentieth century, however, have led to a positive reassessment of late Renaissance Mannerism. Scholars have shown that the word *maniera*, upon which later critics based their critical term "Mannerism," merely meant "stylish" in the sixteenth century. Thus Mannerism has more recently been treated as a "stylish style," which prized the very same values that later critics found distasteful. Sixteenth-century Mannerism, an artistic movement that influenced art in Rome, Florence, and much of Central Italy, has now been shown to derive from certain assumptions about elegance and beauty that differed from those of the High Renaissance. In place of older assessments of the period as one of artistic decline, Mannerism has now come to be positively assessed as a rich era of creative individual artistic expression.

INSPIRATIONS. Many of the stylistic tendencies of the later Mannerist artists derived from the works of Michelangelo's Sistine Chapel ceiling frescoes and the late Raphael, particularly his "Fire in the Borgo" frescoes for the Vatican apartments (painted between 1514 and 1517). In these compositions Michelangelo and Raphael artfully arranged their human figures, placing them in positions that were elegant, beautiful, and which demonstrated the physical possibilities of the human form. They painted these figures heavily muscled and set within spaces defined by vivid colors. In these ways they helped extend the boundaries of artistic style. A second source

a PRIMARY SOURCE *document*

THE NATURAL OFFENSE

INTRODUCTION: Of Michelangelo's many achievements, the *Last Judgment* frescoes on the altar wall of the Sistine Chapel were among the most influential. They were also among his most controversial. Conservative tastes found the work's nudity offensive, as Vasari relates in his *Lives of the Most Eminent Painters, Sculptors, and Architects.* Eventually much of the painting's nudity was covered over, but even in its altered style, the willful, highly creative style that Michelangelo revealed in the painting became an important source for Mannerist artists.

Michelangelo had brought three-fourths of the work to completion, when Pope Paul went to see it; and Messer Biagio da Cesena, the master of the ceremonies, a very punctilious man, being in the Chapel with the Pontiff, was asked what he thought of the performance. To this he replied, that it was a very improper thing to paint so many nude forms, all showing their nakedness in that shameless fashion, in so highly honoured a placing; adding that such pictures were better suited to a bathroom, or a road-side wine-shop, than to a Pope. Displeased by these remarks, Michelangelo resolved to be avenged; and Messer Biagio had no sooner departed than our artist drew his portrait from memory, without requiring a further sitting, and placed him in Hell under the figure of Minos, with a great serpent wound round his limbs, and standing in the midst of a troop of devils; nor

did the entreaties of Messer Biagio to the Pope and Michelangelo, that this portrait might be removed; suffice to prevail on the master to consent; it was left as first depicted, a memorial of that event, and may still be seen ...

Truly fortunate may that man be esteemed, and happy are his recollections, who has been privileged to behold this wonder of our age. Thrice blessed and fortunate art thou, O Paul III, since God has permitted that under thy protection was sheltered that renown which the pens of writers shall give to his memory and thine own! How highly are thy merits enhanced by his art! A great happiness, moreover, has most assuredly been his birth for the artists of our time, since by the hand of Michelangelo has been removed the veil of all those difficulties which had previously concealed the features of Painting, Sculpture, and Architecture; seeing that in his works he has given the solution of every difficulty in each one of those arts.

At this work Michelangelo laboured eight years. He gave it to public view on Christmas-day (as I think in the year 1541). This he did to the amazement and delight...of the whole world. For myself, I, who was at Venice that year, and went to Rome to see it, was utterly astounded thereby.

SOURCE: Giorgio Vasari, *Lives of Seventy of the Most Eminent Painters, Sculptors, and Architects,* Vol. 4. Trans. and Eds. E. H., E. W. Blashfield, and A. A. Hopkins (New York: Scribner, 1896): 139–140; 145–146.

of Mannerist inspiration derived from the works that Michelangelo completed during his residency in the city of Florence between 1516 and 1534. During these years Michelangelo's art grew more turbulent and willful, as he became ever more involved in the construction of the Medici family tombs and the Laurentian Library. Like most of Michelangelo's projects, the Medici tombs were never completely finished in the way in which they had initially been planned. For this commission Michelangelo relied upon the traditional language of Brunelleschi's architecture to form a backdrop to the tombs. The sculptures that Michelangelo carved for the tombs departed from the harmonious classicism he had used in his earlier works. The nudes that adorn the tomb were heavily muscled, artificially elongated, and arranged in contorted positions. Michelangelo also completed two statues of the Medici family sons, Lorenzo and Giuliano, for the tombs. Although these figures were seated, the artist carved them, too, in a highly idealized, elongated, and elegant style in an effort, he admitted, to immortalize

them. The project for the Medici family tomb consumed much of Michelangelo's time during this period in Florence. It required the artist to hire and supervise the work of more than 300 workers and demonstrated Michelangelo's keen organizational skills. The Medici family fortunes, however, waxed and waned in Florence during the 1520s, and between 1527 and 1530, the family was expelled from the town. During this period work ceased on the tomb and the library. When the family returned to power in 1530, Michelangelo continued with these projects, but with less enthusiasm than before. Gradually, he began to spend more of his time in Rome, and by 1534, he had abandoned Florence completely in favor of the church's capital.

LAST JUDGMENT. The Rome of the 1530s was a very different place than it had been during the High Renaissance. In 1527, imperial forces of the army of Charles V had sacked the town, and the city's economy and cultural life had fallen into decline. The election of Paul III, a reform-minded pope, however, signaled the

beginning of a renewal. Paul commissioned Michelangelo to complete a number of projects in the city, the first and perhaps most important being the *Last Judgment* fresco for the Sistine Chapel. To paint this massive fresco, which lies on the end wall of the chapel behind the High Altar, Michelangelo had to destroy part of his ceiling frescoes completed just twenty years before. The resulting composition bears little resemblance to those earlier frescoes. In place of the serene and idealized figures of the ceiling, the *Last Judgment* on the end wall appears as a swirling mass of human figures that circulates around the central Christ figure. Everything is set against a blue background and the earth is only suggested as the scene of this drama at the very bottom of the composition. None of the traditional trappings of a Last Judgment scene are to be found in Michelangelo's vision. Christ does not sit on a throne doling out rewards and punishment to the righteous and impious, but instead hovers at the top of this swirling humanity with his right arm extended in condemnation. He is a gigantic, commanding figure, whose scale is greater than any other actor on the wall. Throughout the painting Michelangelo also relied upon an interesting scale. The figures arising from their graves at the bottom of the painting are about one-half the size of the saints and blessed that surround Christ himself, while at the top of the painting the angels who carry Christ's cross and column heavenward are again portrayed in the smaller scale used at the bottom of the wall. In this way the entire work takes upon the appearance of several swirling circles, filled with fascinating figures that cannot be comprehended in a single viewing. Originally, Michelangelo painted all the male figures in the work nude, but the developing religious senses of the Counter Reformation eventually prompted the church to summon one of the artist's students to paint draperies over the figures. Even these did little to diminish the sheer power of the human forms Michelangelo created.

LATER WORKS OF MICHELANGELO. Shortly after completing the *Last Judgment,* the artist set to work on two other large frescoes, this time for the Pauline Chapel in the Vatican. Since the chapel has long been a private place of worship used by the popes and their entourage, Michelangelo's paintings there are far less familiar. The subject for these frescoes, *The Conversion of Paul* and the *Crucifixion of St. Peter* are treated in ways that are an outgrowth of the *Last Judgment.* Here Michelangelo used similarly elongated human forms and turbulent compositions placed before the sparest of backgrounds. Yet in contrast to the *Last Judgment,* a quiet, meditative strain runs through both paintings, one which is reflective of

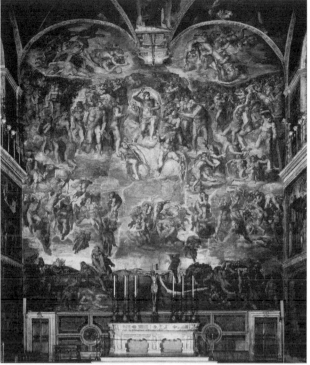

The Last Judgment fresco in the Sistine Chapel, Rome. **PUBLIC DOMAIN.**

the deeply religious impulses that Michelangelo embraced late in his life. Concerns with his approaching death and his ultimate salvation are also reflected in the late unfinished work, the *Rondanini Pietà,* a sculpture Michelangelo worked on between 1554 and his death in 1564. Like the earlier, more famous *Pietà,* this late work projects a quiet beauty, even in its incomplete state. Instead of supporting the dead Christ across his mother's lap, as in the earlier composition, Michelangelo planned to have the Virgin Mary support the body of her son while standing. During these last years of his life, though, Michelangelo's work as supervisor of the construction of the new St. Peter's Basilica and his poor health frequently stalled his progress on the statue. His execution of the *Rondanini Pietà* dissatisfied him and at several points he destroyed the composition so that he could begin key parts again. Sadly, there may not have been enough marble left to complete the sculpture, but even unfinished, the work suggests the religious intensity and depth of feeling of the aged artist.

PAINTING IN FLORENCE AND CENTRAL ITALY. In Florence and Central Italy a number of artists of genius practiced throughout the sixteenth century. Some of these kept alive High Renaissance traditions of idealized beauty and serenity. Others experimented with the new

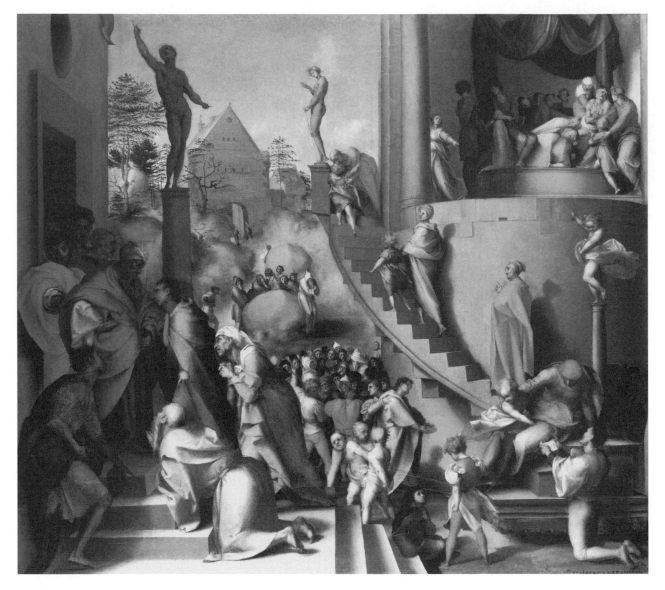

Joseph with Jacob in Egypt by Pontormo. © NATIONAL GALLERY COLLECTION; BY KIND PERMISSION OF THE TRUSTEES OF THE NATIONAL GALLERY, LONDON/CORBIS.

aesthetic concerns of Mannerism, with its emphasis on elegance, individual creativity, and distortion, and its preference as well for difficult and sometimes incomprehensible themes and iconography. Andrea del Sarto (1486–1530) was one of the most prominent of artists in the first of these two groups. His *Madonna of the Harpies*, painted in 1517, is typical of his style. Here he idealized the faces of his subjects and suffused his composition with the calm imperturbable beauty typical of Raphael and da Vinci at the height of their powers. By contrast, one of del Sarto's most accomplished pupils, Jacopo Pontormo (1494–1557), experimented with the more willful and personal dimensions of Mannerism. In 1518, Pontormo painted his *Joseph in Egypt*, a work that

relied upon new compositional techniques. In this work he painted three scenes from the life of Joseph on a single canvas, an innovation that abolished the unity and ready comprehensibility preferred by High Renaissance artists. Through the use of a staircase, a raised dais, and other architectural props Pontormo divided the painting into three spaces, which nevertheless appear strangely linked together as an artistic, rather than a narrative unity. The scenes that are retold—Pharaoh's dream, the rediscovery of Pharaoh's cup in Benjamin's sack of grain, and the reconciliation of Joseph with his brothers—are relegated to various parts of the canvas, while statues that appear to be living gesture to the observer to take note of the important events the artist is narrating. Through-

out the work the dramatic use of light and dark, too, creates a mood very different from the works of Pontormo's teacher, Andrea del Sarto. Pontormo's painting continued to be influenced by his friend Michelangelo, as seen in his somewhat later *Entombment*, painted for the Church of Santa Maria Felicità in Florence between 1525 and 1528. Like Michelangelo's later work on the Sistine Chapel ceiling, the artist only suggests the earth as the stage for his drama; his attention falls instead on the variety of human forms that accompany the dead Christ to be placed in his tomb. The languid body of the corpse harkens back to the dead Christ of Michelangelo's *Pietà*, while the twisted web of figures that accompany this cortége face inward, outward, and sideways. In this way the artist dissolved the typical stage-like setting long used by Renaissance artists and instead provided his observers with a scene captured in the moment. His dramatic use of color, which relied upon electric oranges, pinks, and even chartreuse, similarly departed from the gemlike conventions of the time. And finally, his use of elongated human forms was also typical among Mannerist artists as well.

ROSSO FIORENTINO. Pontormo's paintings pointed to a new willful creativity that helped to dissolve the conventions prized by artists in the first decades of the century. Another Florentine artist, Rosso Fiorentino (1495–1540) created works that were even more personally expressive. Among contemporaries, Rosso earned wide recognition for his emotionalism and individuality. In his early works, the artist combined influences from Michelangelo with insights he had gained from studying Northern European engravings to create a number of highly sophisticated paintings. One of the masterpieces of this early phase of Rosso's career, his *Descent from the Cross*, is a work whose dramatic colors are lit as if by a bolt of lightning. No landscape interest distracts from the central event that Rosso retells, but instead the artist places his actors before a slate blue sky. In place of the pyramidal compositional structures often favored by Renaissance and High Renaissance artists, he creates a gigantic figure eight out of the characters in his panel. The men who remove Christ from the cross struggle with the corpse's dead weight, a body the artist renders in a sickening green. Below, a woman looks out at those who observe the scene, as if to implicate all onlookers in the guilt for the crime that has just been committed. On the other side of the panel a grief-stricken apostle tears at his hair, while between these two figures, a woman struggles to support one of the ladders on which the men above are working. Charged with a brilliant emotional intensity, Rosso Fiorentino's *Descent from the Cross* pro-

a PRIMARY SOURCE *document*

MOURNING A FRIEND

INTRODUCTION: During the 1540s, the Cardinal Ercole Gonzaga served as a regent to his nephews, who were by birth lords of the city of Mantua. Over time, the severely moral Gonzaga befriended the court artist, Giulio Romano, a figure who had long been a fixture in the family's household. The relationship was unusual given the social divide that separated artists from nobles. In 1546, Romano died, and Ercole wrote to his brother lamenting the death of his trusted friend.

We lost our Giulio Romano with so much displeasure that in truth it seems to me that I have lost my right hand. I did not want to inform you of this at once, as I thought that the later you would hear of such a great loss, the less it would affect you, especially since you are taking your water cure. Like those who from evil try always to extract some good, I try and convince myself that the death of this rare man will at least have succeeded in taking away my appetite for building, for silverware, for paintings, etc., for in fact I would not have the heart to do any of these things without the design of this beautiful mind; therefore, when these few are done, whose designs I have with me, I think I shall bury with him all my desires as I have said. God give him peace; which I hope well is certain, for I have known him as an honest man and pure toward the world, and I hope also toward God. I cannot have enough of talking about him with tears in my eyes, yet I must end, since it has pleased Him who governs all to end his life.

SOURCE: Cardinal Ercole Gonzaga, "Letter to his Brother Ferrante, November 7, 1546," in *Italian Art, 1500–1600: Sources and Documents.*. Eds. Robert Klein and Henri Zerner (Englewood Cliffs, N.J.: Prentice Hall, 1966): 49–50.

vides its observers with a catalogue of the effects of grief upon the human psyche. As he shows, the sense of personal loss produces variety of psychological states ranging from anguish, to quiet suffering, and even to the nervous and uncomfortable leer that Rosso paints upon the face of Joseph of Arimathea.

ROME AND FRANCE. In 1523, Rosso left Florence for Rome, where he fell under the influence to an even greater degree of the art of Michelangelo, particularly the Sistine Chapel ceiling frescoes. Under the great artist's influence, Rosso developed a more elegant and reserved

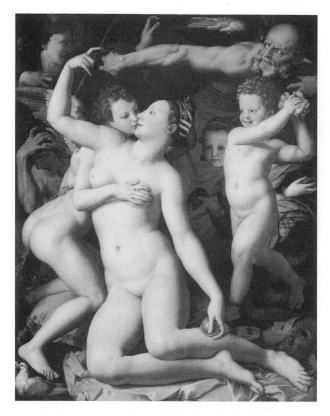

An Allegory with Venus and Cupid by Agnolo Bronzino, c. 1540. NATIONAL GALLERY COLLECTION; BY KIND PERMISSION OF THE TRUSTEES OF THE NATIONAL GALLERY, LONDON/CORBIS.

style, with less of the emotionalism typical of his earlier *Descent from the Cross*. In 1527, the sack of Rome forced him to flee the city, and he worked in several Central Italian towns until 1530, when he accepted the invitation of King Francis I to paint in France. Among the more important works he completed there was the Galerie of François I in the Palace of Fontainebleau. In this chamber Rosso worked with the Italian artist Primaticcio to create a highly ornamental and decorative style that influenced other Northern European designers.

ROMANO. A more whimsical side of the Mannerist movement can be seen in the work of Giulio Romano (1499–1546), an artist who served the Gonzaga lords in Mantua. Trained by Raphael in Rome, Romano entered the service of the Gonzaga lords in 1524 and remained there for the rest of his life. Among his most unusual Mannerist works was the Palace of the Te, a country villa set in an idyllic meadow on the outskirts of the city of Mantua. In the massive facade of this work Romano violated classical canons of design and proportion. The villa's rustic appearance, though, soon fades as the observer moves inside. In the palace Romano designed a series of opulent rooms that were fit to entertain the

Hapsburg emperor Charles V and other dignitaries. Romano decorated the rooms of the Te with illusionistic frescoes, their allegorical subjects drawn from ancient mythology. In one of the most famous of these salons, Romano depicted the story of the *Fall of the Giants*. Here the artist demonstrated his mastery of perspective and foreshortening so that the toppling columns he painted on the chamber's walls appear to be moving. Indeed the room's walls seem about to crash in upon those inside the space. Admired by the Gonzaga lords, Romano took on many decorative projects until his untimely death in 1546.

BRONZINO. The Florentine artist who was to carry the style of his teacher, Jacopo Pontormo, and of Rosso Fiorentino, into the second half of the sixteenth century was Agnolo Tori, who was known as Bronzino (1503–1572). Like Fiorentino and Pontormo, Bronzino developed the Mannerist tendency to disperse his figures to the edge of the surfaces he painted, rather than to arrange them in High Renaissance fashion symmetrically in the center. This trait can be seen in the panel he painted entitled *An Allegory with Venus and Cupid*, a work which is made up of an interlacing of its characters. In the right rear background of the painting, the figure of Father Time, lifts back a drapery from before the couple to expose Cupid's sensuous fondling of Venus. Bronzino made use of the heavily muscled figures that Michelangelo had introduced into sixteenth-century Italian art. The foreground figures of Venus, Cupid, and a little boy who is pelting the couple with roses appear as if they were polished marble. Masks litter the foreground, as do Venus's doves. Behind the lovers, an ugly woman, Envy tears her hair, while a beautiful girl offers a honeycomb to the couple with her left hand which is curiously attached to her right arm. Following the lines of this charming figure's body we find that her form ends with a lion's legs and a griffin's tail. Bronzino's allegory, complex and some might even say contrived, provided a kind of intellectual enjoyment to his sophisticated Renaissance audience, which gloried in complex iconographical themes. In the sixteenth century the Renaissance writer Baldasar Castiglione's *Book of the Courtier* had recommended books of emblems for the enjoyment of the cultivated urbane figures who worked and lived in Italian courts. Emblems were a kind of reverse jigsaw puzzle in which men and women tried to decode a message by reading the iconographical clues. Bronzino's *Allegory* arose from a similar set of sensibilities and a similar sense of fun. From the time of its completion around 1546, the work has continued to confound its admirers with its use of complex and ob-

scure symbols. Bronzino was also a portrait painter of merit, who applied the same brilliance of finished surfaces, cool detachment, and rich colorism to the mostly aristocratic figures he painted. Among the most famous of his portraits, that of Eleonore of Toledo, now in the Uffizi Gallery in Florence, ranks among his most accomplished creations. In it, Eleonore is shown against a brilliant blue background with the complex luxury of her gown competing for visual interest against the human subject herself.

HIGH RENAISSANCE AND MANNERISM IN PARMA.

In the city of Parma in Northern Italy an important school of painting developed after 1500. It was led at first by the High Renaissance master Antonio Allegri (1494–1534), who was known as Correggio after the place of his birth. During his short life the artist became one of the most important masters in Northern Italy, developing a flowing style characterized by movement and a skillful use of light. Although the artist lived past the date at which Mannerism began to make inroads into Northern Italy, Correggio never made use of the raw emotional intensity of painters like Rosso Fiorentino or Jacopo Pontormo. Instead his works are characterized by a warmth and tenderness of expression. Correggio's best frescoes, including those completed for the interior of the dome of the Cathedral of Parma, make use of movement and drama in a way similar to later Baroque artists of the seventeenth century. With the artist's premature death in 1534, leadership of Parma's school of painters passed to his younger contemporary Francesco Mazzola (1503–1540), who was known as Parmigianino. Unlike Correggio, Parmigianino traveled to Rome to absorb High Renaissance principles firsthand. There he also became familiar with the tenets of the developing Mannerist style. In 1524, Parmigianino painted his *Self Portrait in a Convex Mirror*, a work which shows the artist's taste for the stylish distortion favored by Mannerist artists. His most famous work *The Madonna of the Long Neck*, painted between 1534 and 1540, demonstrates a similar tendency to elongate and attenuate the human form. In this elegant painting, the artist depicts the Virgin Mary as if she were an earthly queen, complete with an aristocratic long neck. Bejeweled and holding a languid Christ child on her lap, she appears as the very picture of refinement and taste. The Christ child himself is shown with the body of a four- or five-year old, the long lines of his form mirror the attenuated shape of the Virgin. To the left, a group of idealized children gather around the mother and child, while the most forward of these presents an amphora to the Virgin. To the right in the background a prophet appears unrolling

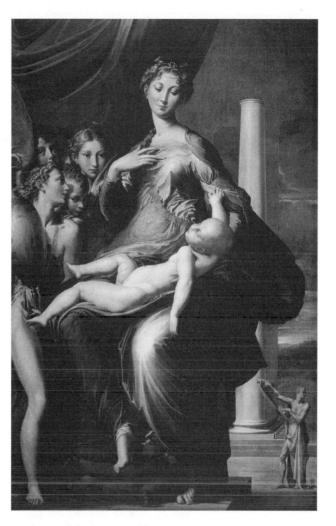

Madonna of the Long Neck by Parmigianino. THE ART ARCHIVE/DAGLI ORTI.

a scroll. Although he is near to the central figures of the painting, Parmigianino has painted the prophet to look as if he is far away. Over the years the *Madonna of the Long Neck* came under a great deal of critical scrutiny as to the meaning of the iconographical details the artist included. No satisfactory explanation has ever been discovered for these, leading many to conclude that perhaps Parmigianino, like other Mannerist artists, intended his work to be curious and enigmatic.

IMPLICATIONS.

The Mannerist movement dominated Florence, Rome, and much of Central Italy by the mid-sixteenth century. Mannerist painters moved to dissolve the harmonious, symmetrical, and serene beauty that had been prized by artists of the High Renaissance. In its place they developed an art that was often emotionally expressive, contorted, and characterized by an intricacy of compositional arrangements. Some Mannerist artists like Parmigianino and Bronzino favored

elegance and abstruse and difficult iconographical constructions in their works. Others like Pontormo and Rosso Fiorentino favored a style that was more emotionally expressive, and which demonstrated their artistic willfulness and individuality. By the end of the sixteenth century a new set of stylistic tastes, prompted in part by the religious changes of the Counter Reformation, began to outlaw the Mannerist taste for luxury and for subjects that were difficult to understand. By 1600 the rise of this new dramatic style of painting, which eventually became known as the Baroque, expressed a different set of values. In place of the Mannerist taste for an elegant art, the practitioners of the Baroque favored monumentality, idealization, dramatic movement, and clear intelligibility.

SOURCES

J. Briganti, *Italian Mannerism*. Trans. M. Kunzle (Princeton, N.J.: Van Nostrand, 1962).

S. J. Freedberg, *Painting in Italy, 1500–1600* (New Haven, Conn.: Yale University Press, 1993).

M. B. Hall, *After Raphael: Painting in Central Italy in the Sixteenth Century* (Cambridge: Cambridge University Press, 1997).

J. Pope-Hennessy, *Italian High Renaissance and Baroque Sculpture*. 3 vols. (Oxford: Oxford University Press, 1986).

J. Shearman, *Mannerism* (Harmondsworth, United Kingdom: Penguin, 1967).

H. Voss, *Painting of the Late Renaissance in Rome and Florence*. Trans. S. Pelzel (San Francisco: Alan Wolfsy, 1997).

SEE ALSO *Architecture: The Later Renaissance in Italy; Religion: The Council of Trent*

THE ARTS IN SIXTEENTH-CENTURY NORTHERN EUROPE

ACHIEVEMENT. During the fifteenth century Netherlandish artists had dominated Northern European painting. A distinguished lineage of painters, particularly in the wealthy city of Flanders, had perfected the medium of oil painting, developed a highly realistic art, and produced scores of altarpieces, religious panel paintings, and portraits. Netherlandish art had often affected painters in regions far from Flanders and Holland, and a lineage of fine painters continued the tradition of achievement in the sixteenth century. After 1500, though, artistic leadership in Northern Europe passed to Germany, a region that had been somewhat of an artis-

tic backwater in the previous century. This great flowering of German art occurred at roughly the same time that the High Renaissance was shaping artistic values in Italy. The German artists of the first half of the sixteenth century learned both from Netherlandish and Italian examples, while developing their own native traditions. Although they were expert in practicing the new medium of oil painting, German artists did not rely on the kind of free and dramatic brushwork that was typical of many Venetian and Italian artists at the time. Their work, moreover, never concentrated on the beauty of the human body in the same way that Italian artists did. The nude human form, in particular, often looks somewhat uncomfortable in the works of sixteenth-century German artists. And while these German painters studied the traditions of classical Antiquity, they did not usually fill their works with the trappings of ancient Greece or Rome, as Italian masters at the same time did. German painting and engraving relied instead on finely drawn and sinuous lines to create great dramatic effect. This great flowering of artistic activity in Germany developed suddenly after 1500, and faded just as quickly after 1550. In the first half of the sixteenth century the High Renaissance in Germany produced a number of masters, including Albrecht Dürer, Albrecht Altdorfer, Matthias Grünewald, Lucas Cranach, and Hans Holbein. By 1550, however, great figures like these ceased to appear, and the achievement of the German Renaissance drew to a close rather quickly. Even as it faded, new centers of artistic innovation appeared in other Northern European centers, making the sixteenth century an era of undeniable achievement in the visual arts throughout the continent.

ALBRECHT DÜRER. The greatest artist of the High Renaissance in Northern Europe was Albrecht Dürer (1471–1528), a native of the central German city of Nuremberg. Like Leonardo da Vinci and Michelangelo Buonarroti, Dürer kept journals that provide a glimpse of his ideas about art. These writings show that Dürer had a high sense of his calling as a creator and an artistic innovator. He was the first Northern European artist to write about art as something more than a mere craft, and his writings reveal that he had a unique sense of his own individuality. The artist was the son of a local goldsmith, and his father had emigrated from Hungary to Nuremberg. Even before the young Albrecht had been apprenticed he displayed a natural artistic ability. This ability can be seen in the *Self-Portrait*, a drawing Dürer completed when he was only 13. The artist followed this first *Self-Portrait* with a series of other such works completed before he was thirty. Even at this tender age, Dürer

a PRIMARY SOURCE *document*

REFLECTIONS ON DÜRER

INTRODUCTION: The Nuremberg scholar Joachim Camerarius included this personal description of Albrecht Dürer in the foreword to a Latin translation of the artist's *Four Books of Human Proportions*, published in 1532. The work thus appeared shortly after the artist's death, and Camerarius' description is noteworthy for the depth of personal details it includes.

Nature bestowed on him a body remarkable in build and stature and worthy of the noble mind it contained; that in this, too, Nature's Justice, extolled by Hippocrates, might not be forgotten—Justice, which, while it assigns a grotesque form to the ape's grotesque soul, is wont also to clothe noble mind in bodies worthy of them. His head reminded one of a thoroughbred, his eyes were flashing his nose was nobly formed ... His neck was rather long, his chest broad, his body not too stout, his thighs muscular, his legs firm and steady. But his fingers—you would vow you had never seen anything more elegant.

His conversation was marked by so much sweetness and wit that nothing displeased his hearers so much as the end of it. Letters, it is true, he had not cultivated, but the great sciences of Physics and Mathematics, which are perpetuated by letters, he had almost entirely mastered. He not only understood principles and knew how to apply them in practice, but he was able to set them forth in words. This is proved by his Geometrical treatises which, as far as I can see, leave nothing to be desired within the scope judged appropriate by him. An ardent zeal impelled him toward the attainment of all virtue in conduct and life, the display of which caused him to be deservedly held a most excellent man. Yet he was not of a melancholy severity nor of a repulsive gravity; nay, whatever conduced to pleasantness and cheerfulness, and was not inconsistent with honor and rectitude, he cultivated all his life and approved even in his old age, as is shown by what is left of his writings on Gymnastic and Music ...

SOURCE: Joachim Camerarius, Foreword to *Four Books of Human Proportions* by Albrecht Dürer, in *Northern Renaissance Art, 1400–1600*. Trans. and ed. Wolfgang Stechow (Englewood Cliffs, N.J.: Prentice-Hall, 1966): 123–124.

already shows an astonishing clarity of observation, technical finesse, and individuality of expression, all of which reveal him to have been a natural prodigy. Dürer perfected these gifts, first in the workshop of the Nuremberg engraver, Michael Wolgemut, and then in several years spent traveling after 1490. He returned to Nuremberg in 1494, but soon left on a journey to Italy. On those travels, he visited Mantua and Padua before settling in for a longer time in Venice. Ten years later, Dürer returned to Venice and for a time his art emulated the painterly style of the Venetian artists Giorgione and Bellini. By temperament and training Dürer was always an engraver, and since the art of engraving placed a high premium on the skills of drawing, the artist came in his maturity to develop his use of line, rather than the painterly deployment of color.

ENGRAVINGS. While Dürer was an accomplished painter, his greatest works are engravings and woodcuts. This latter medium required artists to draw their designs onto blocks of wood and then to cut away everything but the lines of their drawing. It was a time-consuming method that required a steady hand. Up until this time, most woodcuts had fairly simple designs with the drawing merely providing the outward lines of the forms and objects that the artist was portraying. Dürer developed the technique so that he included lines for shading and

rendering patches of light and dark. These new refinements can be seen in his woodcuts of the *Apocalypse*, a series of fifteen works based upon the biblical book of *Revelation*. Dürer completed these prints during 1498 and sold the works together as a set. The works display the artist's powerful hand and his subtle sense of shading. Dürer continued to develop his skills as a printer throughout his life, mastering new techniques to enhance the process of copper engraving. As a result, he extended the boundaries of what was achievable in this medium beyond those that had already been established by Martin Schongauer in the late fifteenth century. Dürer made full use of the possibilities of the medium, applying straight and curved hatching, stippling, and cross-hatching to create forms within his engravings that appeared sculptural. He lit his works with a light that seems inspired by fifteenth-century Netherlandish traditions. At the same time he applied the techniques of perspective common to the Italian art of the period. During 1514, the artist produced three prints generally accepted as the highest expression of his achievement in the graphic arts. These include his *St. Jerome in His Study*; his *Melancolia I*, a work that muses about the solitary pursuits of the artist; and *The Knight*. The grandeur of these prints helped to found a great tradition of graphic arts that was practiced by many accomplished German artists in the following decades and centuries.

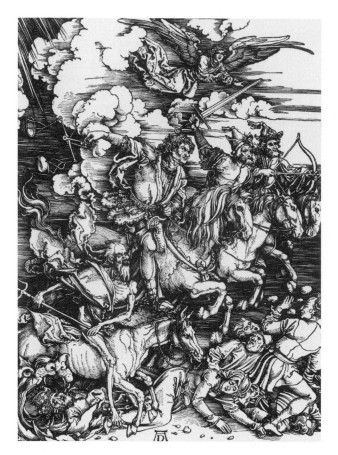

Four Horsemen of the Apocalypse by Albrecht Dürer. ©
BURSTEIN COLLECTION/CORBIS. REPRODUCED BY PERMISSION.

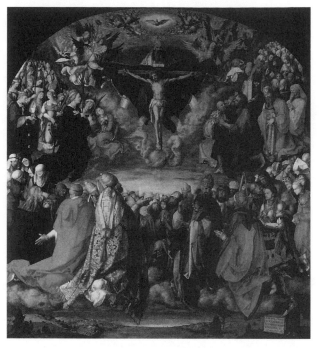

The Adoration of the Trinity by Albrecht Dürer, oil on wooden
panel, 1511. © FRANCIS G. MAYER/CORBIS. REPRODUCED BY PER-
MISSION.

PAINTING. Dürer's achievements in woodcuts and
copper engravings marked him as an artist of the highest
order. In painting, he rarely achieved the level of finesse
common to his graphic art, although Dürer was im-
mensely prolific, and in some cases he succeeded in en-
dowing his paintings with the same depth and finesse
typical of his prints. One of these works is the artist's
Adoration of the Trinity, completed in 1511 for a chapel
in Dürer's hometown of Nuremberg. The painting shows
a vision of heaven in which God the Father, Jesus Christ,
and the dove of the Holy Spirit are worshipped by a
throng of onlookers, including popes, kings, princes, and
ranks of human admirers. Rich colors—reds, greens,
blues, and yellows—combine here with Dürer's typically
florid use of line and his expert compositional skills. The
work presents a traditionally medieval conception of the
communion of saints and the Augustinian notion of the
City of God. About a decade following its completion,
though, Dürer became one of the first Northern Euro-
pean artists to accept the premises of the Protestant Re-
formation. In his writings the artist paid homage to
Luther as the "Christian man" who had helped relieve

him of "many anxieties." Ironically, it was the Protestant
Reformation that ultimately moved to confine greatly the
role of the visual arts in Northern European religious life.
The Reformation, in other words, served to dampen the
great artistic flowering the Renaissance had created in
Germany. Dürer, though, accepted the doctrines of the
new movement. In 1526, one year after Nuremberg had
adopted the new religious teachings, the artist presented
his famous panel paintings of the *Four Apostles* to the
Nuremberg city council. While there was nothing ex-
plicitly Protestant about the style of the work, the choice
of the four apostles—Matthew, Mark, Luke, and John—
highlighted the artist's new faith in the scriptures. Dürer
seems as well to have intended his gift to encourage the
city's rulers to remain steadfast in their commitment to
the Reformation.

PORTRAITS. Another area in which the artist excelled
was in the production of portraits of German notables
and wealthy patrons. The artist completed several por-
traits of important princes and dignitaries as engravings,
and these were widely circulated at the time. At home in
Nuremberg he also painted a number of portraits for the
town's wealthy burghers. Dürer and Hans Holbein were
the two greatest portraitists at work in Northern Europe
at the time. A Holbein portrait was usually a dramatic
tour de force, filled with opulent trappings that lent
majesty to the noble and princely figures he immortal-

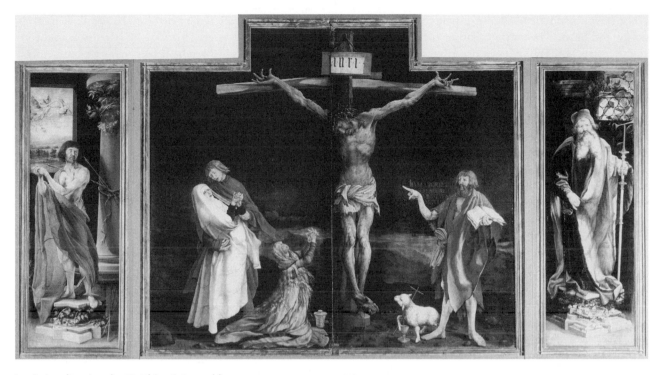

Isenheim altarpiece by Matthias Grünewald. THE ART ARCHIVE. REPRODUCED BY PERMISSION.

ized. Dürer, on the other hand, strove to present an accurate image of his subjects while at the same time providing his viewers with some deeper psychological insight about the person's internal character. Dürer practiced portraiture increasingly in his final years, perhaps because of the poor state of his health, which seems to have been damaged by a malarial fever he contracted while visiting the Netherlands in 1520–1521. In these years he also wrote theoretical treatises on art, battle fortifications, and human proportions. The artist's fame continued to grow after his death, and his prints had many collectors throughout Germany. During the years between 1570 and 1620, the artist's style inspired a "Dürer Renaissance" among engravers who imitated the artist's dramatic engravings. In subsequent centuries Dürer continued to be celebrated as Germany's greatest artist, and this reputation sometimes prevented a realistic assessment of the other great figures that contributed to the German Renaissance. More recently, these artists' reputations have been reassessed, while Albrecht Dürer's role in the country's artistic flowering has not diminished.

MATTHIAS GRÜNEWALD. Little is known about the training and early work of Matthias Grünewald (c. 1475–1528), a German painter who was likely born in the city of Würzburg on the Main River in central Germany. In 1510 he joined the archbishop of Mainz's court at Aschaffenburg, where he served as a painter and superintendent of public works. Soon after that appointment Grünewald won a commission to paint an altarpiece for the monastery church of St. Anthony at Isenheim in Alsace (now in eastern France). This great work is one of the strangest and most macabre pieces produced during the German Renaissance. Grünewald created the Isenheim altarpiece as a carved work that had two sets of wings and which could consequently be displayed with three different views. Although the work has long since been disassembled, when it was originally closed the altarpiece showed a gruesome Crucifixion, in which rigormortis has already set in on the body of the dead Christ. The Savior's flesh is a mass of pockmarks and on his legs are visible the scourge marks from his recent tortures. The Isenheim monastery ran a hospital that cared for those suffering from leprosy and the plague, a fact that helps to explain Grünewald's gruesome depictions of Christ's skin. Below, Mary Magdalene, John the Beloved, the Virgin Mary, and John the Baptist witness the harrowing tortures of the Savior, while a Paschal lamb accompanies the figure of the Baptist, a symbol that recalls both Christ's divine and human natures. The entire scene is set before a dark landscape, the nighttime sky lit only by patches of a deep greenish color. When the first set of the altarpiece's wings were opened, this gruesome horror of the *Crucifixion* is transformed into scenes of joy that recount the Annunciation, the early life of Christ, and his Resurrection. In place of the somber and often disturbing colors of the closed altar-

piece, Grünewald here adopts a palette of vivid reds, golds, and blues. The culmination of these three scenes, the Resurrection, is an awe-inspiring work in which Christ seems to have surged dramatically from the tomb and now floats above the soldiers stationed there to guard his dead body. In this panel the wounds of Christ's skin have been transformed into rubies while his hair and beard are now pure gold. The ascending Christ appears before a vivid halo of red, gold, and green. With the altarpiece in its third position, the work revealed a sculptural central panel in which a seated St. Anthony was flanked by Saints Augustine and Jerome. On each side Grünewald painted scenes from the life of St. Anthony, the patron of the Isenheim Church. One theme that ran throughout the work was of disease and suffering, and the possibility of both medical and spiritual intervention to overcome these earthly trials. St. Anthony, long a patron of the sick, is presented in the final Isenheim setting as a refuge against the otherwise unstoppable forces of disease. The artist's grim vision of illness coupled with his reassurances of the possibility of either an earthly or a heavenly cure were intended as consolation for those being treated at Isenheim.

OTHER WORKS. The Isenheim altarpiece was Matthias Grünewald's indisputable masterpiece. Relatively few of the artist's other works survive, but these show a similarly dramatic temperament. In 1526, Grünewald left his post in Catholic Aschaffenburg, perhaps because of his sympathies for the developing Lutheran movement. Shortly after Grünewald's death, Luther's close associate, Philip Melanchthon, listed the artist just behind Albrecht Dürer in a ranking he compiled of major German painters, one measure of the enthusiasm with which the sixteenth-century audience received the artist's tempestuous vision. In the intervening centuries, though, the memory of Grünewald's works faded, and the artist was left largely to twentieth-century connoisseurs to rediscover.

THE DANUBE SCHOOL. At the same time as Dürer and Grünewald were active in Central Germany, a prolific school of artists was coalescing to the southeast along the Danube River. The Danube School of painters flourished in Germany between 1500 and 1530 in the towns and cities that lay between the city of Regensburg and Vienna along this major river artery. In this region a number of venerable and wealthy monasteries commissioned many lavish altarpieces from these masters. Among the greatest practitioners of the Danube school was Lucas Cranach the Elder (1472–1553), who came to the region from the neighboring German province of Franconia in 1500. Cranach took up residence in the

city of Vienna where he began to acquire skills as a notable portrait painter. In 1505, he left the Danube region for Saxony, where he became court painter to the elector Friedrich the Wise, who later protected the Reformer Martin Luther. In Cranach's maturity he was won over to the Protestant cause, became a friend of Luther, and used his art to propagandize for the Reformation. The artist ran a notable studio in which he trained a number of pupils, including his two sons. Of the many artists associated with his workshop, though, only his son Lucas Cranach the Younger was to have a notable career. Another great figure of the Danube School was Albrecht Altdorfer (c. 1480–1538). Altdorfer was a native of the Danubian city of Regensburg and he worked there throughout his life. The influence of Cranach and Dürer is detectible in Altdorfer's early work, but over time he acquired an altogether more personal and dramatic style. He also evidenced an interest, early among Northern European artists, in the painting of landscape. In works like his *Battle of Alexander and Darius on the Issis* Altdorfer relied on dramatic lighting effects to bring alive the lakes, mountains, and rivers in which he set this famous battle from Antiquity. Similarly, in his many religious paintings Altdorfer achieved a great harmony between his human subjects and their surrounding natural environment. Other artists who were active in the Danube School included Jorg Breu and Wolf Huber, who shared Altdorfer's and Cranach's fascination with landscape. Both figures set many of their works within the dramatic vistas that were a common feature of this river valley region.

HANS HOLBEIN. The final great figure of German Renaissance painting was Hans Holbein the Younger (c. 1497–1543), one of the greatest portraitists ever in the European tradition. The artist was born in Augsburg and his father, brother, and uncle were all painters. Like Dürer, Holbein traveled widely as a young man, arriving in Basel in Switzerland in 1515. There he met and became friends with the great Dutch humanist Erasmus, who asked the young Holbein to illustrate his satirical farce, *The Praise of Folly*. Throughout his career the artist also made illustrations for other famous books, including Luther's translation of the Bible. One of his most successful sets of prints was a series of 41 illustrations retelling the story of the *Dance of Death*. Holbein stayed in Basel for almost a decade, but in 1524 he left the town for France in search of work. At this time Basel had become riddled with factional strife resulting from the Reformation, and the market for religious art was quickly drying up. In France he worked for John, the Duke of Berry, but soon returned to Basel. In the meantime the situa-

tion had grown increasingly worse there, and so in 1526, Holbein left the city again, this time to travel to the Netherlands and England. In England, he presented a letter of introduction from Erasmus to Sir Thomas More, a close associate of the Dutch humanist. Holbein painted More's family, and a portrait of the humanist and More opened doors for the artist among the prominent patrons of the island. Richly rewarded for his portraits, Holbein returned to Basel, where he set up his shop again, this time staying until 1532 when he returned permanently to England. Eventually, Holbein became court painter, undertaking more than 100 full-size and miniature portraits for the English crown and nobility. These works display the hallmarks of Holbein's mature style: a sure and certain use of line and brilliant, gemlike colors. Among the many English portraits the artist created, his *Portrait of Henry VIII* from around 1540 is one of the most accomplished and famous. One of a series of portraits the painter completed of the king, the work shows the notorious monarch in a fully frontal pose in which Holbein enhances the visual interest of the monarch through his intricate rendering of the king's dress. Though this impressive garment provides a suitably royal frame, Holbein still manages to endow the king's visage with a steely will and frightening intensity. The artist's linear skill and his ability to render infinite detail is also to be seen in his famous portrait of two French ambassadors. Surrounded by curiosities and the attributes of cultivated court life, the artist paints each item in the room using a perfect and minutely rendered perspective.

PAINTING IN THE SIXTEENTH-CENTURY NETHER-LANDS. During the sixteenth century the Netherlands continued to produce a number of accomplished painters. At first these figures followed in the tradition laid out by Jan van Eyck and other fifteenth-century masters. But over the course of the sixteenth century Netherlandish painting was to be reinvigorated by the journeys of Low Country artists to Italy and by a shift in the centers of artistic productions. The city of Antwerp, long a site with only a negligible circle of artists, gradually became the leading center in pioneering new forms in the visual arts. The town benefited from the decline of nearby Bruges as its harbor silted up and traders moved east to Antwerp. Among the accomplished artists who worked there in the sixteenth century were Quentin Metsys (also spelled Massys) (c. 1465–1530), Jan Gossart (c. 1478–1532), and Joachim Patinir (active 1515–1524). Metsys settled in Antwerp in 1491, where he painted a number of portraits and religious works. Deeply pious sentiments and the use of finely drawn lines characterized his religious paintings, while over time Metsys de-

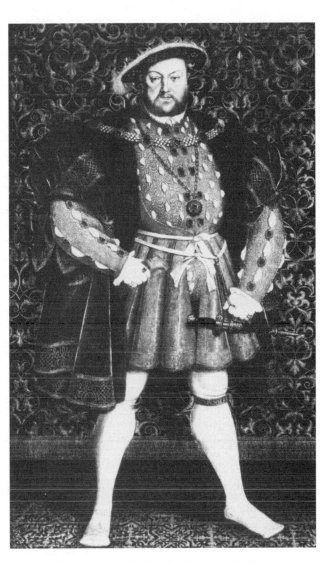

Portrait of King Henry VIII of England by Hans Holbein. THE LIBRARY OF CONGRESS.

veloped the portrait as a vehicle for great individuality of expression. By contrast, Joachim Patinir created wild and fanciful landscapes to serve as the backgrounds of his religious paintings. He filled these with jagged rocks, perfectly conceived villages, and other details that showed that these were not real, but imaginary realms drawn from the artist's own conception of what constituted the glory of Creation. The final figure, Jan Gossart, brought the lessons that he learned on a journey to Italy back to Antwerp, and over the next decades he worked to integrate Italian techniques and attitudes into his works. At first his allegiances remained firmly tied to Netherlandish traditions. Over time, however, he painted more as a "Romanist," adopting the proportions and classical iconography typical of Italian Renaissance art. Gossart won the praise of the famous Italian art historian and biographer, Giorgio Vasari, who noted that

a PRIMARY SOURCE *document*

MASTER OF NATURE

INTRODUCTION: Carel van Mander, the great sixteenth-century biographer of Northern Renaissance artists, admired the work of Pieter Bruegel for its clear observation of nature. Van Mander believed that Bruegel was primarily a rustic peasant, largely unschooled, who painted the life of peasants sympathetically because he himself had been born a member of the class. More recent research has shown that the currents of humanism deeply affected Bruegel, and he was in conversation with many of the most sophisticated intellectuals in the Netherlands. His paintings of peasants were not mere visual journalism, but were filled with philosophical musings about the tie of all human beings to the earth and the natural cycles that governed all existence.

In a wonderful manner Nature found and seized the man who in his turn was destined to seize her magnificently, when in an obscure village in Brabant she chose from among the peasants, as the delineator of peasants, the witty and gifted Pieter Breughel, and made of him a painter to the lasting glory of our Netherlands. He was born not far from Breda in a village named Breughel, a name he took for himself and handed on to his descendants. He learned his craft from Pieter Koeck van Aelst, whose daughter he later married. When he lived with Koeck she was a little girl whom he often carried about in his arms. On leaving Koeck, he went to work with Jeroon Kock, and then he traveled to France and thence to Italy. He did much work in the manner of Jeronn van den Bosch and produced many spookish scenes and drolleries,

and for this reason many called him Pieter the Droll. There are few works by his hand which the observer can contemplate solemnly and with a straight face. However stiff, morose, or surly he may be, he cannot help chuckling or at any rate smiling. On his journeys Breughel did many views from nature so that it was said of him, when he traveled through the Alps, that he had swallowed all the mountains and rocks and spat them out again, after his return, on to his canvases and panels, so closely was he able to follow nature here and in her other works. He settled down in Antwerp and there entered the painters' guild in the year of our Lord 1551. He did a great deal of work for a merchant, Hans Franckert, a noble and upright man, who found pleasure in Breughel's company and met him every day. With this Franckert, Breughel often went out into the country to see the peasants at their fairs and weddings. Disguised as peasants they brought gifts like the other guests, claiming relationship or kinship with the bride or groom. Here Breughel delighted in observing the droll behavior of the peasants, how they ate, drank, danced, capered, or made love, all of which he was well able to reproduce cleverly, and pleasantly in water colors or oils, being equally skilled in both processes. He represented the peasants—men and women of the Camping and elsewhere—naturally, as they really were, betraying their boorishness in the way they walked, danced, stood still, or moved …

SOURCE: Carel van Mander *Life of Pieter Breugel*, in *Northern Renaissance Art, 1400–1600: Sources and Documents.* Trans. and Ed. W. Stechow (Englewood Cliffs, N.J.: Prentice-Hall, 1966): 38–39.

he was the first Northerner to paint the nude body with the beauty of the Italian style.

BRUEGEL. The greatest Netherlandish painter of the sixteenth century was Pieter Bruegel (c. 1525–1569). Although Bruegel's life is shrouded in obscurity, he did sign and date his paintings, a fact that permits the reconstruction of the development of his art. These show a transformation from early landscapes which were conceived and executed according to the traditions of Flemish realism to later works which were more Italian in character. Bruegel traveled in Italy between 1551 and 1555, and while on the way there, he kept a visual record of his journeys. His drawings of the Alps rank as some of the best landscapes ever sketched by a European artist. While in Italy, the beauty of the southern Italian landscape inspired his *Landscape with the Fall of Icarus*, a work that retold the story of the ancient figure who flew

too close to the sun. The story traditionally had been used to condemn pride and too great ambition. In Bruegel's hands, however, he elevated the story into a moralizing sermon that instead exulted the toil of earthbound peasants. In the foreground one such figure plows the soil, while behind him a shepherd tends his sheep. Neither takes notice of Icarus himself, who is barely visible, a floundering form upon the sea. In this work the typically harmonious balance the artist struck between the more monumental traditions of Italian art and the landscape conventions of the Netherlands became visible. Upon Bruegel's return to the Netherlands he settled in Antwerp where he often worked for a local printer, Hieronymous Cock, the town's most distinguished engraver. Bruegel produced designs for Cock, even as he also painted a number of works in the tradition of Hieronymus Bosch, an artist who was undergoing a surge of popularity at the time. The artist increasingly painted

landscapes, particularly after his move to Brussels in 1563. Bruegel elevated landscape painting into moral sermons, reflecting the long Flemish tradition of seeing religious and moral significance in simple everyday things. Such is the case in Bruegel's *Harvesters*, a work that celebrates the simple toil of peasants and the human tie to the soil as a consoling inevitability. In these late landscape creations the artist endowed his peasants with a deep humanity while placing them within a grand landscape. No Netherlandish artist who followed Bruegel ever again achieved this great harmony.

PAINTING IN SIXTEENTH-CENTURY FRANCE. In comparison to the fourteenth and fifteenth centuries, the sixteenth century produced few great native artists in France. For much of the 1500s the French court imported its artists from Italy. Leonardo da Vinci spent the last years of his life working in France; somewhat later the Italian mannerist Rosso Fiorentino and Francesco Primaticcio popularized their style in the country through their work in royal palaces. Native artists, though, did flourish as portraitists. The French artists Jean Clouet (c. 1485–1541) and his son François Clouet (1510–1572) served the crown for many years in this capacity. The origins of this family of painters lay originally in Flanders and they infused their works with the conventions of Netherlandish realism. Holbein probably saw the portraits that Jean Clouet had completed for the king of France while visiting the country on one of his European journeys since something of their stiff formalism and opulent grandeur also appear in his portraits of the English royal family. By contrast, Jean's son, François was more affected by Italian examples than his father; his works seem to be influenced by the contemporary portraits of the Florentine Mannerist Bronzino. If great native painters were relatively few in sixteenth-century France, the country did produce two sculptors of merit, Jean Goujon (c. 1510–1568) and Germain Pilon (c. 1535–1590). Goujon completed most of his sculptures within the contexts of architectural projects, the five surviving reliefs he created for the *Fountain of the Innocents* in Paris being among his masterpieces. These works show a dramatic adoption of Italian Mannerism, with its elongated forms, supple drapery, and elegant refinement. At the same time the grace of these figures points forward to trends that French artists developed later during the Rococo period of the eighteenth century. By contrast, Germain Pilon's sculptures were altogether more powerful. While originally influenced by Italian mannerism, Pilon developed a style that was more realistic and natural. The artist excelled in both bronze and marble and was a particular favorite of the French

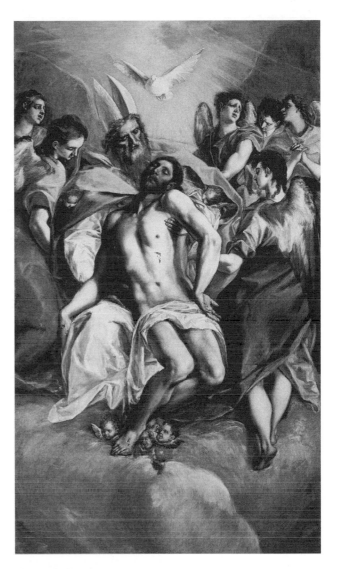

The Trinity by El Greco. © ARCHIVO ICONOGRAFICO, S.A./CORBIS. REPRODUCED BY PERMISSION.

kings. He worked on the tombs of several French kings and completed sculptures for the royal palaces of the Louvre and Fontainebleau.

SPAIN. Despite its great colonial empire and wealth, Spain produced few painters and sculptors during the sixteenth century. The country imported most of its artists from abroad. The greatest of these figures was the brilliant El Greco (1541–1614), which means literally, "the Greek." The artist, whose real name was Domenikos Theotokopoulos, was a native of the island of Crete in the Eastern Mediterranean, which at that time was a colony of Venice. When he was about 20, El Greco settled in Venice, where he had an active career painting works for the local Greek community. The dramatic and fluid brushwork of the Venetian artist Tintoretto

strongly influenced the development of El Greco's style, as did a visit to Rome somewhat later during 1570. There he admired the sculptural forms of Michelangelo, an influence which is evident in his painting of the *Pietà*, completed soon after his arrival in Rome. There he came into contact with a group of Spaniards who encouraged him to immigrate to Toledo in 1577. In Spain he developed his own inimitable style, characterized by extremely elongated human forms, wildly vivid, even garish colors, and unusual compositional groupings. These tendencies grew more pronounced as El Greco matured, and late in life, the artist developed an intensely mystical and personal style. One of the first masterpieces of El Greco's Spanish maturity was *The Burial of the Count of Orgaz*, which he completed in 1586. The subject of the painting was the interment of a saintly medieval nobleman. This burial is attended by ranks of Spanish aristocrats and important church dignitaries. Above this scene Orgaz's soul rises to heaven to be met by the Virgin Mary, Christ, and ranks of saints. In this work El Greco has already begun to elongate his human figures, a tendency that increased over time. During the artist's late years his art also grew more feverishly intense, as can be seen in his view of *Toledo* and his famous *Resurrection*, both completed after 1600.

CONCLUSIONS. The period between 1300 and 1600 was one of amazing achievement in the visual arts throughout Europe. Change was constant throughout these centuries, and artistic styles frequently overlapped, with medieval styled works continuing to appear at the same time the newer more naturalistic styles of the Renaissance flourished. The primary achievements of Renaissance artists lay in their observation of the world, their discovery of nature and its complexities, and their ability to produce space and the human body realistically. Renaissance artists also considered new themes in their art. Sometimes they drew these subjects from pagan Antiquity; at other times they recorded the lives of their fellow countrymen in genre paintings and portraits. The growth and development of portraiture over the period points to the appearance of a new kind of individualism, as both painters and their patrons strove to immortalize the outward appearance and inward spirit of the personality. During the sixteenth century religious issues made the visual arts increasingly subjects of controversy. In Northern Europe the Protestant Reformation moved to limit the uses of religious art, while in Italy and other Catholic regions the Counter-Reformation aimed to reform painting and sculpture. Counter-Reformation artists gave expression to the church's demand for an art that was clearly intelligible and which

stirred the faithful to pious living. In time the new style they fashioned gave rise to the seventeenth-century Baroque, a style that drew upon the achievement, innovations, and sheer inventiveness that Renaissance artists had demonstrated over the previous centuries.

SOURCES

J. Brown, *The Golden Age of Painting in Spain* (New Haven, Conn.: Yale University Press, 1998).

S. Buck, *Hans Holbein the Younger: Painter at the Court of Henry VIII* (London, England: Thames and Hudson, 2002).

C. D. Cuttler, *Northern Painting; From Pucelle to Bruegel* (New York: Holt, Rinehart and Winston, Inc., 1968).

W. S. Gibson, *Bruegel* (London, England: Thames and Hudson, 1977).

J. C. Hutchinson, *Dürer* (Princeton, N.J.: Princeton University Press, 1990).

J. Snyder, *Northern Renaissance Art: Painting, Sculpture, the Graphic Arts from 1350 to 1575* (New York: Harry N. Abrams, 1985).

SEE ALSO *Architecture: The Architectural Renaissance Throughout Europe*

SIGNIFICANT PEOPLE
in Visual Arts

ALBRECHT DÜRER
1471–1528

Painter
Graphic artist

EARLY LIFE. Albrecht Dürer was born in Nuremberg to a large family. His father had migrated to Germany from Hungary, and had by the time of the younger Dürer's birth established himself as a successful goldsmith in this prosperous German city. Dürer's father expected him to carry on in the family's trade, but early in life the child demonstrated great skill as a draftsman, and the son soon became an apprentice to the local artist Michael Wolgemut, a painter and book illustrator. In 1490 Dürer completed his apprenticeship, and he undertook a series of journeys through Germany and Switzerland during which he made acquaintances in the printing trade and befriended a number of artists. Along the way he supported himself by occasionally un-

dertaking printing projects. Upon his return to Nuremberg in 1494, he married the daughter of a wealthy artisan, but an outbreak of the plague several months later encouraged the artist to leave the city, this time for Venice. Along the way Dürer kept both a written and visual record of his journeys. The drawings he completed on this trip were some of the first independent landscapes in European history. When the artist returned to his native city, he began to publish prints. The first undeniable masterpiece, his woodcut *Apocalypse* series, appeared as a book published in a joint venture with his godfather, the accomplished Nuremberg printer Anton Koberger. In these woodcuts Dürer relied on amazingly precise techniques to invoke the horrors of the biblical prophecies concerning the end of the world. During this early stage of the artist's career he also painted, designed stained glass, and undertook a number of decorative projects. His theoretical interests in art and aesthetics also grew, and the author kept written records of his thinking on these subjects. From his youth, the artist had also painted and drawn self-portraits. In 1500, he completed the last of these portraits, one that shows the artist staring at the viewer in a Christ-like pose. While Dürer portrayed himself as serene, a restless temperament seemed always to lie beneath his calm exterior. By 1505, for instance, the artist's love of travel and adventure caused him to set out on a second journey to Italy.

VENICE. When Dürer arrived in Venice for the second time, his reputation preceded him. Although several Venetian artists befriended the German, Dürer wrote home to a friend in Nuremberg that he was the constant victim of Italian jealousy. The artist admired the higher status and social standing of Italian painters and he longed to see artists treated similarly in Germany. In Venice Dürer won a commission for an altarpiece, the *Madonna of the Rose Garlands*, from a confraternity of German merchants who lived in the city. Criticism from Italians about his skill in painting caused the artist to devote considerable time and attention to this picture, which showed the influence of the great Venetian artist Bellini on its completion. Soon after finishing the work, though, Dürer returned home and entered into another very productive period. He demonstrated his mastery of the lessons he had learned in Italy by painting life-size nudes of Adam and Eve as well as his altarpiece panel the *Adoration of the Trinity*. These works demonstrated the artist's mastery of the skills of the painter, while at the same time his skills in graphic arts, particularly in the copper engraving process, improved tremendously. Throughout the 1510s the artist released a number of new series of engravings, including his famous *Melancolia I*, *The Knight*, and *St. Jerome in His Study*. Professional recognition also mounted in this period, which culminated in Dürer's receiving a lifetime pension from the German emperor.

LATER YEARS. In 1520 the artist embarked with his wife on his final travels, a visit to the Low Countries. Dürer ostensibly set off on this journey to make certain that the new emperor, Charles V, would not revoke his pension. But he indulged his taste for art and spent months exploring the Netherlands. As he had done in the past, Dürer supported himself and his wife on these journeys by selling his prints and undertaking occasional commissions along the way. Unfortunately, during one of his many side trips, he developed a fever, which may have been malaria, and he returned to Nuremberg with weakened health. Because of his frailty, the artist spent the last years of his life painting portraits of local dignitaries and writing about art. Earlier, Dürer had begun a painter's manual, similar to those written by many Italian artists. He now took the opportunity to work on this manual, as well as several other works on proportions and civil engineering. Although pioneering in their scope, the publication of several of these works after the artist's death did not have an immediate effect on German artists. Instead it was the example of Dürer's engravings that survived to stimulate graphic art production in Germany during the following generations. Like many German artists at the time, Dürer also followed the religious debates that were erupting in his native country at the time. Humanism had deeply colored the artist's outlook in the previous decades, and he aligned himself with the Lutheran cause. In 1526, Dürer painted his two panels of the *Four Apostles* to be hung in Nuremberg's town hall. Although there was little that was specifically Lutheran about these works, his choice of subject—the apostles Matthew, Mark, Luke, and John—was an expression of his hope that the town would continue to follow the Reformation's biblical path in religious matters.

SOURCES

F. Anzelewsky, *Dürer: His Art and Life*. Trans. H. Grieve (New York: Alpine Fine Arts Collection, 1980).

J. C. Hutchison, *Albrecht Dürer* (Princeton, N.J.: Princeton University Press, 1990).

E. Panofsky, *The Life and Art of Albrecht Dürer* (Princeton, N.J.: Princeton University Press, 1955).

D. H. Price, *Albrecht Dürer's Renaissance: Humanism, Reformation, and the Art of Faith* (Ann Arbor, Mich.: University of Michigan Press, 2003).

GIOTTO

c. 1267–1337

Painter
Architect

SIGNIFICANCE. Even during his lifetime, this Tuscan artist was credited with innovations that created a new style in Italian art. Giotto is mentioned in the works of Dante, Petrarch, and Boccaccio as a figure of the highest importance. In the fifteenth century Lorenzo Ghiberti, the Florentine sculptor, enhanced Giotto's reputation further in his writings, and in the sixteenth, Giorgio Vasari stated a version of the Giotto legend that would persist for centuries. He admired Giotto for his lifelike style of painting, for abandoning the traditions of Gothic stylization, and for his rise from humble beginnings to a position of eminence among all European artists. In truth, however, not every feature of this "Giotto legend" was accurate, nor can every feature—such as his humble birth—be verified by documentary sources. Like many figures of the fourteenth century, many aspects of Giotto's life are shrouded in some mystery. In modern times, too, the artist's style has been re-interpreted and Giotto has been seen less as a figure of the early Renaissance than of the late Gothic. At the same time Giotto's revolutionary introduction of a greater naturalism into his works continues to be seen as one element of his work that fifteenth-century artists like Masaccio would build upon.

CAREER. Giotto was born in the village of Vespignano near Florence, and may have been apprenticed to Cimabue. His own art, though, took quite different turn from this master. In place of the stylized depiction of the human figure that was common in Italian art at the time, Giotto painted his characters, particularly in his frescoes, in real-life poses. In one of his most famous series of works painted around 1300 in the Arena Chapel in Padua, Giotto tried intuitively to paint his surfaces as if they had depth and perspective. Sometimes his efforts in this vein were not completely successful, and at times he varied the use of depth in his constructions, so that some of the scenes appear to have a very shallow space, while others take on a greater relief. The artist's observations of emotions and gestures, however, are perhaps even more significant than his spatial experimentation. Giotto endowed his figures with body movements and facial expressions that suggested pain, joy, and suffering, and he modulated the use of these emotions to the particular circumstances narrated in the chapel's many individual scenes. Among the other achievements attributed to his hand are the famous frescoes in the Upper Church of St. Francis in Assisi as well as those completed in the 1320s

for the Bardi and Peruzzi chapels in the Church of Santa Croce in Florence. Giotto was also a master of panel painting, and a number of these works survive, either from his own hand or from that of his studio in the city of Florence. By 1334, Giotto's reputation as an artist of great individual expression had been established, and the city of Florence appointed the artist to oversee construction of the cathedral. Giotto died three years later and long before this monument was completed. A drawing for the cathedral's famous tower or *Campanile* survives from around 1334 at the time at which Giotto assumed administration of the building's construction. The work has long been attributed to Giotto, and if this attribution is correct the drawing shows that the artist was astute in his understanding of structural engineering.

IMPLICATIONS. Giotto helped to establish a tradition of greater naturalism in Italian painting that survived his death. His chief followers, Bernardo Daddi and Taddeo Gaddi, continued in the tradition of realistic painting introduced by the master, even if their art did not rise to the same high level. Giotto's innovations had admirers outside Italy, including Northern European masters. Elsewhere in Central Italy the traditions of Byzantine stylization persisted, and, following the Black Death, the tastes of Florence's patrons and artists turned to favor "International Gothic" art. In contrast to the more lifelike observations of Giotto, these artists relied on sinuous lines, intricate drapery folds, and a mysterious emotionalism that conveyed the intense religious fervor of the age. In the first quarter of the fifteenth century the short-lived genius Masaccio would return to the perfecting of naturalism and perspective in painting—two values that had been anticipated in the works of the fourteenth-century master Giotto.

SOURCES

F. Flores D'Arcais, *Giotto* (New York: Abbeville Press, 1995).

A. Ladis, *Giotto: Master Painter and Architect* (New York: Garland Publishing, 1998).

H. B. J. Maginnis, *Painting in the Age of Giotto: A Historical Reevaluation* (University Park, Pa.: Pennsylvania State University Press, 1997).

HANS HOLBEIN

1497–1543

Painter
Engraver

EARLY LIFE. The younger Hans Holbein was the son of a prominent Augsburg artist who was a contem-

porary of Albrecht Dürer. The son trained initially with his father, but left around 1515 to become an apprentice in the studio of Hans Herbster, a Basel artist. Here he developed his skills as a book illustrator and also became closely associated with the town's circle of humanists. One of the lifelong friends he made at Basel was Desiderius Erasmus, who charged Holbein with illustrating his famous satire *The Praise of Folly*. The accomplished illustrations that Holbein created for this best-selling intellectual farce brought the artist to the attention of Johannes Froben, a Basel printer and then one of the most important publishers of humanist texts in Europe. In 1516, Holbein became a designer in Froben's shop. During this period in Basel Holbein also painted panel paintings, which are evidence of his father's influence on his style. His manner was at the same time more monumental and balanced. In this early stage of his career Holbein also painted his *Dead Christ*, a work that displays the same sharp clarity and realism the artist developed later in his portraits.

REFORMATION. The Reformation gathered support in Basel during the early 1520s, and as in many other towns in Switzerland, supporters of the new movement aimed to curb the uses of religious art. Eventually, these new sensibilities resulted in violent attacks upon statues and altarpieces. During these early years of the Reformation the new movement caused a decline in many artists' fortunes. The Reformers found distasteful the elaborate altarpiece paintings that had been frequently commissioned in the fourteenth and fifteenth centuries, and a falloff in the production of new works of this kind soon became evident in the 1520s. This situation restricted the possibilities for a young artist like Hans Holbein, and while he remained in Basel he began to turn to portraiture to support himself. During 1523 and 1524 he painted several portraits of his friend Erasmus. The local market, however, failed to provide sufficient support, and so in 1524, he traveled to France, where he painted works for John, the Duke of Berry. A brief return to Basel in 1526 produced two works on mythological themes, but the climate in the city had now grown increasingly intolerant of painters. Again Holbein left Basel, this time for the Netherlands, and eventually England. On this journey he carried letters of introduction from Basel's prominent citizens, including one from his friend Erasmus. While he stopped in Antwerp for a time, he soon moved on to England, where he presented his letter from Erasmus to the English humanist Sir Thomas More, a close friend of Erasmus. More commissioned the artist to paint a portrait of his family, and from this panel Holbein also painted his famous portrait of More during 1527. Soon the artist was at work producing a

number of portraits of prominent English men and women, and he returned to Basel in 1529, enriched by his stay in England. At home he purchased two houses in the city, and set up his shop once again.

SECOND SOJOURN IN ENGLAND. Basel's artistic climate, though, had not improved in the intervening years, and so in 1532, Holbein returned to England for a second time. Basel's town council had attempted to keep Holbein in Switzerland by offering the artist a pension, but since there was little work in the city and the town's atmosphere was disturbed by Reformation controversy, he set off. He never returned, although his wife stayed behind, the beneficiary of a Basel municipal pension. In England, Holbein found a more congenial atmosphere, soon painting his famous portrait *The Ambassadors*, a painting of two French royal emissaries at work in London at the time. The work shows the ambassadors with all of the attributes of the humanistically trained intellectual. A lute, globe, and other items scattered on the table behind the men demonstrate their breadth of learning. One unusual feature of the painting is an elongated and distorted skull that appears in the foreground before the men, a manneristic detail in an otherwise extremely realistic work. This realism, which approached the level of Jan van Eyck and other Netherlandish painters of the fifteenth century, was consistent in the remaining ninety portraits that Holbein produced in England before his death from the plague in 1543. During these later years the artist rose to the position of court painter to Henry VIII. He was responsible for painting portraits of the royal family and other important members of the English court, but the king also kept him busy decorating the royal apartments with murals and in producing engravings and small miniatures. In a small and remote country like England, the job of the royal portrait painter was an important one, since in the sixteenth century royal ambassadors frequently arranged dynastic marriages. These officials took with them portraits of the royal and noble children for whom they arranged strategic marriage alliances. Accuracy and realism, two areas in which the artist excelled, were necessary in the genre. In addition, Holbein endowed those he painted, even the youngest royal children, with a sense of commanding majesty. His portraits set a standard that would influence later artists, as portraiture became an increasingly important art form in Northern Europe in the late sixteenth and seventeenth centuries. Portraiture, too, was at this time to become an increasingly vital source of support to artists, particularly those who worked in Protestant countries, as the demand for religious images shrank in the wake of the Reformation.

SOURCES

S. Buck, *Hans Holbein the Younger: Painter at the Court of Henry VIII* (London, England: Thames and Hudson, 2002).

J. North, *The Ambassadors' Secret: Hans Holbein and the World of the Renaissance* (London, England: Hambledon, 2002).

D. Wilson, *Hans Holbein* (London, England: Weidenfeld and Nicolson, 1996).

LEONARDO DA VINCI

1452–1519

Painter
Engineer

UNIVERSAL MAN. Although largely unschooled in an institutional sense, Leonardo da Vinci ranks as one of the most accomplished figures in European history. He practiced the arts of painting, sculpture, and drawing to a high level of perfection. At the same time he also found employment as an architect, a civil and military engineer, and even a theatrical designer. In his private *Notebooks* he kept a record of his many theoretical explorations of subjects in mechanics, physics, anatomy, geometry, and mathematics. While the artist's output of paintings was comparatively small, his emphasis on physical idealization, landscape painting, and proportion helped to establish the standards of High Renaissance style after 1500. Because of the range of his pursuits, Leonardo has long been accepted as one of the highest expressions of the Renaissance concept of the "universal man."

EARLY CAREER. Da Vinci was born at Anchiano, a small village near Vinci, the illegitimate son of the notary Piero da Vinci and a peasant girl. As a child he displayed precocious talent in drawing, and as he reached maturity he became an apprentice to the Florentine painter Andrea del Verrocchio, in whose studio he developed his skills as a painter and eventually became the artist's chief assistant. By 1472, Leonardo joined the painter's guild at Florence, although he seems to have remained an employee of Verrocchio until at least 1476. During this early period da Vinci painted his famous portrait of *Ginevra de' Benci* (now in the National Gallery in Washington, D.C.) and worked on his *Adoration of the Magi*, a painting he never finished. In 1483 the painter settled in Milan where he received several commissions and eventually worked for Ludovico Sforza, the city's ruling duke. The most important project that da Vinci undertook during his years in the city was his *Last Supper*, a mural painting for the refectory or dining room of the Monastery of Santa Maria delle Grazie. He painted this work—one of the most famous in the European tradition—with an experimental technique he developed, and unfortunately the work began to decay immediately. The *Last Supper* continued to be damaged by restoration projects conducted over the centuries, although a preservation campaign completed in 1999 did much to remove the tampering of later artists. In the work, da Vinci relied on a careful balancing of groups of disciples around Christ. In addition, his use of perspective seems to set the work off in a higher plane, as does the brilliant idealization of the artist's painting of the figures' faces and hands. In 1499, two years after completing the *Last Supper*, the artist returned to Florence following the seizure of Milan by French forces. He remained there for two years, and although he received several commissions for paintings, he seems to have completed little work during this time. In 1502, the artist accepted employment with Cesare Borgia, the son of the reigning pope, Alexander VI. At the time Borgia was conducting campaigns of conquest in Central and Northern Italy, and Leonardo became the despot's architect and military engineer. Leonardo soon returned to Florence, where he began a number of works. The most important project of this period in Florence, though, was the *Mona Lisa*, a portrait of the wife of a high-ranking Florentine government official. Most of the other works that da Vinci commenced during these years in Florence were left incomplete at his death or have since been lost.

LATER YEARS. The artist's later years were spent in Milan, Rome, and finally France. During this time Leonardo painted less, but devoted himself increasingly to his scientific studies. Mechanics and anatomy, which had been lifelong interests, now absorbed more of the artist's attentions. Leonardo had been called to Milan in 1508 to work for the French rulers who governed the city at the time. His inventions came to the notice of Pope Leo X, who called the artist to Rome. In 1516, though, King Francis I asked the artist to accept a pension and to settle in France. Francis gave da Vinci a manor house in Amboise and allowed him to continue his scientific studies. Shortly after his arrival in France, the artist suffered a stroke that damaged the right side of his body. He made only a partial recovery, but continued to work on his *Notebooks* and scientific experiments until his death in 1519.

SOURCES

D. A. Brown, *Leonardo da Vinci; Origins of a Genius* (New Haven, Conn.: Yale University Press, 1998).

K. Clark, *Leonardo da Vinci: An Account of His Development as an Artist* (Cambridge: Cambridge University Press, 1939).

M. Kemp, *Leonardo da Vinci* (New Haven, Conn.: Yale University Press, 1981).

P. C. Marani, *Leonardo* (Milan: Electa, 1994).

MICHELANGELO

1475–1564

Painter
Sculptor
Architect

EARLY LIFE. Michelangelo was born in the small town of Caprese in rural Tuscany, the son of a Florentine official then serving a short term of office in the countryside. Soon after the child's birth the family moved back to Florence, where Michelangelo attended Latin school until he was thirteen. Becoming an apprentice to the successful Florentine painter, Domenico Ghirlandaio, Michelangelo advanced far enough in his craft to join the large entourage of artists, poets, and scholars who surrounded Lorenzo de' Medici, who was the de facto ruler of Florence at the time. In the Medici household Michelangelo received a rudimentary exposure to humanism and Latin literature. Although he never became a scholar, he did spend two years within the Medici household (1490–1492), an experience that exposed him to the world of learning that flourished in Florence at the time.

FIRST WORKS. The death of Lorenzo de' Medici, Michelangelo's patron, left the artist without support, and in 1494 Florence expelled the Medici family altogether. Michelangelo followed the Medici faction to Bologna where he lived for a time with a wealthy family before returning to Florence. Still without a patron, Michelangelo traveled to Rome in 1496 with letters of recommendation from a member of the Medici family. Here the ancient monuments of the city seem to have inspired the sculptor, and he quickly carved his *Bacchus*, a work that imitated the style of Antiquity and which many contemporaries believed could not have been carved by a contemporary artist. Emboldened by his success, the artist carved his *Pietà*, a work commissioned by the French Cardinal Jean Villiers. The fame of that work securely established the artist's reputation, and he would never again want for commissions and wealthy patrons.

ASTONISHING PRODUCTIVITY. The early decades of the sixteenth century were a time of remarkable productivity for the artist. In 1501 Michelangelo returned to Florence where he carved the famous *David*, a work immediately revered as a masterpiece. To honor this achievement, the town gave the colossal nude a position of honor in front of the city's town hall. In 1505, Michelangelo returned to Rome, where he had been summoned by Pope Julius II to work on the pope's tomb. Difficulties and disagreements vexed this project, which took almost forty years to complete. Despite those hardships Michelangelo managed to complete the ceiling and sidewall frescoes of the Sistine Chapel between 1508 and 1512. These frescoes, recently cleaned and restored during the 1980s, allow us to trace Michelangelo's stylistic development in this crucial period of his life. In these years the artist left behind the painting style of the fifteenth-century Renaissance in which he had been trained in Ghirlandaio's studio. In the Sistine Chapel ceiling frescoes, for instance, he came over time to develop a new more dramatic and monumental style, characterized by tension and heavily muscled figures. Somewhat later, around 1520, the artist began to develop his skills as an architect. The Medici family commissioned Michelangelo to design a set of tombs in the New Sacristy of the Church of San Lorenzo in Florence. Michelangelo now brought to his sculpture the same heavily muscled and tense style he had used in the later panels of the Sistine Chapel ceiling. During the 1520s, the artist developed his aesthetic ideas even further, displaying a highly individualistic, even willful side in his designs for the Laurentian Library he designed at Florence. This work, notable for its violations of the acceptable classical canons of design popular at the time, formed one of the foundations for the development of mannerist architecture.

LATER WORKS. As Michelangelo matured, his work continued to evolve. This evolution can be seen in his *Last Judgment* frescoes in the Sistine Chapel. That work, a great swirling mass of figures located behind the high altar of the chapel, was finished in 1541. The *Last Judgment* carried Michelangelo's search for a dramatic and highly personal style to its logical conclusion, although the artist continued to rely on this idiom in two frescoes he painted soon afterward in the Pauline Chapel in the Vatican. By 1546 Michelangelo had been appointed chief architect for the rebuilding of St. Peter's Basilica. Over the years the skills that Michelangelo had acquired in his many sculptural and architectural projects meant that he was an efficient manager, both of teams of workmen and of finances. His astute management of the Vatican project corrected errors in the work's construction up to this point and firmly placed the artist's stamp upon the building's future. Although St. Peter's would not be completed for another hundred years, it remains one of the artist's finest creations. Michelangelo combined his

attention to projects at the Vatican with other commissions completed in the city of Rome. These included his design for the Capitoline Hill (the Campidoglio) and his transformation of the ancient Baths of Diocletian into the Church of Santa Maria degli Angeli. At the same time as Michelangelo involved himself in these projects, he also underwent a deepening of his own religious life. Affected by the religious movements of the age, he expressed the depths of his religious faith in his later years through poetry and sculpture. His friendship with Vittoria Colonna, a pious and admirable Roman noblewoman, kept him abreast of the great religious and spiritual debates that were occurring at the time. With his death in 1564 at the age of 89, Michelangelo had lived almost twice as long as the average sixteenth-century man. The styles that he had developed during his life continued to affect artists in the following generations.

SOURCES

H. von Einem, *Michelangelo*. Trans. R. Taylor (London, England: Methuen, 1973).

N. Harris, *The Art of Michelangelo* (New York: Excalibur Books, 1981).

H. Hibbard, *Michelangelo* (Boulder, Colo.: Westview Press, 1998).

L. Murray, *Michelangelo* (Oxford: Oxford University Press, 1980).

DOCUMENTARY SOURCES
in Visual Arts

Leon Battista Alberti, *De Pictura* (On Painting, 1435)—This treatise on the art of painting was written by one of Florence's most distinguished fifteenth-century humanists. Alberti revives classical ideas about proportion and beauty and he outlines a method by which painters can make their pictures appear to have depth.

Benvenuto Cellini, *Autobiography* (1562)—This swashbuckling and adventurous memoir was not published until 1728. The author was an accomplished, but admittedly second-rank sculptor and painter (that is, when compared to the great figures of the sixteenth century). Sometimes he indulges in a taste for braggadocio. At other points, though, he is remarkably humble. Like Leonardo da Vinci, he continually denies that he is a

learned man, but his use of motifs and episodes drawn from earlier literary traditions show that he had at least received a passably good education. Cellini, moreover, winds a good yarn of a story.

Albrecht Dürer, *Writings* (1528)—Like Leonardo da Vinci's *Notebooks*, this collection of the works of the great German artist are filled with intellectual and philosophical insights. While he was more able to complete his projects than Leonardo da Vinci, Dürer's writings reveal a similar psyche, one troubled by perfectionism and anxiety.

Leonardo da Vinci, *The Notebooks* (1519)—This collection of Leonardo's studies and thoughts on various matters makes for fascinating reading. The works were first collected during the sixteenth century, and most found their way into the Ambrosian Library in Milan. Other works from da Vinci's hand, though, have continued to come to light and to confound our notions about this complex genius.

Carel van Mander, *Lives of the Dutch and Flemish Painters* (1604)—This collection of lives written by a seventeenth-century art theorist provides us with some of the richest evidence concerning the social world in which the Netherlandish artists flourished. Van Mander has long been known as the "Dutch Vasari," in comparison to his more famous Italian counterpart. Like Vasari, his accounts must sometimes be read cautiously because they are filled with rumors and legends.

Michelangelo Buonarroti, *Letters* (1490–1564)—The critical edition of all letters by and to the famous artist fills six volumes. Michelangelo's own letters have been translated into English, and they record the joys, agonies, and tedium of a life spent in artistic pursuits during the High and Later Renaissance.

Giorgio Vasari, *Lives of the Most Eminent Painters, Sculptors, and Artists* (1550)—This is one of the first attempts to write a history of art from a biographical perspective. Vasari was himself a painter and he treats Italian artists from the time of Giotto until Michelangelo. He is frequently opinionated and his work gave rise to a number of legends about various artists. He stresses that the development of Italian art occurred as an organic process. According to Vasari, the visual arts first began to bud in Italy in the time of Giotto. Later, the bud turned to a bloom in the years after Masaccio, before coming to full flower in the time of Leonardo and Michelangelo. This seductive notion cast a long influence over later art histories. At the same time the work is indispensable because of the many interesting episodes it recounts from the lives of artists.

GLOSSARY

Academy of Poetry and Music: An institution founded in 1570 by the poet Jean de Baïf that established classical literary and aesthetic forms in French literature and music. The Academy was especially influential in the development of early *ballets de cour*.

Act of Supremacy: The act of Parliament that established King Henry VIII as the head of the Church in England in 1534, permitting his divorce from Catherine of Aragon.

Allemande: Popular sixteenth-century dance step, derived from the fifteenth-century *bassedance*. The word *allemande* is French for "German" and may indicate the dance's origins.

Alumbrado: Term for sixteenth-century Spanish mystics suspected of harboring heretical views.

Anabaptist Movement: A religious movement that practiced a "second baptism" for adult members, and believed in establishing a Christian community separate from the world. Their participation in the Revolution of the Münster Prophets in 1533 and 1534 resulted in widespread persecution.

Ancient Theology: Philosophy that argued that a pre-Christian but divine wisdom was to be found in all the world's religions. Developed by Renaissance Platonists, it had its origins in the Latin *prisca theologica*.

Anglicanism: The English form of Protestantism.

Anthem: A native musical composition that flourished in late-Renaissance England; anthems relied on mostly-English lyrics and were generally written without elaborate harmonies in order to heighten the audience's understanding of the texts.

Anticlericalism: Sentiment that is critical of the special rights and privileges of the clergy.

Aristotelianism: A philosophy that has its inspiration in the ancient Greek thinker Aristotle. Aristotelians typically placed a high emphasis on the importance of matter and thus are often called materialists. Aristotelian elements were to be found in medieval scholasticism, but during the Renaissance a revival of Aristotle's works also led some thinkers, most notably Pomponazzi, to deny the immortality of the soul.

Ars nova: Literally, the "new art," a style in early fourteenth-century French music that emphasized greater freedom of rhythm and harmony and that eventually came to be adapted elsewhere in fourteenth-century Europe. It led eventually to the development of a new "international style" of musical composition.

Art of Dying: Popular theme in Renaissance literature, which outlined how to prepare oneself for a good death.

Autos sacramentales: Religious plays popular in early sixteenth-century Spain; literally "sacramental acts."

Avignon Papacy: The period between 1309–1378 when the Roman pope ruled from the French-speaking city of Avignon. The Avignon Papacy became synonymous with luxury and corruption, and this period was sometimes referred to as the "Babylonian Captivity," a phrase that likened the Israelites' imprisonment in ancient

Babylon to the church's at the hand of the French king. In truth, the French king did not control the popes at Avignon as thoroughly as once thought, and the period gave rise to many innovations in papal government that strengthened the church's financial position. The Avignon Papacy was to have ended with the return to Rome in 1378, but a splinter of cardinals in the French city elected their own rival pope, thus giving rise to the Great Schism (1378–1415).

Ballade: A lively medieval French song frequently used to accompany dancing. The form spread throughout Europe as a result of the internationalization of musical styles that occurred during the Renaissance.

Ballet de Cour: French court entertainment combining a story line with poetry, dancing, music, and other theatrical elements. Ballets de cour were first performed in the late sixteenth century, and survived into the Baroque period, at which time they inspired innovations in French opera and the ballet.

Baptism: One of the seven sacraments of the medieval church, baptism was performed on infant children to wash away the stain of original sin. In the Reformation, infant baptism was one of two sacraments retained by most Protestants. The Anabaptists, however, replaced the practice with a rite performed on adults.

Barrel vault: A rounded vault used in Renaissance churches that had its origins in the ancient Roman arch. It became popular through the architectural theory of Leon Battista Alberti and was used in Renaissance churches of the later fifteenth and sixteenth centuries, including the famous Il Gesú at Rome.

Bassedance: A processional dance popular in fourteenth- and fifteenth-century Burgundy.

Bembismo: A literary movement popular in early sixteenth-century Italy that imitated the difficult and artful syntax and stylistic elements of the works of Pietro Bembo.

Black Death: A massive epidemic of bubonic plague that began to spread throughout Europe late in 1347 and did not recede completely until 1351. During these years the plague reduced the continent's population by as much as a third. This sudden decline in population had massive effects on the economy of Renaissance Europe, sponsoring a rise in wages and inflation as two of its more prominent effects in the fifteenth century. After the first outbreak of the disease, the bubonic plague continued to recur in Europe until the late seventeenth century.

Boethius: An early-medieval philosopher who was active in Visigothic Spain. Boethius communicated much ancient knowledge to the Middle Ages, and his philosophical classic, *The Consolation of Philosophy*, continued to be read throughout the Middle Ages and the Renaissance.

Bonfire of the Vanities: The custom of throwing cards, dice, and frivolous clothing into huge public bonfires to demonstrate a commitment to lead a more serious and moral life; generally followed the preaching missions of fifteenth-century religious figures like St. Bernard of Siena or St. John of Capistrano.

Book of Common Prayer: The book of English services first sanctioned for use in the Church of England by Edward VI (r. 1547–1553). Later done away with under the rule of Edward's half-sister Mary I, the Book of Common Prayer re-surfaced during the reign of Elizabeth I (r. 1558–1603). The work had a massive impact on the development of English literary style in the late sixteenth and seventeenth centuries.

Book of Hours: A collection of prayers used in late-medieval and Renaissance private devotion, often elaborately decorated and commissioned by the wealthiest aristocrats of the time. The greatest of these works, like the *Very Rich Hours* of the duke of Berry, are masterpieces of Northern Renaissance art.

Braccio: An Italian unit of measurement for cloth, roughly about 20 inches long.

Branle: A lively dance popular in France in the early sixteenth century. In England, the form was often known as the "brawl." Many variations on the dance flourished in the 1500s, and some often contained elaborate "pantomimes" that imitated folk customs.

Brethren and Sisters of the Common Life: A lay religious movement popular in the Netherlands and the Rhineland in the fifteenth century. The Brethren of the Common Life valued education in the Christian classics, and affected the growth of Christian humanism in Northern Europe through their network of secondary schools. The Sisters of the Common Life's foundation actually preceded that of the Brethren.

Bubonic Plague: *See* Black Death.

Bull: A papal letter that defined issues of church doctrine and practice. The term comes from *bulla*, meaning "stamp" or "seal," and had its origins in the practice of sealing these letters with a round lead seal.

Burgundy: One of the most powerful states of fifteenth-century Europe, located north and east of the kingdom of France. Burgundy's rise to prominence began as France struggled in the Hundred Years' War. Eventually, the dukes of Burgundy controlled large areas of eastern France as well as the rich cities of the Netherlands and Flanders. The elaborate court life of the

duchy affected styles in dance, music, and art in much of northern Europe, even after control of the vast Burgundian lands was divided between the Habsburgs and the Valois dynasty of France following Charles the Bold's death in 1477.

Byzantium: The Eastern Mediterranean descendant of the ancient Roman Empire. Byzantium's capital and last remaining territories fell to Turkish control in 1453. The crisis that preceded Byzantium's collapse led to the importation of many priceless ancient texts into fifteenth-century Italy.

Cabalism: An occult or magical philosophy practiced in medieval Judaism that was embraced by Renaissance intellectuals, particularly by Platonists in the late fifteenth and sixteenth centuries.

Calvinism: The form of Reformed Christianity that traces its origins to John Calvin (1509–1564) and the city of Geneva where he worked. Calvinism became a vast international movement in the late sixteenth century, and was a popular religious ideology among the Puritans, English Protestants who eventually founded New World settlements in the Massachusetts Bay Colony.

Cambridge Wits: A group of late sixteenth-century London playwrights that had received their university education at the University of Cambridge. The most famous of the wits was Christopher Marlowe (1564–1593).

Camerata: A loose organization of Florentine intellectuals in the late sixteenth century who studied ancient music and poetry. It was influential in the development of early opera.

Campanile: The Italian word for "bell tower." Campaniles were popular additions that accompanied late-medieval and Renaissance building projects, the most famous being that at Florence as well as the Leaning Tower of Pisa.

Canon: Meaning "law" or "rule." A late-medieval and Renaissance form of musical counterpoint in which the first singer sets out the theme that is to be imitated by other voices, who are expected to follow according to the laws set down by the composer.

Canon law: The body of law used in the medieval and Renaissance church.

Cantus firmus: A plainsong melody originally sung in unison. With the rise of polyphonic musical composition in the Renaissance, cantus firmus melodies gave structure and unity to settings of the Mass.

Capuchins: A reformed order of Franciscans founded in 1529 that became a force for Catholic reform in the later sixteenth century.

Carols: Songs originally used in the Middle Ages to accompany dances. During the Renaissance, English composers embraced innovations in the writing of carols that made the genre a distinctly national kind of musical form.

Cassoni: Meaning "casket." Richly, decorated *cassoni* carried the dowry payments of wealthy women through the streets of Italian Renaissance cities in the days before the celebration of a wedding.

Catholic Reformation: A broad movement within the Roman Catholic Church of the sixteenth and seventeenth centuries that gave rise to many efforts to deepen piety.

Chaconne: A sixteenth-century dance of Spanish origin that may have its roots in New World dances. The chaconne was notable for its sexual overtones.

Chanson: French for "song." Between the fourteenth and early sixteenth centuries French styles of song composition were adopted in many places throughout Europe. In the mid-sixteenth century the rise of the genre of Parisian chansons attempted to revive a native French style in a genre that had by that time become international in nature.

Chantrist: A priest charged with repeating the Mass for the benefit of the souls of the dead.

Château: French for "castle." In the sixteenth century châteaux acquired a more domestic and less fortified appearance.

Chiarentina: A lively Italian dance of the fifteenth and sixteenth centuries, consisting of an elaborate choreography of hops, skips, and jumps.

Chiaroscuro: An Italian painting term used to describe the rendering of light and dark shading on a panel or canvas so the composition takes on an appearance of volume.

Chivalry: A medieval code of conduct that stressed military valor, honor, and personal loyalty as signs of distinction for knights and nobles.

Choir: The part of a church behind or surrounding the High Altar.

Chopines: A Renaissance form of woman's shoe constructed with high platform soles made out of wood or cork.

Chorale: A German hymn popular in Lutheran churches that made use of pre-existing or newly composed melodies.

Choreography: The compositional arrangement and flow of steps in a dance.

Chorography: A discipline that mixed geography, history, and descriptions of customs and which was popular especially among the humanists of sixteenth-century Germany.

Chromaticism: Music that makes use of close and dissonant harmonies. In the sixteenth century chromaticism's rise was associated with the revival of classical Greek forms of musical composition.

Church of St. John Lateran: The pope's church within the city of Rome, at which he presides as bishop of that city. Several important church councils were held during the Middle Ages and Renaissance in this church.

Ciceronianism: A sixteenth-century literary movement, popular especially in Italy, that tried to revive the elegant Latin style of rhetoric associated with the ancient Roman orator Cicero (d. 43 B.C.E.).

Civic humanism: A form of humanism particularly widespread in Florence and other Italian cities that discussed the arts of good government and the ethical qualifications necessary to participate in public life.

Codicology: The study of variant forms of a literary text in order to establish the original and authoritative version.

Codpiece: A pouch, flap, or bag that concealed the opening between the legs of men's britches in the fifteenth and sixteenth centuries.

College of Cardinals: The body of high officials in the Roman Church charged with the election of new popes.

Commedia dell'Arte: An improvised form of comedy originally performed as street theater in sixteenth-century Italy that mixed short sketches, pantomimes, dances, and music.

Conciliarism: A political philosophy that emerged in the late fourteenth and early fifteenth centuries as a result of the crisis of the Great Schism in which rival popes ruled the church from Rome and Avignon. The conciliarists advocated a church council to resolve the crisis, something realized finally at the Council of Constance (1413–1417). In the aftermath of that meeting, many conciliarists continued to argue that the church needed a permanent assembly to approve or disapprove of the actions of the pope. By the end of the fifteenth century conciliar opposition to papal power, though, had grown increasingly weak.

Confession: A written statement of faith that played an important role in defining religious positions during the Protestant and Catholic Reformations.

Confirmation: One of the seven sacraments of the medieval church, which marked official entrance into the life of the church. Confirmation was typically received as a child stood on the verge of adulthood at twelve or thirteen. Although Protestants denied the sacramental nature of confirmation, most retained some version of the ritual in their church reforms.

Confraternities: Brotherhoods and sisterhoods of lay people and clergy that met for prayers and to perform pious good works. Some confraternities adopted penitential rituals like flagellation (self-whipping) and the wearing of hair shirts to deepen their piety. The pious ideals of most of these organizations were closely modeled on the disciplines of monastic life.

Converso: A Christian convert from Judaism in fifteenth- and sixteenth-century Spain.

Corinthian Order: The most elegant and decorative of the architectural orders of antiquity. The capitals or peaks of Corinthian columns are decorated with acanthus leaves.

Council of Constance: The church council that met in the southern German city of Constance between 1413–1417 and resolved the crisis of authority in the church known as the Great Schism. The council also condemned the heresy of the Bohemian heretic John Huss.

Council of Trent: A council of the Roman Catholic Church that convened in the northern Italian city of Trent during three sessions in the years between 1545–1563. The council defined Catholic teaching and religious practices as well as answered Protestant criticisms of the church. Its definitions of Catholic doctrine largely stood until the Second Vatican Council of the 1960s.

Counter Reformation: A phrase originally used to describe the attempts of Catholic reformers to negate and condemn the criticisms of Protestantism. It has increasingly been replaced with Catholic Reformation, a phrase that highlights the many positive as well as negative dimensions of renewal in the church between the sixteenth and eighteenth centuries.

Counterpoint: The construction of two or more melodic lines in a musical composition to create an overall harmonic structure.

Depravity: A teaching concerning sin that was enthusiastically embraced by sixteenth-century Protestant reformers. Their emphasis on human depravity stressed that human beings were utterly controlled by their desire to sin, and thus had no free will to act or participate in their salvation.

Dialogue: A popular humanist literary form that records the discussion of religious or philosophical issues among two or more people in a lively conversational format.

Diet of Worms: The meeting of the German parliament in 1521 in the city of Worms at which Martin Luther was called to answer charges of heresy. Luther was condemned to death as a result of the questioning he underwent, but was subsequently spirited away and protected by the elector Frederick the Wise.

Diptych: A work of religious art painted on two hinged panels and usually intended to serve as an altarpiece.

Dominicans: An order of friars or itinerant preachers founded in 1215 by St. Dominic (1170–1221). The Dominicans became vital on the education scene of later medieval and Renaissance Europe and were often charged with inspecting regions for heresy. In the sixteenth century many members of the order were powerful opponents of the teaching of Martin Luther.

Donation of Constantine: A document allegedly written by the ancient Roman emperor Constantine I that ceded control over western Europe to the pope. In the Middle Ages the Donation of Constantine was one of the foundations for the growth of papal power. In 1440, Lorenzo Valla revealed the document as an eighth-century forgery.

Doric Order: The simplest of the architectural orders derived from the buildings of antiquity in which the capitals are squared.

Doublet: A close-fitting jacket usually worn under a robe by men during the Renaissance.

Dowry: A woman's share of her father's inheritance that is conferred to her husband's control at the time of her marriage.

Dualism: Any philosophical teaching that includes a strong contrast between the realms of the spirit or soul and that of the physical universe or body.

Eclogue: A rustic form of verse that evoked country themes and was popular among Renaissance poets. The form has its origins in the works of the ancient Latin poet Vergil.

Edict of Nantes: A proclamation of King Henri IV of France in 1598 that granted a limited degree of toleration to French Protestants.

English Peasants' War: A rebellion staged in 1381 in protest of the archbishop of Canterbury's plans to introduce a new universal poll tax in England. An angry mob killed the archbishop, who was serving at the time as a royal minister.

Engraving: The cutting of designs and pictures in a wood or copper plate. German Renaissance masters at the end of the fifteenth and beginning of the sixteenth centuries brought a high level of technical skill to the art form.

Entablature: An upper section of a wall that is usually decorated and supported by a row of columns.

Epic: A long narrative poem that retells the exploits of a hero or group of heroes.

Epicureanism: An ancient philosophy promoted by Epicurus that embraced intellectual pleasure as the highest principle of life. In the mid-fifteenth century the Italian philosopher Lorenzo Valla developed a Christian form of Epicureanism by insisting that the religion's answers to the intellectual problems of existence were the most profound and capable of creating the greatest peace of mind.

Erudite Comedy: A form of learned comedy inspired by the ancient works of the Latin playwrights Terence and Plautus. Erudite comedies were particularly popular in Italy, from where their five-act structure spread throughout Europe in the later sixteenth century to affect the works of figures as diverse as William Shakespeare in England and Lope de Vega in Spain.

Eucharist: One of the seven sacraments of the medieval church, also known as Holy Communion. According to medieval theology, the body and blood of Christ were made physically present in the rite through priestly ministration. This doctrine, known as transubstantiation, was rejected by all Protestants, who nevertheless retained the Eucharist as one of the central rituals of their churches.

Evangelical: Any religious position that places a strong emphasis on the Christian gospels, usually associated with the followers of Martin Luther, who emphasized the doctrine of justification by faith. Also used in Italy to refer to followers of groups like the Oratory of Divine Love, that emphasized the role of divine grace and human unworthiness in their teachings about salvation.

Extreme Unction: One of the seven sacraments of the medieval church that involved the anointing of the sick and dying in preparation for death. Also known as Last Rites, Extreme Unction was rejected as a sacrament by sixteenth-century Protestants.

Farce: A short and light comedy popular in sixteenth-century France.

Farthingale: A wide support of hoops that swelled out the hips of skirts worn by wealthy and aristocratic women in the sixteenth century. In Spain, where these hoop-skirt contraptions originated in the fifteenth century, farthingales were known as *verdugado*.

Feast of Corpus Christi: A religious celebration held to commemorate the Eucharist and the Christian community as the Body of Christ. Corpus Christi was usually observed in June, and its celebration often included mystery play cycles in the fifteenth and early sixteenth centuries. Protestants, especially Calvinists, eliminated the Feast from their religious life, and in France, the annual celebrations of the event often erupted into riots and precipitated religious murders.

Franciscans: An order of friars or preachers who followed the teachings of St. Francis of Assisi (1182–1226). The Franciscans were particularly important on the urban scene, and in the fifteenth century members of the order like St. Bernard of Siena promoted an uncompromising morality that aimed to reduce splendor in dress and consumption.

Fresco: A medium of painting images on walls while the plaster was still wet, so that the pigments became fused with the wall surface itself. From the Italian word for "fresh."

Galliard: A lively dance usually consisting of five steps that were combined in many different patterns. The galliard was particularly popular in sixteenth-century court societies.

Gesso: A thin coat of whitewash or plaster applied to a panel or canvas to prepare it for painting.

Golden Mean: A teaching of the ancient Greek philosopher Aristotle from his *Nichomachean Ethics* that argued that human beings should avoid extremes in thoughts and physical actions.

Great Schism: The split in the Western church occasioned by the return of the papacy to its ancient capital in Rome in 1378. At Avignon, where the papacy had resided between 1309–1378, a rival remnant of cardinals elected their own pope, whose successors continued to compete for allegiance with Rome until 1415. The Council of Constance relied on conciliar teachings to heal the schism by deposing both popes and appointing a new head of the church.

Greek Cross: A style of church construction in which all four radiating wings of a building are of equal length.

Heresy: An opinion or teaching that is contrary to the official or "orthodox" views of the church.

Hermeticism: A body of medieval and Renaissance philosophy texts that traced its origins to the legendary ancient Egyptian author Hermes Trismegisthus (meaning literally, "Thrice Great Hermes"). Hermeticism embraced occult practices like astrology and alchemy (the art of transforming matter), and was popularized in particular through the work of Renaissance Platonists.

Holy Orders: One of the seven sacraments of the medieval church that involved the taking of priestly or monastic vows. These vows set off the clergy as a separate caste in society and granted them certain rights and privileges, while at the same time requiring that priests, monks, and nuns observe celibacy and other restrictions. Protestants rejected the sacramental nature of Holy Orders.

Holy Roman Empire: The vast confederated set of states in central Europe that traced its origins to the early medieval empire of Charlemagne. At the beginning of the Renaissance the Holy Roman Empire consisted of some 300 individual states, city-states, and territories. Although it still claimed control over portions of northern Italy at this time, its effective power there was, by the time of the Renaissance, largely a fiction. The government structure of the Holy Roman Empire consisted of an emperor who was chosen by seven electors and a diet or parliament to which the various states sent delegates. By the sixteenth century long-standing traditions of local control had made the empire relatively weak as an international force in Europe, especially when compared to the great centralized monarchies that lay farther west in France, Iberia, and England.

Homophonic: An adjective used to describe any musical form that makes use of a single melodic line.

Huguenots: Sixteenth-century French Protestants who were persecuted for their faith. The term may have its origins in the followers of Besançon Hugues, who led a revolt of French-speaking Swiss in 1532. Members of this movement swore an oath (*aignos*), possibly giving birth to the word "Huguenot."

Humanism: A nineteenth-century word coined to describe those who practiced the *studia humanitatis* or "humane studies" in the Renaissance. The disciplines recommended by humanists differed from place to place and over time, but usually included a strong emphasis on rhetoric, grammar, moral philosophy, history, and literature.

Hussitism: Followers of the teachings of John Huss in Bohemia. The Hussites rejected many key orthodox teachings of the medieval church and more importantly celebrated the Eucharist by allowing the laity to receive wine and bread, a departure from medieval practice. Although several crusades were mounted to try to suppress the movement, Rome granted concessions to some of its more moderate followers, thus giving rise to a national church in parts of Bohemia (the modern Czech Republic) with religious practices different from Rome.

Icon: A religious image constructed according to styles that flourished in the Eastern or Byzantine Empire, and popularly used for private devotions in Western Europe.

Iconoclasm: The destruction of religious images and statues. Some radical forms of Protestantism sponsored iconoclastic outbreaks from time to time in sixteenth-century Europe, perceiving the use of religious images as a form of idolatry.

Iconography: The use of symbols and images in art to convey philosophical and religious truths.

Il Gesù: The home church of the Jesuit Order in Rome. The Gesù was constructed in the second half of the sixteenth century, and its style, which included an impressive barrel vault, was used in many famous churches of the Jesuit Order throughout Europe.

Index of Prohibited Books: A list of books forbidden to Catholics as dangerous to church truth. While there were numerous such indexes that circulated throughout Europe during the sixteenth century, the Index eventually became a defined office in the church, charged with inspecting the contents of books at Rome.

Indulgences: A remission of the punishments or penances that were imposed by a priest in the sacrament of confession. Indulgences were awarded for many pious activities in the Middle Ages and Renaissance and usually stipulated that those who received them were to receive so many days off their time in purgatory following their deaths. The belief in indulgences prompted Luther to write his *Ninety-Five Theses* in 1517.

Intermedi: Interludes that consisted of music, dancing, or short dramas that were mounted in the theatrical productions of sixteenth-century Italy.

International Gothic: A style in sculpture and painting that was particularly popular throughout Europe around 1400. Some of its features included elegant drapery, gold-leafed backgrounds, and an exaggerated sway in the depiction of the human form.

Intonaco: In Italy, a rough plaster sometimes used to finish the façades of palazzi and churches.

Intronati: A group of university-educated comics that flourished in the sixteenth-century city of Siena, and that influenced styles of theatricals elsewhere in Italy.

Ionic Order: One of the architectural orders of antiquity widely used by Renaissance designers. Ionic columns are especially notable for the spiral volutes that adorn their capitals.

Italian Wars: A series of wars waged in Italy by France, Spain, and the Holy Roman Empire between 1494 and 1559.

Jacquerie: A French peasant revolt that occurred in 1358 and whose cause lay in part in the economic dislocations the Black Death (1347–1351) produced in Europe at the time.

Jesuit Drama: Latin school plays embraced by the Jesuit Order as a way of teaching proper language usage to the students in their secondary schools. By the end of the Renaissance these Jesuit dramas had grown increasingly more complex, and had come to rely on many art forms simultaneously, including rich music, stage design, and dance.

Jesuits: An order of priests founded by St. Ignatius of Loyola in 1534 that became a major force in Catholic renewal in the sixteenth and seventeenth centuries. The Jesuits were also notable for their educational and missionary efforts. By the later sixteenth century Jesuit missionaries were active in the Far East and in the New World.

Justification by Faith: The doctrine first formulated by Martin Luther and adopted by most Protestants that taught that human beings could not aid in or earn their salvation through works. Salvation was instead a free gift of grace that made the sinner appear "just" in God's eyes.

Keep: The most heavily defended part of a medieval or Renaissance castle.

Latin Cross: In church architecture, the term "Latin Cross" is used to describe a church in which one of the arms, the nave, is longer than the other three.

Lieder: Native German songs that began to be written down at the end of the fifteenth century and circulated in the sixteenth through printed music. The popularity of Lieder gradually gave way to madrigals in German-speaking Europe in the second half of the sixteenth century.

Limewood Sculptors: An accomplished group of wood sculptors that were active in southern Germany in the late fifteenth and sixteenth centuries. Most prominent among these figures were Tilman Riemenschneider and Veit Stoss.

Linear Perspective: A system for rendering three-dimensional space and volume on a two-dimensional picture plane. This system was perfected in the early fifteenth century in Florence through the efforts of the painter Masaccio and the architect Brunelleschi. Slightly later the humanist and artist Leon Battista Alberti publicized these techniques in a treatise on painting, spreading their knowledge quickly among fifteenth-century artists.

Lollards: Followers of John Wycliffe in fifteenth- and sixteenth-century England, who advocated a simplified piety based in biblical teachings.

Lute song: A genre of musical compositions popular in late sixteenth-century England that set fine poetic lyrics to music with lute accompaniments.

Lutheranism: The religious system that developed out of the teachings of Martin Luther (1483–1546).

Machiavellianism: The view that politics functions in a realm in which normal moral considerations play no role. Machiavellianism was traced to Niccolò Machiavelli's *The Prince* and almost always criticized for its amorality in the later Renaissance.

Madrigal: Medieval form of Italian song, transformed in the High and Late Renaissance into a complex polyphonic creation. In these works composers set to music some of the best verse of the Italian Renaissance. Published and circulated in printed editions, Italian madrigals also inspired national fashions for the form in England, France, Germany, and Spain in the late sixteenth and seventeenth centuries.

Mannerism: An artistic style that flourished in Florence, Rome, and central Italy in the mid- to late sixteenth century. It found its inspiration in the works of the mature and late Michelangelo, and was characterized by artful elongation and distortion as well as a penchant for difficult themes.

Martyrology: Literary work that commemorates the ultimate sacrifices of Christians. In the overheated confessional disputes of the late sixteenth century, both Protestant and Catholics produced many martyrologies in an attempt to demonstrate the potency of their religious truths.

Masque: A form of courtly entertainment first imported into England in 1512 by King Henry VIII. Throughout the sixteenth century court masques grew increasingly more complex and costly, culminating in the great productions of Ben Jonson and Inigo Jones in the first decades of the seventeenth century.

Mass: The central religious rite of the medieval church, believed to be a sacrifice beneficial to the living and the dead. The latter part of the Mass consists of the Eucharist or Holy Communion.

Mennonites: Followers of the religious reformer Menno Simons (d. 1559) from Frisia in Holland. The Mennonite Church derived from Anabaptist teachings, including simplicity of life and worship and the rejection of the custom of taking oaths and bearing arms.

Metaphysics: Literally, those subjects that go "beyond physics." In philosophy, the branch of metaphysics was concerned with all those things that could not be seen or perceived with the senses, and Renaissance metaphysicians were often fascinated by the occult.

Modern Devotion: The pattern of religious and devotional life popularized by the Brethren and Sisters of the Common Life in the fifteenth-century Netherlands and Rhineland. In particular, the modern devotion promoted prayer, biblical study, an inward contrite heart, and the concept of the "imitation of Christ."

Modes: The scale system of medieval and Renaissance music, of which there were eight. Some of these resembled the keys used in music after the seventeenth century. Other modes had a very different sound quality than in the modern system of tonality.

Monody: Music in which a single sound produced either by an instrument or the human voice was intended to imitate the simplicity of ancient Greek music.

Monstrance: A vessel used for displaying a consecrated wafer used in the sacrament of the Eucharist.

Morality Play: An allegorical theatrical production popular particularly in the late fifteenth and early sixteenth centuries.

Moresco: A whirling dance performed in Italy, Spain, and elsewhere in Renaissance Europe, thought to imitate the dances of the Islamic Moors.

Motet: A polyphonic musical composition in which the various vocal parts originally sang contrasting texts. Motets were some of the most widely performed sacred music of the Renaissance, and the form witnessed rich elaboration over the course of the fifteenth and sixteenth centuries. In the Roman Catholic Church motet writing survived into modern times.

Mystery Play: A medieval religious drama often staged by guilds or confraternities whose themes treated the life, death, and sacrifice of Christ. In particular, the Feast of Corpus Christi was one important occasion in the fifteenth century usually commemorated by the performance of one of these plays.

Mysticism: A term that refers to any set of religious teachings that tried to foster a direct, unmediated communion between God and the sinner in the medieval and Renaissance world. Mysticism was enormously varied and included affective, speculative, and Platonic forms.

Natural Philosophy: The branch of matter in the philosophical curriculum of the Middle Ages and the Renaissance that was concerned with nature and matter.

Naturalism: The term used to describe the attempt to relate the natural world faithfully in art, using the testimony of the eyes as one's guide.

Nave: The main or longer wing of a church built in the Latin Cross-style of construction.

Nominalism: A theory propounded by the fourteenth-century philosopher William of Ockham that denied that there were universal essences or realities. Instead Ockham taught that concepts were the result of the consequences of human speech, as people created nouns or names to describe those things they commonly observed in the world.

Novella: Any of a genre of short tales or fables that was popular in Renaissance Italy in the fourteenth and fifteenth centuries. Among the most famous collections of *novella* was Giovanni Boccaccio's masterpiece, *The Decameron.*

Octave: A musical interval or harmony in which the upper or lower tones are separated by eight tones.

Oculus: A circular window often built into domes to admit light into a structure.

Orthodoxy: The established or conventional teachings of the church.

Palazzo: The Italian word for "palace," used to refer to any kind of substantial urban building. During the Renaissance the construction of domestic palaces expanded enormously in towns like Florence and Venice.

Palladianism: An architectural style that imitates the works of Andrea Palladio, the sixteenth-century northern Italian architect who developed a classical language notable for its great elegance, light, and delicacy.

Pastoral: Literary work set in the countryside and frequently involving conversations between shepherds, nymphs, and satyrs. Pastorals were particularly popular throughout Europe at the end of the Renaissance.

Patrilineal Inheritance: The legal custom of passing the bulk of a father's estate to male heirs.

Pavan: A stately court dance that flourished in sixteenth-century Europe. Of Italian origin, the dance consisted of only two small steps, followed by a double step. The name "Pavan" may derive from the Spanish word for a peacock's tail, or from the dance's origins in the city of Padua.

Peace of Augsburg: The treaty that ended religious hostilities between Protestant and Catholic rulers in 1555. Its provisions allowed princes to choose the religion their subjects were to follow.

Peasants' War: A rebellion of peasants that began in the German provinces of Swabia and Franconia and came to encompass many areas of the Holy Roman Empire during 1524–1525. Its manifesto, the Twelve Articles, demanded the establishment of "godly preaching" in the countryside as well as the abolition of recently revived feudal dues and taxes. The war was bitterly suppressed, an event that Luther sanctioned in the spring of 1525.

Penance: One of the seven sacraments of the medieval church, also known as confession. The word "penance" also refers to the specific acts that are given to Christians as punishment for sin after confession to a priest. Sixteenth-century Protestants rejected penance as a sacrament.

Petrarchism: In literature, the effort to imitate the style of Francesco Petrarch (1304–1374), an effort that was particularly strong among some writers in early sixteenth-century Italy.

Philology: The study of words and literature in their historical context which reveals changes language has undergone over time.

Pièta: Literally, "Pity." Any depiction of the dead Christ being mourned. Among the most famous is Michelangelo's High-Renaissance masterpiece of the same name.

Pietra Serena: A blue-gray stone typically used to ornament the interiors of buildings in Florence and surrounding Tuscany. The contrast between *pietra serena* and white plaster became a design principle in the early Renaissance works of Filippo Brunelleschi, and the use of this decorative style survived in the region until the nineteenth century.

Plainsong: A style of unison chanting used in the medieval and Renaissance church.

Platonism: A philosophy that develops out of the key ideas of the ancient figure Plato. Revivals of Platonism have occurred throughout Western history. In medieval Europe, the efforts of the scholastic philosophers popularized realism, a philosophy derived in part from his works. Later the Renaissance Platonists of the late fifteenth century studied the philosopher's works more vigorously, giving rise to attempts to harmonize Platonism with Christianity, like Marsilio Ficino's at Florence.

Pleiades: A group of French poets who in the second half of the sixteenth century tried to imitate the literary style of ancient Greece.

Politiques: A body of political philosophers in late sixteenth-century France who argued that allegiance to the king and his state should take precedence over the attempt of Protestants and Catholics to establish religious uniformity.

Polyglot Bible: Editions of the Bible that contained several different ancient versions printed side by side. These

allowed scholars to study several different versions of the text at once. The most famous of several printed Polyglot Bibles produced in Renaissance Europe arose from the University of Alcalà in the early sixteenth century, and was known as the Complutensian Polyglot.

Polyphony: A style of musical composition in which two or more voices are arranged around each other in complementary fashion.

Poulaine: A pointed-toe shoe popular in Burgundy, France, and other court cultures in the fifteenth century. Poulaines had no heels and were usually made from felt. In dance, they extended the line of the foot, making a dancer appear more elegant. Very much in fashion at the end of the fifteenth century, they were to be replaced with new heeled and soled shoes in the sixteenth century.

Predestination: The belief that God determines a person's salvation or damnation before one is even born.

Privy Council: The private council of the monarch in England, which met regularly to advise the king or queen on royal policies.

Protestantism: A term that originates from a protest staged during the Imperial Diet at Augsburg in 1529. Originally coined to describe the followers of Martin Luther, it very quickly began to be used for anyone who rejected the power of the pope and the teachings of the Roman Church.

Quadrivium: The four mathematical arts of the liberal arts curriculum: arithmetic, geometry, music, and astronomy.

Radical Reformation: A third wing of the Reformation that developed more extreme teachings than Lutheranism and Calvinism. Radical Reformers frequently evidenced a concern for separating their churches from society's wickedness, for purifying it of all medieval traditions, and with imitating the life of the ancient church.

Real Presence: The notion that in the performance of the Eucharist, Christ's presence comes to reside in the bread and wine of the service.

Realism: The philosophical school of thought that teaches that the mind understands what the senses present to it because it recognizes these things from higher universal concepts.

Recusants: English Catholics who practiced their religion in secret for fear of persecution at the hands of Protestant authorities.

Reformed Christianity: The second major branch of the Reformation to develop, originating in the Zürich of

Zwingli and the Geneva of John Calvin. Those who practiced Reformed Christianity focused on purifying the church of customs and practices that had no scriptural foundation. Worship was more severe and unadorned than in the Lutheran or Anglican tradition, although the Puritans, followers in the Reformed tradition, came to agitate for these kinds of reforms in the Church of England.

Relief: A mode of sculpture in which human forms, landscape, and other pictorial devices are carved into a surface plane of stone or marble or forged in bronze or other metals.

Reliquary: A vessel created to house the bones, teeth, or other remains of a saint.

Reuchlin Affair: A dispute that raged in Germany in the first two decades that involved the famous Hebraist Johannes Reuchlin. His efforts to extend knowledge of Hebrew among scholars were opposed by the recent Jewish convert Johann Pfefferkorn, prompting more than ten years of debate and bitter dispute over the issue of Jewish books.

Revolt of the Ciompi: A rebellion begun in 1378 by the wool carders at Florence and joined by other minor guild members in the city. They demanded their own guilds by which they might oppose the high-handed tactics of the great masters who dominated these institutions. After six weeks in power the Ciompi were defeated.

Rhetoric: The art of speaking and writing gracefully in order to convince others of one's position. Humanists very much prized this skill.

Romance: A verse or prose genre that was often based on legend and in which the code of chivalry usually played a strong role.

Rondeau: A melodic song that originated in medieval France that made use of a two-part refrain.

Royal Entries: A ceremony popular in the later Middle Ages and Renaissance in which kings entered the major cities of their realm. Entries grew to be increasingly imposing occasions for showing off royal power.

Rustication: The intentional use of rough-hewn stone in a wall.

Sacraments: Ceremonies in the medieval church believed to result in the transfer of divine grace to those who participated in them and to work a benefit upon the soul of the Christian. In the medieval church there were seven sacraments: Baptism, Confirmation, Penance, Eucharist, Holy Orders, Marriage, and Extreme Unction. Protes-

tants generally reduced the number of sacraments from seven to two.

Sarabande: A dance of Spanish origin that became wildly popular in Iberian cities at the end of the sixteenth century, prompting attempts on the part of state and urban officials to prohibit it. The sarabande was feared in its early history as lewd and sexually lascivious, although it soon made its way into courtly society in the seventeenth century, where it became a staid and stately dance.

Schleitheim Confession: The statement of religious belief set down in the Swiss village of Schleitheim in 1527 that encapsulated the teachings of the young Anabaptist faith. The confession expressed a Christianity that was rooted in community, which did away with the elaborate ritual of the medieval church, and which was intended to isolate the Anabaptists from the wickedness of the world.

Schmalkaldic League: A league of Protestant cities and territories active in Germany in the 1540s and 1550s in opposing the plans of the emperor to enforce a single religion on Germany. The name derives from the small town of Schmalkalden, where the league was first founded.

Scholasticism: A medieval philosophical movement that long dominated education in Europe's universities. The scholastics used a rational method of argument to arrive at truth and were consequently masters of the arts of logic.

Scotism: One form of scholasticism that traces its origins to the ideas of John Duns Scotus, a Scottish philosopher who died in 1308. Scotus emphasized philosophical realism and the importance of the human will, and he tried to harmonize the conflicting teachings of Aristotle and Plato. Scotism was particularly popular in the fourteenth- and fifteenth-century universities, and its founder was known as the "subtle doctor."

Seven Liberal Arts: The secondary educational curriculum that usually provided preparation to enter a university. The arts were divided into the literary disciplines (grammar, rhetoric, and logic) known as the trivium, and four mathematical arts (arithmetic, music, astronomy, and geometry) known as the quadrivium.

Sfumato: An Italian word that describes the painting of atmosphere.

Shrove Tuesday Plays: Plays performed on the Tuesday before Ash Wednesday. These works, known in German as *Fastnachtspiele* were particularly popular in that country, where they were often staged by young apprentices and journeymen as a form of release before the beginning of Lent. They often made use of raucous and bawdy humor

in the later Middle Ages. During the Reformation the sexual humor was toned down as writers like Hans Sachs, the Meistersinger of Nuremberg, transformed the Shrove Tuesday plays into vehicles for promoting Lutheran morality.

Slashing: The custom of making cuts in the layers of Renaissance clothing so that the elaborate undergarments showed through.

Sonnet: A poem of fourteen lines that was Italian in origin and perfected first in the great sonnets of Francesco Petrarch (1304–1374). During the Renaissance the form, usually written in an iambic pentameter rhyme scheme, was adopted in many European languages, including English. The sonnets of William Shakespeare are some of the highest expressions of this short form.

Sprezzatura: Meaning "effortless" or done "with graceful ease." The concept of *sprezzatura* is frequently mentioned in much Italian writing on painting, sculpture, and literature. The ability to do difficult things so that they appeared easy was widely admired at the time, and was also celebrated in works like Baldassare Castiglione's *Book of the Courtier* as a necessary skill of the astute courtier.

Statutes of Provisors and Praemunire: Laws enacted by Parliament in England that limited the power of the church. In 1351 the Statute of Provisors claimed for the king the right to appoint bishops and archbishops, while the somewhat later Statute of Praemunire (1353) forbade English subjects from appealing to Rome in legal cases.

Sumptuary Laws: Laws common throughout Europe in the Renaissance that were designed to regulate the expense of clothes and the displays surrounding celebrations of weddings and the observance of funerals.

Tempera: A method of painting commonly employed in medieval and Renaissance Italy in which pigments were suspended in egg whites before being applied to panels.

Theatines: An order of priests established by Gaetano da Thiene in 1524 with the express purpose of raising the standard of clerical morality and fighting heresy.

Theocracy: A government in which clerical figures share power with state officials. John Calvin's Geneva is commonly identified as one of the theocracies of the sixteenth century.

Thomism: The rationalistic philosophical method perfected by St. Thomas Aquinas (1225–1274), a scholastic theologian. Thomas made use of the philosophical concept of realism, a teaching that posits that the human mind comprehends what is presented to it by the senses

because it recognizes these concepts from higher universals.

Tragicomedy: A literary and theatrical genre that began to emerge in Italy in the late sixteenth century that merged both tragic and comic elements. Often these tales were enacted in pastoral settings.

Transubstantiation: The orthodox teaching of the medieval church that the bread and wine used in the Eucharist are transformed into the physical body and blood of Christ. All Protestants rejected this teaching in the sixteenth century.

Triptych: A religious image or statue that is carved or painted on three panels that are hinged together.

Trivium: The three language disciplines of the liberal arts curriculum: rhetoric, logic, and grammar.

Trousseau: The gifts of clothing and household items that families made to their daughters as they entered marriage. Prospective husbands were often expected to counter these gifts with the presentation of an almost equally lavish counter-trousseau.

Twelve Articles: The manifesto adopted by the rebels of the German Peasants' War in 1524–1525. These demanded the establishment of "godly preaching" in villages and the abolition of recently enacted feudal dues and taxes.

Ursulines: A teaching order of nuns founded in Italy in the 1530s that exerted a significant influence on Catholic reform efforts in the later sixteenth century.

Vatican: The headquarters of the pope's government just outside the medieval and Renaissance town walls of the city of Rome. The word is often used to refer more generally to papal government.

Vernacular: The language that is native to a particular region, such as French to France, and German to Germany.

Virelais: A lively French song popular in the later Middle Ages and Renaissance as an accompaniment to dances. The virelais form included a refrain that preceded and followed the work's two interior verses.

Virginalists: A group of English composers who composed keyboard variations at the end of the sixteenth century. Most notable among the Virginalists was William Byrd.

Volta: A sixteenth-century Italian dance in which couples moved around the floor in a tight embrace and at regular intervals the man raised the woman from the floor.

Vulgate: The ancient Latin translation of the Bible completed by St. Jerome and authorized for use in the medieval church. Erasmus and other humanists criticized the Vulgate's inadequacies in the sixteenth century.

Weser Renaissance: A flowering of great architectural distinction that occurred in late sixteenth-century Germany along and in the vicinity of the Weser River valley.

Woodcut: A print that was made by incising drawings or letters into wooden blocks. Although woodcutting continued to be used as a printing medium for pictures in the sixteenth century, it gradually came to be replaced by the process of copper engraving.

Zwinglianism: The religious teachings that trace their origins to the works of Ulrich Zwingli and the extreme reforms he made in church practice in the city of Zürich during the 1520s. Zwingli is less remembered today than in the sixteenth century because his influence over Reformed Christianity was gradually superseded by that of John Calvin.

FURTHER REFERENCES

GENERAL

John Bossy, *Christianity in the West, 1400–1700* (Oxford and New York: Oxford University Press, 1985).

Thomas A. Brady Jr., Heiko A. Oberman, and James D. Tracy, eds., *Handbook of European History during the Late Middle Ages, Renaissance and Reformation, 1400–1600.* 2 vols. (Leiden, Netherlands: Brill, 1994).

Euan Cameron, ed., *Early Modern Europe, An Oxford History* (Oxford and New York: Oxford University Press, 1999).

A. G. Dickens, *The Age of Humanism and Reformation; Europe in the Fourteenth, Fifteenth and Sixteenth Centuries* (Englewood Cliffs, N.J.: Prentice-Hall, 1972).

G. R. Elton, ed., *The Reformation 1520–1559.* Vol. II of *The New Cambridge Modern History.* 2nd ed. (Cambridge and New York: Cambridge University Press, 1990).

Paul F. Grendler, ed., *Encyclopedia of the Renaissance* (New York: Scribner, 1999).

John R. Hale, *The Civilization of Europe in the Renaissance* (New York: Atheneum, 1994).

De Lamar Jensen, *Reformation Europe: Age of Reform and Revolution.* 2nd ed. (Lexington, Mass.: Heath, 1992).

———, *Renaissance Europe: Age of Recovery and Reconciliation.* 2nd ed. (Lexington, Mass.: Heath, 1992).

H. G. Koenigsberger, George L. Mosse, G. Q. Bowler, *Europe in the Sixteenth Century.* 2nd ed. (London and New York: Longman, 1989).

Charles G. Nauert Jr., *Humanism and the Culture of Renaissance Europe* (Cambridge and New York: Cambridge University Press, 1995).

David Nichols, *The Later Medieval City, 1300–1500* (London and New York: Longman, 1997).

Steven E. Ozment, *The Age of Reform (1250–1550): An Intellectual and Religious History of Late Medieval and Reformation Europe* (New Haven, Conn.: Yale University Press, 1980).

Eugene F. Rice Jr. and Anthony Grafton, *The Foundations of Early Modern Europe, 1460–1559.* 2nd ed. (New York: Norton, 1994)

John Stephens, *The Italian Renaissance; The Origins of Intellectual and Artistic Change Before the Reformation* (London and New York: Longman, 1990).

James D. Tracy, *Europe's Reformations, 1450–1650* (Lanham, Md.: Rowman and Littlefield, 1999).

ARCHITECTURE

James S. Ackerman, *Palladio* (Harmondsworth, United Kingdom: Penguin Books, 1977).

Eugenio Battisti, *Filippo Brunelleschi: The Complete Work.* Trans. R. E. Wolf (New York: Rizzoli, 1981).

Creighton Gilbert, *History of Renaissance Art (Painting, Sculpture, Architecture) Throughout Europe* (New York: Abrams, 1973).

Richard Goldthwaite, *The Building of Renaissance Florence* (Baltimore, Md.: Johns Hopkins University Press, 1980).

Frederick Hartt and David G. Wilkins, *History of Italian Renaissance Art.* 5th ed. (New York: Abrams, 2003).

Henry-Russell Hitchcock, *German Renaissance Architecture* (Princeton, N.J.: Princeton University Press, 1981).

Deborah Howard, *The Architectural History of Venice* (New Haven, Conn.: Yale University Press, 2002).

Joan Kelly, *Leon Battista Alberti; Universal Man of the Early Renaissance* (Chicago: University of Chicago Press, 1969).

Francis W. Kent, *A Florentine Patrician and His Palace* (London: Warburg Institute, 1981).

Wolfgang Lotz, *Architecture in Italy.* Trans. Mary Hottinger (New Haven, Conn.: Yale University Press, 1995).

John F. Millar, *Classical Architecture in Renaissance Europe, 1419–1585* (Williamsburg, Va.: Thirteen Colonies Press, 1987).

Peter Murray, *The Architecture of the Italian Renaissance* (New York: Schocken Books, 1966).

———, *Architecture of the Renaissance* (New York: Abrams, 1971).

Frank D. Prager and Gustina Scaglia, *Brunelleschi: Studies of His Technology and Inventions* (Cambridge, Mass.: MIT Press, 1970).

Howard Saalman, *Filippo Brunelleschi: The Buildings* (London: Zwemmer, 1980).

Christine Smith, *Architecture in the Culture of Early Humanism* (New York: Oxford University Press, 1992).

Robert Tavernor, *Palladio and Palladianism* (London: Thames and Hudson, 1991).

Rudolf Wittkower, *Architectural Principles in the Age of Humanism* (Chichester, United Kingdom: Academy Editions, 1998).

DANCE

Mark Franko, *The Dancing Body in Renaissance Choreography* (Birmingham, Ala.: Summa Publications, 1986).

S. Howard, *The Politics of Courtly Dancing in Early Modern England* (Amherst, Mass.: University of Massachusetts Press, 1998).

The International Encyclopedia of Dance (New York: Oxford University Press, 1998).

Nigel Allenby Jaffé, *Folk Dance of Europe* (Skipton, United Kingdom: Folk Dance Enterprises, 1990).

Stanley Sadie, ed., *The New Grove Dictionary of Music and Musicians.* 2nd ed. (London: Macmillan, 2001).

Roy Strong, *Splendor at Court: Renaissance Spectacle and the Theater of Power* (Boston: Houghton, Mifflin, 1973).

FASHION

Millia Davenport, *The Book of Costume.* Vol. 1 (New York: Crown Publishers, 1972).

Georges Duby and Michelle Perrot, *A History of Women in the West.* Vol II of *Silences of the Middle Ages* (Cambridge, Mass.: Harvard University Press, 1992).

Carol Collier Frick, *Dressing Renaissance Florence; Families, Fortunes, and Fine Clothing* (Baltimore, Md.: Johns Hopkins University Press, 2002).

Alan Hunt, *Governance of the Consuming Passions: A History of Sumptuary Law* (New York: St. Martin's Press, 1996).

Rosalind Jones and Peter Stallybrass Jones, *Renaissance Clothing and the Materials of Memory* (Cambridge and New York: Cambridge University Press, 2000).

Catherine Kovesi Killerby, *Sumptuary Law in Italy, 1200–1500* (Oxford: Clarendon Press, 2002).

James Laver, ed., *Costume of the Western World* (New York: Harper and Brothers, 1951).

Luca Molà, *The Silk Industry of Renaissance Venice* (Baltimore, Md.: Johns Hopkins University Press, 2000).

Iris Origo, *The Merchant of Prato* (New York: Knopf, 1957).

LITERATURE

Peter Brand and Lino Pertile, eds., *The Cambridge History of Italian Literature* (Cambridge and New York: Cambridge University Press, 1996).

Grahame Castor, *Pléiade Poetics; A Study in Sixteenth-Century Thought and Terminology* (Cambridge: Cambridge University Press, 1964).

Eric Cochrane, *Historians and Historiography in the Italian Renaissance* (Chicago: University of Chicago Press, 1981).

John Cruickshank, ed., *French Literature and Its Background: Vol. 1 The Sixteenth Century* (London and New York: Oxford University Press, 1968).

Thomas M. Greene, *The Light in Troy: Imitation and Discovery in Renaissance Poetry* (New Haven, Conn.: Yale University Press, 1982).

Brad Gregory, *Salvation at Stake; Christian Martyrdom in Early Modern Europe* (Cambridge, Mass.: Harvard University Press, 2001).

James Hardin and Max Reinhart, *German Writers of the Renaissance and Reformation, 1280–1580* (Detroit: Gale Research, 1997).

Margaret King, *Women of the Renaissance* (Chicago: University of Chicago Press, 1991).

Jill Kraye, ed., *The Cambridge Companion to Renaissance Humanism* (Cambridge: Cambridge University Press, 1996).

Paul Oskar Kristeller, *Renaissance Thought and the Arts*. Rev. ed. (Princeton, N.J.: Princeton University Press, 1990).

Deborah Lesko, *The Subject of Desire: Petrarchan Poetics and the Female Voice in Louise Labé* (Lafayette, Ind.: Purdue University Press, 1996).

I. D. McFarlane, *Renaissance France, 1470–1589* (London and New York: Barnes & Noble Books, 1974).

Roy Pascal, *German Literature in the Sixteenth and Seventeenth Centuries: Renaissance, Reformation, Baroque*. 2nd ed. (Westport, Conn.: Greenwood, 1979).

David Quint, *Origins and Originality in Renaissance Literature* (New Haven, Conn.: Yale University Press, 1984).

Charles Trinkaus, *The Poet as Philosopher: Petrarch and the Formation of Renaissance Consciousness* (New Haven, Conn.: Yale University Press, 1979).

Helen Wanabe-O'Kelly, ed., *The Cambridge History of German Literature* (Cambridge: Cambridge University Press, 1997).

Retha M. Warnicke, *Women of the English Renaissance* (Westport, Conn.: Greenwood, 1983).

Richard Waswo, *Language and Meaning in the Renaissance* (Princeton, N.J.: Princeton University Press, 1987).

MUSIC

Allan W. Atlas, *Renaissance Music* (New York: Norton, 1998).

Friedrich Blume, *Renaissance and Baroque Music*. Trans. M. D. Herter Nelson (New York: Norton, 1967).

Howard M. Brown and Stanley Sadie, eds., *Performance Practice: Music Before 1600* (Basingstoke, United Kingdom: Macmillan, 1989).

Howard M. Brown and Louise K. Stein, *Music in the Renaissance*. 2nd ed. (Upper Saddle River, N.J.: Prentice-Hall, 1999).

Edward Doughtie, *English Renaissance Song* (Boston: Twayne Publishers, 1986).

Alfred Einstein, *The Italian Madrigal*. 3 vols. (Princeton, N.J.: Princeton University Press, 1949).

David Fallows, *Dufay* (London: J. M. Dent, 1987).

Ian Fenlon and James Haar, *The Italian Madrigal in the Early Sixteenth Century* (Cambridge and New York: Cambridge University Press, 1988).

Charles Garside Jr., *The Origins of Calvin's Theology of Music* (Philadelphia: American Philosophical Society, 1979).

———, *Zwingli and the Arts* (New Haven, Conn.: Yale University Press, 1966).

D. J. Grout and C. V. Palisca, *A History of Western Music*. 5th ed. (New York: 1996).

John Harley, *William Byrd: Gentleman of the Chapel Royal* (Aldershot, United Kingdom: Ashgate, 1997).

Joseph Kerman, *The Elizabethan Madrigal* (New York: American Musicological Society, 1962).

Peter LeHuray, *Music and the Reformation in England, 1549–1660* (New York: Oxford University Press, 1967).

Jeremy Montagu, *The World of Medieval and Renaissance Musical Instruments* (Newton Abbot, United Kingdom: David and Charles, 1976).

Ann E. Moyer, *Musica Scientia; Musical Scholarship in the Italian Renaissance* (Ithaca, N.Y. and London: Cornell University Press, 1992).

Claude V. Palisca, *The Florentine Camerata: Documentary Studies and Translations* (New Haven, Conn.: Yale University Press, 1989).

———, *Humanism in Italian Renaissance Musical Thought* (New Haven, Conn.: Yale University Press, 1985).

———, *Studies in the History of Italian Music and Music Theory* (Oxford and New York: Oxford University Press, 1994).

Nino Pirrotta, *Music and Culture in Italy from the Middle Ages to the Baroque* (Cambridge, Mass.: Harvard University Press, 1984).

Gilbert Reaney, *Guillaume de Machaut* (London: 1971).

Gustav Reese, *Music in the Renaissance*. Rev. ed. (New York: W. W. Norton & Company, 1959).

————, ed., *The New Grove High Renaissance Masters: Josquin, Palestrina, Lassus, Byrd, Victoria* (London and New York: Norton, 1984).

Gary Tomlinson, *Monteverdi and the End of the Renaissance* (New York and Oxford: Clarendon Press, 1987).

PHILOSOPHY

Hans Baron, *The Crisis of the Early Italian Renaissance: Civic Humanism and Republican Liberty in an Age of Classicism and Tyranny*. 2nd ed. (Princeton, N.J.: Princeton University Press, 1966).

Marcia L. Colish, *Medieval Foundations of the Western Intellectual Tradition* (New Haven, Conn.: Yale University Press, 1997).

Konrad Eisenbichler, ed., *Ficino and Renaissance Neoplatonism* (Ottawa, Canada: Dovehouse Editions, 1986).

Arthur M. Field, *The Origins of the Platonic Academy of Florence* (Princeton, N.J.: Princeton University Press, 1988).

Felix Gilbert, *Machiavelli and Guicciardini* (Princeton, N.J.: Princeton University Press, 1965).

Anthony Grafton and Lisa Jardine, *Defenders of the Text; The Traditions of Scholarship in an Age of Science, 1450–1800* (Cambridge, Mass.: Harvard University Press, 1991).

————, *From Humanism to the Humanities: Education and the Arts in Fifteenth- and Sixteenth-Century Europe* (London: Duckworth, 1986).

Denys Hay, *Europe in the Fourteenth and Fifteenth Centuries*. 2nd ed. (New York: Longman, 1989).

Paul Oskar Kristeller, *Renaissance Thought: The Classic, Scholastic and Humanist Strains*. Rev. ed. (New York: Harper, 1961).

Heiko A. Oberman, *The Harvest of Medieval Theology: Gabriel Biel and Late Medieval Nominalism* (Cambridge, Mass.: Harvard University Press, 1963).

Richard H. Popkin, *The History of Skepticism from Erasmus to Spinoza* (Berkeley: University of California Press, 1979).

Albert Rabil Jr., ed., *Renaissance Humanism: Foundations, Forms, and Legacy*. 3 vols. (Philadelphia: University of Pennsylvania Press, 1988).

Erika Rummel, *The Humanist Scholastic Debate in the Renaissance and Reformation* (Cambridge, Mass.: Harvard University Press, 1995).

Charles B. Schmitt, et al., eds., *Cambridge History of Renaissance Philosophy* (Cambridge and New York: Cambridge University Press, 1988).

Jerrold E. Siegel, *Rhetoric and Philosophy in Renaissance Humanism: The Union of Eloquence and Wisdom, Petrarch to Valla* (Princeton, N.J.: Princeton University Press, 1968).

Lewis W. Spitz, *The Religious Renaissance of the German Humanists* (Cambridge, Mass.: Harvard University Press, 1973).

Charles E. Trinkaus, *In Our Image and Likeness: Humanity and Divinity in Renaissance Thought* (Chicago: University of Chicago Press, 1971).

————, *The Scope of Renaissance Humanism* (Ann Arbor, Mich.: University of Michigan Press, 1983).

Roberto Weiss, *The Renaissance Discovery of Classical Antiquity*. 2nd ed. (Oxford and New York: Oxford University Press, 1988).

Donald G. Wilcox, *In Search of God and Self: Renaissance and Reformation Thought* (Boston: Houghton Mifflin, 1975).

Ronald G. Witt, *In the Footsteps of the Ancients: The Origins of Humanism from Lovato to Bruni* (Leiden, Netherlands: E. J. Brill, 2000).

RELIGION

Jodi Bilinkoff, *The Avila of St. Teresa: Religious Reform in a Sixteenth-Century City* (Ithaca, N.Y.: Cornell University Press, 1989).

William J. Bouwsma, *John Calvin; A Sixteenth-Century Portrait* (London and New York: Oxford University Press, 1988).

Thomas A. Brady Jr., *Turning Swiss: Cities and Empire, 1450–1550* (Cambridge and New York: Cambridge University Press, 1985).

Caroline Bynum, *Holy Feast and Holy Fast: The Religious Significance of Food to Medieval Women* (Berkeley, Calif.: University of California Press, 1988).

Pierre Chaunu, ed., *The Reformation.* Trans. V. Acland (Gloucester: Alan Sutton, 1989).

Natalie Z. Davis, *Society and Culture in Early Modern France* (Stanford: Stanford University Press, 1975).

Jean Delumeau, *Catholicism between Luther and Voltaire* (London: Burns and Oates, 1977).

A. G. Dickens, *The German Nation and Martin Luther* (London: Harper & Row, 1974).

Eamon Duffy, *The Stripping of the Altars: Traditional Religion in England, c. 1400–c. 1580* (New Haven, Conn.: Yale University Press, 1992).

Mark Greengrass, *The French Reformation* (Oxford and New York: Oxford University Press, 1987).

R. Po-Chia Hsia, *Social Discipline in the Reformation* (London and New York: Routledge, 1989).

Richard Marius, *Martin Luther* (Cambridge, Mass.: Harvard University Press, 1999).

A. Lynn Martin, *The Jesuit Mind* (Ithaca, N.Y.: Cornell University Press, 1978).

Alistair McGrath, *A Life of John Calvin* (Cambridge, Mass.: Harvard University Press, 1990).

John T. McNeil, *The History and Character of Calvinism* (New York: Oxford University Press, 1954).

William Meissner, *Ignatius of Loyola* (New Haven, Conn.: Yale University Press, 1992).

Suzanne Noffke, *Catherine of Siena: Vision through a Distant Eye* (Collegeville, Minn.: Michael Glazier, 2000).

Francis Oakley, *The Western Church in the Later Middle Ages* (Ithaca, N.Y.: Cornell University Press, 1979).

Heiko A. Oberman, *Luther: Man Between God and the Devil* (New Haven, Conn.: Yale University Press, 1989).

John C. Olin, *Catholic Reform: From Cardinal Ximenes to the Council of Trent* (New York: Fordham University Press, 1990).

John O'Malley, *The First Jesuits* (Cambridge, Mass.: Harvard University Press, 1993).

Lyndal Roper, *The Holy Household: Religion, Morals and Order in Reformation Augsburg* (Oxford and New York: Oxford University Press, 1989).

J. J. Scarisbrick, *The Reformation and the English People* (Oxford and New York: Oxford University Press, 1984).

R. W. Scribner, *For the Sake of Simple Folk: Popular Propaganda for the German Reformation* (Cambridge and New York: Cambridge University Press, 1981).

Lewis W. Spitz, *The Protestant Reformation 1517–1559* (New York: Harper and Row, 1985).

W. P. Stephens, *The Theology of Huldrych Zwingli* (London and New York: Oxford University Press, 1986).

Gerald Strauss, *Luther's House of Learning: Indoctrination of the Young in the German Reformation* (Baltimore, Md.: Johns Hopkins University Press, 1978).

R. N. Swanson, *Religion and Devotion in Europe, c. 1215–c. 1515* (Cambridge: Cambridge University Press, 1995).

Thomas N. Tentler, *Sin and Confession on the Eve of the Reformation* (Princeton, N.J.: Princeton University Press, 1978).

Keith Thomas, *Religion and the Decline of Magic: Studies in Popular Beliefs in Sixteenth- and Seventeenth-Century England* (London: Scribner, 1971).

Allison Weber, *Teresa of Avila and the Rhetoric of Feminity* (Princeton, N.J.: Princeton University Press, 1990).

George Huntston Williams, *The Radical Reformation* (Philadelphia: Westminster Press, 1962).

THEATER

Martin Banham, ed., *The Cambridge Guide to World Theatre* (Cambridge: Cambridge University Press, 1988).

Charles P. Brand, *Torquato Tasso* (Cambridge: Cambridge University Press, 1965).

A. R. Braunmiller and Michael Hattaway, *The Cambridge Companion to English Renaissance Drama* (Cambridge and New York: Cambridge University Press, 1990).

Michael D. Bristol, *Carnival and Theater: Plebeian Culture and the Structure of Authority in Renaissance England* (New York: Methuen, 1985).

Christopher Cairns, *The Commedia dell'Arte from the Renaissance to Dario Fo* (Lewiston: E. Mellen, 1989).

Louise G. Clubb, *Italian Drama in Shakespeare's Time* (New Haven, Conn.: Yale University Press, 1989).

Marvin Herrick, *Italian Comedy in the Renaissance* (Urbana, Ill.: University of Illinois Press, 1960).

———, *Italian Tragedy in the Renaissance* (Urbana, Ill.: University of Illinois Press, 1965).

Brian Jeffrey, *French Renaissance Comedy* (Oxford: Clarendon Press, 1969).

George R. Kernodle, *The Theatre in History* (Fayetteville, Ark.: University of Arkansas Press, 1989).

Dennis Looney, *Compromising the Classics: The Canonization of Orlando Furioso* (Detroit: Wayne State University Press, 1996).

Irving L. Matus, *Shakespeare, in Fact* (New York: Continuum, 1994).

Russ McDonald, *The Bedford Companion to Shakespeare: An Introduction with Documents* (Boston: Bedford Books, 1966).

Cesare Molinari, *Theatre Through the Ages* (New York: McGraw-Hill, 1972).

Steven Mullaney, *The Place of the Stage: License, Play, and Power in Renaissance England* (Chicago: University of Chicago Press, 1988).

Charles Nicholl, *The Reckoning: The Murder of Christopher Marlowe* (London: J. Cape, 1992).

Roy Strong, *Art and Power: Renaissance Festivals, 1450–1650* (Berkeley: University of California Press, 1984).

Simon Trussler, *Cambridge Illustrated History of British Theater* (New York: Cambridge University Press, 1994).

Glynne Wickham, *The Medieval Theatre*. 3rd ed. (Cambridge: Cambridge University Press, 1987).

VISUAL ARTS

Michael Baxandall, *The Limewood Sculptors of Renaissance Germany* (New Haven, Conn.: Yale University Press, 1980).

————, *Painting and Experience in Fifteenth-Century Italy* (Oxford and New York: Oxford University Press, 1972).

David A. Brown, *Leonardo da Vinci: Origins of a Genius* (New Haven, Conn.: Yale University Press, 1998).

Kenneth Clark, *The Art of Humanism* (London: J. Murray, 1983).

Charles D. Cuttler, *Northern Painting from Pucelle to Bruegel* (New York: Holt, Rinehart, and Winston, 1968).

Richard A. Goldthwaite, *Wealth and the Demand for Art in Italy, 1300–1600* (Baltimore, Md.: Johns Hopkins University Press, 1993).

Frederick Hartt and David G. Wilkins, *History of Italian Renaissance Art* (New York: Abrams, 2003).

Norbert Huse and Wolfgang Wolters, *The Art of Renaissance Venice: Architecture, Sculpture, and Painting 1460–1590.* Trans. Edmund Jephcott (Chicago: University of Chicago Press, 1990).

Jane Campbell Hutchison, *Albrecht Dürer* (Princeton, N.J.: Princeton University Press, 1990).

Roger Jones and Nicholas Penny, *Raphael* (New Haven, Conn.: Yale University Press, 1983).

Hayden B. J. Maginnis, *Painting in the Age of Giotto: A Historical Reevaluation* (University Park, Pa.: Pennsylvania State University Press, 1997).

Linda Murray, *Michelangelo: His Life, Work, and Times* (London: Thames and Hudson, 1984).

John T. Paoletti and Gary M. Radke, *Art in Renaissance Italy* (New York: H. N. Abrams, 1997).

John Pope-Hennessy, *The Portrait in the Renaissance* (Princeton, N.J.: Princeton University Press, 1989).

John Shearman, *Mannerism; Style and Civilization* (Harmondsworth, United Kingdom: Penguin, 1967).

Alastair Smart, *The Renaissance and Mannerism in Italy* (New York: Harcourt, Brace, 1971).

————, *The Renaissance and Mannerism in Northern Europe and Spain* (New York: Thomson, 1972).

James Snyder, *Northern Renaissance Art: Painting, Sculpture, and the Graphic Arts from 1350 to 1575* (Englewood Cliffs, N.J.: Prentice-Hall, 1985).

Charles de Tolnay, *Michelangelo: Sculptor, Painter, Architect* Trans. Gaynor Woodhouse (Princeton, N.J.: Princeton University Press, 1975).

Martin Wackernagel, *The World of the Florentine Renaissance Artist: Projects and Patrons, Workshop and Art Market.* Trans. Alison Luchs (Princeton, N.J.: Princeton University Press, 1981).

MEDIA AND ONLINE SOURCES

GENERAL

Christian Classics Ethereal Library (http://www.ccel.org)—One of the oldest online databases of "public access" texts, this website is now a venerable mainstay of the academic community. Located at Wheaton College in Illinois it provides highly readable online versions of major classics in the Christian tradition. Its collection is particularly rich in works treating the Renaissance centuries.

The Complete Works of William Shakespeare (http://the-tech.mit.edu/Shakespeare/)—Maintained at the Massachusetts Institute of Technology (MIT), this website has the complete texts of the bard's plays and sonnets.

Folger Shakespeare Library (http://www.folger.edu/Home_02B.html)—Long one of the most venerable resources for the study of William Shakespeare and his time, the Folger Library's website provides wonderful online exhibits and a plethora of information for those that want to study Renaissance English literature.

Heritage: Civilization and the Jews (1984)—Episodes Four and Five of this PBS series explore the interplay between Judaism and Christianity in Renaissance and early-modern Europe and stress, in particular, the role that Jewish knowledge and philosophy played on the development of European intellectual life.

In Search of Shakespeare (2003)—This four-part PBS series narrated by historian Michael Wood explores the world of late-sixteenth-century England and its greatest poet, William Shakespeare.

Luminarium (http://www.luminarium.org/lumina.htm) This unique anthology of English literary sources from the medieval, Renaissance, and early-modern periods includes online texts of most of the major playwrights of Elizabethan England, or links to where they may be found on the Internet.

A Man for All Seasons (1966)—Although it is not altogether historically reliable, this sympathetic portrait of Sir Thomas More recreates the dangers and excitement of life in Tudor times. Rated G.

The Medici: Godfathers of the Renaissance (2003) This Lion Television documentary details the relationships between the famous Florentine family and the art, culture, and philosophy of the Renaissance. It highlights the development of Niccolò Machiavelli's political philosophy as well as other elements of Florence's learned culture in the fifteenth and sixteenth centuries.

The Western Tradition (1989)—Episodes 23 to 27 of this 52-part series explore the history of late-medieval and Renaissance Europe. The series is beautifully illustrated and consists of lectures given by noted UCLA historian Eugen Weber.

ARCHITECTURE

archINFORM (http://www.archinform.net/)—This international database contains information about major architectural monuments from the European past. The website allows for searching, and includes photographs and brief summaries of the significance of each monument.

445

Civilisation (1969)—Although its production values are now somewhat dated, Kenneth Clark's series still manages to present an enormous amount of information about the culture of the Renaissance. Episodes four to six treat the history of the period.

Florence: Birthplace of the Renaissance (1992)—This documentary explores the importance of Florence's early Renaissance art and architecture.

Michelangelo: Matter and Spirit (1992)—This film explores the multi-faceted career of the great Renaissance genius as a sculptor, painter, and architect.

Palladio (1996)—Produced by Increase Video, this documentary explores the architecture of the great northern Italian designer Andrea Palladio.

Renaissance and Baroque Architecture (http://www.lib.virginia.edu/dic/colls/arh102/)—This website features an online collection of images of Renaissance and Baroque architectural monuments from the University of Virginia's Library.

The Vatican (http://www.vatican.va/)—The website of the Vatican includes information on the rich architectural and artistic collections of Roman Catholicism's capital.

Vitruvio.ch (http://www.vitruvio.ch/)—This database of major architectural monuments is particularly strong in listings from early-modern Europe. The website includes photographs, brief bibliographies, and other information about the monuments. It also provides for searching of major architects and the buildings they designed.

DANCE

European Dance Information Research Directory (http://www.c3.hu/~dienesbu/)—This website is a major European clearinghouse for specialists and students interested in the history of dance. The directory includes a country-by-country listing of institutes and performing groups.

Dancetime! 500 Years of Social Dance (2001)—The first volume in this series treats the history of European dance from the fifteenth to the nineteenth centuries.

The Diamond of Ferrara: Music from the Court of Ercole I (2001)—This recording features music from the famous Renaissance court, where the famous Domenico da Piacenza was dancing master and a court composer. It is recorded on the Dorian label.

Early Dance, Part I (1995)—This video covers the history of dance from the Greeks through the Renaissance. It is narrated by Hal Bersohn, and demonstrates the pavan, galliard, saltarella, canarie, and volta—all popular Renaissance dances.

How to Dance Through Time (2000)—Volume III in this six-part video series teaches the social dances of the Renaissance era, and focuses on the social history of the art in the era.

Il ballarino: The Art of Renaissance Dance (1990)—Compiled and narrated by noted dance historian Julia Sutton, this video explores the art of dancing during the Renaissance. Its focus is primarily on the popular Italian dances of the sixteenth century, and the presentation includes a demonstration of how to perform the necessary steps.

The Institute for Historical Dance Practice (http://www.historicaldance.com/)—This Belgian institute is dedicated to research concerning the performance of Renaissance and Baroque dance. Its website includes many informative links as well as information on European dancing from the fifteenth to the nineteenth centuries.

Negri: Le gratie d'Amore (2000)—Early music performing group Ensemble La Folia performs music for dances in Cesare Negri's manual *The Grace of Love*. Recorded on the Dynamic label.

Thoinot Arbeau, Orchesography (1993)—The New York Renaissance Band performs music for Thoinot Arbeau's famous Renaissance dance manual. Recorded on the Arabesque Recordings label.

Western Social Dance: An Overview of the Collection (http://memory.loc.gov/ammem/dihtml/diessay0.html)—This Library of Congress website reviews the dance instruction manuals published in Europe since the Renaissance. Of particular interest are the video clips of dance steps practiced during the Baroque period.

FASHION

Bata Shoe Museum (http://www.batashoemuseum.ca/)—This collection of this Canadian museum includes footwear from the Renaissance.

Early Modern Resources: Dress and Fashion (http://www.earlymodernweb.org.uk/emdress.htm)—This website provides links to any number of sites exploring the importance of the regulation of dress and the conventions that governed fashion in Renaissance Europe.

Elizabeth (1998)—Although the historical veracity of this film by Shekhar Kapur is gravely suspect, the costume and set design is outstanding. Rated R.

The Elizabethan Costuming Page (http://costume.dm.net/)—This website explores the role of dress in Elizabethan England.

Romeo and Juliet (1968)—Another production from veteran Italian producer Franco Zeffirelli which, though not completely historically accurate, still manages to capture the fashions of early Renaissance Italy. Rated PG.

Shakespeare in Love (1998)—While not an historically accurate portrayal of the life of Shakespeare, the costuming of this light-hearted work manages to capture the excesses of Elizabethan London. Rated R.

The Taming of the Shrew (1967)—This production from famed Italian director Franco Zeffirelli stars Elizabeth Taylor and Richard Burton. Although not completely historically accurate, it manages to capture the visual dimensions and fashions of life in a sixteenth-century Italian city quite admirably. Rated PG.

LITERATURE

Decameron (1970)—This film from innovative Italian director Pier Paolo Pasolini manages to capture the good fun and bawdy sexual humor of Boccaccio's great fourteenth-century classic. Rated R.

The Decameron Web (http://www.brown.edu/Departments/Italian_Studies/dweb/)—This website offers a look at Boccaccio's time and his great masterpiece. It includes a complete English translation and commentary as well as a variety of information designed to enhance the reader's understanding of the *Decameron*.

Electronic Text Center (http://etext.lib.virginia.edu/french.html)—The University of Virginia's online center for electronic texts provides a special link to online versions of the French classics.

Project Gutenberg (http://promo.net/pg/)—The collections of the oldest online repository of e-texts are particularly rich in literature from the Renaissance period.

Renascence Editions (http://darkwing.uoregon.edu/~rbear/ren.htm)—This website maintained at the University of Oregon includes handsome online editions of major classics written in English between the fifteenth and late eighteenth centuries.

The Story of English (1986)—This nine-part PBS series is hosted by Robert McNeill and traces the evolution of the language with particular emphasis on the age of Shakespeare.

MUSIC

The Best of the Renaissance (1999)—This album is a moderately priced two-volume introduction to the music of the period. Available on the Philips label.

Classicalnet (http://www.classical.net)—An invaluable source for composers' biographies and information about the developments of musical forms and styles, this website also includes thousands of reviews, many by noted authorities, on current recordings of classical music.

The Cradle of the Renaissance. Italian Music from the Time of Leonardo da Vinci (1995)—Recorded by the early music group Sirinu, this CD includes a broad range of compositions from composers active in Italy during the late fifteenth and early sixteenth centuries. The recording is available on the Hyperion label.

Early Music Directory (http://www.earlymusic.org.uk)—This British website aims to be a clearinghouse of information on groups currently performing Renaissance music worldwide.

Early Venetian Lute Music (2000)—Available on the budget Naxos label, this recording of Venetian music for the lute introduces the most popular domestic instrument of the Renaissance. It features lutist Christopher Wilson.

The Essential Tallis Scholars. The First Thirty Years (1995)—This album is a retrospective collection of this venerable group of Renaissance music scholars' best recordings. Available on the Gimell label.

Here of a Sunday Morning (http://www.hoasm.org)—Maintained by noted early music enthusiast Chris Whent, producer for WBAI-New York, this website includes invaluable information about medieval and Renaissance composers and their music.

Josquin: Motets and Chansons (1983)—This album is a brilliant introduction to the music of Josquin des Prez, the figure who was celebrated as a musical equivalent to Michelangelo during the High Renaissance. The disc features the notable early music group, the Hillard Ensemble, and is available on the Virgin label.

Spem in Alium (1994)—Another one of the many fine recordings of Renaissance music by the Tallis scholars, this CD features the forty-voice motet, "Spem in alium," a tour de force of early music that points to the complexity and sophistication of Renaissance polyphony and counterpoint. Available on the Gimell label.

The Tallis Scholars Website (http://www.gimell.com/index.html)—The website of this respected Renaissance vocal consort includes information about their tours as well as their scholarship on the music of the period.

PHILOSOPHY

American Philosophical Association (http://www.apa.udel .edu/apa/index.html)—The APA's website contains a listing of philosophical texts available on the Internet.

The Great Books (http://www.anova.org/gb.html)— Sponsored by the Access Foundation, this website provides links to many of the best philosophical texts available on the Internet.

The Internet Encyclopedia of Philosophy (http://www.iep .utm.edu/)—This online resource of articles contains well written and thoughtful discussions of major philosophers throughout history.

Society for Medieval and Renaissance Philosophy (http:// www.lmu.edu/smrp/)—The links page of this academic society is particularly valuable in outlining the best resources concerning the history of philosophy on the web.

RELIGION

Anne of the Thousand Days (1969)—Although its lush sets and production values reveal more of a Hollywood mentality than that of sixteenth-century England, this film's dramatization of the circumstances leading to England's split from Rome still manages to capture the issues of the day.

Church and Reformation (http://www.bbc.co.uk/history/ state/church_reformation/index.shtml)—This BBC website includes a wealth of information about the course of the Reformation in England, as well as multimedia clips that offer tours of some of the most important churches in Britain.

Elizabeth R (1971)—This dramatization of the life of the great English queen stars Glenda Jackson in the title role. Nine hours in length, the series manages to capture most of the major dilemmas regarding religion that occurred during Elizabeth's reign.

English Literature and Religion (http://www.english.umd .edu/englfac/WPeterson/ELR/elr.htm)—This website at the University of Maryland includes a database bibliography of more than 8,500 works treating the history of religion in England. It also includes links to online versions of major religious texts, including the various versions of the Anglican *Book of Common Prayer*.

Luther (2003)—Starring Joseph Fiennes in the title role, this film explores the key events in the great sixteenth-century reformer's life. Rated PG-13.

Martin Luther (2001)—This two-hour PBS documentary explores the life and times of the famous Reformation leader. It includes interviews with modern Luther scholars, and is available from PBS in VHS and DVD formats.

Medieval Sourcebook: The Renaissance (http://www.fordham .edu/halsall/sbook1x.html)—This collection of complete sources and excerpts from Renaissance documents includes many which bear on the history of the church and religion in the Renaissance and Reformation.

Project Wittenberg (http://www.iclnet.org/pub/resources/ text/wittenberg/wittenberg-home.html)—This website offers online translations of many of Martin Luther's most influential works.

THEATER

Association for Classical Hispanic Theater (http://www .trinity.edu/org/comedia/index.html)—This academic association's website provides online translations of many *comedias*, Spanish dramas of the Golden Age.

Dr. Faustus (1968)—This film has its origins in a version of Christopher Marlowe's *Faustus* that Richard Burton staged at Oxford University in 1968. Burton reprised his role as Faustus in the movie version filmed one year later, and his then-wife Elizabeth Taylor is featured in cameo roles. Members of the Oxford Dramatic Society also act in the film.

Electronic Text Center (http://etext.lib.virginia.edu/ shakespeare/)—Located at the University of Virginia, this website offers links to the works of Shakespeare that are available online, as well as other major Renaissance dramatists.

Medieval and Renaissance Drama Society (http://acs2.byu .edu/~hurlbut/mrds/)—This academic society's website includes back issues of their journal treating the history of the theater and drama in the Middle Ages and Renaissance.

The Renaissance Stage: The Idea and Image of Antiquity (1990)—This excellent documentary explores the attempts of Italian Renaissance stage and theatrical designers to recreate the theater of antiquity. Available through Films for Humanities in Princeton, New Jersey.

Richard III (1956)—Starring Sir Laurence Olivier, this adaptation of the great Shakespeare history play is still unmatched for the quality of its dramatic intensity. Not rated.

Shakespeare and the Globe (1985)—Produced by the University of California at Berkeley's public television station,

this documentary explores the London stage of Shakespeare's time.

Société d'Histoire du Théâtre (http://www.sht.asso.fr/)—This French academic society's website includes issues of their journal treating the history of the theater in France.

VISUAL ARTS

Albrecht Dürer: Image of a Master (1994)—This video explores the great Northern Renaissance artist's role in spreading knowledge of Italian art among his colleagues and his influence on shaping the artistic revival in sixteenth-century Germany.

Alte Pinakothek, Munich (http://www.pinakothek.de/alte-pinakothek/index_en.php?)—One of Germany's most respected museums, this museum now has an easy-to-use website that features a clickable index of all artists and their works in its large collection.

Art of the Western World (1989)—Produced by WNET, New York, with funding from the Annenberg/CPB Project, this nine-part series treats the history of Western art from antiquity to modern times. Episodes three and four deal with the early and High Renaissance.

Galleria degli Uffizi, Florence (http://www.uffizi.firenze.it/)—This famous museum of Florentine and Italian Renaissance art also has a wonderful website that even includes a virtual tour of the museum.

Giotto: The Arena Chapel (1994)—This documentary explores the proto-Renaissance style of this great artist as displayed in Padua's Arena Chapel.

The Louvre, Paris (http://www.louvre.fr/louvrea.htm)—A handsome website from one of the world's greatest art museums, this site features a virtual tour of the highlights of the collection as well as a history of the museum itself.

The Louvre: The Visit (1998)—This documentary provides a guided private tour through the wealth of this great museum's collections.

Metropolitan Museum, New York (http://www.metmuseum.org/)—Certainly one of the finest of the world's museums, the Met's website is also a clear standout. Images of all its 2,200 paintings are accessible from its webpages.

The National Gallery, London (http://www.nationalgallery.org.uk/)—This London museum has a collection rich in the works of the Renaissance.

The National Gallery of Art, Washington, D.C. (http://www.nga.gov/)—The website of this Washington museum includes a virtual tour of its fine collections, which are particularly rich in Italian Renaissance works.

Piero della Francesca (1993)—This video explores one of this great early Renaissance artist's most enigmatic works, his *Flagellation*, and tries to unlock its secrets.

Renaissance: A Fresh Look at the Evolution of Western Art (2000)—Six one hour segments explore the history of art in the Renaissance. Shot on location throughout Europe, this series takes its viewers directly to the places in which the great masterpieces of the age were created. It also features commentary from the noted critic Graham Dixon.

The State Hermitage Museum, St. Petersburg (http://www.hermitagemuseum.org/html_En/index.html)—The collection of this, perhaps the largest museum in the world, includes 120 rooms displaying Western European art, with a particularly strong emphasis on the Italian and northern European Renaissances. The website of this vast museum can only show the highlights of this enormous collection.

The Vatican Museum, Rome (http://www.vatican.va/museums/)—The Vatican Museum's collections are particularly rich in Renaissance art, and the attractive website of this venerable institution offers a glimpse of this great wealth.

ACKNOWLEDGMENTS

The editors wish to thank the copyright holders of the excerpted material included in this volume and the permissions managers of many book and magazine publishing companies for assisting us in securing reproduction rights. Following is a list of the copyright holders who have granted us permission to reproduce material in this volume of Arts and Humanities Through the Eras. Every effort has been made to trace copyright, but if omissions have been made, please let us know.

COPYRIGHTED MATERIAL IN ARTS AND HUMANITIES THROUGH THE ERAS: RENAISSANCE EUROPE WAS REPRODUCED FROM THE FOLLOWING BOOKS:

Alberti, Leon B. From "On Painting," in *A Documentary History of Art Vol. II.* Edited by Elizabeth Holt. Princeton, 1958. Copyright © 1947, 1958 by Princeton University Press. Renewed 1986 by Elizabeth Gilmore Holt. All rights reserved. Reproduced by permission.—Alberti, Leon B. From "On the Art of Building," in *A Documentary History of Art, Vol. II.* Edited by Elizabeth Holt. Princeton, 1958. Copyright © 1947, 1958 by Princeton University Press. Renewed 1986 by Elizabeth Gilmore Holt. All rights reserved. Reproduced by permission.—Ambrosio, Giovanni. From "The Art of Dancing," in *Fifteenth-Century Dance and Music: Twelve Transcribed Italian Treatises and Collections in the Tradition of Domenico da Piacenza.* Edited by Wendy Hilton and translated by A. W. Smith. Pendragon Press, 1995. Copyright Pendragon Press 1995. Reproduced by permission.—Arbeau, Thoinot. From *Orchesography.* Translated by M. S. Evans. Dover Publications, Inc. Copyright © 1967 by Dover Publications, Inc. All rights reserved. Reproduced by permission.—Aretino, Pietro. From "To Titian," in *Italian Art, 1500–1600.* Edited and translated by R. Klein and H. Zerner. Prentice Hall, 1966. Reproduced by permission.—Barbaro, Francesco. From "On Wifely Duties," in *The Earthly Republic.* Edited and translated by B. G. Kohl and R. G. Witt. Pennsylvania University Press, 1978. Copyright © 1978 by Benjamin G. Kohl and Ronald G. Witt. All rights reserved. Reproduced by permission of the University of Pennsylvania Press.—Baxandall, Michael. From *Painting and Experience in Fifteenth Century Italy: A Primer in the Social History of Pictorial Style.* Oxford University Press, 1972. © Oxford University Press 1972. Reproduced by permission of Oxford University Press.—Bembo, Pietro. From "Book Two," in *Gli Asolani.* Translated by R. B. Gottfried. Books for Libraries Press, 1954. Copyright 1954 by Indiana University Press. Renewed 1982 by Rudolf B. Goffried. Reproduced by permission of Random House, Inc.—Boccaccio, Giovanni. From an introduction to *The Decameron.* Translated by G. H. McWilliam. Penguin Books, 1972. Copyright © G. H. McWilliam, 1972, 1995. All rights reserved. Reproduced by permission of Penguin Books, Ltd.—Boccaccio, Giovanni. From "Decameron: Tenth Day," in *The Decameron.* Translated by G. H. McWilliam. Penguin Books, 1972. Copyright © G. H. McWilliam, 1972, 1995. All rights reserved. Reproduced by permission of Penguin Books, Ltd.—Brandolini, Raffaele. From "On Music and Poetry," in *Raffaele Brandolini, On Music and Poetry (De musica et poetica, 1513).* Translated by

Ann E. Moyer. MRTS v. 232. Tempe, AZ: Arizona Center for Medieval and Renaissance Studies, 2001. Copyright Arizona Board of Regents for Arizona State University. Reproduced by permission.—Buonarroti, Michelangelo. From "Letter to Giorgio Varsari, May 1557," in *A Documentary History of Art, Vol. II.* Edited by Elizabeth Holt. Princeton, 1958. Copyright © 1947, 1958 by Princeton University Press. Renewed 1986 by Elizabeth Gilmore Holt. All rights reserved. Reproduced by permission.—Camerarius, Joachim. From "Four Books of Human Proportions," in *Northern Renaissance Art, 1400–1600: Sources and Documents.* Edited by Wolfgang Stechow. Prentice–Hall, Inc. © 1966 by Prentice–Hall, Inc. Used by permission of Prentice–Hall/A Division of Simon & Schuster, Upper Saddle River, NJ.—Caroso, Fabritio. From "How Gentlemen Should Conduct Themselves When Attending Parties," in *Nobilita Di Dame.* Translated by J. Sutton. Oxford University Press, 1986. Used by permission of Oxford University Press.—Erasmus, Desiderius. From "Fifth Rule," in *The Essential Erasmus.* Translated by John P. Dolan. New American Library, 1964. Copyright © 1964 by John P. Dolan. All rights reserved. Reproduced by permission of Dutton Signet, a division of Penguin Group (USA) Inc.—Ficino, Marsilio. From "Five Questions Concerning the Human Mind," in *The Renaissance Philosophy of Man.* Edited by E. Cassier, P. O. Kristeller, and J. H. Randall, Jr. The University of Chicago Press, 1948. Copyright 1948 by The University of Chicago. Renewed 1976 by Paul O. Kristeller. All rights reserved. Reproduced by permission.—Frick, Carole Collier. From *Dressing Renaissance Florence: Families, Fortunes, and Fine Clothing.* The Johns Hopkins University Press, 2002. © 2002 The Johns Hopkins University Press. All rights reserved. Reproduced by permission of The Johns Hopkins University Press.—Gonzaga, Ercole. From "Ercole Gonzaga to His Brother Ferrante," in *Italian Art, 1500–1600.* Edited and translated by R. Klein and H. Zerner. © 1966 by Prentice–Hall, Inc. Used by permission of Prentice–Hall/A Division of Simon & Schuster, Upper Saddle River, NJ.—Langschneider, Thomas. From "Part I,'" in *Letters of Obscure Men.* Translated by F. G. Stoke. University of Pennsylvania Press, 1964. Reproduced by permission of the University of Pennsylvania Press.—Luther, Martin. From a preface to *The Complete Edition of Luther's Latin Works (1545).* Translated by Andrew Thornton. © 1983 by Saint Anselm Abbey. Reproduced by permission.—Machiavelli, Niccolò. From "Prologue to 'The Mandrake'," in *The Comedies of Machiavelli.* Edited by David Sices and James B. Atkinson. Translated by David Sices. University Press of New England.

Copyright © 1985 by Trustees of Dartmouth College. Reproduced by permission.—Mander, Carel van. From "Life of Hieronymous Bosch," in *Northern Renaissance Art, 1400–1600: Sources and Documents.* Edited by Wolfgang Stechow. Northwestern University Press, 1989. All rights reserved. Reproduced by permission of Northwestern University Press.—Mander, Carel van. From "Life of Pieter Bruegel," in *Northern Renaissance Art, 1400–1600.* Edited by Wolfgang Stechow. Prentice–Hall, Inc., 1966. © 1966 by Prentice–Hall, Inc. All rights reserved. Used by permission of Prentice–Hall/A Division of Simon & Schuster, Upper Saddle River, NJ.—Manetti, Antonio. From "The Life of Flippo di Ser Brunellesco," in *A Documentary History of Art, Vol. II.* Edited by Elizabeth Holt. Princeton, 1958. Copyright © 1947, 1958 by Princeton University Press. Renewed 1986 by Elizabeth Gilmore Holt. All rights reserved. Reproduced by permission.—Montaigne, Michel de. From "Of Cannibals," in *The Complete Essays of Montaigne.* Translated by Donald M. Frame. Stanford University Press, 1958. © Copyright 1948, 1957, 1958, by the Board of Trustees of the Leland Stanford Junior University. Renewed 1986 by Donald M. Frame. All rights reserved. Reproduced with permission of Stanford University Press, www.sup.org.—Origo, Iris. From *The Merchant of Prato: Francesco Di Marco Datini.* Alfred A. Knopf, 1957. © Iris Origo, 1957. Reproduced by permission of The Estate of Iris Origo. In the U.S, P.I. by permission of Alfred A. Knopf, Inc., a division of Random House, Inc.—Paleotti, Gabriele. From "Pictures with Obscure and Difficult Meaning," in *Italian Art, 1500–1600.* Edited and translated by R. Klein and H. Zerner. Prentice Hall, 1966. © 1966 by Prentice–Hall, Inc. Reproduced by permission.—Palladio, Andrea. From "The Architecture of A. Palladio, in Four Books," in *A Documentary History of Art, Vol. II.* Edited by Elizabeth Holt. Princeton, 1958. Copyright © 1947, 1958 by Princeton University Press. Renewed 1986 by Elizabeth Gilmore Holt. All rights reserved. Reproduced by permission.—Perry, Mary E. From *Crime and Society in Early Modern Seville.* University Press of New England, 1980. © 1980 by The Trustees of Dartmouth. All rights reserved. Reproduced by permission.—Piacenza, Domenico da. From "Of the Art of Dancing," in *Fifteenth–Century Dance and Music: Twelve Transcribed Italian Treatises and Collections in the Tradition of Domenico da Piacenza.* Translated by A. W. Smith. Pendragon Press, 1995. Copyright Pendragon Press, 1995. Reproduced by permission.—Pico della Mirandola, Giovanni. From "Oration on the Dignity of Man," in *The Renaissance Philosophy of Man.* Edited by E. Cassirer, P. O. Kristeller, and John Herman Randall,

Jr. The University of Chicago Press, 1948. Copyright 1948 by The University of Chicago. Renewed 1976 by Paul O. Kristeller, University of Chicago. All rights reserved. Reproduced by permission.—Pizan, Christine de. From *The Book of the City of Ladies.* Translated by E. J. Richards. Persea Books, 1982. Copyright © 1982 by Persea Books, Inc. All rights in this book are reserved. Reproduced by permission.—Poliziano, Angelo. From *The Earthly Republic: Italian Humanists on Government and Society.* Edited by Benjamin G. Kohl & Ronald G. Witt. University of Pennsylvania Press, 1978. Copyright © 1978 by Benjamin G. Kohl and Ronald G. Witt. All rights reserved. Reproduced by permission of the University of Pennsylvania Press.—Poliziano, Angelo. From "Stanzas for a Jousting Match," in *The Stanze of Angelo Politian D. Quint.* Translated by D. Quint. Pennsylvania State University Press, 1993. Copyright © 1993 by Pennsylvania University Press. All rights reserved. Reproduced by permission of David Quint.—Raphael. From *A Documentary History of Art, Vol. II.* Edited by Elizabeth Holt. Princeton, 1958. Copyright © 1947, 1958 by Princeton University Press. Renewed 1986 by Elizabeth Gilmore Holt. All rights reserved. Reproduced by permission.—Valla, Lorenzo. From "Dialogue on Free Will," in *The Renaissance Philosophy of Man.* Edited by E. Cassier, Paul Oskar Kristeller, John Herman Randall, Jr. The University of Chicago Press, 1948. Copyright 1948 by The University of Chicago. Renewed 1976 by Paul O. Kristeller. All rights reserved. Reproduced by permission.—Veronese, Paolo. From "Testimony Before the Inquisition," in *Italian Art, 1500–1600, Sources and Documents.* Edited by Robert Klein and Henri Zerner. Prentice–Hall, Inc., 1966. © 1966 by Prentice–Hall, Inc. Used by permission of Prentice–Hall/A Division of Simon & Schuster, Upper Saddle River, NJ.

INDEX

P